Art, Power, and Patronage in Renaissance Italy

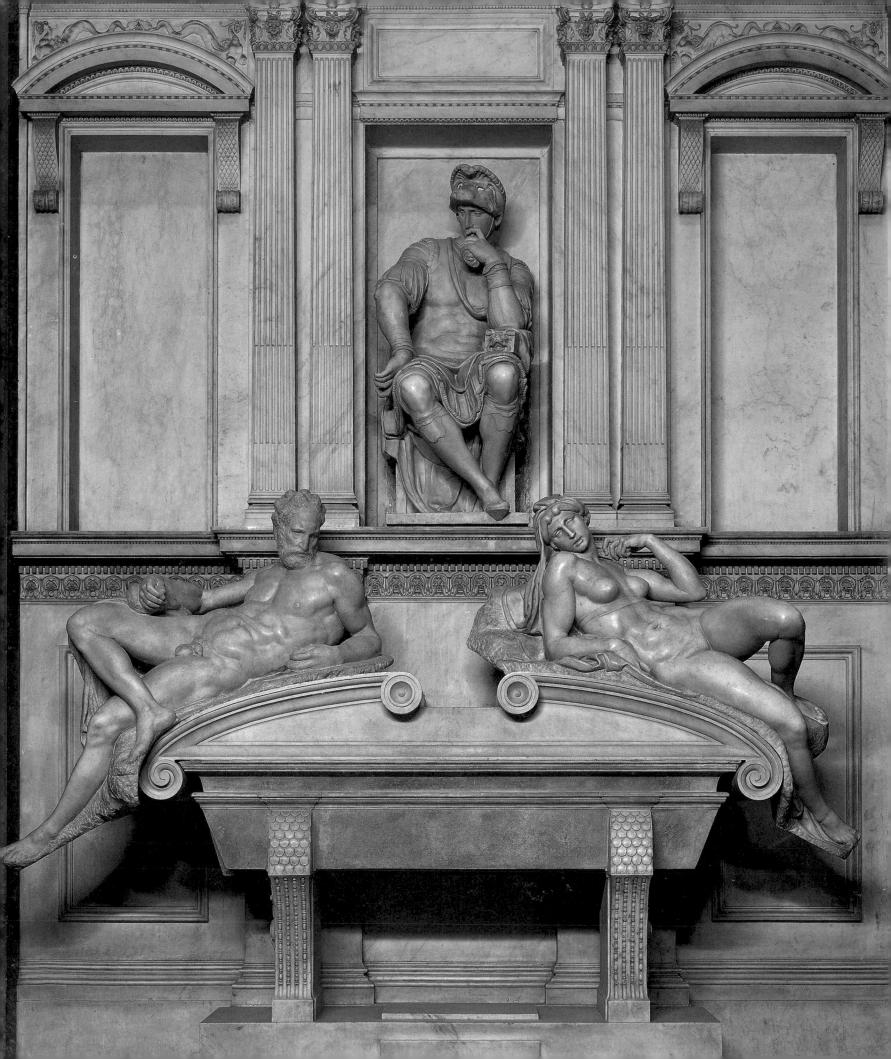

Art, Power, and Patronage in Renaissance Italy

Third Edition

John T. Paoletti Wesleyan University

Gary M. Radke Syracuse University

Library of Congress Cataloging-in-Publication Data

Paoletti, John T.

Art, Power, and Patronage in Renaissance Italy / John T. Paoletti, Gary M. Radke. -- 3rd ed. p. cm.

Includes bibliographical references and index.

ISBN 0-13-193510-0 (pbk) -- ISBN 0-13-193826-6 (trade case)

1. Art, Italian. 2. Art, Renaissance--Italy. 3. Italy--Civilization--1268-1559. I. Radke,

Gary M. II. Paoletti, John T. III. Title.

N6915.P26 2005 709'.45'09024--dc22

2005043146

Editor in Chief: Sarah Touborg Editorial Assistant: Keri Molonari Manufacturing Buyer: Ben Smith Marketing Manager: Sheryl Adams

Credits and acknowledgments borrowed from other sources and reproduced, with permission, in this textbook appear on page 566.

Copyright © 2005, 2002, 1997 John T. Paoletti & Gary M. Radke

Published 2005 by Pearson Education, Inc., Upper Saddle River, New Jersey, 07458.

Pearson Prentice Hall. All rights reserved. Printed in China. This publication is protected by Copyright and permission should be obtained from the publisher prior to any prohibited reproduction, storage in a retrieval system, or transmission in any form or by any means, electronic, mechanical, photocopying, recording, or likewise. For information regarding permission(s), write to: Rights and Permissions Department.

Pearson Prentice Hall $^{\mathsf{m}}$ is a trademark of Pearson Education, Inc.

Pearson® is a registered trademark of Pearson plc.

Prentice Hall® is a registered trademark of Pearson Education, Inc.

Pearson Education Ltd.

Pearson Education Australia PTY, Limited

Pearson Education Singapore, Pte. Ltd.

Pearson Education North Asia Ltd.

Pearson Education, Canada, Ltd.

Pearson Educación de Mexico, S.A. de C.V.

Pearson Education-Japan

Pearson Education Malaysia, Pte. Ltd.

This book was designed and produced by Laurence King Publishing Ltd., London www.laurenceking.co.uk

Every effort has been made to contact the copyright holders, but should there be any errors or omissions, Laurence King Publishing Ltd would be pleased to insert the appropriate acknowledgment in any subsequent printing of this publication.

Editor: Richard Mason

Picture Researcher: Sue Bolsom Typesetter: Marie Doherty

Designer: Ian Hunt

Front cover: Michelangelo Buonarroti, Creation of the Sun, Moon, and Planets, 1508-12,

Sistine Chapel, Rome. Fresco. Photo Vatican Museums.

Back cover: Michelangelo Buonarroti, Moses, c.1515, San Pietro in Vincoli, Rome. Marble. © Vincenzo Pirozzi, Rome.

Frontispiece: Michelangelo Buonarroti, Tomb of Lorenzo de' Medici, 1524-34, Medici Chapel, San Lorenzo, Florence. Marble. © Studio Fotografico Quattrone, Florence.

For Rebecca and Sarah and Lydía

Contents

Preface 10

Introduction: Art in Context 12

Contemporary Scene: Art and Offerings 15 Patronage 16 Artists' Workshops 17 The Image of the Artist 17 Workshop Training 18 Contracts 21 Contemporary Voice: An Artist's Life 21 Materials and Methods 22 The Painting Studio 23 Wall Painting 23 Contemporary Voice: Terms of Employment 24 Tempera and Oil Painting 26 Mosaic and Stained Glass 27 The Sculpture Workshop 28 Bronze Sculpture 31 Drawings 32 Architecture 33 Other Workshops 36 Print Media 36 Renovations and Restorations 37 Historiography and Methodology 42 Vasari's Three Ages 42 Contemporary Voice: Fashioning the Female Artist 43 Naming the Renaissance 44

The Late Thirteenth and the Fourteenth Century 47

1 The Origins of the Renaissance 48

St. Francis and the Beginnings of Renaissance Art 48
Francis of Assisi 49.

Contemporary Voice: Francis as Another Christ 50
The San Damiano Crucifix: Christus triumphans 50
Christus patiens 50
Defining St. Francis 52
St. Clare 53
Style and Meaning 53
Urban Contexts 55
Types of Cities 55

2 Rome: Artists, Popes, and Cardinals 56

Rome's Revival under Nicholas III 57 The Sancta Sanctorum 59 Contemporary Scene: Art and Miracles 60
Nicholas IV at Santa Maria Maggiore 61
Patrons from the Papal Curia 62
Pope Boniface VIII and an Imperial Language
of Power 64
Creating Images for an Absent Papacy 65

3 Assisi and Padua: Narrative Realism 67

Frescoes in San Francesco 69
Nave Frescoes 69
Contemporary Voice: St. Francis and the Christ Child 70
Padua: The Scrovegni Chapel 71

4 Florence: Traditions and Innovations 77

St. John the Baptist and the Baptistry 79 The Palazzo della Signoria and Urban Planning 80 Contemporary Scene: Art and Violence 82 Mendicant Churches 82 Santa Croce and Santa Maria Novella 82 Altarpieces Dedicated to the Virgin 84 Cimabue's Altarpiece for Santa Trinità 84 Duccio's Altarpiece for the Confraternity of the Laudesi 85 Giotto's Ognissanti Madonna 86 Santa Croce Frescoes 86 The Bardi Chapel 87 The Peruzzi Chapel 88 The Baroncelli Chapel 90 Altarpieces for Santa Croce 92 The Santa Croce Refectory Frescoes 93 The Cathedral Complex 94 Andrea Pisano's Baptistry Doors 96

5 Siena: City of the Virgin 99

The Cathedral 100
The Pulpit 101
The Façade 103
Duccio's Maestà 104
Contemporary Voice: The Procession of the Maestà 104
Altarpieces in the Transept Chapels 107
Later Sienese Altar Painting 110
Tomb Sculpture 110
Arezzo: The Tarlati Tomb 112
The Palazzo Pubblico 112
Simone Martini's Maestà for the Palazzo Pubblico 113
Lippo Memmi's Maestà for San Gimignano 113

Contemporary Scene: Art and Popular Piety 114
Secular Imagery in the Scala del Consiglio 116
The Sala della Pace: "Good Government" 116
Siena's Political System and Civic Art 120
Painting in the Palazzo Pubblico 120
Enhancements to the Campo 122

6 Naples: Art for a Royal Kingdom 124

The Court and the Importation of Artists 124
Architectural Commissions 127
Consolidating Angevin Rule:
A Queen's Commissions 128
Cavallini and Giotto in Naples 129
Robert of Anjou 131
The Altarpiece of St. Louis 131
Sancia of Majorca and the Church of Santa Chiara 132
Tomb Monuments and Robert the Wise 132
The Tomb of Mary of Hungary 132
The Tomb of Robert of Anjou 133

7 Venice: The Most Serene Republic 135

St. Mark's Basilica 138 Piazza San Marco 140 Images of the State and the Individual 140 Doge Andrea Dandolo 140 Contemporary Voice: The Image as Document 141 Enhancements to St. Mark's 141 The Pala d'Oro 141 St. Mark's Baptistry 141 The Choir Screen 143 The Facade 144 The Church of Santi Giovanni e Paolo 145 The Tomb of Doge Michele Morosini 145 The Doge's Palace 146 Santo Stefano 147 Sculpture on the Doge's Palace 147 Painting in the Doge's Palace 148

8 Pisa and Florence: Morality and Judgment 152

The Camposanto Frescoes in Pisa 152

Santa Maria Novella in Florence 155

The Strozzi Chapel 155

The Strozzi Altarpiece 156

The Black Death 156

The Guidalotti Chapel 158

The Apotheosis of St. Thomas Aquinas 159

The Way of Salvation 161

Contemporary Voice: The Bridge of Salvation 163

Social Upheaval and Civic Works in Florence 163

Or San Michele 167

Family Commissions 168

The Castellani Chapel 168

The Legend of the True Cross 169
Frescoes at San Miniato 170
Other Civic Imagery 171
Domestic Painting 173

9 Visconti Milan and Carrara Padua 174

Milan: The Visconti Court 174 Azzone Visconti and the Idea of Magnificence 176 Contemporary Voice: In Praise of Magnificence 177 Azzone Visconti's Tomb 178 Embellishments of the City 178 The Altarpiece of the Magi 181 The Equestrian Monument of Bernabò Visconti 181 The Cansignorio della Scala Monument in Verona 182 The Castello Visconteo 182 Manuscript Illumination 184 Contemporary Scene: Art and Gastronomy 185 Padua: The Carrara Court 185 The Padua Baptistry 186 Contemporary Voice: Illustrious Men 187 Patronage at the Santo 187 The St. James (San Felice) Chapel 187 St. Anthony of Padua 188 The Oratory of St. George 188 Milan: Giangaleazzo Visconti 189 The Certosa of Pavia 190 Cathedral Architecture 191 Cathedral Sculpture 193 The International Gothic Style 194 Manuscript Illumination 194 Michelino da Besozzo 195 Secular Frescoes 196 The Last Visconti and the Durability of the International Style 197 North Italian Influences in Naples 199 Aristocratic Patronage 199 Queen Giovanna II and the Monument to King Ladislas 201 The Caracciolo Chapel 201

The Fifteenth Century 203

10 Florence: Commune and Guild 204

Sculpture for the Cathedral Complex 204

The Competition for the Second Baptistry Doors 205

Contemporary Voice: Ghiberti versus Brunelleschi 207

Buttress Sculpture 209

Façade Sculpture 211

Or San Michele 212

The Foundling Hospital 217

Brunelleschi's Dome 218

Contemporary Scene: Art and Childbirth 219 Contemporary Voice: In Praise of Artists 220 Family Commissions 221 The Bartolini-Salimbeni Chapel 221 The Strozzi Chapel at Santa Trinita 224 The Quaratesi Altarpiece 225 Masaccio and the Brancacci Chapel 226 The *Trinity* and Single-Point Perspective 231 Altarpieces at Mid-Century 233 Civic Imagery 235 Narrative Frescoes 236 Castagno at Sant'Apollonia 236 Piero della Francesca in Arezzo 237 Sculptural Commissions Outside Florence 239 Siena: The Baptismal Font 239 Quercia in Bologna 241 Donatello and Michelozzo in Naples 242 The Brancacci Tomb 242 The Florence Cathedral Interior 243 The Gates of Paradise 246 The Tomb of Leonardo Bruni 250 11 Florence: The Medici and Political

Propaganda 251

The Medici's Civic and Domestic Commissions 252 San Lorenzo 252 The Old Sacristy 253 San Marco 256 Contemporary Voice: A Job Application 257 The Medici Palace 259 Portrait Busts 260 The Medici Chapel 261 Other Decorations 262 Donatello in Padua 264

The Santo Altarpiece 264

The Gattamelata Monument 265

The Medici and Donatello's Late Work 267

Donatello's Bronze David and Judith and Holofernes 267

The San Lorenzo Pulpits 269

The Golden Age and Lorenzo the Magnificent 271

The Tomb of Piero and Giovanni de' Medici 271

The Mercanzia Niche at Or San Michele 272

The Devotional Image 272

Family Chapels 275

The Sassetti Chapel 275

The Strozzi Chapel 277

Portraiture 278

The Architecture of Magnificence 279

The Façade of Santa Maria Novella 279

The Strozzi Palace 281

Classical Antiquity and the Golden Age 281

Contemporary Scene: Art and the Collector 285

Antiquarianism 286

Savonarola and Reform 287

12 Rome: Re-establishing Papal Power 289

Martin V, Eugenius IV, and Nicholas V 289 A Cautionary Fresco 290 The Papal Basilicas 290 Santa Maria Maggiore 290 St. Peter's 291 The Vatican Palace 292

Contemporary Voice: Ruins and Dreams 293

Pius II 294

Cardinals' Commissions 297

Pienza 298

Paul II 299

Palazzo Venezia 300

A Roman School of Painting 300

Sixtus IV: Roma Caput Mundi 302

The Papal Family 302

The Hospital of Santo Spirito 303

Roman Churches 303

Santa Maria del Popolo 303

Sant'Agostino 304

Commemorative Monuments 305

The Cancelleria 305

The Sistine Chapel 306

Innocent VIII and Alexander VI: Power and

Pleasure 309

Cardinals' Commissions 310

The Carafa Chapel 310

Michelangelo's Pietà 311

13 Venice: Affirming the Past and Present 313

Sculpture on the Doge's Palace 313

The Palazzo Foscari 315

The Ca' d'Oro 315

Contemporary Voice: Finishing Touches 316

The Cappella Nova 316

The Scuola della Carità 318

Jacopo Bellini 319

The Cappella Nova in the late 1440s 321

Andrea Mantegna 322

The San Zeno Altarpiece 323

Venice: Heir of East and West 324

The Arsenal 324

Religious Architecture 325

Painting 327

The Scuole and Lay Commissions 330

Commemorative State Commissions 333

14 Courtly Art: The Gothic and Classic 336

Ferrara: The Este Family 336 Medals for Leonello d'Este 336

Pisanello in Verona 337

Contemporary Voice: Praise for Pisanello 338

Contemporary Scene: Art and Punishment 339

Borso d'Este 340 Borso's Bible 340 The Palazzo Schifanoia 341 The Palazzo dei Diamanti 343 Naples: Alfonso the Magnanimous 343 The Castello Aragonese 343 An Arch for a Humanist Ruler 344 Rimini: Sigismondo Malatesta 347 Urbino 349 Portraits 350 Altarpieces 350 The Palazzo Ducale 351 Mantua: The Gonzaga Family 353 Sant'Andrea 353 The Palazzo Ducale 355 The Sala Pisanello 355 The Camera Picta 356 Male and Female Decorum 359 Contemporary Voice: Fighting for Chastity 361

15 Sforza Milan 362

The Sforzas 362
Completing Visconti Ecclesiastical
Foundations 363
The Certosa 363
The Cathedral 364
Private Commissions 364
Ludovico il Moro and a Grand Classical Style 367
Santa Maria presso San Satiro 367
Santa Maria delle Grazie 367
Leonardo da Vinci 371
The Last Supper 371
Contemporary Voice: A Man of Many Talents 371
Madonna of the Rocks 373
Leonardo at Ludovico's Court 374

The First Half of the Sixteenth Century 377

16 Lombardy: Instability and Religious Fervor 378

Leonardo at Court 379 Commemorative Commissions 380 Alternatives to Leonardo 382

17 Florence: The Renewed Republic 387

The Republic as Patron 387

A New Civic Hero: Michelangelo's *David* 388
Sculpture at the Cathedral 389
The Imagery of State 390
The St. Anne Altarpiece 390
The Battle Paintings 392

Private Patrons 393
Portraits 393
Religious Painting 395

18 Rome: Julius II, Leo X, and Clement VII 397

The Imperial Style under Julius II 397 A New St. Peter's 398 The Tomb of Julius II 399 The Sistine Ceiling 402 Contemporary Voice: Michelangelo the Poet 403 Contemporary Scene: Art and Dissent 408 The Stanza della Segnatura 409 Roman Civic Imagery 410 The Stanza d'Eliodoro 412 Portraits 414 Contemporary Voice: The Courtier as Artist 415 Leo X: Papal Luxury 416 The Stanza dell'Incendio 416 The Sistine Tapestries 416 The Suburban Villa and Sybaritic Pleasure 418 Raphael and Michelangelo 422 Clement VII: The Dissolution of Papal Power 423

19 Mantua, Parma, and Genoa: The Arts at Court 425

Mantua: The Pleasure Palace 425
The Loves of Jupiter 428
Parma: Elegance and Illusionism 429
Correggio at San Paolo and the Cathedral 429
Parmigianino and Self-Conscious Artifice 429
Genoa: A Princely Republic 433
Doria Portraits 433
Villa Doria 434
Genoa in the Second Half of the Sixteenth Century 435

20 Florence: Mannerism and the Medici 437

Emerging Transformations of the Classical Style 438 A New Social Order 439 Domestic and Villa Decoration 441 Altarpieces 444 Michelangelo and the Medici 447 The Medici Chapel 447 The Laurentian Library 450 Florence under Cosimo I 452 Portraits 452 The Chapel of Eleonora of Toledo 454 Art as a Symbol of the Advanced State 457 A Dynasty Supported by History and Myth 457 Contemporary Voice: Casting the Perseus 459 Restructuring Civic Space: The Uffizi 460 The Sala del Gran Consiglio 461 The Florentine Academy 462

21 Venice: Vision and Monumentality 464

Visual Poetry 465
Eroticism and Antiquity 466
Poetic Altarpieces 469
Energized Altarpieces 470
Tullio Lombardo: Classicism for Ecclesiastical
Patrons 473
Venetian Artists Working for Alfonso d'Este 474
The Studio di Marmi 474
The Camerino d'Alabastro 475

Titian in Urbino 477

Refashioning the City Triumphant 479

The Zecca 479
The Library 479
The Loggetta 480

Titian: Images for the International Elite 481

The Vendramin Family 481

Charles V 482

Mythology and Sensuality 482 *Colorito* versus *Disegno* 484

The Palazzo Corner 480

Titian: The Artist as his Own Patron 484

Narrative Imagery in the Scuole 486

Celebrating the City in the Doge's Palace 488

Patronage of Commercial and Ecclesiastical

Projects 490

The Fabbriche Nuove 490

The Rialto Bridge 491

Palladio 492

San Giorgio Maggiore 492

Contemporary Voice: Plague in Venice 493

The Redentore 493

Villa Barbaro 494

The Villa La Rotonda 496

The Teatro Olimpico 496

The Later Sixteenth Century 499

22 The Rome of Paul III 500

Michelangelo's Last Judgment 501
The Deposition 504
Contemporary Voice: A Word of Advice 505
Triumphalist History 505
Urbi et Orbi: The City 507
The Capitoline Hill 508
St. Peter's 510

Private Commissions 511 The Villa Giulia 511 The Farnese Hours 512

23 The Demands of the Council of Trent 513

Decrees on the Arts 514
Reform and Censorship 515
Contemporary Voice: Veronese Before the Inquisition 516
Reform and New Religious Orders 517
The Gesù 517
Painting for the Gesù 520
San Stefano Rotondo 521
Women as Patrons 523
Church Reform and Local Politics 524

24 Northern Italy: Reform and Innovation 527

Devotional Painting 527 Milanese Architecture 529 Portraits 531 Still-Life Painting 535

25 Rome: A European Capital City 538

Sixtus V and the Replanning of Rome 538
Urban Monuments 539
The Obelisks 539
The Roman Columns 541
The Acqua Felice 541
Papal Basilicas 542
Santa Maria Maggiore 542
Contemporary Scene: Art, Pilgrimage, and Processions 543
The Dome of St. Peter's 546
Continuity and Change 546

Genealogies 548 List of Popes 553 List of Venetian Doges 553 Time Chart 554

Glossary 556 Bibliography 558 Literary Credits, Picture Credits 566 Index 567

Preface

For four centuries the history of art produced in Renaissance Italy has been presented as a series of biographies of individual artists. Formulations such as "Michelangelo's David," "Leonardo's Last Supper," or "Palladio's Villa La Rotonda" ring true to modern ears, because they celebrate the creative individuality of these masters and their works. But in structuring histories of Renaissance art around artists, rather than according to the places in which they worked, the persons and institutions whom they served, and the societal expectations they met-the point of view taken in this text-historians have often failed to indicate that the critical interrelations of these social forces with the arts gave them a compelling visual life over time. Italian Renaissance artists were no more solitary geniuses than are most architects and commercial artists today. They understood that they might gain personal recognition and fame from their creations. They also knew that their patrons civic leaders in the case of the David, the Duke of Milan with the Last Supper, and a wealthy churchman for the Villa La Rotonda—expected even greater renown for their patronage and their astute exploitation of the visual arts.

Our point of view-that art must be seen in terms of its patronage and the specific times and circumstances in which it was created-is hardly new to art history. Many specialized studies and a number of more geographically and chronologically limited books have used such an approach. This volume, however, provides a comprehensive, fully illustrated, pan-Italian consideration of art from the thirteenth through the sixteenth century. We have broadened our consideration of the diverse traditions of cities throughout Italy, rather than focusing primarily on Florence (which has too often been used to make other centers, even well-recognized ones such as Venice and Rome, seem like cultural and artistic satellites of the Tuscan capital). Expanded geographic and stylistic parameters provide a richer picture of art produced in Renaissance Italy, including works of Florentine art that have previously been accorded marginal or problematic status. We have also rejected a rigid separation of the arts by media, preferring to discuss painting, sculpture, and architecture as complementary arts, recognizing that most artists worked in a variety of forms and that they and their patrons regularly thought in terms of ensembles, not isolated masterpieces.

To set our selected works of art more firmly into their original historical fabric, we have incorporated several special features to this book. Wherever possible, captions indicate the patron as well as the artist who created the work. "Contemporary Scene" boxes give a glimpse of daily life during the Renaissance, suggesting some of the sociological "givens" that affected people's view of the world: their religious practices, how they entertained themselves, the foods they ate, and more. "Contemporary Voice" boxes provide actual period texts, drawn not just from literary figures and the theorists and historians who wrote about art but also from authors who wrote for more mundane purposes, tempering the elite bias that a focus on patronage—or, in previous texts, on artistic genius—can sometimes bring to art-historical discussions.

In this revised Third Edition we have enlarged the chronological limits of our chapters in order to provide more opportunity for understanding local traditions and stylistic continuities as well as innovations. Thirty-one shifts of focus in earlier editions have been reduced to four Parts organized into twenty-five chapters. This new organization allows for a more sustained examination of individual cities, especially at the beginning of the book. It also allows for more comprehensive overviews of complex topics such as Mannerism and responses to religious reform in the later sixteenth century.

Some readers may find that works of art they consider important—even crucial—to an understanding of the history of Renaissance art are not discussed in our text. Such "omissions," in tandem with the addition of unusual works of art, are inevitable in a book that attempts to change the very mode of presentation of the material by expanding its scope. Fortunately, our editors have allowed us to add many new works and new color illustrations to the Third Edition. Many of our additions are details of larger works, providing a closer look at the complex fresco cycles that dominate much artistic production in this period and allowing viewers to see more evidence of the actual physical production of other paintings and sculptures. In this Third Edition we have also added a discussion of art restoration, a field that continues to expand and complicate our understanding of Renaissance art, and a range of sixteenth-century works that dispel the myth of a certain stylistic homogeneity in this period.

We hope that readers will see in our selections a manifestation of the truly challenging intellectual and artistic richness of the Renaissance. The intention of this book is to provoke questions about approach and stylistic development, not to provide a new canon. We are living in a particularly vital time in historical thinking, when old prescriptive boundaries have been breached. It is critically important to participate in the adventure of these changes.

As is the case with most books of this nature, we have not footnoted the text. However, we have included a bibliography at the end, thereby recording the main source materials we have used and our profound debt to earlier scholars. This bibliography could well be treated as a guide to further reading and understanding of the art and ideas presented in the book. We have also provided a glossary of technical terms, which are highlighted in the text in boldface type.

The problem of translating Italian terms into English is always an issue in books on the Renaissance. By and large we have favored English terms and English forms of names according to common usage. In the rare instances of technical terms that do not have an exact equivalent, we have provided an approximate translation in the text the first time that the word appears, but we then continue to use the Italian term because of its specificity. Nomenclature changed during the period under discussion, but by and large family surnames were not used. Thus artists are referred to in the text either by first name (Michelangelo and not Buonarroti), or by nickname where it was or has become the accepted form (Veronese and not Paolo Cagliari), or by surname (Vasari) if that has become customary usage. There are confusing instances in which an artist's patronymic has become transformed in modern usage to a surname: thus Simone di Martino now commonly appears as Simone Martini. In these very few cases usage in the text varies, but the bibliographical references clarify how one can search for more information on the artist.

From the very outset of this project, the First Edition, Rosemary Bradley was a quietly encouraging editor. We still owe her an enormous debt of gratitude. Melanie White took over editorial responsibilities for the book at that time and provided firm and helpful direction at critical moments when a gargantuan project threatened to overwhelm us all. We were also privileged to work with Lesley Ripley Greenfield, our ever attentive editor at Laurence King, and with the ever supportive Julia Moore, formerly at Abrams. From the time of the First Edition, we wish also to remember and thank Ursula Payne for her kindly persistence, impeccable eye for accuracy, and good humor.

For the Second and Third Editions Richard Mason has guided the editorial process with a sure hand and an imaginative eye, assisted by Michael Bird, Donald Dinwiddie, and Ian Hunt, the designer. We are immensely grateful for all their help. Susan Bolsom has been the photo editor

for all editions and we are deeply appreciative of her indefatigable efforts and keen eye.

Many of our colleagues have read and commented on various aspects of this text. We are immensely grateful for their generous offers of assistance and for their criticism. Listing them by name hardly seems appropriate gratitude, but we hope that their students will see their names and realize the dedication of their teachers to their teaching and to their discipline. In particular, we would like to note Steven Bule, Jill Carrington, Anthony Colantuono, Roger Crum, Brian Curran, Anne Derbes, Phillip Earenfight, Patricia Emison, Gail Geiger, David Gillerman, Marcia B. Hall, Adrian Hoch, Allan Langdale, Ellen Longsworth, Sarah McHam, Susan McKillop, Anita Moskowitz, Jacqueline Musacchio, Gabriele Neher, Jonathan Nelson, Joy Pepe, Christopher Platts, James Saslow, Richard Turner, Mary Vaccaro, Louis Waldman, and Shelley Zuraw. Over the years a number of students have also helped to critique and shape our text. To those whose names are mentioned in the First and Second Editions we would like to add Monica Azar, Lauren Lean, and Jennifer Palladino, who helped as researchers for this Third Edition. Of course, our greatest gratitude goes to our wives, Nancy Romig Radke and Leslie Hiles Paoletti, who watched this book grow from the outset, heard more about the difficulties of putting nearly four centuries of Italian art between two covers than they ever needed to know, and still managed to encourage us in our work. While this book is dedicated to our children, it also belongs to them.

John Paoletti and Gary Radke, February 2005

Introduction: Art in Context

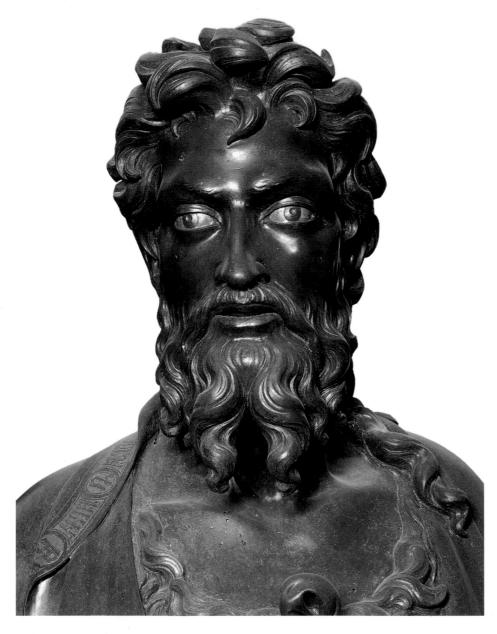

Art mattered in the Renaissance. Viewers expected works of art to be meaningful, purposeful, and functional, not just beautiful. Visual imagery was so important—and the physical manufacture of works of art so complicated—that artists very rarely worked alone. They collaborated with one another and with a wide range of patrons, responding sensitively to the differing civic, social, political, and historical contexts in which they worked. Art

mattered because it was the product of an entire society. It both forged and reflected societal values.

The governing point of view in this text-that works of art were made to serve the particular purposes of those who commissioned them-makes the form as well as the content of the art directly dependent on its use. Formal properties such as composition or figural form that we might now view merely as aesthetically pleasing were often intended as part of the moral or political content of the work, much as we understand an image of statesmen shaking hands as an expression of political alliance or concord. That is not to say that aesthetic pleasure had no role to play in people's perceptions of works of art. Texts of the period suggest just the opposite. At the end of the fifteenth century Matteo Colaccio, a Sicilian, visited Padua and wrote of his pleasure at seeing the wood intarsia choir stalls in the church of Sant'Antonio (the Santo):

[I] am almost struck dumb with admiration. Everything seems real to me, I cannot believe it is feigned. I come closer, and run my hands over them all... near the angel Gabriel and Mary, you admire branches with such leaves and fruit that nature does not produce truer... Who could be sated of admiring that silk veil stretched over a chalice, both for the color and for the fineness of the weave, all in folds of

purple, and for those sinuous folds produced by the inequality of the falling ends?

Aesthetics, however, were not the driving force behind the commission and creation of works of art. Quite mundane or awkward images of a Madonna and Child may have been just as efficacious as devotional objects as those generally admired images that have come to define the Renaissance

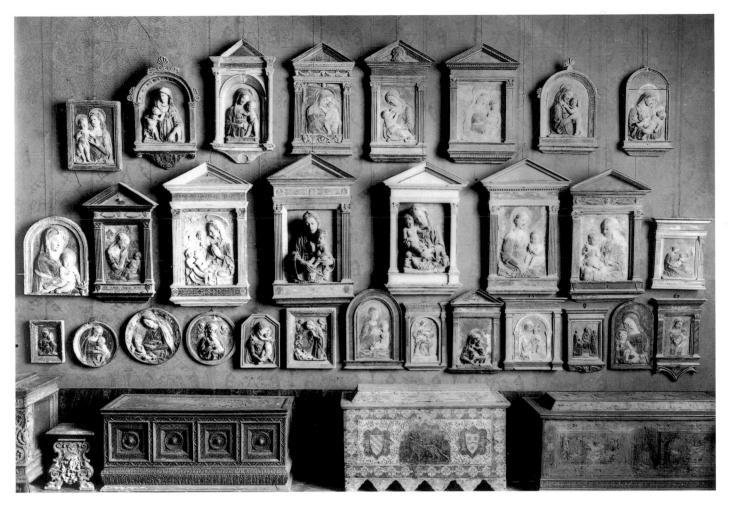

1 Museo Bardini, Florence, nineteenth-century photographic view of the interior showing plaster and stucco casts of Virgin and Child reliefs

These repeated images document the mass-production market for such popular objects during the fifteenth century (as well as their replication—and forgery—during the late nineteenth and twentieth centuries).

artistic canon. Copies after works by acknowledged masters (Fig. 1) provide a welcome antidote to the elitist bias that a focus on wealthy patrons imposes on artistic production in the Renaissance. They also document the diffusion of art throughout Renaissance society and highlight the innovations and exceptional quality of those works that have dominated historical discussion since the sixteenth century.

Attempts to imagine how objects and monuments of the past were seen in their own day are important, even though it is impossible to reconstruct precisely the original visual impact of these works, especially if they have been removed from their original location. Any commission for a work of art during the Renaissance manifested not only the wishes of the purchasers but also the history of the site into which it was to be placed. Where the site was a public place its history might stretch as far back as the mythic beginnings

(opposite) St. John the Baptist (detail), c. 1412/13-17, commissioned by Arte del Calimala from Lorenzo Ghiberti for the east side of Or San Michele, Florence. Bronze (original now in the Museo di Or San Michele, Florence)

of the city where it was located. Where the site combined private and corporate activity—for example, a private chapel in a monastic church—the collective histories and wishes of both patron and host religious order influenced the final form of the work produced. Most art of the period reflects this rich historical, familial, communal, and social fabric.

Renaissance art obviously spoke more immediately to its contemporaries than it does to a modern viewer. The images and attributes of saints, classical heroes, or local rulers, along with their symbolic meanings, were part of an individual's intellectual equipment in the culture of the time. For example, St. John the Baptist could be identified by his gaunt features, short hair shirt, and thin reed staff; St. Catherine of Alexandria by the spiked wheel on which her persecutors attempted to torture her. Such images of saints not only made them recognizable, but also recalled the popular stories connected with their lives, thus speaking directly to story-telling traditions and to the imagination of the viewer.

Works of art existed over time, since worshipers stood before devotional images repeatedly and citizens daily passed public statues of their rulers. The messages of these works must have been thoroughly assimilated, if only unconsciously, by every observer. Insofar as images tended to be repeated in similar form over long periods of time, even personifications of abstract concepts such as Justice (holding a sword or scales, or both) became clearly recognizable to a wide population.

It is worth noting that only a very small percentage of works of art from the Renaissance survives. Perhaps the highest losses occur among mass-produced objects, often by students within a master's shop, and, in the case of sculpture, made of inexpensive materials such as stucco or plaster (see Fig. 1) that replicated or imitated already accepted models. Thus repetitive images were far more pervasive than the surviving evidence suggests. It is also important to note that many Renaissance paintings and sculptures carried labels, sometimes simple captions identifying the figures represented and at other times long and discursive inscriptions not only identifying the event depicted but interpreting it as well. Mutually reinforcing exchanges between word and image (see Figs. 2.7 and 4.23) were common and open important avenues for understanding. People at all levels of society, whether literate or not, simply could not fail to assimilate the tenets of religious and civic belief that had governed their society for generations.

Much of the surviving art of the Renaissance is fragmentary, requiring an active effort on the part of the viewer to reconstruct not only the original object but also the context in which it existed. Altarpieces have been broken apart for multiple sales; public sculpture has been defaced as the political figures represented fell out of favor (as recently occurred in Iraq and in the separating states of the former Soviet Union); and buildings have been renovated and rebuilt to accommodate new owners or needs. A large category of ephemeral visual history has simply disappeared. Figurated banners, large-scale plaster sculpture, temporary parade architecture, and floats built for special occasions rarely outlived the events for which they were produced. It is also true that in Italy nineteenth-century restorers often excessively stripped sculpture of pigmentation and buildings of decorations, while at the same time they misleadingly repainted damaged paintings in order to make them appear whole (a practice still current as we shall see).

Efforts of reconstruction must work two ways: they need to address how public spaces accumulate meaning over time as events occurring in them become part of their history, and they must strip away later additions to works of art despite what such additions tell us of the history of their own time. Any reconstruction must also consider the possibility that time has added a distancing quality of venerability to works of art. When excessively devout viewers scratched out the faces of Judas or the "bad" thief crucified with Christ, or an accompanying devil in paintings of his Passion, that act of disfigurement illustrated the effectiveness of the image in conveying the message of the narrative.

In some cases, a work of art also had, in its original context, a practical dimension often lost through its history. For example, mules were allowed to cross through the Cathedral of Florence, through the side doors and across the nave, so as to avoid the longer exterior route around the building. People might have been in awe of religious images and sacred sites, but they also had very emotional and pragmatic reactions to them.

Contrary to the implications of museum displays, works of art were not always stationary. Many were portable. Small painted devotional images, such as **diptychs** or **triptychs**, could be taken from a city palace to a country villa and could be opened or closed as required, painted banners were carried in religious processions (see Fig. 12.18), and miracle-working images and relics were carried through urban spaces inviting divine intervention in human affairs. Works of art were functional in this culture and could, therefore, be renewed or even discarded according to need. Thus miracle-working images were simply replaced as they became damaged over time in order to maintain devotional practice.

Consideration of the function of works of art has important implications for a discussion of style. Once a compositional scheme became associated with an image or iconography-such as the seated elect in Last Judgment scenes placed either side of the frontal Divinity (see Figs. 2.8, 3.12, and 8.2)-it was extremely difficult to dislodge. Nor would patrons have wished to support willful iconographical innovation, whatever stylistic developments may have occurred, lest the legibility of the image-and thus its efficacy-be compromised. Typology, that is, the canonic formal properties of a subject, was part of the history of important familiar subjects, thus making repetition or imitation a necessary component of any artist's decisions about compositional presentation. When Michelangelo stepped outside the boundaries of such typologies for his own Last Judgment (see Fig. 22.1) there was an immediate negative response to the work that almost led to its destruction.

Perhaps one of the easiest ways to see the importance of images conforming to established types for the Renaissance is to look at a single typology, that of the Virgin and Christ enthroned (Fig. 3). Established during the Middle Ages, the image was perhaps the most enduring and most repeated Christian devotional image (see Figs. 4.12, 4.13, and 4.14), in large part because it conformed both to what was most familiar in human terms (that of mother and infant child) and to metaphorical interpretation (the Church and her faithful or the Church as the bearer of the Christian message). As a typology the enthroned Virgin and Child is distinct from other images of Mary and Christ-say images of the Nativity-insofar as the figures are both removed from a narrative or temporal context and are ennobled by the majestic framing element of the throne (thus the term "Maestà" for this type of representation). The central

Art and Offerings

People in the Renaissance expected to leave something of themselves in their churches: not just prayers and offerings but physical mementos and records of direct engagement with the power of God and the saints. As is evident in Carpaccio's painting The Vision of Prior Ottobon in Sant'Antonio di Castello (Fig. 2), churches contained a wide variety of objects and furnishings, most of them donated by the pious laity. Since rights to altars were sold to the wealthy in perpetuity, new and old donations intermingled, often resulting in a mixture of styles on a single wall. In Carpaccio's painting, different-sized Gothic polyptychs occupy the first two bays at the right. A much taller and classically framed altarpiece from later in the period dominates the third bay. Its position, closest to the choir screen-and therefore to the high altar-confirms the impression that this was the costliest altar of the three, certainly more prestigious than the modest altar in the corner next to the entrance wall. Families who could not afford their own altar might have sufficient funds to hang a painting on one of the columns of the nave arcade, in the manner of the framed plaque (in this case perhaps an official Church notice or decree) located on the column at the center of the painting, much like those in Florence Cathedral (see Fig. 4.26).

Many worshipers also felt impelled to leave *ex votos* (symbolic thank offerings) in their churches. Candles, flags, banners, medals, miniature representations of body parts, and scale models of ships fill the upper reaches of the first two bays of Carpaccio's church, while others hang across the choir screen. Objects were strewn over and around images, testifying to "graces received": healings, miraculous

interventions, protection from danger, and successful births. At certain very powerful shrines-for example, the altar of the Madonna in the Church of the Annunziata in Florence-worshipers left sculpted and painted portraits of themselves so that they could be perpetually present in the church. An industry of mannequin makers, working faces and hands in wax, provided full-scale, clothed representations of illustrious devotees, including Lorenzo de' Medici who commissioned figures of himself for the convent church of the Chiarito, dressed in the actual bloodstained clothes he had worn during the unsuccessful attempt on his life in the Pazzi Conspiracy of 1478. Like most people of his time, Lorenzo believed in publicly displaying his gratitude for divine intervention and protection.

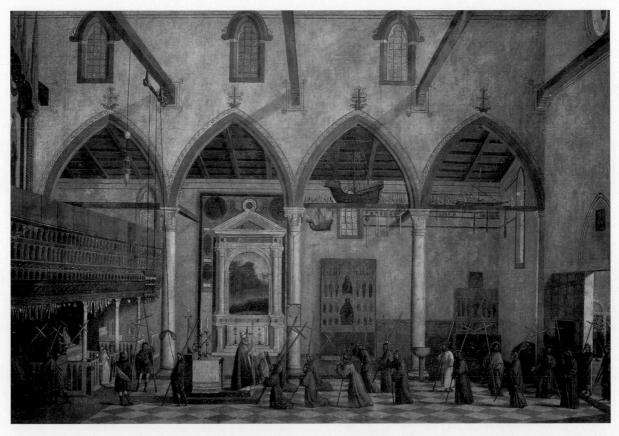

2 Vision of Prior Ottobon in Sant'Antonio di Castello, c. 1515, commissioned from Vittore Carpaccio for Sant'Antonio di Castello, Venice. Oil on canvas, 47½ × 68½" (121 × 174 cm) (Accademia, Venice)

message conveyed by the simple construction of the Virgin and Child seated on a throne remains the same whether they are surrounded, or not, by angels or saints, or whether the throne is placed in a radiant, heavenly glow—as in early examples—or in a classicizing architecture—as in later examples (see Fig. 10.32 and p. 336). Moreover, typologies are free of stylistic constraints, so that the canonic image may be represented in any of a variety of artistic styles without necessarily altering its meaning.

Patronage

Over the last fifty years much art historical writing suggested that in virtually all cases a work of art was commissioned, rather than produced by the artist on his own initiative. More recently, however, research

has indicated that at least from the mid-fifteenth century artists made work for sale "over the counter" (see Fig. 1) for a consumer culture becoming more and more affluent in the burgeoning urbanization taking place across Europe. Whether specifically ordered or produced for an unspecified purchaser, art during this time was not made as art but because someone had a particular need for an image. Even if that need extended beyond particular devotional practice or family propaganda to what Pierre Bordieu called "symbolic capital," the products of artists' workshops constituted a visual language that gave Italian (and other) cities and their inhabitants their distinctive character and place within an increasingly competitive culture.

Since a mass market culture is now difficult to trace with any degree of accuracy (most objects having been destroyed), this book treats patronage as a critical definer of context. "Patronage" is a complicated term and does not articulate as clearly as it might the complex set of social exchanges that it encompasses for the period under consideration. The Italian language uses two terms to make the concept clear. The first, clientelismo, is construed in the political sense to mean a series of exchanges, or favors granted, which bind the participating bodies-patron and client-together. Intricate and carefully observed social, political, economic, and even religious conventions of the Renaissance demanded such exchanges, not only within particular social groups, but up and down the social scale. The social cohesion that they provided was an antidote to the frequent violent factionalism that permeated Renaissance cities. A second term, mecenatismo, refers exclusively to the purchase of works of art and the support of artistic projects. The word derives from the name of Gaius Cilnius Maecenas (c. 70-8 B.C.E.), renowned for his enormous wealth and luxurious living. It was this sense

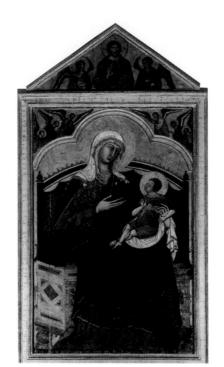

3 Enthroned Madonna and Child, c. 1260, commissioned by the Dominicans from Guido da Siena for the high altar of San Domenico, Siena. Main panel, 9' 4½" × 6' 4" (2.86 × 1.93 m) (Chapel of St. Bernard, San Domenico, Siena)

In many cases, the faces of figures in such devotional paintings were so heavily abraded by repeated cleaning that the green underpaint was revealed. In this case the heads of the Madonna and Child were actually repainted at a slightly later date to make them conform to the style of Duccio.

of patronage that the fifteenth-century sculptor and architect Filarete (Antonio Averlino) referred to when, in a provocatively gendered simile, he referred to the patron as the father and the artist as the mother of the work of art. In a hierarchically structured and patriarchal society such as that of Renaissance Italy it was clearly the patron, not the artist, who was

perceived, until late in the period, as the dominating figure in artistic creation.

It is in the overlap of these two concepts of clientelismo and mecenatismo that patronage of the arts during the Renaissance functioned. Commissioned works of art, whether generated by the state, the Church, monastic communities, civic and corporate groups such as guilds, or private individuals, were conceived with specific goals in mind and were meant to convey publicly specific messages often more complex than their subjects would indicate. Private patrons could present works of art to the Church with the expectation that God and the saints would reward their gifts and the faith that they signify with salvation. Rulers could beautify their cities as manifestations of their legitimacy, power, and generosity with the expectation that their subjects would support their continued supremacy. Religious orders, particularly new ones anxious to demonstrate their presence within the culture and the sanctity of their founders (and thus their own legitimacy), were also important patrons within the urban culture of the period, providing expansive church interiors where their stories could be told and where the laity could, through impressive donations, assert their own positions within the cultic life of the city. New research indicates that, despite the dominant role of the male in Renaissance society, women, following the examples of earlier female patrons-notably in the Early Christian and late medieval periods-also commissioned works of art, including extensive and costly architectural projects and altarpieces and frescoes where they appear in significant numbers as donors. Each commission set up particular interrelationships and exchanges: sometimes primarily between patron and artist-as, for instance, in the commission of a private portrait; sometimes between patron, monastic community, and artists—as

in a fresco cycle for a private chapel in a monastic church; sometimes between corporate bodies such as guilds or confraternities and artists—as in commissions for images of patron saints for their meeting rooms or for processional banners. Moreover, we know from countless numbers of wills that even men and women of very humble means left small amounts of money that were intended to provide modest, but nonetheless visible, records of their existence and their devotion in their parish churches, many of which were cluttered with ex votos and small frescoed images jostling with one another for attention on the walls of the building. Art was an integral part of the functioning social and political fabric. It provided visual structures for the patterns that governed not only earthly life, but life in the hereafter as well.

Viewers' reactions might be determined by their understanding of the patron's generosity, wealth, or power; the efficacy of the monastic order or guild in ensuring social stability; the artist's degree of skill or genius; or the depicted saint's perceived ability to intercede with God. At the center of this network of social relationships stood the work of art. To it the human participants brought, consciously or unconsciously, a complex set of historically accepted conventions of representation which were circumscribed by tradition and by pre-existing models. History—of the patron, of the site, of the typology to which the image belonged—is an unseen but critical factor in the creation of works of art in the Renaissance (and in fact for all pre-modern periods).

Artists' Workshops

An anonymous print of the late fifteenth century (Fig. 4) depicts the arts in a time of active production and prosperity under the guidance of their patron, the god Mercury, whose chariot floats in the sky and whose earthly spokesman, Hermes Trismegistus, is represented in discussion below. In the upper floor of the building at the right an organist energetically plays away, assisted by a young man working the bellows. Below them a book dealer shows his wares to a customer; one assumes that the scribes in his employ are hidden deeper in the building, busily copying manuscripts. On the building opposite a painter decorates the façade with a garland and ribbon pattern, part of inscribed and pigmented pattern work known as sgraffito, while an assistant prepares pigments for him. Below them is a sculptor's studio with a somewhat tattered young master kneeling in front, carving a marble bust of a woman. Inside the sculptor's shop young pupils, called garzoni, staff the sales counter where wares, including the bust of a man (most likely made of painted wood or terracotta) and more practical ewers and salvers, are being sold to maintain a steady income for the shop. One young garzone is practicing his drawing skills. In a somewhat schematic manner this print shows that the arts-broadly interpreted to include

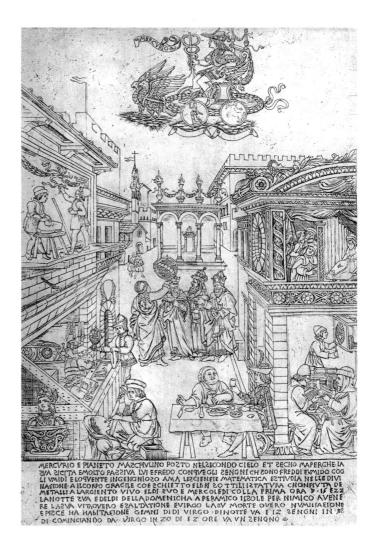

4 *Mercury*, c. 1460, attributed to **Baccio Baldini**. Engraving, $12\% \times 8\%''$ (32.4 × 22 cm) (© British Museum, London)

The artist has placed this imaginary scene before the actual main civil piazza of Florence. In the background on the left is the crenellated façade of the Palazzo della Signoria and the now destroyed church of San Piero Scheraggio, and in the center background is the Loggia della Signoria.

all objects of visual or material culture—were part of an economic as well as a cultural exchange during this period. Their production was structured within traditional workshops headed by a master craftsman and staffed by a team of artisans at various stages in their training. The image of the solitary artist-genius, popularized in the nineteenth century, has little place in Renaissance Europe.

The Image of the Artist

Although the image of the artist represented in the print of the workshops is essentially true, it is one that underwent significant change during the fifteenth and sixteenth centuries. Comparison between a relief showing a traditional sculptor's workshop by Nanni di Banco (Fig. 5) and the *Self-Portrait* of the sculptor Baccio Bandinelli (Fig. 6) suggests both the evolving role of artists within their own society and their own perception of that role. Although artists

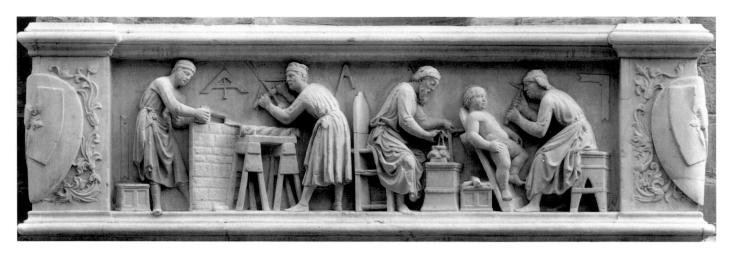

5 Sculptor's Workshop, c. 1416, commissioned by the Arte dei Maestri di Pietra e Legname from Nanni di Banco for the base of the guild niche at Or San Michele, Florence. Marble

had long held positions of civic responsibility within their city-states, Nanni's relief concentrates on the craft aspect of the sculptor's studio, with each worker assigned specific tasks to ensure an efficiently operating shop. The craftsmen are all dressed in working clothes and attend to their duties with true single-mindedness. A little more than a century later, Bandinelli's self-portrait shows the artist seated in an impressive classical architectural setting and pointing to a drawing of two male nudes, perhaps representing Hercules and Cacus, the subject of one of Bandinelli's most famous sculptures (see Fig. 20.3). The well-dressed artist, seated in a classicizing architectural setting, seems to be giving a lecture about the drawing, or perhaps about disegno, the art of drawing, more as an academician or philosopher than as a craftsman. In fact nowhere in the painting is there any indication of the tools of his trade, although Bandinelli has self-consciously demonstrated his technical virtuosity in the complicated pose of his own body, in the wrinkles along the edges of the drawing, and in his ability to depict a drawing (a medium in which he was particularly well known) in oil paint. Bandinelli presents himself as a gentleman wearing the gold chain and shell pendant of the chivalric Order of St. James. Clearly in the interval between the relief by Nanni di Banco showing craftsmen struggling with their stone and the painting by Bandinelli showing the artist as a socially prominent commentator on the arts, the artist's perception of his role within society had changed.

Changing social, political, and economic forces caused shifts in artistic production which, from the thirteenth to the sixteenth century, gave artists increasingly prominent social, critical, and theoretical roles in their societies. While endowing artists with almost heroic stature, these changes also shifted the value of their production. Art, which had been integrally connected to daily life, over time became detached from its affective role in the culture. Works that previously had been produced as religious devotional objects or public civic symbols embodying their culture's

image of itself now came to be seen as works of art, today almost exclusively encountered as part of a museum culture where they are segregated from the lived experiences of the mass population.

Workshop Training

Despite changes in the social position of the artist and in the ways that artists thought about their work, the actual production of art remained remarkably unchanged during the Renaissance. In many instances workshops passed from father to son or uncle to nephew, from generation to generation. A group portrait by Bernardino Licinio (Fig. 7) shows the artist with his nephews, whom he is trying to teach. The boy on the left holds a moderately accomplished drawing done from the model of a classical sculpture held by Licinio, while the young man with the worried look at the right tries to complete a similar drawing. On the drawing of the enthusiastic boy are the words "Oh, look how good this drawing is" while that of the perhaps more aware older student bears an inscription stating how difficult drawing is. In either case, the draughtsmen conform to traditional studio practice of drawing from a three-dimensional model in an attempt to catch the illusion of spatial volume on a flat two-dimensional surface. Despite the self-assured words of the young boy, it is clear that a continuous critique is part of this workshop situation. Once the viewer reads the words on the two fictive drawings, he or she becomes an unwitting participant in the process of criticism by having to accept or reject the uttered words and thus think about the very act of artistic creation.

The strength of the workshop system for preserving what was valued as artistic expression from generation to generation was clearly articulated by Cennino Cennini around

6 (opposite) Self-Portrait, c. 1530, Baccio Bandinelli. Oil on canvas, 57% × 44" (147 × 112 cm) (Isabella Stewart Gardner Museum, Boston)

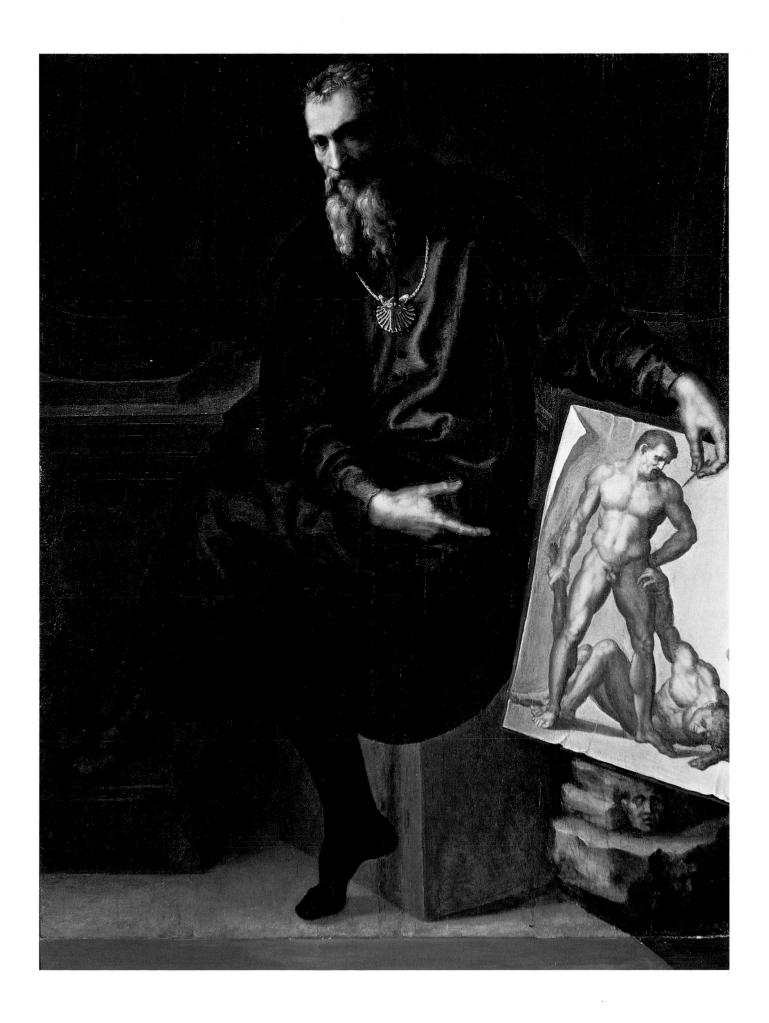

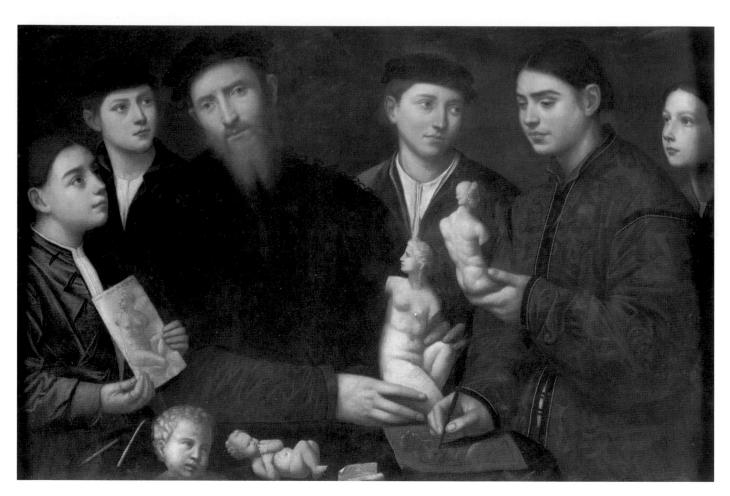

7 The Artist with his Nephews, 1530s, Bernardino Licinio. Oil on canvas (Collection of the Duke of Northumberland, England)

1410 in the preface to a painting manual that he wrote called Il Libro dell'arte (The Craftsman's Handbook). There Cennino says that he "was trained in this profession for twelve years by my master, Agnolo di Taddeo (Gaddi; 1333-96) of Florence; he learned this profession from Taddeo (Gaddi; active 1332-63), his father; and his father was christened under Giotto and was his follower for four-and-twenty years . . ." Families of artists, such as the Licinio and the Gaddi, and interlocking family workshops were not unusual for the period. Such structures made for remarkable continuity over time and assured a coherent style in large projects such as the sculptural and painted decoration of large churches, where many artists had to work together. Whether in the sixteenth century or the fourteenth, imitation was valued rather than deprecated in workshops like these.

Master painters and sculptors normally accepted apprentices in their early teens. In exchange for their assistance in the shop, the master gave his pupils training in his particular craft, room and board, and occasionally a modest salary. A contract of 1467 between the father of an apprentice named Francesco and the painter Francesco Squarcione outlines the expectations placed on both teacher and student. Squarcione agreed:

... to teach ... Francesco ... the principle of a plane with lines drawn according to my method, and to put figures on the said plane, one here and one there, in various places on the said plane, and place objects, namely a chair, bench or house, and get him to understand these things, and teach him to understand a man's head in foreshortening by isometric rendering, . . . and teach him the system of a naked body, measured in front and behind, and to put eyes, nose, mouth and ears in a man's head at the right measured places, and teach him all these things item by item as far as I am able and as far as the said Francesco will be able to learn . . . and always keep him with paper in his hand to provide him with a model, one after another, with various figures in lead white, and correct these models for him, and correct his mistakes.

Training progressed from quite menial tasks to learning drafting and modeling skills, how to prepare materials and how to use necessary tools. If pupils learned quickly and well, the master assigned them specific tasks in the major commissions on which he was working, eventually allowing them full collaborative status. In some instances work coming from a large studio was totally the product of student assistants; the master's signature on such works usually

indicated only that he had provided an initial design and perhaps some guidance along the way. Students could also produce copies of their master's works to sell over the counter (see Fig. 4). The seemingly endless number of Madonna and Child images in both painting and sculpture (see Fig. 1) give ample testimony of this practice, which both allowed students to test their craft and propagated the fame of the master. The few extant artists' account books of the period attest to the careful records kept by masters of their assistants' work. As assistants grew older they hired themselves out at day wages; some, like Taddeo Gaddi or Leonardo da Vinci, functioned as virtually independent artists while remaining affiliated with their teacher's shop.

Contracts

The master of a workshop not only had to teach and manage students, but also had to oversee a wide range of subcontracting operations. Sculptors and architects had to arrange for the quarrying and delivery of stone, which could involve large numbers of day laborers. On occasion sculptors also subcontracted the painting of objects carved by themselves to specialists in this kind of work. Painters had

to work with carpenters to procure frames and panels. At each step of the way the master craftsman was responsible for the economics of the transaction and had to be able to figure such costs into the final price of his work.

Contractual arrangements often required the artist to submit a drawing (in the case of painting and sculpture) or a model (in the case of sculpture and architecture) to give the patron a clear idea of what he or she could expect for the finished product. Presentation drawings, as they are called, are significantly different from the sketches that an artist might make preliminary to a finished compositional scheme. They had the weight of a legal document, as did models. Sculptural and architectural models were often subcontracted to a professional craftsman, so that their detailing would be accurate. Comparison of presentation drawings to finished products, as in Taddeo Gaddi's Presentation of the Virgin in the Temple (Figs. 8 and 9) and Lorenzo Vecchietta's full-scale drawing for the building committee of the Ospedale della Scala in Siena of the bronze tabernacle which he proposed to make for the altar of the hospital chapel (Figs. 10 and 11), show that the designs of presentation drawings were expected to be adhered to rather closely.

CONTEMPORARY VOICE

An Artist's Life

In *The Craftsman's Handbook* (c. 1410), Cennino Cennini not only instructs painters in the techniques of their calling but also advises them on the proper attitude to their work and a way of life conducive to success in it.

CHAPTER II

It is not without the impulse of a lofty spirit that some are moved to enter this profession, attractive to them through natural enthusiasm. Their intellect will take delight in drawing, provided their nature attracts them to it of themselves, without any master's guidance, out of loftiness of spirit. And then, through this delight, they come to want to find a master; and they bind themselves to him with respect for authority, undergoing an apprenticeship in order to achieve perfection in all this. There are those who pursue it, because of poverty and domestic need, for profit and enthusiasm for the profession too; but above all these are to be extolled the ones who enter

the profession through a sense of enthusiasm and exaltation.

CHAPTER III

You, therefore, who with lofty spirit are fired with this ambition, and are about to enter the profession, begin by decking yourselves with this attire: Enthusiasm, Reverence, Obedience, and Constancy. And begin to submit yourself to the direction of a master for instruction as early as you can; and do not leave the master until you have to.

CHAPTER XXIX

Your life should always be arranged just as if you were studying theology, or philosophy, or other theories, that is to say, eating and drinking moderately, at least twice a day, electing digestible and wholesome dishes, and light wines; saving and sparing your hand, preserving it from such strains as heaving stones There is another cause which, if you indulge it, can make

your hand so unsteady that it will waver more, and flutter far more, than leaves do in the wind, and this is indulging too much in the company of woman. Let us get back to our subject. Have a sort of pouch made of pasteboard, or just thin wood, made large enough in every dimension for you to put in a royal folio, that is, a half; and this is good for you to keep your drawings in, and likewise to hold the paper on for drawing. Then always go out alone, or in such company as will be inclined to do as you do, and not apt to disturb you. And the more understanding this company displays, the better it is for you. When you are in churches or chapels, and beginning to draw, consider, in the first place, from what section you think you wish to copy a scene or figure; and notice where its darks and half tones and high lights come; and this means that you have to apply your shadow with washes of ink; to leave the natural ground in the half tones; and to apply the high lights with white lead.

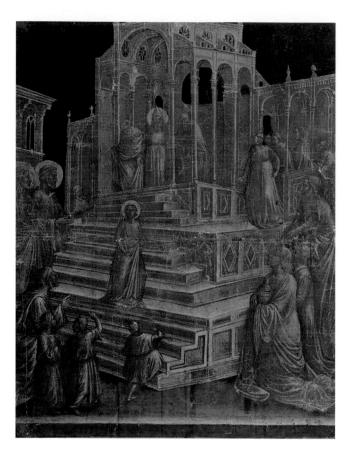

8 Presentation of the Virgin in the Temple, c. 1332, **Taddeo Gaddi**. Presentation drawing for the fresco in the Baroncelli Chapel, Santa Croce, Florence; silverpoint with white highlighting, green and blue pigments on green prepared paper, $14\% \times 11\%''$ (36.4×28.3 cm) (Musée du Louvre, Cabinet des Dessins, Paris)

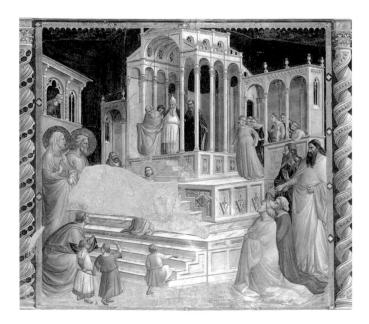

9 Presentation of the Virgin in the Temple, c. 1332, commissioned by the Baroncelli family from **Taddeo Gaddi** for the Baroncelli Chapel, Santa Croce, Florence. Fresco

Surviving contracts describe virtually nothing of the complicated exchanges that must have occurred in a highly stratified society between patron and artist in establishing the content and meaning of the work of art. They are for the most part bare-bones business contracts, meant to have legal weight should either artist or patron default. The terms frequently mention that the work is to be done by the artist's own hand, a recognition of the workshop practices of the period, and they stipulate the quality of the pigments and how much gold or lapis lazuli should be used. Contracts sometimes specify the subject of the commission (although in most cases that is assumed, given prior discussion) and also give a final date for completion of the work, along with terms of payment and indication of penalties for failure to meet the terms of the contract. The production of art was to a great extent an economic transaction. Whether fulfilling a public or private commission, the artist had to be ever vigilant in ensuring his just compensation. Litigation was not unusual in Renaissance shops; artists frequently brought in outside specialists to adjudicate a just price for their work because of a complaining patron, and patrons brought suit because an artist failed to meet the stipulated deadline for the delivery of the work.

Despite the tightly structured and remarkably tenacious workshop system, some individual artists did achieve reputations of international stature. Giotto painted not only in his native Florence but was called to Padua, Milan, and Naples as well. Gentile da Fabriano traveled to Venice and to Florence and was finally called to the papal court in Rome. Antonello da Messina worked in Naples and Venice as well as his native Sicily. And Michelangelo had invitations from both the French king and the Turkish sultan in Constantinople (modern Istanbul) for his services. Thus, while some shops were of remarkable longevity, others were put together quickly to meet the needs of a particular commission overseen by a visiting artist. The peripatetic careers of such artists were in part responsible for transplanting personal styles to new locations, since the visiting artists trained local craftsmen as they moved from city to city. Conversely, artists could absorb new stylistic ideas from the places to which they traveled, thus enriching both their own work and ultimately the artistic language of their home city.

Materials and Methods

Although individual workshops for painting, sculpture, and architecture had some procedures and structures in common, they all required considerable skill in organizing specialized group activity. Artists were sometimes productive in more than one medium, but each art had its own set of problems to solve and each its own types of materials. Moreover, virtually all artistic workshops undertook a variety of jobs in order to ensure their commercial viability. Painting shops are a case in point. In addition to large-scale fresco cycles or free-standing paintings, the Renaissance

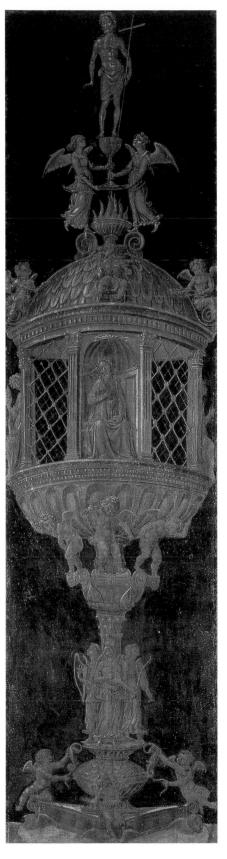

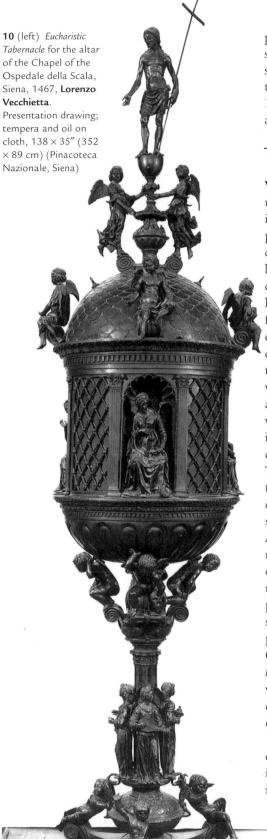

11 (right) Eucharistic Tabernacle, 1467-72, commissioned under the rector Niccolò Ricoveri from Lorenzo Vecchietta for the altar of the Chapel of the Ospedale della Scala, Siena. Bronze (Siena Cathedral)

Although originally on the altar of the hospital chapel, the tabernacle was moved in 1506 to the high altar of Siena Cathedral, where it replaced Duccio's *Maestà* (see Fig. 5.9).

painter could be engaged in painting works of sculpture, preparing presentation drawings for sculptors and architects, producing small devotional images or large-scale cloth banners (see Fig. 12.18), decorating household furniture (Fig. 12), and devising and producing festival decorations.

The Painting Studio

Wall Painting Among the most complex projects undertaken during the Renaissance was the painting of fresco. Fresco (literally "fresh") is simply painting on wet plaster. This medium was used to decorate large wall areas of both public and private buildings. The wall, usually of rough stone and cement, was first prepared by the application of a layer of rough plaster, called the arriccio. Then a finer layer of wet plaster, called intonaco, was laid on the arriccio in sections; each section was painted, using pigments mixed with water, and allowed to dry before a new section was begun. Painters worked from the top down to avoid dripping on an already finished surface. Ensuring that pigment was always laid on a plaster of equal wetness was important for guaranteeing that the colors would dry evenly to the same tone over the entire fresco. This process meant that each patch of wet plaster (called a giornata, or "day's work"—though in many cases more than one was completed in a day) slightly overlapped the edge of the adjacent patch. Areas of complicated painting, such as faces, are relatively small, whereas simple expanses of sky or landscape are quite large. These overlaps allow modern restorers to trace the progress of the painting from beginning to end by plotting the sequence of the overlaps. Sometimes frescoes were painted on plaster surfaces that were already dry. Called fresco secco (dry fresco) to distinguish it from buon fresco (good, or true, fresco), this technique was used most often for corrections and for fine details, on costume, for example. It was much less durable than buon fresco.

Such sizable paintings, in which timing was of critical importance, took careful planning and involved a number of assistants. A precise plan in the form of a drawing, or of many drawings,

was required so that the composition would fit exactly on the designated wall. Painting at wall size involved a problem comparable to that of carving a large-scale sculpture from a small model: how to transfer the figures in a small drawing to a large wall. One way of doing this was simply to place a grid of squares over the drawing, like the one Uccello used for his

Terms of Employment

Although contracts between patrons and artists varied considerably, even within the same town, the following contract, between the Prior of the Ospedale degli Innocenti in Florence and the painter Domenico Ghirlandaio, is fairly typical. This was for a painting of the *Adoration of the Magi* (which may still be seen at the Ospedale today).

Be it known and manifest to whoever sees or reads this document that, at the request of the reverend Messer Francesco di Giovanni Tesori, presently Prior of the Spedale degli Innocenti at Florence, and of Domenico di Tomaso di Curado [Ghirlandaio], painter, I, Fra Bernardo di Francesco of Florence, Jesuate Brother, have drawn up this document with my own hand as agreement contract and commission for an altar panel to go in the church of the abovesaid Spedale degli Innocenti with the agreements and stipulations stated below, namely:

That this day 23 October 1485 the said Francesco commits and entrusts to the said

Domenico the painting of a panel which the said Francesco has had made and has provided; the which panel the said Domenico is to make good, that is, pay for; and he is to colour and paint the said panel all with his own hand in the manner shown in a drawing on paper with those figures and in that manner shown in it, in every particular according to what I, Fra Bernardo, think best; not departing from the manner and composition of the said drawing; and he must colour the panel at his own expense with good colours and with powdered gold on such ornaments as demand it, with any other expense incurred on the same panel, and the blue must be ultramarine of the value about four florins the ounce; and he must have made and delivered complete the said panel within thirty months from today; and he must receive as the price of the panel as here described (made at his, that is, the said Domenico's expense throughout) 115 large florins if it seems to me, the abovesaid Fra Bernardo, that it is worth it; and I can

go to whoever I think best for an opinion on its value or workmanship, and if it does not seem to me worth the stated price, he shall receive as much less as I, Fra Bernardo, think right; and he must within the terms of the agreement paint the predella of the said panel as I, Fra Bernardo, think good; and he shall receive payment as follows—the said Messer Francesco must give the abovesaid Domenico three large florins every month, starting from 1 November 1485 and continuing after as is stated, every month three large florins

And if Domenico has not delivered the panel within the abovesaid period of time, he will be liable to a penalty of fifteen large florins; and correspondingly if Messer Francesco does not keep to the abovesaid monthly payments he will be liable to a penalty of the whole amount, that is, once the panel is finished he will have to pay complete and in full the balance of the sum due.

(from Michael Baxandall. Painting and Experience in Fifteenth-Century Italy. Oxford: Oxford University Press, 2nd ed., 1988, p. 6)

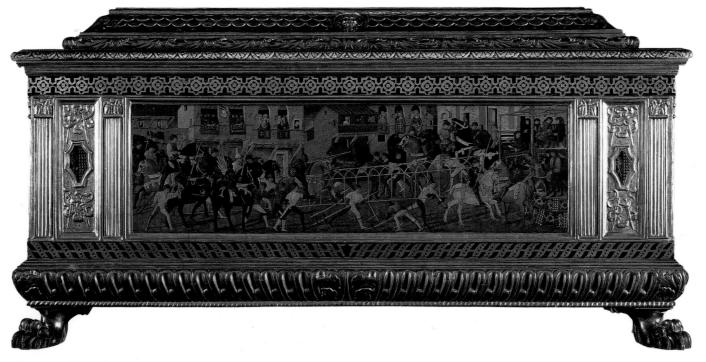

12 Cassone with a painted front panel showing a tournament in the Piazza Santa Croce, Florence, c. 1460. Tempera on panel, chest $40 \times 80 \times 14''$ ($103 \times 203 \times 66$ cm), panel $15 \times 51''$ (38×130 cm) (National Gallery, London)

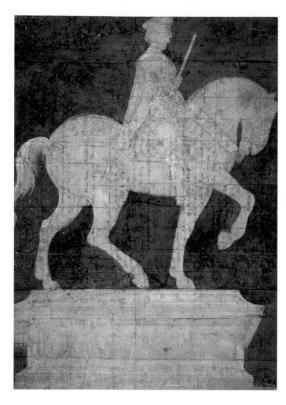

13 Sir John Hawkwood, c. 1436, commissioned by the Signoria of Florence from Paolo Uccello for Florence Cathedral. Preparatory drawing, squared with a stylus, for the fresco; silverpoint heightened with white on a light green, prepared ground, 18 × 13" (46 × 33 cm) (Gabinetto dei Disegni, Galleria degli Uffizi, Florence)

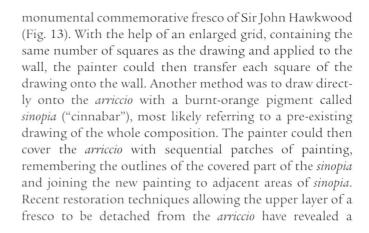

- 14 (below left) St. Jerome and the Trinity, 1455, commissioned by Girolamo Corboli from Andrea del Castagno. Preparatory sinopia drawing (now detached from wall) for fresco, $9' 9'' \times 6' 7'' (2.97 \times 1.78 \text{ m})$ (Cenacolo di Sant' Apollonia, Florence)
- 15 (below) St. Jerome and the Trinity, 1455, commissioned by Girolamo Corboli from Andrea del Castagno for the Corboli Chapel, Santissima Annunziata, Florence. Fresco (now detached from wall), $10' 10'' \times 6' 10'''$ $(3 \times 1.79 \text{ m})$

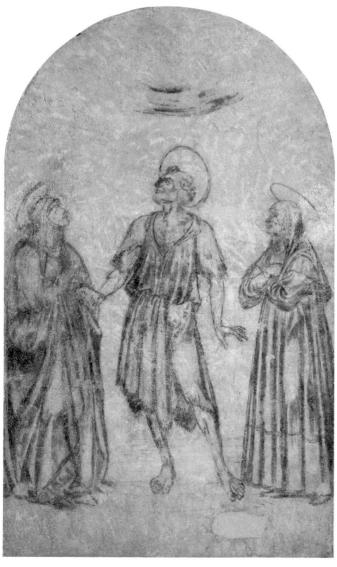

wealth of sinopia drawings from the fourteenth century, when this technique seems to have been most often employed. The use of the sinopia drawing as a preparation for the final fresco allowed the artist some freedom to alter his composition as he went along, as Castagno's frescoes for Santissima Annunziata demonstrate (Figs. 14 and 15). Although the figures appear in approximately the same positions in the sinopia as in the final fresco, Castagno significantly changed their poses from a three-quarter view for the two flanking figures to a near profile. Castagno furthermore changed the costume and the position of the arms and the head in the central figure of St. Jerome, diminishing his size to accommodate the representation of the Trinity above. Typically, sinopie show the broad features of the figures but do not include landscape details or, as in Castagno's drawing, ancillary attributes like the lion.

In the fifteenth and sixteenth centuries the **cartoon** (from an Italian word *cartone* indicating heavy paper) seems to have replaced the *sinopia* underdrawing as a way of transferring the artist's conception to the wall. Cartoons were full-scale simplified drawings of sections of the final fresco. The image could be transferred to the wall in one of two ways. The artist could place an individual cartoon against

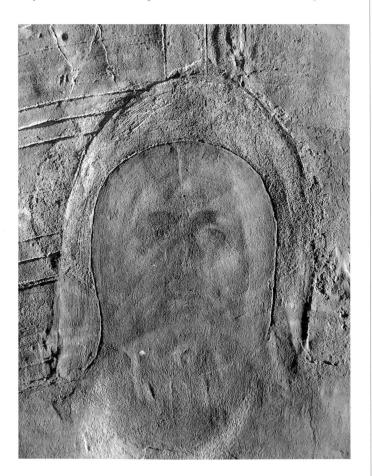

16 *Trinity*, c. 1425, commissioned by a member of the Lenzi family from **Masaccio** for Santa Maria Novella, Florence. See also Fig. 10.38.

This detail of the head of God in a raking light shows the stylus marks on the wet plaster, outlining the head and marking the vaulting system.

the wet plaster and draw with a stylus over the lines, thus leaving an incision in the plaster; once painted over, the marks of the stylus are hardly noticeable except in sharp raking light (Fig. 16). Alternatively, the artist could prick holes in the lines of his drawing, then place the drawing against the wet plaster and pound a small bag made from very fine cloth and filled with charcoal dust against the drawing; in this technique, called pouncing, the dust penetrated the pricked holes, leaving a small dotted outline of the composition on the wet plaster. These charcoal dots could then be painted over; close, detailed inspection of the finished frescoes often reveals these charcoal dots beneath the finished surface (Fig. 17), but, even more than the marks of the stylus, they are difficult to read at a distance.

Tempera and Oil Painting Panel painting, although a very different medium from wall painting, and serving very different functions, also required careful stages of preparation before paint could be applied to the surface. The wooden support for the painting and the frame that was attached to it were either ordered from a woodworker to the specification of the painter or provided by the patron who had procured it from a woodworker. The selection of the wood—

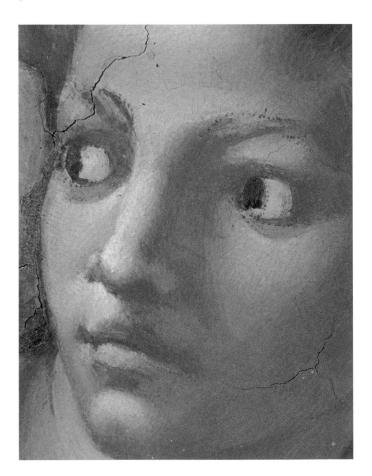

17 *Head of Eve* (detail), Sistine Chapel ceiling, Rome, Creation of Adam, 1508–12, commissioned by Julius II from **Michelangelo**. Fresco

The charcoal dots from the pricked cartoon are evident in the eyebrows.

18 Magdalene Altarpiece (before recent overpainting), second half of thirteenth century, Magdalene Master. Tempera on panel, 41½ × 63" (104.9 × 160 cm) (University Purchase from James Jackson Jarves, Yale University Art Gallery, New Haven)

The presence of the youthful St. Leonard at the Virgin's right side suggests that the painting was made for the high altar of San Leonardo, Arcetri, just outside Florence. The Magdalene Master is a generic term for a style rather than a reference to a single artist.

usually poplar-and its curing were important aspects of the work; improperly aged panels could warp and crack, causing damage to the painted surface. When the painter received the raw wood panel, often with its framing and decorative elements already in place, he and the members of his shop had to prepare it for painting. They covered the smooth

surface with fine linen onto which they brushed a coarse layer of gesso (gesso grosso) made from ground plaster and glue. This layer acted as a base for the application by brush of several layers of very fine gesso (gesso sottile), continuously applied to the surface before any one layer dried completely. When the gesso surface had hardened it was scraped and polished to give it a very smooth finish. The various layers of this built-up surface can be seen in a much-damaged altarpiece of Mary Magdalene (Fig. 18) where raw panel, linen, and gesso surface all showed through the abraded surface (now restored) and where even the burn mark of a candle gave some hint of the damages to which such paintings are prone over time. Decorative details such as haloes or borders of costumes or even inscriptions could be built up on a panel's surface with plaster (pastiglia) so that they became a noticeable low relief on the panel that imitated the actual three-dimensional forms that they depicted (see Fig. 7.19). This technique of building a relief-like volume on a flat surface was used in fresco as well.

It was customary to make a drawing of the planned painting with fine charcoal on the gesso surface of the panel. This could be erased and altered as required. Once the painter was satisfied with the drawing, it could be reinforced and clarified with ink. No unfinished panels bearing such drawings have survived, but X-rays of existing paintings often reveal traces of drawings beneath the surface.

Large areas of gilding were applied before the painting began (see p. 124). Areas to be gilded were painted with red **bole**, which was suspended in a liquid medium of **glair**, or size. The bole gave added luster to the thin foil of gold leaf which merely had to be pressed onto its wet surface in order to adhere. A preparatory layer of green pigment was laid down on areas that were to represent flesh, so that when the pink flesh tones were painted over it the interaction of the color opposites gave vitality to the skin. In paintings where the layers of skin tone have now worn away the green undermodeling lies exposed in a manner never intended by the artist. The medium used for panel painting was tempera, in

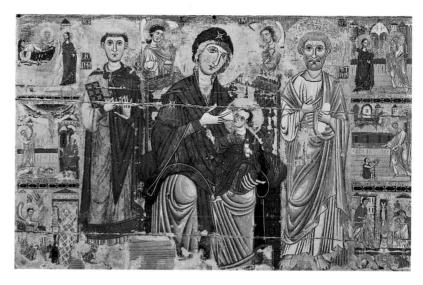

which the pigments were suspended in a medium of egg yolk. Tempera was a slow, painstaking process, as the short, repeated strokes that make up any surface of one of these panels attests (see p. 124).

Once the painting was finished, metal punches could be used to add decorative borders around the individual panels, to the haloes, or to the clothing of the figures. This decorative surface, like the raised plaster areas of the panel, caught and reflected the light from candles and oil lamps in a shimmering manner intended to intensify the otherworldly quality of the images and, more practically, to make them legible in the darker areas of churches.

By the mid-fifteenth century Italian artists in Naples, Venice, and Florence began to incorporate the technique of oil painting into their repertoire. Although at first used on panel and often mixed with other media such as tempera, oil painting was later more often employed with a cloth support such as linen. In this technique pigments are suspended in an oil medium, often linseed oil, giving an easy fluidity of application and allowing corrections and adjustments as the painting progresses. Using oils, a painter could apply successive layers of paint to the surface. This not only made it easy to change the composition of the picture during the process of painting but also allowed greater richness of color, as the overlapping tones interacted with one another. The effect of light penetrating the various layers of paint or playing over the glazes that the painter also applied to the surface achieves a luminous brilliance that would have been appreciated by artists seeking an ever more naturalistic effect. The creative freedom that the medium allowed led ultimately to a surface where color, refracted light, and richness of textured pigment became a vehicle for the emotional impact of the story depicted (see Fig. 21.35).

Mosaic and Stained Glass No material was more reflective and resplendent than mosaic (see Fig. 2.6). In this medium, as in the production of stained-glass windows (both much more common in Italy than is usually supposed), a master painter provided a full-scale cartoon for a glass specialist to translate into his medium. In order to piece together the image, the mosaicist employed tiny squares of colored glass called tesserae, some of them with gold or silver leaf sandwiched between sheets of glass. These tesserae were set in a plaster ground, their individual surfaces deliberately set at irregular angles the better to catch and reflect in a shimmering manner the irregular light of candles and oil lamps. A master window glazer cut larger pieces of blown glass into irregular pieces and joined them together with canes of lead. Either he or, occasionally, the painter who had provided the cartoon would add the lines and shadows of the figures to be depicted in grisaille, a dark pigment that was fused at high heat onto the glass itself. Thus, although individual panes of colored glass might give local color to individual features of the narrative, the details were presented in monochrome. For a culture in which light carried implications of the divine, reflective mosaic and glass were highly effective media for carrying sacred narratives. Moreover the heavenly light reached the viewer through the saintly figures depicted on the stained glass windows, figures who were literally transmitters of the divine to humankind through their own bodies.

The Sculpture Workshop

Sculpture workshops were arguably the most complex and diverse of the Renaissance. A sculptor might choose to work in stone, wood, terracotta, stucco, plaster of Paris, papiermâché, wax, bronze, gold, or silver (see Fig. 8.11), although most limited themselves to one or two of these media. Moreover, the work could be figural or purely decorative, free-standing or relief, a colossal exterior statue or a very small medal. The artist could be paid a specified amount of money for a figural work or a price per given unit of measurement if he were providing decorative sculpture such as moldings. Some sculptors cast bronze within the shop, others subcontracted out the casting once a finished model was ready, especially for large-scale works. The shop could be a private one, owned by an independent master, or it could be one established under the auspices of a building committee for a large building in need of decoration, such as a cathedral. In the former case the artist could control and govern who worked in the shop, bringing in new talent as the need demanded and letting others go when there was no work. As with painting workshops, the result of this system of training under a master was designed to produce a uniform shop style, in which everything produced had the look of the master.

In a large, corporate shop, artists of different training, style, and even national background were often hired to work side by side in an effort to complete large decorative programs as quickly as possible. Although a certain amount of consistency would be lent to such programs by the initial selection of the artists and by the supervision of the

capomaestro, or head of the shop, it was more important to get the work done than to have complete uniformity of style, as Alfonso I's triumphal arch in Naples (see Fig. 14.15) demonstrates. Nanni di Banco's relief for the Arte dei Maestri di Pietra e Legname (Stone and Wood Workers' Guild) in Florence (see Fig. 5) shows that there was also division of labor within the shop, with some artists adept at architectural detailing such as twisted columns, others being entrusted with the leafy details of capitals, and still others with figures.

Stone sculpture required the sculptor either to travel to the quarry himself or to send a trustworthy assistant in order to find a block of stone not only the right size and shape but also without imperfections such as veins of minerals which would jeopardize the structural integrity of the work or its surface beauty once it was complete. The stone had to be quarried and shipped, often over large distances, requiring travel both by boat and by oxcart (Fig. 19). With tolls based on weight or size having to be paid along the way, it was important that the sculptor not order more than was necessary for the commission. Once the rough stone arrived at the shop, assistants could begin to block out the figure, using a model in wax or terracotta provided by the master or a rough drawing on the block itself. For figural sculpture, points were marked on the model, usually at the knees, the buttocks, and the shoulders. These points were then transferred and enlarged to the scale of the large block by mechanical and mathematical devices (Fig. 20). Similar techniques could also be used to replicate ancient sculpture.

The sculptor worked in from the block of the stone, constantly refining the form, first working with drills and pointed chisels and then progressing to chisels with finer and finer claws (cutting edges) as the carving became more delicate. Stone rough from the chisel had to be smoothed, using files and abrasives such as pumice. Finally, polishing with straw and cloth gave the surface its smooth character

19 Transportation of Carrara marble by ox-cart, shown in a nineteenth-century photograph

20 Transferring from a model to a block of stone, from Francesco Carradori, Istruzione elementare per gli studiosi della scultura, Florence, 1802

which over time took on a luster. In some rare instances unfinished sculpture was actually installed (Fig. 21), giving the modern historian some idea of how carvers went about shaping the figure from the large block and carving the stone. In most cases sculptors painted their completed marbles, either to clarify the separation of figures from background, in the case of relief sculpture, or to add naturalistic details of color to the white marble of figural sculpture (Fig. 22). Often this amounted simply to gold detailing of architecture, of drapery borders, and of haloes. Most of this **polychromy** has subsequently worn away or been effaced in later "cleaning" projects, leaving a quite misleading and falsely classicizing notion of how Renaissance sculpture originally looked.

21 Tomb monument of Carlo of Calabria, detail showing the unfinished head of Charity, 1332-33, commissioned by the House of Anjou from Tino da Camaino.

Marble (Santa Chiara, Naples)

Sculptors also worked in wood, a medium that has only recently received serious scholarly attention. Most wooden figures, carved from sections of the trunks of trees, were virtually life-sized. In order to prevent major cracks in the figures as the wood aged and slowly dried, the tree trunk was often hollowed out from the back, allowing the figure to be more pliable in responding to changes in temperature and humidity. Wooden sculpture could be pieced together from several logs, especially for crucifixes, in which the arms of the figure extended out from the main core of the body and thus needed to be carved from separate pieces of wood. In all cases wood sculpture was completely painted, so that the figure imitated as accurately as possible the human form it represented. This required that the wood

surface be covered with gesso or with a fine linen fabric which itself was then covered with gesso; that plaster surface could then be colored much the same as a panel painting. It was not unusual for a sculptor to subcontract out the painting of wooden sculpture to workshops that specialized in such tasks as part of the mass production of devotional objects and painted furniture. Wooden statues were often completed by the addition of metal attributes (St. Peter's

22 *Isabella of Aragon* (?), c. 1490, **Francesco Laurana**. Marble, height 17½" (44 cm) (Kunsthistorisches Museum, Vienna)

23 *Crucifix*, c. 1412–15 (?), **Donatello**. Painted wood, height 6' 6'' (1.68 m) (Santa Croce, Florence)

Like many other statues carved in wood, this sculpture was overpainted with a brown pigment to simulate bronze by a later generation attempting to confer value on the work and to transform its realistic rendering of the human body into a classical one

keys, for example) or by clothing, heightening the sense that the naturalistically painted figure was a human presence. Not surprisingly, given the fragile, flammable nature of wood and of fabric, most of these wooden figures have been lost.

What remains, however, opens rich reconsideration of how this sculpture functioned as part of religious rituals such as processions and liturgical drama. Many figures were clothed in special costumes for festival days, blurring the boundary between the real and the represented. Some wooden crucifixes were carved with arms attached on pins, so that the body could be removed from the cross, the arms folded down, and the Christ "buried" as part of the liturgy for Good Friday (Fig. 23). Some of these crucified Christ figures were even carved with a smooth scalp so that wigs of real human hair could be added, just as loincloths of real material were sometimes used.

Terracotta sculpture, like wood sculpture, was also brightly painted. The earliest extant examples of such sculpture come from the second half of the fifteenth century.

24 Lamentation, 1492–94, commissioned by Alfonso II of Naples from **Guido Mazzoni** for the Chapel of Alfonso II and Gurello Orelia (now Chapel of the Sepulchre), Church of Monteoliveto, Naples. Terracotta

The life-size kneeling figure on the left is a portrait of the patron, Alfonso II, in the role of Joseph of Arimathea.

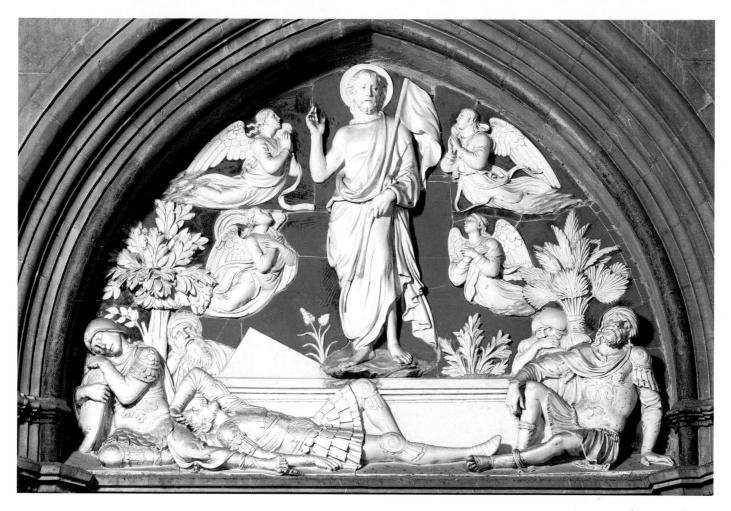

25 Resurrection, 1442–45, commissioned by a building committee of the cathedral (Opera del Duomo) from Luca della Robbia for a lunette over the door to the north sacristy, Florence Cathedral. Glazed and polychromed terracotta, 6' $7'' \times 8'$ 8''' $(2 \times 2.65 \text{ m})$

Because of the fragile nature of terracotta very little remains of what must have been a sizable production in this medium. Generally, independent figural sculpture in terracotta is life-sized (Fig. 24). During the fifteenth century the shop of Luca della Robbia developed a way of glazing terracotta sculpture so that it became quite durable and could be used for both exterior and interior spaces. Although the colors of the glazes were limited, they added brilliant polychromatic possibilities to this humble medium, and increasingly large-scale work in terracotta remained popular well into the sixteenth century—not only figures and reliefs (Fig. 25) but whole altarpieces as well.

Bronze Sculpture Bronze sculpture of the Renaissance varies in size from small medals which can be held in the palm of the hand to large free-standing public sculpture. Most bronze statues are hollow shells of metal; smaller ones may be cast solid. Benvenuto Cellini's autobiography and treatises and Vannoccio Biringuccio's *De la pirotechnia* (1540) described how to make such bronze sculpture, and technical examination of large Renaissance bronze sculptures has confirmed them to be lost-wax casts (Fig. 26).

26 The lost-wax casting process

The lost-wax process allowed the sculptor to replicate a wax model in the permanent—and very expensive—material of bronze, but with a hollow core that saved on both material and also weight, important for transport costs (see Contemporary Voice box, p. 459).

The lost-wax process (from the French *cire-perdue*) can be divided into "direct" and "indirect" casting, although written evidence and technical studies indicate that variations were used. The "direct" method is a straight translation of an original and unique wax model into a unique metal cast. In the "indirect" method, the wax model used for casting is made by taking an intermediary, reusable mold from the original model, which introduces another procedural step. This method permits the production of multiple casts and the preservation of the original model.

The Renaissance sculptor (or workshop) produced a hollow wax model (A) either by hand or with a reusable mold. The wax model was rigged with a network of wax rods, or "sprues" (B). These create the passageways through which the wax, metal, and air circulate in the fire-resistant mold placed around the model. If the figure was hollow, metal core pins were inserted through the wax into the internal mold or "core" made of fire-resistant, or "refractory," material such as sandy clay (B); pins project on the inside and outside of the wax shell and hold the core in place. The sprued wax was embedded in refractory mold material (C). The mold was heated (D) to dry it thoroughly and melt out the wax. Meanwhile, the founder liquefied the alloy of copper and tin (often zinc and lead as well) in a crucible, or furnace. He poured molten bronze through the funnel created by the casting cup until it filled the cavity created in the mold by the melted wax (E). Once the metal solidified, the newly cast figure was broken out of the mold (F) and freed of its oxidized metal, network of sprues, and other imperfections (G). It was repaired, cleaned up, and any separately cast parts joined.

When the cooled bronze was freed from the mold, the air tubes, now filled with solid bronze, had to be cut away and the entire rough surface of the bronze (Fig. 27) filed, chased, polished, and given a patina (sometimes varnish, sometimes colored oil) to enhance the luminous surface of the material. Before patinating, fine details of costume or of facial features could be incised into the bronze sculpture, and gilding, if required, could be added (see Fig. 10.59). Given the technical complications of bronze casting, professional casters (sometimes bell-makers and at other times artillery specialists) were often given the job of turning the sculptor's models into their final form-yet another example of the collaborative nature of artistic production in this period.

27 Hercules, 1470s, **Antonio del Pollaiuolo**. Bronze, height of figure 11½" (30 cm); height of figure and base 17½" (44.1 cm) (© Frick Collection, New York)

The surface of the bronze is unfinished. Small, precious table bronzes such as this were regarded as collectors' items from the last decades of the fifteenth century, as a representation of the owner's fascination with, and knowledge of, antiquity.

Drawings

Drawings served important functions in painting and sculpture workshops. They could be used to train garzoni to draw the figure (Fig. 28)-as Squarcione's contract with his pupil Francesco indicates (see p. 20)-or they could be records of motifs for use by both the master and his students (Fig. 29) or for manufacture in other shops. These drawings were kept in notebooks, functioning essentially as model books which could be lent, facilitating the transfer of ideas and motifs from one artistic studio to another or even from one city to another. Drawings, some at full scale, were often employed by architects and sculptors as models for the assistants in the shop to use in completing large projects. Documents indicate that Jacopo della Quercia had full-scale drawings of his intentions for the Fonte Gaia (see Fig. 5.34) placed on an interior wall of the town hall in Siena, both so that his patrons would know what to expect of the finished fountain and so that his assistants would know what to carve during the master's absences from the city. For obvious reasons no traces of such drawings remain: they were utilitarian steps in a process which, when complete, made them obsolete.

The history of drawings during this period suggests that they served an exclusively functional role until the beginning of the sixteenth century, when patrons, bent on forming a collection of work by artists of major importance, seemed satisfied, if not completely happy, to have a draw-

ing by a chosen artist if they could not persuade him to deliver a painting. Thus Isabella d'Este pestered Leonardo da Vinci for a painted portrait, but received, ultimately, only a drawing. Vasari seems to have

been the first person actively to collect draw-

ings, which he pasted down in notebooks, then framed and even embellished with ink drawing of his own, as part of his record of the genius of the artists about whom he wrote (see Fig. 28). Even before Vasari began collecting, however, there were clearly some drawings that were meant to be appreciated not just for their technical competence and their contractual value, but for their beauty as well. Different from sinopia drawings, which were painted over in large fresco cycles (see Figs. 14 and 15), and different from model book drawings (see Fig. 29), some presentation drawings are so stunning in their use of prepared colored paper and coloristic highlights (see Fig. 8) that one must assume that they were meant to convince the patron of the artist's abilities as much by their sheer aesthetic splendor

as by their promise of a finished product

that would suit the patron's needs. Some

workshop drawings of the later fifteenth century (see Fig. 28) are drawn on richly colored paper in silverpoint, a very fine wire of silver used like lead that oxidizes to leave a refined and elegant line on the paper; the richness of the medium with its white wash highlighting gives drawings such as these a shimmering quality of changing light that belies their mundane subjects of studio models. Clearly the technical finesse and restrained coloristic beauty of such drawings suggest that they could have been used as demonstration pieces for the artist's craft despite their humble subject matter, especially since so many of them represent nearly nude figures, the standard test of an artist's true ability to render an illusion of reality as Licinio's painting attests (see Fig. 7). In other cases, especially in drawings of practical objects such as liturgical vessels or domestic furnishings, it has recently been suggested that artists used such carefully crafted images as a marketing tool, to induce prospective buyers to order costly objects from the shop that, for practical reasons of expense, could not be made for show.

28 A page from **Giorgio Vasari**'s drawing book in which he pasted drawings from his collection and added frames to structure a composition on the page (Christ Church, no. 1338, fol. 240r, Oxford)

The drawings are in silverpoint on prepared paper by Filippino Lippi, c. 1475.

29 Ornamental design for fabric, 1448-49, **Pisanello** (Musée du Louvre, Cabinet des Estampes, Paris)

Architecture

Although the term "architect" does appear in some formal documents of this period, there seems not to have been a prescribed course of training for this position. Many architects began their careers as sculptors (Lorenzo Maitani, Filippo Brunelleschi, Bernardo Rossellino, Michelangelo, Jacopo Sansovino) or as painters (Giotto, Bramante, Raphael). Some, such as Brunelleschi or Leonardo, seem to have had a thorough grasp of engineering; others most likely used master builders, whose practical expertise guided a building's progress.

Constructing a building during the Renaissance was a collaborative process, as it is today, which involved many teams of people directed by an architect or master builder and—in the case of a public building—by the commissioning officials. The initial conception for a new building could be visualized for a patron or a building committee in two ways. An architect might provide a presentation drawing (perhaps one drafted by someone else under his direction, comparable to practice today) which gave precise indications of his design; a drawing on parchment for the

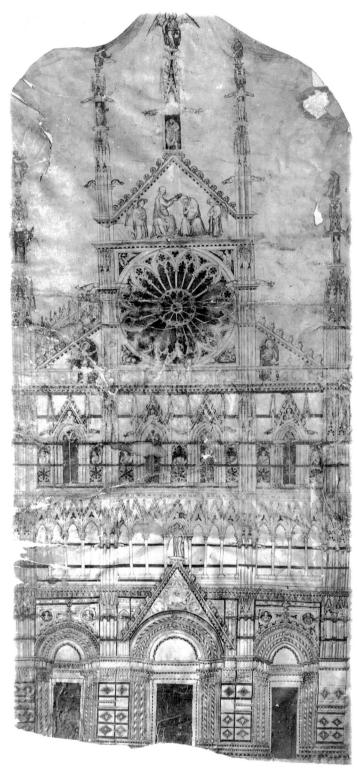

30 Façade of the Baptistry of Siena, c. 1316–17. Presentation drawing; ink on parchment (Museo dell'Opera del Duomo, Siena)

façade of the Sienese Baptistry (Fig. 30) is one of the few remaining examples of such drawings. Another practice was to provide a model of the planned building, which would give the patron a sense of the three-dimensional substance and detail of the planned structure. Wooden models such as that for Brunelleschi's dome of the cathedral of Florence

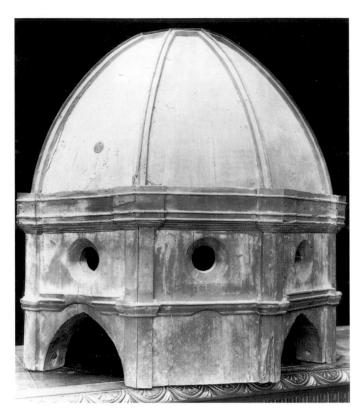

31 Model of the cupola of Florence Cathedral, c. 1420, commissioned by the Opera del Duomo from **Brunelleschi**. Wood (Museo dell'Opera del Duomo, Florence) (see Fig. 4.24)

(Fig. 31) were made by professional woodworkers from the designs of the architect. Stucco or clay models could be made within the shop of the architect. Before finished drawings or models were presented to the patron, however, there were undoubtedly numerous sketches and preliminary plans made by the architect for the project. Regardless of the numbers of drawings that may have existed, including detailed solutions of specific aspects of the building used by artisans on the site (Fig. 32), there must have been a certain amount of on-the-spot problem solving by the master builder and the craftsmen.

Since there was little open space within the walls of Italian cities, builders had to accommodate their new structures to already existing buildings on the site. Sometimes this amounted only to wrapping a skin of stone or stucco around one or more pre-existing structures and re-ordering the new façade on the street—as in the façade of the Palazzo Rucellai in Florence (Fig. 33) by Leon Battista Alberti. One can still see the ragged right edge of the building where construction was halted—ostensibly because the Rucellai had failed to acquire the adjacent building in order to complete it. Interior remodeling would also be required in order to accommodate the new spacing of windows and doors on the street or to transform a row of houses belonging to more than one owner into a building for a single extended family. Even new churches were built on the foundations of

32 Design projects for stairwell in the vestibule of the Laurentian Library, Florence (see Fig. 20.14), c. 1523, commissioned by Pope Clement VII from **Michelangelo**. Black ink, red pastel, and watercolor, $12' 7'' \times 9' 2'' (3.9 \times 2.8 \text{ m})$ (Casa Buonarotti, Florence)

The drawings show early phases in the development of Michelangelo's thinking about the design possibilities for the stairwell. The watercolor drawings are templates for column bases that would have been replicated (sometimes on metal), cut out in profile, and used by stone carvers as directions for their work.

earlier ones which they replaced, sometimes extending the structure considerably in proportions, retaining the earlier measurements and thus adding a formal constraint to the architect's imaginative freedom. The economics of building, then as now, often dictated such continued reuse, as did the fact that complete destruction of pre-existing structures would have been too time consuming.

An architectural project required large teams of craftsmen, laboring over long periods of time. Since major buildings took decades to complete, they were often the product of several different architects. Even if a single architect saw a project through from beginning to completion, he was, himself, responsible for overseeing a constantly changing body of workmen including quarriers, carriers, masons, stonecarvers, and provisioners (Fig. 34). In the case of public buildings all of this work, including its financing, was overseen by a specially elected committee called the Opera

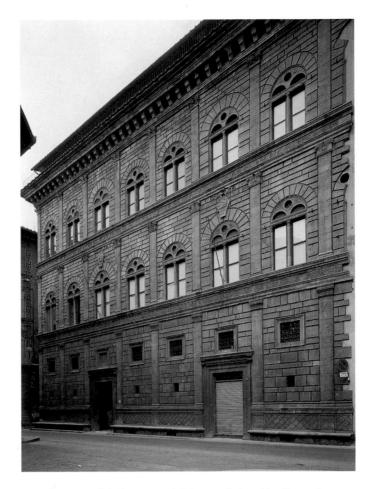

33 Palazzo Rucellai, Florence, c. 1450, commissioned by Giovanni Rucellai from Leon Battista Alberti

34 Drawing of the reconstruction of San Francesco, Rimini (see Fig. 14.17), c. 1455, **Giovanni Bettini** (Bibliothèque de l'Arsenale, Paris)

(the Works). Often the head of that body, the *operaio*, was elected for life. The membership of the Opera changed frequently, thus guaranteeing a range of expertise for any major building project.

Other Workshops

Although painting, sculpture, and architecture dominate histories of art, to some degree because of early histories like Vasari's *Lives*, it is important to remember that the visual culture of the Renaissance was enriched by a range of other arts as well. Such objects as banners and armor for frequent processions or tournaments; temporary stage sets and other constructions in wood and plaster of Paris for civic ritual; tapestries to cover large walls and shut out the cold; carved and painted furniture; jeweled reliquaries man-

ufactured by goldsmiths for liturgical use (and often later destroyed for their precious materials); liturgical vessels and vestments; manuscript illumination; even pilgrims' amulets and souvenirs were all part of the lived visual experience of the people of this period and must also be considered integral to their visual language.

Print Media

Perhaps the most significant technical artistic innovation during this time was the print. Coincident with the invention of printing, this medium allowed a rapid dissemination of images over a geographically wide area and, it might be argued, an increasing internationalism of artistic language.

During the Renaissance the most widely used print media were the woodcut and the engraving, both of which

35 Poliphilus in a Wood, from Hypnerotomachia Poliphili, Aldus Manutius, Venice, 1499. Woodcut, 4½ × 5" (10.6 × 13 cm) (© British Museum, London)

The Aldine Press was one of the foremost European printing houses at the end of the fifteenth century and throughout the sixteenth century. It was a center of classical scholarship; among the visitors to the Press was Erasmus of Rotterdam, who carefully edited texts published there.

36 Battle of the Sea Gods, 1470s, Andrea Mantegna. Engraving and drypoint, 11% × 32%" (28.3 × 82.6 cm) (Duke of Devonshire Collection, England)

The print is made from two plates, printed on separate sheets of paper and joined at the center. The raging female figure of Envy (upper left) has led to the suggestion that the print represents a competition between rival engravers. Whatever Mantegna intended as content for the print, it is clear that it is an exercise in wit, for the powerful, classical sea gods do battle with bones and knots of fish, hardly capable of defending them, while a standing statue of Neptune, the god of the sea, turns his back on the whole scene.

came to prominence in Italy in the 1470s. In the former, the desired image was drawn on a smooth piece of wood. The artist would then carve away part of the wood, leaving only the drawn lines standing in relief. These raised areas of the block were inked and the block printed, giving a reverse of the block's image on the paper. Normally the result produced an unmodulated line of dense black ink on the surface of the paper (Fig. 35).

Engraving, a technique related to the decorative work of the goldsmith, reverses the principle of the woodcut. On a metal plate-most often copper-the artist first drew the design, then engraved the lines with a burin, a triangularshaped instrument like an awl. A viscous ink was then pushed into the incised grooves and the surface of the plate wiped clean. Pressure in the printing press forced the paper slightly into these grooves, where it picked up the ink, again producing a reverse image (Fig. 36). In both woodcut and engraving the plates could be used repeatedly until the intense pressure of the printing press caused them to distress and crack. Like the prints themselves, the plates could also travel from place to place. And in a number of instances images were pirated as they entered the mass market, so that it is not unusual to see plates from one book appearing in another with minimal changes. Ultimately the print allowed artists to reach a much larger audience than they could with their private commissions. The printing process also had the effect of enhancing the status of artists, as well as their public reach, since they often delegated to craftsmen the job of producing prints from their drawings, thus helping to forge the distinction between the "pure" artist, who conceives and creates an image, and the artisan who gives it final form.

Renovations and Restorations

A great deal of information about technique and the construction of works of art during the Renaissance has been learned from modern attempts to clean and preserve them. Restoration and renovation—undertaken in past centuries as well as recently-also raise significant questions about what viewers actually see today when they look at works purportedly coming from the period, especially those that have been taken from their original settings and are now in museums. It is certainly understandable that any work of art that is centuries old, regardless of what protected environment it has enjoyed over the years, suffers change or wear. That is particularly true for works that had functional usage, like tapestries, banners, maiolica plates, or devotional images carried in procession. The very efficaciousness of devotional art often led to its renovation and repair, so that it could continue to evoke the presence of the divine in contemporary affairs. All these changes form part of the accumulated history of the objects discussed in this book. Now that so many of them are in private hands, in museums, or on the art market, the issue of condition is particularly vital—and especially vexing.

What constitutes adequate restoration and repair in order to conserve the object as an historical artifact? Do aesthetic considerations trump historical ones, so that restorers-especially on the commercial market but also in many museums-feel no compunction about significantly overpainting damaged pictorial surfaces in order to provide a pleasing object to look at rather than a fragment or one whose damages vie with the remaining surface for the viewer's attention? How do we determine that the objects we see

37 Jacob and Joseph (detail before restoration), Sistine Chapel, Rome, 1508-12, commissioned by Julius II from Michelangelo. Fresco

are actually Renaissance objects and not modern simulacra of some ghostly originals—or for that matter outright fakes?

The simplest interventions-and they are never "simple"-are cleanings in which layers of accumulated dust and dirt are removed in order to reveal the original surface of the object. This is particularly evident in public sculpture which over time becomes encrusted with the dust and dirt of urban life. Ghiberti's St. John the Baptist (see p. 12) recently had its surface cleaned, revealing not only the richly patinated and sleekly smooth original bronze surface, but even silver inlays for the eyes. Such cleaning not only gives us a captivating visual experience, but also allows us to reconceptualize the artist's goals in communicating the emotional reality of the figure, even if it is otherwise of a uniformly dark bronze color. This patinated surface was also part of the original beauty of the sculpture, meant to assert its presence across the urban space of the city. Modern restoration, which often employs distilled water or the strategic use of lasers, is careful not to damage this surface, unlike earlier attempts at cleaning. In 1843 Michelangelo's David was washed with a 50% solution of hydrochloric acid to remove dirt and wax, a cleaning that stripped the marble surface of whatever polish remained on it after having stood in an open and public square in Florence since 1504. Wood

sculpture (see Fig. 23) that had been painted over to make it appear as if it were bronze, and thus more valuable and more "classical," has within the past fifty years been given increasing attention; by cleaning off overpainting the original pigmentation has reemerged, graphically demonstrating how important it was for people at the time of their creation to see the images as surrogate humans.

Perhaps the most highly debated restoration of recent times was the cleaning of Michelangelo's Sistine Ceiling (see Fig. 18.12). In this case the ceiling was given a kind of gentle bath so that nearly 500 years of soot from candles and oil lamps that had obscured both the color and the individual forms of the ceiling was cleaned off the surface with small cotton swabs. A view of the same area of the fresco before and after cleaning (Figs. 37 and 38) shows what a radically new image of the ceiling appeared. Michelangelo's palette-shocking to many who had grown accustomed to the darkness of the ceiling before cleaning-was not just brilliant in hue, but novel in its juxtaposition of different colors. After the cleaning the figures were legible from the floor in a way that they had not been for hundred of years. The cleaning of Titian's Meeting of Bacchus and Ariadne (see Fig. 21.20), however, has been widely criticized as restorers seem to have removed Titian's glazes along with the dirt,

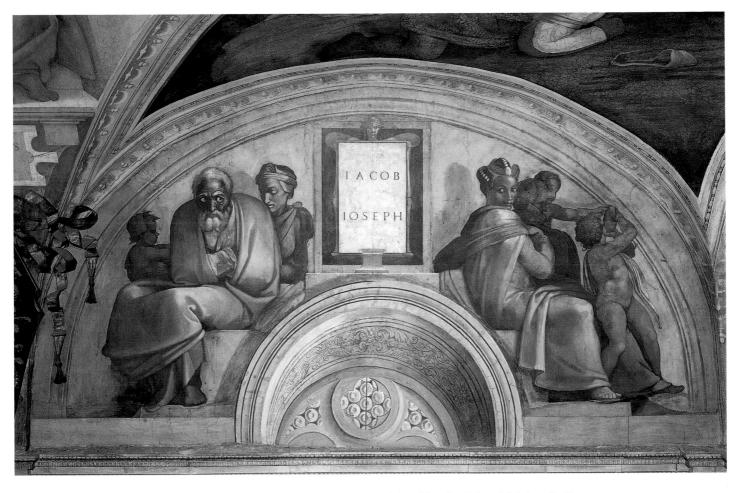

38 Jacob and Joseph (detail after restoration), Sistine Chapel, Rome, 1508-12, commissioned by Julius II from Michelangelo. Fresco

leaving a brilliantly colored painting that is pleasing to modern eyes trained in the traditions of Impressionist color and light, but which would have been somewhat startling to Titian's contemporaries.

The cleaning of Leonardo da Vinci's Last Supper (see Fig. 15.14) raised other concerns. The fresco, painted in an undocumented, novel technique by the artist, began to deteriorate shortly after Leonardo finished it and was subjected to several disastrous cleanings, repairs, and repaintings over the course of the last three centuries. To make matters worse, the building was fire-bombed during World War II; the fresco survived only because it had been protected by sand bags, although it was open to the elements for a time after the bombing. As a result there is very little of the original fresco remaining on the wall. The conservators' job in this instance was far more complicated than cleaning. They had to determine what pigments on the wall were actually Leonardo's and what pigments were from later restorations. They also had to determine what to do with glues and waxes that earlier restorers had used to fix Leonardo's remaining pigment to the wall. Precise scientific analysis joined with historical scholarship on pigments and techniques used in Renaissance workshops now allows restorers to determine through the study of microscopic

cross-sections of the wall surface (within certain parameters of accuracy) whether existing surfaces of paintings are original or later reworkings. The danger in the actual process of cleaning is that some of the original surface will be lost, especially since, in the Last Supper, some of those areas were very small. Two overarching questions govern this whole process: how much of the accumulated reworkings should the restorers remove, since these additions may protect some of the original and also provide glimpses of the fresco's accumulated history; and once removed, how does one deal with the lacunae that remain on the surface where no original pigment remains? Looking at the Last Supper today from the room, rather than on a scaffold close-up, one sees the familiar image of a painting that seems to be in relatively good condition. But when close to the fresco (Fig. 39) one can see that most of the surface has been inpainted-not to trick the viewer into thinking that the surface was original, but, quite contrarily, to reveal exactly where the modern restorers have "re-painted" a Leonardo. This technique, done in the Italian manner called tratteggio (hatching), uses short parallel strokes of differently colored pigments that are clearly visible in detail but which mix optically at a distance, similar to the brushwork of Impressionist paintings. In situations like this one, there is

39 Detail of inpainting (*Last Supper*, left lunette) showing *tratteggio* technique around the garland, 1494?–97/98, commissioned by Ludovico Sforza and Beatrice d'Este from **Leonardo da Vinci** for the Refectory, Santa Maria delle Grazie, Milan. Tempera and oil on plaster

both a record of the actual Leonardo painting and a reconstructed image that allows the viewer to re-imagine how the image originally functioned. While the restored painting is only a ghost of what Leonardo originally produced and the restorers had to make many judgment calls about what colors and additions would best complement what remains of Leonardo's original, the painting has re-emerged as an aesthetically satisfying object. Should tastes and restoration techniques change over the years, as they inevitably will, all the inpainting can be removed easily from the surface, meeting modern demands that wherever possible such work be reversible.

Still, inpainting is subject to debate, especially when a work is displayed in an academic setting, where revealing the history rather than the aesthetic value of the work might have profound educational value. Thus, in the midtwentieth century the altar frontal by the Magdalene Master in the Yale University Art Gallery (see Fig. 18) was radically cleaned, removing all pigment that could not be determined to be from the thirteenth century. As mentioned earlier, that cleaning left significant patches of raw

wood and exposed linen and gesso. Recently such archaelogical purism has been questioned and the painting has been equally drastically restored, obscuring much of the history of the panel by filling in all the vacant surfaces with a light yellowish tan color that gives some uniformity to the surface but does not attempt to provide coloristic continuity. In the earlier "restoration" the viewer was asked to see a fragment, much as we see fragments of antique sculpture, to appreciate the image that remained, to see something of its creation and history (including the burn mark of a candle) and to engage intellectually with the meaning of the object not only in its original usage, but in its modern form as an historical artifact-different from an aesthetic objectthat had a good deal to say about the culture from which it derived. Now it is a less fragmented and more coherent work, but its condition still requires explanation.

At the extreme end of the inpainting spectrum are "restorations" where inpainting is done to imitate what the restorer "thinks" the original painter would have done, melding new pigment with old, in order to give a completely unified surface. This was a standard form of restoration for dealers attempting to sell damaged Renaissance paintings in the last two centuries and it is becoming more and more accepted practice in museums that see their charge as pro-

40 Laocoön and His Sons (as restored by Montorsoli), second to first century B.C.E. or a Roman copy of first century C.E., **Agesander, Polydorus**, and **Athenodorus of Rhodes**. Marble, height 7′ 10½″ (2.4 m) (Vatican Museums)

viding visitors primarily with an aesthetic—as opposed to an historical or an intellectual—experience. Of course, the end result of such repaintings is a surface that says at least as much about modern historical understanding and aesthetics as it does about how the painting may originally have looked.

This "counterfeiting" of the original is an activity that goes back to the Renaisance itself when fragments were made whole as they became more and more valued for their market value as well as their artistic properties. Countless numbers of antique sculptures were treated essentially as spolia (remains) and either included as part of other works, as was the case at the Basilica of San Marco in Venice (see Fig. 7.4) or as a core element of a new work intended to be read as wholly classical, as was the case with the St. Theodore perched on a column in the Piazzetta San Marco (see Fig. 7.2). In the event that a statue was missing only its limbs as was most often the case-or its head or feet (see Fig. 11.44), owners often asked sculptors to provide the missing forms in order to have a complete work, precisely what some modern restorers are doing. The most famous example of this procedure is the Laocoön (Fig. 40), a Roman copy of a Greek sculpture discovered in January 1506 in a Roman vineyard when its owner began tilling his field. Known

from classical sources (Pliny), the figure was such a great discovery that the pope, Julius II, quickly paid the farmer a nominal sum for the work and made it the central focal point of the antiquities collection of the Vatican, where it still remains. A special niche was built for the statue; its designation as a "cappella" in the documents suggests how revered the sculpture was at the beginning of the sixteenth century. Baccio Bandinelli restored the right arm of Laocoön in the early 1520s and in the next decade another sculptor, Giovanni Montorsoli, intervened with another restoration. Apparently Bandinelli showed the figure with his arm bent and moving towards his head, as he does in replicas that he made of the work. Montorsoli changed the configuration of the arm, extending it straight out from the body into space and thus adding a considerable dramatic impact to the gesture. When a fragment of the original arm was found in the early twentieth century, modern restorers re-restored the sculpture along the lines suggested by Bandinelli.

Such additions and changes to the original also occur in restorations of paintings. An egregious example is Giotto's Funeral of St. Francis (Figs. 41 and 42) in the Bardi Chapel in Santa Croce in Florence (see Fig. 4.15). There, damage to the wall had been so great due to the addition of funerary

41 Verification of the Stigmata (before restoration), c. 1320, commissioned presumably by Ridolfo di Bartolo de' Bardi from Giotto for the Bardi Chapel, Santa Croce, Florence. Fresco, 9' 2½" × 14' 9½" (2.8 × 4.5 m)

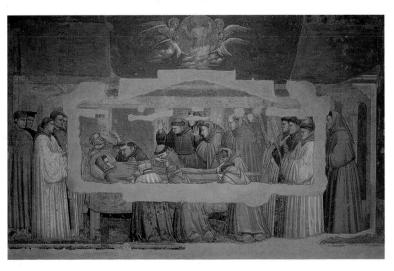

42 Verification of the Stigmata (after restoration), c. 1320, commissioned presumably by Ridolfo di Bartolo de' Bardi from Giotto for the Bardi Chapel, Santa Croce, Florence. Fresco, 9' $2\%'' \times 14'$ 9%'' $(2.8 \times 4.5 \text{ m})$

monuments, that restorers in the nineteenth century had an open invitation not only to fill in the voids, but to imagine what might have been there. Notions of Renaissance space as rational and volumetric, controlled by perspective, caused them to add extensive architectural elements in the background, essentially making Giotto conform to modern conceptions of the Renaissance. When the fresco was again restored in the 1950s, the additions of the previous century were stripped off, their historical existence now relegated to a photographic record; moreover, the restorers decided to leave bare patches of plaster on the wall where the original fresco had been damaged. What is left is still easy to read despite its lacunae and emphasizes a more intense focus on the dead Francis than the competing, busy architectural details of the nineteenth-century restorers.

As seen in the cases of the *Laocoön* and the *Funeral of St. Francis*, all restorations are an elusive mix of available information, scholarship, and personal sensibilities. They always intervene in our process of attempting to re-visualize Renaissance imagery and to gain some sense of how it functioned during its own time. Thus twenty-first-century viewers must be vigilant in ascertaining whether what they see is an authentic or a re-presented object.

Historiography and Methodology

Anyone wishing to understand Renaissance art must also pay close attention to how prior writing on the subject conditions our response to it. This process began in the Renaissance itself, where the dissemination of artistic ideas was supported by an ever-increasing production of artistic treatises, especially after the introduction of the printing press in Italy in the later fifteenth century, and by the establishment in the mid-sixteenth century of artistic academies where theory could be proposed and debated by both artists and intellectuals interested in the arts. These two forcesthe treatise and the academy—helped to transform the perception of the arts from a craft-based to an intellectual activity. These well meaning efforts on behalf of the visual arts have also sometimes proven anachronistic and misleading, imposing inappropriate standards of a later period onto an earlier one and judging one urban center's art by the standards of another. The Renaissance was too long and the variety of artistic locales too wide for any single explanatory theory or narrative to encompass its richness. Still, it is worth examining part of the written record to appreciate how passionately and cogently authors considered art in our period.

First among the Renaissance treatises was Leon Battista Alberti's *De Pictura*, written in Latin in 1435 and translated into Italian in 1436 as *Della Pittura*. The Latin text—dedicated to Gianfrancesco Gonzaga of Mantua—indicates that Alberti first thought of the educated patron as his audience (Filarete's "father"). The Italian translation dedicated to the artists from whom Alberti had learned his practical

information (see p. 220, Contemporary Voice: In Praise of Artists) retained the classical references which lard the original Latin text and initiated the formal transformation of the arts from manual skills to intellectual endeavor.

With the proliferation of treatises (especially on architecture for which the Roman architect, Vitruvius, provided a well-known model existing in the Renaissance in multiple manuscript copies), writers moved increasingly toward theoretical issues and then to recording the recent history of the arts that flourished so spectacularly during this period. The sculptor Lorenzo Ghiberti seems to have been the first to have attempted such a history in his autobiography, left unfinished at his death in 1455. In his manuscript he essentially lists artists whose accomplishments he believed had been markers in the development of the arts, much as Cennini listed his own personal artistic lineage going back to Giotto. This "great man" approach to history was developed into a full-scale biographical model one hundred years later by Giorgio Vasari in his Lives of the Artists, first published in 1550 and then revised and greatly expanded for a second edition of 1568. The Lives has provided a dominating critical and historical framework for understanding Italian art. Despite a challenging array of new theoretical approaches to this art-and to the entire field of art history-Vasari's narrative has been remarkably tenacious within the critical literature and therefore deserves some attention.

Vasari's Three Ages

Vasari ordered the history of Renaissance art into three distinct—and progressive—periods or "ages" as he called them, which essentially divide history by century from the fourteenth into the sixteenth century. For Vasari the arts of antiquity provided a model of excellence which had been debased by what he referred to as the "barbarian" style of the Middle Ages. Their revival began with Giotto in the fourteenth century, matured in the work of artists such as Masaccio and Donatello in the fifteenth century, and culminated in the work of Michelangelo in the sixteenth century. For Vasari perfection in the arts consisted of the ability to reproduce forms in a naturalistic manner while adding an ineluctable aspect of grace to figural movement and to emulate, if not surpass, the artistic accomplishments of ancient Greece and Rome.

Given the biographical format of Vasari's *Lives*—and perhaps also the fact that he was himself a painter and architect—it is not surprising that individual creative genius governs his presentation. Vasari chose each artist either because he provided new forms for the arts, or because he carried a new idea into a more complete phase of development, or because he produced important new milestones along a continually developing path for the arts. There is but one woman, Properzia de' Rossi (1490 Bologna–c. 1530 Bologna) to whom Vasari gives a "life"—albeit a brief one (see Contemporary Voice, p. 43)—in the 1550 edition, with only

passing reference to a few other female artists added to this account in the second edition. By using biography as a structure for his history Vasari borrowed a narrative literary form that had its own history and traditions, including the freedom to invent stories when the facts of the subject's life were not available. The lives of the saints were other conventional models for Vasari's biographies, so artists often appear as

exempla, moral and otherwise, of artistic behavior, individual genius, and—importantly for Vasari—elevated status. By Vasari's time an artist like Michelangelo was referred to as "divine," his genius as an artistic creator metaphorically compared with the power of the original Creator.

In recent historiography Vasari's three "ages" have been supplanted by such unhelpful terms as "proto-Renaissance,"

CONTEMPORARY VOICE

Fashioning the Female Artist

This account of the life of a female artist is fraught with contradictions. Somewhat ludicrously, Vasari asserts that Properzia de' Rossi carved peach pits because she possessed a formidable intellect, neglecting to note that as a woman she had extremely limited access to the usual sculptor's materials and training. Two examples of her pit carving survive: one a cherry pit

with dozens of small bearded faces carved on it (Museo degli Argenti, Pitti Palace, Florence), the other a jeweled escutcheon of the Grassi family set with peach pits (Museo Civico Medievale, Bologna).

Nor have they [women] been too proud to set themselves with their little hands, so tender and so white, as if to wrest from us the palm of supremacy, to manual labours, braving the roughness of marble and the unkindly chisels, in order to attain to their desire and thereby win fame; as did, in our own day, Properzia de' Rossi of Bologna, a young woman excellent not only in household matters, like the rest of them, but also in sciences without number, so that all the men, to say nothing of the women, were envious of her.

This Properzia was very beautiful in person, and played and sang in her day better than any other woman of her city. And because she had an intellect both capricious and very ready, she set herself to carve peach-stones, which she executed so well and with such patience, that they were sin-

gular and marvellous to behold, not only for the subtlety of the work, but also for the grace of the little figures that she made in them and the delicacy with which they were distributed. And it was certainly a miracle to see on so small a thing as a peach-stone the whole Passion of Christ, wrought in most beautiful carving, with a vast number of figures in addition to the apostles and

43 Joseph and Potiphar's Wife, c. 1525–26, commissioned by the Fabbrica of San Petronio, Bologna, from **Properzia de' Rossi** for the façade of San Petronio. Marble, $1'9'' \times 1'11''$ (0.54 \times 0.58 m) (Museo di San Petronio, Bologna)

Properzia was paid for two sibyls, two angels, and one relief on August 4, 1526.

the ministers of the Crucifixion. This encouraged her, since there were decorations to be made for the three doors of the first façade of S. Petronio, all in figures of marble, to ask the Wardens of Works, by means of her husband, for a part of that work; at which they were quite content, on the condition that she should let them see some work in marble executed by her own

hand. . . . In this, to the vast delight of all Bologna, she made an exquisite scene, whereinbecause at that time the poor woman was madly enamoured of a handsome young man, who seemed to care but little for hershe represented the wife of Pharaoh's Chamberlain, who, burning with love for Joseph, and almost in despair after so much persuasion, finally strips his garments from him with a womanly grace that defies description. This work was esteemed by all to be most beautiful, and it was a great satisfaction to herself, thinking that with this illustration from the Old Testament she had partly quenched the raging fire of her own passion. . . She also made two angels in very strong relief and beautiful proportions, which may now be seen,

although against her wish, in the same building. In the end she devoted herself to copper-plate engraving, which she did without reproach, gaining the highest praise. And so the poor love-stricken young woman came to succeed most perfectly in everything, save in her unhappy passion.

"early Renaissance," and "High Renaissance." By implying a linear conception of history, loosely related to a biological model of birth and maturity, terms such as these are misleading. To define any work of art as "proto" or even "early," for example, is to define it by its relationship to something else, not by its own inherent qualities. Similarly, to describe a work of art as "high" is to suggest that it is qualitatively better than anything previous, once again diminishing the effective power of earlier works.

Despite Vasari's occasional forays outside Tuscany, the Lives is essentially about Florentine and other Tuscan artists, perhaps not surprising since Vasari dedicated the book to Cosimo I de' Medici, the ruler of Tuscany and his patron. It is easy to come away from a reading of the Lives believing that the Renaissance was essentially a Florentine phenomenon which did not spread to other areas of Italy and Europe until late in the fifteenth and on into the sixteenth century. Artistic developments and works of extraordinary power in major cities such as Milan or Naples, which are integral to an understanding of the artistic history of the period, seem to have no place in Vasari's scheme of history, a bias which this book seeks, at least in part, to redress. His Tuscan bias may have its uses in defining certain stylistic innovations, but it plays havoc with the wealth of differing artistic styles in the peninsula, where individual cities functioned as separate states, each with its own traditions, forms of government, and history of artistic patronage. Given the different artistic styles of the various Italian city-states any simple definition of the Renaissance becomes problematic at best.

Vasari's biases are evident in his biography of Properzia de' Rossi. His narration of this extraordinary woman's life and works is relatively short, partly because she was a woman, but also because she did not work in Florence or Rome. In his biography, Vasari initially idealizes Properzia's character and education. He paints a perfect picture of a perfect Renaissance woman: delicate, musically talented, and "excellent not only in household matters . . . but also in sciences without number." At the same time, Vasari's Properzia is subjected to the narratives of her own art, in this case her relief of Joseph and Potiphar's Wife for San Petronio, Bologna (Fig. 43). Like the biblical character, Properzia was supposedly spurned by "a handsome young man, who seemed to care but little for her," and the relief "was a great satisfaction to herself, thinking that with this illustration from the Old Testament she had partly quenched the raging fire of her own passion." It was difficult for most men, not just Vasari, to believe that women could be both creative and virtuous.

Documents confirm that Properzia did indeed have a fiery, even unconventional spirit. In 1520 she and her lover (the documents call her his "concubine") were charged with entering and destroying the garden of her neighbor. In 1525 she and a male painter friend were arrested for having trespassed on the property of another painter, where she threw

paint in his face and scratched his eyes. She spent her last years penniless in Bologna's Ospedale di San Giobbe. But does this information actually provide an adequate insight into the meaning of the relief? While Properzia may indeed have exploited her own experience to carve a powerful, determined Potiphar's wife, payments indicate that some of her compositions were carved from models provided by other artists. She is unlikely to have chosen the subject herself. It is more likely that it was assigned to her by men on the building committee of San Petronio. And to many viewers who were unaware of the political machinations within the workshops of the Fabbrica, it was merely a story among many from the Old Testament extolling male virtue. Looking at a work of art in a broader context than Vasari did, not just as a reflection of the maker's biography, is more likely to reveal its fuller significance.

Naming the Renaissance

A critical issue in the study of Italian art of the fourteenth through the sixteenth centuries centers around the word "Renaissance," a term that immediately generates controversy and that has produced some of the most acrimonious historical debate of the last fifty years. Meaning "rebirth," the word "Renaissance" first appeared in a historical context in 1855, in the seventh volume of Jules Michelet's Histoire de France, which he titled La Renaissance. Michelet's Renaissance, however, dealt with the emerging French nation of the sixteenth century, not the politically fragmented Italy of the fourteenth and fifteenth centuries. In 1860 Jacob Burckhardt used Michelet's terminology in his Kultur der Renaissance in Italien (The Civilization of the Renaissance in Italy), still a fundamental text for the period. Burckhardt's exclusive focus on Italy from the fourteenth to the sixteenth century provided both the time frame and the location that have determined virtually all modern discussions both of the term and of the phenomena of the Renaissance. The title of the book, moreover, conflates in one word, "civilization," the art and the politics of the period as visualizations of the modern state. It is the expansion of this Burckhardtian approach, with a more inclusive interpretation of the meaning of culture, that governs more modern approaches to the period.

Since "Renaissance" remains in current usage it is useful to try to unpack some of its meaning. It is a curious term for a historian to use for it implies a definitive rupture in the historical flow. Such a conception of history has its roots in fourteenth-century Italy, where it was used to serve very specific purposes. In 1336, in a poem called "Africa," Petrarch wrote that the grandsons of his contemporaries would be able to walk out of "this slumber of forgetfulness into the pure radiance of the past." Such an assertion suggests three things: the beginning of a new age in history; the existence of the Dark Ages (another historical term essentially empty of meaning, in this case describing an historical concept

that Petrarch coined); and a time frame of three generations (Vasari's three "ages") for the revival of the arts and learning of classical antiquity. Together these concepts came to define the Renaissance. In their roles as collectors and editors of antique texts, as well as writers, Petrarch and his successors laid the foundations for the studia humanitatis, known by the technical term "humanism." From its origins in the fourteenth century, humanism flourished for the next two hundred years. It was fundamentally the study of the literary style, moral content, and political theory of classical antiquity, although the texts of the Church Fathers were also carefully and critically studied. Writers from Petrarch to Vasari reclaimed the antique as an ideal of form and urged its revival in art and letters. Vasari even used the Italian word for rebirth (rinascita) in the Lives. There he claimed, however, not just the perfection of antique forms, but their closer temporal relation to the moment of Creation itself. When Vasari called up the antique as a source of perfection it was not simply because of its formal properties, but because it reflected the divine more clearly than any later art could.

Yet modern historians have quite rightly begun to stress the continuities between historical periods rather than the disjunctions noted by writers like Petrarch and Vasari. Established iconographical types, such as the Last Judgment, for example, show few signs of change in compositional pattern from their initial formulation to their disappearance, even if figural style differs over time. Scholars, lawyers, and doctors used textual sources from both antiquity and the Middle Ages as foundations for their own thinking and writing, tying them to the past even as they attempted to interpret and expand upon these earlier ideas. History was deeply felt as an influential force for cultural and social definition. Petrarch's extreme formulation is but one manifestation that earlier ideas were so pervasive in the culture that the writer felt a need to distance himself in a stark manner from their influence by relegating them to some imagined dark age. More recently historians have supplanted the term "Renaissance" with "early modern," which may raise as many problems as it solves, but which has the benefit of changing the terms of discourse from rebirth or revival to continuity with the present (although the use of "early" does raise the specter of a simple evolutionary model for history).

The term "Renaissance" will be used in this book as a convenient designation of a chronological period, not as a description of style. Social, political, religious, and psychological self-perceptions were vastly different from one city-state to another and from the beginning of the fourteenth to the end of the sixteenth century. Elsewhere in Europe, new nation states were forming, making the Italian pattern of independent city-states anachronistic by 1600. The once monolithic Christian community splintered into several independent churches. An economic system, focused on the Mediterranean since antiquity, collapsed with the gradual enlargement of the Islamic Ottoman Empire, with explo-

rations around the coast of Africa, and with the European "discovery" of the Americas. And the tenaciously held notion of a geocentric universe eventually gave way to new scientific investigations that revealed the earth as merely a satellite of the sun. In a world where such fundamental challenges to people's self-perceptions were occurring, to define the Renaissance in the arts as a phenomenon based on naturalistic representation, reverence for classical antiquity, and Vasari's notion of perfection is myopic. The history of the period is enormously exciting, but its events, its artistic creations, and its lessons are even more compelling if they are seen in a context that includes multicultural variables from city to city.

It is important to underscore here that the art of the Renaissance, like that of other historical periods, represents a marriage of intellect and craft. Artistic forms do not flow automatically from the hand of the artist but are carefully structured by an incisive, critical, and open intellect. Michelangelo emphasized the importance of the artist's intellectual genius when, in 1546, he wrote complaining of the pressures being placed on him to finish his sculpture for the tomb of Julius II: ". . . a man paints with his brains and not with his hands, and if he cannot have his brains clear he will come to grief."

Following Vasari's approach, art historians have concentrated on those artists who either departed from the stylistic conventions in which they were trained; invented new ways of representing their subjects; or combined accepted modes of representation in new and powerfully effective ways. Such innovations were, however, part of a complicated pattern of response to the demands of patrons and commissions. In a situation in which an artist's ability to pursue his career was dependent upon the receipt of commissions, any novel form of representation needed to find a positive and knowledgeable response from the patron. Stylistic and iconographical innovations remain intriguing because of their sheer imaginative and aesthetic power and because that power was joined to a web of social, religious, and political events. It is the typical, however, rather than the exceptional, that in many ways governs our lives. Examining the exceptional work of art in the context of the typical enhances the meaning of each.

When Vasari wrote his *Lives* he essentially foreclosed discussion of the Renaissance by declaring his own era—Michelangelo's era—an age of artistic perfection. Today, renewed study of Italian Renaissance art calls for continued re-evaluation not only of the arts themselves, but also of past histories and of the many new critical methodologies for interpreting them. Since this art raises fundamental issues about perception and self-promotion (whether of the individual or the state), the interpenetration of the spiritual and the physical worlds, and the models appropriate for carrying a given meaning, the ability to understand these arts provides a window into understanding our own world as well as that of Renaissance Italy.

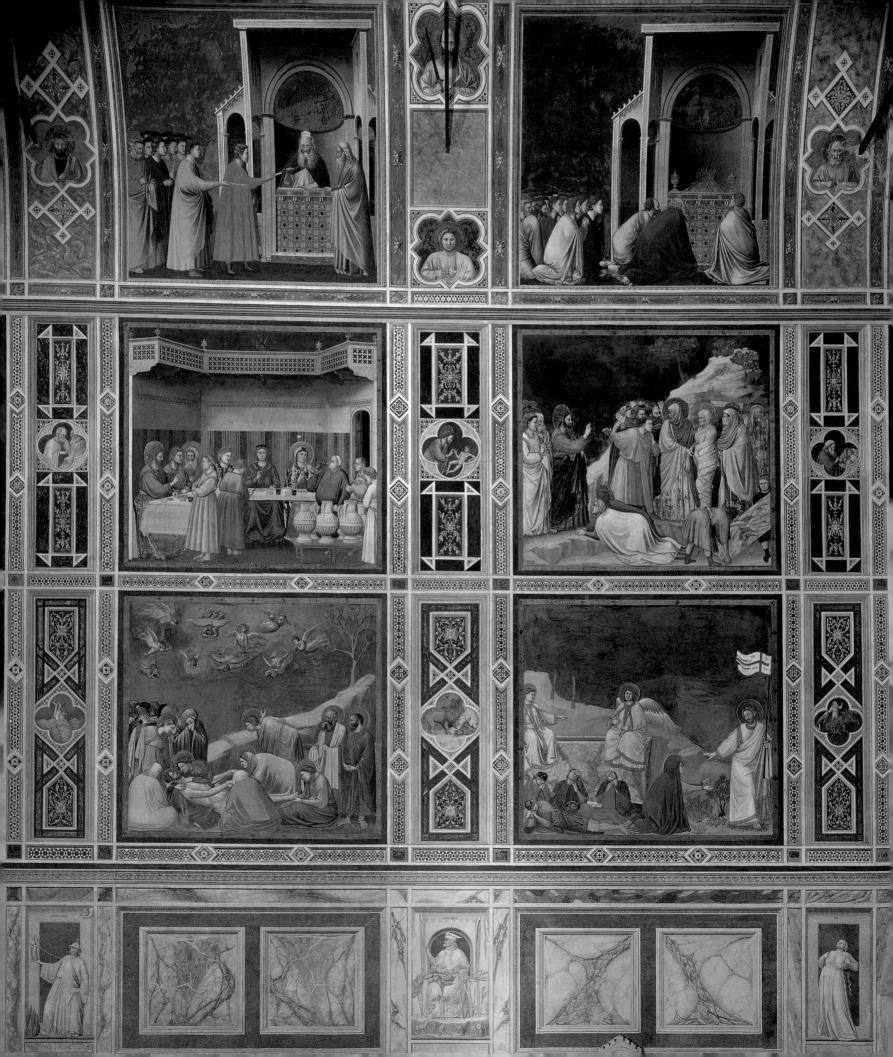

The Late Thirteenth and the Fourteenth Century

1	The Origins of the Renaissance	48
2	Rome: Artists, Popes, and Cardinals	56
3	Assisi and Padua: Narrative Realism	67
4	Florence: Traditions and Innovations	77
5	Siena: Çity of the Virgin	99
6	Naples: Art for a Royal Kingdom	124
7	Venice: The Most Serene Republic	135
8	Pisa and Florence: Morality and Judgment	152
9	Visconti Milan and Carrara Padua	174

n the thirteenth century burgeoning urban centers required the construction of new public gathering places, governmental buildings, guild and merchant facilities, and large places of worship. All these were embellished with paintings, sculpture, and both precious and practical objects necessary to instruct, impress, and delight the populace.

Although princely rulers and the Church hierarchy dominated artistic production in Italy's most important cities, they were increasingly obliged to consider and adapt to the wishes of a powerful mercantile class that provided funds for new commissions within monasteries and churches as well as private palaces and government centers. Just as the boundaries between social groups were porous, so also were the distinctions between the secular and religious life of the community. Rich individual patrons enhanced their status by their donations to religious sites; powerful city-states identified themselves visually with the specially chosen patron saints who were seen as protectors of their communal well-being; and governments underscored their legitimacy with public images in which religious virtues took on civic meaning. In both settled and unsettled times the visual arts provided vehicles for giving order to an increasingly complicated and expanding world.

The Origins of the Renaissance

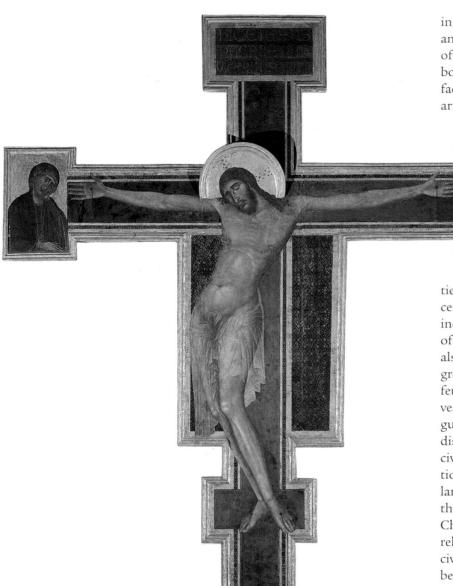

Simply enumerating so-called "influences" or "sources" embedded in the visual arts of late thirteenth- and fourteenth-century Italy does not adequately address the pressing questions of why artists and patrons embraced and exploited the models they did. Many of their sources had been available for centuries, and encounters with cultures outside the Italian peninsula were hardly new. Ancient Roman art, models from the Byzantine Empire centered

in Constantinople (modern-day Istanbul), Islamic culture, and trans-Alpine art all contributed to a rich amalgam of influences that helped to forge new ways of presenting both novel and conventional ideas. Moreover, numerous factors—social, economic, religious, and political, as well as artistic—contributed to stylistic choices, although changes

in style occurred unevenly over time in the Italian cities.

Among the most important incentives to change was a major shift in population. While Italy remained largely agricultural until modern times, it was also home to more large cities than any other region of Europe. These walled cities served not only as places of protection but as symbols of the possibili-

ties for a secure social order. At a practical level they were centers for commercial production and trade that linked individual cities with one another and gave them experience of a wider world beyond. The social order and politics also changed. Successful merchants and artisans acquired great wealth and put enormous pressure on medieval feudalism's creaky class structure of lords, vassals, and serfs, vesting new and greater power in themselves and their guilds and merchant organizations. Art became a way of distinguishing between a past social history and a present civic identity. Religion also underwent a great transformation. Rather than vesting religious power and influence largely in isolated, monastic communities, as had been the case earlier in the Middle Ages, the institutionalized Church found a vital home in cities where secular and religious leaders saw themselves as partners in promoting civic order and pride. At the same time, religious reformers began to speak more directly to, and serve the needs and concerns of, a disturbingly large number of disenfranchised urban poor.

St. Francis and the Beginnings of Renaissance Art

One of the most important of these reformers was St. Francis of Assisi (Francesco Bernardone, c. 1181–1226). Because Francis's new religious vision had major consequences for the style and form of many works of art, he and

his followers (the Franciscans), as well as other reformers, will appear throughout this book. Art changed in the Renaissance as patrons and artists encountered new ideas and developed new visual needs and expectations. While we do not subscribe to the view held by some earlier art historians that a study of Francis and Franciscanism suffices to explain the birth of Renaissance art, we do believe that the story of Francis and his impact on institutionalized art and religion does offer a series of very useful insights into the complex genesis of art during the Renaissance.

Francis of Assisi

Francis was the son of a wealthy cloth merchant from Assisi and his French wife. After leading a carefree and privileged youth, at age twenty-one Francis went with troops from Assisi in a war between his home town and the neighboring city

of Perugia. Assisi lost the war, and Francis was imprisoned in Perugia for a year before his father ransomed him. Throughout 1204 Francis lay sick at home, probably the result of a deep depression, only to set off for war in Apulia at the end of the year or early in 1205. A day after his departure, he returned to Assisi, apparently having had some form of religious conversion en route. In the autumn of 1205 he stumbled into an abandoned church outside the city walls of Assisi and fell to his knees before a crucifix (Fig. 1.1). He saw the crucifix move its lips and heard it speak to him saying, "Francis, go repair my house, which, as you see, is falling completely to ruin." At first Francis took the advice literally and rebuilt the walls of the small edifice with his own hands, but he soon came to understand his calling more broadly. Believing that God had called him to abandon his life of luxury, he sold or gave away all his worldly goods and became a mendicant, a person who begged for alms. Following the pattern of the original Apostles who were itinerant mendicant preachers, Francis believed that he could come closer to God by rejecting worldly goods and committing himself to a severe personal regimen of prayer, meditation, fasting, and mortification of the flesh. At the same time Francis showed genuine compassion for individuals who were not as disciplined as he, celebrating the positive aspects of earthly life. He expressed an especially profound love of natural beauty. The words of Francis's Canticle of the Sun (begun in the summer of 1225), a mystical poem in which he addresses "brother sun and sister moon" as manifestations of God's presence in the world, suggest the immediacy with which he embraced the natural universe. In 1224, just two years before his death, he developed marks on his hands, feet, and side corresponding to the

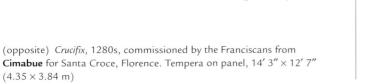

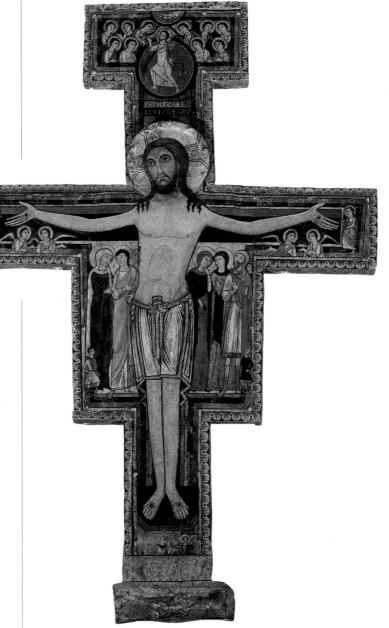

1.1 San Damiano Crucifix, twelfth century, unknown **Umbrian artist** for San Damiano, Assisi. Tempera on panel, $6'\ 2\mbox{\em 2}''\times 3'\ 11\mbox{\em 1}'''\ (190\times 120\ cm)$ (Santa Chiara, Assisi)

wounds of Christ. The stigmata, as these wounds are called, marked Francis in the eyes of some of his followers as a second Christ (alter Christus). Just as he wrote of seeing God "through all that you have made" in the natural world, his followers could have a vision of Christ through Francis. Through his exemplary life and through his preaching that relied on familiar images of the world as metaphors of the divine, Francis helped bring about major reforms that made institutional religion measurably more attractive and accessible to the entire population. Moreover, the simplicity of Francis's new religious vision and his compelling preaching raised expectations that religious stories and doctrines would be represented vividly and personally.

Francis as Another Christ

In this typical passage from his life of St. Francis (known as the *Legenda Maior* because it superseded all other lives of the saint), St. Bonaventure engages the reader with rich anecdotal detail, at the same time making clear the symbolic and religious implications of all he reports.

On the feast of the Exaltation of the Holy Cross, while he was praying on the mountainside, Francis saw a Seraph with six fiery wings coming down from the highest point in the heavens. The vision descended swiftly and came to rest in the air near him. Then he saw the image of a Man crucified in the midst of the wings, with his hands and feet stretched out and nailed to a cross. Two of the wings were raised above his head and two were stretched out in flight, while the remaining two shielded his body. Francis was dumbfounded at the sight and his

heart was flooded with a mixture of joy and sorrow. He was overjoyed at the way Christ regarded him so graciously under the appearance of a Seraph, but the fact that he was nailed to a cross pierced his soul with a sword of compassionate sorrow. . . .

Eventually he realized by divine inspiration that God had shown him this vision in his providence, in order to let him see that, as Christ's lover, he would resemble Christ crucified perfectly not by physical martyrdom, but by the fervor of his spirit. As the vision disappeared, it left his heart ablaze with eagerness and impressed upon his body a miraculous likeness. There and then the marks of nails began to appear in his hands and feet, just as he had seen them in his vision of the Man nailed to the Cross. His hands and feet appeared pierced through the center with nails, the heads of which were in the palms of his hands and

on the instep of each foot, while the points stuck out on the opposite side. The heads were black and round, but the points were long and bent back, as if they had been struck with a hammer; they rose above the surrounding flesh and stood out from it. His right side seemed as if it had been pierced with a lance and was marked with a livid scar which often bled, so that his habit and trousers were stained. . . .

True love of Christ had now transformed his lover into his image, and when the forty days which he had intended spending in solitude were over and the feast of St. Michael had come, St. Francis came down from the mountain. With him he bore a representation of Christ crucified which was not the work of an artist in wood or stone, but had been reproduced in the members of his body by the hand of the living God.

(from Marion A. Habig. St. Francis of Assisi: Writings and Early Biographies. Chicago: Franciscan Herald Press, 1973, pp. 730-2)

The San Damiano Crucifix: Christus triumphans

Examining the twelfth-century crucifix that spoke to St. Francis (see Fig. 1.1) reveals a great deal about art in Italy before the sweeping stylistic changes that came about during the Renaissance. This painting was clearly extremely powerful, capable of "speaking" to Francis in spite of its bold stylization and many unnaturalistic details. On the San Damiano cross Christ is superhuman, enduring substantial pain and suffering, as witnessed by blood spurting profusely from his hands, feet, and a wound in his side. At the same time, he seems to be immune to death, as indicated by his wide staring eyes and smooth, unblemished body. Rather than hanging upon the cross, Christ seems to levitate in front of it, his eyes raised to heaven, which the artist has suggested by busts of conversing angels beneath his arms and a small figure of the risen Christ striding towards other angels at the top of the crucifix. Theologians termed this a Christus triumphans (triumphant Christ): an image that effectively represented Christian belief in resurrection and everlasting life, but which had little to do with the actual physical sufferings of the historical Jesus, who was whipped, nailed to a cross, and left to die from asphyxiation and prodigious loss of blood. Although someone of St. Francis's sensitivity could perceive Christ's personal suffering with an image like the Christus triumphans, to many, this type of Christ must have seemed aloof and distant, a reminder of the enormous gulf between the human and the divine. Instead of grieving, the figures of Mary and Christ's followers that are painted to Christ's left and right sport beatific smiles, and Christ himself remains impassive and unapproachable.

Christus patiens

Depictions of the crucified Christ changed dramatically in the 1230s and 1240s. While it is never possible to determine the exact reasons for stylistic change-artists, patrons, and society all interact in this process-it is intriguing to note that precisely in these years Francis's followers began to travel extensively. Some took their missionary zeal as far as the eastern Mediterranean where they came into direct contact with Byzantine art; the vast majority spread throughout central Italy and eventually across Europe, where they preached a new, more empathetic gospel, inspired by Francis's own total identification with Christ's ultimate sacrifice. Artists, especially those working for the Franciscans and other new mendicant orders, now showed Christ with eyes closed and overcome by death, although free of the horrific details of actual crucifixions. This type of suffering Christ (Christus patiens) quickly replaced the regal, live Christ over altars and on choir screens throughout Italy. Their model seems to have been a large crucifix, now lost, that was painted by Giunta Pisano (active 1236-54) for the basilica of San Francesco, which Brother Elias built in

1.2 *Crucifix*, 1270s (?), commissioned by the Dominicans from **Cimabue** for San Domenico, Arezzo. $11' \times 8'$ 9" $(3.36 \times 2.67 \text{ m})$

Assisi to honor St. Francis after his death (an imposing structure we will discuss in Chapter 3). Replicating this model in crucifixes for other churches was thus to imitate not just the form of the Assisi

crucifix in the home church of the Franciscan order, but to vivify the presence of Franciscan spirituality wherever it appeared.

One of the most poignant examples of this new type of crucifix was painted in the 1270s by the Florentine artist Cimabue (Cenni de Pepi; active 1260s-1302 Florence, Arezzo, Assisi, Pisa, and Rome) for the Dominican church of San Domenico in Arezzo (Fig. 1.2), showing how quickly other religious orders accepted the Franciscan model as an effective devotional image. Very little is known about Cimabue's life, but his work indicates that he, like many of his contemporaries, was deeply impressed by Byzantine art. The type of suffering Christ he created for Arezzo had already appeared in Byzantine art in the eleventh century. It gained popularity in Italy only in the thirteenth century, however, when the emotional and immediate spirituality of reformers like Francis and St. Dominic (Dominic de Guzman, c. 1170-1221), founder of the rival Dominican order, encouraged worshipers to identify with Christ more closely. Retaining the traditional format of earlier crucifixes, Cimabue stripped away most of the distracting secondary figures, mercilessly forcing the

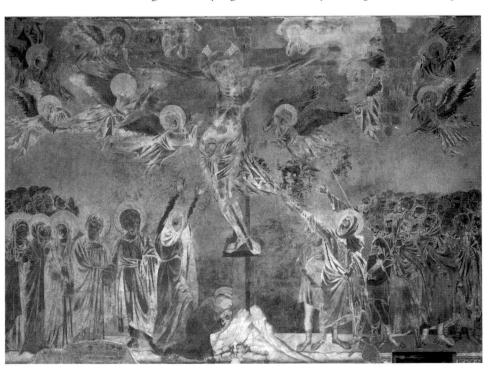

viewer to focus on Christ's human sacrifice. Christ's long hair is as stylized as on earlier crucifixes, but it moves nastily in scratchy tracks along his neck and shoulders. Sharp gashes mark his eyes, and his skin

> stretches tightly across the bony chest. Muscles appear on his arms, and his abdomen now heaves within its rib cage, only to collapse in a wide arc well to the left of the cross's

central axis. The image communicates sadness, not eternal power, and compels individual identification with Christ's sufferings—behavior exemplified by the grieving figures of the Virgin Mary and St. John who hold their heads in mourning in the rectangular panels at the ends of the arms of the cross.

The theme of the Crucifixion was so central to the thought and experience of Francis and his followers that they had it painted in both transepts of the basilica of San Francesco. The subject underlined Francis's identification with Christ and his sacrifice while reminding the Franciscan friars who wor-

shipped in the apse and transept to follow his example. Cimabue's fresco (Fig. 1.3) is compelling in spite of the fact that the lead white pigments have oxidized, reversing the original relationships of light and dark. In this narrative work Cimabue had more license and pictorial space to tell the story of Christ's death. Everything is windblown and charged with dramatic intensity. At the very center the painter chillingly contrasts the deathly, sinuous slump of Christ's body with a loincloth that flaps freely in the howling wind. Mary Magdalene to the left and the Roman cen-

turion Longinus, who realized Christ's divinity from the tumultuous circumstances of his death, thrust their arms desperately toward Christ. Angels bring the moment to its final fevered pitch, fretting, twisting, and crying in response to this universal tragedy. Only Francis, kneeling at the foot of the cross, finds solace in the moment of horror. Crowds press in from either side, but Francis, miraculously transported in time to the moment of the Crucifixion, clings to the foot of the cross, as if the intensity of his devotion had collapsed time, allowing him to participate fully in this crucial event in Christian history, just as he participated in Christ's Passion by carrying the stigmata on his own body.

Cimabue tempered this new emotionalism when he painted a later crucifix for the

1.3 *Crucifixion*, after 1279, commissioned by the Franciscans from **Cimabue** for the transept of the Upper Church, San Francesco, Assisi. Fresco, $17 \times 24'$ $(5.18 \times 7.32 \text{ m})$

52

Franciscans of Santa Croce in Florence (see p. 48), respecting the greater sense of decorum expected from such a work. For all its restraint, however, the work is no less gripping. Cimabue paid closer attention to Christ's anatomy than he had in his earlier, more stylized crucifix in Arezzo (see Fig. 1.2) and pushed Christ's softer body into an even more slumped and dramatic curve. By placing Christ's hands higher on the cross arms, Christ seems to hang from it, as he had in the fresco at Assisi. Most startling, however, is the daringly transparent loincloth, revealing Christ's thighs and buttocks. Contemporaries understood this as signifying Christ's nakedness, the ultimate expression of Christ's full humanity and humility. A Franciscan devotional tract of the late thirteenth century, the Meditationes, instructed worshipers how to approach such an image: "Turn your eyes away from His divinity for a little while and consider Him purely as a man." The huge size of Cimabue's crucifix, the naturalistic softness of the carefully modeled surfaces of the body, the bust-length grieving figures of the Virgin and St. John at the ends of the cross arms, and the enlarged inscription made such a message difficult to avoid.

Defining St. Francis

The Franciscans also worked diligently to develop a compelling image of their charismatic founder. For the institutionalized Church, promoting the cult of St. Francis meant controlling, enhancing, and sometimes sanitizing his image. In 1228 Pope Gregory IX (r. 1227–41) commissioned a biography of the saint from Thomas of Celano.

Official biographies, commissioned by the papacy at the time of canonization and read on a saint's feast day, were primary vehicles

for allowing the Church to ensure that the proper lessons were drawn from a saint's life. Celano's work gave a gritty portrait of a man with foibles and weaknesses who was also a formidable miracle worker. Sixteen years later Celano was told to make extensive revisions of the life, softening his emphasis on Francis's asceticism and dispensing with any posthumous miracles so as to focus on Francis's saintly acts during his lifetime.

Francis's official image was finally codified in 1260 with the commissioning by the Franciscans themselves of a third and canonical—that is, final and definitive—biography from Bonaventure of

Bagnoreggio, a young Franciscan and future Minister General of the Order. Taking familiar stories from Francis's life but framing them metaphorically, Bonaventure composed a mystical portrait of the saint as a modern Elijah, Moses, John the Baptist, angel of the Apocalypse, and faithful imitator of Christ. He admitted Francis's radical commitment to poverty and simplicity, but emphasized how Francis had worked within the institutional Church to effect his reforms. In Bonaventure's work, known as the *Legenda Maior*, Francis's radical life was tamed and fitted for use by the official Church. All previous lives were ordered destroyed.

Images of Francis underwent notable changes as artists and patrons attempted to find the most effective ways to communicate who Francis was and what he stood for. Early on, Byzantine examples once again furnished appropriate models. In 1235 Bonaventura Berlinghieri (active 1228-74), an artist from Lucca noted for his highly stylized, icon-like representations, produced the earliest known signed and dated altarpiece representing St. Francis (Fig. 1.4). Although the work was created only nine years after Francis's death, the central standing image of Francis shows nothing of the saint's renowned good humor and accessibility that was so evident in Celano's contemporaneous biography. Instead, Francis appears highly formal, even forbidding, in a rigid frontal pose emphasizing his asceticism-a style considered suitable for an altarpiece, an image for contemplation and worship. The figure conforms to the traditions of saintly representations in Byzantine art, noted for the aura of sanctity and mystery with which the holy figures are portrayed.

of the sainted figure, but also apparently consciously attempted to depict St. Francis's actual features since many of the people who saw the painting would also have seen Francis. The "por

In this case Berlinghieri provided the iconic form

have seen Francis. The "portrait" of the saint thus retained the essence of the original figure, recalling much older presumed portraits of saints painted in ancient times.

The iconic aspects of Byzantine art were well suited to emphasizing the spiritual aspects of Francis. The identification of him as an individual is achieved through attributes: the knotted cord of his brown habit, his tonsure and beard, and the stigmata

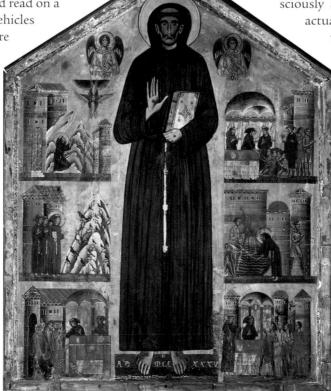

1.4 Altarpiece of St. Francis, 1235, commissioned from **Bonaventura Berlinghieri** for San Francesco, Pescia. Tempera on panel, $60 \times 45\%$ " $(1.52 \times 1.16 \text{ m})$

on his hands and feet. Three small scenes to either side of the saint's looming figure mitigate some of his sternness. These more lively images were meant to be read as stories, providing insight into Francis's popular deeds and miracles and the reasons he was to be revered. For example, Francis is shown receiving the stigmata from a seraph. The positioning of this event at the upper left (that is, to the saint's right) suggests that it was the most important in Francis's life. Other scenes depict the saint preaching to birds and making various miraculous cures—a blending of the official and the popular, but all within a narrative context meant to convey the historical facts of miraculous events, thus demanding a more animated and naturalistic style than did the central iconic figure of Francis.

St. Clare

The same general compositional scheme of the altarpiece was used for many other depictions of saints in this period, including St. Clare (c. 1194-1253), the founder of the second (or female) order of Franciscans known as the Poor Clares (Fig. 1.5). Clare was a noblewoman of Assisi. When she became a follower of St. Francis in 1212 and began her religious order, she apparently intended to create a female community comparable to the original Franciscans. Francis insisted, however, that the Poor Clares live in strict clausura, cloistered away from the world. Clare's community, too, grew to a sizable one, and she was known as a miracle worker. When she was canonized in 1255, just two years after her death, Pope Alexander IV (r. 1254-61) commissioned Thomas of Celano to write her official biography. Figure 1.5, dated to the 1280s, represents St. Clare in much the same manner as Berlinghieri's painting of St. Francis. A central iconic image of the saint on a gold ground is flanked by eight scenes from her life taken from Celano's biography. Her history throughout the narrative panels-the first to represent a contemporary female saint-is tied to St. Francis. Her parents' disapproval of her wish to follow Francis, depicted at the upper left, mirrors his confrontation with his father, for example, and her death and funeral rites on the two panels to the lower right are depicted in a way comparable to those of Francis. Yet the middle two narrative panels on the right, depicting Clare's miraculous feeding of her religious sisters and her death, place her solely in the company of women. She is presented as a model of chastity, as well as obedience, having accepted Francis's demands that her order be cloistered.

Still, the unknown painter commissioned by the Poor Clares to depict their founder gave her a livelier and more approachable presence than we find in any early image of Francis. St. Clare is depicted within an architectural niche, almost as if she were modeled in space, much like painted wooden figures sometimes used as the centers for elaborate multi-paneled altarpieces. The top side panels are arched, creating the illusion that the sides are wings that could be

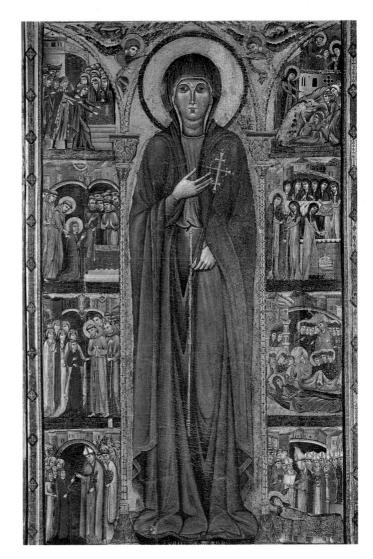

1.5 Altarpiece of St. Clare, 1280s, probably commissioned by the Clarissan sisters of the monastery of Santa Chiara, Assisi. Tempera on panel, $9 \times 5\%' (2.73 \times 1.65 \text{ m})$

folded in to match the arch behind Clare's head. The painting thus has the characteristics of small, private, portable devotional images, appropriate for the cloistered nuns, and at the same time it is of the scale of a major pilgrimage object honoring an important saint. Clearly the tensions between the intercessory power of this woman and the traditional submissive role assigned to women in the society (and underscored again and again in Celano's biography) underlie this image of St. Clare.

Style and Meaning As we have seen, art associated with Francis and his followers varied in its style and tone according to the purposes for which it was made and the audiences it was meant to address. Byzantine art provided severe, stylized models for images of saints but also empathetic compositions such as the Christus patiens type for crucifixes. Differences between devotional and narrative works (crucifixes and altarpieces versus narrative frescoes) also affected how artists approached their models. While Vasari universally disparaged the maniera greca (the Greek manner, his term for the Byzantine style), Byzantine art actually

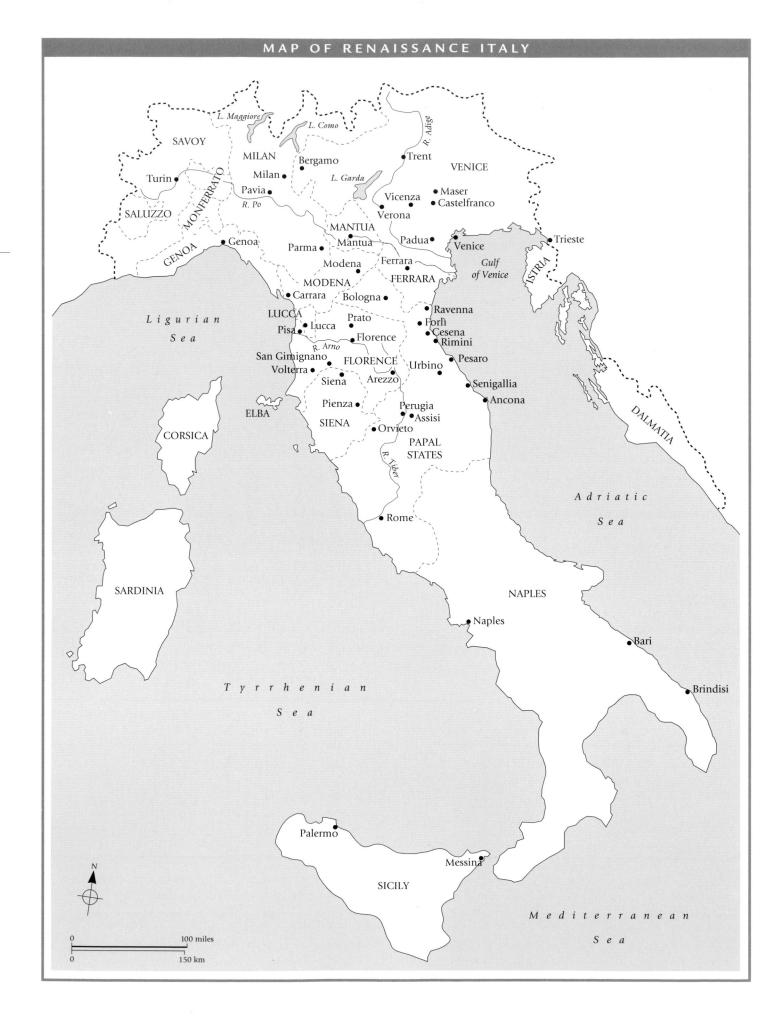

offered a highly nuanced and rich repertoire of possibilities to artists and patrons in thirteenth- and fourteenth-century Italy. Harnessed to the engine of Franciscan religious reform, it took on new life and expressive properties.

Urban Contexts

At the same time, many other forces were at work throughout Italy. In Rome the popes began to restore early Christian monuments that contained numerous, inspiring cycles of ancient Roman paintings. Architects and sculptors in Rome and other Italian cities often turned to French Gothic models, too, and artists undertook their own explorations of how best to respond to and shape a changing world. To see these forces at work most coherently, we will turn to a series of portraits of Italy's leading urban centers in the late thirteenth and fourteenth centuries.

First it is important to emphasize that Italy as we know it did not exist in the Renaissance. There were no "Italians" in the modern sense—only Venetians, Milanese, Florentines, Sienese, Romans, Neapolitans, and other groups whose identities were defined by the city-state or territory in which they lived. City-states dominated the peninsula, each possessing and cherishing a distinct history, dialect, set of popular traditions, social and governmental structures, economy, and artistic and cultural expectations.

Geography and history conspired to keep city-states apart. Although nothing but the broad Lombard and Paduan plains separate Venice and Milan, the two cities effectively occupied two different worlds. Venetians took advantage of their site on the Adriatic Sea to tie the city's economic and cultural life to the eastern Mediterranean, especially Constantinople and Crete, whereas Milan looked the other way, standing as it did just south of a pass in the Alps on one of the major routes through Burgundy to Paris. The Appenine Mountains, running down the central spine of the peninsula, split east from west, while hilltops, affording natural protection from invaders, were crowned with many insular towns. The jagged coastline played its own part in isolating one maritime Italian state from another. Little wonder that the political unity of Italy in ancient Roman times was only vaguely remembered throughout the Renaissance and that the modern nation of Italy (finally unified in 1870) has had to work so hard to hold itself together.

At the same time, Italy's geography and history also distinguished it from the rest of Europe. The Italian peninsula is a distinct geographical feature, jutting freely into the Mediterranean Sea. At its north the Alps establish a formidable barrier, protecting Italy from the colder climate of northern Europe and from easy military invasion. The history of this land stretched back over two thousand years; and the fact that its people had been united in ancient Roman times meant that they were conscious of sharing a common cultural heritage. In 1347 Cola di Rienzi (1313–54), a fiery Roman civic leader and advocate of reviving a "sacred Italy,"

invited representatives from all the major cities of the peninsula to meet in Rome to confirm their common Roman citizenship; twenty-five accepted. The cities saw each other as rival siblings rather than separate nations.

By the thirteenth century every city on the peninsula had already created and accumulated centuries of artistic and cultural traditions that gave each a distinctive personality in the eyes of contemporaries. This process of self-definition continued unabated through the Renaissance, constantly refreshed by active commercial and diplomatic exchange between cities and with states far beyond the peninsula. Concurrently, a measure of unity was imposed by newly founded religious orders, whose monastic communities spread throughout the length of the peninsula. In all of this the arts served as the primary means for cities, corporate bodies, religious orders, and individuals to convey ideas about themselves and their place in the world (and throughout the Christian world and its colonies).

Types of Cities

The Italian city-states fall into three broad political categories: 1) republics, such as Venice, Florence, and Siena; 2) states ruled by a sovereign, such as Naples, Milan, and many small principalities of northern Italy; and 3) the Papal States, including Rome, under the temporal authority of the pope. This categorization offers a useful way of thinking about Italian cities which indicates their similarities as well as differences. While Naples and Milan, for example, are farther from one another than any other two cities discussed in this book, their ruling families inter-married, and artistic activity at both courts centered around exalting the ruler and his dynasty. These two cities offer ample opportunities for comparing and contrasting the distinctive ways artists and patrons maneuvered within comparable social and political structures. A similar situation applies in the republics. Venice, Florence, and Siena often emphasized differences in their topography, local history, legends, and artistic traditions, yet all three cities were concerned with promoting a communal ideal, linking Church and state, and generally giving citizens a stake in their city's fashioning and embellishment. Papal Rome was different again, the city's thousands of years of history and unique position as the capital of western Christendom deeply conditioning the character of art that was produced there.

As we introduce each of these important centers, we will pay attention to how their particular history, geography, social structures, and artistic traditions intertwine. Rather than seeking a single "source" or "origin" for the Renaissance, we will distinguish the many strands that constitute our period's beginnings. We are primarily interested in how artistic developments in each of these cities were important for their own time and place, but we will also suggest how they are related to one another and the ways in which they opened up avenues for further exploration and discovery.

2 Rome: Artists, Popes, and Cardinals

o city in Italy could boast as rich and complex a history as Rome. A fifteenth-century woodcut emphasizes its papal and imperial monuments (Fig. 2.1). The palace of the popes (clearly labeled *palatium pape*) stands on the horizon immediately to the right of Old St. Peter's Basilica, burial site of the Apostle who was the first pope. The prominent position of these structures on the Vatican hill reflects the city's domination by the papacy. Major

monuments of Roman antiquity stretch across the foreground of the print, documenting the city's former grandeur. Many of these had acquired or been given Christian significance. At the far left appears a corner of the Colosseum (sacred site of Christian martyrdom), followed by the dome and portico of the Pantheon (rededicated as a church to the Virgin Mary) and the column of Trajan (an ancient monument to one of the Roman emperors whom Christians recognized as "good"). At the far right stands the huge drum-shaped Castel Sant'Angelo, originally the mausoleum of the Emperor Hadrian but later endowed with fortifications by several popes. Hefty ancient walls continued to define the city's limits.

Even so, Rome was but a shell of its former self. Whereas other cities repeatedly outgrew and expanded their ancient and medieval walls, Rome rattled around inside them. Huge fields of ruins stood starkly in what once had been densely populated neighborhoods; sheep and cows grazed in the remains of the imperial fora. Most of the population lived in the neighborhood at the bend on the river Tiber where the Vatican met the old imperial city.

The woodcut shows a good number of houses in front of the Vatican, along with a porticoed church-like building and enormous courtyard that made up the papal hospital of Santo Spirito, an institution committed to public chari-

ty. As effective rulers of Rome, the popes, who claimed that their temporal rulership of the state had been conferred on them by Constantine before he moved the capital of the Empire to Constantinople in the fourth century, were responsible for all aspects of life in the city. Although the Roman Senate continued to exist as the official civic government, real control over the city was exercised by the pope and a few very strong factionalized feudal families such as

2.1 View of Rome, from Hartmann Schedel, Liber chronicarum, 1493. Woodcut

1 Colosseum; 2 Quirinal Hill (and Horse Tamers); 3 Nile River God (now on Capitoline Hill); 4 Trastevere; 5 Pantheon; 6 Column of Marcus Aurelius; 7 Obelisk of Augustus; 8 Old St. Peter's; 9 Hospital of Santo Spirito; 10 Sistine Chapel; 11 Papal Palace; 12 Tomb of Romulus (destroyed 1496); 13 Castel Sant' Angelo; 14 Belvedere of Innocent VIII; 15 Santa Maria del Popolo; 16 Porta del Popolo

the Colonna and the Orsini whose histories went back to classical antiquity, or so they claimed.

Artistic patronage in Rome was determined by the peculiar nature of papal authority, which was both religious and secular, local and international, and by the papacy's need to respond to the political demands of the Senate and the city's leading families. The lineage of the papacy had been continuous and unbroken since Peter, the first pope, but it was non-dynastic. A pope was elected for life by the cardinals, his major subordinates within the hierarchically organized institution of the Church. Presumably celibate, a pope had no heirs to whom the office could descend. The cardinals and the popes were not always Roman or even Italian, a situation that led inevitably to power struggles between the popes and local families who sought favorable treatment from the papacy. Thus the popes had to construct an artificial lineage, associating themselves with the histories and deeds (including artistic commissions) of their predecessors, so as to underscore the continuity of the papal office and their unbroken connections with its previous holders. Given these concerns and the imposing, ubiquitous reminders of past glory, it is not surprising that art and culture in Rome were often highly traditionalist. Within these traditions, however, were some of the key

(opposite) The Last Judgment (detail), c. 1290, commissioned by Jean Cholet from **Pietro Cavallini** for Santa Cecilia in Trastevere, Rome. Fresco

elements from which artists and patrons would fashion a new art. Rome boasted unsurpassed riches of ancient and Early Christian art, including vast expanses of painting and mosaic as well as imposing architectural remains.

Rome's Revival under Nicholas III

In 1277 Cardinal Giangaetano Orsini ascended the papal throne as Nicholas III (r. 1277-80)-an event that was to stimulate a revival of Rome. His immediate predecessors had been mainly Frenchmen unwelcome in the city. During the three years of his papacy Nicholas initiated a major expansion to the popes' palace at the Vatican as well as the restoration of Early Christian frescoes at the papal basilicas of St. Paul's Outside the Walls and Old St. Peter's. Construction at or near St. Peter's served both personal and papal needs. By concentrating his efforts at the Vatican, rather than at St. John Lateran, the official cathedral of Rome, Nicholas underscored the papacy's descent from St. Peter, who was buried there and whose cult centered around the Vatican's own basilica. At a practical level Nicholas's work in the Vatican benefited from the fact that the Orsini, his family, controlled the district directly across the Tiber, thus giving him a strong power base in the city. Nicholas himself had served as an archpriest at St. Peter's, and some of his relatives had been buried there.

Nicholas made substantial additions to the papal palace in the Vatican, determining much of the basic structure of the later Renaissance palace. Although it was significantly altered over succeeding centuries, Nicholas's palace included a large chapel, audience hall, and state chambers, surrounded by a great park. Some of the decorations of Nicholas's chambers survive above later dropped ceilings (Fig. 2.2). In one of the frescoes lively birds play amid leafy garlands; in another, a corbeled arcade runs along the top of the wall. These motifs appear again and again in Roman medieval art. But unlike their immediate predecessors, which had become increasingly linear and schematized from repeated copying and imitation, these motifs are vigorous and animated. Some, especially the birds, seem almost to be drawn from life. The leafy garlands, on the other hand, derive from a renewed acquaintance with antique frescoes that Nicholas's artists were restoring next door in St. Peter's. What appeared new was actually very old. This conscious revival of a late antique style gave formal unity to the decorative program at the Vatican and, more importantly, recalled the early days of the Church in Rome-an association with positive meaning for Nicholas as he sought to reestablish the papacy in Rome.

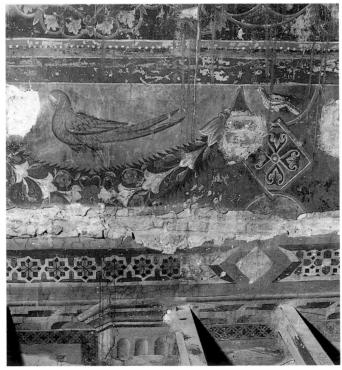

2.2 Birds, garlands, and architectural motifs, c. 1277, commissioned by Nicholas III for the Vatican Palace, Rome. Fresco

The Sancta Sanctorum

A major earthquake in 1278 offered Nicholas III the opportunity to rebuild the Sancta Sanctorum, the popes' private chapel at the Lateran Palace (Fig. 2.3). Nicholas graciously conceded recognition to his builder, Cosmatus, in a marble plaque on the entrance wall. The architect provided the pope with a compact cubical space where decorations again link Nicholas to his predecessors by carefully blending old and new. The chapel is crowned with cross-ribbed vaulting, "modern" insofar as these sorts of masonry structures covered most new churches in Europe in this period, but the vaults themselves spring from reused Roman columns in the corners of the basically square space. The rectangular apse is marked by a marble entablature supported on reused porphyry columns, an Egyptian stone so expensive and highly prized that in ancient times its quarrying and use were under the direct control of the emperors. Nicholas had the words "NON EST IN TOTO SANCTIOR ORBE LOCUS" ("There is not a holier place in the entire world") inscribed on the architrave, referring to the fact that here the popes housed one of Christianity's most sacred relics, the Acheropita, a presumed true portrait of Christ. Two of

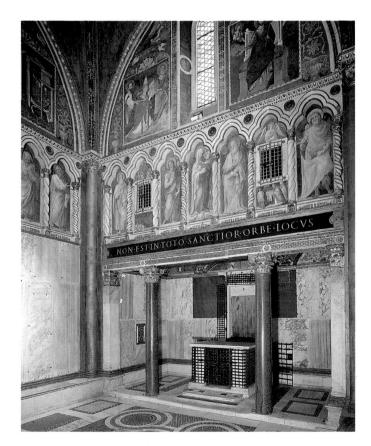

2.3 Sancta Sanctorum, 1278, commissioned by Nicholas III from Master Cosmatus for the Lateran Palace, Rome (Scala Santa)

The stairs leading up to this chapel originally served as the entrance to the medieval Lateran Palace. Legend said that they had come from Pilate's house in Jerusalem, where Christ was said to have walked on them. Out of respect, pilgrims climb the steps on their knees.

2.4 Nicholas III Kneeling with SS. Paul and Peter before Christ, 1277-80, commissioned by Nicholas III for the Sancta Sanctorum, Lateran Palace, Rome. Fresco (Scala Santa)

Nicholas is accompanied by the papal patrons, St. Paul and St. Peter.

Nicholas's most powerful thirteenth-century predecessors, Innocent III (r. 1198-1216) and his successor Honorius III (r. 1216-27), had enshrined the image in gold, silver, and bronze. Now Nicholas rebuilt the chapel for its adoration, both linking himself to his predecessors and graphically proclaiming his contact with Christ, his ultimate source of authority.

Frescoes recounting stories of saints whose relics were kept in the Sancta Sanctorum brighten the side walls of the chapel. Gold mosaics add luster to the vaults over the altar. Saints Peter and Paul—one the first pope, the other the early Church's most ardent and eloquent proselytizer, both martyred and buried in Rome-present Nicholas to the perpetual company of the Savior and the saints (Fig. 2.4). The pope kneels, assuming the pose typical of patrons in the Middle Ages and Renaissance, and presents a model of his chapel to Christ who sits enthroned in a paired fresco on this same wall (see Fig. 2.3). Nicholas's portrait is a highly personable image, confident and relaxed in a manner that none of the scores of earlier representations of popes as donors had been.

Art and Miracles

During the Renaissance, as in other periods, art was on occasion vested with supernatural powers. A carved wood image of the Christ Child (Fig. 2.5) preserved at the Franciscan church of the Aracoeli in Rome, was rushed to the bedside of mortally ill children and credited with numerous miraculous recoveries. Reliquaries (see Fig. 6.4) were carried through the streets to stave off plague and military threats. The Madonna of Impruneta in the countryside outside Florence was regularly brought into the city to control the weather, and the Madonna and Child at Or San Michele in Florence (see Fig. 8.12) intervened when nature got fully out of control, saving devotees from drowning in the city's frequent

The figures of miracle-working images exhibited great sympathy for their human devotees and themselves manifested very human characteristics: they could be saddened and weep; they could close their eyes when offended; they bled; they could be jealous and moody, refusing their normal thaumaturgical activities if not accorded appropriate respect. Above all, they were fiercely loyal, protecting cities, communities, and individuals from natural and human disasters.

Ironically the works credited with effecting miraculous cures, assisting in the accomplishment of difficult or perilous tasks, or protecting devotees from harm or misfortune were most often works with little or no aesthetic pretension. The very power of the miracle existed in some large measure in surprise. Just as miracles could not be planned, miracle-working images could not be manufactured. They had their greatness thrust upon them. And their very ordinary quality, embedded in the life of the community, helped to lend them power and veracity. Although an artist might sometimes be called upon to update or enhance a miracle-working image, as was the case

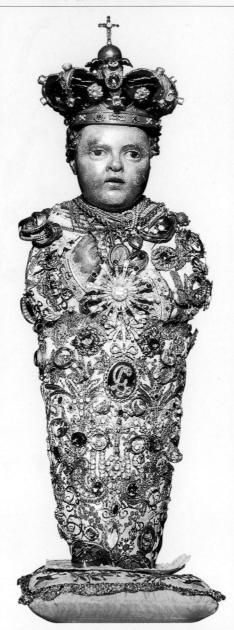

2.5 The Bambino of Aracoeli, second half of the fifteenth century, commissioned by the Franciscans of Santa Maria d'Aracoeli, Rome. Polychromed wood

Legend has it that the sculpture was carved from wood from the Mount of Olives in Jerusalem.

with Bernardo Daddi's Madonna and Child for Or San Michele, the "creation" of miraculous images was largely a popular phenomenon.

The divine chose to dwell in images serendipitously, but once an image began working miracles, it could be kept efficacious through devout reverence. Figures like the Christ Child in Rome were dressed in elegant outfits and fitted with crowns. Statues of the Madonna were adorned with necklaces and earrings. Often the object was enhanced architecturally. Santa Maria dei Miracoli in Venice (see Fig. 13.29) was built to house what had been a simple devotional image on a street corner. At Santa Maria delle Carceri in Prato the original wall upon which the Madonna had been painted was deemed so sacred that it was incorporated physically into the structure of the fifteenthcentury church, even though the curve of the original apse did not correspond to the geometry of the new structure.

How did the Church tolerate what seems to most modern viewers extraordinarily pagan and idolatrous behavior? Christians believed that God had taken on human form in their savior Christ, and that God continued to act directly and sometimes dramatically in the lives of believers. Church authorities maintained, in spite of what much of the general public might have believed, that the images themselves did not perform miracles. Instead, God and his saints worked through images. Theologians distinguished between reverence and worship, only the latter being due to God. In countering charges of paganism at the end of the sixth century, Gregory the Great had insisted that physical representations of the deity were merely aids to contemplation of the divine, not direct manifestations of divinity itself. Statues and paintings were allowed, even encouraged, because they invited reverence and served didactic purposes, especially for the illiterate.

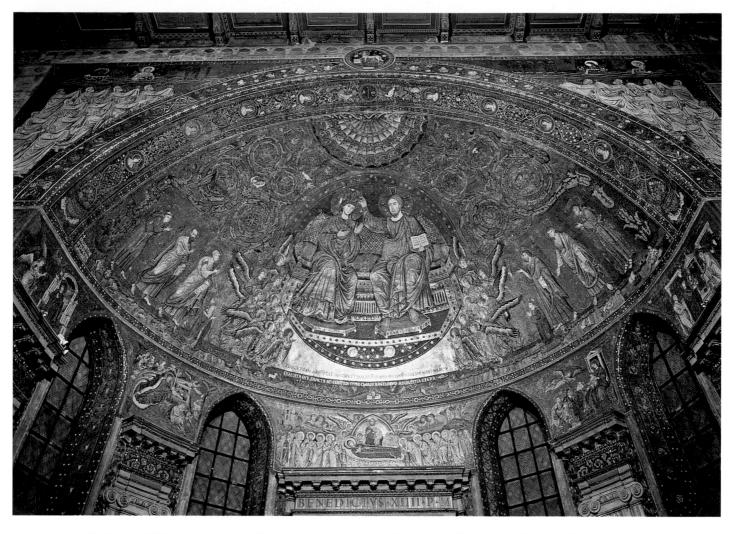

2.6 Coronation of the Virgin, c. 1294, commissioned by Nicholas IV from Jacopo Torriti for the apse of Santa Maria Maggiore, Rome. Mosaic.

Nicholas IV at Santa Maria Maggiore

Pope Nicholas IV (r. 1288-92), a native of Ascoli and the first member of the new reforming Franciscan order to head the Church, continued the cultural policies of Nicholas III. His major focus was Santa Maria Maggiore, the papal basilica in the neighborhood controlled by the Colonna family, who effectively adopted this non-Roman pope, a redressing of urban power after the earlier Orsini pope. Nicholas replaced the old apse at Santa Maria Maggiore with a larger, more impressive structure that included a transept, enhancing its similarities to Old St. Peter's. He lined the apse with marbles and mosaics by the Roman painter and mosaicist Jacopo Torriti (active 1270–1300 Rome) depicting the Coronation of the Virgin in a star-studded blue orb (Fig. 2.6). Imperially clad figures of the Virgin and Christ sit upon a golden throne softened with scarlet and blue cushions. Raising his right hand to the Virgin's head, Christ completes the coronation of his Queen of Heaven while angels steady the celestial sphere. The Latin inscription below it comes from the liturgy for the August 15 feast of the Assumption of the Virgin, the anniversary of the traditional founding of the basilica. It calls explicit attention to key elements in the representation: the Virgin's assumption to the heavenly throne, the starry realm of Christ the King, the chorus of angels, and the Virgin's royal status. This depiction of the Virgin as the Queen of Heaven can also be seen as a reference to Mary as Ecclesia, or the Church, the bride of Christ, a metaphor based on the Old Testament Song of Songs. In this role Mary/Ecclesia appears as coruler with God, like him capable of granting salvation. It is a powerful image of the Church controlling Christian destiny and of the popes who were its head.

To the left of the central image a small figure of Nicholas in a scarlet coat and papal tiara kneels as patron before standing figures of the saints Peter and Paul, who appear to be presenting the pope to the celestial court. To the left of these saints Torriti represents the plainly clad and tonsured figure of St. Francis, an appropriate inclusion for a patron who had begun his ecclesiastical career as a Franciscan. At the right a miniaturized Cardinal Jacopo Colonna kneels before another pair of saints, John the Baptist and John the Evangelist; at the far right St. Anthony of Padua, another Franciscan, completes the Franciscan "bracketing" of the scene.

Torriti's full, soft forms and the poses of his figures recall the Byzantine imperial style of the mid-1260s that had abandoned the characteristically insistent linear patterns of Byzantine art. The mosaic's lush green rinceaux (stylized, scrolling vine patterns) sprout red flowers and give roost to splendid paradisiacal birds—peacocks, cranes, and partridges. These motifs and the water flowing from river gods along the base of the mosaic suggest that late classical models also formed part of the mosaicists' repertoire. Here, in fact, the artists may have been replicating or even reusing elements from the original fifth-century apse. Obviously, neither Byzantine nor late antique models had outlived their usefulness, primarily because both were still vibrant, living traditions.

Patrons from the Papal Curia

Commissions by two cardinals at their titular churches in Rome document the competitive spirit that prevailed among patrons at the papal court. Toward the end of the thirteenth century, at Santa Maria in Trastevere, Cardinal Bertoldo Stefaneschi commissioned the Roman painter Pietro Cavallini (Pietro dei Cerroni; c. 1240/50-1330s) to renovate the church's mid-twelfth-century apse mosaic by the addition of a band of scenes from the life of the Virgin below it. Cavallini was an artist of considerable genius, who has been under-appreciated by many art historians—partly, no doubt, because he was largely unknown by Vasari, who credited many of Cavallini's innovations to the Florentine artist Giotto. Cavallini made his reputation working for Pope Nicholas III, restoring Early Christian frescoes in the

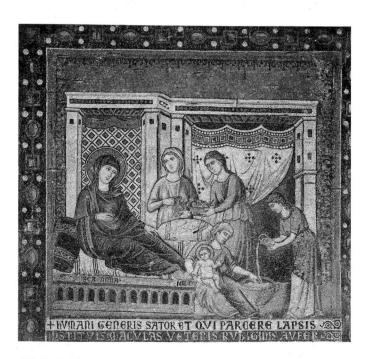

2.7 Birth of the Virgin, c. 1290, commissioned by Bertoldo Stefaneschi from Pietro Cavallini for the transept wall of Santa Maria in Trastevere, Rome. Mosaic

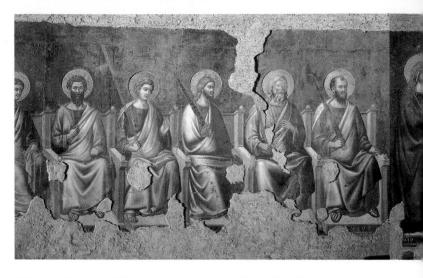

2.8 Last Judgment, c. 1290, commissioned by Jean Cholet from Pietro Cavallini for Santa Cecilia in Trastevere, Rome. Fresco. See also p.56

papal basilica of St. Paul's Outside the Walls, works that disappeared when that church burned in 1823. There Cavallini's task seems to have been to replicate badly deteriorating Early Christian images, thus training himself to produce an essentially late Roman stylistic vocabulary at will. That experience allowed him to give Byzantine prototypes new vitality and a greater sense of movement, enhancing their three-dimensionality and heightening the human interaction among them.

In one of the scenes at Santa Maria in Trastevere, the Birth of the Virgin (Fig. 2.7), Cavallini placed St. Anne (the mother of Mary), her attendants, and the infant Virgin in three tightly connected planes parallel to the picture surface: the maids preparing the child's bath far forward, the large reclining figure of St. Anne in the middle, and two more servants behind the bed. The parted curtain at the far right implies further space beyond this densely clustered composition, as does the space around the stage-like architecture and its receding diagonals. The effect is both noble and domestic. Intimate in its scale, the scene communicates dignity and solemnity through the strong vertical and horizontal lines of its architectural setting.

Around the same time that Cavallini was working on these mosaics, the French cardinal Jean Cholet engaged him to create a larger and more extensive cycle of frescoes for his titular church of Santa Cecilia, also in Trastevere. Frescoes were cheaper than mosaic, but the scope of this project was larger. For the nave walls of Santa Cecilia, Cholet commissioned a now-ruined cycle of Old and New Testament scenes, directly imitative of established models that Cavallini knew intimately from the papal basilicas. The entire back wall of the church was reserved for a Last Judgment (Fig. 2.8), a subject traditionally placed in that location to complete the cycle of Christian history begun in the biblical scenes on the side walls.

Enough of the Last Judgment survives to give a solid understanding of this mature phase of Cavallini's art. Christ sits at the center of the composition, flanked to left

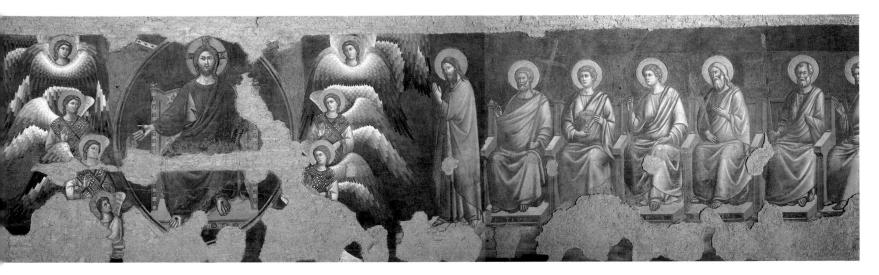

and right by enthroned apostles. Beneath them, in areas now obscured, angels attend to persons who are about to be saved on Christ's right (the viewer's left), while on the other side devils take possession of the bodies of the damned. Cavallini's debt to the increasing naturalism of northern Gothic art of the period is evident throughout these frescoes, especially in some of the complicated curving border of the drapery folds. However, neither Gothic sources nor the Byzantine prototypes that clearly inspired the iconography of his frescoes (see, for example, the similar subject in the Florentine Baptistry, Fig. 4.4) fully explain the warmly modeled reality of his figures, the way drapery actually seems to flow volumetrically around them, the deep thrones in which each of the figures sits, the effective way that bright light from either side of the composition throws them into relief, and the remarkable coherence of his overall composition. These we must credit to Cavallini's own genius. A detail of two of the apostles shows the hard work that Cavallini put into each of these figures (see p. 56), with the shading of the apostles' faces suggesting three-dimensionality. Varying the size of his brush and the intensity with which he moved it on the wet plaster, Cavallini convincingly distinguishes between the right apostle's soft beard and flowing locks. Long strokes of light paint add glimmer to his hair, and highlights suggest the play of light down his arm and shoulder. Rather than merely mimicking what he found in artistic models around him, Cavallini was synthesizing them, learning their lessons, and applying them in novel ways to his own work. While the multi-colored wings of the angels surrounding Christ's throne owe much to earlier prototypes, never before had an artist created such a carefully gradated meditation on tonal variation.

Cardinal Cholet also hired the Florentine sculptor/architect Arnolfo di Cambio (c. 1245–1302?) to create a new *baldacchino* (baldachin), or altar canopy, for his church (Fig. 2.9). Arnolfo was well qualified for the job, having worked as an assistant in the workshop of Nicola Pisano before creating an impressive *baldacchino* for the papal basilica of St. Paul's Outside the Walls in 1285. The canopy at Santa Cecilia (1293) deftly combines classical Roman and French Gothic elements. Like earlier such canopies, the structure is

supported on four ancient Roman columns. Arnolfo inserted delicate bar tracery under the tentatively pointed main arches, transformed the corners of the canopy into pinnacles, and edged the gables with sprouting Gothic **crockets** (stylized leaves). Traditional Roman elements are also used to decorative effect. Beribboned laurel wreaths hover at the apex of each arch, and impost blocks over the capitals raise the canopy's height, lessening the apparent weight of the structure upon the richly mottled columns. Arnolfo placed captivating figures of popes and saints in niches across the four corners; one of them even comes galloping out on horseback. This is another work of brilliant synthesis, well

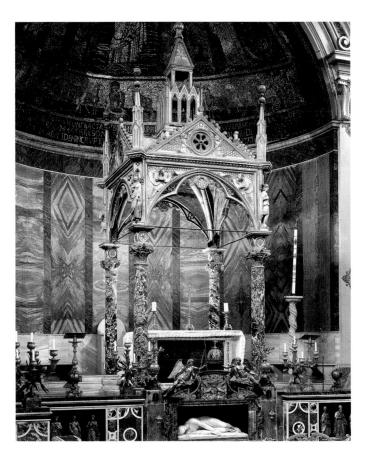

2.9 Baldachin, 1293, commissioned by Jean Cholet from **Arnolfo di** Cambio for Santa Cecilia in Trastevere, Rome. Marble

suited both to its Roman setting and to a non-Roman patron at the international papal court.

Pope Boniface VIII and an Imperial Language of Power

Pope Boniface VIII (r. 1294-1303), himself an active patron of the arts while still a cardinal, set a new standard for unabashed pomp and visual splendor. It is probably just a quirk of history that Boniface is the first pope whose luxurious possessions-including pheasant-plumed fans; goblets encrusted with garnets, enamels, and sapphires; knives with handles of ivory, coral, sandalwood, jasper, and lapis lazuli-are documented. Much of this he must have inherited from his predecessors. But there was something imperial about the material display of his papacy, as well as his own demeanor and brash confidence in the unassailability of the papacy. He would have been as comfortable on the ancient Palatine Hill among the emperors as he was at the Lateran and Vatican palaces. The apocryphal report that he once announced "I am the emperor" does not stray far from his estimation of himself and the papacy.

Like his predecessors, Boniface spent money on building repairs and renovations, the most famous of which was the construction of a new benediction loggia at the Lateran Palace (Fig. 2.10). Boniface emblazoned the loggia (used by the pope to bless the faithful) with imperial parasols and the coat of arms of his family, the Caetani, and supported it both physically and symbolically with reused ancient columns. Sculptural figures of the saints Peter and Paul flanking the loggia's gable emphasized the pope's rightful succession to apostolic power.

A portrait bust from Boniface's tomb, which he commissioned before his death, tells us yet more about papal ambitions in this period (Fig. 2.11). Boniface's tomb monument in the chapel of St. Boniface in Old St. Peter's included this vivid image of benediction along with a recumbent effigy of the pope and a mosaic in which Peter and Paul recommended him to the Virgin and Child. The message of these three images is clear: the individual pope may die but the dignity of his office, manifest in the bust by the papal tiara and keys, lives on. While the mosaic speaks of Boniface's personal admission to salvation, his bust implies the eternal efficacy of his benediction for others. His mortal body was placed in its tomb, but the papacy which he had embodied was to live forever. The conceit of Boniface VIII's tomb was sophisticated, stopping just short of self-exaltation. Little wonder his enemies charged him with idolatry.

2.10 Pope Boniface VIII Imparting a Blessing from the Benediction Loggia at the Lateran, seventeenth-century miniature recording the composition of a fresco, c. 1300, inside the Benediction Loggia at the Lateran Palace, Rome (Biblioteca Ambrosiana, ms. F. inf. 227, 8v, Milan)

Arnolfo gave Boniface an impassive but powerful face and loaded the papal tiara, stole, and gloves with jewels set in rich mounts, originally picked out in full color and gilt. A less than sympathetic eye would have seen as much a representation of Boniface's personal pride as the dignity of the papacy.

These confident images belie Boniface's stormy relations with the Roman aristocracy, especially the Colonna, whose stronghold at nearby Palestrina he leveled and began to replace with a new papal estate. The Colonna's French allies then actually attacked

> the pope in his own palace in Anagni. Only his valiant defiance saved the day. Awaiting his would-be captors in full papal regalia and thus projecting the image of authority which appeared in his tomb monument, Boniface forced his attackers to humiliate the papacy as well as himself. Learning of this affront, the local

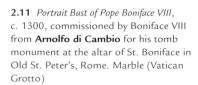

townspeople, who held little affection for Boniface the man, rose up to defend the office he represented. Still, neither Boniface nor the papacy emerged unscathed. He died soon thereafter, a broken and bitter man. Broken, too, was the confidence of the papacy in its ability to manage its affairs in Rome. Subsequent popes—especially those who did not come from Roman families—found it impossible to control the Eternal City and its often hostile, competing clans.

Creating Images for an Absent Papacy

Offered a safe haven at Avignon in 1306, Pope Clement V moved the institutional offices of the papacy to that small town in the south of France, beginning what was to be more than a century of exile. Without the patronage of popes and cardinals, major construction and artistic production in Rome could be sustained only with great difficulty. As it became increasingly evident that the papal court was well established in Avignon, new artistic enterprises in Rome slowed to a trickle.

Nevertheless popes and cardinals engaged in various attempts throughout the fourteenth century to reclaim and renovate their traditional seat of authority. Cardinal Jacopo Stefaneschi—brother of Bertoldo, who had enhanced Santa Maria in Trastevere—commissioned a large mosaic for the atrium of Old St. Peter's (Fig. 2.12), along with a double-sided altarpiece (Fig. 2.13) probably intended for the canons' choir in the nave of the building at the boundary of the transept. Both works included a kneeling portrait of the cardinal and should be seen as attempts by Stefaneschi

to reassert the rightful place of the papacy in Rome while commemorating himself as he approached death.

Stefaneschi then turned to the shop of the Florentine artist Giotto di Bondone (c. 1267/75 Vespignano-1337 Florence) for each of these commissions, perhaps because artists like Torriti and Rustici, already with established records of success in mosaic, had died or because Cavallini had already moved to Naples, where he was in the employ of the Angevin court by 1308. The literary tradition recounted by Dante and Vasari that Giotto had been a student of Cimabue needs to be supplemented by the fact that Cimabue was recorded in Rome in 1272 and that the older artist was technically working for the papacy in the late 1270s when he was painting in

Assisi. Giotto may well have visited Rome before the Jubilee Year of 1300, at the height of Cavallini's new stylistic experiments at Santa Cecilia in Trastevere. Thus it is not surprising that Giotto's style seems to owe so little to extant work in Florence of this period, but a great deal to the innovations of Roman style under Cavallini and perhaps also Rustici. Both Giotto and Cavallini were obviously inspired by classical art, using light boldly to create increasingly massive and three-dimensional figures. By the time of Stefaneschi's commissions Giotto had achieved an international reputation.

Giotto's mosaic, now lost, originally decorated the inner, gateway façade of the courtyard in front of St. Peter's (see Fig. 25.3, far right). It represented the Navicella ("little ship"), an image of the Church in perilous times supported by the command of Christ. Just as Peter did not drown in the turbulent waters around the fishing boat when he went forward to greet Christ, who had been miraculously walking on the water, so the Roman Church expected the papacy to survive all challenges. Although based on a pre-existing work, the theme had a special poignancy at this time, which was known as the Babylonian Captivity of the papacy. The scope and scale of the work were overwhelming, occasioning awed commentary well into the sixteenth century. Surviving fragments suggest that subtle colors and impressionistic devices heightened the mosaic's dramatic effects.

Stefaneschi's altarpiece, signed by Giotto but attributed to his workshop, paired two images of papal authority: an enthroned Christ flanked by scenes of the martyrdoms of St. Peter and St. Paul on one side and an enthroned St. Peter and flanking saints on the other, echoing one another to

2.12 *Navicella*, commissioned by Jacopo Stefaneschi from **Giotto**, drawing after the lost original mosaic for the atrium of Old St. Peter's, Rome (Vatican Library, Vat. Barb. Lat. 2733, fols. 146v/147r, Rome)

make clear the identification between Christ and his papal successors. Illusionistic space in the altarpiece was kept to a minimum; St. Peter raises his right hand in benediction, while in the left he holds the oversized keys that symbolized his and the papacy's authority (see Fig. 2.11). Peter's staring visage and rigid, frontal placement against an imposing marble throne further emphasize his supremacy, as does his enlarged size, relative to the donor portrait of Cardinal Stefaneschi on Peter's right, who reverently presents a miniaturized version of the altarpiece. On St. Peter's left

St. Peter Morone submits a deluxe manuscript which may represent Stefaneschi's biography of this pope whom rumor had it was convinced to resign by the ambitious Boniface VIII.

Although the popes were not to return permanently to Rome for over a century, imagery like this continued to mark the city as the rightful capital of Western Christendom. Rome's relics, ancient monuments, papal basilicas, and works of art spoke powerfully throughout the papal absence.

2.13 Stefaneschi Altarpiece, early fourteenth century, commissioned by Jacopo Stefaneschi from **Giotto**, probably for the canons' choir of Old St. Peter's, Rome. Tempera on panel, 7' 2½" × 8' ½" (2.2 × 2.45 m) (Pinacoteca, Vatican)

This two-sided altarpiece was intended for viewing from both within the canons' choir and from the transept, which it adjoined. The panels were originally set in much more elaborate frames.

3 Assisi and Padua: Narrative Realism

ne of the earliest documented assimilations of the newly naturalistic style of painting first seen in Rome occurred in the hilltown of Assisi, birthplace of St. Francis. St. Francis's canonization in 1228 virtually demanded that a church in his honor—as a focus for devotion to the most popular of Italian saints—be built in his home town of Assisi. The issue of ownership of property such as churches and convents had already divided the Franciscans within

Francis's own lifetime. On the one side were the Spiritualists, who wished to maintain the vow of absolute (or apostolic) poverty upon which Francis had founded his order. On the other side were the Conventualists, for whom the success of the order in terms of its numerous communities throughout the Christian world indicated the need for permanent established churches and convents. In order to satisfy Francis's vow of poverty and yet meet the need for a cult church for Francis's relics and a home church for the Franciscan order, the papacy became the nominal patron and "owner" of the Basilica of San Francesco; the church was by deed a papal basilica, not a Franciscan church. The close relationship between the Franciscans and the papal hierarchy ensured that the church containing the mortal remains of a man who zealously abjured physical wealth and comforts was one of the most lavishly conceived structures of its time, although St. Francis's tomb, unlike the tomb of any other monastic founder during this period (see Fig. 9.6), was hidden from view under the building. (It was only recovered in the nineteenth century and now rests in a specially constructed crypt.) Poverty and simplicity rarely prevailed at a shrine controlled by the papacy.

Preparations for the construction of the Basilica of San Francesco (Fig. 3.1) began even before Francis's canonization in 1228. Pope Gregory IX built a papal residence within the adjoining monastic

complex, and a papal throne sits within the church's apse. The aisleless, double-storied structure of the church (Fig. 3.2) was immediately recognizable as a palatine chapel, an architectural form given one of its best-known expressions at about the same time in Paris in Louis IX's splendid Sainte

3.1 Upper Church, San Francesco, Assisi, begun 1228, consecrated 1253, commissioned by the Franciscans with the support of the papacy

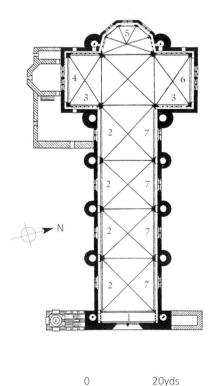

20m

3.2 Upper Church, San Francesco, Assisi, plan

- 1 Scenes from the Life of St. Francis; 2 Scenes from the Life of St. Francis, with New Testament scenes above; 3 Cimabue, Crucifixion;
- 4 Cimabue, Scenes from the Book of Revelation; 5 Scenes from the Life of the Virgin; 6 School of Cimabue, Lives of St. Peter and St. Paul;
- 7 Scenes from the Life of St. Francis, with Old Testament scenes above

chapels in the lower church was added over time. Both the lower and upper churches were laid out basically in the form of a tau (see Fig 3.2), the T-shaped cross which had inspired Francis's own design of his friars' habits. The broad, low bays of the nave and the stubby transepts culminate in a shallow five-sided apse, whose number recalls the five wounds of the crucified Christ and by extension Francis's own stigmata. From a functional point of view the nave of the upper church at Assisi was separate from the apse and transepts since, as in most medieval monastic churches, a large screen, now removed, created a barrier at the end of the nave beyond which most laypeople were not

allowed to pass. The areas beyond this-the choir stalls

and apse with the high altar-were for the privileged use of

The architecture itself is rather simple, with large expanses of wall providing large surface areas suitable for elaborate fresco cycles (see Fig. 3.1). The present proliferation of

Chapelle (1240s). Bundles of thin colonettes and finely carved crocket capitals demonstrate an up-to-date knowledge of key features of the French kings' coronation church at Reims as well. Thus although San Francesco is ostensibly a Franciscan site—the home church of the order—it must also be seen as a princely papal site, with all that this implies

for its decoration.

the friars.

Frescoes in San Francesco

Many of the artists responsible for the early decoration of the Basilica of San Francesco in Assisi had connections with papal Rome, either as natives of the city or as artists who had worked there. The most important of these was the Florentine Cimabue, who was in Rome by 1272. Assisted by his workshop, he was largely responsible for the apse and transept decoration of the upper church (see Fig. 1.3). Befitting Francis's special devotion to the Virgin, the apse presents apocryphal stories of her death and afterlife flanking the centrally placed papal throne. One of these, the Coronation of the Virgin, repeats the imagery seen in Roman basilicas (see Fig. 2.6) and may also indicate the papal presence in this building. Five scenes from the lives of the saints Peter and Paul in the south transept, now largely ruinous, also underscored the Franciscans' Roman and papal associations by reproducing the same subjects and virtually the same compositions as the papal frescoes in the courtyard of Old St. Peter's. Frescoes of the Crucifixion in both transepts provided a model of sacrifice closely emulated by Francis and his followers.

Nave Frescoes

Frescoes painted on the nave walls in the upper church pair Old Testament stories on the right side with the life of Christ on the left, repeating the subject and compositional order of narratives of the major Early Christian basilicas in Rome and expanding upon subject matter also treated in stained glass windows in the apse and transepts. In the nave scene of the Kiss of Judas (p. 67) we see how Romantrained artists adopted Early Christian and Byzantine prototypes with their sense of emotional gravity, solid figural mass, and modeled drapery forms revealing the body beneath them to enliven stories from the life of Christ. Since at least the sixth century, Byzantine art had shown Judas striding towards his master to kiss his cheek. Here Judas is dressed in a sulphurous yellow robe that marks him as Christ's traitor. Christ, the great law giver of Early Christian iconography, holds a scroll in his left hand, and stares forward, ready to accept his fate. He extends his right arm (largely hidden by Judas's body) in a standardized gesture of address towards St. Peter whom he chastises for cutting off the ear of the high priest's servant, whom Christ subsequently heals. Though a murderous crowd of soldiers and religious leaders presses in around them, and lances, torches, and lanterns jut into the sky, Christ's placid facial expression blunts much of the drama, calling attention instead to his divinely inspired cooperation with his captors, a theme emphasized by Bonaventure in the Lignum vitae (The Tree of Life), a Franciscan devotional tract of c.1259-60. This fresco emphasizes that Christ was the ready victim and gracious healer even in the face of violent death.

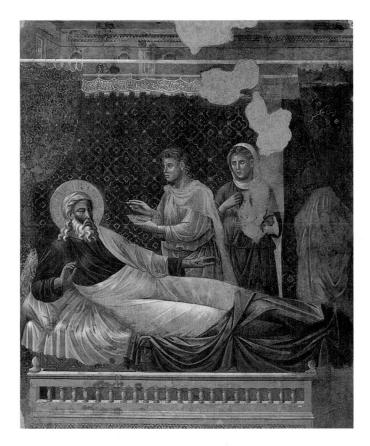

3.3 *Esau Before Isaac*, 1290s (?), commissioned by the Franciscans from the so-called **Isaac Master** for the upper right wall of the nave of the Upper Church, San Francesco, Assisi. Fresco

On the opposite wall the scene of *Esau Before Isaac* (Fig. 3.3), like Cavallini's work in Rome at this same time, structures the narrative in successive stages of receding architectural volumes. Neat crisp folds wrap around the reclining figure of Isaac, evoking the images of majestic classical prototypes. The tremulous and hesitant gesture of the blind and blankly staring Isaac as he gradually realizes that he has been duped into giving the birthright to Jacob rather than to his first-born, Esau, marks an important moment in the depiction of psychological awareness and emotional intensity, a naturalistic development very different from the frescoes of the transept and apse of the building and especially well-suited to the crowds of laypeople who filled this part of the church.

Below the Old and New Testament scenes are other stories obviously directed toward the ever-growing crowd of pilgrims visiting San Francesco: an extensive cycle of the life of St. Francis stretching around the entire lower part of the nave and entrance walls. Although it is not clear by whom and when they were painted—suggested dates range from the 1290s well into the fourteenth century—recent studies show that the painting techniques are distinctly Roman, quite close to Pietro Cavallini (see Fig. 2.8 and p. 56), and extremely different from the broader manner of Giotto, to whom they have often erroneously been attributed. The twenty-eight scenes present the story of the saint in a

3.4 St. Francis Kneeling Before the Crucifix in San Damiano, St. Francis Renouncing His Worldly Goods, and the Dream of Pope Innocent III, late thirteenth to early fourteenth century, commissioned by the Franciscans from the so-called **Assisi Master** for San Francesco, Assisi. Fresco, each scene 8' 10" × 7' 7" (2.7 × 2.3 m)

straightforward and highly accessible manner. An inscription from Bonaventure's official biography of Francis, the *Legenda Maior*, accompanies each scene beneath its painted molding. The frescoes have a noticeably institutional emphasis, repeatedly illustrating St. Francis's respect for Church authority by presenting the episodes of his life before popes and cardinals. Francis's sanctity is recognized through an extended depiction of his death, funeral rites, and canonization. Avoiding poetic and mystical images,

these frescoes are overtly didactic, intended to tell an officially sanctioned version of the saint's life.

The frescoes closest to Cavallini's style occur early in the cycle and demonstrate the same spatial richness and narrative intelligence that we saw in Rome (see Fig. 2.7). Each bay (Fig. 3.4) contains three scenes framed by twisted columns and fictive marble corbels that recall the mosaic-encrusted medieval cloisters at the papal basilicas in Rome. In the frescoes at Assisi the corbels splay left and right as though the

CONTEMPORARY VOICE

St. Francis and the Christ Child

In this passage from Bonaventure's *Legenda Maior*, St. Francis is credited with having created the first Nativity scene, or crêche, in the little village of Greccio, halfway between Rome and Assisi, in 1223. The presence of real animals in the scene and the devotional atmosphere led the worshipers to believe that the Christ Child himself lay in the crib.

Three years before he died St. Francis decided to celebrate the memory of the birth of the Child Jesus at Greccio, with the greatest possible solemnity. He asked and obtained the permission of the pope for the ceremony, so that he could not be accused of being an innovator, and then he had a

crib prepared, with hay and an ox and an ass. The friars were all invited and the people came in crowds. The forest re-echoed with their voices and the night was lit up with a multitude of bright lights, while the beautiful music of God's praises added to the solemnity. The saint stood before the crib and his heart overflowed with tender compassion; he was bathed in tears but overcome with joy. The Mass was sung there and Francis, who was a deacon, sang the Gospel. Then he preached to the people about the birth of the poor King, whom he called the Babe of Bethlehem in his tender love.

A knight called John from Greccio, a pious and truthful man who had aban-

doned his profession in the world for love of Christ and was a great friend of St. Francis, claimed that he saw a beautiful child asleep in the crib, and that St. Francis took it in his arms and seemed to wake it up.

The integrity of this witness and the miracles which afterwards took place, as well as the truth indicated by the vision itself, all go to prove its reality. The example which Francis put before the world was calculated to rouse the hearts of those who are weak in the faith, and the hay from the crib, which was kept by the people, afterwards cured sick animals and drove off various pestilences. Thus God wished to give glory to his servant Francis and prove the efficacy of his prayer by clear signs.

viewer is standing at the center of each bay. This unified point of view extends to the arrangement of individual scenes within each triad. In the second bay, for example, the overall composition pivots around the gap-both physical and psychological-separating St. Francis and his father in their confrontation in the main square of Assisi. On the right the embarrassed bishop of Assisi covers Francis's nakedness after the saint had stripped himself of his clothing; on the left his indignant father, barely restrained by worried onlookers, lurches forward to strike his apparently mad son for selling bolts of cloth from their shop to feed the poor. The bifurcated composition opens a dramatic space for the appearance of the hand of God reaching down diagonally towards the outstretched arms of the saint. In the scenes at the left and right the painter has also placed the architectural settings at a diagonal, so that they seem to point inwards toward the central bay. At the left Francis kneels in the ruinous church of San Damiano, whose walls are crumbling and roof beams partly exposed. On the altar stands the crucifix that commanded him to repair the church. In the right panel Pope Innocent III, identified even in his sleep by his papal robes and tiara, dreams of Francis upholding the porch of the papal basilica of St. John Lateran, which tips perilously. In the inscription below the fresco, taken from Bonaventure's officially authorized Legenda Maior, the pope says of Francis, "Truly this is he who by his work and teaching shall sustain the church of Christ," thereby underlining the notion of Francis as an alter Christus and appropriating his work (and that of the Franciscan order) for the institutional Church.

The style of the frescoes is particularly well suited to their task. Impressively naturalistic and illusionistic, they communicate with unprecedented eloquence. Francis himself had urged his followers to imagine their religious experience in visual, tangible terms. In the scene of the Crib at Greccio (Fig. 3.5) we see Francis constructing the first Nativity scene before the altar of the little church at Greccio for a Christmas Eve mass in 1223 (see Contemporary Voice, "St. Francis and the Christ Child"). In this painting the friars in the rear of the choir enclosure open their mouths wide as if singing the Christmas liturgy; the clergy and a townsman near the altar canopy bend to get a closer look; town leaders bear witness by their sober presence; and a group of women, normally not given entrance to this sacred part of the church, crowd forward through a central doorway. The broad solidity of their bodies seems to occupy actual space—an impression greatly enhanced by rear views of a pulpit and crucifix that lean out into the nave. Candles, festoons, and other small details of clothing and architecture help to make the scene visually compelling.

The time and degree of collaboration required to produce a decorative program as complex as that of the church of San Francesco make it difficult to specify who may have been responsible for any particular section. In many ways that is as it should be. Artists at Assisi were not asked to

3.5 Crib at Greccio, late thirteenth to early fourteenth century, commissioned by the Franciscans from the so-called Assisi Master for San Francesco, Assisi. Fresco

Conspicuously absent in this cycle of St. Francis's life are the many stories that Bonaventure tells about St. Francis's extreme asceticism and self-mortification. Instead, the frescoes emphasize Francis's compassionate nature and his support of the institutional Church.

produce highly individual or idiosyncratic works; rather, they were working together with their Franciscan and papal patrons to create a broad, visual biography for Francis of Assisi. Whereas previous generations of worshipers had focused much of their devotion on local Early Christian martyrs, the thirteenth century turned for inspiration to Francis and other contemporary preaching saints, such as the Spaniard St. Dominic. Both Francis and Dominic inspired enthusiasm for a renewed, more accessible religious experience. The search for means to express these new and vivid ideas, though linked to the great traditions of the Church, proved extremely fertile ground for artistic experimentation.

Padua: The Scrovegni Chapel

The small university city of Padua, west of Venice, traced its history back to the mythic figure of Antenor, a Trojan soldier who, according to Virgil, sailed westward after the Trojan War, ultimately to found Padua. A massive medieval sarcophagus honoring Antenor still stands in the city. Thus

Padua's constructed history is one that consciously imitates the myth of Rome's founding by the Trojan prince Aeneas, although the Roman historian Livy, himself born in Padua, claimed that the city had been founded only in 302 B.C.E., successfully resisting a Spartan attack the following year. Padua flourished during the Republic and the Empire. It became a commune in the eleventh century and retained that status until the Carrara family took control of the city in 1318. Padua's university was founded in 1222, which makes it the second oldest in Italy after Bologna (1119). Its faculties of law, medicine, physical science (especially optics), and classics made it one of the most important intellectual centers in Italy; Galileo was but one of its more notable teachers. St. Anthony, the most popular Franciscan saint besides St. Francis himself, died in Padua in 1231; a basilica in his honor, now known as the Santo, was begun in 1232 and soon became one of the most frequented pilgrimage sites in Europe.

One of the city's leading banking families was the Scrovegni. Their head in the late thirteenth century was Reginaldo Scrovegni, whose flagrant usury (the lending of money at unconscionably high rates of interest) earned him a place in Dante's *Inferno* (Canto XVII, 43–78) as the most notorious practitioner of this sin. Reginaldo's son Enrico initially continued in his father's footsteps, but later became troubled by the possible consequences of his actions. In 1302, by way of expiation for his ill-gotten gains, he began to erect a family chapel dedicated to the Virgin of Charity (Santa Maria della Carità). Because the Scrovegni Chapel, like the adjacent (later demolished) Scrovegni Palace, was erected on the site of the old Roman arena, it has come to be known also as the Arena Chapel.

Work on the chapel apparently proceeded quickly, since there is a document recording the dedication of the site in 1303 and a record of March 1304 of indulgences granted by Pope Innocent XI to visitors to the chapel. The chapel was formally dedicated on March 25, 1305, the feast of the Annunciation, which marked the day beginning the process of Christian redemption and the day legendarily associated with the foundation of Venice, Padua's powerful neighbor to the east. For the dedication of the Scrovegni Chapel the High Council of Venice agreed to lend tapestries to enhance the festivities for the occasion. This support from the Venetian state and from the pope in the building project indicates the extraordinary social and financial power of the Scrovegni family.

In order to decorate the interior of his chapel (Fig. 3.6), Scrovegni hired Giotto di Bondone of Florence. Giotto's commission was to paint scenes of the redemption of humanity, including scenes from the lives of the Virgin Mary, her parents, and Christ on the arch and side walls. A *Last Judgment* fills the entire entrance wall of the building. On the lowest part of the side walls fictive marble panels frame monochrome paintings of the virtues on the south side of the building (the window side) and their corresponsing

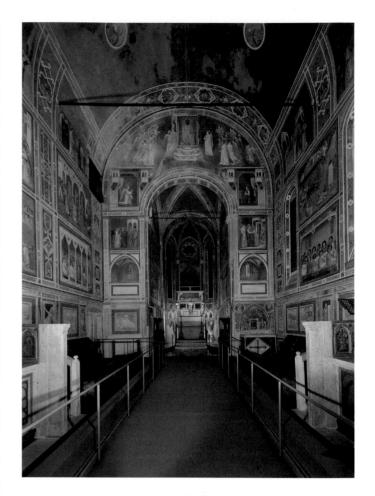

3.6 Scrovegni Chapel, Padua, c. 1303-05, frescoes commissioned by Enrico Scrovegni from **Giotto**

ding vices on the north wall—rendered so as to resemble relief carvings. This complex fresco cycle is the earliest work universally accepted as the work of Giotto and is the touchstone for all other attributions to the artist. Giotto has sometimes been credited as the architect of the chapel, but this is unlikely since he faced numerous challenges in wrapping an extensive fresco cycle around the interior of the deceptively simple barrel-vaulted building. He walled in a pre-existing door on the end of the south wall and seems not to have been satisfied with the height of the side walls, extending his top band of panels into the curve of the barrel vault.

The cycle begins at the top of the arched wall framing the altar at the front of the chapel. God the Father (painted on a wooden panel now thought to date from much later in the century, perhaps replacing an original glass window) sits enthroned at the apex of the arch, about to begin the work of human redemption by commissioning the archangel Gabriel to intervene in human history. Below, Gabriel and the Virgin Mary face each other in matching turreted chambers, their communication across the altar arch made palpable by a glow of divine red light. Giotto recounts the legendary events leading to this encounter in bands of scenes along the top of either side of the chapel. He must

have spent a good deal of energy working out his scheme, for each "chapter" in the narrative fits succinctly within the space available. The first of these, recounting scenes from the lives of Joachim and Anna, the Virgin's parents, begins with the Expulsion of Joachim from the Temple (Fig. 3.7). According to late medieval apocryphal tales, Joachim's offering had been rejected at the temple because he and his wife were childless. Giotto depicts the most painful moment in the story as a priest, arm extended, pushes Joachim out of the temple-imagined as a typical medieval altar precinct with altar ciborium and raised pulpit. The priest's gesture and the diagonal placement of the architecture propel the narrative forward. Joachim looks back with pained incomprehension, his fate made doubly poignant by the fact that another, younger man receives the desired blessing within the altar enclosure even as Joachim has nothing but emptiness ahead of him. Careful study of the fresco has confirmed that Giotto never intended to fill the large blank area at the right, thus leaving an anguished abyss into which Joachim is thrust.

Giotto's narrative continues in the following panels with a slump-shouldered Joachim coming upon two skeptical shepherds who reluctantly provide him with a place to sleep. Meanwhile, Anna is at home, where the angel Gabriel flies into her bedroom window to tell her that, in spite of her advanced age, she will have a child. Joachim, too, receives the angelic message, and the two are reunited outside the Golden Gate of Jerusalem (Fig. 3.8). The resolute mass of the city gate, set at an oblique angle like the altar enclosure beginning the sequence, brings the story to a forceful close and brackets the first episodes in the exten-

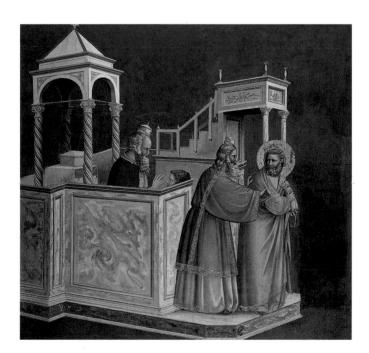

3.7 Expulsion of Joachim, c. 1303–05, commissioned by Enrico Scrovegni from **Giotto** for the Scrovegni Chapel, Padua. Fresco, 6' $6\%'' \times 6'$ 1'' $(200 \times 185 \text{ cm})$

sive narrative sequence of the chapel. Joachim and Anna stand as a stable triangular mass at the base of one of the gate's fortified towers, embodying the matrimonial ideal that two shall become one. Anna reaches her hand around Joachim's neck and places the other softly on his cheek as they kiss. This untoward breaching of contemporary public decorum amuses a group of young women under the archway, who smirk at as much as share in the couple's delight. Their black-veiled companion, who has never been successfully identified, contributes an ominous element as well. Giotto's story telling, while succinct and essential, is rich with dramatic tension and offers pointed insight into the feelings and behavior of his fellow human beings.

In constructing his narratives, Giotto gave them an extraordinary sense of unity through a careful use of perspective. A diagram of the altar wall (Fig. 3.9) shows that each scene is organized according to a unified two-point perspective scheme which orders the architecture of all levels of the wall and also unites both sides of the building in a single coordinated scheme of diagonal lines. The same is true for the side walls where, for example, the architecture depicted in all the frescoes is conceived as if it were to be viewed from the center of the chapel. Thus the perspective is slightly distorted in the outer two scenes of the south wall to compensate for the viewer's angle of vision. In each frame, however, the architecture extends equally deeply into space, so that there is a consistency to the depth of the illusionistic field from one scene to another. The same is true of landscape, where it appears. In the adjacent panels of the Lamentation and the Noli Me Tangere, the landscape also seems to continue behind the painted architectural

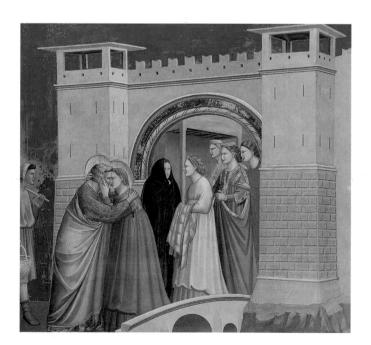

3.8 Meeting at the Golden Gate, c. 1303–05, commissioned by Enrico Scrovegni from **Giotto** for the Scrovegni Chapel, Padua. Fresco, $6'6\%''\times6'1''(200\times185\text{ cm})$

3.9 Scrovegni Chapel, Padua, perspective scheme of the front wall (after Adriano Prandi)

frames and to drive the narrative forward from one panel to the next.

Giotto positioned the *Kiss of Judas* (Fig. 3.10) strategically, situating it—the only scene at the third level that takes place in a landscape—at the center of the wall, directly in front of

an ideal viewer whose position in the chapel is indicated by the way the perspective organization of the entire wall radiates from it. Not only has Giotto located the beginning of the Passion in a critical position on the wall—ironically above the figure of Justice in the bottom row—but he

> has also dramatized the event in ways unimagined by earlier artists (see p. 67). The brilliant yellow cloak of Judas virtually obliterates the figure of Christ. Caught in a maelstrom of unrelenting stares, Judas and Christ stand nose to nose, Christ's searching and compassionate eyes undimmed by Judas's angry glare. Giotto uses stereotypical characterizations of good and evil in the scene, presenting Christ with handsome features and Judas with a brutish face. The psychological intensity of the event is heightened, at the left of the scene, by Peter's act of violence: cutting off the ear of the high priest's servant. The compositional pairing of the right-facing Peter and Christ against the hooded figure and the heavily cloaked Judas powerfully plays violence and human emotion against divine acceptance of God's plan for redemption.

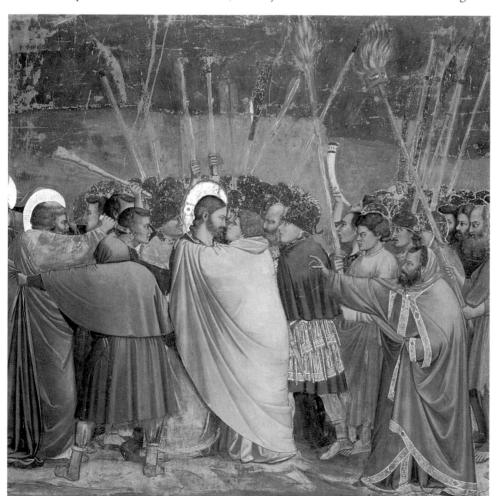

3.10 Kiss of Judas, c. 1303–05, commissioned by Enrico Scrovegni from **Giotto** for the Scrovegni Chapel, Padua. Fresco, 6' 6''' × 6' '''' (2 × 1.85 m)

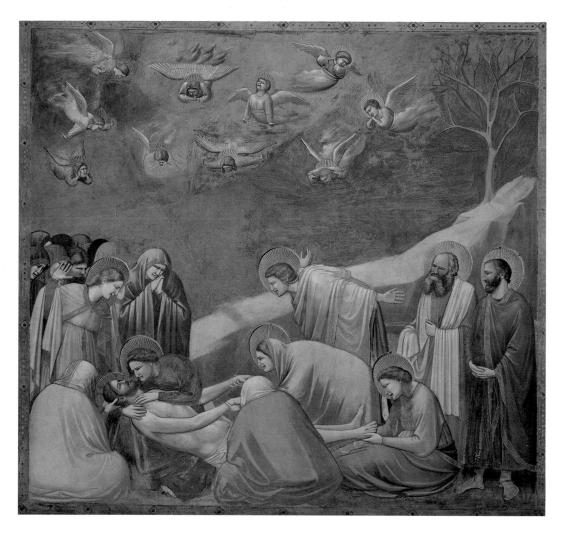

3.11 Lamentation, c. 1303–05, commissioned by Enrico Scrovegni from **Giotto** for the Scrovegni Chapel, Padua. Fresco, 6′ 6½″ × 6′ 1″ (200 × 185 cm)

The Passion scenes conclude with a magisterial rendering of the Virgin Mary and Christ's Apostles mourning over his dead body (Fig. 3.11). This compositional type had long been established in Byzantine art, but Giotto gives the formula new power through his intense reading of human reactions to the event. Reducing his setting to a single barren outcropping and leafless tree-apt symbols of Christ's death-he uses this device to drive the viewer's eye down to the body of Christ. The Virgin wraps her arms around his head, held tenderly in place by another figure who is only seen from the back, and looks longingly into his face; standing female saints wring their hands in grief, while St. John the Evangelist spreads his arms back, recalling both his iconographical symbol, the eagle, and the oft-repeated gesture of mourners on certain antique sarcophagi; yet others stand and sit in mournful dejection. Even the angels respond with human hearts-wailing, thrashing, and catapulting through the sky.

The *Last Judgment*, which occupies the entire entrance wall (Fig. 3.12), presents the culmination of the process of redemption begun on the altar wall of the chapel. Christ sits in majesty in the center, flanked to his left and right by choirs of angels and seated Apostles. Below him and to his right are the elect, to whom he gestures. In the lower right

quadrant of the wall is a vision of hell with a large personification of evil devouring the damned. Just over the door of the chapel at the bottom center of the fresco Giotto has depicted Enrico Scrovegni in the kneeling pose of a donor, presenting his chapel in the metaphorical form of a model to three haloed figures: probably Gabriel, the Virgin of Charity, and the Virgin Annunciate, the latter two embodying the double dedication of the chapel. The two figures of the Virgin are crowned, as is the allegorical figure of Charity on the lower south wall of the Chapel. The Virgin of Charity wears a dalmatic, the liturgical robe of the deacon, who in the early Church was responsible for dispensing alms (or charity); the Virgin also wears that costume in the Annunciation on the altar wall and in the Visitation fresco just beneath it, as if the very act of redemption initiated at the moment of the Annunciation was an act of charity. Although there is some dispute about the identification of these three figures, there can be no doubt about the importance of the Virgin Annunciate for this chapel and for Scrovegni's intentions. The eccentric placement of Scrovegni, the heavenly figures, and his model seems to be explained by the fact that on March 25, the feast of the Annunciation, a beam of light enters the building from the south window nearest the entrance wall and falls on the Last

Judgment in the area between the donor and the model, a sign of divine approval for the gift that Scrovegni made.

Scrovegni's repentance is conveyed not only by the image of himself as donor but also by two representations of Judas which point up the dangers of ill-gotten gains. In the depiction of hell and its denizens, he is shown hanging disemboweled from a tree, and he appears again on the altar wall opposite, receiving the thirty pieces of silver for betraying Christ—a panel that is out of sequence in the narrative. By placing these two images of Judas to either side of the imagined viewer, Giotto underscored the moral message of the chapel which he further emphasized by pairing Judas's betrayal on one side of the altar arch with the visitation

on the other (see Fig. 3.6). At first this seems an unlikely pairing-the Visitation recording the meeting of the pregnant Mary and her cousin Elizabeth, also pregnant-but a long tradition held that usury was a kind of illegitimate procreation, money breeding money when, in fact, it was only barren metal. Mary and Elizabeth, on the other hand, are exemplars of divinely inspired fertility, Mary having conceived miraculously as a virgin and her cousin giving birth in very old age. The frescoes, then, contrast the unnatural generation of money through usury with the supernatural generation of Christ. What is more, the scene of the Visitation was often associated with Charity, the antithesis of avarice and usury, and therefore crucial to Scrovegni's dedication of the chapel to the Virgin

of Charity.

The power of the Scrovegni chapel frescoes lies partly in the all-enveloping nature of the work. It also derives from the psychological intensity of the individual scenes. Like the painter of the Isaac stories in Assisi (see Fig. 3.3), Giotto has infused the familiar biblical stories with a human poignancy which helps to transform these stories of remote history into comprehensible and moving events. In this respect Giotto provided a drama comparable to the tableaux vivants and stylized performances which had taken place in front of the former chapel on the site and which most likely continued within the Scrovegni chapel once it was completed: the panel of God the Father, high on the altar wall, is actually a wooden door from which an actor representing an angel would appear. From this level he could be lowered by ropes threaded through holes in the ceiling immediately in front of the door to the floor below. The ephemeral action of such liturgical dramas found permanent form in Giotto's frescoes.

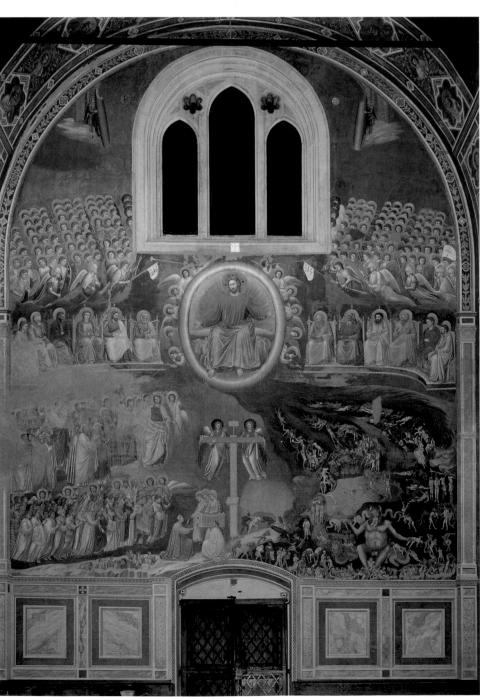

3.12 Last Judgment, c. 1303-05, commissioned by Enrico Scrovegni from Giotto for the Scrovegni Chapel, Padua. Fresco, 32' 9%" × 27' 6¾" (10 × 8.4 m)

4 Florence: Traditions and Innovations

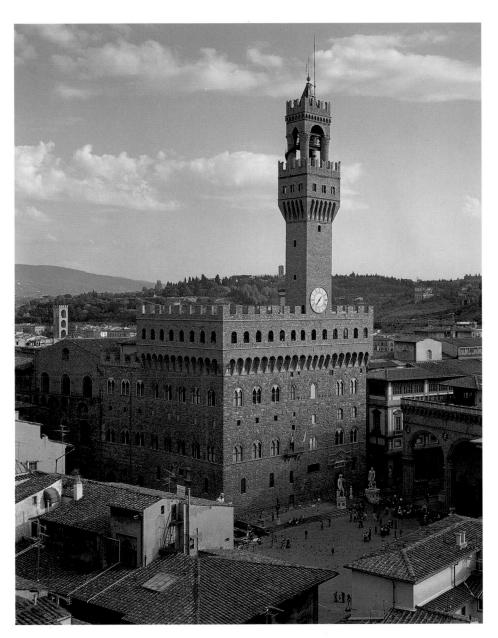

Plorentines literally walked on Roman streets. Founded by soldiers during the Roman republic of the first century B.C.E. and named Florentia (Fiorenza, with its double meaning of "flower" suggesting beauty and "flowering" suggesting fertile development), the city claimed a continuous existence back into Roman antiquity. Its history is physically manifest in the grid plan of its central core, corresponding to the original ancient military *castrum* or camp. This

Roman history, and especially its republican origins, became a constant reference in political discourse and the visual arts. Antique stylistic and iconographical quotations in Florence, far from being simply literary or aesthetic, were tied to a history constructed as politics. As early as the twelfth century Hercules with his club appeared on the Florentine state seal with the inscription *Herculea Clava Domat Florencia Prava* ("Hercules' club subdues Florence's wickedness"), a clear statement of the difficulties of controlling unruly and factional urban populations during the late Middle Ages.

Florentines built their city in a broad valley on the river Arno (Fig. 4.1). The river provided them with drinking water and fish, as well as a means for powering flour mills and washing and dyeing raw materials in the production of woolen goods which dominated the Florentine economy. Although not completely navigable, the Arno also facilitated transporting products to and from the Tyrrhenian sea, approximately 50 miles (80 kilometers) to the west. While substantial hills around the city provided some protection from invaders, city leaders girdled Florence with walls fortified with towers. The fortifications visible in our illustration were built in the thirteenth century to replace a twelfth-century ring of walls that itself had replaced the outgrown limits of the city's cramped ancient Roman core (see map, page 79). Great gates with double

and triple sets of iron-studded wooden doors and imposing metal grates opened at daybreak to admit travelers and farmers from the countryside. The city shut tight again at dusk.

(above) Palazzo della Signoria, Florence, 1299–1310, commissioned by the Florentine government from **Arnolfo di Cambio**

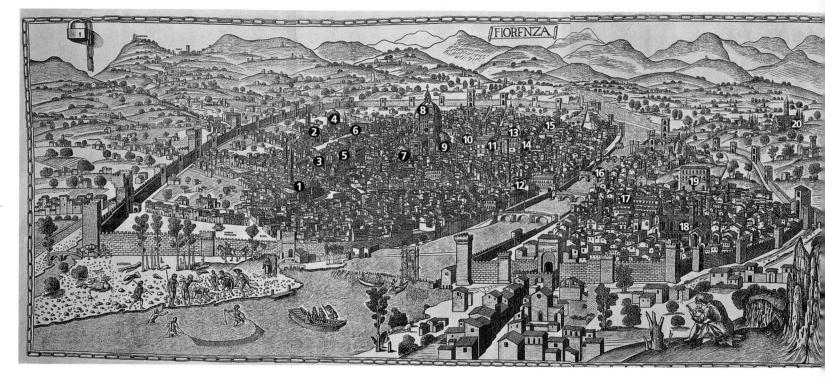

4.1 Chain Map of Florence, detail, 1480, anonymous. Woodcut (Galleria degli Uffizi, Florence)

1 Santa Maria Novella (Dominican); 2 San Marco (Dominican); 3 San Lorenzo; 4 Santissima Annunziata (Servite); 5 Medici Palace; 6 Innocents' Hospital; 7 Baptistry; 8 Cathedral; 9 Campanile; 10 Or San Michele; 11 Marzocco; 12 Santa Trinità; 13 Palazzo della Signoria; 14 Loggia della Signoria; 15 Santa Croce (Franciscan); 16 Ponte Vecchio; 17 Santo Spirito; 18 Church of the Carmine; 19 Pitti Palace; 20 San Miniato

Many of the city's streets were narrow and wayward (Fig. 4.2). Shops opened directly onto the street, allowing merchants to display their wares on counters which could be shuttered tight at night. Living quarters were located above or adjacent to most people's places of employment, assuring a heterogeneous population throughout the city. Even so, each neighborhood was dominated by a few wealthy families. Their private towers, which served as status symbols and as fortified perches in the frequent battles among competing clans, soared above the streets.

Florence's urban plan embodied critical social messages. Cathedral and city hall are at opposite ends of the main east-west street of the Roman grid with the guild oratory of Or San Michele situated on the same axis. Church, state, and corporate economy, the structuring elements of this body politic, therefore control the urban spine from which all other features extend. Urbanistically they are united, just as they were in terms of their operations, with members of the leading families of Florence acting as governors of their guilds, elected officials in the town hall, and members of the building committees of the cathedral. Boundaries between Church and state were clearly permeable. The same seamless interaction that characterized relations within the state can be seen in the overlapping of antique past and Christian present.

4.2 Via dei Girolami, Florence

Space was at such a premium in parts of Florence that the inhabitants of some neighborhoods built enclosed bridges and balconies—known as *sporti* (seen in the photograph)—out over public streets. City officials attempted to discourage such practices by imposing fines, but many people chose to pay the fines rather than lose precious living space. Workshops on ground level spilled out into the street.

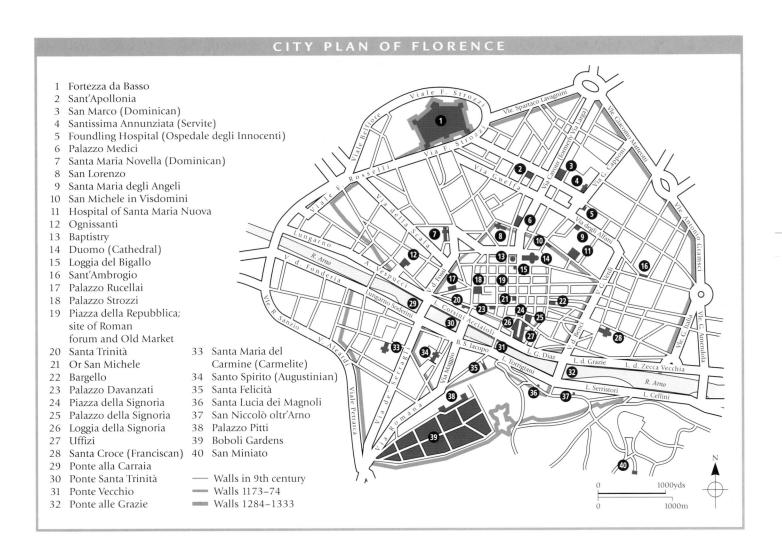

St. John the Baptist and the Baptistry

Florentines claimed St. John the Baptist as their civic patron. The city's Baptistry of San Giovanni, dedicated to him, served as a primary site of civic and religious selfidentification (Fig. 4.3), overshadowing the city's cathedral, which was a relatively modest structure until its rebuilding in the fourteenth and fifteenth centuries. At San Giovanni one became a Christian and a Florentine at the same time, the Baptistry serving as the single place of baptism for the entire city. Although completed in its present form in the late eleventh and twelfth centuries, the Florentines believed that the building had served originally as a temple dedicated to Mars-a belief that reflects Florentine pride in their Roman past as well as their belief that the city would be victorious in its military endeavors, guided as it was by the god of war. The Baptistry's marble cladding, its use of classically detailed pilasters, friezes, and tabernacles, along with the reuse of actual Roman columns in its interior and flanking its entrances, served to reinforce the impression of great antiquity.

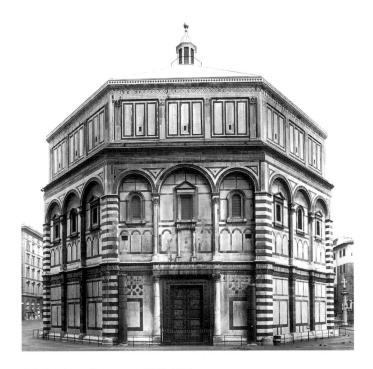

4.3 Baptistry, Florence, c. 1059-1150

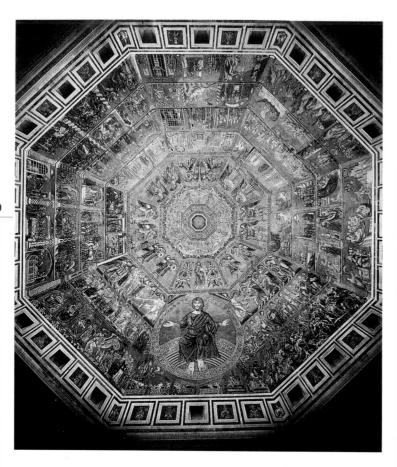

4.4 Baptistry, Florence, showing the mosaics by **Coppo di Marcovaldo** (?) in the vaults, late thirteenth to early fourteenth centuries

Management of the Baptistry's maintenance and embellishment was entrusted to the wealthy Arte del Calimala (Wool Merchants' Guild), which oversaw the Opera di San Giovanni (the building works of the Baptistry). This organizational structure initiated a pattern that was to see the guilds assume responsibility for a number of major ecclesiastical buildings in the city. Guilds not only monitored and regulated commerce but also dominated the city government and thus its major building projects. In this manner, mercantile values came to dominate the city.

Throughout the thirteenth and early fourteenth centuries guild officials endowed the vaulted surfaces and balustrades of the Baptistry's interior with glittering mosaics (Fig. 4.4). The mosaics in the main dome may have been designed by a Florentine artist steeped in the Byzantine tradition. Coppo di Marcovaldo (active 1260–76 Siena, San Gimignano, and Orvieto) is frequently suggested as the designer, but artists trained in Venice who possessed special expertise in this medium installed them. An official act of 1301 commissioned a certain Constantinus and his son to work on the Florentine mosaics and to invite other artists from Venice to join them. Civic loyalty did not impede artists from working in rival towns; then, as now, they went where there was work. Patrons may actually have sought out foreign artists in a spirit of competitiveness.

The mosaics cover the whole area of the octagonal dome in concentric bands. Directly above the opening into the apse and the altar looms a colossal figure of Christ in Judgment, his divinity marked by the crackling light shining from the gold striations of his stylized robes. At his feet naturalistic figures of the dead rise from their tombs on the last day. Christ's awesomely contorted hands and feet extend toward the gold and patterned circular band as if he majestically encompassed the boundaries of the universe. He welcomes with outstretched palm the elect in the vault segment to his right and condemns the damned in the vault segment to his left with the back of his hand. The five vault segments that complete the dome contain bands of narratives depicting the Creation and the life of Joseph, followed by the New Testament lives of John the Baptist and Christ. Although there are naturalistic touches in the narrative depictions, the imposing iconic figure of Christ dominates the dome and offered Florentines a glimpse of the grandeur of God's universe and a sense of their diminutive place in it. The Church, its teachings, and its practices-which included secular as well as spiritual powers-loomed large throughout the Renaissance.

The Palazzo della Signoria and Urban Planning

Throughout much of its early history the communal government of Florence—like many others on the Italian peninsula—met in churches, another indication of the close links between Church and state. At the end of the thirteenth century such improvised arrangements no longer sufficed, however, and in the following century local governments constructed city halls for their own use (see p. 77; Fig. 5.22). These buildings have many features in common, being more or less rectangular in plan and somewhat blocky in form. All had courtyards on their ground floors and an impressive hall for meetings of citizens' councils on the upper floor. They also included one or more chapels, meeting space for smaller administrative groups, government offices, and residential quarters for government leaders.

At the same time, each city hall offered a distinctive image for its civic government. In Florence the resolute masonry walls and exaggerated battlements of the Palazzo della Signoria (begun in 1296; see p. 77) powerfully express the need to uphold and defend civic liberty from any and all assailants. Even though the architect for the Palazzo della Signoria, Arnolfo da Cambio, had studied with Nicola Pisano and was recently returned from Rome where he had worked for the pope (see Fig. 2.11) and high-ranking cardinals (see Fig. 2.9), there is no hint of classical form in the building. It remains resolutely traditional using indigenous castle architecture as its vocabulary, not unlike its predecessor building, the Palazzo del Podestà, known today as the Bargello. When the Palazzo della Signoria was built the city

4.5 Piazza della Signoria, Florence, and the area surrounding the Palazzo della Signoria. Plan of spatial expansion during the fourteenth century (from Marvin Trachtenberg, *Dominion of the Eye: Urbanism, Art, and Power in Early Modern Florence*)

was deeply factionalized between Guelf and Ghibelline parties. The first nominally supported the popes and the latter were generally loyal to the medieval German emperors but both fought battles over local issues. The merchant class, wresting power from the predominantly aristocratic Ghibellines in the late thirteenth century, erected the tower of the Palazzo della Signoria off-center on the stump of a pre-existing Ghibelline tower, symbolically triumphing over the rival faction.

The Signoria not only demolished the palace structures of the Ghibelline Uberti family at the site, but over a period of years continued to acquire property around the site of the new Palazzo della Signoria (Fig. 4.5). This spatial extension into the fabric of the city accomplished a number of things: it essentially erased the existence of the Uberti from the center of the city; it added a grandeur to the building by isolating it from any nearby structures, both giving it a visual prominence in the city and making it safer; it provided a public space for the citizenry to gather in front of the town hall to hear the decisions of their governors; it brought the building—through its piazza—to the edge of the major north-south axis of the city, thus linking it with the cathedral; it allowed the long west façade to become the new entrance façade of the building rather than the shorter

northern side; and it allowed multiple points of view of the building as it was approached by different routes through the city, most notably coming from the cathedral and from the Ponte Vecchio and the other side of the Arno river.

This concern for marking the building on the wider urban landscape is evident in early schematic representations of the city (Fig. 4.6), where it stands firmly in the center rather than in its actual location to the south and near the river (see map, p. 79). Dispensing with city streets and piazzas, our illustration shows what dominated civic consciousness: the city's large churches, imposing private palaces, and its solid ring of walls. This centering of the Palazzo della Signoria was highly appropriate, of course, insofar as it was the seat of government. Its tower was also purposefully taller than any other tower in the city (see p. 77). Its height is actually measurable on the ground since it determined the distance from the corner of the building

4.6 Bird's Eye View of Florentine Monuments, from Poggio Braciolini, Historia Fiorentina, after 1474, Urb. Lat. 491, fol. 4v. (Vatican, Biblioteca Apostolica). Tempera on parchment

Art and Violence

Renaissance cities were rife with raucous behavior and sometimes violence. Rivalries with competing city-states and intense local political factionalism often led to armed conflict within the city itself as well as on the battlefield. It was not always clear who posed a greater danger: the soldiers of an opposing city-state or one's neighbors.

In an attempt to control violence within their jurisdictions, city governments passed

laws limiting the carrying and use of arms. To enable people to let off steam, they also provided officially sanctioned opportunities for engaging in violent and often dangerous behavior. Rules were relaxed especially during Carnival, a festival in late winter just before the start of the penitential season of Lent. During Carnival men were allowed to dress as women, slaves as masters, laity as clergy.

As seen in Figure 4.7, a sixteenth-century Venetian print, neighborhood groups and city officials also organized thrilling-and cruelspectator sports. In the right foreground young men run up a bridge and leap to grasp a tethered goose by its neck; both successful and unsuccessful participants landed unceremoniously in the canal below. At the left, two masochistic figures on a platform submit themselves to clawing by a cat strapped to a board. Just behind them dogs bait a bear. In the background spectators run from an

enraged bull. In the center square, citizens enjoy a gentler pastime, a hip-rocking dance.

Although coarse and often inhumane, these events appealed to a wide audience, including the noblewomen shown here perched in windows and balconies overlooking the scene. City officials were proud of such events. For example, when King Henry III of France visited Venice in 1574 he

4.7 From *Giacomo Franco*, Habiti d'huomeni et donne venetiane con la processione della serenissima signoria et altri particolari cioe trionfi feste ceremonie publiche della nobilissima città di Venetia, Venice, 1600s, reprint 1878. Engraving

was treated to a stick fight. Representatives from the two major factions in the city—one claiming to have their origins on the mainland, the other from the islands in the lagoon—donned rough iron helmets and chain mail before fighting for control of the top of the Carmini Bridge. The king called off the event after three hours, saying that it was less violent than an actual battle but more dangerous than a game really

should be.

In Rome visitors and citizens enjoyed the vicarious terror of watching wild horses run down the Via del Corso (Street of the Race) to the base of the Capitoline Hill. Siena was-and still isfamous for men on horseback careening around the Piazza del Campo to claim the city's palio (ceremonial banner). In Florence tournaments held in the large squares in front of the mendicant churches of Santa Croce and Santa Maria Novella were a bit more ritualized in their violence, though the public could indulge its taste for blood and physical contact by cheering on their neighborhood players in the annual rugby-like soccer matches staged in the city's piazzas. Sometimes these events got out of hand, occasionally leading to riots-as hotly contested games may do even today-but for the most part they reinforced both civic and group solidarity, domesticating and limiting civic violence.

to the street entering the piazza from the cathedral and Or San Michele. Its position off the center axis of the west side of the building also meant that it was framed by another street entering the piazza from the thoroughfare that connected the Ponte Vecchio to the Old Market of the city. Carefully calculated vistas sharpened awareness of the superiority of this tower and of the power of the factions that had ordered its construction.

Mendicant Churches

Santa Croce and Santa Maria Novella

As befits a culture where Church and state were bound tightly together, Florence's communal government also provided major subsidies for the construction of large new churches for the Franciscans and the Dominicans. These

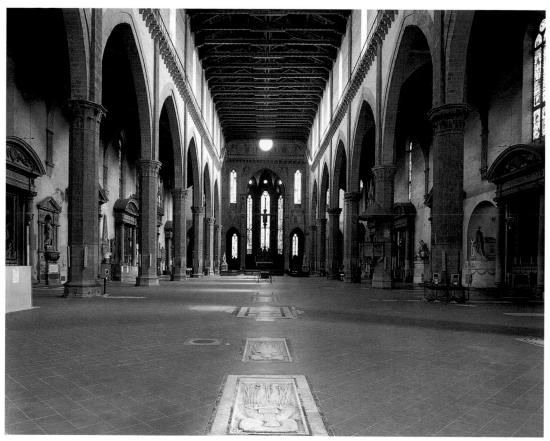

private citizens, probably from
Arnolfo di Cambio

4.9 (below) Santa Croce,

4.8 Santa Croce, Florence, begun 1294, commissioned by the Franciscans with the support of the Florentine government and

Florence, plan of church and convent showing fourteenth-century chapel dedications and sixteenth-century nave chapel renewals

1 Zanchini Chapel, Bronzino, Christ in Limbo; 2 da Verrazzano Chapel, Naldini, Entombment; 3 Medici Chapel, Santi di Tito, Resurrection; 4 Berti Chapel, Santi di Tito, Supper at Emmaus; 5 Guidacci Chapel, Vasari, Incredulity: 6 Asini Chapel, Stradano, Ascension; 7 Biffoli Chapel, Vasari, Pentecost; 8 Risaliti Chapel, Macchietti, Trinity; 9 Alberti Chapel, Agnolo Gaddi, Legends of the True Cross; 10 Bardi Chapel, Giotto, Life of St. Francis; 11 Peruzzi Chapel, Giotto, Lives of St. John the Evangelist and St. John the Baptist; 12 Baroncelli Chapel, Taddeo Gaddi (and Giotto), Life of the Virgin; 13 Castellani Chapel, Various artists, Lives of the Saints; 14 Pazzi Chapel, Minga, Agony; 15 Corsi Chapel, Barbiere, Flagellation; 16 Zati Chapel, Coppi, Ecce Homo; 17 Buonarroti Chapel, Vasari, Way to Calvary; 18 Alamanneschi Chapel, Santi di Tito, Crucifixion; 19 Dini Chapel, Salviati, Deposition; 20 Choir screen (destroyed 1565); 21 Refectory, Taddeo Gaddi, Last Supper and Tree of Life; 22 Cloisters

position on opposite ends of the city. In Florence the Franciscan church of Santa Croce (Figs. 4.8 and 4.9) was begun on the eastern side of the city in 1294; the Dominicans built their church of Santa Maria Novella in the western part

(Figs. 4.10 and 4.11). This turned out to be an effective strategy for serving burgeoning urban populations, and it also served to emphasize that the two orders held distinctly different theological orientations: the Franciscans emphasized a mystical, personal faith while the Dominicans articulated Christian theology in more rational, philosophical terms. Still, both churches are cavernous enlargements of earlier monastic structures on their sites, reflecting the size of the congregations who came to hear the preaching for which

buildings must be read as civic monuments as well as monastic churches, indications of the city's beneficial cultic life. In fact, when Santa Croce was still unfinished in the 1430s, city officials lamented how poorly its delay reflected on the city as a whole.

Mendicant friars focused much of their mission on the urban poor, who in Florence largely toiled in the demanding, poorly compensated work of combing and dyeing wool before it was transformed into valuable woolen cloth. A large number of these workers lived and worked on the periphery of

the old walled city, and it is here that the Franciscans and Dominicans found the open land and low property values to allow them to construct enormous church complexes. Large piazzas in front of these churches served as often for civic jousts and tournaments (see Fig. 12) as they did for preaching (see Contemporary Scene, "Art and Popular Piety," Fig. 5.23).

The Dominicans and Franciscans, while engaged in a common mission, became major rivals, expressed in their

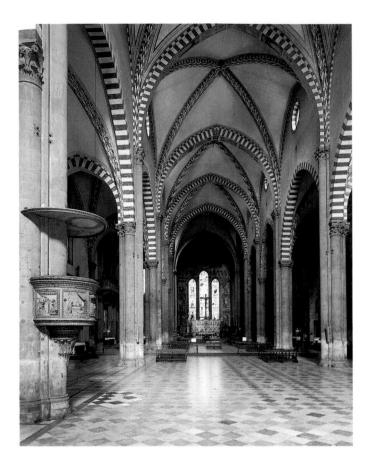

4.10 Santa Maria Novella, Florence, founded before 1246, nave begun after 1279, commissioned by the Dominicans with the support of the Florentine government and private citizens

both orders were renowned and attesting to the growth of the city in general.

In spite of their size, both churches are relatively restrained in their decoration, compared to the rich marbleand mosaic-encrusted surfaces of the Florentine Baptistry, for example. Both churches are laid out in modified cruciform plan, with a shallow apse, whose simple rectangular forms appropriately recall the geometric severity of churches built for the Cistercians, an older religious order that had also promoted ecclesiastical reform. At Santa Maria Novella the nave wall is pierced only by simple oculi, and hardly a molding protrudes from its flat surface. Similarly at Santa Croce the open wooden truss roof and unelaborated lancet windows project an image of relative austerity, albeit on a monumental scale. Recalling the great Early Christian basilicas of Rome in their large size, these mendicant order churches testify to a desire to animate the institutional Church with the values of an earlier era.

Altarpieces Dedicated to the Virgin

The increasing spaciousness of mendicant and other urban churches, along with the need for devotional objects to be clearly visible within them, inspired artists and patrons to create impressively large crucifixes (see Fig. 1.2 and p. 48)

and equally outsized altarpieces of the Virgin and Child: ten-foot (three-meter) and higher images became common in the second half of the thirteenth century. Like crucifixes, altarpieces dedicated to the Virgin were increasingly imagined in human terms, responding to and intensifying the popularity of the Virgin and her cult.

Cimabue's Altarpiece for Santa Trinità Cimabue, who had worked in Rome and Assisi, created a twelve-foot (three-and-a-half-meter) high image of the Enthroned Madonna and Child (Fig. 4.12) for the Vallombrosan church of Santa Trinità in Florence. As before, he employed Byzantine types, presenting Christ and his mother in majesty (hence the Italian term for this subject, Maestà), but his work is distinctive insofar as it depicts a deep and complex space around the figures. Cimabue also had rediscovered the original purpose of gold highlights and linear embellishments common in much Byzantine painting. Rather than using typical fishbone striations merely as abstract patterns on the surface of the painting, Cimabue understood that gold highlights referred directly to actual folds and creases in drapery. Equally important, he used crisp lines to construct space around and in front of the Madonna. The platforms under her feet and the oblique angles created by the arms of her architectonic throne suggest a degree of perspective, although some spatial ambiguities result: in what plane, for example, are the Old Testament prophets below the throne? Cimabue's altarpiece, with its shimmering gold throne flanked by the muted violet and pastel robes of the angels, retains the ability of Byzantine art to evoke the transcendent nature of the divine. At the same time, it makes the incarnation of God in Christ through Mary more believable through a new emphasis on humanly observable phenomena.

Duccio's Altarpiece for the Confraternity of the Laudesi

On April 15, 1285 the Confraternity of the Laudesi, a lay group associated with the Dominicans in Florence and dedicated to charitable work and praise of the Virgin, commissioned a huge altarpiece for their chapel in the right transept of Santa Maria Novella. They called upon a young Sienese artist, Duccio di Buoninsegna (active c. 1278–1318 Siena), to provide a suitable image (Fig. 4.13). Duccio may have trained with either Cimabue or his fellow Sienese painter Guido da Siena (active 1262/67–1280s Siena), but his work breaks notably with that of his predecessors. His new, more naturalistic style—particularly in the rendering of facial features and soft, mobile bodies—was to dominate Sienese art and transform much of Florentine painting for decades.

Duccio's enthroned Madonna and Child—now familiarly known as the *Rucellai Madonna* because of its subsequent placement in a chapel belonging to the Rucellai family—reveals in its frame the special concerns of the Laudesi. Thirty small roundels depict saints who include St. Catherine of Alexandria (a favorite saint in Dominican contexts), St. Dominic (the founder of the Dominican order), St. Zenobius (a patron saint of Florence), and St. Peter Martyr (founder of the confraternity).

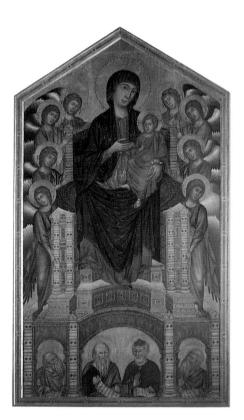

4.12 (left) Enthroned Madonna and Child (Maestà), 1280s, commissioned from Cimabue for Santa Trinità, Florence.
Tempera on panel, 11′ 7″ × 7′ 4″ (3.53 × 2.24 m) (Galleria degli Uffizi, Florence)

4.13 (right)
Enthroned Madonna
and Child (Maestà),
1285,
commissioned by
the Confraternity of
the Laudesi from
Duccio for their
chapel in Santa
Maria Novella,
Florence. Tempera
on panel, 14' 9%" ×
9' 6%" (4.5 × 2.9 m)
(Galleria degli Uffizi,
Florence)

Comparison of Duccio's altarpiece with Cimabue's large panel for Santa Trinità reveals some of the shifts taking place in Italian painting at the end of the thirteenth century. Whereas Cimabue tied his figures to a Byzantine model, with smooth ovoid shapes defining the structure of the faces and with crisp, angular gold striations used to model drapery. Duccio seems to have looked to French models as well. His throne is light and airy, set at an angle to suggest space. The surrounding angels kneel convincingly even as their bodies seem to levitate, a compositional scheme seen in northern stained glass windows. The facial features of his figures betray sources similar to Cimabue's in their abstracted shapes, but the drapery of the figures adheres much more closely to the physical forms beneath. The border of the Virgin's robe, carefully tooled in gold, ripples in a sinuous pattern which seems to delight in graceful curvilinear movement for its own sake; while suggesting the folds of the fabric it also "works" as an elegant surface pattern. Even the soft shift of the axes of the Virgin's body (compare Cimabue's Madonna, who is aligned on a single axis, apart from her right leg) suggests new concern for activating the figure. Duccio shades and models his figures so that the Madonna's right knee seems to push against her robe, and the angels' legs and arms are clearly present under their translucent, pastel garments.

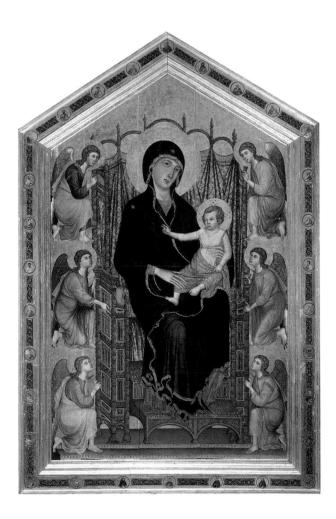

4.14 Ognissanti Madonna and Child (Maestà), c. 1310–15, painted by **Giotto** for the high altar of the Ognissanti Church in Florence. Tempera on panel, 10' $8'' \times 6' 8 / 2'' (3.2 \times 2 \text{ m})$ (Galleria degli Uffizi, Florence)

Giotto's Ognissanti Madonna Giotto offered another alternative for images of this type, translating the monumental style of his Scrovegni frescoes in Padua to his impressive Madonna and Child for the Church of the Ognissanti in Florence (Fig. 4.14). Although the specific patron is unknown, the church was the headquarters of the Umiliati, a mendicant order that was renowned for its wool production as well as its acts of charity. The painting is normally dated to c. 1310 on the basis of style. The stolid Virgin, her robes draping heavily over her limbs to reveal the masses of the body beneath, is formally very much like the Christ figure in the Last Judgment of the Arena Chapel (see Fig. 3.12) and the enthroned St. Peter of his Stefaneschi Altarpiece in Rome (see Fig. 2.13) while also recalling some of the solidity of Cimabue's earlier composition (see Fig. 4.12). But while Giotto used the conventional gold background seen in previous Maestà images, he eliminated the decorative patterns of light in Cimabue's versions of this same subject and the decorative border arabesques seen in Duccio's Maestà (see Fig. 4.13). Moreover, he conceived space in a completely volumetric manner, so that the Gothic throne in which the Virgin and Child sit frames the figures, providing a believable volume for their bodies. Rather than the vertical columns of angels in the earlier paintings, Giotto has placed the angels around the throne, their spatial depth indicated in part by the fact that the foreground angels partially obscure those behind them and in part by the volumes of their individual forms. Giotto's radical transformation of the style of the devotional image so evident in the *Ognissanti Madonna and Child* (and perhaps in other paintings now lost) marks an important moment in the acceptance of his new style in Tuscan panel painting at the beginning of the fourteenth century.

That said, it is probably just as important to recall how similar such devotional images were, rather than to emphasize their differences. Duccio's, Cimabue's, and Giotto's altarpieces purposefully presented similar subject matter in similar ways in order to allow worshipers to forge a coherent image of the divine. The power of these altarpieces derived in no small part from the collective image they left on the minds of the faithful. Looming out of the semi-darkness of countless churches, the Madonna and Child became familiar, accessible, and omnipresent, a highly effective means of approaching God.

Santa Croce Frescoes

Like Enrico Scrovegni in Padua, wealthy Florentines also commissioned major fresco cycles as manifestations of their hopes for salvation—and of their social position. The strongest and wealthiest citizens of Florence had very early allied themselves with the Franciscan and Dominican orders through family members who became friars; these prominent families established their presence within urban monastic churches such as Santa Croce and Santa Maria Novella by endowing them with chapels. Although these chapels were built with funds from the Commune and with pious donations for the general construction of the church, the religious orders ultimately sold them to private families who could be relied on to decorate them in a way that would bring honor to the church and to the monastic community resident there. Such chapels were held as family property by the heirs of the founders until they were sold or the family died out. The size of such a chapel and its proximity to the high altar indicated the prominence of the family who owned it and established in a clearly propagandistic manner its position of honor within the religious, social, and economic fabric of the city.

The programs for the frescoes decorating these chapels were subject to the approval of the order that maintained the church. Both private patron and monastic community had audiences to address. An artist had to be aware of the interlocking network of patron, religious order, audience, and site; and he himself added yet another level of complexity as his own vision gave form to these relationships.

The Bardi Chapel The first chapel to the right of the choir of Santa Croce (Fig. 4.15) belonged to the Bardi family, who controlled one of the most famous banking houses in Europe until its collapse in 1346, caused in part by the failure of the English king to repay his extensive outstanding loans. They commissioned Giotto to decorate its walls with scenes from the life of St. Francis. Later other members of the family were to contribute another chapel to the left of the high altar and a third quite large chapel at the end of the left transept. Clearly the various branches of the family were determined to declare their prominence in their quarter of the city and to ensure prayers for their family by the magnitude of their patronage. The fresco cycle depicting events in the life of St. Francis, the patron saint of the order that oversaw the church, indicates, however, that the Franciscans were able to dictate the subject matter for the painted decorations of their building regardless of how important the individual families were who owned the chapels, just as they did for the chancel (the story of the True Cross) and the chapel to its left (stories from the Life of the Virgin) both of which depict subjects central to Franciscan spirituality.

The date of the Bardi Chapel frescoes is uncertain. Giotto apparently joined the Florentine guild of the Medici e Speziali (the Pharmacists and the Spice-sellers, where painters purchased their pigments) in 1327;

however, the frescoes may have been begun as early as 1320. The frescoes cannot be dated on the basis of stylistic comparison with other works by Giotto since the only earlier extant frescoes securely attributed to him are those in the Arena Chapel in Padua of around 1305, leaving too great a gap in time between their proposed dates for meaningful comparison.

Giotto divided the side walls of the Bardi Chapel into three levels. The episodes from the life of St. Francis move from top to bottom and from left to right, beginning with Francis's renunciation of his earthly goods and ending with his posthumous appearances. Giotto treated the width of the wall as a single expanse for the presentation of one narrative episode, rather than dividing the surface into separate framed narrative panels as he had done in Padua. In all of the scenes Giotto used architecture to strengthen the narrative, much as did the painters of the nave frescoes in the upper church in Assisi (see Figs. 3.1 and 3.4). In the lower scenes in the Bardi Chapel such as the Trial by Fire (Fig. 4.16) Giotto extended the architecture to the very borders of the pictorial space, using it not only to provide a

4.15 Bardi (left) and Peruzzi (right) chapels, Santa Croce, Florence, seen from the transept, showing Giotto's fresco cycles

Giotto painted a fresco of the Stigmatization of St. Francis on the outside wall of the chapel over the arch, which identifies the dedication of the chapel from a distance and at the same time provides the Franciscans with a large-scale image within the church itself of a defining moment in the life of their patron and founder.

unified and symmetrical framework for the narrative, but also to highlight or focus on dominant figures in the stories and to create a consistent spatial depth from one tier of the chapel to the next. Giotto also increased the scale of the architecture in relation to the figures, so that the figures take up only about half of the height of each scene. These compositional devices give the narrative a monumental scale. The figures themselves are fully modeled, with drapery falling in sensuous, heavy folds over their bodies. Although Giotto tends to place his figures in a shallow band of space within the architectural frame, their gestures, as well as their positions and grouping, create a sense of volume, particularly in relation to the blank surfaces of the architecture, which run parallel to the picture surface. This

4.16 *Trial by Fire*, c. 1320, commissioned presumably by Ridolfo di Bartolo de' Bardi from **Giotto** for the Bardi Chapel, Santa Croce, Florence. Fresco, 9' 2" × 14' 9" (2.8 × 4.5 m)

relief-like device is one that Giotto, like contemporary sculptors, must have learned from looking at ancient Roman sculpture.

Giotto also shows himself to be a masterful story teller and student of human psychology. Anger, sorrow, confusion, amazement, and even boredom are among the many emotions and reactions he registers in the body language and faces of his figures. In the *Trial by Fire*, which tells the story of Francis's challenge to the Islamic clerics of the Egyptian Sultan to prove their faith by walking through fire, Francis, at the far right, is the embodiment of stalwart devotion to his beliefs. He shields his eyes from the

heat of the fire blazing in front of him and lifts his gown, ready to step into the flame. His companion, hands clenched within his habit and head tilted to the side, seems both to implore the saint to refrain from such a rash act and pray for God's protection should he go through with it. Giotto shows the Sultan at the center of the composition in conflict by having him point across his body to Francis and look askance in the opposite direction at his own clerics skulking away out of the scene at the left. A turbaned servant reinforces the Sultan's challenge, his hand also pointing back towards Francis, while the priest next to him holds his cloak up high as if to protect himself from such a dangerous test. His companion to the left puts one hand to his ear, unwilling even to hear the challenge. Packed into a very few figures, then, is a psychologically rich narrative, both compelling and believable because of the humanity of its protagonists.

Equally moving is Giotto's rendition of the funeral of St. Francis (see Fig. 42), placed at the bottom of the left wall and just above the eye level of relatives who buried their own dead in the chapel. The composition is quiet and simple, dominated by the bier on which St. Francis's body lies. Giotto frames the scene by a piece of stage architecture that is parallel to the picture surface and helps to set off the figures as volumetric reliefs. As in the Isaac frescoes in the upper church at Assisi (see Fig. 3.3) he leaves room at the top and at the left and right, suggesting an openness beyond. Against the regular pairing of kneeling Franciscan friars on either side of the bier (also placed parallel to the picture plane) Giotto places groups of figures at the left and right that establish a slow, decorous diagonal flow into the space of the room, befitting the solemnity of the occasion. Behind the body of Francis individual friars give vent to their anguish, each responding with personal gestures of

grief, thus animating the carefully structured composition. Their reactions are all the more powerful for being contrasted with the bland expressions of the candle bearers and other functionaries, who seem to be present more out of duty than devotion. In the foreground, the Knight Jerome in a crimson cape, opens the side of Francis's robe to reveal the stigmata, a manifestation of a miracle that proves Francis's sanctity. Like the Berlinghieri altarpiece (see Fig. 1.4), these frescoes were more than a simple narrative of the saint's activities; they were meant to document divine intervention in his life.

The Peruzzi Chapel Not to be outdone by the Bardi, Donato di Arnoldo Peruzzi, a leader of another Florentine banking family, left funds in his will for the construction of a chapel immediately to the right of the Bardi Chapel. For this, his grandnephew, Giovanni di Rinieri Peruzzi, commissioned Giotto to paint scenes from the lives of John the Baptist (on the left wall) and John the Evangelist (on the right wall), one of whom was presumably Giovanni's patron saint. The frescoes probably date from the early 1320s; the left wall may have been painted considerably before the right one. These frescoes were painted a secco and much of the surface has flaked away, precluding any detailed stylistic analysis. They reveal a compositional order significantly different from that which Giotto had used in the Bardi Chapel. The Ascension of St. John the Evangelist (Fig. 4.17) illustrates a popular story claiming that the Evangelist rose while still alive into heaven, cheating death, the only Apostle to have escaped martyrdom. Rather than stretch the architectural framework of the composition skin-like over the wall surface, as he had done in the Bardi Chapel, Giotto gave the architecture in the Peruzzi frescoes a three-dimensional mass, constructing it along diagonal axes which continually thrust into the pictorial space. The true purpose of this device can be understood only if the chapel and its paintings are seen as a whole, as they would be when viewed outside the chapel from the transept of the building (see Fig. 4.15). Then one can see that the diagonal axes of the painted architecture move from the entrance wall to the rear wall of the chapel providing a convincing illusion of space, rather than the puzzling and awkward zigzags of architectural forms dominating

photographs taken of the frescoes straight-on. The activation of the architectural frame creates spaces through which individual figures and groups of figures can move, adding greater realism to the narrative.

In the *Feast of Herod* (Fig. 4.18) these devices give Giotto space to portray the tower in which John the Baptist is imprisoned on the far left; the banquet hall in the center where Salome danced so alluringly that Herod offered her anything she might desire (it turned out to be the head of the Baptist); and, on the right, an anteroom where Salome

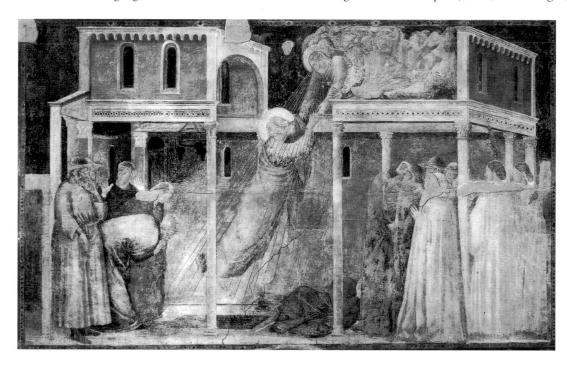

4.17 Ascension of St. John the Evangelist, 1320s, commissioned by Giovanni di Rinieri Peruzzi from **Giotto** for the Peruzzi Chapel, Santa Croce, Florence. Fresco, 9' 2½" × 14' 9½" (2.8 × 4.5 m)

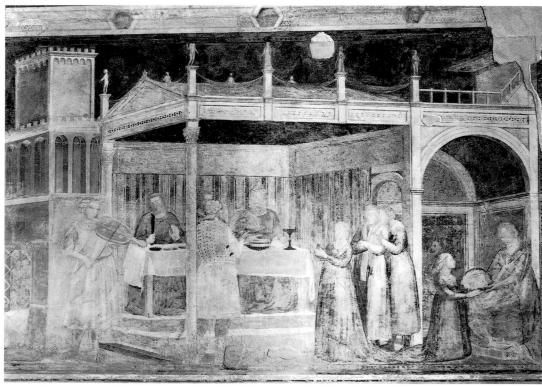

4.18 Feast of Herod, 1320s, commissioned by Giovanni di Rinieri Peruzzi from **Giotto** for the Peruzzi Chapel, Santa Croce, Florence. Fresco, 9' 2½" × 14' 9½" (2.8 × 4.5 m)

kneels and presents the head to her mother, who had suggested the request because of her anger over the Baptist's criticism of her illicit relationship with Herod. To ensure that the three episodes are joined together in a single narrative, rather than read as unrelated events, Giotto positions figures at the two junctures between the three spaces: a viol-playing musician at the left and onlookers at the right, underscored by the trains of Salome's skirts, which seem to join as she is first seen standing at the left and then kneeling on the right.

The Baroncelli Chapel Giotto's work had an important influence on the frescoes for the chapel of yet another of Florence's leading banking families, the Baroncelli. Their chapel, at the end of the right transept, is decorated with scenes from the life of the Virgin, painted between 1332 and 1338 by Giotto's leading pupil, Taddeo Gaddi (active c. 1328–66; Fig. 4.19). Taddeo most likely took charge of Giotto's Florentine workshop when Giotto went to Naples in 1328. The Baroncelli frescoes provide yet more evidence that the style of Giotto and his pupils had found favor with

4.19 Scenes from the Life of the Virgin, 1332–38, commissioned by the Baroncelli family from **Taddeo Gaddi** for the Baroncelli Chapel, Santa Croce, Florence, detail of left wall. Fresco. See also Figs. 8 and 9.

the Franciscans and with their eminent patrons. While depicting the lives of saints in a reverent manner, the new style also gave them a naturalistic, human quality.

The scenes depicted on the wall of the Baroncelli Chapel narrate highly involved legends about the Virgin's early life. At the upper left her father, Joachim, is driven from the temple in Jerusalem, clutching a sacrificial lamb which has been rejected by a scowling priest who is even more condemnatory than Giotto's earlier representation in Padua (see Fig. 3.7). The architecture, too, looms larger, meant to suggest the entire temple rather than just the altar precinct. Joachim and his wife Anna were childless and therefore, according to medieval legend, cursed by God. At the right, Joachim has gone into exile in the barren countryside where an angel appears in the sky announcing that his aged wife will bear a child after all, a scene obviously invented to correspond to the later annunciation of Christ's conception to Mary herself and the announcement of Christ's birth to the shepherds. The story continues in the second tier, where Joachim and Anna grasp one another's arms as they stride toward an eager reunion outside the walls of Jerusalem. Comparison of this section of the wall with a similar scene at Padua (see Fig. 3.8) indicates both differences of artistic personality and the development of style over time. Gaddi's figures are longer in proportion than those of Giotto. They tend to emphasize the narrow band of space across the composition rather than to create volumetric masses within it. Gaddi's linking of the husband and wife happens only at their arms; otherwise they are each distinct from the other, a decorous reticence of behavior that Giotto had eschewed in his intensely emotional embrace at Padua. To the right of this panel Gaddi depicts Anna giving birth; nursemaids admire the baby Mary in front of her mother's bed. Mary is soon a little girl and reappears in the lower tier (see Figs. 8 and 9), mounting the huge steps of the temple, where legend had it that she was cared for and educated by nuns. Dwarfed by the huge steps of the temple, she looks down for encouragement from a woman who crouches and sends other little girls up the stairs to join her. The Virgin's youth and childhood conclude in her marriage to Joseph at the bottom right. The story continues on the right (actually the back window) wall of the chapel with the Annunciation at the top and the announcement of Christ's birth to the shepherds below, as well as other episodes from Christ's youth.

The Baroncelli Chapel frescoes, like the earlier Peruzzi cycle, were conceived to be seen from the transept, as the architecture in the top and bottom tiers indicates. Because the Baroncelli Chapel is deeper than the chapels that extend along the length of the transept, Taddeo was constrained to divide the wall surface into separately framed scenes in the conventional manner rather than extending individual narratives the entire width of the wall. He chose to do so with a series of twisted columns, whose witty *trompe-l'oeil* demonstrates the painter's consciousness of his ability to transform a flat surface into architectural volume and spatial

depth. Taddeo's architecture is more thinly membered and much more vertical than the massive forms that characterize Giotto's frescoes in Santa Croce.

Taddeo Gaddi seems to have delighted in unusual effects, such as the dramatic lighting of the Annunciation to Joachim and of the night scene of the shepherds (Fig. 4.20). The soft lunar light that he depicts so beautifully in his fresco may stem from his close observation of nocturnal light on the landscape, but Gaddi apparently was also fascinated by solar eclipses and his inspiration may also have come from this phenomenon. He was in fact blinded by looking at the eclipse of 1339, a disaster that his confessor apparently thought was divine punishment for Gaddi's sinfulness. The pale light in the scene emanates from the angel approaching the shepherds. Gaddi shows the men gradually awaking, their sheep still asleep around them. Only the dog at the bottom left seems fully awake, his muscles tensed at the sudden apparition of the angel and the light, a naturalistic touch that lends veracity and familiarity to the scene.

4.20 Annunciation to the Shepherds, 1332–38, commissioned by the Baroncelli family from **Taddeo Gaddi** for the Baroncelli Chapel, Santa Croce, Florence. Fresco

Perhaps the most interesting scene is that of the *Marriage* of the Virgin at the lower right of the composition on the chapel's left wall (see Fig. 4.19). Here the decorum of earlier painted narratives in Santa Croce has been abandoned in favor of a more contemporary interpretation. The noisy crowd and the mocking **charivari** ritual of raucous music-making that accompany the bridal couple—with ribald suggestions of the pair's sexual union—suggest not a biblical event but, rather, Italian wedding celebrations of the time. Joseph, the old bridegroom, is being publicly ridiculed for foolishly marrying a pregnant woman—an element of sharp Florentine humor that must have amused viewers by playing to mocking medieval stories of Joseph.

The impression created by the transept chapel decorations in Santa Croce seen as a whole is that of a fairly consistent stylistic development over the course of some twenty years. Since most of the chapels were painted by Giotto and his students, it is apparent that the church's clergy and lay patrons appreciated the attention to narrative detail and increasingly naturalistic presentation of the new style.

Altarpieces for Santa Croce

This impression is tempered by the fact that the original altarpiece for the main altar of the church, a depiction of the Virgin and Child flanked by saints, was painted not by Giotto or a member of his studio, but by a Sienese painter, Ugolino di Nerio (active 1317–27; d. 1339?), who had trained in Duccio's workshop. This training is perhaps most clearly evident in the predella panels which virtually replicate similar images from Duccio's *Maestà* for the main altar of the cathedral of Siena (see Fig. 5.10). Although Ugolino's altarpiece is now completely dismembered, its original form is known from an eighteenth-century drawing (Fig. 4.21). Why, given the adventurous cycles of frescoes in the family chapels to the left and right of the main altar,

did the Franciscans and the donor family (most likely the Alberti, another very powerful Florentine banking family) retain Ugolino? Significantly, Ugolino also provided the altarpiece for the high altar of Santa Maria Novella, so the Dominicans, as well as the Franciscans, must have had a reason for making what would appear to be a very conservative choice of painter, especially when placed in the context of other paintings in the transept chapels. It seems likely that while the friars were quite glad to have narrative scenes rendered in a naturalistic manner, they felt that an image intended to be the object of devotion on

4.21 Santa Croce Altarpiece, c. 1324–25, eighteenth-century drawing of the lost painting by **Ugolino di Nerio** (Biblioteca Apostolica Vaticana, Rome, Vat. Lat., 9847, fol. 92r)

their high altar should retain the iconic, hieratic quality that had served this purpose so well in the past. Different needs occasioned different styles, each designed to elicit different reactions. Their coexistence as part of a complete decorative program suggests an assumption on the part of ecclesiastical patrons that worshipers could read different visual languages concurrently and use them as different, but equally valid, routes to spiritual truths, as, indeed, they did with saints' altarpieces.

The Ugolino altarpiece makes the altarpiece of The Coronation of the Virgin (Fig. 4.22) for the Baroncelli Chapel only a decade or so later seem almost revolutionary. Below the central panel of the Coronation is an inscription reading: "Op[us] Magistri Iocti d[e] Flor[enti]a" ("The work of Master Giotto of Florence"). Although stylistic and technical weaknesses suggest that Giotto did not actually paint this altarpiece, the inscription does indicate the active involvement of his workshop. He may have provided the design for the panel, if not for the whole chapel. Unlike Ugolino's painting of the iconic Virgin and Child flanked by isolated individual saints, the Baroncelli altarpiece presents a completely unified field across its five panels, more akin to the Maestà paintings of Duccio and Simone Martini, who were also breaking with tradition in Siena (see Figs. 5.9 and 5.24). More importantly the Baroncelli altarpiece depicts an event involving the Virgin-her Coronationrather than simply presenting her as an object of adoration, as in the iconic figures of Ugolino's altarpiece and of virtually every other extant altarpiece of the time, including Giotto's own triptych for Old St. Peter's (see Fig. 2.13). This may explain why the two central protagonists are treated in a full and volumetric manner, with drapery hanging heavily from their limbs and falling in deep folds, while the numerous figures in the side panels are layered in a flattened space which precludes imagining fully dimensional bodies beneath their heads. This stylistic throwback to an earlier

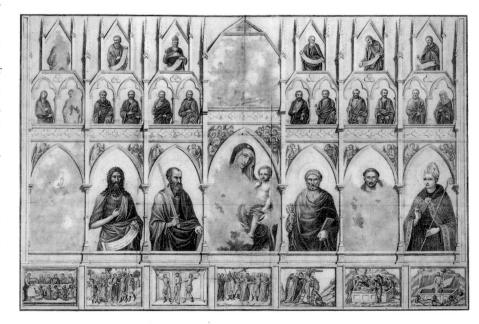

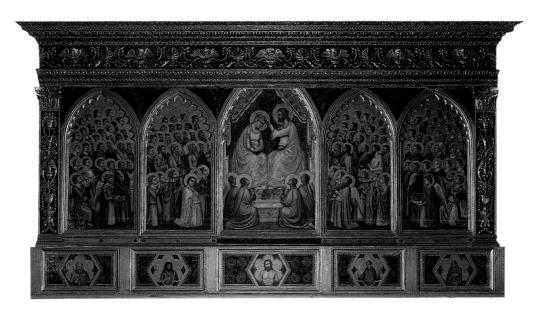

4.22 Coronation of the Virgin, c. 1332–38, commissioned by the Baroncelli family from the workshop of **Giotto** as the altarpiece for the Baroncelli Chapel, Santa Croce, Florence. Tempera on panel, 6' ½" × 10' 7½" (1.85 × 3.23 m)

The frame of the painting was substantially altered in the fifteenth century when its original elaborate Gothic framework was transformed into a classicizing rectangular format that was more suited to the tastes of that time. The figures of angels in the spaces between the arched panels that had once been covered by the Gothic frame were added at that time.

period is not entirely explained by the painting's attribution to Giotto's workshop, rather than to the master himself. Its use of traditional formulas for the depiction of the figures in the side panels seems, rather, a deliberate attempt to emphasize the miraculous aspects of the event depicted and the devotional purpose of the altarpiece, in contrast to the narrative naturalism of the central figures or of the frescoes on the walls of the chapel. Here, as in Ugolino's altarpiece (see Fig. 4.21), the style responds to the function of the painting rather than following an unbroken development toward naturalism.

The contrasts in the styles of the Ugolino and the Baroncelli altarpieces illustrate the distinguishing characteristics of Sienese and Florentine painting and the differing but compatible styles in Tuscan painting in the 1320s and 1330s. They also reflect the different intentions of the patrons—in the one case the Franciscan order, clinging to traditional religious images as a solemn backdrop for the celebration of the mass at the high altar, in the other wealthy, private donors celebrating the lives of Christ, the Virgin, and patron saints, keen to be in the vanguard of artistic developments. In the family chapels of Santa Croce, the dominance of the new style points to its eventual triumph.

The Santa Croce Refectory Frescoes

Two other frescoes in the monastery of Santa Croce underscore the range of styles available to Florentine artists and patrons. For the end wall of their refectory the Franciscans commissioned Taddeo Gaddi, probably in the 1330s, to paint a *Last Supper*, an appropriate subject for the friars' dining hall. Above the *Last Supper* Gaddi painted a *Tree of Life* (the *Lignum vitae*; Fig. 4.23), a devotional subject derived from the writings of the Franciscan St. Bonaventure. To reinforce both its Franciscan and refectory context, the mystical tree is surrounded by a depiction of St. Francis's stigmatiza-

tion at the upper left and three holy events that take place at meals, including the penitential image of Mary Magdalene washing the feet of Christ with her tears at the lower right.

The *Last Supper* below is remarkable for its startling illusion of high relief. The painter has thrust the figures into space in front of the wall, rather than creating a spatial platform or cavity behind it in the usual way. Thus the figures, larger than any others on the wall above them, project into the space of the friars who would have been taking their meals in this room, bridging the gap between image and reality.

Immediately above, the Tree of Life includes at its lower level volumetric groups of figures creating both actual and contemplated reactions to the event of the Crucifixion being depicted. Conspicuous among them is a kneeling female donor, dressed in the robes of a Franciscan tertiary (the lay order of Franciscans); she is slightly smaller in scale than the saintly, haloed figures at the foot of the cross. Given the presence of Manfredi coats of arms on the fresco, this woman has been identified as Mona Vaggia Manfredi, who died in 1345 and was buried in Santa Croce. Her presence in this important fresco exemplifies the critical role women played throughout this period as donors, either in their own right as secular patrons or nuns, or as executors for their husbands' estates. Despite contemporary Florentine regulations stipulating that women could act in financial matters only through an appointed male agent, many cases of women commissioning large-scale works of art have recently come to light.

Surrounding the crucifix in the *Tree of Life* are banderoles (unfurled scrolls) and stylized branches that carry texts and weave around medallions bearing images of prophets and yet further inscriptions calling on the viewer to contemplate and identify with the mystery of Christ's sacrifice. Any illusion of space is counteracted by the repetitive curves of the branches, which create a flat surface against the wall itself,

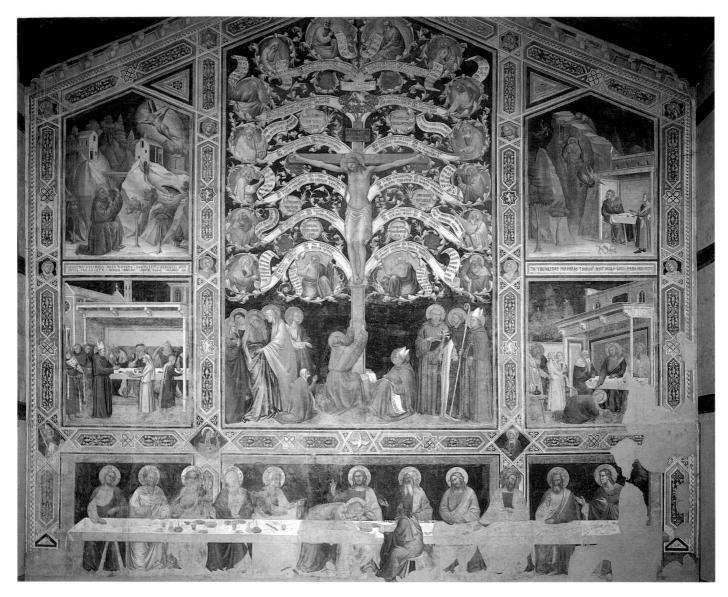

4.23 Last Supper, Tree of Life, and Four Miracle Scenes, c. 1330–40, commissioned by Mona Vaggia Manfredi (?) from **Taddeo Gaddi** for the Refectory, Santa Croce, Florence. Fresco, 36′ 9″ × 38′ 3″ (11.2 × 11.7 m) (Museo dell'Opera di Santa Croce, Florence)

almost as if the wall had become a flat page of text only incidentally illuminated by the portraits in the medallions. These figures have something of the stylized anonymity of those in Ugolino's altarpiece, despite their more naturalistic three-quarter poses. The painting is didactic and non-narrative in its straightforward presentation of Bonaventure's text and relies as much on word as on image to convey its message. Taken together, the Last Supper and the Tree of Life present a virtual compendium of the pictorial possibilities available to painters in the first half of the fourteenth century. They also caution against seeing an unbroken development toward a naturalistic style either within the Giotto workshop or in the world of ecclesiastical patronage. Whatever stylistic predilections painters might have had, they had to respond to the conventions of the subject matter and the religious purpose in order to insure that their paintings would be legible to a visually literate community.

The Cathedral Complex

While the Florentine government and wealthy citizens were subsidizing the construction and decoration of enormous mendicant churches, they also decided to build what would become one of the largest cathedrals in Christendom. The cathedral of Florence (Figs. 4.24, 4.25, and 4.26), called the Duomo (as an Italian cathedral is often called; the term derives from the Latin *domus*, "house," implying both the house of God and the residency of the local bishop), was conceived as a civic monument as well as a religious one, being built and financed by the Florentine Republic. Although plans to build a new cathedral were discussed as early as 1285 and the building committee (Opera del Duomo) was operating by 1294, the construction of the building did not begin until 1296. The new building was to surround and replace the small medieval church of Santa Reparata, which

4.24 Aerial View of the Cathedral complex, Florence. Baptistry, c. 1059–1150; Campanile, 1334–c. 1360; Cathedral, begun 1296.

itself had supplanted an Early Christian structure built next to the walls of the ancient Roman city. City officials planned the new building to be large enough to hold the entire Florentine population, which in the early 1300s may have numbered as many as 90,000. Funds were raised through the imposition of a special tax on all personal property. In the project's early years, the twelve major guilds exerted managerial control over it, but in 1331 the Woolworkers' Guild (the *Arte della Lana*) was given charge of the building; from that time forward this guild had responsibility for building, decorating, and maintaining the structure, essentially managing the public funds that paid for the work, an arrangement that guaranteed lay control over it. The archbishop of Florence officiated at services in the Duomo, but he had only partial control over much of its form.

The building history of the Duomo is complicated and controversial. Arnolfo di Cambio was apparently the original architect of the new building, since he appears as *capomaestro* (chief master of the shop) of the project in a document of 1300. The first plan of the Duomo, as it can be reconstructed from the first two bays of the existing building, apparently called for a wooden **truss** roof structure comparable to that used in the Florentine church of Santa Croce (see Fig. 4.8) and in the Early Christian basilicas of Rome where Arnolfo had previously worked. Arnolfo's project was most likely continued after his death under the jurisdiction of a committee drawn from the twelve major guilds.

In 1334 the Arte della Lana appointed Giotto *capomaestro* of the structure. The document of appointment also names Giotto as architect for the city walls, for fortifications, and for whatever other civic structures might be ordered by the governors of Florence, indicating the general esteem in which

Giotto was held since he had no (known) experience as an architect. Giotto initiated work on the Duomo's free-standing bell tower, the Campanile (see Fig. 4.24). This enlargement of the original project suggests competition with neighboring Pisa whose campanile—now familiarly known as the Leaning Tower of Pisa—was begun in 1173. Work was suspended on the Pisa tower when its sandy subsoil caused it to begin tilting and was not resumed until 1275. The completion of both towers at roughly the same time, in the 1350s, further suggests an element of civic rivalry.

Unfortunately we cannot define precisely what Giotto and his successor, Andrea Pisano, may have planned for the

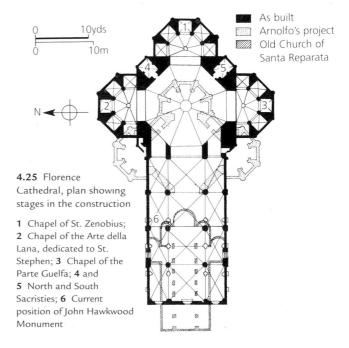

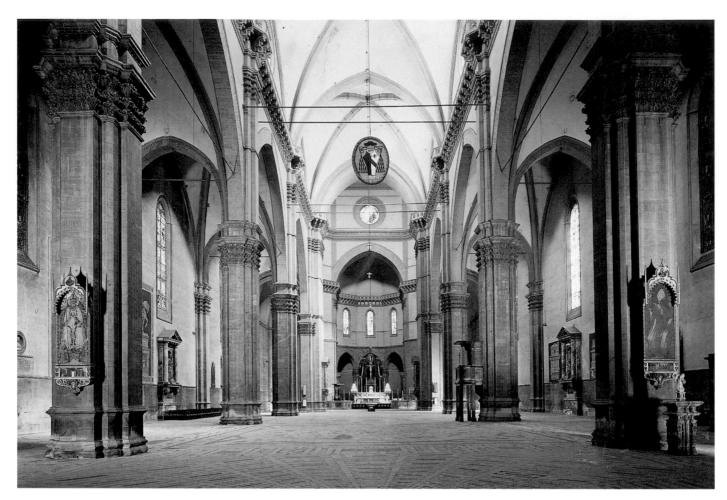

4.26 Florence Cathedral, begun 1296.

The first architect was Arnolfo da Cambio; a revised plan of 1357 was built under Francesco Talenti

cathedral building itself, since the present building follows plans of 1357 and 1365, drawn up after their involvement in the project. It is unlikely that by mid-century much more than the first two bays of the building had been completed. The change at that time from a traditional Tuscan timber beamed roof to the existing Gothic stone vaults suggests a new internationalism. The size and scale of the building and its projected dome would have given the Duomo a prominence equal to or surpassing all but Old St. Peter's in Rome. At the same time the polygonal **tribunes** that radiate from the central area of the building beneath the dome are unmistakable references to the neighboring octagonal Baptistry (see Fig. 4.3), placing the Duomo firmly within Florence's architectural traditions.

Andrea Pisano's Baptistry Doors

The date of 1330 inscribed on the magnificent bronze doors of the south entrance of the Baptistry (Fig. 4.27) marks the commission given by the Arte del Calimala to Andrea Pisano (c.1295 Pontedera–1348 Orvieto?); the work for this enormous project actually continued until 1336 when the doors were finally put in place. The magnitude of

this project was clearly meant to assert the power of the Calimala in the Duomo precincts, just at the time when the guild had lost control of the cathedral itself to the Arte della Lana.

Andrea's doors contain twenty-eight quatrefoil panels, twenty of which narrate the life of St. John the Baptist, the patron saint of the building and also of the city of Florence. The bottom eight panels depict seated personifications of virtues. At the interstices of the panels are decorative lions' heads, recalling the marzocco, or shield-bearing lion, which was one of the emblems of the city. Within each of the quatrefoils Andrea created a carefully structured composition of nearly free-standing figures moving across a narrow platform, like a stage. Each relief is enhanced by gilding, which is applied not only to the figures but also to the architecture and landscape features to distinguish them from the bronze background. The figures are indebted to Giotto's treatment of form in the determined articulation of their bodies beneath the drapery and in the psychological intensity of their participation in the event depicted.

4.27 (opposite) South doors, 1330–36, commissioned by the Arte del Calimala from **Andrea Pisano** for the Baptistry, Florence. Gilt bronze

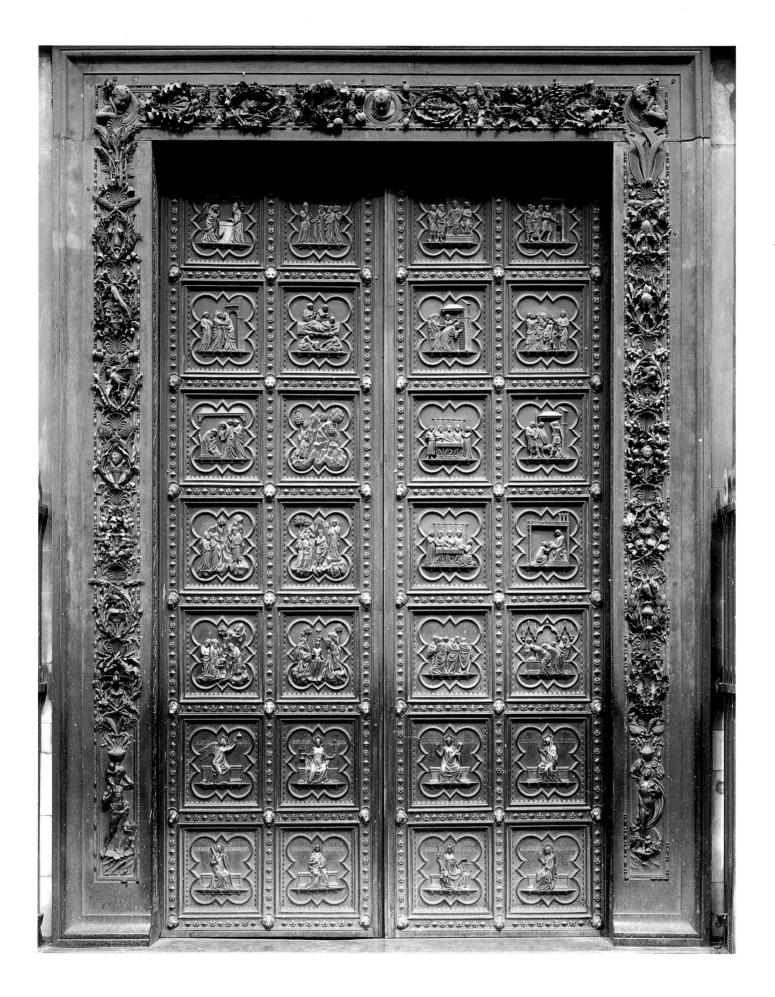

In the *Naming of the Baptist* (Fig. 4.28) Elizabeth tenderly holds the swaddled infant Baptist near her cheek, displaying him to his father Zachariah, who intently scribbles the boy's name, communicated to him by an angel, on a tablet which he perches on his wobbly knees. As in Giotto's *Meeting at the Golden Gate* in Padua (see Fig. 3.8) two women behind Elizabeth snicker at Zachariah's muteness, a divine punishment for his having doubted his wife's pregnancy. In writing out John, the Baptist's God-given name, Zachariah regained his speech. All this is told in the simplest of Giotto-like stage sets: a shallow platform for the actors, a chair and platform for Zachariah, and a tidy polygonal roof, neatly snuggled up into the relief's frame on brackets.

Besides learning from Giotto, Andrea was also clearly influenced by Gothic art from north of the Alps. The quatrefoil shape of the panels is itself reminiscent of reliefs on cathedral façades such as those of Amiens, Rouen, and Auxerre. The decorative border patterns of the drapery in Andrea's panels are also similar to northern Gothic forms, as is the lyrical simplicity of the figures. Like many other artists, Andrea may have traveled to France or Germany, where he could have seen this sculpture for himself. He could also have had access to a northern style through imported portable objects such as reliquaries; having trained as a goldsmith (he is called *orefice* in the documents),

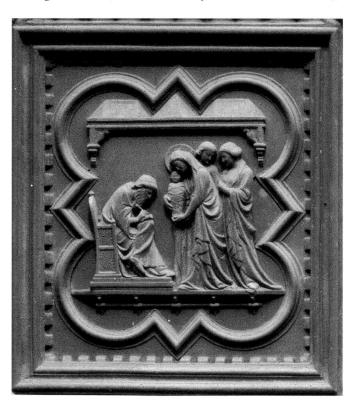

4.28 Naming of the Baptist, 1330–36, commissioned by the Arte del Calimala from **Andrea Pisano** for the doors of the Baptistry, Florence. Gilt bronze, $17\frac{1}{2} \times 15^{\prime\prime}$ (45×38 cm)

Andrea would have looked at such work very carefully. Or he might have assimilated such stylistic elements from contemporary Italian artists—including Giotto—who had already made them integral to their own work. By the time Andrea acted as an independent sculptor at the South Doors, he was clearly a mature artist who had completely integrated both classical and contemporary elements into his personal style. He was thus able to provide the Calimala with a sculptural work not only of amazing technical virtuosity but of great artistic sophistication, rivaling medieval examples such as the bronze doors for the cathedral of Pisa.

Andrea succeeded Giotto as director of construction for the Campanile of the cathedral and provided a series of reliefs to decorate its exterior at approximately the same time. The program was encyclopedic, including the seven Sacraments, seven virtues, seven planets, seven Liberal Arts, and seven Mechanical Arts, including in the latter Weaving (Fig. 4.29), referring to the guild responsible for working with the Opera del Duomo and to a craft that had contributed so much to Florence's prominence.

4.29 *Weaving*, from a series of the Mechanical Arts, c. 1337, commissioned by the Opera del Duomo from **Andrea Pisano** for the exterior of the Campanile, Florence. Marble, $33 \times 27''$ (83×69 cm) (Museo del Opera del Duomo, Florence)

5 Siena: City of the Virgin

at night, a part of the myth recalled by Siena's heraldic crest, the *balzana*, divided horizontally with a white field above and a black one below. The myth is recalled repeatedly on the façade of Siena's town hall with sculpted images of Romulus and Remus being suckled by the She-wolf and with the *balzana* appearing under each arch (see Fig. 5.23).

But Siena's civic traditions were also deeply Christian. In 1260, just before a decisive military victory at Montaperti over their arch rivals, the Florentines, the Sienese dedicated themselves and their city to the Virgin Mary. Thereafter the citizens saw the Virgin as their protectress against natural disaster and human aggression. Thus she appears accompanied by angels on the cover of the city's official 1467 account books (see the illustration on this page), extending her grace over the city "in time of earthquakes" ("al tenpo de termuoti" in old Italian). A particularly severe set of tremors hit the hill top city and its surrounding countryside during 1466 and 1467, motivating many citizens to set up camp in the city's piazzas and outside the city wallssuggested by the tents and temporary wooden structures depicted in the foreground. Golden rays pour down from heaven on its pink brick walls and towers, marking the city as both protected and blessed. At the center, located behind and to either side of an impressive city gate, rise Siena's two most significant communal monuments: the splendidly striped cathedral complex and the battlemented tower of the Palazzo Pubblico, Siena's city hall. As in Florence, the two are located only

Siena's foundation myth is mythological, claiming that the city had been founded by Senius and Aschius, the sons of Remus, one of the twin founders of Rome. Thus Siena claims a history virtually as old as Rome's. Fleeing their uncle, Romulus, after having stolen the shrine of the She-wolf in Rome, Senius (from whom the city took its name) and Aschius were protected on their journey northwards by a white cloud during the day and a black cloud

(above) Biccherna Cover, The Virgin Protects Siena in the Time of Earthquakes, 1468, commissioned by the officials of the Biccherna (financial administration) probably from **Francesco di Giorgio Martini**. Tempera on panel, $21\% \times 16\%$ " (54×41 cm)

The Roman numerals on this panel provide the date January 1, 1466, but given that the new year did not begin in Siena until March 21, this would correspond to the modern year 1467. The cover was probably commissioned the following year, 1468, when the accounts were completed and bound.

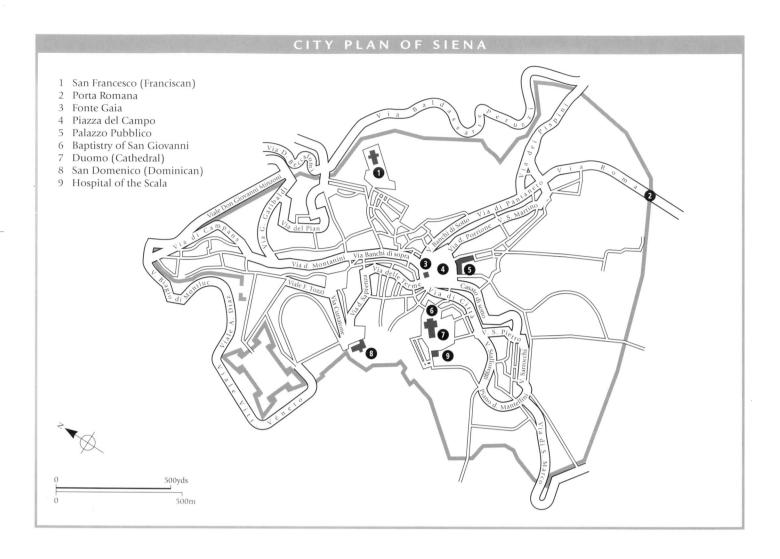

a short distance from one another, and a processional road winds up the hill between them. Their dual primacy in civic consciousness is emphasized by their nearly equivalent height on the horizon—no small structural feat for the communal tower given the fact that the Palazzo Pubblico is located in a low part of the city and the cathedral at its highest.

In the thirteenth century Siena was a republic dominated by merchants and bankers. The coats of arms and names of the city's leaders appear on our account book panel, which is framed so that it could be put on public display to celebrate the city's financial well-being and exemplary fiscal government. While Siena did not enjoy a location on the sea or a navigable river, her economy flourished because a major highway (the old Roman Via Francigena) passed directly through the city on the way to Rome from France (see map on this page). Thus, pilgrims traveling to Rome from the north and commercial trade routes passed through the city. Substantial deposits of high quality silver in the surrounding hills also encouraged commerce and banking, empowering the Sienese to become the papacy's principal bankers from the early thirteenth century through much of the fourteenth century.

The Cathedral

When the Sienese dedicated their cathedral (Figs. 5.1 and 5.2) to the Virgin of the Assumption they were expressing both religious and civic aspirations. The *operai* (building supervisors) were mostly laymen chosen by the city government, to keep accounts and supervise work. Citizens were also expected to contribute time and money to the cathedral's construction, including a twice-yearly commitment to provide carts and beasts of burden for transporting building materials to the site.

Siena Cathedral was structurally complete by the 1260s. Unlike earlier central Italian cathedrals, which generally had plain columnar supports and a wooden truss support for the roof, Siena's Duomo boasts compound piers supporting round diaphragm arches and a vaulted ceiling. These elements may reflect the example of a number of monastic complexes built by northern European monks around Siena or perhaps have sources as far away as Germany or southwest France, where similar construction was popular. Siena's traders and bankers conducted business across Europe, and the cathedral suggests their awareness of contemporary architectural developments in France and Germany.

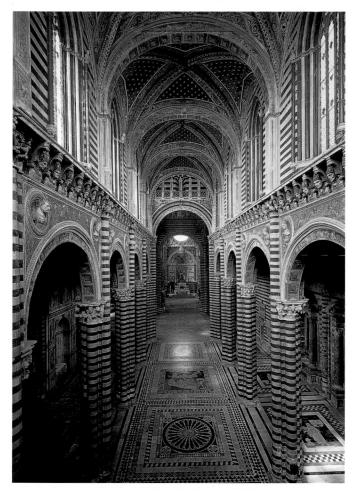

5.1 Siena Cathedral, complete by the 1260s, vaults raised and apse expanded c. 1355-86, commissioned by the Operai of Siena Cathedral

5.2 Siena Cathedral, plan.

1 Chapel of San Savino, Pietro Lorenzetti, *Birth of the Virgin*; 2 Chapel of Sant'Ansano, Simone Martini, *Annunciation*; 3 Main altar, Duccio, *Maestà*; 4 Chapel of San Vittorio, Bartolomeo Bulgarini, *Nativity*; 5 Chapel of San Crescenzio, Ambrogio Lorenzetti, *Purification of the Virgin*; 6 Baptistry on level below; 7 Projected nave of enlarged church, planned 1321–22, foundation laid 1339, work halted 1348

The Pulpit

In 1265 the Sienese hired Nicola Pisano (c. 1220–1284) to design and carve a new marble pulpit for their cathedral (Fig. 5.3). Nicola seems to have begun his career in the southern Italian workshops established by the Holy Roman Emperor Frederick II (1194–1250). The classically oriented ideals Nicola learned in the imperial court served him well in his first documented commission, a marble pulpit completed and signed in 1259/60 for the Pisa Baptistry (Fig. 5.4). Pisano's reputation as a highly talented sculptor and head of an efficient workshop must have brought him to the attention of the Sienese Opera.

As in Pisa, the Siena pulpit consists of a polygonal platform raised on columns and faced with marble reliefs depicting key moments in the life of Christ, culminating in scenes of the Crucifixion and the Last Judgment beneath the lectern. In Siena, however, Nicola substantially elaborated the original scheme. The Siena pulpit is octagonal, whereas Pisa's is hexagonal, allowing a corresponding increase in the number of reliefs from five to seven; each panel includes more figures and episodes, and the figures are freed more completely from their stony matrix. In both pulpits he demonstrated a knowledge of Gothic

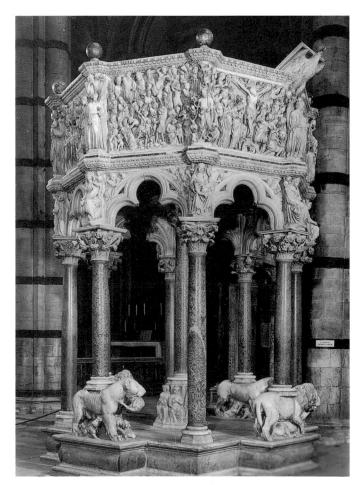

5.3 Pulpit, 1265, commissioned by the Operai of Siena Cathedral from **Nicola Pisano** for Siena Cathedral. Marble

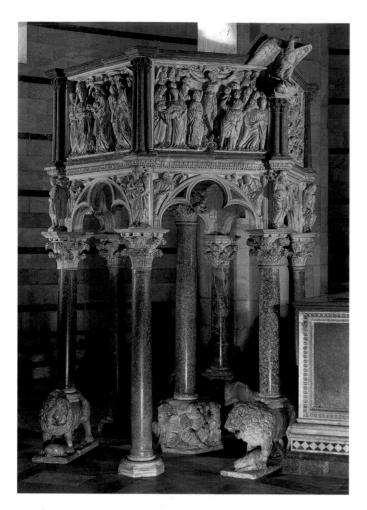

5.4 Pulpit, 1259/60, commissioned by Bishop Federico Visconti from **Nicola Pisano** for the Baptistry, Pisa. Marble, height c. 15′ (4.6 m)

architectural forms such as the trilobed cusping on the arches under the relief panels and in the attached triple columns placed between each relief at Pisa, but the Siena pulpit is more thoroughly Gothic in details. Unlike the Pisa pulpit, with its rigid separation of relief panels and columnar frames (not unlike the architectural separation of narrative reliefs on Roman triumphal arches), the Siena pulpit follows the example of Gothic church portals, transforming the columnar divisions into human figures and unifying the entire surface of the pulpit. Nicola may well have made a trip to northern France, as his son Giovanni is later thought to have done, for images such as the handsome Christ figure (Fig. 5.5) separating the panels of the Massacre of the Innocents and the Crucifixion, along with the writhing crucified Christ, can be traced to earlier examples of this type in the Île de France.

On the other hand, the reliefs on Nicola's earlier pulpit all manifest his deep appreciation of classical Roman sculpture, especially the compact and dense compositions of Roman sarcophagi, many of which he could have studied in Pisa's civic burial ground, the Camposanto (see Figs. 8.1 and 8.2). In the *Annunciation, Nativity*, and *Annunciation to the Shepherds* (Fig. 5.6), Mary reclines majestically like a Roman

goddess. Her curly hair, flat nose, full lips, and broad face all recall ancient prototypes, as does her pose, relaxed and dignified at the same time. Holding her head erect, she pays no specific attention to Joseph or the small female figures, reduced in size according to the conventions of hieratic perspective, who bathe the Christ Child below her. The Child appears again above her lap, tightly swaddled in his crib, where the shepherds (now headless) hear the news of Christ's birth from an angel seemingly wedged between the limbs of two trees. The entire composition is cramped and tight, so much so that the scene at the far left of the angel Gabriel appearing to the Virgin is partially truncated. Still, the scale and crisp drapery folds surrounding the protagonists make the relief highly legible.

In Siena Nicola abandoned graphic clarity in favor of greater emotional veracity. In the *Crucifixion* relief Christ hangs heavily from the cross, which emphasizes his suffering, rather than appearing as he did in Pisa with his arms and hands outstretched and relaxed. While both reliefs emphasize the horror of the event with figures cowering under the cross and the Virgin fainting in empathetic grief (see Fig. 5.5), in Siena they are thinner and more mobile, truly capable of the emotions that Nicola attributes

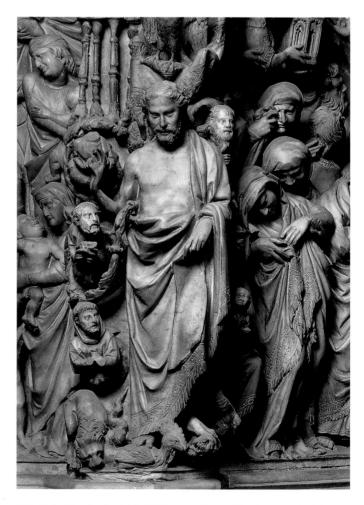

5.5 *Christ* (detail of pulpit), 1265, commissioned by the Operai of Siena Cathedral from **Nicola Pisano** for Siena Cathedral. Marble

5.6 Nativity, detail from the pulpit, 1259/1260, commissioned by Bishop Federico Visconti from **Nicola Pisano** for the Baptistry, Pisa. Marble, 2' 9% × 3' 8% (85×113 cm)

to them. In The Massacre of the Innocents at the left (see Fig. 5.3), a violent story which appears on the Siena pulpit but not at Pisa, soldiers thrust daggers into writhing babies. Mothers tear their hair in grief. Space flows around all the figures, who are thus able to move more freely than the weighty figures of the Pisa reliefs. Still, in its vertical piling up of figures, the Siena reliefs suggest that Nicola continued to be impressed with what he had seen on late Roman battle sarcophagi, where figures are similarly disposed, even while so many other aspects of the

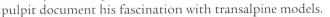

Since Vasari, historians of the Renaissance have tended to respond more positively to the Roman classicizing style of Nicola's Pisa pulpit than to his work in Siena, because the Renaissance was construed as a revival of the early Roman antique. However, the classical traditions embodied in the Pisa reliefs constituted but one strand to which Renaissance artists and patrons turned for inspiration. The Gothic naturalism, movement, and expressivity of the Siena reliefs document other possibilities.

The Façade

Around 1284 Sienese officials placed Nicola's son, Giovanni (1245/50 Pisa-1319 Siena), who had collaborated with his father on carving in Siena and played an active role in other major commissions in Bologna, Perugia, and Pisa, in charge of providing a façade for Siena's Duomo (Fig. 5.7). With its triple portals and dramatically rising gables Giovanni's façade demonstrates a familiarity with northern Gothic models. But the relatively modest width of the cathedral's nave and aisles left little room for the sculptural decoration around the portals that was a standard feature of the Gothic tradition. Instead Giovanni conceived an ensemble of figures on narrow platforms just above the portals and extending around the turreted sides of the façade. Many of Giovanni's sibyls, prophets, and other Old Testament figures seem to be engaged in conversation with one another and with the world below. Giovanni knew that the figures would be seen from a good distance below, so he dramatically exaggerated their poses and carving, and positioned

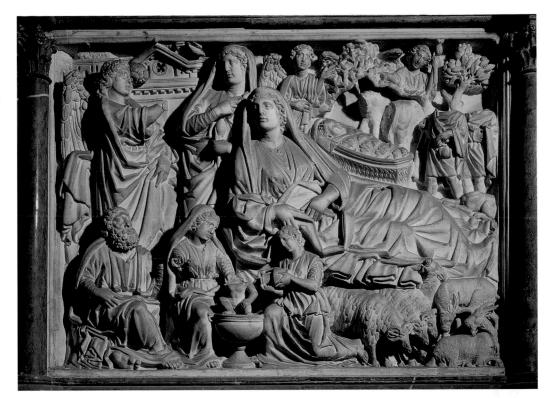

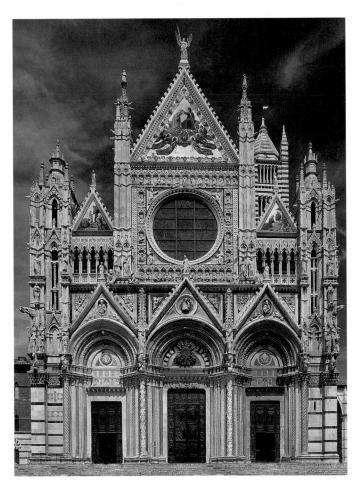

5.7 Siena Cathedral, 1284–99, lower half of façade, including statues, commissioned by the Operai of Siena Cathedral from **Giovanni Pisano** (originals now in Museo dell'Opera del Duomo, Siena)

5.8 Isaiah, c. 1284, commissioned by the Operai of Siena Cathedral from Giovanni Pisano for the façade of Siena Cathedral. Marble, height of entire figure 6' 2%" (1.89 m) (Museo dell'Opera del Duomo, Siena)

them to lean forward into space. In the figure of Isaiah, for example (Fig. 5.8), Giovanni peppered the prophet's beard with numerous drill holes which enhance the dramatic play of light and shadow across and around the face. In spite of the statue's weathered surface, its expressive facial features still evoke a prophet's impassioned exhortations.

Duccio's Maestà

On October 9, 1308, the head of the cathedral works signed a contract with Duccio for a large altarpiece for the cathedral's main altar, then under the dome. The main panel of the altarpiece, which depicts the Virgin in Majesty, is now known simply as the *Maestà* (Fig. 5.9). It expresses visually the dedication of the city to the Virgin made formal at the time of the Battle of Montaperti against the Florentines in 1260. Duccio's altarpiece followed six years after his commission for another altarpiece of the same subject for the chapel of the ruling council of Siena (the *Nove* or Nine) in the Palazzo Pubblico (city hall). Thus both cathedral and city hall repeat the same imagery, attesting to the continuous interpenetration of sacred and secular art in Italian city states of this time.

Because the *Maestà* occupied a free-standing position under the dome, it was painted on both sides. Its bright colors, set against luminous gold backgrounds in the iconic tradition, and its original elaborate gilded frame with finials punctuating the space between the uppermost panels, must have shone brilliantly against the somber black and white marble interior of the cathedral, bathed

CONTEMPORARY VOICE

The Procession of the Maestà

The completion of Duccio's *Maestà* in 1311 and its installation in the Duomo occasioned a city-wide celebration. The panel was removed from Duccio's workshop on the outskirts of the city and carried in procession to its designated position above the cathedral's high altar. This contemporary account reflects not only the splendor of the occasion but also the inseparable connections between civic and religious life in European cities during the Middle Ages and Renaissance.

At this time the altarpiece for the high altar was finished, and the picture which was called the "Madonna with the large eyes," or Our Lady of Grace, that now hangs over

the altar of St. Boniface, was taken down. Now this Our Lady was she who had hearkened to the people of Siena when the Florentines were routed at Monte Aperto [the battle of Montaperti, 1260], and her place was changed because the new one was made, which is far more beautiful and devout and larger, and is painted on the back with the stories of the Old and New Testaments. And on the day that it was carried to the Duomo the shops were shut, and the bishop conducted a great and devout company of priests and friars in solemn procession, accompanied by the nine signori, and all the officers of the commune, and all the people, and one after another the worthiest with lighted candles in their

hands took places near the picture, and behind came the women and children with great devotion. And they accompanied the said picture up to the Duomo, making the procession around the Campo, as is the custom, all the bells ringing joyously, out of reverence for so noble a picture as is this. And this picture Duccio di Niccolò the painter made and it was made in the house of the Muciatti outside the [city] gate And all that day they stood in prayer with great almsgiving for poor persons, praying God and His Mother, who is our advocate, to defend us by their infinite mercy from every adversity and all evil, and keep us from the hands of traitors and of the enemies of Siena.

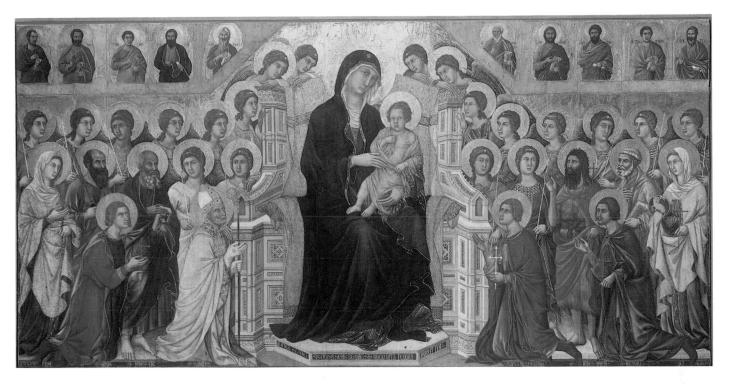

5.9 Maestà (front side), 1308–11, commissioned by the Opera del Duomo from **Duccio** for the high altar of Siena Cathedral. Tempera and gold leaf on panel, $7 \times 13'$ (2.13 \times 3.96 m) (Museo dell'Opera del Duomo, Siena)

in the light streaming down from the windows of the dome (later, sadly, filled in). Additional, colored light from the huge round stained glass window depicting the *Death, Assumption, and Coronation of the Virgin*, also by

Duccio, in the east wall of the building, would have given it an almost magical radiance. Thus painting and window functioned together to glorify Siena's patron, the Queen of Heaven.

5.10 *Maestà* (reverse side), 1308–11, commissioned by the Opera del Duomo from **Duccio** for the high altar of Siena Cathedral. Tempera and gold leaf on panel, $7 \times 13'$ (2.13 \times 3.96 m) (Museo dell'Opera del Duomo, Siena)

The altarpiece was removed from the cathedral in 1771, when it was sawn into several smaller pieces. The heraldic crest of the Opera of the cathedral probably appeared on the original frame.

5.11 Maestà, detail of reverse side showing the Washing of the Feet and Last Supper, 1308–11, $40 \times 21''$ (102×53 cm)

The front of the *Maestà* shows the enthroned Virgin and Child, flanked by saints and angels. The main panel was surmounted by truncated figures of Apostles and, at the next level up, by separate panels showing scenes from the life of the Virgin. Small panels depicting angels may originally have crowned each of these scenes. Among the figures flanking the Virgin in the main panel are other saints: Ansanus, Savinus, Crescentius, and Victor who kneel in the front row. Though relatively obscure members of the saintly hierarchy, these are patron saints of Siena, and their prominence indicates that this was as much a civic as an ecclesiastical commission. This fact is spelled out in the inscription on the Virgin's footstool: "Holy Mother of God, be the cause of peace to Siena, [and] of life to Duccio because he has painted thee thus."

The prominence of Duccio's name on the face of the altarpiece is a measure of his status as one of Siena's most

5.12 *Maestà*, detail of reverse side showing the *Entry into Jerusalem*, 1308-11, $40\times22''$ (102×56 cm)

renowned citizens, and serves as a reminder that artists had long marked both their pride in their work and their piety by placing their names in conspicuous positions on their work. Documents of the period record high fees paid to leading artists and even indicate that some on occasion served as political emissaries for their city-states.

With the Maestà Siena at last had a work by Duccio that could compare with the Rucellai Madonna (see Fig. 4.13), which he had made for the Compagnia dei Laudesi in Florence more than twenty years earlier. Predating Giotto's Ognissanti Madonna and Child by several years (see Fig. 4.14), the Madonna in Duccio's Maestà now sits on a substantial and believable marble throne holding a hefty Christ Child who is more softly and realistically rendered than any Florentine or Sienese baby of the period. In the Maestà, the faces are both fuller and softer, and the throne is more satisfyingly three-dimensional than in his earlier Rucellai

Madonna. Duccio also made a conscientious effort to suggest the rounded volumes of the figures and their spatial relationships through their overlapping forms.

The development of Duccio's style seen by comparing the *Ruccellai Madonna* and the *Maestà* may owe something to a trip to Paris he may have made in the intervening years. There are documentary references to a "Duch de Siene" (Duccio of Siena) in Paris in 1297 which coincide with his absence from any documentary reference in Siena between 1295 and 1302. Thus it appears that Duccio traveled north to see for himself the fully developed Gothic style of the French court.

Duccio's accomplishments were so noteworthy that artists were asked to update earlier paintings. One of these, commissioned from Guido da Siena (active 1262/67-1280s Siena), stood on the high altar of San Domenico in Siena (see Fig. 2). It had been commissioned soon after the Battle of Montaperti, when Siena dedicated itself to the Virgin, and the figures and throne bear the generally flattened and stylized characteristics of the Byzantinizing style that had been common in Siena for some time. Originally the faces of the Madonna and Child would have been more linear, too, but they were repainted in the fourteenth century to make them softer and more up-to-date. That the rest of the painting remained unchanged should remind us that styles did not simply replace one another, but were deployed intelligently and strategically. In the case of Guido's painting, the artist may have consciously archaicized the image from the start, that is, he seems to have designed it to look older than it was. The panel carries the date 1221, which does not refer to the date of its creation (c. 1260) but rather to the death of St. Dominic, the founder of the order that commissioned the work. The conservative style of the work more closely matched the style of Dominic's day, making the altarpiece appear more venerable and potentially more efficacious than it otherwise might have been. Stylistic conservatism sometimes had as much, if not more, power than innovation.

The reverse side of the *Maestà* (Fig. 5.10) is composed of separate panels depicting events in the life of Christ. Various students assisted Duccio on these panels (as well as on those for the front of the altarpiece) in a collaboration that helped to perpetuate the distinctive Sienese school of painting into the next generation. However, it must have been Duccio himself who devised the compositional scheme, ensured consistency in the individual panels, and gave a clear visual form to the stories depicted.

A comparison of Duccio's narratives with the work of other artists reveals some interesting similarities. On the reverse of the *Maestà*, the central icon of Christianity, the *Crucifixion*, is placed on the central axis and is given twice the space of the other panels, as it was in the fresco cycle in Old St. Peter's in Rome. Although schematized, the architecture of the individual panels provides a uniform geometrical frame and spatial envelope for the actions depicted and is consistent with the most current developments of depictions of space. Even the space that Duccio leaves at the

top of panels such as the Last Supper (Fig. 5.11) compares with similar treatment in the Isaac panels in Assisi (see Fig. 3.3) or Giotto's painted architecture in the Scrovegni Chapel. Although landscape features tend to be simple schematic rock forms, they give a consistent sense of spatial depth from panel to panel, bringing additional unity to the various events of the narrative. Most compelling, of course, is the dramatic response to events with which Duccio invests the scenes. In the Entry into Jerusalem (Fig. 5.12), for example, each of the participants is intensely focused on his response to the event. There is a clear axis of movement from left to right and a naturalistic, even anecdotal, rendering of the figures and their activities. The figures of the two young men in the trees suggest either that Duccio knew Giotto's rendering of this same subject in Padua or that both artists used a similar model.

Altarpieces in the Transept Chapels

In the late 1320s the officials of the Siena cathedral workshop devised a plan to complete the central space of the cathedral. Four altars, situated symmetrically in the transept and flanking the main altar under the dome, were to be dedicated to the four patron saints of Siena (see Fig. 5.2) who are shown kneeling in the foreground of Duccio's Maestà. The altarpieces for the four altars were to depict important events in the life of the Virgin, whose image as eternal heavenly queen graced the main altar. These are the first altarpieces of this period to utilize such a narrative structure rather than a standard icon such as a Virgin and Child or a standing saint. The program for the four altars repeats the iconography of a now lost series of frescoes once on the exterior wall of the main hospital in Siena, the Ospedale della Scala, facing the façade of the cathedral. This repetition, like the Maestà paintings for the cathedral and city hall, continually reasserted the city's dedication to the Virgin and ensured its protection.

In 1333 Simone Martini (c. 1284 Siena-1344 Avignon), one of Duccio's prize students and assistants on the *Maestà*, completed an altarpiece depicting the *Annunciation* (Fig. 5.13) for one of the cathedral altars, that of St. Ansanus. Despite its abraded surface, the painting is still astonishing for its opulence. The gold of the haloes is richly tooled, so that light refracts from the **punch work** and seems literally to radiate. Gabriel's robe is intricately worked with gold, and his flowing cloak is richly patterned in plaid.

The *Annunciation* shows an initially puzzling retreat from the naturalism of a *Maestà* Simone painted for the Palazzo Pubblico some eighteen years earlier (see Fig. 5.24), which had faithfully developed Duccio's composition. The weighty quality of both figures and drapery in that fresco contrasts sharply with the nervous and febrile linear qualities of the figures in the *Annunciation*, particularly the near-impossible twisting of the body of the Virgin herself, although the faces in both the fresco and the panel painting share the same hard, ovoid structure.

5.13 Annunciation, c. 1329/31–33, commissioned, presumably by the Opera del Duomo, from **Simone Martini** for the altar of St. Ansanus, Siena Cathedral. Tempera and gold leaf on panel, 10′ × 8′ 9″ (3 × 2.67 m) (Galleria degli Uffizi, Florence)

The flanking figures of St.

Ansanus and St. Margaret (?)
may have been painted by Lippo
Memmi, Simone's brother-in-law
and assistant. They were already
cut from the central panel by the
eighteenth century. The present
frame is modern.

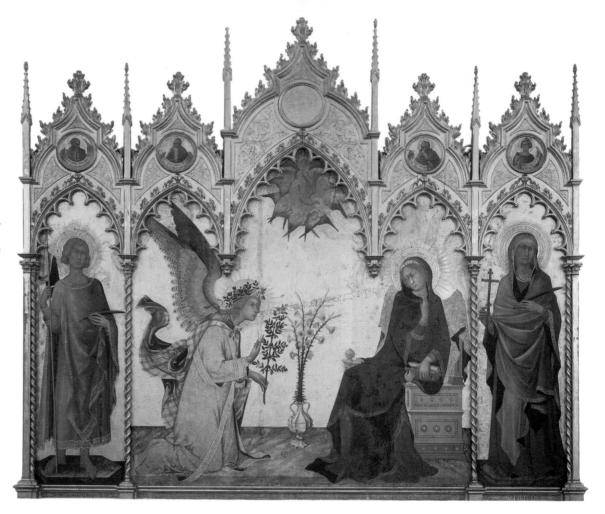

The explanation for this apparent stylistic shift may lie in the purpose that the altarpiece served. Because the *Annunciation* was intended to function as a narrative extension to Duccio's *Maestà* on the high altar, Simone echoed the style of the earlier painting in order to provide a unified decorative program for the cathedral. Thus, like Duccio's *Maestà*, Simone's *Annunciation* uses a gold background and elongated figures, the edges of whose drapery create a sinuous surface pattern quite independent of the bodies beneath.

The mutability of style during this period can be seen again in Simone's frescoes for the Montefiore Chapel in the lower church at Assisi, painted for the Franciscan cardinal Gentile Partino da Montefiore (d. 1312) before he received the commission for the Siena *Annunciation*. The cycle depicts events in the life of St. Martin of Tours. When compared to both earlier and later work by Simone these frescoes demonstrate clearly that he had access to a variety of stylistic possibilities and used them as they were appropriate to the subject matter of his painting. For this narrative sequence he employed a naturalism reminiscent of the work of Giotto. Although the musicians standing at the right of *The Investiture of St. Martin* (Fig. 5.14) are dressed in rich decorative robes befitting princely retainers (St. Martin

5.14 The Investiture of St. Martin, c. 1320-30, commissioned by Gentile Partino da Montefiore from **Simone Martini** for the Lower Church, San Francesco, Assisi. Fresco, width c. 9′ 2¼″ (2.8 m)

5.15 Birth of the Virgin, c. 1335–42, commissioned by the Opera del Duomo from **Pietro Lorenzetti** for the altar of St. Savinus, Siena Cathedral. Tempera on panel, 6' 1½" × 5' 11½" (1.87 × 1.82 m) (Museo dell'Opera del Duomo, Siena)

anteroom off the birthing chamber in front of a luminous pink courtvard that rises with remarkable amplitude in the background. To the right Anna reclines in a doublebayed room surrounded by attendants: one holds a striped fan; others bring food and drink; two others wash the holy child, the woman in green seen from the back clearly derived from figures such as those introduced by Giotto in his Lamentation in Padua (see Fig. 3.11). Piero's only apparent debt to local Sienese traditions is his use of richly decorative details such as the brightly colored vaults, the inlaid floor tiling, and the plaid bedclothes, all demonstrating an empirical, though not quite fully accurate, perspective. The stylistic differences between Simone's and Pietro's altarpieces can be well explained in several ways: differ-

ences of artistic training and personal style; the artists' willingness or unwillingness to transform their individual styles to conform to that of an existing image at the site; and, politically, from the wishes of the Nine to suggest close relations with their erstwhile rival Florence, to which they were allied as members of the Tuscan League by the time Pietro received his commission.

In his Purification of the Virgin (Fig. 5.16) Ambrogio Lorenzetti (active 1317-48, Siena) went even further than his brother in exploring illusionistic space. Ambrogio had worked in Florence where he enrolled in the painter's guild in the 1330s, but appropriate to the commission he set Mary's ritual cleansing and the Christ Child's Presentation in the Temple in a building clearly evocative of the interior of the cathedral in which it stood (see Fig. 5.1). In so doing, Ambrogio conflated time and space, making the Virgin's life a present part of Sienese experience. As Giotto had done in the Peruzzi Chapel in Florence (see Figs. 4.17 and 4.18), Ambrogio shows both the interior and exterior of the building and perches figures and festoons along the roof's edge, miniaturizing them to suggest great height. The two larger statues on the front of the structure, on the other hand, allude directly to Sienese precedents, especially Giovanni Pisano's façade figures (see Figs. 5.7 and 5.8). Inside the structure all eyes are on the infant Jesus, whom the prophet

here being made a knight), they betray their concern for singing the notes correctly by their worried facial expressions and the difficulty of blowing through the pipes by bulbous cheeks. The volumetric density of the figures and the carefully structured architectural frames were most likely painted in the years between the Gothic elegance of Simone's *Maestà* and his *Annunciation*, thus precluding any simple description of his style as moving in a linear fashion toward naturalism.

By 1342, when Pietro Lorenzetti (active 1306-48 Siena) completed his Birth of the Virgin (Fig. 5.15) for the altar of St. Savinus in Siena's cathedral, the stylistic unity for the overall program for the cathedral altars had been breached. Pietro's Florentine training dominates this painting and suggests that the new naturalistic style was beginning to win favor even in Siena. Like Simone's Annunciation, Pietro's Birth of the Virgin was originally flanked by a pair of saints, now lost. But unlike Simone, Pietro has created a unified illusionistic space across the panel, imagining the divisions of the frame as architectural supports that coordinate with the space he paints behind them and endowing his subject with all the anecdotal detail familiar in Florentine painting of this time. At the far left a young boy dressed in blue speaks into the ear of Joachim, telling him that his daughter has been born. Their encounter takes place in an

5.16 *Purification of the Virgin*, 1342, commissioned by the Opera del Duomo from **Ambrogio Lorenzetti** for the altar of St. Crescenzio, Siena Cathedral. Tempera on panel, $8' 5\%'' \times 5' 6\%'' (2.57 \times 1.68 \text{ m})$ (Uffizi Gallery, Florence)

Simeon holds with covered hands, showing the same reverence that priests demonstrated for the host during processions of the Eucharist. This is the live and true body of God incarnate: a child who sticks his fingers in his mouth and kicks his feet in an eye-catching wrap of red cloth shot with blue highlights. While all is calm and sedate among the Virgin, her female companions, and Joseph at the left side of the altarpiece, Christ's energy is palpable on the right, where the prophetess Anna, wrapped in a remarkably vibrant violet robe, points to the child. Her gesture gives meaning to the words on her scroll recognizing the child as the long-awaited savior.

The altarpieces around Duccio's *Maestà* concluded with a later *Nativity* (c. 1361) by Pietro's student Bartolomeo Bulgarini (active 1337–78 Siena), providing the Sienese with a telling display of the richly varied work of their greatest painters and of the greatness of their own city.

Later Sienese Altar Painting

Sienese painting in the second half of the fourteenth century perpetuates the figural styles established earlier in the century by Duccio and Simone Martini despite the work of the Lorenzetti brothers. This conservatism may have been a reaction to the political uncertainty that prevailed after the expulsion of the Nine in 1355. For example, the Adoration of the Magi (1390s?; Fig. 5.17) by Bartolo di Fredi (active 1353-97 Siena) employs the same curiously stylized rock-like structures for mountains, compressed space, arabesque curves of drapery, and elongated figures previously encountered in Duccio's Maestà (see Fig. 5.12). The horses and the Magi pile up in front of the Virgin and Child in a colorful heap, their procession threading fairytale-like in the background, where they encounter Herod in a Jerusalem that once again is styled as Siena itself. Almost as if in conscious opposition to Florentine style, painters such as Niccolò di ser Sozzo (active 1334-63 Siena) and his sometime collaborator Luca di Tommé (active 1356-89 Siena) created altarpieces (Fig. 5.18) that to all intents and purposes are indistinguishable from those of the earlier part of the century. Saints stand in isolation to the sides of the enthroned Madonna and Child as they had in the altarpieces around Duccio's Maestà (see Fig. 5.13). Blond hair, tooled gold, and delicate facial features mark these works as

unmistakably Sienese. Their distinctive style of painting was a civic treasure to be cherished and maintained as a political act of self-definition distinguishing Siena, through its art, from its neighboring— and rival—city-states.

Tomb Sculpture

Sienese sculpture was equally rich, and its practitioners found ready patrons both in and outside the city, especially at the courts of Milan and Naples. Tino di Camaino (c. 1280 Siena-1337 Naples), a leading early fourteenth-century Sienese sculptor who trained in the workshop of Giovanni Pisano, served as *capomaestro* of the cathedral workshop of Siena in 1319–20. His only authenticated work in that city is the marble tomb of Cardinal Riccardo Petroni (d. 1314), begun around 1318. The Petroni Tomb (Fig. 5.19) would

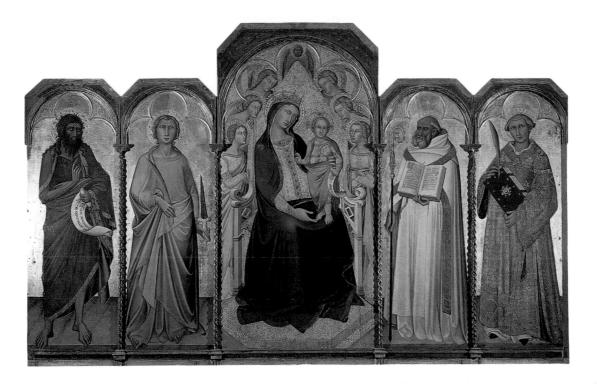

5.17 (below) *Adoration of the Magi*, 1390s (?), **Bartolo di Fredi**. Tempera on panel (Pinacoteca Nazionale, Siena)

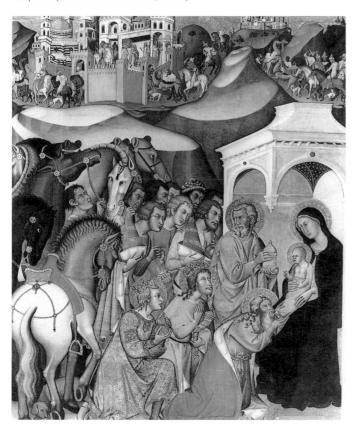

originally have been partly painted, and areas such as the decorative borders of the cardinal's chasuble would have been filled with colored glass paste, giving the monument greater impact. The front face of the Petroni Tomb carries three reliefs of biblical narrative, whose subject matter—the *Noli Me Tangere*, the *Resurrection*, and the *Incredulity of St. Thomas*—all relate to the Resurrection and are thus appropriate for a

5.18 (above) Madonna and Child, 1362, Niccolò di ser Sozzo and Luca di Tommé. Tempera and gold leaf on panel (Pinacoteca Nazionale, Siena)

5.19 Petroni Tomb, 1318, commissioned by Riccardo Petroni's heirs from **Tino da Camaino** for Siena Cathedral. Marble, height 51½" (130 cm)

funerary monument. In their massive and blocky forms the figures of the Petroni Tomb seem more like those of the marble pulpit of the cathedral (see Fig. 5.3) than the elongated and restless figures decorating the cathedral's façade. Appropriately for the tomb of a cardinal, the images on the tomb and their arrangement derive in part from papal and curial tombs, particularly in details such as the angels holding apart the curtains that surround the figure of the dead cardinal. Using a tomb type imitating Roman sources and most often seen in the papal city, the Petroni Tomb suggests the international language of the Church, while its style refers to an earlier decorative program in the cathedral.

Arezzo: The Tarlati Tomb

In contrast to the Petroni monument, no devout imagery adorns the Tarlati Tomb in the Duomo of Arezzo (c. 1329–32; Fig. 5.20) by three Sienese sculptors, Agostino di Giovanni (active 1310–c. 1347), Agnolo di Ventura (active 1312–49), and Agostino's son, Giovanni d'Agostino

5.20 Tarlati Tomb, c. 1329–32, commissioned by Guido Tarlati's brother, Pietro Saccone, from Agostino di Giovanni, Agnolo di Ventura, and Giovanni d'Agostino for Arezzo Cathedral. Marble

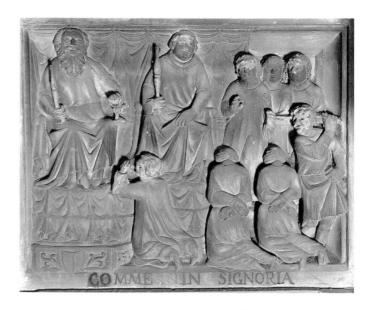

5.21 Tarlati Tomb, detail showing the Comune in Signoria. Marble relief

(c. 1311-c. 1347). A grandiose monument glorifying the reign of the Tarlati family in Arezzo and in particular Bishop Guido Tarlati who is buried in it, the tomb strains the boundaries of propriety for personal commemoration. For one thing, it is enormous, filling one entire bay wall of the cathedral. The monument bears sixteen narrative reliefs representing important events in the history of the Tarlati family and of Arezzo under Guido Tarlati's tenure as bishop. In some of the panels, such as the Comune in Signoria (Fig. 5.21), where a prisoner at the right is about to be beheaded while another, kneeling, pleads his case before the seated judge, the sculptors used compositional devices comparable to those in Lorenzetti's later Allegory of Good Government (see Fig. 5.28) to indicate the stability of Arezzo's government under the Tarlati. Guido Tarlati's tomb was unique in the unabashedly secular character of its decoration. Significantly, it was not imitated.

The Tarlati Tomb marks an early appropriation by an individual (the commissioner, Pietro Saccone, the bishop's brother and executor) of civic imagery for use as propaganda for one family. The political intent of the tomb and its reliefs was not lost on the citizens of Arezzo, who defaced the monument when the Tarlati were expelled in 1341.

The Palazzo Pubblico

As they had done with the lavish sculptural decoration on the façade of their cathedral and the richly ornamented paintings within it, the Sienese chose visual seduction when they built their city hall (Fig. 5.22). Unlike the brute stony strength of Florence's civic fortress (see p. 77), here brick walls gently bend to embrace the amphitheater-shaped Piazza del Campo which it faces. Thin marble columns supporting Gothic arches decorate the windows. An astonishingly tall bell tower—clearly surpassing the height of the

civic tower of their rival city Florence-extends from the left wing of the building, dominating other such structures which spiked the urban landscape. A later chapel beneath the tower extends out into the public square and indicates the fusion of Church and state in this city dedicated to the Virgin. The expansion of the Campo in front of the Palazzo gives a measure of the importance of rule extending out from the building to the population congregating before it. At the same time, this extraordinary sloping shell-like space-a natural concavity at the meeting of Siena's three hills-suggests that power flowed reciprocally from the citizenry to their representative government. The city government carefully controlled the form, legislating the height and general style of buildings that could ring it. The Campo hosted not only meetings of the body politic but also public religious and sporting events. Public sermons (see Fig. 5.23) supported by the state manifested also the connections between religion and politics, calling divine favor upon the entire urban community. Events such as the Palio, the wild bare-backed horse race still run around the Campo today, were a way to entertain the population while channeling aggressions in a crowded and populous space.

5.22 Palazzo Pubblico, Siena, begun 1298, commissioned by the Sienese government

Simone Martini's *Maestà* for the Palazzo Pubblico

The power of Duccio's Maestà and its symbolic value for the city is clearly evident in the fact that soon after it was finished the governing body of the Nine commissioned Simone Martini to paint a fresco of the same subject (Fig. 5.24) for the main meeting room of their newly completed city hall (Fig. 5.25). Simone included exactly the same saints who appear in Duccio's great Maestà and arranged them in much the same order. The imitative nature of Simone's work was determined by the needs of the program, which undoubtedly called for consistency in the depiction of the city's protectress. Here in the city hall, as in the cathedral, the image served a propagandistic purpose. The inscription at the base of the throne of the Virgin in Simone's Maestà, "The angelic little flowers, the roses and the lilies which adorn the heavenly fields do not delight me more than righteous council," is an exhortation to the rulers of the city who met in this room to carry out their responsibilities in a just and equitable manner.

Two rondels painted in the center of the dado of the wall beneath the border, although badly damaged and repainted, contain images of the seal of the Captain of the People, a rampant lion, and of the Communal Seal of the city of Siena with the Virgin and Child flanked by candle-bearing angels surrounded by a Latin inscription which reads: "The Virgin protects Siena which she has long marked for favor." Unlike the Virgin in Duccio's Maestà, Simone's Virgin wears a crown, her queenly status appropriate in a room dedicated to the business of government.

In his Maestà Simone integrated some of the spatial realism and corporeality of earlier painting in Florence, Rome, and Naples into the Sienese style. Simone's angels and saints have more space between one another and are organized so that they create diagonal rows from front to back of the composition, thus emphasizing the deep stagelike space formally constructed by the baldacchino which covers the entire group. Simone also structured the folds of the material clothing his figures to make them appear fuller and more weighty than Duccio's sinuous, decorative draperies, though he follows Duccio in including complicated folds and pooling of fabric at the base of his figures. The elaborate Gothic throne in which the Virgin and the Christ Child are placed also differs from Duccio's heavy marble throne, which recalls indigenous Tuscan architecture. The thin window-like arches of Simone's throne suggest the elaborate frames of contemporary altarpieces and the Gothic architecture of Naples, with which Siena had long-standing political alliances. Simone, in fact, moved to Naples shortly after completing this fresco.

Lippo Memmi's *Maestà* **for San Gimignano** The success of Simone's *Maestà* is suggested by its repetition in the Palazzo Pubblico of San Gimignano, a small hill town

Art and Popular Piety

Throughout the history of organized religion, preachers of extraordinary skill and charisma have from time to time emerged

to capture the imagination and fervor of large audiences. The Franciscan friar San Bernardino of Siena (1380-1444), like St. Francis and St. Peter Martyr before him (see Fig. 8.8), drew large crowds who were captivated by his passionate calls for repentance. In many instances civic authorities or clergy would hire such preachers to deliver sequences of sermons during special liturgical seasons such as Lent. Thus townspeople had the opportunity to hear ideas recapitulated and developed over several days. Scribes often transcribed the sermons as they were delivered, giving modern historians texts that must closely approximate the sentiments and energies of the speaker, if not all of his actual words.

In Siena in 1427, Bernardino gave a number of sermons standing in a temporary pulpit which had been erected in front of the Palazzo Pubblico. In these sermons he preached not only moral reform but also civic peace. Sano di Pietro's painting of one of these occasions (Fig. 5.23) shows a rich curtain draped across much of the lower façade of the town hall, before which are seated the priors of the city. Men and women kneel in devoted attention to Bernardino's words-and were chastised by the preacher when they failed to pay attention. The sexes are separated by a barrier which extends from Bernardino's pulpit across the piazza (here called the

Campo, or field) which forms the very heart of the city. The stone surfaces of the buildings must have carried the sound of

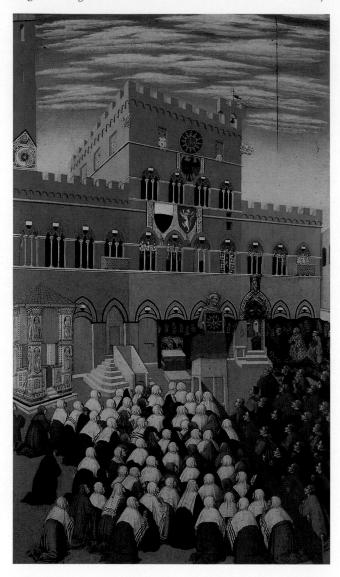

5.23 St. Bernardino Preaching in the Campo, 1445–47, probably commissioned by the Confraternity of the Virgin from **Sano di Pietro**. Tempera on panel, $63\% \times 40''$ (162×101.5 cm) (Chapterhouse, Siena Cathedral)

This may have been a side panel to a large triptych for the confraternity's assembly rooms located beneath the hospital of Santa Maria della Scala, opposite the cathedral.

Bernardino's voice to distant members of his audience, just as they amplify sound today. Bernardino holds an emblem of

> a radiant sun surrounding the initials IHS, signifying Christone that he consistently used in his preaching, and which was copied in reduced amulet form for his devotees to carry away as a reminder of his exhortations to repentance. So persuasive were Bernardino's arguments in support of civic obedience that the grateful governors of the city agreed to place his symbol high on the façade of the Palazzo Pubblico, where it still remains. Despite Bernardino's popularity, however, street gangs-called Noise and Scratch-continued to exist in Siena and to threaten the civic concord which Ambrogio Lorenzetti depicted in the Room of the Nine (see Fig. 5.28) in the town hall.

> Bernardino's impact on popular piety in Siena was so great that he was canonized in 1450 by Pius II, another Sienese citizen. At the festivities honoring the event, numerous paintings of the saint were commissioned, and a lifesized figure of Bernardino accompanied by music-making angels was hoisted along the wall of the Palazzo Pubblico, from the ground to a representation of Paradise at the top of the building, as if Bernardino were floating into Heaven where God the Father waited to receive him. This tableau vivant was so successful that it was repeated with the image of St. Catherine when she was canonized in 1461.

which was then a dependency of Siena. In 1317–18 Simone's sometime collaborator and later his brother-in-law, Lippo Memmi (active 1317–c. 1350 Siena), was commissioned by Nello di Mino Tolomei, then *podestà* (chief magistrate) and Captain of the People in San Gimignano, to paint a *Maestà* in the town hall there (Fig. 5.26). Lippo

adjusted the composition of Simone's fresco to accommodate the different commission. He replaced the Sienese patron saints in the front row with Nello, kneeling in a donor pose, and with St. Nicholas (Nello's patron saint) standing behind him. St. Gimignano, the patron saint of the city, stands at the left of the Virgin, and the coat of arms

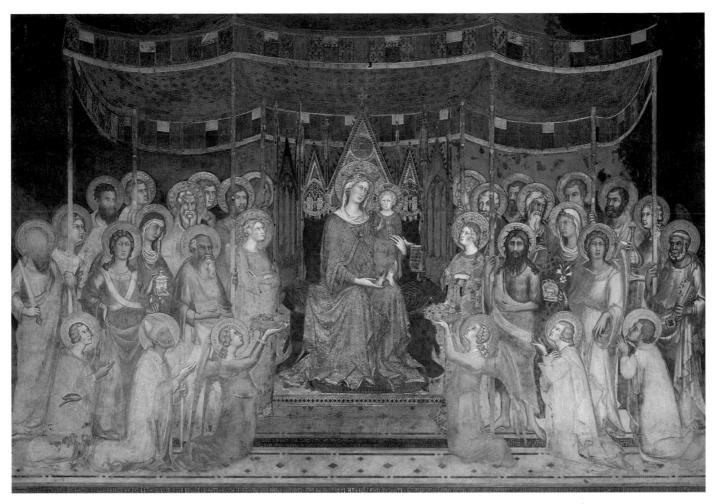

5.24 (above) *Maestà*, c. 1315, repaired and repainted in 1321, commissioned presumably by the governing body of the Nine from **Simone Martini** for the Sala del Consiglio (Room of the Council), Palazzo Pubblico, Siena. Fresco, 25′ × 31′ 9″ (7.62 × 9.68 m)

Damage to the fresco over time was caused by the storage of salt in basement rooms of the Palazzo Pubblico beneath the fresco. Moisture carried the salt up through the inner walls of the building and caused crystals to form beneath the surface of the paint. These pushed the pigment forward and damaged the structural integrity of the plaster. The Christ Child holds an actual parchment scroll that has been adhered to the surface of the fresco: it reads: "Love Justice you who judge the earth."

5.25 View of the Sala del Consiglio (Room of the Council), Palazzo Pubblico, Siena.

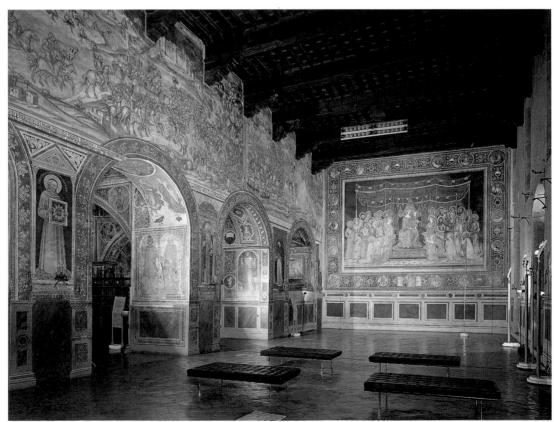

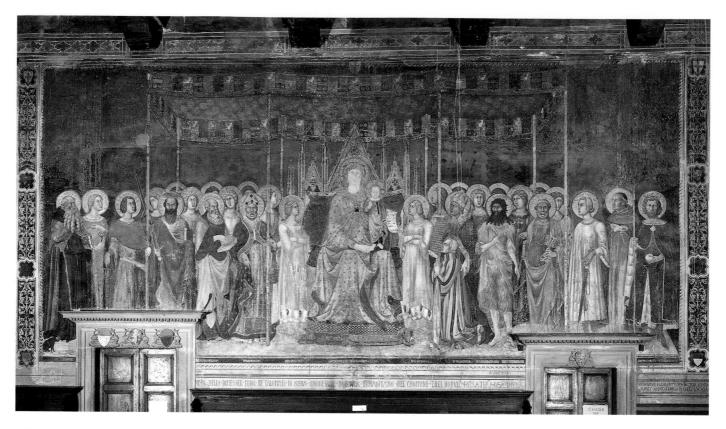

5.26 Maestà, 1317-18, commissioned by Nello di Mino Tolomei from Lippo Memmi for the Palazzo Pubblico, San Gimignano. Fresco

The paired figures to the left and the right were added by Bartolo di Fredi when the fresco was enlarged in 1367. The fresco was repaired along the lower edge in the 1460s by Benozzo Gozzoli, who may have repainted the heads of the two figures to the far right.

of the Tolomei family appears in the *baldacchino* above. If nothing else this rather pedestrian painting indicates how powerful the language of civic imagery was. By placing the copy of Simone's *Maestà* in the town hall of San Gimignano, Nello made very clear Siena's political control over the small town and his power as legate in enforcing that control.

Secular Imagery in the Sala del Consiglio

Accompanying Simone's Maestà in the Sala del Consiglio in the Palazzo Pubblico were a number of secular images. Frescoes commemorated battles and important military captains, and a huge rotating map by Ambrogio Lorenzetti (now destroyed) set Sienese events in a world context. One of the best surviving examples of this reportorial art was commissioned from the painter and miniaturist Lippo Vanni (active 1341-75 Siena) to record the Sienese victory in the Val di Chiana over English mercenaries in 1363 (Fig. 5.27 and see Fig. 5.25). His monochromatic fresco, like many such civic images painted exclusively in central Italian town halls, records the progress of the battle and the disposition of the troops episodically across the wall; it is a graphic chronicle of the event rather than a naturalistic reconstruction, with cities carefully labeled and the armies identified by the heraldic flags of their leaders. Here again, function determined style.

The Sala della Pace: "Good Government"

One of the most elaborate decorative programs for the Palazzo Pubblico of Siena was commissioned from Ambrogio Lorenzetti for the room adjacent to the Sala del Consiglio in 1338. This was the meeting room of the Nine: the Sala dei Nove or the Sala della Pace (Room of Peace). The membership of the Nine, who led the Sienese government from 1287 to 1355, changed every two months, always drawn from the Sienese aristocracy, despite repeated attempts to widen the sources of representation. Legislation of 1318 made them responsible for "the ordering and reformation of the whole city and *contado* ('countryside') of Siena." For the Sala della Pace Lorenzetti designed an allegorical fresco cycle underscoring the benefits of good government and the dangers of bad government.

The cycle consists of three frescoes: the Allegory of Good Government, the Effects of Good Government in the City and in the Country, and Bad Government and the Effects of Bad Government in the City. The Allegory of Good Government (Fig. 5.28) occupies one short wall of the room and is the central image in it. A complicated and fragmented work, it lacks a single compositional focus and thus must be read episodically. The largest image on the wall, and therefore, according to the hierarchies of the period, the most important, is the seated male figure on the right, who is clothed in the

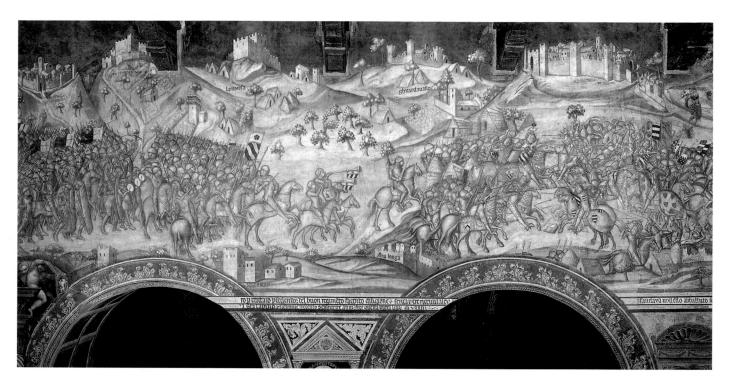

5.27 Victory of the Sienese Troops at the Val di Chiana in 1363, c. 1364 (?), Lippo Vanni, Sala del Consiglio (Room of the Council), Palazzo Pubblico, Siena. Fresco

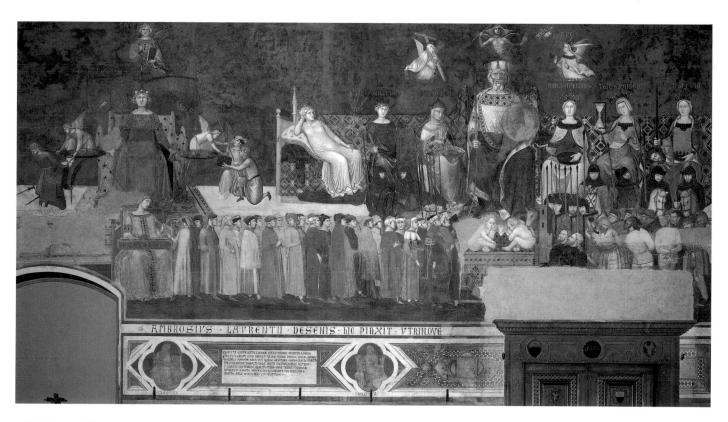

5.28 Allegory of Good Government, 1338–40, commissioned by the governing body of the Nine from **Ambrogio Lorenzetti** for the Sala della Pace (also known as the Room of the Nine), Palazzo Pubblico, Siena. Fresco, length c. 25′ 3″ (7.7 m)

The text in the lower border of the fresco reads: "This holy virtue [of Justice] where she rules, induces to unity the many souls [of the citizens], and they, gathered together for such a purpose, make the Common Good their Lord; and he, in order to govern his state, chooses never to turn his eyes from the resplendent faces of the Virtues who sit around him. Therefore to him in triumph are offered taxes, tributes and lordship of towns; therefore, without war, every civic result duly follows—useful, necessary, and pleasurable." (Trans. Diana Norman)

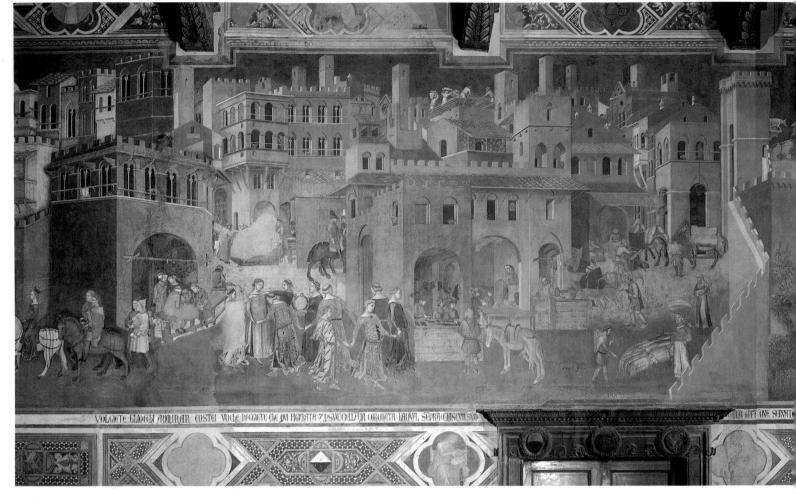

5.29 Effects of Good Government in the City and in the Country, wall to the right of the Allegory of Good Government, Sala della Pace (Room of the Nine), Palazzo Pubblico, Siena, detail. Fresco, length c. 46′ (14 m)

Securitas (Security), flying in the air at the city gate holding a gibbet with a man hanging from it, also holds a scroll that reads: "Without fear every man may travel freely and each may till and sow, so long as this commune shall maintain this lady [Justice] sovereign, for she has stripped the wicked of all power." (Trans. Diana Norman)

heraldic black and white colors of Siena and identified with gold lettering, halo-like around his head, as "CSCV," or "Comune Senarum Civitas Virginis" ("The Sienese Commune, the City of the Virgin"). The Commune, or in this case the Buon Comune or Good Government, is flanked left and right by six female personifications of the virtues, each clearly labeled above her head. Above the head of the Buon Comune float three much smaller winged figures identified as the three cardinal virtues: Faith, Charity, and Hope. Thus the state manifests an ideal of Christian virtue.

In depicting the *Buon Comune* flanked by virtues, Lorenzetti adopted a configuration typically used for the Last Judgment. Thus anyone reading his image would see the *Buon Comune* as omnipotent, like the central figure of God in the Last Judgment (see Fig. 3.12), and would also read the Commune as judge. To underscore this reading Lorenzetti included bound criminals at the lower right of the composition (to the *Buon Comune's* left side) and the upright citizens, or—to use Last Judgment iconography—the elect, at the *Buon Comune's* right side. Moreover, the

inscription over the heads of the criminals repeats that of the communal seal depicted in the border of Simone's *Maestà* in the next room and underscores verbally the protection of the Virgin and of the Commune that represents her. Civil and moral law come together in this image.

At the left side of the fresco a female figure of Justice sits in much the same pose as the *Buon Comune*. An admonitory inscription taken from the opening of the Book of Wisdom, "Choose Justice, you who judge the land," arches over the figure. Justice looks up at the winged figure of Wisdom above her head, who holds scales labeled as distributive and commutative justice. Distributive justice, showing one man stripped of his possessions about to be beheaded and another about to be crowned, is painted immediately over the former door to the room. A female figure of Concord sits at the feet of Justice. Across the bottom of the fresco, from Concord to the right edge of *Buon Comune's* throne, Sienese citizens move two by two in a peaceable procession, concord being the natural result of governance whose structure is visualized metaphorically above their heads.

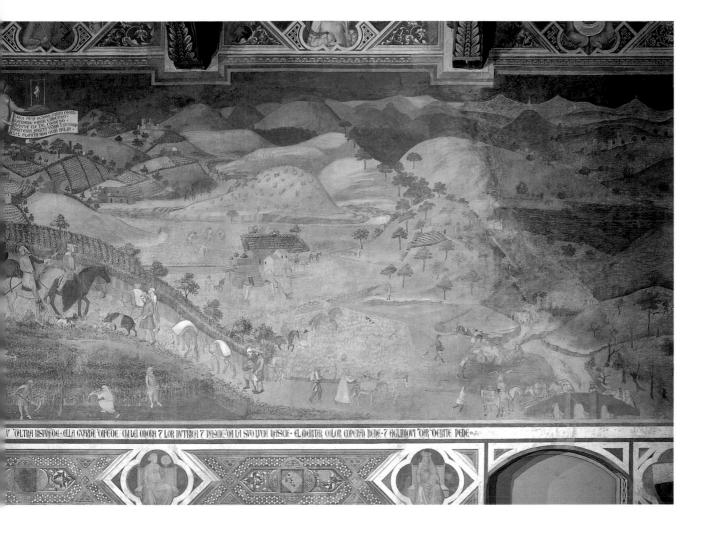

Lorenzetti's style demonstrates how well he had managed to integrate some of the stylistic principles of Giotto into his own work-not surprisingly, as he had worked in Florence from 1321 to 1327 and again from 1332 to 1334. Figures are naturalistically rendered (especially the citizens and soldiers) and fully modeled, their volumetric solidity enhanced by the depth of the benches on which they sit or by their three-quarter poses. Yet this fresco also contains non-naturalistic elements, such as the use of changing scale to suggest the relative importance of different people. In fact the fresco as a whole is non-narrative and the individual allegorical figures are conventional, just as allegory is an artificial, conventional, and formal literary device. It is only in the lowest tier of the fresco, where the quasi-historical figures of the citizens of Siena appear, that the fresco utilizes completely naturalistic stylistic conventions.

To provide visible proof of the efficacy of the abstract concepts of the *Buon Comune* fresco, Ambrogio painted a long two-part fresco of the *Effects of Good Government in the City and in the Country* on the adjacent long wall to the right (Fig. 5.29). This is a busy scene of everyday urban and rural life, crammed with an extraordinary richness of detail: masons and carpenters construct buildings, cobblers make shoes, a teacher instructs his class, visitors to the city stroll

through it, while outside the walls peasants tend the crops and wealthy citizens ride through the countryside. It is a fascinating panorama of the late-medieval city-state at work, a purely secular painting, with no indication of the religious rituals that punctuated citizens' lives.

On the wall opposite the Effects of Good Government and to the left of the Buon Comune Ambrogio painted another fresco called Bad Government and the Effects of Bad Government in the City (Fig. 5.30), which uses the same forms and compositional devices as the other frescoes in the room, but inverts them. The malevolent-looking figure representing Bad Government, pointedly labeled as Tyranny, is enthroned like the Buon Comune and stares hieratically out at the observer. Neither male nor female, it is fanged, crosseyed, and porcine, clearly bloated with corruption. In place of the cardinal virtues, personifications of Avarice, Pride, and Vainglory fly over its head. Tyranny is flanked by clearly labeled seated figures representing Cruelty, Treason, and Fraud at the left and Frenzy, Divisiveness, and War at the right. A bound figure representing Justice lies at its feet. The city to its left is falling into ruin, robbers roam the streets, and, in the foreground, a group of ruffians drags a woman by her hair. Even in its now ruinous condition the image conveys a dire warning.

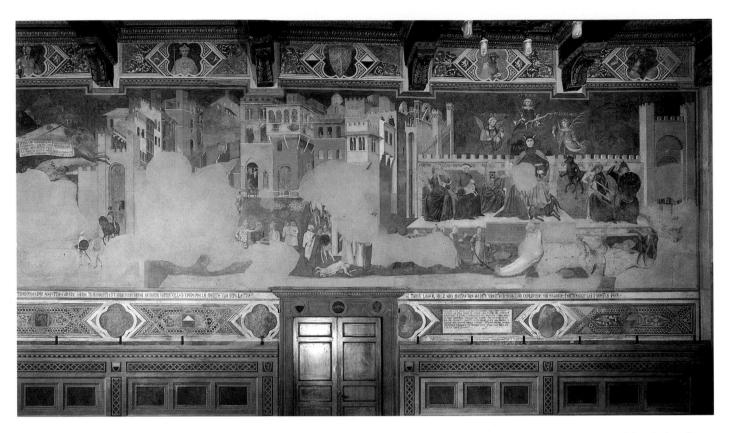

5.30 Bad Government and the Effects of Bad Government in the City, wall to the left of the Allegory of Good Government, Sala della Pace (Room of the Nine), Palazzo Pubblico, Siena, detail. Fresco

There is reason to believe that the inscriptions along the bottom border of each fresco are modern restorations, although they may reproduce original texts. Timor (Fear) in the upper left corner, facing Security across the room, holds a scroll that reads: "Because each seeks only his own good, in this city Justice is subjected to Tyranny; wherefore, along this road nobody passes without fearing for his life, since there are robberies outside and inside the city gates." In the border a text reads: "There, where Justice is bound, no one is ever in accord with the Common Good, nor pulls the cord straight; therefore it is fitting that Tyranny prevails. She, in order to carry out her iniquity, neither wills nor acts in disaccord [sic] with the filthy nature of the Vices, who are shown here conjoined with her. She banishes those who are ready to do good and calls around herself every evil schemer. She always protects the assailant, the robber, and those who hate peace, so that her every land lies wasted." (Trans. Diana Norman)

In sum, the imagery that the Sienese created for their cathedral and town hall was optimistic and celebratory. It taught lessons, confirmed religious and civic faith, and exhorted individuals to do their best to meet high communal standards. Increasingly naturalistic and visually beguiling, it served as both an ornament to and an instrument of Church and state.

Siena's Political System and Civic Art

The system of government in Siena changed significantly and repeatedly during the last half of the fourteenth century. The Nine were driven from power in 1355 to be followed by a troubled period of coalition under the Dodici (the "Twelve"), merchants who were assisted in their roles as governors by twelve nobles. A reform government led by the popolo minuto or "little people" took over in 1368, but itself fell from power in 1386, leading to a period of instability that made it easy for Giangaleazzo Visconti of Milan to take control of the city in 1399. The Sienese regained control

of their city only in 1404 with a coalition republican government led by ten Priors, which brought some order to political life in the city for the remainder of the century.

Painting in the Palazzo Pubblico

Restoration of the republic after 1404 enabled the Priors to turn toward an extensive embellishment of the Palazzo Pubblico. This work amounted to a reaffirmation of civic ideals, drawing on earlier traditions depicted within the Palazzo Pubblico and at the same time adding new humanist overtones to the Sienese stylistic repertoire. Among the first of the commissions for the building was the redecoration of the chapel holding a Maestà from 1302 by Duccio and located next to the room in which Simone Martini had painted his Maestà (see Fig. 5.24). In 1406-07 Taddeo di Bartolo (1362/63 Siena-1422 Siena), perhaps a student of Bartolo di Fredi (see Fig. 5.17), decorated its walls with frescoes of scenes from the life of the Virgin, the city's patron saint (Fig. 5.31). Taddeo's fresco shows apostles and a large crowd of mourners accompanying the body of the Virgin outside the city walls for burial. For the most part Taddeo

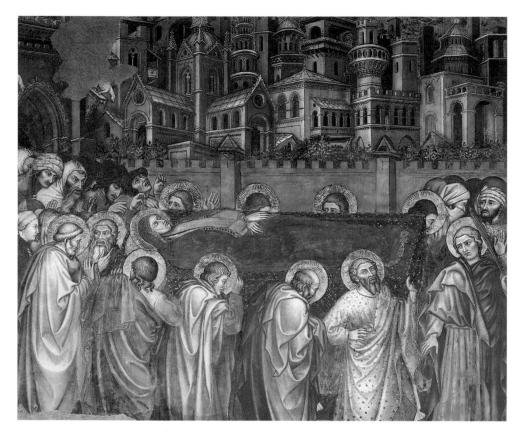

5.31 *The Funeral of the Virgin*, 1406–7, commissioned by the Priors from **Taddeo di Bartolo** for their chapel, Palazzo Pubblico, Siena. Fresco, 10' 6" \times 11' 4" $(3.2 \times 3.45 \text{ m})$

employs earlier conventions of spatial organization and figural composition. The way Taddeo truncates the faces of the apostles behind the bier indicates that he is sometimes interested in naturalistic observation. Yet none of the apostles seems to be actually bearing the weight of the bier, their wiry outline and sharp, angular poses are stock features in Taddeo's work. Along with the stylized or blank backgrounds in the frescoes these features would have given the decorative program of the city hall a stylistic consistency spanning over a century.

In 1407 the Priors commissioned Spinello Aretino (Spinello di Luca Spinelli; 1350/52 Arezzo-1410 Florence), assisted perhaps by his son, Parri Spinelli (1387 Arezzo- 1453 Arezzo) to paint the walls of their meeting room, the Sala dei Priori (Fig. 5.32). The subject matter of the two-tiered frescoes, which cover all four walls of the room, concerns the Sienese pope Alexander III Bandinelli (r. 1159-81). Supposedly this subject was chosen as the result of a visit of Pope Gregory XII to Siena, the frescoes being

5.32 Scenes from the Life of Alexander III, 1407, commissioned by the Priors from **Spinello Aretino** for the Sala dei Priori, Palazzo Pubblico, Siena. Fresco

intended to remind the current incumbent of a Sienese citizen who had been pope and who had even brought the fearsome Barbarossa to his knees. They fit the needs of a civic site by honoring one of its famous citizens, and they may also serve contemporary history by suggesting a comparison between Alexander's alliance with the Lombards and the Priors' Milanese alliance with the Visconti. The frescoes' Florentine sense of spaciousness, their massive, solid figures, and naturalistic details indicate that historical narrative demanded a dramatic and naturalistic style.

In 1413–14 the Priors again turned to Taddeo di Bartolo to paint a cycle of paintings for the antechapel of the Palazzo Pubblico, a space that functioned as an important passage between other rooms of the palace. The Priors thought this space important enough to assign Pietro de' Pecci, a lawyer and teacher in Siena, and Cristoforo di Andrea, the city's

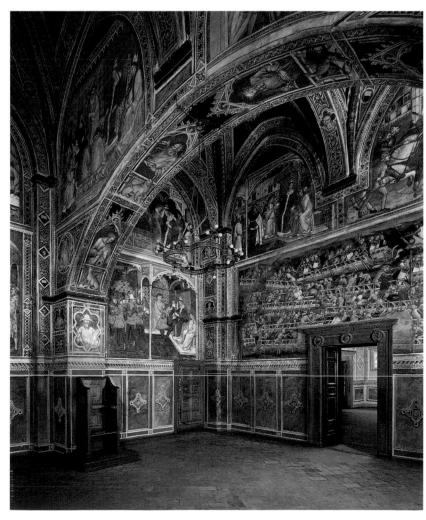

chancellor, as advisors to Taddeo in determining the fresco program. On one wall Taddeo painted allegories of Justice and Magnanimity under the two arches; beneath each he placed a figure from Roman history exemplifying the concept (Fig. 5.33). Each group of Roman heroes is labeled with an inscription in Latin, and each figure bears a further Latin inscription below his feet. The inscriptions between M. Curius Dentatus and F. Furius Camillus claim them as founders of Siena, while others under Cicero and Cato speak of their fight for liberty and justice. Despite the elaborate humanist program, with its complex Latin messages, the figures belong to the medieval tradition of the uomini famosi. The soldiers' elaborate costumes follow chivalric painterly traditions rather than historical accuracy. The one inscription in Italian in this room which might have been readable by Siena's counselors is placed between the two groups of heroes and urges them to look to the example of Rome, to seek for the common good and to emulate the examples of just counsel. Given Siena's recent history, it is significant that the central message of the inscription is a plea for unity. It is also significant that the Priors commissioned a Sienese artist whose style places the imagery well within formal conventions of Sienese painting.

Enhancements to the Campo

New civic commissions extended out into the Campo in front of the Palazzo Pubblico. In December 1408 the Sienese sculptor Jacopo della Quercia (1371/75? Siena- 1438 Siena) was commissioned to design and carve the reliefs for a large public fountain, now known as the Fonte Gaia ("Happy Fountain") (Fig. 5.34). The design for the fountain was set at the time of the contract, and a full-scale drawing for it was made on an interior wall of the Palazzo Pubblico. Modifications and changes in the contract occurred in 1409, but Quercia seems not to have begun actual work on the project until 1414, shortly after he had to leave a project in Lucca because of accusations against him and his assistant, Giovanni da Imola, of theft, adultery, and sodomy. The project dragged on until 1419, to the exasperation of the commissioners.

Even in its now-ruined state the Fonte Gaia conveys some of the splendor which it originally added to the center of Siena and underscores the civic imagery important for such a site. A central relief of the Virgin and Child recalls the city's dedication to Mary and the imagery of most of its civic commissions. She is flanked to the left and right by

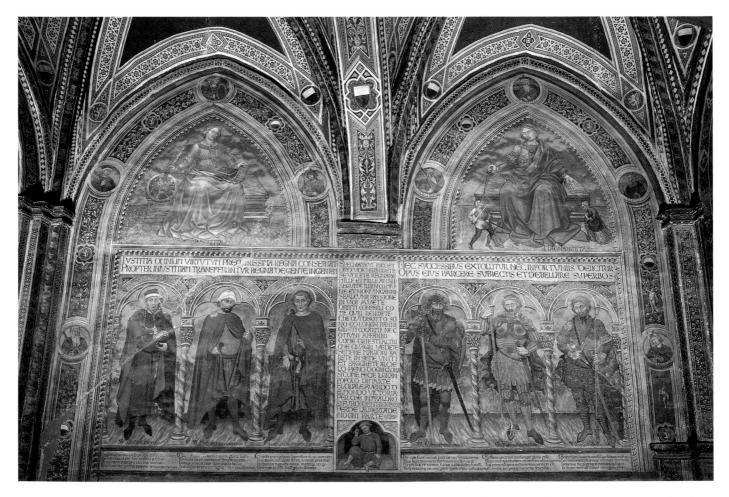

5.33 Justice with Cicero, M. Porcius Cato, and P. Scipio Nasica and Magnanimity with Curius Dentatus, Furius Camillus, and Scipio Africanus, 1413-14, commissioned by the Priors from Taddeo di Bartolo for the antechapel, Palazzo Pubblico, Siena. Fresco, each lunette 8' 10%" × 10' 6" (2.7 × 3.2 m)

5.34 Fonte Gaia, 1408–19, commissioned by the Priors from **Jacopo della Quercia** for the Piazza del Campo, Siena. Marble, center span 33′ 4″ wide (10.15 × 5.55m) (Ospedale della Scala, Siena)

The fountain was removed in 1858 and replaced by a modified replica made between 1858 and 1868 by Tito Sarocchi.

niches containing figures of virtues, much as Lorenzetti's Buon Comune (see Fig. 5.28) is flanked by allegorical personifications. Although the original plan called for figures of Gabriel and the Virgin Annunciate facing one another at the ends of the wings, a revision ordered in 1415 substituted reliefs of the Creation of Adam and the Expulsion from Paradise (Fig. 5.35). The Expulsion adds an important focus on Justice to the fountain, again echoing the theme of the Good Government fresco in the Palazzo Pubblico. Quercia had most likely looked carefully at work in Florence, where he had competed for the second set of the Baptistry's bronze doors, but local references are equally important, too. The rounded, soft forms of Quercia's bodies refer to Etruscan terracotta sculpture most likely already available from looted local tomb sites, and the heavy, decorative drapery of the Virtues echoes the reliefs of the Liberal Arts formerly decorating the base of the Cappella di Piazza immediately across the Campo from the Fonte Gaia. For a civic commission such references to indigenous history would naturally have been appropriate. Partly because of Quercia's ability to assimilate such divergent stylistic components into his work, his position in the history of art has been somewhat marginalized, despite the power of his sculpture and the obviously high reputation that he enjoyed in his own time.

5.35 Expulsion of Adam and Eve from Paradise, detail of the Fonte Gaia (Ospedale della Scala, Siena)

6 Naples: Art for a Royal Kingdom

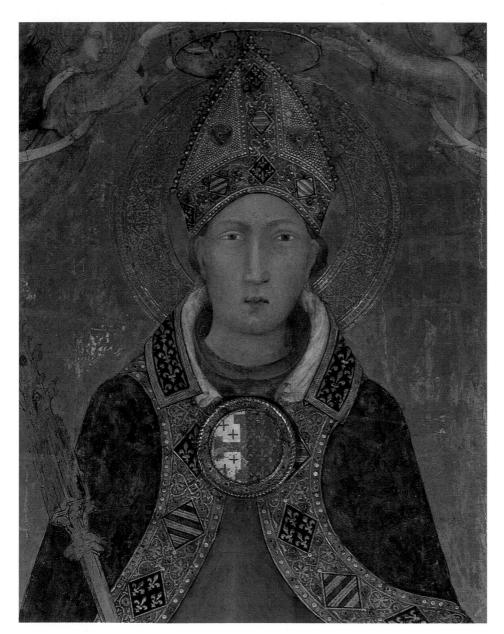

The best early view of Naples, the so-called *Tavola Strozzi* of 1464 (Fig. 6.1), shows a city that shares numerous similarities with the cities we have already examined. A dense urban fabric, partially dating from its ancient Greek past, accommodates many churches, including several major mendicant complexes crowning the city's skyline. Walls and a fortified harbor provide impressive defense. The single most prominent building, however, is not the city's

cathedral, which housed the miracleworking remains of its patron saint, Gennaro, but the seaside fortress, the Castel Nuovo (completed in 1284), which served as the residence of the kings of Naples. Situated apart and aloof from the rest of the city, this structure embodied both the power and the wariness of an autocratic ruler. Even the most fortified of the republics' city halls, the Palazzo della Signoria in Florence (see p. 77), stood accessible and vulnerable on a major civic square. Here, by contrast, several lines of defense surrounded the imposing castle of the king of Naples in order to isolate and protect him from his subjects.

The Court and the Importation of Artists

The Neapolitan court in the late thirteenth century was dominated by foreigners. In 1264 Pope Clement IV (r. 1264–68) granted Charles of Anjou, brother of King Louis IX of France and the first of the Angevin kings of Naples, sovereignty over all of southern Italy (the so-called Kingdom of the Two Sicilies). King Charles hired artists to help him validate his new dynasty, sustaining his rule not only with military subsidies from the papacy but by a policy of political and cultural imperialism. Charles placed Frenchmen in charge of all his government agencies,

and he also imported French masters and craftsmen to undertake his artistic projects. (When he founded several new monasteries he even insisted that the monks come from France.) Local artists were allowed only menial tasks; the literal importation of Gothic forms that Charles required demanded workers from abroad.

Some works of art were imported from France-among them illuminated manuscripts displaying the confident

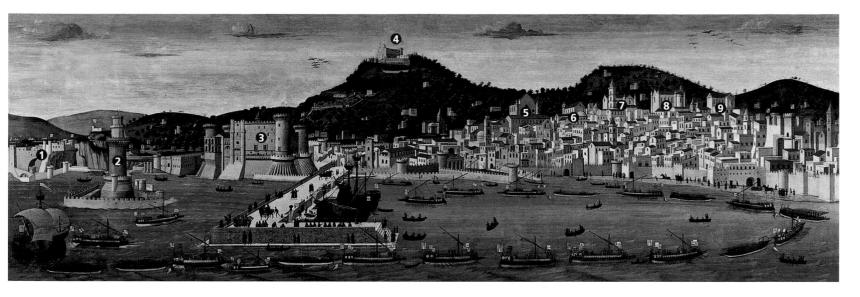

6.1 Panorama of Naples (Tavola Strozzi), 1464. Tempera on panel (Gallerie Nazionali di Capodimonte, Naples)

1 Castel dell'Ovo; 2 Molo di San Vincenzo; 3 Castello Aragonese (Castel Nuovo); 4 Certosa di San Martino; 5 Santa Chiara; 6 San Domenico Maggiore; 7 San Lorenzo Maggiore; 8 Duomo; 9 San Giovanni a Carbonara

and festive forms characteristic of Parisian art. An Old Testament picture book produced in Paris around 1250 probably made its way to Naples by the late thirteenth century (Fig. 6.2). The miniatures in this manuscript are extremely large, leaving barely enough room for an Italian scribe to add a few lines of text identifying each scene. The detail shown, of a battle, captures the dynamic energy of the conflict. Clear and brilliant color, complex poses, and entangled figures command attention in a manner that may recall destroyed wall paintings and other large-scale compositions from mid-thirteenth century Paris.

Fragments of a royal tomb for the French queen Isabella of Aragon suggest the sophistication of sculpture in southern Italy during Charles's reign (Fig. 6.3). A royal stonecarver was probably dispatched to Cosenza soon after January 28, 1271, when Isabella died there. Her husband, Philip III (nephew of Charles of Anjou; r. 1270–85), took her bones back with him to the royal burial church of St. Denis, outside Paris, but he left her entrails in Cosenza, following the common French practice of dispersing royal bodies for entombment and hence commemoration and recognition in several locations.

Life-sized portraits of the French king and queen kneel before an under-life-sized Virgin and Child. The heads of the royal couple are placed deferentially lower than Mary, the

(opposite) Altarpiece of St. Louis of Toulouse (detail), c. 1319, commissioned by Robert of Anjou from **Simone Martini**. Tempera on panel, with a gilt-glass morse and now-lost paste pearls and gems on the cope; main panel $78\% \times 54\%$ (200×138 cm), predella $22 \times 54\%$ (56×138 cm) (Gallerie Nazionali di Capodimonte, Naples). See also Fig. 6.13.

Queen of Heaven, but the larger size of the king and queen accentuates their royal status. The figures' alert demeanor and the soft but precise folds of their garments invite comparison with such famous works of the 1260s as the regal *Vierge Dorée* of Amiens Cathedral or the life-sized prophets that stand gracefully before the piers inside Louis IX's Sainte Chapelle in Paris. Like them, the Cosenza figures surely

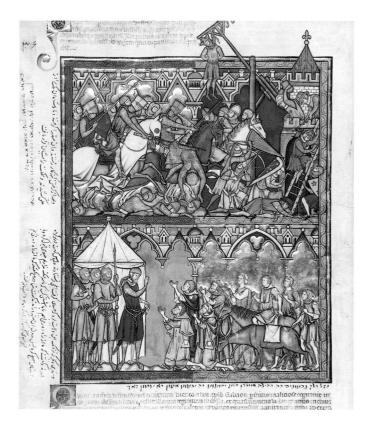

6.2 Battle Scene from the Book of Joshua, from an Old Testament Picture Book, c. 1250, commissioned by a royal patron in Paris. Vellum, 15% × 11%" (39 × 30 cm) (Pierpont Morgan Library, ms. 638, fol. 10V, New York)

Parisian artists were major exporters of portable works of art, including manuscripts and small devotional panels in ivory.

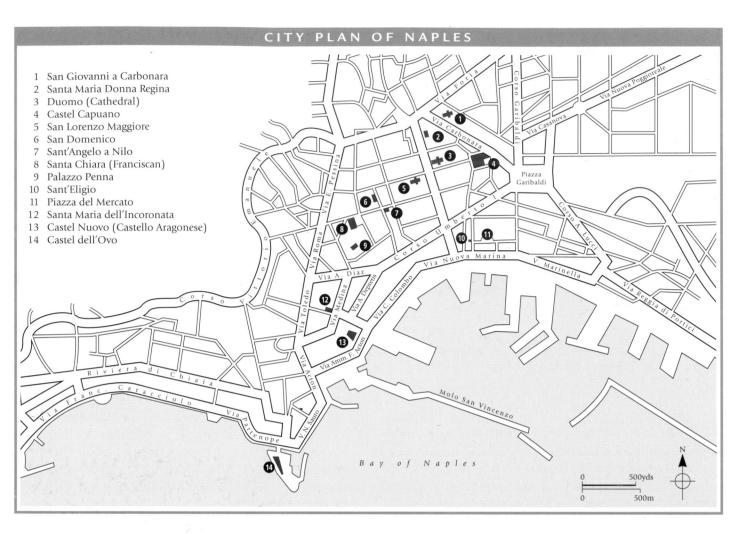

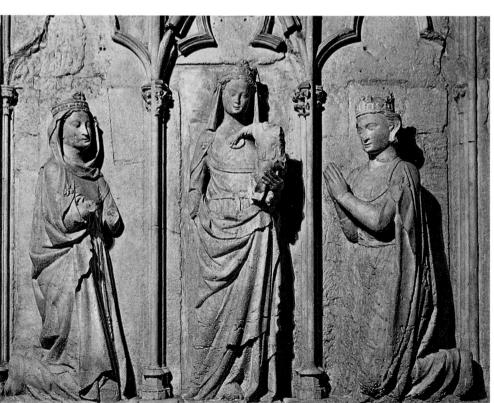

6.3 Philip the Bold and Isabella of Aragon Kneeling before the Virgin, 1271-76, commissioned by Philip III from a Parisian sculptor for Cosenza Cathedral

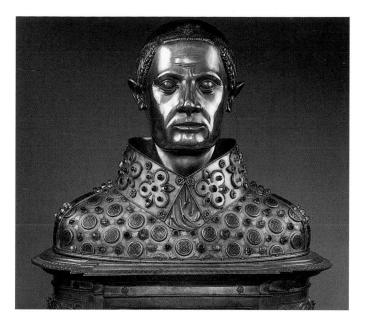

6.4 Reliquary Bust of San Gennaro, 1304, commissioned by Charles II of Anjou from Etienne Godefroyd, Guillaume de Verdelay, and Milet d'Auxerre. Gold and silver with inlaid enamel and multicolored jewels (Cathedral Treasury, Naples)

Relics were carried through city streets on festival days and in times of peril.

were intended to be painted in the bold, rich colors and patterns seen in the *Old Testament Picture Book* (see Fig. 6.2).

Charles and members of his court were active as patrons of luxury arts. Continuing this practice, in 1304, Charles's son and successor, Charles II (1254-1309), commissioned three Provençal goldsmiths, Etienne Godefroyd, Guillaume de Verdelay, and Milet d'Auxerre, to produce a reliquary bust of the patron saint of Naples, San Gennaro (Fig. 6.4). Probably intended to mark the one-thousandth anniversary of the saint's martyrdom and thus to link the Angevin dynasty directly to Naples's most ancient and sacred Christian history, the figure consists of a head even more lifelike than the representation of Philip the Bold at Cosenza. Because the reliquary was intended to hold the surviving bones of the saint's cranium—its head is hinged just between its tonsure (ritualistically shaved head) and tight wavy hair-it has good reason to suggest as much as possible the actual features of the saint. Slight bags under the eyes and lines to their sides, along with somewhat sagging cheeks, offset the otherwise traditional conventions of saintly passivity and immobility. What might be read as merely bejeweled splendor is in fact a cunning use of color and rich materials to associate the saint and the Angevin dynasty. The head emerges from a broad collar enlivened with blue and red gems (the Angevin heraldic colors) set on multilobed decorations that recall the royal fleur-de-lys, a motif that recurs across the saint's chest and shoulders in red and blue inlaid enamels alternating with different-colored gems. As the faithful offered their prayers to this image of their city's patron, they also saw emblems of their kingsrulers who exploited the divine to reinforce their reign.

Architectural Commissions

The Angevin kings expected members of their court to sponsor works in the French style. In 1270 three of Charles I's courtiers, Jean d'Autun, Jean de Lyon, and Guy de Bourguignon, hired French master masons to supervise the erection of a church and hospital for war veterans near King Charles's new public markets—that is, in the southeastern corner of the city relatively near the harbor. Dedicated to three of royal France's most revered saints, Eloi (or Eligio, the name by which it is now known), Denis, and Martin of Tours, it exemplifies the elegance of Gothic architecture. The interior boasts finely detailed, extremely graceful crossribbed vaults supported by stylishly narrow and highly pointed arches. On the exterior, a side portal (Fig. 6.5) features multiple arches crowned by a steep gable as well as ornamentation based on designs of the 1260s used on the north transept of Notre Dame in Paris.

For San Lorenzo Maggiore, Naples's largest Franciscan church, Charles I's architects began the work in the king's preferred northern mode, exploiting the sophisticated technology of flying buttresses to support a complex system of vaults over a soaring choir (Figs. 6.6 and 6.7). But so much effort must have gone into trying to make the buttresses

6.5 Side portal, Sant'Eligio, Naples, 1270, commissioned by Jean d'Autun, Jean de Lyon, and Guy de Bourguignon

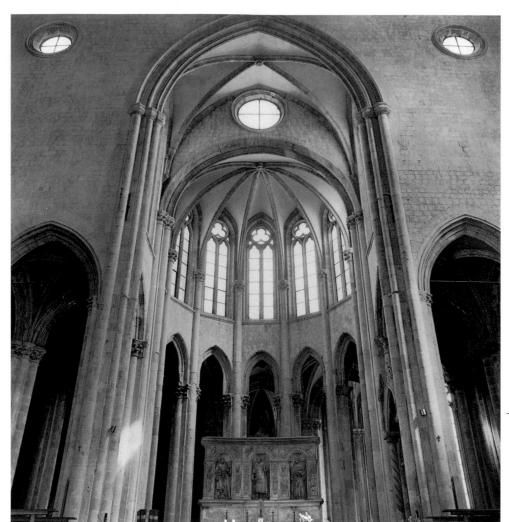

6.6 (left) San Lorenzo Maggiore, Naples, begun early 1280s, commissioned by the Franciscans with support from Charles I and Charles II of Anjou and their court

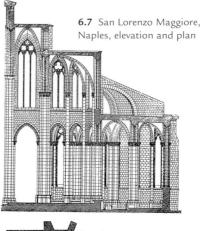

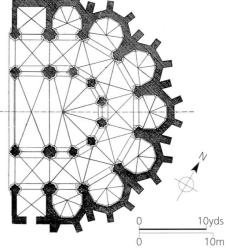

from the weak local tufa (volcanic stone) that French masons did not attempt many fine details. Already by the early 1280s Charles's attempts to impose French style were being compromised. Tracery designs at San Lorenzo Maggiore show the direct influence of St. Denis in Paris, but the execution of the leafwork and capitals was increasingly standardized and repetitive rather than newly invented. The cavernous nave and its unarticulated walls bring to mind Franciscan churches throughout Italy.

As construction proceeded into the fourteenth century, Charles I's strategy of artistic imperialism gave way to more expedient practices of accommodation and coexistence. Only the elegant and refined spirit, not the structure, of earlier Gothic buildings prevailed. While Charles's children and grandchildren continued to admire aspects of French culture, the Angevins found themselves comfortably ensconced in Naples, so it made sense for them to take greater interest in artistic developments in Italy than those in France. The period of outright importation of French styles and workmen, then, was relatively short-lived, but it added significant new forms to the visual repertoire available to Neapolitan artists and patrons.

Consolidating Angevin Rule: A Queen's Commissions

Charles of Anjou's son, Charles II, oversaw the completion of many of his father's building projects, while his wife, Queen Mary of Hungary (d. 1323), initiated an active tradition of royal female patronage in Naples. Founding the convent of Santa Maria Donnaregina in 1307, she provided a propitious site for her own retirement and eventual burial close by the city's cathedral (Figs. 6.8 and 6.9). As at San Lorenzo, the apse of Mary's church was conceived as a luminous cage for stained glass, its brightness made especially compelling by the lower, dark nave that precedes it. Above the nave, and necessitating the construction of piers and vaults that darken it, is a substantial nuns' choir. While lay worshippers entered the church and spent much of the mass in semi-darkness, Mary and her fellow nuns found themselves surrounded by the glowing stained glass windows and an extensive but poorly preserved fresco cycle. Adapting the general scheme of Cavallini's frescoes at Santa Cecilia in Rome (see Fig. 2.8), the program includes a Last

6.8 Santa Maria Donnaregina, Naples, founded 1307, commissioned by Queen Mary of Hungary

The queen's coats of arms appear in the keystones of the vaults. She is buried in a handsome tomb within the church (see Fig. 6.16).

6.9 Santa Maria Donnaregina, Naples, plan

Judgment on the back wall, Old and New Testament scenes in three tiers on the side walls, saints' lives beyond them, and a celestial vision above the apse. Deriving from the grand schemes of papal Rome, and therefore full of historical resonance, the frescoes provided these religious women with a rich compendium of subjects for contemplation and meditation.

Cavallini and Giotto in Naples

The frescoes at Santa Maria Donnaregina document the impact of Pietro Cavallini's arrival in Naples in 1308, the narrative scenes painted by his followers and artists from other centers. A series of prophets that includes King David (Fig. 6.10) may come directly from Cavallini's hand. Like the faces of the apostles in the *Last Judgment* at Santa Cecilia in

Rome (see p. 56), David's visage is evocatively rendered. Soft shadows, delicate highlights, rounded volume, and the shift of the figure's eyes make for a compelling, even riveting portrayal.

Unfortunately, only a small portion survives of the painting produced in early fourteenth-century Naples that decorated the many new buildings erected by the Angevins. Judging from this remnant our loss of the others is an artistic disaster. The fragmentary, undocumented, and contested works that remain indicate that Angevin rulers and other Neapolitan patrons commissioned works that were second to none in Italy, both in their quantity and quality. Giotto, for example, was a member of the royal household from December 1328 until 1332, actively producing frescoes and panel paintings, now lost. His imprint, though not his hand, is clearly visible in frescoes produced by one of his followers in the Brancaccio

Chapel in San Domenico Maggiore, a royal foundation of 1283 (Fig. 6.11). In the *Noli Me Tangere* (literally, "do not touch me," Christ's command to Mary Magdalene when she

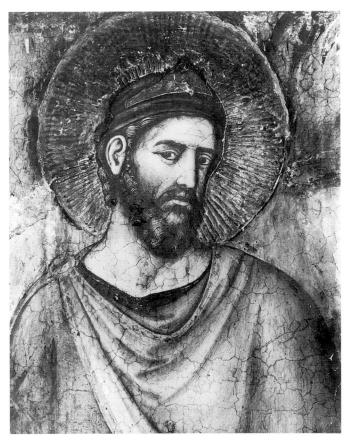

6.10 *David*, detail of the head, after 1308, commissioned by Queen Mary of Hungary from **Pietro Cavallini** for Santa Maria Donnaregina, Naples. Fresco

6.11 Noli Me Tangere, c. 1310, probably commissioned by Cardinal Landolfo Brancaccio from a **Follower of Giotto** for his family chapel in San Domenico Maggiore, Naples. Fresco

Other scenes in the chapel depict events in the lives of the apostles Andrew and Peter.

encountered him newly resurrected) the artist exploits landscape as a foil for human interaction much as Giotto had done at the Scrovegni Chapel in Padua (see Fig. 3.11). The composition is anchored around the imploring figure of the Magdalene, her triangular form repeated in the hill on which she kneels before Christ. The lid of Christ's tomb, set in the lower left of the panel, propels the action up the hill from left to right. In the background a substantial walled city, presumably Jerusalem, glimmers in contrast to the darker hill on which it is set. While the vegetation remains highly schematic, the

drapery of the figures is convincingly modeled in light and shade as it falls softly around their bodies. The intensity of

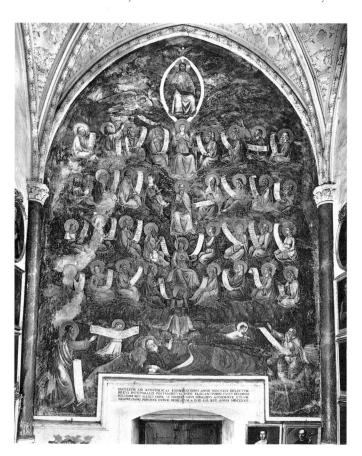

6.12 Tree of Jesse, c. 1320, commissioned by Uberto d'Ormont from Lello da Orvieto for Naples Cathedral. Fresco

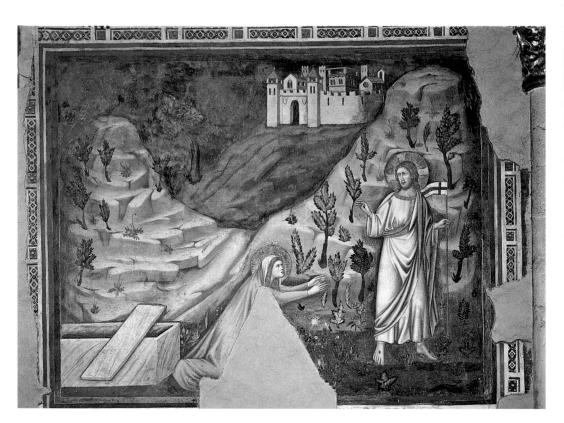

the gazes exchanged by the holy figures also compares with the increasing attention to psychological awareness seen first in the frescoes at Assisi (see Figs. 3.3 and 3.5) and later in Giotto's works (see Fig. 3.10).

The enduring impact of both Cavallini's and Giotto's innovations can be seen in the work of Lello da Orvieto, who, like so many artists, was called to Naples from central Italy. Around 1320 Lello painted his impressive Tree of Jesse (Fig. 6.12) on the side wall of the Chapel of St. Paul in the cathedral of Naples for Archbishop Uberto d'Ormont. The subject would not initially appear to lend itself very well to naturalistic depiction; it is a genealogical table of Christ's ancestors, reaching back to the Old Testament patriarch Jesse, from whom the tree issues. Christ's ancestors are placed, as always, up the central trunk of the tree; prophets, sages, and saints fill its branches. Unlike most earlier representations of this subject, however, Lello's tree has real life and substance. The figures actually seem to sit or recline upon the soft, cushion-like foliage, and they turn to one another and gesticulate, showing off their scrolls or pointing to the figure of Christ at the very top of the composition. At the bottom left of the wall we see a figure from the back striding into the scene, inviting the viewer to imagine himor herself doing the same. The figure of Jesse (now greatly damaged) reclines in the middle. To the right a man on horseback also raises his hand and draws us into this very palpable vision. Similar in composition to Taddeo Gaddi's Tree of Life in the refectory of Santa Croce in Florence (see Fig. 4.23), Lello's work is also didactic but more approachable and visually alluring, bearing witness to the warm humanity of Cavallini and Giotto's schools in Naples.

Robert of Anjou

When Robert of Anjou succeeded to the throne of Naples in 1309 he continued the lavish patronage of his parents and completed the transformation of the city into one of the most impressive in Europe. Known as Robert the Wise, King Robert was a highly learned ruler, a characteristic recorded by both Dante and Petrarch. Robert's assumption of power in southern Italy, although planned by his father, Charles II, was not completely uncontested. He was, in fact, the third son; his oldest brother, Charles Martel (named after the illustrious Frankish ruler), had died in 1295, leaving a young son, Carobert (Carlo Roberto), to succeed him as heir to the thrones of both Hungary and Naples. Charles II, however, refused to accept his grandson as his successor. Charles II's second son, Louis, was especially devoted to the Franciscan order and renounced his claim to the throne of Naples in the summer of 1296 in order to join the Franciscans. A few months later, Pope Boniface VIII made a reluctant Louis bishop of Toulouse. Scarcely had Louis arrived in his diocese when, on August 19, 1297, he died. This left Robert the designated heir to Charles II.

The Altarpiece of St. Louis Soon after Louis's death, his father launched a campaign to have him canonized, a project pursued with equal vigor by his brother Robert after Charles II's own death. Louis was finally proclaimed a saint in April 1317 by John XXII in Avignon; he thus joined with other canonized members of his family, including Louis IX of France (his grandfather's brother) and Queen Elizabeth of Hungary (the great-aunt of Sancia of Majorca, Robert's wife), to form a heavenly pantheon of support for the Angevin household. To exploit the saintly connection and so enhance his family's legitimacy, Robert commissioned a huge altarpiece depicting his older brother placing the crown on his head. Given Robert's close political ties to Siena, it is not surprising that he called Simone Martini, Siena's leading painter, to Naples to paint this monumentally scaled panel.

In Simone's *Altarpiece of St. Louis of Toulouse* (Fig. 6.13 and see p. 124), the saint is seated in a rigid frontal pose. His staring immobility recalls earlier saints' altarpieces (see Figs. 1.4 and 1.5) and

6.13 Altarpiece of St. Louis of Toulouse, c. 1319, commissioned by Robert of Anjou from **Simone Martini**. Tempera on panel, with a gilt-glass morse and now-lost paste pearls and gems on the cope; main panel $78\% \times 54\%$ " (200×138 cm), predella 22×54 " (56×138 cm) (Gallerie Nazionali di Capodimonte, Naples). See also p. 124.

The patterns inscribed in the gold surface around the perimeter of the main panel, on the saint's halo, his mitre, and the crown he holds over the head of King Robert were produced with dies that were repeatedly punched into the surface. Punch marks often differ from one artist's studio to another.

implicitly declares his status as an intercessor with God. Despite placing diagonals on the floor to create perspective and treating his head, hands, and abdomen volumetrically, Simone makes it clear that St. Louis belongs to a realm outside normal time and space. Louis's left hand and the royal crown it touches hover against the elaborately tooled gold ground. This is obviously celestial space, as indicated by the angels at the top of the altarpiece, who award an even more precious heavenly diadem to Louis. The coronation of the king thus parallels the crowning of God's saint, lending divine sanction and protection to Robert's rule.

The extraordinary luxury of the painting—especially in the richly embroidered and gold-tooled cloak which

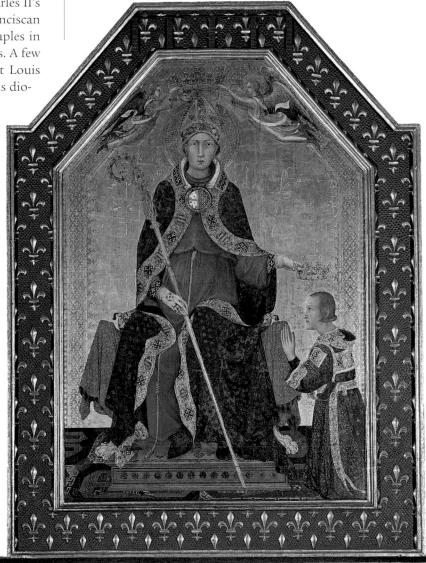

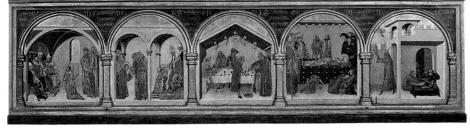

Louis wears over the drab brown tunic of a mendicant Franciscan—conveys clearly that this is a royal image. Angevin territorial claims also figure prominently in it. The frame of the painting (original) surrounds the two brothers with the Angevin crest of the gold fleur-de-lys on a blue ground. The red and yellow heraldic colors of Provence, of which Louis was count, and the crest of the city of Jerusalem, to which the Angevins laid claim, also appear on the clasp of Louis's cloak, indicating the breadth of Robert's realm.

Sancia of Majorca and the Church of Santa Chiara

As part of their duties as divinely ordained rulers of Naples, Robert and his wife, Sancia of Majorca (1286-1345), built impressive monastic churches within the city. Queen Sancia was particularly instrumental in promoting the Franciscan order. Her commissions constitute an important chapter in the history of artistic patronage by women, begun by her mother-in-law Queen Mary of Hungary. Sancia apparently used her own inheritance as well as her dowry money to underwrite building costs, virtually independent of male control. The best-known of Sancia's churches is that of Santa Chiara (Figs. 6.14 and 6.15), one of four convents she patronized in Naples. Although founded in 1310 for the Poor Clares, the female Franciscans, it ultimately expanded to a double convent, housing both men and women, and became a safe haven for the renegade Spiritual Franciscans, who espoused extreme poverty. Sancia herself had been a Clarissan novice before her marriage to Robert of Anjou in 1309, which explains her passionate support of the order through her artistic patronage of a church dedicated to the order's founder, St. Clare.

The architect of the church was most likely the Neapolitan Gagliardo Primario (active 1306/7-48), an artist whose name appears in court documents but about whom little is known. Because the interior of the building was almost totally transformed during the baroque period and the structure itself bombed during World War II, the present church must be examined with care. Nonetheless, the reconstructed interior is one of the purest manifestations of the Italian Gothic style. The long, single-aisled nave is covered with a truss roof, as are the interiors of many other Franciscan Italian churches, such as Santa Croce in Florence (see Fig. 4.8). The walls, although massive in the typical Italian style, are pierced with tall lancet windows. The apse end of the building is flat, and the windows in the center wall rise high to accommodate the multi-storied tomb of Robert of Anjou. From the sequestered choir behind, the nuns could view the elevation of the Host during mass in the church. Sancia was particularly devoted to the Eucharist and had originally wished to dedicate the church to Corpus Christi (the Body of Christ). It may have been the queen's intervention that gave the nuns at Santa

Chiara an unprecedented direct view of the high altar, allowing them to see as well as to hear mass.

Tomb Monuments and Robert the Wise

Probably as a result of the challenge to Robert's claims to the throne of Naples by his nephew, Carobert, the king continued to bolster his dynastic status with imposing works of art. As part of this strategy, he transformed the interior of Santa Chiara into a burial church for his branch of the house of Anjou. In fact, he seems to have intended to fill all of Naples with images of his family, which had ruled the city for a mere three generations. The campaign of sculpture was impressive, especially given the short period of its execution during Robert's reign. No fewer than ten members of the royal family had tomb monuments constructed in various Neapolitan churches during the twenty-year span between 1325 and 1345.

The Tomb of Mary of Hungary

Robert erected the first of his royal Angevin tombs in Naples for his mother, Mary of Hungary (Fig. 6.16). Because his grandfather, Charles of Anjou, had established a local school of builders, there was a competent architect on hand, Gagliardo Primario, to design the tomb's structure; but the king was obliged to go outside Naples to obtain the services of Tino da Camaino for the sculpture. Tino moved to Naples from Siena in 1323 and spent the remaining fourteen years of his life in Angevin employ. The tomb of Mary of Hungary was placed in Santa Maria Donnaregina, the church that Mary herself had built and into whose monastic community she retired after her husband's death in 1309 (see Fig. 6.8).

The sculpture on Mary's tomb emphasizes her success at providing male heirs: rulers not only for all of southern Italy but for Hungary as well-not to mention a saint. The sarcophagus is decorated with niches holding seated figures of her seven sons (tellingly her five daughters are not represented). As one might expect, St. Louis of Toulouse, her second son, occupies the central position of honor. To Louis's right—a position, then as now, connoting honor and privilege-sits a crowned Robert of Anjou holding symbols of royal power. To Louis's left sits Charles Martel, king of Hungary at his death in 1295. To the left of Robert of Anjou are Philip of Taranto and Pietro Tempesta, and to the right of Charles Martel are Giovanni di Durazzo and Raimondo Berengario. The side panels of the tomb show relief figures of court counselors, suggesting the queen's active involvement in affairs of state. The tomb chest itself is supported by figures of four virtues, standard funerary iconography of the time. Mary's own effigy has the long, curving lines of late Gothic forms. Her face is a crisply modeled ovoid

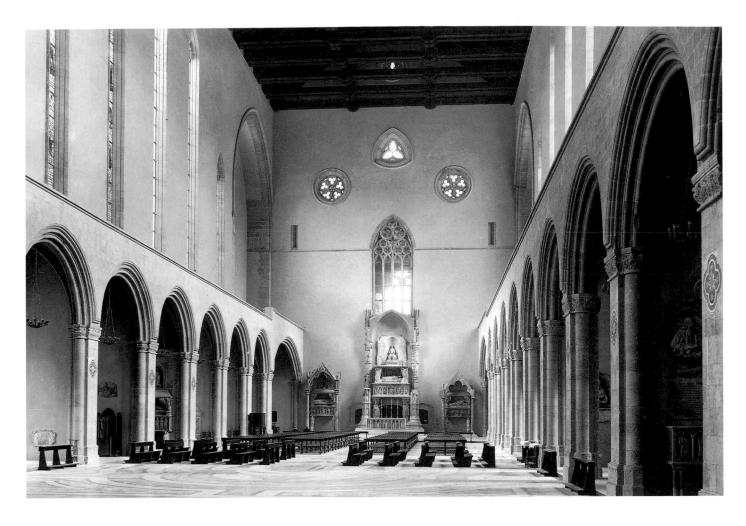

6.14 (above) Santa Chiara, Naples, begun 1310, commissioned on behalf of the Franciscans by Sancia of Majorca probably from

Gagliardo Primario

The church was severely damaged by bombs in World War II. Although its structure has been faithfully reconstructed, most of the church's extensive painted and sculptural decoration was destroyed.

1 High altar and Tomb of King Robert of Anjou of Naples; 2 Nuns' choir

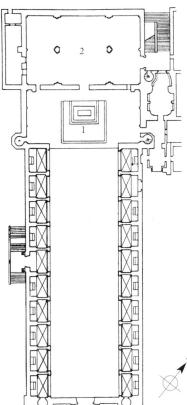

reminiscent of the work of Simone Martini. The figures of the sons, however, derive from standard seated ruler iconography; they are repetitive and severe in their frontality, with heavily massed draperies, characteristic of Angevin monuments of this period.

The Tomb of Robert of Anjou

The construction of Robert's own tomb in Santa Chiara (Fig. 6.17), undoubtedly planned, in intention if not in fact, before his death in 1343, was formally overseen by his granddaughter and successor, Giovanna I. The sculptors Pacio and Giovanni Bertini (documented 1343-45), like Tino, with whom they probably trained, and most of the other artists in Robert's employ, came from outside the region of Naples, in their case from Florence. The tomb is impressive not only because of its size but also because it looms over the main altar in front of the nuns' choir at the east end of the church. It thus is the focal point for a visitor entering the building, occupying a site normally reserved for the church's patron saint. The tomb now bears three carved images of Robert: a relief of the seated king at the center of the sarcophagus, a recumbent effigy on the sarcophagus itself and, above this, a free-standing seated ruler under a canopy. Originally a fourth figure

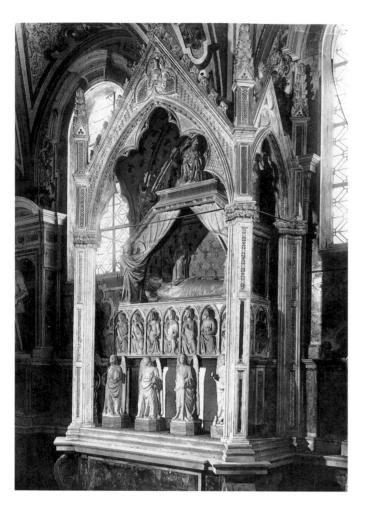

6.16 Tomb of Mary of Hungary, 1325, commissioned by Robert of Anjou from Gagliardo Primario and Tino da Camaino for Santa Maria Donnaregina, Naples. Marble

The church in which this tomb is located was founded by the queen. A monumental balcony across the back of the church allowed resident nuns to worship unseen and undisturbed by the laity.

of the king, kneeling in a donor pose to the right of a Madonna and Child, appeared at the summit of the monument.

Like Simone's altarpiece depicting St. Louis of Toulouse, Robert's tomb indicates that he and his artists were intensely conscious of the power of traditional imagery to carry meaning. In the upper, seated figure of the king, Robert assumes a rigid pose derived from Roman antiquity and reserved for rulers. The Latin inscription at his feet translates, "Behold King Robert, recognized by his virtue." The use of the Latin term *virtus* is appropriate for a Christian tomb, with its hope for the afterlife, but may also refer to the original Roman meaning of the word, manliness, and its traditional connotations of strength and valor, concepts appropriate for a king.

The effigy of the dead king shows him crowned but also barefoot and in the tunic of a Franciscan friar, the clothes he had chosen for his burial. Whereas the crown symbolizes his secular power, the friar's tunic marks his devotion to the Franciscan order. Robert is depicted on the burial chest in the center niche. He is flanked on the right by his first wife and his son and daughter-in-law. To the left of Robert, at his more prestigious right side, are the two main patrons of his tomb and this church: Sancia of Majorca, his second wife, who survived him by two years, and his successor and granddaughter Queen Giovanna I, as well as an unidentified male figure. At the sides of the chest are figures of two infants. Since Robert had the tombs of his son and daughter-in-law constructed in Santa Chiara, he was visually and actually surrounded by his family.

6.17 Tomb of King Robert of Anjou of Naples, planned c. 1343 (damaged in August 1943), commissioned by Giovanna I at the behest of Robert of Anjou from **Pacio** and **Giovanni Bertini** of Florence for Santa Chiara, Naples

The grate in the wall behind the tomb allowed the cloistered nuns in the choir beyond to see the high altar during the celebration of the mass.

Venice: The Most Serene Republic

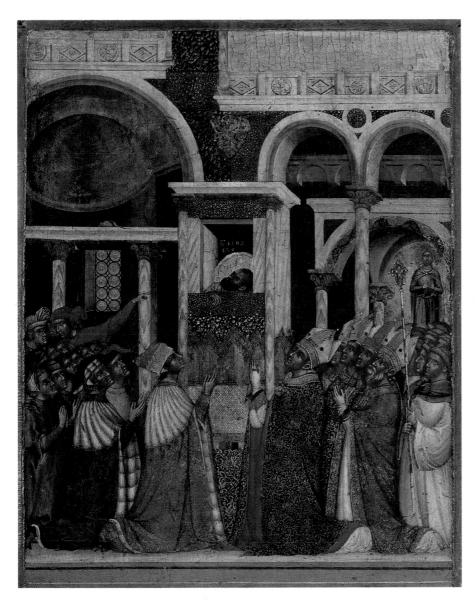

Rew Italian cities could rival Venice's success at defining and securing a unique self-image and international reputation. Built during the fifth-century invasions of Italy on hundreds of small islands off the Adriatic coast, the city looked like none other: canals served as its main thoroughfares, and the surrounding lagoon provided natural fortification. A late sixteenth-century print (Fig. 7.1) presents this watery marvel from a bird's eye perspective, better to admire the city's major features and surrounding ring of islands and marshy mainland. Tall towers, difficult to build on

shifting alluvial soil, mark the city's numerous churches and monasteries, but once again none is taller than the communal tower, which dominates the governmental and religious center of Piazza San Marco at the heart of the city. Just to the left, the Grand Canal, the city's prestigious main waterway, snakes through the most densely populated part of the city in a reverse S pattern, bridged at its midpoint by the famous Rialto Bridge. The naturally protected location and relatively raised elevation of Rialto (riva alta, literally "high bank") attracted the city's first major settlement and eventually became its chief commercial district. As in other cities, a major shopping street from Rialto to San Marco, called the Merceria, connected the poles of commercial, religious, and governmental life. The city's two major industrial districts are located at the top and right of Hogenberg's view: the islands of Murano, center of Venice's renowned glass making facilities, kept separate from the city to diminish the likelihood of fire, and the huge rectangular precinct of the Arsenal, home to the city's shipyards, close to the main shipping lanes.

By the thirteenth century, Venice boasted the most impressive commercial and military fleet in the Mediterranean. Exerting dominion over an empire that made claims as far east as Constantinople (a city that the Venetians sacked, looted, and then occupied with their Frankish allies at the time of the Second Crusade in 1204), Venice was

arguably "lord of quarter and half a quarter of the world." Whenever the Venetians had a chance, they reminded

(above) Rediscovery of the Relics of St. Mark, signed and dated April 22, 1345, commissioned by Doge Andrea Dandolo from Paolo Veneziano and his sons Luca and Giovanni for part of the cover of the Pala d'Oro, St. Mark's, Venice. Tempera on panel

Altarpieces were regularly covered during parts of the year, especially during penitential seasons, although most much more simply than this example.

7.1 Perspective View of Venice and the Lagoon, 1572, commissioned from **F. Hogenberg** for G. Braun, Civitatis orbis Terrarum (Cologne, 1572)

Hogenberg's view is based on a remarkably accurate and enormous $(53 \times 111'' [134.5 \times 281.8 \text{ cm}])$ woodcut view of the city made by Jacopo de' Barbari in 1500.

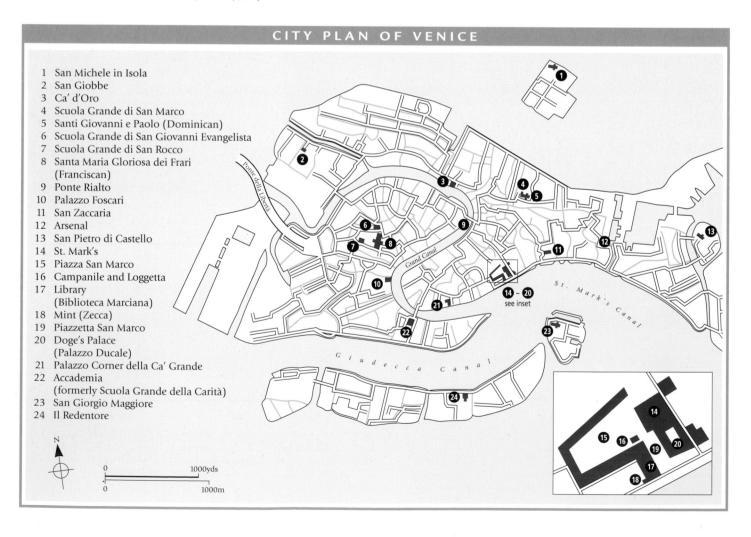

the world that in 1177 their Doge (the elected head of the Venetian government) had presided over the reconciliation of Emperor Frederick Barbarossa and Pope Alexander III, marking Venice as at least equal and perhaps superior to the papacy and the empire. Venetians fashioned their city and its monuments both to reflect and to enhance their status as a world power, incorporating the plunder of their conquests into the fabric of the city as a way of commemorating their victories.

Understandably, standard depictions of Venice show the city with its formal point of entrance from the sea (Fig. 7.2). A visitor arriving by ship would have been greeted by the façade of the Doge's Palace (labeled on a detail of Jacopo de' Barbari's woodcut map of the city as Pala[zzo] Civi[co], "civic palace") with its ceremonial and honorific loggia for the doge at the center of its upper level. Two freestanding columns guard the entrance to the Piazzetta, the name given to the open area flanking the Doge's Palace and leading from the lagoon to the city's main civic space, the Piazza San Marco. They recall imperial commemorative

monuments in Rome and Constantinople and are themselves spoils from monumental ancient buildings on the mainland. A bronze winged lion, symbol of the city's patron saint St. Mark but reworked from a Persian chimera, crowns the column on the right. In 1329 the Venetians paired the lion with a statue of St. Theodore on the other column. The torso of the figure is a re-used fragment from a Roman curaiss statue of a military leader, the spolium used to manufacture an ancient history for Venice. Both fierce images, they stood over an area marked for public executions, leaving little doubt that the Venetian government was committed to maintaining public order. While the columns and their statues form a processional gateway into the city, the statues look toward the city, not toward the sea. They simultaneously direct movement into the Piazzetta San Marco, which moves along the flank of the Doge's Palace to St. Mark's, and confer the city's protection on people leaving the city. Moreover, they were clearly visible to legislators inside the Doge's Palace; an early account indicates that when they saw the lion of St. Mark struck

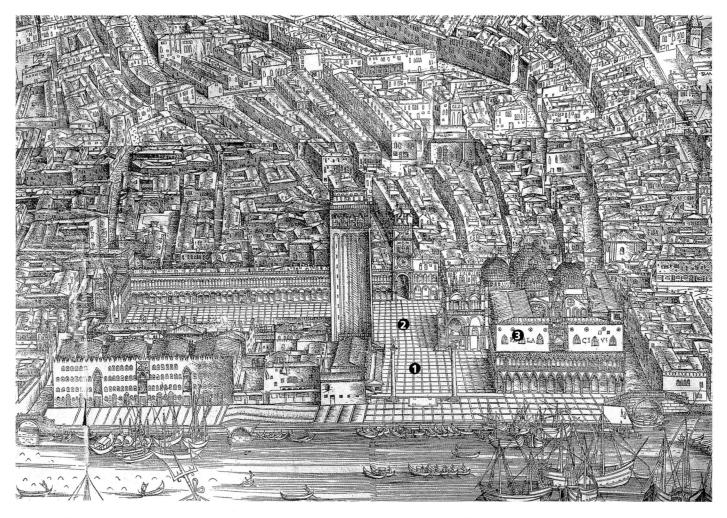

7.2 Map of Venice (detail), 1500, Jacopo de' Barbari, published by the Nuremberg merchant Anton Kolb. Woodcut (Museo Correr, Venice)

¹ Piazzetta San Marco; 2 Piazza San Marco; 3 Ducal Palace

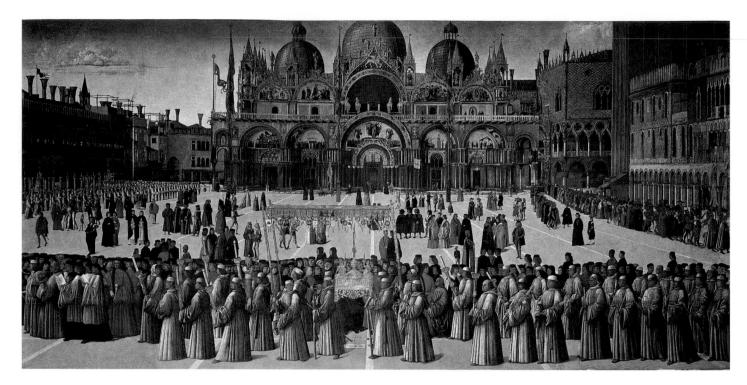

7.3 Procession in St. Mark's Square, part of the cycle Miracoli della Croce, 1496, commissioned by the Scuola di San Giovanni Evangelista, Venice, from **Gentile Bellini**. Oil on canvas, $10'~7'' \times 14'~(3.67 \times 7.45~\text{m})$ (Galleria dell'Accademia, Venice)

St. Mark's is the church structure in the background; the palace of the Procurators is on the left; a corner of the Doge's Palace is on the right.

by lightning during one of their sessions, they took it as a very bad omen indeed.

St. Mark's Basilica

Moving past the columns and the Doge's Palace one encounters St. Mark's Basilica (Fig. 7.3), officially the chapel of the doge, whose palace it adjoined. According to legend, two merchants, called Buono of Malamocco and Rustico of Torcello (names obviously fabricated-the "Good Man" and the "Rustic," from islands in the archipelago owing allegiance to Venice) stole the body of St. Mark from Alexandria in Egypt and carried it back to Venice. In 828/29 they presented their saintly relic not to the patriarch (head of the Venetian Church) but to the doge, thus linking St. Mark inextricably to the state. It was the doge who ordered the construction of the basilica to house the saint's remains; the city's official cathedral is marginalized at the far end of the city beyond the Arsenal.

The flank of St. Mark's which adjoins the Doge's Palace (Fig. 7.4) originally featured a major entrance at its left end (now closed) and a series of war trophies that are still visible on the right. Two square pilasters, traditionally called the pillars of Acre but brought from the abandoned church of St. Polyeuctus in Constantinople as war booty, stand in front of a splendid marble revetment, also pillaged from ancient monuments. A small porphyry group from the fourth century marks the corner of the treasury at the far right. These figures, who represent the Tetrarchs or four co-emperors of the late Roman Empire, had lost their original identifications to legends that emphasized their conspiratorial

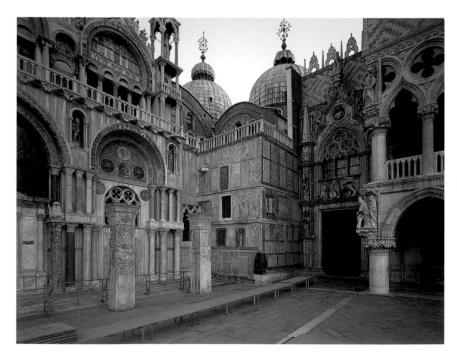

7.4 Pillars of Acre and Four Tetrarchs, view of southwest corner of St. Mark's, Venice

139

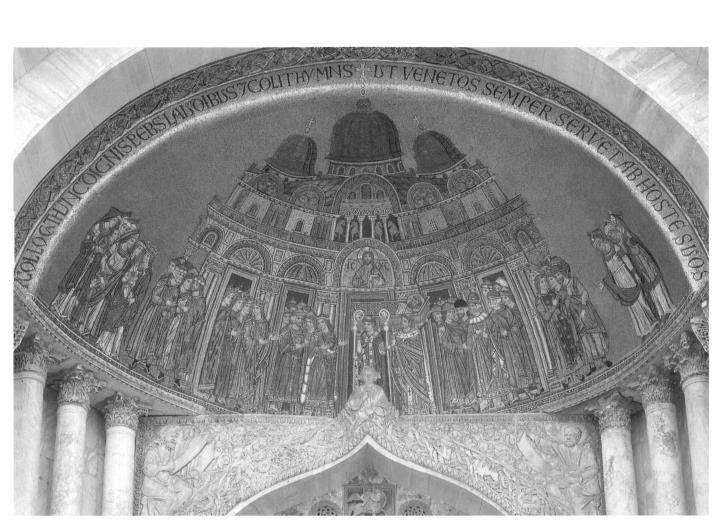

7.5 Translation of the Relics of St. Mark, c. 1270, commissioned by the Procurators of St. Mark's for the left portal of St. Mark's, Venice. Mosaic

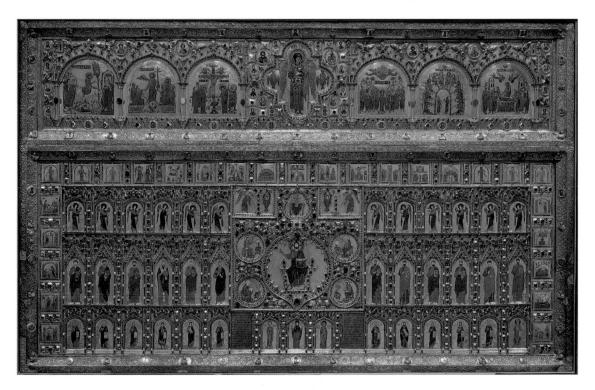

7.6 Pala d'Oro, restored and embellished in 1345 by **Andrea Dandolo** for St. Mark's, Venice. Gold and enamel, $137 \times 55''$ (348 \times 140 cm)

character. As told by the Venetians, one pair plotted against the other and their factionalism led to their mutual assassination. Legend had it that their substantial wealth was inherited by the consensual Venetian state, which preserved it in the treasury of St. Mark's inside the building just behind them. The reused carvings, then, celebrated the triumph of the common good over factionalism in Venice.

Piazza San Marco

Moving in front of the church, the visitor entered one of the largest civic spaces in all of Italy, what Napoleon later called the most splendid drawing room in Europe. Already in the 1160s and 1170s, when most Italian cities had not yet begun a systematic process of creating large, open, communal spaces in their central districts, the Venetians pulled down small houses in front of St. Mark's and covered over pre-existing canals to create the enormous piazza visible in Giovanni Bellini's later representation of the celebration of the feast of Corpus Domini in that space (see Fig. 7.3). In 1266 the piazza was paved, and in 1269 the palace of the procurators, high ranking citizens charged with the embellishment and maintenance of St. Mark's and its surrounding public buildings and squares, was restored, giving a unified façade on the long axis of the piazza.

Dominating the entire space were the exotic forms of St. Mark's Basilica, built between 1063 and 1094. The transferal of St. Mark's relics into the church is represented in a mosaic over the far left portal of the basilica (Fig. 7.5). One of the most accurate architectural representations of the thirteenth century, the mosaic shows the church before it received the elaborate white cresting and tabernacles that have crowned the facade since the fifteenth century. Nevertheless the late eleventh-century church is clearly identifiable. Its central and subsidiary domes link it to the well-known form of earlier Byzantine churches deriving from Constantine's Church of the Apostles in Constantinople, an appropriate model for a church dedicated to St. Mark who was himself an apostle. While the patriarch guides the body of St. Mark into the basilica, the doge, recognizable in his domed red hat and splendid red and gold vestments to the right of center, joins throngs of Venetian leaders who participate in the miraculous event. Some time between 1267 and 1275 a Venetian chronicler, Martin da Canal, cited the mosaic to establish the validity of the basilica's foundation myth: "And if some of you wish to verify that those things happened just as I told you, come to see the beautiful church of St. Mark's in Venice, and look at it in front, because this story is written there just as I have told it to you." Art rivaled the written word as a record of civic traditions.

Local myth and legend also surrounded four ancient lifesized gilt bronze horses, represented clearly over St. Mark's central entrance in the mosaic and in Bellini's painting of the Piazza San Marco (see Fig. 7.3). Plundered from the Hippodrome in Constantinople in 1204 during the Fourth Crusade, the horses evoked a metaphor for the *quadriga Domini*, the chariot of the Lord, which medieval writers imagined as being drawn by the four evangelists, another apt image for a church and city dedicated to St. Mark, one of the gospel writers. Because the horses held pride of place on a platform from which the doge made public pronouncements and the animals were bridleless and thus triumphantly free, Venetians saw them as consummate emblems of their independence and liberty. As military loot they also testified to the success with which Venice defended and extended its power.

It is clear from this civic imagery that Venice looked to Constantinople and the Byzantine east for many of its models. Alone among Italian city states in seeming not to have an actual Roman history, the Venetians formulated myths as fantastical and charming as the city itself. New archaeological excavations ten feet below the ground line of the modern city, however, have revealed Roman streets and traces of other habitation dating to c. 200, sites that were buried as inhabitants of the city continuously built up the islands to escape the encroaching sea. As the old remains of the city disappeared the Venetians replaced the actual and most likely dimly remembered real Roman history of the city with a new mythology of place, claiming another "Rome"-that founded by Constantine in the east-as a model. This model, far more impressive than the modest remains of Roman Venice suggest, simultaneously asserted an ancient history and yet distinguished Venice from other city states in Italy as unique in its classical heritage.

Images of the State and the Individual

Relatively little art survives from late thirteenth- and early fourteenth-century Venice—in spite of the fact that we know that the Venetians spent considerable effort reclaiming land for new neighborhoods, expanding civic shipbuilding facilities, and supporting the new mendicant orders as they gained popularity among the general populace. Painting and mosaics in this period depended heavily on Byzantine prototypes and their style was remarkably resistant to change. In the mid-fourteenth century, earthquakes, flood, famine, and plague, as well as wars with Crete and Genoa, threatened Venice's stability, but the city's political and social structures remained stable: not without reason did Venetians dub their city "La Serenissima"—the "most serene" republic.

Doge Andrea Dandolo

Expanding definitions of the office of doge gave the head of the Venetian state an increasingly powerful and visible role in the city. A key player in this development was Andrea

The Image as Document

In the prologue to the second part of *Les Estoirs de Venise*, a history of the Venetian Republic written between 1267 and 1275, the chronicler Martin da Canal argues for the importance of painted as well as written accounts of events.

I will tell you the deeds and battles that the Venetians carried out in those days [of Doge Ranieri Zeno, r. 1253-68] just as I have recounted the deeds and undertakings of their ancestors because there are many people in the world who would like to know of these things, and this is not possible—for one man has died, a second is dying and a third is being born, and thus one cannot recount to everyone what has happened in those times—unless it is made known to them by means of writing or painting. We see writings and paintings with our eyes, so

that when one sees a story painted or hears a naval or land battle recounted or reads about the deeds of his ancestors in a book, he seems to be present at the scene of battle. And since events live, thanks to paintings and oral accounts and writing, I have undertaken to occupy myself with the deeds that the Venetians have accomplished in the service of the Holy Church and in honor of their noble city.

(from Patricia Fortini Brown. "Painting and History in Renaissance Venice." Art History, 7 [1984]: pp. 263-94 [extract p. 265])

Dandolo (doge 1343–54). A literary scholar (he was a friend of Petrarch's), Dandolo articulated the ideal of the doge as the personification of the Venetian state. In his *Chronica extensa*, a major history of the republic, Dandolo emphasized how individual doges gave glory to Venice. In their accomplishments, the abstract ideal of the ducal office took on concrete, particularized form, newly celebrated by Dandolo.

Enhancements to St. Mark's

The Pala d'Oro

Andrea Dandolo made his concept of the ducal office evident in a major artistic project that built upon the work of several of his predecessors. This was the embellishment of the Pala d'Oro (Fig. 7.6), the great golden altarpiece above the high altar of the doges' own chapel, St. Mark's Basilica. The original altarpiece-perhaps the first of its kind in Western Europe to stand on rather than in front of an altar-consisted of a number of enameled gold panels depicting saints. The Pala d'Oro was commissioned in 976 in Constantinople by Doge Pietro Orseolo I. A later doge, Ordelafo Falier, enlarged the altarpiece in 1105, and yet more panels-including some looted from Constantinople after the Venetians' conquest of that city-were added in 1209. In its present dazzling form, however, the Pala d'Oro dates from 1345, when Andrea Dandolo added a sumptuous Gothic-style gold frame, some new enamels, and an enormous number of pearls and precious stones, including rubies, sapphires, and emeralds. He also added two inscription blocks, commemorating his own contribution and those of his predecessors.

The central figure of the altarpiece, an enthroned Christ, pays homage to the past through its iconic Byzantine pose, but Dandolo's goldsmith, working in the *cloisonné* enamel

technique established in the earlier panels, enhanced the figure with crisply pleated drapery, carefully placed feet, and three-dimensional cast fingers and hands, making the entire figure distinctly more lifelike than the similarly positioned Christ in the earlier mosaics of the Florence Baptistry, for example (see Fig. 4.4). On the *Pala d'Oro* gems and pearls adorn Christ's halo, his throne, and the open book on his lap. Meticulously cast golden leaves and a filigree border in the lozenge around Christ wed flowing Gothic curves to Byzantine splendor.

Dandolo called on Paolo Veneziano (active 1333-58 Venice) and his workshop to provide painted wooden panels to cover the enamels on non-feast days. Paolo came from a family of painters; he is among the first to be documented as an official civic artist. Particularly striking is the panel depicting the rediscovery of St. Mark's relics within the basilica (see p. 135). At the center the doge and the Venetian patriarch kneel before an altar on which stands a small golden polyptych. St. Mark's head and hand emerge from a niche in one of the marble and porphyry piers behind it. Pious crowds of prelates, city officials, and citizens look on, one on the far left leading the gaze of his compatriots with an outstretched arm and hand pointing toward the saint. The precise rendering of the basilica's marble screens, balconies, and apse, its window of leaded glass roundels, and its standing saint in a glowing gold niche suggests that the work served partly as documentation, anchoring the event depicted in a setting immediately recognizable to Venetians.

St. Mark's Baptistry

Dandolo selected St. Mark's Baptistry as his burial site and replaced earlier fresco decorations with mosaics (Fig. 7.7) inspired by Byzantine models. Seated evangelists occupy the entrance arch, while the central cupola bears an image

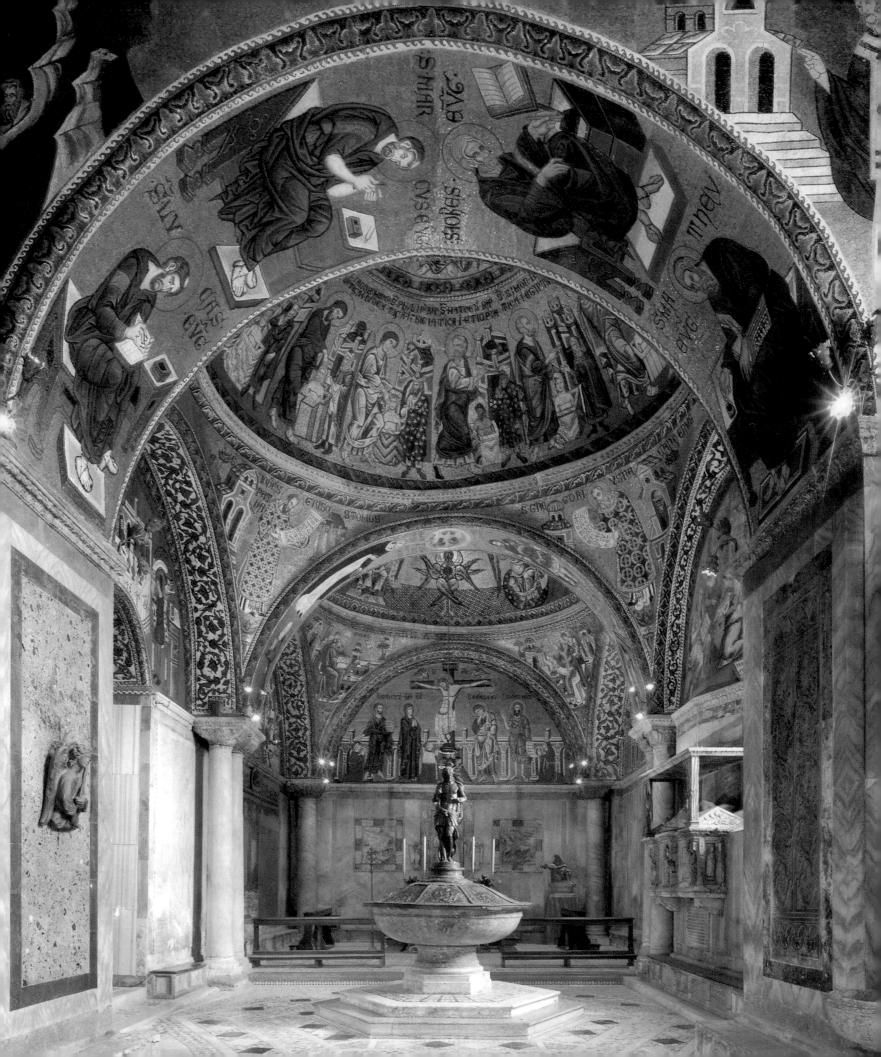

7.7 (opposite) Baptistry, St. Mark's, Venice, 1342-54, mosaics and tomb commissioned by Andrea Dandolo

The bronze baptismal font is a later addition, commissioned from Jacopo Sansovino c. 1545, but produced by his workshop.

of Christ in Glory surrounded by a ring of standing Apostles depicting the *Mission of the Apostles*. Smaller figures next to each Apostle, one submerged to his chest in a baptismal font and the other standing before a miniaturized building, graphically illustrate Christ's command to the Apostles that they preach and baptize. The international theme would have resonated with the Venetians, whose commercial activities and political ambitions extended across the Mediterranean. Scenes narrating episodes from the life of St. John the Baptist on the side walls share the same gold backgrounds and miniaturized settings as the cupola mosaics and the Crucifixion on the end wall, ensuring decorative unity, but the mosaicists turned to more recent models for storytelling, relaxing some of the figures in a manner reminiscent of northern Gothic art.

Dandolo's contributions to the Baptistry were completed by his funerary monument (Fig. 7.8 and see the right side

7.8 Tomb of Doge Andrea Dandolo, before 1354, commissioned by Andrea Dandolo for the Baptistry, St. Mark's, Venice. Marble

The inscription beneath the tomb reads: "This small space of a cold tomb contains the limbs of the valorous one whom the venerable army of virtues never deserted. Tenets for him were probity, judgment, penetrating intelligence, moderation, and deeds of nobility of high renown, and noble work. He secured for the country long-lasting honor for which he is worthy of memory. And because his shining deeds resound to the nations throughout the world, the pen allows the recording of many meritorious things worthy of recounting. Andrea, to whom the noble house of Dandolo gave birth, worthy in every respect of the Venetian state, when the seventh day of September, in 1354, he died." (Trans. Debra Picus)

wall in Fig. 7.7), which he was planning shortly before he died. Unlike the tomb monuments of all his predecessors, Dandolo's tomb celebrates the individual holding the ducal office. It is the first to provide an effigy of the deceased doge and to incorporate other features long seen on important tombs elsewhere in Italy: angels parting a cloth of honor, niches, and narrative reliefs. A lengthy inscription below the tomb is one of the earliest to laud the specific achievements of a doge. The elected nature of the ducal office in republican Venice discouraged any representation of the doge as a living figure comparable to those of absolutist rulers (see Fig. 6.17). Yet Andrea Dandolo's monument marks a bold step in that direction. At the center of the sarcophagus sits an enthroned Madonna and Child, a gentle but persuasive image of authority. The city's traditional founding date of March 25, the feast of the Annunciation, is represented by a statuette of the Angel Gabriel on the right-hand corner of the sarcophagus and one of the Virgin on the left. The effigy of Dandolo, the statuettes, and narratives of the martyrdom of Andrea's patron saints, John the Evangelist and Andrew, are fluidly carved and convincingly threedimensional; originally polychrome decoration made their forms and the lush leafwork around them more vivid.

The Choir Screen

In 1394 the brothers Pierpaolo (active 1383–1403 Mantua, Bologna, and Venice) and Jacobello dalle Masegne (active 1383–c. 1409 Mantua, Bologna, and Venice) finished a new choir screen for the basilica (Fig. 7.9). Sons of a Venetian stonemason, they seem to have been aware of contemporary developments in Tuscan sculpture as well as local traditions in Venice. An inscription indicates that Doge Antonio Venier, who ruled for the unusually long period of eighteen years (1382–1400), along with two of the officers responsible for oversight of the building, chose the brothers and were the sponsors of the project.

The general arrangement of the choir screen, with its paneled balustrade, columnar supports, and surmounting figures of Apostles, conforms to local traditions. The creative challenge for the dalle Masegne was to enhance the traditional composition in such a way that the new screen was both more splendid than its predecessor and still harmonious with the rest of the basilica. The screen echoes the basilica's marble-faced walls with geometric inlays, attached columns (in the lowest level), and broad horizontal bands of decoration. The spiritual intensity of the standing Apostles in the much earlier mosaics above animates the statues on the top of the screen. Their taut, thin form and almost metallically bright, crisp finish also evoke the previous metalwork of liturgical vessels, reliquaries, and the famous Pala d'Oro (see Fig. 7.6) glimmering behind them. At the same time, the statues are more lifelike in pose and demeanor than earlier works, encouraging emotional and psychological engagement with the mourning Virgin and 7.9 (right) Choir screen, 1394, commissioned by Antonio Venier with Pictro Cornaro and Michele Steno, Procurators of St. Mark's, from Pierpaolo and Jacobello dalle Masegne for St. Mark's, Venice

The crucifix over the center of the screen is a work in silver; the flanking statues are carved from marble. An inscription states that the work was made "in the time of the excellent lord Antonio Venier, by the grace of God, Doge of Venice, and of the noblemen the lords Pietro Cornaro and Michele Steno, honorable procurators of the blessed and most holy church of the Evangelist St. Mark."

7.10 (below) Choir screen (detail of the Virgin, Crucifix, and St. John), 1394, commissioned by Antonio Venier with Pietro Cornaro and Michele Steno, Procurators of St. Mark's, from Pierpaolo and Jacobello Dalle Masegne (Virgin and St. John) and Jacopo di Marco Benato (Crucifix) for St. Mark's, Venice. Marble (Virgin and St. John) and silver (Crucifix)

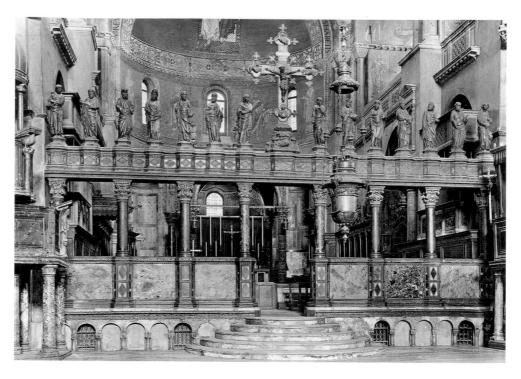

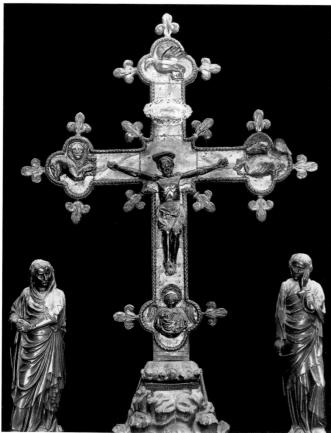

St. John flanking the more iconic silver Crucifix at the center (Fig. 7.10). The Virgin wrings her hands in grief and turns her head away from her son. Her forehead, eyebrows, and eyes bend and stretch in anxious tension, as do those of St. John, who, hand to his face, expresses a quieter but just as intense sorrow.

The Façade

On the exterior of St. Mark's the Venetians added spiky columnar tabernacles to the upper edges of the north (left) façade, continuing these around all three of the exposed façades (see Figs. 7.3 and 7.5). This Gothicizing sculptural embellishment, begun in 1384, continued into the 1420s. Local Venetian carvers were joined by sculptors from Tuscany and Lombardy, all of whom submerged much of their individuality for the benefit of the overall scheme. The addition of these tabernacles may have been suggested by the fact that the corners of St. Mark's were already marked by open two-story porches with attached columns on the lower level and by similar smaller structures at its upper corners. Economically building on pre-existing forms, the Venetians thus validated tradition even as they embraced innovation. The tabernacles epitomize Venetian Gothic exuberance, with their gracefully poised, cone-shaped roofs, each encircled with a corona of decorative, flame-shaped crenellations. Similar canopied tabernacles were inserted into the depressions between each arch of the façades. As was the custom on church façades throughout Europe, and also on many royal and noble tombs, figural sculpture occupied these airy perches. The Venetians also added Gothic peaks of billowing marble fronds over the rounded crowns of the brick walls. Bust-length prophets, many holding elaborately twisted and flapping banderoles, rise from every other crest. The Venetians showed themselves adept in employing fashionable Gothic forms without, however, having to sacrifice any of the pre-existing structure or accumulated decoration. Even the coverings over the domes, rebuilt after a fire in 1419, retained their unmistakably Veneto-Byzantine character when they were raised to a

greater, more stylish height and capped with fanciful little cupolas resembling inflated parachutes. Paradoxically, this building, with its idiosyncratic mixture of Byzantine and Venetian Gothic styles, achieves a sense of imminent levitation that many a purely Gothic church, despite flying buttresses and soaring vaults, fails to equal.

The Church of Santi Giovanni e Paolo

Andrea Dandolo was the last doge to be buried in St. Mark's. Many of his successors (twenty-five of them) chose instead the church of Santi Giovanni e Paolo (Fig. 7.11), making this Dominican church (whose name is commonly shortened to San Zanipolo in the Venetian dialect) the third major focus of civic ritual after St. Mark's and the Doge's Palace. The church was begun around 1333, and the crossing and apse must have been complete by the early 1360s, when Giovanni Dolfin (doge 1356-61) was buried in a tomb on one of the side walls of the choir. In its spaciousness and lofty vaulting, the church resembles others built by and for the Dominicans, such as Santa Maria Novella in Florence (see Fig. 4.10). In Venice, however, the vast open space is especially remarkable given the wet, sandy subsoil on which it had to be built. Although mainland models inspired the soaring nave arcade, cross vaults, polygonal apse (with complex window tracery), and transept chapels,

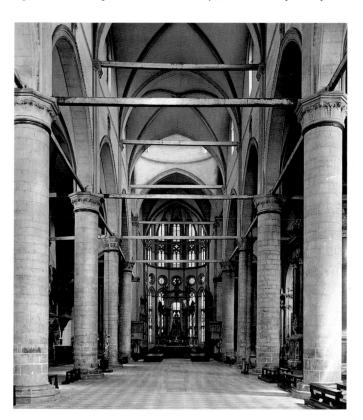

7.11 Santi Giovanni e Paolo, Venice, begun c. 1333, commissioned by the Dominicans

local structural compromises included building both the piers and the outer walls of relatively lightweight brick rather than stone, the vaults of wood, and tying the entire structure together with an insistent grid of wooden beams at both the height of the capitals and the springing of the vaults. A Byzantine-style dome was later added over the crossing to stress Venetian traditions, but the overall impression is Gothic spatial expanse, a testament to the strong influence of northern artistic models and international expectations that mendicant churches should be suitably large to accommodate their increased following.

The Tomb of Doge Michele Morosini

Santi Giovanni e Paolo provided a splendid setting for ducal funerary monuments. The tomb of Doge Michele Morosini (died 1382) is a multi-media extravaganza of marble, mosaic, and fresco well suited to the enormity of the chancel wall on which it hangs (Fig. 7.12)—and a testimony to the possibilities opened earlier in the century by the tomb of Andrea Dandolo (see Fig. 7.8). Morosini's body lies in state under a marble tabernacle whose architectural

7.12 Tomb of Doge Michele Morosini, 1382, commissioned by the Morosini family for Santi Giovanni e Paolo, Venice. Marble, stone, mosaic, and fresco

forms were repeated in a towering fresco behind it. Where earlier doges had shunned self-celebration, Morosini's body is tipped toward the viewer and his face is carved of glowing Carrara marble that contrasts with the duller local stone used for his body and clothing. In the lunette he and his wife appear kneeling and being recommended by their patron saints to Christ, the Virgin Mary, and St. John. This subject had appeared on painted panels in earlier ducal tombs and on the back wall of the Baptistry at St. Mark's, where Dandolo was buried, but never before had the costly medium of mosaic been used directly on a ducal tomb, evoking St. Mark's and all the power and prestige with which that monument was invested. As we shall see, the fictive niches, piers, and spires of the fresco behind his tomb had further civic resonance insofar as they recalled the similar structure of frescoes in the Doge's Palace, where the doge sat enthroned (see Fig. 7.17).

The Doge's Palace

In 1340 the Venetian Senate decided to rebuild a large portion of the Doge's Palace (Fig. 7.13) so as to provide more ample space for gatherings of the Great Council. Like the church of San Zanipolo and the *Pala d'Oro*, the palace

displays many Gothic features-in this case, notably, the rich arcading on the first two storeys. Above, a taut skin of interlocking, diamond-patterned pink and white stone further softens any appearance of weight and mass. At the roof line, the usual severe crenellations are replaced by fanciful flames of white stone. The effect is exotic and may owe some of its flavor to Islamic precedents, of which the seafaring Venetians would have been well aware. Venetian Gothic is well-laced with Eastern luxury. Reversing normal expectations of a heavy ground story to support less weighty areas above, the open arcades suggest a levitated structure in which light and air move around freely even at the corners, where a slightly enlarged pier deftly provides the necessary feeling of stability. The building is a visual tour de force, celebrating the confident Venetian state and the security of its maritime site. The date of 1344 inscribed on one of the ground floor capitals indicates that work moved ahead under Doge Andrea Dandolo. Just what the building looked like by the time he died, however, is highly debatable. The structure was still unroofed in July 1348 when the Senate ordered the building to be covered and debris to be hauled away. Five days later, the project was cut short by the onset of plague. Work resumed in February 1350 and must have been completed by 1365.

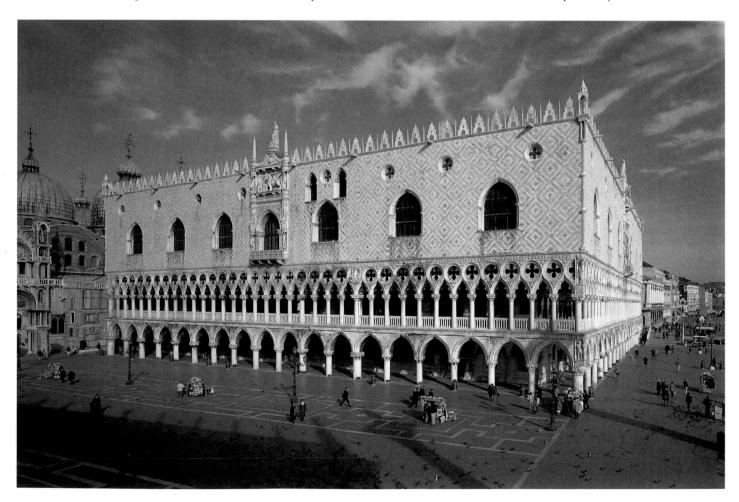

7.13 Doge's Palace, Venice, 1340-1438 (extension toward St. Mark's begun 1424), commissioned by the Venetian government

Santo Stefano

The attractiveness of the Doge's Palace to Venetian patrons is evidenced by its imitation—in both stone and paint—in other buildings. An example of simulated stonework can be found in the Augustinian church of Santo Stefano (Fig. 7.14). Exact dating of the structure of the church is uncertain, though it was evidently restored and expanded in the early fifteenth century. Painted diaper patterns of repeated geometrical units on the upper walls evoke the real stone patterns on the Doge's Palace. Bands of florid leaf work, painted in grisaille (grey and white) to resemble unpainted stonework, follow the nave arcade, mimicking another key civic monument, the renovated facade of St. Mark's. Above each cusp ride bust-length figures of exemplary Augustinians holding fluttering banderoles. Thus the decoration, in its economy, suggests monastic poverty while still underlining ties to the Venetian state.

The church's wooden ceiling is also characteristically Venetian, though few other examples have survived centuries of fires and renovation. Resembling the inverted keel of a large boat, it reflects local expertise in ship building and provides an elaborately profiled but relatively lightweight covering which respects the structural difficulties of building in this island city. Its apparent **coffering** (that is, its division into small square panels) is also carried out in

7.14 Santo Stefano, Venice, c. 1407, commissioned by the resident Augustinian friars

Most of the architectural decoration of this interior is painted, not carved.

paint rather than three-dimensionally, an excellent example of how patrons without a great deal of money could create effects emulating the city's more expensive and prestigious monuments.

Sculpture on the Doge's Palace

Sculpture populates all the capitals on the lower story of the Doge's Palace and marks its exposed corners. As in the reliefs on the Campanile of Florence's Duomo (see Fig. 4.29), the capitals narrate scenes from sacred history and celebrate the city's economic life. Sculptural groups placed at the corners are far more admonitory, commemorating human weakness and frailty, the rationale for the establishment and rule of government. At the near corner stand Adam and Eve with the Archangel Michael hovering over them in the story above (Fig. 7.16). Michael is both a judgmental and hopeful image. He expelled Adam and Eve from the garden and will weigh human souls and mete out punishment at the end of time, but he also leads the chosen to paradise. As such, he is a singularly effective exemplar of civic order and justice. His flattened, iconic form, familiar in such iconography, contrasts markedly with Adam and Eve below. Their bodies are convincingly three-dimensional,

7.15 Drunkenness of Noah, 1340s, commissioned by the Venetian government for the Doge's Palace, Venice. Istrian stone

Noah's third son is depicted on another relief across the arch to the right (not visible in this illustration).

and the sculptor has paid close attention to the structure of their legs. Their faces, fashioned with the tight features of contemporary German sculpture, express clear-sighted self-awareness that is manifest, too, in their raised right hands, more gestures of warning than responses to their own temptation. The trunk of the Tree of the Knowledge of Good and Evil, which effectively marks the edge of the building, joins them in a single composition; its sprouting branches cover the first couple's genitals and provide them with shade.

A complementary image of the *Drunkenness of Noah* (Fig. 7.15) appears at the far end of the lagoon façade of the Doge's Palace. The three-quarter relief is divided into two planes by a sturdy grapevine which undulates back and forth, again playing along the limits of the virtual corner of the building. At the left is the drunken figure of a slightly under-life-sized Noah, whose limp right hand spills the wine that has inebriated him. To the right, one son covers his naked father and begs indulgence for him, while the other gestures disapprovingly to his own eyes and the drunkenness of his father. The soft, fleshy body of Noah, the intricate carving of the vine, and the sturdy portrait-like presence of Noah's sons are so compelling that the relief

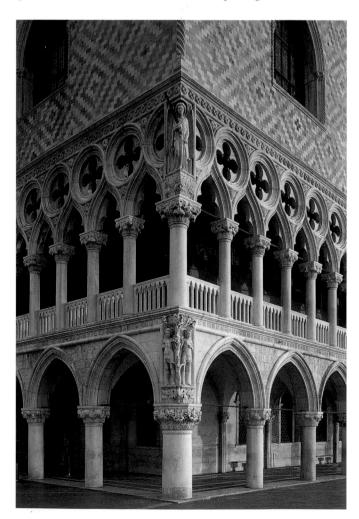

7.16 Adam and Eve; Archangel Michael above, 1430s, commissioned by the Venetian government for the Doge's Palace, Venice. Istrian stone

has sometimes been given a much later date, well into the early fifteenth century. Recent studies, however, have noted convincing similarities between this group and smaller figures on the capitals of the building's lower arcade dating from the 1340s. Also at this time, Lombard sculptors in Verona were creating highly complex sculptural groups (see Fig. 9.9). Venice and some of its north Italian neighbors stood in the vanguard of sculptural production, probing psychological states and modeling their figures with remarkable realism.

Painting in the Doge's Palace

To decorate the interior of the palace's Great Council Chamber, the Venetian Senate turned in 1365 to Guariento di Arpo (active 1338; dead by 1370), an expert in fresco who had worked for the Carrara family in Padua and at the Church of the Eremitani there. Guariento's imposing Coronation of the Virgin (Fig. 7.19) was irreparably damaged by fire in 1577, but the general composition can still be made out in fragments that were found behind Tintoretto's huge replacement painting of Paradise (see Fig. 21.40) and that were then removed to another room, where they can now be seen. Still impressive in its size (over 70 by 20 feet [21.3 by 6 meters]) the fresco must have had a tremendous impact in its pristine state and its dominant position on the end wall of the Great Council Hall. As a key civic image, it was, like Simone Martini's Maestà in Siena (see Figs. 5.24 and 5.26), copied many times for commissions in Venice and on the mainland. One of the best preserved of these copies is a panel by Jacobello del Fiore (active 1400-39 Venice) for the Ceneda Cathedral commissioned by the Venetian nobleman and bishop Antonio Correr, who kneels at the very bottom of the composition (Fig. 7.17). Both Guariento's original and Jacobello's copy are multi-tiered extravaganzas, spreading out from an elaborate double Gothic throne containing the figures of Christ and the Virgin, an image of authority with clear roots in papal Rome. Fiery winged angels surround the upper part of the throne while other music-making angels occupy marble choir stalls in the flaring substructure, turning their heads and bodies up towards the four evangelists who sit in front of traceried niches; predictably, St. Mark occupies pride of place directly below the Virgin and to Christ's right. Rank upon rank of other civic saints, clearly identified with banderoles, fill the outer reaches of the composition.

The subject is the same as Jacopo Torriti's thirteenth-century composition at Santa Maria Maggiore in Rome (see Fig. 2.6) and reminiscent of Nardo di Cione's *Paradise* in the Strozzi Chapel in Florence (see Fig. 8.3). But Guariento has enlivened the scene with Christ reaching across the niche to crown the Virgin and by the spectacularly undulating forms of the architectural elements. Heaven is alive with energetic forms. In Venice the image carried particular force because the Virgin was understood not only as a protectress of the

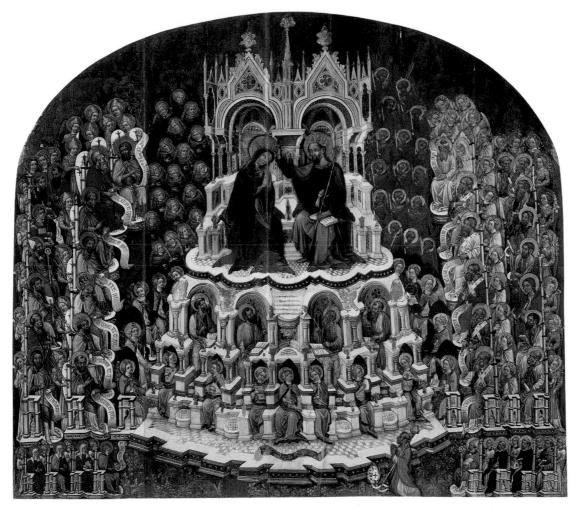

7.17 Coronation of the Virgin, early fifteenth century, commissioned by Bishop Antonio Correr from **Jacobello del Fiore** for Ceneda Cathedral. Panel, 9' 2%" × 9' 11" (281 × 302 cm) (Galleria dell'Accademia, Venice)

7.18 Enthroned Justice Flanked by St. Michael the Archangel and the Angel Gabriel, 1421, commissioned by the Magistrato del Proprio from **Jacobello del Fiore** for their offices in the Doge's Palace, Venice. Panels with gold work; Justice 6′ 9½" × 6′ 4½" (2.08 × 1.94 m), Gabriel 6′ 9½" × 5′ 4″ (2.08 × 1.63 m), Michael 81½ × 52½" (208 × 133 cm) (Galleria dell'Accademia, Venice)

Government offices regularly contained paintings the subject matter of which encouraged officials to act wisely and diligently. The crowned Justice says: "I shall obey the admonitions of the angels and the words of Holy Writ, dealing gently with the devout, angrily with the wicked, and proudly with the vainglorious". Gabriel's scroll at the right carries the following message: "My voice [brought] the message of peace to the Virgin's birth; she entreats you as a leader in troubled matters." Michael the Archangel's scroll at the left reads: "Punishment to crime, worthy rewards to virtues, and he gives to me purged souls with kindly lance."

7.19 Coronation of the Virgin, 1365, commissioned by the Venetian government from **Guariento** for the Great Council Hall of the Doge's Palace, Venice. Fresco (anteroom to the Great Council Hall)

state but as its very embodiment. Her purity was seen as analogous to Venice's unblemished history of independence, and the authority given to the Queen of Heaven was understood as a representation of divine favor and authority awarded to Venice itself. A typically Venetian *Annunciation* bracketed Guariento's composition and bust-length portraits of the doges around the Council Chamber complemented the main work.

As an official state painter, Jacobello del Fiore received the respectable salary of 100 ducats a year from the Venetian government. His commissions, which extend well into the fifteenth century, cloak traditional subjects in the new International Gothic Style (see pages 194–199 in Milan for a discussion of these developments), documenting the continuity of official subject matter in the face of stylistic change. In 1421 he painted an *Enthroned Justice Flanked by St. Michael the Archangel and the Angel Gabriel* (Fig. 7.18) for the offices of the Magistrato del Proprio, the civil and criminal court in the Doge's Palace, where it hung above the judges' benches, confirming and enhancing their juridical

authority. The panel is extraordinarily lavish, a painted counterpart to the recently completed sculptural extravaganza above the façades of St. Mark's (see Fig. 7.3). Jacobello turns and twists drapery and banderoles even more voluptuously than on the façades. He also employs richly worked gilt *pastiglia* (raised plaster detailing) on the armor and breastplates of all three figures, making them stand out from the surface in glittering relief.

Jacobello's painting conveys a clear message equating Venice with Justice, a point made explicit by three long inscriptions accompanying each of the figures. Justice is seated in a rigid iconic pose familiar from images of law and power (see Fig. 5.28) and flanked by the lions of St. Mark/Venice, here further referenced to the throne of Solomon which was supported by lions. The Angel Gabriel, holding a lily on the right, turns and gestures toward the figure of Justice, who in Venetian eyes was identified with the Virgin Mary and with Venice itself; thus the angel's gesture is a reminder of Venice's legendary founding on the Feast of the Annunciation. His banderole terms the

Virgin birth as "a message of peace" and implores her for guidance in difficult situations. St. Michael, present in sculptural relief on the outside of the building (see Fig. 7.16), holds a set of scales like the central figure and asks Justice/Venice/the Virgin to award damages or inflict penalties according to the merits of each case, recommending purified souls to her benevolence and balanced decision.

Accompanying Guariento's Coronation, an image of authority with clear roots in papal Rome, were twenty-eight frescoes recounting the stories of battles between Pope Alexander III and the Emperor Frederick Barbarossa, who were reconciled by Doge Sebastiano Ziani in 1177. This cycle of paintings showing Venetian superiority to the popes and emperors was destroyed by the fire of 1577. The documentary record regarding the slowly executed project is quite slim, and only drawings and sketches suggest the details of some of its compositions. Still, the project is worth examining, for it offers important insights into Venetian ways of thinking about narrative art in this governmental setting.

A drawing (Fig. 7.20) has been convincingly linked with scenes commissioned between 1415 and 1422 from the young painter Pisanello (Antonio Pisano; c. 1395 Pisa or Verona-1455 Rome?), who had received his training in Verona. As Guariento had done in his Coronation, Pisanello gave the event depicted-Emperor Frederick Barbarossa being implored by his son for peace—an elaborate setting. The complicated set of arches and balconies recalls the tradition of architectural rendering in late fourteenth-century Paduan paintings by another Veronese-trained artist, Altichiero da Zevio (active 1369-84; see Fig. 9.21). The main action and naturalistic placement of the figures also conforms to relatively recent Paduan precedents, but in essence the scene corresponds person by person to what can be reconstructed of the same scene in an earlier cycle in a chapel in the palace. The action in each painting centered around the seated emperor stretching out his arm to the left in response to his son's entreaties for peace. Two secular figures and one in monastic dress accompanied them in both cycles. The consistency from one image to the other emphasized the historical accuracy of the representation and made the subject recognizable-much as artists portraying the Nativity or other well-known biblical subjects usually arranged their figures in set, familiar patterns.

It is clear that Venetian art of the fourteenth and early fifteenth centuries was both conservative and progressive. Subjects and even compositions were repeated happily, enlivened with touches of Gothic decorative modernization. In a city as conscious of tradition as Venice, innovation was not always a positive value; rather, established forms and familiar subjects wielded substantial influence and power, providing enduring meaning and significance.

7.20 Emperor Frederick Barbarossa Receiving the Entreaties of His Son for Peace, c. 1409–15, drawing reflecting composition of commission by the Council of Ten to **Pisanello** for the Great Council Hall, Doge's Palace, Venice. 10½ × 7½″ (27.5 × 18.4 cm) (Sloane Collection, © British Museum, London, drawing number 5226–57v, London)

Pisa and Florence: Morality and Judgment

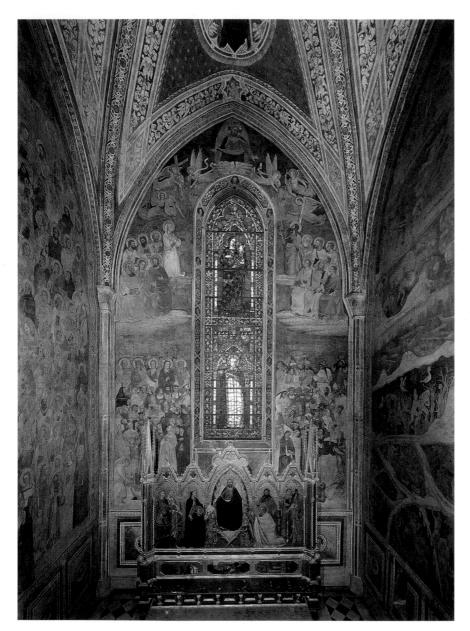

The second half of the fourteenth century in Tuscany did not see the formidable stylistic innovations that characterize the art of the early years of the century. The reasons for this apparent leveling off of artistic energy are embedded in the social fabric of the culture and the needs of patrons. Bankruptcies in two leading Florentine banking houses, drought and famine in the middle years of the 1340s throughout Tuscany, the onset of the Black Death

in 1348 and its repeated recurrence, a papal interdict against Florence, and the revolt of the city's wool workers in 1378 all delivered shocks to the social order. Nonetheless the actual structures of the Tuscan political order remained remarkably resistant to change through the fourteenth century. Colossal unfinished building projects like the cathedral and the church of Santa Croce in Florence, initiated at the end of the thirteenth century, still dominated the city and challenged the patronage of civic leaders. Buildings required sculptural and painted decoration to give precision to their meanings and form to the myths that lent individual city-states their distinctive character. Both their programs and style were often informed by the rigorous intellectuality of the Dominican order.

The Camposanto Frescoes in Pisa

Extensive decorative programs begun in Pisa in the 1330s were made possible by Pisa's wealth as a major shipping power. Foremost among them were the frescoes of the Camposanto ("holy field"), the enclosed burial ground adjacent to the cathedral, which tradition claims contains earth brought from the Holy Land, thus making it literally a holy field. Strong Dominican influence over the University of Pisa determined the theological content of the Camposanto frescoes since the Dominicans apparently assisted in devising their program. Although the site was heavily

damaged during the bombings of World War II, enough remains of the frescoes on the walls of the portico which surrounds the interior courtyard of the Camposanto—much like a cloister—to assess their importance. The earliest of them depict the story of the Passion of Christ, the *Triumph of Death* (Fig. 8.1), and the *Last Judgment* (Fig. 8.2)—fitting themes for a burial ground. Although these frescoes have been attributed to Francesco Traini (active 1300s Pisa),

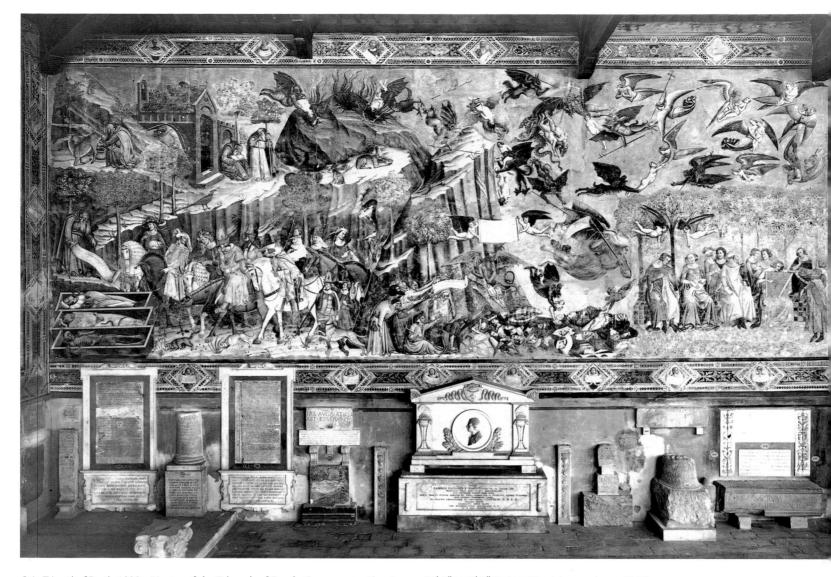

8.1 Triumph of Death, 1330s, Master of the Triumph of Death, Camposanto, Pisa. Fresco, 18' 6" × 49' 2" (5.64 × 15 m) (state prior to 1944)

a local painter trained in Sienese workshops, and to Buffalmacco (active 1315–36 Pisa), a painter known more through literary texts than through any documented work, there is little secure evidence to support these claims.

The *Triumph of Death* is painted on a wall facing a short axis of the loggia. Since it is the same width as the loggia, the fresco is a framed focal point of attention as one moves through the space; it must have been considered an important image within the overall program. To the left of the *Triumph of Death* is a Crucifixion, a juxtaposition indicating that the frescoes in this corner of the Camposanto form a narrative of salvation. The *Triumph of Death* is an extraordinary mixture of disparate scenes, few of them ostensibly about death. A riding party of noble men and women occupy the left front plane; since they face left they are oblivious of the maimed peasants at the lower center of the fresco. Elsewhere in the picture hermit monks, a group of courtiers

and musicians, and flying angels and demons seem unaware of each other. There is little or no attempt at either compositional or narrative unity. Yet the individual scenes and characters are powerful, the work of an artist with both vision and skill.

Close reading of the fresco indicates a wealth of meanings and metaphors. The courtly group of men and women on horseback in the left foreground of the painting have encountered three dead bodies lying in coffins. The artist's concern for naturalistic detail is typified by the male rider who holds his nose because of the offensive odor of the corpses, each in a different state of decomposition. These figures represent an old visual and literary tradition in which the living are forced to confront their own mortality by an encounter with death. This theme is made didactically clear by the appearance of the hermit saint Macarius, at the very left of the composition; he holds out a scroll with an inscription that translates: "If your mind will be well aware, keeping here your view attentive, your vainglory will be

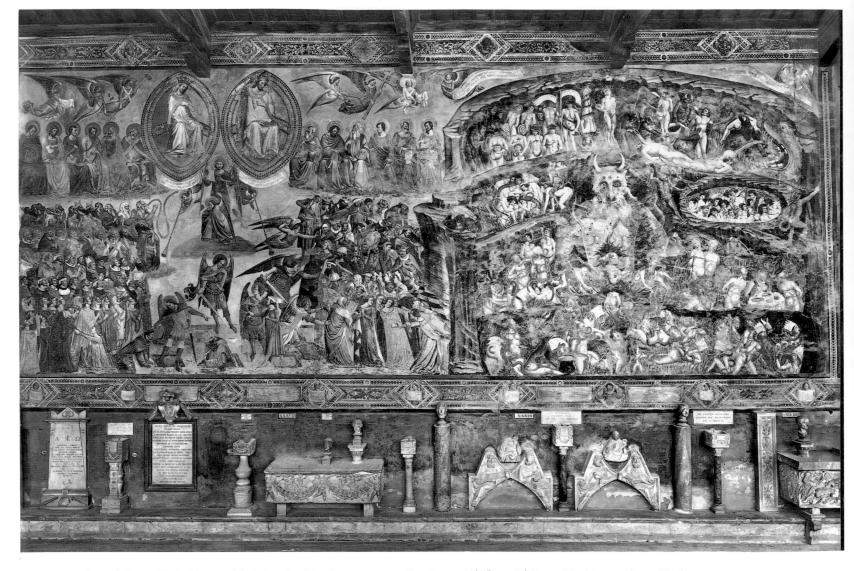

8.2 Last Judgment, 1330s, Master of the Triumph of Death, Camposanto, Pisa. Fresco, 19' 8" x c. 50' (6 x c. 15 m) (state prior to 1944)

vanquished and you will see pride eliminated. And, again, you will realize this if you observe the law which is written."

The juxtaposition of St. Macarius and the hunting party indicates that despite the naturalism and descriptive coloring of the figures, a moral allegory—not a simple narrative—is being presented here. Behind and above the band of aristocrats a group of hermits—praying, meditating, and milking a doe—occupy a peaceful hillside retreat, where even the falcon and the rabbit seem to coexist in harmony. The tranquil hermits, who spend their lives preparing for salvation, are clearly meant to be read in contrast to the surprised nobles who evidently—given their startled reactions to the corpses before them—have given little thought to death and the afterlife.

Just to the right of the maimed peasants at the center of the painting lies a heap of dead bodies, whose ascending souls are being fought for by hosts of flying demons and angels. A female figure of Death carrying a scythe lunges vengefully toward a serene party of courtly figures seated in an orange grove, listening to a musician playing a psaltery. While Death prepares to destroy their insouciance, the crippled peasants at the center beg to be freed from their earthly miseries. Their words appear on banderoles that they hold: "Since prosperity has completely deserted us, O Death, you who are the medicine for all pain, come to give us our last supper!" Death, then, is seen as merciful as well as vengeful.

Landscape plays an important metaphorical role in the fresco, one aspect representing virtue, the other vice. The hermits' landscape is severe and rocky, one of retreat and asceticism. By contrast, the courtiers' landscape, at the right, is luxuriant, with its carpet-laid ground and fruit-bearing trees. One is a landscape of prayer, the other a landscape of pleasure. Moreover the courtiers—arranged flatly over the surface in a row, different from the narrative at the left of the fresco—are given attributes that allow us to read them as a collective symbol of the sin of "luxury," or lust. The central woman, dressed in a pink gown, holds a lap dog,

a slang reference, linguistically, to female genitalia, while the men hold hunting birds, a well-known and popular phallic reference since the term for bird was used colloquially to refer to the phallus in medieval Italian (and other European languages), as it is now. Comparable scenes of lovers are often depicted on contemporary luxury objects such as ivory combs and cosmetic boxes, attesting to the familiarity of such iconography at this time. The complex warnings against luxury and lust as impediments to salvation in this fresco seem aimed at the wealthy Tuscan banking and mercantile class. At this same time the new mendicant orders, the Franciscans and Dominicans, were focusing attention on holy voluntary poverty, recalling the asceticism of the early Church Fathers.

The fresco immediately to the right of the Triumph of Death is an extraordinary Last Judgment (see Fig. 8.2) in which the entire right half of the painting is given over to a representation of hell. Christ, in contrast to his frontal pose usual in depictions of the Last Judgment, is here shown turning toward the damned. His left hand points to the wound in his side, a gesture recalling Thomas's placing of his hand in the wound as a proof of Christ's resurrection and thus of the possibility of salvation for all humans. Christ is accompanied in a paired mandorla by a figure of the crowned Virgin, who represents Ecclesia, the institutional Church, just as she does in Torriti's mosaic in Santa Maria Maggiore in Rome (see Fig. 2.6). Here, too, the crowned Virgin/Ecclesia appears as co-regent with Christ. This powerful image conforms to the teaching that the papacy was the absolute power within the institutional Church—a tenet vigorously supported by the Dominicans and suggests Dominican influence in this series of frescoes.

The part of the fresco representing hell has areas that also suggest Dominican intervention in support of orthodoxy and of the power of a united Church. Although most of the inscriptions that originally identified the figural groups in hell have worn away, two at the top left of the image read "Antichrist" and "Niccolo"; the figure identified as Niccolo is being hacked to pieces by demons and is further described by an inscription indicating that he loves Muhammad. These two figures have been identified as the prophet of Islam, Muhammad, and the antipope, Nicholas V, the latter having visited Pisa in 1328. The Pisans supported the Avignon papacy and therefore regarded the Rome-based rival claimants, of which Nicholas V was one, as schismatic. Nicholas's debased presence in this fresco is a further sign of orthodoxy. The catalogue of sins represented by horrifically tortured figures cascading over the wall, each punishment duly identified with an inscription, has the same scholastic completeness to it as Dante's narration of the fate of the damned in the Inferno. This detailed and didactic representation of hell may indicate an academic religious figure (possibly the Dominican friar and poet Fra Domenico Cavalca, of the convent of Santa Caterina in Pisa) as an advisor for the painting.

Santa Maria Novella in Florence

Just as the Dominicans had influenced the development of the arts in Pisa, so also did they provide an environment for some of Florence's most extensive projects of the late 1300s. The transept and surrounding altars of their church of Santa Maria Novella, although begun at the same time as the Franciscans' Santa Croce, apparently took longer to complete. It was only in the mid-fourteenth century that the sanctuary and the chapel at the north end of the transept were complete and ready to receive their decoration (see Fig. 4.11), long after Giotto and Taddeo Gaddi had completed their major fresco cycles at Santa Croce.

The Strozzi Chapel

At the north end of the transept two brothers who were heads of a very large and active workshop, Andrea di Cione-known as Orcagna (active 1343/44-68 Florence)and Nardo di Cione (active 1343-66 Florence), provided the altarpiece and frescoes for the Strozzi Chapel, one of the most important decorative programs of its time. The Strozzi Chapel (see p. 152) looks today much as it did when it was completed in 1357. It is raised over what had originally been the communal burial ground for the Dominican friars affiliated with Santa Maria Novella and it is dedicated to St. Thomas Aquinas, arguably the most important Dominican saint after Dominic himself and St. Peter Martyr. The codifier of Church theology and a leading figure in the philosophy of scholasticism, Thomas had been canonized in 1323. This chapel provided an important opportunity for an exposition of Dominican thought.

The wall facing the entrance to the chapel is divided vertically by a large central lancet window whose stained glass shows a standing Virgin and Child, the primary devotional image of the Dominicans, and, below them, a standing figure of St. Thomas Aquinas. The frescoes on this wall depict the *Last Judgment*, with Christ appearing at the apex of the window arch. Below him are the Virgin and St. John the Baptist with the Apostles, whose preaching and proselytization the Dominicans, also known as the Order of Preachers, emulated. To the left of the window on the lowest tier of the fresco are the haloed elect and on the right the tormented figures of the damned.

Dominican commitment to orthodoxy, order, and the institutional Church is evident on the left wall of the chapel. There a *Paradise* (Fig. 8.3) shows the elect arranged row upon row, around and beneath the figures of the enthroned Divinity and the Virgin. Both figures are crowned; the figure of God even holds a scepter. In this configuration the Virgin—or metaphorically, Maria Ecclesia (the Church)—shares unmistakably the power of the Godhead on the model familiar from Roman thirteenth-century mosaics (see Fig. 2.6). Tellingly, at the bottom right of the fresco an angel leads a female donor figure into the

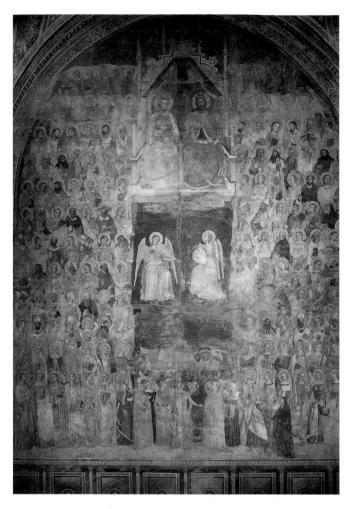

8.3 *Paradise*, c. 1355, **Nardo di Cione**, Strozzi Chapel, Santa Maria Novella, Florence. Fresco

ranks of the elect in Paradise, not unlike the image of Mona Vaggia Manfredi in Taddeo Gaddi's refectory fresco in Santa Croce (see Fig. 4.23). Although there is no clear documentary evidence of a particular patron within the Strozzi family for the chapel and its decoration, this donor figure strongly suggests the involvement of a female member of the family in the commission. On the right wall of the chapel, opposite the Paradise, is a depiction of hell. Like the Last Judgment fresco in the Camposanto in Pisa, Nardo di Cione's vision of hell places each of the major sins in a separate ledge-like compositional frame which creates its own illusion of depth. A torment fitting the nature of the sin racks the body of each figure. Nardo also carefully labeled each of the sins so that there would be no doubt about what was being represented, again repeating the scholastic catalogue seen at Pisa and the enumeration of punishments of Dante's Inferno.

The Strozzi Altarpiece Orcagna's Strozzi Altarpiece (Fig. 8.4), which still stands on the chapel's altar, also incorporates iconography relating to both the Dominican order and the Last Judgment. It is a richly decorative painting, with tooled

gold background, gold punchwork imitating embroidered fabric, and large areas of expensive lapis lazuli blue. The sheer opulence of the painting indicates its importance. At the center of the altarpiece is a figure of God, seated rigidly and frontally in a radiant mandorla of cherubim, suspended in a light-filled heaven which defies specific spatial description. On his right he is flanked by a crowned Virgin (the dedicatee of the church) in a Dominican habit who presents her protégé St. Thomas Aquinas to him. St. Thomas (who should perhaps be understood as representing the Dominican order as a whole) kneels before God in a typical donor pose. To God's left St. Peter kneels to receive the keys that symbolize his office—and his power—as pope. Behind Peter is St. John the Baptist, the two forming a group that balances that of the Virgin and St. Thomas. The saints in the outermost compartments of the altarpiece include St. Michael the Archangel, a figure weighing the relative merits of the elect and the damned in Last Judgment iconography; St. Catherine of Alexandria, a saint especially dear to the Dominicans; St. Lawrence, whose hagiography includes the curious tale that on each Friday he descends from heaven to purgatory to release one soul from torment; and St. Paul, who, when paired with Peter, often personifies the papacy. Thus the saints at the outer edges of the painting are, like St. Thomas and St. Peter, references to the Dominicans and their support of the papacy as well as to death and the Last Judgment.

The blank, staring aspect of the central figure of the painting and its placement in an undefined space has suggested quite reasonably to some scholars a throwback to thirteenth-century saints' altarpieces (see Fig. 18). When such interpretations of this iconic representation are coupled with the notion that style developed progressively along the naturalistic lines evident in the paintings of Cavallini and Giotto, however, they lead to a misleading hypothesis that the *Strozzi Altarpiece* represents a radical shift in style away from the innovations of these artists.

The Black Death

A common explanation for this presumed retrograde style places its cause in the psychological devastation brought about by the catastrophic mortality rates of the bubonic plague. The Black Death—so called because of the color of the lesions that it caused on the bodies of the plague victims—struck central Italy in 1348, following upon years of bad crops and famine. It had begun in Central Asia and had been carried to Europe by Italian trading ships traveling from the Crimea to the Italian peninsula. In the virulent form that the plague took during the summer months of 1348, infected persons, bitten by engorged fleas carried by brown rats, usually developed red-ringed black buboes or lesions in the groin or the armpits and died within a matter of days, leaving no time for either spiritual or material preparation.

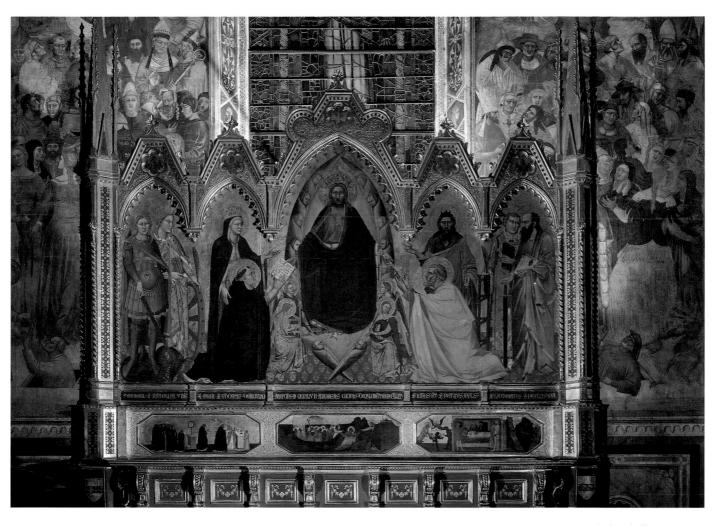

8.4 Strozzi Altarpiece, 1354–57, Andrea di Cione (called Orcagna), Strozzi Chapel, Santa Maria Novella, Florence. Tempera on panel, 9' × 9' 8" (2.74 × 2.95 m)

Boccaccio (1313–75), perhaps the most gifted writer in central Italy in the mid-fourteenth century, described the ravages of the plague in the first book of the *Decameron*. He indicated not only the rapacity of the disease itself but also the social breakdown that accompanied it:

"...people behaved as though their days were numbered, and treated their belongings and their own persons with equal abandon. Hence most houses had become common property, and any passing stranger could make himself at home as naturally as though he were the rightful owner. But for all their riotous manner of living, these people always took good care to avoid any contact with the sick. All respect for the laws of God and man had virtually broken down and been extinguished in our city. For like everybody else, those ministers and executors of the laws who were not either dead or ill were left with so few subordinates that they were unable to discharge any of their duties." The sick and the dying were left untended out of fear; normal rituals of prayer and penance surrounding death which acted as a transition to the afterlife were largely suspended; and the very continuity of the family and community seemed threatened by the irrational violence of the disease.

One contemporary explanation for the plague, as Boccaccio noted, was that it was a "punishment signifying God's righteous anger at our iniquitous way of life."

The plague was particularly virulent during the summer months of 1348, then abated during the colder winter season. Carried to other parts of Europe through trade, the plague reached England and Scandinavia in the early 1350s. Although it then appeared to have run its course, the plague had not died out. Especially destructive epidemics were recorded in Italy in 1363 and 1400, and minor outbreaks occurred throughout this period and well into the sixteenth century.

Historians have tended to concentrate on the 1348 occurrence of the Black Death because it is the first example of plague in the modern period; because literary accounts of it, such as Boccaccio's *Decameron*, are so vivid; because death was both inevitable and quick once the disease was contracted; and because the mortality rate in that year was so high. In Tuscany, for example, a conservative estimate places the death rate in the cities (always greater than in the country) at 60 percent of the population. A contemporary observer wrote of 1,800 people dying in Florence

on the feast of St. John the Baptist (June 24), the patron saint of the city, and another 1,800 the following day. Even allowing for exaggeration, in a city of fewer than 100,000 people those numbers are startling, especially given the duration of the plague through the summer months.

Advocates of the long-accepted theory that the plague had a major impact on the style and iconography of the visual arts have often used the iconic and flattened forms of the central figures of the *Strozzi Altarpiece* (see Fig. 8.4) and the presentation of hell in the Pisa *Last Judgment* (see Fig. 8.2; now dated *prior* to the plague) to support the theory. But if the 1348 plague had truly been as influential in the arts as some critics have suggested, stylistic and iconographic references similar to those of these two paintings should also occur in works of art from other parts of Italy, where the plague had mortality rates nearly as high as those in Tuscany. Since this seems not to have been the case, it seems

8.5 Glorification of St. Thomas, c. 1355, commissioned by the Dominicans from **Lippo Memmi**, formerly attributed to Francesco Traini, for Santa Caterina, Pisa. Tempera on panel

To Thomas's right, in the conventional position of honor, is Aristotle. Plato is to Thomas's left while Averroes is at his feet

unlikely that the style used for the figure of Christ in the *Strozzi Altarpiece* was primarily a response to the plague.

From the transept of the church the Strozzi Altarpiece is seen together with the Last Judgment wall (see p. 152). The figure of God in the altarpiece can be seen as the seated Judge which the lancet window precluded in the fresco of the Last Judgment on the wall behind. Read this way, the stylistic particulars of the figure stand well within the conventions of this subject matter. Paintings such as Simone Martini's St. Louis of Toulouse Altarpiece (see Fig. 6.13) or Ambrogio Lorenzetti's Allegory of Good Government (see Fig. 5.28) also depict images of rulership and judgment in a conventional hieratic form. In fact the Dominicans employed a similar type of figure for the first major altarpiece dedicated to St. Thomas for their church in Pisa. In this painting, once attributed to Francesco Traini but now to Lippo Memmi (Fig. 8.5), St. Thomas is also seated in a spatially ambiguous mandorla, and his flattened pose is decidedly different from virtually all of the other figures in the painting. This convention of the seated, hieratic figure was repeatedly used in illustrations in legal treatises during this period. There the figure of God as the fountainhead and provider of civil and canon law is seated with a king at his left and a pope at his right in the same flattened compositional arrangement as the central three figures of the Strozzi Altarpiece. Thus Orcagna and his Dominican patrons apparently wished to use this visual convention of authority to convey the orthodoxy of the order's teaching through the writings of St. Thomas and to suggest the special relationship between the order and the papacy. It is telling in Memmi's depiction that Averroes, an Arab philosopher used to represent heresy, is humiliated (literally "on the ground") beneath the feet of Thomas, who holds his own writings in his lap.

A close reading of the Strozzi Altarpiece reveals that the figures, other than those framed by the central three arches, are not flat, nor are they situated in a spaceless environment. On the outer edges St. Michael the Archangel and St. Catherine, in particular, are fully volumetric and naturally posed, typical of current developments in the depiction of human figures. Orcagna's use of both naturalistic and iconic styles in his altarpiece is governed by the function each figure performs within the work. Given the multiple messages that the altarpiece conveys-including the devotional needs of the Strozzi family who endowed the chapel, the establishment of the Dominican St. Thomas Aquinas as an important saint within the Christian hierarchy, the Dominicans' alliance with the papacy, and their support of orthodoxy-it is not surprising that the painting conflates several conventions of style and iconography.

The Guidalotti Chapel

Also within the precincts of Santa Maria Novella is another major fresco cycle from the middle years of the fourteenth century. In 1365–67 Andrea Bonaiuti (Andrea da Firenze;

active 1346 Florence-after 1379 Florence) painted the walls of the Guidalotti Chapel (Fig. 8.7) in the church's cloister. Andrea was an esteemed member of his profession, serving on an advisory panel of painters to the Florence Duomo and as a consul of his guild. Here he was called on to decorate a space that was used as a burial chapel for the Guidalotti family and also as a chapter house for the resident Dominican community. Mico [Buonamico] Guidalotti's tomb slab still remains on the floor before the altar; the inscription filling its border indicates that he was a merchant who had the chapel built and painted. It adds, tellingly, that he was buried in a Dominican habit, a privilege allowed him as much for his generosity, one assumes, as for his goodness. Andrea's impressive and remarkably well-preserved frescoes provide a compendium of the stylistic possibilities in painting in this period.

A Crucifixion narrative (Fig. 8.8) decorates the altar wall of the chapel. Opposite it, on the entrance wall, is a cycle narrating the life of St. Peter Martyr (c. 1205–52; Fig. 8.6), a Dominican saint particularly venerated in Florence, where he had been perhaps the most popular preacher of his day. In the Way of the Cross and the Harrowing of Hell, which occupy the lower part of the Crucifixion, architecture and landscape create a convincing illusion of depth behind the figures. In the Crucifixion scene itself the crosses of the two thieves create recessional axes into space, although the actual space depicted is relatively shallow. The thieves twist convulsively on their crosses while a group of figures runs from an attacking soldier at the right. The Preaching of St. Peter Martyr depicts an event that occurred in the piazza outside Santa Maria Novella. The saint stands in a pulpit (rendered with

careful attention to perspective) while the listening figures, crowded into the space around him, twist and turn, actively gesturing in response to his sermon. Figures in both the *Crucifixion* and *Peter Martyr* frescoes respond in ways that enhance the emotional aspects of these events. They have all of the naturalism and dramatic intensity that characterize figures in the most advanced painting of the century.

The Apotheosis of St. Thomas Aquinas Completely different compositional structures appear in the frescoes on the side walls of the chapel. In the Apotheosis of St. Thomas (Fig. 8.9) on the left wall of the chapel, St. Thomas sits enthroned in a Gothic aedicule flanked by figures of Apostles and prophets. Comparison of this fresco with the Glorification of St. Thomas (see Fig. 8.5) suggests that Thomas's flattened frontal pose was canonic and that his word is law, the definer of orthodoxy for the Church. The configuration of a centrally placed figure flanked by smaller figures spread out in a row is familiar from Last Judgment imagery and from works such as Lorenzetti's Buon Comune (see Fig. 5.28). In the Apotheosis St. Thomas is also accompanied by personifications of virtues, who float in the sky overhead. At his feet there are representations of Sabellius, Averroes, and Arius, leaders of wellknown religious groups considered by the papacy—and thus by the Dominicans-as heretical. Below St. Thomas fourteen seated figures represent the seven divisions of theology and the same number of the liberal arts; below each sits the historical personage who best represents the theological or scholarly concept. Thus the emperor Justinian is seated before the figure of Civil Law, St. Augustine before Theology, Pythagoras before Arithmetic, Euclid before Geometry, and

8.6 Scenes from the Life of St. Peter Martyr, detail, c. 1365-67, chapel and frescoes provided by Buonamico (Mico) Guidalotti; frescoes commissioned from Andrea Bonaiuti for the Guidalotti Chapel, Santa Maria Novella, Florence. Fresco.

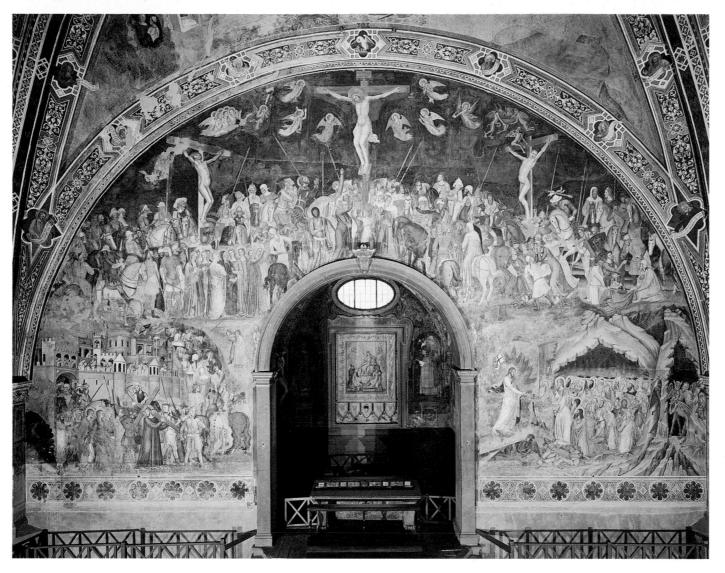

8.8 Crucifixion c. 1365-67, chapel construction and fresco decoration provided for in the 1355 will of Buonamico (Mico) Guidalotti; frescoes subsequently commissioned from **Andrea Bonaiuti** for the altar wall of the Guidalotti Chapel, Santa Maria Novella, Florence. Fresco, width 38' (11.6 m)

Cicero before Rhetoric. Given the prominent role that the Dominican order played in education during this period, it is no surprise to see knowledge personified and codified in this way with St. Thomas. Yet despite the orthodox, didactic content of this fresco Andrea allowed himself some artistic experimentation, overlapping the painted architectural frame of the fresco with fictive thrones as if to suggest that they actually extend out from the wall, thus pushing figures illusionistically into the space of the room.

The Way of Salvation The fresco on the wall opposite the *Apotheosis* represents the *Way of Salvation* (see Fig. 8.7). It is unlike any of the other three walls of the room in the way that it is divided compositionally into several different areas. Figures change scale radically from one group to the

8.7 (opposite) *Way of Salvation*, c. 1365–67, chapel construction and fresco decoration provided for in the 1355 will of Buonamico (Mico) Guidalotti; frescoes subsequently commissioned from **Andrea Bonaiuti** (called **Andrea da Firenze**), for the right wall of the Guidalotti Chapel, Santa Maria Novella, Florence. Fresco, width 38' (11.6 m)

next and include both hieratic and natural types. In some areas space is compressed parallel to the picture plane, as in the foreground; in others it is three-dimensional, as in the treatment of the landscape at the upper right. Each section of the fresco seems to illustrate some different aspect of Dominican activity and belief, strung along in no immediately apparent order, but often brought into focus by the familiar white and black robes of the Dominican friars, whose punning black and white dogs, the *Domini canes* ("Dogs of God"), rush about at their feet at the bottom of the composition chasing the wolves of heresy.

In the lower left quadrant of the wall a representation of the Florence Duomo, unfinished at this time, symbolizes the universal Church. The Duomo provides a backdrop for a group of seated figures whose relative status is conventionally indicated by size. In the center of this group are the pope (probably Innocent VI; r. 1352–62) and the emperor, Charles IV. The pope sits slightly higher than the emperor, a clear indication of the Dominican belief in the supremacy of the spiritual ruler over the temporal one. Cardinal Giles Albornoz, the most important papal diplomat in Italy during

this period, is seated in a position of honor immediately to the pope's right. Other religious and temporal leaders flank this central group and provide another unmistakable image of authority within the chapter house, comparable to the Apotheosis of St. Thomas on the opposite wall. Above the Duomo the elect are welcomed into heaven by St. Peter, a juxtaposition making clear the Church's authority in providing salvation. The Dominicans figure prominently as the layperson's guide on this journey. In the lower right corner of the fresco Dominicans are preaching and converting heretics. Above them, another Dominican points to the heavenly reward awaiting confessed and absolved Christians. Four courtly figures seated in a bower mid-right are reminiscent of the elegantly dressed nobles listening to music in the Camposanto frescoes in Pisa (see Fig. 8.1), and may represent the worldly life before conversion. They provide the antithesis to the good work of the Dominicans.

The seated figure of the judging Christ in the apex of the fresco conspicuously displays the keys of papal power. In the vault above him is a depiction of the *Navicella*. This image of the Church as the ship of state or the vessel of salvation is

the same subject depicted by Giotto in Old St. Peter's at the beginning of the century (see Fig. 2.12). The compositional linkage of the *Navicella*, the judging Christ, and the relative positions of the two frescoes may be a metaphor for the support given to the Church by the Dominicans.

In this room, where the Florentine Dominican community met regularly, where novices were received into the order, where each friar confessed his sins to the prior and to the community, these frescoes provided a constant message of indoctrination for the monastic community. They provided a model for preaching in the person of St. Peter Martyr, a model for learning in the figure of St. Thomas, and incentives to obedience to the institutional Church. Whereas the Crucifixion fresco contains imagery fitting for Mico Guidalotti's funerary chapel, the Way of Salvation and the other frescoes emphatically assert the Dominicans' control of this important space. Each of the subjects given to Andrea da Firenze presented him with different narrative and allegorical demands. It is not surprising that he responded with such variations of style from one wall to another.

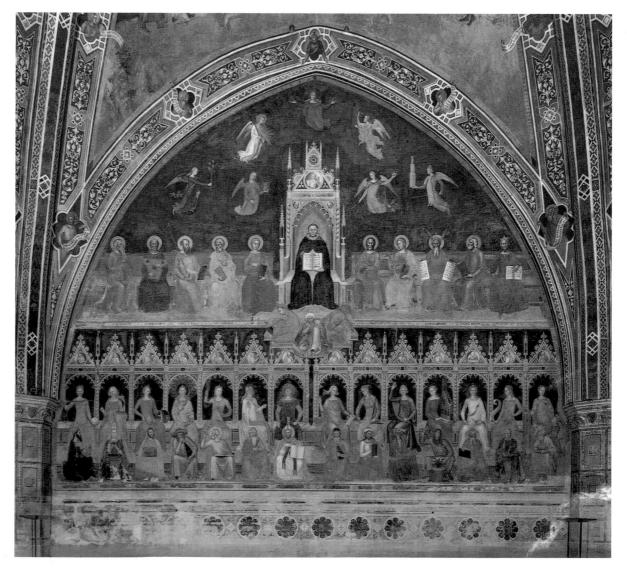

8.9 Apotheosis of St. Thomas, c. 1365-67, chapel construction and fresco decoration provided for in the 1355 will of Buonamico (Mico) Guidalotti; frescoes subsequently commissioned from Andrea Bonaiuti (called Andrea da Firenze), for the left wall of the Guidalotti Chapel, Santa Maria Novella, Florence. Fresco. width 38' (11.6 m)

163

The Bridge of Salvation

In this passage from *The Dialogue*, by St. Catherine of Siena, the metaphor of a stepped bridge represents Christ the Redeemer. St. Catherine (1347–80) was a Dominican nun and the author of several devotional works and poems. It was largely through her influence that Pope Gregory XI was persuaded to return to Rome from Avignon. She was interrogated about her sometimes unorthodox beliefs by Dominican inquisitors in the Chapterhouse at Santa Maria Novella.

Then God eternal, to stir up even more that soul's love for the salvation of souls, responded to her:

Before I show you what I want to show you, and what you asked to see, I want to describe the bridge for you. I have told you that it stretches from heaven to earth by reason of my having joined myself with your humanity, which I formed from the earth's clay.

This bridge, my only-begotten Son, has three stairs. Two of them he built on the wood of the most holy cross, and the third even as he tasted the great bitterness of the gall and vinegar they gave him to drink. You will recognize in these three stairs three spiritual stages.

The first stair is the feet, which symbolize the affections. For just as the feet carry the body, the affections carry the soul. My Son's nailed feet are a stair by which you can climb to his side, where you will see revealed his inmost heart. For when the soul has climbed up on the feet of affection and looked with her mind's eye into my Son's opened heart, she begins to feel the love of her own heart in his consummate and unspeakable love Then the soul, seeing how tremendously she is loved, is herself filled to overflowing with love. So, having climbed the second stair, she reaches the third. This is his mouth, where she finds

peace from the terrible war she has had to wage because of her sins.

At the first stair, lifting the feet of her affections from the earth, she stripped herself of sin. At the second she dressed herself in love for virtue. And at the third she tasted peace.

So the bridge has three stairs, and you can reach the last by climbing the first two. The last stair is so high that the flooding waters cannot strike it—for the venom of sin never touched my Son

When my goodness saw that you could be drawn in no other way, I sent him to be lifted onto the wood of the cross. I made of that cross an anvil where this child of humankind could be hammered into an instrument to release humankind from death and restore it to the life of grace. In this way he drew everything to himself: for he proved his unspeakable love, and the human heart is always drawn by love.

(from Susan Noffke. Trans. Catherine of Siena: The Dialogue. New York: Paulist Press, 1980, pp. 64-5)

Social Upheaval and Civic Works in Florence

Florentine history for the later decades of the fourteenth century is punctuated with moments of social upheaval. In 1363 the plague struck again with particular severity. In the next decade the Florentines opposed the papacy over control of land, leading to a papal interdict on the city from 1376 to 1378. This meant that normal liturgical functions were suspended; among other prohibitions, the dying could not be confessed and the Eucharist could not be exposed, thus effectively closing the routes of salvation for the populace. Even the bells of the churches were silenced, which in a late-medieval city not only eliminated the one sound that could communicate over a large area, but effectively limited the ability of people to measure their days. (The two years of the interdict are known as the War of the Eight Saints to honor the eight governors of the city, who staunchly maintained what they perceived to be Florentine independence from an encroaching neighboring power, namely the papacy.)

Then in 1378 the wool workers (*ciompi*) revolted against their guild, the Arte della Lana, which controlled their livelihoods, and against the owners of their shops, causing a

political eruption known as the Ciompi Revolution, which essentially toppled the upper classes from political power. When, in 1381, the wealthy classes regained control of the government they punished the workers with particular ruthlessness.

In this environment, the city's major building projects were subject to delays. Work at the Duomo seems to have progressed in fits and starts during the fourteenth century, with repeated changes in plans and challenges to the already established program. In mid-1355 a committee of twelve laymen and artists was appointed to judge the feasibility of a model for the choir end of the building that had been submitted earlier that year by Francesco Talenti (active 1300s). In 1357 a new plan with three bays in the nave had been approved, and by this time the octagonal crossing and the surrounding spaces had already been assigned. In 1366 three concurrent commissions were charged with developing a new plan, which apparently was agreed upon in 1368 when competing designs were ordered to be destroyed. At various times plebiscites were held to choose the best of competing models—an indication of civic investment in the planning of the Duomo. The model of 1368 gave the Duomo its present form of a four-bayed nave (see Fig. 4.26). Its three equal-sized tribunes, the cluster of polygonal shapes that make up the eastern end of the Duomo,

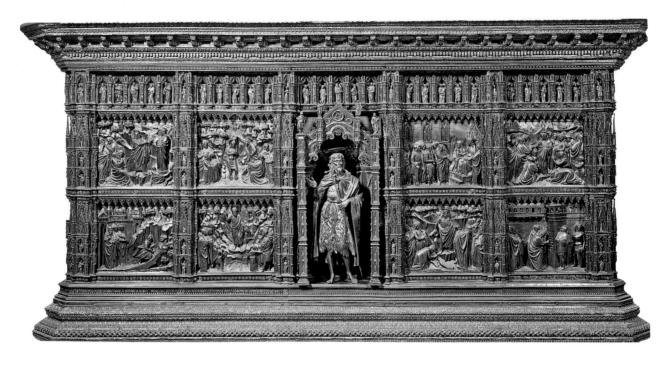

8.10 Silver altar, 1366–77, commissioned by the Arte del Calimala from **Leonardo di ser Giovanni**, **Betto di Geri, and others** for the Baptistry, Florence. Silver on a wooden base, front face 3′ 9½″ × 8′ 7″ (1.15 × 2.62 m) (Museo dell'Opera del Duomo, Florence). See also Fig. 8.11.

The central niche figure of St. John the Baptist was added to the altar in 1452; the sculptor is Michelozzo di Bartolomeo.

echo the shape of the Baptistry and suggest a deliberate intention to create a harmonious group of forms in the heart of the city.

In 1366, the same year that the commission initiated the last plan for the Duomo, the Arte del Calimala commissioned the goldsmiths Leonardo di ser Giovanni (active 1358-71 Florence), Betto di Geri (active 1366-1402 Florence), and others to make a large silver-covered altar (Fig. 8.10) for the Baptistry. Conceived on a lavish scale meant to demonstrate the guild's economic power in the city, the altar was not finished until the sixteenth century. Rectangular reliefs depicting scenes from the life of St. John the Baptist, to whom the building is dedicated, were set into the front and sides of the altar; the architectural frame is composed of numerous Gothic niches, each containing a small statuette. The reliefs (Fig. 8.11) differ significantly from those on the same subject created by Andrea Pisano for the south doors of the Baptistry (see Figs. 4.27 and 4.28); their architectural backgrounds offer more illusionistic spaces for the action, all of which appears to take place behind the plane of the relief rather than in front. Taking advantage of the malleability of silver, the sculptors revel in the fine detail of armor, hair, and embroidered borders. Enamel evokes the deep blues, ochers, and greens of fine stained glass set in precisely detailed tracery. Clearly the artists must have closely studied contemporary architecture and narrative painting.

A comparison with the *Pala d'Oro* in Venice (see Fig. 7.6) indicates that, while the silver altar is not as lavish in its

coloration or in the variety of its component parts, it does share a repetition of form, and an insistent multiplicity of similar units, as if sheer opulence was itself the raison-d'être of the commission. On the other hand, the restrained geometry of the silver altar subordinates the myriad Gothic niches containing tiny statuettes to an overall structural order. This allows the narrative reliefs of the life of the patron saint of the church and of the city to read through the richness of the decoration, appropriate for the altar of a building that is itself inscribed with a severe if bold geometrical design. Six of the eight panels on the front of the altar show a figure dominating the narrative from the center of the panel. The central niche with the statuette of St. John the Baptist is framed with scenes from his life, recalling early saints' altarpieces (see Figs. 1.4 and 1.5), as if the reuse of an earlier compositional format—and perhaps even the squat figural types seen in the reliefs—were appropriate for the decoration of this Romanesque building.

8.11 (opposite) Silver altar (detail), 1366-77, commissioned by the Arte del Calimala from **Leonardo di ser Giovanni**, **Betto di Geri, and others** for the Baptistry, Florence. Silver on a wooden base, front face $3'\,9\%''\times8'\,7''$ (1.15 $\times\,2.62$ m). (Museo dell'Opera del Duomo, Florence.) See also Fig. 8.10.

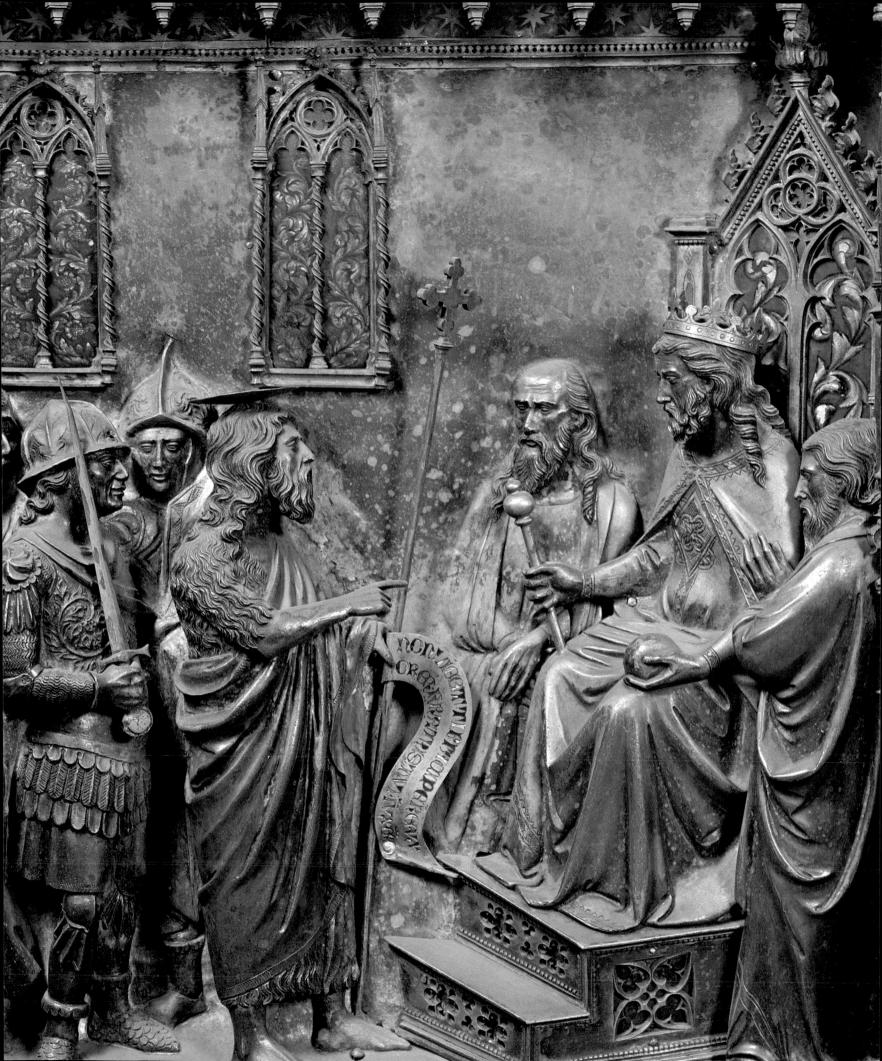

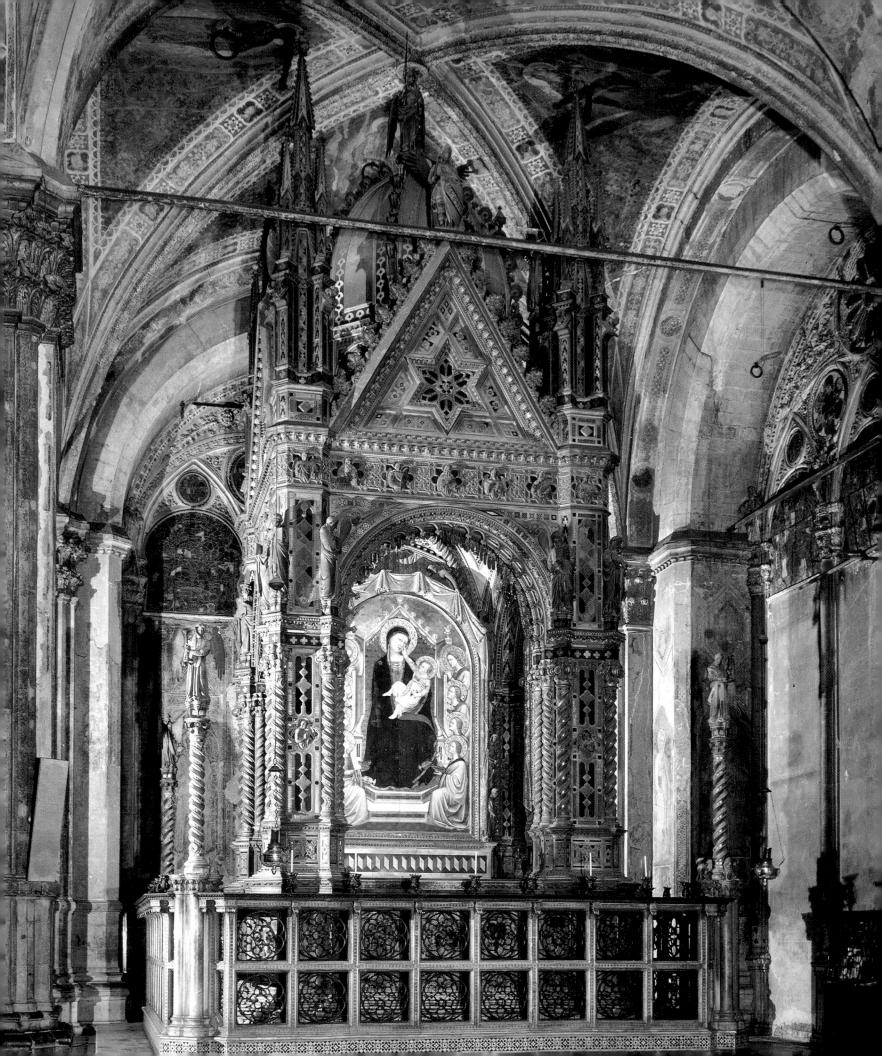

Or San Michele

Or San Michele was originally simply an open loggia built in 1337 around a modest architectural tabernacle protecting a miracle-working image of the Madonna and Child, then in the grain market of the city. The upper stories of the building were added after the plague of 1348 as a granary to protect against famine. Located in the heart of the city on an axis extending from the cathedral to the town hall, Or San Michele functioned as a guild church to which each of the guilds contributed an image of its patron saint to mark its participation at the site. The most important single addition to Or San Michele at this time was an architecturally-scaled marble tabernacle (Fig. 8.12) to house a painting already at the site by one of the most successful students to come from Giotto's workshop, Bernardo Daddi (active c. 1320-48 Florence). Daddi's painting had replaced an earlier miracle-working image of the Virgin and Child around 1346. The tabernacle, built with donations made after the plague of 1348, has an inscription on its back under a large relief of the Burial and Assumption of the Virgin (Fig. 8.13) dating it to 1359 and bearing the name of Orcagna. A railing was added to the tabernacle in 1366, protecting it from the milling crowds that often filled the building's ground floor-at that time not yet completely walled in. The dome that crowns the tabernacle may echo a proposed design for the dome of the unfinished cathedral-much like the dome in Andrea da Firenze's fresco of the Way of Salvation, completed at about the same time (see Fig. 8.7). The form of Orcagna's tabernacle underscores the importance of the Duomo's construction in the artistic life of the city.

Despite awkward passages which betray the contributions of several members of Orcagna's workshop, the sculpture on the tabernacle is notable for its naturalism. Even where conventional patterns of composition dictate form and where abstract patterns of mosaic make up the background, as in the *Assumption of the Virgin*, the figures have a sense of volumetric fullness that places them in the tradition of painting established by Giotto and also exemplified by Orcagna's own painting style. The Virgin, for example, the masses of her limbs clearly evident beneath the drapery, extends her hand toward the kneeling St. Thomas as she prepares to hand him her belt, proof that it is really she who is being lifted into heaven. Even given his flattened profile pose, the volumes of Thomas's body betray the urgency of his action.

By contrast, the paintings in Or San Michele, which were designed to cover virtually every surface of the interior, including its piers, show what appear to be deliberate inclusions of an iconic or non-naturalistic style. A typical example is *St. John the Evangelist* (Fig. 8.14), painted by Nardo di Cione's student Giovanni del Biondo (c. 1333/35)

8.13 Tabernacle, c. 1355–59, detail of back wall showing the *Burial and Assumption of the Virgin*, **Andrea di Cione** (called **Orcagna**), Or San Michele, Florence. Marble, inlaid stone, and glass

Florence-1399 Florence) for the Arte della Seta (the Silk Manufacturers' and Goldsmiths' Guild), which was attached to a pier immediately facing the tabernacle. St. John is seated frontally against a gold ground, in a familiar pose and style for the period. Although the painting is somewhat awkward in its handling of form, it is clear that Giovanni was attempting to create an intense, emblematic image of the patron saint for Or San Michele, appropriate for a building conceived as an expression of the power of the guilds in Florence.

Unlike other images of St. John, Giovanni's painting includes figures of Pride, Avarice, and Vainglory trampled under the feet of the seated saint. These vices are the same ones that appear flying over the head of Tyranny in the Lorenzetti fresco of *Bad Government* in Siena (see Fig. 5.30). Thus it appears likely that the powerful Arte della Seta—far from commissioning a simple devotional image—deliberately used iconography related to civic order. The dating of the altarpiece is problematic, although current opinion places it, on the basis of style and the history of Or San Michele, to the years around 1381, shortly after the Ciompi Revolution and the papal interdict. The Arte della Seta, governed by the same social class that had been threatened by the *ciompi*, here seems to equate its own image with political

8.14 *St. John the Evangelist*, c. 1381, commissioned by the Arte della Seta from **Giovanni del Biondo** for Or San Michele, Florence. Tempera on panel, $92 \times 41''$ (234×104 cm) (Galleria dell'Accademia, Florence)

and social stability. If, indeed, that was the intended message, it would explain the frontal pose of the saint. A political message has supplanted the religious one normally conveyed by this pose. The painting is thus a reminder of

the inextricable connections between the civil, corporate, and religious spheres of the Italian communes of this time. Here in Or San Michele, one of the major centers of corporate and religious activity in Florence, the guilds clearly articulated their central, powerful role in the city's life. If there is a conservative reaction in the painting styles of the fourteenth century in Florence, this is it, and it is tied to issues of power and hierarchy similar to those explored by the Dominicans in Santa Maria Novella.

Family Commissions

After the Ciompi Revolt of 1378, the disruptions caused by the papal interdict in 1376–78, and the restitution of the oligarchy in 1381, a family's public presence was a matter of some consequence. Thus it is not surprising that during the last two decades of the fourteenth century prominent families continued to commission large fresco cycles for their chapels. The style used for these cycles established a pattern for fresco painting in Florence that was to last well into the fifteenth century.

The Castellani Chapel

When Michele di Vanni Castellani wrote his will in 1383 he stipulated that his heirs build and decorate a new chapel at Santa Croce to honor him and their family. As many as four painters, including Agnolo Gaddi, Taddeo Gaddi's son, may have worked on the chapel, an indication that there was some pressure to have the project completed quickly. Each bay of the side walls of the chapel has a narrative program of a different saint especially revered by the Castellani family (John the Baptist, Nicholas, Anthony Abbot, and John the Evangelist). Figures and spatial environments throughout the chapel recall the Giottesque tradition—not surprising given the fact that Gaddi's father had been trained by Giotto.

Immediately to the left of the entrance to the chapel is an image of St. John on Patmos (Fig. 8.15) which presents a virtual quotation from Giotto's Peruzzi Chapel frescoes, just across the transept (see Fig. 4.15). Rather than merely slavishly copying a venerated painting tradition, however, the Castellani's artists may have been seeking to link their patrons to earlier oligarchic Florentine families, represented by the Peruzzi. The stylistic similarities between the frescoes might suggest an equal status of the patrons but, more importantly, an unbroken leadership of oligarchic families, despite the Ciompi Revolt (during which the Castellani Palace had been burned). The inclusion in the Castellani frescoes of St. Louis of Toulouse, the patron saint of the oligarchic Guelf Party, and of St. Anthony Abbot, whose feast day marks the day of the return of the oligarchy to power after the Ciompi Revolt, supports an interpretation of this decorative program tied to the political fortunes of the family. The Castellani had managed to retain their mercantile

8.15 St. John on Patmos, c. 1385-90, commissioned by the Castellani family for the Castellani Chapel, Santa Croce, Florence. Fresco

and economic power and would have had every reason to see themselves in the tradition of the powerful banking families from the beginning of the century.

The Legend of the True Cross

The sanctuary of Santa Croce (see Fig 4.8) is decorated with a huge fresco cycle depicting the Legend of the True Cross, by Agnolo Gaddi (active 1369-96 Florence). Lack of documentary evidence precludes precise dating of the cycle; however, the Alberti family is mentioned in early records pertaining to the chapel, and their crest is carved on its piers, so it is more than likely that they, in conjunction with the Franciscans, were the patron family of this cycle, which illustrates the dedication of the church to the Holy Cross (Fig. 8.16). Since members of the Alberti family were exiled by the oligarchy in 1387 for their liberal political views and since there seems to be no break in the pictorial unity of the frescoes themselves, they were probably either completed before 1387 or not begun until members of the family returned to the city and felt the moment opportune to reassert their presence with this high-profile act of patronage.

Agnolo Gaddi's portrayal of the *Legend of the True Cross* was derived from a collection of the thirteenth-century religious writings by Jacopo da Voragine known as the *Golden Legend*. The frescoes provided the pictorial model which the Franciscans followed for the next century (see Fig. 10.47). The narrative tells the story of Christ's cross which, according to tradition, was made from a tree planted over Adam's grave by his son Seth. Although Solomon had intended to

use this tree in his temple, it was made into a bridge instead. When the Queen of Sheba crossed the bridge she had a vision that the Savior would be crucified on its wood and that the kingdom of the Jews would then cease to exist—a prediction that led Solomon to have the wood buried. It was recovered, however, and fashioned into Christ's cross, which was ultimately stolen by the Persian king Chosroes. Chosroes was subsequently defeated by Heraclius, who returned the cross to Jerusalem. In order to depict the complexities of this tale Agnolo spread the narrative across the entire width of the wall, with groups of figures moving from left to right depicting different episodes, but with the background landscape and architecture providing a single unifying frame for the painting.

Agnolo's figures derive their essentially static style from his father's frescoes in the Baroncelli Chapel (see Fig. 4.19), although his own hand is evident in their elongated, elegant poses, their grouping to suggest volumes in the landscape, and their placement in full, open spaces. Throughout the frescoes there are examples of compellingly individualized facial features which suggest that they were drawn from life. The individual scenes are suffused with light which enhances the solidity of buildings and landscape features against the dark background. The colors of the costumes are lighter than in earlier frescoes, lending the entire cycle a vivacity commensurate with the animation of its figures. These frescoes mark the end of a long development of fourteenth-century painting in Santa Croce which, beginning with Giotto's frescoes for the Bardi Chapel (see Fig. 4.15), established new ways of realizing narrative.

By transforming that tradition they provided a model for the generation of painters working into the first two decades of the fifteenth century.

Frescoes at San Miniato

The influence of Agnolo's refined and elegant style is evident in a fresco cycle of the life of St. Benedict in the sacristy of the church of San Miniato al Monte (Fig. 8.17). Painted by Spinello Aretino (Spinello di Luca Spinelli; 1350/52 Arezzo-1410 Florence), the cycle was commissioned by Benedetto degli Alberti before he and other male members of his family were exiled in 1387. St Benedict was the patron saint of both Benedetto and of the Olivetan Benedictines who, along with the Arte del Calimala, had charge of the church. The scenes concentrate on miracles associated with St. Benedict, including his resurrection of a monk killed by a falling wall and his exorcism of a monk possessed by a devil. In each case evil is represented by a winged fiend whom Benedict has managed to expel through his own holiness. The same thinly membered, detailed, and miniaturized

architecture that characterizes Agnolo Gaddi's work serves as a frame for the episodes in Spinello's cycle. The buildings, like the figural groupings, usually have one face parallel to the picture surface, their adjacent sides, on a diagonal, leading the eye deeper into space. The figures, like those in Agnolo's *True Cross* cycle but unlike Agnolo's elongated and softly swaying figures, are grouped episodically across the painting and call to mind the slow, heavy movement and weighty massing typical of Giotto and his followers.

Although the Castellani and the Alberti were political opponents—the former allied to the faction that exiled the latter—the commissions of the two families are remarkably similar, suggesting that social position rather than political persuasion was a determinant of style. Of course the choice of Agnolo Gaddi for the Santa Croce frescoes may have been determined by the resident Franciscans, just as the prior of the Olivetans at San Miniato seems to have been responsible for selecting Spinello, who had already worked for the Olivetans in Arezzo. The commissioning of major public fresco cycles was rarely a simple matter between a single patron and an artist.

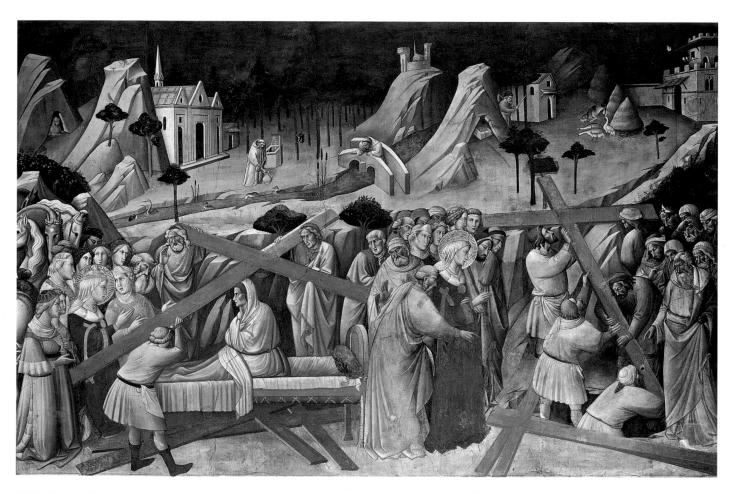

8.16 Discovery of the True Cross, before 1387, commissioned by the Alberti family (?) from Agnolo Gaddi, choir, Santa Croce, Florence. Fresco

St. Helena, the Emperor Constantine's mother, discovers the True Cross and the two crosses of the thieves crucified with Christ at the right of the fresco. At the left, she identifies which of the three crosses is the True Cross as it miraculously brings a dead man back to life.

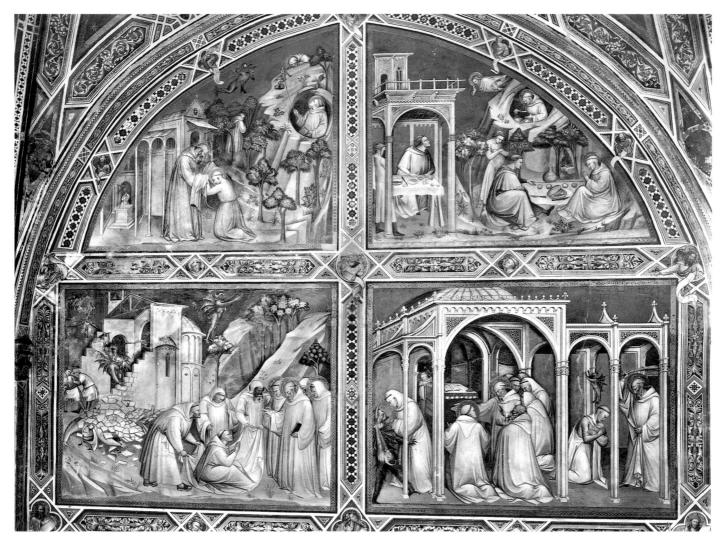

8.17 Scenes from the Life of St. Benedict, 1386-88, showing St. Benedict Retires to Subiaco and is Given the Habit by the Monk Romano; St. Benedict Visited by a Monk Sent by God on Easter Day; St. Benedict Founds Monte Cassino and Resurrects a Monk Crushed by a Falling Wall; and St. Benedict Exorcises a Possessed Monk, commissioned by Benedetto degli Alberti from Spinello Aretino for the sacristy of San Miniato al Monte, Florence. Fresco

Other Civic Imagery

Even secular painting had different audiences. There was a large category of painting intended to record specific historical events that took place at or near the sites they decorated within the city. Most of these are now lost, but the few that do survive suggest that their painters were aware of the special demands that the genre made on style. One of these, the Orphans Assigned to their New Parents (Fig. 8.18) was painted in 1386 by Niccolò di Pietro Gerini (active 1366-1415 Florence) and Ambrogio di Baldese (1352-1429 Florence) for the charitable Confraternity of the Misericordia. The fresco originally decorated the exterior of the confraternity building (which itself appears in the painting) immediately across the street from the Baptistry. Gerini, whose artistic roots lay in the art of both Andrea Orcagna and Taddeo Gaddi, clearly made an effort at naturalism, despite the rather stolid figures. Gerini's children react in differing animated ways to their new mothers, while the adults act in

a decorous manner, presumably befitting their new roles as parents. Of course, given what we know of the often horrendous conditions for lower-class children and orphans during this period, this image is most likely more a wished-for model than a representation of fact.

Gerini ordered the figures into different groups, depending on their activity, blocking them within the lines of the background architectural units, in order to structure the reading of the narrative. At the same time, he crowded the figures at the foreground of the composition, framed the confraternity members in the arches of the honorific loggia of their building to indicate their status, depicted the building itself rather schematically (although leaving no doubt about its identity), and included at the far left a tower-like structure decorated with figures representing Adam and Eve perhaps as symbolic models for the new parents depicted in the fresco. The cramped space is unlike other Florentine narrative painting of the time and suggests a forced and somewhat stylized visual concentration on the

8.18 Orphans Assigned to their New Parents, 1386, commissioned by the Confraternity of the Misericordia from Niccolò di Pietro Gerini and Ambrogio di Baldese for the façade of their headquarters. Fresco (Museo del Bigallo, Florence)

The fresco was removed from the exterior of the building in 1777 and partially destroyed at that time. The male figure in the center arch wears the insignia of the Misericordia. The Confraternity of the Misericordia merged with the Orfanotrofio del Bigallo in 1425, but subsequently re-emerged as a separate entity in 1527, building new confraternal structures and leaving its original building to the Bigallo, by which name it is now known.

act of charity taking place. Thus, as conventional as Gerini's style in this fresco may now appear, he was responding to the needs of a public painting of an historical event. His understanding of convention made him one of the most sought-after painters of his time, working for the major guilds as well as for monastic communities.

Another important project of this period was a now-lost fresco cycle of twenty-two *Uomini Famosi* ("famous men") commissioned in about 1385 for the Audience Chamber of the Signoria in the Palazzo della Signoria. It was to be paralleled by an unexecuted series of sculpted monuments to famous Florentines in the Duomo. Coluccio Salutati, the chancellor (official secretary) of the city of Florence and a pupil of Boccaccio, most likely helped to plan the cycle, and he provided a series of epigrams to accompany each figure. Based on Petrarch's De viris illustribus (On Illustrious Men), Salutati's choice of figures included Alexander the Great, Augustus, Brutus, Cicero, Constantine, and Charlemagne. There are echoes of Florentine history in the choices of the figures, since the city's foundation myths included stories of its having been settled both at the time of Caesar and at the time of Charlemagne. Salutati also included Dante, Petrarch, and Boccaccio, native sons, among the Uomini Famosi as examples of Florence's greatness. In his desire to claim the major figures of fourteenth-century humanism and letters for Florence, Saluti rehabilitated these figures, placing them in a Florentine pantheon and ignoring some of the more controversial aspects of their careers for the republic (Dante, for example, having died in exile).

Outside the Palazzo della Signoria, civic imagery took a somewhat more traditional turn in the sculptural decoration for the newly completed Loggia della Signoria (see p. 77, at the far right). The Loggia was begun in 1373/74 and is remarkable for its time in its monumental scale, recalling not only Roman triumphal arches but the remains of ancient ruins such as the Basilica of Constantine. Standing at a right angle to the Palazzo Vecchio, it served both to frame important public civic events and to define

8.19 Prudence, 1386, Giovanni d'Ambrogio (after a design by Agnolo Gaddi), Loggia della Signoria (now also called the Loggia dei Lanzi), Florence. Marble

one side of a heroically scaled piazza then still being carved out of the heart of the city (see Fig. 4.5). Seven seated figures of virtues in star-studded hexafoils decorate the spandrels between the arches. Originally painted and set on a colored ground, these reliefs were designed by Agnolo Gaddi and were carved in 1386-7 by Giovanni d'Ambrogio (active 1382-1418 Florence) and Jacopo di Piero Guidi (active 1376-1412 Florence), each of whom later became a capomaestro of the cathedral workshops. Giovanni's Prudence (Fig. 8.19) sits in a three-quarter pose, giving her heightened three-dimensionality against the flat patterned surface and within the niche's complex triangular-lobed frame. Andrea Pisano's Virtues for the south door of the Baptistry (see Fig. 4.27) found their successors in these figures for the Loggia della Signoria. The ease in their presentation is a clear sign that the principles of form introduced nearly a century earlier by artists working in Rome, Padua, and Florence had now been fully assimilated.

Domestic Painting

In frescoes commissioned for private houses, different stylistic tendencies could and did exist. A more artificial style was often favored in these works. A case in point is the Story of the Chastelaine de Vergi (Fig. 8.20). Painted high on the walls around a room in the Palazzo Davanzati, it illustrates a thirteenth-century French chivalric romance-subject matter diffused throughout Italy (see Fig. 9.12). Based loosely on the story of Pyramus and Thisbe, two ill-fated lovers in Ovid's Metamorphoses, the tragic tale tells of a secret love between the chastelaine and a young knight. When the knight refuses the advances of the Duchess of Burgundy, the wife of his liege lord, and tells the duke both of the duchess's infidelity and of his own secret love, the duchess drives the chastelaine to her death. The grief-stricken knight commits suicide. The duke, convinced of his wife's guilt, kills her; he then joins the Knights Templars. The figures in the fresco are depicted in a very narrow space under a fictive loggia. Stylized trees are centered within each arch and fan out to conceal any possible background space. A bed and chessboard are tipped up in defiance of the spatial system created by the loggia. This medieval romance and its depiction within a private home clearly demanded a style different from civic and biblical narratives. Both styles—the naturalistic and the artificial-existed concurrently, both were commissioned by the ruling class, and both respond to the particular subjects they treat and the functions they were meant to serve.

8.20 Story of the Chastelaine de Vergi, c. 1395, Palazzo Davanzati, Florence. Fresco

9 Visconti Milan and Carrara Padua

Milan: The Visconti Court

Milan has always been a center of innovation and international exchange, but its role in Renaissance art has often been neglected, in part because the city has been rebuilt and reinvigorated so frequently. While very few of its medieval and Renaissance neighborhoods survive, Milan played a key cultural, economic, and political role in the Renaissance. As a major commercial and industrial center, it was especially

renowned for the production of high-quality armor and armaments. The city also imported and developed rice and silk production from Asia.

As elsewhere in Italy, Milan's key civic monuments—the cathedral and ducal castle—date from the fourteenth and fifteenth centuries. Their grand scale owes much to Milan's proud Roman and medieval past. In the fourth century the Roman emperor Constantine chose Milan, over Rome, as his capital in the West. Strategically well placed in relation to northern Europe but protected to the north by the Alps, and with a population of nearly 100,000, ancient Milan justly assumed the title of a new Rome.

The city's fourth-century walls, built by Constantine's predecessor, Maxentius, determined the imperial scale and basically circular shape of the city. Renaissance maps and views (Fig. 9.1) emphasize the city's two concentric circles of defenses, the inner corresponding to the Roman walls, the outer to medieval fortifications that were begun in the twelfth century, completed in the second half of the fourteenth, and reinforced with new bastions in the sixteenth. Moats and canals provided efficient transport of heavy goods around and through the city. Publicists for the city never failed to note that since the circle is the symbol of perfection, Milan was surely ideal as well. The city's enormous cathedral dominates its center, but as in Naples (see Fig. 6.1), the ruler's castle stands apart. The autocratic rule of the Visconti and Sforza families who controlled the city was clearly understood as divinely ordained and inspired. Accompanying Christ at the top of our illustration are Milan's heavenly protectors: the Virgin Mary, St. Ambrose, and St. Victor on the left and three saints often invoked during plague, the saints Christopher, Sebastian, and Roch, on the right.

Except for the cathedral, the city's most impressive early churches, San Lorenzo (see Fig. 24.4) and Sant'Ambrogio, stand between the two rings of walls, a reminder that the earliest Christian foundations in most Roman cities were necessarily on the periphery where there was more room for construction and where they did not disturb pre-existing temples and public buildings. Constantine's famous Edict of Milan, issued in the city in 313, was a declaration of religious toleration, not a proclamation of Christian empire. The city's bishops—most notably Ambrose (c. 339–397), who became the city's patron saint and gave his name to Milan's unique manner of celebrating the Eucharist, the

(opposite) Crucifixion (detail), 1370s, commissioned by Bonifazio Lupi from Andriolo de' Santis and Altichiero for the St. James Chapel, the Santo, Padua. Fresco

This view of Milan was drawn to commemorate the end of a plague in 1578. The primary structures outside the city walls include the courtyard of a civic plague hospital on the far right, wooden huts for isolation of some of the sick below it, and a civic graveyard at the bottom left.

so-called Ambrosian rite-moved quickly to Christianize the entire city but could not completely undo Milan's previous political geography. Conquered by the itinerant Lombards in the sixth century, Milan survived as an important civic center throughout the Middle Ages. Led by strong bishops, it eventually became a republic that headed a federation of northern Italian city states, the so-called Lombard League. Factionalism, however, doomed the republic. In 1277, at the very moment that governments in cities like Florence and Siena were becoming more and more representative, the Visconti family seized control of the city and continued to rule Milan until the mid-fifteenth century. Of ancient Milanese stock, many of their number served as archbishops of the city, giving the family power that it ultimately transformed into political rulership. The Visconti identified themselves with local traditions and were especially attentive to the city's imperial legacy and the reputation of her local saints. Splendor and magnificence were two hallmarks of their patronage.

We are fortunate in possessing a detailed prose description of the city at the time the Visconti gained power. Written by a schoolmaster, Bonvicino da Riva, and completed not later than 1288, it embodies a fervent patriotism that was typical of writers in every Italian city. Bonvicino called Milan the rose of Lombardy, outstanding for its fertility, fortitude, and good faith. He praises the city's site, its climate (neither too hot nor too cold), its excellent canals and water supply, plentiful food, and numerous and long-lived inhabitants who are good, friendly, and honest. Wide streets, beautiful palaces, and 12,500 houses "packed in, not scattered but continuous, stately and adorned in a stately manner" served a population he optimistically over-estimated to be 200,000. Half that number would seem more likely.

Azzone Visconti and the Idea of Magnificence

HAMMAN

The first surviving, large-scale works of Visconti patronage date from the rule of Azzone Visconti (d. 1339), who revived the idea of a Lombard League with Milan as its capital. Seeking to forge a collective identity for the Milanese state, he embarked on a

program of constructing churches, towers, and other public buildings, paving streets, and opening squares. The centerpiece of his building program was a palace complex close to Milan's cathedral. An extraordinarily detailed and vivid description of the palace by Azzone's court advisor, the Dominican friar Galvano Fiamma, admits us to the Milanese court. Fiamma both describes Azzone's palace and justifies its grandeur. Adopting Aristotle's notion of magnificence, Fiamma says that private expenditure by the prince is intended to create a kind of public magnificence that serves the com-

mon good. Investment in a palace with ample accommodation for court officials and offices impresses the public and keeps the general populace from wishing to attack the ruler. Devoting funds to churches confirmed his status as a pious, Christian prince.

Only the tower of San Gottardo (Fig. 9.2) survives from Azzone's palace complex, but, with its traditional Lombard crown of marble columns and an angel holding a banner with the Visconti coat of arms, it exemplifies Azzone's magnificence. The top of the tower included a clock with bells that rang out at every hour, defining time for the entire community. The chapel's interior was especially lavish: a choir with ivory paving and pulpits, stained glass windows, gold and silver reliquaries, and liturgical vessels encrusted with pearls.

The adjoining Visconti palace was equally impressive. Fiamma describes in detail the exotic birds and animals that Azzone kept in cages in the palace, the lush gardens and numerous fountains. When he boasts that blacksmiths, scribes, sculptors, glaziers, carpenters, and various other craftsmen all actually lived in the complex, the extent of Azzone's dedication to magnificent display becomes clear. Workers needed to be close at hand not only to decorate the palace but to provide the trappings for processions and ceremonies that took place regularly throughout the city, extending Azzone's splendid image wherever he went.

Fiamma describes the multi-storied palace in meticulous detail, even including the washrooms. Its gardens included a courtyard ringed with paintings of the Punic wars. Another fresco of Vainglory celebrated the fame of Azzone in the company of Charlemagne and the leading founders of ancient cities. An idea of what part of this painting may have looked like can be gained from an illustration of Vainglory in a central chariot surrounded by an entourage of excited horsemen which is preserved in a

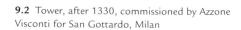

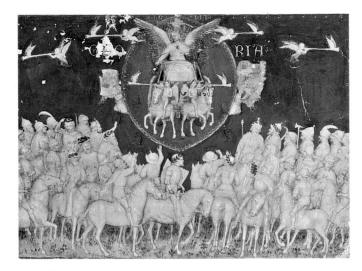

9.3 *Vainglory*, from Francesco Petrarch, *De Viris Illustribus*, after 1336, manuscript recording composition of frescoes in the palace of Azzone Visconti, Milan, originals probably by **Giotto** (Bibliothèque Nationale, ms. Lat. 6069, Paris, presentation copy, 1379, frontispiece "A")

later presentation copy of Petrarch's writings (Fig. 9.3). There is good reason to think that the original painting may have been by Giotto, who was sent to Milan by the Signoria of Florence in 1335, having earlier decorated parts of the interior of the Angevin kings' castle in Naples. Seen variously from the back, side, and head on, the horsemen turn to one another and gesticulate in highly convincing ways.

Giotto's legacy also is clearly evident in a page illustrating the *Death of Jacob and Joseph* from the *Liber Pantheon* of Goffredo da Viterbo, an encyclopedic text copied in

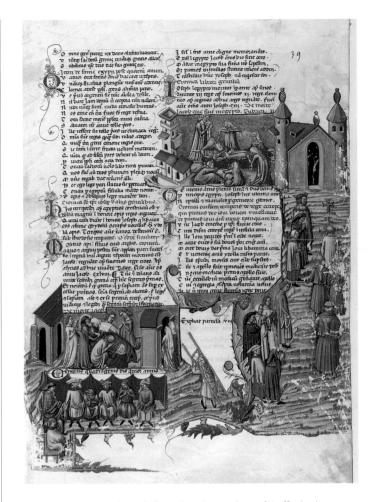

9.4 *Death of Jacob and Joseph*, from the *Liber Pantheon* of Goffredo da Viterbo, 1331, commissioned by Azzone Visconti. Vellum (Bibliothèque Nationale, ms. Lat. 4895M, fol. 39, Paris)

CONTEMPORARY VOICE

In Praise of Magnificence

The lavish expenditure of Azzone Visconti was not—according to his supporter Galvano Fiamma—inspired merely by a desire for self-glorification. A very respectable justification for such display could be found in the writings of the revered Greek philosopher Aristotle (384–322 B.C.). In the fourth book of Aristotle's Nicomachean Ethics, the philosopher praises lavish expenditure by those possessed of great wealth, provided its object is worthy: "The magnificent man is an artist in expenditure . . . he will think how he can carry out his project most nobly and splendidly."

Fiamma shows how his employer has applied Aristotle's precepts to his own residence:

Azzo Visconti, considering himself to have made peace with the Church and to be freed from all his enemies, resolved in his heart to make his house glorious, for the Philosopher says in the fourth book of the Ethics that it is a work of magnificence to construct a dignified house, since the people seeing marvellous buildings stand thunderstruck in fervent admiration, as is stated in the sixth book of the Politics. And from this they judge a Prince to be of such

power that it is impossible to attack him. A magnificent habitation is also an appropriate place of residence for a multitude of officials. In addition, it is required of a magnificent prince that he build magnificent, honourable churches, for which reason the Philosopher says in the fourth book of the Ethics that the honourable expenses which a magnificent prince should defray pertain to God. For this reason Azzo Visconti began work on two magnificent structures, the first for the purpose of divine worship, that is a marvellous chapel in honour of the Blessed Virgin, and a magnificent palace, fitting to be his dwelling.

(from Galvano Fiamma. "On the Magnificence of Buildings." Chapter 15 of Opusculum de rebus gestis ab Azone, Euchino et Johanne Vicecomitibus. Louis Green. "Galvano Fiamma, Azzone Visconti, and the Revival of the Classical Theory of Magnificence." Journal of the Warburg and Courtauld Institutes, 53 [1990]: p. 101)

9.5 Tomb of Azzone Visconti, c. 1342–44, commissioned by Azzone's brother, Archbishop Giovanni Visconti, for San Gottardo, Milan

The tomb was originally brightly painted and crowned by a baldachin. It carried the inscription: "In this tomb is buried the nobleman Azzo Anguiger, a man mild in his rule, sometimes gentle, sometimes cruel: he girded the city with walls, and accepted kingly power: he punished crimes and built fortresses: he deserves a long life, if it were in the fates that virtue could endure for many years." (trans. Ellen Longsworth)

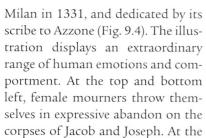

bottom, men wait on a bench outside the death chamber, not yet aware of what has occurred, even though a man carrying a wood and rope bier on his back is already making his way up the rocky path. Among the seated men a figure stands as if to share the news, while another, who is presented almost entirely from the back, cranes to hear the message. The wait has been too long for another, however, who slumps over in bored dejection, providing a dramatic foil to the concern on the face of his companion to the right and the outright anguish communicated by the upraised hands and tilted head of the next.

Azzone Visconti's Tomb

Azzone's image of princely magnificence continued in death. His tomb (Fig. 9.5) was placed in the palace chapel of San Gottardo, which he had so lavishly embellished. Attended by angels, his effigy rests on the cover of the sarcophagus, which is further decorated with relief sculpture commemorating his reign. At the center is Milan's patron, St. Ambrose (340–97), sheltering two seated figures, possibly Azzone's successor Lucchino Visconti (1292–1349) and the Holy Roman Emperor Ludwig of Bavaria (r. 1314–46), from whom he received the prestigious title of imperial vicar, or deputy. To his right and left kneel personifications of the cities that owed him allegiance, including Como, Brescia, and Monza, presented by their patron saints.

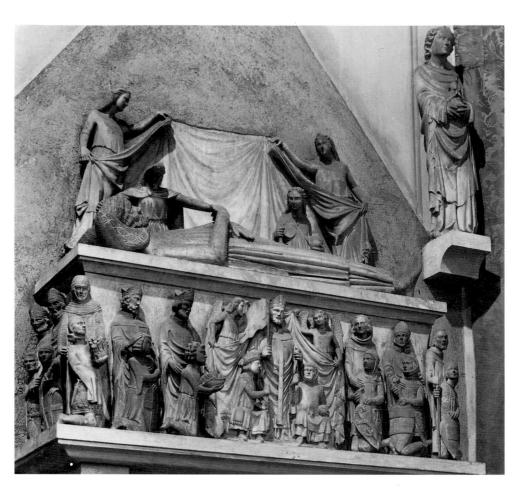

Although Visconti rule was not as neatly hereditary as in royal states—Azzone's realm was divided at his death among competing cousins—the tomb conveys the implied hope that his legacy would endure. The sturdy three-dimensionality of the figures, careful attention to anecdotal detail in their armor and ecclesiastical dress, and the individualization of some of the faces indicate that Azzone's carvers were fully aware of sculptural developments in the rest of Italy.

Embellishment of the City

Azzone's example encouraged other prominent Milanese to contribute to the artistic embellishment of the city. An outstanding example is the new free-standing tomb that Dominicans commissioned to honor St. Peter Martyr (Fig. 9.6) at Galvano Fiamma's Dominican convent of Sant'Eustorgio. Peter Martyr was a famous inquisitor who was murdered in 1252. In 1253 a modest tomb for his miracle-working body had been set up in the left aisle of Sant'Eustorgio, where it attracted great crowds of pilgrims.

9.6 (opposite) Tomb of St. Peter Martyr, 1330s, commissioned by the Dominicans of Sant'Eustorgio with the support of noble patrons from **Giovanni di Balduccio** for Sant'Eustorgio, Milan. Marble

The tomb was originally located in its own chapel along the left aisle of the church.

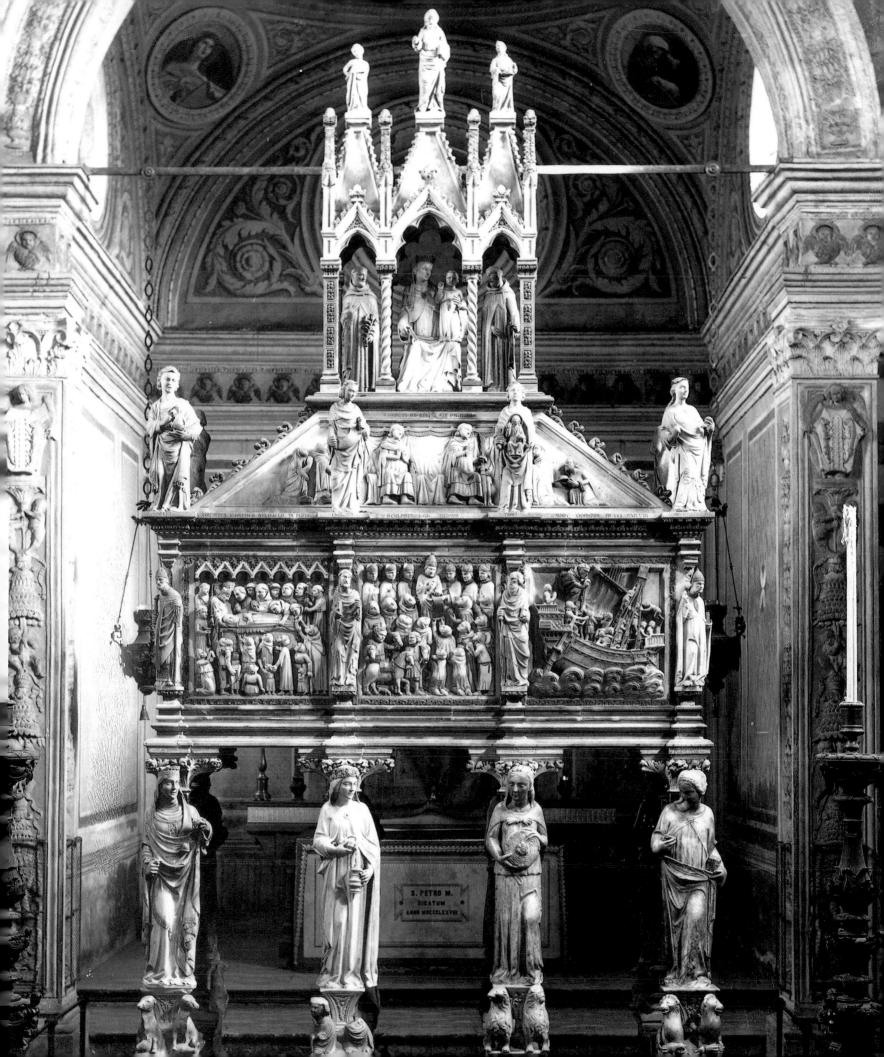

In the climate of artistic magnificence established by Azzone and promoted by Fiamma in the mid-1330s, the tomb must have seemed inadequate for the second most important saint of the order after St. Dominic himself. The friars wished to emulate the Bolognese tomb of their founder by Nicola Pisano, and to this end they secured the services of a Tuscan artist, Giovanni di Balduccio (active 1317–49), who, as a collaborator of Giovanni Pisano in Pisa, had a reputation as a designer of impressive tomb monuments.

The king and queen of Cyprus, Azzone Visconti, and his uncle Archbishop Giovanni Visconti all made major contributions toward the project for St. Peter Martyr's tomb and are represented on the lid of the sarcophagus kneeling alongside paired saints. Their figures, however, are barely noticeable in the context of this spectacular composition, which bears the stamp of the Dominicans' wish to promote the cult of their saint. The sarcophagus containing the body of the saint is raised above the ground so that it would be visible even when thronged by crowds seeking to touch it. Eight caryatids representing the virtues support it, each elegantly posed and turned toward the center of the monument. Particularly compelling are the two figures at the left, whose soft faces and suave motion are among the most advanced of their time. Doctors of the Church, saints, and

angels appear as statuettes around the monument, which is crowned by a tabernacle holding a seated Madonna and Child flanked by saints Dominic and Peter Martyr.

Reliefs on the front of the sarcophagus depict the saint's funeral, his canonization, and his miraculous intervention in a storm at sea. Carved in a more archaic but very legible style, figures neatly arranged row by row and the protagonists enlarged according to the conventions of hieratic perspective, they make it clear that the saint's remains are both highly efficacious and sanctioned by Church authority. In the funeral scene, supplicants with bent hands holding crutches and seated on wooden walkers seek healing through sheer proximity to the saint's body. The canonization scene places central attention on the pope and on a banderole representing the papal bull admitting Peter Martyr to the ranks of sainthood. As the papacy's strong right arm in supporting orthodoxy, the Dominicans naturally tended to underscore their direct ties to the institutional Church. The maritime miracle at the right may even be a reference to the Navicella (see Fig. 2.12), with the sea calmed not by Christ but by the order's own saint. It is certainly an odd subject for a landlocked city like Milan, but most appropriate for the Dominicans, who used such imagery in other important commissions such as the Chapter House of their monastery in Florence (see Fig. 8.6).

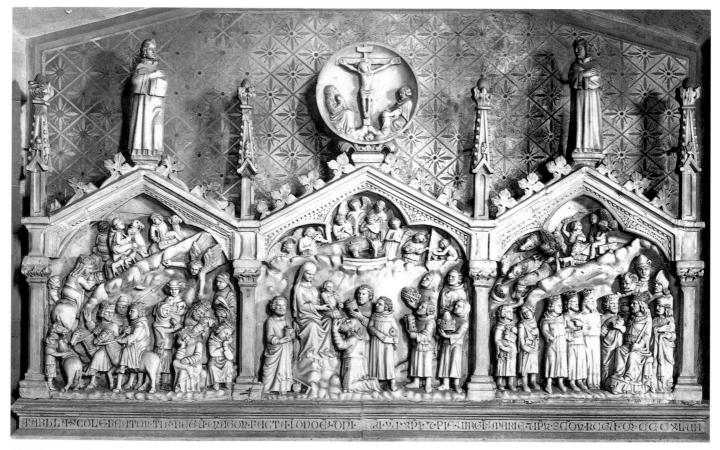

9.7 Altarpiece of the Magi, 1347, commissioned by the Scuola dei Magi for Sant'Eustorgio, Milan. Marble, 2' 3½" × 7' 2½" (70 × 220 cm)

Even though the church's relics of the Three Kings had been stolen several centuries earlier by Germans, who then built an elaborate shrine for them in Cologne, the Milanese continued to pay homage to the Magi.

The Altarpiece of the Magi

The Visconti devoted special attention to the cult of the Three Magi (wise men) or Three Kings, who had brought gifts to the infant Jesus. Every year on the feast of the Epiphany (January 6) they sponsored a procession of three "kings" across the city to a representation of Herod's palace constructed among the ancient Roman columns in front of the Early Christian church of San Lorenzo; from there the procession moved down the street and out the city gate to Sant'Eustorgio, where the "kings" adored a figure of the Christ Child in a crib at the high altar. Accompanied by large crowds and exotic beasts, including monkeys and baboons borrowed from the Visconti menagerie, the parade then swung around the city and reentered through the Porta Romana.

In 1347 the Scuola dei Magi, a prestigious lay group dedicated to the Three Kings, commissioned a marble altarpiece for their chapel in the church of Sant'Eustorgio (Fig. 9.7) which had once held the supposed relics of the Magi themselves in a huge stone sarcophagus. The altarpiece suggests the popular character of the Magi's cult in Milan. Carved in a direct, even slightly naive manner (note, for example, the rather stumpy figures and spatial ambiguities in the background), the narratives nonetheless evidence some new developments in their foregrounds, where figures move more freely and believably in space. The narrative begins in the right panel with the Magi making their way through densely carved hills in the background to an audience before King Herod. The central relief shows the Magi fervently adoring the Christ Child and presenting their gifts. At the left an angel commands the sleeping kings not to return to Herod but to seek another way home, again back into the compacted hillside at the upper left of the relief.

The Equestrian Monument of Bernabò Visconti

Sometime before 1363 Bonino da Campione (active after 1357, d. after 1397), a Lombard sculptor who had worked in the shops of the Milan cathedral, produced a life-sized equestrian statue of Bernabò Visconti as part of the Milanese ruler's funerary monument (Fig. 9.8). As Lord of Milan, Bernabò was a fierce and domineering ruler, intimidating his subjects with attack dogs and boasting of the fact that he had sired more than thirty illegitimate children. He had no trouble dominating his much more reticent cousin Galeazzo Visconti, with whom he shared rulership in Milan and its territories. Galeazzo wisely set up primary residence at Pavia, a safe distance of 22 miles (35 kilometers) from Bernabò in Milan.

It was a common north Italian custom to celebrate local leaders with individualized equestrian images. These were usually placed over doorways and on top of tomb monu-

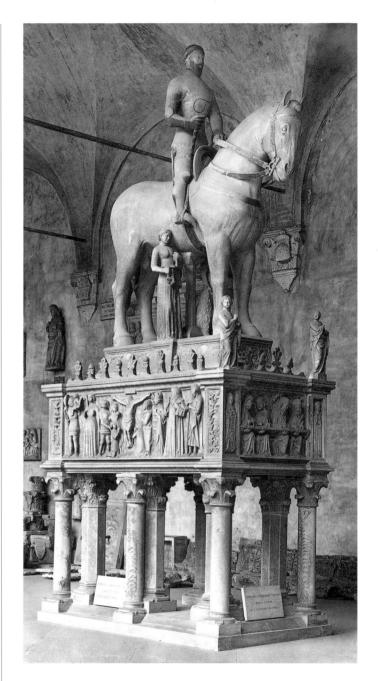

9.8 Equestrian Monument of Bernabò Visconti, before 1363, commissioned by Bernabò from **Bonino da Campione** for the high altar of San Giovanni in Conca, Milan. Marble, height (including sarcophagus and columnar supports) 19' 8" (6 m) (Castello Sforzesco, Milan)

ments outside churches (see Fig. 9.9), but Bonino's statue of Bernabò was designed to stand above the high altar of the Milanese church of San Giovanni in Conca. In claiming such an exalted site, normally reserved for royalty (see Fig. 6.17), Bernabò displayed a remarkable arrogance.

The horse and rider, carved from a single block of stone, rise above a sarcophagus whose main face shows Bernabò being presented by St. George, his patron saint, to the crucified Christ. The relief on the back depicts a subject equally suited to the sacrificial connotations of an altar and the funereal connotation of the monument itself: Christ as the

Man of Sorrows (a bust-length figure of Christ displaying the wounds of the Crucifixion), flanked by saints. Stylistically, the stark and immovable horse and rider differ remarkably from the more naturalistically carved reliefs, where the figures stand in front of their frames and give some illusion of distance through their diminishing size. Once again, a more iconic mode was adopted for the image of authority, a more relaxed mode for narrative and devotion.

Part of the statue's magisterial authority also derives from the equestrian type itself, which since ancient Roman times had been associated with imperial power. An example of this genre, well known to the Visconti, was the equestrian statue of Emperor Septimius Severus (146-211), popularly known as the Regisole ("sun king"), which stood in Pavia until it was destroyed in 1796. Bonino exploited and even transcended the conventions of this form; he shows Bernabò not merely seated astride the horse but standing erect in the stirrups—a force to be reckoned with. From the nave of the church, Bernabò would have been seen in profile, the standard view on coins and medals (see Fig. 9.15), and another, more subtle reminder of his authority. Gold and silver patterns on the horse, rider, sarcophagus, and supporting columns suggest costly metal. At the same time, Bonino disarmed the viewer with numerous realistic details, such as the horse's parade drapery bunching on its barrel chest, the delicately incised hairs of its mane, and minute attention to Bernabò's armor-all serving to vivify this imposing icon of power.

The Cansignorio della Scala Monument in Verona

Both Bonino and Bernabò may have been inspired in this commission by the impressive series of equestrian-topped tomb monuments that the lords of Verona, the della Scala, had begun erecting to themselves in the 1320s, next to the church of Santa Maria Antica. Indeed Bonino's success in Milan seems to have brought him to the attention of Cansignorio della Scala, who commissioned him, sometime before 1375, to produce the most splendid of the series (Fig. 9.9). An outsized tabernacle surrounds Cansignorio's sarcophagus and effigy, his worldly remains guarded by figures of warrior saints in tabernacles. On one end of the sarcophagus, just beneath the head of his effigy, a relief shows the popular, knightly saint George (who had also been shown recommending Bernabò Visconti to Christ) assuring Cansignorio's entrance into heaven by presenting him to the Virgin. A Coronation of the Virgin provides an aptly regal image on the other end, while the road to salvation is represented by scenes from the life of Christ on the sides. Virtues and angels holding della Scala coats of arms fill the upper niches, rising to the base of Cansignorio's equestrian portrait, a triumphant image for the della Scala dynasty. The entire monument is thoroughly Gothic.

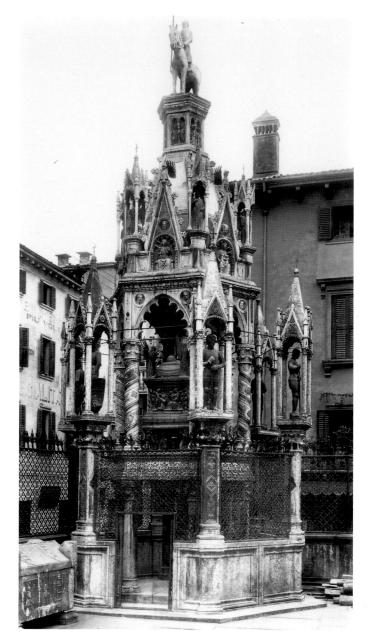

9.9 Funerary Monument of Cansignorio della Scala, before 1375, commissioned probably by Cansignorio from **Bonino da Campione**, outside Santa Maria Antica, Verona

This monument stands amidst a large number of others in a cemetery adjacent to the entrance of the church.

Bonino rejected the square plan and relatively restrained decoration of earlier canopied monuments in favor of a complex polygonal plan, open tabernacles, tall spires, and steeply pointed gables to house his graceful figures, clad in soft and swaying drapery.

The Castello Visconteo

Not to be outdone by either his cousin Bernabò Visconti or the lords of Verona, Galeazzo II Visconti of Milan erected an imposing new residence in Pavia in the 1360s (Fig. 9.10). Pavia provided Galeazzo with a seat of power independent

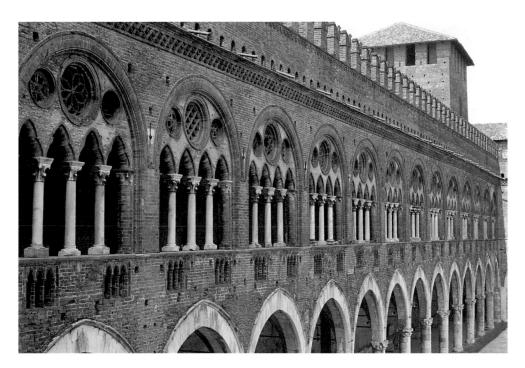

9.10 Castello Visconteo, Pavia, courtyard, c. 1360, commissioned by Galeazzo II Visconti

of his overbearing cousin and with an enhanced aura of legitimacy, since the city was the traditional capital of the Lombard kings, who ruled this region from the sixth to the eleventh century.

Galeazzo's new residence, the Castello Visconteo, was erected on the edge of town next to the city wall. It measured a formidable 465 feet (142 meters) across and was nearly as deep; its four corners (of which only two remain) were buttressed by square towers (Fig. 9.11). For its time it is an extraordinarily regular structure, both in plan and elevation. Despite these and other fortifications, including a moat, drawbridge, and crenellations, the structure had more the air of a palace than a castle: its long, two-storied façade, pierced with large Gothic-style windows, would have offered scant protection against attackers. While borrowing Gothic forms from northern Europe, the builders of the Castello Visconteo drew also on conservative Lombard precedents, barely pointing the arches of the courtyard's lower arcade and inserting traditional plate tracery into the rounded arches of the upper story. These round motifs recall late thirteenth-century civic buildings.

The design of Galeazzo's palace/castle, like that of most secular buildings, emphasized functionality over beauty. The ground and subterranean areas served as cellars, stables, storerooms, and prison. The courtyard was large enough to serve as an arena for jousts, tournaments, and grand banquets of over a dozen courses, served in great splendor. The upper story consisted of a single row of rooms, which provided audience and administrative space as well as apartments for Galeazzo and his extended family. Only fragments of the original sumptuous decoration survive, but it included mounted knights, geometric designs, heraldic devices, a panoramic view of the city of

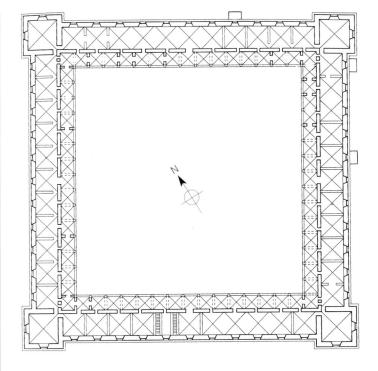

9.11 Castello Visconteo, Pavia, plan of upper floor as in 1469, including reconstruction of destroyed wing

Pavia, and numerous portraits of Galeazzo. The entire complex impressed Petrarch, one of Galeazzo's many illustrious guests, as "the most noble production of modern art." This opinion probably referred both to the building itself and to its contents, including a renowned manuscript library which was among the very largest in Europe. An inventory taken in 1426 listed 988 manuscripts, 371 of which still survive.

Manuscript Illumination

Galeazzo, Bernabò, their wives, and other Visconti family members were notable patrons of manuscript illumination. When Bernabò married his daughter, Valentina, to Louis of Touraine in 1389, her luxurious trousseau included manuscripts as well as the usual jewels and embroidered robes. Among the most splendid of the manuscripts commissioned by the Visconti court in Milan is an illustrated copy of the knightly romance, the Legend of Guiron le Courtois (Fig. 9.12). Bernabò's monogram, which appears on his tomb and on coins minted during his reign, has recently been noticed within the manuscript, revealing a gentler side of Bernabò's otherwise daunting personality. In this work we again encounter the image of the soldier on horseback, but instead of conveying intimidation and power, the image is used to illustrate a fable about the mysterious helmeted knight, known as Fieramonte, at the court of Artù.

The illumination shown, rendered with light strokes and colored with pastel delicacy, packs a great deal of narrative information into a relatively constricted space. The fore-, middle- and background merge compactly behind the words of the text, itself arranged in two columns which seem to lie directly on the picture plane. Beneath the right column Blioberis kneels before the king to ask permission to challenge the mysterious horseman, who in courtly fashion is accompanied by a dwarf riding on his own miniature steed. Behind them and to the left rests the ship that has brought them across the sea to this encounter. Between the two columns of text, ladies of the court stand in a wooden enclosure awaiting the tournament that will soon follow, while at the far right the king's retainers exchange knowing and worldly glances. The high etiquette, stylized costume, and conventionalized behavior of life at court emerge clearly from this illumination.

9.12 Fieramonte at the Court of Artù, from the Legend of Guiron le Courtois, 1389, commissioned by Bernabò Visconti (Bibliothèque Nationale, ms. fr. 5253, fol. 2V, Paris)

Courtly romances, which were usually written in French, were popular at north Italian courts well into the fifteenth century.

In a slightly more popular vein but still informed by the same precious and courtly sensibilities as the Guiron manuscript is an illustration of *Spring* (Fig. 9.13) from a *Tacuinum Sanitatis*, an illustrated health handbook owned by Verde Visconti, another daughter of Bernabò and the wife of Leopold of Austria. Verde's copy of this popular manual—one of the first mass-produced texts after the invention of printing in the fifteenth century—

uses naturalistic shorthand to provide instructions on medical self-help. Following the conventions of this sort of manuscript, which limit space and extraneous detail in order to focus on one subject, the picture depth is shallow

9.13 Spring, from a Tacuinum Sanitatis (illustrated health handbook), 1380s (?), commissioned probably by Verde Visconti (Bibliothèque Nationale, ms. lat. 6977A, fol. 103, Paris)

CONTEMPORARY SCENE

Art and Gastronomy

A Renaissance Italian would hardly recognize modern Italian food. Tomatoes, potatoes, corn, green and red peppers, certain kinds of white beans, chocolate, and coffee—all native to the Americas—were unknown in Europe until the sixteenth century. The diets of rich and poor alike centered around meat and fish, which were

usually dried and salted—the most efficient means of preserving foods before modern refrigeration. Heavy doses of spices, rose water, and flower petals helped to disguise off-flavors. Soups, stews, and porridges were the mainstays of most people's diets; a spit-roast capon was enough of a luxury that Sienese officials chose it to impress Lorenzo Ghiberti when they were courting him for work in their Baptistry in 1417.

No part of an animal was left unutilized. In Figure 9.14, two women in long aprons prepare tripe-the one on the left scraping the cow's stomach, while another on the right boils it in a large cauldron. Their product is deposited in rectangular and round bowls made of wood or ceramic, though the plate being presented at the table in the background may just as likely be a trencher made of stale bread. Broth or juices softened the bread and made it edible. Small rolls-any leftovers of which would be ground into crumbs for thickening dishesaccompanied meals, along with plenty of wine.

As now, medical professionals offered advice about diet. Each food was associated with a particular "humor" or physical and psychological tendency related to one of the four essential elements: earth, fire, air, or water. For example, the hardworking businessman Francesco Datini of Prato was counseled by his physician to avoid fruit

Intertia. 1. busecha.

Diferrar unterna, pplo.fr. et le mê. Clecté arten. muamitum bimb; from natte.ca. unquo etbi fruet. I comitum bimb; nances. groffa ucuas inoluna i crumby porfic regenment. Remo nori. fi pellifentur bii per iparentur, ci aceto pipe galegae finalil. Cuto grafi fla groffinn f Collematemag. ca et etc. unumb) by eme et motania masile.

9.14 Preparing Tripe, from a Tacuinum Sanitatis (illustrated health handbook), late fourteenth century, Lombardy (Österreichisches Nationalbibliothek, ms. ser. nov. 2. 644, fol. 81, Vienna)

of all sorts because its "cold and wet" properties would lead to lethargy and putrification of the blood. Melon, berries, cherries, figs, almonds, honey, wine, and mint were allowed in small quantities because they were somewhat "warmer." Bacelli beans, apples, chestnuts, and pears were completely off-limits.

Table manners were informal: many dishes were eaten communally and with the fingers, as seen in the picture. In 1290 Fra Bonvicino da Riva wrote an admonition that was often repeated well into the sixteenth century: "Thou must not put either thy fingers into thine ears, or thy hands to thy head. The man who is eating must not be scraping with his fingers at any foul part." Although every table was set with at least one large knife-also visible in the illustration-forks were relatively rare. Imported from the Byzantine East by a princess named Theodora, who married Doge Domenico Selvo (1071-84), they were two-pronged and gold, and initially struck Venetians as superfluous. However, forks became fashionable in Italy in the fifteenth century when the ecumenical councils of the 1430s and the fall of Constantinople in 1453 brought many Greek Byzantines to Italy. The fork did not gain wide acceptance in the rest of Europe until the eighteenth century, which earned Italians the reputation of being particularly elegant eaters.

and the background is left blank. A young woman with long blond hair casually tied in the back smells a flower while her male companion, stylishly clad in long pointed shoes and a scallop-edged cloak, holds a hunting bird and points to a spring landscape beyond a wattled fence. The illumination and accompanying text are succinct and direct, the greenery swept across the page in broad outlines, the meandering branches sketched casually on the darker ground.

Padua: The Carrara Court

Another major north Italian center of artistic innovation in this period was the university city of Padua. The city's lord, Francesco da Carrara (r. 1350–88), became a close friend and avid correspondent of the internationally renowned poet and scholar Petrarch, who lived in and around Padua from 1370 until his death in 1374. Conversations and

9.15 Medal of Francesco da Carrara, Lord of Padua, c. 1390. Silvered bronze, 14" (33 mm) (© British Museum, London)

The emblem on the reverse is a highly stylized representation of a four-wheeled cart, or *carro*, a reference to the Carrara family.

correspondence with Petrarch probably encouraged Francesco to join other north Italian rulers in exploiting aspects of Roman art and history to support his regime. When Francesco's son recaptured Padua in 1390 after a two-year break in the Carrara family's rule, he commissioned the coining of small medals (Fig. 9.15), the first of their kind of the Renaissance, portraying himself in the guise of a Roman emperor. Earlier Francesco had used Petrarch's collection of biographies of famous Romans (De viris illustribus) as the basis for a series of frescoes in the Carrara palace. The narrative scenes seem to have depicted Roman history in contemporary rather than antique dress; classical content did not require classical form. Each famous Roman was accorded an individual portrait, and the cycle included one of Petrarch as well. The original fresco survives in highly damaged and altered form, better known through a precise manuscript illumination (Fig. 9.16). Here Petrarch occupies a highly coherent and illusionistic space that recalls types first created by Giotto in the Scrovegni Chapel (see Fig. 3.7). The scholar sits before a desk on which he turns the pages of a manuscript, other volumes ready at hand on a circular stand to his left. His pet dog curls up comfortably in front of a storage chest. Diagonally-placed ceiling beams lead the eye back to a closet whose open doors reveal other volumes. The open panel of a window with precisely-rendered leaded glass roundels admits light and air into the homey interior. All these details lend a remarkable anecdotal realism to the image, unusual for painting of this time.

The Padua Baptistry

Padua's ruler did not neglect his city's religious buildings. For the decoration of the Padua Baptistry (Figs. 9.17 and 9.18), which Francesco da Carrara and his wife Fina Buzzacarini chose as their burial place, Francesco turned to the Florentine painter and late follower of Giotto, Giusto de' Menabuoi (active 1349–90 Padua). By 1370 Giusto was at work in the church of the Eremitani in Padua, where he may have come to their attention. The commission for the Baptistry frescoes was instigated around 1378 by Fina. She

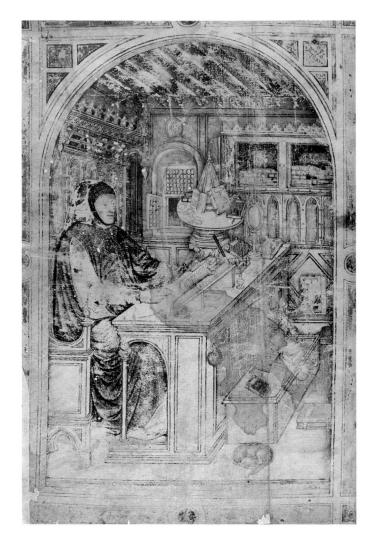

9.16 Petrarch in His Study, manuscript illumination recording the composition of frescoes commissioned by Francesco da Carrara for the Sala Virorum Illustrium, Carrara Palace, Padua (Hessische Landes- und Hochschul-Bibliothek, Handschriftenabteilung Codex 101, fol. 1v, Darmstadt, Germany)

Although Florence claimed Petrarch as one of the city's most famous sons, he spent most of his life at the papal court in Avignon, France, and in northern Italy.

CONTEMPORARY VOICE

Illustrious Men

In 1379, five years after the death of Petrarch, his good friend and literary executor, Lombardo della Seta (d. 1390), produced the first manuscript version of the poet's unfinished *Uomini Illustri* ("Illustrious Men"). The preface that Lombardo provided for the work dedicated it to the lord of Padua, Francesco il Vecchio Carrara, and paid graceful tribute to the

frescoes that Francesco had commissioned as a visual complement to these biographies.

As an ardent lover of the virtues, you have extended hospitality to these *viri illustres*, not only in your heart and mind, but also very magnificently in the most beautiful part of your palace. According to the custom of the

ancients you have honored them with gold and purple, and with images and inscriptions you have set them up for admiration To the inward conception of your keen mind you have given outward expression in the form of most excellent pictures, so that you may always keep in sight these men whom you are eager to love because of the greatness of their deeds.

(from Theodor E. Mommsen. "Petrarch and the Decoration of the Sala Virorum Illustrium in Padua." Art Bulletin, 34 [1952]: pp. 95-116 [extract p. 96])

appears in one of the frescoes kneeling before the Madonna as the putative patron. Her presence in the birth scene from the Life of St. John the Baptist and the unusually large number of women in other scenes suggest that she left a strong personal impact on the program which was probably not complete at her death when her last will and testament left remaining decisions about the decoration and its execution to her husband.

The Padua Baptistry is a centrally planned structure with a domical vault supported on pendentives. Giusto and his assistants covered every wall surface of the Baptistry with frescoes. They were also commissioned to paint the altarpiece for the small adjoining sanctuary—itself centrally planned in imitation of the main structure. One of the primary themes of the program is the end of time, the Day of Judgment, when the elect will join Christ in his kingdom. Concentric tiers of saints and angels ring the center of the dome, whose height is enhanced by the progressive diminution of the figures' sizes toward the central, looming figure of the blessing Christ. Directly beneath him and on axis with the Baptistry's entry door and Fina's tomb (subsequently destroyed and replaced by an inscription) hovers the Virgin in a glowing gold mandorla. In the sanctuary the theme is made explicit with illustrations of the Apocalypse, including the dead being called from their graves and schematic representations of the frightening beasts that loom large in the biblical account of the end of the world.

Patronage at the Santo

The St. James (San Felice) Chapel

The Lupi clan, who served the Carrara as *condottieri* (mercenary soldiers), claimed prize patronage sites at the Basilica of Sant'Antonio—the Santo—Padua's famed pilgrimage church, and its adjacent cemetery. For the decoration of their burial chapels, the Lupi chose a more innovative style than was used so successfully in the solemn space of the

Baptistry, hiring the adventurous Altichiero da Zevio (active 1369–93 Verona and Padua).

Some of Altichiero's most impressive works line the walls of the chapel that Bonifazio Lupi commissioned from the sculptor and builder Andriolo de' Santis (active 1342–75; Fig. 9.19). Located in the right transept of the Santo, directly opposite the miracle-working tomb of St. Anthony in the left transept, the chapel was dedicated to Bonifazio's patron saint, St. James. Scenes from James's life occupy the side walls, while the altar wall is dominated by an enormous Crucifixion. Appropriately for the chapel's function as a burial place, a small fresco of the dead Christ being lowered into his tomb occupies the wall over the tomb of Bonifazio's predecessors to the left, while a Resurrection provides a more hopeful image for the patron's own tomb to the right, completing the frescoed Passion cycle for the chapel.

The *Crucifixion* extends across three of the five bays above the altar, functioning as an enormous altarpiece. Though rich in anecdotal detail and portrait-like renderings, the fresco does not include the crosses of the two thieves who were crucified with Christ, concentrating instead on the central sacrifice. The cross is set in the foreground of a broadly coherent space which extends in greater and greater depth as it moves to either side, culminating in a hilltop castle on the far right and a firmly rendered and believably scaled pedestrian bridge, city gate, walls, and towers on the far left.

Throughout the frescoes Altichiero captures and communicates a great depth of emotional intensity that is unmatched throughout most of the Renaissance. At the foot of the cross and directly at eye level, Mary Magdalene arches her red-cloaked back in horror mixed with adoration. Her companion in blue slumps in despair, experiencing Christ's sacrifice in her own way. Other figures stand and gawk, kept in line by efficient guards and soldiers on horseback behind the cross. Soldiers at the right (see p. 174) lean over their dice, intent on winning the prize of Christ's seamless white garment, which is being stretched and tested by custodian priests behind them. A cowled figure holding a lance bends

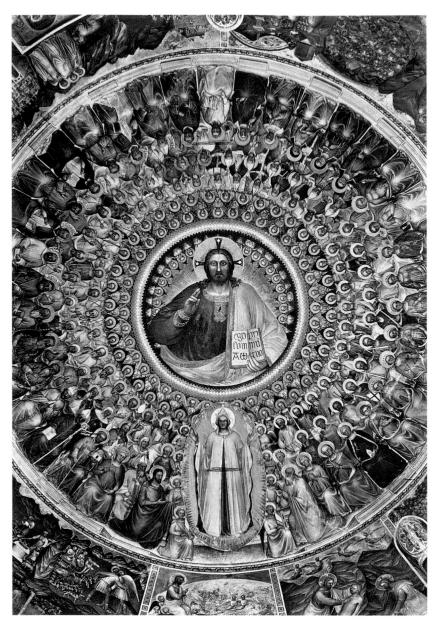

over them—almost certainly a portrait, as is the equally individualized guard crouched in front of him. Shot colors on the clothing of many of the figures—yellow highlights on pink, blue on green, for example—intensify the compelling realism of the scene. The Crucifixion becomes horrifyingly real, a visual parallel to the fiery sermons and intense devotional practices of the Franciscans and their exemplary saint, Anthony of Padua, to whom the basilica is dedicated.

St. Anthony of Padua

Anthony's ability to stir the emotions of worshipers through realistic, down-to-earth imagery was legendary. After his death, in 1231, his jaw and tongue were preserved and then later encased in transparent reliquaries, so that they would be visible to the faithful (Fig. 9.20). Worshipers believed that they had been miraculously spared from decomposing—visible signs of the saint's close and special

9.18 Dome of Heaven, 1370s, commissioned by Fina Buzzacarini from Giusto de' Menabuoi for the Baptistry, Padua. Fresco

relationship to God. By approaching the relics and either contemplating or touching them, a devotee hoped to gain access to the sanctity associated with them. The reliquary made in 1349 to contain Anthony's jaw features a crystal globe in which one can see the jaw, contained in a golden enameled and bejeweled bust. The rest of his body was buried in a stone sarcophagus which the faithful were encouraged to touch. Throngs of pilgrims still flock to the Santo because of their belief in St. Anthony's ability to intervene in everyday events, dispelling imminent danger and healing illness. As at virtually all major pilgrimage sites, they have always left behind gifts and tokens of his interventions (small paintings, miniaturized versions of healed limbs and body parts, abandoned crutches, and even richly jeweled necklaces and diadems like those on the jaw reliquary), adding their own visual contributions to the ensemble created by artists and patrons.

Thus the ultra-realism of Altichiero's frescoes played into expectations that the divine could be experienced in the here and now. Although the actual workings of God remained mysterious even in miracle-working shrines like the basilica of the Santo, God's volitional intervention on the part of humankind allowed and even encouraged naturalistic depiction and illusionism.

The Oratory of St. George

Altichiero's success in the frescoes for St. James's Chapel led to his receiving a subsequent commission in 1377 for a mortuary chapel, next door to the Santo, from another member of the Lupi clan,

Raimondino. These frescoes, too, impress with their convincing depiction of complex architectural spaces, the variety of demeanor shown by the figures, and the individuality of their characterization. In the scene of St. George Baptizing King Servius (Fig. 9.21) the saint is dressed as a contemporary knight. He stands before a precisely detailed Gothic church whose arches and vaults are picked out in alternating red and white. The realism was enhanced by silver gilt, now darkened, on the footed basin before which the king kneels. Members of his family and the court look on-each evidently a portrait likeness, each responding intently and individually to the event. To the far right and left, other onlookers, also responding appropriately according to their age, rank, and proximity to the action, stand in and around a handsomely delineated courtyard. The scene is full, but not overcrowded, the space coherently structured with remarkable assurance, and the figures rendered with particular integrity—all in all a major narrative achievement.

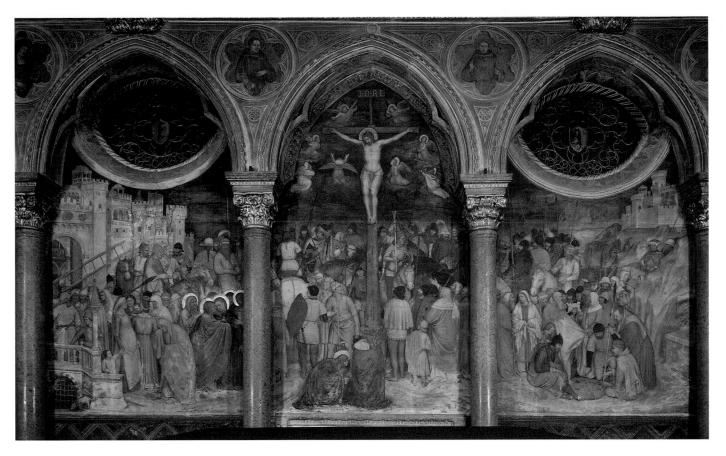

9.19 *Crucifixion*, 1370s, commissioned by Bonifazio Lupi from **Andriolo de' Santis** and **Altichiero** for the St. James Chapel, the Santo, Padua. Fresco The current dedication to San Felice dates from the early sixteenth century. See also p. 174.

Milan: Giangaleazzo Visconti

The final chapter of Visconti patronage in the fourteenth century was written by Giangaleazzo Visconti, son of Galeazzo II Visconti. Like his father he first ruled at Pavia, but then in 1385 he took over Milan. Ten years later the Hapsburg emperor, Wenceslas, proclaimed Milan a duchy, the only one of its time in Italy. Giangaleazzo earned his title of Duke through military acumen, diplomatic treachery, and a substantial contribution to the imperial treasury, giving him greater autonomy than other Italian princes. When he accepted the ducal crown in 1395 Giangaleazzo was already master of most of Italy north of the Apennines except for Venice. He soon extended his dominion well into central Italy, securing Pisa and Siena and laying siege to Florence. By 1402 he was poised to unify northern and central Italy under a single ruler, and he might have done so had he not died suddenly in the summer of that year.

Giangaleazzo seemed an unlikely person to achieve such international prominence. He cut a very poor public figure. Retiring and secretive, more a thinker than a soldier, he was, however, a supreme strategist, entering into alliances both to subdue rivals and to learn their vulnerabilities so he could make them his next targets. Giangaleazzo even feigned a reli-

uncle, Bernabò (see Fig. 9.8), ambushing him during a faked religious procession around Milan.

gious conversion in order to overthrow his fearsome

As a patron of the arts Giangaleazzo expanded upon the precedent set by his father, Galeazzo, and also emulated the cultural sophistication of Burgundy and the Île-de-France. Married at a young age to Isabelle, daughter of King John II of France (r. 1350–64), through whom he assumed the title of Comte de Vertus in Champagne, he further tied the Visconti to the French crown through the marriages of his niece and his daughter to French royalty. Not surprisingly, he gauged Milanese accomplishments by international standards.

9.20 Reliquary of the jaw of St. Anthony, 1349, the Santo, Padua. Gold, enamel, jewels, and crystal

A companion reliquary displayed the saint's tongue. Both reliquaries honored St. Anthony's legendary preaching skills.

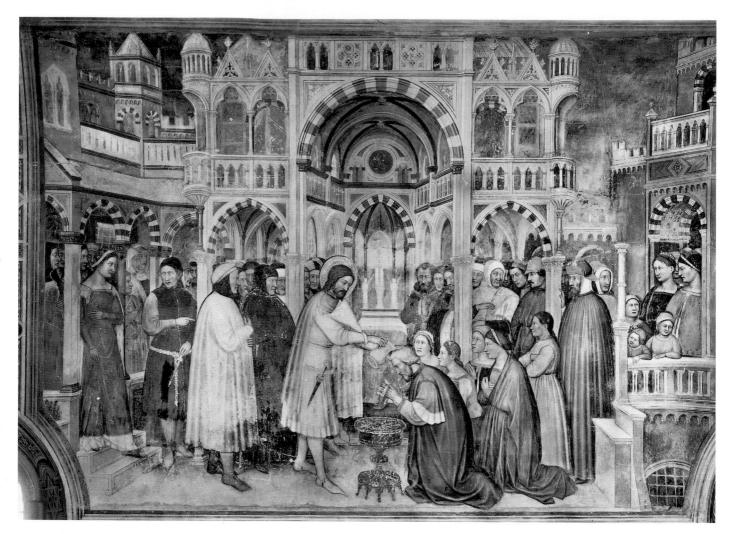

9.21 *St. George Baptizing King Servius*, 1377, commissioned by Raimondino Lupi from **Altichiero** for the Oratory of St. George, Padua. Fresco

A multi-tiered marble tomb with statues of members of the Lupi family once stood in the center of the oratory. It was so ornate that later pilgrims confused it with a saint's shrine.

The Certosa of Pavia

Soon after assuming the title of Duke of Milan, Giangaleazzo launched plans for the grandest of his commissions, the Certosa of Pavia (begun 1396). He intended this huge Carthusian monastery (Fig. 9.22)—which was not completed until well into the fifteenth century—to serve as his dynasty's mausoleum, emulating Jean de Berry, Duke of Burgundy, who had, in 1383, founded another Carthusian monastery, the Chartreuse de Champmol, for the same purpose. Giangaleazzo chose a site on the edge of the ducal hunting grounds outside the city of Pavia, confirming his family's associations with the town while at the same time ensuring exclusive control over the monastery. The first order of business was to erect quarters for the monks, who were committed to a solitary life of prayer and meditation.

9.22 Certosa, Pavia, plan, begun 1396, commissioned by Giangaleazzo Visconti

¹ Main entrance; 2 Church of Santa Maria; 3 Small cloister; 4 Monks' cells

Each individual was given a small three-room dwelling, complete with individual garden-generous accommodation by monastic standards, which must have enhanced the sincerity with which the monks prayed for the souls of deceased Visconti. Construction then began on the church. Although the present building is largely a product of much later intervention by other Milanese dukes, Giangaleazzo's ivory altarpiece (Fig. 9.25), which was to stand on the high altar in close proximity to his tomb, survives in nearly pristine form. It, too, follows a Burgundian precedent, Jean de Berry having ordered similar triptychs from the same artist, Baldassare degli Embriachi (active 1390-1409 Florence and Venice), for Champmol and Poissy in 1393. Ivory was a favorite medium among noble patrons, who appreciated its expense and luxury, while the Carthusian monks would have approved the purity of its color, embellished only with gold and some ebony inlay, which conformed to their tendency to avoid worldly color and pattern.

The Pavia triptych is extraordinarily large for a work in ivory, constructed of thousands of pieces of carved elephant tusk. The architectural frame, which is reminiscent of Giotto's design for Florence's Campanile and reflects Baldassare's training in Florence before he set up his own workshop in Venice, contains fifty-four niches for saints. The panel at the left contains eighteen reliefs depicting stories from the life of the Virgin; the one on the right, an equal number from the life of Christ. In the large central panel appear scenes from the lives and legends of the Three Kings, a subject chosen by Giangaleazzo to recall the Milanese cult of the Magi and, by association, to emphasize his own princely patronage. Most of the incidents in his altarpiece are carved from several narrow pieces of ivory. The Magi narrative was so important, however, that Baldassare and his workshop carved several of its reliefs from much larger pieces of ivory, joined with great ingenuity, which facilitated the inclusion of larger elements and more expressive interchange among the figures. In the scene of The Magi

9.23 The Magi Being Greeted on their Return Home, detail of the ivory altarpiece, 1390s, commissioned by Giangaleazzo Visconti from Baldassare degli Embriachi for the Certosa, Pavia. Elephant ivory and ebony

Being Greeted on their Return Home (Fig. 9.23) the eldest Magus leans well forward to extend his hands across the juncture of two broad pieces of ivory, grasping the outstretched arms of a younger man who has come out to meet him. They exchange joyful greetings, their emotion echoed by a child with upraised arms and a loyal dog who turns a perky head up toward his master. Another hound runs beneath the Magus's gold-caparisoned steed, a familiar image in courtly art. In spite of the precious medium and miniature scale, the relief's illusionistic space is deep and complex. In the background a deer appears in a cleft of one of the mountains, and trees give way to rooftops and towers as the procession nears the city.

Cathedral Architecture

Foremost among other patrons in Giangaleazzo's Milan was the Fabbrica, or building committee, of the cathedral. Led by the archbishop and supervised by a semi-

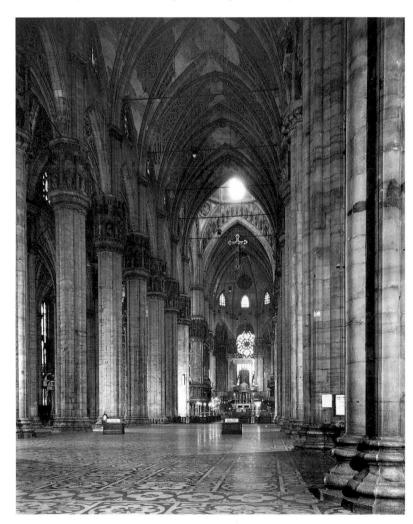

9.24 Milan Cathedral, begun 1386, commissioned by the Fabbrica of Milan Cathedral with the support of Giangaleazzo Visconti from **Simone** da **Orsenigo** and **Bonino da Campione**

The interior is extremely dark for a Gothic church because the builders refused to use flying buttresses which they found ugly.

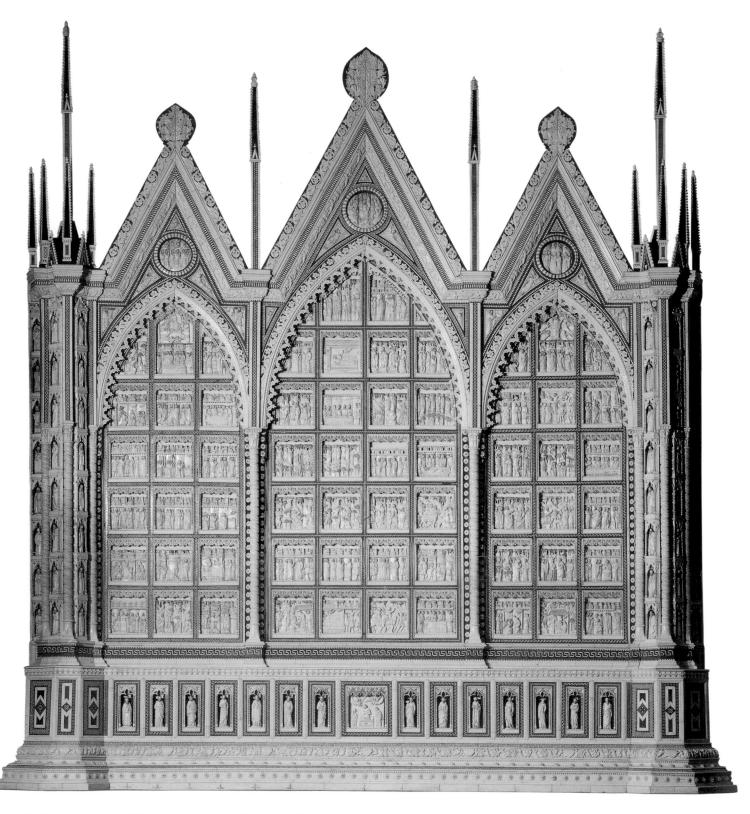

9.25 Ivory altarpiece, 1390s, commissioned by Giangaleazzo Visconti from Baldassare degli Embriachi for the Certosa, Pavia. Elephant ivory and ebony

autonomous citizens' council, which by 1395 numbered 300 members, the Fabbrica allowed a certain amount of artistic self-determination in this otherwise autocratically controlled city, encouraging the entire population to identify with a single project that exalted the city. Surviving account books record donations ranging from large sums given by aristocrats down to a few coins contributed by a

prostitute. Because a splendid cathedral could be of propagandistic value to the duke, he, too, was happy to facilitate its construction. He provided subsidies and exclusive access to important quarries. In acknowledgement of his contributions, the Visconti emblem of a radiating sun appears in the center of the lancet window behind the cathedral's high altar (Fig. 9.24).

The archbishop and leading citizens of Milan had been laying plans for a new cathedral for several decades, but Giangaleazzo's predecessor, Bernabò, had declined to support the project. Giangaleazzo was of another opinion. Soon after seizing power from Bernabò in 1385 he instituted several measures that endeared him to the citizenry, including lowering taxes and reforming the city's law code, as well as agreeing to the construction of a new cathedral. In September of the next year the foundations were being dug, led by Simone da Orsenigo (active 1380s–90s) and advised by Bonino da Campione and other local artisans. Day laborers were assisted by alternating troops of volunteer workers drawn from the city's guilds and parishes.

The building is both profoundly Lombard and distinctly international, grounded in Roman and Romanesque architectural ideas but executed with northern Gothic detail. The double-aisled nave and ambulatory (Fig. 9.26) follow the precedent of the large Romanesque cathedrals at the Lombard cities of Piacenza and Cremona. Vast space spreads into the double side aisles. The structure appears solid and massive—northern Gothic verticality and insubstantiality countered and balanced by huge capitals that crown the piers with statues set within Gothic niches. Small broad clerestory windows assure that the upper reaches of the vaults remain in mysterious shadow.

The complex piers of bundled colonettes, the highly pointed arches above them, and the thin, flamelike tracery patterns in the apse windows, however, were clearly inspired by transalpine models. Just as Giangaleazzo emulated the French aristocracy, the Fabbrica called upon architects from

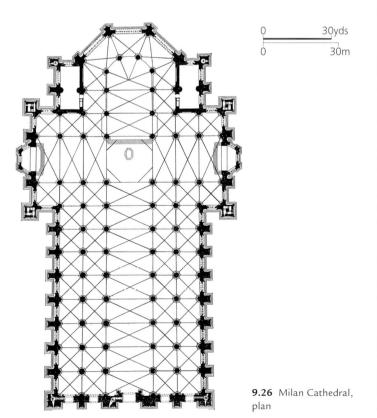

across northern Europe to advise on the construction of their cathedral. In 1389 they first turned to Paris, engaging Nicholas de Bonaventure; the next year they called upon a Master Johann from the German city of Freiburg; in 1391 and 1392 candidates were sought from Cologne and Ulm, finally resulting in the hiring of Heinrich Parler of Schwäbisch-Gmünd, who was working in Prague. He was succeeded by Jean Mignot of Paris, who was unusual in lasting several years on the job.

The design and construction process was filled with acrimony, vividly documented in the minutes of meetings held in 1392, 1400, and 1401. The Fabbrica had very clear ideas about the kind of building it wanted, and so did the northern European architects. Both sides based their recommendations regarding the shape of the building on ideal geometric schemes of squares and triangles, but neither had the ability to calculate accurately the actual forces at work within the building. Typical of Italian cathedrals in this period, the plan had been established, foundations laid, and piers built before final decisions were made about the size and shape of the vaulting or the kind of buttressing that would be required to sustain it. The northern architects imagined a high nave and low side aisles steadied in typically northern fashion by flying buttresses. But the Fabbrica criticized the exterior of Notre Dame in Paris for these features. The Milanese preferred a lower and broader church with higher side aisles which would make the structure essentially self-supporting. They also defended the unusual proportions of the nave piers and capitals in anthropomorphic and essentially Roman terms, insisting that the capital (or head) be several times larger than the base (or foot). Thus, the weightiness of the present building and the unusual form of its piers are direct expressions of clearly expressed local aesthetic preference.

Cathedral Sculpture From the start the cathedral project entailed an ambitious sculptural program. Masters were enlisted both locally and from abroad to carve figures for pinnacles and for reliefs between the traceried windows. Sculpture also embellished interior walls and the tabernacled capitals of the nave piers. Much of this work has a linear quality—the result of the method used in commissioning it. The Fabbrica first engaged painters and manuscript illuminators to produce drawings for sculptural decoration; these were then auctioned to sculptors who offered the best price for what was expected to be competent but not necessarily innovative work. When the sculpture was complete it was presented to the Fabbrica for comparison with the initial drawing.

For sculpture intended to occupy a prominent position, the Fabbrica was more selective. In 1419 they gave the very experienced master carver Jacopino da Tradate (active 1401–40 Milan and Mantua) a commission to produce a nearly twice-life-sized high relief carving of Pope Martin V for the interior of the cathedral (Fig. 9.27). Martin had

dedicated the high altar in October 1418. While adhering to the convention of a frontal and enthroned pose for the pope, Jacopino enlivened the image with cascades of drapery on the back and sides of the throne and over the majestic figure of the pontiff. Apart from the purposefully rigid pose and fixed gaze of the pope, every element has been carefully observed from nature and rendered with the utmost fidelity. Martin's legs and his raised right arm and hand, offering his blessing in perpetuity, extend realistically into space; his torso has weight and presence. A rectangular frame and a two-tiered corbel display lushly undercut foliage.

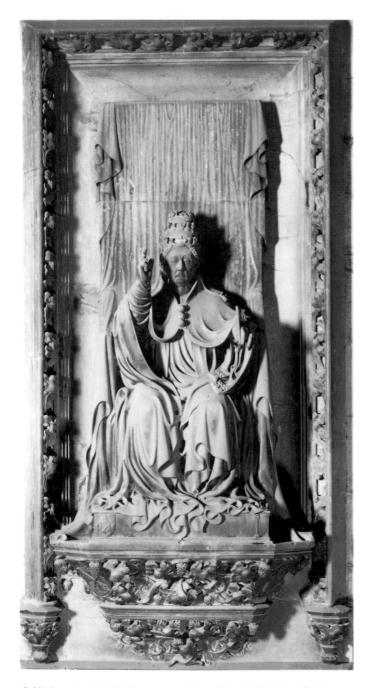

9.27 Pope Martin V, 1419-21, commissioned by the Fabbrica of Milan Cathedral with the encouragement of Filippo Maria Visconti from **Jacopino da Tradate** for Milan Cathedral. Marble, twice lifesize

The International Gothic Style

The artful combination of naturalism and stylization evident in Jacopino's sculpture is characteristic of what has come to be known as the International Gothic Style. Developed in northern Europe and given its most prestigious form at the highly cultured court of the dukes of Burgundy, the style combined sumptuous patterns and materials with linear artifice and close study of nature. All across Europe, late fourteenth- and fifteenth-century artists embedded detailed studies of flora and fauna within disembodied extravaganzas of color and pattern. Refined, complex forms were as at home in architecture (notably window tracery), sculpture, and wall painting as they were in the luxury art of manuscript illumination. Much of this was a logical outgrowth of dual Gothic tendencies toward naturalism and stylization, but sophisticated patrons now looked at these works in new ways. Both north and south of the Alps scholars were moving ahead with Petrarch's project to recover the ancient past. Reading classical authors, they were struck by Greek and Roman descriptions of art and nature that seemed to confirm their own predilections for a combination of the natural and the extravagant. For the most part, however, they were uninterested in serious archaeology, so visual discrepancies we now recognize between the art of their own day and that of the ancient past mattered little.

Manuscript Illumination

Manuscript illuminators led the way in promoting and popularizing the conventions of the International Gothic Style. One of its earliest exponents in Lombardy was Giovannino dei Grassi (active 1380s-1398 Milan), a multi-talented illuminator and painter who provided designs for Milan Cathedral. Around 1395 Giovannino produced a prayer book for Giangaleazzo Visconti, whose portrait, surrounded by the blazing device of the Visconti family, appears with a text from Psalm 118 (see Fig. 9.28). Typical of the International Gothic Style and of manuscript illumination in this period, the page includes a variety of artistic modes: some highly conventionalized, others strikingly naturalistic. Giangaleazzo's portrait, for example, is precisely rendered in profile. Derived from the tradition of Roman coins and medals, this formal pose allowed the ruler's distinctive features to be recognized easily by his subjects (see Fig. 9.15).

A much more fanciful and delicate decorative mode informs the illumination at the center of the text. Anchored at its four corners by the Visconti coat of arms, the basically square field supports a spiraling ribbon carrying the French fleur-de-lys and framing King David, traditionally regarded as the author of the psalms. The setting is illusionistic enough to suggest a shallow cavity of space within the initial, but linear and decorative enough to respect the graphic demands of the letter it is enhancing. The bas de page, or lowest range of the manuscript, is most detailed and

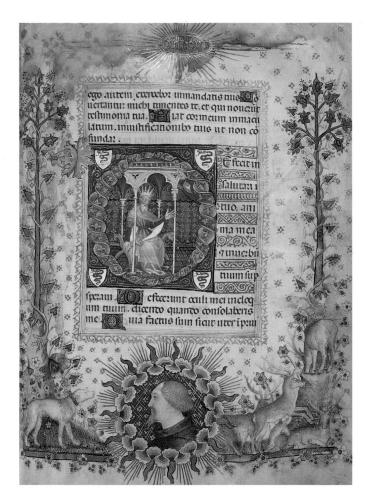

9.28 Psalm 118:81, from the *Visconti Book of Hours*, c. 1395, commissioned by Giangaleazzo Visconti from **Giovannino dei Grassi**. Tempera and gold on parchment, $9\% \times 6\%$ " (24.7 × 17.5 cm) (Banco Rari, Biblioteca Nazionale, 397, fol. 115, Florence)

This small book fits easily in one's hands. It was used for personal devotions on a regular schedule throughout the day.

realistic. This was considered a less important area of a manuscript since it did not include written text. Three of Giangaleazzo's hunting dogs on the left raise their muzzles in anticipation of pursuing the deer on the right. One of their quarry leaps across the rocky setting, while another, radically foreshortened in the background, grazes contentedly; yet another two sit in the foreground. The differing modes of depiction on a single page are obviously conscious choices, as is confirmed by a page of animal studies from Giovannino's own sketchbook (Fig. 9.29). At the top, a pack of hunting dogs viciously attacks a wild boar which itself seems to have mortally wounded a hound whose muzzle is thrown back in agony at the top of the group. On the lower half of the page, in contrast, a leopard set in a garden and chained to a radiant circle is a heraldic design and therefore much calmer and more stylized. Giovannino and his Lombard contemporaries were so renowned for their meticulous renditions of animals from life that this kind of work came to be known throughout Europe by the French term ouvraige de Lombardie ("Lombard work"), a noteworthy achievement in this otherwise French-dominated art.

9.29 Animal studies, from the notebook of **Giovannino dei Grassi**, 1390s. 10% \times 6½" (26 \times 17.5 cm) (Biblioteca Civica, ms. Δ , VII, 14 = Φ 9-6, Bergamo)

Michelino da Besozzo The most widely known Lombard illuminator of the early fifteenth century was Michelino da Besozzo (Michelino Molinari; active 1388-1445 Milan). Time has not been kind to Michelino's reputation. Much of his work has been destroyed, and the surviving examples are of a fragile preciosity that runs counter to the classicizing trend traditionally thought to be typical of Renaissance art. But the early humanist Umberto Decembrio singled out Michelino's art as superior to all others, and the Duke of Berry even sent his agent to interview Michelino; the agent returned with the report that Michelino was "the most excellent painter among all the painters in the world." Such hyperbole cannot be taken completely at face value, but there is no denying that European connoisseurs were dazzled by Michelino's artistry. He began his career in Pavia, went to Venice where he was in contact with Gentile da Fabriano (Gentile di Niccolò di Massio; c. 1385 Fabriano-1427 Rome), and then received major commissions in Milan. After the death of Giangaleazzo and during the troubled reign of Giovanni Maria Visconti (r. 1401-12), Michelino took his practice to Vicenza and Venice, an area highly receptive to his refined, delicate style. He returned to Milan in 1418, where he worked until his death.

A page from the Eulogy for Giangaleazzo Visconti (Fig. 9.30), written by an Augustinian monk, Pietro da Castelletto, and illuminated by Michelino, exemplifies the refined sensibilities that appealed to aristocratic patrons. A garland of flowers with fragile leaves and threadlike tendrils frames the text. In the upper rectangular field a cloth of honor overlaid with the imperial and Visconti coats of arms forms the delicate backdrop for the culminating event of Pietro's eulogy, Giangaleazzo's heavenly coronation by the Christ Child. The Christ Child is the most robust of all the figures, everyone else having been reduced-apart from their firm hands and heads-to wraith-like forms, perhaps to convey the ethereal nature of heavenly existence. In the decorated initial below, a more substantial and clearly earthbound Pietro da Castelletto addresses his fellow Augustinians, his hands firmly grasping a pen and the pulpit from which he speaks. Clearly, Michelino had a repertoire of styles, employed as appropriate for different subjects.

Michelino's work, closely related to similar art at the Valois courts in France, had obvious appeal for patrons like the Visconti, with their dynastic ambitions and royal mar-

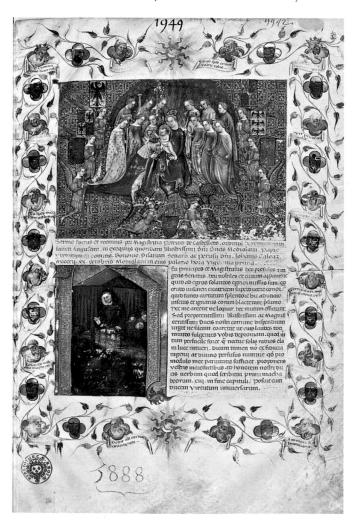

9.30 Eulogy for Giangaleazzo Visconti, 1402/03, commissioned by the Visconti court from **Michelino da Besozzo**. $14\% \times 9\%$ (37.5 \times 24 cm) (Bibliothèque Nationale, ms. lat. 5888, fol. 1, Paris).

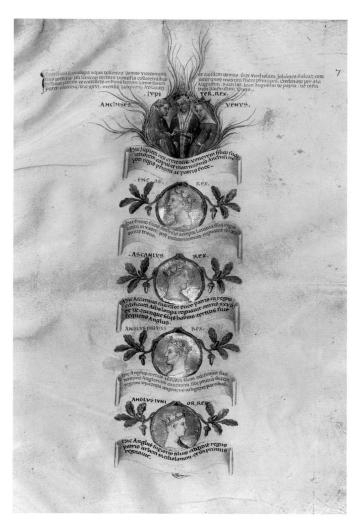

9.31 Visconti genealogy, from the *Eulogy for Giangaleazzo Visconti*, 1402/03, commissioned by the Visconti court from **Michelino da Besozzo**. $14\% \times 9\%''$ (37.5 × 24 cm) (Bibliothèque Nationale, ms. lat. 5888, fol. 7, Paris)

riage alliances. The opening page of the Visconti genealogy from the *Eulogy* (Fig. 9.31) lines up profile images inspired by Greco-Roman coins and medals to trace the Visconti lineage from its legendary origins in the marriage of the Trojan prince Anchises and the goddess Venus, performed by Jupiter. The mythic couple and Jupiter appear at the top of the manuscript, depicted, in Michelino's refined manner, as contemporary aristocrats; the same delicacy informs the Roman profiles of the Visconti. These antique references—evidence of humanist activity at the Visconti court—are deftly integrated, through Michelino's deceptively casual manner, into a medieval legend.

Secular Frescoes

The extent to which the International Style left an imprint on northern Italy can be appreciated by examining a fresco cycle by an unknown painter in the city of Trent in the foothills of the Alps, north of Verona. Commissioned sometime between 1391 and 1407 by the city's prince-bishop, George of Lichtenstein, the frescoes cover the walls of

one of the large towers in his residence, the Castello del Buonconsiglio. They represent the twelve months of the year (Fig. 9.32). The paintings, sensitively restored in 1534, provide a rare opportunity to experience vicariously the life and artistic sensibilities of early fifteenth-century courtiers.

The wooden beams, intervening ceiling panels, walls, and window surrounds all pulsate with decoration. Tall, thin, twisted colonettes divide one month's representation from another, set above a fictive dado that seems to be hung with brightly colored, brocade fabric. Once again, we encounter a natural world constructed with careful artifice, reminiscent of earlier illustrations of the *Tacuinum Sanitatis* type (see Fig. 9.13), a famous copy of which was owned by Prince-Bishop George. The scenes shown here represent, from left to right, the months of April, May, June, and July. In the April landscape amorous noble couples cavort on a floral field. Behind them rises a fortress, perhaps representing one of Prince-Bishop George's dependencies. Similar representations appear in luxurious Burgundian manuscripts of this time, such as the Limbourg Brothers' *Très Riches Heures*

for the Duke of Berry. In the scenes of June and July, however, hardly an aristocrat is present, for work under the scorching summer sun was delegated largely to peasants. The carefree amusements of the aristocrats contrast tellingly with the vigorous labor of the peasants, who often appear smaller than the aristocrats—not only because the artist wished to suggest some depth in the scenes but also because of the peasants' lower social status.

The Last Visconti and the Durability of the International Style

Aristocratic pastimes included playing party games that required both skill and sometimes cunning deceit. Elegant depictions of some of these entertainments appear inside the Casa Borromeo in Milan (Fig. 9.33). Dating from well into the fifteenth century, the frescoes demonstrate the long-lived vitality of the International Style, especially for aristocratic patrons at northern courts, and document a type of decoration that was very prevalent but which rarely

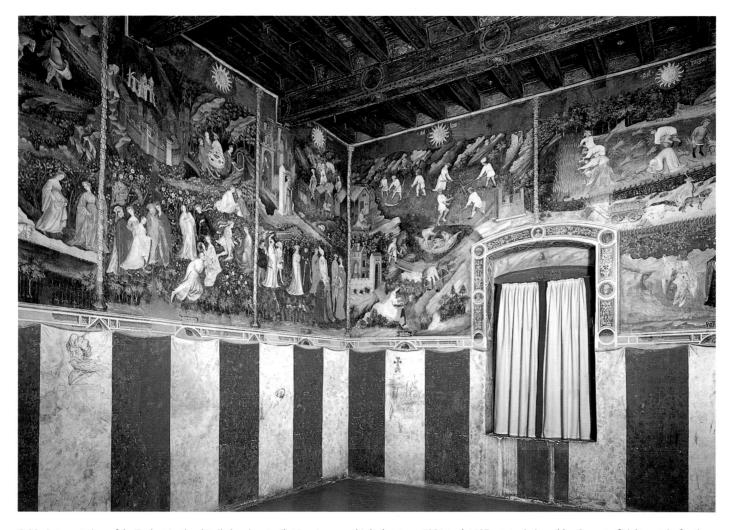

9.32 Representations of the Twelve Months, detail showing April, May, June, and July, between 1391 and 1407, commissioned by George of Lichtenstein for the Castello del Buonconsiglio, Trent. Fresco

A snowball fight in the January scene (not shown here) is one of the earliest surviving representations of a snow scene in western European art.

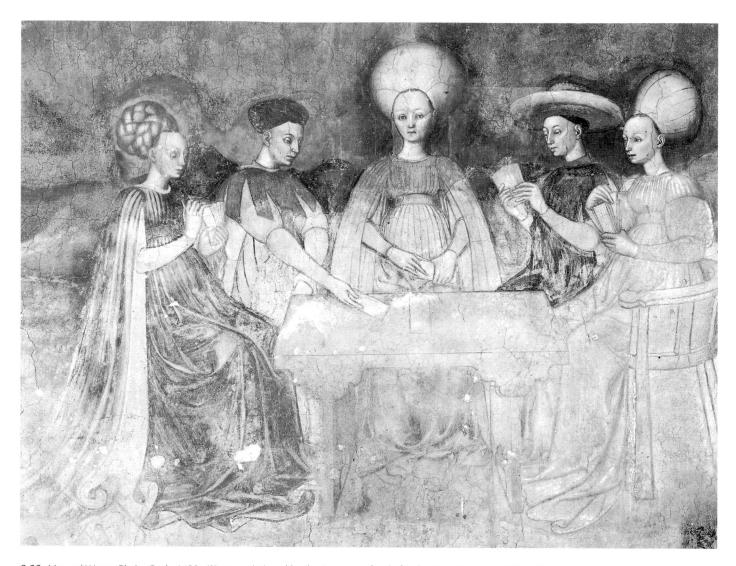

9.33 Men and Women Playing Cards, 1430s (?), commissioned by the Borromeo family for the Casa Borromeo, Milan. Fresco Literary sources describing the decorations of other palaces in this period suggest that these figures may represent members of the Borromeo family.

survives. The frescoes, located in one of the living halls probably destined for use by female members of the family, depict women and men amusing themselves by batting balls, chasing one another in a game of tag, and, in this illustration, playing cards. The figures, remote and emotionless in their fashionable clothing and headdresses, sit in a vast landscape whose vegetation is limited to three perfect trees on each wall. Since women in this period were expected to be modest and demure, their activities are performed in a highly ritualized manner, graceful and balletic even in the more energetic scenes. The frescoes both mirrored contemporary behavior and, no doubt, encouraged similar comportment from the room's occupants.

The figures in the Casa Borromeo frescoes are playing with tarot cards painted on stiff paper showing different figures and symbols (swords, goblets, coins, and batons) carrying specific numeric values. Widely diffused in the fifteenth century, they were used for games of skill and chance, each pictorial card representing a virtue, vice, force

of nature, or mythical character. Most were produced as block prints, but for aristocratic clients like the Borromeo, illuminators provided hand-painted and gilded versions. A splendid set was created between 1441 and 1447 for Bianca Visconti, daughter of Duke Galeazzo Maria Visconti-the last Visconti duke—and her husband, Francesco Sforza (Fig. 9.34). The pair shown represents the pope on the right and an enthroned female figure known as the Papessa or female pope on the left, identifiable by her papal tiara and brown mendicant robes. Medieval legend claims that a woman had once been elected pope by disguising her gender. Here she plays the female counterpart to the pope, much as the Virgin Mary complemented Christ. Associated with the moon, the Papessa represented knowledge, intuition, divinatory power, penetration of mysteries, recognition, secret knowledge, wisdom, and common sense. Given the patriarchal bias of medieval and Renaissance society, she was, nevertheless, one of the lowest-valued figural cards; only the King of Carnival and Fool ranked lower.

9.34 *Papessa and Pope* (tarot cards), 1441–47, commissioned by Bianca Visconti and Francesco Sforza. Gold leaf and paint on parchment pasted to papier-mâché board, each $6\% \times 2\%$ " (17 × 7 cm) (Pierpont Morgan Library, New York)

All in all, Visconti patronage was among the most splendid in Europe and probably more recognizeably "European" than art produced in any other Italian center in this period. Linked by geography, commerce, banking, politics, and marriage to Europe's most exalted northern courts, the Visconti and their court supported artists who, while highly sensitive to local traditions and needs, appropriated and developed artistic models that would have been as much at home north of the Alps as south. The Visconti's artistic legacy greatly affected the course of art across all of Italy—especially in aristocratic courts but also in the Italian republics (see, for example, Fig. 7.18).

North Italian Influences in Naples

Milanese and other North Italian models had a particularly strong impact upon art in early fifteenth-century Naples, whose golden age under the Angevins did not survive the death of King Robert the Wise in 1343. Different branches of the French royal family struggled in vain for control of the city until Ladislas of the house of Durazzo (r. 1399–1414) brought relative peace to southern Italy, a situation conducive to a major increase in artistic activity.

Aristocratic Patronage

The foremost patron after the royal family was Cardinal Enrico Minutolo, archbishop of Naples, who sponsored the

carving of elaborate portals for the façade of Naples Cathedral in this period. The main portal (Fig. 9.35) is a spectacular, composite affair designed by Antonio Baboccio (c. 1351 Piperno–1435), a native of Piperno, south of Rome, who had probably worked previously in Milan. The program focuses upon two images of the regal Virgin, an enthroned Madonna and Child in the **tympanum** and a representation of her coronation in the **oculus** above. Although the choice of subject may seem surprising in a cathedral dedicated to the Neapolitan bishop-saint Gennaro, it is consistent with the flourishing cult of the

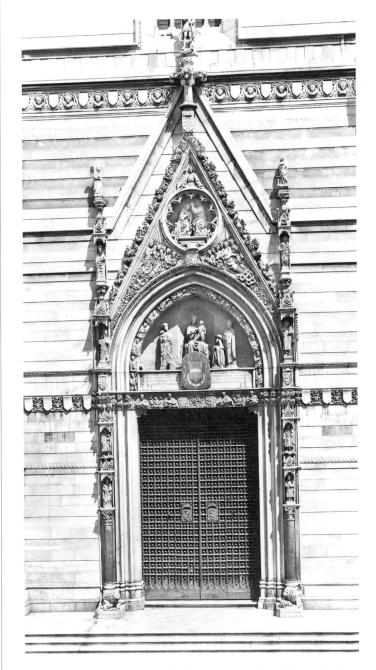

9.35 Main portal, Naples Cathedral, 1407, commissioned by Cardinal Enrico Minutolo from **Antonio Baboccio**. Marble

Baboccio reused some small figures from an earlier monument to supplement his own carvings.

Virgin in Europe generally and may reflect Minutolo's own previous position as cardinal archpriest of Santa Maria Maggiore in Rome. Smaller statues of saints in tabernacles to the sides of the doorway represent several of the city's other protectors, though a number owe their inclusion personally to Cardinal Minutolo, who himself kneels in the tympanum. Just below, his coat of arms shares a place of honor with busts of the four Evangelists, along with the seal of the cathedral and the coat of arms of King Ladislas, a schematic representation of social negotiation in this city.

Baboccio's overall design resembles the exuberant work of Milanese carvers (see Fig. 9.27). Fleshy leaves sprout along the edges of the gable; crimped ribbons of stylized cloud gather into frothy bouquets in the spandrels. The portal incorporates reused antique porphyry columns, two crouching lions probably appropriated from the dismantled tomb of Charles Martel, and a Madonna and Child by the Sienese sculptor Tino da Camaino. All of these elements attest to the eclecticism of Neapolitan art in the early 1400s, and to its desire to link the present to the past.

Similar eclecticism, as well as exuberance, characterizes the Palazzo Penna, erected in 1406 by Antonio Penna, the king's secretary (Fig. 9.36). Its entire lower story is faced with smooth **rustication**, the upper blocks of which carry incised decoration. Three rows at the height of the

9.36 Palazzo Penna, Naples, 1406, commissioned by the royal secretary Antonio Penna

The facade was originally lavishly painted and gilded.

doorway bear a feather pen (a literal rendition of his family name—Penna—and an apt emblem for the king's secretary). The vast majority carries the fleur-de-lys of the Angevin/Durazzesco dynasty. The rustication is surmounted by an arched corbel frieze which displays the devices of Penna's employer, King Ladislas—a rare privilege in the highly stratified courtly society of Naples. Within its simple rectangular frame the stilted arched doorway (characteristic of Durazzesco building) is carved from white marble. It carries a fluttering ribbon on which Penna flaunts his literary knowledge and anticipates criticism with an epigram by the classical author Martial: "You who pull faces and find it disagreeable to read such words, may you envy everyone else, jealous man, and may no one envy you."

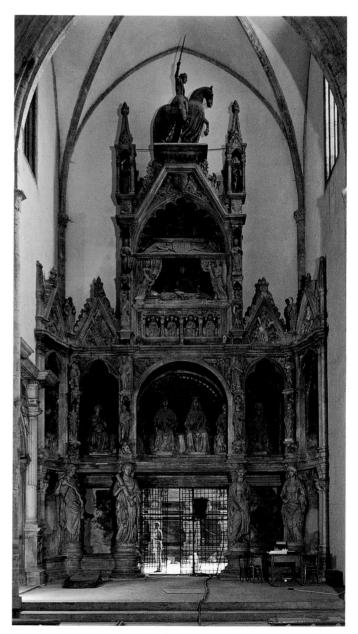

9.37 Tomb of King Ladislas, 1414-28, commissioned by Giovanna II from **Andrea and Matteo Nofri** and others for the chancel of San Giovanni a Carbonara, Naples. Marble

Queen Giovanna II and the Monument to King Ladislas

The standard for such display was set by the royal court. King Ladislas's sister and successor, Queen Giovanna II (r. 1414-35) saw to it that Ladislas's tomb monument, begun in 1414 and completed in 1428, would set new standards for royal grandeur (Fig. 9.37). Her sculptors-among them the stone carvers Andrea (Andrea da Firenze; 1388c. 1455 Florence) and Matteo Nofri from Florence-followed a plan, probably laid out by a Neapolitan. Occupying virtually the entire height and breadth of the chancel of the church of San Giovanni a Carbonara, the monument competes internationally with the multi-storied tombs of the della Scala in Verona (see Fig. 9.9), the equestrian monuments of the Visconti in Milan (see Fig. 9.8), and the canopied extravaganzas of the dukes of Burgundy in Dijon. Locally, it represents an amplification of the tomb of Robert the Wise (see Fig. 6.17), with a life-sized statue of the queen sitting next to her brother in the second level. Giovanna's portrait is blocky and severe, an unassailable image of regality, her individuality repressed to express the dignity of her office.

The monument culminated dramatically in the triumphant equestrian image of King Ladislas himself at its apex. As in Michelino da Besozzo's genealogy for the Visconti (see Fig. 9.31) and the inscription on the Palazzo Penna, ancient Roman ideas are presented in chivalric garb. Following Roman imperial custom, the words "Divus Ladislus" appear on the tomb. Thus Giovanna claims divine rank for her brother—shocking arrogance for the tomb of a Christian ruler. The heroic and classical/pagan themes are encapsulated in the concluding line of his epitaph: "his soul, single and free, sought starry Olympus."

The Caracciolo Chapel

Queen Giovanna's transformation of the chancel of San Giovanni a Carbonara encouraged Sergianni Caracciolo, the queen's lover, chief advisor, and the court's grand seneschal, to build his family's burial chapel directly behind the high altar and Ladislas's tomb. It was a piece of exquisite courtly ambiguity, at once modest, since the chapel is almost invisible from the nave, and yet shrewdly opportunistic in its effective conversion of Ladislas's monument into an enormous triumphal frontispiece for his own chapel. The polygonal plan of Caracciolo's chapel may deliberately recall the form of ancient Roman imperial mausolea, giving the structure another level of exalted status.

Three rows of frescoes adorn the walls. The top two include scenes from the life of the Virgin by Leonardo da Besozzo (active 1421-88 Milan and Naples), son of Michelino, the renowned Milanese painter, miniaturist,

9.38 Coronation of the Virgin, c. 1428, commissioned by Sergianni Caracciolo from **Leonardo da Besozzo** for the Caracciolo Chapel, San Giovanni a Carbonara, Naples. Fresco

and building master (see Figs. 9.30 and 9.31). Leonardo's presence in Naples in 1428 demonstrates the artistic connections between the two courts. In the *Coronation of the Virgin* (Fig. 9.38) he employed interlocking and curving patterns similar to those that Baboccio had used in his music-making angels on the Naples Cathedral portal (see Fig. 9.35), though softened with his own version of the delicate features and finely spun detail for which his father was famous. Sergianni appears in the *Coronation* kneeling in his best damasks and furs at the bottom left of the angelic aureole, accompanied by portraits of other courtiers and the sensitive, searching features of adoring saints.

One would never sense from these splendid commissions that Giovanna's reign was particularly difficult, challenged throughout by her barons and then by a competitor of her own making, Alfonso of Aragon, whom she adopted as her successor. Alfonso ousted her from the throne after a long struggle and thus established a new, Aragonese, dynasty in Naples whose art we will discuss in Part II.

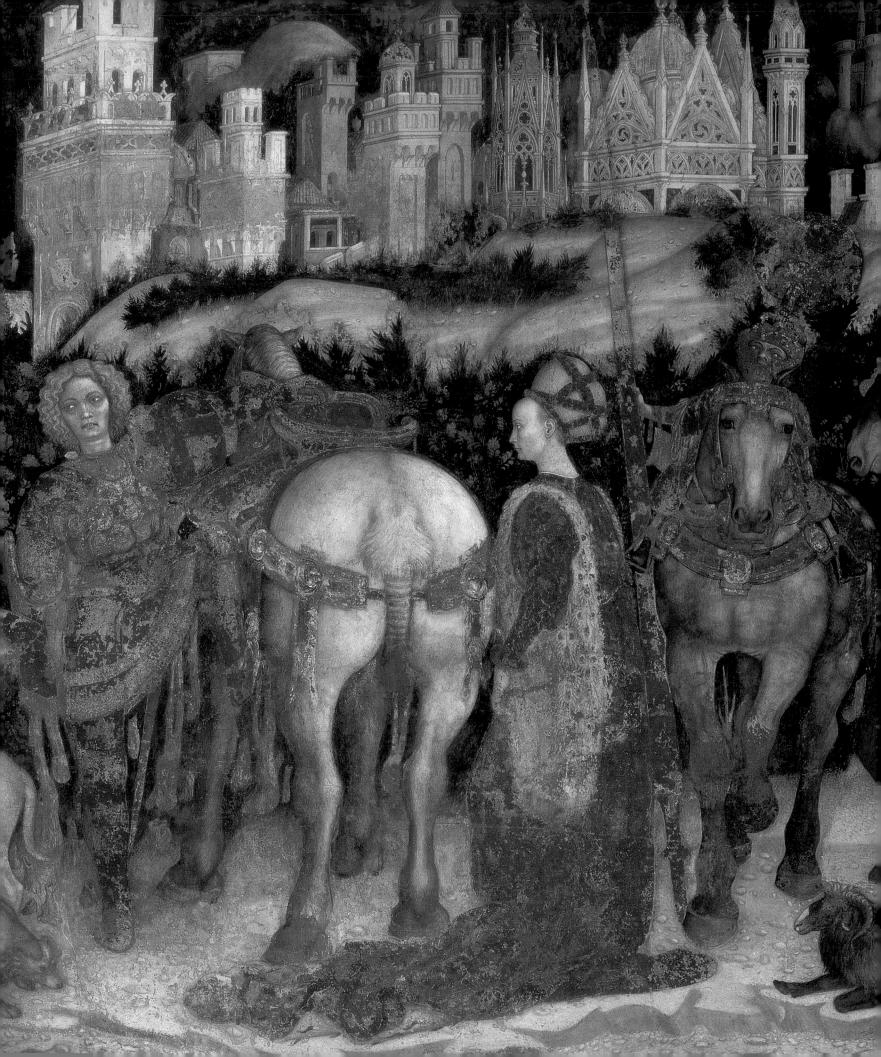

\prod

The Fifteenth Century

10	Florence: Commune and Guild	204
11	Florence: The Medici and Political Propaganda	251
12	Rome: Re-establishing Papal Power	289
13	Venice: Affirming the Past and Present	313
14	Courtly Art: The Gothic and Classic	336
15	Sforza Milan	362

arly writers like Vasari mistakenly saw the fifteenth century as a kind of adolescence, halfway between the purportedly naïve work of the fourteenth century and the supposedly unsurpassable maturity of the sixteenth, but none of the works we have discussed or will be discussing can in any way be said to be unsophisticated or immature. The fact that an artist like Simone Martini from the early fourteenth century could have produced paintings of such contradictory styles within a few years of one another underscores a characteristic of Renaissance art: artistic style varied not because it provided the next step in some scheme of formal development but because it was an effective carrier of the patron's and the artist's intentions.

We always need to ask why artists were inclined to the stylistic measures they chose and in what circumstances they were working. Any credible history of art, moreover, must pay as much attention to continuity as it does to change. New artistic, political, or social structures rarely obliterate or immediately supplant prior traditions and practices. In fact, it is in the overlap or competition between stylistic possibilities that the issues behind stylistic change often become clearest. To describe a sequential development from one discrete style to another both denies history and removes the excitement of historical study. We cannot "predict" a fifteenth-century artist like Masaccio by studying Giotto's style. We might, however, newly appreciate certain characteristics of Giotto's art when we see them integrated in Masaccio's painting.

The fifteenth century in Italy is difficult to characterize artistically and historically, in part because many of the traditions established in the previous century were very long-lived. Artistic forms changed in the fifteenth century, but the reasons behind those changes often echo those of stylistic developments we saw in the thirteenth and fourteenth centuries. The power of the International Gothic Style was hardly diminished by the appearance of more classically inspired styles, and exchanges between courts and republics assured sophisticated blends of the two. Architectural projects spanned the fourteenth and fifteenth centuries and demanded not only that new work be current but that it maintain stylistic harmony with what had preceded it. By the middle of the fifteenth century, Italy began to enjoy unprecedented political tranquility, only to be followed by major upheavals at century's end. Yet even then, artists and patrons continued to reach for the new, while realizing the power of the old to convey established meaning.

(opposite) St George and the Princess (detail), 1430s, commissioned by the Pellegrini family from **Pisanello** for the Pellegrini chapel, Sant'Anastasia, Verona. Fresco

Florence: Commune and Guild

Plorence's republican form of government survived a number of challenges to its existence from the end of the fourteenth century through the first quarter of the fifteenth century. The Ciompi Revolt of 1378, Milanese military incursions led by Giangaleazzo Visconti throughout the 1390s until that leader's death in September 1402,

subsequent threats by King Ladislas of Naples from 1409 to his death in 1414, and Filippo Maria Visconti's renewed plans for Milanese territorial expansion lasting from 1420 until 1425—these were all thwarted by Florentine diplomacy and politics. In the face of continued threats to their independent existence during this time it is not surprising that Florentine artists and patrons sought a new visual language to convey their hard-won republican ideals in the most important civic sites of the city.

Sculpture for the Cathedral Complex

The first site to bear this new language was the Porta della Mandorla, an entrance abutting the tribune on the north side of Florence's Duomo (Fig. 10.1). The sculpture decorating this portal is unmistakably classical, the outer jambs being covered with a foliate pattern framing figures depicting the heroic labors of Hercules. Hercules had first appeared representing the Florentine state in the twelfth century, when a standing nude figure of the god began to appear on the city's official seal. A series of classicizing figures decorates the inner reveals of the door, the most notable of which is a small nude Hercules with the skin of a lion he had slain draped over his shoulder (Fig. 10.2), very similar to his image on the Florentine seal. The antique figural style of the Hercules, with its contrapposto pose and naturalistically modeled musculature, contrasts with the overall decorative program of the Porta della Mandorla, which includes simplified Gothic angel head reliefs and curling banderoles. The different stylistic forms that coexist in the sculptural decoration of the door would

continue to be a feature in Florentine art throughout the fifteenth century. Importantly in this case, Hercules, a classical subject, imitates the formal stylistic properties of ancient sculpture in its heroic pose, its tactile surface, and its sense of animation, bringing new coherence to subject and style.

10.1 Florence Cathedral, 1754, Giuseppe Zocchi. Etching

This view shows the north flank of the cathedral and the north tribune with a reconstruction of the program of buttress statues. The Baptistry is to the right. The axial street extending into the distance from the piazza between the cathedral and the Baptistry moves past Or San Michele, whose rectangular mass rises midway at the right. The street ends at the piazza of the Palazzo della Signoria, whose tower is just visible in the far distance.

10.2 Hercules, detail of the Porta della Mandorla, 1391-97, commissioned by the Opera del Duomo for the north flank of Florence Cathedral. Marble

The Competition for the Second Baptistry Doors

In 1401 the Arte del Calimala initiated a competition for a second set of bronze doors for the Baptistry. Significantly, the competition for this enormously expensive undertaking was opened just at the time that Milanese troops were advancing on the city. Thus the competition may have been a way for the Arte del Calimala to vie for prestige with the

(opposite) St. Louis of Toulouse, c. 1423, commissioned by the Guelf Party from **Donatello** for the east side of Or San Michele, Florence. Fire-gilt bronze, height 8' 8\%" (2.66 m) (Museo di Santa Croce, Florence)

Arte della Lana, which was in charge of the Duomo, or a way to manifest civic solidarity in enhancing the beauty of the city at the time of threat, or both. The Arte del Calimala stipulated that each contestant was to submit a relief showing the sacrifice of Isaac. The subject depicts the moment when Abraham, ordered by God to sacrifice his son, is about to plunge the knife into Isaac's neck, but is stopped by the miraculous intervention of an angel. The reliefs were to employ the quatrefoil format used by Andrea Pisano in his first set of doors for the building from sixty-five years earlier (see Fig. 4.27), an attempt to make a coherent decorative program for the exterior of the Baptistry.

The two extant competition reliefs were both submitted by young artists trained as goldsmiths: Lorenzo Ghiberti (Lorenzo di Cione di ser Buonaccorso; 1378 Florence–1455 Florence) and Filippo Brunelleschi (1377 Florence–1446 Florence). Each was destined to make a major impact on the art of Florence, Ghiberti as a sculptor in bronze and Brunelleschi as an architect and inventor of scientific perspective. Their two bronze reliefs encapsulate alternative possibilities of style in early fifteenth-century Florence (Figs. 10.3 and 10.4). Both artists portray the subject on a flat background similar to Andrea Pisano's treatment of figures and ground. Both seem fascinated with repeated curves of drapery, which are independent of the body beneath; the edges of drapery in Brunelleschi's relief flutter in the wind to heighten the drama of the event. But there

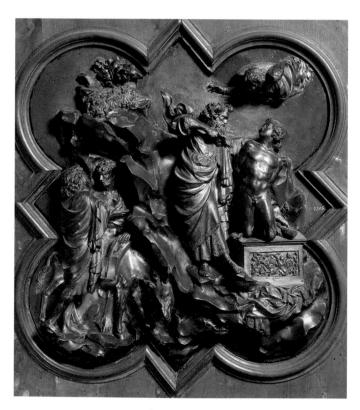

10.3 *Sacrifice of Isaac*, 1401–3, competition panel, commissioned by the Arte del Calimala from **Lorenzo Ghiberti** for the doors of the Baptistry, Florence. Parcel-gilt bronze, $17\% \times 15''$ (45×38 cm) (Museo Nazionale del Bargello, Florence)

are also differences. Ghiberti's Isaac, like the Porta della Mandorla Hercules, is a model of classical form, his sleek torso turning slowly on its axis to face Abraham. Brunelleschi's figures, however, are positioned—even twisted—to reinforce the surface of the plane. Their exaggeration gives an appropriately nervous feeling to the relief, especially at the point where the angel grasps Abraham's wrist—locked in place on the central axis—just as he is about to plunge the dagger into his son's throat. The servant in the lower left of Brunelleschi's relief, a direct quotation from an ancient Roman bronze, the *Thorn Puller*, disguises its origins as an antique nude youth with elaborate drapery folds, suggesting the complexity of allusions to classical sculpture during this period.

In the end Ghiberti gained the commission for the doors, maintaining that he had won the competition outright; Brunelleschi's biographer, Antonio Manetti, claimed that the Arte del Calimala had called the competition a tie. Whatever the facts, the lyrical quality of Ghiberti's figures, his decorative treatment of form, and his superbly detailed workmanship (his relief was cast as a single piece, Brunelleschi's was composed of separately cast elements) embodied the most advanced visual language in Europe at the time. These factors must have suggested to the Arte del Calimala that he was ideal for the job. By the time Ghiberti signed his contract for the doors, at the end of 1403, the Calimala had changed the subject matter from an Old

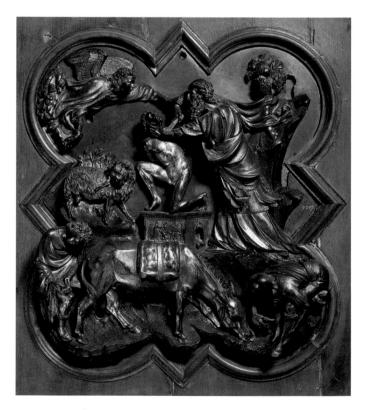

10.4 *Sacrifice of Isaac*, 1401–3, competition panel, commissioned by the Arte del Calimala from **Filippo Brunelleschi** for the doors of the Baptistry, Florence. Parcel-gilt bronze, $17\% \times 15''$ (45×38 cm) (Museo Nazionale del Bargello, Florence)

Ghiberti versus Brunelleschi

In these two accounts of the competition for the second set of doors for the Florence Baptistry—one by Lorenzo Ghiberti (written c. 1450) and the other by Filippo Brunelleschi's biographer, Antonio Manetti (written c. 1480)—we get a flavor of the intense rivalry that this contest engendered between these two great artists.

First, Ghiberti's version:

In my youth in the year of Christ 1400, because of the corrupt air in Florence [plague] and the bad state of the country, I left that city with an excellent painter whom Signor Malatesta of Pesaro had summoned. He had had a room made which was painted by us with great care. . . . However, at this time my friends wrote me that the governors of the church of S. Giovanni Battista [the Baptistry] were sending for skilled masters whom they wished to see compete. From all countries of Italy a great many skilled masters came in order to take part in this trial and contest. I asked permission of the prince and my companion to leave. The prince, hearing the reason, immediately gave me permission [to go]. Together with the other sculptors I appeared before the Operai of [the Baptistry]. To each was given four tables of bronze. As the trial piece the Operai and the governors of the church wanted each [artist] to make one scene for the door. The story they chose was the Sacrifice of Isaac. . . . To me was conceded the palm of the victory by all the experts and by all those who had competed with me. To me the honor was conceded universally and with no exception. To all it seemed that I had at that time surpassed the others without exception, as was recognized by a great council and an investigation of learned men. . . . It was granted to me and determined that I should make the bronze

door for this church. This I executed with great care. This is my first work: the door with the frame around it cost about twenty-two thousand florins. Also in the door are twenty-eight compartments; in twenty are stories from the New Testament, and at the bottom are the four Evangelists and the four [church] Doctors, and around the work are a great number of human heads. With great love the door was diligently made, together with frames of ivy leaves, and the door jambs with a very magnificent frame of many kinds of leaves. The work weighed thirty-four thousand pounds. It was executed with the greatest skill and care.

And from Brunelleschi's point of view:

Filippo sculpted his scene in the way that still may be seen today. He made it quickly, as he had a powerful command of the art. Having cast, cleaned, and polished it completely he was not eager to talk about it with anyone. . . . It was said that Lorenzo was rather apprehensive about Filippo's merit as [the latter] was very apparent. Since it did not seem to him that he possessed such mastery of the art, he worked slowly. Having been told something of the beauty of Filippo's work he had the idea, as he was a shrewd person, of proceeding by means of hard work and by humbling himself through seeking the counsel . . . of all the people he esteemed who, being goldsmiths, painters, sculptors, etc. and knowledgeable men, had to do the judging. While making [his scene] in wax he conferred and . . . tried to find out how Filippo's work was coming along. He unmade and remade the whole and sections of it without sparing effort...

Since none of [the judges] had seen Filippo's model they all believed that

Polycleitus-not to mention Filippo-could not have done better [than Lorenzo].... However, when they saw [Filippo's] work they were all astonished and marveled at the problems that he had set himself: the attitude, the position of the finger under the chin, and the energy of Abraham; the clothing, bearing, and delicacy of the son's entire figure; the angel's robes, bearing, and gestures and the manner in which he grasps the hand; the attitude, bearing, and delicacy of the figure removing a thorn from his foot and the figure bending over to drinkhow complex these figures are and how well they fulfill their functions (there is not a limb that is not alive). . . .

Those deputized to do the judging changed their opinion when they saw it. However, it seemed unfeasible to recant what they had said so persistently [i.e. that Lorenzo's would surely win]. . . . Gathering together again they came to a decision and made the following report to the Operai: both models were very beautiful and for their part, taking everything into consideration, they were unable to put one ahead of the other, and since it was a big undertaking requiring much time and expense they should commission it to both equally and they should be partners. When Filippo and Lorenzo were summoned and informed of the decision Lorenzo remained silent while Filippo was unwilling to consent unless he was given entire charge of the work. On that point he was unyielding. . . . The officials threatened to assign it to Lorenzo if he did not change his mind: he answered that he wanted no part of it if he did not have complete control, and if they were unwilling to grant it they could give it to Lorenzo as far as he was concerned. With that they made their decision. Public opinion in the city was completely divided as a result.

(from Ghiberti. Commentaries. In Elizabeth G. Holt. A Documentary History of Art. New York: Doubleday, 1957, pp. 156-8; and from Antonio Manetti. The Life of Brunelleschi. Ed. Howard Saalman. University Park: Pennsylvania State University Press, 1970, pp. 46, 48, 50)

Testament to a New Testament narrative, the life of Christ, ostensibly to complement Andrea Pisano's life of John the Baptist on the south doors. Yet given the fact that the city was threatened by siege at the very time of the competition, it is hard not to see the subject of Abraham's sacrifice for the competition as one responding to the historical situa-

tion of the moment, one no longer so pressing in 1403 when Ghiberti received his contract for the doors.

Modeling, casting, gilding, and finishing of the doors lasted until 1424, when they were finally installed on the east face of the Baptistry facing the cathedral (Fig. 10.5). Over the twenty-one years Ghiberti spent creating the

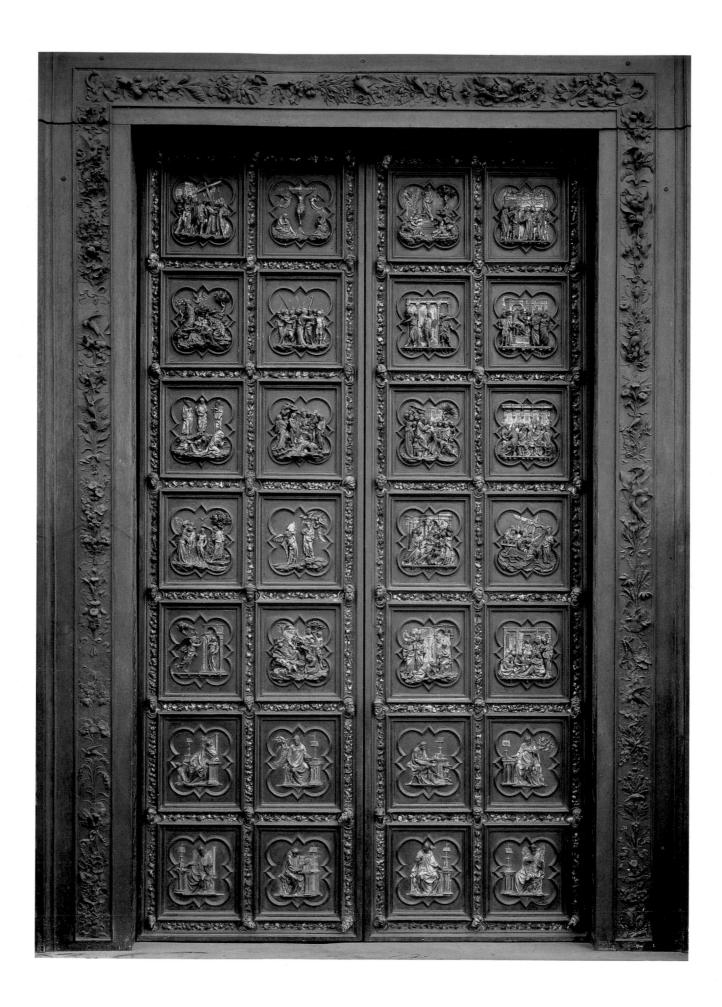

10.5 North doors, Baptistry, Florence, 1403–24 (modeling of reliefs complete c. 1417), **Lorenzo Ghiberti**. Bronze (between 1424 and 1452 set into the east face of the Baptistry)

reliefs, his ideas for them evolved. Reliefs like The Adoration of the Magi (Fig. 10.6) from earlier in the modeling history of the doors show Ghiberti generally indebted to Andrea Pisano's interpretation of the Gothic (see Fig. 4.28) in his construction of a narrow spatial ledge in front of the relief to suggest some spatial setting and in the decorative and lyrical complexity of the drapery and the energetic swaying of the bodies. But instead of setting his action parallel to the picture plane and modeling his figures with equal threedimensionality whether they stand in the front or back of the composition, Ghiberti grades his relief levels to suggest greater depth and sets his action and architecture diagonally across the picture plane. Thus the eldest Magi crouches on the ground and reaches across the center of the relief to touch the foot of the Christ Child; he, with his mother, sits further back in space. Behind them Joseph's body is only partially articulated because he is peeking out from the architecture; the rest of his body is assumed into the atmospheric depth suggested by the gilding.

In *The Flagellation of Christ* (Fig. 10.7), one of the last reliefs to be designed, Ghiberti returned to a frontal composition with great effect. He placed his figures against a simple arcaded porch fronted by a double row of Corinthian columns, the second set barely emerging from the back of the relief and yet creating an illusionistic space that is deep

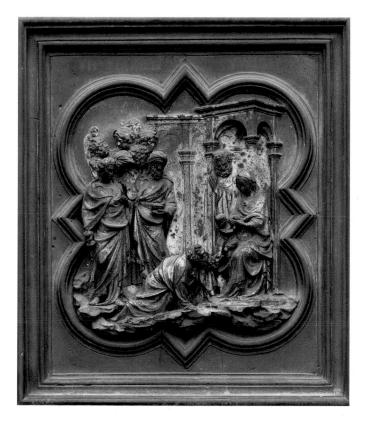

10.6 Adoration of the Magi, detail from the north doors of the Baptistry, Florence. Bronze, $20\%\times17\%''$ (52×45 cm)

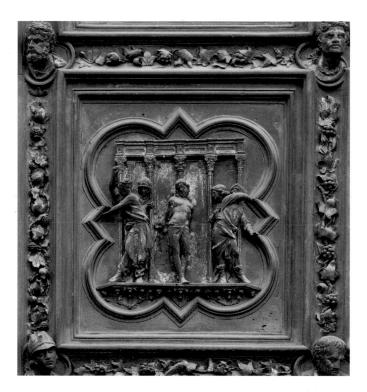

10.7 *The Flagellation of Christ*, detail from the north doors of the Baptistry, Florence. Bronze, $20\% \times 17\%'''$ (52 \times 45 cm)

enough to accommodate the projecting hand and foot of the helmeted figure at the left. The architecture also establishes a regular internal order within the outer quatrefoil frame and allows a more focused view of the subject—quite different from the Sacrifice of Isaac, in which the servants, the angel, and Abraham and Isaac occupy separate areas, or the Adoration of the Magi, where the figures and setting occupy much of the complicated geometrical field in which they are placed. At the same time, Ghiberti remains fully conscious of his frame. While the figures in the Flagellation panel set up a pattern across the surface as regular as the architecture, the persecutors link to the curving lobes of the quatrefoil through the arcs of their arms and the positions of their feet placed at the very center of the circular forms that are implied by the round lobes of the frame. Gothic decorative elegance and classical form seem to combine effortlessly, as is equally evident in the figure of Christ, whose complicated contrapposto derives from ancient prototypes but responds more to the generally fluid curving lines of the composition than to his actual writhing on the column.

Buttress Sculpture

The pursuit of decorative projects at the Duomo as the main body of the building neared completion brought two young sculptors to prominence: Nanni di Banco (c. 1374/80–85 Florence-1421 Florence) and Donatello (Donato di Niccolò di Betto Bardi, c. 1386 Florence-1466 Florence). Nanni learned his trade in the cathedral work-

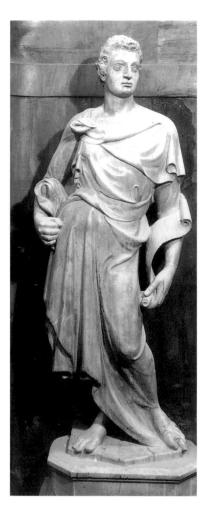

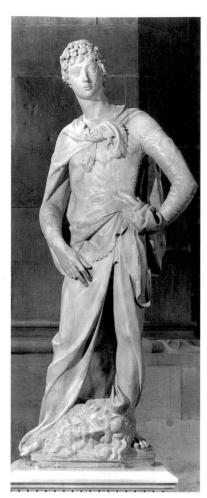

shops assisting his father who was also a sculptor there. Donatello's origins are more obscure. He is first documented in Pistoia in 1401, where he was arrested for hitting another man over the head with a club. He subsequently worked in Ghiberti's workshop on the Baptistry doors. On January 24, 1408, the Opera del Duomo commissioned Nanni (along with his father) to carve a figure of Isaiah to be placed outside the cathedral, high on one of the buttresses of the north tribune (see Fig. 10.1) as one of a program of twelve Old Testament prophets. A month later Donatello received a commission for a David for the same location. Nanni's unusually youthful Isaiah (Fig. 10.8) was finished by the end of the year. Donatello was paid for a David in June 1409, beginning a decade of apparently close collaboration between the two sculptors which led to a new style for free-standing figural sculpture in Florence.

For the last fifty years it has generally been assumed that a marble *David* ultimately taken to the Palazzo della Signoria in 1416 and now in the Bargello was the work for which Donatello was paid in 1409 (Fig. 10.9). Both the Bargello *David* and Nanni's *Isaiah* are youthful (a most unusual characteristic for prophets in this period), they stand at nearly the same height, both curve their arms out from their swaying bodies, and both cock their heads and stare. They would seem excellent candidates for works that

10.8 *Isaiah*, 1408, commissioned by the Opera del Duomo from **Nanni di Banco** for the north buttress of Florence Cathedral. Marble, height 6' 4" (1.93 m) (Florence Cathedral)

10.9 *David*, 1408–9, presumably commissioned by the Opera del Duomo from **Donatello**; requisitioned for placement in the Palazzo della Signoria in 1416. Marble, height 6′ 3″ (1.91 m) (Museo Nazionale del Bargello, Florence)

were to crown buttresses around the cathedral's tribunes. But recently the identification of the *David* mentioned in the 1409 document with Donatello's Bargello *David* has been challenged in favor of another statue that for centuries stood in one of the niches of the cathedral bell tower (Fig. 10.10). A rough break across its pentagonal base suggests that it may have been chipped away to allow the sculpture to fit into the niche. Curiously, there is no surviving documentation for this figure—in spite of the fact that all the

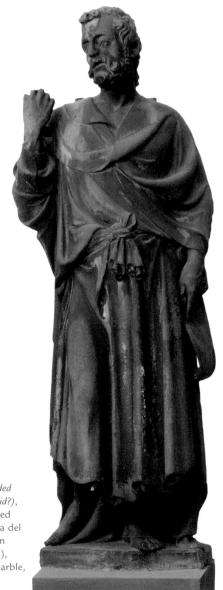

10.10 Bearded Prophet (David?), commissioned by the Opera del Duomo from Donatello(?), c. 1408?, Marble, height 6′ 2″ (1.88 m)

other statues at the site can be accounted for in documentary sources.

Clearly a prophet, as indicated by his beard and the scroll that hangs from his left hand, the figure is iconographically appropriate to the sculptural program of either the buttresses or the bell tower and is comparable in height to both sets of figures, but the shape and condition of its base make it a better candidate for a buttress figure. The front sides of the prophet's base splay at exactly the same 135 degree angle as do the sides of Nanni's base, and the overall dimensions of its and Nanni's bases are much closer to one another than to the base of the Bargello *David*.

This proposed re-attribution is not simply a matter of proper identification on the basis of style-the prophet's face has been compared convincingly to the features of Donatello's wooden crucifix (see Fig. 23)—but a challenge to how we determine the style of an artist during his early career. The prophet figure newly proposed as Donatello's 1408-09 David shares some of the Gothic sway and gentle drapery of Nanni's Isaiah and thus would have provided a stylistic coherence with Nanni's figure. Admittedly, the Bargello David, so clearly identified as the biblical hero by the head of Goliath at his feet and the sling whose strap would originally have been made of wire extending from Goliath's head to David's right hand, essentially mirrors Nanni's Isaiah. However, the Bargello David shows a characteristic that Donatello was only later to develop in other work at the cathedral: the removal of areas of drapery from the body to reveal the human form beneath, a gesture toward a more visually compelling understanding of how the animated body would move through space. Donatello may have been recalling the pose of Nanni's earlier sculpture but developing its implications.

We may never know the true sequence of events in the making of these three sculptures. They are, therefore, a provocative challenge to stylistic analysis and to modern notions of artistic individuality, suggesting how artists could imitate one another as part of a learning process within a traditional workshop situation in an attempt to bring stylistic cohesion to a sculptural program with multiple parts. In the end, the Opera found neither of the statues for which they had paid acceptable, possibly accounting for the prophet figure's reassignment to the bell tower. Evidently the statues were too small to be seen well from the street below, despite their life-sized scale. Legibility was important.

To test empirically the appropriate size for the buttress statues the Opera commissioned Donatello to make a larger statue of Joshua. Made of terracotta, which was both inexpensive and quick to model, then whitened with gesso and paint to make it look like marble, the *Joshua* was in place on the north tribune by 1410, where it remained until it disintegrated, most likely in the eighteenth century. Nearly 18 feet (5.5 meters) tall, this colossal figure was clearly intended to capture the viewer's attention from the street below.

Façade Sculpture

Also at the end of 1408 the Arte della Lana began commissioning sculpture for the unfinished façade of the cathedral, engaging Nanni di Banco, Niccolò Lamberti (c. 1370 Florence-1451 Florence), and Donatello each to make a seated Evangelist for the niches on either side of the main door (Figs. 10.11, 10.12, 10.13, and 10.14). Once again Donatello and Nanni made figures similar to one another, although in a style significantly changed from their earlier work. Notable in both Donatello's St. John and Nanni's St. Luke is the awareness that the figure would be seen from below and thus require adjustments in form-or optical corrections-to accommodate the viewer's angle of vision (see Fig. 10.14). Thus when seen straight on (Fig. 10.13), the torso of the St. John is too long, the drapery rather ponderous, and the hands limp. When seen from below, however, St. John's outward glance seems to respond to a vision, his torso nests back into the lower sections of the figure, and the curving drapery between the legs not only opens up the mass of the stone but connects with the arms to lock the figure together in an oval frame which also draws attention to the saint's head. In both figures the drapery creates pockets of real space and hangs heavily over the armature of the body, endowing the physical form beneath it with a sense of power.

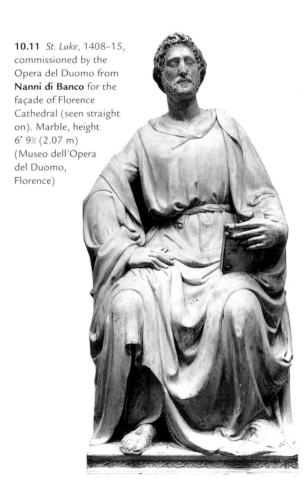

10.12 St. Mark, 1408–15, commissioned by the Opera del Duomo from Niccolò Lamberti for the façade of Florence Cathedral (seen straight on). Marble, height 8' 1½" (2.17 m) (Museo dell'Opera del Duomo, Florence)

10.13 St. John, 1408-15, commissioned by the Opera del Duomo from Donatello for the façade of Florence Cathedral (seen straight on). Marble, height 6' 10½" (2.1 m), width at base 34½" (88 cm) (Museo dell'Opera del Duomo, Florence)

Of these three sculptors, Lamberti had worked longest in the Duomo workshops. His response to what he must have perceived as competition from younger artists was to produce a St. Mark (see Fig. 10.12) that is a technical tour de force and a mark of his knowledge of the International Style (see Fig. 9.27). Extravagantly decorative curves and folds of drapery cascade over the figure and even spill over the base. Straps hang off the Gospel book, and the saint's right hand extends freely in space. For all its technical brilliance, however, the St. Mark is a curiously static figure. By 1416 Lamberti had moved to Venice, where the decorative properties characteristic of this work well suited the elaborate program for the façade of St. Mark's (see Fig. 7.3). He ceded his position in the Florentine cathedral shops to the younger sculptors, whose more classical style was commensurate with the

10.14 St. John, 1408–15, commissioned by the Opera del Duomo from **Donatello** for the façade of Florence Cathedral (seen from below). Marble, height 6' 10½" (2.1 m), width at base 34½" (88 cm) (Museo dell'Opera del Duomo, Florence)

political rhetoric of the state.

Or San Michele

In 1406 the Signoria (governors) of Florence, impatient to bring the decorative program of the guild church of Or San Michele to completion, declared that those guilds owning rights to niches on the exterior of the building should fill them with statues of their

patron saints within ten years. Only five of the fourteen niches had been completed by 1406, even though they had been assigned to the individual guilds as early as 1339. Over the next two decades Ghiberti, Donatello, and Nanni each contributed three statues to this program (Fig. 10.15), giving the

guilds an important visual presence on the city's major thoroughfare between cathedral and town hall.

Donatello's *St. George* for the Arte dei Corazzai (Armorers' Guild) (Fig. 10.16), perhaps begun shortly after 1410, originally carried a real sword and wore a real protective helmet—both produced by the guild. Although it has become a commonplace to discuss this figure as a manifestation of the new civic humanism in Florence

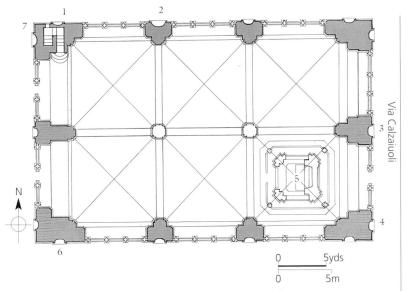

10.15 Or San Michele, Florence, plan showing guild responsibility for exterior niches

1 Arte dei Corazzai, Donatello, *St. George*; 2 Arte dei Maestri di Pietra e Legname, Nanni di Banco, *Four Crowned Saints*; 3 To 1459, Guelf Party, Donatello, *St. Louis of Toulouse.* After 1459, Mercanzia (Merchants' Court), Verrocchio, *Christ and St. Thomas*; 4 Arte del Calimala, Ghiberti, *St. John the Baptist*; 5 Tabernacle, c. 1355–59, Andrea di Cione, called Orcagna (see Fig. 8.12); 6 Arte dei Linaiuoli, Donatello, *St Mark*; 7 Arte del cambio, Ghiberti, *St. Matthew*.

responding to the military threats of Giangaleazzo Visconti and King Ladislas, it seems more reasonable to place this statue within the chivalric traditions of late Gothic realism, exemplified by the warrior knights placed on the tomb of Cansignorio della Scala in Verona (see Fig. 9.9) or depicted in the frescoes of Altichiero in Padua (see Fig. 9.21). The chivalric treatment of the legend of St. George is also evident in Donatello's relief beneath the statue's niche (Fig. 10.17), which depicts the saint slaying the dragon that had been menacing the elegantly posed princess at the right of the relief. Employing a *schiacciato* ("squashed") relief for the first time in his career, Donatello created with barely incised lines a sense of atmospheric space receding into the far distance, a transfer of painterly conventions to low sculptural relief which was to have lasting impact.

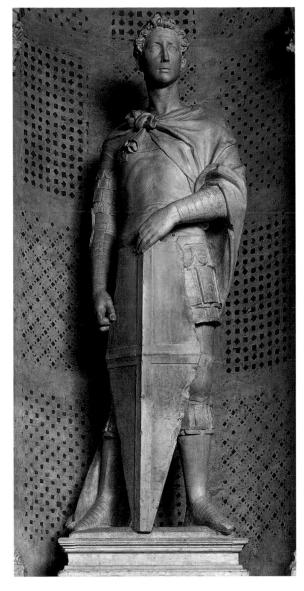

10.16 Niche of the Arte dei Corazzai (Armorers' Guild) with *St. George*, c. 1410–15 (?), and relief of *St. George Slaying the Dragon*, c. 1417, commissioned by the Arte dei Corazzai from **Donatello** for the north side of Or San Michele, Florence. Marble, statue height 6' 10%" (2.09 m), relief $15\% \times 47\%$ " (39 \times 120 cm) (the statue and relief are now in the Museo Nazionale del Bargello, Florence)

10.17 *St. George and the Dragon*, c. 1417, commissioned by the Arte dei Corazzai (Armorers) from **Donatello** for the north side of Or San Michele, Florence. Marble, 15%" × 47%" (39 cm × 120 cm) (Original now in the Museo Nazionale del Bargello, Florence)

The contrast with Nanni's relief under the adjacent niche for the Stone and Woodcarvers' Guild (see Fig. 5) is remarkable. Whereas Nanni, Ghiberti, and Brunelleschi conceived of relief as a series of nearly free-standing figurines set against a background, Donatello treats the marble as though it were malleable wax or clay (materials he would have worked with in Ghiberti's casting shop). The soft flow of forms on the surface suggests rather than defines space, veiling both his figures and their setting with atmospheric effects-even before such devices were used in painting. More than the diagonal lines of the loggia behind the princess and the receding crisscross pattern of tiles within, it is the merging of figures and space and of one spatial area with another through the pictorial illusionism of the very thin relief that creates a sense of a unified pictorial space extending from the foreground into the deep background. In such an evocative environment, trees in the distance and St. George's cape in the foreground can blow in the wind, both dramatizing and energizing the scene.

Donatello's *St. Mark* of c. 1411-13 for the Arte dei Linaiuoli (Linen Weavers' Guild) (Fig. 10.18) shows a thorough integration of classicizing principles in the sculptor's work. The classical *contrapposto* pose, with the weight resting on one foot, producing a gentle turn of the figure around its central axis, suggests that the saint is about to move out of the niche. At the same time Donatello anchored his figure with strong verticals in the columnar folds of material covering the saint's right leg. The drapery adheres closely to the chest and arms, revealing the contours of the body despite the heavy folds and crimped border. The intensity of the saint's expression and the realistic modeling of his hands, with their veins pulsing just beneath the skin, re-create the human form in a highly naturalistic manner.

Nanni's Four Crowned Saints (Fig. 10.19), for the niche of the Arte dei Maestri di Pietra e Legname at Or San Michele, represent four Christian artists of the third century who were asked by the emperor Diocletian to produce a pagan image. Refusing to do so, they were condemned to be beheaded. Nanni chose the moment of the men's dawning awareness of their fate. The Roman gravity in the three older men is played against the more active pose of the youngest figure—calm resignation paired with defiance (Fig. 10.20). Each figure presents the viewer with a different possible response to adversity, but as a group they suggest duty accepted and discharged; the Christian tale becomes

10.18 Niche of the Arte dei Linaiuoli (Linen Weavers' Guild) with *St. Mark*, 1411–13, commissioned by the Arte dei Linaiuoli from **Donatello** for the south side of Or San Michele, Florence. Marble, figure height 7' 8½" (2.36 m) (original now in Museo di Or San Michele, Florence; copy in the niche)

The niche was commissioned from the stonecarvers Perfetto di Giovanni and Albizzo di Pietro in 1411. They received 200 florins for the work; Donatello received 100 florins for his statue of David (see Figs. 10.9 and 10.10).

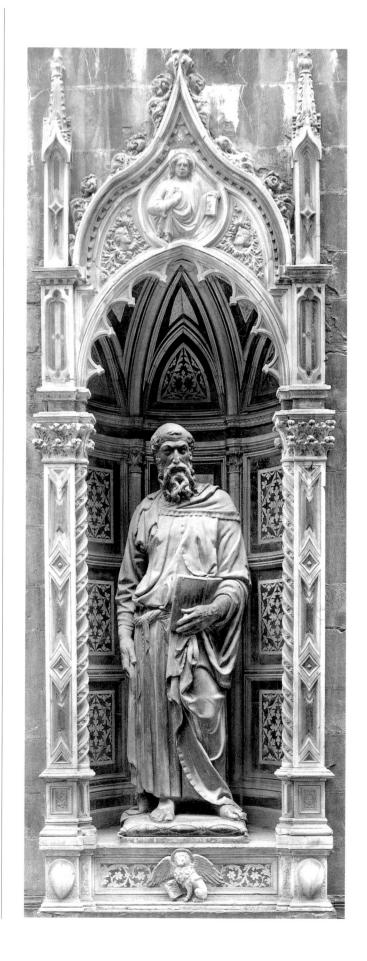

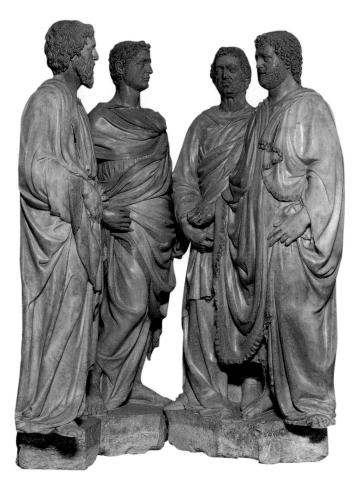

10.19 From the Niche of the Arte dei Maestri di Pietra e Legname (Stonecarvers' and Woodworkers' Guild) with *Four Crowned Saints*, c. 1414–16, commissioned by the Arte dei Maestri di Pietra e Legname from **Nanni di Banco** for the north side of Or San Michele, Florence. Marble, figure height 6' (1.83 m) (original group now in the Museo di Or San Michele, Florence)

a metaphor for responsible citizenship. Stylistically, the classicizing manner in which the *Four Crowned Saints* are depicted is appropriate for figures who lived in antiquity. And the direct, but inward gaze of the figures, recalling the stoic faces of ancient Roman sculpture where a decorum of personal gravity served as a metaphor for Roman morality and personal virtue, suggests individual reflections on their choice.

The Arte del Calimala chose Ghiberti in 1412 to make their statue of *St. John the Baptist* (Fig. 10.21) for Or San Michele—a natural choice since he was then already in their employ for the bronze doors for the Baptistry. They thus chose a sculptor whose fluid, elegant style contrasted with the more severe classicism of the other artists at work on sculpture for the building. The repeated elongated curves of the Baptist's drapery (on the border of which Ghiberti inscribed his own name) and the carefully arranged S-curves of his hair and of his hair-shirt focus attention on graceful patterns, a reflection of the International Gothic Style, perhaps appropriate for a guild whose governors were among the wealthiest citizens of the city. The silvered eyes (see p. 12), framed by extraordinary eye lashes made of

fine bits of wire, add an aura of psychological intensity to this hermit prophet and preacher, perhaps a response on Ghiberti's part to the new emotional impact of Donatello's sculptures. Moreover, the frontal pose of the *Baptist*, quite unlike Donatello's *St. Mark* or *St. George* or Nanni's *Four Crowned Saints*, splays his arms to the side as if to maintain an invisible plane across the face of the niche. Ghiberti seems to be conscious of the architectural integrity of the niche as an indentation into the flat surface of the wall, just as he emphasized the relief plane of his panels for the Baptistry doors.

When he was given a second commission by the Arte del Cambio (the Bankers' Guild), for a figure of *St. Matthew* (Fig. 10.22), Ghiberti made subtle shifts in his style, as if to respond to the innovations of Donatello and Nanni. This figure, also in bronze, employs a slightly more animated pose, suggested by the extended right leg pulling at the drapery to outline the leg beneath, the turn of the right side of the body toward the front of the niche and the apparent receding of the left shoulder back into the niche. Both are achieved more by the illusions of the drapery folds and the suppression of the mass of the left shoulder than by any actual torsion of the body, as a side view of the statue would demonstrate. St. Matthew also curves his arms out of the

10.20 Four Crowned Saints (detail), c. 1414-16, commissioned by the Arte dei Maestri di Pietra e Legname (Stonecarvers' and Woodworkers' Guild) from Nanni di Banco for the north side of Or San Michele, Florence. Marble, figure height 6' (1.83 m) (original group now in the Museo di Or San Michele, Florence)

10.21 (left) Niche of the Arte del Calimala (Wool Merchants' Guild) with St. John the Baptist, c. 1412/13-17, commissioned by Arte del Calimala from **Ghiberti** for the east side of Or San Michele, Florence. Bronze, height 8′ 4¼″ (2.55 m) (original now in the Museo di Or San Michele, Florence; niche now empty)

10.22 Niche of the Arte del Cambio (Bankers' Guild) with *St. Matthew*, 1419-22, commissioned by the Arte del Cambio from **Lorenzo Ghiberti** for the west side of Or San Michele, Florence. Bronze, height 8' 10" (2.69 m) (original now in the Museo di Or San Michele, Florence)

niche (partially a factor of the shallowness of this niche as opposed to most of the others) and away from the trunk of the body, creating deep pockets of space. At the same time, however, the drapery forms, while simplified, still use the swinging, decorative curves of the *Baptist* that compete with the implied volumes of the figure. Even the cap of tousled hair on St. Matthew's head, with its wonderful irregular locks, is opposed by the ordered symmetry of the beard. Similarly, the niche, which was designed by Ghiberti following ancient musical proportions, combines classical elements such as the triangular pediment, shell motif behind the saint's head, and Corinthian capitals with leafy Gothic crockets and a pointed niche.

Ghiberti's continuation of a late Gothic drapery style into the late 1420s, despite the successes of the weighty volumetric classicizing forms of Donatello and Nanni

di Banco, and his mixed architectural vocabulary are normally treated as manifestations of his personal stylistic predilections. However Ghiberti's commissions at Or San Michele were from the major and most powerful guilds of the city, whereas Donatello's and Nanni's were from minor guilds, a distinction in status clearly suggested by the costly medium of bronze used by Ghiberti and the much larger size of his figures. The social hierarchy of the guilds, therefore, may also have acted as a determinant of style for the Or San Michele niche statues.

Donatello's St. Louis of Toulouse (see p. 204) was commissioned in the early 1420s by the Guelf Party, a political union with a long and illustrious history in the city. The St. Louis was the only statue on Or San Michele not made for a guild. Completely gilded, it outstripped the other niche figures in its visual impact. For the statue Donatello and his partner, Michelozzo (Michelozzo di Bartolommeo, 1396 Florence-1472 Florence), designed an unremittingly classicizing niche framed by Corinthian pilasters, decorative swags, and flying putti. The statue is unlike any other at Or San Michele. Donatello's use of bronze for this statue placed him in direct competition with Ghiberti, then the acknowledged master of this medium in Florence; his overworked volumetric folds provide a clear alternative to Ghiberti's treatment of fabric. Unlike the ascetic St. Louis of Toulouse known to history (see Fig. 6.13), Donatello's figure is completely enveloped in elaborate vestments, almost as if the saint's reluctant acceptance of the office of bishop, here represented by his regalia, has overwhelmed his personal dedication to Franciscan poverty. The sculptor's emphasis on the power of St. Louis's office provided a visual analogue to the power of the Guelf Party in Florence during the early part of the century.

The Foundling Hospital

The extensive sculptural programs for the Duomo, the Baptistry, and Or San Michele were matched by new building projects which were to change the fabric of the city of Florence as much as the building of the cathedral and the Palazzo della Signoria and the transformation of Or San Michele had done in the fourteenth century. The leading architect for this transformation was Filippo Brunelleschi (1377 Florence-1446 Florence). By 1419 he was at work for the Arte della Seta (Silk Manufacturers' and Goldsmiths' Guild) for their special benefice in the city, the Foundling Hospital (Ospedale degli Innocenti; Fig. 10.23), an orphanage where unwanted children could be left anonymously to be cared for by guild charity. The history of such charitable institutions goes back to the thirteenth century, when cities were forced to provide shelter and care for an increasing population of poor and unwanted (see Fig. 8.18). Located in what was then a relatively underdeveloped part of Florence, the Foundling Hospital stands at a right angle to the church of the Santissima Annunziata, which housed a miracle-working image of the Annunciation and which was one of the main pilgrimage sites in the city. At this site Church and corporate foundation work hand in hand to define the character of the city as divinely favored and civically responsible, demonstrating the reciprocal relations between God and citizen in architectural terms.

The loggia that Brunelleschi designed for the hospital is not, in its basic form, unusual. This type of structure seems to have been used consistently in late medieval hospitals. Street loggias providing shelter for pedestrians were common in other Italian cities, particularly Bologna, Padua, and Venice. The question of the sources that may have inspired

10.23 Foundling Hospital, Florence, begun 1421, commissioned by the Arte della Seta (Silk Weavers' Guild) from Filippo Brunelleschi

the graceful rhythms of Brunelleschi's Foundling Hospital loggia has been much debated. Art historians have traditionally searched for ancient Roman precedents for specific characteristics of Brunelleschi's architecture to support the idea that the Renaissance was essentially a revival of antiquity. Yet there is little in the massing of Brunelleschi's architecture that can easily be associated with Roman forms, despite details of column capitals and mouldings that imitate Roman ornament. Evidence suggests that he was not only familiar with Byzantine architecture, especially as manifested in Venice, but perhaps also in Constantinople itself, but that he knew building techniques practiced by the Persians (his own vision being far more encompassing than the European bias of modern historians). The row of domed vaults in the porch of the Foundling Hospital, for example, can be compared with a similar arrangement in the narthex of St. Mark's in Venice, where slightly pointed arches support six small domes. Since Brunelleschi cannot be traced either in documentation or in works of art between 1404 and 1415, he may well have traveled far more widely than Rome, where he is traditionally thought to have lived during this time. At home he was certainly impressed by the abstract classicism of the revetment on Florence's Baptistry (see Fig. 4.3), which, in the sharp alternation of light and dark geometric forms, he imitates in the architectural membering of the Hospital.

The building itself is a remarkably light one, given the stone and masonry architecture of the city. Each of the members—columns, arches, and window enframements—is thin, a fact of the plans alluded to in the documents, which specifically provide for iron tension rods to brace the arches of the portico. The sole exceptions to this thin membering are the heavy cornice above the arches and the strong Corinthian pilasters that gird the structure at the left and right. The cornice runs the entire length of the building and ties the façade structure together compositionally as well as giving a defining frame for the piazza on which the building stands. Later glazed terracotta roundels of babies in swaddling clothes (*innocenti*) made by the della Robbia workshop fill the spandrels between the arches and identify the purpose of the building.

Brunelleschi presumably envisioned a rectangular piazza bordered on two sides by the Foundling Hospital and Santissima Annunziata—one that was not built until the sixteenth century. In the 1420s such a piazza would have been unusual as an unencumbered space in the city, although significantly the Loggia della Signoria and the Palazzo della Signoria defined the governmental piazza in much the same way (see p. 77). A more likely precedent for Brunelleschi's plan is the Piazza San Marco in Venice (see Fig. 7.3), which was also flanked by loggias, with the Basilica forming the boundary of one short side of the square, just as the Annunziata did in Florence. Rectangular piazzas flanked by arcades also formed part of ancient Roman fora and were used frequently thereafter in Christian sites such

as the atrium in front of Old St. Peter's. It is perhaps not accidental that the church of the Annunziata was one of the major pilgrimage churches of Florence, just as St. Peter's was in Rome, and thus needed occasionally to accommodate large numbers of visitors in its precincts. At the Foundling Hospital, therefore, the Arte della Seta was provided with an especially grand space which proclaimed its charity and wealth not only to the city but to foreign pilgrims as well.

Brunelleschi's Dome

While working on the Foundling Hospital, Brunelleschi also supervised the work for which he was—and is—most famous, the dome, or **cupola**, of Florence's cathedral (see Fig. 4.24). Although a large dome had been planned for the cathedral at least from the mid-fourteenth century, no architect had apparently solved the problem of how to vault such a large space; the diameter of the octagonal crossing measures nearly 140 feet (43 meters), almost as great as the Pantheon in Rome.

Having worked on plans for this project from 1417, Brunelleschi submitted in 1418 a model (see Fig. 31) that did not require the usual temporary wooden scaffolding or centering. Brunelleschi's scaffolds cantilevered from the base of the drum and were moved upward as the dome progressed in a series of horizontal courses. This audacious plan ultimately won him the commission, but, as had been the case with the early history of the cathedral itself, progress was not smooth at the outset. A change in the overseeing committee in 1419 occasioned an open competition for the project in which Donatello and Nanni di Banco participated. Brunelleschi's model for this competition was topped with a gilt banner bearing the Florentine lily, an indication of the civic component of the commission. A decision by the building committee in 1420 gave responsibility for the project jointly to Brunelleschi, Ghiberti, and a master mason, Battista d'Antonio, the last an assertion of practical know-how as a guard against Brunelleschi's theory and Ghiberti's minimal experience in architecture.

Construction began in 1420 and continued until August 1436, when the dome was closed at the level of the lantern. At that time the city ordered trumpeters and pipers to play for a great feast for the workmen, the building committee, and the priests of the cathedral. This ceremony was the last in a series that had begun when Pope Martin V had sent the cathedral a branch of miniature roses fashioned of gold (now in the cathedral's museum) to mark the extraordinary efforts of the city to complete the dome. With the imminent completion of the dome, Pope Eugenius IV, then resident in the city, rededicated the cathedral to Santa Maria del Fiore (St. Mary of the Flower) on March 25, 1436 (the feast of the Annunciation). The name derives from the name of the city, Firenze or then Fiorenza, meaning flowering. For this dedication the Flemish composer Guillaume Dufay wrote a

CONTEMPORARY SCENE

Art and Childbirth

Having children was a much less private concern in the Renaissance than it is today. Since infant mortality was high (like mortality as a whole, due to disease and war), both Church and state encouraged parents to have large families. Childlessness was interpreted as a mark of disfavor with God; moreover, it weakened the community's chances for survival and advance-

ment. City governments in both Florence and Venice, for example, established brothels on the principle that lusty young men not yet in a financial position to marry (which they normally did in their thirties) could reinforce their heterosexuality and eventually become fathers. Civic foundling hospitals cared abandoned and orphaned children,

training them for

basic trades essential to the city's economic

well-being.

Not surprisingly, the birth of a new child was marked by ceremony and celebration, the mother often receiving gifts from visitors (see the figures behind the bed in Cavallini's Birth of the Virgin, Fig. 2.7)— who might include city officials as well as friends and relatives. The most common gifts for a new mother were sweets and fruits presented on a keepsake desco da parto ("birth dish") made of wood or ceramic. Sometimes guests offered beverages from a

matching flask or pitcher. Often painted on both front and back, the dishes showed scenes of the mother presenting the new child to guests and/or allegorical and literary themes extolling love and virtue. The parents' coats of arms often appear as well, tying the individual birth to its familial context. In Florence, all sorts of items designed specially for infants and young mothers were available, from practical items such as wooden bowls to embroidered linens to charms and amulets for a successful birth.

In our illustration (Fig. 10.24), trains of both men and women come to celebrate the birth of the child.

Young women accompanied by nuns make their way around an interior courtyard to the door of the birthing chamber, where the mother, still in bed, leans on her arms to speak with them. Matrons are caring for her child, who is tightly swaddled and wearing a coral amulet to protect him from evil spirits. At the far left, trumpeters from the Signoria, their horns displaying the heraldic lily of the republic, announce the arrival of two men carrying a gold vessel and plate.

On the back of this birth plate a nude boy plays with a little dog. On other examples babies urinate streams of silver and gold, and figures play games. The general theme is of a blessed and healthy childhood, a talisman for the very dangerous and susceptible early years of life.

motet whose structure made explicit reference to the measurements and proportions of both Solomon's Temple and Florence's cathedral. The text referred both to Martin's gift and to the presence of Eugenius who "with his own hands . . . dedicate[d] this immense temple." Thus the grandeur of this building project was honored by none other than the popes, granting renown to the building within the Christian community and adding to the magnificence and reputation of the city of Florence.

Although Brunelleschi's dome is considered one of the masterpieces of Renaissance architecture, it deviates from classical precedents. It is pointed, rather than hemispherical, and employs ribs—eight visible and sixteen concealed (Fig. 10.25)—in a manner similar to the construction of Gothic vaults. Other construction features include the use of stone and chain girdles at several levels to counteract the lateral thrust of the dome's weight, a complex herringbone pattern of brickwork (known only in Persian architecture at

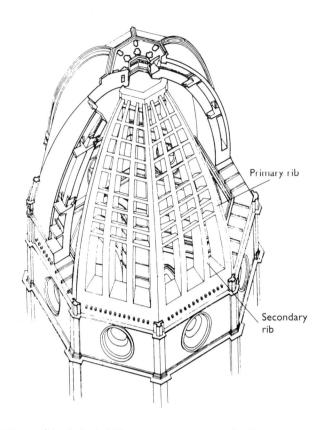

10.25 Dome of the Cathedral, Florence, isometric view, after Piero Sanpaolesi

this time) to reduce cracks due to settling, and double shell construction (also used in Persian architecture) to minimize weight and simultaneously to provide access for maintenance.

All of these details were laid out in two long legal memoranda in 1420 to ensure that the work on this novel project would be carried out in exacting detail. Specifications about thickness of walls, curvature of the dome, width of space between the double shell (ceiling/roof) construction, the type of stone used for reinforcement, the placement of the chain girders, the type of brickwork and the weight of each brick, and details of water drainage are all noted, as is the intention voiced at the very outset that the dome be "magnificent and swelling," a result of the extra height given to the exterior shell by its raised curve. There is even a note that the ceiling was to be built to accommodate mosaics, indicating that at least some envisioned the interior of the dome matching the dome of the Baptistry (see Fig. 4.4), just as the floor plan of the cathedral imitated the earlier structure. The technology of the dome, more than its stylistic properties, however, won Florence enormous prestige and gave it an architectural wonder comparable to, if not surpassing, its Tuscan neighbors and rivals, Siena and Pisa. When Leon Battista Alberti wrote metaphorically in his Della Pittura of 1436, the year of the closing of the oculus, that the dome "covered the entire Tuscan people with its

CONTEMPORARY VOICE

In Praise of Artists

Alberti wrote his text first in Latin in 1435 and then translated it into Italian in 1436 so that his artist friends could read it. The prologue to the *Della Pittura (On Painting)* is both a recognition of the genius of a new generation of Florentine artists and a *paragone*, or competitive comparison, between the present and the antique past.

I used to marvel and at the same time to grieve that so many excellent and superior arts and sciences from our most vigorous antique past could now seem lacking and almost wholly lost. We know from [remaining] works and through references to them that they were once widespread. Painters, sculptors, architects, musicians, geometricians, rhetoricians, seers and similar noble and amazing intellects are very rarely found today and there are few to praise them. Thus I believed, as many said, that Nature,

the mistress of things, had grown old and tired. She no longer produced either geniuses or giants which in her more youthful and more glorious days she had produced so marvellously and abundantly.

Since then, I have been brought back here [to Florence]-from the long exile in which we Alberti have grown old-into this our city, adorned above all others. I have come to understand that in many men, but especially in you, Filippo [Brunelleschi], and in our close friend Donato the sculptor [Donatello] and in others like Nencio [Ghiberti], Luca [della Robbia] and Masaccio, there is a genius for [accomplishing] every praiseworthy thing. For this they should not be slighted in favour of anyone famous or of long-standing in these arts. Therefore, I believe the power of acquiring wide fame in any art or science lies in our industry and diligence more than

in the times or in the gifts of nature. It must be admitted that it was less difficult for the Ancients-because they had models to imitate and from which they could learn-to come to a knowledge of those supreme arts which today are most difficult for us. Our fame ought to be much greater, then, if we discover unheard-of and never-before-seen arts and sciences without teachers or without any model whatsoever. Who could ever be hard or envious enough to fail to praise Pippo the architect on seeing here such a large structure, rising above the skies, ample to cover with its shadow all the Tuscan people, and constructed without the aid of centering or great quantity of wood? Since this work seems impossible of execution in our time, if I judge rightly, it was probably unknown and unthought of among the Ancients.

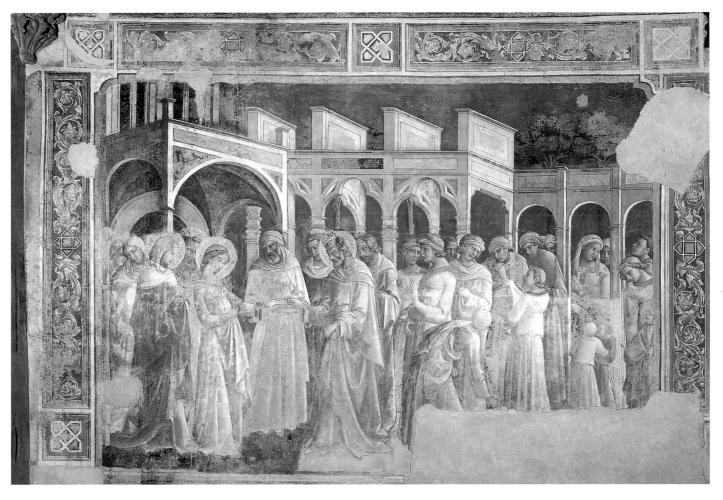

10.26 Marriage of the Virgin, early 1420s, commissioned by the Bartolini family from Lorenzo Monaco for the Bartolini Chapel, Santa Trinita, Florence. Fresco, 6' 10½" × 7' 6½" (2.1 × 2.3 m)

shadow," he referred not just to the size of the structure, which stands over the skyline of the city and can be seen from a great distance, but also to the cultural, economic, and technological hegemony of Florence over the entire region. More than the glory of God was at stake in Brunelleschi's project for the dome of the cathedral.

Family Commissions

In the preface to his manual on painting, written at the turn of the fifteenth century, Cennino Cennini expressed pride in the long tradition to which he belonged:

I was trained in this profession for twelve years by my master, Agnolo di Taddeo [Gaddi] of Florence; he learned this profession from Taddeo, his father; and his father was christened under Giotto, and was his follower for four-and-twenty years; and that Giotto changed the profession of painting from Greek [Byzantine] back into Latin, and brought it up to date; and he had more finished craftsmanship than anyone has had since.

Tenaciously held traditions such as Cennino's shaped subsequent thinking about artistic development during the fifteenth century and have obscured consideration of clearly developed alternatives to the Giottesque tradition outlined in so linear a manner by Cennino. In fact, as the Florentine oligarchy became stronger after crushing the Ciompi Revolution and successfully thwarting the Milanese threats to the city's liberty, noticeable stylistic changes occurred in Florentine painting, marking expensive public family commissions as a manifestation of new communal structures of power.

The Bartolini-Salimbeni Chapel

The frescoes for the Bartolini-Salimbeni Chapel in Santa Trinita (Fig. 10.26) are a case in point. These frescoes were painted by Lorenzo Monaco (Lorenzo the monk, born Piero di Giovanni; c. 1370 Siena?–1425/30 Florence), who may have been trained by Agnolo Gaddi or as an illuminator in the scriptorium of Santa Maria degli Angeli, where he was a monk. Completed between 1420 and 1424, Lorenzo's paint-

10.27 *Annunciation*, early 1420s, commissioned by the Bartolini family from **Lorenzo Monaco** for the Bartolini Chapel, Santa Trinita, Florence. Tempera on panel, $9' \cdot 10'' \times 8' \cdot 11\%'' (3 \times 2.74 \text{ m})$

ings of events from the Life of the Virgin cover an earlier fresco cycle by Spinello Aretino believed to have been commissioned by Bartolomeo Salimbeni in 1390-almost as if the family were seeking to assert its status by assimilating a new style associated with the courts in the north. The painted architecture of the Bartolini-Salimbeni frescoes extends over the entire narrative, stepping back along sharp diagonals, while the row of figures moves in a gradual diagonal back into space, a composition that suggests Lorenzo's close study of Agnolo Gaddi's frescoes at Santa Croce (see Fig. 8.16). Lorenzo's debt to earlier sources is also evident in the figure of St. Joseph, whose gathered yellow cloak falls in two large curves and then loops along the ground. The altarpiece for this chapel (Fig. 10.27) recalls the miracleworking image at Santissima Annunziata in Florence, recast in the earlier Sienese Gothic forms of Simone Martini's Annunciation (see Fig. 5.13) in its decorative details and elongated figures, with their long S-curves and arabesque drapery edges. Apart from the fact that Lorenzo came from Siena, the reason for the references to Simone's altarpiece, then still in Siena's cathedral, is not clear. In painting as in

sculpture, however, the juxtaposition of recent Florentine and older Sienese references in one chapel suggests how thoroughly painters in Florence had assimilated the International Gothic Style imported from France, and how such a style might distinguish a new group of patrons from others of their contemporaries.

Lorenzo's elegant style reached maturity in his very large altarpiece of the *Coronation of the Virgin* (Fig. 10.28) for the high altar of his conventual church of Santa Maria degli Angeli in Florence. In both the Santa Maria degli Angeli altarpiece and the Bartolini Chapel frescoes, the patrons apparently regarded Lorenzo's style as the most novel in Florentine painting of their time and the most likely to distinguish them from their predecessors as a new social power within the city. The church of Santa Maria degli Angeli is itself referred to in the altarpiece both by the many angels who accompany the saints and by the white robes of the Virgin, which evoke the white monastic robes of the Camaldolite order, whose church it was. In Lorenzo's *Coronation* the edges of the figures' garments have an animation quite independent of the actual movement of the

figures. Although the composition of the painting is quite conventional, the figures display a new fluidity in their poses and in the movements of their drapery which is suggestive of the International Style then being employed in sculpture by Ghiberti and Niccolò Lamberti (see Figs. 10.21 and 10.13). Surface patterns vie for attention with the

volumes of the figures; even the superimposition of figures tends to read as pattern. Brilliant, light-toned color and the lavish use of gold and expensive ultramarine blue pigment would have made the painting a strong focal point in the church and would also have testified to its importance and to the donor's extraordinary generosity.

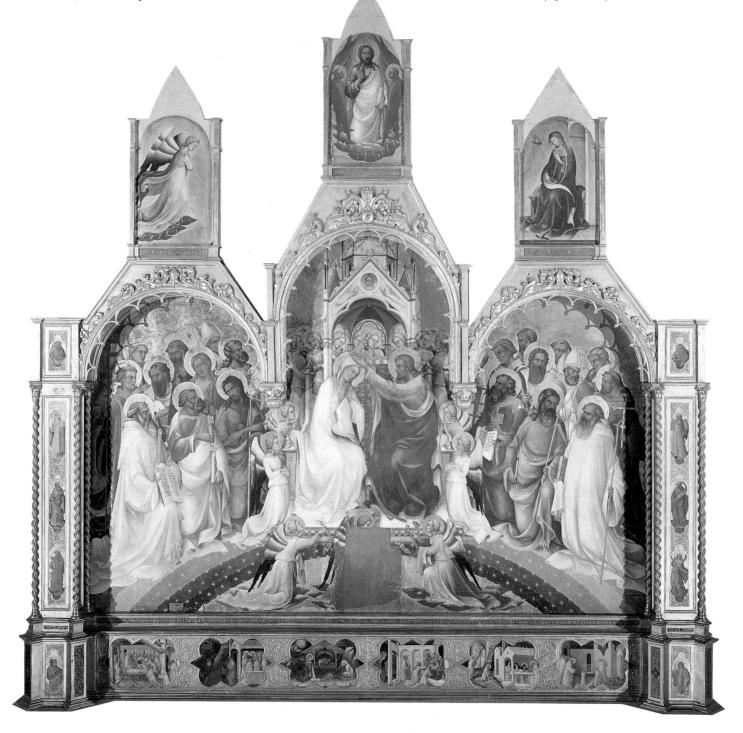

10.28 Coronation of the Virgin, 1414, commissioned by a member of the Della Frasca family (perhaps Domenico di Zanobi) to honor Zanobi di Ceccho della Frasca and other members of the family from **Lorenzo Monaco** for the main altar of Santa Maria degli Angeli, Florence. Tempera on panel, 16′ 9½″ × 14′ 9″ (5.12 × 4.5 m) (Galleria degli Uffizi, Florence)

The inscription that runs along the base of the painting reads: "This picture was made for the soul of Zanobi di Ceccho della Frasca and his family in compensation for another altarpiece that was placed in this church for him. The work is by Lorenzo di Giovanni, a monk of this order, and his [shop]. He painted it in the year of our Lord 1413, in the month of February, during the time of Matthew's priorate of this monastery."

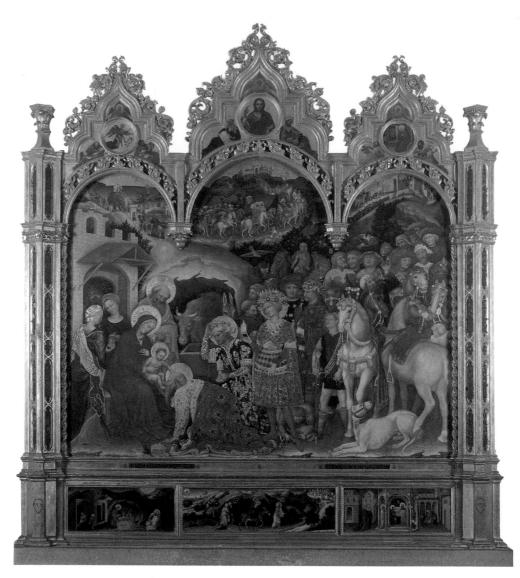

10.29 Adoration of the Magi, 1423, commissioned by Palla Strozzi from Gentile da Fabriano for the Strozzi Chapel, Santa Trinita, Florence. Tempera on panel, 9' 10" × 9' 3" (3 × 2.82 m) (Galleria degli Uffizi, Florence)

The Strozzi Chapel at Santa Trinita

At the beginning of the fifteenth century Onofrio Strozzi was head of the wealthiest family in Florence. When he died in 1418 he had already initiated work on his family burial chapel at Santa Trinita—which was also to serve as the church's sacristy. The chapel and much of its decoration were commissioned by Onofrio's son, Palla Strozzi. Documentary evidence indicates that Ghiberti was the architect—a choice that may reflect the fact that Palla Strozzi served as a member of the committee that ordered Ghiberti's north doors for the Baptistry (see Fig. 10.5).

The centerpiece of the chapel was the *Adoration of the Magi* (Fig. 10.29) by one of Italy's leading proponents of the International Gothic Style, Gentile da Fabriano (Gentile di Niccolò di Massio; c. 1385 Fabriano–1427 Rome). Befitting the work of an artist who had enjoyed great success in Venice (where he painted narratives in the Great Council Hall) and at the court of Pandolfo Malatesta in Brescia, it is one of the most lavish paintings made in fifteenth-century Florence, a manifestation of the Strozzi's enormous wealth. The altarpiece luxuriates in gold, elaborate tooling, patterned costumes, and decorative details, which even adorn

its frame. The opulence of Gentile's Adoration should not, however, obscure two other critical aspects of the painting, typical of the work he produced during his Florentine years: the suffusion of light throughout the composition and the beautifully modeled figures whose features are subtly put in relief by the play of light upon them, effects already evident in Gentile's earlier works. This is especially noticeable in the predella panel of the altarpiece depicting the Nativity (Fig. 10.30). There the luminous radiance emanating from the body of the Christ Child suffuses the central part of the small panel, bathing the figures and the landscape in a soft glow that is as much a depiction of natural moonlight on landscape forms as it is a manifestation of the supernatural. The light extends to the left edge of the panel where it casts distinct (if inaccurate) shadows on the shed framing the two reclining women there. A comparable depiction of the divine through the carefully-observed natural phenomena of light appears in the upper right of the panel where the angel appears to the shepherds to announce the birth of the Christ. These effects and the softness of colors in the Adoration differ from Lorenzo Monaco's sharper tonalities, setting Gentile's painting apart from the leading painter in Florence at the time. Another noteworthy feature is the aristocratic

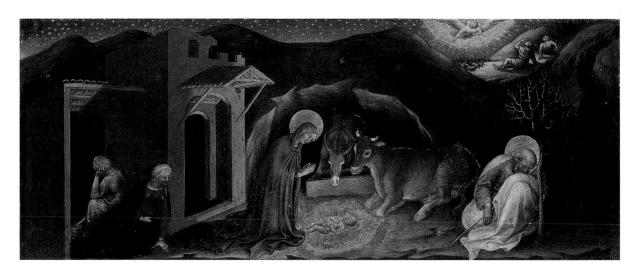

10.30 Nativity (predella panel from Adoration of the Magi), 1423, commissioned by Palla Strozzi from Gentile da Fabriano for the Strozzi Chapel, Santa Trinita, Florence. Tempera on panel, 12½ × 29½" (32 × 75 cm). (Galleria degli Uffizi, Florence)

quality of both subject and treatment. Not only does the altarpiece have a regal cast of characters in the Three Kings, but it portrays the event with the full panoply of princely life, including hunting dogs, pet monkeys, and falcons—in spite of the fact that the Strozzi were merely bankers.

10.31 *Quaratesi Altarpiece* (reconstruction), 1425, commissioned by a member of the Quaratesi family from **Gentile da Fabriano** for the high altar of San Niccolò sopr'Arno, Florence. Tempera on panel, center panel, including frame, $87\% \times 32\%''$ (222.7 × 83 cm)

The Virgin and Child is in the National Gallery, London (on loan from Her Majesty the Queen); Mary Magdalene, St. Nicholas, St. John the Baptist, and St. George are in the Galleria degli Uffizi, Florence.

The Quaratesi Altarpiece

Soon after completing the *Adoration of the Magi*, Gentile painted an altarpiece, now dismantled, for the main altar of San Niccolò sopr'Arno, over which Bernardo di Castello Quaratesi had property rights. The *Quaratesi Altarpiece* (Fig. 10.31) is signed and dated to 1425 on the center panel and may have been commissioned by one of Bernardo's heirs after his death in 1423. It is much more conventional in its composition than the Strozzi *Adoration*, with the Madonna and Child enthroned between the patron saints of the

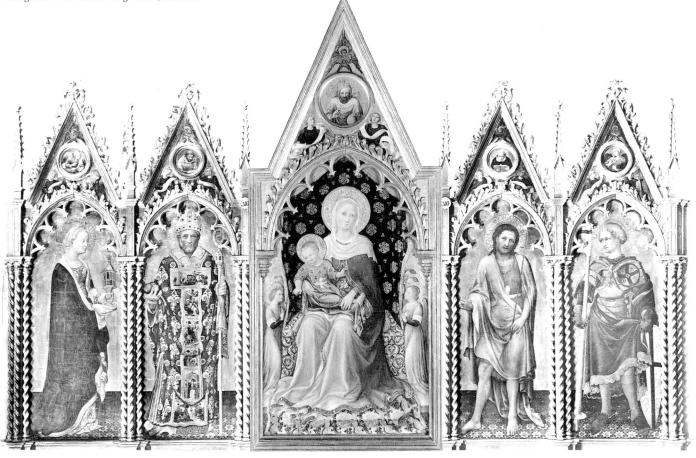

family and the church. Despite the traditional gold ground behind the saints and the schematic pattern of the floor on which they stand, their volumetric treatment in space (which originally would have been even greater with wooden colonnettes between the panels creating an arcaded loggia) gives them a presence unlike those of previous altarpiece figures. Although St. Nicholas (second from the left, and in the place of honor to the Virgin's right) appears in an iconic frontal pose as the patron saint of the church, the other figures turn and gesture in a manner more naturalistic even than Ghiberti's St. John the Baptist (see Fig. 10.21), which they resemble in certain details of drapery. The same natural quality can be seen in the Virgin and Child, who, although seated on a throne covered with four different patterns which tend to flatten space, are fully modeled and spatially convincing. The drapery of the Madonna falls heavily from her knees and, despite the gentle arabesques of its edges, its volume creates a sense of the mass of the figure beneath, much like the evangelists for the façade of the cathedral (see Figs. 10.11-10.14). The projecting knees of the Virgin catch the light from the left, the drapery hanging heavily between them, and the smooth faces are delicately modeled with red highlights on the cheeks blurring into a soft pink. The gray shadows on the figures' left darken imperceptibly as they help to structure contour—touches of the natural within the elaborate decorative surfaces of the painting. Whatever Gothicizing style Gentile brought with him to Florence, he was obviously influenced in turn by the innovations in style he observed there.

Masaccio and the Brancacci Chapel

At about the time that Gentile painted the *Quaratesi Altarpiece*, a young revolutionary Florentine painter now known as Masaccio (Tommaso di ser Giovanni di Simone Guidi; 1401 San Giovanni Val d'Arno–1428 Rome) began to explore new ways of representing the real world on a two-dimensional surface. His career was very short, although he is known to have been painting by the age of sixteen. His first extant major commission for a large multi-paneled altarpiece was completed in 1426 for the choir screen of a chapel in the Carmelite church of Santa Maria del Carmine in Pisa that belonged to a notary of that city.

Like Gentile, Masaccio was obliged to use a gold background—still considered necessary for the iconic figures of an altarpiece. He placed his Madonna and Child (Fig. 10.32) on an architectural throne whose ornaments of Corinthian capitals and rosettes and **strigillated** base distinguish it from those in earlier Florentine paintings of the enthroned Virgin (see Fig. 4.14). Her arms create an oval, opening a space into which the child fits. The full volumes and heavy massing of the drapery over her clearly defined body show that Masaccio had looked carefully at the sculpture of his friend Donatello (see Fig. 10.14). The play of light over facial features is indebted to Gentile, although Masaccio

heightened the effect of light with the strong shadows created by the left side of the throne and by the figures themselves. This meticulous treatment of light and shadow, responding to the actual source of light in the chapel, attests to Masaccio's concern for naturalism, seen also in the amusing gesture of the Christ Child stuffing grapes (a Eucharistic symbol) into his mouth, much as any child would do.

Masaccio's frescoes for the Brancacci Chapel in Florence's Santa Maria del Carmine, another Carmelite church (Fig. 10.33), mark a milestone in the history of wall painting. They enhance Giottesque traditions of naturalism with new vitality, not merely in their formal properties of space and volume, but also in the psychological intensity that permeates the narrative. The frescoes were assigned to Masaccio, and to a slightly older Florentine painter now known as Masolino (Tommaso di Cristofano di Fino; 1383 Panicale di Val d'Arno-c. 1440 Castiglione Olona) who may have received early training in the workshop of Agnolo Gaddi and who was employed in Ghiberti's workshop between 1407 and 1415. The nicknames given the two painters-Masaccio being a derogative form of Maso perhaps connoting slovenliness or brutishness or even forcefulness, Masolino being another diminutive of Maso contrarily implying gentleness-are responses to their distinctive painting styles and have unfortunately colored understanding of their work since the sixteenth century. The simplified opposition that the nicknames establish (implying a daring exploration of a new heroic style as opposed to an easy assimilation of the elegant forms of the late Gothic Style) takes little account of the fact that the artists worked together on more than one occasion and thus that their patrons would have assumed that their collaboration would produce a harmonious work.

The Brancacci Chapel was created through a bequest of Pietro Brancacci, who died in 1367. Because of the deaths of Pietro's sons and brothers by the mid-1390s, ownership of the chapel eventually passed to his nephew, Felice Brancacci, and it is generally believed that he was the patron who commissioned the frescoes from Masolino and Masaccio. Until his second marriage to Lena di Palla Strozzi (the daughter of Gentile's patron for the Adoration of the Magi), Felice was closely allied to Cosimo de' Medici, then at an early stage of his financial and political ascendancy in the city. Felice also had strong connections to the papal court, in part through two members of his family who were cardinals and also through another relative who was the head of the Dominican order in Florence. When Palla Strozzi was exiled from Florence in 1434, Felice was charged with political intrigue against the new Medici regime, ostensibly because of his Strozzi marriage alliance. He was himself exiled from the city in 1435, when the frescoes were still unfinished, and his goods were confiscated by the state, precluding any further work on the decoration of the chapel at that time.

Most of the frescoes of the Brancacci Chapel depict scenes from the life of St. Peter, the patron saint of the original donor, Pietro Brancacci. They are also specifically connected to the liturgy of the Carmelite order that had charge of the church in which the chapel is located, thus linking the patron and the religious order in a mutual display of self-presentation. Masolino seems to have been the first of the two artists to have been commissioned. He painted the vaults and the lunettes of the chapel, all of which were destroyed in a fire of 1748. Of the extant frescoes Masaccio was responsible for the left wall, Masolino for the right wall; it appears both painters worked on the altar wall. Although Masolino was already working on the frescoes

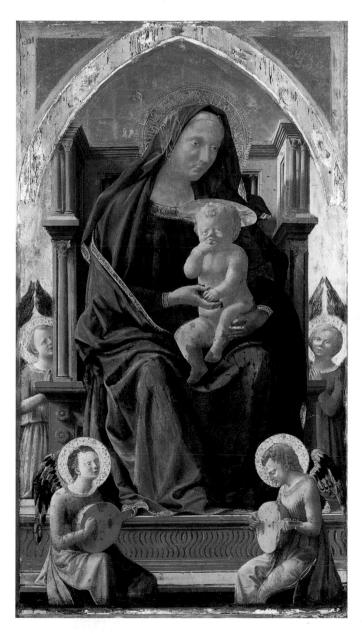

10.32 *Pisa Altarpiece*, center panel, 1426, commissioned by ser Giuliano di Colino degli Scarsi da San Giusto from **Masaccio** for a chapel in Santa Maria del Carmine, Pisa. Tempera on panel, center panel $53 \times 28\%''$ (135 \times 73 cm) (National Gallery, London)

by 1425, he had left for Hungary by September of that year, perhaps never to return to them; Masaccio went to Rome in 1427, leaving his part of the commission also unfinished.

Old Testament subjects of the Temptation of Adam and Eve by Masolino and the Expulsion from Paradise by Masaccio are depicted on the entrance arch to the chapel-a reminder of the Original Sin and the need for redemption that lies behind the narrative scenes in the chapel. Standard comparisons between the two frescoes (see Fig. 10.33, top left and right; see Fig. 10.37 left) propose that Masolino represented the end of the Gothic tradition and Masaccio the beginnings of a new and more powerful tradition of figural representation in Florence. Although there may be some truth to this characterization, it is clear from other family chapels and from the ongoing careers of painters such as Lorenzo Monaco and Gentile da Fabriano that an elegant style was still in great demand in Florence and that Masolino was responding to this stylistic disposition as he assimilated the gently modeled forms and coloration of Gentile's work into his own painting.

Masaccio's figures seem to have no precedent in contemporary painting; again, as in the *Pisa Altarpiece*, his naturalistic human forms demonstrate, rather, the influence of Donatello. The muscular Adam in the *Expulsion* bends and turns at the same time, racked with shame and fear; he creates a core of space with his body that is directed to the right even though his deformed right leg drags behind his body, as if attempting to slow the inevitable expulsion from Eden. Eve attempts to hide her nakedness while her face is contorted in a paroxysm of uncontrollable grief. Modeled on a classical *Venus pudica* type, she is schematic as a physiological representation, but compelling as an expressive psychological depiction.

On the other hand, in the St. Peter Healing with his Shadow and Baptism of the Neophytes (Figs. 10.34 and 10.35) in the upper right and lower left registers of the chapel's altar wall (see Fig. 10.33) there seems to be an attempt at a more accurate naturalism. In the Baptism heavy, nearly-nude bodies are modeled by natural light in the simplified landscape, the volumes of their forms dramatically described as if by the light coming from the window immediately to the left of the painting. The neophyte to the far right clutches his arms in front of him as if shivering in the cold water of the river, a gesture that casts a shadow over his upper torso, creating a volumetric hollow within the movement of the figure. The massing of the body and the somewhat angular movement of its parts is reminiscent of monumental relief sculpture of the period (see Fig. 5.35) and again calls attention to the powerful influence that sculpture had on painting at this time. In St. Peter Healing with his Shadow the urban landscape closely approximates what one would have seen within the city, placing the narrative in a familiar setting and thus making it more approachable. Even the cripple and the beggar must be seen in the light of contemporary

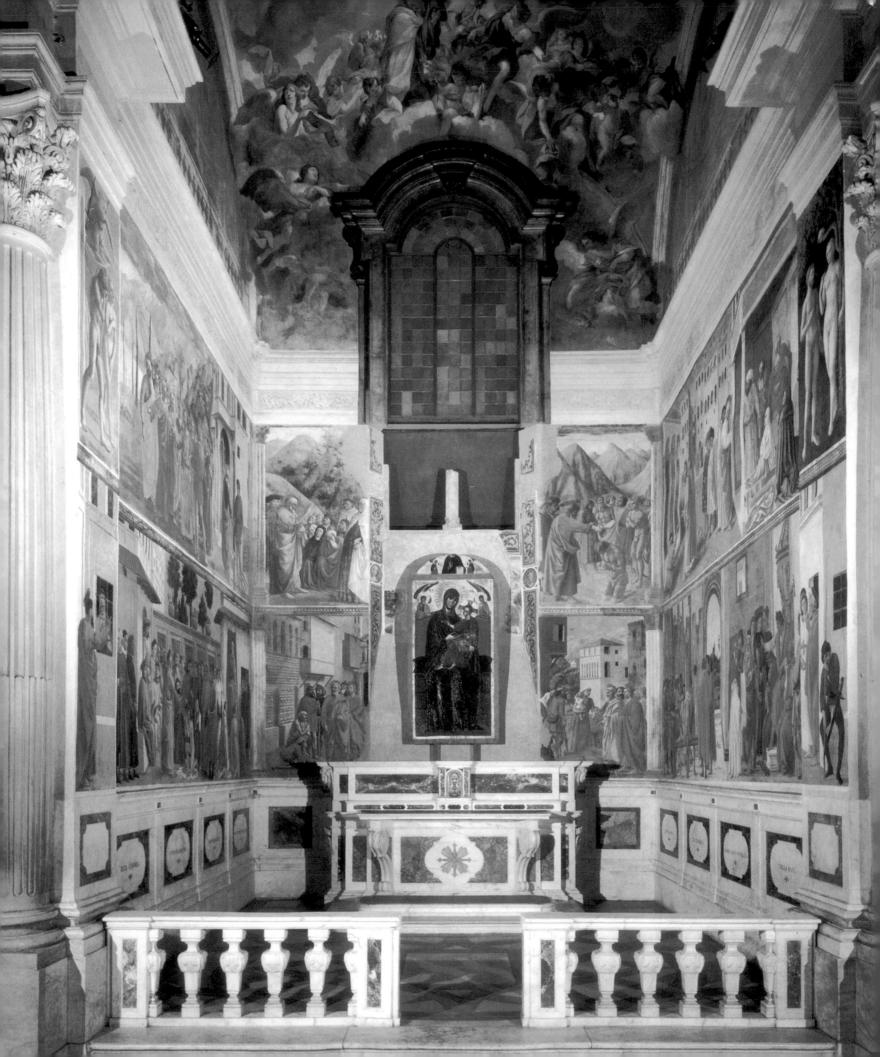

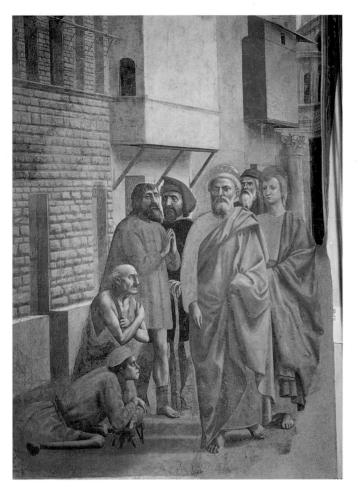

10.34 *St. Peter Healing with His Shadow*, **Masaccio** and **Masolino** for the Brancacci Chapel, Santa Maria del Carmine, Florence. Fresco, 7′ 7″ × 5′ 4″ (2.31 × 1.63 m)

urban realities. The perspectival recession of the architecture coordinates with the fresco of *St. Peter Distributing Alms* on the other side of the altar wall, creating a unified field across the entire wall despite the interruption of the window. Here, too, shadows fall as if made from the light coming from the window at the right. In both frescoes, the two painters have included a number of portraits of their contemporaries; although they are now unidentifiable, these portraits must have given the biblical narratives a strong contemporary resonance, as well as providing an opportunity for the men depicted to see themselves publicly presented as members of an artistic or social elite.

Masolino was primarily responsible for *The Raising of Tabitha and the Healing of the Lame Man* (from Acts, III: 1-10

10.33 (opposite) Brancacci Chapel, plan originated by Pietro Brancacci, partially painted c. 1424–27 by **Masolino** and **Masaccio** (**Filippino Lippi** painted the lower right wall and the unfinished part of the lower left wall in the mid-1480s), Santa Maria del Carmine, Florence. Fresco

Recent cleaning of the chapel was begun in 1984 and completed in 1990.

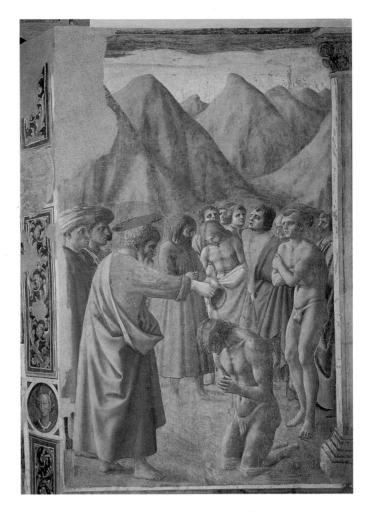

10.35 Baptism of the Neophytes, Masaccio and Masolino for the Brancacci Chapel, Santa Maria del Carmine, Florence. Fresco, $8'\ 1'' \times 5'\ 8''$ (2.46 \times 1.73 m)

and IX: 36-43; Fig. 10.36) on the right wall of the chapel. The stories are not joined in the biblical account, and neither are they here. At the left St. Peter heals a lame man, the saint's hand tentatively addressed to the cripple whose own arm is fully extended, as if he knows he will be lifted up and walk again. Peter hardly seems to believe in his own power, given his furrowed brow, whereas the cripple's faith is expressed in the incipient movement of his body. At the right Peter raises a dead woman, Tabitha, still wrapped in her winding sheet, her ashen face descriptive of her recent state. The men around her bier have strong physical reactions to the miracle that they are witnessing; the man wearing a white turban may be Masolino's attempt to indicate the eastern Mediterranean city of Joppa where the miracle took place. The two women at the right, sometimes identified as Carmelite tertiaries wearing the robes of the Carmelite order who staffed the church where the Brancacci Chapel is located, are more restrained in their reactions, their bodies encased in voluminous black drapery that creates a sense of physical mass without being descriptive of any body beneath.

Curiously, all reference to commercial life has been removed from the image, in terms both of markets and of shops in the ground stories of the buildings. Still, small everyday details in the windows at the second and third stories give a sense of the city as a lived-in space: sheeting and cloths at the windows; a bird cage suspended in one of the windows at the center of the painting; a pet monkey tied at a window above it; and two people leaning out of top-story windows talking with one another.

In *The Tribute Money* (Fig. 10.37; taken from Matthew 17:24–27), on the wall opposite Masolino's fresco, Masaccio depicts Christ's commands to Peter as events already realized. In the center the messenger from the Temple asks Christ for the yearly tax for maintaining the Temple in Jerusalem. Christ, claiming to be free from the tax, nonetheless orders Peter to catch a fish, shown in the middle distance on the left where Peter opens the mouth of the fish to find the coin of tribute miraculously inside. On the right Peter pays the tax collector the coin, actually worth twice the required tax.

Masaccio's landscape is missing the leaves that were originally painted *a secco* on the trees, but the overall effect remains remarkable for its realism. Colors fade into a hazy monochromatic distance where hills meet sky, creating an atmospheric perspective analogous to that attempted in stone by Donatello in his St. George relief (see Fig. 10.17). The crisply delineated architecture on the right serves to frame Peter and the tax collector as a distinct moment in the narrative.

In the central group of figures Christ anchors the composition, being the focal point of the narrative, as he directs an unwilling Peter to pay the Temple messenger. Peter's pose echoes that of Christ, the gesture of their right arms directing attention to the next scene in the narrative. The paired gestures imply an equation between Christ's authority and Peter's, an assertion of the legitimacy of papal power. Furthermore, in both instances where Peter confronts the temple tax collector, their two bodies are mirror images of one another. This opposition strengthens the narrative by locking the two protagonists of the story into a single compositional unit. The figural opposition also serves to enhance the three-dimensional quality of the image by providing enough information for the viewer to construct mentally a fully rounded pair of figures-front and back in one case, right and left sides in the other. Masaccio modeled his forms' surfaces so that light plays smoothly over them, leaving dark pockets of shadow in the drapery and soft convexities of flesh in the figures, thus adding to the dramatic impact of the story.

There have been attempts to see in *The Tribute Money* references to the institution of a state tax based on a declaration of income and assets (the *catasto*) first taken in 1427. However, these are unconvincing for the simple reason that the Brancacci would have been allied to the faction opposing the tax. A more likely interpretation connects this particular scene with Pope Martin V's 1423 agreement that the Florentine Church be subject to state tax. The cycle as a

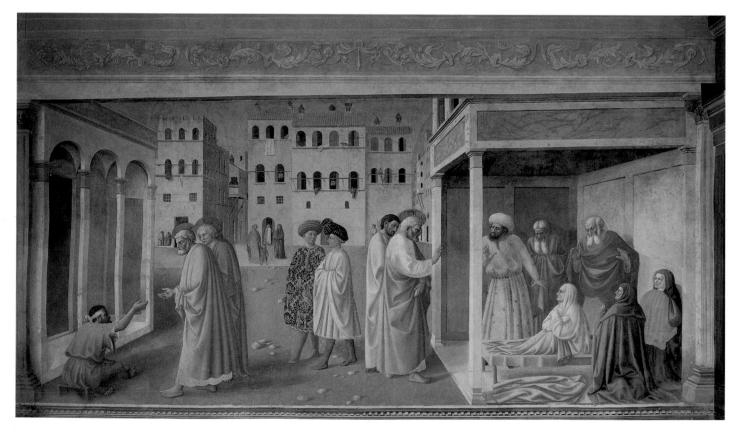

10.36 Healing of the Cripple and The Raising of Tabitha, Masolino for the Brancacci Chapel, Santa Maria del Carmine, Florence. Fresco, 8' 1" × 19' 3" (2.46 × 5.87 m)

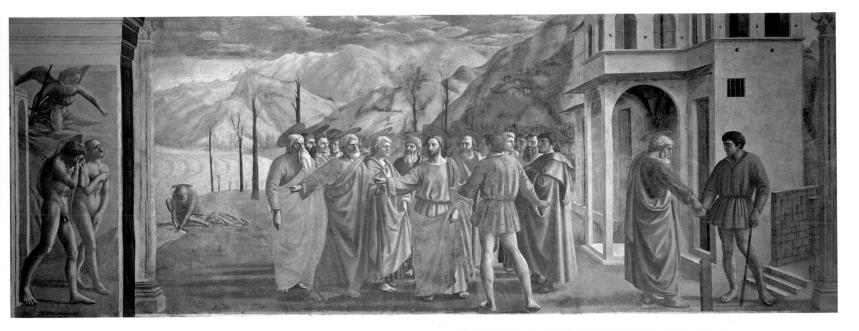

10.37 Expulsion and The Tribute Money, **Masaccio** for the Brancacci Chapel, Santa Maria del Carmine, Florence. Fresco, 8' $4\%'' \times 19'$ 7%'' $(2.54 \times 5.97 \text{ m})$

whole may refer simply to the original donor of the chapel, Pietro Brancacci, or it may reflect Felice Brancacci's close connections to the papacy, here represented by St. Peter. The presence of Carmelite monks in some of the frescoes is a clear reference to the order whose liturgical books provide a convincing source for the individual scenes of the chapel. In these powerful images Masaccio transformed the traditions of monumental narrative painting, opening up alternatives to the style exemplified by the Bartolini-Salimbeni frescoes of about the same time.

The *Trinity* and Single-Point Perspective

Perhaps Masaccio's best-known painting is the one for which there is the least concrete information. The *Trinity* (Fig. 10.38) was painted on the left wall of the church of Santa Maria Novella. During Vasari's remodeling of the church in the 1560s, Masaccio's fresco was covered by a stone tabernacle and a painting, which were not removed until 1860–61. At that time the *Trinity* was detached from the wall, suffering severe damage in the process. Because there is an early record of a tomb slab for Domenico Lenzi and his family placed in the pavement in front of the fres co's original position in 1426, the kneeling donor figure on the left side of the *Trinity* is generally assumed to be Lenzi, and the figure at right his wife.

10.38 *Trinity*, c. 1426-27 (?), commissioned by a member of the Lenzi family from **Masaccio** for Santa Maria Novella, Florence. Fresco detached from the wall, $21' 10''' \times 10' 4''' (6.67 \times 3.17 \text{ m})$

The *Trinity* depicts a small chapel containing the Three Persons of the Trinity, with God the Father standing above and behind the Son on the Cross, as if presenting him to the worshiper, and the dove of the Holy Spirit hovering above Christ's head. The painted chapel provided the patron and his wife with a substitute for a real one, which either they could not afford to build or—because the wall on which it is painted is contiguous with the cloister—was architecturally unfeasible. However, at the opposite side of the church from Santa Maria Novella's side door, then used as a major entrance to the building, the fictive chapel of the *Trinity* would have resembled a real space.

Mary and John the Evangelist stand at the foot of the cross, as they do in more literally rendered Crucifixion scenes. Here separated from that narrative context they appear to be contemplating a religious icon, with Mary looking out toward the viewer and gesturing toward the crucified Christ. All of the sacred figures exist behind the architectural frame, separated in their own space, while the donor and his wife kneel on a ledge in front of it, thereby illusionistically sharing the viewer's space and, importantly, providing models for the viewer's devotion before the image. At the base of the painting is a fictive altar supported by four thin columns; beneath it is an open sarcophagus supporting a skeleton whose inscription warns, "What you are now I once was, what I am now you will be." Thus tomb, donors, and devotional image are spatially sequenced to direct the viewer toward the sacred icon of the Trinity.

The means of achieving this fusion of real and depicted space lie in part in Masaccio's ability to render his figures as if they are three-dimensional, as he did in *The Tribute Money*. Equally important is his use, for the first time in the history of painting, of a fully developed single-point perspective system. The development of this linear system for the representation of space occurred when the increased realism of the figures demanded a commensurate realization of their surroundings. Single-point perspective, despite its importance, must be seen as part of a whole development and as one of a number of pictorial devices that artists might use—or not use—in depicting their subjects.

The single-point perspective system was invented by the architect Filippo Brunelleschi. Since a fully developed, rationalized space does not appear in painting until the *Trinity*, Brunelleschi's invention should perhaps be dated to around 1424–25; the actual development of single-point perspective must have taken place over some time.

Reconstruction of the history of this pictorial invention stems from Antonio Manetti's life of Brunelleschi, written in the 1480s, in which the author describes two small panels painted by Brunelleschi: one of the Palazzo della Signoria, the other of the Baptistry. In each, the building was set within its surrounding urban context. According to Manetti, Brunelleschi painted the panel of the Baptistry by standing some 6 feet (2 meters) inside the main doors of the cathedral. He either looked directly across the small piazza

10.39 Drawing showing **Filippo Brunelleschi**'s perspective panel of the Baptistry held before a mirror and viewed from behind through a peephole (after Alessandro Parronchi)

that separates the two buildings or into a mirror with his back to the Baptistry so that what he painted was a replica of the mirrored image. From this vantage point Brunelleschi saw not only the east face of the Baptistry (where Ghiberti's first bronze doors were placed in 1424; see Fig. 4.3) but also the streets and buildings to the left and right. The geometrical regularity and precision of the decorative elements of the Baptistry would certainly have aided the construction of the demonstration panel. Manetti describes the panel as half a braccia (literally "arm," a Florentine unit of measure) or approximately a foot (30 centimeters) square, painted with a miniaturist's care, with the sky made of reflective burnished silver so that "the [mirrored] clouds seen in the silver are carried along by the wind as it blows." It appears that Brunelleschi's concern was to re-create an illusionistic reality (on a small scale) as closely as possible.

Manetti also says that the panel was intended to be viewed from the back, by looking through a hole drilled at the central vanishing point at a mirror held up in front of it (Fig. 10.39). This would have achieved three goals. First, it closed the viewer's vision to the panel itself, excluding any surrounding and competing "reality." It also required the viewer to use only one eye, thus making the illusion of space in the panel more vivid. And, as Manetti points out, the distance between panel and mirror was to be approximately one braccia. Since the actual distance between the Baptistry and the spot where Brunelleschi painted the image was 60 braccia and the image represented an actual width of 30 braccia, the relationship of distance between the panel and the viewer's eye and the width of the panel was 2:1 just as the represented distance was 2:1, thus again helping to replicate the vision of reality. The concept of the vanishing pointthe point in the distance, appearing at eye level, where lines

in the field of vision appear to converge—is implied in this construction. Behind the construction of the perspective panel lie Brunelleschi's careful measurements which ensured that actual spatial relationships were translated to their proportional equivalents as the panel was seen in the mirror. Clearly this is not a system that translates easily to ordinary painting.

In Masaccio's Trinity the many difficulties of applying Brunelleschi's system, based on real buildings, to an imaginary space, in which figures play a major part, remain partially unresolved. It is difficult to imagine where God the Father is standing or how his position in space relates to Christ's. The orthogonal lines (diagonal lines moving to the centric point) of the vaulting system, however, all meet at a point somewhat below the base of the cross—roughly at the eye level of the viewer. The perspective system not only creates a space inside the picture, but positions the viewer in the space before the painting as well, dictating a position out from the painting on a center line toward which the Virgin gazes. Despite the unresolved aspects of perspective in this painting, Masaccio-perhaps with the assistance of Brunelleschi, who was a friend-had established a mode of pictorial representation in the Trinity that was to dominate European visual language until the nineteenth century.

Altarpieces at Mid-Century

The work of Filippo Lippi (c. 1406 Florence–1469 Spoleto), whose workshop was one of the most active and notable in Florence during the 1440s and 1450s, demonstrates the range of stylistic possibilities available to central Italian patrons in the years after Masaccio's death. Filippo's earliest dated work is known as the Tarquinia Madonna (Fig. 10.40) because of its location in the town of that name. It was presumably painted as a private devotional image for the Florentine archbishop Giovanni Vitelleschi, who was born in the town. Filippo's early training may have occurred in the workshops of the church of Santa Maria del Carmine in Florence, since he had joined the Carmelite order in 1421, shortly before Masaccio and Masolino painted the Brancacci Chapel (see Fig. 10.33). A payment in 1434 for an unspecified painting produced during a stay in Padua, where he apparently was acquainted with the local painter Squarcione, indicates that he was already an established painter by that time. The Virgin of the Tarquinia Madonna demonstrates Filippo's assimilation of the massive sculptural forms of Masaccio's painting; the realistically lively Christ Child shows the influence of Donatello's sculpture as well, especially his Cantoria (see Fig. 10.56) for the Duomo, then being carved. The smoothly ovoid shape of the Virgin's head suggests that Filippo had also looked carefully at contemporary Sienese painting by artists such as Sassetta during his stay in that city as sub-prior of the Carmelite order there in 1428-29. The steeply tipped perspective of the framing architecture and the meticulous

details of jewelry and embroidery, with their glistening spots of reflected light, imply that he also had models of Flemish painting in mind—not surprising, given the vigor of Florentine commerce with Flanders.

Filippo's larger-scale work shows the same fusion of solid figures with refined elegance. The *Coronation of the Virgin* (Fig. 10.41), which was commissioned for the high altar of Sant'Ambrogio in Florence by Francesco Maringhi, the prior of the church, shows a celestial coronation of the Virgin; a group of saints fills the frontal plane of the composition with the patron kneeling in reverence at the lower right. St. Ambrose, the patron saint of the church, is standing at the left; St. John the Baptist, the patron saint of Florence, is standing in front of Maringhi in the right foreground. Filippo ordered his composition in a traditional

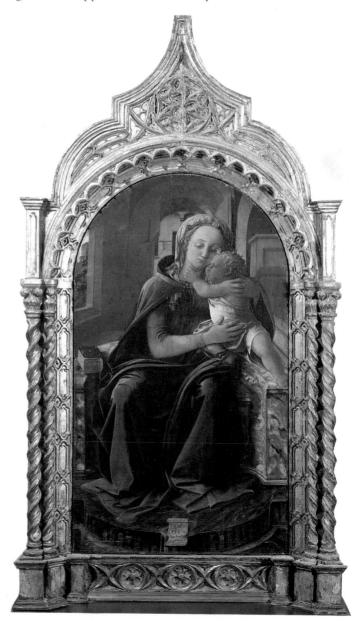

10.40 *Tarquinia Madonna*, 1437, commissioned by Giovanni Vitelleschi from **Filippo Lippi**. Tempera on panel, $45 \times 25\%$ (114 \times 65 cm) (Palazzo Barberini, Galleria Nazionale, Rome)

manner, with arches separating the coronation itself from the accompanying angels and saints. Even the figural grouping of the angels is conventional, as they line up row upon row in a manner not far removed from Simone Martini's Maestà (see Fig. 5.24), painted a century earlier or Lorenzo Monaco's Coronation of the Virgin (see Fig. 10.28). Every surface in the painting, whether architectural or figural, is manipulated for decorative purposes. Elaborate costumes, intricate folds of material, and animated poses make this one of the most extraordinary Florentine altarpieces of the mid-century. Most notable, perhaps, is the profusion of gold over the surface (much of which has since disappeared). Thick gold buttons, gold threaded through fabric, and gold stippling and gold dust in the haloes and the surfaces of the costumes give the painting an opulence comparable to that of Gentile's Adoration of the Magi (see Fig. 10.29), but with a textured quality not achievable with gold leaf. Many of the saints in the center foreground are discretely labeled so that their identities are established, although it is not yet clear why Lippi or his patron chose these particular and unusual saints (including Job at the left of the group, Martin, Eustachyus, and Tempisten).

It has been suggested that the family group of St. Eustace and St. Theopista and their two young sons at the center and right of the group is a reference to the new emphasis on family during the middle years of the century, but they may have as much to do with competing patronage concerns in the church, the altar at the right of the main altar being dedicated to St. Eustace. That altar had as its patrons the Barducci family, one of whose members, Suora Antonia, was the abbess of Sant'Ambrogio when Lippi was at work on this altarpiece for the church. Here, too, the religious and the personal intersect.

A contemporary of Filippo Lippi's whose work also appealed to Florentine patrons was Domenico Veneziano (c. 1405 Venice?–1461 Florence). He was apparently born in or near Venice, as his nickname indicates, but received his training in Rome and Florence. His St. Lucy Altarpiece (Fig. 10.42) was painted for the high altar of the small church of Santa Lucia dei Magnoli to replace a painting of 1332 by Pietro Lorenzetti. The presence of Florence's two patron saints, John the Baptist and Zenobius, suggests that the patron of the altarpiece wished to be seen as a supporter of the city's traditions.

10.41 Coronation of the Virgin, 1447, commissioned by Francesco Maringhi from Filippo Lippi for the main altar of Sant'Ambrogio, Florence. Tempera on panel, 6' 7" \times 9' 5" (2 \times 2.87 m) (Galleria degli Uffizi, Florence)

The *St. Lucy Altarpiece* bears some similarities to the work of Filippo Lippi in the simplification of the physical features of the women, in the fascination with jeweled and embroidered detail in the cope and miter of St. Zenobius at the right, and in the general volumetric massing of drapery forms. Yet the whole mathematically-controlled environment of this picture seems suffused with a white light quite

10.42 *St. Lucy Altarpiece*, c. 1445–47, **Domenico Veneziano**, originally on the main altar of Santa Lucia dei Magnoli, Florence. Tempera on panel, 6' $6'' \times 6'$ 9%''' (1.98 \times 2.07 m) (Galleria degli Uffizi, Florence)

different from Filippo's darker interiors. Art historians have tended to see Domenico's coloration as a reflection of his Venetian background, yet there is little in Venice to which it can be compared. The loggia, despite its pointed arches, recalls Brunelleschi's new Hospital of the Innocents (see Fig. 10.23) in its clear articulation of architectural membering and referencing of the marble veneer of the exterior walls of the Baptistry and the Cathedral. Both allusions, along with the figures of John and Zenobius, argue for reading the painting as reflecting a new communal pride in the city. The saints, standing in a unified space and grouped by twos under the side arches, are usually said to be engaged in sacra conversazione (holy conversation), but they still read as individual figures much as the figures in the separate arches of Gentile's Quaratesi Altarpiece (see Fig. 10.31).

Civic Imagery

A series of history paintings containing clearly recognizable portraits of prominent citizens, the first extant example of which is the *Consecration of St. Egidio* (Fig. 10.43) by Bicci di Lorenzo (c. 1373 Florence–1452 Florence), provided another means for Florentine citizens to mark important events in their city and to fashion a visual record of civic leadership. The fresco derives from Masaccio's lost

monochrome (*terra verde*) fresco of the *Consecration of Santa Maria del Carmine* (c. 1424–27), then in the cloister of that church. From written accounts and drawings it appears that Masaccio, like Bicci, painted ranks of prominent citizens participating in what was both a religious and a civic event, where ritual demonstrated both the Florentines' religious devotion and their communal solidarity. The *Consecration* is in the same class of painting as Gerini's fresco for the Confraternity of the Misericordia (see Fig. 8.18), a straight-

10.43 *Consecration of St. Egidio*, 1430s, **Bicci di Lorenzo**, Ospedale di Santa Maria Nuova, Florence. Fresco

The small shed-like roof extending out from the façade of the church behind the pope may have been intended to protect the terracotta tympanum figures of the *Coronation of the Virgin* sometimes attributed to Dello

forward record of an historical event (regardless of how carefully composed it is), as opposed to a moral and civil allegory such as Lorenzetti's *Buon Comune* (see Fig. 5.28), in which citizens also appear. The particularized facial features and serried organization of the figures indicate that Bicci and his patrons intended to present a formal record of the participants as an *exemplum* of the harmony among different groups within the state. It thus served a purpose similar to Lorenzetti's allegory, but makes its point in the context of a specific time and place as a form of public document. The fresco also indicates that the event and its patrons were important enough to warrant Martin V's participation in the consecration.

Narrative Frescoes

Castagno at Sant'Apollonia

The conservative nature of narrative frescoes in midfifteenth-century Florence is shown by a cycle painted by Andrea del Castagno (c. 1419 Castagno–1457 Florence) for the cloistered Benedictine nuns of Sant'Apollonia (Fig. 10.44). Castagno first won attention for his evidently compelling portrayals of hanged men painted on the exterior walls of the Bargello which provoked his nickname, Andreino degli Impiccati, or Little Andrea of the Hanged Men. Despite this reputation for convincing representation,

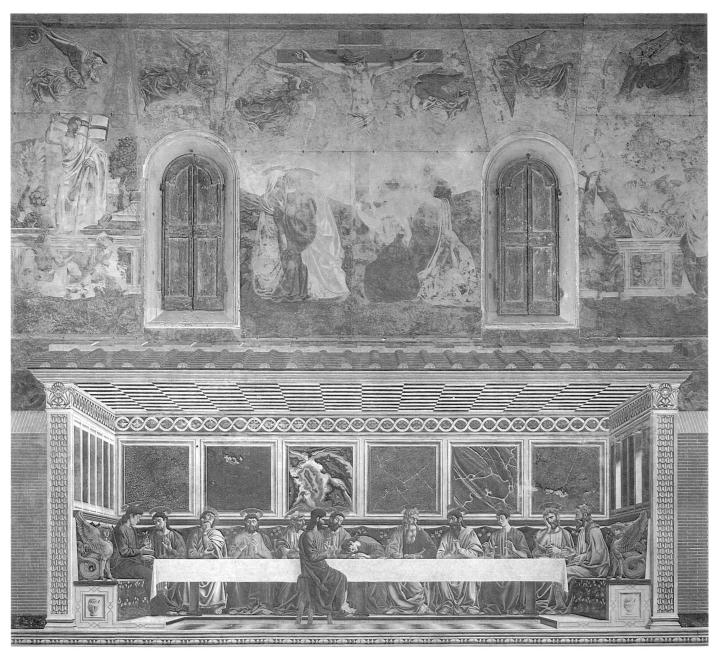

10.44 Last Supper, Crucifixion, Entombment, and Resurrection, 1447, **Andrea del Castagno**, former refectory of Sant'Apollonia (now Castagno Museum, Florence). Fresco, 30′ 2½″ × 31′ 6″ (9.2 × 9.6 m)

the idiosyncratic expressions and gestures of the individual figures in his Last Supper have a static quality reminiscent of the fresco of the same subject by Taddeo Gaddi (see Fig. 4.23) in the refectory of Santa Croce from a century earlier. Castagno's space is more deeply rendered and more insistent in its perspectival organization, but the scene, like Gaddi's, comes forward illusionistically from the wall, as if on a constructed stage. The drama played out on that stage has the character of a sequenced series of discrete individual responses to Christ's announcement of his coming betrayal. At the very center of the composition (Fig. 10.45), St John, the youngest and, according to some accounts, the favorite of the apostles, breaks the pattern of bolt upright figures that stretches across the fresco by falling forward and leaning toward Christ. Judas, the apostle about to betray Christ, is isolated on the opposite side of the table from Christ and the other apostles, his very placement identifying him as an outcast. Moreover, Judas's facial features are coarse, his ugliness being the conventional symbol for his sin of betrayal. Linked to Judas and Christ in the three heads framed by the elaborately patterned fictive marble square behind their heads is St. Peter, the apostle who was to become Christ's successor as the head of the new Church. Thus within this unusually dense figural area, founder, betrayer, and successor provide a continuous narrative of the history of the Church from its beginnings and presumably on to the present because the pope was Peter's successor. The frescoes of the Crucifixion, Entombment, and Resurrection above-culminating the event depicted in the Last Supper-are somewhat more dramatic in the agitated movements of the figures, the naturalism of the nude crucified Christ, and the sharp contrasts of light and shadow. Here too, however, the figures are pushed forward to the front of the composition, with the distant landscape either hidden by the figures or schematically rendered in order to concentrate the viewer's attention on the event. Although the nuns of this community came from some of the city's most prominent families and could thus commission (either themselves or through the generosity of their families) one of Florence's best-known painters, the commission is one that reinforces established traditions, the better to inspire piety and devotion.

It should not be surprising that Florentine art in this period is so varied in its forms. Artists such as Domenico Veneziano came to Florence from other cities while Florentine artists spent time abroad (Ghiberti in Venice, 1425; Uccello in Venice, 1425-c. 1430; Filippo Lippi in Padua, 1434; Castagno in Venice, 1442-43; Donatello in Rome, 1432-33, and in Padua, 1443-53). Patrons commissioned and collected paintings from the new generation of Flemish artists such as Jan van Eyck (c. 1389-1441) and Rogier van der Weyden (1400-64) thereby influencing the remarkably fluid styles of the mid-fifteenth-century. An extended period of peace and increased wealth gave patrons new opportunities for embellishing their environments and

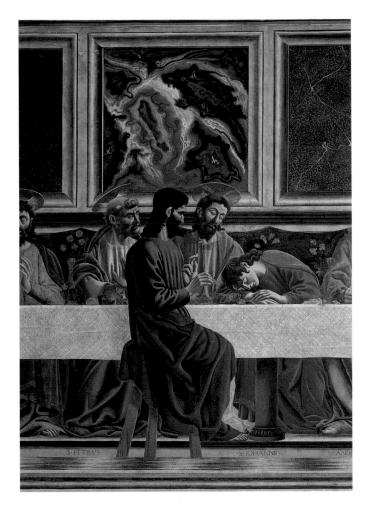

10.45 Christ, Judas, and John (detail of Last Supper), 1447, Andrea del Castagno. Fresco (Castagno Museum, Florence)

for asserting their presence in the social aristocracy of the city. It is no accident that while the artistic projects of the first part of the century included many corporate and civic commissions, those of the middle years of the century were predominantly private.

Piero della Francesca in Arezzo

As Florence extended its political control into the Tuscan countryside, the emerging styles of the city predictably followed into the areas beyond. Piero della Francesca (c. 1415 Borgo San Sepolcro–1492 Borgo San Sepolcro) had trained locally in his native town of San Sepolcro. He was in Florence in 1439 working on a fresco cycle (now virtually completely lost) overseen by Domenico Veneziano at Santa Maria Nuova, the largest hospital in the city. For reasons not known he returned to his home town where he remained for most of the rest of his life, with only brief stays in other cities where he took commissions. Sometime in the late 1440s he began the decoration of the main apse of the Franciscan church in Arezzo (Fig. 10.46). There he covered the walls with a cycle depicting the history of the True Cross, the same subject that the Franciscans had used for

the chapel surrounding the high altar in Santa Croce in Florence (see Fig. 8.16).

The frescoes bear Piero's distinctive style. In *The Discovery* of the *True Cross* (Fig. 10.47) Piero tells the story of St. Helena's discovery of two crosses and the identification of one of the two upon which Christ was crucified by its miraculous healing of the nude man at the far right. Piero seems to freeze the movement of figures along the frontal plane of the composition to a glacial pace. The simplified geometry of the bodily forms and unfocused staring of the figures run counter to the particularities of description seen

in the works of other painters and lends the participants a mannequin-like but noble appearance. Piero treats the narrative as if it is a liturgical drama played out in front of a stylized stage set, albeit in this instance one that recalls the architecture of Arezzo. Such simplified forms may be useful for identifying the site of the story or for distinguishing the unfolding sequential episodes of the narrative, but they set the story at a remove from reality, giving it the feeling of a "once-upon-a-time" tale like so many of the lives of the saints recounted in the *Golden Legend* from which its subject in fact derives.

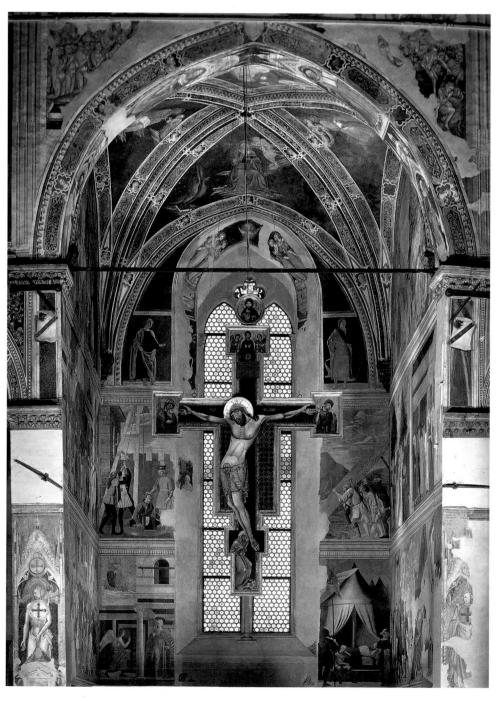

10.46 Legend of the True Cross, c. 1450s, commissioned by the Franciscans from **Piero della Francesca** for the apse of San Francesco, Arezzo. Fresco

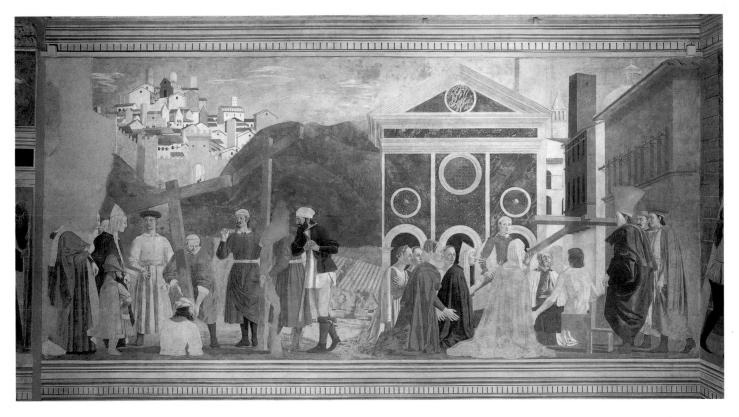

10.47 Discovery of the True Cross, c. 1450s, commissioned by the Franciscans from Piero della Francesca for the apse of San Francesco, Arezzo. Fresco

Sculptural Commissions Outside Florence

Discussions of paths of influence and of the mutual exchanges between center and periphery have recently significantly changed our notions of the cultural predominance of Florence during the fifteenth century. Certainly Brunelleschi used a number of formal elements in his architecture that he had seen in his travels and that he could not have seen in Florence. Non-Florentine artists as well as Florentine ones were often called to other urban centers because of the quality of their work, sometimes that quality being measured as much for its technical accomplishments as for its stylistic innovations. While artists like Piero took versions of what they had learned in Florence back to their home environments, Florentine artists not only traveled to other cities to work (as noted above), but even set up workshops there that trained local artists.

Siena: The Baptismal Font

The Baptismal Font in Siena is a telling case of the complexities of artistic exchange between urban centers and the jockeying between artistic workshops for a competitive edge in the marketplace. In 1414 the Opera del Duomo of Siena decided to construct a new baptismal font (Fig. 10.48) for the city's Baptistry. The project was not implemented until

1416, when the Sienese invited Lorenzo Ghiberti to visit the city as an advisor to the project and ultimately as its designer. Given the Sienese predilection for a conservative style in their religious painting, the choice of Ghiberti, then still working in a style deeply indebted to the International Gothic, makes complete sense. Not only would the Sienese be placing themselves on an equal with their arch-enemy, Florence, by hiring its most skillful goldsmith, but they could be certain that Ghiberti would provide them with a style that coincided with their own deeply-held artistic traditions. Early in 1417 Ghiberti sent a trial relief to Siena, indicating that a full-scale sculptural model of the font already existed. The Opera had clearly been impressed with Ghiberti's project for the doors of the Florentine Baptistry, and, not to be outdone by Florence, they hired the same sculptor to decorate the interior of their own baptistry. The commission is a measure of the competition between the two cities, here being played out in artistic terms with art functioning as politics.

In 1417—as if to maintain their pride in local artists—the Opera commissioned four bronze reliefs for the hexagonal font: two from Jacopo della Quercia (1371/75? Siena-1438 Siena) and two from the workshop of a local Sienese goldsmith, Giovanni di Turino (1384 Siena-c. 1455 Siena). Only then did they award Ghiberti his commission for the last two reliefs of the font. The Opera's motive, like that of the Florentine Opera in the commissions for the Evangelists for the façade of the Duomo (see pages 198-199), was to

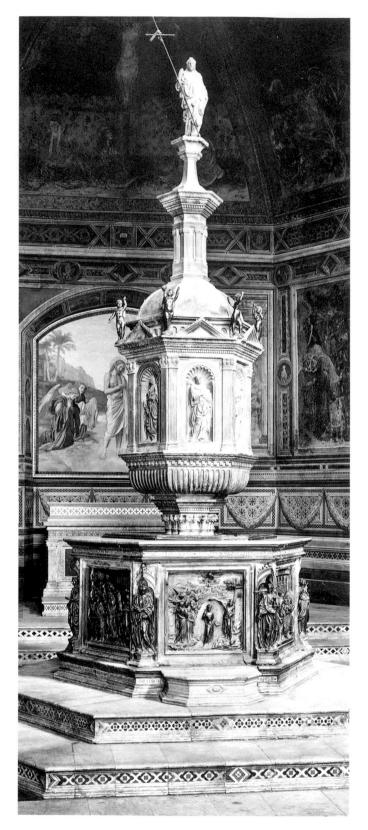

10.48 Baptismal font, basin 1416-27, commissioned by the Opera del Duomo and designed by Lorenzo Ghiberti, with reliefs by Ghiberti, Jacopo della Quercia, Donatello, and Giovanni di Turino, for the Baptistry, San Giovanni, Siena. Gilt bronze reliefs in a marble frame

The tabernacle, added to the font, was designed by Quercia and begun in 1427; work was complete by 1434. Donatello was also responsible for two of the Virtues at the corners of the font and for three of the musical angels at the cornice of the tabernacle.

add a competitive charge between artists in the hope that the work would be completed promptly. Donatello also entered the project in 1423, when he was awarded a commission for a relief assigned to Quercia. His presence in the project must have been intended as a provocation to Ghiberti who, like Quercia, had done virtually nothing on his reliefs for the font. By 1427 all six reliefs were in place, thanks to pressure and threats from the Opera and legal proceedings against Quercia for violating the terms of his contract, which had stipulated delivery of his reliefs within two years.

Ghiberti's Baptism of Christ (Fig. 10.49) for the font was the pivotal work between his quatrefoil reliefs for the Baptistry's north doors in Florence (see Fig. 10.5) and his later square reliefs for its east doors, the Gates of Paradise (see Figs. 10.59, 10.60, 10.61, 10.62). By the time that he had been awarded the commission for the second pair of doors, his reliefs for the Siena font had already provided him with a new compositional format for his pictorial relief sculpture. Ghiberti completely gilded his Siena reliefs, as he was later to do with those for the Gates of Paradise, making the Siena Baptism of Christ more opulent than any relief on his first set of doors for the Florentine Baptistry. His Baptism suggests that Ghiberti had also looked carefully at the relief sculpture of Donatello, particularly the schiacciato carving exemplified by the latter's St. George relief (see Fig. 10.17) at Or San Michele. Although Ghiberti's Christ figure is in high relief, the angels floating above his head disappear into the background as if into space. Clearly the competition that the Sienese had provoked between the Ghiberti

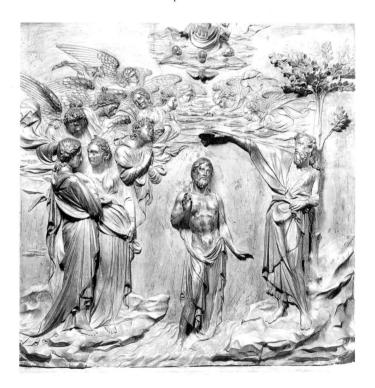

10.49 *Baptism of Christ*, detail of the baptismal font, c. 1423–27, **Lorenzo Ghiberti**, San Giovanni, Siena. Gilt bronze, $31 \times 31''$ (79×79 cm)

10.50 *The Head of the Baptist Brought Before Herod*, detail of the baptismal font, with perspective measures superimposed, 1423–27, **Donatello**, San Giovanni, Siena. Gilt bronze, $23\% \times 23\%$ " (60 \times 60 cm)

and Donatello bore fruit. Ghiberti, while late in providing the Sienese with their relief because of his work on the Florentine doors, nonetheless extended the stylistic possibilities of his earlier work, giving the Sienese a pictorial relief that the Florentines were not to see for some time. Ghiberti also provided drawings to Giovanni di Turino, assuring that his figural style would have a presence at the font beyond his own reliefs.

Donatello's Head of the Baptist Brought Before Herod (Fig. 10.50) for the Siena font was one of his first bronze sculptures (roughly contemporaneous with his St. Louis of Toulouse; see p. 204). His relief is an investigation of the single-point perspective system recently invented by his friend Brunelleschi, although the orthogonals cluster toward the empty center of the relief rather than meeting at a single focal point, as if to split the composition apart, leaving Herod and the severed head of the Baptist at the left and Salome at the right. In fact, the man at the right with his hand on his hip illustrates the system of perspective that Alberti was to write about in his Della Pittura of 1435, one that, because of its simplicity, supplanted the empirical mathematical system used by Brunelleschi. According to Alberti, an artist should use a figure standing on the ground line of a pictorial composition as the numerical module for the composition. Using the principle that the human figure is six heads tall, Alberti divided the standing figure into six equal vertical units, each measuring a head in length (marked in Fig. 10.50 at right). This measure derives

from submitting observed human proportions to an average and thus creating an ideal form. Two of these head units—a third the height of the body—then provide the measure of the divisions of the ground line of the composition (marked on Fig. 10.50) from which the artist can then extend orthogonals to a central vanishing point, thus, importantly, using human measure to structure the world being constructed in the painting or relief. Thus, it appears that Alberti's treatise, written nearly a decade after Donatello designed his Siena relief, recorded well-established studio practice.

In the highly emotional scene a severed head is brought on a platter to the birthday feast of Herod. Food is shown on plates flanked by knives, and each figure in the foreground reacts intensely to the horrific sight. Contrary to the focus that single-point perspective normally brings to a composition, Donatello has used it here to create a wedge separating the two figural groups in the foreground-the dance at the right and the result at the left-and to direct the viewer to a second perspective grid formed by the two left arches that frame, in flashback fashion, earlier moments of the narrative with the musician of the dance in the mid-ground and the head of the Baptist being carried to the feast in the background. Donatello both knew the conventional rules of the newly formulated single-point perspective and manipulated and inverted them to enhance the expressionistic aspects of the story. For the first time Donatello integrated a single-point perspective into relief sculpture, again giving Siena precedence over Florence in the stylistic novelty of the work—a competitive victory that would have trumped Siena's deliberate pursuit of a conservative style in their religious art.

Quercia in Bologna

Quercia's delay in delivering his relief for the font was due to the fact that he was away from the city, working first in Lucca and then in Bologna. In 1425, before he had even finished the model for his relief for the font, he accepted a commission for a colossal project of decorating the main door of the church of San Petronio in Bologna (Fig. 10.51), a project that continued well into the sixteenth century (see also Fig. 45). The Expulsion (Fig. 10.52) derives from Quercia's own relief on the Fonte Gaia (see Fig. 5.35), but the figures have become more muscular and tense, as if to compensate for the greater distance between this work and an hypothetical viewer looking at the whole door. Here, as in other reliefs for the portal, the lingering lyricism of the Sienese style is transformed by the expressive animation and the heroically proportioned bodies of the figures, a formal language that he had learned at least in part from Florentine stylistic innovations at the beginning of the century in a monumental program of sculptural decoration that would have been the envy of any workshop in Italy at the time. Quercia had breathed new life into the Sienese

10.51 Main portal, 1425–39, commissioned by Louis Aleman, papal legate in Bologna and archbishop of Arles, from Jacopo della Quercia for San Petronio, Bologna. Marble

style, but he had done so outside the city of Siena. In his native city sculptural commissions—public by nature—were limited and embedded in the Sienese competition with Florence. This competition was to surface again in midcentury when the Opera of the cathedral tried to hire Donatello to make a set of bronze doors for the building, once more pitting Donatello against Ghiberti, and Siena against Florence.

Donatello and Michelozzo in Naples

The Brancacci Tomb Donatello's work had also come to the attention of the Neapolitan Cardinal Rainaldo Brancacci during the latter's stay in Florence with the papal court during 1419–20. Most likely related to Felice Brancacci, the commissioner of Masaccio's and Masolino's frescoes (see Fig. 10.33), and resident in Felice's house during his Florentine visit, Rainaldo would have been keenly aware of the new art in Florence. Thus, when it came time to plan his own tomb monument, it is not surprising that he chose the sculptural team that Donatello had formed with Michelozzo (Michelozzo di Bartolommeo; 1396 Florence–1472 Florence), a marble carver and master bronze caster who had worked at the Florentine mint (Fig. 10.53).

10.52 Expulsion of Adam and Eve from Paradise, detail of the main portal, mid-1430s, **Jacopo della Quercia**, San Petronio, Bologna. Marble, height $39 \times 36\%''$ (99×92 cm)

The practical matter of there being no sculptural workshop in the Naples of that period able to handle such a project undoubtedly played a decisive role in his decision. Brancacci placed his tomb in a frescoed chapel, Sant'Angelo a Nilo, at his newly endowed hospital near the Brancacci family home in the center of Naples. The tomb, carved largely in a workshop that Donatello set up in Pisa and then assembled in Naples, is a mix of Florentine and Neapolitan elements, an exported style conforming to local traditions. The classical, fluted columns, paired pilasters, classicizing caryatid figures carrying the tomb chest, and the schiacciato relief decorating the chest are characteristic of Florentine art, but the shape of the tomb with its baldachin-like architectural frame and the angels standing behind the figure of the dead cardinal and pulling apart the draperies as if to reveal it are typical of Neapolitan tombs (see Fig. 9.37) Although the poses of the winged putti blowing trumpets at its sides may be classically inspired, they serve the same kind of decorative function as the pinnacle figures on the tomb of King Ladislas and the cathedral portal. This is definitely not a work intended for the sculptors' native Florence, where surviving tombs are not usually supported by caryatids nor crowned by such an elaborate canopy. Its eclectic fusion of classical and Gothic elements perfectly suited to the

10.53 Tomb of Cardinal Rainaldo Brancacci, c. 1425, commissioned by Rainaldo Brancacci from **Donatello** and **Michelozzo** for Sant'Angelo a Nilo, Naples. Marble, height of each caryatid c. 5' 5'' (1.65 m)

sophisticated Neapolitan court. Whatever Donatello's reputation, he clearly had to conform to local traditions.

In all of these cases, the transfer of style from one urban center to another provided opportunities for change and cross-fertilization, suggesting that the center did not always hold as a dominating force when confronted by the periphery, if for no other reason than that one person's periphery was another's center.

The Florence Cathedral Interior

In Florence, commissions for monumental public statues were in noticeable decline. Military expenditures in Florence's efforts to stave off the threatening advances of Filippo Maria Visconti after 1420 eventually led to a shortage of funds for large public projects and, in 1427, to a moratorium on new sculptural programs for the Duomo. However, the prospect of completing the building's dome—itself an enormously costly and competitive drain on funding—and the end of a protracted war with the neighboring state of Lucca, which lasted from 1429 to 1433, encouraged the Opera to initiate new decorative projects for its interior in the 1430s.

Sir John Hawkwood (Fig. 10.54), a huge fresco on the cathedral's left wall, was such a project. It was commissioned

10.54 *Sir John Hawkwood*, 1436, commissioned by the Opera del Duomo from **Paolo Uccello** for Florence Cathedral. Fresco, without frame $24'\times13'$ 3" $(7.32\times4.04~\text{m})$

The frame was added in the sixteenth century, most likely in 1524 by Lorenzo di Credi; the fresco was detached from the wall in 1842 and transferred to canvas. See Figs. 4.25 and 4.26 for location in the Duomo—originally slightly higher than the current placement.

10.55 *Cantoria*, 1430–38, commissioned by the Opera del Duomo from **Luca della Robbia** to go above the south sacristy door of Florence Cathedral. Marble, overall 10′ 9″ × 18′ 4″ (3.28 × 5.6 m), upper reliefs 44½ × 36¾" (103 × 93.5 cm), lower reliefs 38¾ × 37″ (98.5 × 94 cm) (Museo dell'Opera del Duomo, Florence)

from Paolo Uccello (Paolo di Dono; 1387 Florence-1475 Florence), yet another artist to have emerged from Ghiberti's workshop. He was a master of painting and mosaic, and was renowned for his obsessive study of perspective. His fresco commemorates an event relating to the security of the state. John Hawkwood (known in Italian as Giovanni Acuto, d. 1394) was an English mercenary soldier (condottiere) employed by Florence, and responsible for staving off early threats to Florentine independence by Giangaleazzo Visconti. In gratitude, the Opera del Duomo agreed in 1393 to construct a marble tomb for Hawkwood after his death-one of a series of eight monuments of famous men projected for the cathedral. This plan was simplified and reduced in cost in 1395 when the Opera instead commissioned Agnolo Gaddi and Giuliano d'Arrigo (Pesello; 1367-1446) to paint a fresco depicting Hawkwood on horseback, a commission that mirrors a painted series of uomini famosi ("famous men") in the Palazzo della Signoria.

In March 1433, as the dome of the cathedral was nearing completion, the Opera announced a competition to replace the existing Hawkwood fresco, and in May 1436 Uccello was told to begin work on the project. A drawing squared for transfer (see Fig. 13) that Uccello prepared for the fresco suggests that he had learned this technique from Brunelleschi, whose biographer notes the architect's use of squared paper to record ancient Roman buildings. This is the earliest extant squared drawing, although Masaccio must also have used the technique since there are remains of incised grid lines on the Trinity fresco (see Fig. 10.38), just as there are on the Hawkwood monument. Uccello's fresco was complete in 1436, at the time of the cathedral's consecration. Like Masaccio's trompe l'oeil chapel of the Trinity, Uccello's fresco of Hawkwood, although painted in monochrome, is a convincing replication of three-dimensional

shapes-in this case a bronze equestrian monument. Although Uccello depicted the base of the illusionistic monument from below, he portrayed the horse and rider in profile, adding an iconic power to the figure. As part of a tradition of equestrian portraits of condottieri and despotic rulers (see Fig. 9.8), the fresco flirted with a type of image that could easily have been misinterpreted in the republic, with its distrust of tyrants; thus the Opera stipulated that the inscription state that Hawkwood was English, and thus that he was a hireling, rather than someone who had risen to power from within the state. The inscription uses words from Plutarch which describe the Roman Republican hero of the Second Punic War, Fabius Maximus Cunctator, who had had a bronze statue raised in his honor in Rome by the state and thus implicitly identifies Florence as a new Rome, as well as honoring Hawkwood. The Opera ensured that the successes of the state would form part of the decoration of the new cathedral and that the ecclesiastical space would also be perceived as a civic space, as indeed it was, funding for its building and decoration coming from the Signoria.

The Opera also ordered two shallow marble *cantorie*, or singing galleries, from Luca della Robbia (Luca di Simone di Marco; 1399/1400 Florence-1482 Florence) and Donatello (Figs. 10.55 and 10.56) to be placed over the north and south sacristry doors. Both *cantorie* are richly carved with relief sculpture, but they are strikingly different in style. Luca received the contract for his *cantoria* in 1430. Although Luca's career before the commission for the *cantoria* is unknown, he may have trained in the cathedral workshops under Nanni di Banco. His invention of polychromed glazed terracotta as a medium for sculpture was certainly indebted to Donatello's experimental *Joshua* for the north tribune of the cathedral (see Fig. 10.1). His *cantoria* illustrates Psalm 150, "Praise ye the Lord," each figured

10.56 *Cantoria*, 1433–c. 1440, commissioned by the Opera del Duomo from **Donatello** to go above the north sacristy door of Florence Cathedral. Marble and mosaic with bronze heads, overall 11′ 5″ × 18′ 8½″ (3.48 × 5.70 m); frieze of putti, front 38½ × 205½″ (98 × 522 cm), sides 38½ × 52″ (98 × 132 cm) (Museo dell'Opera del Duomo, Florence)

The two *cantorie* were removed from the cathedral in 1688 on the occasion of the wedding of Ferdinando de' Medici with Violante Beatrice of Bavaria. Parts of the marble architectural framing of Luca's pulpit were used for repair work at the cathedral; one piece was found in the lantern of the Baptistry. The upper cornice of Donatello's *cantoria* is modern, and diverges from his original design, which consisted of repeated paired dolphins and a stylized leaf pattern.

panel depicting one verse of the psalm. The formal classicism of the architecture framing the panels, the Roman lettering of the inscriptions, and the toga-like clothing of the musicians counter the lively anecdotalism of some of the panels. In one, adolescent boys cluster around a single hymn book (Fig. 10.57)—a reminder that a confraternity of young boys associated with the Duomo had responsibility for singing the canonical hours there. In place of the rather generic adolescent putti that decorate the lower reliefs of the cantoria, the upper reliefs include startling incidents of observed reality, with a trumpeter blowing out his cheeks in order to sound his instrument and a young singer looking with furrowed brow at his choral book, either trying to find his place or attempting to hit the right note. Although such images are anomalous in Luca's sculpture, they do indicate-especially here in the repetitive narratives of the psalm—the importance of familiar physical actions as a way to engage a viewer in the action, not unlike Masaccio's Christ Child absent-mindedly stuffing himself with grapes (see Fig. 10.32).

Donatello was not awarded the commission for his *cantoria* until July 1433, partly because he had been in Rome for over a year. His contract stipulated that his *cantoria* should follow Luca's in its design of multiple panels. But by 1435 Donatello seems to have decided to substitute a continuous relief of dancing putti (actually carved from four stones, two across the front and one at each side) screened by paired columns. The figures evoke Roman antiquity, but the architectural frame contrasts strikingly with the classicizing pilasters of Luca's *cantoria*. Stylized and compressed leaf patterns, repetitive and flattened decorative motifs, and a surface covered with colored mosaic suggest, rather, Early Christian and medieval art. Fresh from his experiences in Rome, Donatello may have used the context of his *cantoria*

10.57 Boys Singing (detail of Cantoria), 1430–38, commissioned by the Opera del Duomo from **Luca della Robbia** to go above the south sacristy door of Florence Cathedral. Marble, $38\% \times 37''$ (98.5 \times 94 cm) (Museo dell'Opera del Duomo, Florence)

to re-create some of the forms and images he had seen there, especially in the cloisters of the papal basilicas of St. John Lateran and St. Paul's Outside the Walls. The putti (Fig. 10.58) are fascinating in the way that they combine a relieflike flatness with nearly complete three-dimensional form. In retaining the sense of a plane similar to Roman sarcophagi (which the main container of the cantoria so clearly imitates), Donatello has animated his figures in such active running or gesturing movements that he is able to disguise how impossible some of the bodily positions actually are. Having proved his ability to carve naturalistically convincing human figures with his sculptures for the cathedral façade and for the bell tower, he once again seems willfully to be breaking the rules and asserting his distinctive creativity as he provides a cantoria diametrically opposed in style to Luca's.

The Gates of Paradise

In 1425, shortly after completing the second set of bronze doors for Florence's Baptistry (see Fig. 10.5), Ghiberti received a commission from the Arte del Calimala for the third and final set (Fig. 10.59). At the time of the commission, Leonardo Bruni, the chancellor of the city of Florence (see Fig. 10.65), wrote to the Board of the Calimala: "It is my opinion that the twenty stories of the new doors . . . should mainly have two qualities: one, that they should show splendor, the other that they should have significance. By splendor I mean that they offer a feast to the eye through variety of design: significant I call those which are

sufficiently important to be worthy of memory." Ghiberti certainly satisfied Bruni's demands.

Originally, these doors, like the two earlier sets, were intended to include twenty-eight panels; however, in the early stages of the commission the number was reduced to ten. They depict Old Testament stories, with statuettes of individual prophets and sibyls placed in the frames of each door. Instead of the quatrefoil frames used for his first doors, Ghiberti used a new square format for these reliefs, based on the ones he was then producing for the baptismal font in Siena (see Fig. 10.49). Ghiberti's second set of doors was completely gilded—like the Siena reliefs, but unlike the reliefs for his first doors in which only the raised surfaces were gilded.

It took Ghiberti twenty-seven years (1425–1452) to complete these doors. When they were finished, their extraordinary splendor won them pride of place on the east side of the Baptistry, facing the cathedral; his original doors for that site were moved to the north side of the building. The space between the Florentine Baptistry and the cathedral was known in Italian as the *paradiso* because of its use as a cemetery during the late Middle Ages, giving Ghiberti's doors the name by which they are usually known, the *Gates of Paradise*.

Each panel of the *Gates of Paradise* depicts several episodes of a biblical narrative. In the *Creation of Adam and Eve* (Fig. 10.60), God brings Adam to life at the lower left. Adam, whose Hebrew name means earth, lies on the ground, the material from which he was created. Paired at the right of the panel is the expulsion from Paradise. Here, Adam and

10.58 *Running Putti* (detail of *Cantoria*), 1433–c. 1440, commissioned by the Opera del Duomo from **Donatello** to go above the north sacristy door of Florence Cathedral. Marble and mosaic (Museo dell'Opera del Duomo, Florence)

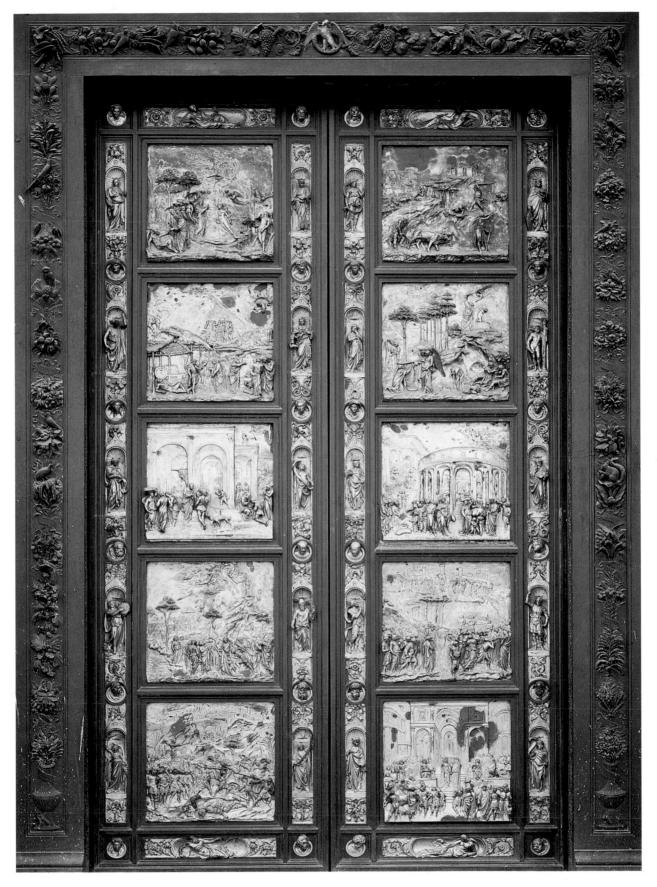

10.59 East doors, 1425–52, reliefs and some framing elements cast by 1436, followed by finishing and gilding, commissioned by the Arte del Calimala from **Lorenzo Ghiberti** for the Baptistry, Florence. Gilt bronze (Soprintendenza and Museo dell'Opera del Duomo, Florence)

A replica has now replaced the original doors on the Baptistry. This photograph was taken before the originals were removed for restoration.

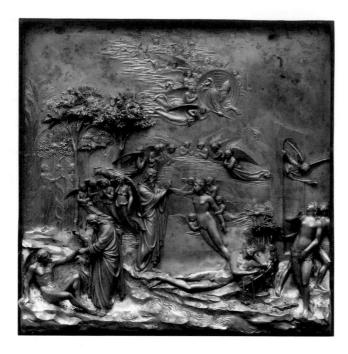

10.60 *Creation of Adam and Eve* (detail from the east doors of the Baptistry, Florence), 1425-52, commissioned by the Arte del Calimala from **Lorenzo Ghiberti**. Bronze, $31\% \times 31\%''$ (80×80 cm). (Museo dell'Opera del Duomo, Florence)

Eve are not as expressionistically treated as Masaccio's figures for the Brancacci Chapel (see Fig. 10.37) but retain the lyrical fluidity of Ghiberti's own distinctive style. At the center of the panel is the Creation of Eve, her body emerging from one of Adam's ribs. In this episode Ghiberti proves that he also could use compositional structure as a means of conveying narrative, as he places a wide gulf of space between God and Eve at the very center of the panel, as if to illustrate her future fall from grace. The centrality of this image may also be due to Eve's function as an antetype to Mary, to whom the cathedral was re-dedicated in 1436. Just beneath the Creation of Adam and Eve on the doors is the panel depicting Noah and the Flood (Fig. 10.61). The figure of the reclining Noah at the lower left echoes the figure of Adam on the panel above, and the center line of the composition through the figure of one of Noah's son's connects visually with the open space between God and Eve above. Although Ghiberti did not, apparently, model the panels for the door in any consecutive narrative order, he nonetheless thought carefully about the overall composition of the reliefs and our reading from one to another. The Noah panel, after all, represents another kind of fall of mankind, with Noah being the new Adam from whom humankind will again populate the earth. The ark in the distance, in the shape of a pyramid, seems to extend the entire width of the panel, again suggesting that its contents would repopulate the entire earth. The Greek theologian, Origen, many of whose works were recently rediscovered in Rome, reconstructed the ark in this most peculiar and mistaken form.

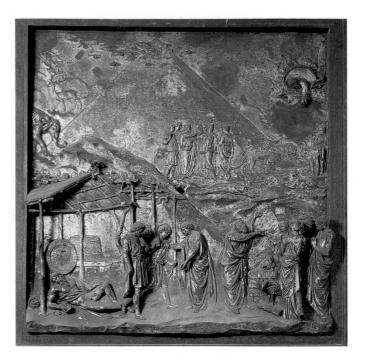

10.61 *Noah and the Flood* (detail from the east doors of the Baptistry, Florence), 1425–52, commissioned by the Arte del Calimala from **Lorenzo Ghiberti**. Bronze, $31\% \times 31\%''$ (80×80 cm). (Museo dell'Opera del Duomo, Florence)

In the panel depicting the story of the rival brothers Jacob and Esau (Fig. 10.62), the latter's exchanging of his birthright as the eldest son for some food from his younger brother Jacob is depicted in the center background. In front of this scene in the center foreground is Esau and

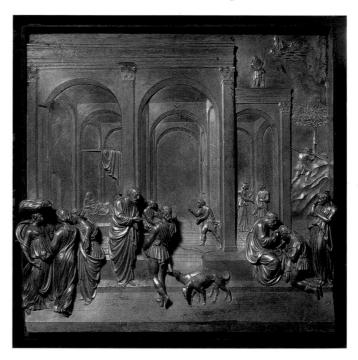

10.62 *Jacob and Esau* (detail from the east doors of the Baptistry, Florence), 1425–52, commissioned by the Arte del Calimala from **Lorenzo Ghiberti**. Bronze, $31\% \times 31\%''$ (80×80 cm). (Museo dell'Opera del Duomo, Florence)

his hunting dogs being sent by his old and blind father Isaac to hunt for deer, while Esau's departure on this quest is represented in the background at the far right. During Esau's absence, Jacob and their mother, Rebecca, execute a plan whereby Jacob, dressed in the animal skins typical of Esau, approaches Isaac, and thereby deceives him into recognizing the disguised Jacob as his heir. These scenes are illustrated under and in front of the arch on the right. In the foreground the seated Isaac blesses a kneeling Jacob, who has an animal skin slung over his shoulder, while his elderly mother looks on.

The *schiacciato* relief deriving from Donatello's sculpture and the single-point perspective system allow the space in this panel to recede illusionistically, the figures becoming flatter as well as smaller as they move into the distance. The grouping of figures also helps to create a sense of space as the four women at the left pose dance-like in a circle and as Esau moves diagonally toward his father and into the space of the relief at the center foreground. At the same time the figures of the woman at the left and of Rebecca at the right spill out over the frame, suggesting continuity between the space outside the frame and the space inside it.

In both the *Jacob and Esau* and the *Joseph* panels, located left and right at the mid-point of the doors, the architecture is structured on a single-point perspective scheme. The perspectival plans of the two panels work together (Fig. 10.63) to unite both valves of the doors. Such a scheme places the

10.63 East doors, Baptistry, Florence, reconstruction of the perspective system, with a figure standing before them (after **Alessandro Parronchi**)

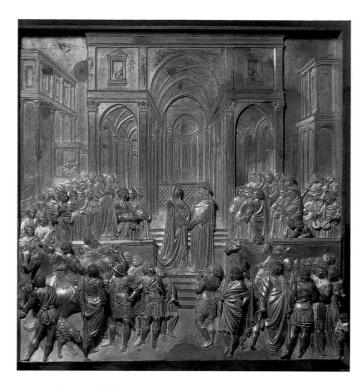

10.64 *Solomon and Sheba* (detail from the east doors of the Baptistry, Florence), 1425–52, commissioned by the Arte del Calimala from **Lorenzo Ghiberti**. Bronze, $31\% \times 31\%''$ (80×80 cm). (Museo dell'Opera del Duomo, Florence)

viewer at a particular position in space toward which the faces of Ghiberti and his son, Vittorio, gaze from small roundels in the frame of the door between the two panels.

The subject matter of the Meeting of Solomon and Sheba at the bottom right of the doors (Fig. 10.64) is rarely depicted in this period, leading to speculation that it was included deliberately to represent the union of the Eastern and Western churches, which was announced on the steps of Florence's Duomo on July 9, 1439, as the fruition of a Church council which had met there. Virtually the entire Byzantine court, including the Emperor of Byzantium, John VIII Paleologus (see Fig. 14.1), had traveled from Constantinople to participate in this council. The Eastern Church is metaphorically represented by Sheba, the queen who came to Solomon "from the East," while the Western Church is represented by Solomon. The figures in the midground, separated by parapets, align in formal, diagonal rows at either side of Solomon and Sheba, enhancing the sense of spatial recession. The figures in the foregroundperhaps representing those come to hear the reading of the decree of union-jostle for glimpses of the meeting. The doors ultimately were placed to face the steps of the Duomo where the decree of union had been read, a triumphal moment in the history of the city that saw the court of the successor to the Roman emperors of the east and the papal court within its walls at the same time.

Although there are certain classicizing stylistic details evident in the east doors—some of the heads in the roundels

of the frame, the nude figure of Samson in the niche in the right frame, the architecture in the central two panels—they are overshadowed by Ghiberti's continued fascination with elegant sweeps of drapery, repeating cascades of decorative

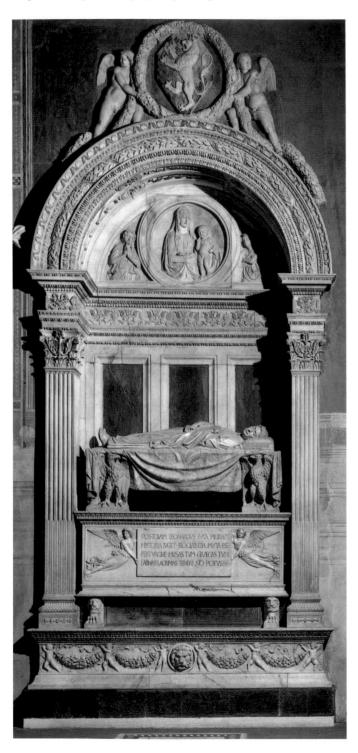

10.65 Tomb of Leonardo Bruni, late 1440s, commissioned by the Signoria (?), most likely with the assistance of Bruni's native city, Arezzo, and his family, from **Bernardo Rossellino** for Santa Croce, Florence. Marble, height 23′ 3½″ (7.15 m)

Bruni's epitaph, inscribed on the sarcophagus, reads: "After Leonardo departed from life, history is in mourning and eloquence is dumb, and it is said that the Muses, Greek and Latin alike, cannot restrain their tears."

folds, and gently swaying figures that stem from the late International Gothic Style in which he had been trained. Thus the immediate favorable response to the doors when they were installed in 1452 suggests the continued viability of the late Gothic style over time.

The Tomb of Leonardo Bruni

The new classicizing style was more wholeheartedly embraced in the Tomb of Leonardo Bruni (Fig. 10.65). Unlike earlier monuments to civic figures intended for, or built in, the Duomo, this tomb was placed in Santa Croce (see Fig. 4.8). This humanist scholar (1370-1444) had been chancellor of Florence from 1427 until his death. His tomb was presumably commissioned by the Signoria and is traditionally ascribed to Bernardo Rossellino (1407/10 Settignano-1464 Florence), the head of a family of stone carvers from one of the quarry towns in the hills outside Florence. The figure of the dead Bruni appears on his funerary bier, clutching to his chest his history of Florence, written as part of his duties as chancellor. He is crowned with a laurel wreath, a symbol of undying fame because the laurel leaf was reputed never to wither. During Bruni's funeral, in imitation of ancient Roman ceremonies, Gianozzo Manetti (1396-1459), one of Florence's leading humanists and political figures, had actually closed his oration by placing a crown of laurel on the head of the dead Bruni.

The carved effigy is a remarkable work of portraiture. Bruni's face, turned to catch the light coming from the nave of the church, is uncannily lifelike, with its bulbous nose and slightly crooked mouth, most likely the result of a contracted muscle caused by death and rigor mortis, caught on a death mask from which the image was made. The decorative elements of the tomb, however, are carefully chosen to eulogize Bruni, and by extension the state. The arch that frames the tomb evokes, in its profusion of rich classicizing detail, the splendor of ancient Rome. Two robust putti support a wreath enclosing a lion, the Florentine civic symbol of the marzocco (a heraldic lion whose name is believed to be a corruption of Martocus, "little Mars"-the Roman god of war). Other lions appear in the roundel below the sarcophagus and in its supports. The eagles supporting the bier recall the Roman symbol of a soul carried to the afterlife by an eagle. The only specifically Christian reference in the decorative program for the tomb is the roundel of the Virgin and Child under the arch. Nowhere on the tomb is Bruni's family name given; he is simply "Leonardus," deracinated as a symbol for the state whose history he holds in his hands.

In this case the overt classicism of the iconography and of the decorative forms must have been considered appropriate for the classical scholar and for the chancellor of a republic whose history extended back to ancient republican Rome. Like Uccello's *Hawkwood Monument* (see Fig. 10.54) of the previous decade, the classical vocabulary of Bruni's tomb called up important myths of the state.

1 1 Florence: The Medici and Political Propaganda

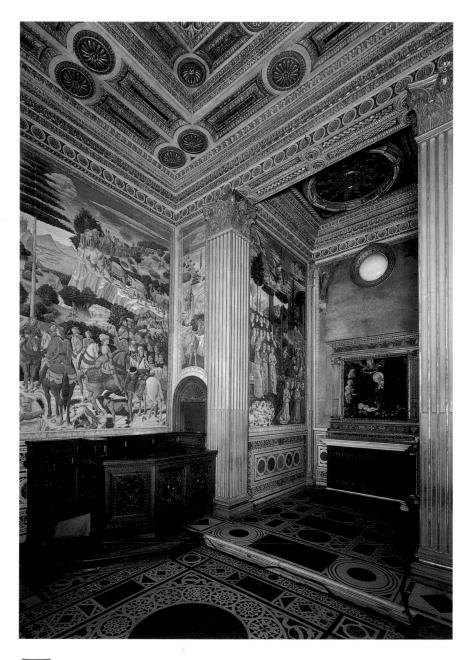

that were to affect its remaining history. In that year the leaders of the oligarchy managed to win enough power in the government to exile the leading male members of the Medici family who were the apparent leaders of the popolano ("populist") faction. The acknowledged head of the Medici, Cosimo di Giovanni (see genealogical chart in the backmatter), left Florence for Venice in October. The Medici were strong enough politically, however, to reverse the tables despite their absence from the city. In 1434 Cosimo re-entered Florence in triumph and exiled his opponents as a first step to his eventual control of the political life of his city, control which was passed on to his son Piero and grandson Lorenzo. Among those banished from Florence were Palla Strozzi and Felice Brancacci, who had been the patrons of some of the more audacious artistic projects in the city just a few years before their exile (see Figs. 10.29 and 10.33). A question naturally arises about whether the styles of art patronized by these men would also be excised from the culture so that a new language for new leaders could supplant it. In other words, this decisive socio-political change offers an opportunity to test how style was used to identify individual political factions much as it was used to identify city states. The decades after 1434 were a critical period in the history of Florentine art which helped to establish imagery—and new styles for the changing power structures in the city, simultaneously maintaining the traditional images of Church and state to suggest continuity and stability, as if the republic remained essentially unchanged.

The Florentine republic and its civic and guild structures had undertaken an extraordinary series of commissions during the early years of the fifteenth century, culminating in the completion of the dome of the cathedral in 1436. Factionalism, exacerbated by the dispute over the institution of the *catasto* in 1427, eventually erupted in 1433 and changed the structures of power within the city in ways

(above) Medici Chapel, Medici Palace, Florence, c. 1459, frescoes commissioned by Piero de' Medici from **Benozzo Gozzoli**

The original altarpiece for the chapel was an *Adoration of the Christ Child* by Filippo Lippi (now at the Staatliche Museen Preussischer Kulturbesitz, Berlin); a copy by the Pseudo Pier Francesco Fiorentino replaces the original.

The Medici's Civic and Domestic Commissions

The rise to power of the Medici in Florence began in 1418 when Giovanni di Bicci de' Medici (c. 1360–1429) became the banker to the papacy and established the family's wealth on a solid footing. Giovanni's son, Cosimo (1389–1464), steadily increased the control of his family over the political fortunes of Florence after his return from exile in 1434, leading eventually to their *de facto* rulership of the city until they were ousted in a revolt in 1494.

Cosimo and his heirs worked carefully to maintain control of the government through an elaborate political network supported by their wealth. They also sought to dismantle or dominate power bases in the city that were threats to their control. Ultimately the Medici brought the city under their influence, without, however, disturbing the appearances of the formal structures of government which had been in place for two centuries. In name Florence remained a republic, while in practice the Medici functioned rather like princes.

San Lorenzo

Sometime around 1418 a group of citizens living in the neighborhood of the church of San Lorenzo decided to act together to rebuild their parish church. The building already at the site was an eleventh-century Romanesque church, itself a replacement for an Early Christian basilica dedicated in 393 by no less a person than St. Ambrose, who had also consecrated Florence's first bishop. San Lorenzo, then, represented the entire Christian history of Florence more so, even, than the Duomo, which had a later foundation. Led by Giovanni, each member of the group agreed to contribute funds for the construction of his family's chapel around the transept of the proposed new structure. Giovanni agreed to build the **sacristy** of the new building as a family burial site and also to build an adjacent double chapel at the end of the transept (Fig. 11.1). This gave the Medici patronage rights over a traditionally important part of the building-the sacristy-and also over much more space than any other family participating in the project.

Brunelleschi's plans for San Lorenzo are somewhat unclear, since he died before the nave of the building was begun. But the transept, the chapels around the transept, and sacristy are his and are instructive for what they tell of the layers of meaning embedded in Renaissance architecture. For example, the rectangular chapels and main altar area extending from the transept derive from the plans of mendicant churches in Florence and elsewhere (see Fig. 4.11). The essentially basilical plan of the building is certainly not unusual, but the arrangement of arches springing continuously along the nave from one column capital to the next (Fig. 11.2) and the uninterrupted wall

between the arches and the row of clerestory windows recall major Early Christian buildings in Rome such as St. Paul's Outside the Walls. Brunelleschi's original plan for the building apparently called for side walls unbroken by chapel spaces, another feature that would have made the plan similar to Early Christian basilicas. The juxtaposition of cool white stucco in the spandrels and other flat surfaces with the warm slate coloring of the *pietra serena* arches and pilasters may derive from the black and white exterior decoration of Romanesque architecture in Florence, such as the Baptistry. This juxtaposition was later used for the Duomo as well and its use for San Lorenzo suggests a conscious attempt to place the church within the revered traditions of local architecture despite its stylistic innovations.

The two-color scheme also helps to clarify San Lorenzo's modular structure. Among the structural elements moving the viewer through the space is a narrow cornice projecting from the wall above the nave arcade, which moves unbroken from the entrance wall of the building to the transept, giving a strong longitudinal pull while at the same time unifying the space of the nave. A band of white stucco separates the cornice from a thin **stringcourse** that lies over the arches. These horizontal elements separate the clerestory from the arcade and lift the weight of the clerestory visually from the lower part of the building, giving it a lightness and buoyancy augmented by the light flooding in through the clerestory windows. The arches of the nave arcade spring from impost blocks, which creates the impression that they are floating above the columns that actually support them, and thus have a longitudinal momentum of their own. Brunelleschi's decorative forms-capitals, mouldings-are pure classical revivals; like the Early Christian references,

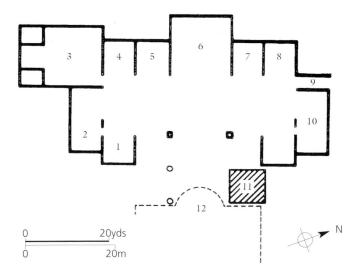

11.1 San Lorenzo, Florence, first plan of transept area (1418) showing chapel ownership and pre-existing Romanesque church

¹ Martelli; 2 Medici; 3 Medici (Sacristy): 4 Neroni; 5 Rondinelli; 6 Medici after 1442 (Canons' choir); 7 della Stufa; 8 Ciai; 9 Ginori corridor; 10 Ginori; 11 Belltower; 12 Romanesque church of San Lorenzo

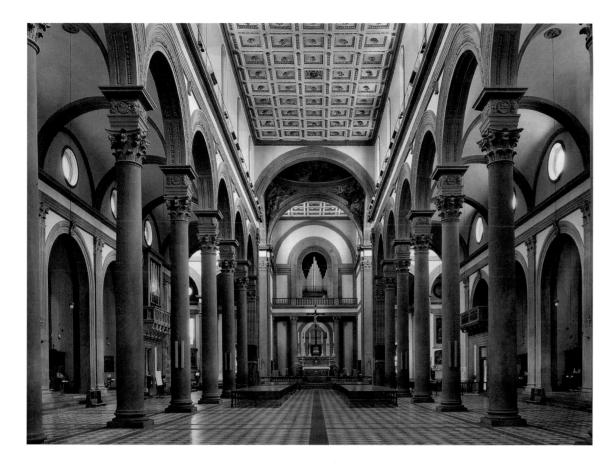

11.2 San Lorenzo, Florence, 1418-c. 1466, original project commissioned by Giovanni di Bicci de' Medici and others from Filippo Brunelleschi; nave built by Cosimo de' Medici after 1442, modifying original plan

they may reflect the time he spent in Rome after 1404 measuring and drawing ancient buildings. Rather than being mere architectural quotation, however, these references tie San Lorenzo stylistically to its earliest history.

Work that had begun so earnestly on the transept of San Lorenzo in 1418 had all but ceased by the time of Giovanni di Bicci's death in 1429. In 1442 Cosimo declared that he would himself pay for the construction of the new building. In doing so he assumed property rights over the main altar area and he stipulated that no family crest other than that of the Medici appear in the church. Cosimo's assumption of the building costs effectively transformed San Lorenzo into a Medici structure, despite the presence of families who maintained control of the chapels along the transept. Insofar as the building marks the site of the first Christian church in Florence, Cosimo also symbolically appropriated the entire religious history of the city for his family; the princely overtones of this act recall royal foundations such as St. Denis, outside Paris, or the Visconti patronage of the Certosa of Pavia. In a city that called itself a republic, this form of patronage must have seemed extraordinary.

The Old Sacristy The sacristy of San Lorenzo built for Giovanni di Bicci (now called the Old Sacristy; Figs. 11.3 and 11.4) was designed as a family mausoleum as well as a sacristy. It contains the tombs of Giovanni and his wife, Piccarda de' Bueri, who are buried beneath the dome. The centralized plan of the Old Sacristy relates it to the

Baptistry in Padua (see Fig. 9.17), where its patrons, Francesco I da Carrara and Fina Buzzacarini, were buried. In plan, the Old Sacristy is a perfect square. The small altar area is also a square, the perfected geometrical form of the main space repeated. The dimensions of this altar and the small service rooms to the left and the right were determined by use of the golden section. The vertical divisions of the main room are simple numerical subdivisions of the square plan; the ground level, the tympanum elevation, and the height of the dome are each half the measure of the side of the square. The harmonic relations of the chapel provide an extremely ordered and restful space, but they also suggest the imitation of a macrocosmic universal structure on a very small scale, since Brunelleschi's contemporaries believed that the universe was also ordered on measures relating to the golden mean. Thus, this man-made world of the sacristy echoes the God-created world of the universe, the two in harmony with one another.

The architectural details of the sacristy seem, furthermore, to be structured on a theme of resurrection. The exterior of the lantern of the Old Sacristy has a curious spiraling decoration which refers to the structure built over the tomb of Christ in Jerusalem; thus it provides a symbol of resurrection and suggests the hopes of the Medici for their afterlife. That lantern area with its incoming light—itself a symbol of the divine—is the focus of the interior space of the chapel, attention being drawn to it by the ribs of the veil vaulting of the dome and its position on the central

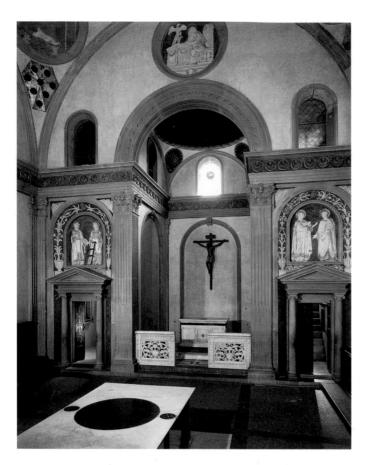

11.3 Old Sacristy, San Lorenzo, Florence (after restoration), c. 1418-28, commissioned by Giovanni di Bicci de' Medici from **Filippo Brunelleschi**. Central square room c. 37' $9'' \times 37'$ 9'' (11.5 × 11.5 m)

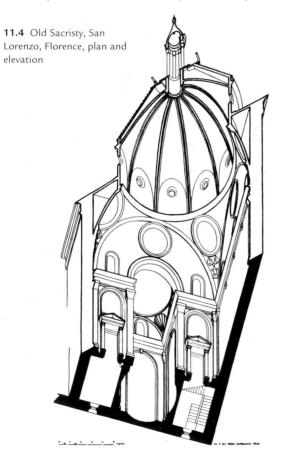

dominating vertical axis of the room. The architectural **membering** in the chapel (non-load-bearing since it is applied to a stone rubble construction) suggests structure, but at each place where weight and gravity might be evident Brunelleschi manipulated the forms to create lightness and a vertical drive. The *pietra serena* ring from which the dome springs does not touch the main arches of the room, a thin margin of white stucco allowing it to float free. The bases of these arches are separated from the pilasters in the corners of the room—theoretically their supports—by a protuding heavy cornice. The cornice is itself split by a series of roundels with painted stucco reliefs of cherubim, again alleviating mass and lifting the upper part of the room from the lower. The effect throughout the room is one of light and lightness.

Although the Old Sacristy was substantially complete at the time of Giovanni di Bicci's death in 1429, it owes most of its subsequent decoration to his sons Cosimo and Lorenzo (not to be confused with Lorenzo the Magnificent, Cosimo's grandson). The activity of the two brothers in the Old Sacristy reveals important new patterns of patronage. Donatello's roundel depicting the *Apotheosis of St. John* (Fig. 11.5), one of four placed in the pendentives of the Sacristy, shows how crucial the function and shape of a space is to the form of a design placed within it. The complex perspective system seems a deliberate confusion of Brunelleschi's single-point perspective system since there is more than one vanishing point suggested by the receding background orthogonals. However, since the relief is placed on a surface

11.5 Apotheosis of St. John (after restoration), before 1433, probably commissioned by Cosimo and Lorenzo de' Medici from **Donatello** for the Old Sacristy, San Lorenzo, Florence. Painted stucco, diameter 7' 6" (2.15 m)

11.6 *St. Lawrence and St. Stephen* (after restoration), between 1434 and 1443 (?), commissioned by Cosimo and Lorenzo de' Medici from **Donatello** for the Old Sacristy, San Lorenzo, Florence. Painted stucco, 7' $6'' \times 5'$ 11'' $(2.15 \times 1.8 \text{ m})$

curving over the head of the viewer, the orthogonals of the foremost building point to the roundels of the Evangelists on the adjacent walls. The vertical edges of the buildings in the *Apotheosis* are not quite plumb, but angle slightly toward a center line which, when projected from the curving pendentive into space, directs attention to the lantern, whose resurrection symbolism Brunelleschi had made explicit by its curious spiraling shape. The classically inspired sarcophagus of Giovanni di Bicci and his wife, Piccarda, lies directly below the lantern, emphasizing the patrons' hopes for eternal life.

Large stucco reliefs by Donatello over small doors on either side of the altar wall present dramatically-posed standing figures of saints Lawrence and Stephen on the left (Fig. 11.6) and saints Cosmas and Damian on the right. These figures could simply be titular saints—Lawrence (Lorenzo), for the church in which they appear and Cosmas and Damian, who in life had been doctors (which in Italian is *medici*), for the family that had built the Old Sacristy. These saints, however, are also the patron saints of Lorenzo and Cosimo, who probably commissioned these reliefs after their father's death, the sons appearing in the guise of their patron saints just as Giovanni does in the roundel of St. John the Evangelist above the altar arch. Beneath each of these reliefs is a set of bronze doors by Donatello, each con-

taining ten panels with paired standing and gesticulating figures. The door on the right (Fig. 11.7) under Cosmas and Damian has figures of saints John the Baptist and John the Evangelist at the top left and saints Peter and Paul at the top right. St. John the Evangelist could refer to Giovanni di Bicci and the chapel's dedication or to Cosimo's son, also named Giovanni. John the Baptist unmistakably alludes to the patron saint of Florence and marks the first time that the Medici had joined their own iconography with that of the city. St. Peter refers to Cosimo's other son, Piero, and the paired Peter and Paul (Fig. 11.8) to the papacy, an appropriate reference for the papacy's bankers and for a family that was a strong supporter of Pope Eugenius IV, then resident in Florence. But what ultimately appears is a dynastic line from Giovanni, high in the altar arch, to Cosimo on the stucco relief, to Piero and Giovanni on the bronze doors

11.7 Bronze doors to the right of the altar with figures of Apostles and the Doctors of the Church, between 1434 and 1443, commissioned by Cosimo and Lorenzo de' Medici from **Donatello** for the Old Sacristy, San Lorenzo, Florence. Bronze, $92\% \times 43''$ (235 \times 109 cm)

11.8 *Pair of Apostles* (detail of bronze doors to the right of the altar), between 1434 and 1443, commissioned by Cosimo and Lorenzo de' Medici from **Donatello** for the Old Sacristy, San Lorenzo, Florence. Bronze, $14\% \times 13\%''$ (36.5×34.5 cm)

(see Fig. 11.3). Nowhere in previous Florentine art are dynastic lines so graphically articulated.

Stylistically the panels for the doors are also fascinating, since they seem so contrary to the spatial illusion that Donatello had earlier used in his relief for Siena (see Fig. 10.50). Here he places his paired figures on the simple ground line of the frame, against a blank background, with no attempt to provide any setting for the action of the figures. He also presses the figures into the relief, a version of the *schiacciato* relief, but here without the rationale of pictorial illusionism. The stylized, repeated paired figures over the multiple panels of the two doors refer to the familiar iconographical imagery of debaters, likely a reference to the contentious arguments of the Church Council of Ferrara-Florence that met in Florence in 1438–39 with the financial support of the Medici.

The choice of bronze for the two doors was itself a daring gesture. Bronze had previously been reserved for important civic commissions, notably the Baptistry doors. The Medici thus appropriated a medium that, in itself, gives this space a civic resonance. Although all of these references appear in a sacristy, a site traditionally used to enhance a powerful family's status and mark their devotion and hopes for the afterlife, the Medici subtly seem to have invested their sacristy with extra dimensions of civic and dynastic power.

But the initial plans for San Lorenzo and the sacristy should be seen as something more than a neighborhood and family project. It was just at the time that Giovanni di Bicci had agreed to build the sacristy with Brunelleschi as his architect that Onofrio Strozzi (died 1418) and his son Palla were engaged in building the sacristy at Santa Trinità with Ghiberti as his architect. Familial and political rivalries were joined with artistic rivalries. The Medici and the Strozzi were members of opposing political factions in the city. Although in 1418 the Strozzi were considerably wealthier than the Medici, the Old Sacristy of San Lorenzo was considerably larger and more insistently classicizing than the Strozzi commission. The sheer scale of the Medici architectural project at San Lorenzo gave the family an architectural prominence in the city far surpassing the Strozzi. This insistence on public generosity was part of the strategy of Giovanni's son Cosimo at this same time. Cosimo de' Medici acted as one of four operai for the commission of Ghiberti's St. Matthew for the Bankers' Guild at Or San Michele (see Fig. 10.22); a forced assessment of guild members in 1420 indicates that Medici contributions were significantly more generous than those of the Strozzi. Even in a commission contracted by a guild, family and personal rivalries played important roles. The different styles used by the two families for their commissions thus underscore the use of style as a signal of different factions in the social order.

San Marco

Cosimo's activities at San Lorenzo were not his only endeavors at church-building. When the Dominican order took charge of the dilapidated monastery of San Marco in 1436, Cosimo hired Michelozzo di Bartolommeo to rebuild it. Cosimo also added a library (which he then helped to fill with books), a cloister, a chapter room, a bell tower, a bronze bell, and church furnishings, including an imposing altarpiece by Fra Angelico (Guido di Piero; c. 1395 Vicchio-1455 Rome) for the main altar.

The San Marco Altarpiece (Fig. 11.9) was badly abraded through faulty restoration in the nineteenth century, yet it is still remarkable for what it says of Fra Angelico's work and of his patron's wishes. In some sense the image is profoundly traditional, with a centrally placed group of the Virgin and Child flanked by angels and saints. This may befit the work of a painter who was a Dominican friar living at San Marco, where he also painted devotional images in the cells of the cloister in which the friars lived. Yet the setting of the San Marco Altarpiece has an arrestingly open, spacious quality. As if in response to this new concern for a rational, mathematical spatial construction, Fra Angelico gave the altarpiece a square shape, a decisive shift from earlier compartmentalized, arched altarpieces. The architectural throne, with its shell niche framing the Virgin and Child, is large and decorated with classical garlands and Corinthian pilasters. Space expands not only into the distance, but also behind and around the figures. A singlepoint perspective defined by the lines in the carpet both establishes a deep spatial stage for the figures and focuses on the hand of the Virgin, tellingly placed in front of her womb, emphasizing the Incarnation of Christ and her maternity, a central concern in Dominican theology. The inscription from the Dominican Little Office on the hem of the Virgin's garment emphasizes this tenet: "... like a vine I caused loveliness to bud, and my blossoms became glorious and abundant fruit." The background landscape, framed by patterned draperies, is remarkably naturalistic in its depiction of trees, of the sea meeting the land, and of the sunlit sky. It too relates to a holy text; in the Old Testament book of Ecclesiasticus, Wisdom says, "I have grown tall as a cedar on Lebanon, as a cypress on Mount Hermon; I have grown tall as a palm in Engedi, as the rose bushes of Jericho; as a fine olive in the plain, as a plane tree I have grown tall" (24:13-15). The illusionistic draperies, tied to the frame at the upper left and right, refer to contemporary altarpieces, which were occasionally actually covered by cloth, drawn open only on festival days. Here, by contrast, the mood would always be jubilant, a stage set for the adoration of the Child whose redemption of the world is symbolized by the crucifix on the small tabernacle door that interrupts the composition at the bottom, an image that completes the life cycle of Christ begun with the Madonna and Child directly above it.

The draperies of the kneeling figures, with their thick folds and weightiness, suggest that Fra Angelico, for all the tranquility of his images, had looked carefully at the more dramatic painting of Masaccio. Such features as the hanging cloth behind the figures and the expressive modeling of the faces also suggest that he had studied the work of Gentile da Fabriano. His simplified oval faces also indicate that he was familiar with Sienese painting—especially with the work of Sassetta (1392 Cortona–1450 Siena), with whom he had shared a commission at the Dominican monastery in Cortona in 1438.

Although there are obvious differences in spatial organization and figural structure between Fra Angelico's *San Marco Altarpiece* and Gentile's *Adoration of the Magi* (see Fig. 10.29) painted for Palla Strozzi, the Medici altarpiece has a sense of opulence no less finely calibrated than the Strozzi. Rich gold-embellished draperies hang not only at the left and right of the composition but behind the Virgin and Child as well. Gold is used generously in the haloes of the figures, as it was originally in the borders and surfaces of many of the robes worn by them. The luxuriousness of the arboreal landscape is matched by the richness of the patterning on the cloth separating it from the figures and of that on the carpet.

It is worth noting, however, that instead of choosing the courtly subject matter of the Magi, Cosimo ordered a traditional *sacra conversazione* for his altarpiece. The sobriety of the figures is appropriate for their Dominican location, yet their poses give them the gravity of Roman statesmen, unlike the lively, elegant figures in Gentile's altarpiece.

CONTEMPORARY VOICE

A Job Application

This letter from the painter Domenico Veneziano to Piero di Cosimo de' Medici illustrates the groveling expected of artists (until quite recent times) when addressing important patrons. Amid all the flattery, however, the writer tries earnestly to convey his superiority to other candidates—or at least their unsuitability because of existing commitments. However, Domenico's plea went unheeded: the commission for the *San Marco Altarpiece* (see Fig. 11.9) went to Fra Angelico.

To the honorable and generous man Piero di Cosimo de' Medici of Florence, . . . in Ferrara

Honorable and generous Sir. After the due salutations. I inform you that by God's grace I am well, and I wish to see you well and happy. Many many times I have asked

about you, ... and having first learned where you were, I would have written you for my comfort and duty. Considering that my low condition does not deserve to write to your nobility, only the perfect and good love I have for you and all your people gives me the daring to write, considering how duty-bound I am to do so.

Just now I have heard that Cosimo [de' Medici, Piero's father] has decided to have an altarpiece made, in other words painted, and wants a magnificent work, which pleases me very much. And it would please me more if through your generosity I could paint it. And if that happens, I am in hopes with God's help to do marvelous things, although there are good masters like Fra Filippo [Lippi] and Fra Giovanni [Angelico] who have much work to do. Fra Filippo in particular has a panel going to Santo

Spirito which he won't finish in five years working day and night, it's so big. But however that may be, my great good will to serve you makes me presume to offer myself. And in case I should do less well than anyone at all, I wish to be obligated to any merited punishment, and to provide any test sample needed, doing honor to everyone. And if the work were so large that Cosimo decided to give it to several masters, or else more to one than to another, I beg you as far as a servant may beg a master that you may be pleased to enlist your strength favorably and helpfully to me in arranging that I have some little part of it . . . and I promise you my work will bring you honor. . . .

By your most faithful servant Domenico da Venezia painter, commending himself to you, in Perugia, 1438, first of April.

11.9 San Marco Altarpiece, c. 1440, commissioned by Cosimo and Lorenzo de' Medici from Fra Angelico for the high altar of San Marco, Florence. Tempera on panel, 7' 2%" × 7' 5%" (2.2 × 2.27 m) (Museo San Marco, Florence)

The painting was badly damaged in an early restoration, leaving its surface stripped.

Cosimo and Fra Angelico seem deliberately to have employed a visual language that could be seen as an alternative to that used by the leading member of the oligarchy—and yet at the same time to have incorporated some of the signs of wealth and social prestige that characterize the Strozzi commission.

As in the decoration for the Old Sacristy (see Figs. 11.5–11.7) there is a dynastic "subtext" in the imagery in the San Marco Altarpiece. Its patron, Cosimo de' Medici, appears in the guise of St. Cosmas kneeling in the traditional position of the donor in the left foreground of the painting. As in Donatello's stucco relief for the Old Sacristy, St. Cosmas is paired with St. Damian, his brother. John the Evangelist, standing second from the left, probably represents Giovanni di Bicci, Cosimo's father; and St. Lawrence, at the far left, looking out and holding a small martyr's palm, Cosimo's brother, Lorenzo, who died in 1440, shortly before the painting was completed. Although none of these figures is a portrait in the strict sense of the word, the homophonic references that they establish would have been clear to anyone seeing the altarpiece. Red balls on a gold

ground appear along the border of the rug at the bottom of the altarpiece and refer to those of the Medici family crest. The red and white floral garlands hanging at the top of the painting, although most likely referring to Ecclesiasticus, also represent the heraldic colors of the city of Florence, uniting Medici and civic imagery once again. Thus, just before taking control of the main altar of San Lorenzo in 1442, Cosimo also visually appropriated the high altar of San Marco, just a short distance away from his home, further enhancing his presence in the city.

Within the monastery, newly enlarged through Cosimo's generosity, Fra Angelico also painted a number of frescoes specific to the life of Christ and to the rule of the Dominican order. In the *Annunciation* (Fig. 11.10) Fra Angelico imagines the angel Gabriel appearing to the Virgin Mary in a portico that recalls the actual cloister of the monastery, which the viewer would just have seen as he climbed a staircase from the ground floor to the upper corridor of the cloister; the fresco is framed by the entrance door at the top of a stairway, the space established by the fresco extending the avenue of the stairwell. The graceful

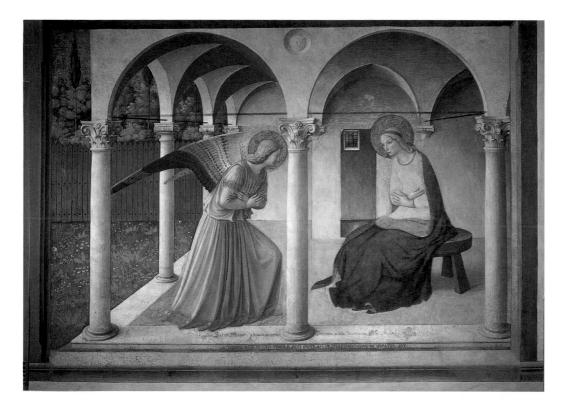

11.10 Annunciation, 1438–45, commissioned by Cosimo de' Medici and the Dominicans from Fra Angelico for Dormitory Corridor, Monastery of San Marco, Florence. Fresco, 7' 6" × 10' 5" (2.29 × 3.18 m)

movement of the angel and of Mary set the quiet tone for the other frescoes along the corridor and in each of the friar's cells on this floor. The cloister was, after all, a place for meditation and prayer. An inscription on the bottom of the fresco made such devotional practice explicit: "As you venerate, while passing before it, this figure of the intact Virgin, beware lest you omit to say a Hail Mary."

The Medici Palace

When, in about 1445, Cosimo de' Medici began to build his palace (Figs. 11.11 and 11.12) on the Via Larga (now the Via Cavour), he had apparently already hired and dismissed Brunelleschi as its main architect, supposedly because Brunelleschi had provided a model for too grand a structure. Yet the palace that Cosimo built was more splendid than any in the city, leading to recent speculation that Brunelleschi's project placed the palace opposite the church of San Lorenzo rather than on its current site. Such a configuration of church and palace, given Cosimo's take-over of San Lorenzo, would have referenced to a well-known architectural iconography of authority most typically seen in juxtapositions of bishops' palaces and cathedrals, a message that would have been too blatant for Cosimo, who maintained that he was merely an ordinary citizen of the republic, despite his de facto control over the state.

Cosimo replaced Brunelleschi with Michelozzo, who had begun his career as a founder in the Florentine mint before becoming one of Ghiberti's many assistants and, in 1423, a partner in Donatello's workshop. He may have appealed to Cosimo because he could work in Brunelleschi's manner,

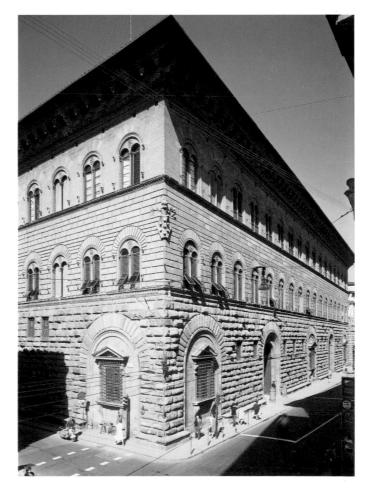

11.11 Medici Palace, Florence, c. 1445–c. 1460, commissioned by Cosimo de' Medici from **Michelozzo**

but was more malleable than the senior architect. The palace he designed for Cosimo is striking in its use of extremely heavy rusticated masonry on the ground story, which gives the building a fortress-like aspect-softened in the increasingly refined treatment of surface on the stories above. The rustication of the lower story is typical of Florentine palazzi of the fourteenth and early fifteenth centuries, a conservative element suggesting Cosimo's adherence to tradition and his equality with other citizens who had built similar, if smaller, palaces. Yet the extreme heaviness of the rustication and the double lancet windows of the upper stories can be found elsewhere only at the Palazzo della Signoria (see p. 77), thus linking the Medici architecturally with the city's main site of sovereignty. None of this vocabulary is classical in form, although some have seen the unrelieved rustication as an echo of the massive wall around the back of the Forum of Augustus in Rome, thus lending further suggestions of rulership to the Medici inhabitants.

Deviating from normal building practice in Florence, Cosimo built his palace from the foundations up, having destroyed whatever pre-existing structures were on the site. A more common practice was for owners to acquire adjacent properties, which they then enveloped with a thin facing of stone; this presented a unified façade to the street while the interior spaces maintained some of the haphazard arrangements of the original buildings. A renovation and restructuring of family properties begun by Giovanni

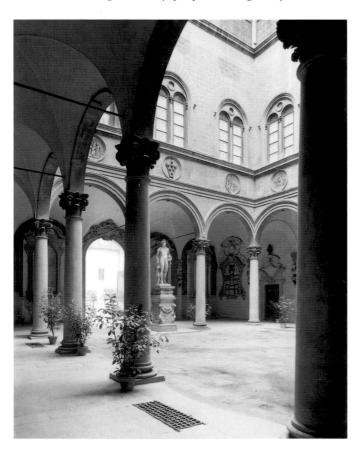

11.12 Medici Palace, Florence, courtyard

Rucellai (see Fig. 33) just shortly after work began on the Medici Palace demonstrates both the innovative and the traditional aspects of Cosimo's home. What appear as masonry blocks across the facade of the Palazzo Rucellai are merely a veneer over the surfaces of a row of buildings; this façade ends raggedly at the right in anticipation of the purchase of another property. Each story is separated into bays by pilasters, with a different order of capital used at each level-a hierarchy also used on the Colosseum in Rome. Thick cornices decorated with classicizing ornament divide the stories. The uniformity of the Rucellai façade also disguises the commercial function of the ground floor implied by rustication by removing the differentiation of surface treatment between the stories so carefully maintained in the Medici Palace. Both palazzi, however, like their predecessors in Florence, present a block-like solidity on the street that suggests the unity of the family living behind the façade and declares their presence in the city. Such families, of course, normally included at least two generations of males, with their wives, children, and servants.

The central courtyard of the Medici Palace (see Fig. 11.12) is strikingly different from the exterior of the building. Here the novelty of the building becomes obvious in the refined classical detailing of the arcade which completely surrounds the courtyard, and in the sculpted roundels suggesting ancient Roman gems that decorate the frieze above the arcade. Whether Cosimo and Michelozzo drew on local sources for this courtyard or on courtyards that they would have seen in northern Italy during Cosimo's exile in 1433–34, the size, the uniform order, and the allusions to classical forms were new to Florentine architecture.

Portrait Busts Cosimo was the patron for the architecture of the Medici Palace, but his son Piero apparently took responsibility for the lavish decoration of its rooms. One of Piero's earliest commissions marks his inventiveness. He employed Mino da Fiesole (1429 Papiano-1484 Florence), who may have trained under Michelozzo and thus within the influence of Donatello, to carve marble portrait busts of himself (Fig. 11.13) and his brother Giovanni. Piero's portrait is a vivid portrayal of the actual features of the man combined with a stoic vitality in his firmly set features and turning head. It was fairly common practice at this time to make life masks or death masks of important people from wax or plaster of Paris; but Piero's bust, finished in 1453, marks the first example in marble to recall antique Roman portraits, a model appropriate for a citizen of a republic. Somewhat earlier medals of princely rulers (see Fig. 14.2), also modeled on Roman sources, may also have influenced Piero's commission. Earlier reliquary busts of saints (see Fig. 6.4) undoubtedly lay behind Mino's severely truncated figure as well, the form itself being an invitation to reverence. The vertical borders of his clothing are carved with Piero's personal crest of a diamond ring with a ribbon woven through it bearing the word semper (Latin for

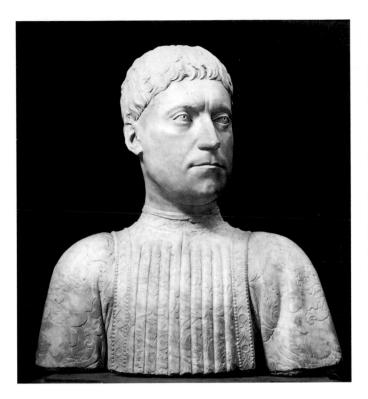

11.13 Piero de' Medici, 1453, commissioned by Piero de' Medici from Mino da Fiesole. Marble, height 21½" (55 cm) (Museo Nazionale del Bargello, Florence)

"always"). The message of Medici permanence rings loud and clear to anyone who might have thought that Medici power in republican Florence was a passing aberration.

The Medici Chapel The small chapel of the Medici Palace (see p. 251) is strikingly ornate. The elaborately coffered and gilded ceiling and the richly inlaid marble floor centered around a porphyry disk form a suitably grand setting for the spectacular frescoes on the walls. Beginning on the right wall of the chapel and moving clockwise around the room are frescoes by a pupil of Fra Angelico, Benozzo Gozzoli (Benozzo di Lese; c. 1420 Florence–1497 Pistoia) depicting the procession of the Magi to Bethlehem. With one king and his retinue occupying each wall, the procession directs the viewer to the altarpiece, which depicts the Adoration of the Christ Child.

The wall with the youngest king (Fig. 11.14) is particularly lavish in its treatment of costume, recalling the treatment of the same subject (see Fig. 10.29) commissioned by Palla Strozzi. Piero seems to have appropriated both the subject matter and the style of the earlier painting, as if to supplant the exiled Palla Strozzi by assuming the very pictorial vocabulary that had characterized his commission.

The two mounted figures behind the young king are Piero de' Medici, on the white horse, and Piero's father, Cosimo, on the donkey. Piero's young son, Lorenzo, appears in the second row at the left in three-quarter view, wearing a red hat, his ski-jump nose a clear mark of his identity.

Although there is considerable dispute over the identity of the young king, he probably represents a second idealized ten-vear-old Lorenzo (1449-92), who, in luxurious costume, had ridden the lead horse during an elaborate public ceremony staged by Piero in 1459 to honor Pope Pius II and Galeazzo Maria Sforza of Milan, both then visiting Florence. This role as one of the Magi would have been appropriate for Lorenzo, since he had been baptized on January 6, 1449, the feast of the Magi. Moreover the men of the Medici family belonged to the Company of the Magi, a confraternity that processed through the city on the feast of the Magi, from the monastery church of San Marco, where relics of the Magi were kept, past the Medici Palace, to the Baptistry. Thus this fresco in the private chapel of the Medici, where Cosimo sometimes greeted visiting dignitaries, gave a noticeably royal cast to the family while at the same time celebrating their civic generosity and religious devotion.

The original altarpiece for the Chapel (Fig. 11.15; replaced by a replica in 1494) is a complex amalgam of civic and devotional imagery. Unlike conventional church altarpieces using sacra conversazione iconography, Filippo Lippi's painting presents an historical, iconic, and mystical image of the Virgin adoring the Christ Child locked into an iconography of the Trinity, with God the Father and the Holy Spirit appearing at the top of the composition and Christ at the bottom. A youthful St. John the Baptist—who, according to biblical history, should be the same age as Christ-stands a-temporally at the left of the composition, apart from the other figures; thus he appears more in his role as patron saint of Florence than as a full participant in the devotional iconography of the painting. St. Bernard, seen half-length behind a rock formation at the upper left, almost as if in a vision, is a saint connected to heremetical meditation, but in Florence he was also another patron saint of the city. The Priors' chapel in the Palazzo della Signoria was dedicated to him, and thus the Medici chapel discreetly echoes the one in the city hall. Both the St. John and the St. Bernard, therefore, are instances of the Medici linking their imagery to that of the city whose political life they sought to control.

The sophisticated complexity of this imagery, interlocking Medicean propaganda and Christian exegesis, is evident in the iconographical details of the painting. At the lower left near three stumps (others are scattered throughout the painting) is an axe handle, separated from its blade, on which Lippi has signed the painting FRATER PHILIPPUS P[inxit]. More than a clever device for artistic self-presentation, the handle refers to a passage from the New Testament (Luke 3:9) describing the preaching of St. John the Baptist: "The axe is already at the root of the trees, and every tree that does not produce good fruit will be cut down and thrown into the fire." While the biblical passage is intended as a warning against immorality, one has to wonder what someone like Palla Strozzi or any other political opponent

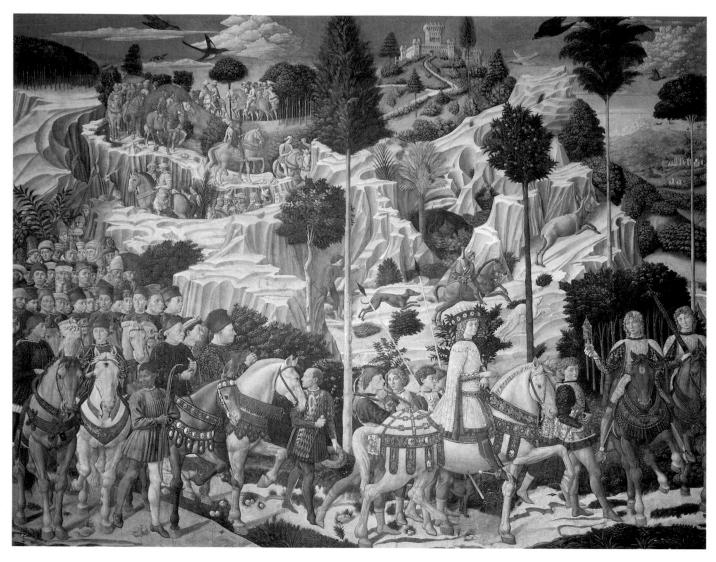

11.14 Medici Chapel, Medici Palace, Florence, detail of right wall showing the retinue of the youngest king, c. 1459, commissioned by Piero de' Medici from Benozzo Gozzoli. Fresco

The artist appears in the third row at the left in a red hat looking directly out toward the viewer.

of the Medici might have perceived the implications of such a reference to be had he been able to see it. The passage from Luke's gospel also describes the Baptist in the words of Isaiah as a "voice crying in the wilderness" saying: "Every valley shall be filled in, every mountain and hill made low. The crooked roads shall become straight, the rough ways smooth." Despite the implied political messages of the painting and the luxury and the pageantry of the scenes of the Magi painted on the walls of the chapel, this altarpiece is a deeply meditative one befitting what we know of the spirituality of Cosimo de' Medici and of the mystical religiosity of Lucrezia Tornabuoni, the wife of his son Piero.

Other Decorations Other rooms in the palace conveyed equally complex messages. Inventories of the period indicate that a room marked as Lorenzo's was decorated with three large paintings by Paolo Uccello showing the battle of San Romano (1432). Although two of the three may have

been commissioned by another Florentine patron, the Medici clearly chose this ensemble depicting Florentine military success and hard-won peace as an appropriate image for the young Lorenzo, perhaps to counter his image as a humanist prince, known for his erotic love poetry, his mystery plays, and his patronage of classical scholarship. The victorious general, Niccolò da Tolentino, appears in one of the paintings (Fig. 11.16) with a banner carrying his device of a knot floating above his head. Uccello's paintings of this battle have a curiously frozen, doll-like quality. The geometrically simplified humans and animals and the carefully arranged angles of the fallen lances indicate the painter's reputed obsessive interest in the new science of perspective. Behind the figures at the left of the panel are trees bearing bright oranges, a fruit known during this time as mala medica, or "medicinal apple." Since the Medici name means "doctors," it was natural for them to choose this fruit as their symbol.

11.15 Adoration of the Child, late 1450s, commissioned by the Medici family from Fra Filippo Lippi for the Medici Chapel, Medici Palace, Florence. Panel, 50 × 45%" (127 × 116 cm) (Staatliche Museen, Berlin)

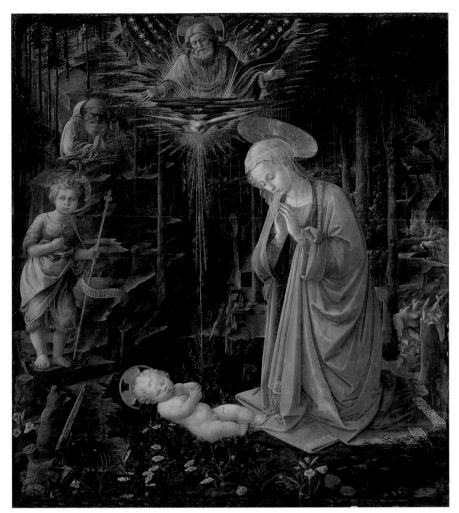

11.16 (below) The Battle of San Romano, 1430s (?), by Paolo Uccello. Oil on panel, 6' × 10' 7" (1.83 × 3.23 m) (National Gallery, London)

New archival discoveries indicate that Lorenzo purchased the Uccello paintings from another owner. Whatever the meanings of the paintings may have been for the previous owner, it is nevertheless clear that they were intended as part of an overall decorative ensemble in Lorenzo's living quarters.

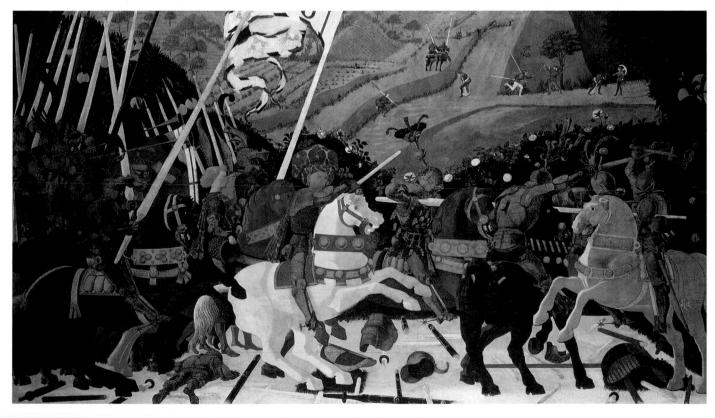

In addition to their charm these battle scenes are important because such subject matter was at that time depicted in the palaces of princes (see Fig. 14.29) and on the walls of city halls (see Fig. 5.27) to commemorate state military victories. Thus Lorenzo's room seems to have conflated not only citizen and prince but also private room and public council chamber, giving the family a visual language of rule.

An even more obvious appropriation of civic imagery can be seen in a small table bronze of Hercules and Anteus (Fig. 11.17) made for the Medici by Antonio del Pollaiuolo (Antonio di Jacopo Benci; c. 1432 Florence-1498 Rome), who produced paintings, metalwork, embroidery designs, and engravings. Hercules had been represented on the state seal of Florence since the end of the thirteenth century. Pollaiuolo's sculpture depicts the defeat of Anteus, achieved by lifting him off the ground, since Anteus derived his strength from his mother, Earth (Ge). Every muscle in the contorted bodies of the men is tense, emphasizing the ferocity of their struggle although not indicating that Pollaiuolo had actually made anatomical studies, as some have claimed. The detailed modeling of the bronze, polished to a high luster, fragments reflected light in a manner that further heightens the tension. The statuette is a technical tour de force. In medium as well as subject matter, such bronze statuettes, imitative of antique examples, mark an innovation in Florentine sculpture and the extension of a classical vocabulary into the domestic interior.

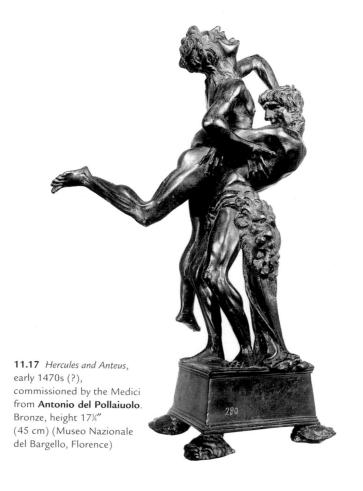

Donatello in Padua

During a critical period of Medici political ascendancy, the sculptor who had helped to establish a new monumental sculptural vocabulary in the city and who had been employed by the Medici to do the same for their family was out of Florence employed on an impressive series of commissions in Padua, again in bronze. Donatello began working in that city in about 1444 and remained there for a decade. The city was a major center of classical and humanist studies. The Paduans' active promotion of the cult of St. Anthony had also encouraged the exploitation of very realistic modes of presentation. Donatello's own active, passionate interest in antiquity, human psychology, and the convincing representation of reality made him an ideal candidate to undertake work in Padua.

The Santo Altarpiece

The entire ensemble for the high altar of the Santo (Fig. 11.18) was modeled and cast in less than two years, temporarily assembled for the saint's feast day on June 13, 1448, but still not completely chased and polished when Donatello left Padua in 1454. Intended to give glory to the city's beloved, miracle-working saint, the altar included four large reliefs of St. Anthony's miracles, six lifesized statues (three Franciscans, including Anthony, and three other local saints), a limestone relief of the Lamentation over the dead Christ, and bronze reliefs of the symbols of the Evangelists and of music-making angels. It was a sculptor's tour de force of free-standing and relief sculpture, all set within an elaborate architectural framework as if the figures existed on a liturgical stage.

Donatello's relief of *The Ass of Rimini* (Fig. 11.19) for the altar tells the story of a man who doubted the Church's doctrine of Transubstantiation, that is, the miraculous but actual, physical presence of Christ in the sacrifice of the mass. When St. Anthony displayed a consecrated Host to the man's donkey, as he is shown doing in the center of the relief, the beast recognized the divine presence and fell to its knees. Church doctrine was confirmed and heresy refuted by a beast of burden—a reminder of St. Francis's own use of animals in his preaching and miracles and a confirmation of Anthony's effectiveness as a defender of orthodoxy.

Donatello imagined the event as both momentous—and therefore worthy of a grand setting—and emotionally and spiritually transforming, as suggested by the intense, personal reactions of the attending figures. The action takes place before three huge barrel vaults, whose monumentality suggests those of the Basilica of Maxentius and Constantine in the Roman Forum. Donatello enlivened the cavernous space with classical pilasters, putti in the arches' spandrels, and rectangular coffering which leads the eye back to iron grates through which yet deeper spaces can be seen. The strategic application of gilding keeps the complex volumes

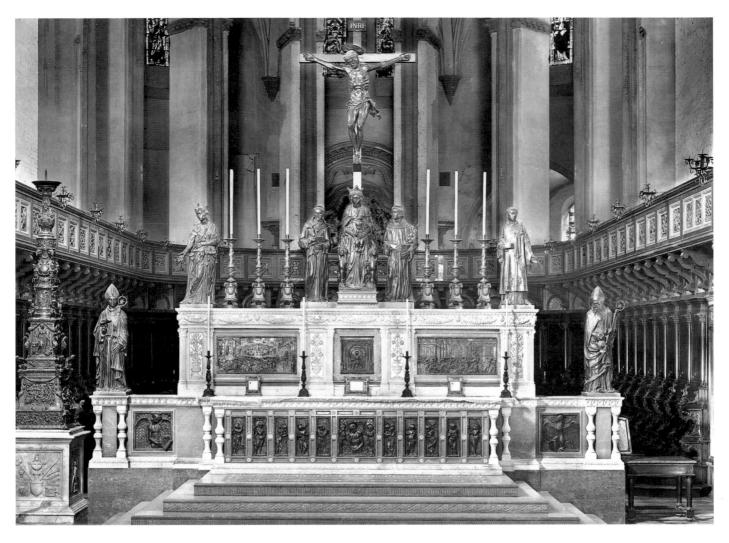

11.18 High Altar, the Santo, Padua, 1446-53, commissioned by the governors of the Santo from Donatello. Bronze, partially gilt

The arrangement of the statues does not correspond to their original disposition, which included an architectural canopy for most or all of the figures, perhaps roughly comparable to the architectural structuring of Mantegna's San Zeno Altarpiece (see Fig. 13.13). Donatello's bronze crucifix was not part of the altar program.

of the architecture legible, although the figures seem to stand right on the front edge of the relief plane.

On the other hand, Donatello's *Madonna and Child*, around which his other figures on the altar are grouped, is traditionally iconic in its composition, representing in its strict frontality the allegory of Mary as the Throne of Wisdom as she supports an equally severely frontal Christ Child. The Madonna is both formidable and approachable. As regal as a Byzantine empress in her headdress of winged cherubs, she presents the worshiper with the true and palpable body of Christ, a literal counterpart to the presentation of the Host in the relief discussed above. Surrounded by the parting drapery of her gown, the Christ Child seems born before our very eyes.

The Gattamelata Monument

While Donatello and his large workshop were producing the altar for the Santo, they were also engaged in creating an over-lifesized bronze equestrian statue of the Paduan-born leader of the Venetian army, Erasmo da Narni, known to history by his nickname Gattamelata ("honeyed cat"; Fig. 11.20). The earliest recorded payments for this work date from 1447; in 1453 the work was appraised and in place. It was financed by the late general's wife and son but made possible only by authorization of the Venetian government. The epitaph composed by the humanist Giantonio Porcello de' Pandoni for Gattamelata's tomb inside the Santo phrased it succinctly: "The Senate and my pure faithfulness rewarded me with worthy gifts and an equestrian statue."

Occupying a prominent position in the piazza in front of the Santo, the monument to Gattamelata is extraordinary in many ways. Not only is it a major technical and artistic achievement—the first surviving monumental bronze equestrian statue since antiquity—but it confers the Roman imperial dignity of this form to a person of less than sovereign status, the Venetian republic's hired military leader. Previous Venetian *condottieri* had been portrayed in

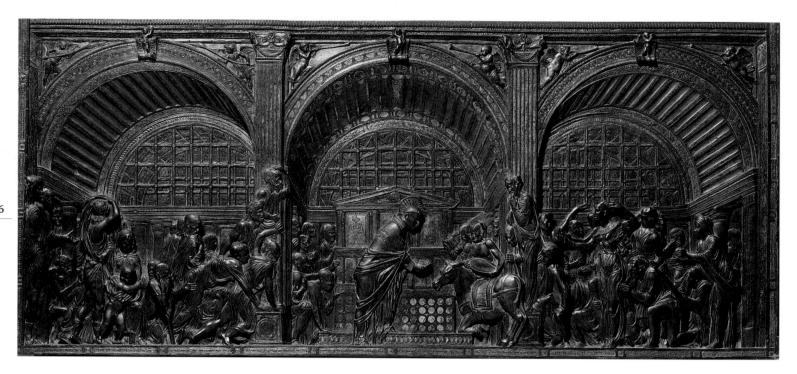

11.19 The Ass of Rimini, 1446-53, detail of the high altar, the Santo, Padua, commissioned by the governors of the Santo from **Donatello**. Bronze, partially gilt, $22\% \times 48\%''$ (57 × 123 cm)

contemporary guise, in much more humble materials, and inside churches; exterior equestrians throughout northern Italy had been reserved for rulers such as the della Scala (see Fig. 9.9) or Niccolò III d'Este, whose bronze monument in Ferrara (now destroyed) was commissioned by Leonello d'Este shortly before Donatello began work in Padua, a measure of the learned princely pretensions of rulers in the northern Italian courts. Donatello not only added some Roman features to Gattamelata's armor, he also created an idealized portrait of a Roman hero, whose stoic features reflect the Roman civic virtue of gravitas. Gattamelata sits astride a massive horse, whose pose and features suggest a crossbreed of the horses on the façade of St. Mark's and the heftier animal ridden by Marcus Aurelius then in front of the basilica of St. John Lateran in Rome in a position comparable to Gattamelata's placement before the Santo. In this formidable image the state and the individual are inextricably fused.

By removing Gattamelata from the present and recasting him as an ancient hero, Donatello avoided calling attention to the facts—discomforting to both parties—that Gattamelata represented the military force of Venice, which had conquered Padua, and that he was actually less successful as a soldier than the Venetians hoped he might be. Significantly, the monument never received an inscription, which would have tied it to a specific time and place. Instead, Gattamelata is every hero, an embodiment of virtue, the noble Roman who exhibits self-control, dignity, and pride in everything he does, a model for all viewers whatever their political or ideological allegiance.

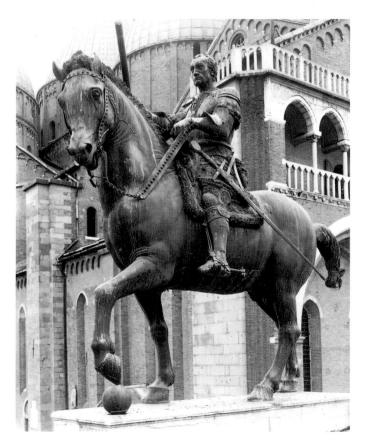

11.20 Equestrian Monument to Erasmo da Narni (Gattamelata), 1447–53, commissioned by his wife and son from **Donatello** to be placed outside the Santo, Padua. Bronze, height 12′ 2″ (3.7 m)

This is a cenotaph monument. Gattamelata's actual tomb monument and burial site are located inside the Santo.

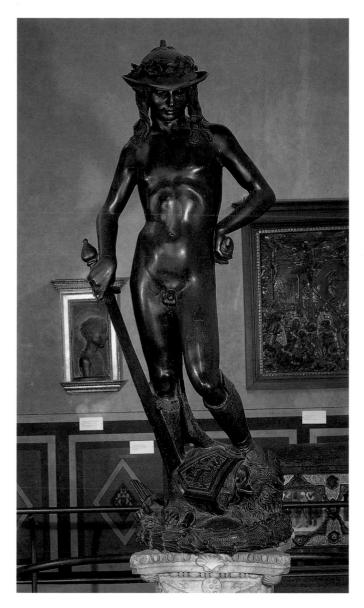

11.21 *David*, 1460s (?), commissioned most likely by Piero de' Medici from **Donatello**. Bronze, height $5' 2 \frac{1}{2}'''$ (1.58 m) (Museo Nazionale del Bargello, Florence)

The head of Goliath may be a self-portrait of the artist. An inscription, now known from manuscript sources, was in the fifteenth century on the base of the *David*: "The victor is whoever defends the fatherland. God crushes the wrath of an enormous foe. Behold! A boy overcame a great tyrant. Conquer, o citizens!"

The Medici and Donatello's Late Work

When Donatello finally returned to Florence in about 1454 after having been courted by the Opera of the cathedral of Siena, it was to work for the Medici, again in the civic medium of bronze, the material of his most recent successes in Padua. According to sources from the period, Cosimo de' Medici and Donatello had a warm personal friendship, but Cosimo's son, Piero, may well have been the actual commissioner for some of Donatello's late works for the family.

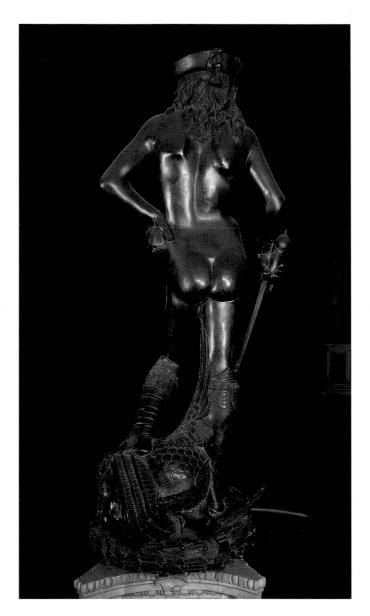

11.22 David (rear view), 1460s (?) most likely commissioned by Piero de' Medici from **Donatello**. Bronze (Museo Nazionale del Bargello, Florence)

Donatello's Bronze David and Judith and Holofernes

Donatello's bronze *David* (Fig. 11.21) is one of the best known of the Medici commissions and yet one of the most perplexing. Despite recent dating of the statue from as early as the late 1420s to as late as the mid-1460s, and recent interpretations of the figure's purported androgyny, his sexuality, and his homoerotic charge (Fig. 11.22), there are no factual records of its commission or of its patron. The *David* is first recorded in 1469 in a description of the wedding festivities of Piero's son, Lorenzo, and Clarice Orsini. The slightly smaller than life-sized statue then stood on a column in the courtyard of the Medici Palace, although there is a slight possibility that the figure may have been made for another site. The sleekly sensual depiction of the

adolescent David, who stands in a languid pose, his left foot carelessly resting on Goliath's severed head, is remarkable for its naturalism. Donatello departed however, from familiar images of David by presenting him nude, in the manner of a classical ephebe or slim, pre-pubescent boy. The unusual representation of the *David*, departing as it does both from the biblical text and from classical forms of heroism, suggests that Donatello intended to convey more than just the narrative of David and Goliath.

The Medici were, of course, aware that Donatello's earlier marble statue of David (see Fig. 10.9) stood in the Palazzo della Signoria, placed in front of a wall which was painted blue and decorated with gold fleurs-de-lys, one of the symbols of Florence. David had become a metaphor for the city, strong in protecting its freedoms from external threat. Piero's placement of the David in the private context of the palace thus appropriated civic imagery for the Medici, just as Uccello's battle paintings had (see Fig. 11.16). Contemporary awareness of this strategy of appropriation can be found in two later events. In 1476 Lorenzo and Giuliano de' Medici sold to the Signoria a traditionallyclothed bronze David by Andrea del Verrocchio (1435 Florence-1488 Venice) in their collections for placement in the Palazzo della Signoria, thus parting with the less problematic of their two Davids. In 1495, after the expulsion of the Medici from the city, the Signoria transported Donatello's bronze David from the Medici palace to the courtyard of the Palazzo della Signoria. A new inscription made explicit recognition of the civic iconography that the statue must also have carried in the family setting of the Medici Palace.

David's youthfulness is key to understanding its placement in the center of the palace courtyard (see. Fig. 11.12) where it would have been visible from the street when the main doors of the building were open. The Medici were consistent in the 1450s and 1460s in their appropriation of the imagery of youth. The young St. John for the altarpiece of their palace chapel (see Fig. 11.15) and the youthful magus standing in for Lorenzo in the same space (see Fig. 11.14) are both cases in point, as was the 1459 civic procession honoring the Pope and Galeazzo Maria Sforza. Thus David, John the Baptist, and the young magus merge civic, religious, and personal imagery as visual propaganda for Lorenzo. Piero must have suspected that his virulent gout would truncate his life, and he worked very hard to insure that his son would be able to take the reins of his family in a smooth transition. No one would have forgotten that David became King David, one of the most respected rulers of the Old Testament and founder of a dynasty. Nor would anyone have forgotten that David's history was one divinely ordained. Donatello's David provided the Medici with a powerful image of rulership that extended beyond the figure depicted-or metaphorically represented-into the future, a return to the dynastic imagery they had earlier used in the Old Sacristy and in the San Marco Altarpiece.

Some modern historians have challenged the identity of the figure as David, proposing Mercury instead. Depictions of Mercury from the fifteenth century show the god with a particular hat called a petasus, similar to that worn by the *David*. A viewer's position beneath the statue would have made the decapitated head barely visible and its identity as Goliath or Argo (whose head was cut off by Mercury) hard to ascertain. Interpretation of the statue as a Mercury would have allowed the Medici to avoid the charge of appropriation of public imagery for private use, Mercury being the patron god of merchants as well as of the arts (see Fig. 4), and thus an appropriate symbol for the family. In fact, the statue did not have to read *either* as David *or* as Mercury, but could have been read as *both*.

The sensuality of the figure still needs further study in the light of evolving understanding of gender and sexuality for the period. Since facts about Donatello's personal life are virtually non-existent, it is risky to associate the erotics of the David with Donatello's purported homosexuality. The reference in Angelo Poliziano's Daybook to Donatello "painting" his workshop assistants has a slightly kinky edge to it but falls well within the traditions of lubricious story-telling of this time: it may hint at something real or it may simply be an all-too-familiar witticism at the expense of another's sexuality. On the other hand, Poliziano and his contemporaries would have known that a paint brush (pennello) was a slang reference to penis, giving the story a more pointed meaning. The feathered wing sliding up David's right leg, invisible from the front of the statue, but clearly evident from the rear view that one would have had when re-entering the courtyard from the relaxed garden space behind the palace (see Fig. 11.22) has been used as a formal clue to the homoerotic content of the figure and thus to Donatello's homosexuality. Insofar as "bird," then as now, also refers to penis, Poliziano's story seems one that provides evidence if not of Donatello's own sexuality, then of a kind of wit based on double-entendre present in the literature of the day and most insistently, in fact, in Lorenzo the Magnificent's poetry. Recognizing this erotic charge does not, of course, explain how such meanings might have been read when the statue was in the courtyard of the Medici Palace, although the conventions that it represented were well enough integrated into the emotional and intellectual life of the period to allow the David an honorable presence in the central courtyard of the Palazzo della Signoria after 1495.

Paired with the *David* in Medici imagery was Donatello's bronze statue of *Judith and Holofernes* (Fig. 11.23) situated in the small garden area just beyond the main courtyard of the Medici Palace. As a woman who saved the Jewish nation from foreign domination by slaying the Assyrian general Holofernes, Judith is obviously a counterpart of David. In that respect she is also a civic icon. The statue is an early example of sculpture meant to be seen in the round, with no single viewpoint fixed for the observer. Judith's heavy

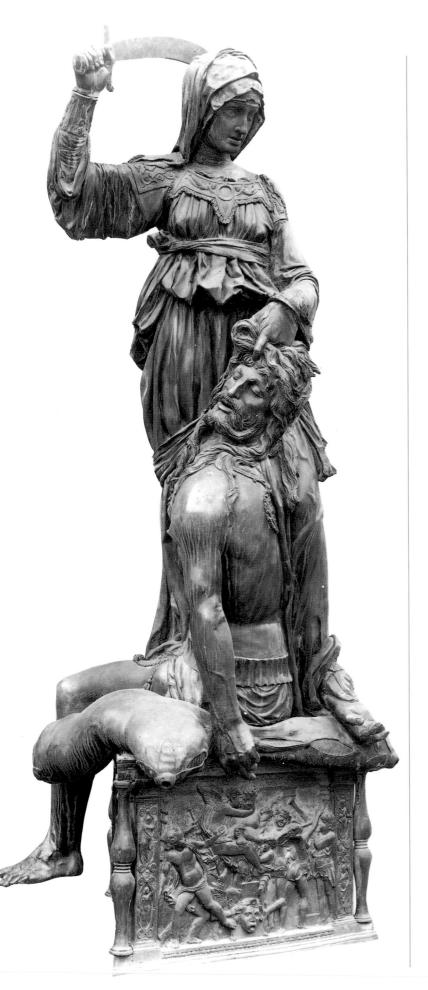

11.23 *Judith and Holofernes*, late 1450s (?), commissioned most likely by Piero de' Medici from **Donatello** for the garden of the Medici Palace. Bronze with traces of gilding, figure group height 7′ 9″ (2.36 m) (Palazzo Vecchio. Florence)

A second inscription on the original column supporting the sculpture read: "Kingdoms fall through luxury, cities rise through virtues; behold the neck of pride severed by the hand of humility." When the statue was moved to the Palazzo della Signoria in December 1495 a new inscription was placed at the top of its new base: "The citizens placed this example of public health [here in] 1495."

garments contrast with the near nakedness and overtly sensual fleshiness of Holofernes. Judith's foot is placed squarely on Holofernes's groin as her hand rises for the second time to strike at his already partially severed head. Were the Judith intended originally as fountain, it would have had water trickling from spouts (still not drilled through) in the faces of the triangular base on which the figures are placed—a startling addition of a gurgling sound to the already grisly scene. The sculpture could be interpreted simply as virtue overcoming vice, this metaphorical separation from a particular narrative perhaps underscored by the stilled raised right arm of Judith and the unprotesting body of Holofernes. However, a political meaning is clearly implied by the inscription that Piero originally placed on the group: "Piero, son of Cosimo, has dedicated the statue of this woman to that liberty and fortitude bestowed on the republic by the invincible and constant spirit of the citizens." Even in the relaxed space of a garden, Piero made reference to political liberty (as if he were not in control of the state) while at the same time including as part of the garden's decorations a newly reconstructed (by Mino da Fiesole) ancient statue of Marsyas, a satyr horrifically punished by flaying for daring to challenge a god. Like the palace itself, its decorations were designed to provide messages of civic propriety, virtue, and (sometimes not very subtle) political control.

The San Lorenzo Pulpits

Although Piero had taken charge of most Medici painting and sculpture commissions by the mid-century, his father, Cosimo, was, according to Vasari, responsible for one last, critically important commission, that for the reliefs now on two bronze pulpits in San Lorenzo (Figs. 11.24 and 11.25). The original commission for the reliefs modeled and cast by Donatello and his assistants is still unclear, since they were not completed at the time of Donatello's death in 1466 and were not incorporated into pulpits until 1515. Suggestions that they were begun as reliefs for a tomb for Cosimo, which would have been placed in the choir of San Lorenzo, or for the high altar are compelling, but as yet unsubstantiated. Their delayed placement in the church resulted in their having minimal impact on near-contemporary sculpture.

The reliefs on the south pulpit (see Fig. 11.24) narrate the *Passion and Crucifixion of Christ*, while those on the north

pulpit (see Fig. 11.25) contain scenes of the *Harrowing of Hell*, the *Resurrection*, the *Ascension*, and the *Martyrdom of St. Lawrence*. The reliefs for both pulpits are extraordinary in their expressionistic, occasionally violent, portrayal of these events. The action is compressed into a compacted space; the figures writhe and lunge. Drapery details and physical features seem gouged into the bronze, as if Donatello were deliberately rejecting the heavy volumes characteristic of his early work. The compositions of some reliefs are abruptly

cut at the edges, leaving figures sliced in half, as if the image continued beyond the frame. Donatello also placed figures in front of the pilasters separating the reliefs of the south pulpit so that they blur the boundaries between what is outside and what is inside the frame. In these reliefs Donatello has taken the expressionistic aspects of his earlier reliefs for the baptismal font in Siena (see Fig. 10.50) and for the high altar of the Santo in Padua (see Fig. 11.19) to increased intensity.

11.24 South pulpit, c. 1460-66 (placed on present column supports between 1558 and 1564; completed with reliefs by later sculptors), commissioned by Cosimo de' Medici from **Donatello** for San Lorenzo, Florence. Bronze, 48 × 145" (123 × 292 cm)

11.25 North pulpit, c. 1460-66 (placed on present column supports between 1558 and 1564; completed with reliefs by later sculptors), commissioned by Cosimo de' Medici from **Donatello** for San Lorenzo, Florence. Bronze, $54 \times 110\%$ " (137 \times 280 cm)

The Golden Age and Lorenzo the Magnificent

When Lorenzo de' Medici took charge of his family, on the death of his father Piero in 1469, he was just twenty years old. Although a masterful political tactician, Lorenzo did suffer one serious threat to his power in the city. On Sunday April 26, 1478, members of the Pazzi family and their cohorts, having been encouraged by Pope Sixtus IV, attacked Lorenzo and his younger brother Giuliano during mass in the cathedral. Giuliano was murdered, suffering twenty-seven knife wounds, but Lorenzo, though wounded, managed to escape. The Pazzi Conspiracy, as the attack is known, was brutally put down, with Medici supporters rallying in the streets of the city. The men responsible for the attack were either murdered or sent into exile. One insurrectionist even fled as far as Constantinople, only to be extradited to Florence by the sultan as a favor to Lorenzo; he was hanged from a window of the Palazzo della Signoria as a warning to any others who might challenge Medici hegemony. Lorenzo's power clearly extended far beyond the walls of the city and remained unchallenged after the Pazzi Conspiracy until his death in 1492.

Lorenzo was known as "the Magnificent" in his own lifetime because of the extensiveness of his patronage and his position within the social structures of Florence. He was a friend of famous writers, notably the Platonist Marsilio Ficino (1433–99), and Lorenzo himself wrote poetry, based on classical and traditional Tuscan models. Although he commissioned relatively few paintings and sculptures, Lorenzo used his family's resources to fund new architectural projects and to amass a collection of antique carved gems and goblets made from semiprecious stones which was one of the most remarkable of its time. He also advised a number of other families in their commissions, encouraging the arts even when works were to enhance the prestige of others—thereby establishing himself as the arbiter of taste within the city.

The Tomb of Piero and Giovanni de' Medici

Lorenzo's first major commission, the tomb of his father and his uncle (Fig. 11.26), was one he undertook with his brother Giuliano about 1470. The sculptor for the project was Andrea del Verrocchio (1435–88), who was to remain active in Medici commissions. The tomb was placed in an open arch in the wall between the Old Sacristy of the church of San Lorenzo and the double chapel owned by the Medici in the adjacent transept (see Fig. 11.1, nos. 3 and 2). The red porphyry sarcophagus is decorated by lush bronze acanthus leaves and circular green marble inserts. It is supported by lion feet, and the platform on which it rests is itself supported by four bronze tortoises. Piero's heraldic diamond ring modeled in bronze tops the sarcophagus. Every detail

of the monument bespeaks imperial power. Red porphyry is a material that was reserved in antiquity for the sarcophagi of emperors and their families. The lion is a traditional symbol of sovereignty and had been used as a Florentine state symbol for at least two centuries. Even the tortoises, attached to the motto "Festina lente" ("Hurry slowly"), refer to Augustus and Constantine, from whom Piero had adopted the motto. In commissioning this tomb monument, Lorenzo and Giuliano proved that they had learned their lessons well, for the tombs of both their grandfather and their great-grandfather (see Fig. 11.3) had employed red

11.26 Tomb of Piero and Giovanni de' Medici, c. 1470–72, commissioned by Lorenzo and Giuliano de' Medici from Andrea del Verrocchio for San Lorenzo, Florence. Marble, red porphyry, green serpentine, bronze, and pietra serena; height of arch 14′ 9½″ (4.5 m), width of plinth 7′ 10½″ (2.41 m), depth of plinth 42½″ (108 cm)

The inscription running around the marble base reads: "Lorenzo and Giuliano, sons of Piero, placed [this tomb here] for their father and their uncle MCCCLXXII [1472]." The inscription on the green serpentine tondo facing the sacristy (as in the illustration) reads: "Piero lived 53 years, 5 months, and 10 days; Giovanni lived 42 years, 4 months, and 28 days." The inscription on the similar tondo on the other side of the tomb reads: "To Piero and Giovanni de' Medici, sons of Cosimo Pater Patriae H[oc] M[onumentum] H[eredem] N[on] S[equatur]." This last formula, like all the Latin on the tomb, is pure classical Latin, indicating a refined and erudite classicist as the author. As a legal formula it indicates that the property is inviolable and cannot pass to its neighbors. It is thus a learned humanist translation of Piero's motto "Semper" ("always") into an appropriate antique indication of permanence built on legal right.

porphyry. The elegant style characteristic of this tomb was to develop in the following years into a symbol of a golden age under Lorenzo; however, at the beginning of his career a number of styles existed concurrently in Florence, each of which offered possibilities for future development.

The Mercanzia Niche at Or San Michele

In 1463 the guilds' juridical tribunal, known as the Mercanzia, bought the niche belonging to the Guelf Party at Or San Michele and commissioned Verrocchio to replace Donatello's *St. Louis of Toulouse* (see p. 204) with a new bronze group, the *Incredulity of St. Thomas* (Fig. 11.27). Piero de' Medici had been involved in this project from its outset, and before his death his place on the building committee was taken by his son Lorenzo; so it is not surprising that the *St. Louis*, the most important public symbol of their political rival, the Guelf Party, was removed. Placed on the façade of Santa Croce, a center of Guelf activity, the image of the Franciscan St. Louis could be assimilated into the order's iconography and thus be drained of its political potency.

11.27 Incredulity of St. Thomas, 1465–83, commissioned by the tribunal of the Mercanzia from **Andrea del Verrocchio** for their niche at Or San Michele, Florence, bought from the Guelf Party. Bronze, height (Christ) 7′ 6½″ (2.3 m), (Thomas) 6′ 6½″ (2 m) (Museo di Or San Michele; copy now in niche)

Verrocchio's Christ and St. Thomas have a monumentality commensurate with Donatello's splendidly classical niche in which they stand, projecting outward from its confines, Thomas's right foot placed daringly over the edge of the platform on which he stands. The Apostle's gently curving position, as he moves to place his finger in the wound in Christ's side, has some of the same lyricism as figures painted by Filippo Lippi in his later career. This subject frequently appeared in Tuscan town halls as a symbol of justice, and was thus appropriate for the Mercanzia. Perhaps as a result of the nearly two decades it took Verrocchio to complete this commission, there are slight stylistic differences between the two figures, hardly noticeable given the variant poses of the two men. Yet if the comparable swags of drapery swinging over the lower right legs of Thomas and Christ or the similar forms at the waists of the two figures are compared, it appears that the material of Thomas's garment is more intricately folded than Christ's, which recalls the heavy drapery in Donatello's early public sculpture (see Fig. 10.12). The complicated folds of material, the flowing curls of the men's hair, and the extraordinarily realistic and sensual details of the men's bodies suggest a courtly language far removed from the severities of the law-as if style were separating the idea of justice from its earlier civic context.

The Devotional Image

Beginning in the early 1470s, Verrocchio's pupil Leonardo da Vinci (1452 Vinci-1519 Amboise) began to make his presence felt in his teacher's workshop. His first major independent commission, an Adoration of the Magi (begun 1481; Fig. 11.28) for the Augustinian canons of the convent of San Donato at Scopeto, just outside Florence, marks a significant moment of innovation in the tradition of the altarpiece. Preliminary drawings give us some sense of the development of Leonardo's thinking for this painting, which is itself little more than an early and not completely resolved work in progress. A carefully structured singlepoint perspective drawing for the painting (Fig. 11.29) shows an overarching architectural scheme that forces the composition toward the frontal plane of the image, especially at its sides. Although this architecture remains in a residual manner in the planned painting, it has been pushed into the distance and much abbreviated with animated figures moving in front of and within its spaces. In the drawing, the perspective controls the image; in the painting, the figures create not just solid volumes but also spatial environments within and between groups. In the drawing, the architecture creates an artificial structure to the narrative, albeit one that certainly fits the innovations of perspective construction; in the painting, the protagonists in the narrative are the motivating forces for our understanding of the story being told.

11.28 Adoration of the Magi, begun 1481, left unfinished in 1482, commissioned by the Augustinian monks of San Donato a Scopeto from Leonardo da Vinci. Panel, 8' × 8' 1" (2.44 × 2.46 m) (Galleria degli Uffizi, Florence)

11.29 (below) Perspectival study for *Adoration of the Magi*, c. 1481, **Leonardo da Vinci**. Pen and ink, traces of silverpoint and white on paper, 6% × 11%" (163 × 290 mm) (Galleria degli Uffizi, Florence)

11.30 Adoration of the Magi, early 1480s, Sandro
Botticelli. Tempera and oil on panel, 27% × 41" (70 × 104 cm) (Andrew W. Mellon Collection, © 1996 Board of Trustees, National Gallery of Art, Washington, D.C.)

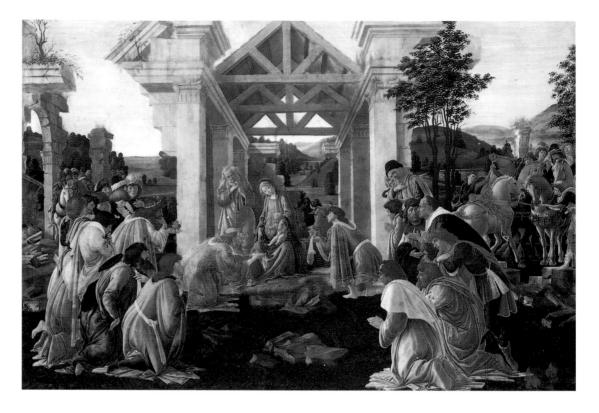

Leonardo left the Adoration of the Magi unfinished with just the underdrawing and perhaps some initial ground painted in; recent technical investigation suggests that at a later time someone added the present thick and muddy shading to make it look even more like a Leonardo (but, anomalously, a Leonardo darkened by time and dirt). The painting shows the Virgin and Child seated, surrounded by the retinue of the Magi, who kneel to present their gifts. The head of the Virgin is at the center of the composition, and her body marks the apex of a triangle created by the kneeling figures. Despite the active, gesturing poses of the other figures and the subordinate scenes in the distance, the main protagonists are locked into a stable compositional order which focuses the viewer's attention on them. In addition to the diagonal movement into the composition, the figures themselves contribute, through their poses, to the illusion of space. The Virgin's head and body are composed of a series of oval shapes, nesting one inside another—head inside upper torso, torso inside the curve of the arms. Each of these shapes turns in opposing, tilting directions, creating not only a convincingly rounded figure, but also a sense of energy in the surrounding space.

Leonardo's concern for unifying his composition extended to his use of the painterly device of *sfumato* ("smokiness") where light washes of pigment would have created shadows to blur the borders between one form and another, fusing them as if their physical forms were as continuous as the space created by the residual perspective scheme in the upper left. Some of this can be seen in the lighter areas of the painting. The current gelatinous pigment apparently added to the painting seems rather to obliterate space by

forming a flat surface on the image unrelated to the forms presumably beneath it. Although *sfumato* is technically a finishing operation added to a painting once the forms have been depicted, the underdrawing of the *Adoration* seems to indicate that even at the early stages of the painting Leonardo was preparing to use this revolutionary technique. By 1482 Leonardo had left Florence for Milan, however, and his painterly innovations were not assimilated into the studio traditions of Florence until he returned nearly twenty years later. The *Adoration*, for all of its excitement, was an event without an immediate sequel.

A contemporary painting of the same subject by Sandro Botticelli (Alessandro di Mariano Filipepi; 1445 Florence-1510 Florence; Fig. 11.30), a pupil of Filippo Lippo, is much more typical of its time, although its relatively small devotional size may have something to do with its style. Botticelli-also a student of Verrocchio-ordered his composition, too, along a carefully plotted triangle, in this case reinforced by the beams of the decaying classical architecture of the stable, a reference to the passing of the Old Law into the New with the birth of Christ. Each of the figures, however, is linearly separated from its adjacent form, the traditional Florentine sense of disegno (in this case "drawing with line" or with outline to define a sculptural volume) isolating rather than uniting solid forms. Clarity of color and a landscape that looks like a stage backdrop, rather than a continuous extension into space, are other traditional aspects of this work. Along with the artificiality of the background, the Virgin has an unnaturally elongated torso, which gives her a courtly elegance somewhat at odds with the biblical stable, but echoed in the elaborated drapery

folds of the surrounding figures. This somewhat chilly artificiality with a motion seemingly stilled in space is typical of Botticelli's work through his career.

The potentialities for this elegant and somewhat airless depiction of narrative can be seen in the work of Filippino Lippi (1457/58 Prato–1504 Florence), the son of Fra Filippo Lippi and the nun Lucrezia Buti. His *Vision of St. Bernard* (Fig. 11.31) was commissioned by Piero del Pugliese for his chapel in the Benedictine church of Le Campora outside the walls of the city. Piero appears at the lower right of the composition in the conventional—albeit remarkably naturalistic—profile pose of the donor, in this case apparently having a vision of St. Bernard having a vision. Bernard is seated, dressed in the robes of a Benedictine monk, in an ascetic stony landscape. His library shelves are outcroppings of rock which also conceal grotesque demons (at right). Their evil work is foiled by the miraculous aid that the Virgin gives to the tired St. Bernard.

A close reading of the painting, however, suggests that overcoming evil is not merely the work of divine intervention. The text that St. Bernard has propped up on the rock (close to the Virgin's face) records in legible Gothic minuscules the gospel account from St. Luke of the Annunciation to Mary, the subject, indeed, of one of Bernard's treatises, a quotation from which appears on the lower edge of the altarpiece's frame. This gospel book provides the text for the manuscript that Bernard is writing with the inspirational

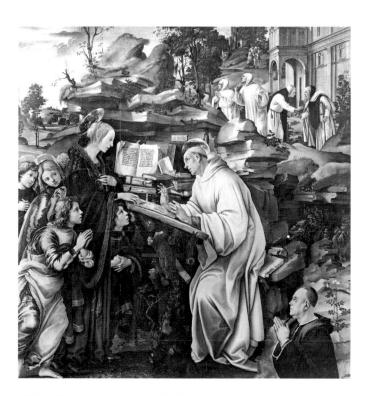

11.31 *Vision of St. Bernard*, c. 1485–90, commissioned by Piero del Pugliese from **Filippino Lippi** for a chapel in the Church of Le Campora, Marignole (outside the Porta Romana, Florence, and belonging to the Badia Fiorentina), owned by Piero del Pugliese from 1479. Panel, $6'\ 10'' \times 6'\ 5''\ (2.08 \times 1.96\ m)$ (Badia Fiorentina, Florence)

guidance of the Virgin in the painting. But Lippi-and his patron Piero—have provided a challenge to the viewer/reader. Although the text of the book on the desk is also quite legible-and written in modern humanist script meant to suggest the most advanced classical philology of the time only partial lines are visible because of the way that the book is placed on Bernard's makeshift desk. Thus the writing would serve merely as a visual clue to the Benedictine monks of the church about a text with which they were presumably very familiar—a test of their scholarship and devotion. It would also remind them (and others) of their patron's own scholarship, since he himself had carefully copied Bernard's writing and given the manuscript to the monastery library. The evident precision with which Lippi produced the two opposing scripts suggests that new scholarship is a route to understanding old truths and is a reminder that humanist research was as much involved with theological as with antique texts.

Family Chapels

Such altarpieces were parts of larger ensembles in chapels where they provided a focal point to devotional practice. Two styles predominate in the large fresco cycles painted for family chapels during this period, although in each there is an overwhelming sense of the wealth and social status of the patron.

The Sassetti Chapel Francesco Sassetti was the general manager of the Medici bank. His burial chapel, in the church of Santa Trinita, painted by Domenico del Ghirlandaio (Domenico Bigordi, 1449 Florence–1494 Florence) is composed of scenes from the life of St. Francis, Francesco's patron saint (Fig. 11.32). Sassetti and his wife, Nera Corsi, are buried in all'antica black marble sarcophagi embedded in the left and right walls of the chapel; their portraits as kneeling donors are painted on either side of the altarpiece much as Masaccio had earlier portrayed the Lenzis in his *Trinity* painting (see Fig. 10.38). The altarpiece itself, representing the *Adoration of the Shepherds*, also includes a number of classical references, attesting to Sassetti's reputation as a patron of classical scholarship.

The fresco on the altar wall just under the vault depicts the *Confirmation of the Franciscan Rule*, while the one immediately below it shows *Francis's Miraculous Resuscitation of a Boy of the Spini Family* (a hagiographic invention). In each case the scene is depicted in a Florentine location; the *Confirmation* shows the Piazza della Signoria in the background (although the event took place in Rome), and the supposed miracle in the Piazza Santa Trinita shows the church to the right and the Palazzo Spini (with the child falling from a window) in the left background. Ghirlandaio treated these scenes as historical narratives, placing contemporary Florentines in rows at the left and right as witnesses to the scenes. The clarity and didacticism of their

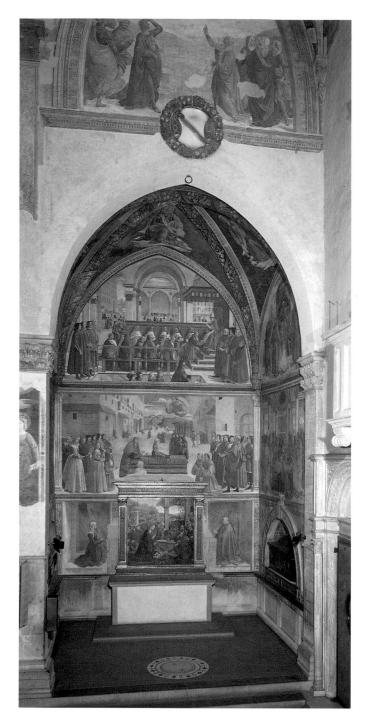

11.32 Sassetti Chapel, 1483–86, commissioned by Francesco Sassetti, with frescoes by Domenico del Ghirlandaio and black marble tombs attributed to Giuliano da Sangallo, for Santa Trinità, Florence

portrayal are reminiscent of historical frescoes such as the *Consecration of Sant'Egidio* (see Fig. 10.43).

Sassetti appears at the right of the *Confirmation* scene with his young son. Immediately to his right stands Lorenzo the Magnificent, and entering the space from a sunken stairway are Lorenzo's three children (Giuliano, Piero who was the eldest, and Giovanni who became Pope Leo X) in the company of their tutors, led by Poliziano. This fresco provides unquestionable evidence of Sassetti's status as a close asso-

ciate of the city's *de facto* ruler; Lorenzo's position is in fact alluded to in the two frescoes high on the transept wall above the chapel. One (not visible in the illustration) depicts the youthful, victorious David standing on a pedestal with an inscription dedicating it "to the safety of the fatherland and to Christian glory." The other, directly over the entrance arch to the chapel, shows the Cumaean Sibyl's prediction of the birth of Christ to the emperor Augustus, a scene appropriate both for the Nativity below and for the evocation of a golden age used by the panegyrists around Lorenzo the Magnificent. Such imagery gave Lorenzo a visible presence in the city (and outside his own neighborhood) without the possibility of a charge that he was asserting himself in ways inappropriate for a private citizen.

Ghirlandaio also painted the Adoration of the Shepherds (Fig. 11.33) which serves as the altarpiece for Sassetti's chapel. It could be argued that the choice of the humble shepherds is a pointed variation of Gentile da Fabriano's Adoration of the Magi for the Palla Strozzi Chapel (see Fig. 10.29), the room immediately adjacent to the Sassetti Chapel; and indeed the Magi can be seen winding their way through the landscape at the far left of Ghirlandaio's painting. Stylistically, however, the shepherds are close imitations of the shepherd figures that appear in Hugo van der Goes's altarpiece painted in Flanders for Tommaso Portinari. This painting had arrived in Florence in 1483 just as Ghirlandaio was beginning work for Sassetti and was placed on the high altar of the hospital church of Santa Maria Nuova, a Portinari benefice (see Fig. 10.43). This quotation is a vivid measure of how Flemish oil painting, meticulously detailed and symbolically loaded, impacted Florentine artists at the end of the century and how Florentine patrons and collectors embraced the importation of art from abroad.

At the same time that Ghirlandaio integrated Flemish elements of style and technique into his painting, he also utilized elaborate Roman classical references that underscore the humanist learning that Sassetti patronized. The Christ Child lies on the central axis of the painting, immediately aligned with the vision of the priest saying mass there, his head seeming to rest on the base of a Roman sarcophagus (cleverly bringing together the entire life cycle of Christ). The stable is supported by Roman piers, and a triumphal arch straddles the roadway bringing the Magi to the manger. These Roman remains are more than a generic evocation of a classical pagan past soon to be supplanted by Christianity, however; they are deeply descriptive of Florentine humanism at the end of the fifteenth century, which sought to synthesize all human learning into a single unified system. So, for example, the triumphal arch carries an inscription that says that Hircanus, the high priest [of the temple in Jerusalem] erected the arch in honor of Pompey in the first century B.C.E. in thanks for Pompey having spared the temple when the Romans conquered the city. This story came from the first-century C.E. Jewish

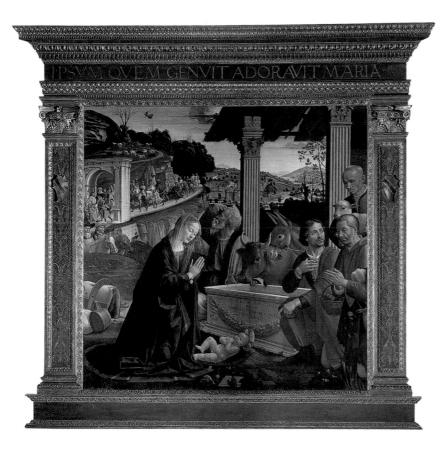

11.33 Adoration of the Shepherds, 1485, commissioned by Francesco Sassetti from **Domenico Ghirlandaio** for the altar of the Sassetti Chapel, Santa Trinità, Florence. Panel, $5'5\%''\times5'5\%''$ (167 × 167 cm)

historian Flavius Josephus's Jewish Wars, a book well enough known for a new edition to have been published in Florence in 1493, just a few years after Ghirlandaio painted this altarpiece. There was, according to modern scholarship, no high priest named Hircanus at the time of Christ's birth, nor is it likely that a high priest would have built a triumphal arch to anyone, let alone a conquering ruler. But the story is telling insofar as it suggests peaceful co-existence of opposing religious and political groups, a peace known in the first century as the Pax Augustana, and a peace that Lorenzo himself had brokered between opposing political factions on the Italian peninsula after the Pazzi Conspiracy of 1478. The past, even a fictionalized one, could be used as a moral exemplar that would usher in a time of peace and prosperity-in spite of the fact that all those who would have read the inscription on the triumphal arch would also have known that the Emperor Vespasian subsequently ravaged Jerusalem in the first century and burned the temple to the ground. Clearly, as the chief manager of the Medici bank, Sassetti had a vested interest in portraying his employer in a favorable light, as well as portraying himself as a particularly well educated man of wealth and piety.

11.34 Strozzi Chapel, 1487–1502, commissioned by Filippo Strozzi, with frescoes of the lives of St. Philip (right) and St. John (left) by **Filippino Lippi** and tomb and relief tondo of the Madonna and Child by **Benedetto da Maiano**, for Santa Maria Novella, Florence

Ghirlandaio also portrayed himself as the youngest of the shepherds, gesturing toward the Christ Child. Although artists had depicted themselves before in such narrative scenes, Ghirlandaio's proximity to the manger (closer even than the patrons) and the highlighting of his facial features give him a special prominence and liveliness in the painting. Moreover, if one follows his gaze, it is aimed directly at Francesco Sassetti, painted in fresco on the wall immediately to the right, seemingly directing the older man in a sequence of movements from eye to hand to Christ Child. Clearly the relationship between painter and patron was a special one, whether or not it would conform to our modern notion of friendship, and indicates the growing social importance of the artist in the commerce of art at this time.

The Strozzi Chapel The Strozzi Chapel in Santa Maria Novella (Fig. 11.34 and see Fig. 4.11, no. 4) illustrates an alternative style in frescoes for family chapels. Filippo Strozzi, its patron, returned to Florence in 1466 from the exile that had been imposed on the Strozzi by

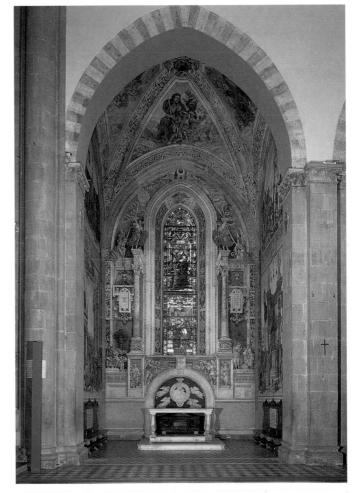

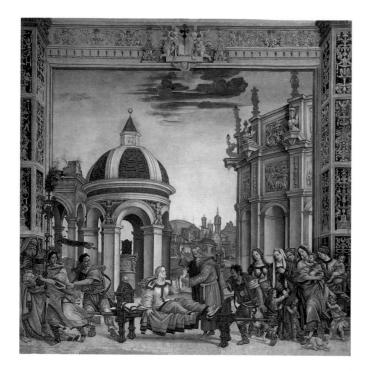

11.35 Raising of Drusiana, detail of the left wall of the Strozzi Chapel, commissioned by Filippo Strozzi from Filippino Lippi for Santa Maria Novella, Florence. Fresco

the Medici, first in 1434, then renewed in 1458. In order to re-establish his family's prominence in the city, Filippo embarked on a number of artistic projects, his funerary chapel being among the most lavish. The chapel's frescoes, best seen from a distance, were painted by Filippino Lippi between 1487 and 1502. Their elaborate, classicizing, illusionistic architecture and fictive sculptural reliefs frame a stained glass window showing large figures of the dedicatory saints, John and Philip (Filippo), also designed by Lippi. Beneath the window and behind the altar, Benedetto da Maiano provided a marble tomb whose simplicity of form belies its costly materials and ambiguous position. From outside the chapel the black marble sarcophagus appears to lie beneath the altar table, rather than behind it; this position is normally reserved for specially venerated persons such as saints. The arch containing a white marble tondo of a Virgin and Child flanked by flying angels is the same width as the altar and thus "reads" as a carved rather than a painted altarpiece for the chapel.

On the left wall of the chapel the *Raising of Drusiana* (Fig. 11.35, a subject which also appears in one of Donatello's tondi for the Old Sacristy) tells of St. John's miraculous revival of a dead woman—appropriate for a funerary chapel, but also metaphorically referenced to the Strozzi's return to Florence after over thirty years of exile. All the figures are in animated poses, their costumes elaborate confections adding both energy and elegance to the scenes. The imagined Roman architecture is also intricately detailed, an echo of Filippino's experiences in Rome during the time these frescoes were painted. The fabulous settings for the narra-

tives and allegories lend a sense of elegance and richness to the Strozzi Chapel which makes the Sassetti Chapel appear staid and decorous by comparison—a manifestation of civic virtue as opposed to the courtly splendor that characterized Strozzi Florentine commissions. The two fresco cycles provide a stylistic measure of traditional values from a family that had been central to the Medicean power structure (the Sassetti), as opposed to pictorial novelty from a patron whose family (the Strozzi) had recently returned from a prolonged exile decreed by the Medici. Filippo Strozzi asserted a fantastical *all'antica* style which definitively set him apart from Medicean public painting in the city while at the same time recalling the opulence of earlier Strozzi commissions such as Gentile da Fabriano's *Adoration of the Magi* (see Fig. 10.29).

Portraiture

The stylistic differences that are evident in fresco cycles also appear in portraiture. Leonardo's *Ginevra de' Benci* and Ghirlandaio's *Giovanna dei Tornabuoni* (Figs. 11.36 and 11.37) illustrate two distinct possibilities for portraiture during this time. Leonardo painted a perfected and perhaps idealized representation of the physical appearance of Ginevra, whose alabastrine and simplified ovoid head is haloed with a bush of juniper (the homophonic *ginepro* in Italian), thus clearly identifying her. A sickly woman, Ginevra faces the viewer with a calm, if not chilly, expression, the triangular shape of her carefully posed body

11.36 *Ginevra de' Benci*, c. 1474? and 1478/80, commissioned from **Leonardo da Vinci**. Oil and tempera on panel, 15′ ½″ \times 14′ ½″ (3.82 \times 3.67 m) (National Gallery of Art, Washington)

enhancing the air of stillness generated by her fixed gaze. A sun-filled landscape, reminiscent of Flemish painting of the time, provides a spacious and scintillating backdrop to the portrait as Ginevra is placed on a very slight diagonal responding both to the space and to the possibility for movement suggested by the glints of light shimmering through her hair. Giovanna, on the other hand, sits in stiff profile within a confining architectural (domestic) setting. Although each detail of figure and costume is meticulously presented, the bright overall light and the ram-rod pose give the figure an unnatural quality. Giovanna is dressed formally in an extraordinarily luxurious costume, her hair arranged both artfully and meticulously, and she wears a large jewel around her neck with another in the cupboard behind. Both dress and jewels function as symbols of her husband's wealth, telling details in that the painting is a posthumous portrait. She is both subject of the portrait and object of social status within the wealthy mercantile and banking culture of Florence. Her very body is encased by metaphors of male success. The inscription from Martial on the small paper behind Giovanna reinforces the idea of her role. It reads: "O art, if you were able to depict the con-

11.37 Giovanna de' Tornabuoni, 1488, commissioned from **Domenico Ghirlandaio**. Tempera on panel, 76×50 cm (Museo Thyssen-Bornemisza, Madrid)

duct and the soul, no lovelier painting would exist on earth." Thus Giovanna's conduct and the pureness of her soul—glossed by the presence of the book of hours in the cupboard behind her (and paired with the jewel to suggest both propriety and beauty)—surpass the powers of art to depict. Clearly implied, however, is the notion that art has succeeded in depicting everything else of importance.

Ginevra, on the other hand, is rather more simply attired, with little conspicuous evidence of the wealth of her family on her body, suggesting that the painting lies outside the bounds of formal portraiture commissioned to mark significant events in the sitter's life. An inscription on the reverse of the painting reads "Beauty Adorns Virtue" and describes a timeless state of being for the sitter, not unlike that implied for Giovanna. The motto is carried on a scrolling ribbon that twines around a small juniper branch and extends left and right to a circlet made of a stem of laurel and palm frond. This emblem, it turns out, is also personal to Pietro Bembo, the Venetian ambassador to Florence on two separate occasions (1475-76, 1478-80). Bembo's own motto, similar to Ginevra's, was "Virtus et Honor" ("Virtue and Honor") and was originally the decoration on the reverse of the portrait before Ginevra's device was painted over it, suggesting an exchange of the painting between them. Whatever the relationship shared by Bembo and Ginevra (both were married), the painting functioned as a special mark of the friendship between the two-Ginevra, like Bembo, was apparently a poet—and thus exists outside the conventions so carefully adhered to by Ghirlandaio for domestic or marriage portraits. Leonardo must have felt emboldened to break with convention and so portrayed Ginevra full-face staring out from the painting, though she does not quite encounter the viewer, reinforcing expectations of modesty for women in polite society. She is as still as Giovanna de' Tornabuoni. Her immovable porcelain features glow in front of darker, more freely painted foliage, originally a vivid green foil to her shining hair and soft velvet dress. In the distance Leonardo softened much of the detail and suggested atmosphere, intentionally smudging some of the surface with his own fingers and depicting the furthest trees, towers, and horizon in blue.

The Architecture of Magnificence

The Façade of Santa Maria Novella

Families other than the Medici also initiated important architectural projects in Florence during the middle years of the fifteenth century. Members of the Pazzi family built the chapter house for the monks at Santa Croce (known as the Pazzi Chapel and left unfinished after the downfall of the family in 1478; now no longer thought to be by Brunelleschi); Folco Portinari built the hospital of Santa Maria Nuova (see Fig. 10.43); and both the Pazzi and the Spinelli built large and important palaces. But perhaps the

most notable of these patrons was Giovanni Rucellai, known best for four impressive architectural projects: the façade of his palace (still incomplete; see Fig. 33) which began a radically new ordering of the traditional Florentine palace façade with its antique cornices and a rising complexity of capitals from the ground story to the roof line; the triple arched loggia modeled on the Loggia della Signoria built across from the palace as a frame for important public family events; the façade of Santa Maria Novella (Fig. 11.38); and his tomb chapel in the church of San Pancrazio, a miniature version of the Tomb of the Holy Sepulchre in Jerusalem.

The façade of Santa Maria Novella—the only completed church façade in fifteenth-century Florence-was designed by Leon Battista Alberti, who was apparently the house architect for Giovanni Rucellai since he was responsible for all four of the Rucellai projects (with the possible intervention of Bernardo Rossellino in the execution of the palace façade). A number of problems faced Alberti in designing this façade. Chief among them was the desire to unify the low side aisles of the building with the high Gothic nave of the church in a coherent compositional structure, here done in part with the architectural scrolls that curve from high in the upper structure to the exterior edge of the lower story. Alberti designed a modular façade whose main unit the second story temple form—is a perfect square with the width equal to the height from the top of the pediment to the cornice that forms its base. This module and proportions derived from it are repeated a number of times in the units for the decorative elements of the façade, further unifying the overall composition.

Alberti also clearly struggled to provide a modern—that is classicizing—façade for the Gothic church of Santa Maria Novella. The pedimented structure rising into the upper story of the façade imitates Roman classical temple forms, despite the rose window of the old building that interrupts the classical order. Alberti used a Roman religious building type as the model for his modern religious building, giving some sense of decorum in architectural imitation. The black marble columns that extend the height of the first story at the left and right ends of the façade and flanking the main portal are also classical insofar as they are capped with Corinthian capitals. On the other hand, Alberti was constrained to retain the medieval avelli or tombs running the length of the façade because the patron family of the two side doors, the Baldesi, thought that their commission granted them rights to the entire façade. The law suit that the Baldesi brought against Giovanni Rucellai was solved in part because Alberti found a way to incorporate their earlier decoration into his new design. Alberti and Giovanni Rucellai, like Brunelleschi before them, also chose to refer to the indigenous Florentine Romanesque exterior design of geometrical units of white and black marble, like the Baptistry (see Fig. 4.3), cathedral (see Fig. 4.24) and, in this case, San Miniato al Monte-all revered structures of the city. Even the Corinthian columns can be seen as part of the decorative ensemble of the Baptistry, an instance of the difficulty of separating out Tuscan Romanesque from classical Roman and a warning about reading classicizing forms in Florence exclusively as antique, even if the architect is a humanist scholar trained in antique forms and texts.

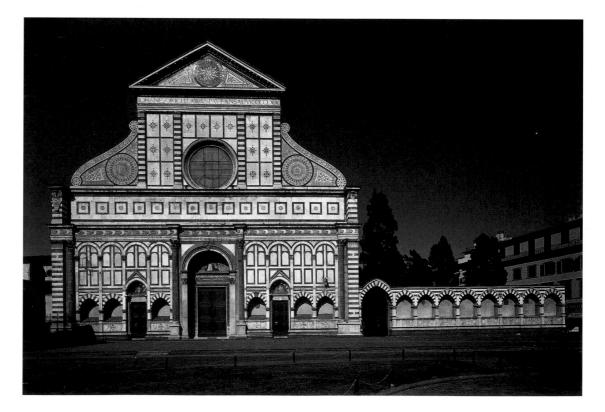

11.38 Santa Maria Novella, façade, 1458-70, commissioned by Giovanni di Paolo Rucellai from **Leon Battista Alberti**

The inscription across the façade of the building reads: "Giovanni Rucellai, son of Paolo, [made this] in the year of Salvation 1470."

281

The Strozzi Palace

Filippo Strozzi's other great commission besides his burial chapel (see Fig. 11.34) was the construction of a family palace in the heart of Florence (Fig. 11.39). The building was most likely designed by Giuliano da Sangallo (c. 1445 Florence- 1516 Florence) who, with his brother Antonio, provided a wooden model for the building in 1489. By the time of this commission, Sangallo had already built a number of other palaces in the city, including that of the Florentine Chancellor, Bartolomeo Scala, and he had worked on a number of architectural projects for Lorenzo the Magnificent. Sangallo's training had been as a woodcarver, but by 1465 he had traveled to Rome to study classical antiquity, his extensive notebooks now being one of the most important sources available to document the appearance of these monuments in the fifteenth century. Sangallo was assisted on the Strozzi Palace by Cronaca (Simone Pollaiuolo; 1457 Florence-1508 Florence), who had also spent an extended period of time (c. 1475-85) in Rome studying ancient monuments.

The exterior cornice of the building provided by Cronaca derives from the Forum of Nerva, a classical cap for a building that otherwise retains a conventional Florentine severity of masonry structure on the exterior, most notable in the smaller Medici Palace (see Fig. 11.11). Here the rustication is carried up through all three stories, the last use of an

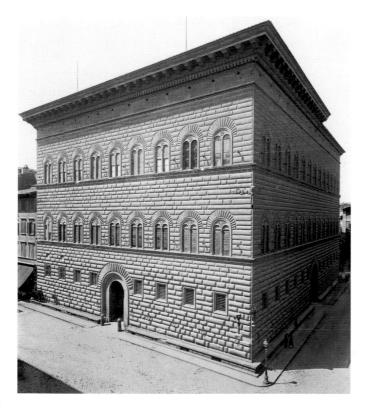

11.39 Palazzo Strozzi, Florence 1489–1507, commissioned by Filippo Strozzi from Giuliano da Sangallo with contributions from Cronaca (Simone del Pollaiuolo)

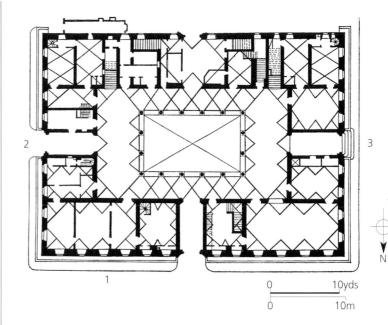

11.40 Palazzo Strozzi, Florence, plan of lower floor1 Via Strozzi; 2 Piazza Strozzi; 3 Via Tornabuoni

entirely rusticated façade in Florence. The plan (Fig. 11.40) shows that the building is symmetrical along its short central axis, each half designed for one of Filippo's two sons—a bold statement of dynastic continuity in the city after the family's long exile. Filippo Strozzi supposedly asked Lorenzo de' Medici's advice on the building of his palace and was encouraged by him to pursue the project. Thus Filippo believed that he had avoided possible reprisals from the Medici for an architectural project which overshadowed the Medici Palace in size, while at the same time Lorenzo enhanced his reputation as artistic arbiter.

Classical Antiquity and the Golden Age

One of the critical innovations of the late fifteenth century was the emergence of mythology as a subject matter for large-scale imagery. Sandro Botticelli's Birth of Venus (Fig. 11.41) shows particular stylistic aspects of this new iconography. Unlike sculpture, there was little in terms of ancient painting, other than vase painting, that was accessible to artists in the fifteenth century, although the buried imperial Roman palaces were beginning to become accessible by the 1470s. Roman and Erruscan vase painting with its linear treatments of form as well as Etruscan incised bronze vessels did give Florentine artists a possible vocabulary for figural depictions on a two-dimensional surface that was, in fact, compatible with the formal language of disegno in which they had been trained. In Botticelli's painting, the figures exist at the frontal plane of the composition, spread over the surface as if in a very shallow stage space,

11.41 Birth of Venus, 1480s, Sandro Botticelli. Tempera and oil on canvas, 5′ 9″ × 9′ 2″ (1.75 × 2.79 m) (Galleria degli Uffizi, Florence)

the background of the sea from which Venus was born being little more than a flattened stylized backdrop incommensurate in scale with the figures. Thus the figures float on the surface of the painting as do figures on ancient vases. Both the zephyr (wind) figures at the left and the figure of the Hour at the right moving to the center of the composition to clothe Venus are posed in a manner that flattens them across rather than into the space of the painting. In fact, it is virtually impossible to imagine how to construct the legs of the female zephyr, so abstractly is she conceived as lyrical surface movement. The figures' forms are clearly outlines, each distinct from the other. The artificiality of the painting-its removal from realism-gives it a quality of otherworldliness that is appropriate for mythology and for the poetics of the classical literary sources from which the tales derive. The central figure of Venus being born from the sea, her identifying seashell being propelled to shore by the figures of the winds, is a virtual copy of a Roman statue, known in many copies as the Venus pudica. Thus Botticelli chose as his model a figure whose identification was the same as the one he was to depict. At the same time he transformed the model in a way that no sculptor could have done: a vertical axis drawn from the supporting left foot of Venus runs along her right side, indicating that the entire weight of the figure lies to the right of the line, a physical impossibility for any standing figure.

Despite considerable scholarly attention, the meaning of many mythological paintings of this period remains elusive. Botticelli's *Primavera* (Fig. 11.42) is a case in point. The painting (whose title means "Spring") seems to have belonged to Lorenzo di Pierfrancesco de' Medici, a cousin of Lorenzo the Magnificent. It presents a tapestry-like frieze of

figures on a flowered ground. Space is pushed to the frontal plane by the grove of orange trees (the mala medica) behind the figures. Venus, the goddess of love, stands very slightly to the right of center, with Cupid aiming his arrow over her head. She is haloed by a laurel bush, a homophonic reference (lauro or alloro in Italian) to Lorenzo. At the far right, an icy blue Zephyrus, the wind god, begins his embrace of Chloris, the spring nymph. A leafy vine extending from her mouth mingles with the blooms on Flora's dress beside her, suggesting that the two women are two manifestations of the single concept of fertility. The Three Graces, to the left, are the counterpart of Flora and Chloris on the right side of the painting. Mercury completes the composition at the far left, perhaps part of the same extended family iconography as Donatello's David-Mercury in the Medici Palace (see Fig. 11.21). There is little interaction between the figures; Mercury, the Graces, Venus, and the group at the right remain isolated from adjacent figures. The compacting of the pictorial space, the elongated proportions of the figures, their attenuated limbs, the sensuousness of costume, and the tapestry-like landscape make this painting one of the most self-consciously artificial images of the century. The reading of the painting is episodic, moving from one figure to another. Connections are rarely made, leaving the viewer to pair figures and embroider the narrative freely, while necessarily displaying his or her classical learning.

The overt, albeit cool, eroticism of the female figures, whose diaphanous drapery does more to reveal than to conceal their bodies; the rape of Chloris at the right (and her subsequent marriage to Zephyrus); the suggestively entwined fingers of the Graces, and the location in the Garden of Venus suggest to some historians that the

painting might be a very elaborate allegory on marriage in honor of Lorenzo di Pierfrancesco's wedding to Semiramide d'Appiano in 1482. Whether the painting need be connected to a particular event is debatable. What is certain is that Botticelli, here as in the *Birth of Venus*, invented a new type of monumental painting which defies all the conventions of naturalism and narrative focus traditionally considered to typify the Renaissance. Along with Filippino Lippi, Botticelli generated a new courtly art—a visual poetry comparable to the Petrarchan love poetry written by Lorenzo the Magnificent and his close associates—for a city that still feigned belief in its republican traditions.

Further complex linkages to and equations with antique art can be seen most vividly in Botticelli's *Calumny of Apelles* (Fig. 11.43). The small size of the painting—and thus the miniature-like and extraordinarily refined detailing of the tiny figures making up the fictive sculpture decorating every surface of the background architecture—indicates that it was meant to be studied closely, each detail savored for its beauty and technical accomplishment and each individual sculptural unit puzzled over to unravel its identity. The *Calumny* is simultaneously a narrative about the Greek painter Apelles who was wrongfully accused of treason by an envious fellow painter and a reconstruction of his

painting depicting this calumny, known through a description provided by the Greek writer Lucian. Thus anyone examining the painting would have been presented with a moral allegory about deceit, envy, and calumny and at the same time an elaborate visual essay that equated Botticelli with Apelles and his painting with the very finest art of classical antiquity. Lucian's Calumny was first translated from the original Greek into Latin in 1408 by Guarino of Verona, and it was from that text that Leon Battista Alberti derived his description of Apelles' painting which he presented in some detail in his De Pictura/Della Pittura of 1435/36. Alberti recommended this painting for emulation most likely because it was one of the few pictures from classical antiquity that was so completely described by ancient authors and thus gave a clearer sense of how contemporary painters measured up to their predecessors.

The painting described in the written sources depicts a foolish king seated at the right with Ignorance and Suspicion whispering in his enlarged donkey ears, a physiological detail present in Lucian's text but not in Alberti's rendition of it, indicating Botticelli's concern for rendering the original with some degree of accuracy. Calumny, beautiful but crafty with a torch in her left hand, moves toward the king, dragging a helpless male clothed only in a violet

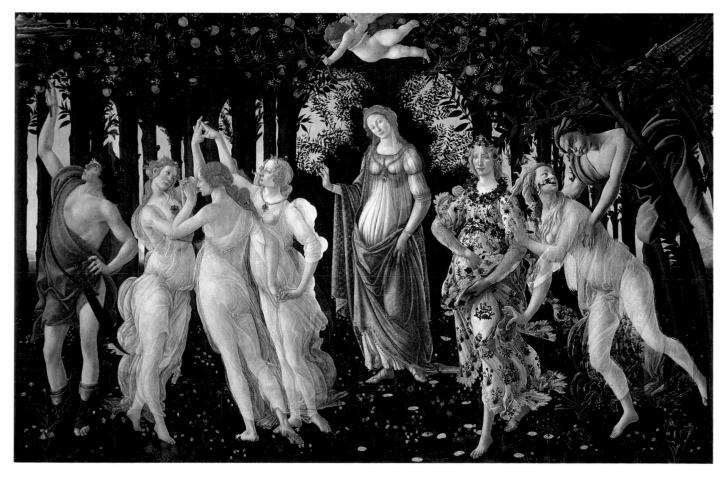

11.42 *Primavera*, c. 1482, commission ascribed to Lorenzo di Pierfrancesco de' Medici from **Sandro Botticelli**. Panel, 6′ 8″ × 10′ 4″ (2.03 × 3.15 m) (Galleria degli Uffizi, Florence)

11.43 Calumny of Apelles, 1497–98 (?), Sandro Botticelli. Panel, $24\%'' \times 36'' (63 \times 91 \text{ cm})$ (Galleria degli Uffizi, Florence)

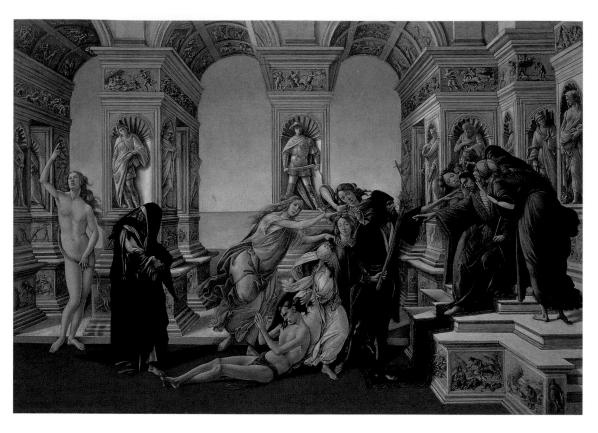

loincloth behind her. Envy and Fraud braid Calumny's hair and tend to her garment, obviously making the morally reprehensible figure deceptively attractive. A brutish and meanly clothed male figure of Hatred stands between the king and Calumny, pulling her forward with his right hand and extending the long-nailed fingers of his left hand towards the unseeing eyes of the king. At the left of the painting a nude female representing Truth is paired with a dejected, black-draped figure of Penitence, the two being opposite in all of their characteristics of body and clothing. Truth derives from a figure on an antique sarcophagus that was used both by Ghiberti for the Eve at the base of the right embrasure to the South Doors of the Baptistry (see Fig. 4.27) and also by Bertoldo di Giovanni for his bronze Battle Relief in the room of Lorenzo the Magnificent in the Medici Palace. Botticelli spread this cast of characters—each a personification of an abstract concept-across the frontal plane of the composition, compressing the bodies to conform-relief-like-to the pictorial surface.

The elaborate architectural frame backing the figures is covered with detail that relates more to the notion of Botticelli's abilities as a painter and a reproducer of antiquity than to the subject of Calumny. The relief on the main step of the throne parallel to the plane of the painting depicts a family of centaurs, a sly doubling of the main reference to Lucian, since it is another replication of an antique painting by Zeuxis described in Lucian's Zeuxis. Diagonally adjacent to it is a relief of Jupiter and Antiope, with Jupiter taking the form of a shepherd to approach the nymph, itself a form of deceit. Not all the fictive reliefs

depict classical myths. The vault of the left arch has reliefs depicting Boccaccio's tale of Nastagio degli Onesti, a story that Botticelli himself had painted for Lorenzo the Magnificent. The vault of the second arch from the left depicts scenes from the history of the Roman general Mucius Scaevola, a moral exemplum opposed to the immoral tale of the Calumny. The standing female figure in the niche at the far right represents Judith with the head of Holofernes at her feet, a shift from antique to Christian subject matter. Thus each of the sculptures challenges the viewer's grasp of mythology, ancient history, and Christian narratives, here intertwined compositionally and suggesting a syncretistic knowledge that ignores differences between different times and cultures.

The reason for Botticelli's choice of subject, other than the artistic, is not clear. He ultimately gave the painting to Antonio Segni, a Florentine banker who worked with the papal Curia, becoming master of the papal mint in 1497. When or why Botticelli did this is not certain. Nonetheless, he must have assumed that Segni would have understood the complex antique references that the painting depicts. Segni's son, Fabio, added an inscription to the painting that Vasari saw when he was preparing his *Lives* for publication: "This little picture warns the rulers of the earth to shun the tyranny of false judgment. Apelles gave its like to Egypt's king [Ptolemy IV Philopator]. That king was worthy of the gift and it of him." The inscription, although later, is instructive in suggesting the exchange that occurred in gift giving of this period, one of intellectual reciprocity as well as patronage.

Art and the Collector

Since a reverence for classical antiquity was a natural outgrowth of humanist scholarship and education during the Renaissance, it is not surprising that collectors began to assemble objects such as ancient Greek and Roman sculpture, gems, and coins, both for study and as signs of their learning and culture. Already in the early fourteenth century Oliviero Forzetta (1300-72), a merchant from Treviso, was seeking such objects from dealers in Venice. In the midfifteenth century, the sculptor Lorenzo Ghiberti claimed in his Commentaries to have a small collection of ancient sculpture, and Donatello was sometimes called upon to appraise the authenticity and value of newly discovered works. Artists became important players in the burgeoning market for objects of ancient art. Since large-scale free-standing ancient sculpture was still extremely rare in the early fifteenth century, collections tended to be of smaller objects such as gems and coins, as well as reliefs and fragments. Thus the precious appearances of the collections echoed those amassed in the previous century by the French royal house and the dukes of Berry. Because of their rarity, such objects were greatly prized and aroused a competitive spirit among individual collectors. Piero de' Medici's illegitimate brother, Carlo, complained that he had been forced to relinquish a collection of important Roman coins because Pope Paul II wanted them for himself. Lorenzo the Magnificent subsequently triumphed in this collectors' contest when he bought virtually all of Paul's collection from his successor, Sixtus IV.

Agents were active for private collectors, seeking to provide their employers with the best examples of classical sculpture and often resorting to overstatements of value and to outright stealing to achieve their goals. Although small objects such as coins were kept in private studies, marbles were placed in the gardens of private palaces, often in a random manner. When the Laocoön (see Fig. 40) was discovered in a Roman vineyard on January 14, 1506, it was appropriated by Pope Julius II for his collection, which already included the Apollo Belvedere, and placed in a niche at the end of the Cortile del Belvedere constructed especially to house it.

The rarity of such free-standing largescale figures made them so desirable that a virtual cottage industry of replication—and forgery—developed to meet the demand.

Early in his career Michelangelo deliberately forged an Eros figure for sale in Rome as an antique. He may have done the same with the Bacchus (Fig. 11.44), seen in a drawing from the period standing amid antique fragments in the sculpture garden of Jacopo Galli, a Florentine banker and friend of Michelangelo's. Today it is valued as an early work of outstanding delicacy and sensuality by Michelangelo, but when it was made in 1496, by a young and virtually unknown sculptor, and grouped with ancient sculpture, it could well have seemed an exceptionally well-preserved antique statue. By the time Heemskerck drew this view of Jacopo Galli's garden, the family was apparently dispersing the collection. Nonetheless the drawing does give some indication of the picturesque nature of such gardens, themselves giving every appearance of a site of classical ruins. Some of the sculptural fragments lie propped against walls as if they were put down in the first available space when they were carried in, while others, like the figural relief, were set into the wall and still others, like the reclining figure in the background, were placed on columns, themselves probably antique fragments.

11.44 Jacopo Galli's Garden in Rome, c. 1532–35, Martin van Heemskerck. Pen and ink on paper (first volume of Heemskerck's sketchbook, fol. 72r, Staatliche Museen, Berlin)

The central standing figure is Michelangelo's *Bacchus* (1496).

Antiquarianism

From the beginnings of humanist study in the fourteenth century, objects of antiquity were prized because-like ancient manuscripts-they helped people to form a truer picture of classical civilization. By the later part of the fifteenth century princely connoisseurs throughout central and northern Italy were amassing significant collections of ancient sculpture, coins, and gems. Lorenzo de' Medici added to the collections of these objects begun by earlier generations of his family and acquired ancient goblets and plates made of precious materials which were displayed on special occasions as a sign of his magnificence. In fact the first mention of Donatello's David (see Fig. 11.21) focuses on a display of gold plate that was arranged beneath its column support. In an inventory of Lorenzo's collections made at his death in 1492 the costliest object was a sardonyx cameo cup 8 inches (20 centimeters) in diameter, now known as the Farnese Cup, which was valued at 10,000 florins, roughly one-third the cost of the Strozzi Palace (see Fig. 11.39). As a further comparison, twelve years later Michelangelo received approximately 400 florins for over three years' work carving the *David* (see Fig. 17.1).

When the antique is refabricated in a self-conscious manner, however, its feigned presence requires careful scrutiny. In one of his most noteworthy acts of patronage, Lorenzo the Magnificent commissioned Giuliano da Sangallo to build a country villa at Poggio a Caiano. Different from traditional, irregularly shaped, crenellated villas (see the example in the background of Fig. 11.14), the residence Sangallo designed was worthy of a humanist prince (Figs. 11.45 and 11.46). He arranged the rooms symmetrically, raised the building on a platform (recalling Vitruvius's comments about the nobility of raised buildings), and marked the entrance itself with a Roman temple portico. Like Botticelli's Primavera or Filippino Lippi's now ruined fresco of the Laocoön myth in the entrance portico of the villa itself, the villa creates another world, evocative in its claims to the ideal, but fundamentally romantic in its artificiality.

The appropriation of the antique seen at Poggio a Caiano was taken to much greater lengths in an early work by an artist destined to be antiquity's greatest rival, Michelangelo Buonarroti (1475 Caprese-1564 Rome). Most likely carved in a studio maintained by Lorenzo the Magnificent in a garden area bordering the piazza in front of the monastery church of San Marco, the Battle of the Lapiths and the Centaurs (Fig.

11.45 Villa Medici, Poggio a Caiano, plan of upper floor

This plan shows the presumed original position of the outside stair ramps.

11.46 Villa Medici, Poggio a Caiano (outside Florence), 1480s, commissioned by Lorenzo de' Medici from Giuliano da Sangallo

11.47 Battle of the Lapiths and the Centaurs, c. 1492, **Michelangelo**. Marble, $33\% \times 35\%''$ (84 × 89 cm) (Casa Buonarroti, Florence)

11.47) is a small relief masquerading as a work of antique sculpture. As on Roman battle sarcophagi, the figures twist not just to suggest the animated frenzy of the battle but also to maintain the relief plane of the sculpture. Space for the densely compacted figures extends vertically rather than into a recessional background. The relief seems to adhere both to antique conventions in sarcophagi and to late medieval uses of those same conventions (see Fig. 5.6). The Battle of the Lapiths and the Centaurs, like Pollaiuolo's Hercules and Anteus (see Fig. 11.17) and the Villa Medici at Poggio a Caiano, blurs the boundaries between the real antique artifact

and the counterfeit so that the possessor can claim the attributes—and the power—of the culture he recreates. This is not a new idea in the history of art. But to counterfeit objects as collectors' items suggests that the value of the image—and its message—resides in its being perceived as an object of art. The connection between collector and ruler would have been obvious, since great rulers in antiquity were known to have amassed extensive and notable collections of art.

The Florence of Lorenzo the Magnificent was one in which republican and civic imagery and values were increasingly displaced by princely and aristocratic ones. While bank managers like Francesco Sassetti continued to commission works rooted in a formal everyday reality, the elite in the social hierarchy—notably the Medici and the Strozzi—supported artists who created lyrical visions of classical antiquity.

Savonarola and Reform

In 1490 a new voice in Florence began to condemn the very luxury that such objects represented. Girolamo Savonarola began his successful preaching in Florence then, and in 1491 he became prior of the monastery of San Marco, the very foundation that Cosimo de' Medici had so generously patronized. Despite his particularly demanding approach to personal morals and ecclesiastical reform, his public sermons drew many hundreds of listeners. He used the model of traditional Florentine youth confraternities as ways of mobilizing young men and boys as leaders of his moralizing crusade which included the famous bonfires of the vanities when, during Lent in 1497 and 1498, Florentines were encouraged to burn objects of luxury and of profanity in large public bonfires in the Piazza della Signoria. We have little information about what actually was burned, but along with jewelry, cosmetics, cards and other gambling items, and most likely some books, there may also have been profane paintings.

Many of Savonarola's sermons were published in the vernacular and provide strict moral lessons for the Christian life. Some of these sermons are accompanied by illustrations (Fig. 11.48) that provide simple visual lessons that would have been quicker to comprehend than the sermons. In The Art of Dying Well both devils and angels wait for the death of the sick man lying in bed. This competition for the souls of the dead is quite conventional (see Figs. 8.1 and 8.2); on the other hand, the setting is a domestic interior that gives a human dimension to the issue of a life well or badly lived that will determine whether angel or devil is successful in carrying away the soul of the dying man. Interestingly, before Martin Luther, Savonarola clearly understood the power of the printed book and its illustrations to carry the preacher's message, and to act as a powerful propagandistic device for carrying the ephemeral preached word to a wider audience over time.

Savonarola's reforms ultimately involved him in Florentine politics. He (wrongly) saw the French king as a potential ally in moral reform, particularly of the Church, then headed by Pope Alexander VI, one of the most licentious popes of the Renaissance. Savonarola's pro-French politics ran afoul of this Spanish pope whose policies were anti-French. His preaching became more and more rabidly apocalyptic, leading him at one time to claim that in a vision he had seen a sword hanging over Florence that was interpreted as a French threat of invasion. Savonarola's castigation of the pope caused Alexander to excommunicate him in 1497, an excommunication that the friar ignored, thus putting the political relationship between the city of Florence and the papacy in jeopardy. The anger of the Pope and the increasing threat of French invasion ultimately caused the Florentine Republic to act. Savonarola was forcibly hauled out of San Marco, tortured, tried as a heretic, hanged with two of his companions until they were nearly dead, and then burned at the stake. His ashes were later thrown into the Arno so that no relics would remain. Savonarola's popularity had been intense and continued in an abated manner after his politically motivated execution, although his followers-called piangnoni or weepers-were considered suspect by the state and thus became very circumspect in their activities, making it especially difficult to posit Savonarolan meaning in images of the period.

One of the very few paintings that can be connected to Savonarolan reform is Botticelli's *Mystical Nativity* (Fig. 11.49). Botticelli has depicted a standard nativity scene at the center of the composition with two shepherds at the right and three kings at the left. But he framed the familiar with the addition at the top of a ring of angels—descending

11.48 The Art of Dying Well, c. 1470, **Unknown Master**. Woodcut, $8\% \times 6\%''$ (219 \times 162 mm)

in a dance-like movement from a circular golden hole in the heavens—and at the bottom of three nearly identical pairs of embracing angels and men placed before a rocky ledge at the base of which are small demons apparently prostrate in defeat because of the union of the earthly and divine. The angels at the top, swinging what appear to be crowns, descend from a light-filled but undefined space, just as did angels in mystery plays with stage machinery designed by Brunelleschi. Thus, despite the elongation and lilting repeated rhythms of the figures, and the radical shifts in scale between the different figural groups, the painting would have recalled popular theatrical imagery of the time in a curious mix of realism and artificiality. Across the top

of the panel is a lengthy and complicated inscription in Greek: "This picture, at the end of the year 1500, in the troubles of Italy, I Alessandro, in the half-time after the time, painted, according to the eleventh [chapter] of Saint John, in the second woe of the Apocalypse, during the release of the devil for three-and-a-half years; then he shall be bound in the twelfth [chapter] and we shall see [him buried] as in this picture." The eleventh and twelfth chapters of the Book of Revelations refer to the birth of Christ, to the death and resurrection of prophetsalbeit two rather than three as we see in the foreground of the painting, and to the confounding of the devil by the angels-apparently what we see in the lower section of the painting. Whether Botticelli painted this picture for himself ("I Alessandro"), since he was a sympathizer of Savonarola's (and his brother was a piangnone) or for a patron learned in Greek is not clear from the inscription. But the references to the Apocalypse seem clearly connected to Savonarola's preaching and to the visionary nature of Revelations. The fact that the picture is a small, private devotional image indicates how careful its owner was being, given the prosecution of piangnoni after 1498. Indeed, there seem to be no large-scale images that can be securely connected to Savonarola or his preaching.

As with earlier historical periods and with the art of other Italian cities, Florentine art of the fifteenth century, despite its clear innovations in volumetric presentation and rational spatial environments, also manifests a variety of styles that depended upon patron, typology, and the intentions carried by the image. It would be difficult to draw a direct line of development from Masaccio to Botticelli, but not so difficult to see stylistic relationships between Gentile da Fabriano and Botticelli. The personality of the artist was certainly one component in the evolution of style in fifteenth-century Florence and of subsequent interpretations of it, as Fra Angelico's nickname ("the angelic one") indicates, but site, subject matter, and patron also played a role in developing the rich and sometimes contradictory character of Florentine art of this time.

11.49 Mystical Nativity, 1500, Sandro Botticelli. Tempera on canvas, $42\% \times 29\%''$ (108.5 \times 75 cm) (National Gallery, London)

Rome: Re-establishing Papal Power

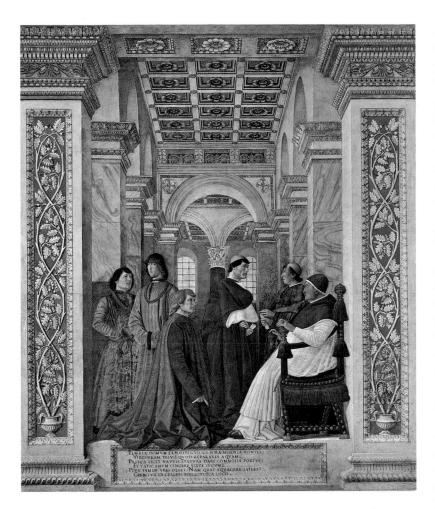

he election to the papacy of Martin V (Oddo Colonna, r. 1417-31; see Fig. 9.27) at the Council of Constance in 1417 ended more than 100 years of disruption within the Church, which had begun in 1308 with the removal of the papal court to Avignon, and was followed in 1378 by the Great Schism.

Martin V, Eugenius IV, and Nicholas V

Martin was a member of one of Rome's oldest and most powerful families, the Colonna, which gave him a local power base. When he finally entered Rome in September 1420, he found a city that was essentially an urban backwater, having suffered a century of neglect by the papal court, which had been its chief source of artistic patronage. Things had not significantly improved when Eugenius IV (r. 1431-47) was elected pope in 1431. Venetian by birth and not accepted by the Roman population, Eugenius's popularity had reached such a low ebb by June 1434 that he fled the city, disguised as a monk, sailing down the Tiber in a little boat. He was received by the city of Florence, where he lived in the papal apartments at Santa Maria Novella until his success in uniting the Eastern and Western Churches at the Council of Ferrara-Florence in July 1439 gave him enough support to consider returning to Rome, which he finally did in 1443.

By mid-century conditions were improving markedly in the city and for the papacy, so upon his election in 1446, Nicholas V (r. 1447-55) declared that the year 1450 would be a Jubilee Year—an event designed to focus attention on the strength of the Church and on Rome. The Jubilee necessitated the continuing renovation of both civil and religious structures in the city in order to accommodate the thousands of pilgrims that were expected and that did arrive.

Martin V, Eugenius IV, and Nicholas V were each well aware that traditions in Rome overrode drastic change; thus, with varying success, each referred to the history of the papacy and to well-established sites of papal patronage as he attempted to re-establish the papal office on a sure footing after a

long period of schism and absence from the city. They were keenly aware that while the papacy functioned as an absolute monarchy within Rome, it was an elected and not a dynastic one; so their legitimacy depended upon establishing strong links with their predecessors.

(above) Sixtus IV Confirming Platina as Papal Librarian, variously dated 14///8 or 1480-81, commissioned by Sixtus IV from Melozzo da Forli for the Vatican Library, Rome. Fresco now detached and transferred to canvas, 12' 1½" × 10' 4" (3.7 × 3.15 m) (Musei Vaticani, Rome)

The inscription beneath the figures, over which Platina's cape extends, reads: "Sixtus, because you restored the churches, palace, streets, forums, walls, bridges, and the Acqua Vergine (Trevi) which had been abandoned, [and] though you are determined to restore the ancient benefits of a harbor to sailors, and to encircle the Vatican Hill, yet the city owes more to you for the library which was in obscure decay and is now in a famous location.'

A Cautionary Fresco

The unsettled and sometimes threatening aspects of urban life in fifteenth-century Rome that papal urban projects were intended to counter can be seen in a set of sixteenth-century drawings of now-lost frescoes from the left transept of the papal basilica of St. John Lateran. The frescoes represented the arrest and execution, in 1438, of two men who had stolen precious gems from the reliquary busts of saints Peter and Paul kept in the tabernacle over the main altar of the basilica. The criminals were taken to the church of Santa Maria in Aracoeli on the Capitoline Hill, stripped of their clothing before the high altar, placed in a wooden cage (Fig. 12.1), and taken to the Campo dei Fiori, one of Rome's oldest and most popular open markets. There, after having had their right hands cut off, they were burned at the stake while an accomplice was hanged from a tree.

The original frescoes thus commemorated a theft that had occurred in the very place in which they were painted and indicate that contemporary secular events could form part of the decorative program within a church. This narrative is portrayed in a straightforward, didactic, and hard-hitting manner—although its warning of the punishments awaiting those who stole Church property was not always heeded. Papal coats-of-arms, prominently displayed in the

12.1 Execution of Capocciola and Garofalo, sixteenth-century drawing after a fresco commissioned by Angelotto da Foschi in 1438–40 for St. John Lateran, Rome. Ink on paper glued to cardboard (Archivio Capitolare Lateranense, Rome)

The drawn record of these destroyed frescoes suggests the existence of other contemporary secular history painting almost all of which is now lost.

frescoes, also suggest a warning to anyone who would dare to attack the papacy, whose church this was, an offence tantamount to the gross sacrilege of defiling relics.

The Papal Basilicas

In 1427 Pope Martin V issued a bull ordering building and restoration at the Lateran Palace, St. John Lateran, St. Paul's Outside the Walls, and the portico of Old St. Peter's, clearly an impressive attempt to renew the Church; like St. Francis, Martin had a sense that he was "rebuilding the church" in both a literal and a figurative manner. In choosing these major sites of earlier papal patronage, with the continuity that this implied, Martin attempted to draw a veil over the papacy's absence from Rome during the previous century. These basilicas were important because they were built as imperial foundations during Christianity's early years as the state religion in Rome. As such they had become important symbols of papal rulership, enriched over time through repeated papal decorative interventions and through gifts of important relics. Thus they became important pilgrimage sites that not only manifested the great strength of Christianity but also demonstrated its governance by a long line of popes extending back to St. Peter.

Santa Maria Maggiore At the basilica of Santa Maria Maggiore, located in the traditional enclave of the Colonna family in the city and previously the recipient of Colonna patronage under Nicholas IV (see Fig. 2.6), Martin (or another member of his family) commissioned a large double-sided altarpiece (Fig. 12.2) from the Florentine painters Masolino and Masaccio (there being no local school of artists because of the papacy's century-long absence from the city). Presumably intended for the main altar, the Santa Maria Maggiore Altarpiece was the first such painting to be commissioned in Rome since the Stefaneschi Altarpiece for the canons' chapel of Old St. Peter's over a century earlier (see Fig. 2.13). Masolino was responsible for this now-dismembered triptych, although Masaccio contributed figures for at least one of the side panels. The central panel of the altarpiece facing the congregation depicted the Assumption of the Virgin, an appropriate subject for a Marian basilica. From the nave of the building this subject would have aligned with the mosaic of the Coronation of the Virgin in the apse (see Fig. 2.6). On the central panel of the side of the altarpiece facing the apse is a depiction of the foundation of the church by Pope Liberius, with the Virgin and Christ looking down from a roundel. This event took place in August 352, when a miraculous fall of snow formed the plan of the building on the ground. The same subject is depicted in the mosaics on the façade of the basilica; the altarpiece thus emphasizes the continuous history of the Church.

In the panel to the right of the *Foundation* is a figure of St. Martin of Tours, dressed in his bishop's regalia. His cope

is embroidered with heraldic Colonna columns (the meaning of the family name), which—along with his strongly characterized features—suggests that this figure may also be a portrait of Martin. All the figures share the intense expressions and weighty presence of those in the Brancacci Chapel frescoes (see Fig. 10.35), despite being placed on a gold ground in an iconic, rather than a narrative, context.

St. Peter's Of all the papal basilicas, none could rival the importance of Old St. Peter's and the adjoining palace on the Vatican Hill, the burial site of the first pope and a site connected as no other with the office of the papacy. Thus when Eugenius made his first, interrupted return to the city after his flight in 1434, he made sure to mark that event with a major artistic commission at Old St. Peter's: a set of silver-gilt bronze doors for the main entrance to the basilica (Fig. 12.3). Commissioned from Filarete (Antonio Averlino, c. 1400 Florence–1469 Rome?), the doors were not completed and installed until 1445. The upper two panels

represent enthroned figures of God and the Virgin. Here the Virgin is again a metaphor for the Church, as in late medieval Roman apse mosaics (see Fig. 2.6). The papal saints, Peter and Paul, are the subjects of the cen-

tral panels. Eugenius IV, his name clearly inscribed, kneels as a donor before St. Peter, his predecessor and the saint to whom the church is dedicated. Below each of the saints is a narrative relief depicting the scene of his martyrdom, echoing similar painted images in the then extant atrium of Old St. Peter's. Silvering and inlaid colored glass originally brightened the major reliefs of the door.

Filarete's doors for St. Peter's could not be more different from Ghiberti's breathtakingly naturalistic doors for the Florentine Baptistry (see Figs. 10.5 and 10.59), which he must have known. The four isolated single figures in the upper four panels are flattened against an essentially blank background and are posed in a stiff, iconic manner, deliberately alluding to an Early Christian style, appropriate for this building, built in the mid-fourth century. The two large narrative reliefs of martyrdom have the slightly disjointed quality of Roman relief friezes from Trajan's Column. It is clear that Filarete wished to convey a sense of distance and spatial recession, despite the vertical perspective he employs.

The curving foliate pattern filling the outside frames of the doors is also related to stylized imperial Roman examples, although the figurative and animal forms that enliven it are naturalistically rendered. Within the circular curves of the vegetation, Filarete included roundels of male and female heads, some of

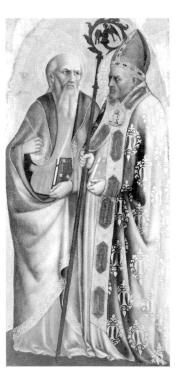

12.2 Santa Maria Maggiore Altarpiece, commissioned by Martin V (?) from **Masolino** (with collaboration by **Masaccio**) for the high altar (?) of Santa Maria Maggiore, Rome, c. 1423–27. Shown in the illustration is the Founding of Santa Maria Maggiore, tempera on panel, $56\% \times 30''$ (144 × 76 cm) (Gallerie Nazionali di Capodimonte, Naples), flanked by side panels representing St. Jerome and St. John the Baptist (attributed to **Masaccio**) (left) and St. John the Evangelist and St. Martin of Tours (right). Tempera, oil, and tooled gold on panel, $45\% \times 21''$ (155 × 55 cm) and $39\% \times 32\%''$ (100 × 52 cm) (National Gallery, London, and John G. Johnson Collection, Philadelphia Museum of Art)

which derive from ancient Roman coins, extending the interest in medallic art that had already appeared in northern Italy in the late fourteenth century (see Fig. 9.15) and which was being promoted in Filarete's lifetime by Pisanello (see Figs. 14.1 and 14.2).

In the narrow horizontal strips between the panels, Filarete inserted diminutive narrative scenes of the Holy Roman Emperor Sigismund in Rome in 1433 for his coro-

12.3 Doors of Old St. Peter's, 1445, commissioned by Eugenius IV from **Filarete** (**Antonio Averlino**) for the main entrance of Old St. Peter's, Rome. Silver-gilt bronze, 20′ 8″ \times 11′ 9″ (6.3 \times 3.58 m) overall (St. Peter's, Rome)

12.4 Doors of Old St. Peter's, detail of left valve under St. Paul showing *Emperor Sigismund Returning to the Castel Sant'Angelo*, with Antonio de Riddo, the castellan, at the left, and the emperor and the pope approaching him on horseback

Eugenius's coats-of-arms are shown on the right shield hanging from the portal of the castle. The inscription above the relief refers to the union of the Greek, Armenian, and Ethiopian churches with Rome as a result of the Council of Ferrara-Florence.

nation in St. Peter's (Fig. 12.4) and of the arrival of the Byzantine court in Italy for the meeting of the Council of Ferrara-Florence. Eugenius's concern to have these important successes of his reign accurately and fully recorded is evident in the careful labeling of people and places in the reliefs and in the portraits they contain. Contemporary and biblical history, then, rely on models that support the claims of the papacy to rulership by making Roman imperial forms an official papal language. Ironically, despite the admonitory fresco in St. John Lateran showing the punishment of thieves, Filarete himself had to flee Rome in 1447, having been charged with stealing the reliquary head of St. John from the Lateran Basilica.

Nicholas V, Eugenius's immediate successor, had even more ambitious plans for Old St. Peter's (Fig. 12.5). His new choir increased the length of the nave of the basilica by a third, and new transepts provided substantial additional space around the main altar marking the burial site of St. Peter in the crypt below. Like his predecessor Nicholas III (r. 1277-80), Nicholas V intended to enhance the burial site of Peter, thus emphasizing his lineage from the first pope and underscoring the continuous spiritual power of the papacy. To this end, he had four large columns taken from the Pantheon to St. Peter's, an acquisition asserting equality between Nicholas and the emperor Hadrian, builder of the Pantheon—one that would have been an important opening salvo in the transformation of the Vatican into a new imperial city. Nicholas also planned to move the ancient obelisk erected by the Roman emperor Augustus, then at the side of Old St. Peter's, to the piazza in front of the basilica, a change of location that did not happen until the end of the sixteenth century. With these Roman remains Nicholas asserted claims to the temporal power of the Roman emperors just as he claimed the spiritual power of Peter.

The Vatican Palace

Simultaneously with his work at St. Peter's, Nicholas initiated major architectural projects at the Vatican. These consisted of new fortifications to protect the Vatican from outside attack and from internal Roman factionalism (see

293

Ruins and Dreams

Ancient Rome had always held power over the imaginations of pilgrims to the city and of the humanist scholars who studied its history. Poggio Bracciolini (1380-1459) wrote this lament on the fickleness of fortune in 1430, just as the papacy was beginning to re-establish itself in the city and to restore some of its most venerated structures. Poggio's Rome, however, was not the Rome of the popes but the Rome of the emperors, sadly all but disappeared by the time of his writing. At the heart of Poggio's text is an implied claim that contemporary civilization was a quiet echo of what it had been during antiquity. He also insinuates that a reconstruction of ancient Rome, known to him more through ancient texts than through actual monuments, was to be gained through precise scholarship and the collecting and accurate reading of inscriptions-an area in which he criticizes no less a humanist than Petrarch.

Not long ago, after Pope Martin left Rome shortly before his death for a farewell visit to the Tuscan countryside, and when Antonio Lusco, a very distinguished man, and I were free of business and public duties, we used to contemplate the desert places of the city with wonder in our hearts as we reflected on the former greatness of the broken buildings and the vast ruins of the ancient city, and again on the truly prodigious and astounding fall of its great empire and the deplorable inconstancy of fortune. And once when we had climbed the Capitoline hill, and Antonio, who was a little weary from riding, wanted to rest, we dismounted from our horses and sat down together within the very enclosures of the Tarpeian ruins, behind the great marble threshold of its very doors, as I believe, and the numerous broken columns lying here and there, whence a view of a large part of the city opens out. . . .

"You may turn all the pages of history, you may read all the long-drawn-out records of the authors, you may examine all the historical annals, but you will find that fortune offers no more striking example of her own mutability than the city of Rome,

the most beautiful and magnificent of all those that either have been or shall be, the city which was described by Lucian, the learned Greek author, when he was writing to a friend of his who wanted to see Rome, as not so much a city as a bit of Paradise. How much the more marvellous to relate and bitter to behold, how the cruelty of fortune has so transformed its appearance and shape, that, stripped of all beauty, it now lies prostrate like a giant corpse, decayed and everywhere eaten away.

"Surely this city is to be mourned over which once produced so many illustrious men and emperors, so many leaders in war, which was the nurse of so many excellent rulers, the parent of so many and such great virtues, the mother of so many good arts, the city from which flowed military discipline, purity of morals and life, the decrees of the law, the models of all the virtues, and the knowledge of right living. She who was once mistress of the world is now, by the injustice of fortune, which overturns all things, not only despoiled of her empire and her majesty, but delivered over to the basest servitude, misshapen and degraded, her ruins alone showing forth her former dignity and greatness. . . .

"Yet truly these buildings of the city, both public and private, which it seemed would vie with immortality itself, now in part destroyed entirely, in part broken and overturned, since very few are left which preserve their original greatness—these buildings were believed to lie beyond the reach of fortune. . . ."

Then I answered, "You may well wonder, Antonio, at the injury wrought by fortune on this mother of cities, now so cruelly damaged that, as I wander through it today, surveying it, I am compelled not only to marvel but to lament that almost nothing survives intact, that there are so few remains of the ancient city, and those half-consumed and lying in ruins. For of all the public and private buildings of this once free city, only some few broken remnants are seen. . . .

"The pyramid set in the walls of the city near the Porta Ostia [is one]; this is the noble tomb of C. Cestius, a member of the college of priests, and the letters inscribed on it refer to it as a work completed in one hundred and thirty days, from the will of Ponthus Clamela. I am the more amazed, since this inscription still survives entire, that the most learned Francesco Petrarca wrote in one of his letters that this is the tomb of Remus. . . .

"This will perhaps seem trivial, but it moves me greatly, that to these monuments I may add-of the once almost innumerable colossi and statues, of both marble and bronze (for it is less surprising that silver and gold statues were melted down), which were erected in honour of illustrious men because of their greatness of character, not to mention the various figures set up by the state for the sake of art and public enjoymentonly these five marble statues, four in the baths of Constantine, two standing beside horses-the work of Phidias and Praxiteles [the Horse Tamers]—two reclining [the Nile and the Tigris River Gods] and the fifth in the forum of Mars, a statue which today bears the name of this forum. And there is only one gilded bronze equestrian statue, which was presented to the Lateran basilica by Septimius Severus. [Equestrian statue of Marcus Aurelius now on the Capitoline.]

"It is indeed most grievous and scarcely to be related without great amazement that this Capitoline hill, once the head and center of the Roman Empire and the citadel of the whole world, before which every king and prince trembled, the hill ascended in triumph by so many emperors and once adorned with the gifts and spoils of so many and such great peoples, now lies so desolated and ruined, and so changed from its earlier condition, that vines have replaced the benches of the senators, and the Capitol has become a receptacle of dung and filth....

"The forum, which, properly speaking, was the most famous place in the city, after the laws had been passed which called the people together and created the magistracy and the distinguished assembly, has become, by the malignity of fortune, a neglected desert, here the home of pigs and wild deer, and there a vegetable garden."

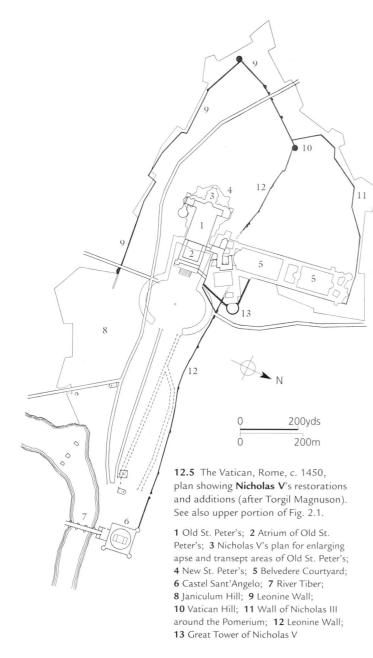

Fig. 12.5), a renewal of the area from Old St. Peter's to the Tiber, designed to house the Curia (the administrative offices of the Church), a new wing and decorations for the Vatican Palace, substantial enlargements and repairs for Old St. Peter's, and a large new piazza in front of St. Peter's to accommodate pilgrims and to provide a suitably grand space for papal appearances. In these plans Nicholas may have been helped by Leon Battista Alberti, an acquaintance from their days together in the humanist circles of Florence, when Nicholas as a young scholar had served as a tutor to the Strozzi and Albizzi families. It was this humanist training as well as Nicholas's desire to re-invent Rome as an imperial city that gave his building projects their classical cast. Alberti, a cleric in minor orders and then a member of the papal Curia, was also a theorist who wrote extensively about the arts and a scholar steeped in the history of classical antiquity, an obvious choice to advise Nicholas on these critically important papal projects.

On the upper floor of his addition to the Vatican Palace, Nicholas commissioned Fra Angelico to paint a fresco cycle of the lives of saints Lawrence and Stephen in his small private chapel (Figs. 12.6 and 12.7). The choice of these saints ties Nicholas V's chapel to Nicholas III's Sancta Sanctorum (see Fig. 2.3), which also contains frescoes of these two early Christian deacon-saints. Fra Angelico's frescoes contain images of the ordination of each saint and the distribution of alms by them, emphasizing the power of the pope to confer office, as well as the charity offered by the Church.

The gold details of St. Lawrence's dalmatic (the costume of a deacon) and the cope worn by Sixtus II give some indication of the original luxury of this chapel. Fra Angelico's figures stand in a relatively narrow apron space close to the picture plane. Yet their grouping along diagonal axes or in semicircular arrangements around a central pivotal figure, and their solid forms placed before a schematic yet deeply recessional architecture, give the scenes a spaciousness and monumentality befitting a papal commission and quite different from Fra Angelico's earlier work in the meditative spaces of the cloister of San Marco in Florence (see Fig 11.10). Behind St. Lawrence, Fra Angelico included a simplified image of the nave of St. Peter's and Nicholas's project for the choir. The classicizing details of the painted architecture, like Nicholas's choice of Alberti as his architect, suggest that while Nicholas sanctioned the destruction of ancient Roman monuments in order to provide building materials for new structures, he also saw the potential for borrowing antique stylistic references to represent a new state controlled by a strong ruler.

Pius II

Pius II (Aeneas Sylvius Piccolomini, r. 1458–64) was born to a noble Sienese family, studied with the classical scholar Filelfo in Florence, and became a leading humanist. An early career in the papal curia led to travel throughout Europe—as far away as Scotland—and a position in the court of Frederick III where he was recognized as an international diplomat. Pius was also a prolific writer. In addition to Latin comedies based on classical sources, his *Commentaries* are the only memoir written by a Renaissance pope. Despite his fondness for high living, he had a strong devotional bent that governed much of his patronage in Rome.

Pius was away from Rome for eighteen months shortly after his election, attending the Congress of Mantua, where he attempted—unsuccessfully—to interest European leaders in a crusade. On his return to Rome in 1460 he immediately began major building and decorative programs at St. Peter's, which were to go on for the remainder of the century. The real incentive for his work in the basilica seems to have been his knowledge that in May of that year, when the Turks invaded the Peloponnesus, Thomas Paleologus, a member of the imperial family of Constantinople, had rescued the relic of the head of St. Andrew, St. Peter's brother, from

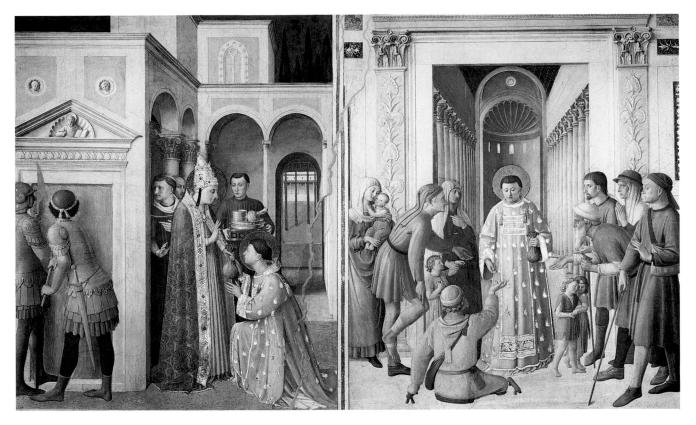

12.6 St. Lawrence Receiving the Treasures of the Church from Pope Sixtus II and St. Lawrence Distributing Alms, 1448–c. 1455, commissioned by Nicholas V from **Fra Angelico** for the Chapel of St. Lawrence (now known as the Chapel of Nicholas V), Vatican Palace, Rome. Fresco

its burial place in Patras, in Greece. Pius had immediately sought to have the head brought to Rome. To reunite it with relics of the heads of saints Peter and Paul, then in the Lateran, would represent a union of the Eastern and Western churches against the Turks and would have supported Pius's ardent wishes for a crusade to reclaim the Holy Lands for Christianity. Pius received the relic in a carefully staged series of public processions during Easter week of 1462. By then St. Peter's already bore the stamp of his patronage.

Pius began his work at St. Peter's by transforming the area before the atrium of the old basilica into a magnificent piazza. He also planned a benediction loggia, which was to extend across the entire façade of the atrium (see Fig. 2.1), and a grand staircase leading to it. The loggia provided Pius with a monumental classicizing architectural frame for appearances to vast crowds of the faithful during ceremonial occasions in the large piazza extending out from it. This project realized the grand scheme of Nicholas V for the enhancement of the site, although the stairs, built with marble quarried from the Colosseum, were not of the imperial porphyry and green marble specified for Nicholas's plan.

To bracket each end of the stairs, Pius commissioned Paolo Romano (Paolo di Mariano di Tuccio Taccone, active c. 1445–70) to carve colossal statues of Peter and Paul. Although little is known of Paolo Romano he was responsible, along with collaborators such as Mino da Fiesole and

Isaia da Pisa (active 1447-64 Rome) who had migrated to Rome from other cities at this time, for a number of important sculptural commissions in the Rome of Pius II. These works—mainly tomb monuments and altars for reliquaries—were to serve as propaganda, transforming Roman church interiors into a visual history of its powerful elites and into focal points for the devotion of pilgrims coming to Rome from all over the Christian world.

Paolo's statue of St. Paul was carved between 1461 and 1462 for the right side of the stair base (Fig. 12.8). The rhetorical bombast of its aggressive pose would have projected over the immense space of the piazza. Its rigid drapery folds bear the same relationship to Early Christian sculptural style as do Filarete's main doors of St. Peter's (see Fig. 12.3), suggesting a consistent referencing over time to the fourth-century origins of the basilica.

To prepare for the placement of St. Andrew's head inside St. Peter's, Pius cleared the interior of the building of hundreds of years of accreted decoration, had its more important monuments moved to the side walls, and commissioned Paolo Romano and Isaia da Pisa to make a tabernacle and altar for the relic (Figs. 12.9 and 12.10). The Reliquary Tabernacle of the Head of St. Andrew was destroyed when the new St. Peter's was built, leaving only remnants of its original sculpture. The iconic appearance of this sculpture again recalls the favored Early Christian style. In form, the monument copied earlier reliquary tabernacles, such as

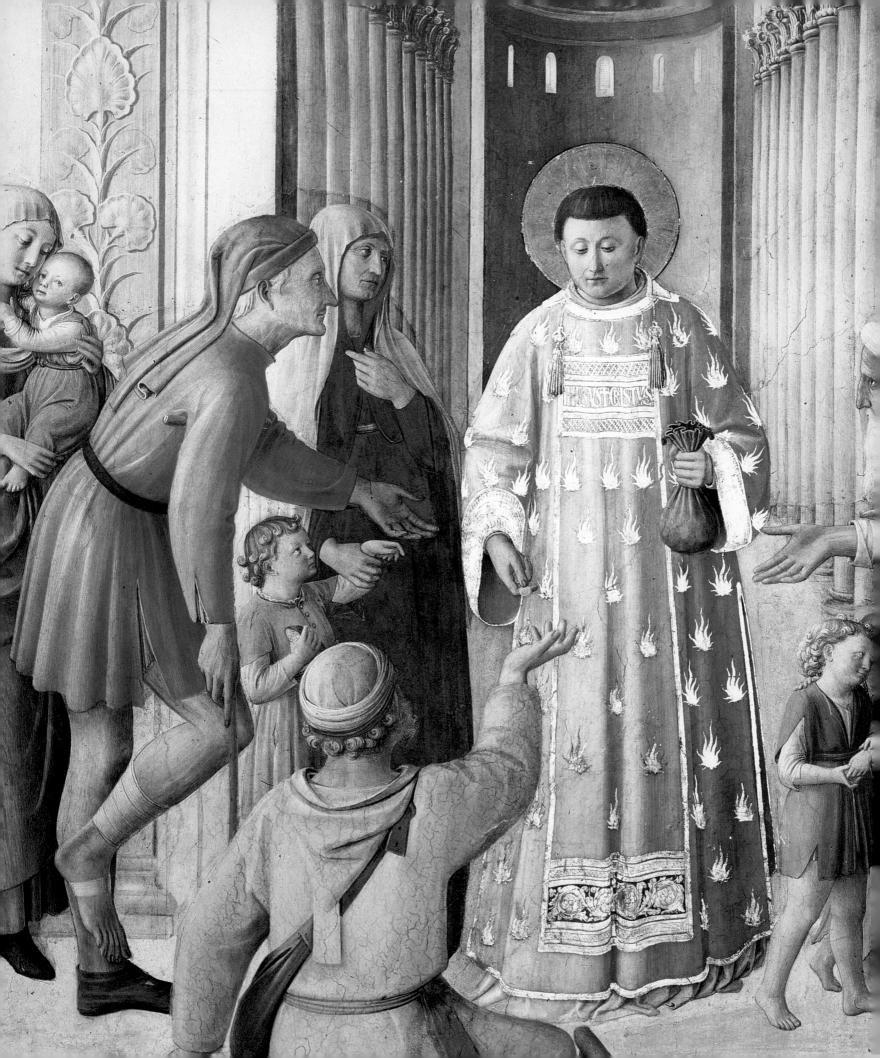

the one over the main altar of St. John Lateran housing relics of the heads of saints Peter and Paul. This form raised the relic high in the church, so that crowds of people could see it, and also provided security for the precious reliquary which contained it.

Cardinals' Commissions

Cardinals in the papal court were also expected to enhance the beauty of Rome by commissioning new buildings and new painting and sculpture for existing structures. Perhaps the most powerful cardinal in Rome during the mid-fifteenth century was the Frenchman Guillaume d'Estouteville. For the basilica of Santa Maria Maggiore, d'Estouteville ordered a marble baldachin from the Florentine sculptor Mino da Fiesole to cover the main altar

à Paulo V. Pont. Max noui gratia Tempos

tedorum artificiosa componatione.

12.8 (above) St. Paul, 1461-62, commissioned by Pius II from Paolo Romano for the right side of the stairs of Old St. Peter's, Rome. Marble (Vatican Apartments, Rome)

The statue originally carried gilt attributes; the right arm carrying the sword was raised.

12.9 (right) Reliquary Tabernacle of the Head of St. Andrew, c. 1463, commissioned by Pius II from Paolo Romano and Isaia da Pisa (with Giovanni Dalmata) from Giacomo Grimaldi, Descrizione della Basilica Antica di S. Pietro in Vaticano, 1619 (Vatican Library, Vat.Barb.Lat.2733, fols. 104v/105r, Rome)

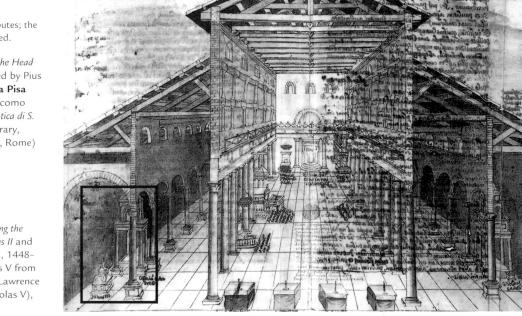

Prospectiva partis veteris Vaticana Basilica

cum altaribus Choris

12.7 (opposite) St. Lawrence Receiving the Treasures of the Church from Pope Sixtus II and St. Lawrence Distributing Alms (detail), 1448–c. 1455, commissioned by Nicholas V from Fra Angelico for the Chapel of St. Lawrence (now known as the Chapel of Nicholas V), Vatican Palace, Rome. Fresco

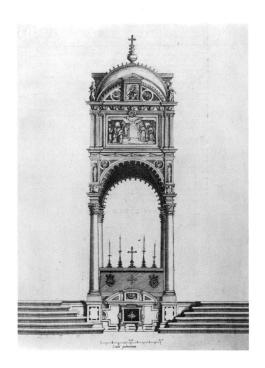

12.11 Tabernacle for Santa Maria Maggiore, c. 1461–63, reconstruction by Paolo de Angelis, *Basilicae S. Mariae Maioris . . . descriptio et delineatio, auctore Paulo de Angelis*, Rome, 1621, 93

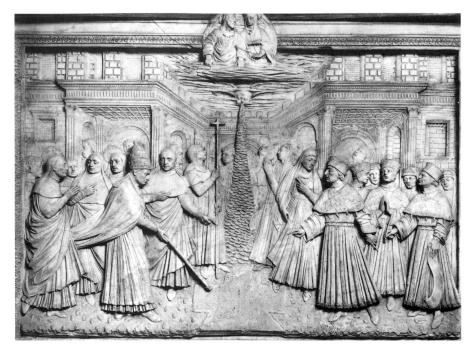

12.12 Tabernacle for Santa Maria Maggiore, detail showing the *Miraculous Fall of Snow*, c. 1461-63, commissioned by Guillaume d'Estouteville from **Mino da Fiesole** for Santa Maria Maggiore, Rome (now immured in the wall of the apse of the basilica)

(Figs. 12.11 and 12.12), similar to the one by Arnolfo di Cambio in Santa Cecilia in Trastevere (see Fig. 2.9). Now dismembered, the tabernacle had marble reliefs on each of its upper faces depicting events related to the basilica, like earlier tabernacles in St. Peter's and St. John Lateran.

Duplicating the imagery of Masolino's and Masaccio's Santa Maria Maggiore Altarpiece (see Fig. 12.2) and the mosaic on the façade of the basilica, Mino carved a relief for the ciborium to face the nave depicting the miraculous August snow that yielded the plan of the basilica. Behind two groups of figures the architecture creates a deep perspective, leaving the center of the composition open for the fall of snow, with God and the Virgin initiating the miracle from above. D'Estouteville, archpriest of Santa Maria Maggiore, looks out of the relief immediately to the right of the pope, here a portrait not of Liberius but of Pius II. The lateral arrangement of the figures, their placement in front of an architectural backdrop, and the alignment of their heads all evoke classical Roman relief style and testify to a renewed and energetic investigation of the antique in the court of Pius II.

The French cardinal, who had hoped to be elected pope in the conclave of 1458 which elected Pius II and who retained that hope throughout his lifetime, claimed the focal point of one of the major pilgrimage sites of the city, declaring his wealth and his power—as well as his generosity—on no uncertain terms. Although there could only be one leader of the Church, there were many aspirants for the throne of St. Peter, and their worthiness could be proclaimed at least in part through their artistic patronage.

Pienza

Although Sienese, Pius had actually been born in a small hill town south of Siena called Corsignano. Beginning in 1459, he attempted to establish this town as a papal seat. In 1462 he rechristened it Pienza in honor of himself, raised it to a bishopric, and hired Bernardo Rossellino, who had previously been a capomaestro on Nicholas V's new apse and transepts for St. Peter's and had worked in an elaborated classicizing style in Florence (see Fig. 10.65), to transform its center into a suitably coherent setting for the town's new status. Rossellino's plan was determined in part by pre-existing streets, by the medieval town hall at the site, and by the precipitous drop of the hill where Pius planned a new cathedral. To either side of the cathedral Rossellino placed the bishop's palace and Pius's own palace, forming a trapezoidal piazza (Figs. 12.13 and 12.14). Pius's own coat-of-arms appears prominently in the gable of the cathedral, whose triple-arched façade recalls ancient Roman triumphal arches. Each structure of this program refers to well-established building types; like the humanist rhetoric in which Pius had been trained, clarity of meaning is enlivened by variety of form. The interior of the papal palace, intended as a pleasant country retreat, renounces the formality of the public square, being built around a courtyard whose south side opens onto a garden and a view of Monte Amiata in the distance. Although the cathedral has a classical appearance, its plan derives from German Gothic hall churches that Pius had admired during his travels for the papal Curia in Austria. In his Commentaries Pius

12.13 Main square, Pienza, c. 1462, commissioned by Pius II from **Bernardo Rossellino**

describes the church and its decorations fully, providing virtually the only real description by a Renaissance patron of his or her architectural accomplishments.

For the church's interior, whitewashed to give it a sense of light, Pius commissioned five altarpieces by painters he referred to as "illustrious Sienese artists." The Assumption of the Virgin (Fig. 12.15) is by Vecchietta (Lorenzo di Pietro; 1410 Siena–1480 Siena), a painter, sculptor, and architect who later produced the extraordinary bronze tabernacle for the

Ospedale della Scala in Siena (see Fig. 11) that was to mark one of the first substantive explorations of this new type of ecclesiastical furnishing. Like the front panel of Masolino's *Santa Maria Maggiore Altarpiece* (see Fig. 12.2 illustrating the rear), Vecchietta's painting depicts the Assumption in the center panel, flanking it with side panels of standing saints, thus connecting this church to one of the major papal basilicas in Rome. The appearance of St. Catherine of Siena (c. 1347–80) at the right of the altarpiece refers to Pius II, who canonized her in 1461, as does,

12.14 Main square, Pienza, plan

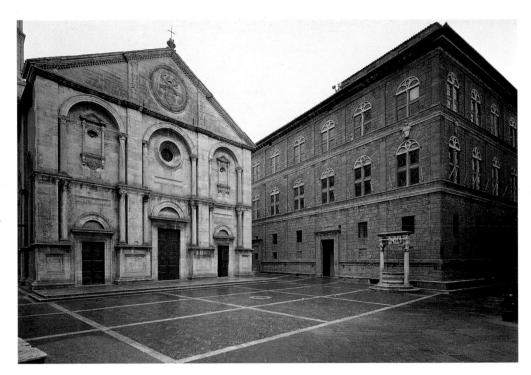

nominally, the figure of Pius I next to her, leaving little doubt about the painting's patron.

Despite the fact that the Pienza altarpieces were completed in 1463, their style recalls that of the great Sienese artists of the beginning of the previous century—not surprising since Pius clearly had in mind a contemporary reprise of the program of altarpieces around the main altar of Siena's Duomo (see Fig. 5.2). The lyrical poses of Vecchietta's figures, the simple ovoid shapes of their heads, the arabesques of drapery, and the gilded background of the panels stamp a Sienese presence in Pienza as clearly as does Pius's heraldic device on the façade of the cathedral. However, Vecchietta's stately lateral saints indicate his exposure to Florentine painting of the mid-fifteenth century, as does the deeply receding landscape at the base of the central panel.

Paul II

Pius died in Ancona in August 1464, while preparing to embark on a crusade to regain the Holy Land for the Christians. His successor, the Venetian Pietro Barbo, who took the name Paul II (r. 1464–71), had been made cardinal by his uncle, Eugenius IV, and was thus the first of the Renaissance popes whose road to office was clearly paved by the widespread practice of nepotism.

Paul II's activity as a patron of the arts had begun during his years as a cardinal in Rome. His keenness for the art, archaeology, and coins of ancient Rome led him to collect antique gems and coins; by the time of his death he had amassed the foremost collection of this kind in Italy, and it was eagerly purchased by Lorenzo de' Medici from his estate. During his papacy Paul II paid for major restorations

12.15 Assumption of the Virgin, 1463, commissioned by Pius II from **Vecchietta** for the second chapel on the left of the nave of Pienza Cathedral. Tempera on panel, $9'\ 2\%'' \times 7'\ 4\%'' (2.8 \times 2.5\ m)$

of the Pantheon, repairs in 1466-68 to the gilt-bronze equestrian statue of Marcus Aurelius then standing outside St. John Lateran, and a restoration of the Arch of Titus (in 1466). He also enacted civic statutes aimed at the protection of Roman antiquities—until then simply used as quarries for new building projects. Even more than Pius II, known for his classical training, Paul II seems to have wished to connect himself with important ancient Roman monuments, uniting pagan and Christian history in one seamless fabric and, like Nicholas V before him, linking his patronage as pope with famous Roman emperors.

Palazzo Venezia

In 1455, before his election to the papacy, Paul had begun building his cardinal's palace in Rome next to his titular church of San Marco, strategically located at the foot of the Capitoline Hill and at the head of the Corso, the main street into the city from the north, thus giving it great

prominence in the city. The palace, possibly designed by the poorly documented Jacopo da Pietrasanta or Francesco del Borgo, was never completed, despite Paul's expanded plans for it after he became pope in 1464 (Fig. 12.16). The courtyard of the Palazzo Venezia (as it is known because of Paul's Venetian origins), with its superimposed

arcades and applied half columns, is reminiscent of the Colosseum. Ample open arches would have provided a grand interior courtyard to the palace, every detail of which imitated ancient Roman architectural forms. In 1467, Paul arranged for the red porphyry sarcophagus of Santa Costanza (now in the Vatican Museums) to be moved to the piazza in front of San Marco. Paul's appropriation of this Roman imperial tomb, traditionally thought to be that of Constantine's own daughter, suggests that he intended his own palace, in the heart of Rome, to carry imperial connotations of rulership and power, in this case associating himself with the emperor who had legitimized Christianity and, moreover, made it a state religion.

A Roman School of Painting

During the papacy of Paul II a Roman school of painting began to flourish. The leaders in this development were Antoniazzo Romano (Antonio Aquili, active c. 1452–1512) and also Melozzo da Forlì

12.16 Palazzo Venezia, Rome, begun 1455, commissioned by Pietro Barbo (later Paul II) from Jacopo da Pietrasanta or, more probably, Francesco del Borgo

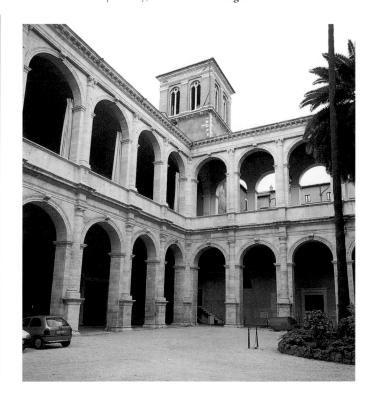

12.17 *Communion of St. Francesca Romana*, 1468, **Antoniazzo Romano**, Oratory of the Oblates of San Francesca in the Tor de'Specchi, Rome. Fresco

(Melozzo degli Ambrosi; 1438 Forlì-1498 Forlì). Both painters spent part of their early careers painting copies of Madonna and Child paintings piously thought to have been painted by St. Luke himself—the sort of mass-market painting that was understandably popular in Europe's leading pilgrimage city. At the same time, each sought to assimilate the innovations of style brought to Rome by painters visiting the papal court.

Antoniazzo's fresco cycle of the life of St. Francesca Romana (1384-1440) was painted in 1468 for a group of lay women founded by Francesca Romana who lived together and dedicated themselves to acts of charity around the city. It tells the story of a Roman matron who had lived the life of a nun after her husband's death. In the Communion of St. Francesca Romana (Fig. 12.17) it is easy to see why these frescoes, with their simplified architecture and gentle, rather doll-like figures, were long confused with the work of Benozzo Gozzoli, one of Fra Angelico's assistants at the Vatican Palace (see Fig. 12.6). A didactic label in late Gothic lettering explicates the events portrayed in Italian rather than Latin, indicating that it was addressed to the female residents of the convent for whom knowledge of Latin would have been an unusual achievement. As the first depictions of a saint whose cult had been authorized only in 1460 (she was not formally canonized until 1608) these frescoes clearly suggest the patrons' wish to establish a canonical history of her life and miracles as a support to the canonization process. The Communion depicts two of these miracles. At the left, as a response to St. Francesca's devotion, the Virgin, seated in glory at the apex of the triangular composition, sends St. Peter to give the saint Communion; St. Paul, dressed as a deacon, but holding his identifying sword, looks on. At the right St. Peter, dressed in full papal regalia, has arrived to consecrate St. Francesca in her religious life. The fresco cycle is a somewhat naive and straightforward rendition of the saint's life, bearing little resemblance to the classicism practiced in architecture and sculpture at this time, but appropriate for its didactic purpose and for bringing the popes, whose patron saints were Peter and Paul, into sympathy with the process of canonization.

A processional banner depicting the Roman Pope St. Mark (r. 336; Fig. 12.18), painted at about the same time as the St. Francesca cycle by Melozzo for Paul II's titular church of San Marco, and probably at his command, suggests the possibilities for including classical forms in traditional contexts. The banner shows the patron saint of the church in a hieratic frontal pose, seated in full regalia on a classicizing throne. The rigid pose—reminiscent of late Roman imperial portraits—does not, however, detract from the full-blown naturalism of the figure, with its deep folds of drapery and fleshy, craggy face. The classical decoration

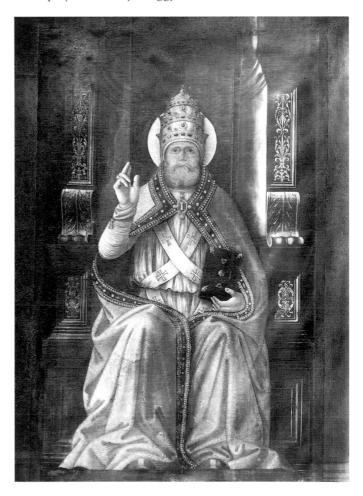

12.18 Processional banner of Pope St. Mark, 1469-70, presumably commissioned by Paul II from **Melozzo da Forlì** for San Marco, Rome. Tempera on red silk

that covers every surface of the throne probably derives more from the early work of Mantegna (see Fig. 14.31) than it does from any painting that Melozzo might have seen in Rome. In the spring of 1459 Piero della Francesca was in Rome, painting in one of the Vatican palace rooms recently constructed by Nicholas V and perhaps also in Santa Maria Maggiore; his frescoes in the palace may have provided a model for the monumentally scaled figures that appear in the *Pope St. Mark* banner and that Melozzo developed more fully in his work of the 1470s for Pope Sixtus IV.

Sixtus IV: Roma Caput Mundi

The history of the papacy—and of the city of Rome—during Francesco della Rovere's reign as Sixtus IV (r. 1471–84) is one of expanding power, expressed in increasingly monumental artistic commissions. Although Sixtus had begun his clerical life as a Franciscan, he had a clear sense that the character of the papal office was most appropriately conveyed through lavish display. His intention, following upon the groundwork laid by Nicholas V and Paul II, was to re-establish Rome as the *caput mundi*, the "head of the world."

In one of his first public acts after his election, Sixtus placed a collection of antique sculpture on the Capitoline Hill (Fig. 12.19), the site of civic government in Rome. Although Martin V and Eugenius IV had set their personal papal crests at the Capitoline Hill it was Nicholas V who had initiated significant papal intervention at the site. He restored the Senators' Palace and built and planned new towers for its corners; he also built a new palace fronted by a portico for the conservators (civic magistrates) of the city. Like Nicholas, Sixtus understood that the papal claim for temporal as well as spiritual power over the city needed to be manifest. Sixtus's gift of sculpture seemed like a

benign way to give the pope visibility at the seat of urban governance, but the messages the gift conveyed were nonetheless quite pointed. The statues came from the papal collections at the Lateran and included two colossal heads: one in marble, known to represent Constantine, and one in gilt bronze, believed also to represent this emperor who, according to the Donation of Constantine—a forged document of the eighth century—had given the

popes control over Rome when he re-established the capital of the empire in Constantinople in 330. The gift of these statues was a manifestation of Sixtus's connection to Roman imperial power at the very site where it might be the most contested—especially since, like most popes, he was not a Roman.

The Papal Family

Nowhere is Sixtus's concept of an imperial papacy more clearly evident than in the fresco by Melozzo da Forlì recording the pope's generosity to the Vatican library and his support of humanist scholarship. The fresco (see p. 289) shows the pope seated in a pose familiar from Roman imperial sculptural reliefs, in which only the emperor is shown seated. Bartolomeo Platina, the humanist scholar whom Sixtus had made papal librarian in 1475, kneels before the pope. The cardinal standing to the right of Platina is Giuliano della Rovere, Sixtus's nephew and later pope Julius II. The cardinal behind Sixtus is Raffaello Riario, another nephew. Each of the figures presents a careful study in portraiture, Melozzo having both captured the physical features and suggested the personality behind them, especially Riario's venality.

The life-sized figures are placed in an imposing room, constructed with meticulous attention to perspective and adorned with a wealth of classical details. The capitals and the coffered ceiling are embellished with gold to suggest the grandeur of Sixtus's reign. Sixtus's support of letters and his fondness for his family (leading to an extraordinary degree of nepotism) are clear messages carried by the fresco. At the same time the classically inspired inscription that forms the base of the painting, and which is formally integrated into it by the way that Platina's drapery illusionistically overlaps

12.19 The Capitoline Hill, Rome, as it appeared c. 1554-60, showing the Senator's Palace with left corner tower and bell tower built by **Nicholas V** and the Conservators' Palace (Musée du Louvre, Cabinet des Dessins, Paris)

its border, refers more broadly to Sixtus's role as patron of the arts throughout the city. It specifically mentions Sixtus's work to bring the city back from squalor, to build churches (*templa* is the first word of the inscription), a hospital, piazzas, walls, and roads, and to repair fountains, especially the Acqua Vergine, later reworked and known today as the Trevi Fountain. The statement is hardly inflated, given the scale of Sixtus's artistic projects.

The Hospital of Santo Spirito

The hospital mentioned in the inscription of Melozzo's fresco is the Hospital of Santo Spirito, built originally in the thirteenth century by Pope Innocent III (Fig. 12.20). The hospital is located near the entrance to the Vatican, in the Borgo, a neighborhood then inhabited by Rome's English colony. Situated in a propagandistically ideal location on the banks of the Tiber (see Fig. 2.1), the hospital faces the Ponte Sant'Angelo, the bridge connecting the Vatican to the rest of Rome. As appropriate for its function, the hospital's architecture is simple and direct. A two story gabled hall allowed unobstructed floor space for the patients' beds. Regularly placed windows at the upper level allowed light and air into the hospital, which was divided into men's and women's wards, with a chapel between them. A cycle of frescoes (Fig. 12.21) by an unknown painter or studio, executed in a manner as direct and unassuming as the building itself, provides a carefully constructed history of Sixtus IV, including his mother's purported vision that he would first be a Franciscan and then rise to power within the Church. Unlike Melozzo's grand image of Sixtus in his library (see p. 289), these frescoes, with their doll-like figures representing the same members of the papal court who appear in Melozzo's fresco, use a didactic and popular style, appropriate for the

12.20 Hospital of Santo Spirito, Rome, 1473, commissioned by Sixtus IV The high octagon at the left is the chapel that separated the men's and women's wards of the hospital.

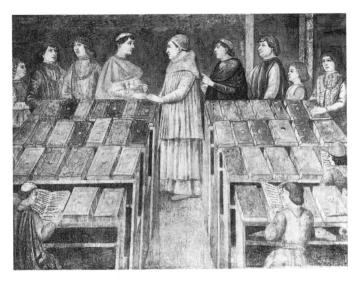

12.21 Sixtus IV with His Nephews in the Papal Library, detail of biographical cycle, Hospital of Santo Spirito, Rome, Fresco

audience of patients in this charity hospital for the poor. For the benefit of literate visitors, each image of the cycle was accompanied by a long inscription, thus making Sixtus's beneficence clear both visually and verbally.

Roman Churches

Santa Maria del Popolo Sixtus was also conscious of his role as spiritual head of the Church and of the need to enhance the religious life of the city. One of his first projects as pope was the complete rebuilding of the church of Santa Maria del Popolo (Fig. 12.22). The church held the miraculous image of the Virgin and Child thought to have been painted by St. Luke and a relic of Pope St. Sixtus I (r. 115–125?), a patron saint of Sixtus IV. Significantly, Santa Maria del Popolo stood immediately adjacent to the gate to the city used by virtually all visitors traveling along the Via Flaminia from the north. In rebuilding Santa Maria del Popolo, Sixtus visually dominated access to the city along this important route. Subsequent popes acknowledged this symbol of papal control by making it the first stop on their ceremonial entrance into the city to assume their office.

Sixtus's architect for Santa Maria del Popolo was most probably the Florentine-trained woodworker and architect Baccio Pontelli (Bartolomeo di Fino; c. 1450 Florence-1492 Urbino). For the façade Pontelli echoed the recently completed façade of Santa Maria Novella in Florence (see Fig. 11.38), although in this case using travertine rather than the typically Florentine geometric marble revetment. The temple form of the upper story is echoed in the pediments of the doors. The lower part of the façade extends the width of the building, although the pilasters are set in high enough relief to suggest the constituent units of the interior spaces that lie behind. The partial segmental pediment form arching up from the left and right wings of the façade (taking the place of Alberti's scrolls at Santa Maria Novella)

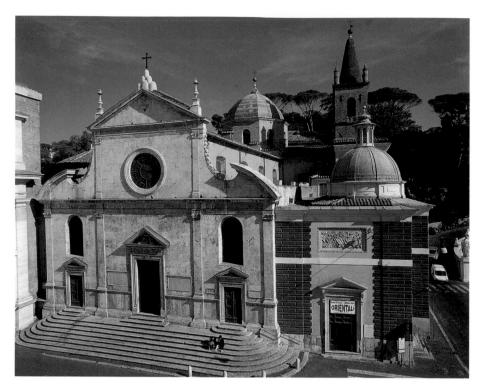

12.22 Santa Maria del Popolo, Rome, 1472–c. 1480, commissioned by Sixtus IV from **Baccio Pontelli** (?)

The Porta del Popolo is at the left.

intersect—somewhat awkwardly—with garlanded forms descending from the top of the upper story, but provide brackets for the extremities of the building that turn attention back toward the center. Were these segments continued into the central unit of the façade they would just graze the frame of the round window, indicating that Pontelli, like Alberti, used a precise geometry to determine the composition of the façade.

Pontelli designed a grand interior space (Fig. 12.23), now transformed by later remodeling. The pentagonal chapels along the side aisles were the first of their kind in Rome and established discrete spaces for individual patronage within the church. Three of these chapels were patronized by members of Sixtus's family, the della Rovere, establishing their presence in a concrete way within the powerful social structures of the city. The groin vaulting, the massing of the travertine piers, with their attached columns, and the steady rhythm of the arches of the nave recalled—albeit in a reduced scale—the monumentality of classical Roman architecture such as imperial basilicas like that of

Maxentius and Constantine (then known as the Temple of Peace) on the Roman Forum.

12.23 Santa Maria del Popolo, Rome, 1472-c. 1480, reconstruction of the original interior on the longitudinal axis

Sant'Agostino Sixtus's example was followed closely by his cardinals. In the last years of construction at Santa Maria del Popolo, the long-lived Guillaume d'Estouteville began rebuilding his own titular church of Sant'Agostino (Fig. 12.24) and marked his extraordinary patronage-rivaling that of the pope-by having his name prominently inscribed across its facade, much as Giovanni Rucellai had done at Santa Maria Novella in Florence (see Fig. 11.38). Despite the awkwardness of the heavy-handed scrolls added to conceal the buttressing and to distract attention from the disproportion between the central and side doors, this church is important in helping to establish a model for church façades. The upper story accommodates the height of the nave, the lower story extends laterally to include the aisles, its cornice doubling to suggest a broken pediment and to unite-

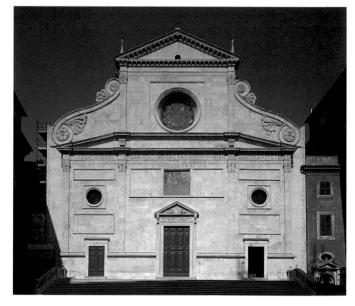

12.24 Sant'Agostino, Rome, 1479-83, commissioned by Guillaume d'Estouteville perhaps from **Giacomo da Pietrasanta**

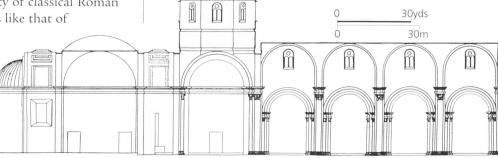

however tentatively—the lower and upper stories. Scrolls, as at Santa Maria Novella, effect the transition between the two stories. Confined in a small space near the Piazza Navona, Sant'Agostino rises grandly from a high podium, its pilasters springing from a tall base. The whole is topped by a pediment, suggesting a temple. The interior also employed a classical Roman vocabulary, with a Composite order and lofty arches. In emulating Sixtus's Santa Maria del Popolo, d'Estouteville connected himself to the official language of the papacy, and in taking responsibility for the entire building project (rather than merely building a grand chapel in a pre-existing building), he gave notice of his own designs on the papacy and of the increasing power and financial means of members of the papal court.

Commemorative Monuments

During the reign of Sixtus IV the grandly-scaled classicizing funerary monument became a common designation of status for the church hierarchy, one increasingly codified in its formal elements. Papal tombs had previously been large and made of costly materials; now cardinals, too, and other important clerics emulated the popes with elaborate wall tombs in their titular churches. The leading workshop in developing this type of monument was that of Andrea Bregno (1418 Osteno, near Como-1503 Rome), who had arrived in Rome from northern Italy in the 1460s. The tomb of Cardinal Pietro Riario (Fig. 12.25), another of Sixtus's nephews-and his favorite-is a fully developed example of this type of tomb. The effigy of the dead cardinal, who died unexpectedly at age 28, lies on a bier above a sarcophagus decorated with festoons, putti, and other motifs. The decoration of the pilasters and entablature and the mourning erotes at either side of the base all employ a classical vocabulary. Riario appears a second time, in the relief above his effigy, being presented by his name saint, Peter, to the Virgin and Child. His brother Girolamo kneels at the right with St. Paul. His connection to Sixtus IV is marked by the papal crest at the top of the monument and again by an inscription in good Roman lettering at the base, which describes Pietro's virtues and success in the Church and indicates Sixtus as the donor. Sixtus used this monument, as he was later to do with Melozzo's library fresco (see p. 289), to assert the presence of the papal family in a city where they were foreigners and where their success was in large measure dependent on the papal office holder.

The Cancelleria

The most important—and certainly the most imposing—palace built in Rome during the late fifteenth century was that of the Cancelleria (Fig. 12.26). It was built by Sixtus's nephew Raffaello Riario, who appears in Melozzo's Vatican Library fresco (see p. 289) and who was also created a cardinal by the pope. The architect of the palace is unknown.

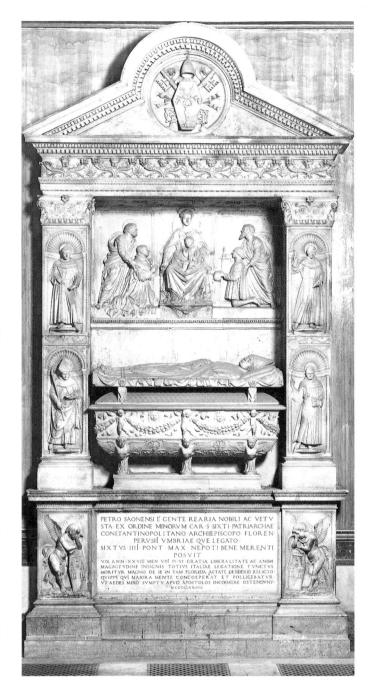

12.25 Tomb of Cardinal Pietro Riario, 1474–77, commissioned by Sixtus IV from **Andrea Bregno** (?), with assistance from **Mino da Fiesole** and **Giovanni Dalmata**, for Santi Apostoli, Rome. Marble, 21′ $4'' \times 11'$ 2'' $(6.5 \times 3.41 \text{ m})$

To make space for it, Cardinal Riario tore down pre-existing structures at the site, including his titular church which he then rebuilt as part of his new building. Its finely-dressed stone courses and rhythmic alternation of windows and pilasters recall Alberti's Rucellai Palace (see Fig. 33) and the papal palace in Pienza (see Fig. 12.13). The slightly projecting bays at the ends help to give a sense of completion to the 300-foot (92-meter) façade (and are a feature previously used only on government buildings). The great size, regular composition, and classicizing decoration of this building,

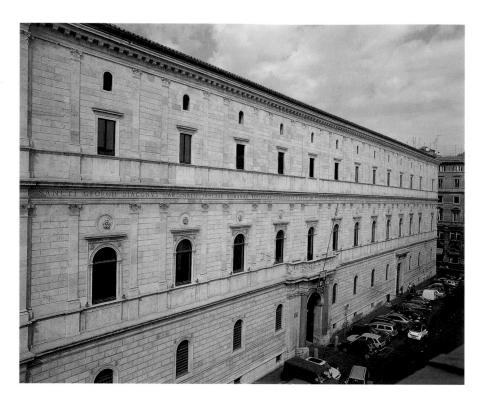

12.26 Palazzo della Cancelleria, Rome, planned shortly after 1483, underway by 1485, mostly complete in 1489, façade finished in 1495, additions between 1503 and 1511, commissioned by Raffaello Riario

When Cardinal Riario was discovered to have participated in a plot against Pope Leo X in 1516 he was forced to deed the palace to the papacy as part of his fine. The building was then used as offices for the papal chancellery, thus giving it its current name.

as well as its domination over the urban landscape, its creation of a piazza on its entrance façade, and its presence on the papal processional route, all made it a model for later Roman palaces.

The Sistine Chapel

The monument for which Sixtus IV is best remembered is a chapel built within the Vatican Palace to accommodate the increasing size of the papal court and to house the conclaves of cardinals that met to choose a new pope. Designed most likely by Baccio Pontelli, who had already worked for Sixtus at Santa Maria del Popolo (see Fig. 12.22), the Sistine Chapel (Fig. 12.27) was built from 1479 to 1481 between the existing papal palace and Old St. Peter's; it replaced an existing fourteenth-century structure known as the Great Chapel. The chapel retains a crenellated fortress-like appearance on the exterior, conforming to the refortification of the Vatican initiated by Nicholas V. The simple rectangular, box-like interior (Fig. 12.28) was designed without protruding architectural elements other than the molding running beneath the windows, suggesting that extensive fresco cycles to cover its walls were intended from the outset, much as the architecture of the Scrovegni Chapel (see Fig. 3.6) implies a fresco cycle as part of its planar surfaces. The chapel has the same

proportions as the Temple of Solomon described in the Old Testament, an architectural conceit that would have implied a connection between King Solomon's position as ruler of Jerusalem (and Israel) and the pope's claim to rule Rome.

Sixtus's claims to temporal sovereignty are implied with more complexity in the frescoes he commissioned for the Sistine Chapel. Beginning under a vaulted ceiling, which may have been painted with gold stars on a blue ground, all four walls of the chapel were completely frescoed (see Fig. 12.28); even the architectural frames of the paintings are painted illusions. Sixtus brought a number of painters to Rome to work on the frescoes to guarantee their completion in a short period of time and to insure their high quality. The participation of Florentine painters such as Botticelli, Ghirlandaio, and Cosimo Rosselli (1439 Florence-1507 Florence) suggests that

12.27 Sistine Chapel, Rome, 1477–81, commissioned by Sixtus IV from **Baccio Pontelli** (?)

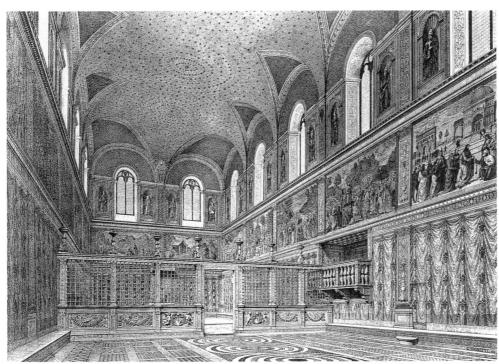

12.28 Sistine Chapel, Rome, reconstruction of the interior at the time of Sixtus IV. Frescoes completed 1481–82

Lorenzo de' Medici may have arranged for a group of Florentine artists to work for the pope as a gesture toward re-establishing amicable Florentine-papal relations after Sixtus's ill-advised participation in the Pazzi Conspiracy of 1478. Two other painters, Pietro Vanucci, called Perugino (c. 1450 Città del Pieve-1523 Fontignano), and Bernardino di Betto, called Pinturicchio (c. 1452 Perugia-1513 Siena), were Umbrian artists. It was Perugino who painted the fresco altarpiece (later covered by Michelangelo's Last Judgment but known from a drawing by a member of Perugino's shop), representing the Assumption of the Virgin, to which the chapel was dedicated. Sixtus assumed a prominent role in the lost altarpiece as a kneeling donor, his papal tiara placed conspicuously on the ground in front of him. St. Peter stood behind Sixtus, touching him on the shoulder with his key, simultaneously presenting the pope to the Virgin and symbolically conferring the papal office on his successor, a reference to the unbroken succession of papal authority.

Between the windows of the upper walls of the chapel, Botticelli and his assistants painted standing figures of the popes who were saints of the Church, beginning with Peter on the wall over the altar (also later destroyed for Michelangelo's *Last Judgment*). These popes establish a continuous lineage for the papacy and repeat an iconography used in St. John Lateran, where roundels containing painted portrait busts of the popes ran the length of the nave on both walls. At the lowest level of the chapel the walls are painted to look as if they were hung with draperies woven in alternating panels with gold and silver thread. Sixtus's coat of arms and the papal keys form part of the woven pattern, again clearly identifying the patron.

A double cycle of biblical narratives occupies the middle level of the chapel and constitutes the main theme of Sixtus's decorative program. Stories from the life of Moses run the length of the left wall, and parallel stories from the life of Christ decorate the right wall (Figs. 12.29 and 12.30). The rare appearance of Moses as a subject in painting of this period suggests that Sixtus intended to remind viewers of the biblical patriarch's role as priest, lawgiver, and ruler, three critical aspects of his own office.

Botticelli's *Punishment of Corah* (Numbers 16:1-35) shows Corah and three others rebelling against the authority of Moses and Aaron (see Fig. 12.29, right section). When they and 250 of their followers

attempted to make an unlawful offering to Yahweh (the Hebrew name for God), Moses raised his rod, and the earth opened and swallowed up the four leaders, and their families, as depicted at the left of Botticelli's fresco. At the center of the painting Moses appears again before the sacrificial altar condemning those who unlawfully assumed a priestly role; the censers of the rebels become unnaturally agitated as they are consumed by fire. At the right of the scene the Israelites flee Yahweh's punishment. As in other paintings of this period, the figures extend across a band of space at the front of the composition while a vast expanse of landscape opens into the background, adding to the monumentality of the whole image. This fresco glitters with gold leaf throughout-the metal censers, the light emanating from Moses's head, and decorative details of clothing and architecture. Despite the horrific tale it tells, the Punishment of Corah conveys a sense of lavishness and wealth. The triumphal arch that anchors the center of the composition is a close rendering of the Arch of Constantine in Rome. The gilded Latin inscription on it translates as "No one can assume the honor [of the priesthood] unless he is called by God, just as Aaron was." Thus the fresco is a warning to anyone who might challenge the divinely ordained power of the pope.

The Testament of Moses (see Fig. 12.29, left section) is by Luca Signorelli (c. 1441 Cortona–1523 Cortona?), a pupil of Piero della Francesca. Signorelli may have gained access to this important commission from Piero, who is documented in Rome as early as 1459, where he had painted at Santa Maria Maggiore and at the Vatican Palace—or, more likely, through the intervention of Lorenzo the Magnificent, since Signorelli, sitting on the town councils of Arezzo, a client state of the Medici, seems to have supported Medican positions and claims. Signorelli's scene from the life of Moses is,

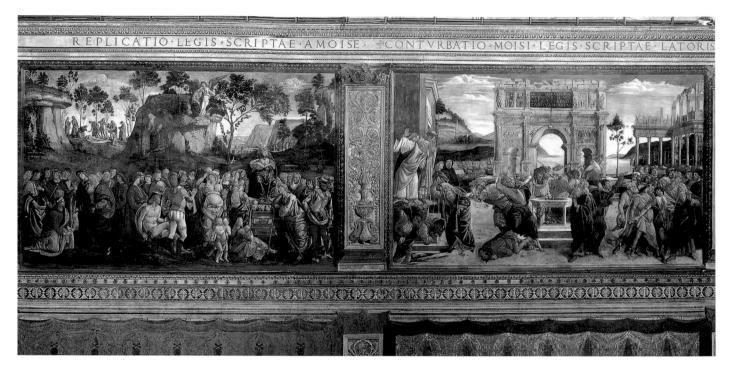

12.29 Testament of Moses and Punishment of Corah, 1481–82, commissioned by Sixtus IV from Luca Signorelli and Botticelli for the left wall of the Sixtine Chapel, Rome. Fresco, each scene c. 11' $6'' \times 18'$ 9" $(3.5 \times 5.72 \text{ m})$

The inscription over the Punishment of Corah reads: "Challenge to Moses, bearer of the written law."

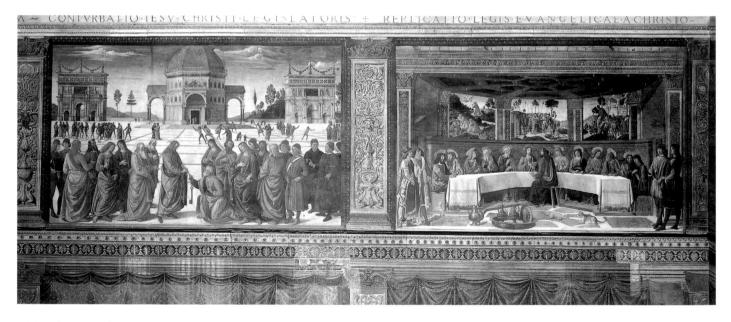

12.30 Christ Giving the Keys to Peter and the Last Supper, 1481–82, commissioned by Sixtus IV from **Pietro Perugino** and **Cosimo Rosselli** for the right wall of the Sistine Chapel, Rome. Fresco, each scene 11′ 5½″ × 18′ 8½″ (3.49 × 5.7 m)

The inscription over Christ Giving the Keys to Peter reads: "Challenge to Jesus Christ, bearer of the law." The two arches in the background contain a single inscription between them: "You, Sixtus IV, unequal in riches, but superior in wisdom to Solomon, have consecrated this vast temple."

like others in the cycle, heavily decorated with gold, and, like Botticelli's scene, presents several moments of the narrative. To the right Moses reads, presumably from the Laws, to the Israelites, while at the left he hands the rod of leadership to Joshua. His death is depicted in the distant left landscape. The nude in the center of the composition has been interpreted as a reference to the Gentiles, "the stranger

in the camp" referred to in Deuteronomy 29:11.

On the other side of the chapel Perugino's *Christ Giving the Keys to Peter* (see Fig. 12.30, left section) emphasizes the continuity between the New Law and the Old. Perugino set his scene in an unnaturally open piazza whose perspective system leads quickly to the ideal, centrally-planned temple in the distance. Triumphal arches like that in Botticelli's

fresco again recall ancient Rome. An inscription continuing over both of the arches compares Sixtus's patronage of his chapel to Solomon's building of the Temple and suggests that Sixtus is greater than Solomon because the new religion has supplanted the Old Law. Sixtus's control of the New Law is asserted in the foreground as Christ hands the keys of temporal and spiritual power to a kneeling Peter. The vast space and serenely ordered geometry of figures and architecture give a sense of grandeur and rhetorical import to the event depicted. By extension, they also enforce theological arguments about the papacy's quasi-dynastic succession from Peter. In virtually all of the narrative scenes in the Sistine Chapel frescoes now unidentifiable members of the papal court stand as mute witnesses to the events depicted and as manifest records of their allegiance to what was arguably the most impressive and learned court in Europe.

Innocent VIII and Alexander VI: Power and Pleasure

Sixtus's successors continued his references to Roman imperial rulership and elaborate contemporary court life. The tomb of Innocent VIII (r. 1484-92; Fig. 12.31), by the Florentine sculptors Antonio and Piero (1443 Florence-1496 Rome) del Pollaiuolo, transforms the traditional wall tomb type by showing the deceased not only as a recumbent effigy but also seated and gesturing as in life, reclaiming imagery first used in the burial chapel of Pope Boniface VIII (see Fig. 2.11). In the original form of the tomb the seated figure with its flanking virtues was below the effigy, which lay immediately beneath the crowning lunette. Innocent holds in his left hand a replica of Longinus's lance, reputed to have pierced the body of Christ, a relic he received in 1492 from the Sultan Bajazet II (r. 1481-1512) for having detained the Sultan's threatening brother, Prince Djem, in Rome. To enshrine this lance Innocent commissioned a reliquary tabernacle comparable to that holding the head of St. Andrew ordered by Pius II (see Fig. 12.9). Innocent's tomb is novel, however, insofar as he appears in the seated pose typical of an emperor (used by earlier popes in civic monuments) and insofar as his double representation adheres to the type of the prince's tomb (see Fig. 6.17), further stressing his temporal powers and his papal office. In the medieval sense of the king's two bodies, that of his person and that of his office, the tomb depicts the end of Innocent's earthly life with his corpse and the continuation of the office of pope, indicated by the full papal regalia worn by the seated Innocent. The figures of the pope appropriately use a naturalistic representation to recall the dead pontiff, whereas the female personifications of virtues in the niches and in the mandorla at the top are idealized, classicizing figures.

Roderigo Borgia, a Spaniard and the nephew of Pope Calixtus III (r. 1455-58), became pope as Alexander VI in 1492. He maintained a lavish court for himself and his family which has become a byword for licentiousness and corruption and was the target of Savonarola's reform preaching. Having bribed his way to the papacy, he lived openly at the Vatican with his mistress and made gifts of papal properties to his family—particularly to his son Cesare Borgia, one of the most feared courtiers and *condottieri* of his time.

As a patron, Alexander concentrated on works that would enhance his image as a Renaissance prince. The most

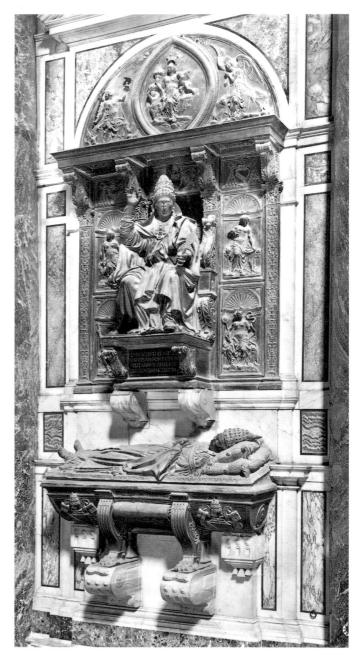

12.31 Tomb of Innocent VIII, c. 1492–98, commissioned by Lorenzo Cibo from **Antonio and Piero Pollaiuolo** for St. Peter's, Rome. Bronze with gilding

The tomb was first moved in 1507 with the beginning of the new St. Peter's; it was disassembled in 1606 and reconstructed in its current position in 1621.

famous of these are the decorations for the papal apartments in the Vatican palace, which had been built by Nicholas V. Pinturicchio, who had worked as Perugino's assistant in the Sistine Chapel, frescoed each of the rooms with a degree of lavishness unsurpassed in the papal residences. Although his Disputation of St. Catherine (Fig. 12.32) imitates the decorous poses and disposition of figures seen in the Sistine Chapel frescoes, the entire surface of the painting is elaborately patterned with different luxurious materials and further adorned with gold. Even the landscape takes on a decorative cast, with trees silhouetted against the sky, not unlike Flemish paintings of landscape. Their leaves, however, are speckled with gold and provide both sparks of light on the surface and abstract patterns comparable to those on the costumes of the figures. A rendition of the Arch of Constantine in the distanceappropriately crowned with the Borgia heraldic bull-is prominently inscribed with gold letters "To the Cultivator of Peace," a reference to Alexander but also to Constantine, whose triumphal arch bears comparable inscriptions. Since Turkish advances into Europe were one of the threats to peace, the appearance at the right of the mounted Prince Djem seems particularly ironic. Djem was detained in the Vatican and was a pawn in papal politics with the Sultan, an attempt to give the latter free rein in exchange for staving off Turkish advances in the Christian west.

Cardinals' Commissions

Members of the courts of Innocent and Alexander aided the popes in the continuing transforming of the city into a vision of a grand and prosperous state, as those courtiers of earlier fifteenth-century popes had done. In particular, cardinals' commissions—in architecture, funerary monuments, and private chapels—were, like those of these two popes, remarkable acts of self-aggrandizement.

The Carafa Chapel The private chapel was an especially effective means of denoting status within the Church hierarchy. The Carafa Chapel at Santa Maria sopra Minerva (Fig. 12.33), commissioned by Cardinal Oliviero Carafa from Filippino Lippi, is among the most ornate of the period. It interrupted Filippino's painting of the Filippo Strozzi Chapel in Florence (see Figs. 11.34 and 11.35) and provided an important incentive to the painter's stylistic development. Every decorative detail displays an archaeological accuracy, suggesting the new discoveries of ancient Roman buildings on the Palatine Hill. The frescoed altarpiece shows Carafa, the Cardinal Protector of the Dominican order, as a witness to the Annunciation; St. Thomas Aquinas, to whom the chapel is dedicated along with the Virgin Annunciate, stands behind him as his advocate. The Carafa family claimed kinship with the Aquinas family,

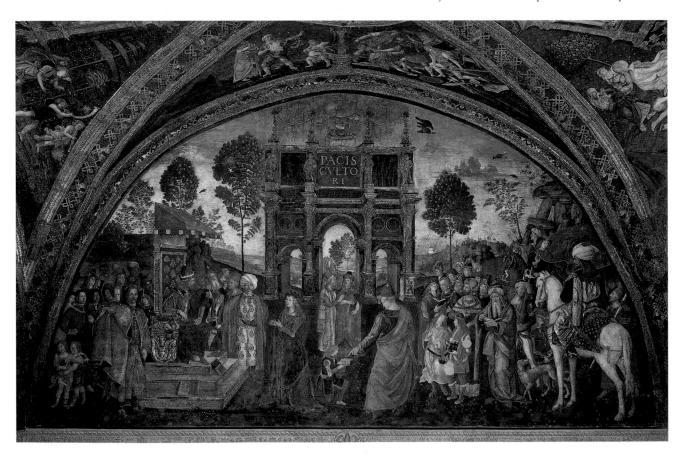

12.32 Disputation of St. Catherine, 1492-95, commissioned by Alexander VI from Pinturicchio for the Room of the Saints, Vatican Palace, Rome. Fresco with gold leaf

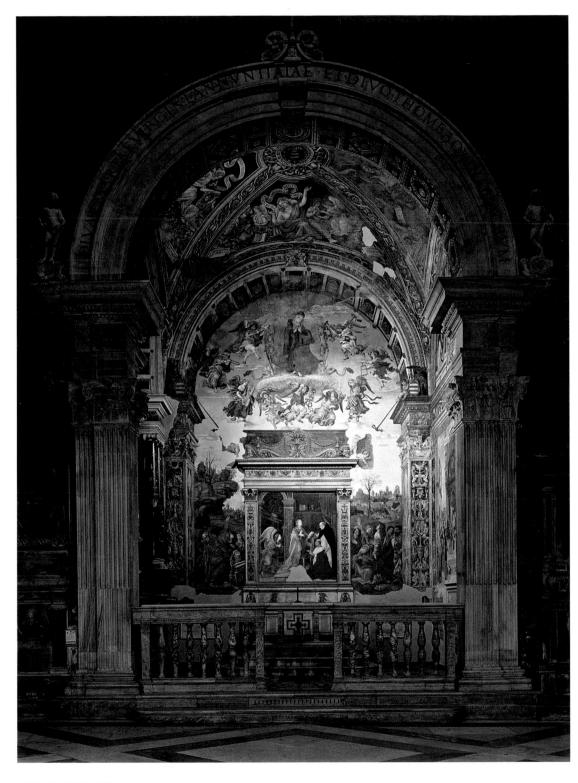

12.33 Carafa Chapel, 1489-93, commissioned by Oliviero Carafa from **Filippino Lippi** for Santa Maria sopra Minerva, Rome. Fresco

On the right wall of the chapel is a representation of the *Triumph* of St. Thomas Aquinas over heresy and, in the lunette above, scenes from the life of the saint. The four reclining female figures in the vaults are figures of sibyls.

making this a particularly poignant image. In the fresco surrounding the altarpiece, Lippi painted an Assumption, thus presenting the first and last miraculous moments of the Virgin's life. Lippi opened the wall of the chapel illusionistically to landscape beyond, giving an even grander sense of space and scale than the already very large chapel would allow. The sumptuousness of the decorative details and the elegance of the individual figures give this prince of the Church an image comparable to that of temporal

princes in Italy and testify to the secure re-establishment of the papacy and its extensive court in Rome by the end of the fifteenth century.

Michelangelo's *Pietà* The lure of patronage at the papal court brought large numbers of artists from across Italy to Rome, as it had since the time of Giotto. Not the least among these was Michelangelo. Having completed his *Bacchus* (see Fig. 11.44) for the Florentine banker Jacopo

Galli in 1496, Michelangelo received a commission from the French cardinal Jean Bilhères de Lagraulas (Jean de Villiers de la Groslaye) for a Pietà for his funerary chapel (Fig. 12.34). The contract for the work bravely asserts that the completed statue would be the most beautiful statue in Rome, leaving open just what was meant by such a claim. Nonetheless, the finished statue is a technical tour de force: palpable flesh, distended veins, extended limbs, lustrously polished surfaces, and complexities of drapery folds and gatherings whose only excuse could have been to show off the skill of the sculptor. The simplified oval form of the Virgin's face and the gentle and welcoming movement of her extended arm lend a calm serenity to what in other instances would have been an expression-filled moment in the narrative of the Passion of Christ. Mary's cradling of her son in her lap recalls another aspect of Marian iconography, that of the Madonna and Child, thus linking Christ's birth and death in a single sculpture and providing the critical reference points in the redemption narrative. The youthful face of the Virgin (Fig. 12.35), at first seemingly incongruous for a woman in her late 40s, allows the still stone to

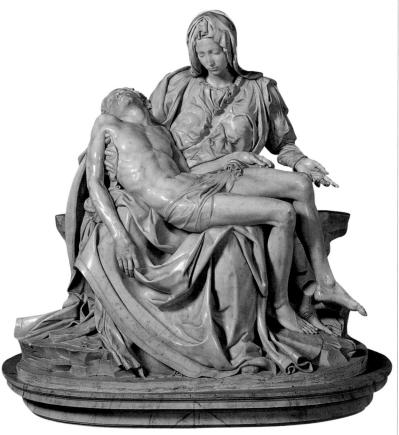

12.34 *Pietà*, 1498-9, commissioned by Cardinal Jean Bilhères de Lagraulas (Jean de Villiers de la Groslaye) from **Michelangelo** for his funerary chapel at St. Peter's, Rome. Marble, 5′ 8″ (1.74 m) high, width at base 6′ 5″ (1.95 m) (Rome, St. Peter's)

The cardinal's burial site was in the round domed church of St. Petronilla attached to the left nave of Old St. Peter's. This chapel was also known as the Chapel of the Kings of France.

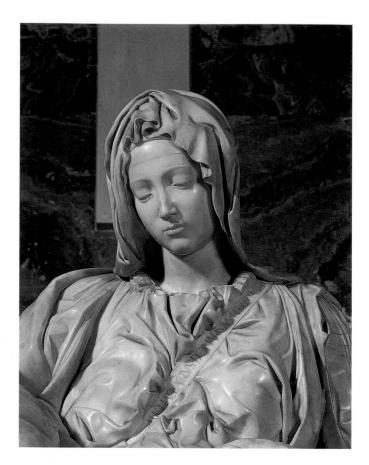

12.35 Virgin Mary (detail of Pietà), 1498-9, commissioned by Cardinal Jean Bilhères de Lagraulas (Jean de Villiers de la Groslaye) from **Michelangelo** for his funerary chapel at St. Peter's, Rome. Marble

provide a meditation over Christ's entire life, much as the incredibly beautiful, soft, eroticized body of Christ, devoid of any but the most reticent indications of his torture and death, carries the meaning of his human incarnation. The group is unprecedented in Italian sculpture in its iconographic form, but relates instead to northern wooden sculpture groups of this devotional type, perhaps a gesture to Michelangelo's French patron. As he was to do repeatedly in his long career, the young Michelangelo here quite deliberately set himself apart from the norm as one way of establishing his presence in the competitive environment of Rome. The story told by his biographer that Michelangelo hid in St. Peter's in order to add his signature (on the belt of the Virgin) to the sculpture after he had heard it attributed to a Lombard artist, illustrates his keen sense that the work was a demonstration piece for his talent. His signature also proudly declares that he is Florentine. Moreover, in using the imperfect verb form of the Latin faciebat, he not only references his work to that of Praxiteles, whom Pliny credits with this verbal oddity; he also suggests, like Praxiteles, that the statue is still in process. This boast, that as extraordinary as the sculpture may now be, it will only get better, also refers to the trajectory of his career as a sculptor. Such a claim-for himself and for the history of Roman art-was truer than even Michelangelo could have imagined.

Venice: Affirming the Past and Present

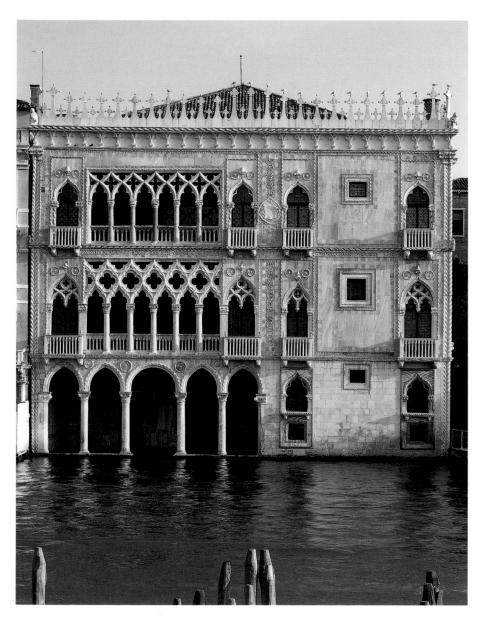

nly a year after taking office in 1423 the young and ambitious Doge Francesco Foscari (r. 1423–57) demolished the entire twelfth-century wing of the Doge's Palace between St. Mark's Basilica and the fourteenth-century wing facing the lagoon. Although the Senate had committed itself to this action before Foscari took office, it was a bold and daring act in tradition-conscious Venice. To compensate for this rip in Venice's otherwise continuous historical fabric and to ensure visual unity, the new wing

faithfully repeated the distinctive design of the fourteenth-century palace, with its graceful Gothic loggia and pink and white stone diaper patterns (see Fig. 7.13). The column capitals, which echo or repeat the subjects of the lagoon façade, celebrate the richness and variety of life lived in a good and just society. Besides emphasizing consistency and stability, this continuation of the fourteenth-century wing on the Piazzetta side greatly enhanced the presence of the palace (the largest civic palace in Italy), giving it a majestic air, rivaling the enormous scale of the palaces of Venice's chief rival, Milan (see Fig. 9.10).

Sculpture on the Doge's Palace

By the mid-1430s work must have been sufficiently advanced to award two special commissions, one for a near lifesized sculpture of the *Judgment of Solomon* (Fig. 13.1) at the corner of the building nearest St. Mark's and another virtually adjacent to it for a new monumental portal, now known as the Porta della Carta (Fig. 13.2), which opens into the palace's courtyard.

The Judgment of Solomon is set at an angle around the corner of the palace so as to be fully visible to anyone approaching the entrance from St. Mark's. It depicts the story in which two women appeal to Solomon, each claiming to be the mother of a child. The king blandly orders a sol-

dier to cut the baby in half and give one half to each woman, whereupon the true mother, aghast, relinquishes her claim in order to save the child's life. The drama is eloquently conveyed by the facial expressions of the main participants:

(above) Ca' d'Oro (Palazzo Contarini), Venice, 1421–37, commissioned by Marino Contarini from **Giovanni and Bartolomeo Bon**, **Matteo Raverti**, and others

The façades of this and other Venetian noble palaces were regularly enhanced with gold leaf, bright colors, and varnish.

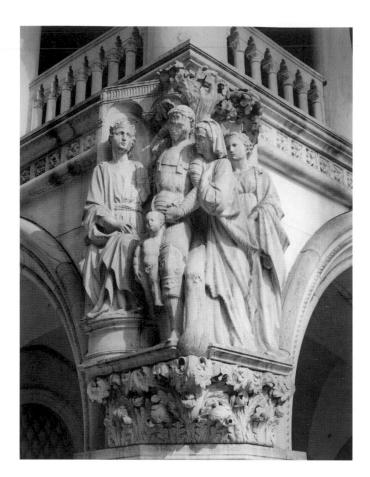

13.1 *Judgment of Solomon*, 1430s, commissioned under Francesco Foscari, possibly from **Bartolomeo Bon the elder**, for the Doge's Palace, Venice. Istrian stone

Solomon appears impassive, befitting impartial justice; the true mother, horrified, as she leans forward to prevent the soldier from obeying the order; the imposter at the far right, dispassionate.

The biblical/historical portrayal of the virtues of the Venetian state seen in the Judgment of Solomon is complemented in more contemporary form on the Porta della Carta (see Fig. 13.2). This magnificent doorway, the new formal entranceway into the Doge's Palace, celebrates Venetian ideals with eye-catching detail. Tall Gothic niches along the side borders hold female personifications of the virtues of Temperance, Charity, Fortitude, and Prudence. Over the entrance the larger than life-sized figure of Doge Foscari kneels before the Lion of St. Mark, clearly conceived as the servant of the state. Above them, the crisp tracery of the tripartite window, with its quatrefoil roundels, recalls that on the palace's loggia. A segmented Gothic pediment above it frames three angelic figures displaying a bust of St. Mark. Putti cavort up the portal's final ascent to the seated figure of Justice, who originally rose free against the sky as did the finials of the flanking turrets.

The creator of this splendid composition, Bartolomeo Bon the elder, proudly carved his name on the doorway's architrave. He received the contract along with his father and teacher, Giovanni. Bartolomeo came from a family of stoneworkers, his earliest surviving work being a wellhead for the Ca' d'Oro (discussed below), which shows an appreciation of the work of Lorenzo Ghiberti. Bon became Venice's leading local sculptor and architect, capable of working in a wide variety of modes. His vigorous portrait of Foscari on the Porta della Carta captures every well-earned wrinkle of this indomitable doge (Fig. 13.3). Lips and mouth firmly set, the veins on his temples pulsing with life, Foscari's eyes are intent on the Lion of St. Mark. We are clearly in the presence of a living individual, the proud and determined leader of the Venetian state. Foscari's features are recorded with documentary accuracy—not to celebrate him as an individual, for such self-aggrandizement by the doge was officially proscribed by the state, but as the chief representative of the republic before whose symbolic leonine representation he kneels, humility and splendor characterizing both the man and the office.

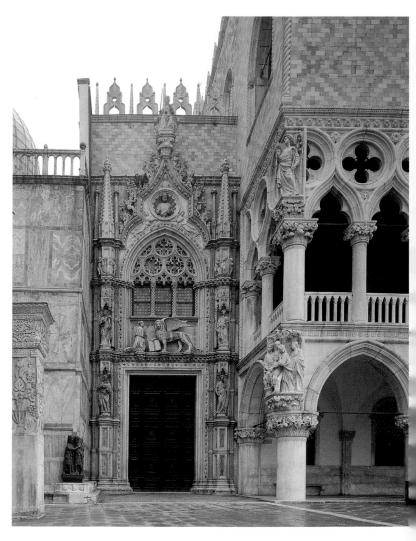

13.2 Porta della Carta, 1438–42, commissioned by Francesco Foscari from **Bartolomeo Bon the elder**, for the Doge's Palace, Venice. Red and white marble and Istrian stone

The head of the doge and the winged lion were knocked down by Napoleonic troops, the present forms are modern replacements.

13.3 Head of Francesco Foscari, 1438–42, commissioned by Francesco Foscari from **Bartolomeo Bon the elder**, for the Porta della Carta, Doge's Palace, Venice. Marble, 1′ 2″ high (0.36 m) (Museum of the Doge's Palace)

The end of the doge's nose and much of his left eyebrow are modern replacements.

The Palazzo Foscari

Like most political leaders, however, Francesco Foscari was neither modest nor self-effacing. The palace he built for himself and his family, starting in 1450 (Fig. 13.4), openly imitates the Doge's Palace, both in tracery on its façade and the placement of its main reception halls at the top of the double-tiered loggia. The geometric orderliness of the façade, balancing symmetrically arranged windows on either side of the central loggias, was typical of larger Venetian palaces. Classicizing putti display the Foscari coat of arms on a large relief which runs across the façade, echoing Florentine forms. Like their smaller counterparts on the Porta della Carta, they document a taste for the antique that was just beginning to be felt in Venice at this rime, although still mainly restricted to decorative elements.

The form and extraordinarily large size of the palace permanently associated Foscari and his family with the office of doge. Cosimo de' Medici was making similar claims for his family in Florence, where the Medici Palace (see Fig. 11.11) clearly evoked associations with the Palazzo della Signoria. Foscari may have felt free to stretch the limits

13.4 Palazzo Foscari, Venice, begun 1450, commissioned by Francesco Foscari

of typical Venetian luxury, since he held the office of doge longer than any of his predecessors. He was also enamored of pomp and display. Foscari's reception in 1438 for the Byzantine Emperor John VIII Paleologus stupefied even the Venetians, who were accustomed to lavish pageantry: twelve floating theaters accompanying the doge's *Bucintoro* ("barge") welcomed the imperial visitor.

The Ca' d'Oro

Foscari's penchant for splendor had a long tradition in Venice. The Palazzo Contarini is known as the Ca' d'Oro ("house of gold"; see p. 313) because of the gold leaf that originally embellished the intricate carving on its façade. This was the home of Marino Contarini, scion of one of Venice's most venerable noble families, who took personal responsibility for overseeing the entire project. It was a confident and aggressive assertion of his family's wealth and social prestige, built on the Grand Canal, the city's most important thoroughfare.

The basic organization of the palace follows a well-established type (Fig. 13.5). As with many small and moderate-sized Venetian Gothic palazzi, the façade is asymmetrical. The main entrance, on the ground floor, is sheltered by the simplest of the three loggias. Behind it is the *androne*, a great open hall, which served the practical purpose of receiving and dispensing shipments of goods; alongside were assorted storerooms. (Many Venetian nobility owed their fortunes to trade, unlike their counterparts elsewhere in Europe.)

Finishing Touches

Today the Ca' d'Oro remains one of the most beautiful of Venetian *palazzi*, with its exquisite white marble tracery. One can scarcely imagine how spectacular it must have appeared when completed—lavishly painted and gilded according to the specifications laid down by its owner, Marino Contarini.

This is the work which . . . Marin Contarini . . . wishes to be done in the painting of the façade of his house at Santa Sofia on the Grand Canal.

And firstly to gild all of the little balls that are on top of the crenellation, and to gild all of the discs of the crenellations that are below the flowers.

And to gild the rosettes which are at the bottom of the little arches.

And to gild all of the leaves of the two large capitals at the corners, which have the lions on the top.

And to fill in the background of the said capitals with fine ultramarine blue.

And in the same way to gild the two lions which are above the said capitals, with the [Contarini] arms that they hold in their paws, the which arms I wish to be finished with ultramarine blue.

And the plinths where the said lions are positioned I wish to be gilded at the front. And below, I wish it to be fine ultramarine blue with small gold stars. . . .

And next I wish to be gilded the rope mouldings on the twenty roundels, and the balls, and also twelve flowers, all gilded.

And next I wish to be gilded the large coat of arms, that is, the shield with the dentils and foliage, and I wish the stripes to be of

of arms, that is, the shield with the dentils and foliage, and I wish the stripes to be of ultramarine blue applied in two coats so that it will appear excellent; and this is all the work that I wish to be gilded on the said façade.

And next I wish that all of the crowning cornice . . . to be finished with white oil paint, and that all of the crenellations are to be darkened in the manner of marble. . . .

And then I wish that all of the red stonework that is in the said façade and all of the red dentil [courses] are to be finished with oil and varnish so that they appear red. And then I wish that all of the roses and vines that are on the said façade are to be finished with white oil paint, and to paint the fields with black oil paint so that it appears well. . . .

All of which work is to be done by maestro Zuan da Franza, painter, of Sant'Aponal, all at his own expense, and I intend that the said *maestro* is to use ultramarine blue at a cost of XVIII ducats per pound, and he is to receive for his work as described 60 gold ducats.

(from Richard J. Goy. The House of Gold: Building a Palace in Medieval Venice. Cambridge: Cambridge University Press, 1992, pp 287-8)

Farther back is a courtyard and garden. Above the *androne*, fronted by another loggia—the most elaborate of the three, with its quatrefoil tracery—is the *gran salone*, the main reception hall, flanked by smaller reception rooms; this floor is known as the *piano nobile* (noble or main floor) in Italian.

0 10yds 0 10m

13.5 Ca' d'Oro, Venice, plan of lower floor

1 Grand Canal; 2 Entrance portico (riva); 3 Central hall (androne); 4 Courtyard; 5 Well-head; 6 Alleyway (Calle di Cà Giustinian) The upper floors contain more private rooms. Providing adequate light for all these rooms was problematical, given the scarcity of land and the narrowness of flanking canals, which meant that palaces stood close together. For this reason the façades were designed with large windows.

As was common practice in Venice, Contarini issued contracts to builders, sculptors, and painters. He entrusted the tracery of the main loggia to Matteo Raverti (active 1389–1434), one of the chief sculptors at Milan's cathedral and perhaps a contributor to the sculptural program of the Doge's Palace. To simulate the sheen of marble, painters applied white lead and oil to the Istrian stone. Red Verona marble details were oiled to bring out their richest tonalities, and the balls on the façade's parapet, along with the window finials, capitals, and architectural moldings were all gilded. Though more extravagant than most private residences in Venice, it epitomizes the luxuriant tenor of much Venetian art.

The Cappella Nova

In 1430 Doge Foscari enlisted the assistance of two noble allies and procurators to create a new chapel in the left transept of St. Mark's (Fig. 13.6), probably as an *ex voto* to the Virgin after a failed assassination attempt on March 11, 1431 (1430 Venetian style since the new year did not begin

13.6 Cappella Nova (now known as Mascoli Chapel), St. Mark's, Venice, 1431-c. 1451, mosaic and marble decoration commissioned by Francesco Foscari from **Michele Giambono** and others

This multi-media complex of colored marbles and mosaics survives almost completely intact.

until March 25). Known as the Cappella Nova, or "New Chapel," until the seventeenth century, when it was taken over by the Confraternity of the Mascoli whose name it now bears, the barrel-vaulted chapel contains an elegant marble altarpiece showing the Madonna and Child flanked by two saints, perhaps Evangelists. An inscription above them records the names of the chapel's founders and the foundation date. Mosaics surrounding an oculus in the lunette and on the barrel vault depict scenes from the life of the Virgin. Variegated marble covers the lower walls; the original traceried balustrade still survives at the chapel's entrance.

The chapel's decoration demonstrates the power of Venice's Byzantine past, which continued to furnish models for figures and compositions while also providing a matrix in which to incorporate new forms imported from outside the republic. In charge of the mosaic decorations was the Venetian painter and mosaicist Michele Giambono (Michele di Taddeo or Michele di Giovanni Bono; 1400 Venice–c. 1462 Venice). In the *Annunciation*, depicted in the lunette of the altar wall (see Fig. 13.6), Giambono sets Gabriel and Mary on a bare stage against a gold ground,

13.7 Birth of the Virgin, early 1430s, commissioned by Francesco Foscari from **Michele Giambono** for the Cappella Nova, (now known as Mascoli Chapel), St. Mark's, Venice. Mosaic

overlooked by God the Father at the top and the descending dove of the Holy Spirit at the upper right, reminiscent of the hauntingly powerful, isolated Byzantine-style figures who hover in the mosaics elsewhere in the east end of the church. Despite their solid volumetric shapes (so at odds with the spaceless environment in which they are placed) Giambono's quietly introverted figures also display a melancholy air characteristic of Venetian-Byzantine figural art.

In the scenes of the Birth of the Virgin (Fig. 13.7) and her Presentation in the Temple on the left side of the barrel vault, Giambono faced the challenge of depicting a continuous narrative. These stories had been very rarely represented in Venetian art up until this time. For inspiration, Giambono thus turned to the most extensive and best-known Virgin cycle in Venetian territory, Giotto's frescoes in the Scrovegni Chapel in Padua (see Fig. 3.6). In the background and to the left of the Birth of the Virgin, the same patient servant waits outside the birthing chamber, which has been modernized with balconies, porches, and Gothic tracery that relate both to contemporary architecture and to the complex architecture of late-fourteenth-century Paduan frescoes (see Fig. 9.21). More important, he took into consideration the fact that the chapel's location in the corner of the basilica's left transept

and the marble barrier in front of it forced most viewers to look at the composition from outside the chapel and to the right. Thus he set his action and the Virgin's birthplace obliquely across the field of vision, encouraging onlookers to move into the action as it evolves continuously from left to right. The clear colors of the figures' garments stand out against the grey and white buildings, making the composition easy to read in spite of its complex settings. The continuous gold background unites the scenes as well, joining them in a long rectangular field which conforms to the format of the other narratives in the church.

The Scuola della Carità

The most prolific painters of mid-fifteenth century Venice were Antonio Vivarini (c. 1418 Murano-1476/84 Venice) and his brother-in-law Giovanni d'Alemagna (d. 1450 Padua). They ran an extremely well-organized shop that specialized in multi-tiered, multi-paneled altarpieces and fanciful Gothic frames, which they subcontracted to various woodworkers. In 1446 they signed and dated a large panel painting of the *Madonna and Child with Saints* for the

13.8 *Madonna and Child with Saints*, 1446, commissioned by the Scuola della Carità from **Antonio Vivarini** and **Giovanni d'Alemagna** for the *albergo* of the Scuola della Carità, Venice. Oil on panel, 11′ 3½″ × 15′ 7½″ (3.44 × 4.77 m) (Galleria dell'Accademia, Venice)

wall behind the officers' bench of the recently expanded *albergo* (officers' meeting room) of the Scuola della Carità (now part of the Accademia painting gallery; Fig. 13.8). Resembling an altarpiece—which it is not—but functioning like Simone Martini's *Maestà* in the Palazzo Pubblico in Siena (see Fig. 5.24) as an inducement to good decision-making, this monumental painting shows the four doctors of the Church (saints Gregory and Jerome at the left, Ambrose and Augustine at the right) in a courtyard around a massive Madonna and Child.

While the unified space in the Scuola della Carità painting may have been inspired by a now dismembered altarpiece that the Florentine artist Filippo Lippi had created for a church in Padua in the 1430s, the two Venetian artists put their model to a different use as an emblem of the Scuola. The Virgin's celestial court is vividly rendered with marbled pink and grey architecture, rich deep colors, costly robes, gilt *pastiglia*, and lovingly observed plant life. Unlike Venetian altarpieces of this and earlier periods, the work represents the supernatural in a physically specific world. Whatever naturalness the space conveys is countered, however, by the elaborately curved platform on which the figures stand.

Jacopo Bellini

Jacopo Bellini (c. 1400 Venice-1470/71 Venice) was an even greater synthesizer than Vivarini and Giovanni d'Alemagna, being equally at home with Byzantine, Gothic, northern European, and central Italian types and modes. He was the foremost student of Gentile da Fabriano and the founder of an artistic dynasty, being the father of both Gentile and Giovanni Bellini and father-in-law of Andrea Mantegna. Jacopo's Madonna and Child Surrounded by an Aureole of Angels (Fig. 13.9), probably created as a private devotional object, reveals several aspects of his artistic personality. Still in its original frame, the image expresses a sadness typical of traditional Veneto-Byzantine Madonnas. A shower of gold dots flickers across the Virgin's robe, evoking the glimmer of Venetian mosaics. The painting also betrays Jacopo's study of northern European paintings. As in certain works by Jan van Eyck and his school, the figures are set behind a parapet which sharply defines the pictorial space. The Child's pleasant, open demeanor and soft, golden curls captivate and charm, even as the Virgin keeps him in the realm of the holy by holding her hand in front of and across his little body.

Jacopo was also a prolific draftsman. A series of 220 drawings by him has been preserved in two volumes, one set on parchment, the other on white paper. They seem to have been created for his own study, not preparatory to any specific commissions, nor necessarily for the instruction of students in his studio. Jacopo purchased the paper unbound in quires (sets of twenty-four or twenty-five sheets), working on the drawings over several decades. His widow called these works "drawn paintings," an apt characterization of their status as works of art in their own right. They are the first works of their kind.

One of the principal artistic challenges that Jacopo addressed in his drawings was how to adapt scientific perspective to Venetian and Paduan preferences for imagining narrative in highly complex environments (see Fig. 9.21), a tradition that grew out of a belief in the documentary value of art. To be true to life, narratives in the Venetian tradition needed to be complicated and filled with anecdotal detail. In a drawing of the *Dormition of the Virgin* (Fig. 13.10) representing the display of the Virgin Mary's corpse, Bellini constructs an expansive urban space in which all diagonal

13.9 Madonna and Child Surrounded by an Aureole of Angels (Madonna of the Cherubim), 1450s, **Jacopo Bellini**. Tempera on panel, $37 \times 26''$ (94×66 cm) (Galleria dell'Accademia, Venice)

13.10 *Dormition of the Virgin*, c. 1450, page from the notebooks of **Jacopo Bellini**. Leadpoint on parchment with later pen retouchings, $16\% \times 11\%''$ (42.5 \times 28.5 cm) (Musée du Louvre, Paris)

lines merge toward a single vanishing point at the eye level of the figures within the drawing, just as prescribed by Alberti in his *Della Pittura*. But Bellini was not content to create the spare and highly focused compositions preferred by Tuscan artists. He shows, instead, a typically Venetian delight in complex architecture. These buildings appear irregular, spontaneous: they are filled with figures going about their business—one on a balcony, another coming down the stairs, another group gathered far to the right background around the column of an arcade.

In the midst of this rich world Bellini placed the apostles mourning over the body of the deceased Virgin Mary, whose soul in the form of a miniaturized body is received by Christ in the small aureole of angels at the very top of the drawing. Just below it rises a radically foreshortened balcony seen from below. This introduces a new dimension. Paradoxically, what had seemed natural and true-to-life suddenly becomes contrived and disturbing, much as the fallen soldiers and regularly arranged lances on the ground in Paolo Uccello's panel paintings (see Fig. 11.16) appear artificial. Jacopo began to domesticate scientific perspective in such compositions but still left room for experimentation.

321

The Cappella Nova in the late 1440s

Jacopo's spatial experiments account for the mosaics added to the right side of the barrel vault in the Cappella Nova in St. Mark's (Fig. 13.11 and see Fig. 13.6), probably between 1448 and 1451. As in Giambono's compositions in the chapel of the early 1430s (see Fig. 13.7), the field contains two major scenes, the *Visitation* at left and the *Dormition* at right. The two scenes are conceived separately, however, each placed before its own illusionistic architectural backdrop.

The distinctive styles of the Florentine Andrea del Castagno (see Fig. 10.44), of Michele Giambono (see Fig. 13.7), and of Jacopo Bellini (see Fig. 13.10), all three of whom worked on the full-scale preparatory cartoons for the mosaics, are visible in the Dormition. Although depicting the same subject as Bellini's drawing, the composition for the Cappella Nova mosaic is evidently not by him but by Castagno. Florentine in conception, it gives prominence to the main actors. Castagno's composition is decidedly more dramatic and legible than Bellini's, but it sacrifices faithful rendition of visual experience and spatial expansiveness for visual clarity. Castagno places only two Apostles to the left of his powerfully large figure of the deceased Virgin-the huddled groups at right bear the imprint of Giambono's and Bellini's intervention. The seated figure, God the Father, who in Bellini's drawing had appeared as a small figure hovering at a believably great height above the buildings, now comes close to the viewer, as do the Apostles and the Virgin's bier.

Castagno probably produced the cartoon for the Cappella Nova mosaics before leaving Venice in 1442,

though the project was left to languish until the late 1440s, when Venice was more receptive to Florentine style. Then Bellini and Giambono added their own figures to the right side, suggesting either that Castagno left the work unfinished or that it was damaged in the intervening years. The Venetians preferred seeing figures subordinate to their setting, as in Jacopo's drawings, rather than dominating it. They also added a little balustrade atop the triumphal arch to soften its Tuscan severity.

Jacopo Bellini seems to have been assigned the task of designing the Visitation mosaic to accompany Castagno's composition. The work tells us much about the Venetian response to Castagno's example. Except for the classicizing language of its architectural elements and the large scale of its figures, the entire scene reads as a rather severe critique of Castagno's work. Mary and Elizabeth encounter one another in the space under the central arch, not in front of it, the area behind them enlivened with a variety of doors, windows, a balcony, a flowering window box, and a framed view of a tall tree, rather than Castagno's plain and deserted street façades. Bellini also included chambers at the left and right for witnesses to the sacred encounter, so important to Venetian documentary expectations. In the upper story a young woman looks on from a window filled with objects, more of which appear, along with a monkey, on the right. The composition is as legible as Castagno's but even more delightful and intriguing to explore.

At mid-century Venetian artists were increasingly cognizant of and ready to experiment with scientific perspective and classical vocabulary. Not only Jacopo Bellini but

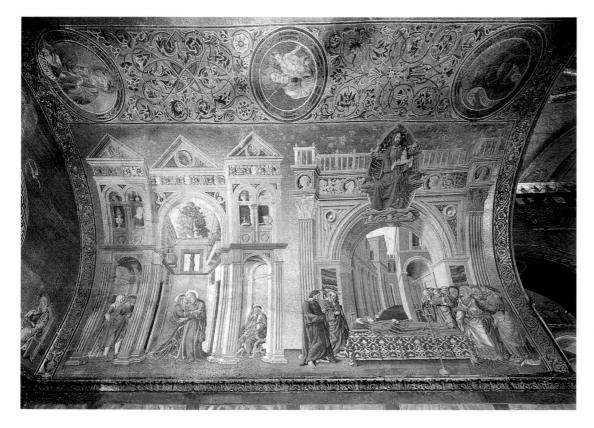

13.11 Visitation and Dormition of the Virgin,
1448-51, commissioned from Jacopo Bellini, Andrea del Castagno, and Michele Giambono for the right half of the barrel vault of the Cappella Nova (Mascoli Chapel), St. Mark's, Venice. Mosaic. (see Fig. 13.6)

also the builders of the Palazzo Foscari and the carvers of the Porta della Carta showed interest in incorporating new elements into their works. At the same time, traditional commitments to visual richness and elaboration as an affirmation of local accomplishments, as well as an ongoing tendency toward synthesis, meant that new elements were not merely adopted but fused with older ones. Eclectic combinations of style and motifs were never richer nor more varied.

Andrea Mantegna

Jacopo Bellini's son-in-law, Andrea Mantegna (1430/31 Isola di Cartura, Padua-1506 Mantua), saw antiquity with a sterner, more archeological eye. A Paduan, he worked primarily outside Venice itself. While he probably admired his father-in-law's work and benefited from the Bellini family's professional connections, Mantegna was more drawn to Florentine art and the work of Donatello in Padua. He was trained by the quirky Francesco Squarcione, an artist entrepreneur who was also his adoptive father. Mantegna's first major fresco cycle, scenes from the lives of saints James and Christopher for the mortuary chapel of Antonio di Biagio degli Ovetari in the church of the Eremitani, Padua, was almost completely destroyed in World War II. Pre-war photographic documentation and surviving fragments in the chapel, however, indicate that all the scenes took place in distinctly classical settings that make the mosaics of the Cappella Nova look rather naïve and contrived, yet in his own day Mantegna's work raised a good number of eyebrows. The patron of the chapel, Ovetari's widow, Imperatrice, sued Mantegna when the artist failed to show all twelve Apostles in a scene of the Assumption of the Virgin on the apse wall. From the start she allotted half of the frescoes to the well-established Venetian team of Antonio Vivarini and Giovanni d'Alemagna, who had provided the impressive polyptych for the Scuola della Carità in Venice (see Fig. 13.8). Their richly decorative manner dominated the vault. Probably so as to expedite the work, Mantegna and a young Paduan artist, Niccolò Pizzolo (1421-53), were assigned the other half of the chapel. But when Giovanni d'Alemagna died in 1450, Vivarini decided to abandon the project, leaving the creations of the younger artists to dominate the chapel.

Taking into account an actual viewing position slightly above eye level, Mantegna imagined the scene of *St. James Being Led to His Execution* from a worm's eye view (Fig. 13.12), that is, from beneath the figures' feet, who seem to loom above us. The effect is dramatic, illusionistically opening a theatrical space into the wall. The coffered barrel vault of a triumphal arch at the left and the cornice of a large house at the right sweep in bold angles down and into the picture space. A Roman soldier at the far right belligerently moves the crowd out of the way, while another, in front of the saint, raises his hands amazed at the miraculous conversion

and healing of the man kneeling at the saint's feet. The events seem to take place at only an arm's reach from the picture plane, a distance Mantegna nearly eliminated in the adjacent scene of the saint's execution, where he placed the martyr's head in the extreme foreground, just before it was to be severed. High drama, a recurrent theme in Paduan narrative fresco painting, had found a powerful new exponent.

Predictably, Mantegna's accomplishments—especially his mastery of perspective-brought him wide attention and praise. Writers such as Alberti and the Paduan Michele Savonarola (not the famous religious reformer with the same surname) used perspective, with its foundation in mathematics, theory, and philosophy, as one of their primary bases for claiming that painting was a liberal (i.e. intellectual) art rather than a mechanical one (i.e. a craft). Such a distinction must have mattered a great deal in a university town like Padua, as did Mantegna's studious evocation of ancient Roman models. Paduan scholars had been active in antiquarian studies for well over a century, having in 1315 revived the ancient practice of crowning a poet laureate and long having celebrated famous citizens like the historian Livy (59 B.C.E.-C.E. 17) whose supposed bones were discovered in a local monastery in 1413. The itinerant

13.12 *St. James Being Led to His Execution*, c. 1455–56, commissioned by Imperatrice Ovetari from **Andrea Mantegna** for her husband Antonio's burial chapel in the Church of the Eremitani, Padua. Fresco

Only shattered fragments of the original fresco cycle still survive, carefully reassembled after extensive bomb damage during World War II.

scholar Cyriac of Ancona, who had traveled around the Mediterranean collecting inscriptions and making drawings of Roman ruins, affirmed local interest in elegant Roman epigraphy. Paduan scholars delighted in these acts of learning and revival. On one occasion Mantegna and some friends dressed up and imagined themselves as Romans while they spent a carefree day boating on Lake Garda.

The San Zeno Altarpiece

Soon after completing the frescoes in the Ovetari Chapel, Mantegna was given an opportunity to work directly with a serious humanist scholar, the Venetian nobleman Gregorio Correr. Correr was abbot of the monastery of San Zeno in Verona and a man of advanced tastes. For him, Mantegna imagined a fully classicizing, spatially unified altarpiece (Fig. 13.13), perhaps comparable in its disposition of figures to the original structuring of Donatello's altar of the Santo in Padua (see Fig. 11.18). The work consists of a Madonna and Child enthroned in the

midst of a courtyard and surrounded by standing saints. The wooden frame is sumptuously gilded, as was the regular practice for altarpieces; but instead of using the still-popular pinnacles and elaborately cusped, pointed arches that continued to surround most north Italian altarpieces well into the 1470s (see Fig. 13.21), Mantegna followed Donatello's lead and framed his subjects with classically detailed pedestals, fluted columns, a rich architrave, and a curved pediment terminating in graceful volutes. The unusually large fields of the rectangular predella panels clearly evoke the scale of Donatello's narrative reliefs on the Santo altar (see Fig. 11.19).

The frame of the San Zeno Altarpiece serves as a portico to a marble courtyard that embraces the entire pictorial field of the altarpiece, the frame and the courtyard just barely separated from one another by swags of fruit and vegetables. In the main panel of the triptych, Mantegna once more simulates Roman architecture and sculpture, both for the throne of the Madonna and Child, flanked by Donatellesque angel musicians, and for the carved roundels and putto frieze which appear on and above, respectively, the sturdy rectilinear piers. His command of perspective allows him to lay out the inlaid marble floor with masterly foreshortening and to place the saints in the two flanking panels back along the sides of the portico and well into the space. For devotional and hieratic purposes he positions the throne of the Madonna and Child well forward in the central panel, giving Mary and Christ a prominence that serves traditional

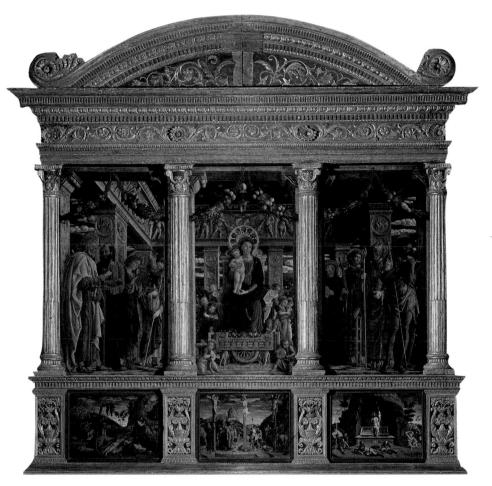

13.13 San Zeno Altarpiece, 1456-59, commissioned by Gregorio Correr from **Andrea Mantegna** for the high altar of San Zeno, Verona. Tempera on panel, height 7' 2½" (2.2 m)

The predella panels are copies of the originals, which are now in France.

religious expectations in new, more illusionistically convincing ways. The altarpiece also sings with bright color—reds, yellows, and greens—probably both in response to local critics who had complained that the Eremitani frescoes looked like tinted statues and owing to the fact that panel painting allowed Mantegna to produce richer, brighter tones than were possible in fresco.

In the Crucifixion panel at the center of the predella (Fig. 13.14) Mantegna sets Christ's last hours on a rocky outcropping far outside the walls of Jerusalem. The primary fissures in the rock all converge toward Christ's cross, which establishes a clear axis separating good from evil. Nearly all the Roman soldiers and a few collaborators appear on Christ's left (sinister) side, set against a shadowed cliff along with the unrepentant thief. Longinus, who will later pierce Christ's side with his lance and become a believer, stands in a depression in the foreground just to Christ's right, close to the company of the good thief, the grieving St. John, and the fainting Virgin. In contrast to the convulsing faces of the Virgin's companions, the Roman soldiers are oblivious to the consequences of their actions. They relieve their boredom by talking to one another, looking up at the writhing thief, and gambling for Christ's seamless cloak. This is the **13.14** *Crucifixion*, 1456–59, commissioned by Gregorio Correr from **Andrea Mantegna** for the *San Zeno Altarpiece*, Verona. Panel, $26 \times 35\%''$ (66×89.2 cm) (Musée du Louvre, Paris)

kind of event that has taken place many times before, as witnessed by the cold pile of skulls and bones thrown into the corner behind the grieving St. John, an allusion to the literal meaning of the site of the Crucifixion, Golgotha (place of the skull). Foot soldiers and horsemen come and go, meticulously diminishing in size as Mantegna imagines them leaving the execution site and climbing the steep road back to Jerusalem. Every detail, whether near or far away, is rendered with merciless precision as Mantegna seeks to capture the actual historical moment of the Crucifixion.

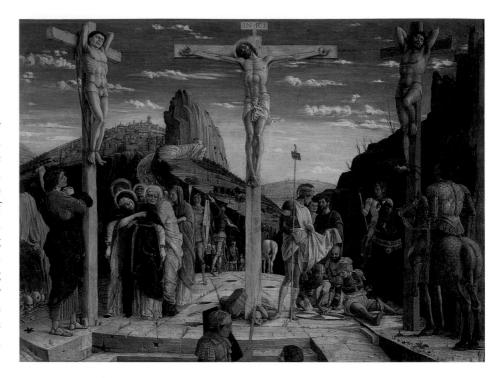

Venice: Heir of East and West

In 1457 the extraordinarily long dogeship of Francesco Foscari came to an abrupt and ignominious end as the old man was forced from office following several scandals and the execution of his son for treason. Always a controversial figure, especially in his commitment to creating a mainland empire for Venice, Foscari was vindicated in the next decade as Venice's holdings on the Italian mainland began to turn a profit. At the same time, Venetian artists and patrons undertook a major new synthesis of their traditional stylistic preferences. The fall of Constantinople to the Ottoman

Empire in 1453 had brought large numbers of Eastern scholars and immigrants to the city, encouraging the city to fashion itself as the rightful successor to the glory of the fallen Byzantine Empire. In the 1460s and 1470s this vision began to be expressed in works that exploited ancient Roman architectural and decorative vocabulary while also making repeated reference to the city's own past. Gothic forms diminished in frequency, but when they were used it was with a reverent appreciation for their associative meanings. The same was true for Byzantine models and motifs, which were exploited—in painting as well as architecture—for their capacity to communicate religious and civic values.

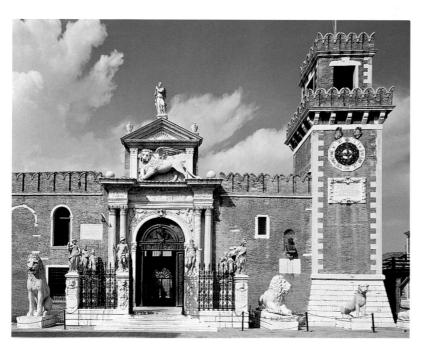

The Arsenal

The first structure built in Venice that consciously adopted ancient and Byzantine models was a new entrance to the Arsenal (Fig. 13.15), the massive civic shipyards. Signaling a distinct stylistic break with the Gothic extravagance of Francesco Foscari (see Figs. 13.2 and 13.4), the new gateway announced Venice's claims to imperial dominion. Doge Pasquale Malipiero (r. 1457–62), whose name appears proudly in the dedicatory inscription to either side of the portal, surely recognized the triumphal significance

13.15 Arsenal Gateway, 1457/58-1460, commissioned by Doge Pasquale Malipiero and the Avogadori di Comun (Leone Molin, Albano Capello, and Marc'Antonio Contarini) for the entrance to the Arsenal, Venice. Marble and Istrian stone

Later additions include the sixteenth-century statue of Santa Giustina above the pediment, the terrace with Mars and Neptune added in 1682, bronze doors commemorating the Venetian reconquest of the Morea in the 1690s, and lions brought to Venice from Athens.

of its form, as did other Italian rulers who also built structures inspired by ancient Roman arches in these decades (see Figs. 14.13, 14.17, and 14.23). Indeed, the Venetians later celebrated their leading role in the naval Battle of Lepanto—where they finally crushed Ottoman forces threatening to take over the entire Mediterranean by adding another inscription above the doorway in 1571. As heirs to the Byzantine Empire, the Venetians flanked their gateway with columns crowned by Byzantine-inspired **basket capitals**, not classical ones. Venetians were as much heirs of the East as the West.

Religious Architecture

Patrons seized upon Early Christian as well as Byzantine models for much religious architecture in this period, as is evident at the monastery church of San Michele in Isola (Figs. 13.16 and 13.17). It was rebuilt beginning in 1469 by Mauro Codussi (c. 1440 Lenna–1504 Venice), who came to Venice from the subject city of Bergamo and became an outstanding proponent of a new classical style. The façade's classically inspired pilasters and arched upper story, masking the side aisles and top of the nave, suggest Codussi's acquaintance with Leon Battista Alberti's designs

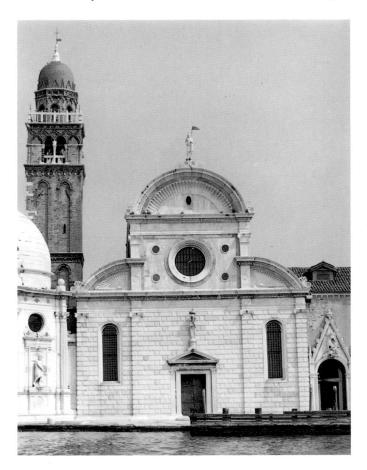

13.16 San Michele in Isola, Venice, 1469, commissioned by Pietro Donà from **Mauro Codussi**

The church now serves as the mortuary chapel for Venice's island cemetery.

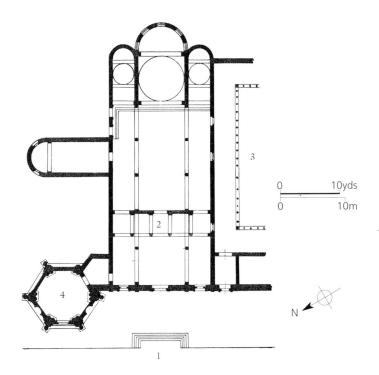

13.17 San Michele in Isola, Venice, plan

1 Lagoon; 2 Choir screen; 3 Cloister; 4 Emiliani Chapel (later addition)

for the Rimini Temple (see Fig. 14.17), but the general scheme may just as credibly derive from the traditional shape of Venetian parish church façades, many of which culminated in arches over the nave and side aisles. More original is Codussi's sure handling of rustication—even of the pilasters, which gives the façade's lower story a weight and monumentality reminiscent of some palace façades (see Fig. 33). The upper story is ingeniously modeled: the pilasters that frame the central portion of the façade wrap around the corners to suggest piers, seemingly grasped by the moldings of the flanking arches; the arches themselves are embellished with fluting.

The simple columnar supports and ample nave arcade of the interior (Fig. 13.18) recall other Venetian churches (see Fig. 7.14), but now classicized with a flat ceiling and round arches. The patron, Abbot Pietro Donà, spent extensive time in Ravenna reforming the abbey of Sant'Apollinare in Classe. The Early Christian and Byzantine basilicas of that city provided stylistic means for this monastic reformer to link his home abbey with the early, presumably purer, days of Christianity. The resulting space then resembles Brunelleschi's Santo Spirito and San Lorenzo in Florence (see Fig. 11.2), but Codussi's space feels different because he seems to have thought of the church interior as a unified spatial volume rather than as an interplay of carefully articulated and positioned walls and arcades. Exploiting the soft white color of Istrian stone, Codussi's supports blend with, rather than stand out from, the gently illuminated space.

In 1483, five years after completing his work at San Michele, Codussi was given responsibility for the even more prestigious project of completing the new church of the

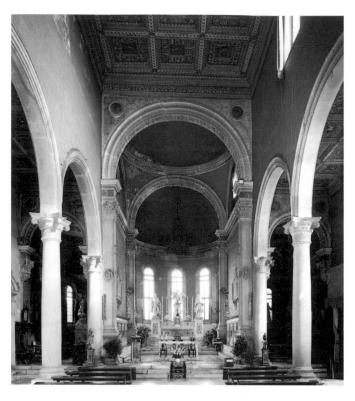

13.18 San Michele in Isola, Venice.

This photograph was taken from just inside the *barco* (choir screen) that still divides the entrance end of the church from the rest of the nave.

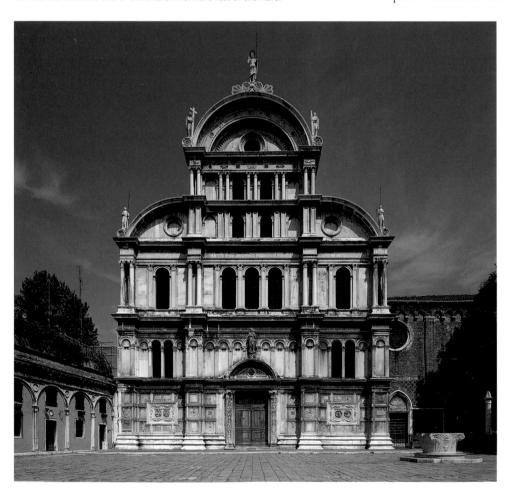

Benedictine convent of San Zaccaria, begun in 1458 by the Venetian builder Antonio di Marco Gambello (active 1458-81 Venice) but stalled for decades. The abbess, Lucia Donà, was a relative of the abbot of San Michele in Isola and, like most of the nuns, came from a prominent Venetian family. The façade of San Zaccaria (Fig. 13.19) vividly documents the stylistic changes sweeping Venetian architecture in this period. The lower storey up to the height of the main doorway was designed by Gambello, who in late Gothic fashion broke the area down into numerous quadrants of red-orange Verona marble framed by twisting colonettes and boldly projecting moldings. Large rectangles swathed with festoons and enclosing bust length representations of four bearded prophets demonstrate only cursory interest in antique prototypes. Codussi rejected Gambello's overall colorism, simplifying and rationalizing the design with a carefully balanced composition of layer after layer of niches, arches, and paired columns and pilasters artfully coordinated with numerous windows. His composition is fashioned almost entirely out of white Istrian stone, only occasionally enriched with soft white and grey marbles. While Codussi's palette is more subdued, the effect is in some ways richer, for the façade suggests a monumental triumphal arch, capped at its summit with a statue of the resurrected Christ, especially appropriate insofar as the doge and the city's senators visited the

church annually on Easter afternoon.

The unusually complex form of the church's apse and choir (Fig. 13.20) can be explained by San Zaccaria's special place in Venetian history and ceremony. The doge and the city's senators annually paid homage to a symbolic replica of Christ's sepulchre located over the high altar (today marked by a sixteenth-century domed tempietto). To accommodate this crowd, Gambello had designed the apse with an ambulatory and radiating chapels, a feature of pilgrimage churches such as the Santo in Padua. Codussi's hand is evident around the ambulatory in the clusters of antique marble columns which carry basket capitals recalling those at San Michele. Above them rise polygonal piers and a pointed arched arcade containing Gothic tracery, consciously archaic

13.19 San Zaccaria, façade, Venice, 1458-89, commissioned by Abbess Lucia Donà and the resident Benedictine nuns from Antonio di Marco Gambello, succeeded by Mauro Codussi

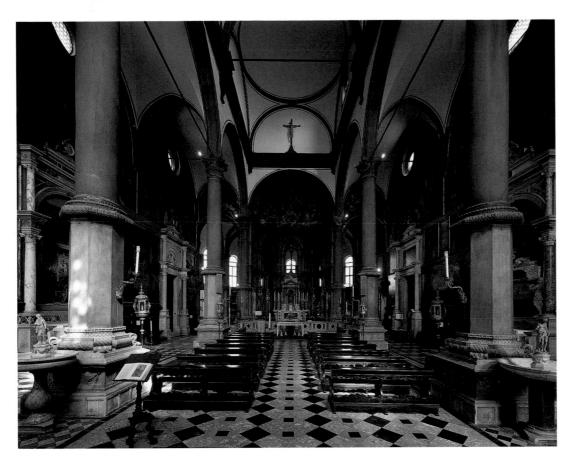

13.20 San Zaccaria, Venice, 1458-89, commissioned by Abbess Lucia Donà and the resident Benedictine nuns from Antonio di Marco Gambello, succeeded by Mauro Codussi

Dark paintings along the nave walls were added in later centuries.

Candle smoke has also distorted the brightness of the space, darkening the columns and arches, which are made of light-colored Istrian stone, not the gray stone commonly used in central Italy.

elements meant to associate the new choir with the past. Above, Codussi turned to even more ancient, Byzantine, models, crowning the apse with a semi-dome and squeezing ovoid hemispheres into the bays of the ambulatory, evidence of a Byzantine revival that pervaded much Venetian church architecture well into the early sixteenth century. In the three-aisled nave, which may have been laid out by Gambello before Codussi took over, the columnar supports stand on high pedestals, like the commemorative columns in the ancient fora of Rome and Constantinople. Their imperial associations are made explicit by eagles carved on the capitals, repeating forms that appeared in the earlier, twelfth-century church and were said to have been granted to the nuns by the Byzantine emperors.

Painting

In a society as conscious of tradition as Venice, the success of new works depended on their ability to evoke and blend with the past. So as Codussi was meeting his patrons' desires to incorporate Early Christian, Byzantine, and Gothic elements into classically informed buildings, painters, too, were creating works that effectively married classical and non-classical forms.

One alternative, promoted by Antonio Vivarini's younger brother Bartolomeo Vivarini (active 1440–1501 Venice) and embraced by his primarily aristocratic patrons, was to accentuate classicizing forms with lush decoration and highly pitched color, making his paintings visually compatible with the dynamic, swirling forms of gilt, Gothic frames that had long been popular in his family's workshop. The figures in the St. Mark Altarpiece (Fig. 13.21), which Bartolomeo Vivarini produced for the Corner family's chapel at the Franciscan church of Santa Maria Gloriosa dei Frari, explicitly recall the work of Andrea Mantegna (see Fig. 13.13) in their demeanor, poses, and clinging drapery, but all their garments are on fire with color. The sky behind the figures glints like gold, shifting dramatically from nearly white on the horizon to midnight blue at top. The carving on St. Mark's marble throne, though inspired by classical models, is as dense and tightly wound as the tracery on the altar's frame. The altarpiece "works" visually because Vivarini thought of his panels and their frame as an integral, decorative whole. In a sense, then, his altarpiece is more like Mantegna's San Zeno Altarpiece than might first appear: the panels in each would be incomplete without their frames.

The same is true of a series of altarpieces produced in the 1470s by one of Venice's most talented and adaptable painters, Giovanni Bellini (1429–30 Venice?–1516 Venice), Jacopo's son and Mantegna's brother-in-law. Giovanni continued to pay homage to Venetian traditions even as he transformed the relationship between painting and frame. In the *San Giobbe Altarpiece* (Fig. 13.22), commissioned by the Confraternity of St. Job, Giovanni set his figures before a glimmering, mosaic- and marble-encrusted apse which evokes the same traditions as the domes and columns at

San Zaccaria, underlining the continuity of Venetian and Byzantine history. At the same time, Bellini ruptures the traditional Venetian conception of an altarpiece as a collection of distinct panels—a tradition with venerable Byzantine roots in the famous Pala d'Oro on the high altar of St. Mark's (see Fig. 7.6). Bellini now systematically coordinated his illusionistic architecture with an actual stone frame-also probably designed by him. The sense of reality is heightened by the light entering the painting from the right, as though from the actual windows in the church. St. Francis, at the left, reveals the stigmata on his hand and seems to invite the worshiper to draw nearer, further bridging the gap between reality and painting. Giovanni's painted architecture reflects the simple, classicizing forms of the church's domed chancel, burial place of Doge Cristoforo

Moro (r. 1462–71), enriched with a coffered barrel-vault, marble panels, and mosaics. Perhaps Bellini's patrons asked him to create an altarpiece that would compete openly with the chancel, since Doge Moro's tomb had dislodged the altar of St. Job from the apse.

Bellini's innovative solution was favored by the altarpiece being commissioned from a confraternity rather than an aristocratic patron. As was the case earlier in the century for the niche sculptures at Or San Michele in Florence (see Figs. 10.16, 10.18 and 10.19), where the lesser guilds commissioned works from the stylistic mavericks Donatello and Nanni di Banco while the major guilds appreciated the more ornate manner of Ghiberti, so in Venice aristocratic families like the Corner at the Frari imposed their taste for the Gothic while Bellini worked with more experimental models and forms for less formidable patrons.

Undoubtedly, formal, artistic considerations also influenced the San Giobbe Altarpiece. Around 1475 he encountered the works of Antonello da Messina (c. 1430 Messina-1479 Messina), a Sicilian probably trained in the Flemish manner in Naples, who may have been invited to Venice by Pietro Bon, a galley owner and Venetian consul in Tunis. Bon commissioned Antonello to produce an altarpiece for San Cassiano (Fig. 13.23), which originally contained eight standing saints and an enthroned Madonna and Child. Because the altarpiece has been cut down and dismembered, it is impossible to reconstruct Antonello's spatial setting, but the remaining figures share much in common with Bellini's. At the left a bishop saint, like St. Francis in the San Giobbe Altarpiece, looks out at the worshiper, and Antonello's Madonna and Child both raise their hands, beckoning the viewer to approach and receive their blessing. Antonello, like Bellini, composes with light, describing full

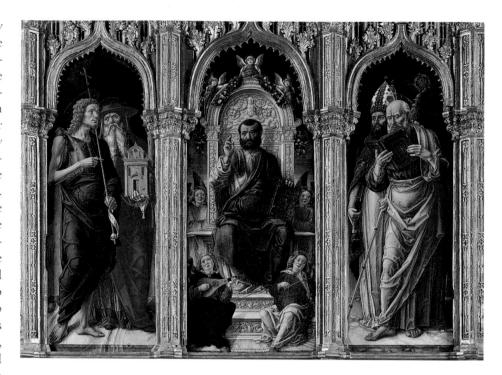

13.21 *St. Mark Altarpiece* (detail), 1474, commissioned by the Corner family from **Bartolomeo Vivarini** for the Corner Chapel, Santa Maria Gloriosa dei Frari, Venice. Tempera on panel, central panel $65 \times 26\%$ " (165×68 cm), side panels $65 \times 22\%$ " (165×57 cm)

forms, free of the linear quality characteristic of earlier painting. Exploiting the technique of painting with oils, which he probably learned in Naples and which he promoted in Venice (though it had already been introduced there), Antonello made his paintings glow with luminous detail, even catching reflections and refractions on transparent objects such as crystal and glass.

Scanty documentation does not permit an exact reconstruction of the events that led to the similarities between Antonello's and Giovanni Bellini's work. Both artists seem to have learned from one another and to have shared common artistic goals. Bellini, for one, may have been aware of contemporaneous Central Italian paintings such as Piero della Francesca's altarpiece for Federico da Montefeltro (see p. 336). Bellini, too, and most likely Antonello as well, set his figures on diagonals in space toward the throne of the Virgin and Child. The trabeated opening at the right of the San Giobbe Altarpiece provides the source of light for the entire scene, gently caressing the sensual body of the nearly nude St. Sebastian at the right and sending light flickering over the strands of his hair. The resonant color and occasional impressionistic effects, such as the daubs of paint which Bellini uses to suggest the sheen of mosaic tesserae, diverge significantly, moreover, from Piero's cool colors and characteristically precise, Tuscan delineation. The glow suffusing the space of the painting—achieved in part by glazes on the painting surface-creates a quiet meditative image where even the figures' movements seem to be slowed in the warm languid light.

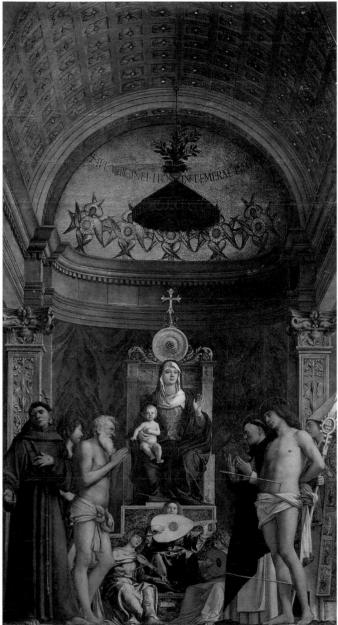

13.22 San Giobbe Altarpiece, before 1478, commissioned by the Confraternity of St. Job from **Giovanni Bellini** for San Giobbe, Venice. Oil on panel, 15′ 4″ × 8′ 4″ (4.71 × 2.58 m) (Galleria dell'Accademia, Venice)

The original stone frame for this altarpiece remains *in situ*—but empty—in the church of San Giobbe.

13.23 Enthroned Madonna and Child with Saints, 1475–76, commissioned by Pietro Bon from Antonello da Messina for San Cassiano, Venice. Oil on panel, three fragments; center Madonna $45\% \times 25''$ (115×63 cm), left $21\% \times 13\%''$ (55.5×35 cm), right $22\% \times 14\%''$ (56.8×35.6 cm) (Kunsthistorisches Museum, Vienna)

Antonello's mastery of the oil medium and its suitability for describing objects both precisely and softly is most evident in his best-preserved work, a small panel showing St. Jerome in his study (Fig. 13.24). Although the work is documented in a Venetian collection in 1529, Antonello may have brought it with him from southern Italy as a demonstration piece. The architectural setting recalls Neapolitan models, as does the framing arch, which resembles the popular depressed form seen around the entrance to the Palazzo Penna in Naples (see Fig. 9.36). He counterfeits the natural flaws and joining of their stone material both with paint and with tiny gashes and incisions in the panel's surface. The still, contemplative mood seems almost sacral, reinforced by the fact that Jerome has removed his shoes and left them at the base of the stairs. Warm, glowing light picks out his books, the containers, and the edges of the vaults. Strikingly similar to work by van Eyck and Memling (to whom sixteenth-century sources say it was sometimes attributed), the painting reveals its Italian origin in Antonello's expert use of scientific perspective. Laying out a grid of tiles that leads to open windows and views of idyllic landscapes and birds gliding against clear blue skies, Antonello fully tames the problems of spatial description, just as he domesticates Jerome's lion, strolling in the shadows at the right.

Giovanni Bellini and his patrons, too, responded positively to Flemish realism and the new luminous capacities of the oil medium. In one of his panels, commissioned for

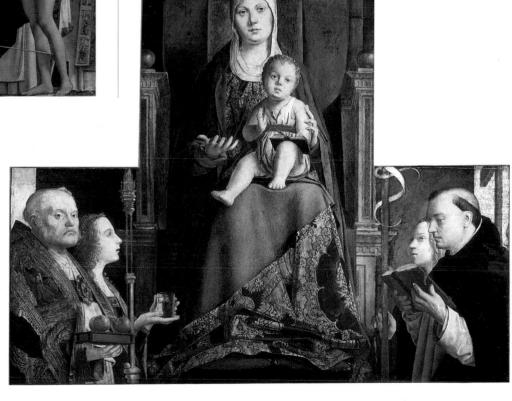

13.24 St. Jerome in his Study, before 1475 (?), Antonello da Messina. Oil on panel, $18 \times 14\%''$ (46×36 cm) (first documented in a Venetian collection in 1529, now National Gallery, London)

a patron who must have had a profound appreciation of Franciscan symbolism (Fig. 13.25), St. Francis stands in the midst of a landscape which is replete with the complex symbolic allusions of Flemish artplants, animals, and household objects alluding to Franciscan ideals of poverty and humility. Resembling a stigmatization (a depiction of St Francis receiving the wounds of Christ), this scene may be, rather, a meditation on Francis's identification with creation. It is dawn, the rocks a cool gray-green, except where the first rays of the sun begin to warm the earth. Francis stretches out his arms and looks skyward, where, in traditional Franciscan stigmatizations, one would expect to find a seraph (see Fig. 1.4), perhaps eliminated when the panel was cut down on top or just as likely absent from the original scheme. Natural

13.25 St. Francis in the Desert, 1470s, Giovanni Bellini. Oil and tempera on panel, $49 \times 55\%$ " (124 \times 142 cm) (© Frick Collection, New York)

beauty and light are sufficient, here, to describe the divine, which Francis himself had done in his *Canticle of the Sun*.

This was but one of many modes in which Bellini conceived his religious paintings. The artist's prolific output of devotional paintings dedicated to the Madonna and Child ranged from highly naturalistic to iconic images. His Madonna Lochis (Fig. 13.26) negotiates several modes, blending the melancholy of one transcendent, shimmering Byzantine Madonna with the energy of a wriggling Christ Child, evocative of Hellenistic sculpture. As in an earlier painting by his father (see Fig. 13.9), the Madonna is seen at half length, as in Byzantine icons, but the traditional immobility of such figures is ruptured by the lively Christ Child who seems to be crawling away from her. Placing her right hand under Christ's slightly exposed genitals, the Madonna calls the viewer's attention to his indisputably human as well as divine nature. Warm light resolves the inherent tension in the subject and unifies its iconic and narrative modes.

The Scuole and Lay Commissions

Purely narrative painting in late fifteenth-century Venice is best studied today in works produced for the *scuole*, charitable lay organizations which were dominated by the citizen class (nobles being explicitly prohibited from holding office in the *scuole*). There was a great deal of civic-minded

13.26 *Madonna Lochis*, 1470s, **Giovanni Bellini**. Tempera on panel, $18\% \times 13\%''$ (47 \times 34 cm) (Accademia Carrarra, Bergamo)

competition among the *scuole* in this period, each seeking to enhance its own position within the city as well as contribute to the city's overall fame. Giovanni Bellini and his older brother Gentile (c. 1429/30-1507) were members of the Scuola Grande di San Giovanni Evangelista, for whose officers' meeting room Gentile produced the *Procession in St. Mark's Square* (see Fig. 7.3). Gentile is less renowned than Giovanni as an artistic innovator, but because of his seniority in the family he preceded Giovanni in receiving governmental honors, including the opportunity in 1479 to sign the long-sought peace treaty that ended the Turkish wars with Sultan Muhammad II, whose portrait Gentile painted.

In his panel for San Giovanni Evangelista, Gentile commemorates the annual procession of all the *scuole* and leading citizens marking the feast of Corpus Christi. Members carry the Scuola's cherished relic of the True Cross, protected by a red canopy, across the Piazza San Marco. White robes declare their group identity, while portrait likenesses distinguish each individual—a longstanding tradition in group portraits of *scuole* members. In fact, the painting depicts a specific historical event: a miracle that occurred in 1444, when a terminally ill child was cured when his father—shown in red to the right of the canopy—dropped to his knees to adore the relic. In Florentine art (see Fig. 11.32)

the miracle would have been set front and center, the occurrence rearranged for narrative emphasis. Here, instead, Gentile sets the event in real time and space, the surrounding crowds and minute description of the buildings on the piazza testifying to the truth of the miracle. Just as Venetian historians in this period preferred to intersperse family matters with public events, recording history in chronicles as it occurred rather than separating public from private and organizing their writings by grand schemes, so Gentile, like his brother Giovanni (see Fig. 13.25), portrays the divine intervening naturally in the world around him.

The bustle of urban life dominates the paintings for the Scuola Grande di San Giovanni Evangelista. In the Miracle at Rialto (Fig. 13.27) Vittore Carpaccio (c. 1460/66 Venice?-1525/6 Venice) records every plank of the city's principal wooden drawbridge (replaced by the present bridge in 1588-92) and catalogues numerous variations on Venetian chimney pots. Carpaccio's precise training is not known, but he was clearly influenced by the work of both Giovanni and Gentile Bellini. As in Ambrogio Lorenzetti's earlier allegories in Siena (see Fig. 5.29), Carpaccio celebrates the living city, catching figures on rooftops as well as in gondolas and on the streets. Almost incidentally the relic of the Holy Cross performs another miracle, this time on a balcony at the left. Other surviving paintings by Carpaccio for smaller scuole, in this same anecdotally rich manner, suggest that the Venetian public as a whole enjoyed imagining sacred events in familiar settings.

During the late fifteenth and early sixteenth centuries, costs for building and enlarging the scuole which contained these paintings grew so high that the government allowed the major scuole to increase their income by enlarging their membership and by classifying their building projects as "charitable works." This freed them from some of their prescribed spending on the poor and destitute. The standard for elaboration was established by the Scuola Grande di San Marco in construction projects to replace buildings destroyed by fire on the night of March 31, 1485. The new façade (Fig. 13.28) is composed in two distinct but related units, reflecting the larger structure of the main meeting hall (sala del capitolo) on the left and the smaller rooms used by the officers (sala dell'albergo) on the right. The project was assigned to the workshop of Pietro Lombardo (Pietro Solari; c. 1435 Carona-1515 Venice). As his name suggests, Pietro hailed from Lombardy, as did most of the stoneworkers in Venice, who were attracted by guild laws enacted in the 1460s prohibiting the importation of work from outside the lagoon but encouraging outsiders to move to Venice. Pietro, who did much to popularize classical architectural forms, was a sculptor as well as an architect, enriching his compositions with delicate carvings. On the façade of the Scuola Grande di San Marco his son Tullio (c. 1455 Venice-1532 Venice) revived the ancient custom of trompe l'oeil relief sculpture, uniting the outer panels of each section of the façade in perspectival compositions focusing 13.27 Miracle at Rialto, c. 1494, commissioned by the Scuola Grande di San Giovanni Evangelista from Vittore Carpaccio for the albergo of their Scuola, Venice. Oil on canvas, 11' 11%" × 12' 9%" (3.65 × 3.89 m) (Galleria dell'Accademia, Venice)

Carpaccio seems to have taken great delight in depicting the decoratively designed chimney tops that vented Venetian fireplaces.

on their respective doorways. True to the Scuola's dedication, lions (symbol of St. Mark) emerge from fictive barrel vaults at the sides of the main entrance. St. Mark himself baptizes and cures the sick in illusionistic porticoes on the right, a subject chosen to emphasize the charitable activities of the Scuola. As in Giovanni Bellini's San Giobbe Altarpiece (see Fig. 13.22), Tullio's illusionism is one with its framing, blurring distinctions between real architecture and its representation.

The Lombardi were well known to the citizen leaders of the Scuola Grande di San Marco because of their previous work in the same neighborhood on the votive church of Santa Maria dei Miracoli (Figs. 13.29 and 13.30). A precious jewel box of a building, the structure was erected by local citizens to house a miracle-working image of the Madonna. Originally located at the corner of a local shop, the image proved so prodigiously beneficent-believers were rescued from sure death and evil deeds were short-circuited by her miraculous intervention-that neighbors decided to erect a church and convent to protect and honor the Madonna's image. The exterior revetment, composed of carefully balanced rectangles, arches, and circles, evokes the splendor of Venice's most important civic church, St. Mark's (see Fig. 7.4), indicating that this was more than a neighborhood church. Indeed, the Council of Ten ordered the participation of all the Scuole Grandi in the cornerstone laying. Panels of porphyry placed to either side of the doorway and fashioned into cruciform patterns

13.28 Scuola Grande di San Marco, Venice, 1485–90s, commissioned by the Scuola Grande di San Marco from Pietro and Tullio Lombardo, succeeded by Mauro Codussi in 1490

On the right can be seen the Monument to Bartolomeo Colleoni, 1479-96, commissioned by the Venetian Senate from **Andrea del Verrocchio**. The casting and base were completed by Alessandro Leopardi, for the Piazza SS. Giovanni e Paolo, Venice. Bronze and marble.

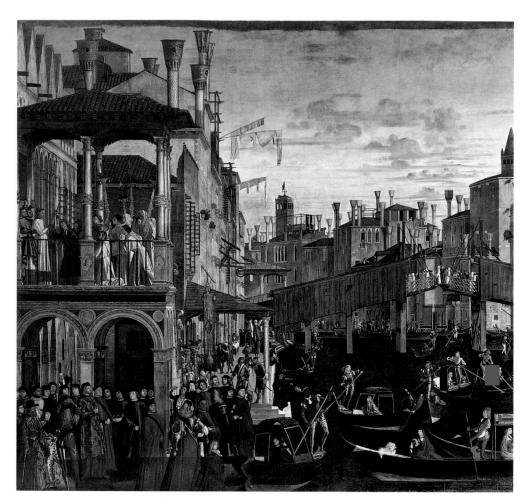

13.29 Santa Maria dei Miracoli, Venice, 1481-5, commissioned by members of the local neighborhood from Pietro Lombardo and his sons for their own devotions and those of resident Clarissan nuns

and decorative roundels higher up on the façade confirm the church's high status, as does the use of the lavish Corinthian and Ionic orders, playfully rendered and positioned without regard to classical rules that expected the Corinthian, not the Ionic order, to occupy the upper story. Carvings of griffins and sea creatures mingle equally freely with busts of saints and angels.

Inside lay worshipers occupied the lower zone of the rectangular nave; the resident Clarissan nuns worshipped from an enclosed balcony at the back of the nave opposite the unusually high, raised presbytery. Like the earlier Clarissans at Santa Maria Donnaregina in Naples (see Figs. 6.8 and 6.9), they enjoyed a privileged position from which to pray for the souls of fellow citizens. Inspired by the Florentine example of Brunelleschi's Old Sacristy (see Fig. 11.3), the chancel is crowned by a centralized dome on pendentives, but the effect is completely different, recalling antique and Early Christian precedents in Ravenna more than contemporary Florentine examples.

13.30 Santa Maria dei Miracoli, Venice, 1481-5, commissioned by members of the local neighborhood from Pietro Lombardo and his sons for their own devotions and those of resident Clarissan nuns

Commemorative State Commissions

Whereas earlier generations had hesitated to provide even an effigy of the leader of the republic, wealthy Venetian families now emulated aristocrats at the Italian courts by commissioning multi-level monuments for their illustrious relatives. In 1476 Filippo Tron, son of Doge Niccolò Tron (r. 1471-73) commissioned a tomb (Fig. 13.31) from Antonio Rizzo (before 1440 Verona-1499 Foligno?), who had begun his career in Verona. Located on the left wall of the Frari's chancel, the Tron tomb consists of five tiers of sculpture, arranged in a classically restrained but imposing 49-foot (15-meter) high composition. The sculpture includes representations of the Annunciation (a traditional allusion to the founding of Venice), the Resurrection, virtues, and warriors. The doge is represented both by a recumbent effigy, and by a life-sized standing portrait—the latter previously reserved in Venice for military heroes. A highly legible, laudatory inscription set above the statue and below the doge's sarcophagus justifies this manner of portraying him, emphasizing Tron's acquisition of Cyprus and active participation in the war against the Turks. The inscription also commemorates his controversial reform of Venetian coinage, on which he placed his own portrait-common in autocratic states (see Fig. 9.15) and visually referenced by roundels of Roman rulers on Tron's sarcophagus, but so contrary to traditional Venetian values that the practice was outlawed

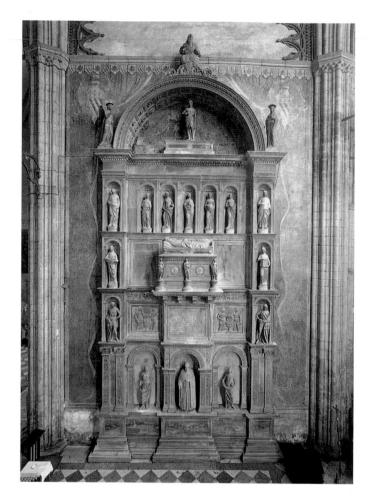

13.31 Tomb of Doge Niccolò Tron, 1476-80, commissioned by his son Filippo Tron from **Antonio Rizzo** for the chancel of Santa Maria Gloriosa dei Frari, Venice. Marble

The inscription beneath the sarcophagus reads: "Nicolò Tron was an unexcelled citizen, an unexcelled senator, an unexcelled prince of the aristocracy. Under his most blessed leadership, the most flourishing state of the Venetians received Cyprus into its empire. With the king of the Parthians, he joined arms against the Turks. He restored the value of money with his living image. His son Filippo has erected this well-earned monument to his most innocent shades for divine aid in everlasting perpetuity." (Trans. Debra Pincus)

for his successors. Doges were expected to serve and promote the state and their office, not themselves or their family.

Although the Venetian government continued throughout this period to limit the doge's actual power, he was presented to outsiders as the prestigious head of state. In 1485 the Senate decreed that the forthcoming coronation of Doge Marco Barbarigo (r. 1485–86) and the reception of ambassadors and visiting dignitaries would take place on a new staircase in the courtyard of the Doge's Palace which was on an axis with the Campanile of St. Mark's and the Porta della Carta (see Fig. 13.2). The design of this staircase (Fig. 13.32) was assigned to Rizzo, who made the authority of the doge and the government implicit by locating a prison cell under its landing, putting eight personifications of Victories in relief on the projecting ends, and covering the sides with colored marbles and dense, classicizing

ornament featuring marine and military motifs that allude to Venetian control of both land and sea. The arms of the Barbarigo family are also greatly in evidence, Agostino Barbarigo (r. 1486–1501) having succeeded his brother Marco as doge in 1486 in an unprecedented and potentially worrisome election for a state that viewed ruling dynasties with abhorrence. The Barbarigo brothers' penchant for grandeur did little to assuage such fears: Agostino scandalized his fellow Venetians by insisting that visitors kneel before him and kiss his hand.

In 1488 Agostino commissioned a seemingly more humble image of himself kneeling before the enthroned Virgin and Child for the Doge's Palace (Fig. 13.33). It is a rare survivor of a common type. Doges and other officials in Venice regularly commemorated their election and underscored their piety by hanging devotional paintings containing portraits of themselves in state offices. However, a close examination of the painting's iconography suggests that this is not an innocent image. As expected, Agostino wears the solemn and even burdensome ceremonial garb of office and kneels reverently before the enthroned Madonna and Child, but while all previous doges had been recommended by their name saints, here St. Mark stands directly behind Agostino and puts his hand on the doge's shoulder; his namesake, St. Augustine, stands in the shadows on the right. This suggests daring dynastic pretensions insofar as St. Mark was not only patron of the city but also of his brother Marco, who preceded him as doge and here, by implication, cedes him the office of doge. Ironically, the two were infamous rivals and Marco is said to have lambasted his brother from his death bed, but Agostino did everything in his power to mask their strained relationship, including commissioning an unprecedented double tomb in Santa Maria della Carità for their common burial. In the painting Bellini includes three birds that refer to fraternal harmony:

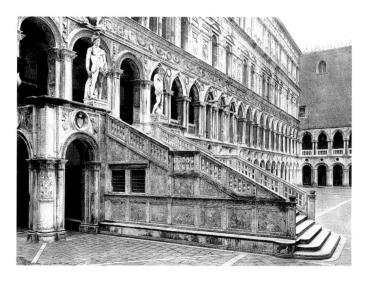

13.32 Scala dei Giganti, 1485, commissioned by the Venetian government from **Antonio Rizzo** for the courtyard of the Doge's Palace, Venice

a partridge on the pavement, a peacock on the railing, and a stork just behind the parapet were all associated by Renaissance authors with familial concord and sacrifice.

Bellini bathes this highly calculated work in cool, serene light, treating the eyes of the city-bound inhabitants of the Doge's Palace to views of verdant countryside, heavily wooded on the left, open and guarded by a castle on the right. The only elements that disturb the preternatural calm are the angel heads that float above eye level. Agostino must already have been planning for the work's final resting place at the convent of Santa Maria degli Angeli (Saint Mary of the Angels) in Murano, where two of his daughters were nuns. In his will he left the painting to the convent and asked that it be framed as an altarpiece for the high altar where the nuns would "always pray for our soul and for the souls of all our [kinsmen] who have passed from this life."

Still, Venetians always remained wary of individual commemoration. When Bartolomeo Colleoni, their famed military captain and successor to Erasmo da Narni ("Gattamelata"; see Fig. 11.20), left a substantial bequest to the city on the condition that he be honored with an equestrian monument in Piazza San Marco, city fathers demurred. They saved face, however, by authorizing its erection in the square in front of the Scuola Grande di San Marco.

Florentine sculptor Andrea del Verrocchio had created a dynamic work that seems about to charge off its pedestal (see Fig. 13.28). Emulating the energy and lithe musculature of the late antique bronze horses that stood on the façade of St. Mark's, Verrocchio lifted his horse's left leg and hoof high off the ground. The considerable technical feat of casting the work was realized by the local Venetian bronze founder Alessandro Leopardi, who also supervised the erection of the handsome, columniated marble pedestal on which the work stands. Standing high in his stirrups, Colleoni glares imperiously at potential foes. The exaggerated folds and intense eyes under his furrowed brow typify the leonine portrait type symbolic of strength and command that Verrocchio's student, Leonardo da Vinci, was later to use so effectively (see Fig. 17.6).

Despite their vacillation in allowing Colleoni's equestrian statue a site in their city, the Venetian authorities must have understood its resonance within the civic iconography that coursed through the streets from the moment one embarked on the Piazzetta San Marco from the sea. There, another warrior, St. Theodore, guarded the Palazzo Ducale and only a few feet away, the Horses of San Marco over the main door of the building gave indication of both Venice's military conquests and her diplomatic skills. Even well established imagery like the equestrian warrior could be seamlessly woven into the fabric of civic propaganda that had been part of the history of the city since the late Middle Ages.

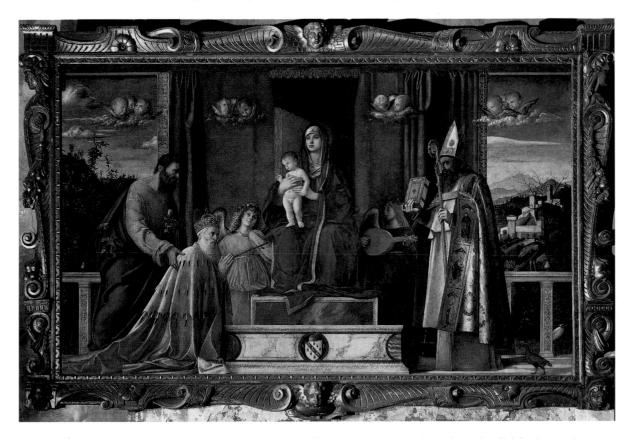

13.33 *Votive Picture of Doge Agostino Barbarigo*, 1488, commissioned by Agostino Barbarigo from **Giovanni Bellini** for the Doge's Palace. Oil on canvas, $7\% \times 12\%''$ (200 × 320 cm) (San Pietro Martire, Murano)

Only recently have scholars realized that this work was commissioned for the Doge's Palace, not for the Barbarigo Palace.

14 Courtly Art: The Gothic and Classic

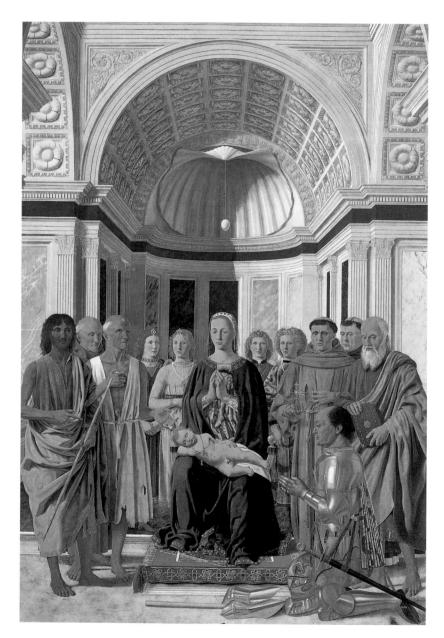

In the fifteenth century the Este family of Ferrara, the new Aragonese dynasty in Naples, the Malatesta of Rimini, the Montefeltro of Urbino, the Gonzagas of Mantua, and the Sforzas of Milan brought the ideal of the perfect identity between a prince and his court to clear and felicitous expression. Initially wedded to the prestigious, effulgent forms of the International Gothic Style (see pp. 194–201), courtly patrons also experimented with and

developed antique models, especially those that increased their magnificence and reinforced their power and authority. In so doing they set new standards for competitive display.

Ferrara: The Este Family

The Este family took control of Ferrara in the late thirteenth century. From then on the city, located midway between Bologna on the south and Venice on the north, acted as a neutral buffer state among the otherwise fractious city states of northern Italy. Niccolò III, first marquis of Ferrara, Reggio, and Rovigo (r. 1393–1441), won renown for his singular commitment to peace. When his son Leonello (1404-50) succeeded him in 1441, Leonello immediately decided to celebrate his father's accomplishments with a bronze equestrian sculpture. This was the first full-scale bronze of this subject since antiquity. Leonello, who had been tutored by Guarino of Verona (see Contemporary Voice, Praise for Pisanello), was very adept at exploiting ancient prototypes to political ends. An inscription on the monument lauded Niccolò d'Este as "three times creator of peace" and gave credit to the civic authorities who financed the project, testifying to the Este family's successful efforts in cultivating a reputation as amicable rulers both at home and abroad. At the same time, the equestrian type underlined Este power and dominion.

Medals for Leonello d'Este

Leonello collected antique coins and jewels, and constructed a special study in which to examine and enjoy them. One of his most notable acts of patronage was commissioning portrait medals

from Vittore Pisano, called Pisanello (c. 1395 probably Pisa–1455 probably Rome). An artistic virtuoso, Pisanello worked across the breadth of Italy. Pisanello and Leonello were inspired both by humanist studies and contemporary pageantry, specifically the visit of the Byzantine Emperor John VIII Paleologus to Ferrara during the great ecumenical council begun there in 1438. Dedicated to reuniting the Orthodox and Western branches of Christendom, and thus

14.1 Medal of Emperor John VIII Paleologus, obverse and reverse, c. 1438, perhaps commissioned by Leonello d'Este from **Pisanello**. Bronze, diameter 4" (1.03 cm) (Museo Nazionale del Bargello, Florence)

Medals were produced in a variety of media, ranging from relatively inexpensive, soft metals, like lead, to precious silver and gold.

lending support to the Byzantine rulers as their empire was crumbling, the conference brought great numbers of Eastern officials to Ferrara. Pisanello made sketches of many of them, and thus was able to give the image of the Byzantine emperor which appeared on one of his medals (Fig. 14.1) an air of authenticity.

Humanists may have suggested the medallic form to Pisanello and Leonello, understanding that the genre had been favored by the ancient Roman emperors, from whom John VIII Paleologus's title of emperor descended. They also would have known of large gold medallions commemorating the emperors Heraclius and Constantine which the Parisian goldsmith Michelet Saulmon (active 1375-1416) had created for the duke of Burgundy at the beginning of the century. Following both ancient and medieval examples, then, Pisanello placed John Paleologus in profile on the obverse (front), surrounded by an identifying inscription (in Greek). On the reverse (back) Paleologus again appears in profile, on his horse, stopping to pray at a roadside cross. He is also shown departing across the rockstrewn landscape at the left. Inscriptions in both Latin and Greek name Pisanello as the medal's creator.

The custom of issuing commemorative medals had been re-established earlier in the small classicizing medals of Francesco da Carrara in Padua (see Fig. 9.15). But whereas the rulers of Padua appeared in Roman guise, Pisanello chose to commemorate a living individual in contemporary garb. Pisanello's "revival" of the ancient Roman medal consisted of taking a form that the Paduan and Burgundian courts had already salvaged from antiquity and giving it a contemporary aspect. Stylistically, Pisanello's medals were

(opposite) Enthroned Madonna and Saints Adored by Federico da Montefeltro, c. 1472–74, commissioned by Federico da Montefeltro from **Piero della Francesca**, perhaps for Federico's burial chapel. Oil on panel, 8′ 2″ × 5′ 7″ (2.51 × 1.72 m) (Pinacoteca di Brera, Milan)

Federico was buried in the church of San Bernardino, which he founded outside the walls of Urbino.

14.2 Medal of Leonello d'Este, obverse and reverse, 1444, commissioned by Leonello d'Este from **Pisanello**. Bronze, 4" (1.03 cm) (Museo Nazionale del Bargello, Florence)

not Roman at all—an incongruity of little concern to a courtly patron who doubtless saw himself as a fancier and reviver, not a slavish imitator, of antiquity.

Leonello d'Este popularized Pisanello's medals, using them as diplomatic gifts to cement relationships with dignitaries throughout Europe. In one example, announcing Leonello's marriage to Mary of Aragon, natural daughter of King Alfonso of Naples (Fig. 14.2), Pisanello anchors his patron's bust with a Latin inscription across his shoulders that translates as "Leonello d'Este Marquis." The qualifying descriptor "of Ferrara and Modena" appears in the curve beneath. The abbreviation "ge r ar" hovers like a coronet above his head, a clever rendition of the Latin words meaning "Son-in-law of the King of Aragon." The obverse provides, as do many of Pisanello's medals, a charming commentary on the event. At the right Cupid patiently points out musical notes on a scroll to a very meek lion, tail between his legs, who is learning to sing—an ingratiatingly modest image of the awkward but diligent bridegroom Leonello ("little lion"). In the background an eagle (one of the devices of his father-in-law) keeps watch. Dated 1444 and carrying Leonello's personal emblem of the column and sail on a stele, the work is inscribed with Pisanello's name above Cupid's head.

Pisanello in Verona

Pisanello was also a remarkable painter. In the 1430s he collaborated with a Florentine sculptor, Michele da Firenze (master of the Pellegrini Chapel; active 1404–43), on the decoration of the Pellegrini Chapel in the church of Sant'Anastasia. Over the entrance arch of the chapel, Pisanello painted a fresco of *St. George and the Princess* (Fig. 14.3), now cut into two pieces. The left side of the fresco portrays the lair of a dragon who has been terrorizing the countryside. His fetid pool is littered with skulls and bones of previous victims, picked clean by lizards and eels, all rendered with the lifelike realism that had been one of the hallmarks of earlier Lombard painting (see p. 174 and Fig.

14.3 St. George and the Princess, 1430s, commissioned by the Pellegrini family from **Pisanello** for the exterior of the entry arch into the Pellegrini Chapel, Sant'Anastasia, Verona. Fresco

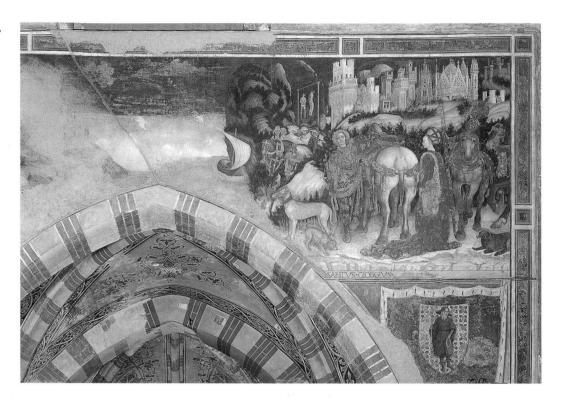

9.21). To add to the horrific effect, Pisanello portrays the dragon's long reptilian tail slithering amidst them, leading the viewer's eye up to the monster's own bloated body and howling head. While clearly a fantastic creation of the artist's imagination, the dragon sports scales and feet based on close natural observation. Careful study also informs Pisanello's representation of a dead deer and of a lion stalking another unfortunate victim above.

On the right (see Fig. 14.3 and p. 202) St. George, the golden-haired hero of the story, has dismounted after rescuing the princess, who stands in regal profile to the side

of his horse. Most of the gold and silver that were glued onto the fresco have fallen away, but the sheer length of the princess' train and the elaboration of St. George's armor suggest how alluring the surface must have been. Everywhere there is something to delight the eye: a body of water at the far left and a boat sailing toward shore; horsemen whose physiognomy suggests they may come from eastern Europe or Asia; two hanged men on gallows; a shining, magical city of Gothic towers and delicate tracery in the background; and hunting dogs rendered with loving accuracy, all combined in a fairy tale of chivalry and romance.

CONTEMPORARY VOICE

Praise for Pisanello

Pisanello's work received an enthusiastic reception among north Italian humanists, many of whom were heavily influenced by the Greek scholar Manuel Chrysoloras (c. 1355–1415). Chrysoloras popularized the Greek tradition of *ekphrasis*, or extended, descriptive praise. Because of the compatibility between Pisanello's work and humanist rhetoric, it was he—not the classicizing Donatello, Brunelleschi, or their compatriot Masaccio—who received most praise from early Italian humanists. A good

example of *ekphrasis* survives in a description of Pisanello's work by Guarino da Verona (1370–1460), Chrysoloras's most famous pupil.

... you equal Nature's works, whether you are depicting birds or beasts, perilous straits and calm seas; we would swear we saw the spray gleaming and heard the breakers roar. I put out a hand to wipe the sweat from the brow of the labouring peasant; we seem to hear the whinny of a

war horse and tremble at the blare of trumpets. When you paint a nocturnal scene you make the night-birds flit about and not one of the birds of the day is to be seen; you pick out the stars, the moon's sphere, the sunless darkness. If you paint a winter scene everything bristles with frost and the leafless trees grate in the wind. If you set the action in spring, varied flowers smile in the green meadows, the old brilliance returns to the trees, and the hills bloom; here the air quivers with the songs of birds.

CONTEMPORARY SCENE

Art and Punishment

Pisanello drew these figures of hanged men (Fig. 14.4) as preparatory studies for his fresco of St. George in Verona (see Fig. 14.3). Carefully observed and detailed, they depict one of the grimmer aspects of life in medieval and Renaissance Europe, where the executions of criminals were public events and where bodies or parts of bodies were left on view in the landscape or in

designated parts of the city as warnings to the population at large against breaking the law. London Bridge, for example, often carried decapitated heads exposed on spikes. And at the Senator's Palace of Capitoline Hill in Rome, men were tortured by having their hands tied behind their backs with a rope, by which they were then hoisted into the air and then repeatedly dropped a certain distance. This punishment, called strappato, tore the muscles of their arms, yet the men were left hanging from the façade of the building between applications of the torture. Bodies placed on wheels, with their limbs brutally broken over the rim, the bones piercing the skin, were erected on tall poles on open fields where they attracted carrion-eating birds.

Pisanello's fresco shows the gallows placed outside the city wall, as was the usual custom, in order that the criminal dead should not defile the city itself. Thus punishment put the trespasser literally outside the bounds of society. Moreover, it denied to the criminal the nor-

mal transitional rites of Christian burial which were meant to usher the soul into the afterlife. Even though confraternities assumed the duty of praying with and for the condemned prisoner, and even accompanied him up the ladder to the gibbet with exhortations to repentance, the final act of execution left the criminal alone and unattended, spatially and spiritually separated

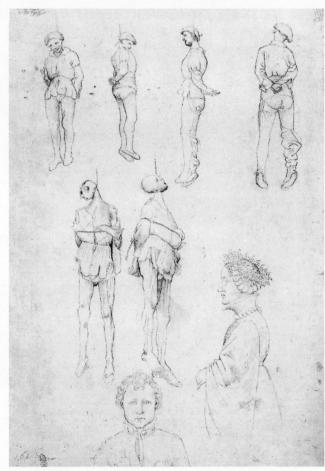

14.4 Hanged Men and Two Portraits, 1430s, **Pisanello**. Metalpoint and pen on paper, $11\% \times 7\%$ " (26.6 \times 19.7 cm) (© British Museum, no. 1895.9.15.441, London)

from the community (see Fig. 12.1). Pisanello's drawing also graphically suggests the degradation of the condemned men, as some of their garments fall away, revealing their nakedness. Prostitutes were often punished by being stripped to the waist and paraded through the streets as a form of public humiliation. In times of insurrection people were sometimes hanged

from windows of the city halls where they had moments earlier been sentenced to death-swift justice in a period of inflamed passions. In Florence, images of hanged criminals were painted on the façades of the Palazzo del Podestà (the governor's palace, now known as the Bargello) and the Palazzo della Signoria. Both Castagno and Botticelli are known to have painted such images; Castagno was even known as Andrea of the Hanged Men, supposedly for the number, if not the fame, of his works in this genre. Accompanying inscriptions identified the criminals, and the images remained as a long-term reminder, not only of the individuals but of the shame that they had brought to their families. These portraits of infamous men, as they were known, served as a vivid counterpart to the portraits of virtuous citizens that decorated the walls of family chapels and the façades of confraternities and churches (see Figs. 8.18 and 10.43). In their own way they are a measure of the power of the visual image to convey messages about civil order.

A similar aesthetic dominates the walls of the chapel, lined with twenty-four terracotta reliefs by Michele da Firenze. The reliefs narrate mainly events from the Passion and Resurrection. They also include a few scenes from the early life of Christ (Fig. 14.5). In the *Adoration of the Magi*, Michele reverses his master Lorenzo Ghiberti's portrayal of the same subject from the second set of bronze doors for the Baptistry in Florence (see Fig. 10.5, third scene on the

third row from the bottom). He also adds charming, almost naïve detail quickly modeled in the terracotta: a parade of the Magi and their entourage among the hills at the upper right; lilies, ferns, and flowers growing as large as and larger than the trees; and an angel and eight-pointed star above a thatched shed sheltering the obligatory ox and ass. Diversity and complexity here take precedence over dramatic unity and coherence.

14.5 Scenes from the Life of Christ, detail of the Adoration of the Magi, 1430s, commissioned by the Pellegrini family from **Michele da Firenze** for the Pellegrini Chapel, Sant'Anastasia, Verona. Terracotta

Pisanello and Michele probably collaborated on this project, which is typical of multi-media decorative complexes in this period. Besides providing a fresco for the entrance to the chapel, the painter may have participated in polychroming the relief sculpture.

Borso d'Este

Borso d'Este (1413-71), Leonello's half brother, succeeded him as marquis of Ferrara in 1450. Few Renaissance princes were as enamoured of courtly display. Renowned for his broad smile and splendid attire, Borso moved freely among his subjects in full court dress, winning loyalty and admiration through a conscious display of the princely virtues of magnificence and jocundity. Succeeding the equally image-

conscious but more restrained and scholarly Leonello (see Fig. 14.2), Borso acted the part of a great prince. He earned the title of duke of Modena and Reggio in 1451 and recognition as the first duke of Ferrara in 1471. Ferrarese art under Borso was extravagant and flamboyant, highpitched, coloristic, and full of decorative verve. While some observers found Borso's penchant for luxury a bit overwhelming—Pope Pius II snidely remarked that Borso wished merely to appear, rather than to be, grandiose and generous—there was no denying the opulence of the Ferrarese court.

Borso's Bible Borso and his artists upheld and enhanced the accomplishments of his predecessors, a strategy for maintaining dynastic power that is made explicit in his commission for the decoration of a deluxe illuminated Bible (Fig. 14.6). Borso's ducal chamberlain made a contract with Taddeo Crivelli (active 1451-died before 1479 Bologna) and his assistant, Franco de' Russi (active c. 1453-82), illuminators who had earlier worked for the Malatesta family on the Adriatic coast. The contract stipulated not only the usual matters of format, price, and completion date of the work, but also instructed the artists to emulate a deluxe French Bible that scholars have identified as a work illuminated by Belbello da Pavia for Borso's father Niccolò III. Since the two Bibles are quite different in the arrangement of their pages, spatial conceptions, and specific style, the artists must have been asked not to copy the earlier work but to use it as a standard of excellence to equal or exceed.

The opening page of the Old Testament book of Ecclesiastes is clearly marked on a fluttering orange ribbon in the center of the upper border and in red lettering in the left column. An enormous floriated initial begins the text itself, surrounded in the border by equally brilliant, nearly enameled flowers laid on a ground of fine gold filigree.

14.6 Bible of Borso d'Este, page from Ecclesiastes, 1455-61, commissioned by Borso d'Este from **Taddeo Crivelli** and **Franco de' Russi** (Biblioteca Estense, Ms. V.G. 12 = Lat. 422, I, fol. 284r, Modena)

The Bible was produced in two large volumes at two different rates of remuneration, the higher one reserved for the opening pages of each book of the Bible.

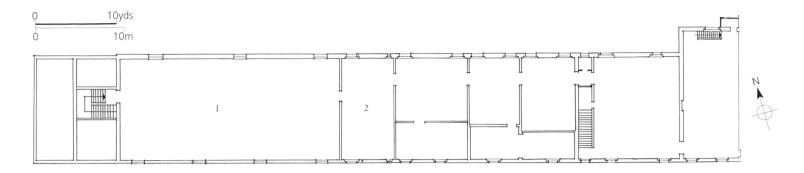

Teardrop-shaped openings reveal heraldic imagery; a deer and leopard in the upper corners reclining on woven baskets of green grass recall much prior courtly imagery (see Fig. 9.29). Lavender cornucopias and a golden vase improbably but splendidly tie the border to an equally fantastic but more illusionistic landscape and pavilion below.

Inside a perspectivally constructed pavilion courtiers and their ladies perform a circle dance accompanied by trumpeters standing at the right. At the left, however, the king

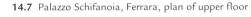

1 Hall of the Months; 2 Hall of the Stuccoes

for whom they perform looks away, contemplating the golden glow of the sky, part of a naturalistic landscape that flanks the pavilion left and right, creating spatial illusions distinct from the flatness of the writing surface and decorative motifs above. The king is the wise ruler of the text of Ecclesiastes, who heeds the writer's condemnation of all

worldly accomplishment and pleasure as "vanity of vanities." How ironic and yet telling for a patron so enamored of display as Borso.

Borso's extravagant Bible with its more than 1000 illuminations served much more than a splendid personal devotional object. It was shown to ambassadors, and Borso carried it when he went to Rome at the end of his life to be invested as duke of Ferrara. Since Borso spent most of his reign working to make Ferrara a duchy, he had to look, act, and spend like a duke, being especially conscious of the example of the dukes of Milan and Burgundy, who were also lavish patrons of manuscript illumination (see Fig. 9.28). The Bible's great expense, some 5000 ducats or fully one hundred times the average yearly rent for an entire house in Ferrara, placed him firmly in their league.

The Palazzo Schifanoia Around 1465 Borso began renovating a late-fourteenth-century pleasure palace in the southeast corner of Ferrara. Known as the Palazzo Schifanoia (literally "away with boredom" but implying casting one's cares to the wind), the palace had traditionally been used as a guest house and site for court entertainments (Fig. 14.7). Substantial remains of its decorative program can still be admired in the main reception hall, the so-called Hall of the Months (Fig. 14.8), and the

14.8 Hall of the Months, detail of April and May, 1469–70, commissioned by Borso d'Este from **Francesco del Cossa, Ercole de' Roberti**, and others according to designs probably provided by **Cosmè Tura** for the Palazzo Schifanoia, Ferrara. Fresco, width of each 13′ 2″ (4 m)

The figures in the dark middle band represent phases of the astrological calendar ruled by Taurus, the Bull.

smaller audience hall and antechamber to Borso's private apartment, the Hall of the Stuccoes (Fig. 14.9). As its name implies, the Hall of the Stuccoes is renowned for a wide band of stucco (plaster) decoration that wraps around the room just below a carved, polychromed, and gilded coffered ceiling bearing shields with Borso's personal emblems. Putti stand amid cornucopias and thick garlands which serve as a kind of celestial court of honor for female personifications of virtues enthroned in shell-topped niches: Charity, Faith, and Hope on the wall contiguous with the duke's chambers and Fortitude, Prudence, and Temperance on the wall adjoining the reception hall.

In a sense, the decorative program of the palace was not complete unless Borso himself was present. Borso saw himself as the embodiment of Justice, the only virtue absent from the iconographic program of the Hall of the Stuccoes. Dressed lavishly, in keeping with the splendor of his surroundings, he would have greeted his most important guests in this room and then have had the pleasure of leading them back into the larger main reception room, where the fresco cycle began with a portrayal of the duke and his courtiers under a portal clearly labeled "Justice." Art and court life were perfect mirrors of one another.

The principal subject of the Hall of the Months (see Fig. 14.8), was an astrological and calendrical cycle resembling schemes such as those at Trent in the early fifteenth century (see Fig. 9.32). The cycle runs counterclockwise around the room, beginning with March, the first month of the year in most Renaissance calendars. It and the adjacent scene of April are the best preserved paintings, having been executed largely in *buon fresco* by an enterprising local artist, Francesco del Cossa (c. 1435 Ferrara–1476/77 Bologna). The lower band of the central bay representing April is

dominated at the right by a classically detailed white, green, and pink pavilion, suggesting the Este's armorial colors of red and green. In its center foreground stands the rotund, smiling Borso and a group of courtiers; his coat and those of two of the more splendid youths are embellished with real gold. A doorway later cut into the wall at the left truncates a composition of Borso engaged in the hunt, both a literal depiction of an aristocratic activity and a metaphorical allusion to Borso's maintenance of peace in the countryside as well as in the city. The two scenes pivot around the ruins of a classical arch, behind which stretches a vast landscape and in front of which sits the charming figure of a courtier, now largely effaced, whose crossed legs seem to extend out into the viewer's space. Above the hunting scene Cossa has squeezed in a representation of the Palio di San Giorgio, an annual race among the city's neighborhoods. Roman ruins at the left blend with a medieval tower and crenellated wall, suggesting, along with the Roman arch at the center of the full panel, that Ferrara is heir to ancient glories now revivified under the virtuous Borso d'Este.

All these mundane activities are given a celestial gloss in the upper zone of the wall by a representation of the Triumph of Venus, her float drawn into safe harbor by a pair of swans. A knight in golden armor kneels before her, chained as her prisoner. He should probably be understood as Mars, the god of war, who according to Tito Vespasiano Strozzi's *Borsiade* (a classicizing biography of Borso) objected to Jupiter's pronouncement that Borso would usher in a reign of peace. Venus, goddess of love, persuaded Mars to change his mind. Amorous young couples confirm that Venus and Borso have triumphed. Numerous pairs of rabbits, renowned for their fecundity, graze across the lavender and green landscape.

Borso had very good reason to be pleased with Cossa's work. It was visually alluring, learned, witty, and filled with intriguing detail. It may come as a surprise to learn, then, that Cossa complained about his compensation and that his requests for additional pay fell on deaf ears. Borso paid him by the square foot for his efforts, rather than by time or by figure. A persuasive theory suggests that Cossa was paid on this basis because the duke's salaried court artist, the slightly older Cosmè Tura (c. 1430 Ferrara-1495 Ferrara), provided detailed drawings for each of the compositions.

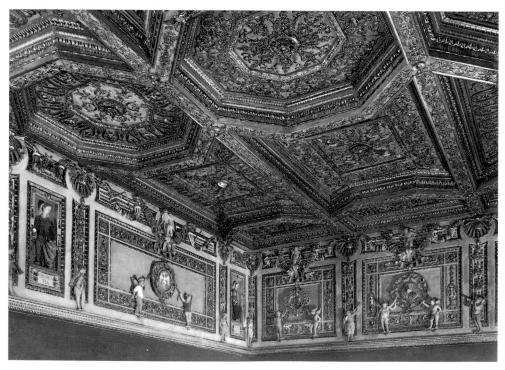

14.9 Hall of the Stuccoes, 1467, commissioned by Borso d'Este from Domenico di Paris and Buongiovanni da Geminiano for the Palazzo Schifanoia, Ferrara. Stucco with polychromy and gilding

14.10 Palazzo dei Diamanti, Ferrara, 1493, commissioned by Sigismondo d'Este from Biagio Rossetti

The palace stands midway between the Este Castle in the old city and what was to have been the site of a 55-foot (17-meter) tall equestrian statue of Duke Ercole.

The Palazzo dei Diamanti

After Borso's death in 1471, his half brother Ercole d'Este (1431-1505) created an entire district of classically inspired buildings along clear, straight avenues emanating directly from the Este palace compound at the center of the city. At the crossroads of the district's main axes, Ercole's brother, Sigismondo (1433-1507), constructed the extraordinary Palazzo dei Diamanti, so-called for the 8,500 diamond-faceted blocks that erupt from its façades (Fig. 14.10). Designed by the court architect Biagio Rossetti, who was responsible for the layout of the neighborhood as well

as for numerous churches and residences within it, the building subtly evokes the fortified character of the Este Castle in its raked plinth and insistent rustication. Rossetti domesticated these forms by applying them decoratively to a classically organized rectangular structure recalling the Palazzo Medici in Florence (see Fig. 11.11). Reversing the usual Tuscan practice of a dominant ground story, Rossetti enlarged the main, upper story, punctuating it with large pedimented windows. Smaller windows, those on the entrance side capped by entablatures, illuminate the lower story. The corner, from which the Este were both to admire their new straight streets and appear splendidly to their subjects, is accented with two lavishly carved, superimposed pilasters and a balcony. Every element is exquisitely detailed, down to the diamond-shaped blocks, whose facets shift from level to level so that they point upward from the bottom, appear perfectly centered in the middle zone, and slightly tilt downward from the piano nobile.

Naples: Alfonso the Magnanimous

On July 5, 1421, the childless Queen Giovanna II of Naples adopted Alfonso of Aragon (c. 1396-1458) as her heir, giving him claim to a kingdom that stretched across the Mediterranean, from Spain to Italy. Two years later Giovanna had second thoughts about empowering the already formidable Aragonese king, preferring instead to recognize the claims of her Angevin cousins. It took twenty years of fierce fighting before Alfonso was able to ride in triumph through his new capital city in 1443, and he was determined that his artistic projects would both proclaim and ensure his sovereignty.

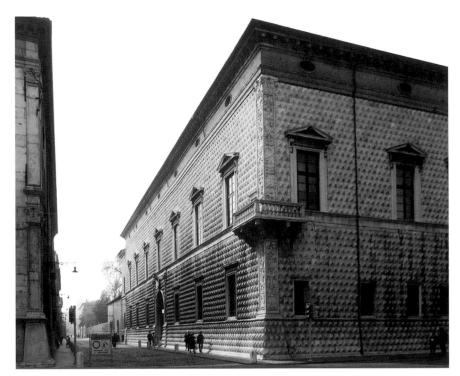

The Castello Aragonese

Alfonso repeated the early Angevin strategy of importation and imposition. He allotted the construction of the castle's greatly enlarged moats and new, defended forecourt, the so-called Citadella, to Italians, but followed the examples of fortifications in Spain and southern France in the renovations of the castle (Figs. 14.11 and 14.12). The building was at once fortress and palace, the congenial home to studies of ancient philosophy, literature, and rhetoric, as well as the site of cold-blooded scheming. It presents a resolutely military aspect, providing lofty interior spaces and efficient defense against newly powerful cannons. By contrast, its entryway suggests an ancient triumphal arch, celebrating Alfonso's conquest of the city (Fig. 14.13). The five enormous towers at its corners rise from splayed bases which functioned as defense against heavy artillery.

The castle's most important ceremonial space, the Sala dei Baroni (Fig. 14.14), occupies one corner of the building, which faces an ample interior courtyard. Its stunning star vault is the work of the Catalan architect Guillermo Sagrera (active 1397 Felanity, Mallorca-1454 Naples). He began the work in 1452; it was fully complete by April 15, 1457, when Alfonso inaugurated the space with a banquet in honor of his nephew. Sagrera's experience as architect of the cathedral of Palma in Mallorca and his designs for the thin, spiraling piers of that city's Lonja del Mar served him well as he undertook the task of vaulting the 85-foot (26-meter)square space to a height of nearly 92 feet (28 meters). Sagrera transformed the square space into an octagon by constructing squinches in its corners. He then sent eight main ribs springing directly out of the wall, creating an

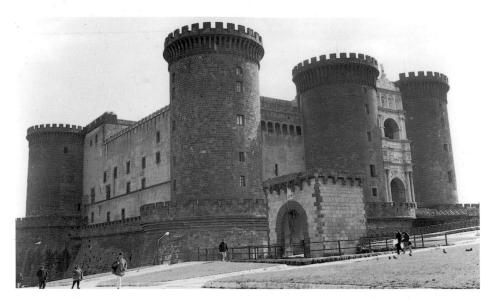

14.11 Castello Aragonese (Castel Nuovo), Naples, renovated after 1443, commissioned by King Alfonso I. See also Fig. 14.13

Alfonso's Triumphal Arch extends between the two towers at the far right. A great fortified forecourt once stood in front of the castle.

impression of organic spontaneity. The vaults are subdivided into smaller units, all the ribs converging toward a central oculus. Carved bosses bear the devices of King Alfonso and punctuate the inner points of the star. No wonder Pope Pius II exclaimed that even the palace of Darius, ancient king of Persia, could not have been grander. Although the room's structure was clearly Gothic, its scale rivaled the most celebrated accomplishments of antiquity.

An Arch for a Humanist Ruler

Within his formidable and splendid castle Alfonso gathered some of the fifteenth century's most renowned humanist scholars. Intensely interested in the study of Greek and Latin literature, Alfonso had Caesar's *Commentaries* read to him on the battlefield and even claimed, somewhat disingenuously, to have learned more about war from the ancient authors than he had from practical experience. Every day after dinner, he and his coterie of scholars retired to his library to engage in spirited, often heated, exchange.

In 1453 Alfonso's interests in ancient civilization took on substantive form in the triumphal arch built as the entrance to his castle (see Fig. 14.13). This was intended to commemorate the temporary arch that had been erected in front of the cathedral when he entered the city in triumph in 1443. Typifying Alfonso's dependence on Spanish staff, the Catalan master Pere Joan (active 1400–58) oversaw the project. Under his direction Pietro da Milano (c. 1410 Milan–c. 1473 Naples), a Lombard sculptor who had spent his early years working in Ragusa in Dalmatia, supervised the work of at least five master sculptors and thirty-three assistants. Sculptural work was allocated to different workers, ensuring a speedy completion of the project.

The multiple-storied arch, made of white marble, fills the opening between two of the main towers of the castle. The lower section accurately imitates an actual Roman monument, the Augustan Arch of the Sergii at Pula, in modern Croatia, which Pietro may have seen while working in Dalmatia. Paired fluted Corinthian columns stand on pedestals to either side of the barrel-vaulted entrance, itself enhanced with classical coffers, while a relief of The Triumphal Entry of Alfonso into Naples (Fig. 14.15) decorates the attic story of this arch. In this relief, groups of figures, all carefully coordinated in size and scale, even though carved by different hands, enact an idealized and simplified version of

Alfonso's triumphal entry into Naples a decade earlier. The sculptors evoke the character and decorum of early Roman imperial reliefs in the proud, calm bearing of nobles who process behind Alfonso, enthroned and elevated on a canopied processional cart, and in the more active figures of the musicians and horsemen who lead the way. The fire at Alfonso's feet, however, comes from Arthurian legends popular at all the Italian courts and represents the Siege Perilous ("dangerous seat") which could be occupied safely only by Sir Galahad, the knight destined to find the Holy Grail. Since Alfonso now occupied that seat symbolically, he was to be seen as a chivalric hero as well as a Roman victor. Thus antique and medieval traditions merged to create a powerful image of kingly rule.

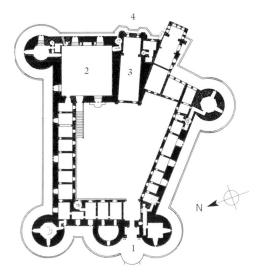

14.12 Castello Aragonese (Castel Nuovo), Naples, plan of upper floor

1 Triumphal arch; 2 Sala dei Baroni; 3 Chapel; 4 Harbor

14.13 (opposite) Triumphal Arch of King Alfonso of Aragon, Castello Aragonese (Castel Nuovo), Naples, 1453-58 and 1465-71. See also Fig. 14.11.

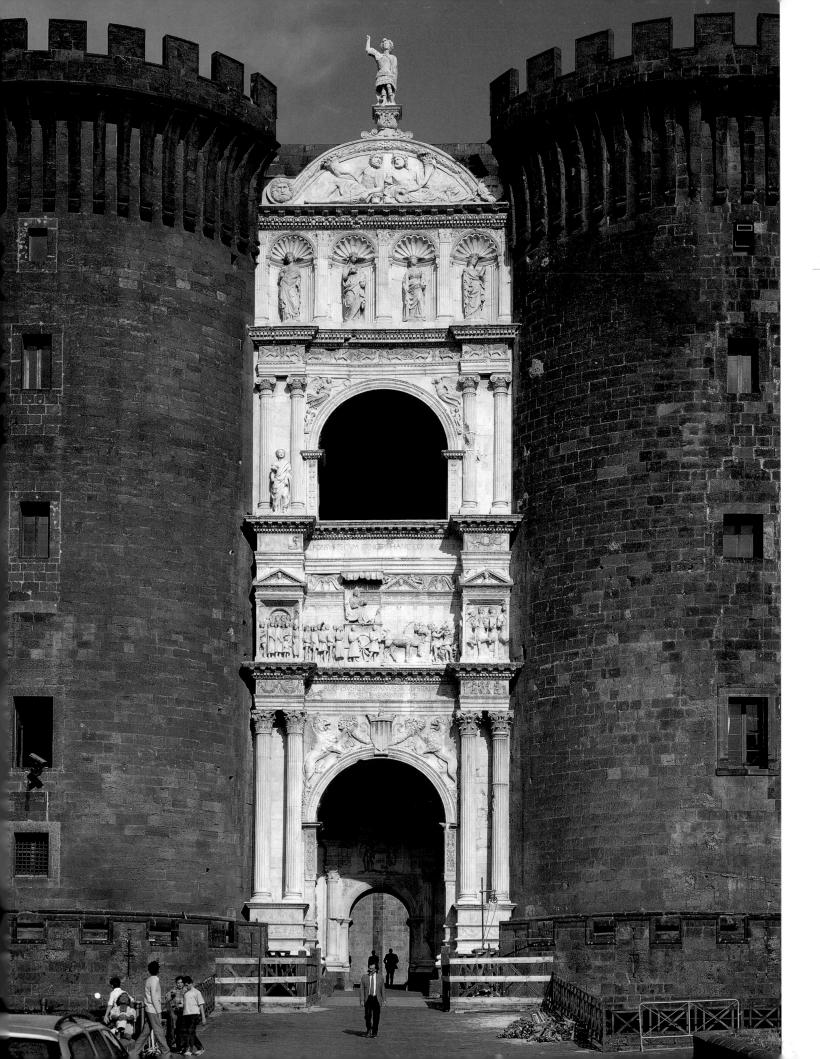

14.14 Sala dei Baroni, Castello Aragonese (Castel Nuovo), Naples, begun 1452, commissioned by Alfonso I from Guillermo Sagrera

An intense fire in 1909 destroyed many of the more subtle architectural details, which included intricate keystones and balustrades filled with complicated tracery.

14.15 *Triumphal Entry of Alfonso of Aragon into Naples*, 1453–58, upper story sculpture 1465–66, commissioned by Alfonso I from **Pere Joan**, **Pietro da Milano**, **and others** for the Triumphal Arch, Castello Aragonese (Castel Nuovo), Naples. Marble

Rimini: Sigismondo Malatesta

In Rimini, a small papal vassalage on the Adriatic coast, antiquity and chivalry also proved effective tools of propaganda for Sigismondo Pandolfo Malatesta (1417-68), one of the most notorious despots of the Renaissance. Sigismondo (whose surname means "bad head") was flagrantly disloyal to those who engaged his services as a condottiere and inflicted appalling cruelties on his enemies. His use of art, literature, and classical learning for unrepentant self-promotion was clearly intended to counteract this horrendous reputation. He so outraged Pius II that the pope publicly condemned him to hell during his life-time. Still, papal vilification of Sigismondo cannot be taken at face value, especially since he maintained good relations with other popes and rulers. He even appears in Gozzoli's frescoes for the Medici family chapel in Florence (see Fig. 11.14, where he is the horseman at the far left). Sigismondo seems to have been well liked by the citizens of Rimini, who reveled in the way their leader claimed equal footing with the great powers of the Italian peninsula.

The key to understanding Sigismondo lies in his renovation of the church of San Francesco in Rimini, the traditional burial place of the Malatesta lords (Figs. 14.16 and 14.17). Medals cast to commemorate its foundation and dedicatory inscriptions on the sides of the church report

14.17 San Francesco (the Rimini Temple), Rimini, 1447–50, renovations commissioned by Sigismondo Pandolfo Malatesta from **Leon Battista** Alberti and Matteo de' Pasti

that Sigismondo "erected at his magnanimous expense this temple to the Immortal God and to the City, and left a memorial worthy of fame and full of piety." Sigismondo was fulfilling a vow he had made during wars between Florence, Venice, and the Sforza contingent of Milan on the one hand and Naples, the Pope, and the Visconti of Milan on the other. He emerged as the decisive player, switching sides in 1447 to fight for the eventual victors, the Florentines, which may explain why both the architecture and its sculptural decoration were commissioned from Florentine artists, and why he appears in the Medici Chapel fresco.

At first Sigismondo only seems to have intended to erect a chapel to his name saint, Sigismund, but by 1450 he had committed to a grander project: renovating the old church of San Francesco with classical elements. He contracted the humanist architect Leon Battista Alberti for the design, but entrusted the supervision of the construction (see Fig. 34) to the builder and artist Matteo de' Pasti (born Verona; active 1441-64). Alberti's solution was to wrap the entire existing Gothic church in a marble classical skin, articulated with arches. Alberti also intended to erect a massive hemispherical dome modeled on the Pantheon over a new choir, although that part of the project was never realized. The façade evokes the forms of an actual Roman Augustan gate in Rimini-an indication of Sigismondo's rulership intentions. On the church, fluted attached columns divide the lower part of the façade into three arched bays. The spandrels above the arches are decorated with roundels, while a triangular pediment marks the door. Alberti enhanced this imperial imagery with geometric inlays of serpentine and porphyry, again recalling Roman precedents in their design and material. For the upper part of the façade Alberti

14.18 San Francesco interior (the Rimini Temple), Rimini, 1450s 60s, renovations commissioned by Sigismondo Pandolfo Malatesta from Agostino di Duccio.

The exposed wooden trusses in the ceiling and the rib vaults partially visible in the side chapels all pre-date Malatesta's renovations, having been part of an existing Franciscan church on the site.

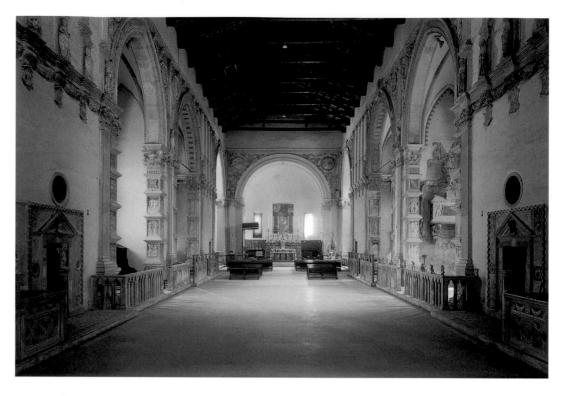

14.19 (below) *Luna*, c. 1453-56, commissioned by Sigismondo Malatesta from **Agostino di Duccio** for the Malatesta Temple, Chapel of the Planets, San Francesco, Rimini. Marble

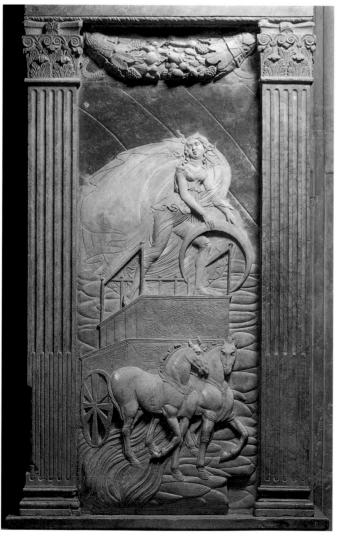

planned a broad pediment with an arch at the center (not completed), flanked by fluted pilasters. The central arch may have been intended to frame the tomb of Sigismondo's saintly brother, Galeotto Roberto, whose miracle-working tomb then stood in front of the original church. The triumphant imagery, suggesting victory over death, thus would have combined Christian and familial themes.

The rebuilt church was to include the tombs of Sigismondo, his mistress and, later, wife Isotta degli Atti, and other members of the family. On the outside, arches along the side of the church, which allowed light to enter the interior, each framed a sarcophagus recalling in their shape ancient types visible in nearby Ravenna, once capital of the Western Roman Empire. The sarcophagi were reserved for illustrious humanist scholars and members of the court, including Basinius of Parma, author of the epic Hesperis which relates Sigismondo's exploits as a condottiere, and the military writer Roberto Valturio, who catalogued much of Sigismondo's war machinery.

A more ornate, chivalric character prevails in the interior of the church (Fig. 14.18), designed by Agostino di Duccio (1418 Florence-after 1481 Perugia), a student of Donatello who had earlier worked in Modena. Whereas Alberti had concealed the Gothic elements of the pre-existing church with a classical skin, Agostino, like most of his contemporaries, preferred to apply classical vocabulary over and around Gothic structure, retaining pointed arches and framing double tiers of Gothic window tracery with classical rinceaux. Agostino's manner is lavish, enhanced by polychromy and the recurrent appearance of coats of arms, chivalric helmets, and such exotic motifs as elephants, the Malatesta family emblem.

A relief representing Luna (the moon; Fig. 14.19) exemplifies Agostino's work within the context of this highly sophisticated court. It forms part of the decoration of the so-called Chapel of the Planets (see 5 on Fig. 14.16), which was actually dedicated to St. Jerome but whose walls Agostino lined with marble reliefs depicting the seven planetary gods and the associated signs of the zodiac. This highly sophisticated program, which Valturio said "could attract those skilled in literary studies," may have been planned by his fellow humanist Basinius of Parma, who composed a richly detailed poem called Astronomica in these very years. Agostino's reliefs ingeniously combine references to it and other ancient and modern sources, including Petrarch's evocative description of a similar cycle he imagined in the Palace of Syphax. As had been traditional from at least the fourteenth century, Agostino's Luna holds a crescent in her hand while standing in a double-wheeled chariot drawn by two horses. More unusual is the rushing stream over which they travel, including ocean life that may reference a Homeric hymn to the Rising Moon. Equally unprecedented are Luna's exposed arms and legs and billowing, diaphanous gown, hallmarks of many of Agostino's figures that may derive from neo-Attic prototypes which allowed Agostino to suggest the energy and dynamism evoked by many ancient texts about the gods and planets.

Urbino

The relative isolation of Urbino, a small hill town 48 miles (77 kilometers) inland from the central Adriatic coast, required that its lord, Federico da Montefeltro (1422–82), cast a wide net for artistic talent. His success as a military captain and diplomat was matched by a reputation for being especially humane and learned. He created a great library at Urbino, purchasing many of his deluxe editions from the humanist bookseller Vespasiano da Bisticci in Florence.

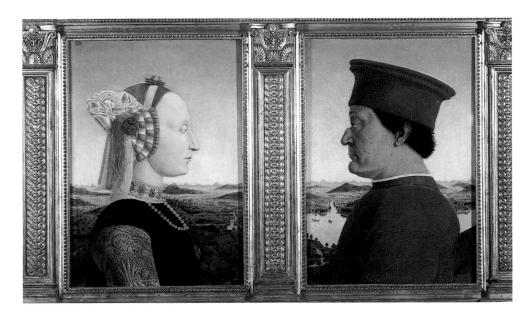

14.20 Battista Sforza and Federico da Montefeltro, c. 1472, commissioned by Federico da Montefeltro from **Piero della Francesca**. Oil and tempera on panel, each $18\!\!\!\!/\times 13\!\!\!\!/$ (47 \times 33 cm) (Galleria degli Uffizi, Florence)

The paintings are not in their original frames, which may have been hinged like a book.

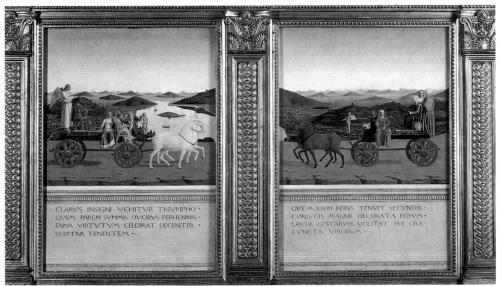

14.21 *Triumphs of Federico da Montefeltro and Battista Sforza* (reverses of Fig. 14.20), c. 1472, commissioned by Federico da Montefeltro from **Piero della Francesca**. Oil and tempera on panel, each $18\% \times 13\%$ (47×33 cm) (Galleria degli Uffizi, Florence)

Beneath each of the triumphal carts, inscriptions in Latin appearing to be carved in Roman capitals extol the gendered virtues of Federico da Montefeltro and Battista Sforza. Federico's reads: "He that the perennial fame of virtues rightly celebrates holding the scepter, equal to the highest dukes, the illustrious, is borne in outstanding triumph." Battista's reads: "She that kept her modesty in favorable circumstances, flies on the mouths of all men, adorned with the praise of the acts of her great husband."

Portraits

A double portrait by Piero della Francesca presents both Federico da Montefeltro and his recently deceased wife Battista Sforza (Fig. 14.20). Piero adopted the traditional convention of profile representation appropriate to the couple's high status, giving dignity to Federico's less than handsome features. Not only did Federico suffer from a skin disease, but he had lost his right eye and part of the bridge of his nose in a tournament in 1450, probably accounting for Piero's decision to show the left side of his face and having him face his wife rather than having her at his left (see Figs. 21.21 and 21.22).

Piero pairs the couple heraldically. In each case their collars are aligned with the horizon, linking them subtly but firmly to continuous but distinct physical worlds. Federico appears before a glowing world of lakes, rivers, and boats which would allow him to venture far beyond the hills of Urbino. Battista, who had been his most trusted confidant and had attended to affairs in Urbino during his frequent absences, is shown in front of an enclosed and fortified landscape denoting traditionally proscribed limits of female activity. The heavy shadows may allude to her recent death. Both landscapes recall elements in popular portraits by Hans Memling of Bruges (c. 1440–94), an indication of Piero's acquaintance with northern European painting and of its high prestige at Federico's court.

On the reverse of the diptych Federico and Battista appear in two sober triumphs (Fig. 14.21). This type of image was popularized by Petrarch's poems on the Triumphs of Love, Chastity, Death, Fame, Time, and Divinity. Latin inscriptions in fine Roman capital letters indicate Federico's high respect for the written word and humanist scholarship. His triumph celebrates active, masculine rulership, personified by the four women sitting on his chariot: the cardinal virtues Justice, Prudence, and Strength facing out and forward; Temperance is seen from the back facing into a landscape similar to the one shown in Federico's portrait on the other side of the panel. Battista, too, rides in front of a landscape that is a continuation of that shown in Federico's triumph but, once again, dominated by earth rather than water. She is deeply engaged in reading what is probably a prayerbook. Her inscription, written in the past tense-in contrast to Federico's living present-extols her modesty and her role as the famous man's spouse. The source of her fame is the traditional feminine virtue of Chastity, underscored by the unicorns drawing her cart. Facing outward at the front of the chariot and emphasizing her piety is Faith. Pride of place, however, is given to an unusual depiction of Charity, a woman clad in a dark dress and holding a pelican, a bird which, according to legend, picks its breast until it bleeds so as to give sustenance to its young-an apt image for a woman whose numerous pregnancies may, according to later writers, have caused her death at the age of twenty-six. Although not

securely identified, the two women standing behind the figure of Battista may be intended to personify her much-lauded modesty and piety.

Altarpieces

Also dating from the period soon after Battista's death, when Federico may have been contemplating his own mortality, is a devotional work by Piero (see p. 336). Mesmerizing in its stillness, the altarpiece shows Federico kneeling in glinting armor before the enthroned Madonna and Child, in the company of mainly mendicant and penitential saints (John the Baptist, Bernardino, and Jerome on the left; Francis, Peter Martyr, and John the Evangelist on the right). Piero constructs his imaginary space with great precision. The saints and Madonna and Child sit and stand in the crossing of a meticulously detailed church reveted with marble panels, fluted pilasters, and classical moldings. Coffered barrel vaults cover the transept arms and chancel behind them, where accompanying angels stand on more darkly colored pavement. Two jutting cornices, one in shadow at the upper left of the painting and the other in light on the right, both connected to the architecture of the original frame, suggest that Federico may instead be kneeling in the nave just in front of them all, distinguishing his human status from that of the holy figures and angels.

The impressive ostrich egg hanging from the shell-topped apse can be understood as an image of birth and resurrection, the emergence of a baby bird from an egg symbolizing both Christ's miraculous Virgin Birth and his dramatic release from the tomb. Ostrich eggs were, in fact, often hung in many chapels dedicated to the Virgin during the Middle Ages and Renaissance (see Fig. 3). The egg in this painting may have also served as a veiled heraldic device, for one of Federico's personal emblems was the ostrich itself.

The altarpiece has been trimmed slightly at the sides and by fully one-ninth of its height (an entire plank of wood) at the bottom. Even so it impresses with its remarkably large, ample space. In only one case did Piero alter normal proportions, enlarging the figure of the Madonna so that she is larger than life-size. Identified closely with the building in which she sits, she should be understood as an embodiment of both this building and the universal Church for which it stands. In kneeling here in front of the Virgin, Federico is clearly pledging his devotion not just to the Madonna but to the institutional Church-a wise move indeed, as he sought in these very years to dispel suspicions of disloyalty that had fallen upon him because of his service against the papacy in the battle of Rimini in 1469. As the loyal son of the Church, he offers his gleaming armor and pious soul to the Madonna representing the Church. Federico's offering was both accepted and rewarded when in 1474, at the time of the completion of the painting, Pope Sixtus IV named him gonfaloniere of the Holy Roman Church.

The Palazzo Ducale

The restrained elegance and balanced order of Piero's imagined architecture mirrored actual forms in Federico's palace in Urbino, which dominates the city both physically and symbolically (Figs. 14.22 and 14.23). Much of the work in the western part of the complex, designed as early as 1465 by the Dalmatian architect Luciano Laurana (c. 1420/25 Vrana, Dalmatia-1479 Pesaro), required substantial engineering since it follows the edge of a steep valley that separates the earlier part of the palace, begun in 1447, from a fortification to the north. On the west side, facing the main road that circled around the city from the coast, Laurana erected a ceremonial façade for the palace, both proudly militaristic in its twin multistoried, round towers and frankly celebratory and classicizing in the four superimposed arches at the center. Overtly recalling the comparable imagery of King Alfonso's arch in Naples (see Fig.

14.13), Laurana's design allows ample space between the individual elements and opens the arches to serve as loggias, both for enjoying a splendid sunset and for giving Federico platforms on which he could appear high above guests approaching and entering the city.

Laurana's design for the palace's central courtyard is justly famous for its lucidity and understated elegance, again in keeping with Federico's own character (Fig. 14.24). Five bays wide and six bays deep, it offers the appearance from one of the shorter sides of being a perfectly balanced square, thanks to the effects of perspective foreshortening. Originally this part of the palace was only two stories tall; even with the additional two stories, the space is much

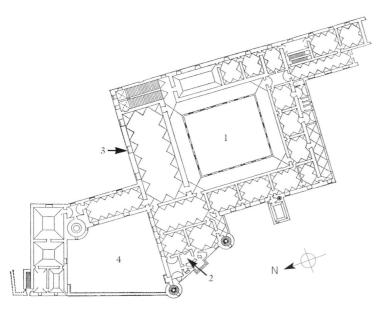

14.22 Palazzo Ducale, Urbino, plan of upper floor

1 Courtyard; 2 Studiolo; 3 Entrance on lower floor; 4 Hanging garden

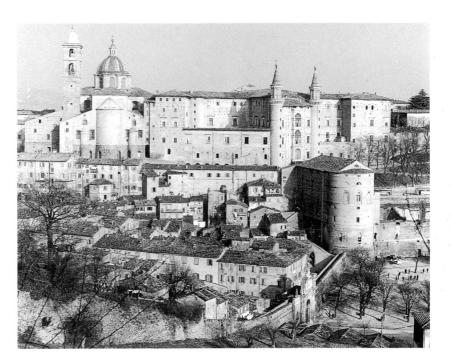

14.23 Palazzo Ducale, Urbino, western façade, mid-1450s-80s, commissioned by Federico da Montefeltro from Luciano Laurana, Francesco di Giorgio, and others

lighter and more open than any of its Central Italian counterparts—a perfected distillation of elements from new Tuscan trends (the graceful arcade, whose proportions recall those in Brunelleschi's Foundling Hospital, see Fig. 10.23, and the courtyard of the Palazzo Medici, see Fig. 11.12) and from Rome. Laurana gave the corners of the arcade an increased sense of stability with L-shaped piers, faced with pilasters.

The handsome inscription running around both frieze levels of the courtyard was not added until after 1474, when Federico was formally named duke of Urbino, but in many ways it sums up the intentions of Federico and his architect. It gives his titles as duke of Urbino and *gonfaloniere* of the Holy Roman Church and says that having won all his battles, assisted by the virtues of Justice, Clemency, Liberality, and Religion, Federico "built this house to his glory and that of his successors."

Inside the palace Federico and his guests enjoyed several handsome suites of rooms. On the lower level were a small series of ancient-style baths, heated by an underground furnace, so that he could follow the approved Roman sequence of hot, warm, and cold water. On the middle level are two tiny rooms, one called the Chapel of Pardon and the other dedicated to the classical Muses. Federico found nothing incompatible about his Christian and Roman-inspired beliefs, preferring a syncretist view which found value in a wide range of thought and revelation.

The crowning glory of Federico's private suite was his *studiolo* ("small study"; Fig. 14.25). The densely carved, gilded, and coffered ceiling carries Federico's personal emblems

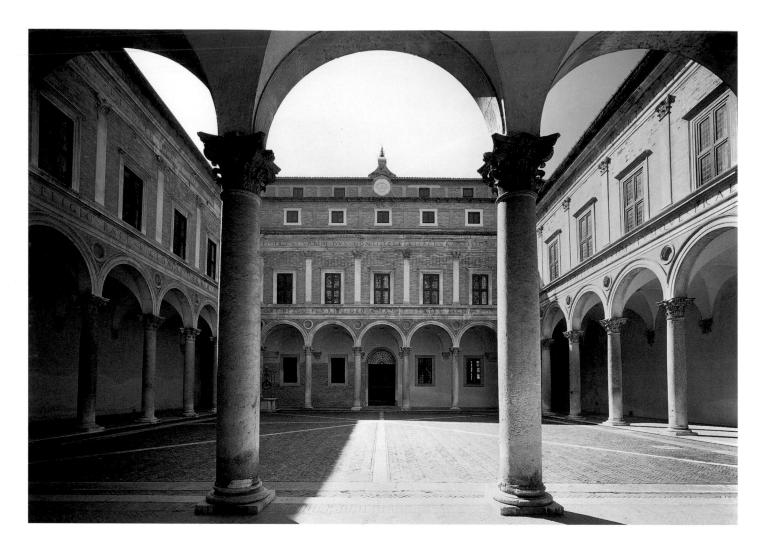

14.24 (above) Palazzo Ducale, Urbino, courtyard, mid-1460s, commissioned by Federico da Montefeltro from **Luciano Laurana**

The clock and the top story with small square windows are not original.

Most of the original paintings are represented by large photographs, the originals having been removed to museums throughout Europe. Federico himself appears in the intarsia panel set in the left niche of the room.

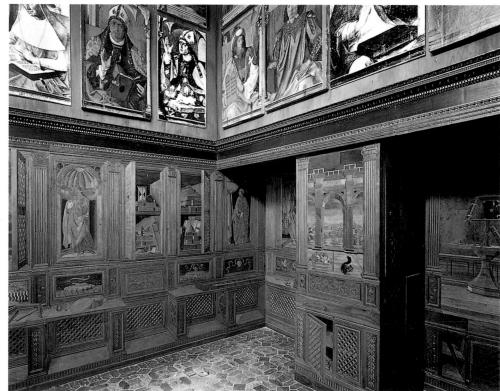

and an inscription giving his noble titles and the date 1476, the decoration being part of extensive renovations and enhancements begun in 1474. As was the case in Leonello d'Este's much earlier, but now destroyed, studiolo, the lower walls are lined in trompe l'oeil wood intarsia. Books, scholarly equipment, musical instruments, and even Federico's armor are all convincingly rendered, mimicking the actual objects kept behind the cupboard doors and even the small work table that folded down in the right niche. It is a breathtaking essay in perspective, composition, and craftsmanship, probably executed by Florentine craftsmen in the workshop of the architect and woodworker Giuliano da Maiano (1432 Maiano-1490 Naples), following designs by several artists, including Botticelli. Tellingly, a book stand is portrayed over Federico's desk, an appropriate contemplative image contrasting with emblems of the active life, Federico's armor, momentarily consigned to a closet but partially falling on the counter in the left niche. War was never far from peaceful contemplation and study.

To modern eyes the intarsia shown at center right may look like merely an elaborate still life of a basket of fruit and a squirrel set on the edge of a carefully constructed piazza and monumental classical arcade, but the unusual presence under the scene of a panel of interlocking Gothic fretwork by 1476 associated primarily with religious architecture and choir stalls-suggests that this composition should be read allegorically, along with the images of the active and contemplative life to either side of it. The squirrel's habits of industriousness and saving for the future (in this case represented by the full basket of fruit) made the animal a recognized image of the prudent ruler. The state for which he provides is founded in religion, alluded to by the Gothic fretwork, and embodied in the idealized city square and also in the view of the luminous landscape and city in the background. Because of Federico's pious thought and prudent actions his realm will flourish.

Above these allegories two rows of paintings depict paired exemplars of the major fields of scholarly learning from antiquity through to Federico's own time, arranged much as the books were arranged in his own library. Typically, classical and Christian authorities were juxtaposed. Since the scheme consists of portraits, for which northern European artists were particularly renowned, Federico commissioned most of the paintings from a Flemish artist, Justus of Ghent (Joos van Wassenhove; active 1460-80), who came to work at Federico's court. In the studiolo, then, Federico brought together a wide range of learning, both ancient and modern, Christian and pre-Christian, and also several contemporary artistic styles. To Federico our categorically opposed labels of "ancient" and "modern," "Italian" and "Flemish," "Gothic" and "Renaissance" would have seemed strangely and unnecessarily exclusive. Neither he nor the artists who worked for him were disturbed by the variety within his decorative scheme. If anything, rich diversity gave the scheme much of its particular power.

Mantua: The Gonzaga Family

The Gonzaga family gained control of Mantua in the early fourteenth century. Their city, located on the edge of three marshy lakes in the midst of the plain between Milan and Venice, was highly susceptible to floods, plagues, and threats from outside powers. So, like Sigismondo Malatesta and Federico da Montefeltro, the Gonzaga hired themselves out as *condottieri* to the highest bidders. They were adept at juggling alliances and softened their reputation as mercenaries by encouraging literary studies and by trading on the history of their city as the birthplace of the Roman poet Virgil, a favorite of the emperor Augustus. As elsewhere, chivalric and classical values co-inhabited the same court.

Sant'Andrea

In 1470 Alberti produced designs for the basilica of Sant'Andrea (Figs. 14.26, 14.27, and 14.28) in the center of Mantua. The site was particularly important to Ludovico Gonzaga (1412–78), marquis of the city, because it stood close by the Gonzaga palace and contained a relic, the supposed Blood of Christ, that had been recognized as genuine

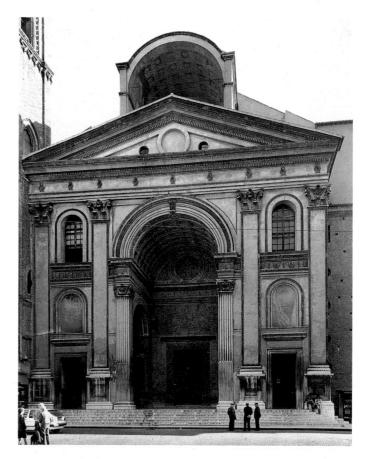

14.26 Sant'Andrea, Mantua, designed 1470, begun 1472, commissioned by Ludovico Gonzaga from **Leon Battista Alberti**, construction overseen by **Luca Fancelli**

The peculiar arch rising above the pediment imitates the barrel vault of the nave of the building.

by a papal council that met in Mantua in 1459. Alberti accurately understood Ludovico's criteria and addressed practical considerations in a letter of October 1470:

I understood in these days that your Highness and these your citizens were thinking of building here at Sant'Andrea. And that your principal intention was to have a great space where many people would be able to see the Blood of Christ. I saw that modello of Manetti's. I liked it. But to me it does not seem suited to your intentions. Ponder and imagine this which I send you. This will be more capacious, more lasting, more worthy and more felicitious. It will cost much less. This type of temple was known among the ancients as the Etruscan. Should you like it, I shall see to drawing it up in proportion.

(Translated in E. Johnson, Sant'Andrea in Mantua, p. 8)

What patron could resist so solicitous and level-headed a proposal-for a building that would be both grander and less expensive than originally projected!

Alberti's design for the façade of Sant'Andrea, like that of his Rimini Temple for Sigismondo Malatesta (see Fig. 14.17), draws its inspiration from Roman triumphal arches, but the Mantuan church takes the idea much further, its design at once more monumental and more complex, adapting a classical form rather than seeking to replicate it. The huge central arch of the exterior portico, with its coffered barrel vault, prefigures the height and vault of the nave. It is flanked by proportionately smaller openings, which also correspond to the church's internal structure, and by a giant order of paired Corinthian pilasters. Their smooth surface complements the richly coffered surfaces of the arch, while their height helps to unify the different levels of the composition. A boldly framed triangular pediment crowns the façade.

Inside the church Alberti honored his promise to provide excellent visibility of the high altar and its sacred relic, creating a broad, single-aisled space covered with a 60-foot (18.3-meter) wide coffered barrel vault, notably the largest since classical times. To support it, he followed Roman precedent, using not columns but huge piers, between

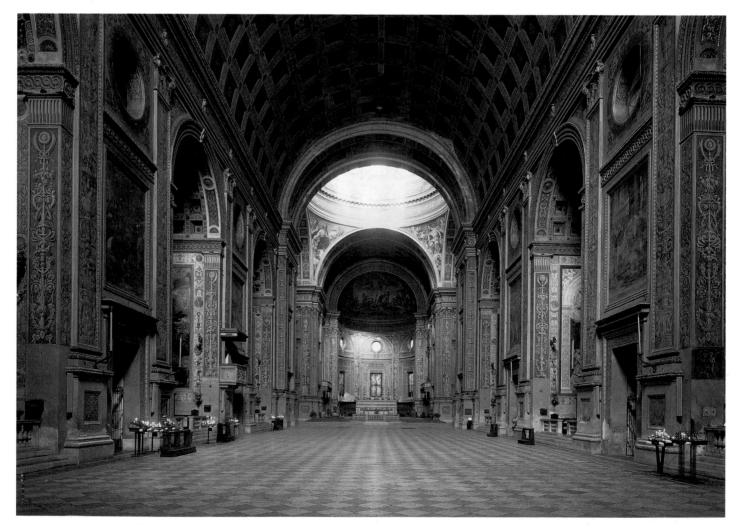

14.27 Sant'Andrea, Mantua, interior, designed 1470, begun 1472, commissioned by Ludovico Gonzaga from Leon Battista Alberti, construction overseen by Luca Fancelli

14.28 Sant'Andrea, Mantua, plan

which he placed side chapels. Alberti's careful coordination of elements throughout the entire structure, interior and exterior alike, as well as his use of large, bold forms, gave Ludovico Gonzaga the distinction of being patron of the first truly monumental, classicizing structure of the fifteenth century.

The Palazzo Ducale

The Sala Pisanello Ludovico's tastes had not always been so overtly classical. Like King Alfonso of Aragon in Naples and Sigismondo Malatesta in Rimini, he surrounded himself with both chivalric and antique imagery. Around 1447–48 Ludovico commissioned Pisanello to paint a series of frescoes for the main reception hall of his immense primary residence, the Palazzo Ducale (Fig. 14.29). The

Lancelot Cycle frescoes tell the story of Bohort, cousin of Lancelot of the Arthurian legends.

The paintings depict a tournament in which Bohort defeats sixty opponents in order to acquire the right to marry a princess. Above each wall appears a frieze of heraldic devices, dominated by Ludovico's personal emblem of the flower and heraldic collar of the German imperial Order of the Swan, of which he and his wife, Princess Barbara of Brandenburg, were the only Italian members. The focus on a brave, noble, and successful knight can be seen as a graceful compliment to Ludovico's activities as a *condottiere*. The Arthurian legends were also popular in Mantua because the knights' search for the Holy Grail was linked in the popular imagination to the relic of the Blood of Christ which the city protected.

Pisanello imagined the tournament as a great mêlée of knights and other people, capturing the spirit of the written texts and their rich detail (Fig. 14.30). Figures-seen from above, below, behind, and to the side-charge, lurch, turn, and fall. They are evenly disposed, tapestry-like, over the wall. Almost all semblance of spatial depth is foregone in favor of a two-dimensional surface, although buildings are placed on a diagonal to emphasize their volume, and individual figures are carefully modeled. Fragments of faces peer out from helmets that would once have been bright with silver foil. Foreshortening dramatizes the fate of those knights who have fallen to the ground; their plaintive features document the wide range of Pisanello's artistic talent. Unfortunately, he never completed the frescoes because he was called to work in the royal court of Naples.

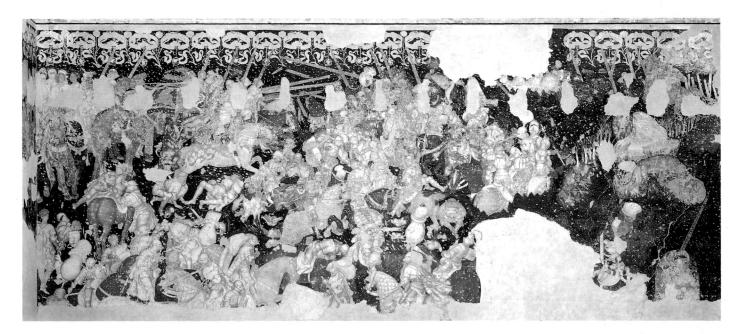

14.29 Legend of Lancelot, c. 1447-48, commissioned by Ludovico Gonzaga from Pisanello for the Palazzo Ducale, Mantua. Fresco

The surviving figures are missing a good deal of final detail that would have been added *a secco*. They are also in a somewhat damaged state, having been plastered over following the collapse of a ceiling in 1480; they were rediscovered only in the 1960s.

14.30 Legend of Lancelot (detail), c. 1447–48, commissioned by Ludovico Gonzaga from Pisanello for the Palazzo Ducale, Mantua.

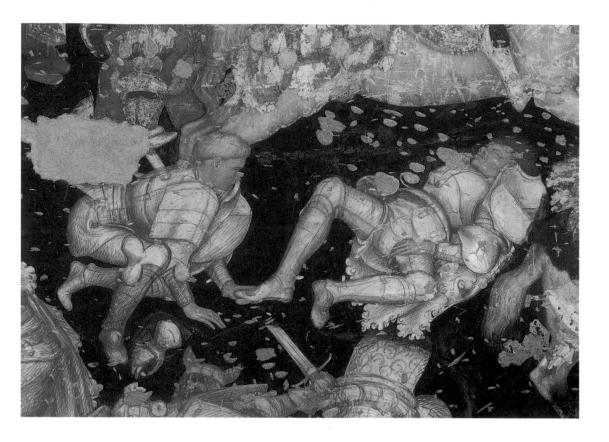

The Camera Picta In 1457 Ludovico hired Andrea Mantegna to replace Pisanello, who had left Mantua nearly a decade earlier; Mantegna finally entered Ludovico's service in 1460. Ludovico's humanist education prepared him to appreciate Mantegna's classicism; however, in the late 1450s Mantegna's paintings were novel (see Fig. 13.12), their sculptural toughness quite different from the dreamy idealism of much court painting (see Fig. 14.8). At this time the duchess of Milan was sending her court painter Zanetto Bugatto (active 1450s-1476) to Bruges to study with Rogier van der Weyden, not Rome to study ancient sculpture. In hiring Mantegna, then, Ludovico Gonzaga was taking something of a risk, especially for the head of a small court that had heretofore followed, rather than led, artistic fashion. The gamble worked: Mantegna gave exemplary service to the Gonzaga court for forty-six years. For it, he produced some of his most celebrated works.

In 1465 Mantegna began to paint the walls of Ludovico's newly renovated bedroom and audience chamber—what contemporaries called the Camera Picta ("painted chamber"; Fig. 14.31) in the part of the Palazzo Ducale known as the Castello di San Giorgio. Mantegna worked on the frescoes for almost nine years, a singularly long time for the sort of commission that was usually carried out in a matter of months as a prince prepared for a wedding or state visit. The main intent of the frescoes must have been to glorify the Gonzaga family. Mantegna makes this clear in the inscription which he depicted as carved Roman letters on a gold plaque over the entrance to the room:

For the illustrious Ludovico, second Marchese of Mantua, best of princes and most unvanquished in faith, and for his illustrious wife Barbara, incomparable glory of womanhood, his Andrea Mantegna of Padua completed this slight work in the year 1474.

This "slight" work (in the obsequious language required of artists until modern times) was, in fact, a grand paean both to Mantegna's employer and to his own talents as illusionist, portraitist, and consummate court artist. The frescoes in the Camera Picta became instantly famous, attracting just the sort of positive attention to Mantua that Ludovico had been cultivating since early in his reign.

The room is a masterpiece of trompe l'oeil. On two adjacent walls, which served as background for Ludovico's bed, Mantegna painted splendid gold brocade curtains, a visual link with the actual bed hangings. From his bed, Ludovico could gaze at the panorama depicted on the other two walls, in which he, his wife, their children, courtiers and attendants appear engaged in various activities. The exact subject of these court scenes remains in dispute; they may relate to events surrounding the raising of Ludovico's son Francesco to the cardinalate (he is shown in the scene to the right of the door) but do not seem to portray any one event as it actually happened. The effect is rather like a publicity film of life at the Gonzaga court, with its members going about their "normal" business and leisure pursuits. Mantegna has used the mantel over the fireplace as the support for a dais, on which Ludovico himself sits with his wife, Barbara of Brandenburg, surrounded by their children, court advisors, and even a female dwarf. In contrast to his elegantly dressed wife and courtiers, Ludovico wears a simple dressing gown and slippers—perhaps an allusion to the room itself, as his semi-private domain; he holds a letter possibly bearing the news of his son's appointment or perhaps news of the sudden illness of his employer, Francesco Sforza of Milan. He turns his head to hear what an attendant or messenger is saying. At the right, courtiers control the approach to Ludovico from steps that descend from the dais.

Above these images of courtly life, Mantegna transformed the simply vaulted ceiling into a brilliant display of faux stucco work (Fig. 14.32). A network of "ribs," apparently embossed with scrollwork, divides the ceiling into segments which are filled with a profusion of ornament. The eight main fields each carry a bust of one of the first eight Roman emperors, surrounded by a laurel wreath carried on the back of a winged putto. All of these elements are painted in *grisaille* against gold backgrounds and modeled as though lit from below so as to simulate relief sculpture. The spandrels between the vaults bear more fictive reliefs showing the deeds of the classical heroes Arion, Orpheus, and Hercules. Clearly Mantegna and Ludovico wished to associate the Gonzaga reign with the grandeur of Roman antiquity, but it must have been a rather tenuous connection,

for Roman literary sources make it clear that the character and deeds of some of the emperors made them somewhat dubious models for an enlightened Christian ruler. Nevertheless, the grandeur and the classical image must have been effective.

The gravitas is delightfully shattered by the oculus at the center of the ceiling-a spectacular example of aerial perspective. Here Mantegna imagines a view into a blue sky through an elaborate balustrade, alive with cavorting putti. Their foreshortened bodies illustrate most strikingly Mantegna's mastery of di sotto in su construction (depiction of objects as though seen from far below). Mantegna draws us further into his make-believe world with the playful putti sticking their heads through openings of the balustrade and with the smiling faces of three servants and a plantfilled washtub balancing perilously on a pole, on the other side of which a court lady seems to be whispering to a visitor or court retainer from Eastern lands. Is the curiosity of the viewer below about to be punished with a shower of greenery-or, worse yet, by a crashing fall of the washtub itself? Mantegna's visual joke suggests that looking is a potentially dangerous exercise—while at the same time he rewards it with all the artistry at his command, providing a fiction that is both witty and ennobling of the Gonzaga court.

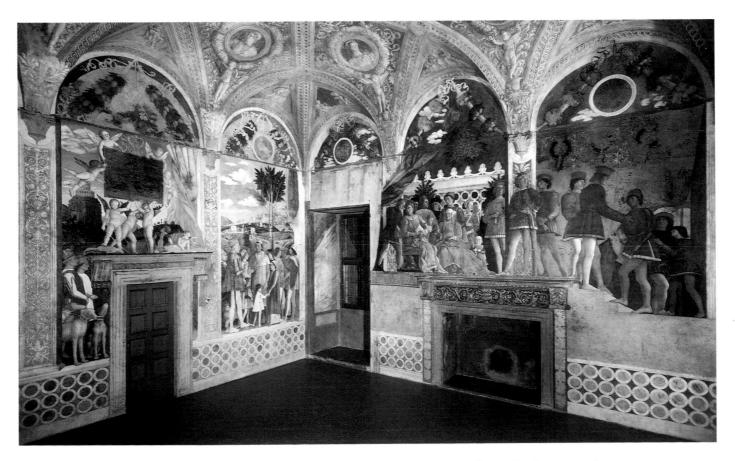

14.31 Camera Picta, 1465-74, commissioned by Ludovico Gonzaga from Andrea Mantegna for Castello San Giorgio, Mantua. Fresco

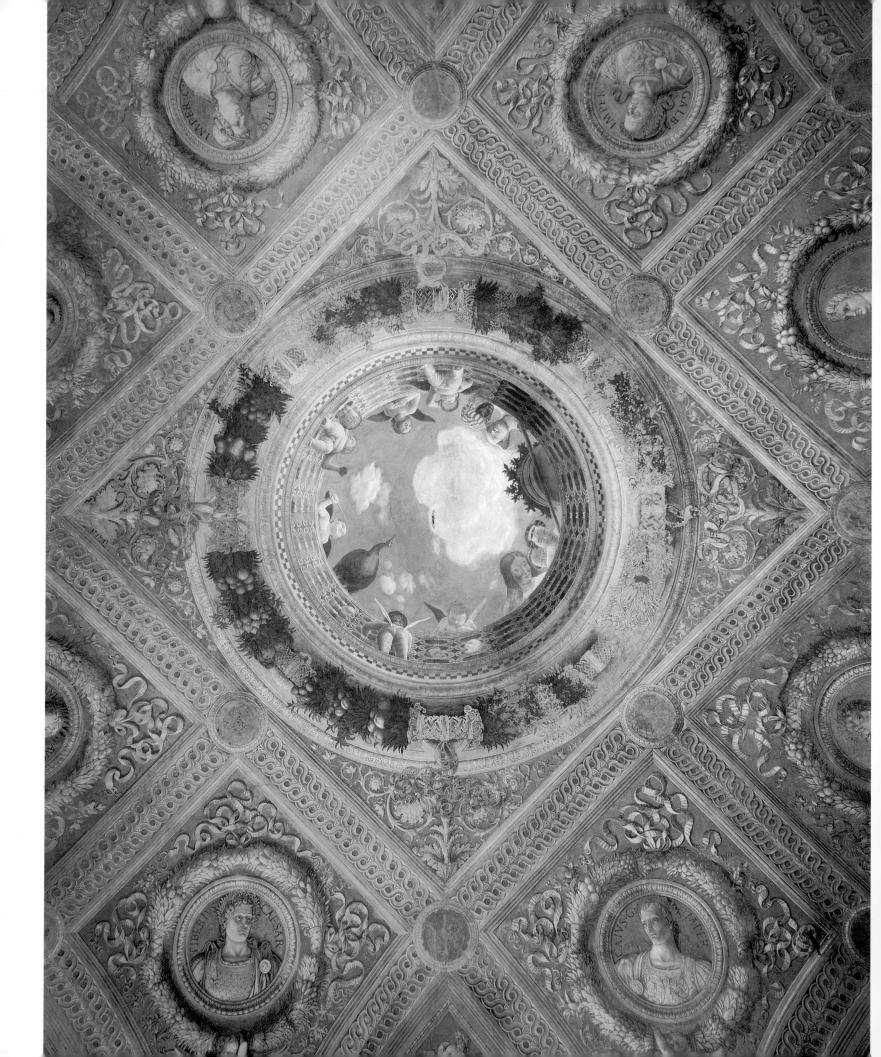

14.32 (opposite) Camera Picta, ceiling, 1465–74, commissioned by Ludovico Gonzaga from **Andrea Mantegna** for Castello San Giorgio, Mantua. Fresco

Male and Female Decorum

After Ludovico's death in 1478, Mantegna continued to work for his successors, fueling their growing passion for antiquity. Chief among them was the young marchesa of Mantua, Isabella d'Este (1474–1539), who had been reared at the court of Ferrara. Her husband, Francesco Gonzaga, grandson of Ludovico, was a military man who had few scholarly interests of his own, but even he encouraged the production of revivalist works, though they were tellingly different from those commissioned by Isabella.

As we saw in Piero's double portrait of Federico da Montefeltro and Battista Sforza (see Figs. 14.20 and 14.21), the virtues, deportment, and activities associated with a ruler and those associated with his consort were quite distinct. Although both men and women collected small-scale works of art, men were largely responsible for erecting buildings and attending to public self-promotion; women more usually commissioned devotional works and organized court entertainments and musical events. These distinctions are evident in two works created by Andrea

Mantegna: a series of nine large paintings entitled the Triumphs of Caesar, for Francesco Gonzaga (Fig. 14.33), and Pallas Expelling the Vices from the Garden of Virtue, commissioned by Isabella d'Este (Fig. 14.34). The Triumphs paintings have been badly damaged over the centuries, partly through clumsy restoration, but in their present condition they still eloquently convey Mantegna's goal: to present Caesar's triumphal return from the Gallic Wars with the greatest authenticity. His close study of ancient sculptural reliefs can be seen in the accurate Roman togas and armor worn by the participants in the first painting of the series, The Picture Bearers. Acquaintance with Flavio Biondo's (1392-1463) scholarly research on ancient Rome

14.33 The Picture Bearers, canvas 1 of the Triumphs of Caesar, 1490s, commissioned by Francesco Gonzaga, perhaps following the lead of his grandfather, Ludovico, from Andrea Mantegna for the Corte Vecchia of the Palazzo Ducale, Mantua. Distemper on canvas, 8′ 8½″ × 9′ 1½″ (2.66 × 2.78 m) (The Royal Collection, London, © Her Majesty Queen Elizabeth II)

informed his long, straight trumpets, the standards topped with bronze statuettes, and banners carrying images of captured cities. Unlike some of Mantegna's earlier paintings, which tend to be stiff and marmoreal, these paintings are relaxed and much more natural. Banners flutter in the breeze, and figures turn and pivot with ease. The three figures at the right of the *Picture Bearers*, led by a sympathetically painted African in parade armor, look behind them, encouraging the viewer to move on to the next canvas in the series.

Mantegna's painting for Isabella (see Fig. 14.34), by contrast, was conceived and executed in more precious and delicate terms, destined for the restricted realm of the *studiolo* where she kept her collection of small luxury objects. Isabella's court advisor, the poet Paride da Ceresara, devised a program of classical allegories for the room, one of which was awarded to Mantegna. The painting is crammed with anecdotal detail and communicates allegorically, rather than in the historic mode of the *Triumphs*. It illustrates dramatically the traditional assumption that the leader's consort was responsible for upholding moral values in the court, while giving this idea a new twist. Popular wisdom held that education was incompatible with female virtue; but here, in a painting intended for the first known *studiolo* created for a woman, Pallas Athene, goddess of wisdom and

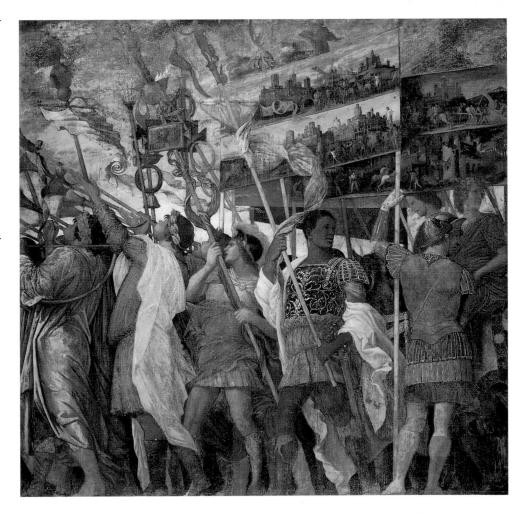

war, strides forward to banish the vices from her realm. Her handmaids lunge toward Lust, represented by the languorous, nearly nude female standing on the back of a centaur. As befits the room of a lady, the vices are depicted with a nice balance of repulsiveness and good taste; their genitals are discreetly hidden or miniaturized, as in the case of the typically lascivious satyr carrying a baby at the right of the painting. Some of them are identified pictorially—for example, the armless Sloth being dragged by a servant—while others are identified with labels.

Given the relatively modest funds at her disposal, Isabella relied on letter-writing campaigns to secure many of the works for her collections, snatching what she could from artists' estate sales and hounding other artists for

whatever they might release to her. Her patronage was thus less systematic than that of some of her male counterparts, but was ironically prophetic of a subtle shift beginning to take place in the relationship between patron and artist—artists becoming gradually more independent and, as we shall see in later chapters, occasionally willful. When Isabella did commandeer artists to illustrate her complex allegorical schemes, the quality of their work sometimes suffered, in large part because she left so little to their imaginations. By collecting rather than commissioning works by others, she increased their reputations. Long after the Renaissance was over, this would lead to the peculiarly modern expectation that the artist rather than the patron should exercise primary control over a work of art.

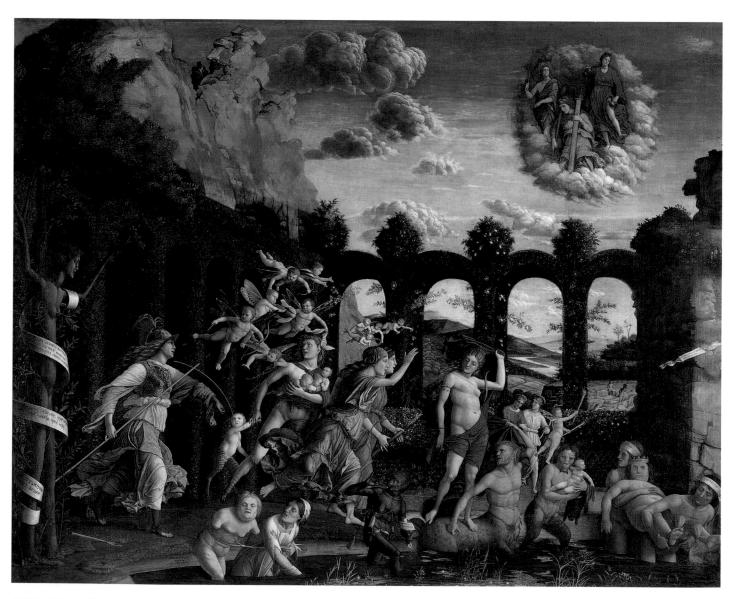

14.34 Pallas Expelling the Vices from the Garden of Virtue, c. 1499-1502, commissioned by Isabella d'Este from Andrea Mantegna for her studiolo in the Palazzo Ducale, Mantua. Tempera on canvas, 5′ 3″ × 6′ 3½″ (1.6 × 1.92 m) (Musée du Louvre, Paris)

The theological virtues (Faith, Hope, and Charity) appear in the cloud in the upper right corner of the painting.

Fighting for Chastity

Isabella d'Este commissioned Perugino to paint the conflict between Love and Chastity for her *studiolo* in Mantua (Fig. 14.35), and she clearly had in mind a definitive treatment of the subject. Her letter to Perugino is exhaustive in its specifications, although she does leave a few minor details to his own judgment and acknowledges that he might find it difficult to accommodate all the figures. Perugino dutifully followed Isabella's instructions, documenting a patron's power to define artistic activity.

Our poetic invention, which we greatly want to see painted by you, is a battle of Chastity against Lasciviousness, that is to say, Pallas and Diana fighting vigorously against Venus and Cupid. And Pallas should seem almost to have vanquished Cupid, having broken his golden arrow and cast his silver bow underfoot; with one hand she is holding him by the bandage which the blind boy has before his eyes, and with the other she is lifting her lance and about to kill him. By comparison Diana must seem to be having a closer fight with Venus for victory. Venus has been struck by Diana's arrow only on the surface of the body, on her crown and gar-

land, or on a veil she may have around her; and part of Diana's raiment will have been singed by the torch of Venus, but nowhere else will either of them have been wounded. Beyond these four deities, the most chaste nymphs in the trains of Pallas and Diana, in whatever attitudes and ways you please, have to fight fiercely with a lascivious crowd of fauns, satyrs and several thousand cupids; and these cupids must be smaller than the first, and not bearing gold bows and silver arrows, but bows and arrows of some baser material such as wood or iron or what you please. And to give more expression and decoration to the picture, beside Pallas I want to have the olive tree sacred to her, with a shield leaning against it bearing the head of Medusa, and with the owl, the bird peculiar to Pallas, perched among the branches. And beside Venus I want her favourite tree, the myrtle, to be placed. But to enhance the beauty a fount of water must be included, such as a river or the sea, where fauns, satyrs and more cupids will be seen, hastening to the help of Cupid, some swimming through the river, some flying, and some riding upon white swans, coming to join such an amorous battle. On the bank of the said river or sea stands Jupiter with other gods, as the enemy of Chastity, changed into the bull which carried off the fair Europa; and Mercury as an eagle circling above its prey, flies around one of Pallas's nymphs, called Glaucera, who carries a casket engraved with the sacred emblems of the goddess. Polyphemus, the one-eyed Cyclops, chases Galatea, and Phoebus chases Daphne, who has already turned into a laurel tree; Pluto, having seized Proserpina, is bearing her off to his kingdom of darkness, and Neptune has seized a nymph who has been turned almost entirely into a raven.

I am sending you all these details in a small drawing, so that with both the written description and the drawing you will be able to consider my wishes in this matter. But if you think that perhaps there are too many figures in this for one picture, it is left to you to reduce them as you please, provided that you do not remove the principal basis, which consists of the four figures of Pallas, Diana, Venus and Cupid. If no inconvenience occurs I shall consider myself well satisfied; you are free to reduce them, but not to add anything else. Please be content with this arrangement.

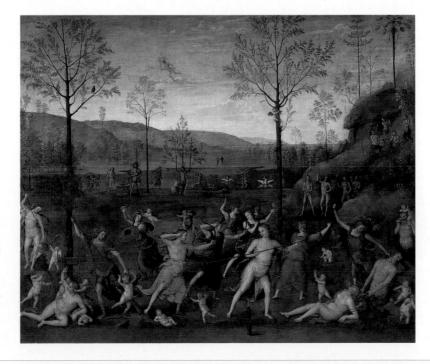

14.35 The Battle of Love and Chastity, commissioned by Isabella d'Este from Pietro Perugino for her studiolo in the Palazzo Ducale, Mantua. Canvas, 63 × 75%" (160 × 191 cm) (Musée du Louvre, Paris)

(from D.S. Chambers. Patrons and Artists in the Italian Renaissance. London: Macmillan, 1970, pp. 136ff.)

15 Sforza Milan

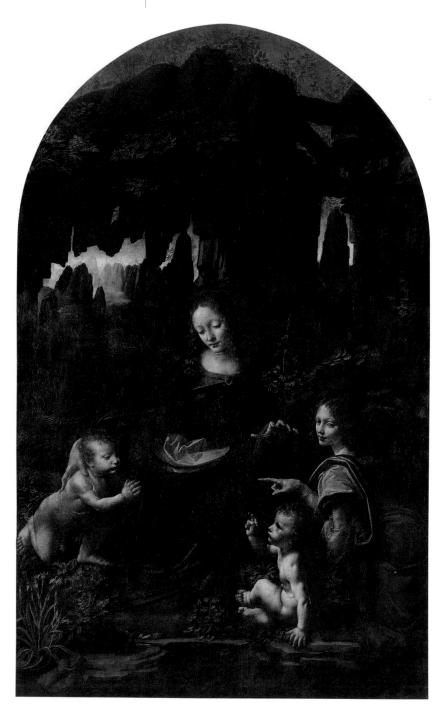

ilan was the most powerful and influential of the courts in the second half of the fifteenth century. A military and commercial giant, the city nurtured and attracted some of the very best talent from across Europe. Local and foreign trained artists responded to the majesty of Milan's imperial past and created monumental works for the newly installed Sforza dynasty.

The Sforzas

Francesco Sforza became ruler of Milan in 1450. A brilliant condottiere, he earned the honor of marrying Duke Filippo Visconti's illegitimate daughter and sole heir, Bianca Maria, because of his military successes for the Visconti. However, when Filippo died in 1447, the Milanese citizenry rebelled and set up their own government, the so-called Ambrosian Republic (1447-50), which was named for St. Ambrose, the founder of Christianity in the city. Francesco spent the next three years gaining control of Milan's subject cities and then, after a three-month siege, recaptured Milan. Having been assisted financially by the Medici Bank and politically by the Medici family in Florence-then interested both in dominating international finance and in eliminating Milanese threats to Florence's liberty—Francesco welcomed central Italian merchants, bankers, and artists to Milan. At the same time, his shaky claims to legitimate rulership impelled him to forge visible links with the Visconti past to which he was tenuously linked through his marriage. He encouraged his artists to restore and enhance the frescoes at the Castello Visconteo in Pavia (see Fig. 9.10), and he resumed construction of the nearby Certosa. As if to drive the point home, he even played the role of Giangaleazzo Visconti, one of his predecessors, in a court costume ball.

Francesco's sons, especially Ludovico Sforza (1451–1508), followed the same policy of claiming the right of rulership through appropriation of Visconti imagery. Called "il Moro" (the Moor) because of his dark complexion, Ludovico dominated Milanese culture and politics for the entire last quarter of the fifteenth century, in spite of the fact that he was the illegitimate and younger son of Francesco Sforza. After the death in 1476 of his elder brother,

the wanton Galeazzo Maria Sforza, Ludovico managed to oust his sister-in-law as regent for his young nephew, Gian Galeazzo Maria, and secured effective control of the state. In 1494 he succeeded in having himself proclaimed duke of Milan—a title he would enjoy for only five years. Obviously, both he and his father needed to deploy the visual arts to legitimate their rule.

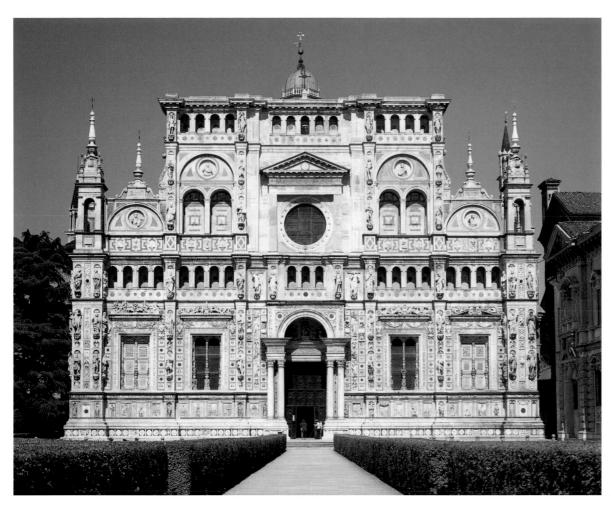

15.1 The Certosa, Pavia, façade commissioned by Galeazzo Maria Sforza from Antonio and Cristoforo Mantegazza and Giovanni Amadeo in 1473, present arrangement of lower stories commissioned by Ludovico Sforza in

Completing Visconti Ecclesiastical Foundations

The Certosa No monument was more intimately linked with the Visconti—and therefore crucial to the Sforzas—than the Certosa di Pavia (Fig. 15.1). As we have seen (see pp. 190–193), it was built in conscious emulation of similar foundations by the dukes of Burgundy and was intended to house the remains of Giangaleazzo Visconti, the first duke of Milan. Construction at the monastery had proceeded haltingly throughout the first half of the century. Under Francesco's patronage, work sped up on the nave and on the cloister nearest the church (Fig. 15.2), which is embellished with a profusion of terracotta reliefs. Gaily cavorting putti and lush garlands and vegetation decorate the arches and

(opposite) *Madonna of the Rocks*, 1483–1508, commissioned by the Confraternity of the Immaculate Conception from **Leonardo da Vinci** for their chapel in San Francesco Grande, Milan. Oil on panel, $6' 6\%'' \times 4' (2 \times 1.22 \text{ m})$ (Musée du Louvre, Paris)

Another version of this painting survives in the National Gallery, London. The precise relationship between the two—one probably replaced the other–remains much debated.

friezes, making reference to Milan's proud Roman imperial heritage. Busts emerging from roundels in the spandrels recall the classical prototype of the *imago clipeata*, often found along with putti and garlands on ancient sarcophagi. Everything is full of movement, every figure and molding

15.2 Cloister, Certosa, Pavia, 1460s, commissioned by the Carthusians with the support of Francesco Sforza from **Guiniforte Solari**. Terracotta

fresh and exuberant, testifying to Lombard delight in decorative complexity and to native facility with clay and brick.

The present façade of the Certosa (see Fig. 15.1) reflects the overall design by Giovanni Antonio Amadeo (1447 Pavia-1522 Milan), approved by Ludovico in 1492. Amadeo was the leading local sculptor, architect, and engineer in Lombardy, active in Bergamo as well as Pavia and Milan. His façade incorporates marble reliefs that had been commissioned in 1473 by Galeazzo Maria Sforza for a somewhat less elaborate design. Neither façade was to have been less than sumptuous, however; the Sforza brothers were renowned throughout Italy for their extravagant pomp and display. For example, Galeazzo's state visit to Florence in 1471 had overwhelmed spectators with a parade of 2,000 horses, 500 pairs of dogs, and 1,000 courtiers and attendants dressed in velvet and silk. The marble facade of the Certosa is as intricate and unabashedly costly, for its size, as the ivory altarpiece that its founder, Giangaleazzo Visconti, had commissioned for the high altar (see Fig. 9.23). The source of patronage of the project is suggested by a series of medallions at the base of the façade depicting Roman emperors. Like the images on the ceiling of the Camera Picta in Mantua (see Fig. 14.32), they point to the historical roots of Ludovico's autocratic power. Biblical reliefs on the next level Christianize the program, completed by dozens of standing saints and prophets.

15.3 The Mocking of Christ, 1482–92, commissioned by Ludovico Sforza from **Antonio and Cristoforo Mantegazza** for the façade of the Certosa, Pavia. Marble

All of the reliefs have suffered damage and weathering, but The Mocking of Christ (Fig. 15.3) is sufficiently well pre served to sustain closer examination. It was produced by the Mantegazza brothers-Antonio (active 1473-95 Milan and Pavia) and Cristoforo (active 1464-81 Milan and Pavia)-Lombard sculptors who specialized in intricate carving of flattened figures evoking the character of ancient gems and cameos. The relief centers around the seated Christ, covered in drapery executed in the wet, clinging manner seen in some ancient sculpture. A triumphal arch leads back to another antique image: a fanciful equestrian statue on a very tall pedestal which may recall the Mantegazzas' model for a never-executed equestrian monument of Francesco Sforza. A crowd of onlookers, the two most forward of whom taunt Christ with their coarse faces and clenched fists, recall north Italian traditions of narrative verism (see Fig. 9.19). The Roman street scene is a sculptural variation on Andrea Mantegna's archaeological reconstructions in Padua (see Fig. 13.12) and the spatial illusionism of Vincenzo Foppa in Milan (see Fig. 15.8). Typically Lombard in its complexity and extravagant decoration, the relief also calls to mind the terracotta decorations in one of the Certosa's own cloisters (see Fig. 15.2), here in the more prestigious material of marble.

The Cathedral As work on the Certosa neared completion, Ludovico pushed forward with plans to enhance Milan's chief shrine, the cathedral. In 1487 the original tower over the crossing was dismantled because it was structurally unsound; but instead of merely replacing the tower, the Fabbrica called a competition for a new, more elaborate structure. All the leading builders and sculptors in Milan submitted plans, including Giovanni Amadeo, Leonardo da Vinci, and Donato Bramante. Tellingly, the judges decided in favor of Amadeo's Gothic spire, with its spiraling exterior staircases (Fig. 15.4). They justified their decision on the grounds that it was more important for the tower to match the style of the rest of the building than to follow the fashion for classical forms. The structure also gave Milan a cathedral unlike any of the other major Italian city-states and underscored its relations with transalpine cities. In addition, the tower was much less heavy than a classical dome might have been, requiring no reinforcement of the pre-existing church.

Private Commissions

Local tastes and traditions also affected the form of commissions undertaken by foreigners in Sforza Milan. When officials of Cosimo de' Medici established the Medici Bank headquarters in the city, in a building given him by Francesco Sforza in 1456, his branch manager, Pigello Portinari, rebuilt the structure to resemble those currently being erected in Florence, but enhanced it with more opulent decoration. The façade of the Medici Bank (Fig. 15.5),

15.4 Crossing tower, Milan Cathedral, designed 1487/90, commissioned by the Fabbrica of Milan Cathedral with the support of Ludovico Sforza from **Giovanni Amadeo**

Commissions continued to be granted for Gothic architectural designs in Milan throughout the sixteenth and seventeenth centuries, especially for the completion of unfinished churches.

known through a drawing in the *Treatise on Architecture* by the Florentine sculptor and architect Filarete, imitates the heavy roof cornice, double-lancet windows, and fortress-like ground story of the Medici Palace in Florence (see Fig.

11.11), but the scheme was enriched with lush terracotta decoration, as in the new cloister at the Certosa. Paying homage to Milan's rich Gothic heritage, the windows of the upper story were set within pointed arches; the main portal was overlaid with numerous heraldic motifs and devices. Sober Tuscan models took on a courtly, celebratory air.

Pigello Portinari also supervised the construction of a burial chapel for his family at the church of Sant'Eustorgio (Figs. 15.6 and 15.7). Its Florentine and specifically Mediciassociated patronage is evident in its plan and elevation, which consciously recall the Old Sacristy at San Lorenzo in Florence (see Fig. 11.3). Here again, however, there are significant alterations to both the proportions and the decoration. In deference to Milanese traditions, Pigello's architect inserted a drum under the dome, increasing the height and providing a field in which polychromed terracotta angels dance and swing heavily laden festoons. The delight in color, so different from Brunelleschi's spare, bichromatic scheme, continues in the vault, where frescoes simulate multiple rings of red, yellow, green, and blue overlapping tiles. The sequence of colors is that codified by Dominicans in the early fourteenth century as constituting the rainbow: a heavenly vision for Pigello, who was buried in the floor directly under the dome and whose coat of arms appeared in the lantern above.

Highly illusionistic frescoes by the Milanese painter Vincenzo Foppa (c. 1428–1515) bring the walls to life. Their primary subjects, the *Annunciation* and *Scenes from the Life of St. Peter Martyr* (Fig. 15.8) ingratiated Pigello to the Sforza regime: Francesco Sforza had formally entered Milan on Annunciation Day 1450, and Peter Martyr, buried at Sant'Eustorgio (though not as now in the Portinari Chapel; see Fig. 9.6), continued to be honored as the city's most important Dominican saint.

On the right wall Foppa cunningly exploits scientific perspective and clear, rich color to place figures and architecture into deep illusionistic space. The scene on the left,

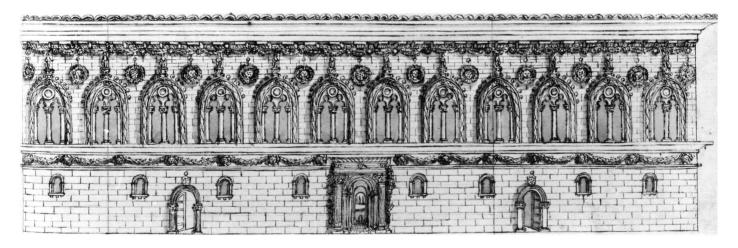

15.5 Medici Bank, Milan, façade, c. 1465, from **Filarete**, *Treatise on Architecture* (Biblioteca Nazionale, Magl. 11.1. 140 fol. 20, Florence) In this treatise, Filarete also imagined and described the buildings of a great new city he called Sforzinda in honor of Francesco Sforza.

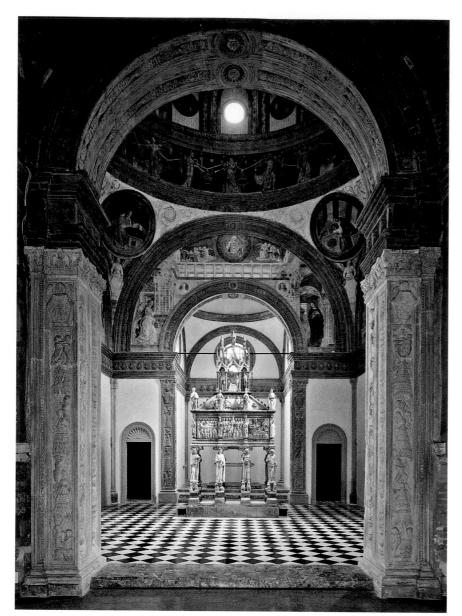

15.6 Portinari Chapel, Sant'Eustorgio, Milan, c. 1468, commissioned by Pigello Portinari, frescoes by **Vincenzo Foppa**

The tomb of St. Peter Martyr at the center of the chapel originally stood in its own chapel in the nave of the church. During the Renaissance, the head of the saint was displayed in the chapel.

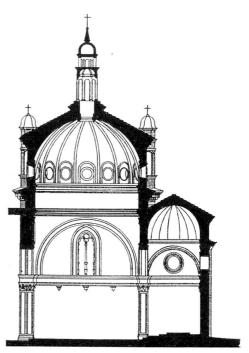

15.7 Portinari Chapel, Sant'Eustorgio, Milan, east-west section

15.8 (below) *Miracle of the Cloud and Miracle of the False Madonna*, c. 1468, commissioned by Pigello Portinari from **Vincenzo Foppa** for the right wall of the Portinari Chapel, Sant'Eustorgio, Milan. Fresco

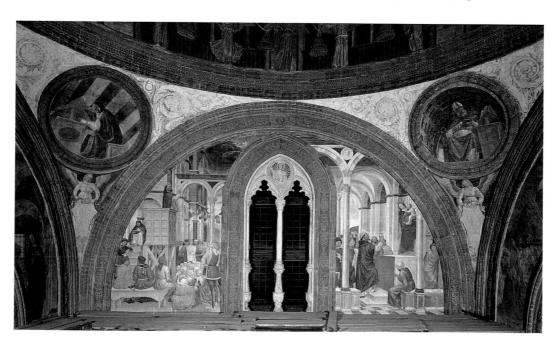

showing the saint preaching, repeats the basic configuration of Andrea da Firenze's earlier fresco of St. Peter Martyr in Florence (see Fig. 8.8). Now, however, figures diminish in size according to their distance from the viewer, and their reactions to his preaching are more subtle and varied. In the middle background Foppa steeply foreshortens one of the men's faces so that he can be seen to observe a black thunder-cloud in the upper sky. According to legend, the cloud was a blessing to the crowd, which had been suffering in the blazing August sun.

On the right Peter Martyr steps up to an altar with the Eucharistic host in his hand to reveal what seems to be a statue of the Madonna and Child but is actually an idol. Both mother

and child suddenly sprout horns. Onlookers, several of them clearly portrait likenesses, react in shock and amazement. A Cathar priest garbed in a red turban holds a sulphurous yellow cloak up to his nose, visualizing the stench of abomination. He skulks away discredited, much as Giotto had shown the sultan's clerics doing in St. Francis's trial by fire (see Fig. 4.16). Admirably straightforward, the frescoes recall, too, nearly contemporary scenes from saints' lives by Benozzo Gozzoli, one of the artists favored by Pigello Portinari's employers, the Medici. The frescoes as well as the architecture, then, make reference to the patron's Florentine origins, translated into a rich Lombard mode.

Ludovico il Moro and a Grand Classical Style

Santa Maria presso San Satiro

After a madman attacked a Madonna and Child on the exterior of the small centralized church of San Satiro, the painting began to bleed and work miracles. Community members quickly organized a confraternity to care for the image, and, as had been the case with the foundation of the church of Santa Maria dei Miracoli in Venice (see Fig. 13.29 and Fig. 13.30), they commissioned a small but impressive church to house it. Called Santa Maria presso San Satiro (Figs. 15.9 and 15.10), the structure began as a long narrow oratory-today the transept and chancel of the church, attached at an eccentric angle to San Satiro so as to respect the course of a pre-existing street. Donato Bramante (Donato di Angelo di Antonio; 1443/44 Monte Asdrualdo/ Fermignano-1514 Rome) provided its design, echoing and enlarging upon the central dome and barrel-vaulted arms of

15.9 Santa Maria presso San Satiro, Milan, plan

the Pazzi Chapel at Santa Croce in Florence (traditionally said to be by Brunelleschi but perhaps by Michelozzo). A native of Urbino, Bramante became one of the most influential architects of the Renaissance. He had grown up on the impeccable classicism and geometric order of Francesco Laurana and Piero della Francesca (see Fig. 14.24 and p. 336), enriching their example with the gravity and dignity he found in the work of Alberti in Mantua (see Fig. 14.27) and ancient buildings in Milan, as evidenced in the building's coffering, bold cornices, and hemispherical dome. Piero's fascination with scientific perspective became especially crucial for Bramante when midway in construction the confraternity purchased land behind the oratory to create a nave, impelling him to create an illusionistic apse on what had previously been the entrance wall. Though the chancel appears to be a four-bayed extension of the barrel vaulted nave, nearly equivalent in depth to the transepts, it is in fact nearly flat, modeled like monumental relief sculpture on a scale even grander than Tullio Lombardo's similar essays for the façade of the Scuola Grande di San Marco in Venice (see Fig. 13.28). The effect of Bramante's composition is most compelling at mid-nave and diminishes as one approaches the altar or views it from the transept arms, but its sheer cunning ensured the architect's fame in Milan.

Santa Maria delle Grazie

Bramante soon came to the attention of Ludovico Sforza, who hired him for both painting and architectural projects. In the early 1490s, Ludovico Sforza put the finishing touches on his brilliantly successful scheme to marry his niece Bianca Maria Sforza to Emperor Maximilian, securing

15.10 Santa Maria presso San Satiro, interior, Milan, begun 1480, commissioned by Ludovico Sforza from Donato Bramante

himself imperial investiture as duke of Milan in 1494, the year after the marriage. It seemed an appropriate time to build a dynastic mausoleum in a grand, classically inspired style for himself and his family. The site he chose was the still quite new church of Santa Maria delle Grazie not far from his residence, the Castello Sforzesco.

The resulting building (Figs. 15.11 and 15.12) may have been a collaboration between Bramante, Amadeo (whose workshop probably provided much of the exterior detail), and Leonardo da Vinci, whose notebooks from the early 1490s include several drawings of centrally planned, domed churches. While retaining the long nave of the existing

15.11 Santa Maria delle Grazie, Milan, plan of the church and monastery 1 Tribune; 2 Refectory; 3 Leonardo da Vinci, Last Supper

church, the architect(s) added a large tribune consisting of a domed crossing, a choir, and three semicircular apses, which evoke associations with the triple apses in the transepts and choir of the Visconti burial site at the Certosa (see Fig. 9.22). The shallow dome rests on a typically Lombard drum, encircled on the exterior by an arcade.

The general scheme of the tribune ultimately derives from Brunelleschi's Old Sacristy (see Fig. 11.3)—a suitable model insofar as the Florentine structure served as a burial place for the Medici family-but the design departs remarkably from this precedent and other fifteenth-century variations of it (for example, Pigello Portinari's chapel at Sant'Eustorgio in Milan, see Fig. 15.6, and the chancel of Santa Maria dei Miracoli in Venice, see Fig. 13.29). All the prior buildings were modestly dimensioned, recalling antiquity in their constituent parts, but lacking Roman scale and monumentality. Likely inspired by the impressive size of late antique buildings in Milan itself (see Fig. 24.4) and by Ludovico's ambitions, the tribune of Santa Maria delle Grazie is an essay in volumetric expanse, the space and massing, not the walls, being of primary architectural interest. Its scale and grandeur ensured that, when Bramante moved to Rome upon Ludovico's fall from power in 1499, he was ready both to learn from the imposing ruins of the ancient city and to fashion his architectural masterpiece: the original centralized plan for the new St. Peter's basilica (see Fig. 18.5).

In keeping with the imposing scale of Santa Maria delle Grazie's tribune, nearly 65 feet (20 meters) square, the architectural details within it are relatively simple.

15.12 Santa Maria delle Grazie, Milan, tribune, begun 1493, commissioned by Ludovico Sforza possibly from Donato Bramante collaborating with Amadeo and Leonardo da Vinci

The roundels in the tympanum arches are fictive, painted architectural decorative details

The numerous oculi in the pre-existing church and in the new apses are echoed by the large painted roundels that adorn the arches and by the laced circles between the ribs of the dome. The monochrome sgraffito decoration on the walls respects the Dominican commitment to austerity. The effect is one of luminous expansiveness.

When Beatrice d'Este, Ludovico's young wife, died unexpectedly in 1497, he commissioned a tomb (Fig. 15.13) for the new tribune at Santa Maria delle Grazie from Cristoforo Solari (Il Gobbo; 1468/70 Milan-1524 Milan). Solari came from Milan's foremost family of builders and architects, some of its members having supervised construction both at the Certosa and on the earlier nave of Santa Maria delle Grazie. He was very popular in courtly circles, working as well for Beatrice's sister, Isabella d'Este, in Mantua and their brother, the duke of Ferrara. Cristoforo's recumbent effigies of Beatrice and Ludovico show his own accomplishments as a sculptor. He has worked the marble slab so that it appears as malleable and fluid as the cloth and flesh it portrays. The couple seems merely resting, ready to rise to meet their ducal obligations, Ludovico in his flowing cloak, Beatrice in her satin gown overlaid with the braided and knotted cords she had popularized in courtly fashions. The two recumbent figures are also remarkable insofar as double tombs of this sort are quite rare in Italy. Most Italian

15.13 Tomb of Beatrice d'Este and Ludovico Sforza, after 1497, commissioned by Ludovico Sforza from **Cristoforo Solari** for Santa Maria delle Grazie, Milan. Marble (Certosa, Pavia)

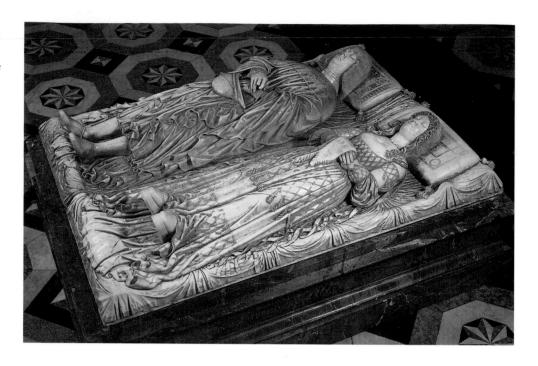

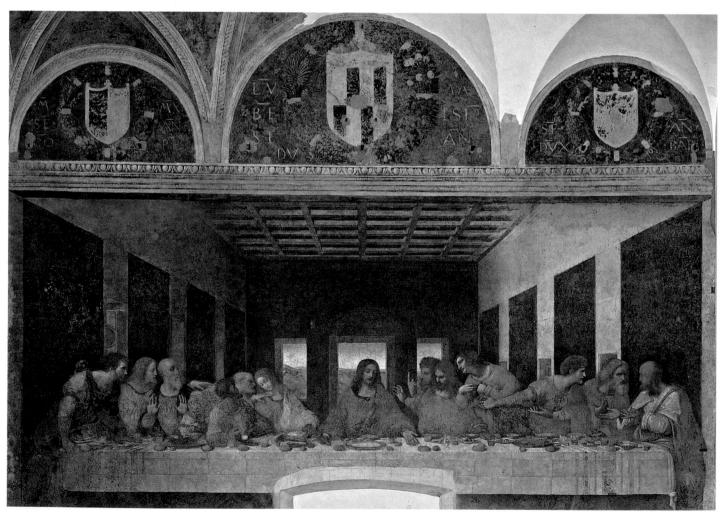

15.14 *The Last Supper*, 1494?–97/98, probably commissioned by Ludovico Sforza and Beatrice d'Este from **Leonardo da Vinci** for the Refectory, Santa Maria delle Grazie, Milan. Painting (tempera and oil) on plaster, 13' $9'' \times 29'$ 10'' $(4.60 \times 8.80 \text{ m})$

The work is ruinous, having been painted in an experimental medium that began deteriorating soon after it was applied.

men were buried with their male relatives, women with other women. Pairing Ludovico and Beatrice speaks of more than their affection: it also reinforced Sforza claims to high aristocratic status. French royal tombs brought king and queen together, if only in effigy (see Fig. 6.3), emphasizing dynasty and lineage, much as we must assume Ludovico intended.

Leonardo da Vinci

The Last Supper The Sforzas also commissioned artists to enhance the living quarters of the Dominicans at Santa Maria delle Grazie. For the refectory they commissioned a fresco of *The Last Supper* (Fig. 15.14) from Leonardo da Vinci. Ludovico's and Beatrice's names and coats of arms appear proudly in the central lunette over the composition; to either side are the emblems of their sons and successors, Massimiliano (r. 1512–15) and Francesco II (r. 1521–24, 1525, 1529–35), yet another dynastic image.

Leonardo had been in Milan since 1481 or 1482 when he wrote a letter to Ludovico offering his services as a military and city planner, sculptor, and sometime painter, an indication that whereas we now esteem Leonardo mainly for his surviving paintings and drawings, he gauged that his skills in engineering were more likely to be appreciated by a potential patron.

The subject of the Last Supper was traditional for refectories (see Figs. 4.23 and 10.44), but Leonardo invested it with a new sense of drama, which has made it one of the most memorable images in Western art. Selecting the moment just after Christ announces that one of his disciples will betray him, Leonardo imagined the apostles' confusion and self-doubt, and portrayed their agitated reactions. He arranged them in four groups, linked by their gestures and turning bodies. Christ (Fig. 15.15) becomes the calm fulcrum in the midst of this turbulence, with all the human energy, as well as the strong diagonals of the deeply tunneling space, resonating around his stable, pyramidal form. Casting his eyes down toward his open left hand, Christ makes a gesture of sacrifice, offering his mystical body through the symbol of a piece of bread. At the same time, he embraces his destiny, reaching out with his right hand to share a portion with Judas, whose shadowed face and body-and the fact that he alone is not

CONTEMPORARY VOICE

A Man of Many Talents

When, in 1481/82, Leonardo da Vinci wrote to Ludovico il Moro offering his services, it was his prowess as a military engineer that he stressed. A few brief references to his artistic abilities were added near the end of the letter, almost as an afterthought.

Most Illustrious Lord,—Having now sufficiently considered the specimens of all those who proclaim themselves skilled contrivers of instruments of war, and that the invention and operation of the said instruments are nothing different to those in common use: I shall endeavour, without prejudice to anyone else, to explain myself to your Excellency, showing your Lordship my secrets, and then offering them to your best pleasure and approbation to work with effect at opportune moments on all those things which, in part, shall be briefly noted below.

(1) I have a sort of extremely light and strong bridges, adapted to be most easily carried, and with them you may pursue, and at any time flee from the enemy; and others, secure and indestructible by fire and battle,

easy and convenient to lift and place. . . .

- (2) I know how, when a place is besieged, to take water out of the trenches, and make endless variety of bridges, and covered ways and ladders, and other machines pertaining to such expeditions. . . .
- (4) Again, I have kinds of mortars; most convenient and easy to carry; and with these I can fling small stones almost resembling a storm; and with the smoke of these cause great terror to the enemy, to his great detriment and confusion.
- (9) [8] And if the fight should be at sea I have kinds of many machines most efficient for offence and defence. . . .
- (5) Item. I have means by secret and tortuous mines and ways, made without noise to reach a designated [spot], even if it were needed to pass under a trench or a river.
- (6) *Item*. I will make covered chariots, safe and unattackable. . . . And behind these, infantry could follow quite unhurt and without any hindrance.
- (7) Item. In case of need I will make big guns, mortars, and light ordnance of fine

and useful forms, out of the common type. (8) Where the operation of bombardment might fall, I would contrive catapults . . . and other machines of marvellous efficacy and not in common use.

(10) In time of peace I believe I can give perfect satisfaction and to the equal of any other in architecture and the composition of buildings, public and private; and in guiding water from one place to another.

Item. I can carry out sculpture in marble, bronze, or clay, and also I can do in painting whatever may be done, as well as any other, be he whom he may.

[32] Again, the bronze horse may be taken in hand, which is to be the immortal glory and eternal honour of the prince your father of happy memory, and of the illustrious house of Sforza.

And if any one of the above-named things seem to anyone to be impossible or not feasible, I am most ready to make the experiment in your park, or in whatever place may please your Excellency, to whom I commend myself with the utmost humility.

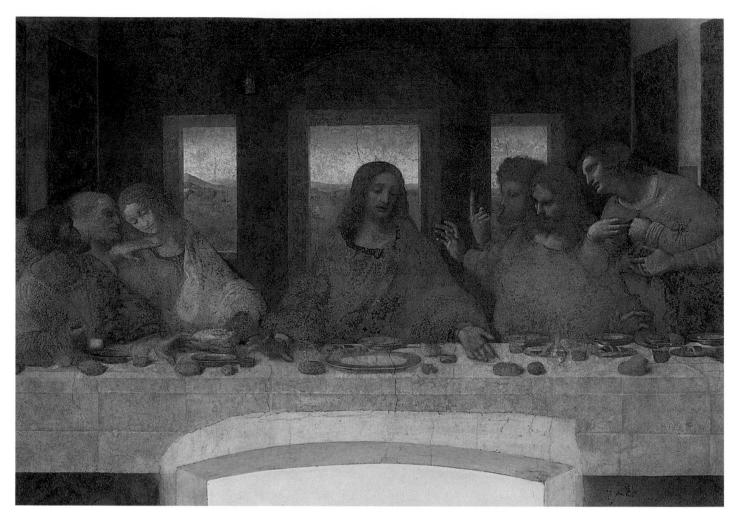

15.15 Christ and Apostles (detail of The Last Supper), 1494?-97/98, probably commissioned by Ludovico Sforza and Beatrice d'Este from Leonardo da Vinci for the Refectory, Santa Maria delle Grazie, Milan. Painting (tempera and oil) on plaster

protesting—indicate his treachery. By placing Christ against a luminous landscape, Leonardo was able to dispense with a conventional halo; nature here embodies and symbolizes the divine.

Leonardo's perspective system is also highly expressive. Constructed from Christ's eye level, just to the left of his head, it creates a deep and measurable space, much more capacious than earlier versions of the scene (see Fig. 10.44). Doorways between the tapestries on the left wall-revealed in recent restorations-and niches between the ones on the right create cross axes, extending the space beyond the perimeters of the room. And yet Leonardo has pushed the apostles' table curiously close to the picture frame, locking his figures in the embrace of the receding walls. He also extended the orthogonals along the edges of his ceiling to the upper corners of the refectory in which the fresco is located, that is, from above and to the sides of the lunettes containing the Sforza family's coats of arms, causing the illusionistic space to tunnel much more quickly than the actual space occupied by the viewer. These devices serve to focus special attention on Christ and the

apostles, creating an exalted vision of an event central to the Christian theology of redemption.

Leonardo's wall painting was like none that ever had been seen before. Novel in its composition and emotional tenor, it was also produced in an experimental technique, largely applied a secco using a mixture of tempera and oil, allowing Leonardo time to achieve effects similar to oil painting. He carefully rendered every stitch of embroidery on the tablecloth, the alternately convex and concave depressions of its crisply pressed folds, the glint of light on the wine glasses, the dull sheen of the ceramic bowls, and the crusty goodness of the bread. But for the most part Leonardo's pigments did not adhere to the wall, causing the surface to deteriorate soon after it was completed. A doorway later punched into the center of the base literally added insult to injury. Modern conservation (see pp. 38-40) has been able to do little more than consolidate spotty patches of pigment. Had it not been for the strength of the overall composition and for copies the work immediately inspired, it would be impossible to imagine the impact it once made, however briefly.

Madonna of the Rocks In commissioning Leonardo to paint the Last Supper, Ludovico was doubtless confident that it would display at least some of the pictorial subtlety Leonardo had already demonstrated in court portraits and in an altarpiece that the artist began soon after arriving in Milan, the Madonna of the Rocks (see p. 362). Commissioned by the Confraternity of the Immaculate Conception for their new chapel in the Franciscan basilica of San Francesco Grande, the painting was the centerpiece of a larger wooden structure which included side panels by the Milanese de Predis brothers-Ambrogio (c. 1455 Milan-after 1508) and Cristoforo (d. 1486)who probably assisted Leonardo in breaking into the Milanese market prior to Ludovico's offer of employment at court. Thick, yellowed varnish has dulled Leonardo's coloristic effects, but otherwise the painting is well preserved. Dramatic but soft spotlighting picks out the figures, recalling a remark Leonardo made in his notebooks about the beauty of faces seen in the subdued light of a courtyard. Exquisitely detailed rocks, mists, water, and plant life, all studied carefully from nature, surround the figures.

Curiously, for a commission that requested only a Madonna and Child accompanied by angels, Leonardo's Madonna of the Rocks includes a prominent figure of an infant John the Baptist kneeling to adore the Christ Child from under the protective right arm of the Virgin. Christ reciprocates with a blessing,

accompanied by a figure traditionally identified as an angel, who points at the Baptist. Coming from Florence, Leonardo would have seen numerous images of that city's patron saint as a child, often in the company of a Madonna and Child in a rocky setting, such as Filippo Lippi's Adoration of the Christ Child (see Fig. 11.15). Even so, once Leonardo had the idea of using this imagery, he must have had to be sure that it also made sense for its Milanese context. Efforts to connect the unusual subject with the cult of the Immaculate Conception, to which the commissioning confraternity was dedicated, have proven fruitless: but since the confraternity's chapel was located in a Franciscan church, the identification of St. Francis as a second John the Baptist by Francis's official biographer, Bonaventure, may have made the confraternity amenable to John's inclusion. They were impressed enough with Leonardo's preliminary work that even though the work remained unfinished for several decades, they neither commissioned another altarpiece nor assigned its completion to another artist-though they did instigate legal action that finally forced Leonardo to complete the work in 1508.

15.16 Star of Bethlehem Flower, 1508-13, Leonardo da Vinci. Pen and ink over red chalk on paper, 7% × 6%" (198 × 160 mm) (Royal Library, Windsor)

As Leonardo was finally finishing the Madonna of the Rocks he was also at work on a series of botanical studies that would have accompanied a scientific treatise. His drawing of a Star of Bethlehem and other grasses and flowers (Fig. 15.16), like the vegetation in the Madonna of the Rocks, pulsates with life. Flower stalks emerge out of a vortex of grasses that suggest dynamic growth, closely related to his own fascination with flowing waters and currents that previously animated the hair of Ginevra de' Benci (see Fig. 11.36) and enlivened his now lost Leda and the Swan, with which the drawing has been connected both as a study for an actual plant that was to grow between the swan's gawky legs and as inspiration for the entwined hairdo he invented for Leda. Whether vegetal, animal, or mineral, the forces of nature all fascinated Leonardo. Better to serve his investigations, Leonardo employed a variety of drawing styles on this page: first a sketch in soft red chalk at the top of the page to capture the forms, then a consolidation of those observations in pen, and tighter pen and ink analyses of other plants at the bottom.

Leonardo at Ludovico's Court Although it was not uncommon for Leonardo to leave his paintings incomplete-his inquisitive nature impelled him on to new studies and experiments—the confraternity may have been willing to exercise patience over the Madonna of the Rocks since Leonardo's services were also claimed by Ludovico Sforza; it is not wise to antagonize an autocrat. Leonardo's notebooks were full of designs for fortifications and machinery that were potentially of use to the Milanese state. Many of his "inventions" are actually ingenious improvements upon military equipment already described by ancient authors and by fifteenth-century military treatises, including designs for crossbows, catapults, lightweight bridges, cannons, and armoured vehicles; but Leonardo's extraordinary powers of visual analysis and description make his renditions more convincing than prior illustrations. Leonardo also turned his intelligence to new matters, including the possibility

15.17 Study of a Flying Machine, c. 1490, from the notebooks of Leonardo da Vinci (Institut de France, ms. B, fol. 80r, Paris)

Leonardo's notes are written in a mirror script as they are throughout his notebooks.

15.18 Study for the Sforza Monument, c. 1488, commissioned by Ludovico Sforza from **Leonardo da Vinci**. Silverpoint on white paper covered with a blue preparation, $5\% \times 7\%$ " (14.8 \times 18.5 cm) (Royal Library, RL12358r, The Royal Collection, Windsor, England © Her Majesty Queen Elizabeth II)

of human flight (Fig. 15.17), which distinguished him from his contemporaries. His design for an enormous bowlshaped helicopter—Leonardo's notes indicate he was imagining a structure 40 feet (12 meters) across with a wingspan twice that size—depends on a man standing in the middle of the machine moving treadles with his head as well as his feet. Unaware of the principles of airflow and lift, in spite of his careful study of the flight of birds, Leonardo was unable to design a workable vehicle. Nonetheless, his sheer inventiveness and knowledge of pulleys and gears, essential to his work as a military consultant, gave him a technological base upon which to build.

Leonardo challenged (and nearly overcame) the limits of his generation's mechanical expertise in plans for a twice life-sized, bronze equestrian monument honoring Ludovico's father, Francesco Sforza. Preparatory drawings (Fig. 15.18) show that Leonardo once again rethought a standard artistic type (see Fig. 11.20), imagining a rearing horse whose hoofs rise over a fallen enemy while the rider leans back and to his side to fight off any other challengers. After turning the rider to a more usual, frontal pose, he was able to complete a full-scale model for the imperial wedding in 1493. Set in the courtyard of the Castello Sforzesco, the group declared the authority and legitimacy of the Sforza dynasty on a colossal scale that ancient authors said was more appropriate to the gods than mere mortals. Never cast because Ludovico requisitioned the necessary bronze to produce cannons in an ill-fated attempt to keep French troops from invading Italy, the model was destroyed when it was used for target practice by soldiers after Ludovico's fall from power in 1499.

Ludovico and Leonardo were well suited to one another. Both were masters of grand gestures and dreams, more than practical accomplishments. Their mutual delight in addressing complex problems, as much for intellectual stimulation as for practical purposes, is evident in Leonardo's paintings for Ludovico's audience chamber in the Sforza Castle, the Sala delle Asse (Fig. 15.19). Leonardo's design has been heavily overpainted, but its witty complexity is still evident. In place of classical motifs, as used by Mantegna on the ceiling of the Camera Picta in Mantua (see Fig. 14.32), Leonardo turned to natural "architecture," imagining the room as a vast tent of interlacing mulberry trees, one of Ludovico's heraldic devices. At their apex appears Ludovico's coat of arms, quartered with those of his recently deceased wife, Beatrice d'Este. Since Beatrice popularized

knotted ornament at court, the intertwining branches may refer on a personal level to the bonds that united Ludovico and Beatrice. However, plaques knitted into the branches on each of the four sides of the room announce Ludovico's primary aim: a celebration of his dealings with and ties to the court of Emperor Maximilian.

Still, imperial connections could not save Ludovico from his own ineptitude. In 1499 the French royal army deposed him, claiming authority for their king through earlier intermarriage with the Visconti. Leonardo, Bramante, and others fled Milan to Florence and Rome, where patrons readily embraced the grand manner which had been promoted by Ludovico Sforza.

15.19 Decorations of the Sala delle Asse, c. 1497, commissioned by Ludovico Sforza from **Leonardo da Vinci** for the Castello Sforzesco, Milan. Fresco The work has been heavily repainted, but the intricate interlace design is original. The inscription on the illusionistic tablet in this section of the ceiling records that Ludovico had been named duke by the Emperor Maximilian.

III

The First Half of the Sixteenth Century

16	Lombardy: Instability and Religious Fervor	378
17	Florence: The Renewed Republic	387
18	Rome: Julius II, Leo X, and Clement VII	397
19	Mantua, Parma, and Genoa: The Arts at Court	425
20	Florence: Mannerism and the Medici	437
21	Venice: Vision and Monumentality	464

he first half of the sixteenth century was an era of stylistic and political realignment. Invasions by foreign troops, challenges to Church authority by Protestant reformers, and a return to inter-city warfare shattered the tranquility of prior decades. In Lombardy some artists and patrons confronted these challenges directly, but elsewhere most commissioned and created works that purposefully masked these hard realities. A heroic classical style in Florence at the beginning of the century served to bolster the city's tenuous return to republicanism. In Rome the popes encouraged Raphael and Michelangelo to paint the walls of the papal apartments and chapel with optimistic visions of stability and harmony, and commissioned Bramante to envision a new St. Peter's and papal palace that implied a universal order under the Roman papacy. In a Venice threatened by the pan-European military force of the League of Cambrai, noble patrons responded enthusiastically to Giorgione's and Titian's poetic evocations of an idyllic golden age, when humans supposedly lived harmoniously with nature and one another. In all these centers altarpieces and narrative frescoes became increasingly dynamic and imposing. Everyday reality often became subject to grand notions of a perfect world modeled on classical idealizations, perhaps inspired in part by new realizations of a greatly enlarged world after 1492. These inclinations were confirmed by the discovery of such awe-inspiring works of ancient art as the Hellenistic Laocoon group (see Fig. 40), whose exaggerated musculature and compositional tour de force artists soon sought to surpass.

Artists and patrons across Italy were also increasingly willing to bend the principles of composition and design formulated over the course of the fifteenth century. Looking more at the concerns of narrative presentation than at formal compositional rules, many artists experimented with new ways of organizing their compositions and articulating their buildings, counting on sophisticated patrons to appreciate novelty and invention. Mannerism and its many variations proved an adaptable tool for expressing the autocratic values that increasingly dominated the peninsula. Artists enjoyed a gradual shift in social position, moving away from the lower social status associated with the craft tradition and capitalizing on the growing recognition of their individual genius. This, the era of Michelangelo, found visual artists writing poetry and treatises even as patrons still kept a close eye on everything they commissioned.

16 Lombardy: Instability and Religious Fervor

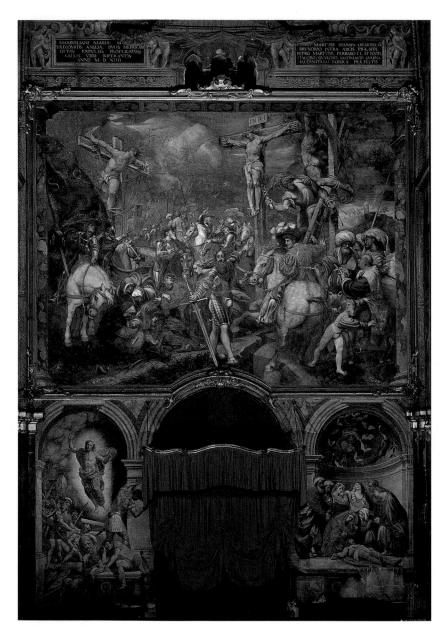

ith the expulsion of Ludovico il Moro from Milan in 1499, the city entered a thirty-six-year period of political turbulence, ruled alternately by the French, the Spanish, and Ludovico's two eldest sons. In these circumstances there was little new building in Milan, but the need for military and engineering expertise, as well as talents in the arts of pageantry and display, continued unabated. In May 1506, the French governor, Charles d'Amboise, Lord

of Chaumont, petitioned the Signoria of Florence to allow Leonardo da Vinci to return to Milan. Charles, like so many Milanese leaders before him, did not seek a radical break with the past. Instead, he employed Leonardo, the most famous artist of the Sforza court, to create works that would, he hoped, seamlessly insert his regime into Milanese history. Leonardo, unusually apolitical for a person of his era, seems to have found no difficulty in working for Charles in spite of his eighteen years of service for Ludovico Sforza. That the Florentine Signoria agreed to release Leonardo to the governor, even though he had not completed painting a fresco commissioned for the Palazzo della Signoria (see Fig. 17.6), indicates respect for the power of Milan's French conquerors.

For a while Leonardo traveled back and forth between Milan and Florence, but in the summer of 1508 he settled in Milan, where he remained until 1513. His renewed presence in northern Italy deeply affected the work of a good number of followers, but many only mimicked the outer trappings of his style, not its substance, and yet other artists proposed boldly realistic and emotional alternatives to his idealized manner. In the end, Lombard art continued its long commitment to naturalism, reinforced by Leonardo's studies of nature but invigorated even more profoundly by contact with Venetian painting and the wide circulation of German prints. While Leonardo was certainly the most famous artist active in the region in the early sixteenth century, numerous patrons and artists worked outside the tight court circle he dominated and paid little attention to his example, seeking instead to express more native values and sentiments. As we shall see, their work is sometimes shockingly different from Leonardo's,

causing some art historians to term them anti-classicists, but such a designation assumes that these artists were rebelling against Leonardo's classical style, when, in fact, it seems simply not to have served their needs. Leonardo was a genius, but by very definition his art stood outside normal local expectations. Moreover, any continuation of Leonardo's stylistic principles in a radically changed political and religious climate became increasingly problematic.

16.1 Two Mountain Ranges, **Leonardo da Vinci**. Red chalk on red prepared paper, $6\% \times 9''$ (15.8 \times 23.0 cm). Royal Collection ©2004, Her Majesty Queen Elizabeth II)

Leonardo at Court

When Leonardo returned to Milan from Florence he once again became the chief court artist, designing pageants, advising on the choir stalls of the Duomo, proposing architectural and urban projects, and attending to military matters. Leonardo traveled widely for Charles. During this period he also began his first series of systematic notes on geology and atmospheric effects, including an examination of marine fossils on mountain heights which led him to the radical conclusion that these objects had not been deposited there by the biblical Flood, as generally believed, but that this land had once formed part of the ocean floor. His drawings of mountain peaks (Fig. 16.1), suggestively rendered in soft red chalk on red paper, offer magisterial panoramas replete with shadow and mist. In the extensive notes accompanying the drawing illustrated, Leonardo marvels at the color of

16.2 (right) Madonna and Child with St. Anne, c. 1505 (?)–13, commissioned from **Leonardo da Vinci**. Oil on canvas, 5' $7'' \times 4'$ 2''' $(1.7 \times 1.29 \text{ m})$ (Musée du Louvre, Paris)

This work, like the *Mona Lisa* (see Fig. 17.8), remained in the artist's personal possession until his death.

(opposite) *Crucifixion*, 1520–21, commissioned by the *masseri* of Cremona Cathedral from **Pordenone** for the retrofaçade of Cremona Cathedral. Fresco, $29' 6'' \times 39' 4'' (9 \times 12 \text{ m})$

mountain flowers seen at a distance through the thin mountain air, which he obviously experienced first hand and at a great height, almost seeming to fly over the vast terrain.

Leonardo's studies of the Alps bore artistic results in the background of his altarpiece of the *Madonna and Child with St. Anne* (Fig. 16.2). Leonardo never completed the drapery on the main figures, gracefully and dynamically interlaced with one another, focusing his attention rather on the mist-covered mountains in the background. His astute observations on the perception of color and light under differing atmospheric conditions, carefully recorded in his notebooks, led him to a radically different depiction of nature than appears in his earlier *Madonna of the Rocks* (see p. 362). Abandoning the uniformly precise rendition of details characteristic of much fifteenth-century art, Leonardo expands

16.3 *Madonna, Child, and Infant St. John the Baptist,* c. 1510–20 (?), commissioned from **Bernardino Luini** for the Carthusian Hospice of San Michele alla Chiusa, Milan. Fresco transferred to canvas, $5'5\%''\times3'8\%''$ (1.66 \times 1.14 m) (Brera Gallery, Milan)

his vision to planetary dimensions. At the foot of the painting he describes every rocky striation and pebble, but as he moves to the back, his brushstrokes soften and then dissolve into light-saturated mists enveloping Alpine crags. He also enlarges the scale of his figures so that they themselves form a mountainous mass, making the entire work seem larger and more imposing than the *Madonna of the Rocks* in spite of the fact that the earlier painting is actually somewhat taller.

Leonardo's art was complex and challenging; it naturally attracted imitators and admirers, but most painters and patrons in Milan and Lombardy appreciated only isolated aspects of his work. Leonardo's subtle half-statements and visual innuendos never fully displaced the declarative clarity and down-to-earth naturalism of local artists such as Vincenzo Foppa (see Fig. 15.8). Bernardino Luini (Bernardino Scapi; 1480–85 Luini–1532 Lugano), for example, owned Leonardo's cartoon of the Virgin and Child with St. Anne and the Infant St. John now in London, which is closely related to the master's Madonna and Child with St. Anne

(see Fig. 16.2), but in a fresco of the *Madonna*, *Child*, *and Infant St. John the Baptist* (Fig. 16.3) Luini shows little interest in Leonardo's highly evolved and sophisticated compositions and subjects, choosing instead to translate Leonardo's composition back into the highly accessible artistic language of the fifteenth century. Rather than suggesting cosmic grandeur, Luini's figures bridge the gap between the sacred and the secular, insisting on a religious experience that is humble and rooted in everyday reality—themes that Church reformers, too, were soon to stress. Indeed, the fresco's direct charm and simplicity were particularly well-suited to its location for a hospice in the strict Carthusian monastery of San Michele alla Chiusa; two of the monks can be seen just to the left of the Madonna's shoulder walking across the landscape in their white hooded habits.

Commemorative Commissions

When Charles d'Amboise died in 1511, Leonardo continued in the service of the new co-governors, the French nobleman

16.4 Studies for an Equestrian Tomb Monument, c. 1511, tomb commissioned by Giangiacomo Trivulzio, co-governor of Milan, from **Leonardo da Vinci** for San Nazaro Maggiore, Milan. Pen and bistre (?) on coarse grayish paper, $11 \times 7\%$ " (28×19.8 cm) (Royal Library, RL12355r, The Royal Collection, Windsor, England © Her Majesty Queen Elizabeth II)

16.5 *April*, 1508-9, commissioned by Giangiacomo Trivulzio from **Master Benedetto**, following designs by **Bramantino**. Tapestry (Museum of Castello Sforzesco, Milan)

Gaston de Foix and the Milanese nobleman Giangiacomo Trivulzio. Both were renowned military men. Trivulzio, for whom Leonardo designed a commemorative tomb monument (Fig. 16.4) had served as condottiere for Ludovico il Moro before joining and then leading the French forces that toppled the Sforza government. As soon as he assumed power he began building a centralized burial chapel reminiscent of a Roman emperor's mausoleum at the church of San Nazaro Maggiore, a potent civic site which had been founded by St. Ambrose and was, until the late sixteenth century, lined with splendid Roman revetments and reliefs, which must have given the church a distinctly imperial air. Leonardo's drawings indicate that Trivulzio intended to appropriate the triumphant imagery that the artist had devised for the ill-fated Sforza equestrian monument (see Fig. 15.18): a galloping horse and rider rearing over a cowering foe. Reduced to life size, the group was to have stood over a chamber containing Trivulzio's effigy and sarcophagus. The smallest of Leonardo's sketches suggest that he was considering a tripartite structure in the form of a triumphal arch; another shows the same theme of conquest expressed in the form of human captives tied to columns.

Trivulzio was not a popular ruler. His heavy hand is already evident in commissions that pre-date his assump-

tion of full power, including a series of twelve huge tapestries depicting the months of the year (Fig. 16.5). Commissioned from Bramantino (Bartolomeo Suardi; c. 1465 Milan-1530 Milan), a local artist who earned his nickname from the fact that he was the protégé of Bramante, the tapestries were woven throughout 1508 and 1509 by masters who worked into the night so that the hangings could be displayed during the traditionally lavish court festivities at Christmas. Unlike the frescoes depicting the same subject at the Castello del Buonconsiglio in Trent (see Fig. 9.32), which feature people dressed in contemporary garb in real settings, Bramantino's cycle consists of allegories populated by figures in Roman guise. To specify their patronage, a huge roundel with Trivulzio's coat of arms hangs from a heraldic border composed of the arms of the noble houses with which he was allied. Inside this self-celebratory frame, figures stand before reconstructions of Roman porticoes and cityscapes wearing brilliantlycolored Roman togas and armor. Oversized male orators represent each month, Latin inscriptions at their feet giving words to their gestures of praise and exhortation. Since the verse for the month April states that the earth becomes green once again and breaks into flower, preparing for joys and games, Bramantino's figures approach the orator

with bowls filled with flowers. In the background humanheaded topiaries glisten with new leaves. Despite such ingenious devices, the tapestries are impressive more for their size than for their quality, compromised as they are by the speed of their execution. What was remarkable was the precocious attempt at classicism in a medium that had for so long been dominated by chivalric themes.

Trivulzio's co-governor Gaston de Foix died at the Battle of Ravenna on April 11, 1512, less than a year after taking office. He thus had little opportunity to develop his own visual iconography, but the French royal house immediately seized upon the occasion of his death to commission an extravagant tomb monument exalting his accomplishments and celebrating French rule in Milan. The project was commissioned from Agostino Busti, known as Il Bambaia (1483 Busto Arsizio?-1548 Milan), who had been trained in the somewhat precious manner of the Pavia workshops (see Fig. 15.3). It called for an idealized effigy resembling Cristoforo Solari's reclining figures of Ludovico il Moro and Beatrice d'Este (see Fig. 15.13), as well as a great number of highly-detailed historical reliefs in marble (Fig. 16.6) to be set within a free-standing architectural framework which would have borne similarities to the lower level of the Trivulzio monument, as well as the structure of French royal tombs. The effect was to have been exquisite. Each relief pulsates with innumerable figures that are so fully carved that the entire foreground seems composed of freely modeled statuettes. Landscape settings and intricately entwined figures rival the complexity of even the most remarkable of earlier Lombard reliefs (see Fig. 15.3). The work was so labor-intensive that in 1517 it was estimated that Bambaia and his assistants from the cathedral workshops would require at least four to six years to complete the work—wishful thinking, it turns out, for a monument that was eventually abandoned unfinished.

Alternatives to Leonardo

The extravagant complexity, preciosity, and sheer costliness of works of art commissioned by the rulers of Milan in the early sixteenth century contrast sharply with commissions outside the capital. Religious leaders and worshippers may in part have been poorly informed of Leonardo's work-little, after all, had actually been completed-but more important, they were used to works of art that were less artificial, and they preferred more concrete expression of their intense religiosity. The kind of religious fervor that had gripped Florence through the preaching of Savonarola in the late fifteenth century continued unabated in northern Italy, where there was widespread awareness, and sympathy for the reforming spirit in nearby Germany that would soon lead to Martin Luther's posting the Ninety-Five Theses against the abuses of the Catholic Church on the doors of Wittenberg Cathedral in 1517. German devotional prints, many produced by pedestrian woodcut makers and engravers, others by sophisticated artists like Albrecht Dürer, who worked in Venice in 1494/95, flooded into Italy, offering apocalyptic and bloody visions of Christian

16.6 The Capture of Brescia, after 1517, probably commissioned by Odet de Foix, governor of Milan, and financed by the French royal family, including Francis I, from **II Bambaia** for Santa Marta, Milan. Marble, $37\% \times 46\% \times 7\%''$ (96 × 118.5 × 19 cm) (Museum of Castello Sforzesco, Milan)

16.7 Sacro Monte di Varallo and its Chapels. Book plate

history. The defense of and return to traditional religious values and practices, which by this time meant in part revisiting the mendicant reforms of the thirteenth century, were incompatible with an art that espoused what some saw as "pagan" artistic models and values. As in our own day, unsettled times bred conservatism and reactionaries.

The Franciscans and Dominicans—Bernardino da Siena and Girolamo Savonarola most notably—had led successive waves of religious reform throughout the fifteenth century. True to their tradition and ever resourceful, the Franciscans continued to imagine new ways to engage the general

populace through their preaching, acts of charity, and by organizing pilgrimages. But with the fall of Constantinople in 1453, failed attempts at crusade, and a consequent wariness to make the arduous journey to the Holy Land, religious leaders sought alternative experiences for their flocks. On December 21, 1486 Fra Bernardino Caimi, an Observant Franciscan whose own pilgrimage inspired him to recreate the holy sites of Jerusalem in the foothills of the Alps, received papal authorization to build a convent and begin the construction of what he called the "New Jerusalem." The Sacro Monte in Varallo (Fig. 16.7) was to include a replica of the Holy Sepulchre-the main goal of all Christian pilgrims to Jerusalem-as well as individual chapels featuring dioramas

of significant events in Christ's life. A guidebook published by Gottardo da Ponte indicates that twenty-eight chapels were completed or under construction by 1514. Pilgrims climbed up the hilly site where they first encountered three chapels dedicated to the infancy of Christ. These were followed by others depicting Christ's Passion from the Last Supper to the Ascension. At the end of the journey came four chapels showing events in the life of the Virgin.

The experience was intensified by the way in which artists created total environments of architecture, painting, and sculpture. Leading the endeavor was the locally trained Gaudenzio Ferrari (1475–80 Valduggia near Vercelli–1546 Milan). As worshipers entered his Crucifixion Chapel

(Fig. 16.8) they stepped directly into history. Lifesized sculpture fashioned out of polychromed terracotta and dressed in actual clothes and wigs of human hair swarmed around them, directing their attention to Christ and the two thieves writhing in agony alongside him. At the far left a pot-bellied old man with the sort of gnarled facial features that fascinated Leonardo and that worshipers had come to expect in emotional Lamentation groups, popular in many churches of the period (see Fig. 24), raises his hand in greeting. It is noisy and dirty, with nowhere for the worshiper to hide. Indeed, the work of art was only complete once worshipers joined it. A painted crowd mirroring the actual one pushes in from the back wearing contemporary clothing,

16.8 Crucifixion Chapel, Sacro Monte di Varallo, c. 1510-23, commissioned from **Gaudenzio Ferrari**

while in the sky angels throw up their hands and tumble through and around large clouds in frenzied grief. In the front, sculptures of villainous solders throw dice for Christ's cloak and a mounted horseman dashes through the crowd. At the far right (not visible in our illustration) the Three Maries and John the Evangelist stand at the foot of the cross consumed with grief and compassion.

This is art that was not meant to be art but functions instead as a vehicle for imagining and reenacting holy mysteries with as little aesthetic mediation as possible. Gottardo da Ponte's guidebook was addressed directly to the reader in the second person singular. Just like the fourteenth-century Meditations on the Life of Christ, which was composed for a Franciscan nun, Gottardo urged the pilgrim to immerse him- or herself in the moment, identifying completely with what was represented, imagining sounds and even smells that accompanied the event. Contemporary reports indicate that many times pilgrims to the Sacro Monte meditated by day and then visited these chapels with lamps and torches by night, leading to particularly powerful and emotional responses. What worshipers had read about and contemplated in their hearts came alive before their very eyes. Little wonder that there are numerous reports of visitors moved to tears.

This search for an unmediated, highly emotional, and cathartic religious experience also provides the context for understanding a series of frescoes commissioned for the interior of Cremona's cathedral, southeast of Milan. Often brutally and exaggeratedly melodramatic, they brought the fervor of religious pilgrimage to the very center of civic life. Tellingly, the one group of paintings that has received the greatest praise from art historians for its sophisticated color, lighting, composition, and antique references seems

to have found little favor with local officials, whose needs and desires ran at cross currents to what is usually understood to be the triumph of classicism in the early sixteenth century throughout Italy.

The fresco cycle began inauspiciously in 1507 with bland paintings of the life of the Virgin and the childhood of Christ. Their tenor changed remarkably when, in December 1516, the *massari* (supervisors and commissioning officers of the cathedral) decided to hire a favorite son, Altobello Melone (c. 1490 Cremona–before May 3, 1543 Cremona), to continue this series. Altobello had once trained and collaborated with the Brescian Girolamo Romanino (1484 or 87 Brescia–1560? Brescia) through whom he became highly

aware of contemporary developments in Venetian and German art. As had been common for centuries, Altobello's Massacre of the Innocents (Fig. 16.9) exploits the violent and disturbing nature of its subject matter, but Altobello's rendition is even more unsettling than usual, fueled in part by the contradictory stipulations of his commissioners. The massari explicitly required that he make his composition as beautiful as those of his predecessors while also graphically recording the pitiful "disheveled women" and "diverse cruelties of the men" who were attacking their babies. Altobello responded by setting his horrible melee in a classically detailed marble courtyard whose detailing recalls the cool classicism of contemporary Venetian architecture (see Fig. 21.15). Herod, seated at the right and dressed in contemporary northern European garb, not biblical robes, kneads the fingers of his right hand and stares vacantly and dispassionately at his victims while his advisors icily eye both the scene and the spectator from under their stylish large hats. The mood and the very mode of painting alter radically in the lower part of the composition where Altobello's brush lashes across the plaster as foot soldiers, clearly identifiable as German mercenaries, do Herod's dirty work with their daggers. While the young mother fallen at Herod's feet is a contemporary beauty, the hideousness of the fate awaiting her child is evident in the cowering dog sniffing a cadaver behind her and in the grotesque lips and goiter of the running nurse maid at the left. Under the arch above her another baby is thrown upside down above the head of a turbaned figure whose massive hands hold the child in place so that it can be slaughtered by his companion. This is not simply a vivid re-envisioning of the biblical story but also a record of the slaughters all North Italians had witnessed in the recent French and German invasions, here given pictorial

16.9 *Massacre of the Innocents*, 1516, commissioned by the *masseri* of Cremona Cathedral from **Altobello Melone** for the nave of Cremona Cathedral. Fresco

bite from models Altobello found in Albrecht Dürer's *Small Passion* and other Northern European prints.

To students raised on the idea that painting in the early sixteenth century is characterized either by the lyricism and grace of Leonardo and Raphael or by the heroicism of Michelangelo, Altobello's work appears aberrational and willfully anti-classical, an artistic revolt of the first order. It is not at all clear, however, that Altobello and his patrons would have seen his work in those terms. First, Lombard art had its own long tradition of gripping naturalism, as we have just seen in the work of Gaudenzio Ferrari. Altobello's patrons are likely to have been as impressed with the suitability of German and other Northern European models to their goal of presenting powerfully engaging religious drama as they would have been uninterested in artificial constructs such as "classical idealism," whatever that term might mean. From our point of view, Altobello appears more a pragmatist than a rebel, an artist who seized upon Venetian models for his fictive architecture while at the same time responding positively to Northern European prints for their emotionality. Polyglot, not purist, he did not have to choose sides; he could have it all, especially when that was exactly what his patrons had demanded of him.

Altobello's example and the demands of his patrons proved critical to a shift in the style of Girolamo Romanino, with whom he had worked closely before the cathedral commission. In October 1517 the *massari* hired Romanino to assess Altobello's frescoes, offering him his own place on the scaffolding two years later. Never before nor after were Romanino's paintings so gripping and emotionally charged as when he worked in Cremona. In his *Christ before Caiaphas* (Fig. 16.10) the viewer confronts Christ's suffering first-

hand. While nothing is as ruthless as in Altobello's fresco, we cannot help but empathize with the humble, shrinking figure of Christ, just dragged across town by a soldier and now confronting the forces of evil personified by the shadowed Mephistopholean features of Caiaphas. A woman-Mary Magdalene or even perhaps Veronica?-attempts to comfort Christ, but her efforts are literally lost in the shadows. Christ's public humiliation takes place right in the streets, a kind of eyewitness reporting similar to the work of artists such as Carpaccio in Venice (see Fig. 13.27) and seen in German prints of the period, updated with the glowing, brilliant light of Venice's most dramatic young painter, Titian. Fluent and sophisticated, down to the reclining nudes Romanino painted over the city gate and his stunning rendering of pieces of armor strewn on the steps of Caiaphas' palace, the fresco strikes most viewers today as a brilliant success, but it seems not to have been sufficiently gritty and down-to-earth to please the massari, who expected a less idealized naturalism. They canceled his contract for a second set of frescoes and replaced him with the bolder and more energetic Giovanni Antonio de Sacchis, known as Pordenone for the name of his birthplace (1483? Pordenone-1539 Ferrara).

Pordenone's *Crucifixion* (see p. 378) occupies the entire back wall of the nave of Cremona's cathedral. It is a raw and brutal work, appropriate both to the subject and to the frenzied emotional tenor Altobello and his patrons had initiated with his *Massacre of the Innocents* but which Romanino had been unable or unwilling to replicate fully. Once again, German prototypes abound: the unusual asymmetrical and off-center placement of the crosses, the figure of the centurion standing at the center and pointing to the cross, the horseman in his plumed hat, and the screeching emotions

all derive from transalpine models. It is the moment immediately after Christ has given up the ghost, the sky has grown dark, and the earth is literally quaking, opening into a chasm that will soon swallow the horseman on the right and perhaps his compatriots, who include turbaned infidels and a man riding on a donkey, a medieval symbol for Synagogue. It is now time for soldiers to put the crucified out of their suffering, and so a soldier climbs a ladder to the unrepentant thief and breaks his legs. While these figures derive from works that Pordenone saw at the Vatican before he came to Cremona (see, for example, Figs. 18.31 and 18.33), they have lost all their idealization and nobility. A storm

16.10 Christ before Caiaphas, 1519–20, commissioned by the masseri of Cremona Cathedral from **Girolamo Romanino** for the nave of Cremona Cathedral.

swirls around the scene, and in the left foreground the Virgin, fully empathetic with her son's death, swoons on the ground, while behind her, Longinus, riding a brown horse and holding the spear with which he will pierce Christ's side, clasps his hand to his heart and recognizes Christ's divinity. To any who would be foolish enough to doubt the wisdom of his revelation, the centurion holding a cross-shaped sword at the center of the fresco glares us into recognition of his famous utterance, "Surely this was the son of God." Never before had a Crucifixion been so theatrical or compelling, fully realizing his patrons' demands for an art that could convert and subdue heresy, an ever more pressing need as the Reformation and challenges to Church doctrine and authority spread rapidly in these years.

Another artist who employed dramatic settings with particular attention to luminous night skies was Giovanni Girolamo Savoldo (active 1506–48 Venice), who acquired a reputation for such work with his paintings for the Mint in Milan. Vasari called his works "nocturnes, with fires, very beautiful" (Fig. 16.11). Savoldo spent most of his career working in Venice, but he called himself "da Brescia" (from Brescia), a commercial center east of Milan, and his work reveals a strain of realism that characterized much art in the Lombard region (see Figs. 24.1 and 24.2). In Savoldo's *St. Matthew*, a subject appropriate for the Milanese mint

insofar as the saint was a tax collector, an angel appears in the darkness to inspire the seated evangelist. Strangely distorting light and shadows play across their drapery and faces, the result of illumination from a small oil lamp placed like a footlight on the table below and in front of them. In the dark recesses at the right, two men attend to a seated figure, probably St. Matthew in the house of the Queen of Ethopia's eunuch after he had preached and discredited some local magicians. Flames and sparks from the fireplace throw the three figures into relief, catching St. Matthew's hands and face with their light, but consigning the rest of his body to near total darkness. At the far left four small figures wander along a moonlit street. Matthew's peasant's hands, rumpled clothes, contorted neck, and slightly scruffy beard all contribute to the immediacy of the scene, so convincingly real as to be unsettling.

Thus as we move on to look at more familiar Florentine and Roman masterpieces from the first half of the sixteenth century it will be crucial to keep in mind that there were numerous alternative expressions available to patrons and artists who sought them. As we shall see in Part IV of this book, by the 1560s it was realism, directness, and emotionalism—the hallmarks of much Lombard art in the early sixteenth century—that came to dominate Italian devotional art, not classicism and idealism.

16.11 *St. Matthew and the Angel*, c. 1534, commissioned from **Girolamo Savoldo** for the Ducal Mint, Milan. Oil on canvas, $36\frac{1}{2} \times 49''$ (93.4 × 124.5 cm) (Metropolitan Museum of Art, New York)

X-rays show that Savoldo originally planned a praying woman, perhaps a donor, at the bottom right of the canvas, but he painted her out.

7 Florence: The Renewed Republic

In November 1494, after sixty years of *de facto* rule, Medici control of Florence came, temporarily, to an end. Having ruled for a mere two years, Piero de' Medici (known to history as "the Unfortunate," in marked contrast to his father, Lorenzo "the Magnificent") was forced by a mob of his fellow Florentines to leave the city. Politically inept, he had responded to threats from rival factions within the city and from the French by allying himself with Naples and

then, when the French invader was on the doorstep, by allying himself with the French king, Charles VIII.

Public attention at this time turned to Savonarola, the Dominican preacher whose sermons fired popular devotion and reform. He used Piero's exile and the Republic's struggling attempts at reforming itself to attempt the superimposition of a theocratic model of government on the city and its governors. His powerful preaching of Christian reform gave such a theological cast to republican values that the meeting room of the Great Council was referred to by some as the Hall of Christ. Yet Savonarola's interventions in the workings of the state proved his undoing and, as we have seen, he was executed in 1498 in front of the very town hall whose policies he sought to influence. Thus twice in a decade, in 1494 and in 1498, Florence had freed itself from what it perceived as tyranny.

The Republic as Patron

With Piero in exile and Savonarola dead, the citizens of Florence turned to the task of reconstructing their cherished republic and reinventing a visual mythology and stylistic language to express its ideals. The Signoria thus embarked on a number of commissions which were to transform the iconography of the Florentine state. These commissions for the renewed Republic did two things.

They provided the physical site of government with a powerful new series of images designed to establish an iconography of restored republican power, and they evoked the

(above) *David* (detail of face), 1501-04, commissioned by the Consuls of the Wool Guild from **Michelangelo** for the north tribune of Florence Cathedral, but on completion installed in front of the Palazzo della Signoria, Florence. Marble (Accademia, Florence). See Fig. 17.1

history of the earlier republican city, both in their iconography and in their placement.

Even before the new works were commissioned, the intentions of the new government were clear. In 1495, not quite a year after Piero's forced exile, the Signoria ordered the removal of several works of art from the Medici Palace. Donatello's bronze David (see Fig. 11.21) was placed inside the Palazzo della Signoria, joining both his marble David (see Fig. 10.9), which had been moved there in 1416, and Verrocchio's bronze David, which Lorenzo and Giuliano de' Medici had sold to the Signoria in 1476. Donatello's bronze Judith (see Fig. 11.23) was moved from the garden of the Medici Palace to the platform immediately to the left of the main entrance of the Palazzo della Signoria. An inscription was added to the statue at that time which said that the citizens placed the statue there as an "exemplum" of public well-being ("salus publica"). In both cases references to the protection of the state from tyrannical forces could not have been clearer. Paintings by Pollaiuolo of the Labors of Hercules, a civic hero central to the mythology of Florence, and by Uccello of the Battle of San Romano, an important event in the political and military history of the state, were also taken to the Palazzo della Signoria from the Medici Palace.

A New Civic Hero: Michelangelo's David

Besides reclaiming civic imagery which had been appropriated by a private family, the placement of these sculptures and paintings at the Palazzo della Signoria initiated a program of state symbolism whose most memorable component is Michelangelo's David (Fig. 17.1). The statue was originally commissioned for the north tribune of the cathedral to continue the decorative program begun by Nanni di Banco and Donatello in 1408-09 (see Figs. 10.8, 10.9, and 10.10) during a golden age of the Republic. The block from which it was carved had lain in the cathedral workshops since 1466 and had, in fact, been partially carved according to a model that still existed in the Opera when Michelangelo received his commission in 1501. When completed in 1504 the David was, instead, placed just to the left of the entrance of the Palazzo della Signoria, having been suspended in a wooden frame and rolled on fourteen greased logs by over 40 men over a period of four days from the cathedral workshops to the Palazzo della Signoria. There it displaced Donatello's Judith and in the process assimilated Judith's meaning of the "salus publica." Had the statue not suffered over 360 years of exposure to the weather and a disastrous cleaning in 1843 with hydrochloric acid that further abraded its surface (before being taken inside in 1873) the sculpture would have had a lustrous polish and suggestive sensuality that would have approximated the sheen of the dead Christ in the Roman Pietà (see Fig. 12.34) or the slightly later nudes for the tomb of Julius II in Rome (see Fig. 18.10).

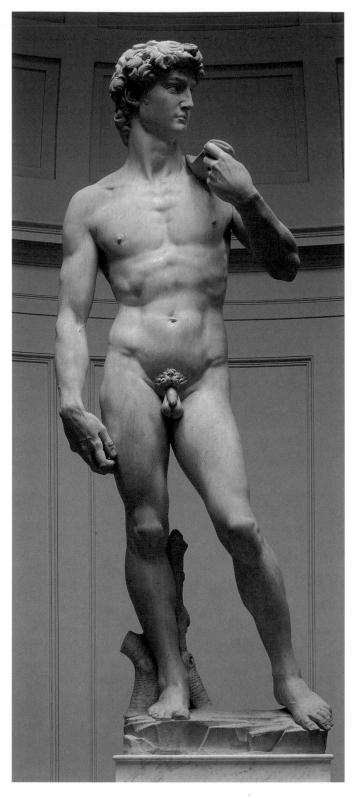

17.1 *David*, 1501-04, commissioned by the Consuls of the Wool Guild from **Michelangelo** for the north tribune of Florence Cathedral, but on completion installed in front of the Palazzo della Signoria, Florence. Marble, height 17' ½" (5.22 m) (Accademia, Florence). See p. 387 and Contemporary Voice, p. 505.

In October 1504 the tree stump supporting the *David* was gilded, a gilt garland was placed on the figure's head, and a belt of twenty-eight gilt-bronze leaves was fixed around its waist.

The *David* is striking both for its realistic representation of the male human body and for the idealism that Michelangelo has projected onto the body. The figure is simultaneously understandable as an ordinary man, essentially free of attributes that would readily identify him (the sling being virtually hidden from sight), and as a hero. The colossal size of the figure—nearly three times life size—implies a link with colossal sculptures of antiquity; the greatness of Greece and Rome now is equalled by that of Florence. But concentration on the statue's formal classical antecedents misses the deliberate tension in the figure between real and ideal, the suggestion that the ordinary can be transformed into the extraordinary by a decisive moment of action.

The nudity of the figure was unusual for a representation of David, Donatello's bronze David (see Fig. 11.21) notwithstanding. The biblical text (I Samuel 17:38-39) leaves little room for interpreting David as a nude. The pose of the figure and David's mature body, along with the nudity, suggest, instead, a classical statue of Hercules. Moreover, the rocky terrain on which the figure stands, as well as the blasted tree trunk behind David's right leg, derive from the well-known tale of Hercules at the Crossroads. Faced with a choice between virtue and vice, allegorically represented as, respectively, a sere and rocky landscape and a lush and flowering landscape, Hercules chose the first. No one entering the Palazzo della Signoria could have missed the moral and political meaning of the statue nor the reference to the classical hero who had appeared on the state seal of Florence since the end of the thirteenth century. Another of Florence's civic symbols may be alluded to in the contracted muscles of David's brow and in his fierce stare (see p. 387). This physiological type, known as the leonine type, recalls the Florentine marzocco, or heraldic lion, a gilt marble example of which stood at the other end of the platform before the Palazzo della Signoria from the David.

The great richness of meaning for the David lies in Michelangelo's strategy of stripping the figure of all but the most minimal iconographical elements so that it may slip back and forth between meanings, thus embracing the widest possible range of civic references and traditions. The reason that the David so quickly became an icon for Florence was not just Michelangelo's extraordinary skill in fashioning a statue from a block of marble that had been quarried and partially carved during the previous century, but that he presented an heroic figure that resonated with the most telling symbols of Republican Florence. At the same time, the nudity of the figure and the virtual absence of attributes also permitted the work to be viewed simply as a work of art, a measure of Michelangelo's extraordinary skills and his ability to compete with and surpass the sculptural successes of classical antiquity. Referred to in the documentary records as a "colossus", the David recalled the Colossus of Rhodes (one of the wonders of the ancient world), a statue that also guarded a gateway.

Sculpture at the Cathedral

Other sculptural commissions at the cathedral indicate the seriousness of the Republic's intentions to associate itself with the artistic commissions of the city before the Medici assumption of power. In 1503, even before the David had been completed, Michelangelo was commissioned by the Opera of the cathedral to carve twelve Apostle figures, like the David recalling the projects of the earlier period. Michelangelo began only one of these statues before his contract was dissolved in 1505 when he went to Rome to work for Pope Julius II. This figure, a St. Matthew (Fig. 17.2), is torqued around its central axis, a spasm of movement far different from the quite traditional pose of the David, indicating how anomalous the David is within Michelangelo's sculpture at this time. Even in its very unfinished state, Matthew's massive musculature suggests a deep reservoir of pent-up energy and divine inspiration.

17.2 *St. Matthew*, 1503–8 (unfinished), commissioned by the Opera del Duomo from **Michelangelo**. Marble, height 8′ 11″ (2.71 m) (Florence, Accademia)

After a brief delay the Apostle commission was begun anew in 1511, with a contract to Jacopo Sansovino (Jacopo Tatti; 1486 Florence-1570 Florence), a sculptor and architect who trained under Andrea Sansovino (Andrea Contucci; 1467/70 Monte San Savino-1529 Monte San Savino) and, like other artists, took his master's name. This led to the completion of four Apostle statues by four different sculptors by 1518. While indebted to Michelangelo's St. Matthew in its contrapposto movement, Sansovino's St. James (Fig. 17.3) does not have the coiled torsion of that figure. Like the St. Matthew it also refers to earlier figures such as Donatello's St. Mark (see Fig. 10.18) in the pose and relationship to the niche. The Apostle commission seems not only to be linked to earlier moments in Florentine republican history, but also to be an active attempt to regain the civic space of the cathedral interior that Lorenzo de' Medici had begun to appropriate for himself, especially with plans from the early 1490s to decorate its main chapel (dedicated to St. Zenobius, one of Florence's chief patron saints) with mosaics.

17.3 St. James, 1511-18, commissioned by the Opera del Duomo from Jacopo Sansovino for the interior of Florence Cathedral. Marble (nave of Florence Cathedral)

The Imagery of State

A major renovation project was underway within the Palazzo della Signoria during the time that Michelangelo was carving the *David*. Expansion of the Florentine Great Council to 500 members in 1495, imitating the Maggior Consiglio of Venice, meant to ensure that no single family or faction like the Medici would once more gain sole power over the state. This in turn necessitated the enlargement of spaces in the building to accommodate the new members, and, although little remains of this project for the Hall of the Great Council (Sala dei Cinquecento [Room of the 500] or the Sala del Gran Consiglio), the program for its decoration is known (Fig. 17.4).

The St. Anne Altarpiece An impressive altarpiece, two large frescoes, carved wooden benches, and a marble sculpture were the main components of the program. In 1498 Filippino Lippi received a commission to paint an altarpiece for the center of one of the long walls of the room, directly opposite the gonfaloniere's bench. His death in 1504 caused delays in the project, but it was eventually assigned to Fra Bartolomeo (Baccio della Porta; 1472 Florence-1517 Florence), then a friar at San Marco, the very monastery from which the forces of the Republic had taken Savonarola in 1498. Fra Bartolomeo had trained with Cosimo Rosselli and then set up a workshop with his fellow student Mariotto Albertinelli (1474 Florence-1515 Florence) until 1500, when he began a term as a Dominican novice, ultimately joining the order in 1501 at San Marco. Fra Bartolomeo's St. Anne Altarpiece (Fig. 17.5) was probably similar in iconography to Lippi's earlier, unexecuted work. In Fra Bartolomeo's painting (left unfinished in 1512 when the Medici returned to power and aborted the program of the Hall of the Great Council) the Virgin and Child sit raised on a platform in the center of the symmetrically constructed scheme, with St. Anne, the Virgin's mother, sitting behind them. These three figures link with the kneeling male saints in the foreground in a triangular composition which, along with the stately background architecture, provides a stable armature for the animation of the figures. Each of the principal figures is conceived in an active pose, his or her body turning in a contrapposto so that the surrounding space is enlivened and attention directed to other forms in the composition. The Virgin looks toward her right, but her lower body turns in the opposite direction toward the kneeling figure in the right foreground of the painting. The interlocking forms of the Virgin and Child, their simplified ovoid faces, and their placement at the center of the composition-where they receive the energy directed toward them by the other figures and are, at the same time, the source of it-recall the work of Leonardo (see Figs. 11.28 and 16.2), who had been an active presence in Florence from 1500, when he returned from Milan, to 1506 when he again left the city for Milan.

10m

17.4 Sala del Gran Consiglio (Hall of the Great Council), Palazzo della Signoria, Florence, reconstruction of the walls and ceiling showing proposed decorative projects initiated by the renewed Republic (after Johannes Wilde)

This plan depicts the ceiling of the room with the walls extending from it, as if hanging from their upper edges. Folding the walls along the lines of juncture with the ceiling would provide a three-dimensional model of the room. 1 Michelangelo, Battle of Cascina; 2 Leonardo da Vinci, Battle of Anghiari; 3 Fra Bartolomeo, St. Anne Altarpiece; 4 Jacopo Sansovino, San Salvatore, marble statue projected for architrave over the bench of the gonfaloniere

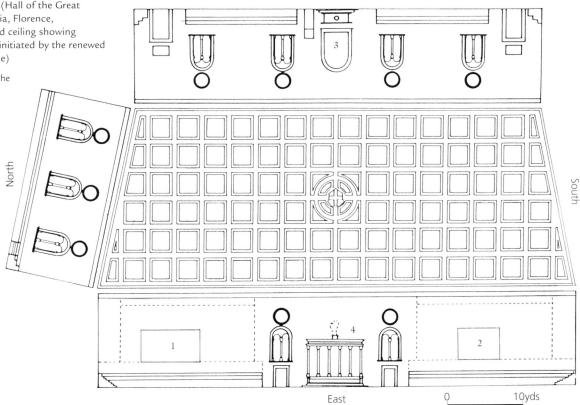

West

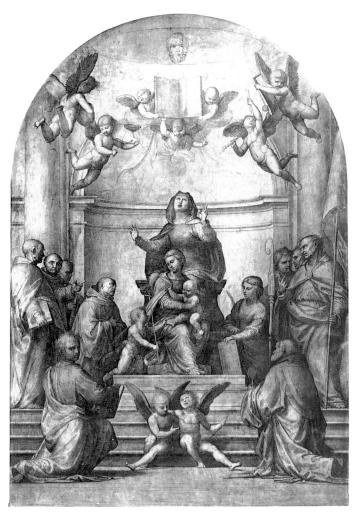

At the same time, the altarpiece is thoroughly integrated into its political context. Each saint depicted in it was intended as a reference to a specific Florentine historical event that had occurred on the day of the saint's feast. The painting, then, is both a devotional image and a record of civic achievement. The image of St. Anne symbolizes the expulsion in 1343 of Walter of Brienne from Florence. Walter had actually been invited by the Florentines to serve as ruler of the city, but he overstepped his power and was expelled on the feast day of St. Anne, a day that henceforward was freighted with overtones of freedom from tyranny. The original contract for Lippi's painting explicitly called for representations of St. John the Baptist, the main patron saint of Florence; St. Zenobius, the city's first bishop; and St. Victor, on whose feast day in 1364 the Florentines defeated the Pisans at the Battle of Cascina. The connection between past and present was also manifest in plans to have Andrea Sansovino carve a figure of the Redeemer to place over the gonfaloniere's seat opposite the St. Anne Altarpiece, for it was on the feast of the Savior (November 9) that Piero de' Medici had been expelled from the city in 1494 and that the new government had legislated as a civic holiday.

17.5 *St. Anne Altarpiece*, 1510–12 (unfinished), commissioned by the Signoria from **Fra Bartolomeo** for the Sala del Gran Consiglio, Palazzo della Signoria, Florence. Oil on canvas (Museo di San Marco, Florence)

In fact, in 1501 Leonardo had apparently exhibited a cartoon (now lost) for a painting of St. Anne with the Virgin and Child and a lamb (see Fig. 16.2) in a room attached to the church of Santa Annunziata in Florence, one of the city's major cult churches. Since preparatory drawings seem to have had little intrinsic value at this time outside the artist's studio, the tale told by Vasari that large numbers of Florentines lined up over the course of two days to see the drawing because it was by a famous native son does not ring completely true. Given that Leonardo subsequently modified this iconography in another large cartoon (London, National Gallery) by substituting for the lamb a figure of the infant John the Baptist, the patron saint of Florence, this story suggests that the image participated in the history of St. Anne as a civic symbol at just the time that Michelangelo was asked to complete work on the unfinished block of the David.

The Battle Paintings Civic history was also to be represented on the walls of the room on either side of the gonfaloniere's seat. In 1503 the Signoria commissioned Leonardo to paint the Battle of Anghiari against the Milanese (1440) on one side, and in 1504 they commissioned the younger Michelangelo to paint the Battle of Cascina on the other side. Michelangelo's subject had particular resonance since the Florentines were again warring with Pisa in a protracted conflict which lasted until 1509. Such battle paintings enlivened the walls of many Italian town halls, commemorating great moments in communal history (see Fig. 5.27). The Signoria pitted Leonardo and Michelangelo against one another in a clear attempt to urge each to his creative limits and at the same time to push for a speedy

completion of the project—a familiar mode of assigning projects. They were successful in the first respect but not in the second, for Leonardo completed only a small part of the actual fresco, and Michelangelo apparently never moved beyond the stage of the cartoon. Yet the preparatory drawings for their frescoes were to influence Florentine artistic developments for years to come, and they still offer a text-book description of opposing pictorial possibilities for the early years of the sixteenth century.

The section of Leonardo's Battle of Anghiari (Fig. 17.6), shown here in a copy by Peter Paul Rubens (1577-1640), was to form the center of the whole fresco, embedded in a vast expanse of landscape containing various moments of the battle. Horses and bodies twist violently, their movement accentuated by details of realistically rendered costume and musculature. Despite the frenzied action, the figures form a tightly structured unit around a central axis, in which arms and swords link with one another, providing both a stable composition and violently animated movement through it; each figure demands individual attention. The movement implicit in Leonardo's early Adoration of the Magi (see Fig. 11.28) is here unleashed so that it becomes part of the subject of the painting. Leonardo wrote in his notebooks of the filth and stench of war; in his depiction of the battle he gives each of his figures leonine faces as if to suggest the bestiality of the event, but he also transforms them into slightly brutish forms, using the pictorial convention of ugliness as a denotation of error or sin. This subtext of meaning is a far cry from the emblematic notions of triumphal victory on a bloodless battlefield that characterized so many earlier historical battle paintings in Tuscan town halls.

Leonardo began the fresco in 1505, and left it in 1506. His unfinished section was framed in 1513 and ultimately replaced by Vasari's paintings after 1563. The Rubens drawing was, therefore, not done from Leonardo's actual fresco, but from some copy made of it before its destruction.

17.7 *Battle of Cascina*, commissioned by the Signoria from **Michelangelo** in 1504, copy of 1542 by **Sebastiano da Sangallo** (?). Grisaille panel (Lord Leicester Collection, Holkham Hall, England)

Michelangelo's Battle of Cascina is known only from his preliminary drawings and from copies (Fig. 17.7), but it is clear from what remains that he, too, made significant changes in the established iconography of civic military victories. He chose a moment when the Florentine troops, bathing in a river, were called to readiness by their leader. This choice allowed Michelangelo to concentrate on the nude body in motion, providing a virtual studio portfolio of poses. Michelangelo pushed his figures forward in the composition, in a frieze-like manner reminiscent of figures on Roman sarcophagi. Opportunities to depict spatial volume seem deliberately rejected as figures move laterally across the space, both physically and psychologically independent of one another. Leonardo's insistent naturalism is here subordinated to the hard sculptural form of the male nude and to the invention of complex, yet graceful, poses for the figures, not unlike the St. Matthew which Michelangelo was designing at the same time (see Fig. 17.2)—almost as if he wished deliberately to provide an alternative to the Battle of Anghiari. Where Leonardo's figures fuse in the shadows of his sfumato technique, Michelangelo's are each clearly delineated, with crisp outlines separating light from dark. In this way, Michelangelo adhered absolutely to the pictorial conventions of Florentine disegno. While the torsions of Leonardo's figures are determined by the immediate moment of the battle in which they participate, the poses of Michelangelo's soldiers are isolated depictions of self-conscious grace and willed complexity that seem only tangentially connected to the moment of alarm, despite the trumpeter in the background. Thus where Leonardo's figures are mired with the sweat and noise and terror of battle, Michelangelo's figures seem far from war, absorbed in their own individual physical artfulness.

Private Patrons

Portraits

Like the public commissions for the Palazzo della Signoria, private commissions during the early years of the sixteenth century indicate a development of earlier painting styles. The presence of the revered Leonardo in Florence coincided with the emerging power of the mature Michelangelo and the assimilative mind of the young Raphael (Raffaello Santi; 1483 Urbino–1520 Rome), newly arrived in the city from his native Urbino, where he had trained with his father, Giovanni Santi, also a painter, and from Perugia, where he had been impressed by the light and jewel-like coloring of Perugino's painting (see Fig. 12.30 for an

example of Perugino's work in Rome). Although we have virtually no documentation concerning interactions among Raphael, Leonardo, and Michelangelo, the intellectual exchanges among them are manifest in their work.

One of Leonardo's greatest accomplishments as a painter was his transformation of the portrait from an icon of status to the representation of a person fully engaged with the viewer, something he had begun with his portrait of Ginevra de' Benci before his move to Milan (see Fig. 11.36). His Mona Lisa, showing an unidentified woman, seated, against the background of a rocky and watery landscape (Fig. 17.8), epitomizes this achievement, based in part on contemporary developments in Venetian painting which Leonardo would have seen when he visited that city in 1500 on his way to Florence after having fled Milan. Her crossed arms form the base of a triangle with her head as its apex. Her face is an idealized oval, emphasized by the sharp, semicircular delineation between the crown of her head and the sky behind. The contours of her face, hands, and body are rendered with the utmost sensitivity, so that convex merges into concave in a continuous movement. Leonardo's use of the sfumato technique-at least as it can be currently understood from this quite dirty painting-blends light and dark and one form with another to enhance the unity of the composition. The lady turns gently to recognize the presence of the viewer, her slight smile—the subject of endless speculation—inviting conversation. Unlike many portraits of women during this period, Mona Lisa is represented without any of the normal attributes of wealth; she wears no rings or other jewelry, although her dress seems made of fine materials. Her hair hangs loose, and a scarf seems casually thrown over her left shoulder, adding an unusual air of informality to the picture. These anomalies, tied to contemporary accounts indicating that Leonardo worked on the painting while he was in Rome after 1513, suggest that, like many of the artist's paintings, the Mona Lisa had a long history. Whatever painting Leonardo may have begun in

17.8 *Mona Lisa*, c. 1503–1513(?), **Leonardo da Vinci**. Oil on panel, 38½ × 21″ (97.8 × 53.3 cm) (Musée du Louvre, Paris)

At one time the figure was flanked by columns whose bases are just visible on the ledge behind her. The identity of the figure is uncertain. Vasari was the first to use the name Mona [Madonna] Lisa, leading to an identification of the figure as Lisa Gherardini, who married Francesco Bartolomeo del Giocondo in 1495. Another writer who had seen the painting in France in 1517 when he visited Leonardo indicated that the painting had been made for Giuliano de' Medici when Leonardo was in Rome, making the identification of Mona Lisa unlikely.

Florence, he may well have modified it at a later date so that it became much more than a portrait. It seems to be a meditation on ideal feminine beauty and an exploration of the sitter's (and perhaps the artist's) psyche. The rivers, streams, and mist-covered mountains in the background and the careful alignment of the sitter's eyes with the horizon mark her as fully part of a larger universe.

When Raphael painted the wedding portraits of Agnolo Doni and Maddalena Strozzi (Figs. 17.9 and 17.10), the *Mona Lisa* (at some early stage in its conception) was clearly his inspiration. Raphael's figures are placed in the same three-quarter pose as the Mona Lisa, looking out at the viewer as if to break down the barrier of the picture plane. They maintain, however, the crisp linear definition of form of central Italian *disegno* that Leonardo had so completely rejected very early in his career with his use of the *sfumato* technique. Perhaps this technique was a hold over from Raphael's early training, but it may also have been in

17.9 *Maddalena Strozzi Doni*, c. 1506, commissioned by Agnolo Doni from **Raphael** as a pendant to Doni's own portrait. Oil on panel, 24½ × 17½" (63 × 45 cm) (Galleria Pitti, Florence)

response to Doni's wishes since he had at the same time commissioned Michelangelo to paint a Holy Family which utilized the clarity of form traditional in Florentine painting. Yet in pockets of space and at the edges of Raphael's figures, where light plays over rounded surfaces, the painter seems to have experimented in these portraits with the blurred shadowing that was so characteristic of Leonardo's work. Apparently the young Raphael was working very hard to assimilate the novelties of form and style that he encountered in Florence. Nonetheless in the Portrait of Maddalena Strozzi Doni Raphael reverted to earlier formal conventions, in which a woman's social position was marked by her fine dress and jewelry (provided by her husband and remaining in his possession) and in which the formality of the image is enhanced by the staring gaze and stiff pose of the figure, as was the case with Ghirlandaio's Giovanna de' Tornabuoni (see Fig. 11.37). The few strands of hair that escape on Maddalena's right side are a rather cautious attempt at a natural effect, far removed from the flowing tresses of the Mona Lisa. In manipulating the marriage portrait type (see Fig. 14.20), Raphael could only make certain formal changes such as the shift from a profile to a three-quarter frontal pose without the meaning of the image being lost.

17.10 *Agnolo Doni*, c. 1506, commissioned by Agnolo Doni from **Raphael**. Oil on panel, $24\% \times 17\%''$ (63×45 cm) (Galleria Palatina, Palazzo Pitti, Florence)

In the Portrait of Agnolo Doni Raphael brings forward the parapet in front of which Doni sits so that the sitter can rest his arm on it, both lending him an air of informality while at the same time enhancing the illusion of volumetric space in the painting. Doni's steady stare is not exactly an invitation to conversation, his Florentine mercantile wariness suggesting a calculated appraisal of any information that he might share with the viewer. (One is reminded that Doni apparently tried to pay Michelangelo less than the agreed-upon price for the image of the Holy Family, leading the artist to raise the price: a rare time that Doni's business acumen did not match his business partner's.) Just as there was a system for female decorum in portraiture, so also were there conventions of male portrayal. Conventional models could, however, more easily be manipulated for male than for female portraits if the poses of Doni and his wife are any indication. Despite Raphael's technical facility and the rapidity with which he assimilated the new work being produced in Florence after his arrival in 1504/05, Maddalena Strozzi Doni and Agnolo Doni rely strongly on older portrait models, as if the new elite in the city wished to ensure their position by lip-service to established conventions.

Religious Painting

Raphael's *Madonna of the Baldachin* (Fig. 17.11), painted for the Dei family but left unfinished, uses the conventional symmetrical composition of the enthroned Virgin and Child flanked by saints. The figures are placed in an austerely classical architectural setting. Despite the availability of Leonardo's and Michelangelo's studies for their battle paintings, Raphael here shows little sign of sharing the older artists' fascination with movement and physical energy. Only the angels holding the drapery of the baldachin at the top of the painting are animated, suggesting that Raphael may have been incorporating the new vocabulary slowly, in ancillary figures. He may also have been constrained by the commission itself to produce a familiar image, in which movement was by convention restrained.

Raphael's interest in the new work of Leonardo and Michelangelo is evident, however, in his *Entombment* (Fig. 17.12), painted for Atalanta Baglione of Perugia to commemorate her dead son, killed at his mother's door by supporters of the uncles and cousins he had murdered. The group of men around the dead Christ creates a centrifugal movement away from the body at the same time that the Magdalene moves toward it, her golden hair blowing sensuously across her bodice. The stances of the two men

17.11 *Madonna of the Baldachin*, 1508, commissioned by Rinieri di Bernardo Dei from **Raphael** for the Dei Chapel, Santo Spirito, Florence, left unfinished when Raphael moved to Rome in 1508. Oil on canvas, $9' \times 7'$ 4" $(2.74 \times 2.24 \text{ m})$

The illustration shows the painting in its original state, without the additions of a later date to the upper part of the altarpiece.

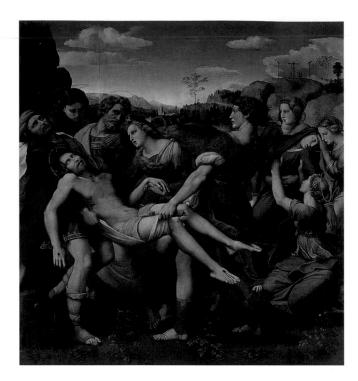

17.12 *Entombment*, 1507, commissioned by Atalanta Baglioni of Perugia from **Raphael** to commemorate the death of her son, Grifonetto Baglione. Oil on panel, $5'11\%'' \times 5'9\%''$ (1.82 × 1.76 m) (Borghese Gallery, Rome)

holding the body seem determined by the dead weight they support. The pristine clarity of the landscape, with trees and crosses silhouetted against open sky, betrays Raphael's training with Perugino and the contemporary popularity of Flemish painting. Raphael's interest in classical models is evident in the figural group as a whole, which is a quotation from a Roman sarcophagus representing the dead Meleager, an appropriate reference for Atalanta's dead son since the classical hero had died as a result of an act of vengeance by his mother—also called Atalanta—provoked by Meleager's brothers. The seated figure at the right is also a quotation, this time from a painting of the Holy Family by Michelangelo made just before Raphael painted this work.

Although Raphael's composition derives from an engraving of the same subject by Mantegna, a drawing for the painting (Fig. 17.13)—one of a series—suggests how concerned Raphael was to follow the lead of Leonardo and Michelangelo in activating the movement of his figures to give them a greater sense of participating in an ongoing narrative action rather than a static *tableau vivant*. Whereas the drawing—an intermediate stage in the development of the final composition—shows the figure of Christ parallel to the picture plane, with the other figures in a frieze-like

arrangement, perhaps inspired by the Roman sarcophagus relief of Meleager, the painting shows Christ turned at an angle into space. The shoulders of the painted Christ have a slight torsion and his head both falls heavily back and turns off axis with the body toward the viewer, giving the figure a decided physical tension despite the fact that Christ is dead. The muscular young man lifting Christ's legs in the painting thrusts back, countering the movement of Christ into space, different from his frontally disposed predecessor in the drawing. And what had begun in the drawing as a rather conventional lamentation scene has in the finished painting been transformed into an astonishing conflation of deposition, lamentation, and entombment iconographies.

By the time Raphael completed the Entombment he had obviously integrated into his work the recent innovations of Florentine painting, but he also equally clearly understood their implicit contradictions. Like the Battle of Cascina, the Entombment deviates from the commonly accepted idea that painting of the early sixteenth century is characterized by a single focus within the narrative, a stable symmetrical composition, and a clear relationship between the individual forms-in short, that it adheres to classical principles. It is no accident that both paintings are narratives with a strongly implied story line, rather than conventional religious images. Moreover, Raphael obviously struggled in his search for a solution to the opposing possibilities for narrative and compositional structures presented by the Battle paintings of Leonardo and Michelangelo (see Figs. 17.6 and 17.7). The rupture in the composition of the Entombment at the right, where Mary and her attendants are separated from the main group, and the residual planar structure of the males at the left, despite the illusion of a deep space beyond, attest to the difficulties facing any painter of this period-even one with Raphael's extraordinary skills-in coming to terms with the divergent visions for the future of painting embedded in the two Battle paintings.

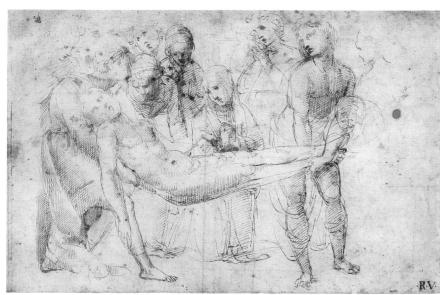

17.13 Entombment, c. 1507, **Raphael**, preparatory drawing for Fig. 17.12. Ink on paper, $8\% \times 12\%''$ (20.9 \times 32 cm) (British Museum, London)

Rome: Julius II, Leo X, and Clement VII

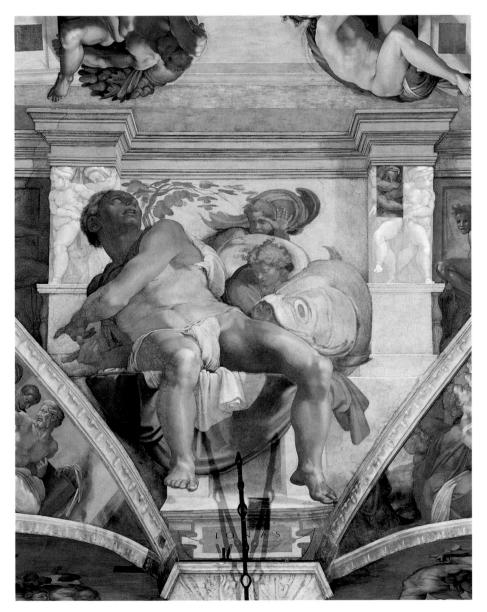

hen Giuliano della Rovere became pope as Julius II (r. 1503–13) he already had a long history as a generous patron of the arts. As the nephew of Sixtus IV he had taken responsibility for completion of his uncle's tomb by Pollaiuolo and had renovated his own titular church of San Pietro in Vincoli, adding to it a palace where he kept his collection of antique sculpture, the most famous example of which was the *Apollo Belvedere*. This early patronage, while extensive, fell comfortably within conventions of the time.

The Imperial Style under Julius II

As pope, however, Julius' patronage needs changed dramatically. Having been elected on a platform of reform, specifically opposing himself to the hedonistic life that characterized the papacy of his predecessor, Alexander VI, Julius had to find a new visual language that would look different from Alexander's courtly papacy to express this change. Such a language also needed to reflect an enlarged Church, which now reached to the Americas and to southern and eastern Asia. The very name he took upon becoming pope (not to mention his self-stylization as "Julius Caesar" on one of his commemorative medals) leaves little doubt that Julius wished his office and his person to be viewed in terms of Roman imperial models.

For his first commissions as pope, Julius concentrated on the Vatican, choosing Donato Bramante to express architecturally his vision of power. Before moving to Rome in 1499, Bramante had worked for the Sforza in Milan (see Figs. 15.10 and 15.12), and he was thus already familiar with the requirements of absolute rulers. The earliest collaboration between Julius and Bramante resulted in the transformation of the existing papal palace by the addition of a huge enclosed courtyard uniting the medieval living quarters with a summer house, called the Belvedere

because of its view, which Innocent VIII had built at the top of the Vatican Hill (Figs. 18.1 and 18.2). Although considerably altered later in the century, the Belvedere Courtyard clearly illustrates the imperial scale of Julius's thinking

18.1 Belvedere Courtyard, Vatican Palace, Rome, begun 1504, commissioned by Julius II from **Donato Bramante**, drawing by Antonio Dosio, c. 1558–61, showing the courtyard under construction

from the outset of his papacy. Long arms of architecture some 300 yards (275 meters) in length engulfed a vast open space, ordering the sloping hill into three discrete levels connected by stairs and ramps. The courtyard provided both a formal garden at the upper level and a space for theatrical display with viewing loggias at the lower level adjacent to the formal rooms of the palace. The sources for such a grandiose scheme lay in the multi-storied Roman imperial palace, in ancient Roman country villas that stretched horizontally over the landscape, and—in the courtyard's lower level—in the three-storied, arcaded Colosseum. The iconography of the architecture was therefore appropriate to Julius's self-representation as a caesar.

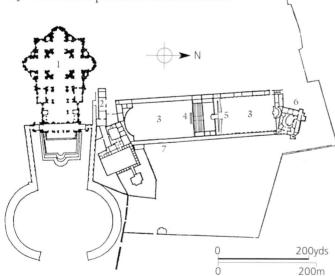

18.2 Vatican Palace and St. Peter's, Rome, plan

1 St. Peter's (Michelangelo's plan, with seventeenth-century extension by Carlo Maderna); 2 Sistine Chapel; 3 Belvedere Courtyard; 4 Stairs; 5 Ramps; 6 Statue Court; 7 Porta Giulia

A New St. Peter's

The boldest of Julius's early projects was his plan to demolish the old St. Peter's, which dated to around 330, and to replace it with an entirely new church. Since Old St. Peter's had been built by Constantine as an imperial donation, Julius's rebuilding also equated him with the power of that Roman emperor, the last to have controlled all of Europe and the Mediterranean basin and the first to legitimize Christianity as a state religion.

Bramante's plan for the new St. Peter's supplanted the Early Christian basilica, composed of nave and side aisles, with a domed centralized plan (see Fig. 18.3). This type of structure, also tied to architecture of the Early Christian period, was known as a **martyrium** and typically marked the place where a saint was buried, thus appropriate for the site of the tomb of St. Peter, the first pope.

Bramante had already used the martyrium form for the small free-standing chapel he had designed for King Ferdinand and Queen Isabella of Spain to mark the site revered as the place of St. Peter's crucifixion (Figs. 18.6 and 18.8). Known as the Tempietto because of its small size and classical allusions, this pilgrimage chapel exists in what was to have been the central unit of a redesigned courtyard at San Pietro in Montorio, one of the Spanish churches in Rome. Bramante's plan for the Tempietto, its columns aligned to columns of the surrounding loggia and its niches aligned to niches and openings in the redesigned courtyard, was completely ordered and symmetrical, providing a space for the pilgrim which mirrored the forms of the symbolic architectural cosmos of the building at the center. Deep in the center of the crypt of the building was a hole in the ground which according to pious legend was the site where Peter's cross was placed in the sandy earth.

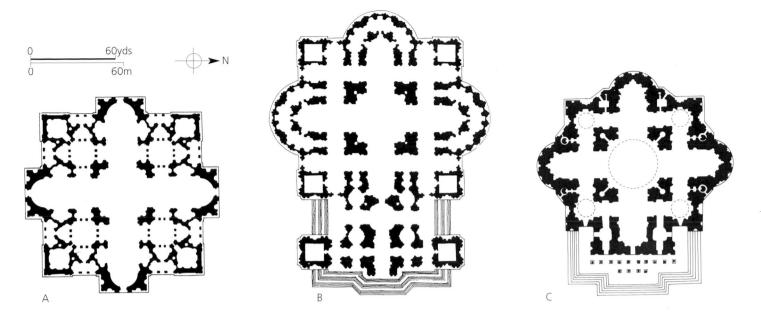

18.4 Foundation

 $\textbf{18.3} \;\; \mathsf{St.} \;\; \mathsf{Peter's}, \; \mathsf{Rome}, \; \mathsf{plans} \; \mathsf{by} \; (\mathsf{A}) \; \textbf{Bramante} \; (1506), \; (\mathsf{B}) \; \textbf{Sangallo} \; (1539), \; \mathsf{and} \; (\mathsf{C}) \; \textbf{Michelangelo} \; (1546; \; \mathsf{after} \; \mathsf{Ackerman})$

For discussion of the Sangallo and Michelangelo plans for St. Peter's see pages 510-511.

A commemorative medal coined at the time of the groundbreaking for the new St. Peter's in 1506 (Fig. 18.4) and Bramante's still extant plans indicate his original scheme for the new St. Peter's (Figs. 18.3 and 18.5). His references to the Pantheon in the dome of the building and to colossal Roman basilicas remained consistent points of departure for all subsequent plans for the building. In its simplest form the plan for the new St. Peter's is an elaboration of circles and squares, the perfect geometrical units mentioned by Vitruvius (active 46-30 B.C.E.), the architect of the ancient Roman emperor Augustus. Leonardo's drawing of Vitruvius's text from De architectura (Fig. 18.7) places the human figure at the center of a perfectly ordered universe, the same geometrical metaphor used by Bramante for his plan for St. Peter's and for the Tempietto. Bramante added the additional symbolic form of the cross in the open spaces extending out from the domed area at the center of the building, fusing Christian and pagan in architectural form as Julius sought to combine Roman imperial splendor with his role as the spiritual leader of Christendom.

The Tomb of Julius II

At the very time that his building projects were getting under way in 1505, Julius commissioned Michelangelo to design his tomb. Michelangelo's first scheme for the tomb was for a colossal free-standing, three-storied monument containing an internal oval burial chamber (Fig. 18.9). The free-standing tomb type recalls Pollaiuolo's tomb of Julius's uncle, Sixtus IV, the construction of which Julius had overseen. The tiered shape of the tomb with a door to an interior burial chamber, niches and sculpture at the lowest level,

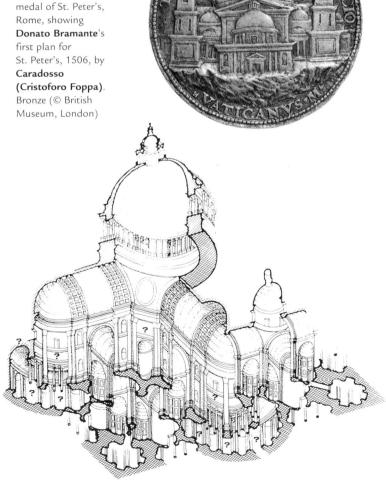

18.5 St. Peter's, Rome, axonometric view after **Donato Bramante**'s second plan of 1506 (after Bruschi)

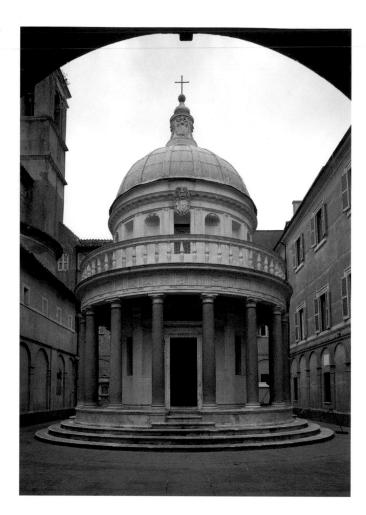

18.6 Tempietto, San Pietro in Montorio, Rome, inscription of 1502, commissioned by Ferdinand and Isabella of Spain from **Donato Bramante**

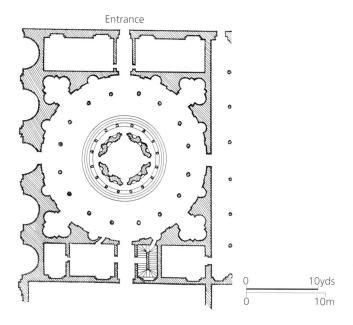

18.8 Tempietto, San Pietro in Montorio, Rome, proposed plan by **Donato Bramante** (after Sebastiano Serlio)

The colonnaded courtyard planned by Bramante to surround the Tempietto was never built,

18.7 *Vitruvian Man*, c. 1487, **Leonardo da Vinci**. Pen and ink, $13\% \times 9\%$ (34.3 × 24.5 cm) (Galleria dell'Accademia, Venice)

and a figure of the deceased at the top recalls Roman imperial funeral pyres shown on the backs of imperial coins; at the apex of the tomb Michelangelo probably intended to place a figure of Julius himself, again imitating Roman imperial funerary monuments. Thus the abstract shape of the tomb, like the formal properties of Julius's architecture and its iconography, gives it an imperial significance and once again marks Julius's pretensions as a new caesar.

The tomb was to measure approximately 23 feet 6 inches by 35 feet 6 inches (7.2 by 10.8 meters), which would have made it Michelangelo's first real essay in architecture and a patent challenge to the restrained forms of Bramante. Around the lower level Michelangelo planned niches containing sculptures of allegorical representations of Victories standing over conquered territories—a reference to Julius's military attempts to reconquer papal lands given away by his predecessor. Each of the niches was to be flanked by an over-lifesized male nude (Fig. 18.10); only six of the projected total of at least sixteen such figures were ever begun. At each corner of the middle level there would have been a seated figure: Moses, St. Paul, and personifications of the active and the contemplative life. Moses (Fig. 18.11),

18.9 Tomb of Julius II, reconstruction of plan of 1505 (after Tolnay), commissioned by Julius II from **Michelangelo**

The figure of the pope on the top tier of the tomb is conjectural. Michelangelo's biographer, Ascanio Condivi, states simply that the tomb was to have been capped by two angels carrying a sarcophagus. Conventionally, papal sarcophagi (and others) showed a recumbent figure of the deceased on the lid.

the only one of the figures to have been carved, refers to the same aspects of leadership-priest, lawgiver, ruler-that Sixtus IV had signified in his commission for the fresco cycle of the Sistine Chapel (see Fig. 12.29). Now placed at floor level, the statue's intended location above the viewer's head accounts for the curious aspects of the figure that the frontal view gives. Like Donatello's St. John the Evangelist for the façade of the Florence cathedral which it so obviously imitates (see Fig 10.14), the Moses was carved with optical corrections in mind. Thus the upper torso would have sprung more energetically from the seated body, the drapery would not have bulked so awkwardly over the right knee, and the head would have gazed forcefully into the distance, all but obscuring the horns (a known mistranslation for a Hebrew word meaning "ray of light") or perhaps even transforming these "horns" from a distance into emanations from the charged mind of Moses. The turn of the body on its axis and the pulling back of the left leg, while suggesting the figure's immanent motion off the block on which he is seated, serve also to accommodate its intended corner placement on the mezzanine story of the tomb,

directing the viewer's attention from one face to another of the huge lower story.

The meaning of the standing male nudes (see Fig. 18.10) still remains incompletely understood. Michelangelo's biographer, Ascanio Condivi, maintained in 1553 that they represented the arts, expiring at the death of Julius II, their greatest patron. They are also commonly-and misleadingly-referred to as "slaves" or "captives," a terminology deriving from the bands of material that seem to constrict the movement of the most completely carved of these figures. Such an identification also relates to the Victory figures which they were to flank, although each Victory seems to have stood astride its own captive. The torsion of the pose heightens the sense of movement only implied in Michelangelo's earlier David (see Fig. 17.1) and is slightly more lyrical in its slow turning than his St. Matthew (see Fig. 17.2). In the uncarved rock supporting two of the nudes Michelangelo included the figure of a monkey, barely sketched in the stone but unmistakably looking out toward

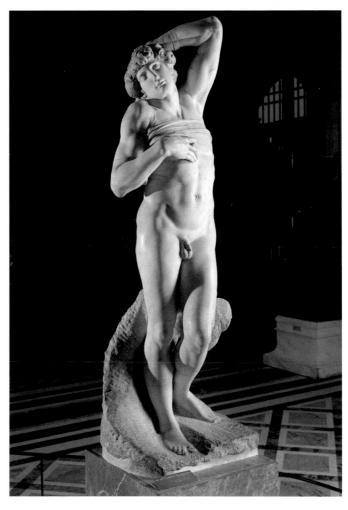

18.10 Tomb of Julius II, commissioned by Julius II in 1505 from **Michelangelo**, detail of male nude, begun after 1512, offered in 1546 as a gift by Michelangelo to Ruberto Strozzi in Lyon, who gave it to Francis I who in turn gave it to the Connétable Anne de Montmorency for his château at Ecouen. Marble, height 7′ 6″ (2.29 m) (Musée du Louvre, Paris)

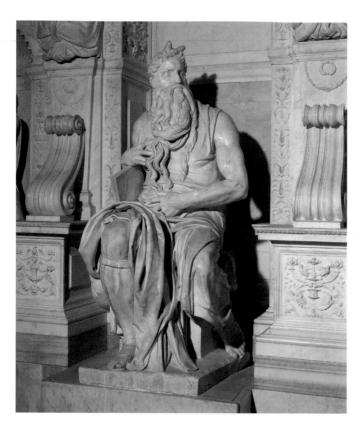

18.11 *Moses* (detail of Tomb of Julius II) commissioned by Julius II from **Michelangelo** for his tomb, c. 1515. Marble, 7′ 9″ (2.35 m) high (San Pietro in Vincoli, Rome)

the right, just beneath the left thigh of the illustrated figure. Often used as a symbol for lust, the monkey also stood for the concept of art aping nature (ars simia natura), a realism emphasized in this sculpture by the sliding pose and by the sensuousness of the figure. Thus Michelangelo seems to have entered into the dispute known as the Paragone which debated whether painting or sculpture was the more noble of the arts. One of the lines of argument in this debate concerned whether painting or sculpture more convincingly depicts a narrative, the former by placing figures in an illusionistic setting, the latter by creating figures in actual space.

But the real meaning of the tomb derives as much from its setting as its constituent parts. While its precise intended location is uncertain, Julius clearly intended to be buried in St. Peter's, thus joining himself physically with the first pope, Peter, who was buried there, and reviving the traditions of the Middle Ages that saw many of the Church's leaders entombed in the old St. Peter's (see Figs. 12.9 and 12.31). This association with the past serves to underscore the continuity of the papal office in this place. The new St. Peter's with its cosmological symbolism of the dome and its linkage as a palatine chapel to the Vatican Palace, recalls an architectural iconography of sovereignty known since classical antiquity and most brilliantly exemplified in Italy in the uniting of the Doge's Palace and St. Mark's Basilica in Venice (see Fig. 7.3).

The Sistine Ceiling

There are indications that as early as 1506 Julius II intended to have the ceiling of the Sistine Chapel painted, but Michelangelo did not sign a contract until May 1508. The first plan for the ceiling called for figures of twelve Apostles in the spandrels between the windows and various ornamental motifs in the main section. However, Michelangelo apparently persuaded the pope that this initial project was unworthy of the chapel and embarked on the program which exists today (Figs. 18.12 and 18.13).

Michelangelo worked until 1512 on the ceiling, standing on a bridge-like scaffold which he had constructed across the width of the building at the upper cornice level and which was moved from the entrance to the altar wall of the chapel as work progressed. He articulated the smooth vaulted space of the chapel with fictive architecture similar to the forms he had proposed for Julius's tomb. At the extremities of the ceiling, narrow bands of blue sky appear as if through an opening in the architecture, illusionistically suggesting a limitless space beyond the vault of the ceiling. Particularly at the altar end of the ceiling the large unframed narrative panels seem to participate in this vision of space beyond the confines of the room. Three groups of three alternating large and small narrative panels extend the length of the ceiling. These tell the Genesis story of Creation (from the altar wall), the creation and fall of Adam and Eve (in the center), and the story of Noah (at the entrance end of the chapel), humanity's fall from grace and promise of redemption. The paintings, however, are oriented for a viewer facing the altar. Looking up and moving from the entrance of the chapel toward the altar, one sees the figures right side up and traces the history of the fall of humankind backwards in time towards Creation, as if to emphasize a new beginning and a return to pre-lapsarian grace. Prophets and sibyls (Fig. 18.14)—men and women who Christians claimed foretold the birth of the redeemer in both the Jewish and the ancient Roman traditions-alternate in the large spandrels between the windows while family groups of Christ's ancestors rest in the lunettes (see Fig. 38).

The colors of the ceiling, newly revealed in the recent cleaning of the frescoes, are intense and often applied in broad areas. Michelangelo also used the technique of changeable color, in which contrasting colors are placed side by side to produce highlighting effects, rather than modeling the dominating color with shadows and highlights. This technique may have been chosen in order to accommodate the great distance between the viewer on the floor of the chapel and the figures on the ceiling, but it also served as an alternative to Leonardo's sfumato technique, just as Michelangelo's composition for the Battle of Cascina had been opposed to Leonardo's companion painting. The ceiling was not only a complex Old Testament exegesis but a demonstration of the possibilities for painting at the beginning of the sixteenth century, making it a constant source of study for painters of the next generation.

CONTEMPORARY VOICE

Michelangelo the Poet

In addition to his formidable gifts in the visual arts, Michelangelo possessed considerable talent as a poet, and his poems were greatly admired by his contemporaries. In this sonnet, one of his best known, he compares the struggle of finding love to the failure of art to ward off death.

Sonnet 151 (c. 1538-44)

Not even the best of artists has any conception that a single marble block does not contain within its excess, and *that* is only attained by the hand that obeys the intellect.

The pain I flee from and the joy I hope for are similarly hidden in you, lovely lady, lofty and divine; but, to my mortal harm, my art gives results the reverse of what I wish.

Love, therefore, cannot be blamed for my pain, nor can your beauty, your hardness, or your scorn, nor fortune, nor my destiny, nor chance,

if you hold both death and mercy in your heart at the same time, and my lowly wits, though burning, cannot draw from it anything but death.

(from James Saslow. The Poetry of Michelangelo. New Haven: Yale University Press, 1991, p. 302)

Michelangelo began his cycle with the Drunkenness of Noah (Fig. 18.15), showing the Old Testament patriarch lying nude on the ground and mocked by one of his sons while the other two cover his nakedness. All four figures are positioned in a narrow frontal plane, its spatial recession blocked by the colossal vat of wine and the flat wall that extends across three-quarters of the background. Michelangelo recalled a variety of sources in his compositions, including woodcuts from an early printed Bible and well known sculpture. The figure at the left hoeing is a near quotation of Jacopo della Quercia's relief of Adam after the fall on the facade of San Petronio in Bologna (see panel at the lower left of the door in Fig. 10.51), which Michelangelo would have known from his time there in 1494-95. His Noah, instead, derives from Ghiberti's similarly posed figure on the Gates of Paradise in Florence (see Fig. 10.61). Both Michelangelo and Ghiberti drew visual parallels between Noah's pose and that of Adam in their creation scenes (see Figs. 10.60 and 18.16); thus the parallel roles of Adam and Noah as populator and repopulator of the world, as well as perfect man and fallen man, are graphically visualized in this reclining pose.

Insofar as the chapel is dedicated to the Virgin it is appropriate that the center panel shows the creation of Eve, the archetype of Mary, who, according to tradition, began the redemption necessitated by the sin of Eve and Adam. Eve also appears as an incipient companion for Adam in the *Creation of Adam* panel (Fig. 18.16), where she looks out anxiously toward Adam from under the left arm of God (see Fig. 17). Adam rests on a schematic green-tinged brown mound since his name translates as "Earth," although nowhere in the ceiling (or anywhere else in his paintings) does Michelangelo show any interest in depicting anything more than the most minimal landscape features. Adam's muscularity recalls the ancient *Belvedere Torso* in the papal collections, and his left hip, raised to display his genitals

like Noah in the earlier panel, makes reference to his future procreation of humankind. Adam's lifeless lassitude is paired with the whirling energy of God the Father. At the moment before their fingers touch in life-giving energy, however, there is a powerfully charged void as if two like-charged magnetic fields were inhibiting contact.

Above the altar platform of the chapel, Michelangelo showed God forming the world. In *The Creation of the Sun and the Moon* (Fig. 18.17), God appears in very similar poses from the front and the back hurling the heavenly bodies into orbit (Copernicus had not yet determined that it was actually the earth that orbited about the sun). Both figures of God are essentially pleated, deeply bent at the waist and knees, giving them an explosive energy capable of propelling themselves across the space of the panel. The central glowing yellow sun anchors the composition with a now barely visible moon at the right and the barest reference to the earth in the green branches at the lower left. Michelangelo used abstract patterns of drapery to emphasize the motion of both figures of God, who has the same visage as the *Moses* for Julius's tomb (see Fig. 18.11).

The images of God are nearly three times the size of the figures in the Noah panel; only their pleated positioning allows their formidable size to fit into the frame of the panel. This large size is part of the overall increase in scale of the figures on the ceiling as Michelangelo progressed in his painting from one end of the ceiling to the next; freed from the more heavily populated subjects of the early panels, he became increasingly sensitive to legibility and confident of his own painterly skills. In the next and last narrative scene on the ceiling, the *Separation of Light from Darkness*, Michelangelo paints God with bold and impressionistic strokes of paint, a daring evocation of God's and his own creative energy.

The lunette figure of *Jonah* (see p. 397) over the altar completely integrates the interaction of figure and space

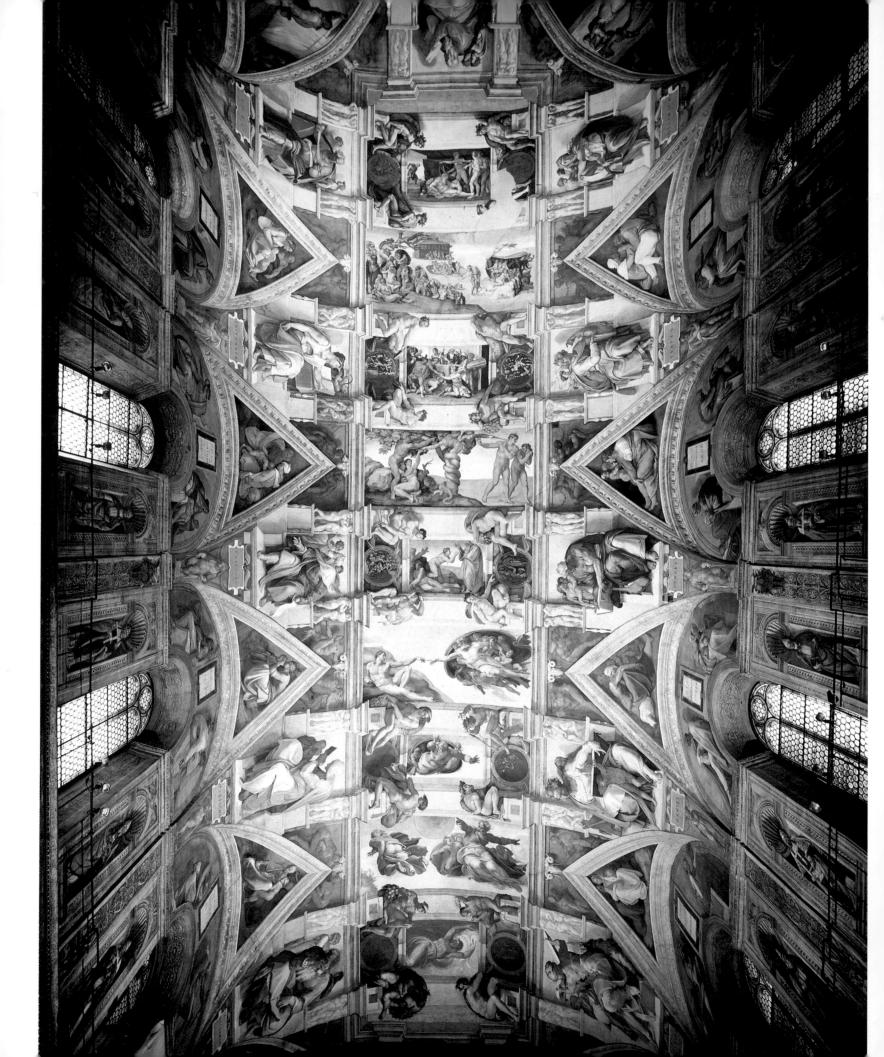

18.12 (opposite) Sistine Chapel, Rome, ceiling as seen from entrance end, 1508–12, commissioned by Julius II from **Michelangelo**. Fresco, $45 \times 128'$ (13.7 \times 39 m)

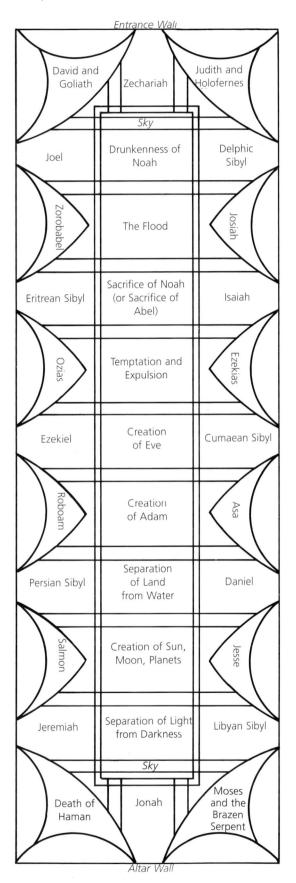

18.13 (left) Sistine Chapel, Rome, plan of ceiling scenes (after Hibbard)

A recent suggestion that the panel traditionally identified as the *Sacrifice of Noah* represents instead the *Sacrifice of Abel* would both remove the single chronological inconsistency in the arrangement of the narratives on the ceiling and also conform to the identification of the panel given by Michelangelo's early biographers.

initiated in the twisted pose of the *Libyan Sibyl*. Jonah both extends forward into space, his left foot lifting off the ground and his right foot seemingly extending out of the frame of the painting, and spirals back towards the architecture, his massive, muscled body providing an animated diagonal and his left arm a moving volume with the hand pointing even farther away. The effect is especially remarkable when seen in person, because the wall curves forward where Jonah's body moves back. Michelangelo further complicated his figure with clear references to various parts of the *Laocoön* group (see Fig. 40)—the spread legs and raised feet of Laocoön, the crossed arm of the son at the left and his upturned head, for example—but he has recombined them in such a knowing and imaginative way that he seems to be replicating the spirit of the work rather than its parts.

Jonah is a symbol for the Resurrected Christ, since he was in the belly of the whale for three days, as Christ was in the tomb for three days, a connection made explicit in the

18.14 *Libyan Sibyl*, the first sibyl on the right as one faces the altar wall of the Sistine Chapel, Rome. Fresco

18.15 Drunkenness of Noah, 1508–12, commissioned by Julius II from **Michelangelo** for the ceiling of the Sistine Chapel, Rome. Fresco

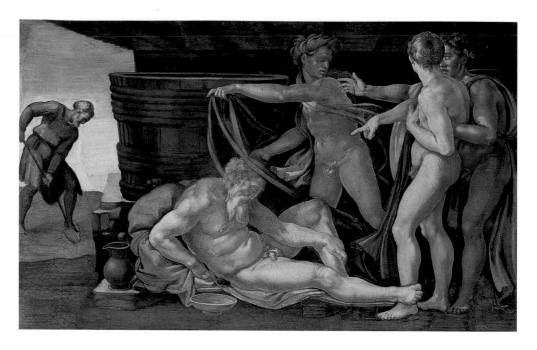

Gospel of Matthew (12:38–40). The reference was appropriate for placement over the altar of the chapel, since the eucharist is a permanent embodiment of Christ. Jonah also directs our attention to the divine by his glance out toward the first Creation scene above.

The whale, here in the form of a very large fish, is placed on a cross diagonal toward the right, disappearing into the depth of Jonah's throne. The sharp shadow thrown by the pier next to it further extends the space. Typically for Michelangelo, space is devoid of naturalistic reference, except, in this case, for the oak branch at the left which is one of Julius's symbols. At the same time Jonah's counterfeit ancient form echoing the *Laocoön* is a pictorial equivalent of Bramante's classical architecture at St. Peter's,

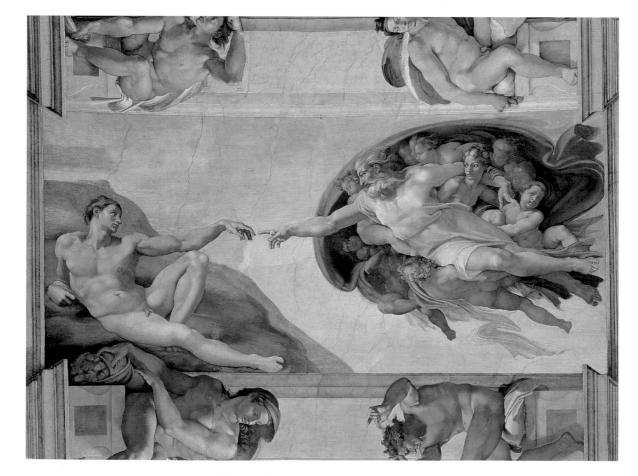

18.16 Creation of Adam, 1508–12, commissioned by Julius II from Michelangelo for the ceiling of the Sistine Chapel, Rome. Fresco

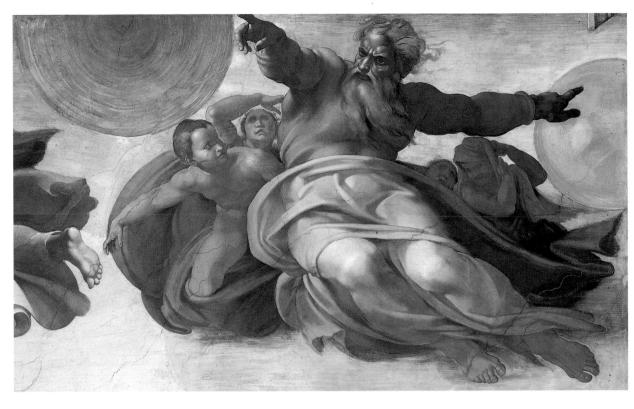

18.17 Creation of the Sun, Moon, and Planets, 1508–12, commissioned by Julius II from Michelangelo for the ceiling of the Sistine Chapel, Rome. Fresco

reinventing Roman models to give Julius a consistent classical vocabulary for all of his arts.

The pendentive areas in the corners of the room show male and female heroes of the Old Testament. David and Judith at the entrance wall carry overtones of Julius's wars against usurpers of papal territories. Scenes from the lives of Moses and Esther in the pendentives at the altar end of the building again suggest Julius's power as a divinely

ordained leader of his people. Moses and the Brazen Serpent (Fig. 18.18) to the right of Jonah is one of the last of the major fields that Michelangelo painted on the ceiling and takes both compositional structure and figural form to new expressive levels. The story from Numbers (XXI: 6-9) tells of the Hebrews setting up a brazen serpent in the desert, an open act of apostasy that unleashed Moses's wrath but which was turned to positive ends by St. John who wrote in his gospel that "...as Moses lifted up the serpent in the wilderness, even so must the Son of Man be lifted up" (John III:14). Thus near the altar where Christ's death was remembered, and next to Jonah, an Old Testament antetype for Christ, Michelangelo depicts another image of

18.18 The Brazen Serpent, 1508–12, commissioned by Julius II from **Michelangelo** for the ceiling of the Sistine Chapel, Rome. Fresco

Christological sacrifice, albeit pushed into the distance and isolated from surrounding figures. The figures are all in contorted poses meant to express their emotional reaction to God's vengeance as they are attacked—like Laocoön—by serpents. The wildly posed and convulsive bodies on the right belie the fact that they are also out of scale with the other figures at the left of the spandrel. The view of these figures from behind may seem to rupture the bounds of

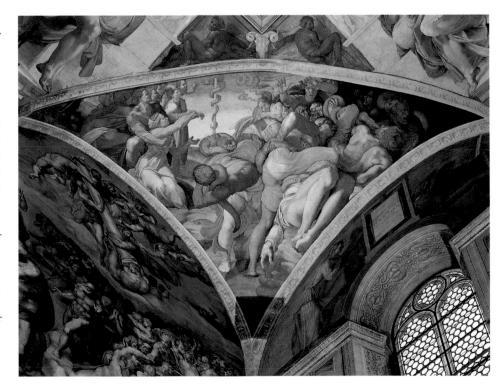

decorum for a papal chapel, but their poses when seen from the far end of the chapel are far less disconcerting than any photograph made looking directly at the pendentive since their position on the curving surface places them nearly along the side wall; thus Michelangelo may have been making some optical corrections to account for viewers in the main body of the chapel.

The nudes framing the smaller narrative panels present the most insistent projections into the space of the chapel as they are posed in front of the illusionistic architecture. They recall both the tense movement of the figures of the *Battle of Cascina* (see Fig. 17.7) and the sensuousness of the nudes for Julius's tomb (see Fig. 18.10). Their illusionistic reality is thrust into space by the architecture and enhanced by the opposition of their naturally colored bodies to the figures of what appear to be carved marble, paired male and female putti that flank them. Again Michelangelo seems to be using the nude as a reference to the critical trope of

CONTEMPORARY SCENE

Art and Dissent

It is a commonplace to refer to art "speaking" to the viewer, but during the Renaissance this idea was given a more literal sense. The painted wooden crucifix in the church of San Damiano in Assisi that allegedly spoke to St. Francis in 1205, admonishing him to "rebuild my church"

and thus setting the stage for the foundation of the Franciscan order, is the most familiar of a number of such painted and sculpted crucifixes believed to act as conduits of divine will.

The tradition of speaking sculpture also extended to works of antique art-found mostly in Rome-that carried written messages for the public weal. Perhaps the most famous of these was the Pasquino (Fig. 18.19), a fragment (6 feet 3 inches [1.92 m] high) of a sculptural group representing Menelaus Carrying the Body of Patroclus (although during the Renaissance it was also thought to represent Hercules vanquishing Geryon). According to one local tradition, the statue received its name because it had lain in the yard of a schoolmaster named Pasquino. A story from the mid-sixteenth century claimed that the sculpture had really been found near the shop of a free-speaking tailor-also called Pasquino-famous for his criticisms of the pope and the papal court. The Pasquino was installed near its present location, at what was then the corner of the Palazzo Orsini, by

Cardinal Oliviero Carafa in 1501. It quickly became the source of witty, scandalous, and politically and religiously charged comments which were written in humanist Latin (scholarly rather than ecclesiastical Latin) on scraps of paper and attached both to it and to the wall behind it. These pithy jibes

18.19 Pasquino, c. 1550, Nicholas Beatrizet, collected and published by Antoine Lafréry (Antonio Lafreri) in *Speculum Romanae Magnificentiae*, Rome, 1550. Engraving

passed for the words of the Pasquino itself, allowing the venting of popular opinions in the safety of anonymity and with a commonly accepted understanding that since the Pasquino was responsible for their coining, no one would be prosecuted for the sentiments expressed. Cardinal Carafa

arranged that the statue be dressed each April (near the feast of Easter-Pasqua in Italian) in the costume of a different classical Roman mythological figure, lending a festive atmosphere of street theater to the city in the spring. In 1513 the statue appeared as Apollo, in honor of the election of Giovanni de' Medici as Pope Leo X (a reference to the new pope's passion for music). Beginning in 1509 the comments of the Pasquino were collected, provided with a printed frontispiece, and published on an annual basis as political and social satire of a sharply critical and sometimes obscene nature. Humanist writers, who delighted in the rhetorical skills of the Pasquino, accused the morally conservative Pope Hadrian VI of wanting to throw the statue into the Tiber in order to rid the city of its corrupting influence. Threats against the sculpture were also made during the religious reformation of the mid-sixteenth century, but the Pasquino continued to issue a running commentary on the foibles of the famous and on the social order of the city well into the nineteenth century.

art imitating nature. The della Rovere heraldic symbols of the oak (*rovere* in Italian) and acorn appear throughout the ceiling to identify Julius as the patron of the work, and the gilt-bronze military shields carried by the nudes refer to Julius's persistent warfare. With Michelangelo's frescoes, Julius completed the program begun by his uncle, Sixtus IV, on the walls of the room below (see Figs. 12.28, 12.29, and 12.30), so that all of Christian history—from the Creation on the ceiling to the Resurrection on the short entrance wall—is represented in the chapel.

The Stanza della Segnatura

Julius commissioned Raphael to decorate his private apartments in the Vatican Palace, now called simply the Stanze ("rooms"). His choice of artist was an implicit rejection of the style and history of his predecessor, Alexander VI, whose own apartments on the floor immediately below had recently been painted by Pinturicchio (see Fig. 12.32). In its grand stateliness Raphael's style directly opposed the lush elegance of Pinturicchio's frescoes.

The work began in the Stanza della Segnatura (Fig. 18.20). There Raphael's images portray four main bodies of human knowledge: Philosophy in the School of Athens, where the best known philosophers and intellectuals of the ancient world group around Plato and Aristotle at the center (Fig. 18.21); Religion in the Disputà, where theologians present their writings about the true presence of Christ in the Eucharist, which is displayed at the very center of the painting (Fig. 18.22); Poetry in the Parnassus, where writers from both the ancient and the modern worlds group around a seated Apollo and figures of the Muses (Fig. 18.23); and Law, where the cardinal virtues of Prudence, Temperance, and Fortitude sit beneath Justice depicted immediately overhead in a roundel in the ceiling. The School of Athens and the Disputà, facing one another across the room, have become the paradigms for the classical style in painting under Julius. In each case, Raphael painted an architectural frame much like a proscenium (the wall itself is actually flat and unadorned architecturally), which effects a transition between the real space of the room and the illusionistic space of the fresco. He also used the arching shape of the wall as the underlying geometrical structure for the composition, so that in the Disputà, for example, banks of clouds create a semicircular, apse-like space in the picture, as do the figures at the ground level. A similar arched shape appears on the vertical axis for the mandorla around the central figure of Christ, echoed by a complete circle for the radiance around the dove of the Holy Spirit and for the monstrance on the altar. Every element of the painting is locked into this geometrical order.

In the *School of Athens* the arch is repeated in the barrel vaults of the architecture behind the figures. In this image the single-point perspective system is structured so that it moves to a point between the heads of Plato and Aristotle, emphasizing their seminal importance for the discipline

of philosophy. The slightly over-scaled figure of Euclid at the right foreground (Fig. 18.24) bends over a slate, demonstrating a point of geometry with a pair of calipers to young students. To the right of Euclid, four standing men group together; the crowned young man in the brilliant yelloworange cloak who is holding a globe is Ptolemy; the bearded figure directly in front of him who is holding a celestial sphere is most likely Zoroaster; to their right and toward whom they are looking is a very young man, the selfportrait of Raphael, looking directly out at the viewer; the man at the farthest right in the white cloak has been variously identified as the Sienese painter Sodoma or the painter Perugino, Raphael's teacher, both of whom had worked in the papal quarters prior to Raphael. Euclid has been identified as Bramante, whose contemporary plans for Julius II of the new St. Peter's are referenced in the building that provides the spatial backdrop for the entire scene. The mathematics of geography, astronomy, and architecture are united here in a single compositional scheme, implying

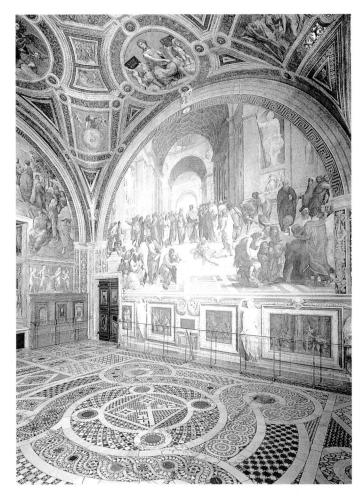

18.20 Stanza della Segnatura, Vatican Palace, Rome, 1508–11, commissioned by Julius II from **Raphael**, view showing *Parnassus* wall on the left and the *School of Athens* on the right. Fresco

In Julius's time the room was a library. It became a room where papal documents were signed only later, when it received its modern designation of the "Room of the Signature."

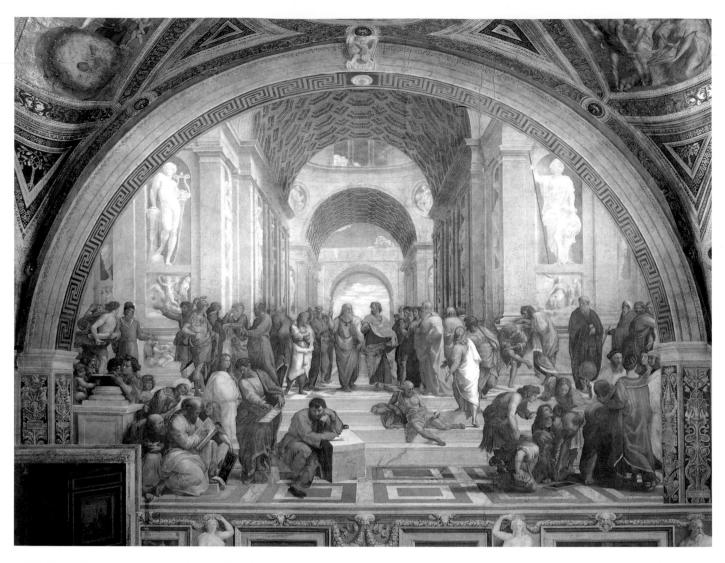

18.21 School of Athens, 1510-11, commissioned by Julius II from Raphael for the Stanza della Segnatura, Vatican Palace, Rome. Fresco, height 19' (5.79 m)

The statues in the two facing niches represent Apollo and Minerva. Plato is thought to represent Leonardo da Vinci, the seated figure of Heraclitus leaning on the block in the center foreground Michelangelo, and the bending bald-headed Euclid at the right Bramante. Raphael included his own youthful self-portrait in the foreground at the far right.

that Julius's new basilica is a microcosm of the universes represented by Ptolemy and Zoroaster.

Raphael repeatedly broke the limitations of the frame in these frescoes. In the *School of Athens*, figures rush into the scene at the left and out of it at the right. In the *Disputà* the figure at the right foreground leans over painted architecture as if into the space of the room. In the *Parnassus* (see Fig. 18.23), Raphael achieved an illusionistic tour de force where figures like the seated Sappho on the left are depicted as if in front of the painted frame of the window, even casting illusionistic shadows on the fictive architecture. The *contrapposto* pose of Sappho indicates that Raphael had looked carefully at Michelangelo's figures in the nearby Sistine Chapel and was quickly incorporating their formal innovations in his own work.

Pope Julius's presence is constantly evident in this room, whether in the symbolic oaks of the *Parnassus*, which transform the ancient Mount Parnassus into the Vatican Hill, or in the far more obvious double inscription of Julius's name in the interlace pattern on the altar frontal in the *Disputà*.

Equations between Julius and ancient imperial patrons appear in the *grisaille* paintings under the *Parnassus*, where Alexander is shown placing the poems of Homer in the tomb of Achilles, and Augustus is depicted saving the *Aeneid* of Virgil from the flames, just as Julius preserved the work of other writers in his library. In the wall of the Law fresco Julius appears beneath the Cardinal Virtues in a life-size portrait as Gregory IX receiving the code of canon law. No one could have entered this room without being struck by Julius's presence as a patron, as a ruler, and as a lawgiver.

Roman Civic Imagery

Not all art in the city of Rome was controlled by the papacy. Constant tensions between the Roman civic government and the papacy over control of the city led both bureaucracies to assert their presence on the Capitoline Hill, the traditional seat of Roman civil government. While the popes marked the place with their collections of antique sculpture, city authorities evolved a visual vocabulary decidedly

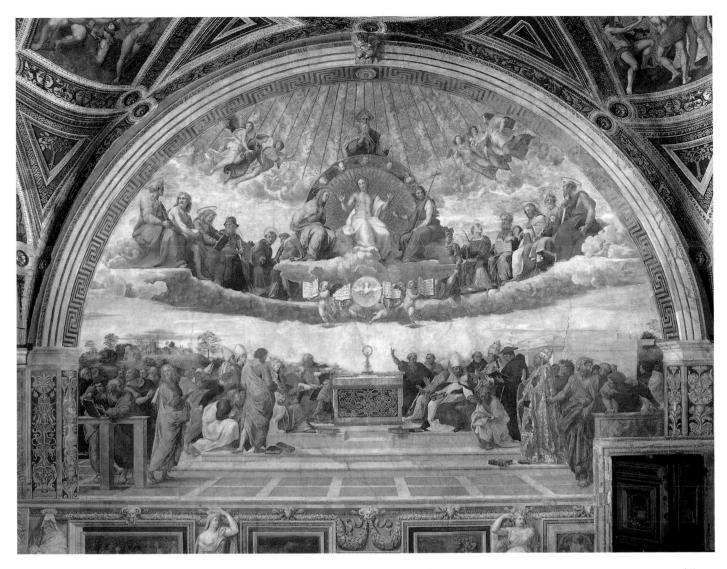

18.22 *Disputà*, 1510–11, commissioned by Julius II from **Raphael** for the Stanza della Segnatura, Vatican Palace, Rome. Fresco, height 19′ (5.79 m)

The standing figure in full papal regalia on the right side of the fresco is a portrait of Sixtus IV, Julius's uncle. Seated at the left and right of the altar are the four doctors of the Church, Gregory the Great and Jerome at the left, Ambrose and Augustine at the right. The figures seated on the cloud bank are from the left St. Peter, Adam, St. John the Evangelist, David, St. Stephen, Jeremiah, and, to the right of Christ, Judas Maccabeus, St. Stephen, Moses, St. Matthew (?), Abraham, and St. Paul.

18.23 *Parnassus*, c. 1511, commissioned by Julius II from **Raphael** for the Stanza della Segnatura, Vatican Palace, Rome. Fresco, height 19′ (5.79 m)

Apollo is seated top center, flanked by the muses. To the left of the image Dante appears in profile, in red, and to his right the blind Homer. To the right of Homer, looking toward Dante, is the Roman poet Virgil who guided Dante through Hell and Purgatory in the Divine Comedy. The hooded man just behind the tree at the left is Petrarch; Sappho leans out from the window embrasure.

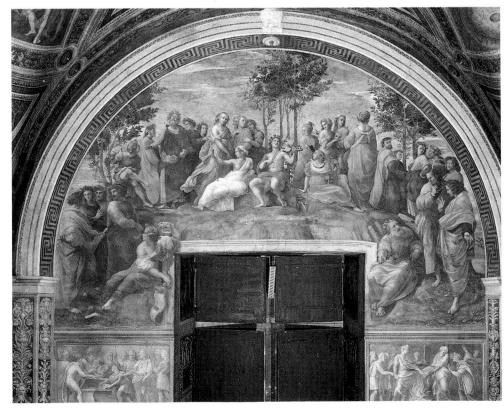

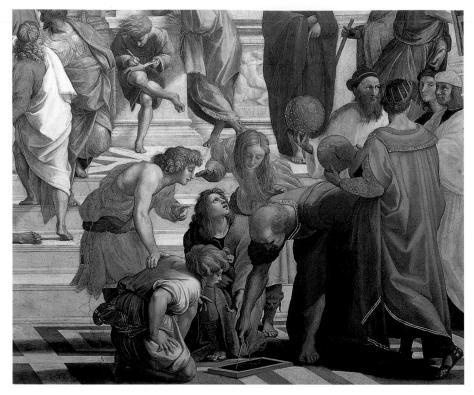

18.24 Euclid and his Students (detail of School of Athens), 1510-11, commissioned by Julius II from **Raphael** for the Stanza della Segnatura, Vatican Palace, Rome. Fresco

distinct from that employed by the papacy. Jacopo Ripanda's (b. Bologna?; active 1490–1516 Rome) frescoes depicting scenes of the Punic Wars in the Palazzo dei Conservatori on the Capitoline Hill are a case in point (Fig. 18.25). Each of the walls of the room in which they are painted retells a story from Livy's history of Rome's war with Carthage. Importantly, the narratives chosen are histories, not mythologies, suggesting a continuous link between the Rome of antiquity and its later governors meeting in this room. Insofar as the frescoes are

in a formal seat of civic governance, they use a stately and formal language deriving from Roman sculpture then visible in the city. Even though Ripanda had worked with Pinturicchio (see Fig. 12.32), he avoided the overtly decorative vocabulary of his teacher's painting, instead employing a didactic classicism in some ways appropriate to the illustration of a Roman historian's narrative. The quadriga, for

18.25 Triumph of Rome over Sicily, 1507–08, commissioned by the Conservators of Rome from **Jacopo Ripanda**, Palazzo dei Conservatori, Room of the Punic Wars

example, is a slightly modified quotation from one of the reliefs of the Arch of Titus, while other figures in the painting are direct copies of figures from those antique reliefs and others. It is just this straightforward antiquarianism-unassimilated as it had been in earlier paintings, such as Sixtus IV's frescoes for the Sistine Chapel (see Figs. 12.29 and 12.30) and not transformed into new idealized models as contemporaries like Raphael were doing (see Fig. 18.21)—that give these frescoes their curious didacticism. As in other painting of the time, the figures in this fresco spread across a stage apron at the foreground of the composition, while a grand landscape stretches like stage scenery behind them. Yet, in choice of subject matter and in mode of depiction, the Triumph of Rome over Sicily provides a telling, albeit brief, moment in the history of Roman art when the civic government asserted its connections to its Roman past and therefore its legitimacy, and did so, moreover,

with a style that itself can be said to distinguish the paintings from those commissioned by the papacy.

The Stanza d'Eliodoro

Raphael's invention of a powerful language of personal and institutional leadership in the *Stanza della Segnatura* led to a commission to paint an adjoining room (Fig. 18.26). Containing frescoes on the theme of divine intervention, it is named for the fresco depicting the *Expulsion of Heliodorus* (Fig. 18.27), on one of its walls. The room also contains other images of divine intervention, including the *Freeing of Peter from Prison* (Julius's titular church as cardinal was San

18.26 View of the Stanza d'Eliodoro, Vatican Palace, Rome, 1512, commissioned by Julius II from Raphael

18.27 Expulsion of Heliodorus, 1512, commissioned by Julius II from Raphael for the Stanza d'Eliodoro, Vatican Palace, Rome. Fresco, base 21' 8" (6.6 m)

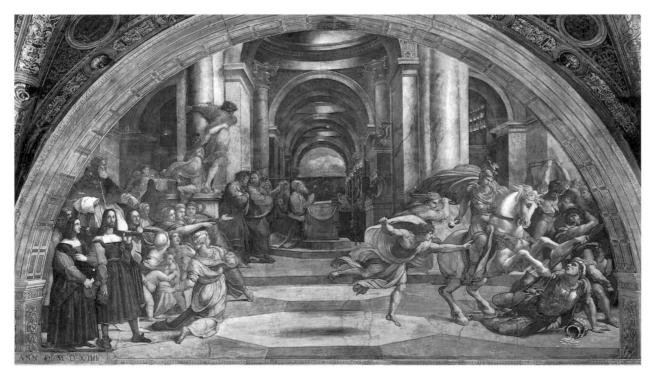

Pietro in Vincoli [St. Peter in Chains]), the Mass at Bolsena, and Leo the Great Repulsing Attila the Hun Outside Rome. Each of these subjects depicts a miracle worked by a pope or a religious leader, implicitly underscoring papal leadership.

In the Expulsion of Heliodorus, from the Second Book of Maccabees (3:1-33) in the Old Testament, the chancellor of King Seleucus, Heliodorus, was ordered by the king to confiscate the treasure of the Temple in Jerusalem. As he was fleeing with the booty, a mounted horseman and two other figures appeared miraculously and beat him to the ground, thus preserving the Temple treasury intact. Later, the high priest, Onias, seen kneeling in the center background of the fresco, prayed for Heliodorus' recovery. The apparitions reappeared, healing Heliodorus and leading to his belief in

the sacredness and inviolate nature of the Temple, here an antetype for the Church. Julius, carried on a papal throne, appears at the left of the painting looking toward Onias who is, like the pope, bearded—their roles as high priests given physical manifestation in their similar appearances. As a witness to the event seemingly staged for his benefit, Julius is nonetheless made an actor in the narrative as if to suggest his control over the fate of contemporaries who would despoil the papal territories. The frescoes in the room—all miracle scenes—suggest that Julius had, however, lost some confidence in his power and counted upon miraculous divine power to ensure the success of his policies.

Despite the success of the balanced composition and perfected geometrical order of the Stanza della Segnatura frescoes, the style which they exemplify seems to have been short lived. Raphael structured the Expulsion, like the paintings in the Stanza della Segnatura, around a single-point perspective system, but the composition fragments into three distinct sections, with the critical action of the priest virtually lost in the background because of the welter of figures to the left and right. A number of pictorial curiosities also distinguish the composition from the stately order of the Segnatura frescoes. Heliodorus, fallen at the right of the fresco, and the twisting female figure kneeling in front of Julius's entourage are of a different scale from nearby figures, thus calling attention to themselves and their poses. Heliodorus derives from an antique river god statue, then on the Quirinal Hill, but moved to the Capitoline in 1517 during the time that Raphael served as Prefect of the Antiquities of Rome (1515-20). The female figure seems to have no role to play in the narrative except to enhance the drama of the moment by her expressive pose. The figure climbing up the wall and clutching the column at the left certainly breaks the decorum of behavior appropriate for a temple. In each case the figure rewards the viewer's own cleverness in recognizing its source in antique art or appreciation of the artist's skill in rendering complex and dramatic forms, issues far removed from the narrative or even the symbolic content of the fresco.

Portraits

Despite the triumphal images of order and control which Raphael produced for Julius II in the Stanze, the pope's hold on the Christian empire was far from secure. Toward the end of his reign, papal territories were in revolt, and his absolutist control over the institution of the Church was threatened from within by some cardinals and bishops who wished for shared rule through open councils, leading finally to a movement to depose him. When Raphael painted Julius's portrait (Fig. 18.28), showing the pope with a beard he had grown when the papal city of Bologna declared independence from his rule in 1510, he depicted Julius as a slightly stooped old man, pensively staring into space. The painting functioned as an ex voto for the high altar area of

Santa Maria del Popolo, a church built for Julius's uncle, Sixtus IV (see Figs. 12.22 and 12.23) and to which Julius added a new choir designed by Bramante. There is a record that the image was placed on the main altar, although it seems more likely to have hung on a nearby pier. The psychological insight of the painting marks a new departure in the history of portraiture, a strangely personal, introspective, and melancholic image for such a public and formal space and for a man with such grand imperial designs. Yet Raphael still surrounded Julius with symbols of his power: the papal keys are woven into the brilliant green fabric behind the pope, the della Rovere acorn appears as the finials on the chair back, his costume defines his office, and the handkerchief held in his hand refers to the mappa, a symbol of office carried by Roman consuls, important governing officials of the ancient empire. The representation is both intimate and official.

Raphael provided another penetrating essay on the character of one of his sitters in a portrait of Baldassare Castiglione (Fig. 18.29). Castiglione came from Raphael's native city of Urbino, whose court was characterized by learned conversations and witty repartee which Castiglione codified in the *Book of the Courtier*, published in 1528

18.28 Julius II, c. 1512, commissioned by Julius II for the altar area of Santa Maria del Popolo from **Raphael**. Oil on panel, $42\% \times 31\%$ (108 \times 80 cm) (National Gallery, London)

18.29 *Baldassare Castiglione*, c. 1514, commissioned by Baldassare Castiglione from **Raphael**, Musée du Louvre, Paris. Oil on canvas, c. $32\% \times 26\%''$ (81.9 \times 67.3 cm)

but actually written between 1508 and 1518. Emphasizing artistic grace, decorum, and nonchalance, the speakers in Castiglione's book address such topics as speech, dress, effortless work by the amateur, desirable qualities in women, duties of good government, and the true nature of love. Their seemingly casual but highly calculated remarks are palpably visible in Raphael's portrait of the author. Castiglione quietly but intensely looks out at the viewer through silver blue eyes, his utter composure and selfconfidence manifest in his firmly clasped hands as he turns gently on axis to respond to the viewer's presence. As was courtly fashion in the sixteenth century, he wears subdued but luxurious black velvet, silvered fur, and white silk. Nothing-not a chair nor a window nor an inscriptiondistracts from his spot-lit visage, an understated, sophisticated, and intelligent ideal.

In one of his last portraits, the so-called *La Fornarina* (Fig. 18.30), Raphael painted what today we read as an unusual portrait, although a number of extant contemporary paintings referred to as the *Mona Lisa nuda* indicate that such

CONTEMPORARY VOICE

The Courtier as Artist

Baldassare Castiglione (1478–1529) was himself a courtier at the highly civilized court of Guidobaldo da Montefeltro, in Urbino. *The Book of the Courtier*, his best-known work, sets out in detail the characteristics of a cultivated person, including good manners and various accomplishments, such as drawing and painting.

"Before we launch into this subject," the Count replied, "I should like us to discuss something else again which, since I consider it highly important, I think our courtier should certainly not neglect: and this is the question of drawing and of the art of painting itself. And do not be surprised that I demand this ability, even if nowadays it may appear mechanical and hardly suited to a gentleman. For I recall having read that in the ancient world, and in Greece especially, children of gentle birth were required to learn painting at school, as a worthy and necessary accomplishment, and it was

ranked among the foremost of the liberal arts; subsequently, a public law was passed forbidding it to be taught to slaves. It was also held in great honour among the Romans, and from it the very noble family of the Fabii took its name, for the first Fabius was called Pictor. He was, indeed, an outstanding painter, and so devoted to the art that when he painted the walls of the Temple of Salus he signed his name: this was because (despite his having been born into an illustrious family, honoured by so many consular titles, triumphs and other dignities, and despite the fact that he himself was a man of letters, learned in law and numbered among the orators) Fabius believed that he could enhance his name and reputation by leaving a memorial pointing out that he had also been a painter. And there was no lack of other celebrated painters belonging to other illustrious families. In fact, from painting, which is in itself a most worthy and noble art, many useful skills can be derived,

and not least for military purposes: thus a knowledge of the art gives one the facility to sketch towns, rivers, bridges, citadels, fortresses and similar things, which otherwise cannot be shown to others even if, with a great deal of effort, the details are memorized. To be sure, anyone who does not esteem the art of painting seems to me to be quite wrong-headed. For when all is said and done, the very fabric of the universe, which we can contemplate in the vast spaces of heaven, so resplendent with their shining stars, in the earth at its centre, girdled by the seas, varied with mountains, rivers and valleys, and adorned with so many different varieties of trees, lovely flowers and grasses, can be said to be a great and noble painting, composed by Nature and the hand of God. And, in my opinion, whoever can imitate it deserves the highest praise. Nor is such imitation achieved without the knowledge of many things, as anyone who attempts the task well knows."

18.30 *La Fornarina* (The Baker Woman), c. 1518, **Raphael**. Oil on panel, $33\% \times 23\%$ " (85×60 cm) (Galleria Nazionale, Rome)

depictions were not uncommon within certain intellectual circles. Whether or not the painting is a true portrait, or the simulacrum of a woman transformed into a sexualized love interest (as indicated by the placement of each of her hands) is not known. The painting is normally discussed as a portrait by Raphael of his own lover, an assertion that has some credibility given the artist's signature on the bracelet on her upper left arm. The painting, however, may have been completed by someone in Raphael's shop after the artist's early death in 1520, accounting for the slightly frozen facial features. Like more traditional and certainly more decorous marriage images such as Raphael's own Maddalena Strozzi Doni (see Fig. 17.9), the Fornarina wears precious jewels—not only the bracelet, but a sizable pearl, attached in this case to her rich and fantastical headdress. Thus she is marked with the gifts that commodify her within the economics of marriage and love during this period. Often compared with a slightly earlier portrait by Raphael known as the Donna Velata, or the veiled woman, because of their similar poses and similar facial features, the Fornarina breaks the boundaries of these standard female portraits where the woman is richly clothed, resituating the image of the woman as a sexualized being.

Leo X: Papal Luxury

The Stanza dell'Incendio

By 1514 Raphael was at work for Julius's successor, Leo X (Giovanni de' Medici, son of Lorenzo the Magnificent), in another room of the papal apartment, the Stanza dell'Incendio, which takes its name from the painting of The Fire in the Borgo (Fig. 18.31) on one of its walls. Each of the walls in this room depicts an event in the life of a previous pope named Leo, clearly intended to aggrandize the current pope. In the Fire it is Leo IV (r. 847-55), who put out a fire in the area known as the Borgo in front of Old St. Peter's, merely by raising his hand in a gesture of blessing. Once again the clearly defined perspective system disguises the fact that very little in the painting makes logical sense, even though the vanishing point is at the entrance to Old St. Peter's depicted in the far distance of the image. There are shifts in scale among the figures; the woman in the center foreground, for example, is larger than many of the other figures surrounding her. The water carrier at the far right could hardly balance the vase on her head if she were in a hurry to get to the fire; her pose is stilled for appreciation of its gracefulness. The nudity of the male figures on the left (Fig. 18.32 and p. 376) seems gratuitous, the man hanging with all his muscles tensed from the wall at the left (which seems unattached to a building, see Fig. 18.31) does so for no reason, since the ground is only a short distance beneath his feet; the figure appears as a meditation on the extended musculature, the grimacing faces, and the twisting poses of Laocoön's sons in the ancient sculpture uncovered in 1506 and the centerpiece of the papal collections of antiquities (see Fig. 40). Leo IV, in the loggia in the distance, is barely visible, although he is supposedly the main character in the painting. While tied to the history of the papacy and to its traditional iconography, this fresco relaxes the narrative focus so that each element in the painting becomes interesting in its own right rather than as a component of the story. Leo X is reputed to have said, "God has given us the papacy, let us enjoy it"; in The Fire in the Borgo Raphael provided an essay in visual enjoyment.

The Sistine Tapestries

The compositional oddities of the *Fire* and the *Expulsion of Heliodorus* disappear in another commission for Leo X that Raphael worked on at approximately the same time. In a series of cartoons for tapestries for the lower walls of the Sistine Chapel (see Fig. 12.28, which shows the painted *trompe-l'oeil* drapery covering the lower walls of the chapel) Raphael used a pictorial decorum that both took into account the official nature of the papal chapel (where Leo himself had been elected pope) and the grand classicism of the frescoes already in the room. The tapestries depict scenes from the lives of Peter and Paul, appropriate for a

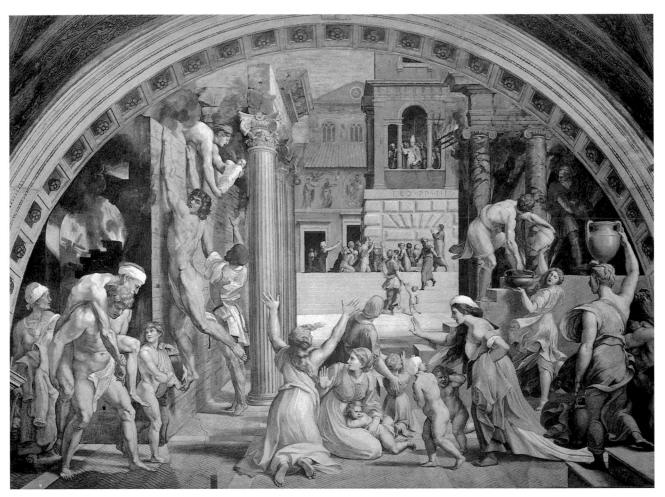

18.31 *The Fire in the Borgo*, begun 1514, commissioned by Leo X from **Raphael** for the Stanza dell'Incendio, Vatican Palace, Rome. Fresco, base 22' 1" (6.73 m)

papal chapel. They also carry the narrative of the 1481-82 cycle immediately above them (see Fig. 12.30) into the future, taking the history of mankind begun on the ceiling (see Fig. 18.12) into the history of the early Church and its leadership by Peter. In The Miraculous Draught of Fishes (Fig. 18.33), the two heroically muscled fishermen in the right boat make reference to Michelangelo's nudes on the ceiling above and yet are appropriately strong for the labor that they pursue. Their self-conscious poses also recall the figures of The Fire in the Borgo, yet their tensed musculature is directly responsive to the heavy net loaded with fish that the two men are attempting to lift into the boat. The boatman does suggest a rather self-conscious quotation of an antique river god statue, yet the overall composition of the cartoon is compellingly naturalistic, with an apparently unbroken movement into a deep recessional space that adds a heroic frame to the entire narrative. Reflections of the men in the boats shine on the water in the foreground, light glints on the surface of the water in the midground,

18.32 The Fire in the Borgo (detail), begun 1514, commissioned by Leo X from **Raphael** for the Stanza dell'Incendio, Vatican Palace, Rome. Fresco

18.33 The Miraculous Draught of Fishes, c. 1515–16, commissioned by Leo X from **Raphael** for the lower walls of the Sistine Chapel. Gouache on paper, later laid on canvas lining, 10′ 5½″ × 13′ 1″ (26.6 × 33.3 cm) (London, Victoria and Albert Museum)

As the tapestries for which these cartoons were designed were woven from behind, the cartoons were themselves created in reverse to accommodate this technical process.

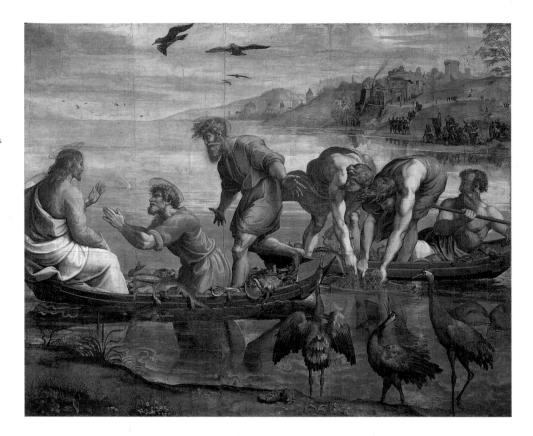

18.34 (below) Loggia of Psyche, view, 1518–19, commissioned by Agostino Chigi from **Raphael** and his studio for the Villa Farnesina (formerly Villa Chigi), Rome. Fresco

and the distant horizon blurs naturalistically into a blue grey haze. The two Apostles gesturing toward Christ reveal—as conventional theory since Alberti had postulated—the workings of their minds through the motions of their bodies. Yet the uncertain pose of the standing Apostle suggests the very real precariousness of a person standing in a small boat. Here, where the site demanded grand drama, Raphael brought a dramatic realism to the history of Christ and the Apostles who were, theologically, the predecessors of the pope and the cardinal bishops who met in this building.

The Suburban Villa and Sybaritic Pleasure

Outside the papal court, fascination with the elegant and mannered style of the later Stanze is evident among the wealthy elite. When Agostino Chigi, a fabulously rich Sienese banker, built a palace in an undeveloped area along the Tiber, he intended it as a suburban villa where he and his guests would be free of the formal cares of the city. For a ground-floor loggia facing out into the garden, Chigi commissioned Raphael and his studio to paint an illusionistic arbor through whose fruit- and flower-decorated trellis shines a painted sky, imitating an actual garden bower (Fig. 18.34). Along the length of the ceiling Raphael designed two large painted fields depicting the marriage of Cupid and Psyche and Psyche being received on Mount Olympus as if they

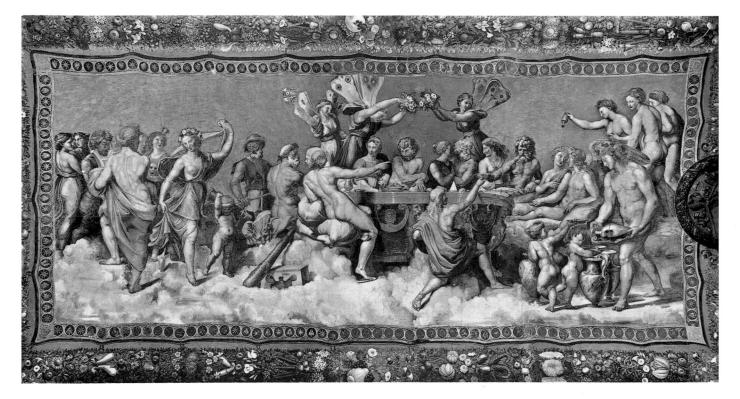

18.35 Loggia of Psyche, detail showing arbor and the *Marriage of Cupid and Psyche* from the western half of the ceiling, 1518–19, commissioned by Agostino Chigi from **Raphael** and his studio for the Villa Farnesina, Rome. Fresco

were tapestries strung overhead (Fig. 18.35). This lush and seductive arbor is populated with nude figures of gods and goddesses, painted in a cool, classical vocabulary as if they were part of a painted sculptural relief, echoing Raphael's study of classical sculpture. At the same time, many are depicted in suggestive poses that are glossed by the phallic vegetables and opened fruits of the garlands.

Inside another room of Chigi's villa, Raphael and Baldassare Peruzzi (1481 Ancaiano-1536 Rome) painted other images that continued the strain of erotic pleasure and clever illusionism that characterizes the ceiling of the Loggia. Raphael's Galatea (Fig. 18.36), based on a poem by Angelo Poliziano, depicts the story of a sea nymph who laughingly dismissed the love song crooned to her by the giant Polyphemus (painted by Sebastiano del Piombo on a nearby wall). She is drawn across a stylized sea by a pair of dolphins, symbols of Venus and thus of love. Flanked on either side by mythological sea creatures like the hippogryph in the right background, Galatea turns in a spiraling pose reminiscent of Michelangelo's unfinished St. Matthew (see Fig. 17.2), but with a greater sense of inhabiting a volumetric space; her movement is one of slow grace as opposed to the spasm of revelation that characterizes St. Matthew's body. A red billowing drapery provides a dramatic counterpoint to her movement, blowing left as Galatea is drawn right. In the Galatea Raphael painted his own response to Botticelli's Birth of Venus (see Fig. 11.41). The subject matter of each is a classical literary conceit, each is an incentive to

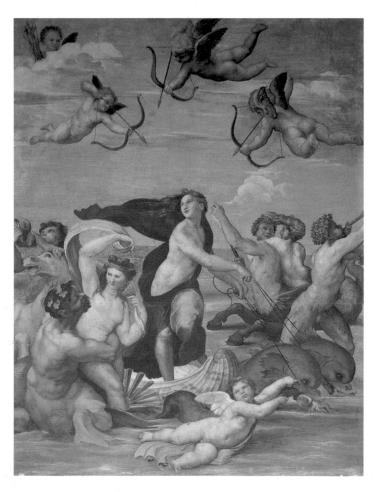

18.36 *Galatea*, 1513, commissioned by Agostino Chigi from **Raphael** for the Sala di Galatea, Villa Farnesina, Rome. Fresco, $116 \times 88\%$ " (295 \times 225 cm)

18.37 Sala delle Prospettive, 1509–11, commissioned by Agostino Chigi from **Baldassare Peruzzi** for the Villa Farnesina, Rome

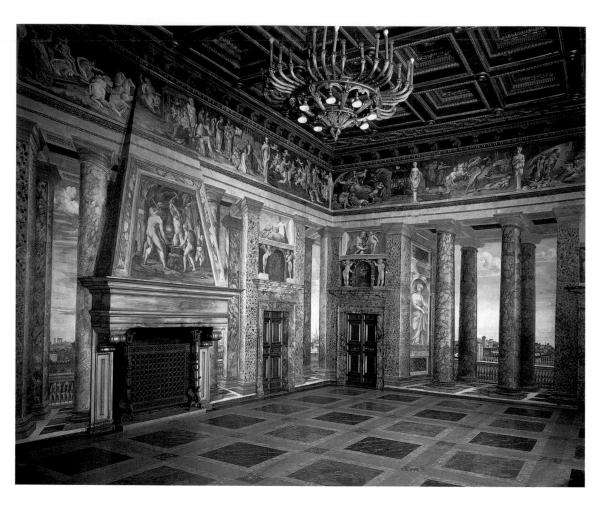

erotic reverie, and each is simultaneously naturalistic in the volumetric immediacy of the central figure and yet completely artificial in its seascape setting. Like poetry, where abstractions such as meter and rhyme are essential to meaning, the formal properties of these two paintings become integral aspects of their narrative. As active as all of the figures are, Raphael has struck a remarkable balance between poise and movement, making this painting one of the central moments of the classicizing style in Rome at the beginning of the sixteenth century.

Opposed to the poetry of the *Galatea* is Peruzzi's essay in illusionistic cityscape painting (Fig. 18.37), which appears rooted in observable fact. On opposite walls in the central room on the upper floor of the villa, directly over the Loggia of Psyche, Peruzzi painted perspective scenes that seem to eliminate the walls entirely, opening the space out onto a fictive loggia through which one can see the city of Rome beyond and some of its major monuments. The illusion is, of course, a lie, but a witty essay in craft, scientific perspective, and imagination that is in full accord with the relaxed and playful life of the suburban villa.

The erotic pleasures so vividly suggested in Chigi's private residence found another form in a set of erotic drawings by Giulio Romano (1499? Rome-1546 Mantua), then working in Raphael's studio and soon to take over his master's shop when Raphael died. Known as *I Modi (The*

Positions), they were engraved by Marc'Antonio Raimondi (1470/82 Argini-1527 Rome) (Fig. 18.38). Raimondi established an active engraving school in Rome and popularized the art of his contemporaries in the print medium, an important contribution to the dissemination of the novelties of Roman style to other urban centers. Raimondi's prints also helped to establish the reputations of artists like Raphael, who not only provided him models with their

18.38 *I Modi*, c. 1517, drawn by **Giulio Romano** and engraved by **Marc'Antonio Raimondi** (© British Museum, London)

18.39 Interior of the Villa Madama, Rome, c. 1515–21, commissioned by Giulio de' Medici from **Raphael** (decorations by **Giulio Romano**, **Giovanni da Udine** and **Baldassare Peruzzi**)

work but who also provided him figure drawings from which he could compose more complicated compositions. His engravings of *I Modi* were not the only prints of this type in Rome at the time, but these acrobatic variations of positions for sexual intercourse landed the engraver in jail, even in the sybaritic environment of Leo's Rome. The scopophilic pleasures of the print were apparently condemned not simply because of the subject's pornographic nature, but because they presumably extended such imagery to an audience outside the narrow circle of court intimates. These courtiers would have known that the imagery derived from antique texts and images, particularly

from ancient coins (*spintria*) that depict sexual activity, some of which Giulio Romano may have owned. So sexual pleasure could be overlaid with a veneer of classical, humanistic scholarship to give it a claim to decorum, something that would not have been the case in the more open circulation of prints through the culture.

Such prints and paintings like the Fornarina (see Fig. 18.30) were part of the charged environments created by Raphael and Peruzzi. They created an Olympus of luxury and license for Chigi, his mistress, and his guests that was unmatched in the city of Rome. For a patron whose gestures of grandeur included having served a banquet on gold plate and then tossing the gold dishes out of the window into the Tiber as a demonstration of his enormous wealth (although servants were stationed below to retrieve the plate), Raphael was obviously challenged to provide fanciful illusionism, references to classical learning, opulence, and erotic pleasure, all aimed to delight the worldly and sophisticated participants in the villa environment.

Raphael's work as an architect is not as well known as his work as a painter, but here, too, he demonstrated both enormous imagination and a profound understanding of classical antiquity. In the *Villa Madama*, built on Monte Mario just outside Rome for Cardinal Giulio de' Medici (who was to become Pope Clement VII in 1523), Raphael designed a modern

version of an ancient Roman country villa. Spreading over the landscape to incorporate elaborate gardens and different landscaping levels into its design, the symmetrical plan of the villa as Raphael actually planned it, and the small part of it that was actually built (Fig. 18.39) show that Raphael intended the entire project to be a recreation of the past. Not only is the architectural vocabulary evocative of Roman antiquity in terms of arches, pilasters, and marble revetments, the stucco decorations that illustrate nearly all of its upper surfaces derive from similar ancient forms that had been uncovered on the Palatine Hill in Rome toward the end of the fifteenth century and that had become part of the fictive vocabulary of painting used by Raphael himself in rooms like the Stanza d'Eliodoro (see Fig. 18.26).

Raphael and Michelangelo

In 1518, at the time he had begun the Villa Madama, Cardinal Giulio de' Medici also ordered two paintings for the cathedral of Narbonne, France, where he was bishop. This commission for Raphael's *Transfiguration* (Fig. 18.40) and *The Raising of Lazarus* (Fig. 18.41) by Sebastiano del Piombo (Sebastiano Luciani; c. 1485 Venice–1547 Rome) renewed the competition between Raphael and Michelangelo initiated by Julius II a decade earlier in the Stanze and the Sistine Chapel, because Michelangelo apparently provided drawings as well as advice for Sebastiano's *Lazarus* painting—as he did on numerous other occasions to help his friend. Although Michelangelo was in Florence working for the Medici, his clever intervention in Sebastiano's commission allowed him to maintain an active presence in Rome where Raphael was the dominant artist in papal circles.

Sebastiano's painting shows Lazarus removing the winding sheets from his body after Christ, still gesturing at the center of the painting, has miraculously brought him back to life (John 11:1-44). Raphael's painting depicts two

18.40 *Transfiguration*, 1518–20, commissioned by Giulio de' Medici (later Clement VII) from **Raphael** for Narbonne Cathedral, where he was bishop. Oil on panel, $13' 5\%'' \times 9' 2'' (4.1 \times 2.79 \text{ m})$ (Musei Vaticani, Rome)

18.41 *The Raising of Lazarus*, 1517–19, commissioned by Giulio de' Medici (later Clement VII) from **Sebastiano del Piombo** for Narbonne Cathedral. Oil on canvas, 12′ 6″ × 9′ 6″ (3.81 × 2.9 m) (National Gallery, London)

distinct but consecutive biblical narratives: one in which Moses and Elijah miraculously appear with the transfigured Christ, witnessed by Peter, James, and John, and a subsequent episode in which the other Apostles, failing to cure a boy possessed by demons, await the return of Christ from the mountain above (Matthew 17:1–20). Both paintings depict gospel narratives of Christ and both are manifestations of his divine power. Giulio Romano, Raphael's heir, may have painted some of the figures in the lower background area of the *Transfiguration* since the painting was apparently not finished when Raphael died in 1520. The importance of the painting in Raphael's career was apparently recognized immediately, since it was placed on Raphael's tomb in the Pantheon at the time of his burial.

These two paintings exemplify many of the artistic currents in Rome at the time of their commissioning and suggest that Raphael and Sebastiano/Michelangelo had achieved an integration of new ideas from a variety of sources. Since being cleaned, the paintings indicate that the brilliant coloring of the Sistine ceiling had finally had an impact on panel painting. The kneeling woman at the foreground of the *Transfiguration* (virtually a mirror image of the comparable figure in Raphael's *Expulsion of Heliodorus*;

see Fig. 18.27) wears an icy pink tunic whose sash uses a changeable color technique. Each of the major figures is clothed in a bright color, perhaps to respond to the large size of the painting. Both Sebastiano, whose training was in Venice where he had been trained in the shop of Giovanni Bellini, and Raphael use typically Venetian chiaroscuro techniques which add luminous effects to the surface and enhance the sense of changing atmospheric conditions in the background. Both the possessed boy and Lazarus have the heavy musculature characteristic of Hellenistic sculpture such as the Laocoon and of Michelangelo's figures. The animated gesturing of the figures in each painting is thrown into sharp relief by being highlighted against a dark ground. Active poses are given added tension because of the compacted space in which they are placed. Pose, highlighting, and gesture enhance figural motion throughout the paintings. These paintings give some sense of the importance of Rome as an international center for art by the beginning of the sixteenth century, a place where artists coming from different regional centers like Venice, Urbino, or Florence could find new ideas in the work of others and begin an integration of very different modes of painting into a coherent new style.

Clement VII: The Dissolution of Papal Power

The stylistic developments so notable in the work of Raphael, Sebastiano, and Giulio Romano were cut short in Rome by a number of events, not the least of which was a radical shift in the group of artists working in the city. Bramante died in 1514, Raphael in 1520. Giulio Romano, Raphael's successor, departed Rome for Mantua and lucrative commissions there in 1524. Michelangelo left Rome for Florence, where he worked on Medici commissions at San Lorenzo.

As important as these figures were for giving Julius II and Leo X a coherent and triumphal visual language for their conceptions of the papal office as a leading player in a newly expanded world and within the strengthened monarchical political structures of Europe, artistic personalities alone were not the sole engines driving artistic development. When Leo X died in 1521 he was succeeded by a Dutch cardinal who took the name Adrian VI (r. 1522-23). Adrian began a series of long-overdue reforms in the government of the Church and in the morals of the papal court. These reforms led to a drastic reduction of artistic patronageseen as the manifestation of an extravagant court-at just the time that a younger group of artists such as Rosso Fiorentino (Giovanni Battista di Jacopo; 1494 Florence-1540 Fontainebleau?) and also Parmigianino (Girolamo Francesco Maria Mazzola; 1503 Parma-1540 Casalmaggiore) had come to Rome, from Florence and Parma respectively, and were promising to develop a new courtly International Style there. By the time of Adrian's short reign, Protestant reformers, led by the German monk Martin Luther, had issued a serious challenge to the Church that was to lead to a split in Western Christendom. Thus, at the very time that the boundaries of the Church had expanded to encompass newly explored territories in the Americas and in Asia, its center began to collapse.

There was loud rejoicing when Giulio de' Medici became pope as Clement VII in 1523, but he was never able, in his eleven-year reign, to reinstitute the impressive scale of patronage of Julius II and Leo X. The myth of Rome's sacrosanctity in the European imagination was shattered in 1527 when the troops of the Hapsburg emperor Charles V (1500–58), ostensibly in Italy to fight the French, sacked the city and despoiled many of its most hallowed sites. Given the short period of time between Clement's accession to the office of the papacy and the Sack, as well as the destruction of artists' workshops by the German soldiers, it is not surprising that little concrete evidence remains for artistic activity in Rome during the early years of Clement's reign.

The Dead Christ (Fig. 18.42) by Rosso Fiorentino is one of the few paintings that can be assigned with any security to this period. Painted for Lorenzo Tornabuoni, a relative of the pope who in 1523 or 1524 was made bishop of Sansepolcro (meaning "Holy Sepulchre," thus perhaps explaining the painting's subject matter), the panel shows a nude dead Christ flanked by angels. Symbols of the Passion lie on the foreground step and illusionistically extend into space. The creamy expanse of Christ's sagging body-modeled in part on one of the sons in the antique statue group of the Laocoön in the papal collections (see Fig. 40)—glows in the sharp light coming in from the left; its details-the red hair, the disembodied hand touching the wound in his side, the pubic hair—only enhance the sensuality of the figure. The sharp contrasting colors of the angels' clothing-deep red, green, and white on the left angel and orange, blue, and violet on the right—play against the white candles they hold and give some indication of how important the brilliant palette of Michelangelo's Sistine Ceiling (known to us only since its recent cleaning, see Fig. 18.18) was for the new generation of artists experiencing it for the first time in Rome. The golden corkscrew curls of the angels are reminiscent of the hair of the Sistine Ceiling nudes, and indicate how carefully artists looked at even the small details of Michelangelo's work, even if the end result of their painting differs significantly in form from the older artist. The soft eroticism of Rosso's painting, even as it emphasizes the humanity of the divine Christ, suggests that imagery in the Clementine court would have returned to the refined and charged sensibilities of Leonine Rome, a deliberate rejection of the austerities under Adrian VI. The Sack all too quickly put an end to this style of painting in Rome, leaving artists like Rosso a hostage to German troops who destroyed much of their work and caused them eventually to abandon the city that had only recently promised extraordinary new patronage possibilities.

18.42 *Dead Christ*, c. 1524–27, commissioned by Bishop Leonardo di Lorenzo Tornabuoni probably for his cathedral church at Sansepolcro, from **Rosso Fiorentino**. Oil on panel, $52\% \times 41''$ (133.5 × 104.1 cm) (Museum of Fine Arts, Boston)

At the time of the Sack of Rome in 1527 Rosso apparently left this painting with the Franciscan nuns of the church of San Lorenzo in Panisperna for safe-keeping. Immediately after the Sack, Rosso was imprisoned in the palace of Cardinal della Valle. When he subsequently tried to retrieve the painting the nuns at first refused to give it up. Sometime shortly afterward it entered into a private collection and never served as an altarpiece, although that was its original purpose.

19 Mantua, Parma, and Genoa: The Arts at Court

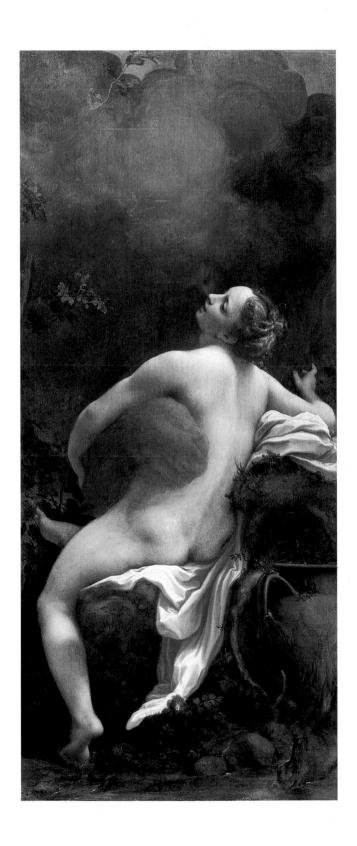

The small cities of Mantua and Parma and the major maritime city of Genoa were centers of particularly sophisticated artistic production in the early sixteenth century. Following the lead of the self-absorbed papal courts of Leo X and Clement VII, provincial aristocratic patrons commissioned works intended to appeal to elite audiences, promoting artifice and formal invention as primary values. Unabashedly luxurious and often precious, the arts were shaped to appeal to connoisseurs and *literati* who had developed a seemingly insatiable appetite for classical antiquity, scholarly allusions, visual puns, and illusionistic effects. Instead of art mimicking life, life now mimicked art—every aspect of speech, dress, and comportment shaped to create a purposefully artificial and refined effect.

Mantua: The Pleasure Palace

The Roman followers of Raphael wittily investigated and extended many of their master's fecund imaginings. In Rome Raphael himself and his closest follower, Giulio Romano, had already felt free to explore surface pattern and graceful design to an unprecedented degree (see Fig. 18.40). At Mantua, where Isabella d'Este had attempted to impose moralistic propriety on the court (see Fig. 14.35), her son Federigo Gonzaga instead engaged Giulio Romano to satisfy his considerable libido with bawdy decorations for a pleasure palace on the outskirts of the city where he stabled his horses and housed his mistress. Giulio arrived in Mantua from Rome in 1524, personally recommended and escorted by the Gonzaga's cultural agent in Rome, Baldassare Castiglione (see Fig. 18.29); he set to work in the Palazzo del Tè, a name deriving from the island on which it was situated.

The general decorative scheme of the room that contains his *Wedding Feast of Cupid and Psyche* (Fig. 19.1) is indebted to Raphael's designs for the Villa Farnesina in Rome (see Fig. 18.35), also built as a retreat for the patron and his mistress. But Giulio and Federigo flaunted the bawdy delights of the gods with a blatant disregard for decorum. Everything that is cool and idealized in Raphael is here flush with color and

(left) Jupiter and Io, early 1530s, commissioned by Federigo Gonzaga from **Correggio** for his pleasure chamber in the Palazzo Ducale, Mantua. Oil on canvas, $29\%'' \times 64''$ (74×163 cm) (Kunsthistorisches Museum, Vienna)

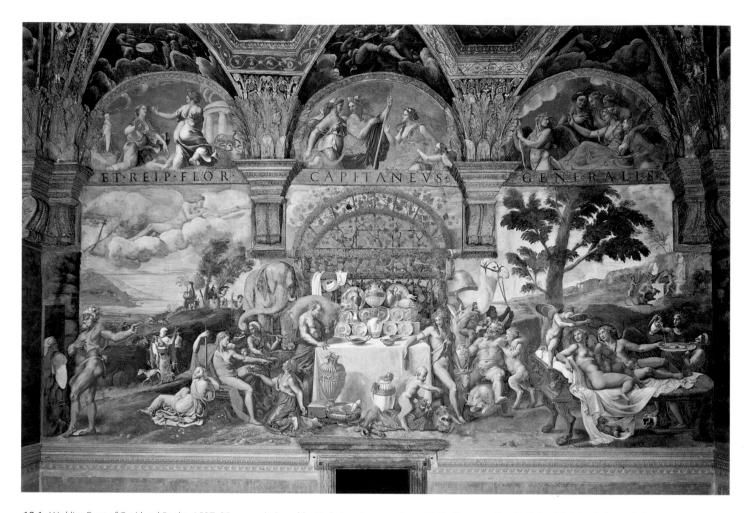

19.1 Wedding Feast of Cupid and Psyche, 1527-30, commissioned by Federigo Gonzaga from Giulio Romano for the Sala di Psiche, Palazzo del Tè, Mantua. Fresco

Emperor Charles V enjoyed dining alone in this room with Federigo as his steward. As a complement to the frescoes on the walls, a marble statue of Venus stood at the center of the room.

heat. Cupid has matured into a fleshy adult, reclining on his marriage couch at the right, nude along with his voluptuous bride, Psyche, and their lascivious and inebriated guests. The lovers turn their heads to receive marriage wreaths from an amorino who balances at the top of their couch, while the rumpled and cascading sheets beneath them suggest a heated and energetic coupling, not too far removed from Giulio's drawings for I Modi (see Fig. 18.38). (Wittily and somewhat crudely Giulio echoes the poses and cupidity of the two through a pet dog stretched out in the lower folds of the sheets.) To the left of the couple, Bacchus barely holds himself upright on the corner of a table displaying fine gold and silver plate. Behind him Silenus's donkey brays uncontrollably. Even Apollo-depicted at the left of the table in a serene profile pose derived directly from ancient cameos-receives the attention of the muses. Above in the lunettes and ceiling Giulio tells the story of Cupid and Psyche and the conquests of Jupiter with similar sexual energy emphasized by erotically charged views of nude bodies seen from below. Nothing is immune from playful, erotic commentary, all knit together with long, sinuous line and graceful exaggerations.

In the frescoes of the Sala dei Giganti, which were created for the second visit of Emperor Charles V to Mantua, Giulio reproduced in paint the spectacular effects of court entertainments. These productions, some of which he himself designed, employed vast machinery to hoist figures up and down from the heavens. In the Fall of the Giants from Mount Olympus (Fig. 19.2), the densely crowded dome of heaven culminates in a vertiginous and off-center gallery, clearly meant to recall and surpass the oculus in Mantegna's palace decorations for Federigo's great grandfather (see Fig. 14.32). In so doing, Giulio underlined Federigo's distinguished pedigree as a patron of the arts while also asserting the superiority of his generation to those who came before him. Beneath the gods, in a melodramatic representation which neither Ludovico Gonzaga nor Mantegna would have countenanced, the giants tumble to earth, seeming to destroy the walls around them that pretended to be the actual walls of the room, thus threatening the merely human-sized spectator within the space. Giulio's paintings entertain with all the subtlety and grace of an amusement park fun house, offering coarse humor and exaggeration as an antidote to the potentially tedious ideal-

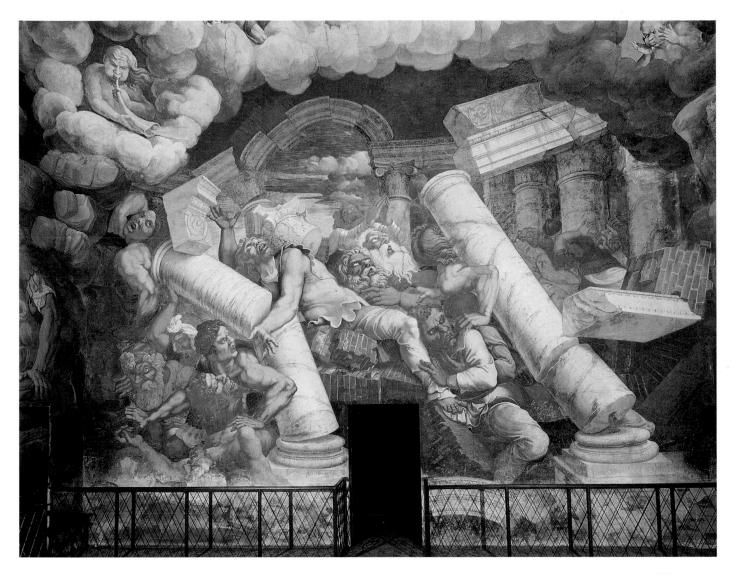

19.2 Fall of the Giants from Mount Olympus, 1530-32, commissioned by Federigo Gonzaga from Giulio Romano for the Sala dei Giganti, Palazzo del Tè, Mantua. Fresco

This room has very peculiar reverberating acoustics that turn any conversation into cacophony. The floor was originally set with pebbles making it difficult to walk as well as hear.

ism of much antique-revival art. Although the *Sala dei Giganti* is often used as a centerpiece in discussions of Mannerist art (see our discussion in Chapter 20), it should be pointed out that Giulio's stylistic choices are appropriate for the subject and intended use of the room, a place to surprise and amuse guests. Form and content are as carefully knit here as they are in Raphael's *School of Athens* (see Fig. 18.21).

The playful and extravagant, at times even wanton, flavor of Giulio's paintings was intended to complement the tongue-in-cheek architectural forms he designed for additions to the palace itself (Fig. 19.3). In this suburban retreat, Giulio expanded a modest, pre-existing rectangular building (now incorporated into the northern wing of the courtyard) into an impressive, multi-zoned complex (Fig. 19.4). Entering through a rustic portico, the visitor is surrounded by the four wings of an ample courtyard, which leads on to a larger portico, fish pools, and eventually a large open expanse for exercising and displaying Federigo's prize horses.

While Giulio articulated the eastern façade of the palace facing the horse field with a pedimented façade, in the courtyard he employed unorthodox combinations of seemingly finished and unfinished forms, different architectural orders, and varying wall systems. Many of them collide, delighting connoisseurs who knew the rules of ancient architecture so well that they enjoyed seeing them willfully disobeyed. Equal bays appear on the northern and southern wings but alternating narrow and wider bays on the east and west. The ends are further distinguished from the sides by Giulio's witty violation of the architrave, a triglyph hanging down as though it is dislodged over every bay. Throughout, baseless pediments are invaded by keystones more appropriate to arches—which split them at their apex. For all this building's apparent massiveness, Giulio seems to say, it is really a stage set, which the architect and his sophisticated patron can shape at will, exploiting stucco and brick to mimic carved masonry and columns and playing

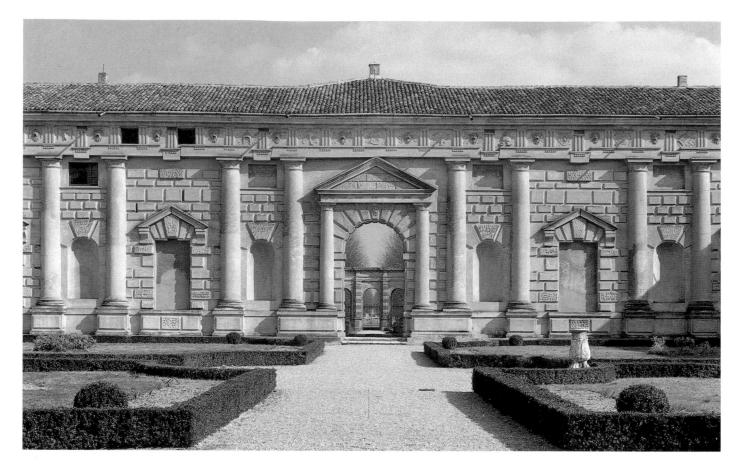

19.3 Palazzo del Tè, Mantua, courtyard, begun 1525, commissioned by Federigo Gonzaga from **Giulio Romano**

on normal expectations of courtly decorum. Some critics have seen Giulio's fantastic paintings and architecture as symptoms of a troubled and shattered world embodying the so-called "psychosis" of Mannerism. But in the context of a pleasure palace, none of Giulio's aberrations were actually disturbing. Instead, they served to give Federigo and his guests a sense of superiority over normal mortals, reinforcing increasingly autocratic and authoritarian political and social realities—as well as pleasure in being able to comprehend the sly wit of the building and its decorations.

The Loves of Jupiter In his main palace in Mantua Federigo Gonzaga intended to create his own version of his uncle Alfonso d'Este's set of paintings for the Camerino d'Alabastro of the Palazzo Ducale in Ferrara (see Figs. 21.19 and 21.20). Combining his interest in erotic subject matter and identification with the Olympian gods, Federigo asked Antonio Allegri, known as Correggio (1489 Correggio–1534 Correggio), to paint a series of works depicting the loves of Jupiter—subject matter comparable to what we have seen at the Palazzo del Tè, but here in a more formal urban environment and using a local painter. Correggio complied by creating some of the most sensuous paintings of the sixteenth century. In his *Jupiter and Io* (see p. 425) the king of the gods appears to the mortal Io in the guise of a cloud. Enfolding her in his nebulous form, Jupiter plants a kiss

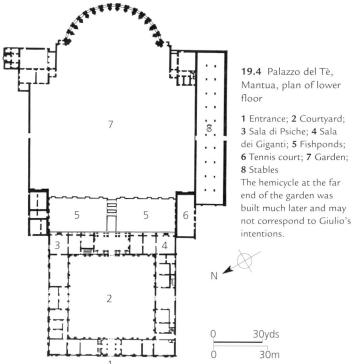

upon her receptive cheek. Io abandons herself to intense, physical pleasure, her outstretched limbs, fingers, and toes charged with delight. Although Correggio seems to have developed his painter's skills without any direct contact with progressive centers such as Venice and Rome, relying on prints after Raphael for Io's complex pose, his native

ability in rendering the different textures and temperatures of cloud, flesh, fabric, and other materials made him well suited to provide visual delights for Federigo's intimate retreat. Here careful observation of nature, so critical to the evolution of painting during this period, and the imitation of revered models such as antiquity or, in this case the near-contemporary Raphael, place paintings such as this within the mainstream of artistic development and well outside the deliberately artificial conventions of Mannerism.

Parma: Elegance and Illusionism

Correggio spent most of his career working in Parma, a short distance from Mantua. Though the city had established a proud artistic tradition in the Middle Ages with the construction of its Romanesque cathedral and pink and white baptistry, it had fallen into provincial obscurity as a dependency of the Visconti and Sforza of Milan. On becoming part of the Papal States in the early sixteenth century, the city experienced a cultural revival.

Correggio at San Paolo and the Cathedral

Among the first patrons to exploit Correggio's talents was Giovanna da Piacenza, the sophisticated abbess of the Benedictine nunnery of San Paolo. Correggio's decorations for a room in her private apartments (Fig. 19.5) demonstrate the extent to which antique subject matter had become accepted and perhaps expected in any major commission from an educated patron, even a nun. Unlike Federigo Gonzaga, however, the abbess predictably stipulated chaste and uplifting subject matter. The precise meaning of the program has yet to be unraveled-an indication that it was specially prepared by a scholar familiar with a wide range of antique texts-but the dominating presence over the fireplace of Diana, the chaste huntress, indicates its high moral character. Correggio used grisaille to depict figures from antiquity in the lunettes around the room, reserving rich color for a verdant trellis on the vaulted ceiling. Innocent putti displaying emblems of Diana cavort in the oval openings of the trellis, adding symbolic purpose to their usual playfulness.

Correggio was a consummate illusionist. Being particularly adept at theatrical visual effects, he was the logical choice to decorate the domes of two of the city's largest churches, San Giovanni Evangelista and the cathedral. His frescoes for Parma Cathedral (Fig. 19.6) catch the Virgin of the Assumption, to whom the cathedral is dedicated, in a luminous vortex of swirling clouds, saints, and angels. The Virgin's ascent seems especially dramatic by contrast with calm representations of the four patron saints of Parma in the squinches: Bernard, Thomas, Hilary of Poitiers, and John the Baptist. Above them, a fictive balustrade barely constrains excited onlookers, who crane their necks to catch a glimpse of the rapidly disappearing Virgin, visible only

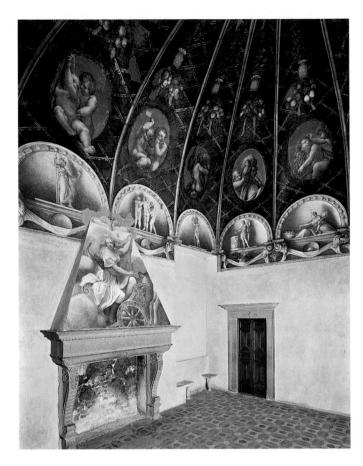

19.5 *Camera di San Paolo*, 1519, commissioned by Abbess Giovanna da Piacenza from **Correggio**, Parma. Fresco

when one has begun to climb the broad stairs leading from the nave to the much higher transept and apse. The viewer's identification with the Virgin's ascent is intensified by the progressively smaller scale of the figures in each ring of the composition, far exceeding what would be necessary to achieve normal foreshortening. At the very center, the composition finally comes to rest in a peaceful and cloudless sky.

Correggio left Parma immediately after completing the dome frescoes. Because the details of his composition must always have been difficult to read—Correggio was more interested in the bold, overall effect than the precise rendition of any single figure—it was rumored that his patrons were dissatisfied with the work. However, admiring remarks from contemporary visitors—including Queen Christina of Sweden, who would not believe that the balustrade around the base of the dome was a fiction until she went to see for herself—indicate that he may merely have sought a rest after having completed such a demanding commission.

Parmigianino and Self-Conscious Artifice

In Correggio's absence, a young native painter trained by his printmaker father and uncles returned to Parma from Rome, having established himself as the darling of the cultural elite. While in his teens, Parmigianino (Girolamo

Francesco Maria Mazzola; 1503 Parma-1540 Casalmaggiore) had worked alongside Correggio. Later at the papal court he acquired an international reputation and cosmopolitan sophistication. Hailed upon his arrival in Rome in 1524 as a new Raphael, he was young, intelligent, and suave, both in personal manner and in his work, epitomizing the courtly ideal of an artist. His self-portrait, which he painted as a demonstration piece just before going to Rome, documents his extraordinary skill at rendering elegantly distorted appearances (Fig. 19.7). Intriguingly, the work is both a transcription of what he saw of himself in a small convex mirror and a careful meditation on its distending effects. It is painted on a small disk of turned wood physically mimicking contemporary mirrors, and indeed, Parimigianino's own hand dominates the foreground, where it appears elongated and boneless, the remarkable tool of his creative intellect. His lovely, almost childlike countenance, the source of his effortless art, looks out at the viewer from the center of the composition surrounded

by an aureole of light, naturally explicable as illumination reflected from the window on the left of the painting but also clearly contrived to underscore his divine talent. The room in which he sits swirls around him, but he remains still and calm, the utter master of his art and environment. No artist had ever before created such a cerebral and self-celebratory self-portrait, clear evidence of why he enjoyed such success in papal Rome.

Parmigianino's brilliant career in Rome was cut short by the city's infamous Sack in 1527. Initially retreating to Bologna, he returned to Parma in 1530, where he received a commission to decorate the vaults and main apse of a new, centrally planned church dedicated to the Virgin, the Madonna della Steccata (Fig. 19.8). This project gave him the opportunity to refine Correggio's illusionistic effects and promote an even more elegant and graceful style which allied his patrons with the most sophisticated developments in contemporary Roman art. Clearly Parmigianino's experiences away from home allowed him to provide his

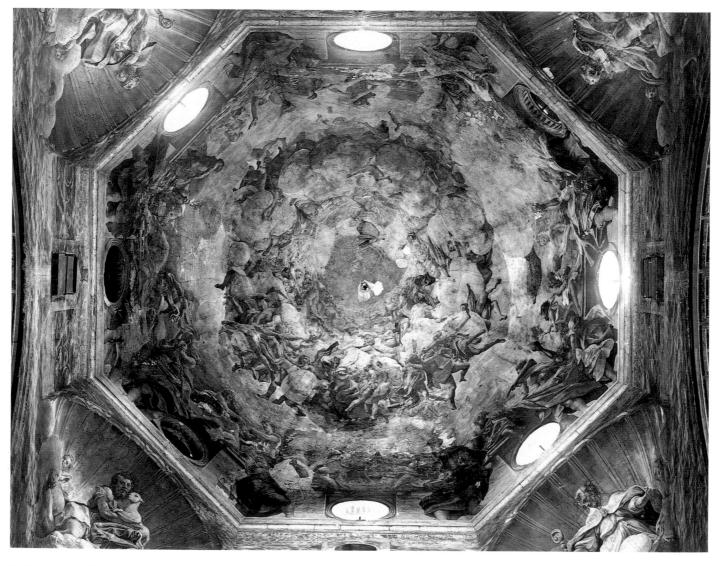

19.6 Assumption of the Virgin, 1522-30, Correggio, Parma Cathedral. Fresco, diameter c. 36' (11 m)

19.7 Self-Portrait in a Mirror, 1524, **Parmigianino**. Oil on panel, diameter 9% (25 cm)

(Kunsthistorisches Museum, Vienna)

patrons with an artful cosmopolitan style not available locally. Parmigianino transformed the broad barrel vault in front of the main apse into a sumptuous gilt, blue, and red field which seems to be bounded by protruding arches overlaid with interlacing gilt strapwork. Only the bosses at the center of the coffers are actually threedimensional; every other figure, niche, and decorative detail is a fiction. The three female figures performing a balletic balancing act on a fictive ledge carry empty lamps which characterize them as the unprepared Foolish Virgins of one of Christ's parables; their wise, mirror-image counterparts appear on the opposite side of the vault. While there are some stylistic affinities with the art of Correggio in these paintings, the elongated figures with their attenuated extremities, the graceful, lyrical poses (the Foolish Virgin on the left being a quotation from The Fire in the Borgo by Raphael [see Fig. 18.31]), and the incipient eroticism of both male and female figures align this commission with aspects of Mannerist style not seen in the earlier painter.

Parmigianino's art offered the Parmesan aristocracy

extraordinary opportunities for self-promotion. In his portrait of Gian Galeazzo Sanvitale, Count of Fontanellato (Fig. 19.9), whose villa Parmigianino brightened with inspired variations on Correggio's frescoes in the Camera di San Paolo, the sitter's self-confidence is extraordinary. The count stares out at the viewer, calmly daring anyone to challenge his innate physical and intellectual superiority. In his right hand he displays a bronze medal marked with the mysterious ciphers "7" and "2," which must have had significance for him and his close circle of friends, but whose inscrutability serves to distance him from the rest of humanity. Even so, the portrait is engaging;

19.8 Three Foolish Virgins Flanked by Moses and Adam, 1531-39, commissioned by the Confraternity of the Madonna della Steccata from **Parmigianino** for the vault in front of the main apse, Madonna della Steccata, Parma. Fresco

the count's helmet, mace, and costume, along with his masterly coordination of the simple background with the figure in front of it, fully embody Castiglione's courtly value of sprezzatura (confident but relaxed grace and ease), typified by the very graceful left hand on the arm of the chair. At the same time there are some deliberately uncomfortable aspects of the depiction that call attention to the artificiality of the whole portrait enterprise. Not the least among these was Sanvitale's frozen stare, so at odds with the apparent naturalism of the depiction and the setting; there is little way to enter into relaxed ongo-

Parmigianino's artful arrangement of

ing conversation with someone appearing so fixed in time. Moreover, Sanvitale's body, though hidden in his heavy clothing, must be twisted in a most uncomfortable pose since the chair in which he is apparently seated is placed perpendicular to the picture plane (if the arm is any indication) while his face is parallel to the surface of the painting. There is nothing natural about this pose.

Exquisitely contrived beauty also rendered power to Parmigianino's religious paintings, their refinement employed as a metaphor for the perfection of God and the saints. One of his most famous religious paintings and an

19.9 Gian Galeazzo Sanvitale, Count of Fontanellato, 1524, commissioned by Gian Galeazzo Sanvitale from Parmigianino. Oil on panel, 43 × 31¾" (109 × 81 cm) (Museo Nazionale, Pinacoteca, Naples)

outstanding example of Mannerism is the altarpiece known as the Madonna of the Long Neck (Fig. 19.10). Commissioned by the noblewoman Elena Baiardi for her family chapel in the church of Santa Maria dei Servi in Parma, the painting takes its subject from a simile in medieval hymns to the Virgin which likened her neck to a great ivory tower or column. Appropriate to the traditional understanding of the Virgin as an allegorical representation of the Church, this imagery was also exploited in poems penned by Andrea Baiardi, the patron's father. Consciousness of such recondite medieval literary conceits pervaded courtly circles. Thus the exaggerated length of the limbs of the Virgin and her son, as well as the presence of columns in the background of the painting, are not contrived merely for their decorative value, but clearly signal the painting's religious meaning. Similarly, the Virgin's engorged nipples need to be understood as emblems of her ability to nourish the faithful. When Vasari saw the painting in the mid-sixteenth century he noted another religious emblem in it: a cross, now barely visible, on the vase that one of the angels offers to the Madonna and Child, indicative of Christ's fate as sacrifice and spiritual food for humanity.

Admittedly, Parmigianino's expression of these religious concepts is so refined and contrived that both the uneducated worshiper of his own day and the modern, secular viewer could easily mistake his intentions. Because there is hardly an element in the painting that faithfully reproduces nature, the viewer is constantly required to question the artist's decisions, to comment on his skill, and to recognize that the subject of the painting is as much the craft of painting and the artist's intellectual agility as it is a Madonna and Child. Typical of courtly styles in this period, the shift in scale is so great that there is no way to move from foreground to background in the painting. The five angels at the left are compacted into a space so constricted that one cannot imagine how their bodies fit into it. The Madonna is much larger than any other figure in the painting; her proportions are distended unnaturally and her hands and head have been elongated to emphasize their elegance. At the same time, the perfect oval of the Virgin's head is crowned with a complicated hair style reminiscent

19.10 Madonna of the Long Neck, begun 1534, commissioned by Elena Baiardi from Parmigianino for the Baiardi Chapel, Santa Maria dei Servi, Parma. Oil on panel, 85 × 52" (216 × 132 cm) (Galleria degli Uffizi,

The painting was left unfinished in 1540, accounting for some of its visual peculiarities, including numerous column bases and shadows but only a single distinct column in the background, and a disembodied foot next to the prophet at the lower right of the frame.

of some figures in Leonardo drawings—a reminder that, regardless of its distortions of form, Parmigianino's art drew considerable inspiration from older masters.

Elements of overt sensuality belie the commission of this work as an altarpiece. The Virgin's right hand moves caressingly over her breast, which is revealed by a wet drapery technique borrowed from antique sculpture. Sliding along the left side of the painting is a smooth, long leg whose sensuous nudity is emphasized by the big toe of the Christ Child which presses suggestively against it. It is easy to understand how the metaphor linking artificial and elegant physical grace to a spiritual state of grace could be lost in the sheer artfulness and sensual beauty of the painting.

Genoa: A Princely Republic

Genoa suddenly emerged as a major center of courtly patronage in the late 1520s. Nominally a republic, this great maritime center on the northern coast of the Ligurian sea had always been dominated by powerful clans of nobles. Now Andrea Doria (1466-1560), an extraordinarily talented naval commander from an impoverished branch of an ancient local family, catapulted himself and the city into the international arena. By commanding impressive fleets and driving hard bargains for compensation with King Francis I of France, Pope Clement VII, and Emperor Charles V, he succeeded in enriching himself and reestablishing Genoese independence after protracted domination by the French. Charles V admitted him to the prestigious imperial Order of the Golden Fleece, and his fellow citizens named him Prince ("Principe") and Father of the Homeland ("Pater Patriae"). He and Genoa's oldest noble families set to refashioning their city-still markedly medieval in its dense urban fabric and precipitously narrow streets-to reflect the city's reemergence as a major player in Italian and international politics.

Doria Portraits

Doria's commanding presence and indefatigable will-he lived to the remarkable age of 94-is ably captured in a portrait by Sebastiano del Piombo, produced in Rome for Doria's employer Pope Clement VII (Fig. 19.11). This is a man of conspicuous determination whose grasp on the control of Genoa was singularly fierce. When, for example, the rival Fieschi family conspired to overthrow him in 1547, he had the clan obliterated. Dressed in black, Doria stares coldly at the viewer, staccato light catching prickly white stubble on the right side of his face. Shadows mask his features-and full intentions-on the left, leading the viewer's eye down to the half round shadow of his head on the back wall and his imperious, gesticulating right hand below. All that is calm and reserved in Raphael's similarly monochromatic portrait of Baldassare Castiglione (see Fig. 18.29) is charged here with ominous drama. While scholars have succeeded in identifying the actual Roman relief on which Sebastiano based the naval motifs to which Doria is pointing, their hieroglyphic meaning remains obscure, adding to the powerful allure of this portrayal.

Doria's self-assured virility—not to mention his position as commander of the imperial navy—allowed him to identify easily with Neptune, the ancient god of the sea. Soon after he liberated the city from the French in 1528, city fathers (presumably with Doria's blessing) commissioned an overlife-sized marble statue of him as Neptune from the Florentine sculptor Baccio Bandinelli (Fig. 19.12). This, the first Renaissance portrayal of a contemporary ruler as a nude Roman god, presented Doria as the pacific (peaceful) Neptune astride two dolphins who spout water into the antique-imitation basin below. The classicizing image is alert and vigilant, a bearded counterpart to Michelangelo's Florentine David (see Fig. 17.1), whose stance and bearing Bandinelli clearly emulated. Like David, Doria was to be seen as the city's liberator and a man of the people—a useful conceit for a "prince" in a city claiming to be a republic.

19.11 *Andrea Doria*, 1526, commissioned by Pope Clement VII from **Sebastiano del Piombo**. Oil on panel, $5' \times 3'$ 6" (1.53 × 1.07 m) (Palazzo del Principe, Genoa)

19.12 Andrea Doria as Neptune, 1528-29 and 1537-38, commissioned by the Signoria of Genoa from Baccio Bandinelli for a city square. Marble (Piazza del Duomo, Carrara)

Villa Doria

Befitting his unique status in Genoa, Doria built himself a splendid seaside villa just outside the city's western gate (Fig. 19.13). An inscription on its façade claimed it was his "retirement" home, but here he hosted dignitaries for months at a time and acted—away from the formal halls of government within the city-the effective lord of Genoa. The site afforded superb views of the city and its harbor, opening onto vistas like ancient Roman country villas and the villas of contemporary would-be princes (see Fig. 11.46).

The Villa Doria also resembled Roman suburban retreats like Agostino Chigi's villa in Rome (see Fig. 18.34) in its general form, incorporation of loggias, and the surrounding gardens. The importance of gardens is suggested by the formidable effort needed to carve terraces from the promontory against which the villa is situated. On the southern, seaward side, a three-armed portico reaches out to a terrace on which stood a fountain featuring an overlife-sized stucco version of Doria as Neptune (the statue visible in Fig. 19.13 is a permanent replacement carved in 1599). Divine imagery was as at home in his villa as in the public square. Doria entrusted the design and decoration of much of this complex to Perino del Vaga (Pietro di Giovanni Buonaccorsi; 1501 Florence-1547 Rome), one of Raphael's students, who, like Bandinelli, escaped papal Rome during its fateful sack by imperial troops in 1527. Perino's common artistic roots with Giulio Romano, another of Raphael's talented pupils, is evident in the designs he made for the street-side façade of the Villa Doria (Fig. 19.14). As Giulio had done at the Palazzo del Tè for Federigo Gonzaga in Mantua (see Fig. 19.3), Perino conceived of the façade as a field for architectural and decorative fantasies. Befitting the "rustic" setting of a villa, both designers employed what look like large rusticated blocks

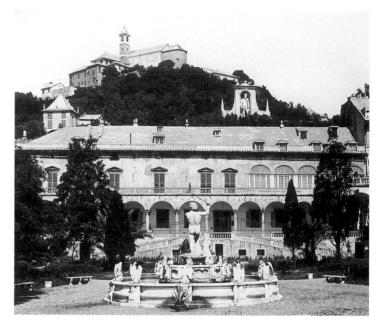

19.13 Villa Doria (now called Palazzo del Principe), Genoa, 1521-33, commissioned by Andrea Doria from Perino del Vaga and others

19.14 Design for the north façade of the Villa Doria (Palazzo del Principe), Genoa, c. 1532, commissioned by Andrea Doria from Perino del Vaga. Ink drawing on paper, $11\% \times 14\%''$ (29.4 × 36.2 cm) (Rijksmuseum, Amsterdam)

19.15 Fall of the Giants, c. 1530, commissioned by Andrea Doria from Perino del Vaga for the Salone dei Giganti, Villa Doria (Palazzo del Principe), Genoa. Fresco

Perino was responsible for the entire decoration of the room, which included very large and elaborate fireplaces built according to his designs.

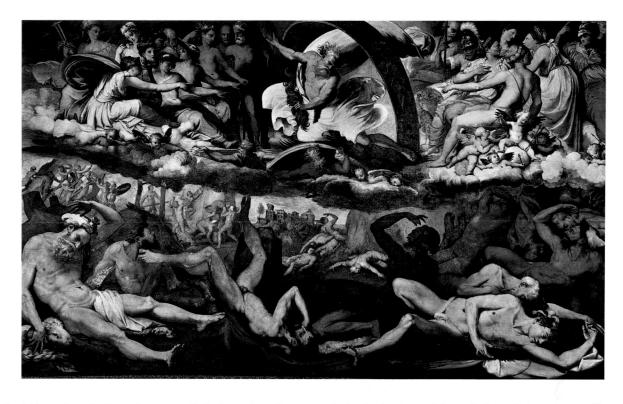

of stone, even imbedding the shafts of some of their columns in stacked blocks of stone—though Perino's façade depicted in the drawing is likely to have been executed almost entirely in illusionistic fresco. Perino's basic attitude toward antique motifs is also very different from Giulio's. Giulio tended toward the grandiloquent and sometimes even melodramatic, especially at Federigo's pleasure palace, where he intended to entertain and delight. For Doria's more stately civic villa, on the other hand, Perino developed the elegant side of both Raphael and Michelangelo. The clearly composed scenes of Furius Camillus expelling the Gauls from Rome (a clear reference to Doria's having driven the French from Genoa) recall Raphael's narrative genius, while the paired nudes reclining above the pedimented windows derive from the ignudi on the Sistine Ceiling (see Fig. 18.12). Inside the villa, further allegories and scenes from antiquity thinly veiled Doria's autobiographical intents. His ancestors appear in Roman military garb on the upper loggia, reestablishing his distinguished lineage, while in the main reception hall Perino crowned the splendidly appointed room-hung with gold and silver tapestries illustrating the loves of Jupiter-with a representation of the Fall of the Giants (Fig. 19.15). Once again the contrast with Giulio Romano's rendition of the same theme (see Fig. 19.2), is dramatic. Perino, like Parmigianino, seized upon the artificial beauty of Raphael's art, arranging the Olympian gods at the top of the panel in a semicircle recalling the form of the Vatican Disputà and the relaxed grace of the Parnassus (see Figs. 18.22 and 18.23). At the center Jupiter swings through the blue ring of the zodiac like God the Father in Michelangelo's Creation of Sun, Moon and Planets (see Fig. 18.17). He is supported by an eagle that is fortuitously both the imperial symbol, and thus a compliment to Emperor Charles V, and a reference to Charles's commander Doria, whose family emblem was the eagle. The indecorously posed, yet elegantly distributed, bodies of the giants in the lower half of the composition display Perino's knowledge of anatomy and lighting effects. At the far left appears a lamb's head and fleece, yet another Dorian reference, in this case to the Order of the Golden Fleece, whose legend had it that the fleece was stolen by one of the giants.

In this suburban retreat Roman conventions of figural form (used also by Parmigianino in Parma) were transported from a center of their inception to a site where they also had resonance as artful, aristocratic, stylish manifestations of an elite culture. Thus Perino's figures are posed in complicated contorted positions whose gracefully arranged limbs seem inappropriate for the violence of a fall from a great height. Shifts in scale create an inconsistent space in the painting and the obsessive gesturing of the figures calls attention to their hands (and to Perino's "hand"), especially in their completely artificial arrangement of spidery fingers. Genoa might be a republic, but Doria clothed himself with the visual language of a princely aristocracy.

Genoa in the Second Half of the Sixteenth Century

Doria's wholesale adoption of Roman artists and artistic models initiated a period of remarkable creativity in Genoa that was to endure well into the seventeenth century. In his *Palazzi Moderni di Genova (Modern Palaces of Genoa*, 1622) Peter Paul Rubens extolled the city as one of the most spectacular urban ensembles in Europe. He was particularly

impressed with the Strada Nuova ("new" street, Figs. 19.16 and 19.17) and published engravings of its grand residential structures as well as many of the city's churches. Laid out for a select group of "old" noble families whose status was being challenged by newer clans around 1550, the street was promoted by them as a civic rather than a private project. Profits from the sale of lots were shared with the cathedral. Still, only a few noble families benefited from the construction, and others—notably the Franciscans, who found the city brothel relocated near their doorstep—definitely suffered. Urban renewal has always had its problems.

Built up against a hill on what was then the edge of the city, the Strada Nuova is not technically a *strada* (street). It was never meant to be a thoroughfare but a modernized version of a traditional Genoese *albergo* (extended family compound). The latter was entered at one end from a small existing piazza and, ending at a garden wall, it was a closed space primarily intended for friends and relatives of the very exclusive group of families who lived there. One scholar has usefully described the Strada Nuova as a "street piazza," reflecting its function as a gathering space as well as a communication route.

In its initial stages, the street was also notable for its bilateral symmetry. The first six buildings on the street function as pairs: their main portals are located directly

19.16 Strada Nuova (now Via Garibaldi), Genoa, initiated 1550, construction begun 1558, commissioned by the city government and noble families of Genoa perhaps from Galeazzo Alessi

Some of the buildings on the far end of the street date from as late as the eighteenth century.

opposite one another, and they are grouped by size. The first two are the shortest and narrowest on the street, the next were the same height but wider than the first (renovations and additions have subsequently altered their proportions), and the third were as wide as the second but taller yet. Given the effects of perspective diminution, reinforced by the substantial length and straightness of the street, the distinctions would have blurred somewhat, contributing to the sense of an organized and coherent program. Each clan adopted its own general scheme for its façades-a rustic and highly sculptural Doric mode for the Pallavicino palaces, flat frescoed blocks for the Spinola, for example. Familial ties and loyalties overruled strict symmetry. The interiors of the palaces on the Strada Nuova are particularly distinctive insofar as they had to accommodate the steeply sloping site along which they were built. Those on the city side of the street required the construction of vast underpinnings to elevate terraces and viewing loggias; those on the hillside required just the opposite: complex engineering to move up the hill in elegant, broad stages. The expense and difficulty of their construction, the sheer amplitude and splendor of their spaces and interior furnishings, and the glorious vistas and gardens made these residences the epitome of aristocratic urban life for generations to come, an urban theatre for the aristocracy.

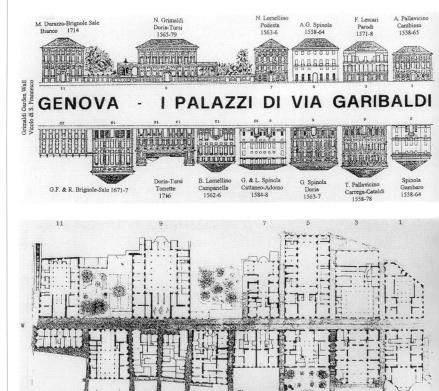

10 8

19.17 Strada Nuova, Genoa, plan

Florence: Mannerism and the Medici

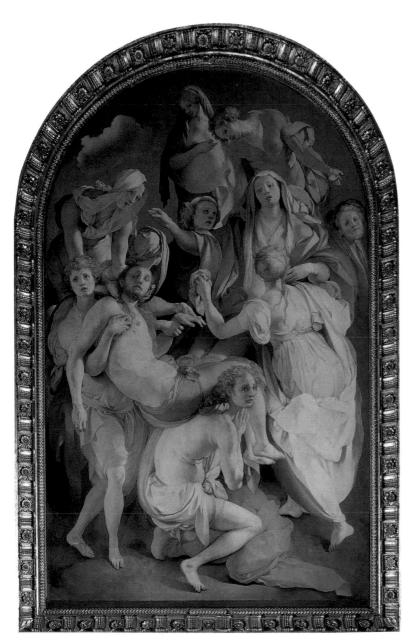

Discussions of Mannerism are now among the most contentious in the history of Renaissance art, with some even denying the existence of such a stylistic category. Others would see a clearly definable style based on grace and artificiality which emerged in the middle of the second decade of the sixteenth century. As is usually the case, there is reason on both sides of the issue with part of the

difference of opinion depending on how one defines the question and the parameters of the discussion. We have been arguing that patronage, site, typology, and personal artistic predilections are all determinants and components of style and that at any given period there may be varieties of styles at work simultaneously. Thus, if Mannerism exists as a style in the sixteenth century, it would be foolish to think of it as consistent or uniform over time and in many different places, since we have not found such monolithic consistency in fourteenth-, or fifteenth-, or early sixteenth-century art, even in individual cities. Like "Renaissance," the term "Mannerism," based on the Italian maniera for "manner" or "style," implies a singular stylistic and already sets the debate on a particular course that should be queried. Of course, a reconstruction of history that recognizes different concurrent styles plays havoc with the convenient but simplistic notion of period style that books like this are supposed to validate, but which now seems far too constraining for reading the history of the Renaissance or of any other time period.

Discussions of Mannerism usually begin with Florence, in large part because of early evidence of fissures in a classicizing style that had characterized a good deal, but not all, of Italian art at the beginning of the sixteenth century. Art historians are in general agreement that this art underwent notable changes in the second and third decades of the sixteenth century, but there is no consensus about the causes for these changes—about how they are to be interpreted, or if they are consistent enough from one artistic center to another to allow describing them as a discrete style.

Numbers of contradictory questions have been raised about the origins and nature of what is called Mannerism. Were artists rebelling against established conventions, especially the relatively restrictive formal aspects of classicism? Or were they simply extending

prior ideas? Should certain shifts in style be read as "anti-classical"? Or were these changes essentially "non-classical"? Was there a loss of artistic talent, ambition, and new

(above) *Entombment*, 1525–8, commissioned by Ludovico di Gino Capponi from **Jacopo Pontormo**, Barbadori-Capponi Chapel, Santa Felicita, Florence. Oil on panel, 10′ 3″ × 6′ 3″ (3.13 × 1.92 m)

insights that caused serious shifts or aberrations in established styles? In this regard the death of Leonardo (1519) and Raphael (1520) or the artistic diaspora caused by the Sack of Rome in 1527 are often cited. Does this art reflect troubled and changing times or is it primarily the vision of neurotic and troubled individuals? Is this art essentially secular and non- or even anti-religious, or does it arise from and depict deeply spiritual concerns given the challenges of the Protestant Reformation? Is it the result of a newly refined court culture (throughout Europe and not just in Italy) searching for an appropriate visual language to define its place in the world? All these questions and others like them testify to the fascinating and often contradictory nature of this art-a visual record that demands and rewards detailed and open discussion, taking into account arguments from conflicting points of view.

Emerging Transformations of the Classical Style

Some of the more obvious stylistic aspects of what is commonly understood as Mannerism can be discerned rather quickly by comparing two paintings: the Madonna of the Harpies (Fig. 20.1) by Andrea del Sarto (Andrea d'Agnolo; 1486 Florence-1530 Florence) and the Visdomini Altarpiece (Fig. 20.2) by Jacopo Pontormo (Jacopo Carucci; 1494 Pontormo-1557 Florence). They were both important commissions painted within a year of one another in the same city and represent the same subject matter of a Madonna and Child enthroned and flanked by saints, making their comparison particularly telling. Andrea probably trained with the quirky painter Piero di Cosimo, though his works reveal the varied influences of Leonardo, Raphael, Michelangelo, and Fra Bartolomeo. Pontormo was Andrea's student (and may also have studied with Leonardo), but his painting deviates noticeably from the classicizing ideals that Andrea had helped to establish as a norm in Florence and which he practiced virtually all of his life. In Andrea's Madonna of the Harpies, the simple sacra conversazione is set within a severe architecture broken only by the harpiesmythological creatures guarding the underworld-at the corners of the Virgin's pedestal. The niche behind the Virgin is shadowed to suggest depth. St. Francis looks out at the left and St. John the Evangelist at the right. Each figure stands in a pose that suggests imminent movement, while at the same time the figures are given stability by the architecture behind them. The gravitas of the figures echoes classical rhetorical dicta for self-presentation in matters of serious import. The bright, fully saturated primary colors of the drapery of the Virgin provide a dramatic focus on the main figures of the painting, while the opposing figures at either side are linked to the central figures through an implied compositional rhombus extending from the head of Mary to the heads of the two saints and then down along

the arms of the saints to the pedestal, locking the figures into an overall compositional structure, even though each figure retains a spatial independence. This union or balancing of opposites can be seen in Fra Bartolommeo's *St. Anne Altarpiece* (see Fig. 17.5) and in many of the paintings of this time in Florence.

In the Visdomini Altarpiece Pontormo flattened the space that Andrea had gone to such careful lengths to form in the Madonna of the Harpies. Its shallowness is emphasized by his deployment of the figures across the picture plane. There is no overlap to suggest spatial recession, but, rather, a vertical space with figures appearing to be above rather than behind one another in the composition. If the kneeling St. Francis at the right were to stand, he would be considerably taller than the figure next to him-a drastic inconsistency of scale that ruptures any realism of form that one might encounter in the painting. None of the figures seems to focus within the composition. While a viewer looks in toward the figures, they look outward in different directions, scattering any possible unified connection to them. Yet Pontormo simultaneously indicated that he knew the "rules" of good painting. The Virgin is on a central axis and the figures create a carefully structured and stable diamond shape in the center of the composition (although there is nothing at the center of that shape). Almost as a jest, the small putti and the child Jesus and John the Baptist playfully betray some knowledge of contrapposto figural structure, the figures twisting to

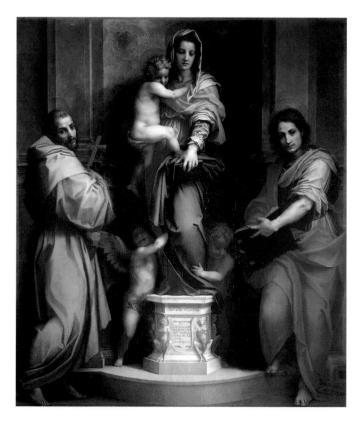

20.1 *Madonna of the Harpies*, 1517, commissioned from **Andrea del Sarto** for the high altar of San Francesco, Florence. Oil on panel, 6' 9½" \times 5' 10" (2.07 \times 1.78 m) (Galleria degli Uffizi, Florence)

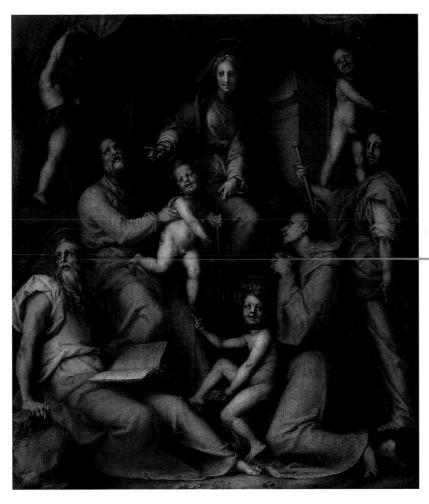

20.2 *Visdomini Altarpiece*, 1518, commissioned by Francesco di Giovanni Pucci from **Jacopo Pontormo** for San Michele in Visdomini, Florence. Oil on paper, $7' \times 6'$ 1" $(2.13 \times 1.85 \text{ m})$

suggest a hollow created by the positions of their arms. By contrast all the adult male figures are flattened, with areas of possible spatial recession and volume—such as overlapping legs or twisting shoulders—deliberately suppressed by drapery or impenetrable shadow. All of these formal elements in Pontormo's *Visdomini Altarpiece* are too consistent and too much a part of a unified presentation to be the mistakes of a young painter, or the serendipitous manipulation of form by a willful artist (nor by a mad-man, as Pontormo is sometimes portrayed—especially late in his career).

The stylistic properties evident in Pontormo's *Visdomini Altarpiece* could be read simply as attempts by one of a new generation of painters to distinguish and to distance himself from the rules of contemporary classicism. Thus this would be an example of "anti-classicism," as it was referred to early in the twentieth century, or a deliberate breaking of the rules of balance, proportion, and focused order. Such an anti-classicism, if that is what it really is, must be understood in terms of artistic practice of the early sixteenth century in Florence and not as a denial of the art of classical antiquity, however; Pontormo seems to be quoting the head of the antique statue *Laocoön* (see Fig. 40) in the figure

second from the left, thus maintaining definitive references to ancient art which is, itself, extremely varied in form. So "anti-classicism" as a descriptive term raises as many questions as it answers.

Another interpretation would then call attention to the willful self-consciousness evident in Pontormo's art. In looking at his Visdomini Altarpiece a viewer can become as interested in the artist's manipulation of forms and in his inverting accepted rules in a subject matter that is, after all, still devotional. The oddities of the painting end up being a demonstration of the artist's presence, emphasizing artifice at the expense of a clear reading of the subject matter of the painting, again a change from the classical style. This may be rebellion, but it could just as easily be a demonstration of skill, not unlike Michelangelo's carefully posed figures in the Battle of Cascina of 1504 (see Fig. 17.7) or even Mantegna's quite artificial display of his classical learning and control of an antique style in his 1470s print of the Battle of the Sea Gods (see Fig. 36). This mannered self-conscious style, calling attention to the hand of the artist's action in the painting, provides a source for the term maniera whose root word in Italian is the same as hand (mano). At the same time, such an assessment also raises questions insofar as it places the development of style squarely within the personal peculiarities of the artist, in this case a young man seeking to find a way for himself outside the rules

of form laid down by his elders—men of such daunting genius as Leonardo and such painterly brilliance as Pontormo's own teacher, Andrea del Sarto. This position resonates with Vasari's construction of art history based on the lives of the artists and in our own modern fascination with the psyche and individual genius of artists. Yet it ignores both the patron for whom the painting was made and the audience for whom it was intended, although the issue of intentionality implied by such a statement, it must be admitted, is one of the more vexing issues of artistic interpretation.

A New Social Order

If we consider the patronage—or more extensively, the social context—in which the young Pontormo worked, it is clear that it differed markedly from the environment in which Andrea del Sarto had matured as an artist. The Medici had returned to power in Florence in 1512. Even with French support, the new Florentine Republic was unable to withstand the combined opposition of the papacy and its allies who supported the Medici. A Spanish army forced the Republic to submit to Medici rule, first to Piero the Unfortunate's brother Giuliano and then, a year later, to his son Lorenzo. The Medici quickly realized that they had to

overcome the very powerful and successful visual propaganda that the Republic had initiated. And, with a clear understanding of the new political order, the Signoria (now stacked with Medici partisans) revoked all laws passed since the Medici expulsion in 1494 and aborted the outstanding artistic commissions that had been undertaken by the Republic, most notably the projects undertaken for the Hall of the Great Council (see Figs. 17.4–17.7). In fact, in that instance, the Medici ordered that the elaborately carved and very expensive wooden benches already made for the new council Hall be burned—a dramatic attempt to erase the memory of the recent Republic.

The Medici's position in the city was guaranteed when Giovanni de' Medici, the second son of Lorenzo the Magnificent, became pope in 1513. As Leo X, he brought the full weight (and wealth) of the papacy to bear upon his family's control of Florence. When Lorenzo the Magnificent's son, Giuliano, married into the French royal house in 1515 and was given the title of the duke of Nemours by Francis I, and when Piero the Unfortunate's son, Lorenzo, also married French royalty, the linkage of French and papal power assured Medici strength in the Florentine state. The merchant-banker status of the family had definitively been transformed, and with it their concept of political control of the city. Florence was on its way to being a court culture, despite ongoing sentiments of republicanism among its older families. A new visual language had to be found that would not only provide appropriate imagery for this new social order, but would also have to be distinguishable from the stylistic language used by the Republic. While artists may have begun to experiment with new modes of expression out of purely personal or formal concerns, questioning older art or seeing new possibilities within it, their innovations could always be harnessed to new social and political ends. We have no evidence that patrons in Florence willed a new style into existence after 1512-as had been the case with Abbot Suger and the creation of the Gothic architectural style in France, for example-but they did establish a new socio-political context in which deeply imaginative artists could experiment with stylistic innovation.

Moreover the Medici and their artists had a sophisticated idea of how style could connote social order and political history, and, thus, they supported stylistic attributes that were meant to be in opposition to the visual language of the renewed Republic between 1494 and 1512. The Medici had to move very cautiously in the first years of their return, but their awareness of the emotional power over the public imagination of earlier commissions like Michelangelo's *David* was evident in their response to the suggestion by Baccio Bandinelli (Bartolomeo Bandinelli; 1493 Gaiole in Chianti–1560 Florence) that they replace Donatello's bronze *David* (see Fig. 11.21) with a new sculpture of the same subject for the courtyard of the Medici Palace. Donatello's figure had been taken by the Signoria to the

courtyard of the Palazzo della Signoria from the Medici Palace in 1495. There it became a symbol for the Republic's victory over Medici tyranny and thus a loaded political image. Cardinal Giulio de' Medici, the illegitimate son of Giuliano de' Medici (who had been assassinated in the Pazzi Conspiracy of 1478), refused the suggestion of a David, clearly understanding that replacing such a loaded political image in the family palace could only be read as an affront to a still viable current of republicanism in the city, a provocation that they could little afford.

Instead Giulio commissioned an Orpheus (see Fig. 11.12) for the courtyard from Bandinelli, then in his early twenties and the son of a goldsmith in the Medici employ, thus giving him an opening wedge into the Medici household where he became essentially the house sculptor. Given the interest in music of Pope Leo X, the family's most eminent member, Orpheus, a demi-god known for his playing of the lyre, was a reasonable choice of subject especially since his return from the Underworld also served as a fitting metaphor for Medici return to power. Also Orpheus could not be associated with earlier public sculpture, so the Medici could not be accused of placing a civic image within their private dwelling. The Orpheus was, however, modeled on the Apollo Belvedere, then one of the focal points of the papal collections of antique sculpture, making it both an appropriate reference to Pope Leo X, the head of the family, and to the Medici history of collecting antiquities. Its convincing imitation of antique style also made the statue a strong statement of the young Bandinelli's abilities as a carver, equating him with the greatest artists of the classical past and, not inconsequentially, equating Leo with the ancient rulers who patronized those sculptors. Although Bandinelli was later to copy the Laocoön (see Fig. 40), it is significant that in this case he chose a very different stylistic model: the elegant, graceful, and sensual Apollo Belvedere. In other words he chose a model far removed from Michelangelo's last commission from the Republic, the St. Matthew (see Fig. 17.2), but one having the same sleek stylistic sensibility as Donatello's bronze David. Thus the Medici could have a statue in their courtyard that at a quick glance was quite new, both in terms of its classical quotation and its subject matter, but that clearly referenced the David stylistically as a part of family history.

The power of artistic style to be charged with political significance is nowhere more clearly evident than in the commission for a Hercules and Cacus group to pair with Michelangelo's *David* on the other side of the main portal of the town hall. Originally the commission for this colossal statue had been given by the *gonfaloniere* of the Republic to Michelangelo in 1508, thus making overt the Hercules iconography that Michelangelo had so carefully built into his earlier figure. The block from which the statue was to be carved was not delivered until 1525, however. At that time the Medici assumed the commission and gave it to Bandinelli rather than Michelangelo, even though

Michelangelo was then in their employ. When the Medici family fell from power briefly between 1527 and 1530, Michelangelo was once more asked by the renewed republican government to take over the carving of the stone. During this time Bandinelli traveled to Genoa to work for Andrea Doria (see Fig. 19.12), giving clear indication that he was so closely associated with the Medici family that it would have been unwise—not to say unprofitable—to remain in Florence. But when the Medici returned to power in 1530 they returned the project to Bandinelli.

Hercules and Cacus (Fig. 20.3), the first major work of Medici visual propaganda after their return, was put in place in 1534 to the right side of the door of the Palazzo della Signoria. Indebted to extant, colossal ancient Roman sculpture such as the Horse Tamers in Rome, Bandinelli's Hercules seems to claim both an ancient precedent of greatness and imperial patronage. When Benvenuto Cellini referred to the Hercules and Cacus as a "bag of melons" he began a tradition of pejorative criticism of Bandinelli's work that has lasted uncritically until the present. Yet with his Orpheus Bandinelli had proved that he was capable of carving an elegant classicizing figure comparable to anything that antiquity then had to offer. So the somewhat overblown stylistics of the Hercules and Cacus must be seen as a deliberate choice on Bandinelli's part to carry explicit meaning for the work. Carving the work as he was for the Medici, and in direct opposition to Michelangelo and the existing republican David (see Fig. 17.1) at the site, Bandinelli had little other option but to choose a style for his statue that was as different from the David as he could imagine. Thus the Hercules is stilled, with both of the hero's feet firmly planted on the ground whereas that of the David, despite its frontality, implies a slow graceful movement by the raised left foot and turn of the head.

The shifting back and forth of this commission between Michelangelo and Bandinelli—between the Republic and the Medici—marks the political fortunes of the city, the role that art played in reinforcing the dominant political order, and the association of individual artists with particular power structures in the city. Bandinelli's *Orpheus* and his *Hercules and Cacus* indicate that artists and patrons—and viewers—were aware of the political and symbolic value of style as a form of public discourse.

On the other hand, Mannerism could not and perhaps never was intended to appeal to the general populace. It could impress generally by its complexity or sheer physical beauty, but it did not speak directly or simply. Often it may have seemed confusing or incomprehensible to all but the most sophisticated viewers—not unlike Botticelli's mythological paintings of the previous century (see Figs. 11.41 and 11.42), also produced for a discerning, classically trained audience. An elite style, it derived much of its attraction from being clever and elegant or making learned allusions to other works of art and recondite literature. It also came in many forms: rather severe and even forbidding in many public

20.3 Hercules and Cacus, 1525–34, commissioned by the Medici from **Baccio Bandinelli** for the Piazza della Signoria, Florence. Marble, height 16′ 3″ (4.96 m)

commissions, more relaxed and playful in private and domestic spheres, wilder and sometimes shocking in its earliest Florentine manifestations, irreverent in some of its courtly appearances, and hyper-elegant and refined in others. Whatever its form, it was always visually intriguing and well-suited to manipulation and exploitation by wily patrons.

Domestic and Villa Decoration

When Piero Francesco Borgherini married Margherita Acciaiuoli in 1515, his father commissioned a series of small panels depicting the life of Joseph from the Old Testament from a number of Florentine artists, including Andrea del Sarto and Pontormo. They were to decorate the couple's bedroom. Although the subject matter of a young boy sold into slavery by his brothers seems curious for wedding paintings, they were apparently treasured by the Borgherini couple, for, according to Vasari, when an agent

came to remove the paintings during Borgherini's enforced political absence, Margherita refused to give them up and rudely turned the agent out of her home. Pontormo's Joseph in Egypt (Fig. 20.4) depicts a standing Joseph at the far left in the role of Pharaoh's governor with his brothers approaching him, the latter not knowing that he is the person whom they had years earlier sold into slavery. The episodic narrative is one of revelation, recognition, and reconciliation, with Joseph's youngest brother revealing to their father at the upper right that his son, whom he had thought dead, was not only alive but successful and would save them from the famine that gripped Israel. As in Pontormo's Visdomini Altarpiece, the space is fragmented (as is the narrative) and discontinuous so that it is unclear how any of the actors in the frontal plane of the composition could possibly move into the mid-ground where figures huddle behind strange and inexplicable landscape formations or how figures mounting the dangerously unbalustered curving stairway of the odd building at the right might actually enter the room within. Figures are not consistent in scale and are elongated and attenuated, giving them a sinuous grace. Joseph as the main protagonist may understandably be the largest figure, but his proportions are severe manipulations of the realities of human proportion. Moreover, there are curious pairings of figural forms that call attention to their odd roles in the narrative. A statue atop a column in the mid-distance is painted to make it appear as marble, while in the foreground at the foot of the stairs an actual child dances precariously atop a column on a parade cart reminiscent of festival performances of the period. Remembering that the painting was made for a bedroom, this figure may read as the hoped-for male child of the marriage (and thus appropriately a point of focus in the composition), but it is nonetheless a curiosity within the overall painting. Pontormo adds further contradictions by depicting a Germanic gatehouse in the back, a feature he borrowed from a print by Albrecht Dürer. Here it should be remembered that Florentine and Umbrian painters of the fifteenth century had carefully imitated Flemish painting for their wealthy patrons. Thus Pontormo's patrons may well not have been troubled by the northern references in his work in the same way that Vasari was later in the century when he had a particular agenda of propagandizing Tuscan art.

Such self-conscious inconsistencies of presentation seem to have appealed to the oligarchic factions in Florence after the fall of the Republic in 1512. Yet too close a tying of style to social factions may be an oversimplification of the subject of style in Florence at this time; the political situation was unsettled and it was not clear whether the Medici, or the traditional oligarchy, or a new form of revived republicanism would ultimately control the political life of the city. Moreover, since this suite of paintings for the Borgherini bedroom also contained paintings rather classically constructed by Andrea del Sarto, the patron may simply have been trying to furnish the interior of the Borgherini Palace

as quickly as possible after the wedding had been contracted, choosing the leading painters in Florence who had already proved their abilities and who had worked together effectively. At the very least it is clear that the rich and powerful appreciated Mannerist as well as classicizing art, and the more they and the artists who worked for them saw of Mannerist inventions, the more their expressionistic aspects came to dominate the artistic scene.

A critical moment in this transformation occurred when Pontormo joined Andrea del Sarto and others in a commission from the twenty-

20.4 *Joseph in Egypt*, c. 1518, commissioned by Piero Francesco Borgherini from **Jacopo Pontormo** for his nuptial chamber, Palazzo Borgherini (now the Palazzo Rosselli del Turco), Florence. Oil on panel, 38 × 43%" (97 × 110 cm) (National Gallery, London)

20.5 Vertumnus and Pomona, 1520-21, commissioned by Ottaviano de' Medici on behalf of Giulio de' Medici and Leo X from Jacopo Pontormo for the Villa Medici, Poggio a Caiano. Fresco, 15' 1½" × 32' 5¾" (461 × 990 cm)

five-year-old Ottaviano de' Medici on behalf of Cardinal Giulio de' Medici and his cousin Leo X for decorations celebrating the pope's father, Lorenzo the Magnificent, and other family members inside the family's villa at Poggio a Caiano (see Fig. 11.46). As appropriate for a suburban villa, Pontormo's fresco celebrates Vertumnus and Pomona, the ancient god and goddess of harvests and fruit trees (Figs. 20.5 and 20.6). The male god is portrayed as an old peasant at the far left of the fresco, and the goddess is imagined as a handsome young woman reclining on the far right garbed in green and white and holding a sickle. Pontormo signed his work with the initials "IFP" under Vertumnus and provides clues to the subject matter with three other inscriptions. The most important of these appears above the large oculus window on a cartouche hung from golden ropes. It is a truncated version of a quotation from the *Georgics* (I,21), Virgil's ancient celebration of country life: "O gods and goddesses, all, whose love guards our fields"-indicating that in spite of their casual poses and demeanor, the primary figures reclining across Pontormo's narrow garden wall and ledge are probably all deities gracing a Medici villa and its properties.

Throughout the fresco Pontormo calls attention to the plane of the wall and carefully flattens the presumed space of the painting. The walls on which the figures are seated are simple slabs parallel to the painting's surface; no diagonals give any indication of recession, nor do the figures diminish in size from the front to the rear step. The figures themselves are disposed in a zig-zag pattern with no overlap between them, each presented as a discrete unit despite their participation in a clear overall compositional structure. The figures' adherence to pattern is reinforced by the positions of their limbs, which are either at right angles

to the steps or extended parallel to them; virtually every diagonal possible within their bodies is suppressed: Yet Pontormo has still modeled the figures to give a sense of their mass.

Comparable to the contradictory nature of the figural composition, the unconventional representation of the gods leaves their identification anything but clear. The young nude at the far left, indecorously splaying his legs and leaning back, may be Apollo but also Liber and the Sun; his female counterpart dressed in red on the right may be Luna (the moon) and also imply Diana and Ceres; the others may relate to the seasons-all emphasizing the cyclical nature of time as did the earlier glazed terracotta relief on the entrance portico of the villa. Such an interpretation makes sense in the agricultural context of a villa, though it refers even more cogently to Medici preoccupations with their turning fortunes: a disk below the window carries the inscription, "GLOVIS," the motto of Lorenzo de' Medici, duke of Urbino (died 1519), which was designed to be read backwards as "si volge" ("it turns"), a witty visualization of its verbal meaning. The fresco indicates that this is to be a turn for the better, made explicit by the putti sitting at the top of the oculus on truncated laurel branches (an unmistakable Medicean emblem since the days of Lorenzo the Magnificent) that are sprouting extravagant new growth. The putti hold banners declaring "Jupiter the Father wishes it,"—it being the rejuvenation of the Medici family. This was of no small concern at the time. The brightest rising star of the family, Leo's nephew Lorenzo, had been made duke of Urbino in 1516 after his uncle, on false pretences, seized control of the duchy from the della Rovere (who had succeeded to the dukedom through intermarriage with the Montefeltro). Unfortunately for the new young duke, his

20.6 Interior, Villa Medici, Poggio a Caiano, 1480s, building commissioned by Lorenzo de' Medici from Giuliano da Sangallo

reign was not uncontested by the della Rovere and he died worn out by disease and battle wounds in 1519, the year before the frescoes were begun, thus essentially ending the male line of the Medici extending from Lorenzo the Magnificent. Playful, erudite, and at the same altogether serious in terms of the Medici family's political ambitions and hereditary concerns, Pontormo's frescoes are much more than personal fantasies.

Altarpieces

Having worked for the Medici, Pontormo continued to receive commissions from the highest echelons of Florentine society. Pontormo's commission from Ludovico di Gino Capponi marks one of the few extant decorative ensembles of early Mannerism (Fig. 20.7). The chapel itself was built by Brunelleschi against the entrance wall of the

convent church of Santa Felicita by Brunelleschi for the Barbadori family at the beginning of the fifteenth century. When Capponi acquired the space in 1525 as a funerary chapel for himself and his male heirs, he retained a reference to the earlier dedication to the Annunciation with frescoes of that subject on the window wall. An inscription also indicates a dedication to "pietà," suggesting not only piety but the subject of Pontormo's altarpiece: the dead Christ in the company of his mother and other mourners (see p. 437). If this is an *Entombment*—the precise subject of the work is

contested by art historians—it is curiously dissociated from identifying elements of the historical narrative, unlike Raphael's painting of this subject (see Fig. 17.12), in which Golgotha is shown in the distance and the rock tomb is indicated at the left. In the Capponi Chapel those narrative elements appear in a separate stained-glass window on the wall over the *Annunciation*.

In the altarpiece the Virgin, larger in size than any other figure in the painting and captivating in her cascading blue drapery, and the coolly liquid figure of the dead Christ

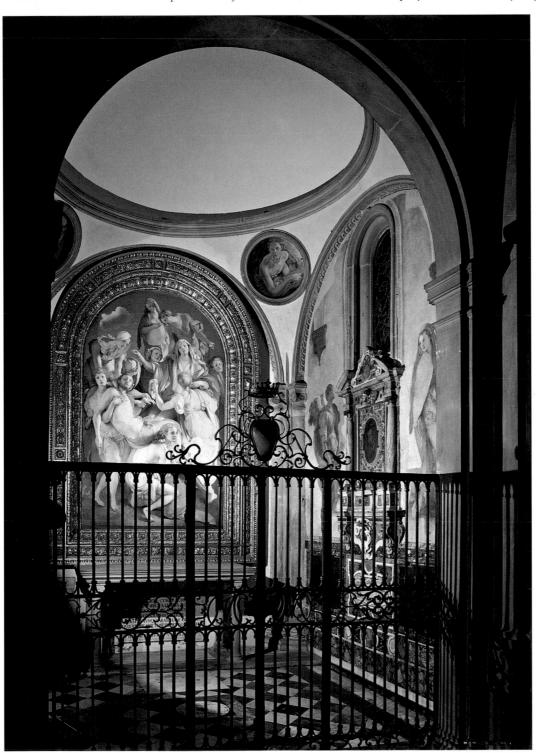

20.7 *Capponi Chapel*, 1525–8, commissioned by Ludovico di Gino Capponi from **Jacopo Pontormo**, Santa Felicita, Florence

The commission included a now lost fresco in the ceiling of God the Father, pendentive roundels of the four Evangelists (with assistance from Agnolo Bronzino), a stained-glass window by Guillaume de Marcillat, the *Entombment* altarpiece (oil and tempera on panel, 10′ 3″ × 6′ 4″ [3.1 × 1.9 m]), and a fresco of the *Annunciation*.

command attention. Yet these very figures are embedded in a welter of billowing drapery and empty hand gestures, which make any single focus impossible. The color, deriving in part from the Sistine Ceiling (especially in the shot hues of the foreground figure), also disperses attention in its brilliant areas of pink against blue, even though the light that spotlights the figures suggests that it comes from the window of the chapel itself-and perhaps from the now lost figure of God the Father in the dome of the chapel. The space of the painting, like the earlier Visdomini Altarpiece, is sharply vertical, with no indication of where the background figures are standing, although the overall composition and figural poses take into account the semicircular form of the upper part of the painting. While the individual details of the painting are compelling in their realistic depiction of form and volume, the figures are both idealized in their simplified volumes and gracefully attenuated both at their extremities and in their overall proportions. This is perhaps most evident in the Virgin, whose legs (at the center of the composition), hands, and head are thinned in comparison with the mass of her body. Curious impossibilities occur throughout the painting: it is difficult, for example, to understand how the Virgin's legs, shown on a diagonal, connect to her torso, shown parallel to the picture plane, or how the kneeling male figure in the foreground could possibly support a dead body, balletically positioned as he is on his toes, or how the male figure on the left can support that same dead body apparently with one hand. Such explorations of weight and support are quite contrary to Raphael's treatment of support in his Entombment.

The perplexing aspects of the painting are nowhere more evident than in the left hand of Christ, which seems to be held out by two disembodied hands. These hands apparently belong to a figure whose head is immediately above the head of Christ, but who is all but indistinguishable from the overall blue coloration of the surrounding figures and the consciously showy patterns of drapery that flow through the painting; there seems, furthermore, to be little actual space for any body beneath that head. In this work Pontormo transformed the devotional altarpiece into a spasm of emotional reactions to the event of Christ's death. Depicted through the dramatic gestures of the bodies and through the icy brilliance of the intensely contrasted colors, this piety is clearly directed outward by the kneeling foreground male, who looks pointedly out of the painting in a gaze of communion with the viewer. Without undermining the purpose of the altarpiece as an incentive to piety, Pontormo has both upped its emotional charge and clothed it with an elegance that responds to the idealizations of the previous generation of painters and the changing social needs of the patron.

An interpretation based on the concept of a reaction "against" the prevailing classicizing style is but one possible way to read Mannerism. It isolates the shift in style obvious in Pontormo's painting within the formal aspects of the

work and ignores the context in which the work was created. Since the classical style had been employed as the language of the Republic after 1494 it would have been inappropriate for the newly restituted Medici rule after 1512 and their deliberate dismantling of the Republic. Mannerism provided the language for the emerging aristocracy under the Medici in Florence. Yet even within the self-conscious artifice of Mannerism there are characteristics suggesting a development of the classicizing tradition rather than a mere rejection of it. From Leonardo onward, painters seem to have realized that regardless of how realistically they were able to reconstruct the physical forms of nature, they could never capture the critical element of motion. The curiously slipping poses of Pontormo's figures and their unstable positions are formal means of suggesting incipient movement, analogous to the contorted figures in Leonardo's and Michelangelo's fresco drawings for the Palazzo della Signoria Battle paintings (see Figs. 17.6 and

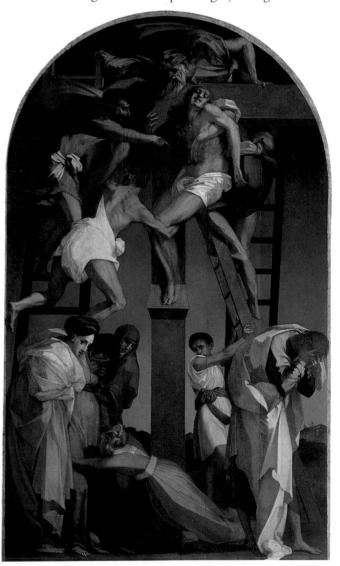

20.8 *Deposition*, 1521, commissioned by the Compagnia della Croce di Giorno from **Rosso Fiorentino** for San Francesco, Volterra. Panel, 12' $4'' \times 6'$ 5'' (375 \times 196 cm) (Pinacoteca, Volterra)

17.7). It is the ghostly images of these Battle paintings with all their implications of motion, emotion, grace, torsion, and monumental grandeur that lie behind Pontormo's style, implying that Mannerism should not simply be read as anti-classical, but also as a profound understanding and development of painterly issues that lay at the root of the classical style in the works of Leonardo and Michelangelo.

Pontormo was hardly alone in testing and pushing the limits of both tradition and innovation. Rosso Fiorentino, whose sensuous Dead Christ we examined in our discussion of Clementine Rome (see Fig. 18.42), had previously put high pitched color and brilliant, fracturing light to dramatic use in a highly emotional altarpiece of the Deposition (Fig. 20.8). Like Pontormo, Rosso spent his early years associated with Andrea del Sarto, in whose workshop the two young artists probably encouraged one another's artistic explorations. In some ways Rosso was the wilder of the two, renowned for owning a disrespectful pet monkey and painting works that early patrons openly rejected or asked to be overpainted. Lack of success in Florence may have caused him to seek patronage in provincial Volterra, where the Compagnia della Croce di Giorno, a local penitent group which held its devotions in a semi-independent chapel attached to the local Franciscan church, received a relic of the True Cross in 1513. Already decorated with a True Cross cycle on its side walls, the chapel, like the confraternity, was dedicated to the Cross and to the Virgin Mary. This dual dedication may explain the fact that while the subject of the altarpiece obviously focuses upon Christ's body being lowered from the cross, Mary Magdalene, positioned at its foot, does not cling to it, as was often the case, but instead rushes to embrace the fainting Virgin. Rosso's altarpiece disrespects many classical conventions of representation: the figures and Christ's cross, cut short by the sides of the altarpiece, are pushed to the foreground; the sky is blank; the figures are inconsistent in scale; the men on ladders are placed in impossibly precarious positions; and blinding light flattens the drapery, faceting it into stark planes of color. All these features and the whirlwind of energy created by the gesticulating and screaming figures around Christ's body and the intensity of grief expressed by the arms of the Magdalene and in the despondent John at the right were well suited to the confraternity's devotions, whose rules urged them to confront Christ's Passion and identify fully with his death, the source of their salvation. The very strangeness of this altarpiece

Michelangelo and the Medici

The Medici Chapel

Michelangelo was in Florence at the very time that this new style blossomed into maturity. When Pope Leo X entered Florence in triumph in 1515, he and his cousin Giulio (later Pope Clement VII) initiated a series of commissions at San Lorenzo which built upon the projects of their Medici ancestors at that church. The New Sacristy, now generally known as the Medici Chapel (Figs. 20.9 and 20.10), was designed as a burial pantheon for the Medici family (see genealogical chart), especially for the brothers Lorenzo the Magnificent (Leo X's father) and Giuliano (Cardinal Giulio's father), and also for Giuliano, the duke of Nemours (1478–1516; Leo's brother), and Lorenzo, the duke of Urbino (1492-1519; Piero the Unfortunate's son). Michelangelo's New Sacristy was designed to mirror Brunelleschi's Old Sacristy (see Fig. 11.3). Yet within these constraints, Michelangelo provided new expressive possibilities for architecture. Where Brunelleschi's decorative elements respected the plane of the wall, Michelangelo transformed surface into sculpture. The structural integrity of the space is enhanced visually by the framework of gray pietra serena stone outlining the main architectural features. Within this ordering system Michelangelo pushed the

central units of the side walls back into tripartite marble triumphal arches and pushed forward tombs and sculpture, which, if executed as planned, would have included reclining river gods on the floor in front of

the sarcophagi. Drawings for a Resurrection indicate that Michelangelo also intended to fill the lunettes over the tombs with frescoes. The coffered ceiling was painted with birds and vines by Giovanni da Udine (1487 Udine–1564 Rome), Raphael's chief decorative assistant at the Vatican Palace. Thus the room was envisaged as an integrated work of painting, sculpture, and architecture, giving the coloristic effects of earlier non-Florentine renditions of the Old Sacristy (the Portinari Chapel in Milan, for example; see Fig. 15.6) an only slightly more Florentine cast.

The tombs of the two dukes show an active Giuliano and a contemplative Lorenzo, both turning away from the altar to face the wall where their forebears, Lorenzo the

Magnificent and his brother, were to be buried in a double tomb (unfortunately never built). Thus the dukes would have directed attention to their ancestors, and also to the Virgin and Child, now provisionally installed on that wall—the tradi-

tional fusion of devotional and familial images. But Michelangelo endowed the chapel with allegorical

gave it its power.

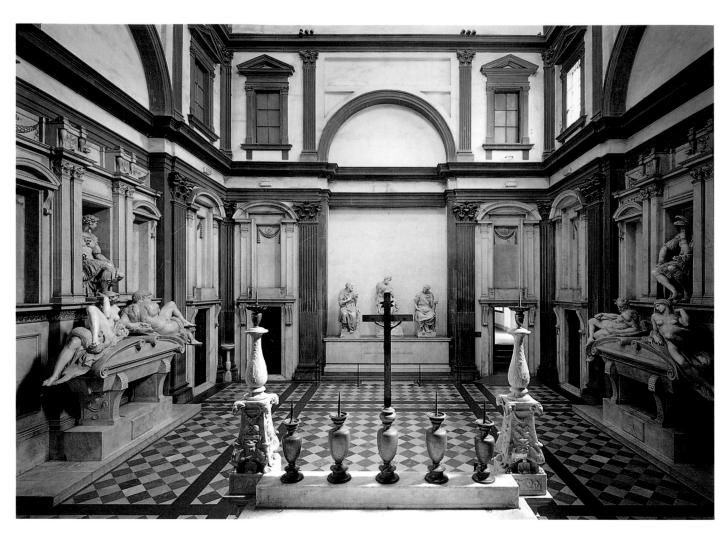

20.10 New Sacristy (also known as the Medici Chapel), San Lorenzo, Florence, 1519–34, commissioned by Leo X and Giulio de' Medici from **Michelangelo** as a funerary chapel for their fathers and for recently deceased members of their family who had played leadership roles in restoring Medici power in Florence The photograph is taken from the position of the priest celebrating mass at the altar of the Chapel.

complexities well beyond any funerary monument then existing in Florence. The four river gods projected for the base of the tombs were to represent the four rivers of eternal Paradise, while the allegorical figures of Dusk and Dawn on the sarcophagus of Duke Lorenzo and Night and Day on the sarcophagus of Duke Giuliano represent diurnal time. Thus the chapel's iconography was to embrace issues of time and immortality. The centralized plan of a martyrial structure and the dome with which it is crowned imply both Christian resurrection and the cosmological order under the Medici princes.

The two dukes are studies in opposites, the one commonly referred to as Giuliano (Fig. 20.11) is clothed in parade armor and leans energetically forward out of the small niche in which he is placed. Lorenzo sits calmly and passively, his hand to his chin and the visor of his fantastical helmet casting a shadow over his eyes. When contemporaries complained that the sculpted images of the dukes did not look like the men they were meant to represent, Michelangelo is said to have replied "they will." Traditionally the two dukes are referred to as allegories of

the active and the contemplative life, here held in balance by the sculptures' symmetrical positioning in space. In fact, their blank faces essentially provide masks for the men, disguising their emotions and forbidding any real contact. Whether their images were erased in deference to their ancestors planned for the altar wall, or whether Michelangelo perversely stripped them of any accurate historical references because of his opposition to Medici control of the city we will never know.

The allegories of the Times of Day reclining on the sarcophagi of the side walls are heroic nudes that seem to embody in their physical forms their meanings, although only *Night* bears any identifying attributes. In the *Dawn* and *Dusk* pair on Lorenzo's tomb (Fig. 20.12 and frontispiece; the figures are gendered female and male according to the Italian nouns) Dawn begins to lift her limbs into movement, turning her head toward the viewer, while Dusk sinks back into quiet, withdrawing his gaze. The slight curves of their bases would have been met by opposing curves of the River Gods that Michelangelo planned to place on the floor beneath them, providing a stable oval composition as well

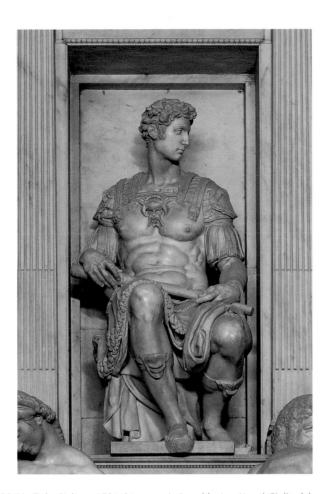

20.11 *Duke Giuliano*, 1524-34, commissioned by Leo X and Giulio de' Medici from **Michelangelo** for the tomb of Giuliano de' Medici, the New Sacristy (also known as the Medici Chapel), San Lorenzo, Florence. Marble, height 5′ 6″ (173 cm)

as active movement forward and backward in space. The composition would have countered the sense of slipping that the statues now give and that is sometimes misleadingly used as an aspect of Michelangelo's involvement with Mannerism.

The figure of Night (Fig. 20.13) can be identified by her symbols of the owl, the poppies, and the mask. She is twisted into an uncomfortable torsion of form that probably accounts for Michelangelo elongating her torso. Her heavily muscled body is as much part of the heroic rhetoric of death that Michelangelo used for the chapel as it is due to the fact that Michelangelo could not have used nude female models. The conventions worked on her physical form are hardly more exaggerated than those used for the figure of Giuliano above her. The mask beneath Night's left shoulder is telling insofar as it is the only facial image in the entire chapel that has distinctive features. It furthermore calls attention to itself by staring directly at the viewer, unlike any of the other faces in the room. Michelangelo was to tell his biographer of an antique faun's mask that he had replicated when Lorenzo the Magnificent had invited him to work in the Medici sculpture garden. Indeed the mask is a self-portrait by the artist. It serves both as a signature and as a remembrance of his indebtedness to the long-dead Lorenzo, who was to be re-buried only a few feet away. Michelangelo's literary fiction unites him with Lorenzo as a father figure and both of them to antiquity. The droll strategy of a mask being a portrait of the artist while the portraits of the dukes are unrevealing masks has some of the mordant wit that would have been appreciated by Florentines, while at the same time it reveals in a cryptic

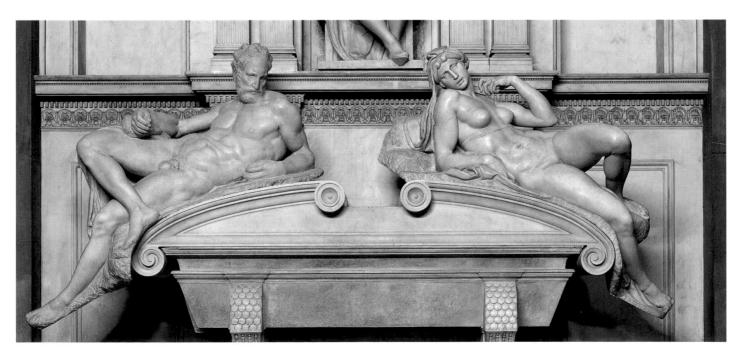

20.12 Dusk and Dawn, 1524–34, commissioned by Leo X and Giulio de' Medici from **Michelangelo** for the tomb of Lorenzo de' Medici, the New Sacristy (also known as the Medici Chapel), San Lorenzo, Florence. Marble, length 6' 9" (206 cm) and 6' 4½" (195 cm), respectively. See also Frontispiece

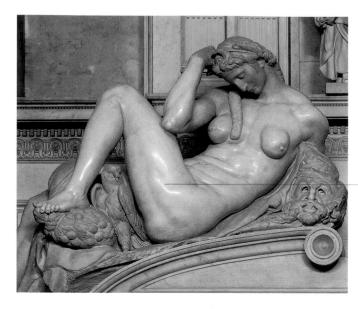

20.13 *Night*, 1524–34, commissioned by Leo X and Giulio de' Medici from **Michelangelo** for the tomb of Giuliano de' Medici, the New Sacristy (also known as the Medici Chapel), San Lorenzo, Florence. Marble, length 6' 4½" (1.94 m)

way some of Michelangelo's deepest reflections about his relations with this powerful family.

If there are competing interpretations of Mannerism in painting there is little coherent discussion of what would constitute a definition of Mannerism in architecture. Although Michelangelo's architecture at San Lorenzo is often called Mannerist, this designation is made solely on the basis of its individual formal components rather than on the overall structure, thus seriously compromising the applicability of the term. Michelangelo was undoubtedly boldly inventive in his manipulation of canonic forms in the New Sacristy. The tabernacle niches over the doors of the room are good examples as they are the largest architectural forms in the chapel and overwhelm the doors beneath them in scale. The segmental pediment extends so far out from the wall that its support by the thin pilasters is compromised; at the same time its base rests on a line with the bases of the Corinthian pietra serena capitals, giving it visual stability within the overall structure of the room. These pediments have interrupted bases and their arcs are broken, undermining their visual power as a capping architectural form. However a rectangular niche intrudes into the pediment and spills into its sides, supporting the pediment at just the point where it breaks forward and creating a richly textured movement of forces both into and out from the wall. Here as in other places in the chapel no single architectural unit functions as a discrete form but interacts in a lively manner with adjacent forms, tying the entire surface of the wall together. Although each form-niche, tabernacle, pediment-echoes canonic structures, none falls comfortably within conventional usage.

If willful manipulation of classical form were enough for a definition of Mannerism, then these tabernacles would qualify for placement within that stylistic category. But just as such willfulness is not sufficient to provide a convincing definition for Mannerism in painting, it is also not adequate for designating the New Sacristy as Mannerist architecture. Regardless of how inventive Michelangelo may have been with individual architectural forms, he was also conscious of the overall space of the room and of the commemorative and devotional practices which took place there. Thus had the chapel been completed, the priest at the altar would have stood on axis with the Virgin and Child on the opposite wall and would have been able to see the tombs of all four of the Medici family members for whom he was praying. The two Medici dukes on the side walls would have emphasized the focal point of the devotions by their gaze toward the image of the Virgin and Child and also to their ancestors, making clear dynastic linkages between generations, similar to Donatello's sculpture for the Old Sacristy. And the central vertical axis of the room would have drawn attention to the light at the lantern of the dome, referencing the divine, again repeating symbolism used in the Old Sacristy. The clarity of this visual order and its messages precludes a description of the space simply as Mannerist.

The Laurentian Library

Michelangelo experimented even more boldly with architectural form in the vestibule (*ricetto*) of the Laurentian Library (Fig. 20.14). Giulio de' Medici commissioned the library complex when he rose to the papacy as Clement VII in 1523, most likely as a way to leave his own imprint on the fabric of San Lorenzo. The library with its long reading room and vestibule was built over the pre-existing cloister of San Lorenzo to house the enormous book and manuscript collection of the Medici family and to provide a place for study.

Michelangelo used the same skeletal membering of gray pietra serena stone against a painted off-white stucco in the vestibule that had characterized building at San Lorenzo since the beginning of the Brunelleschian plan at the start of the fifteenth century. He originally planned a glass ceiling for the room, but the pope complained it would be impossible to keep clean. Such a ceiling would have realized the illusion that Michelangelo had created in the first and last bays of the Sistine Ceiling (see Fig. 18.12), where sky shows through the architectural membering, and that Raphael had depicted in the bower he painted in the Loggia of Psyche (see Fig. 18.34) for Agostino Chigi. Michelangelo clearly intended that the room be a light-filled and pleasant environment, complemented by the cleverness of the architecture. Paired columns are atypically recessed in the walls where they actually function as weight-bearing elements and allow Michelangelo to thin the wall and lessen its weight so that the earlier walls beneath would support the room. In the corners of the room Michelangelo bundled the energies of the columns by placing a pier between them which reads as a reverse corner. The pilasters of the wall tabernacles taper downward, again providing an atypical architectural language, although from the space below their tapering is optically corrected.

The staircase leading from the vestibule to the library reading room a story above nearly fills the entire room and pressures the remaining space outward against the walls. A number of drawings (see Fig. 32) indicate that Michelangelo developed the plan for this staircase through a series of designs, beginning with a simple double staircase extending left and right along the side walls from the library door to the complex one which today spills into the space of the room. Since this room was also left unfinished when Michelangelo left for Rome in 1534 the stairs were built from a model which he later sent back to Florence. The staircase of the vestibule provides a dramatic entrance to the library and is the first of its kind in the early modern period. Had it been built out of rich walnut, as early designs seem to indicate, it would have provided a warm coloristic link to the wooden desks, intricately coffered ceiling, and inlaid terracotta floor of the reading room just beyond.

The stairwell is trapezoidal in overall form so that it creates a visual perspective toward the entrance of the library. Each of the steps in the central flight of stairs bulges forward at the center, setting up a contrary slow flowing movement toward the bottom of the stairs. Small sworls are carved into the ends of the central stairs, adding to their organic, sculptural quality, but also making it difficult to walk at the edges of the staircase where the balustrade would offer some support. The connection of the side stairs to the central flight of steps is screened by the balustrade, making them visually independent units whose bordering podia double as seats and disguising the fact that there are ten risers on the central flight and eleven on the side stairs to reach the same platform two-thirds of the way up the stairwell.

Although every unit in the vestibule of the Laurentian Library has been imaginatively reinvented, providing diversion for the readers coming to or from the serene and serious space of the reading room, the staircase focuses the viewer's attention on the door to the reading room and

20.14 Laurentian Library, San Lorenzo, Florence, 1523-59, commissioned by Clement VII from Michelangelo

20.15 Reading Room, Laurentian Library, San Lorenzo, Florence, 1523–59, commissioned by Clement VII from **Michelangelo**

access to the library. From the top of the stairs looking back into the vestibule the viewer is at a level with the niches whose forms, despite their innovations, are simple and unbroken-unlike the tabernacles of the Medici Chapel, and whose sobriety befits the seriousness of the study taking place in the reading room behind. That room (Fig. 20.15) is as reticent in its forms as the vestibule is playful. Architecturally everything has been done to lighten the weight of the walls carried to the old walls below and to allow as much light as possible into the room to accommodate the readers. The walls are stepped back at the window level and essentially removed in the simply framed blank tabernacles at the attic level. The pilasters between the windows align with the wooden stalls (also designed by Michelangelo) for books and readers, setting up a steady grid of quietude through the space. Small details such as the hanging socles on the upper sides of the windows or the overhanging cornices of the windows recall the formal inventiveness of the vestibule, but they are clearly held in check to maintain the sobriety of the working space.

Clearly Michelangelo responded to the complex needs of the library spaces—for serious study and for respite, for grand entrance and for serene and light-filled study space—and united them in an environment in which the viewer is conscious of purpose and direction, despite the witty play of form along the way. For Michelangelo wit was a form of intelligence. His architecture is a visual response to the high seriousness of the library and to the creative minds that worked there.

Florence under Cosimo I

The last expulsion of the Medici family from Florence lasted from 1527 to 1530 and was directly tied to the fortunes of the papacy under Clement VII. When armies of the German emperor sacked Rome in 1527, forcing the pope to flee to the protection of the Castel Sant'Angelo and, ultimately, to leave the city, the Florentines took the opportunity to oust the Medici regime and declare the restitution of the Republic yet again. Three years later, after restoring relations with Charles V, Clement was able to restore the Medici to power by using the same imperial forces that had sacked Rome against his native city. But it was not until an eighteen-yearold boy, a Medici on both his father's and his mother's side of the family, assumed power after the Battle of Montemurlo in 1537 and slaughtered his political enemies, that the Medici regime was truly

secure in the city. Providently named Cosimo at the time of his birth through the intervention of Leo X, who envisioned him as the reviver of his family's fortunes, just as his namesake had been at the beginning of the fifteenth century, he became duke of Florence in 1537 and later was crowned Grand Duke of Tuscany by Pius V in 1569. Michelangelo, who had supported the Republic by carving figures such as the David (see Fig. 17.1) and by designing fortifications for the short-lived Republic during the siege of 1527–30, refused to serve Cosimo and went into self-imposed exile in Rome, leaving a younger generation to come forward to fashion a new and calculated official style for the autocratic ducal regime.

Portraits

From the time of the first Medici return to power in 1512, members of the family had used portraiture to build historical connections to the past in support of their control of the present. Cosimo and his artists seem to have sensed the importance both of repeating his own image (and that of other individuals in his family) as a form of propaganda and of developing new types of portraiture which would add credibility to his position as ruler.

Cosimo diffused his image throughout Tuscany on coins, medals, bronze and marble sculpture, and painting. One of the most riveting of these portaits is an over-life-sized bronze bust (Fig. 20.16) created by the Florentine goldsmith and sculptor Benvenuto Cellini (1500 Florence-1571 Florence). Active at the papal court in Rome from 1519 to 1540 and at the royal court of Francis I in France for the next five years, Cellini probably created the exquis-

itely detailed portrait as a way of ingratiating himself with a potential patron. Shown wearing a military breastplate, Cosimo appears both in the guise of a Roman emperor and as a contemporary military leader whose ruthlessness is indicated by the roaring lion's head on the armor at his right shoulder, an iconographical reference that also connects Cosimo with the old Florentine political symbol of the marzocco, or lion, here subordinated to the city's new leader. The active turn of his head and the precise details of his features give vitality to the portrait. Another contemporary portrait of Cosimo, by Pontormo's most talented student, Agnolo Bronzino (Agnolo di Cosimo di Mariano; 1503 Monticelli-1572 Florence), also shows him in military armor (Fig. 20.17), providing Cosimo with an image reflecting his control over the state and a reminder that his father, Giovanni delle Bande Nere, was a respected Florentine military leader who had fought against the imperial troops on their way through Italy to Rome. Cellini's portrait was sent to the fortress of Stella (the Star) in Portoferraio on the island of Elba in 1557 to mark Cosimo's conquest of the island and control of shipping in this part of the Mediterranean. Its banishment to Elba gives a telling insight into Cosimo's reaction to it, especially in comparison to the Bronzino portrait. Apparently Cellini's bronze bust, with its vivid sense of motion and its soft depiction of the

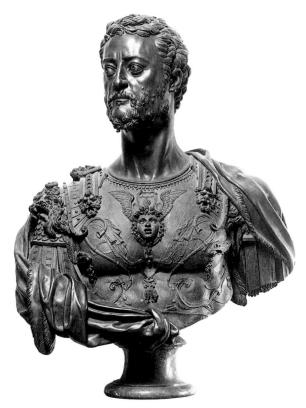

20.16 *Cosimo I*, 1545–47, **Benvenuto Cellini**, in the collections of Cosimo I by 1553, probably having been purchased shortly after its completion. Bronze, originally partially gilt with enamel eyes, height 3′ 7½″ (1.1 m) (Museo Nazionale, Florence)

Cellini claims to have made the bust for his own "pleasure" but it was most likely a way to curry favor with Cosimo I.

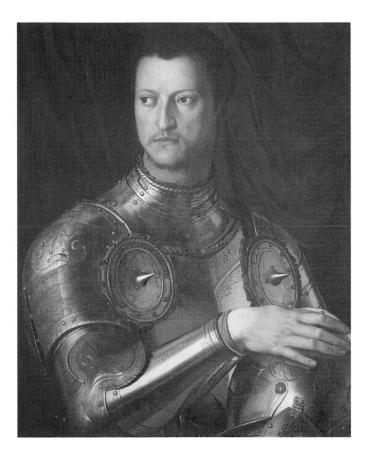

20.17 *Cosimo I*, c. 1545–46, commissioned by Cosimo I from **Agnolo Bronzino**. Tempera on panel, $29 \times 22\%$ " (74×58 cm) (Galleria degli Uffizi, Florence)

flesh of Cosimo's face, was simply too naturalistic, representing what Cellini himself called the "fiery movements of life." In Elba, it seems, the bronze portrait bust communicated Cosimo's determination that Florence become an aggressive maritime power. Official urban court portraiture, on the other hand, demanded the impassive icon of rulership and civic stability that Bronzino so aptly provided.

Cosimo's concerns for dynastic continuity are evident in the images of himself, his family, and his ancestors that began to crowd his living quarters. Bronzino's portrait of Cosimo's wife, Eleonora of Toledo, and their two-year-old son Giovanni (Fig. 20.18) is typical of the portraiture of Cosimo's court. Eleonora was the daughter of Don Pedro di Alvarez di Toledo, Charles V's viceroy in Naples (1532–53). Cosimo's marriage to her brought him an alliance with the powerful court of Charles V, not to mention numerous children whom he could marry to European aristocracy and thereby extend Medici power into the highest echelons of international society. What is more, access to Eleonora's vast personal wealth—she often loaned the duke money—enhanced Cosimo's ability to look and act the prince.

By all accounts Eleonora was a doting mother and loving wife, but she brought severe Spanish protocol to the Florentine court. Bronzino shows her virtually imprisoned in an elaborately embroidered dress prominently featuring

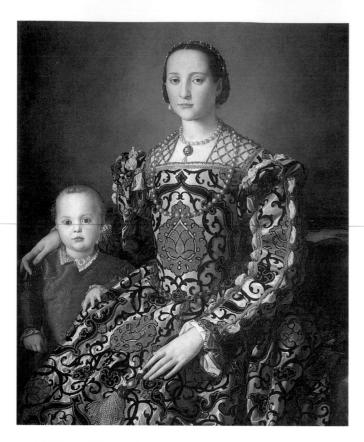

20.18 *Eleonora of Toledo and Her Son, Giovanni*, c. 1546, commissioned by Cosimo I from **Agnolo Bronzino**. Oil on panel, $45\% \times 37\%''$ (115 \times 96 cm) (Galleria degli Uffizi, Florence)

golden pomegranate designs, common in such deluxe fabrics but here appropriately referencing her fertility and Medici dynastic ambitions. Her social position is proclaimed in a traditional manner by the extraordinary size of her jewels. Surprisingly, unlike the images of Cosimo, Eleonora looks directly out of the painting, yet the alabastrine perfection of her features—flattened by the strong lighting—distances her from the viewer. Bronzino refers to paintings like the *Mona Lisa* (see Fig. 17.8) in the pose, the shape of the face, and even in the slight smile of the figure, but Eleonora still projects as an iconic representation of the state whose continuity is assured by her progeny.

Other portraiture of the period betrays this same aloofness and detachment. For example, Bronzino's Portrait of a Young Man (Fig. 20.19) shows an elegantly dressed man in an architectural space that is as difficult to comprehend as he is. His every gesture is self-conscious, from his slow gaze downward toward the viewer to his claw-like finger, marking his place in the book, and perhaps identifying him as a friend from within the literary circles familiar to Bronzino and his wife Laura Battiferri, themselves both accomplished writers and poets. His left hand, resting on his hip, shows an unnatural arrangement of thumb and fingers. The costume is elaborately cut in the latest fashion, with multiple slashes through which another material appears. Laces with gold points decorate both the hat and the codpiece, itself a curious development in the history of costume at this time, calling attention to the presumed virility of the figure.

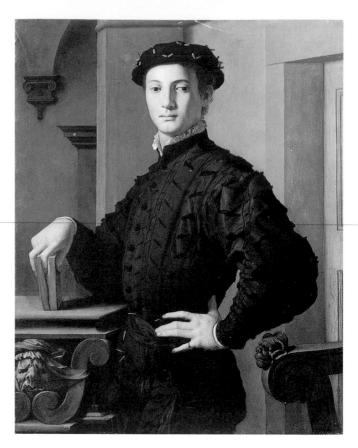

20.19 *Portrait of a Young Man*, c. 1540–45 (sometimes dated as much as a decade earlier), **Agnolo Bronzino**. Oil on panel, $37\% \times 29\%$ (95.5 × 74.9 cm) (H. O. Havemeyer Collection, Bequest of Mrs H. O. Havemeyer, 1929 [29.100.16], Metropolitan Museum of Art, New York)

For all the detailing of the costume, the face of the man is exceedingly bland and refined—in striking contrast to the grotesque head carved on the arm of the chair to the right. The man's eyes, moreover, are not aligned, making any attempt at communication tentative at best. Bronzino includes a witty internal comment on the impenetrable mask-like aspect of the figure with the swag of material carved into the table at the lower left corner; it, too, reads as a flaccid grotesque head, quite unlike the crisp perfected features of the young man. Complexity, refined elegance, self-consciousness (on the part of both sitter and artist), and wit make this portrait a touchstone of *maniera*, what one art historian has aptly called "the stylish style."

The Chapel of Eleonora of Toledo

In 1540, soon after marrying Eleonora, Cosimo moved from the Palazzo Medici into the Palazzo della Signoria, publicly proclaiming his dominance over all civic institutions. No Florentine could have misunderstood Cosimo's inhabiting of the Palazzo della Signoria (subsequently called the Palazzo Ducale) as anything but a manifestation of the end of the Republic and its definitive transformation into a ducal state. Cosimo remodeled the building to accommodate his expanding family and commissioned elaborate decorative programs of the histories of his ancestors, of his own military conquests, and of dynastic portraiture to fill

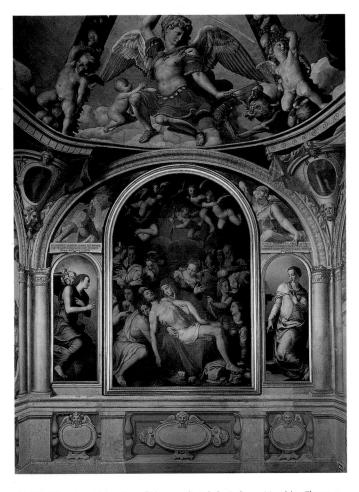

20.20 Chapel and Altarpiece of Eleonora da Toledo, Palazzo Vecchio, Florence, c. 1540, commissioned by Cosimo I from **Agnolo Bronzino**

its vast spaces. Eleonora took up residence with their children on the upper floor of the former city hall in apartments that had been used by the city's republican priors; its entrance was through their former chapel. At the opposite end of the long suite of rooms, Cosimo constructed a smaller, cubical chapel for his wife's private devotions, completely decorated by Bronzino with imagery that ostensibly referred to Christian redemption but which barely veiled his dynastic and political intentions (Fig. 20.20). The wall frescoes all depict scenes from the life of Moses, an uncommon subject in Christian chapels though one which the popes had deployed most effectively at the Sistine Chapel in Rome to stress their right of rulership (see Fig. 12.29). In the Crossing of the Red Sea (Fig. 20.21) Moses, seen crouching and gesticulating on the right in a pose highly dependent on Michelangelo's sculpture of the same subject (see Fig. 18.11), is about to drop his hand after having led the Israelites out of their exile in Egypt; pharaoh's defeated horsemen drown in the returning waters. Theologians interpreted this as a salvific act prefiguring Christ's victory over death, but for Cosimo the story could also refer to the Medici's rightful return to power after repeated exiles and an overt indication of the fate awaiting those who opposed him. The presence of an obviously pregnant woman to the right and behind Moses promises a fecund period of Medicean and Florentine renewal.

The style employed by Bronzino in these frescoes resembles the cool, calculated manner we have seen in his portraits. Bronzino arranged the Israelites more artfully than expressively on the shore, demonstrating his close study of ancient as well as modern works without giving much con-

cern to their presumed emotions of gratitude and relief. A partially nude standing male figure at the left languidly corkscrews his body to face a seated female who fetchingly draws a long braid of hair between her exposed right breast and her left breast, which is hidden but nonetheless vividly suggested by her cupped left hand. It is not clear what this exchange between the two figures signifies, except in artistic terms.

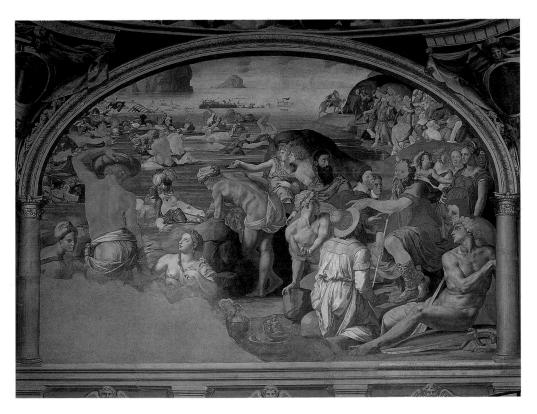

20.21 Crossing of the Red Sea, c. 1540, commissioned by Cosimo I from **Agnolo Bronzino** for her chapel, Palazzo Vecchio, Florence. Fresco, 16′ 1″ (4.9 m) wide

In its pose and the artificial array of drapery around his lower torso, the male recalls earlier figures positioned to draw attention to themselves as elegant and graceful elements within the overall composition, but not particularly to clarify the narrative (see Fig. 18.31). Similarly, instead of flailing and resisting their demise, the doomed Egyptian horsemen are frozen in the glassy stillness of the sea. Bright light flattens the figures into complex surface patterns, in spite of the exaggerated perspective and figural diminution Bronzino deploys in the background. In later frescoes in the chapel he abandoned perspective altogether, verticalizing his space and contorting his figures into ever more difficult—and therefore praiseworthy and stylish—poses.

The altarpiece currently in the chapel, depicting the Lamentation, is a replica Bronzino made in 1553 of his 1545 original (which was sent to France as a diplomatic gift). Bronzino also removed the original flanking panels of Saint John the Baptist, patron saint of the city, and St. Cosmas, onomastic of Cosimo, which clearly stated Cosimo's civic intentions and his personal presence in the space, and replaced them with side panels depicting the Annunciation still visible in the chapel. The design of the altarpiece clearly derives from Pontormo's Capponi altarpiece (see p. 437) but with crucial differences. Bronzino has put Christ's body back on his mother's lap as was traditional in Pietà groups (see Fig. 12.34), and while the space is compressed and individual figures seem psychologically disengaged from one another, the entire composition is more grounded and weighty than his teacher's hallucinatory vision. The subject matter is also more theologically orthodox. The figures in the foreground are easily identifiable as the saints John and Mary Magdalene; Bronzino dresses the aged Virgin Mary humbly as a nun; and Joseph of Arimathea and Nicodemus look on from the right rear. Flying putti carry explicit emblems of the Passion, timely aids to worship and orthodox belief at a moment when religious reformers were beginning to call on artists and patrons to rein in their inventive fantasies. As had been true for centuries in chapel decorations, Bronzino's devotional altarpiece was more conservative than the narrative frescoes that surround them.

Just after Bronzino finished the chapel decorations Cosimo commissioned Pontormo to fresco the unfinished choir of San Lorenzo, which Cosimo Pater Patriae had reserved for his own in 1442 and before which he was buried. Thus Duke Cosimo I not only inserted himself in the long and illustrious tradition of Medici patronage in San Lorenzo but he also associated himself with his namesake, the founder of Medici hegemony in the city of Florence

Pontormo's fresco cycle included scenes from Genesis, a Last Judgment, and the martyrdom of St. Lawrence, the titular saint of the church. The scenes from the story of Noah which would have been on the left wall of the chapel were part of a revival of an old myth which proposed that Noah

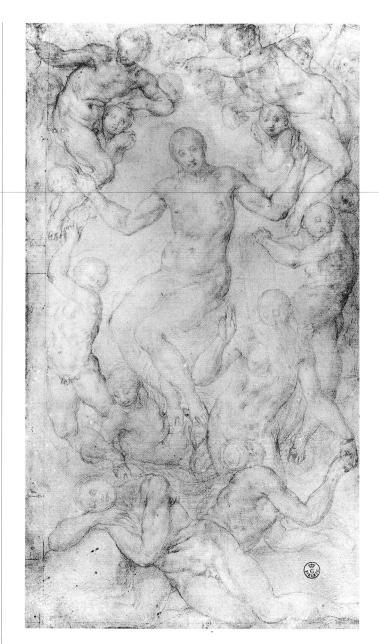

20.22 Christ in Glory and the Creation of Eve, preparatory drawing for the frescoes of the choir of San Lorenzo, Florence, frescoes painted 1546–56, destroyed in 1742, commissioned by Cosimo I from **Jacopo Pontormo**. Black chalk on paper, $12\% \times 7''$ (32.6 × 18 cm) (Galleria degli Uffizi, Florence)

had founded Florence after the Flood. Thus, as ruler of the city, Cosimo I was once again connected with the leaders of the Old Testament. Known mostly from drawings, the figural style of these frescoes recalls the work of Michelangelo, despite the soft fluidity of Pontormo's own draftsmanship. In the Christ in Glory and the Creation of Eve (Fig. 20.22), drawn for a fresco on the center of the upper wall of the choir aligned axially with the nave, the ambiguous sitting/standing pose of the Christ figure imitates the comparable figure in Michelangelo's Last Judgment (see Fig. 22.1) and the roiling nudes around Christ repeat in a slightly more languid fashion the complex poses of their counterparts.

Pontormo's friendship with Michelangelo allowed reverberations of Michelangelo's style in the main chapel at San Lorenzo, although the master himself steadfastly refused to work for the city's new ruler, who had so thoroughly subverted the republican ideals that Michelangelo held so dear.

Art as a Symbol of the Advanced State

At least since the time of Lorenzo the Magnificent, the Medici-like other statesmen-had used objects of art and artists themselves as ways to build alliances between themselves and other powerful rulers. Bronzino's Allegory with Venus and Cupid (Fig. 20.23) was commissioned as one of a long series of important gifts of art to Francis I of France, who in his later years increasingly preferred subject matter of an overtly erotic nature. The lasciviously entwined figures of an adolescent Cupid and his mother, Venus, were obviously aimed at this sensibility, but there is more than salaciousness to the painting. The golden orb which Venus holds in her left hand represents the golden apple given her by Paris when he judged her more beautiful than Juno and Minerva, but it also refers to the orb of royal rule. In her right hand she suggestively displays an arrow plucked from Cupid's quiver. A third brightly lit figure, this of a young

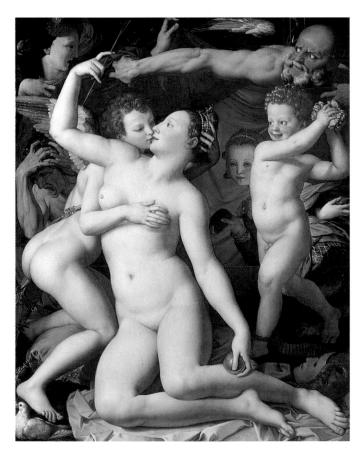

20.23 Allegory with Venus and Cupid, mid-1540s, commissioned by Cosimo I from **Agnolo Bronzino** as a gift to Francis I of France. Oil on panel, $61 \times 56\%''$ (155 × 143 cm) (National Gallery, London)

boy identified as Giuoco—or Playfulness, appears ready to shower them with the roses he holds in his hand, oblivious of the thorn at his foot. Above Giuoco is another well-lit figure, albeit more swarthy in appearance, representing Chronos, or Time. He extends a blue drapery across the background of the composition, essentially throwing the figures before it into relief. This drapery extends to the front of the painting, where it functions as a rumpled sheet on which Venus is seated, its icy blue color playing against the steely red of the cushion on which Cupid kneels.

Chronos and Giuoco are paired in a set of visual oppositions: young/old, light/dark, curly-headed/bald, smiling/ frowning. These suggest an interior dialogue on the actions of Venus and Cupid, although neither Giuoco nor Chronos actually looks at the main protagonists. Chronos looks toward the upper left corner of the painting at a figure variously identified as Fraud or Oblivion, whose head is really an empty shell, cut off behind the ear in mask-like fashion, and not unlike the two masks of Deceit lying at the bottom right. She is one of a trio of troubling shadowy figures in the cramped middle ground that includes a haggard, howling male tearing his hair at the far left and, just behind Giuoco, a beautiful young woman extending a sweet honeycomb. The male figure, once identified as a female Jealousy, is now thought to be a representation of pain ("dolor" is gendered male) or the "morbo gallico," known now as syphilis. At the time syphilis was called the "French disease" in part because its first recorded epidemic appearance occurred with the French troops who had invaded Italy in 1494. The female figure represents either a problematic Pleasure or Fraud, since her body, seen to the right of Giuoco, is that of a dragon, its tail curving past the two masks of Deceit to end in a stinger held in the figure's own right hand.

This esoteric imagery, still disputed by scholars, accords with elaborate Mannerist conceits and parallels the complexity of the poses. Cosimo sent this painting not only as a demonstration of painterly excellence, but as a demonstration of Florentine intellectual cleverness, necessary both for the invention of the imagery and for its unraveling. A princely ruler addressing a king chose an elevated and artificial language as the appropriate one to convey their mutual god-like status while at the same time playing to the king's taste for the erotic.

A Dynasty Supported by History and Myth

Cosimo was determined to reshape the public as well as the private face of Florence to reflect the city's new political realities. For a major sculptural commission in Piazza della Signoria, he turned to Benvenuto Cellini. Cellini lacked the reticence normally preferred at court; his flamboyant and openly counter-cultural lifestyle included, on separate occasions, dressing one of his male assistants as a young woman to accompany him to a party and gilding another's skin. But Cellini also possessed both the technical knowledge

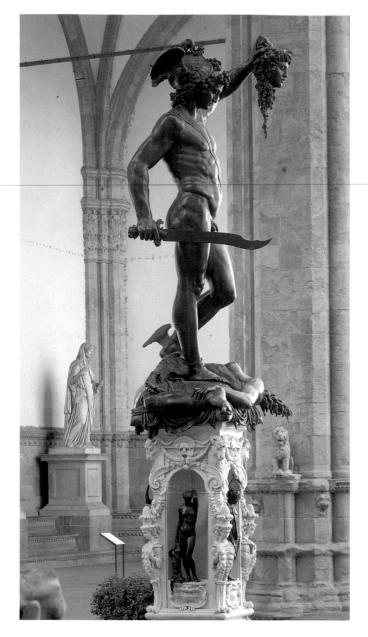

20.24 *Perseus*, 1545-54, commissioned by Cosimo I from **Benvenuto Cellini** for the Loggia della Signoria, Florence. Bronze, height 10′ 6″ (3.2 m)

The base and bronze statuettes are now in the Museo Nazionale del Bargello.

and artistic vision to continue the Medicean decorative program for the exterior of the Palazzo della Signoria initiated by Bandinelli's *Hercules and Cacus* (see Fig. 20.3). Cellini's over-life-size bronze *Perseus* (Fig. 20.24) depicts the slaying of the Gorgon Medusa, so hideous that to look upon her meant instant death by being turned to stone in sheer fright. Designed for the place where it still stands, under the left arch of the Loggia della Signoria, the *Perseus* would have been a companion piece not only for the *Hercules and Cacus* but, more notably, for Donatello's *Judith and Holofernes* (see Fig. 11.23), which then stood under the right arch of the loggia. The act of decapitation, the arm extended in space, and the sensuality of the male body (Fig. 20.25) are

comparable in each statue, so it is not unreasonable to see Cellini's bronze in competition with Donatello's sculpture of the previous century. The *Perseus* is also a critique of the extravagantly muscled body and tormented face of Bandinelli's male nude immediately to its left. Inscriptions on the base of Cellini's group indicate that the *Perseus* was conceived as a reference to the Medici as saviors of the public good who had freed the citizenry from tyrants—an ironic displacement of their own obsession for power. The sculpture's spatial pairing with the *Judith and Holofernes* would, then, have undermined the inscription placed on that statue in 1495 when it was moved to the Palazzo della Signoria and would once again have claimed it for the Medici.

Cosimo's plans for the Piazza della Signoria, the civic heart of Florence, did not stop at such oblique propaganda as the *Perseus* or the earlier *Hercules and Cacus*. Bandinelli received a commission for a large fountain in this space

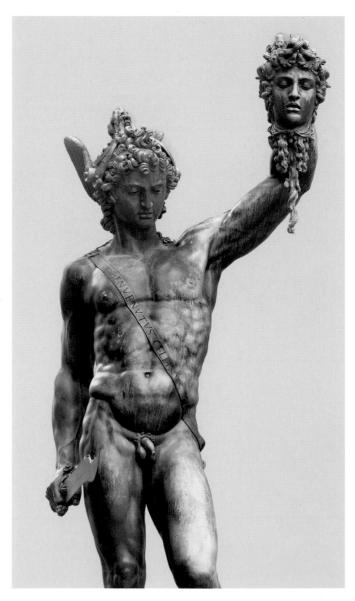

20.25 Perseus (detail of torso), 1545-54, commissioned by Cosimo I from Benevenuto Cellini for the Loggia della Signoria, Florence. Bronze

Casting the Perseus

This passage from Cellini's unfinished autobiography is one of the most famous of the artist's descriptions of his own technical brilliance. In it he pairs his own return to life with that of the bronze cast and plays on his role as Creator through his revivification of the near-failed casting. In this case his divine spark is one of superb technical know-how rather than of intellectual design, itself a witty inversion of the academic arguments then current.

I clothed my Perseus with the clays I had prepared some months previously in order to ensure that they would be properly seasoned. When I had made its clay tunic, as it is called, I carefully armed it, enclosed it with iron supports, and began to draw off the wax by means of a slow fire. It came out through the air vents I had made-the more of which there are, the better a mould fills. After I had finished drawing off the wax, I built round my Perseus a funnel-shaped furnace. It was built, that is, round the mould itself, and was made of bricks piled on on top of the other, with a great many gaps for the fire to escape more easily. Then I began to lay on wood, in fairly small amounts, keeping the fire going for two days and nights.

When all the wax was gone and the mould well baked, I at once began to dig the pit in which to bury it, observing all the rules that my art demands. That done, I took the mould and carefully raised it up by pulleys and strong ropes, finally suspending it an arm's length above the furnace, so that it hung down just as I wanted it above the middle of the pit. Very, very slowly I lowered it to the bottom of the furnace and set it in exact position with the utmost care: and then, having finished that delicate operation, I began to bank it up with the earth I had dug out. As I built this up, layer by layer, I left a number of air holes by means of little tubes of terracotta of the kind used for drawing off water and similar purposes.

I had had the furnace filled with a great many blocks of copper and other bronze scraps, which were placed according to the rules of our art, that is, so piled up that the flames would be able to play through them, heat the metal more quickly, and melt it down. Then, very excitedly, I ordered the furnace to be set alight. . . . the workshop caught fire and we were terrified that the roof might fall in on us, and at the same time the furnace began to cool off because of the rain and wind that swept in at me from the garden.

I struggled against these infuriating accidents for several hours, but the strain was more than even my strong constitution could bear, and I was suddenly attacked by a bout of fever. . . . I told my housemaids to bring into the workshop enough food and drink for everyone, and I added that I myself would certainly be dead by the next day. They tried to cheer me up, insisting that my grave illness would soon pass and was only the result of excessive tiredness. Then I spent two hours fighting off the fever, which all the time increased in violence, and I kept shouting out: "I'm dying!" . . .

In the middle of this dreadful suffering I caught sight of someone making his way into my room. His body was all twisted, just like a capital S, and he began to moan in a voice full of gloom, like a priest consoling a prisoner about to be executed.

"Poor Benvenuto! Your work is all ruined—there's no hope left!"

On hearing the wretch talk like that I let out a howl that could have been heard echoing from the farthest planet, sprang out of bed, seized my clothes, and began to dress. My servants, my boy, and everyone else who rushed up to help me found themselves treated to kicks and blows, and I grumbled furiously at them . . .

I went at once to inspect the furnace, and I found that the metal had all curdled, had caked as they say. I ordered two of the hands to go over to Capretta, who kept a butcher's shop, for a load of young oak that had been dried out a year or more before and had been offered me by his wife, Ginevra. When they carried in the first armfuls I began to stuff them under the grate.

The oak that I used, by the way, burns much more fiercely than any other kind of wood, and so alder or pinewood, which are slower burning, is generally preferred for work such as casting artillery. . . .

When they saw the metal beginning to melt my whole band of assistants were so keen to help that each one of them was as good as three men put together.

Then I had someone bring me a lump of pewter, weighing about sixty pounds, which I threw inside the furnace on to the caked metal. By this means, and by piling on the fuel and stirring with pokers and iron bars, the metal soon became molten. And when I saw that despite the despair of all my ignorant assistants I had brought a corpse back to life, I was so reinvigorated that I quite forgot the fever that had put the fear of death into me.

At this point there was a sudden explosion and a tremendous flash of fire, as if a thunderbolt had been hurled in our midst. Everyone, not least myself, was struck with unexpected terror. When the glare and noise had died away, we stared at each other, and then realized that the cover of the furnace had cracked open and that the bronze was pouring out. I hastily opened the mouths of the mould and at the same time drove in the two plugs.

Then, seeing that the metal was not running as easily as it should, I realized that the alloy must have been consumed in that terrific heat. So I sent for all my pewter plates, bowls, and salvers, which numbered about two hundred, and put them one by one in front of the channels, throwing some straight into the furnace. When they saw how beautiful the bronze was melting and the mould filling up, everyone grew excited.

[I] cried out loud: "O God, who by infinite power raised Yourself from the dead and ascended into heaven!" And then in an instant my mould was filled. So I knelt down and thanked God with all my heart. . . . This was so amazing that it seemed a certain miracle, with everything controlled and arranged by God.

20.26 Fountain of Neptune, 1550-75, Neptune figure completed in 1565, commissioned by Cosimo I from Baccio Bandinelli, ultimately made by Bartolomeo Ammanati and others for the Piazza della Signoria, Florence. Marble and bronze, height 18' 4½" (5.6 m)

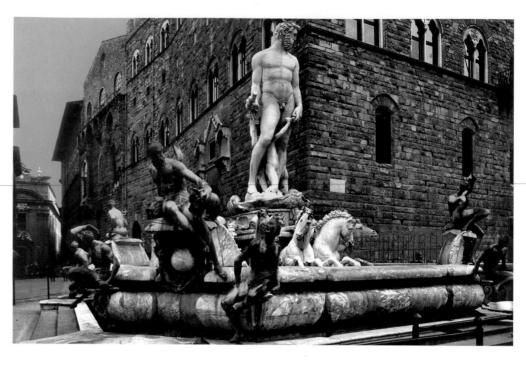

and, with the intervention of Eleonora of Toledo, who apparently despised Cellini, was eventually awarded the central marble statue of Neptune. Bandinelli's death in 1560 unleashed a frenetic competition among a number of sculptors vying for his privileged position as artist within the court. The major part of the work was ultimately awarded to Bandinelli's student and a friend of Michelangelo, Bartolomeo Ammanati (1511 Settignano–1592 Florence). He gave the gigantic marble Neptune surmounting the Fountain of Neptune (Fig. 20.26) the features of Cosimo, leaving little doubt that the generous gift of water to the center of the city was the duke's. In this fountain Cosimo, like a Roman emperor, was deified, repeating an image of power that Bandinelli had used for Andrea Doria in Genoa (see Fig. 19.12).

Representing Cosimo as Neptune, the god of the sea, was highly appropriate since he had recently conquered the city of Pisa, thus opening the Mediterranean to Florentine interests. By the time of the fountain's completion in 1575 (after Cosimo's death) the Neptune/Cosimo was aligned spatially with both Michelangelo's *David* and Bandinelli's *Hercules and Cacus*, toward which it looked, thus assimilating their meanings as both biblical and mythological heroes into Cosimo's propagandistic aims. Stylistically, the Neptune hovers between these earlier statues. Cosimo had claimed the Republic, making their stylistic opposition unnecessary.

Restructuring Civic Space: The Uffizi

In conjunction with Cosimo's sculptural commissions he also ordered the building of the Uffizi (Fig. 20.27). Designed to house all the civil offices (the meaning of *uffizi*), the guilds, and Medici court artists, the Uffizi is

an architectural symbol of a unified bureaucracy under Medici rule. Giorgio Vasari (1511 Arezzo-1574 Florence), the architect of the complex and the impressario of Cosimo's most important artistic commissions after 1555, built a long, U-shaped building whose colonnades at ground level imitate those in the Roman Forum. The reference to imperial rule was made explicit by including Vincenzo Danti's (1530 Perugia-1576 Perugia) statue of Cosimo as Augustus (Fig. 20.28) in a niche in the cross-arm of the building. The statue, showing the emperor in military costume, was appropriate for Cosimo I, whose reputation as a military leader was well understood (see Fig. 20.17). Although the appropriateness of such an image within this civic (not military) context might be questioned, the Arno, flowing west to Pisa, which Cosimo had taken for Florence, could be seen through the open archway at the end of the axis of the building. Danti had studied with Michelangelo and Daniele da Volterra in Rome before coming to Florence in 1557, and thus he know both the traditions of ancient military statues of emperors and the conventions of twisting body poses and fantastical armor (see Fig. 20.11) that were part of contemporary artistic vocabulary.

Vasari ordered the difficult site by dividing the façades into tripartite bays in which triangular and segmented pediments alternate over the windows in an a-b-a pattern and by breaking and extending the cornice lines forward at the separation of each bay. Nonetheless, the unremitting repetition of forms sets up a sense of oppressive order in the urban landscape which could be related to Cosimo's control over the state. As an extension of the Piazza della Signoria, and with its virtual attachment to the Palazzo della Signoria and the Loggia della Signoria (see p. 77), the Uffizi marks the imposition of Cosimo's ducal government over all aspects—political, mercantile, and artistic—of civic life.

20.27 (right) Uffizi, Florence, 1560–80, commissioned by Cosimo I from Giorgio Vasari, completed by Bernardo Buontalenti and Alfonso Parigi

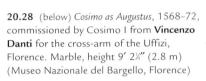

The statue repeats the pose of Michelangelo's *Bacchus* (see Fig. 11.44), which Francesco de' Medici bought for the ducal collection in 15/2. Francesco seems to have been involved with this commission, at least in its early stages. He replaced the statue in 1595 with Giambologna's figure of a standing Cosimo I now still in place.

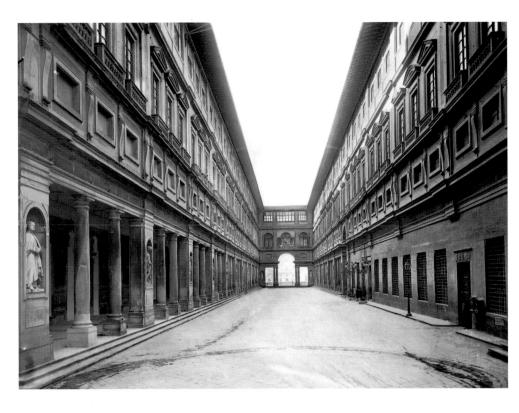

The Sala del Gran Consiglio

Vasari was also responsible for major renovations inside the Palazzo della Signoria, soon to be renamed the Palazzo Vecchio ("old" palace). Besides being commissioned to decorate rooms explicitly dedicated to Cosimo's ancestors— Cosimo Pater Patriae, Lorenzo the Magnificent, and Leo X (Giovanni de' Medici)-Vasari designed a program for the Hall of the Great Council (Fig. 20.29). His scheme covered ceiling, soffits, and walls, necessitating the destruction of the remains of Leonardo's Battle of Anghiari and erasing all memory of the projects for this room initiated by the Republic of 1494–1512. At the center of the focal short wall of the room is an over life-sized seated marble figure of Leo X by Bandinelli, a recognition of Cosimo's debt to the ancestor who had named him and who had brought Florence back under Medici control after 1512. Medici dynastic imagery is somewhat heavy-handedly displayed in the overall set of commissions of which the Leo image is the center: Cosimo's father, the military general Giovanni delle Bande Nere, appears to the left of the pope and Alessandro, his cousin and the first duke of Florence, to his right (both by Bandinelli). The ceiling program merged the history of the city of Florence with Cosimo's military victories. Each narrative carries a didactic inscription. At the center of the enormous room, in a circular panel in the ceiling, is an image of the Apotheosis of Cosimo (Fig. 20.30), surrounded by the heraldic shields of the commune, the people and the city of Florence, and of the twenty-one guilds of the city. This image replaced one of the Glorification of Florence in an earlier plan. Now Flora (Florence) obediently crowns a

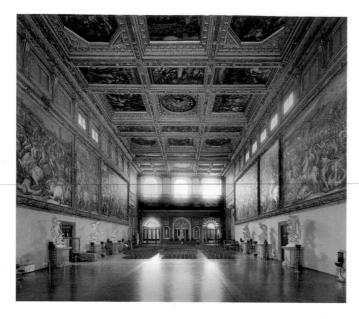

20.29 Interior of Sala del Gran Consiglio, Palazzo della Signoria, Florence.

mask-like Cosimo, dressed in formal military attire, and a small putto holds the ducal crown in the background. When Cosimo finally secured the title of Grand Duke of Tuscany from Pope Pius V in 1569—an honor that had eluded him in his negotiations with Charles V in 1537—he had already fashioned the public spaces and images that would confirm his exalted position.

The Florentine Academy

Just as Cosimo re-ordered the government of Florence, so the founding of the Accademia del Disegno (Academy of Design) by Vasari and others in 1562 re-aligned the arts in Florence. The patron and sponsor of the Academy was the duke himself, to whom Vasari had dedicated the first edition of his *Lives* in 1550. Art and the state were clearly linked, even as artists were encouraged to invent new conceptual structures for their work. The Academy placed a strong emphasis on history and theory, thus removing the arts from the craft traditions which had previously governed their existence.

It also encouraged artists to develop their talents and ideas free of traditional conventions relating to content. The work of Giambologna (1529 Douai–1608 Florence) is a case in point. Trained in his native Flanders by an Italianate sculptor, he himself went to Rome in 1554 and then to Florence in 1556, where he soon came to the attention of the Medici. His *Rape of the Sabines* (Fig. 20.31) was apparently begun as a free invention during his stay at the Academy, intended as a demonstration of his ability to solve difficult compositional problems, in this case with no particular narrative in mind. When Cosimo's son, Grand Duke Ferdinand I (r. 1587–1609), saw the work, he decided it should be placed in the Loggia della Signoria as a pendant to his father's *Perseus*. Asked to name the work, Giambologna suggested that the woman could be Andromeda, the wife of

Perseus, clearly an attempt to unify the program of the Loggia and to connect father and son as patrons/rulers of the city. But Raffaello Borghini, a leading member of the Academy, proposed the Sabines as the subject, a designation which has remained ever since. Although the self-conscious complexities of the physical movements and interactions—interesting in themselves, divorced from content—place this sculptural group well within the conventions of Mannerism, it is the changed role of the artist, supported by the Academy, which made the exploration of formal issues a content in its own right.

These purely artistic concerns—at least as they appear in the fully developed *maniera*—reached their climax in such paintings as Bronzino's late masterpiece, the *Martyrdom of St. Lawrence* (Fig. 20.32), which was another commission for the Medici's parish church of San Lorenzo. There is hardly a stylistic reference that does not appear in this feverish painting: an academic recreation of a Roman city, decorated with quotations from

20.30 Apotheosis of Cosimo, 1562, commissioned by Cosimo I from Giorgio Vasari for the centerpiece of an elaborately coffered and painted ceiling in the Sala del Gran Consiglio, Palazzo della Signoria, Florence

20.31 The Rape of the Sabines, 1579–83, **Giambologna**, Loggia della Signoria, Florence, replaced Donatello's *Judith and Holofernes* in 1582 and was completed the following year. Marble, height c. 13′ 5½″ (c. 4.1 m)

classical sculpture; quotations from the paintings of Michelangelo, the father figure of the Academy; figures, like that in the lower right, who are part of the narrative space, but whose inclusion is more for their references to classical sculpture; a gratuitous use of nudity as a reference to classical antiquity; animated figures whose poses are notable more for their inventiveness and complexity than as reasonable depictions of the actions they pursue; a tour de force of complex compositional arrangements, as if the painter had a limitless supply of imagination from which he could effortlessly draw; a peopling of the figures by those who seem emotionally unaffected by the grisly martyrdom of the central figure, who himself reacts rather too gracefully to the flames that begin to burn his body; and portraits inserted at a reduced scale in the mid-ground, as if the sitters wished to assert their presence within an artistic event rather than participate in a narrative at which none of them bothers to look.

This focus on art and artfulness served both the artists, in their attempts to claim an elevated social role in the culture, and Cosimo I, as the titular head of the Academy, in his efforts to bring all aspects of Florentine life under his control. Mannerism and its refined final phase of *maniera* had proven once again how style could effectively serve social and political ends.

20.32 Martyrdom of St. Lawrence, 1565-69, commissioned by Cosimo I from Agnolo Bronzino. Fresco (Florence, San Lorenzo)

2 1 Venice: Vision and Monumentality

y the beginning of the 1500s, a century of successful expansion onto the Italian mainland had earned Venice the jealous enmity of the pope, the Holy Roman Emperor, the king of France, and the lords of Milan. In 1509 these powers formed the League of Cambrai, a military alliance dedicated to stripping Venice of its mainland possessions. Psychologically and militarily unprepared, Venice watched incredulously as its empire dissolved and

foreign troops advanced on the community of Mestre, just across the lagoon from the city. Over eight centuries of independence seemed on the verge of ending.

Through immense sacrifice, self-determination, and a good deal of luck, Venice did prevail. It regained its prize possession, Verona, in January 1517. Twelve years later, in 1529, the city obtained a final peace, which affirmed its right to holdings nearly as extensive as before the war. Near miraculous in its recovery, Venice became the subject of a carefully formulated civic myth which stressed that the city had been saved because of its unique site and history, its maritime origins having produced an especially stouthearted and selfless citizenry, willing to sacrifice personal profit for communal gain. Although modern historical research has shown that the Venetians were as likely as other Italians to avoid civic duty, especially when it conflicted with their business interests, it is true that traditional communal values helped to bolster local pride and encouraged the Venetians to persevere.

In the midst of often bleak and dangerous times, harshly contrasting with the prized values of stability and serenity which had earned the republic its epithet of La Serenissima, some Venetian patrons naturally preferred the familiar artistic styles of the past, continuing to commission works from such "eyewitness" painters as Carpaccio (see Fig. 13.27). But many others embraced a new style, which was evocative and often ambiguous rather than descriptive. They also sought solace and delight in nostalgia for the remote classical past, many of whose myths and idyllic images had become newly accessible

through Venice's printing industry, one of the most productive and important in Europe. Faced with challenges for which local history and civic rhetoric did not provide ready answers, artists created ideal and elevated images of reassuring beauty, in the process inventing new types of painting (such as the pastoral landscape) and reinvigorating old forms (such as the portrait) with new expressive possibilities.

Visual Poetry

An important innovation in Venetian art of this period was the poesia, or painting that was meant to operate in the indirect manner of poetry. Foremost among painters of the new manner was Giorgione (Zorzi da Castelfranco; c. 1477-78 Castelfranco-1510 Venice), a painter from Castelfranco, a small town northwest of Venice. A painting known since 1530 as the Tempesta (Fig. 21.1) because of the storm that thunders in the background clearly demonstrates his originality. Despite the drama of the storm and the commanding presence of the landscape—itself a novelty in Italian painting at this time-it is the figures that command our attention. A virtually nude woman sits on a hillock at the right nursing a baby. A man carrying a halberd, but dressed in an unkempt manner hardly appropriate for a soldier, stands looking toward them from the left. Contrary to accepted traditions, Giorgione has pushed these figures to the sides of the painting, so that attention is drawn back to the watery middle ground and to a bolt of lightning that flashes eerie light across the walls of a city.

21.1 *La Tempesta*, c. 1509 (?), perhaps commissioned by Gabriele Vendramin from **Giorgione**. Oil on canvas, $32\% \times 28\%''$ (82×73 cm) (Galleria dell'Accademia, Venice)

(opposite) *Pesaro Altarpiece*, 1519–26, commissioned by Jacopo Pesaro from **Titian** for the Pesaro Chapel, Santa Maria Gloriosa dei Frari, Venice. Oil on canvas, 15′ 11″ × 8′ 10″ (4.85 × 2.69 m)

The kneeling figures at the bottom are all Pesaro family members.

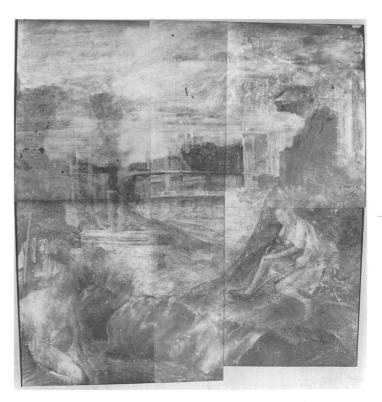

21.2 *La Tempesta* (radiograph of underpainting), c. 1509 (?), perhaps commissioned by Gabriele Vendramin from **Giorgione**.

X-ray photographs of the painting (Fig. 21.2) reveal that Giorgione originally painted a female nude bathing where the man now stands. The change in figures, their ambiguous relationship to the landscape and to each other, and the unpopulated cityscape and ruins have led some writers to believe that the painting simply lacks a subject, in the traditional sense of that word. This argument is upheld by the fact that Giorgione painted over the female in the lower left replacing her with the standing male soldier; the artist was clearly changing the fundamental components of the painting as he went along, precluding a definite, preordained subject ordered by a patron. The soft, feathery leaves, moist landscape, and sparkling highlights give the painting the air of a romantic tale that the viewer's imagination must complete.

Other scholars have sought explanations in ancient mythology and the Bible, seeing the nursing woman as representing such diverse and contradictory characters as Eve, Venus, Ceres (the goddess of grain), or Mater Tellus (Mother Earth). Others see the work not as a narrative concerning one of these figures but as allegorical, which more easily accounts for but does not fully explain its compositional peculiarities and abstruse subject.

Yet another reading sees the painting as a martial allegory. This interpretation depends on the assumption that the Venetian nobleman Gabriele Vendramin, in whose collection the work is first documented in 1530, was the patron of the work. His uncle and brothers were heavily involved in the Cambrai Wars, especially the early and successful

campaign to regain Padua. The arms of the Carrara family, who ruled Padua until its annexation by Venice in 1406, appear on some of the towers in the background of Giorgione's painting along with a separate representation of Venice's Lion of St. Mark. The specific imagery may be related to a statement ascribed by later historians to Doge Leonardo Loredan (r. 1501–21), who asked young Venetian noblemen to take up arms to regain Padua, which had been lost due "to a certain fatal tempest." In combination with the image of the broken columns at the left of the painting, which may refer to fortitude, and the nursing mother at the right, who evokes traditional images of charity, the painting could then be an allegory of patriotism—the storm in the background referring to war and unpredictable fortune.

Whatever the painting's intended subject, it is clearly a revolutionary work, one in which evocative color, form, and light seem both to demand and to frustrate attempts at a literal reading. With this painting visual poetry was born.

Eroticism and Antiquity

One way in which Giorgione and his patrons exploited the new style was through sensual subject matter. The *Sleeping Venus* (Fig. 21.3) is a case in point. The reclining figure was originally accompanied by a small figure of Cupid holding a bird at the right side of the painting, but this figure was painted over in 1843.

Giorgione placed the Venus across the whole width of the painting. She stretches one arm behind her head, making a long, continuous slope of body whose gentle curves echo the hills of the landscape behind and suggest some form of connection between the female depicted and nature. Painted at just the moment when Venice was defending its claims on the terra firma, it may, therefore, be possible to read Venus (Venere) as Venice (Venezia).

Venus's sensuality is heightened by her red lips and by the deep red velvet and white satin drapery upon which her creamy body lies. Significantly, she is asleep, so the issue of decorum is bypassed. Her sleep implies dreaming and transport of the figure to another world like Poliphilus, whose dream took him, accompanied by a nymph, through an imagined ancient bucolic world in the bestseller printed by Aldus Manutius in Venice in 1499, the *Hypnerotomachia Poliphili (The Dream of Poliphilus*; see Fig. 35, from the same book). Thus the painting may be interpreted as a poetic evocation of a classical idyll.

But no amount of poetic mythology or political allegory can override the sensual nature of the image. Apart from her pose, this Venus bears no resemblance to female nudes from ancient Roman sculpture. Instead, she looks like a contemporary Venetian woman who has removed her clothes. Her left hand seems not to be modestly hiding her genitals but apparently pleasuring them (and at the exact vertical center of the painting). According to gynaecological treatises of the time, female masturbation made a woman more fertile. Such a representation of Venus would have been appropriate if—as the horizontal format of the painting suggests-it was integrated into a piece of bedroom furniture, perhaps commissioned around October 1507 when Girolamo Marcello (who owned the Sleeping Venus) married Morosina Pisani. Reclining nude men or women appeared regularly on the inside covers of dowry chests, alluding to the fertility hoped for in marriage. In fact, the first reference to a sleeping Venus in classical literature seems to have been in a poem by the Roman poet Claudianus, written in 399 to celebrate the wedding of two friends. Since the primary goal of marriage was to produce a male child, Venus may well have been a talisman to guarantee Morosina and Girolamo an heir.

Perhaps even more obvious an example of the poetic, pastoral tradition initiated by Giorgione's *Tempest* is his *Pastoral Concert* (Fig. 21.4), a painting sometimes also attributed to the young Titian (Tiziano Vecelli; c. 1488 Pieve di Cadore–1576 Venice), a painter from the Dolomites who early in his career collaborated with Giorgione and then

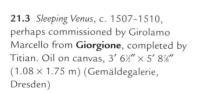

The thatched, steeply-sloping roofs of the buildings in the background are not typically Italian and suggest that Giorgione copied them from Northern European prints.

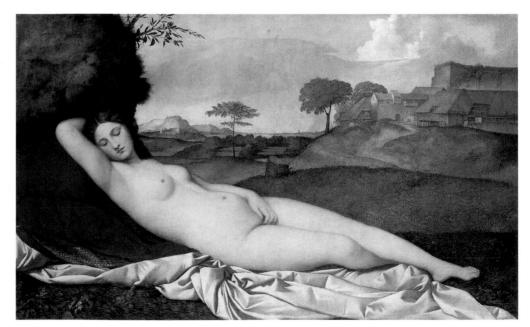

21.4 Pastoral Concert, c. 1509–10, probably by Giorgione, although the painting is sometimes attributed to Titian. Oil on canvas, 43½ × 54½" (110 × 138 cm) (Musée du Louvre, Paris)

The landscape in this painting extends remarkably far into the distance to a misty plain and mountains reminiscent of Leonardo da Vinci (see Fig. 16.2).

went on to become Venice's most eminent Renaissance painter. Here pastoral references, with a shepherd and his flock in the middle distance to the right, are obvious, as is Giorgione's poetic juxtaposition of opposites. Two men are seated in the lush country landscape, one dressed in the elegant costume of a Venetian nobleman, the other barefoot and wearing rustic clothing. They are accompanied by two nude women. Despite their sixteenth-century costumes, the men in this poesia are enveloped in a romantic evocation of pastoral antiquity. The men's faces are shadowed as they turn toward one another, creating a private interaction between themselves from which the viewer—not to mention their companions—is excluded. In fact, they seem completely oblivious of the women, one of whom is seated immediately in front of them and facing them. The other stands outside the central group to the left, her body in a complicated contrapposto position as she empties a glass ewer (Fig. 21.5), reversing the normal practice of taking water from a well. As is evident in the detail, Giorgione has suggested more than delineated the forms of the ewer and her body. His paint brush barely touches the surface of the canvas in some areas, allowing the tinted weave to provide texture and substance to her flesh; on the base and side of the ewer, thick impasto gives substance to reflected light. For the first time in European painting, the artist openly acknowledges the nature of his materials while simultaneously marshalling them to illusionistic effect.

21.5 *Woman Pouring Water* (detail of *Pastoral Concert*), c. 1509–10, probably by **Giorgione**, although the painting is sometimes attributed to **Titian**. Oil on canvas (Musée du Louvre, Paris)

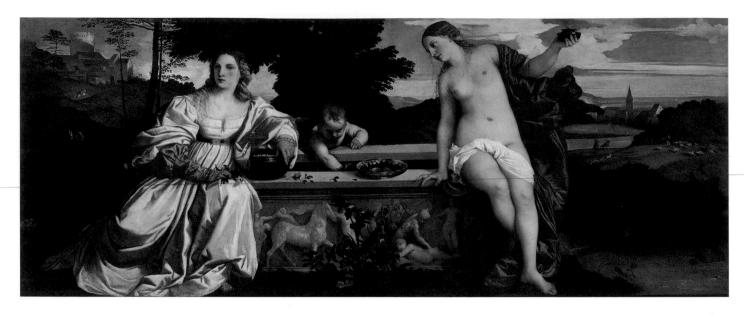

21.6 Sacred and Profane Love, c. 1514, commissioned by Niccolò Aurelio on his marriage to Laura Bagarotto in 1514 from **Titian**. Oil on canvas, 46½ × 109½" (118 × 279 cm) (Galleria Borghese, Rome)

The painting is held together compositionally by the soft light that suffuses the entire landscape, uniting the psychologically distant figures. The compositional elements all point to peace between city and country, but once again a precise meaning and subject seem purposefully avoided. Since it allowed a variety of interpretations, viewers could have made allusions to classical literature and have demonstrated their learning in their comments.

The integration of landscape painting and mythology into the traditions of Venetian art is evident in Sacred and Profane Love (Fig. 21.6) by Titian. Even more elongated than the Sleeping Venus, the painting almost certainly served to adorn a piece of furniture. The facial resemblance between the two women suggests that they may be the same person in two guises. The presence of Cupid behind the sarcophagus stirring the waters of love within it (Fig. 21.7) indicates that the nude figure is the celestial Venus, representing divine love. She holds a burning lamp aloft, its tiny flame silhouetted against the clear blue sky, while her fluttering red satin cloak billows dramatically along the left side of her body, a marked contrast to her creamy smooth flesh. The woman at the left, dressed in heavy, luxurious clothing and wearing gloves, would then be the earthly Venus, for the materials of her clothing appeal to the human senses, as do her low-cut dress and open bodice. The slash of red sleeve against the cool blue of her dress adds to the sensuousness of the satin.

The painting reflects the new classical learning of the period and the new Venetian fascination with landscape while it simultaneously celebrates married sexual love. The floral wreath in the hair and flowers in the lap of the dressed Venus signal fertility, surrounded by emblems of fecundity: the stallion on the sarcophagus and the rabbits in the landscape at the left. The shield on the sarcophagus

identifies the patron as Niccolò Aurelio, the vice-chancellor of the Venetian republic. Nearly hidden in the silver bowl on the edge of the sarcophagus is a second crest belonging to Laura Bagarotto, whom Aurelio married in 1514. The Sacred and Profane Love is certainly a marriage painting for

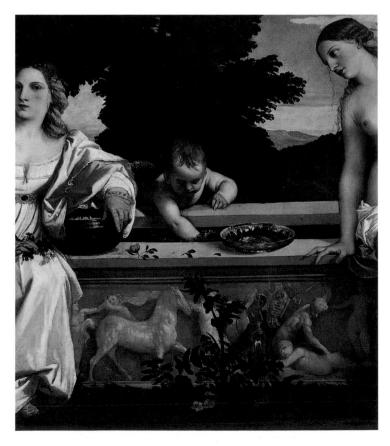

21.7 Sacred and Profane Love (detail), c. 1514, commissioned by Niccoló Aurelio from Titian. (Galleria Borghese, Rome)

this couple, its purpose to remind the wife of her virtuousness and her procreative powers by the double guise of Venus and, unsubtly, by the small rabbits in the fields at the left. It was also to provide the husband with a charged erotic image whose moral message nonetheless maintains the boundaries of decorum.

Poetic Altarpieces

A more poetic approach also characterized religious painting in Venice at this time. Perhaps around 1505, Giorgione painted an altarpiece for the cathedral of his home town, Castelfranco (Fig. 21.8). The painting shares the shimmering light and *trompe l'oeil* effects of Giovanni Bellini's *San Giobbe Altarpiece* of two decades earlier (see Fig. 13.22), making specific reference to Bellini's figure of St. Francis, here shown in a mirror image, and again inviting the worshiper to enter a sacred realm. But Giorgione's figures are set at a distance, no longer existing in a world directly adjacent to the viewer's space. Instead, a pavement intervenes, and the Madonna and Child appear as in a vision on top of an altarshaped throne. Giorgione's considerable illusionistic and

21.8 Enthroned Madonna and Child with St. Liberale and St. Francis, c. 1504 (?), commissioned by Tuzio Costanzo, perhaps to commemorate the death of his son, Matteo, in 1504, from **Giorgione** for Castelfranco Cathedral. Panel, $6' 6\%'' \times 5' (2 \times 1.52 \text{m})$

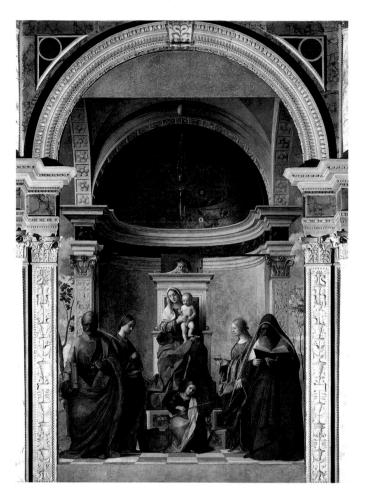

21.9 *Enthroned Madonna, Child, and Saints*, completed 1505, commissioned for the Benedictine nuns of San Zaccaria from **Giovanni Bellini** for San Zaccaria, Venice. Oil on canvas transferred from wood, $16'5\%''\times7'9''$ $(5\times2.35~\text{m})$

descriptive powers do more than counterfeit reality: they enhance and exalt it. Balancing the armor-clad St. Liberale and the fortified landscape on the left with a barefoot St. Francis and a glowing scene of peaceful nature on the right, Giorgione groups his figures into a highly calculated, pyramidal organization very different from the almost casual gathering of Bellini's earlier altarpiece.

This new manner finds parallels in the late work of Giovanni Bellini himself, exemplified by an altarpiece for one of the side chapels of San Zaccaria (Fig. 21.9). As at San Giobbe (see Fig. 13.22), Bellini surrounds his figures with classicizing architecture, but the space inhabited by the holy figures is no longer a literal extension of the actual church. Instead, the scene opens to trees and sky at left and right, suggesting an airy setting for contemplation. As in Giorgione's exactly contemporaneous work, Bellini sets his figures farther back in space, reduces their number, and casts their eyes down or slightly obscures them with shadows. Bellini may have been inspired by Giorgione's work, though it is just as likely that the younger artist drew inspiration from Bellini's example. Whatever the precise relationship between the two artists, they both promoted a

new, more evocative style which quickly came to dominate Venetian painting.

One of the most gifted young artists to follow and promote the new style was Sebastiano del Piombo. Between March 1510 and spring 1511, when he left Venice for the papal court in Rome, Sebastiano painted an altarpiece for the parish church of San Giovanni Crisostomo (Fig. 21.10). The church had recently been reconstructed on a Byzantine-inspired Greek cross plan devised by Mauro Codussi, and Sebastiano responded to its open and essentially centralized plan by turning his composition at an angle into space. This necessitated a break with the traditional frontal placement of his saints, allowing for more complex groups, who are set before a monumental colonnade which reaches above and beyond the frame. Moving from the left, the figures are disposed in a diagonal back into space. This axis is then countered by the tilt and gaze of John the Baptist from the opposite side of the canvas, crossing at the central figure of the seated St. John Chrysostom.

The work, like Giorgione's and Titian's secular *poesie*, is psychologically complex and offers the attuned viewer numerous visual surprises. First there is the reaction of the

21.10 San Giovanni Crisostomo Altarpiece, 1510-11, **Sebastiano del Piombo**, San Giovanni Crisostomo, Venice. Oil on canvas (perhaps transferred from panel), 6′ 6½″ × 5′ 5″ (2 × 1.65 m)

The painting is now in poor condition, but its novel composition merits special attention.

woman on the left, who looks rather askance at the presumed viewer. Next, while St. John Chrysostom, the major dedicatee of the altarpiece, serves as the central fulcrum of the composition, he is lost in both shadow and thought as he writes in a large tome. John the Baptist at the far right poses gallantly and peers inquisitively at the saint, the inscription on his unfurling banderole changed from the usual "Ecce Agnus Dei" ("Behold the Lamb of God," referring to Christ) to "Ecce Sanctus" ("Behold the Saint"), returning the worshiper's attention to John Chrysostom. The soft-focus realism of the figures and the fusion of form and shadow allowed by the medium of oil paint create an evocative rather than descriptive painting, establishing a mood of mystic reverie.

Energized Altarpieces

Titian was more of a story teller than either Giorgione or Sebastiano, and his altarpieces, whether of actual narrative subjects or-traditional devotional themes, offered Venetian patrons a strikingly dynamic alternative to the usually quiet and contemplative character of Venetian devotional art. In 1516 Germano da Caiole, prior of the Franciscan basilica of Santa Maria Gloriosa dei Frari, commissioned Titian to produce a large Assumption of the Virgin for the church's high altar (Fig. 21.11). The epoch-making painting was unveiled on May 19, 1518, a day significant for Venice as well as for the Franciscans because it was the eve of the feast of San Bernardino of Siena, a Franciscan reformer and one of the city's official saintly protectors. It immediately set a new standard for monumentality and drama, confirming Titian's position as the undisputed leader of Venetian painting. In the altarpiece, its subject being derived from the principal dedication of the church to the "glorious" Virgin, Titian created a highly charged representation of the Virgin's bodily ascent into heaven. He also succeeded in establishing a focal point for this spacious church. Flanked by two of the largest of the doges' tombs in the city (see Fig. 13.31), the altarpiece stands directly in front of a multistoried screen of stained-glass windows that fill the apse with rich, glowing light. Titian responded to this imposing setting by breaking his composition into two stories, coordinated with clear divisions in the tracery in front of which it stands. He also made his figures larger than life, dressing them in sonorous shades of red, blue, and green, and directing their gestures heavenward, where God the Father hovers in a circle of golden clouds. A fiery aureole of angel heads echoes the curving top of the altarpiece, completed as a full circle in the clouds and cherubs below who surround the Virgin (Fig. 21.12). She stands firm and erect, even as her dress and cloak swirl around her and she lifts her watery eyes, picked out with white highlights, toward her heavenly reward. Seen from as far away as the church's entrance, Titian's bold composition, eloquent gestures, and pulsating light dominate the church's elaborate interior.

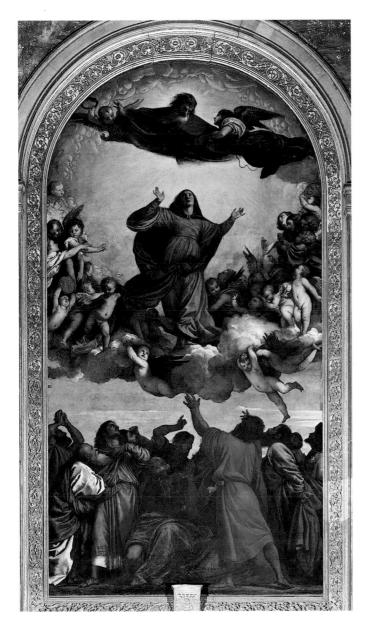

21.11 Assumption of the Virgin, 1516–18, commissioned by Germano da Caiole from **Titian** for the main apse of Santa Maria Gloriosa dei Frari, Venice. Oil on panel, $22'7'''\times11'9'''(6.9\times3.6\text{ m})$

The painting stands in its original frame, which is inscribed with the name of the patron. Statues of the Risen Christ, St. Francis, and St. Anthony stand on its summit.

Given the resounding success of the painting as a celebration of the Virgin's Assumption—a central element in Franciscan theology, and as the visual culmination of nearly two centuries of construction at the Frari, it may seem surprising that Titian's patrons expressed concern about the composition while he was painting it. In particular, they complained that the Apostles at the bottom of the composition were too large. But Titian countered that his strategic shadowing of the Apostles' gesticulating forms would diminish their apparent importance in the composition, while still retaining their function as an essential foil to the light-drenched, heavenly realm above. His self-assurance

was a milestone in relations between artist and patron, furthering the then novel idea of the artist as main begetter of the work.

In an altarpiece commissioned for a side chapel in the Frari by the Pesaro family (see p. 464), Titian built on the example of Sebastiano's *San Giovanni Crisostomo Altarpiece* (see Fig. 21.10), placing his figures against enormous columns, steps, and the corner of a classically detailed palace. The setting seems as grand as, if not grander than, the vast space of the Frari. He also set his figures on a diagonal, so that the worshiper walking down the nave is drawn up and into the composition from the kneeling donor to the Virgin and Child.

The clarity of the composition masks the complexity of its program, which addresses doctrinal, personal, and familial concerns. The altar above which it stands had been dedicated to the Virgin of the Immaculate Conception before Jacopo Pesaro, donor of the altarpiece, acquired patronage rights to it. Since the very doctrine of the Immaculate Conception was so dear to the Franciscans, and because a confraternity dedicated to the doctrine celebrated its feast at this altar, Jacopo seems to have been unwilling or unable to alter the dedication. Titian may have underscored the theme with his two columns and ring of clouds, which evoke a phrase in Ecclesiasticus 24:7 used by the Franciscans to defend the doctrine: "my throne was in a pillar of cloud." The unusual inclusion of St. Peter at the physical center of a Marian altarpiece-though deftly handled by placing him at a less exalted height than the Virgin-is accounted for by an incident in Jacopo Pesaro's life. In 1502 Jacopo was the leader of papal forces who defeated the Turks at the Ionian island of Santa Maura for Pope Alexander VI, whose arms appear on the shimmering victory banner held by a soldier behind him. The turbaned figure at the left, behind the kneeling figure of Jacopo,

21.12 The Virgin (detail of Assumption of the Virgin), 1516-18, commissioned by Germano da Caiole from **Titian** for the main apse of Santa Maria Gloriosa dei Frari, Venice. Oil on panel

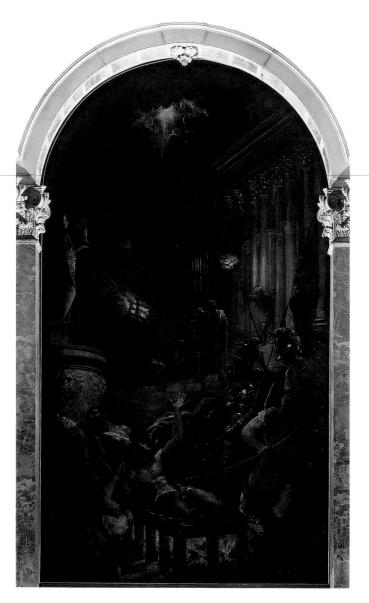

21.13 Martyrdom of St. Lawrence, 1548-57, commissioned by Lorenzo Massolo in 1548 (and confirmed by his widow, Elisabetta Querini, in 1557) from Titian for his chapel in the right aisle of Santa Maria dei Crociferi. Oil on canvas, 16' 4%" × 9' 2\%" (5 × 2.8 m) (Chiesa dei Gesuiti, Venice)

This is Titian's first major depiction of a nocturnal event.

represents the conquered Turk brought to Christianity, the leadership of which is symbolized by St. Peter. Some of Jacopo's male relatives, kneeling at the right, are recommended to the Virgin and Child by St. Francis, who points with his right hand to his namesake Francesco Pesaro, the head of the clan.

Titian's accomplishments at the Frari led the way to numerous other commissions for dramatic, energized altarpieces. In a towering composition dedicated to St. Lawrence (Fig. 21.13), painted two decades later, Titian again paid particular attention to the painting's location within the church. Taking into account that the altarpiece was to be located on the right side of the church, Titian drew the worshiper into the martyr's world by setting the action on the diagonal, a device he previously used, in reverse, in the Pesaro Altarpiece (see p. 464). Titian broke new ground by setting the saint's horrific martyrdom in deep nocturnal darkness, his blazing grill an ironic counterpart of St. Lawrence's words in the Golden Legend (a book of lives of the saints): "My night hath no darkness; all things shine with light!" Embers burn white-hot under the grill, torches flare red and yellow in the night air, and rays of light break through the dense clouds to offer the saint divine recognition and reassurance. All other forms are left in shadow, suggesting the transience of worldly glory, which Titian imagines in terms of imperial Rome. This classical imagery includes a representation of the goddess Vesta on the pedestal at the left (Fig. 21.14). Smoking and burning torches cast a ghostly pallor over her form, pick out the edges of small figures on the steps of her temple, and reveal the glow of its polished marble columns. This close attention to a temple precinct probably derives from Titian's reading of a poem by the fourth-century Roman Christian writer, Prudentius, whose work was published in Italian in Venice by the Aldine Press: "The death the holy martyr died was in truth the death of the temples. That day Vesta saw her Palladian house-spirits deserted and no vengeance follow. All the Romans who used to reverence Numa's libation

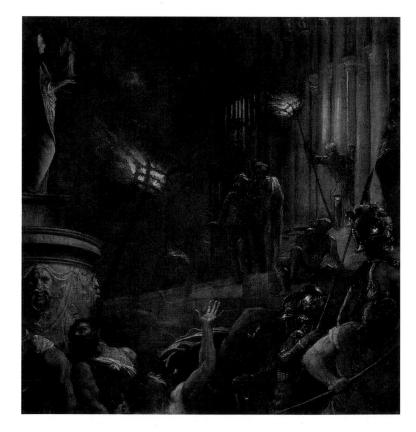

21.14 Vesta and Temple Columns (detail of Martyrdom of St. Lawrence), 1548-57, commissioned by Lorenzo Massolo in 1548 (and confirmed by his widow, Elisabetta Querini, in 1557) from Titian for his chapel in the right aisle of Santa Maria dei Crociferi. Oil on canvas (Chiesa dei Gesuiti, Venice)

cup now crowd the churches of Christ and sound the martyr's name in hymns." The saint's searing torture is thus to be understood as an image of ultimate Christian victory and Titian's nocturnal effects as an emblem of the transition from benighted paganism to full divine illumination.

Tullio Lombardo: Classicism for Ecclesiastical Patrons

During the Cambrai Wars, only the most urgent building projects (which included the rebuilding of the Rialto business district after a fire in 1514) went forward; this included work on the nearby church of San Salvatore (Figs. 21.15 and 21.16), laid out by the head of civic works in Venice, Giorgio Spavento (active 1486–1509 Venice), but continued by Tullio Lombardo (c. 1455 Venice–1532 Venice), son of Pietro Lombardo. Abandoning his father's rather precious and sometimes fussy detail, Tullio successfully emulated the dignity and monumentality of ancient Roman architecture, filtering it, as was usual in Venice, through Byzantine

21.15 San Salvatore, Venice, 1507–32, commissioned by Antonio Contarini from **Giorgio Spavento** and **Tullio Lombardo**

A silver gilt altarpiece on the high altar resembles the *Pala d'Oro* (see Fig. 7.6). It is exposed only from August 3–5; otherwise it is covered by a badly damaged *Transfiguration* (c. 1560–65) by Titian.

21.16 San Salvatore, Venice, plan

sources. The church's link with St. Mark's Basilica can be seen in the nave, which consists of three interlocking, centrally-planned units, each surmounted by a dome and flanked at the corners by smaller domes. Tullio Lombardo, who had already evolved a spare, impressive classicism in his reliefs for the façade of the Scuola Grande di San Marco (see Fig. 13.28), gave visual coherence to the interior with a series of proportionally interrelated pilasters distributed between the nave and the corner units. Crisp but substantial moldings, elegant Corinthian capitals, and broad barrel vaults add to the building's serene elegance.

The revived classicism evident at San Salvatore also informs Tullio's work for the Santo in Padua. His relief of the Miracle of the Miser's Heart (Fig. 21.17) forms part of an unprecedentedly rich scheme of nine large compositions lining the walls of the saint's chapel in the left transept of the Santo. The entire program was designed to bolster the cult of the city's miracle-working saint at the very moment that Protestants in northern Europe and even some of the professors at Padua's university were attacking traditional notions of saints and relics. Tullio and his collaborators went on the offensive, presenting the saint's miracles as nobly and dramatically as possible. Tullio's work centers around the corpse of a miser who St. Anthony, shown preaching at the left, predicted would be found to have lost his heart in his money box-here poised at the back corner of his classically designed bier. The whole composition reads like a Roman imperial relief, its large figures deeply carved and arranged in a uniform row across the composition. Inspired no doubt by the dramatic intensity of Donatello's bronze reliefs in the same church (see Fig. 11.19), Tullio also exploits the vigor and emotional gestures of Hellenistic sculpture, such as the recently discovered Laocoön (see Fig. 40). Classicism was as adaptable to religious as secular subject matter and could be marshalled to promote traditional values, thus ensuring its widespread adoption and popularity.

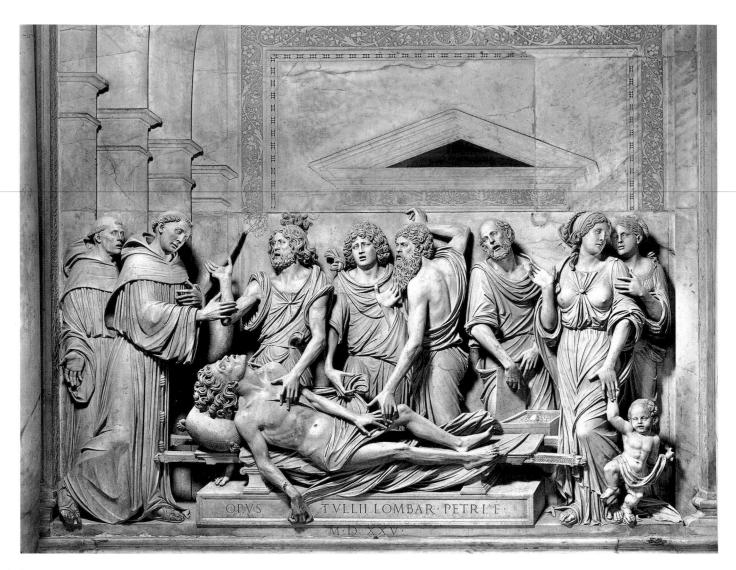

21.17 Miracle of the Miser's Heart, 1520–25, commissioned as a result of a bequest given by Francesco Sansone (1414–99), minister general of the Franciscan order, by the governors of the Santo from **Tullio Lombardo** for the Chapel of St. Anthony, The Santo, Padua. Marble, 51½ × 96" (130 × 245 cm)

Tullio boldly asserted his authorship of this relief by inscribing it on the base of the dead man's bier: "This is the work of Tullio the Lombard, son of Pietro, 1525." All the figures are daringly undercut, leaving them nearly free-standing.

Venetian Artists Working for Alfonso d'Este

Venetian sculptors and painters found an extremely hospitable environment at the court of Duke Alfonso d'Este (r. 1505–34) in Ferrara. Like most members of his family (especially his sister Isabella, *marchesa* of Mantua) Alfonso was an avid antiquarian. He employed agents to purchase Roman antiquities and commissioned artists to revive ancient subject matter in classical style.

The Studio di Marmi

Alfonso assembled some of the most sophisticated decorative ensembles of the early sixteenth century at his castle in the center of the city. Here he asked Antonio Lombardo

(c. 1438 Venice?-1516 Ferrara), elder son of Pietro Lombardo and Tullio's brother, to create a "Studio of Marbles" (Studio di Marmi), a private study lined entirely in marble, making it even more precious and expensive than Federico da Montefeltro's renowned studiolo in Urbino (see Fig. 14.25), which itself had been inspired by Este precedents. In Ferrara, Antonio was responsible for narrative reliefs, friezes, inscriptions from classical authors, and even the marble floor. For the most part he adopted the calm and idealized manner of ancient Greek and Augustan art, underlining the room's function as a meditative retreat intended for the duke's leisure and tranquility; but for the dramatic subject of The Birth of Athena at the Forge of Vulcan (Fig. 21.18) Antonio turned to the pathos of Hellenistic sculpture. At the left a writhing, bearded figure representing Zeus is one of the earliest surviving direct quotations from the recently excavated (1506) Laocoon group (see

Fig. 40). The quotation served to enhance Alfonso's reputation as a patron and collector who had up-to-date knowledge of ancient art. It also gave expression to the pain Zeus must have experienced after Vulcan's axe (being forged by the nude figures at the brazier in the center of the relief) released Athena, fully formed, from his head. The leg of the priest who performed the act can be seen behind Zeus, while Athena, calm patroness of wisdom and peace, stands sedately in the niche above.

The Camerino d'Alabastro

In October 1511, just as work was coming to a conclusion on the Studio di Marmi, Duke Alfonso asked his sister Isabella's court humanist, Mario Equicola, to devise a program of bacchanalian subjects for his Camerino d'Alabastro ("Alabaster Room"), a small chamber containing alabaster decoration, also by Antonio Lombardo, adjacent to the study. This room too was to present classical subject matter, but in the form of frankly sensual and celebratory paintings, counterbalancing the lofty themes of wisdom, peace, and strength dominating the Studio. Alfonso sent Equicola's written instructions to Giovanni Bellini, Titian, Fra Bartolomeo, and Raphael, who were each assigned a composition. For the painters it was an opportunity to pit their talents against one another; for Alfonso, an opportunity to create a gallery of works by the most renowned painters of his day-a conscious ploy to compete with Isabella (see Fig. 14.35) and other eminent patrons. In the end Fra Bartolomeo and Raphael died before they could fulfill the commission, and Bellini completed only one, so Titian painted three canvases, and yet another was allotted to the resident court artist, Dosso Dossi (Giovanni Luteri; 1480–1542), who also provided friezes with ten scenes from Virgil's *Aeneid*.

Bellini's contribution, known as the *Feast of the Gods* (Fig. 21.19), initiated the cycle with a depiction of ancient gods and goddesses associated with the winter solstice. Like the rest of the paintings it revolves around themes of love, in this case represented by three couples: a nature goddess and Neptune (actually a portrait of Alfonso) sitting behind the large bowl of fruit to the right of center, Ceres (Mother Earth) and Apollo (the sun god) to the right, and the lusty Priapus leering over the sleeping nymph Lotis at the far right. They originally rested in front of a continuous background, the grove of trees at the right extending across the entire canvas until Titian added the hill, trees, and sky at the left and repainted the foliage (already altered by Dosso Dossi) to coordinate with his later paintings in the same room. The celebration, first described in the first book of Ovid's Fasti, takes place during the peaceful, so-called halcyon days, marked explicitly by the tiny kingfisher ([h]alcyon in Latin), who was said to mate at this time and so is shown perched on a little twig at the left foreground. Though it is the end of a long day of revelry, the infant Bacchus, god of wine, stoops to fill yet another crystal pitcher from a wine cask just above the bird. Behind him is Silenus, another god of revelry, whose donkey will soon start braying, warning

21.18 The Birth of Athena at the Forge of Vulcan, c. 1508–11, commissioned by Alfonso d'Este from Antonio Lombardo for the Studio di Marmi, Palazzo Ducale, Ferrara. Marble, width 41½" (1.06 m) (Hermitage Museum, St. Petersburg)

Lotis of the lascivious intentions of her would-be suitor, clearly indicated by the protruding drapery between his legs.

Probably in his eighties when he painted this canvas, Bellini was in full control of his art, turning a complex literary subject into a visually satisfying painting—a task that his almost exact contemporary Andrea Mantegna had approached with less sympathy in his heavily labeled allegory for Isabella d'Este (see Fig. 14.34). At the same time there is something delightfully naive about this work, marking it as the product of an older generation. Their approach to antiquity is very different from that of Antonio Lombardo, for example, whose gods and goddesses capture both the spiritual and fleshly aspects of antiquity. In this regard, Mantegna had surpassed Bellini and his generation, but even his passion for archaeology had not allowed him to revivify the sensuous spirit of antiquity fully.

It was left to Titian to bring classical mythology to full, pulsating life. In the second of his paintings for Alfonso's Camerino, the *Meeting of Bacchus and Ariadne* (Fig. 21.20), an exuberant Bacchus leaps from his triumphal chariot (drawn by cheetahs Titian had observed in Alfonso's menagerie) to rescue Ariadne, shown in a reciprocating but wary half-turning pose at the left. Having been abandoned by her former lover, Theseus, on the island of Naxos, she can hardly be very reassured by Bacchus's noisy parade of carousing

nymphs and satyrs, their frenzy intensified by the inclusion of another direct quotation from the snake-entwined Laocoön group. The head of a stag has been dropped on the ground in front of the figure, while behind him another Bacchic reveler wields an animal's leg. It has been freshly torn from its socket, presumably in the wild frenzy that ancient sources said Bacchus induced in his followers. Maidens clang cymbals and tambourines, signaling the way for the debauched, paunchy Silenus in the background small in scale but highly visible thanks to Titian's brightening the green of the tree over his head. Titian contains these unruly figures in an isosceles triangle defined by an imaginary line that runs from the lower left to the upper right corner of the canvas. It grazes the edge of a bronze vase and yellow drape—seemingly casually thrown on the ground but essential to the pictorial structure-and proceeds under Bacchus's foot, through the trees, and into a small patch of blue sky. This diagonal is echoed in Bacchus's leap from his chariot to the relatively tranquil left portion of the composition. Still, a calm resolution is in sight, the limpid sky displaying the constellation that will commemorate Ariadne's peaceful marriage to Bacchus. A safe harbor also awaits her at the city in the background, its subdued color and execution a deliberate contrast with the splashily painted revelers at the right.

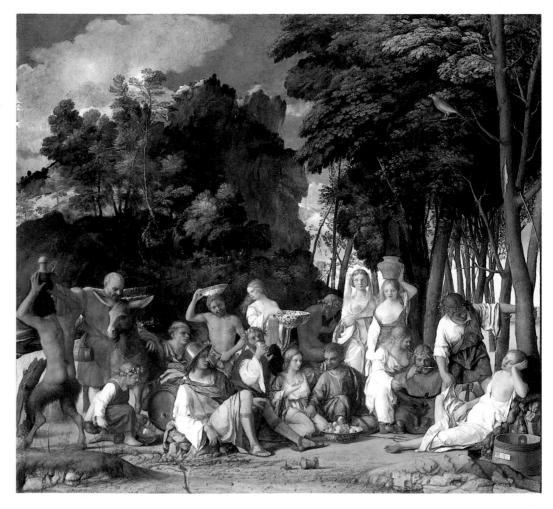

21.19 Feast of the Gods, 1514/29, commissioned by Alfonso d'Este from **Giovanni Bellini** for the Camerino d'Alabastro, Palazzo Ducale, Ferrara. Oil on canvas 5′ 7″ × 6′ 2″ (1.7 × 1.88 m) (Widener Collection, © 1996 Board of Trustees, National Gallery of Art, Washington, D.C.)

The background of the painting was altered by Dosso Dossi and Titian.

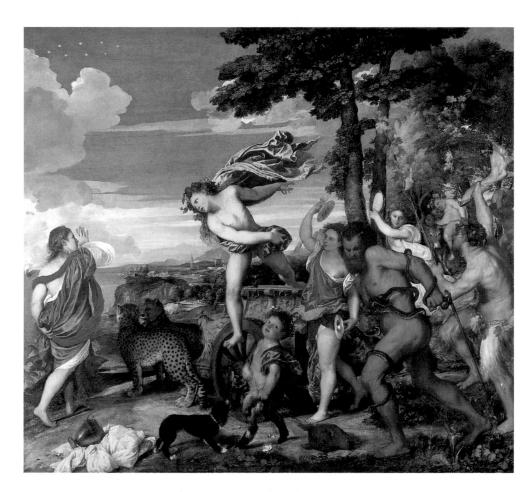

21.20 Meeting of Bacchus and Ariadne, 1522–23, commissioned by Alfonso d'Este from **Titian** for the Camerino d'Alabastro, Palazzo Ducale, Ferrara. Oil on canvas, 5' $9'' \times 6'$ 3" $(1.75 \times 1.9 \text{ m})$ (National Gallery, London)

This painting has been over cleaned, with most of the varnishes removed, resulting in some flattening of form, too brilliant and sharp coloration, and an absence of the atmospheric subtleties present in better preserved works by Titian

Titian in Urbino

Another court that called upon Titian's talents was Urbino. Ruled from 1508 by members of the della Rovere family, whose fortunes had risen high under the papacy of Pope Julius II, Urbino retained and enhanced its earlier reputation for intellectual and behavioral sophistication. Here Baldassare Castiglione (see Fig. 18.29) participated in conversations and court rituals which, through the publication of his *Book of the Courtier*, codified courtly behavior throughout Europe. Worldly and yet extraordinarily decorous, court culture in Urbino demanded that a painter closely gauge his subjects and respect expectations about their representation.

In creating a pair of paintings of Francesco Maria della Rovere and Eleonora Gonzaga (Figs. 21.21 and 21.22), duke and duchess of Urbino, Titian predictably reprised many of the themes seen in Piero della Francesca's double portrait of their predecessors, Federico da Montefeltro and Battista Sforza (see Fig. 14.20). Once again, the male portrait is more rugged and individualized, emphasizing military exploits and adventures. Francesco Maria poses alert in his stunningly rendered, glinting armor, his right arm and baton dramatically thrust out into the viewer's space. Behind him a splendid, plumed parade helmet, reflecting the vibrant, pulsating red of a velvet drape, faces a jauntily

angled set of lances. In marked contrast, Eleonora Gonzaga sits primly in her chair, immobile within her highly detailed but much less lovingly depicted court dress. Described by Castiglione as embodying "wisdom, grace, beauty, intelligence, discreet manners, humanity and every other gentle quality," she was confined to a much more circumspect existence. Even her pet dog lies bored on a table in front of a window. Titian's landscape is expansive but untraversible, marked by a church tower in its idealized blue distance. Only when Titian was painting ideal women-always young-do they seem to come alive. A nearly contemporary portrait of the fiery and determined Isabella d'Este is as lacking in verve and emotion as Eleonora's. This is partly due to the fact that Isabella asked Titian to copy an earlier, youthful portrait, a clear sign that she, like Eleonora, was complicit with the roles and ideals men held about women. In offering a lackluster portrait of Eleonora, Titian was most likely exercising decorum and restraint, flattering her even as he confirmed societal stereotypes.

When it came to painting purportedly mythological subject matter for a bedchamber, Titian enjoyed greater freedom to express female sensuality and desirability. The so-called "Venus" of Urbino (Fig. 21.23) is a live seductress, unabashedly called a "nude woman," not an ancient goddess, in contemporary documents. Instead of placing her in a poetic landscape (see Fig. 21.3), Titian presents his object

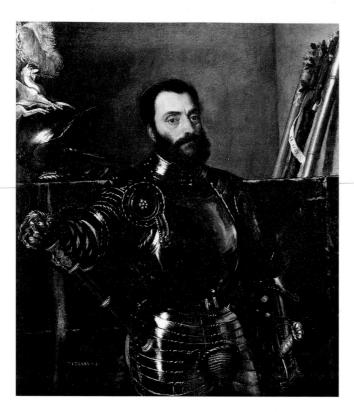

21.21 Francesco Maria della Rovere, 1536–38, commissioned by the sitter from **Titian**. Oil on canvas, $45 \times 39\%$ " (114.3 \times 100.3 cm) (Galleria degli Uffizi, Florence)

of desire inside a handsome palace, displaying herself on white satin sheets and pillows upon a luxurious red couch. Her golden tresses cascade alluringly over her shoulder to her braceleted right arm and hand, which toys with a small bouquet of flowers, while her left is placed provocatively over her genitals. Cool and dispassionate as the morning light which appears in the window at the rear of the room, this

woman is nonetheless alert and available—her small pet dog, a traditional twin symbol of fidelity or lust, having fallen asleep at her feet. Servants in the background search diligently for garments to adorn her alluring and self-confident beauty. Calling to mind the sophisticated and renowned world of Venetian courtesans and court mistresses, whose physical beauty was expected to be accompanied by pleasant and learned conversation—unlike the conventional verbal reticence usually expected of Renaissance women—Titian's "nude woman" is a female "worthy" of male companionship. While the duchess

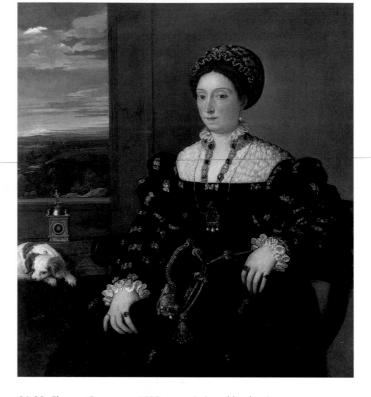

21.22 *Eleonora Gonzaga*, c. 1538, commissioned by the sitter or Francesco Maria della Rovere from **Titian**. Oil on canvas, $44\% \times 40\%$ " (114 × 102.2 cm) (Galleria degli Uffizi, Florence)

of Urbino was presented in the public halls of the palace in the armor of female virtue—erect posture, tightly belted court dress, and covered head—her husband's nights in the bedchamber were presided over by a freely tressed, non-chalant, reclining sybarite. Once again intended audience, function, and location played a major role in determining the character of an artist's work.

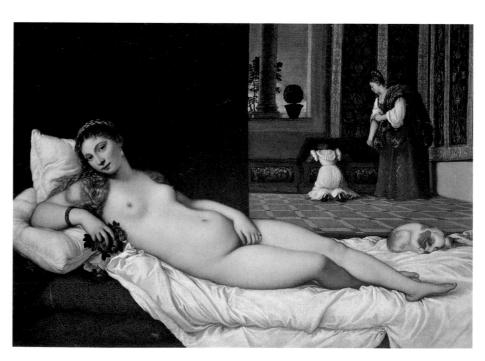

21.23 Reclining Nude ("Venus" of Urbino), c. 1538, commissioned by Guidobaldo della Rovere from **Titian**. Oil on canvas, 3' 11" \times 5' 5" (1.19 \times 1.65 m) (Galleria degli Uffizi, Florence)

Refashioning the City Triumphant

While both Constantinople and Rome were humiliated by foreign armies—the Byzantine capital in 1453 and Rome in the fateful Sack of 1527—Venice remained inviolate. The Venetians benefited directly from their rivals' woes, opening their arms to fleeing artists and scholars.

Among the illustrious refugees fleeing to Venice after the Sack of Rome was the forty-one-year-old Jacopo Sansovino (Jacopo Tassi; 1486 Florence-1570 Venice), who intended to stay only a few months but instead spent the second half of his extremely long life reshaping the face of the city. Sansovino had spent his youth in Florence (see Fig. 17.3) and his early adulthood in Rome, where he was deeply impressed by the works of Bramante, Michelangelo, and Raphael. He thus brought with him a thorough appreciation of the grand manner of ancient Roman architecture which had been revived by Julius II; but instead of merely importing and imposing Roman prototypes, he produced a distinctively Venetian interpretation of classical forms. Always extremely sensitive to the purpose and function of the buildings commissioned from him, Sansovino worked in a number of different modes, adjusting his architectural vocabulary, massing, and ornamentation to the problem at hand.

The Zecca

Soon after arriving in Venice, Sansovino employed his considerable technological knowledge of ancient and modern vaulting to strengthen and restore the domes of St. Mark's, a job that earned him the position of *proto* (architect and chief building superintendent) of St. Mark's from 1529

21.24 The Zecca (Mint), Venice, 1535–47, commissioned by the Council of Ten from **Jacopo Sansovino**

An upper story later added to the building has been removed from this photograph to give a better sense of the Zecca's original relationship to the Library at the right.

until his death in 1570. This position, along with commissions from the Venetian government, gave Sansovino extraordinary opportunities within the city's center, beginning in 1535, when he entered the competition to rebuild the Zecca, the state mint, on the quay facing the city's ceremonial waterfront entrance.

Venice's Council of Ten selected Sansovino's design for the Zecca in 1536. The massive new building (Fig. 21.24), originally only two stories high, confidently announced the city's recovery from the eco-

nomic difficulties of the preceding decades of war. Its great cost was financed by government orders that freed slaves in Venice's dependency of Cyprus for 50 ducats a head. Fireproof, thanks to Sansovino's use of stone vaulting throughout the structure, the Zecca proclaims its impregnability through a bold use of rustication. Above the rugged ground story arcade (leased to cheese sellers, who had traditionally sold their products at the site), the second story employs the Doric order in a highly original way, with banded attached columns that appear to be squeezed at the top between double lintels over the large windows. Making use of forms he would have known from his experience in Rome and from contemporary work such as Guilio Romano's more playful buildings in Mantua (see Fig. 19.3), Sansovino thus suggests the compressive processes used to create coins as well as the strength and dignity of a city gate or fortressthemes well suited to the building's site and function.

The Library

Soon after Sansovino began work on the Zecca, he was also engaged to build a splendid public library, one of the first of its kind (Fig. 21.25). It was intended to redress the embarrassing lack of a permanent home for the renowned collection of Greek and Latin manuscripts that Cardinal John Bessarion, a Greek emigré, had given to the state in 1468. The anteroom adjoining the main reading room was to be home to a school, ensuring the ongoing promotion of humanist values among young Venetian nobles. In its conscious emulation of the public libraries of classical antiquity, it also underscored Venice's image as the successor to the legacy of imperial Rome and Constantinople.

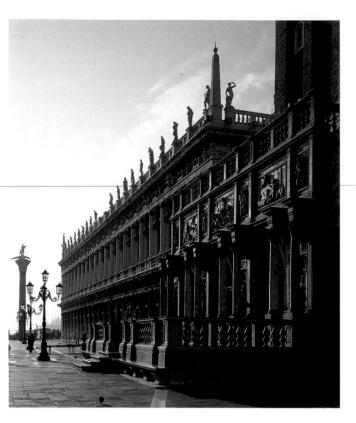

21.25 Library, 1537–91, and Loggetta, 1537–45, commissioned by the Procurators of St. Mark's from **Jacopo Sansovino**, Piazzetta San Marco, Venice

The Loggetta was rebuilt after the Campanile collapsed in 1902.

The forceful architectural vocabulary of the adjacent Zecca was inappropriate to such a commission, so Sansovino's patrons must have requested more elegant forms. He complied by creating an airy palace, which purposefully contrasts in height, scale, and detail with the Zecca (see Fig. 21.24). Taking his cue from the Doge's Palace, directly opposite, Sansovino set two open arcades one upon another but interpreted the scheme in classical language—a Doric order on the ground floor, Ionic above, and, on the top, a balustrade punctuated with statues. Lush garlands bedeck the friezes, and sensuous figures recline in all the spandrels. The effect is lavish and ornate, in emulation of the most splendid examples from antiquity.

A showpiece of classical values, the library won international renown for its elegance and Sansovino's clever solution to a previously unresolved dictum of Vitruvius. The Roman architect had stipulated that a Doric frieze should end with a half **metope**, the blank surface between triglyphs; but since triglyphs were placed over columns it would have been impossible to have even a half metope at the corner of a building supported by a colonnaded loggia without altering the proportions of the triglyphs and metopes or extending the architrave awkwardly beyond the corner column. Sansovino provided an elegant solution by ending his colonnade with a pier rather than a column, at the same time reinforcing the solidity of the building's

corners. He was so proud of his solution—and convinced that no one else would think of it—that in 1539 he sent out disingenuous requests for assistance from architects across Italy, to establish that the idea was his alone. The subsequent publication of his solution marked a new level of concern for, and success in, self-promotion.

Still, Sansovino's bravura did not free him from subservience to his patrons. When the stone vault of the main reading room of the library collapsed during unusually cold weather in December 1545, Sansovino was unceremoniously thrown in jail. Though soon released—following intervention from Titian and the ambassador of Emperor Charles V, among others—Sansovino was further penalized by having his salary suspended for two years and was commanded to make repairs at his own expense.

The Loggetta

In 1537 the Procurators had added to Sansovino's responsibilities by commissioning him to design a new loggia at the base of the Campanile (see Fig. 21.25). Known as the Loggetta, it was to replace a pre-existing structure which had been the traditional meeting place of Venetian noblemen but was now considered inadequate for its location among such imposing buildings. The new Loggetta was intended to serve as a permanent civic stage set, providing a handsome gathering place for the city's nobles and celebrating Venice as a wise, imperial power. Adopting the appropriately symbolic form of a Roman triumphal arch, Sansovino placed allegorical reliefs alluding to Venice's maritime possessions Cyprus and Crete on the attic story and filled the ground-story niches with bronze statues of ancient gods and goddesses. Pallas, at the far left, stood for the wisdom of Venice's patriciate; Apollo, the sun god, represented the city's uniqueness and its remarkable harmony; Mercury, messenger of the gods, symbolized eloquence; and Peace emphasized the republic's commitment to nonbelligerence. Sansovino's deft use of red Verona and other white and grey marbles enriched the site beyond its relatively modest dimensions while linking it visually to the brick tonalities of the Campanile, the then brick piazza, and the pink and white detailing of the Doge's Palace.

The Palazzo Corner

Sansovino's elegant and monumental classicism proved a powerfully expressive vehicle for one of Venice's wealthiest families, the Corner. The Palazzo Corner della Ca Grande, although only half as large as the family once contemplated, set a new standard for its huge size and rigorous Vitruvian detail (Figs. 21.26 and 21.27). The Corner (rhymes with "forbear") were an old patrician family whose wealth was greatly enhanced in the late fifteenth century by their success in persuading their kinswoman, Caterina Corner, to abdicate the throne of Cyprus that she had inherited

from her husband so as to return control of the island to the Venetian government. Already wealthy merchants, they received special concessions and huge land holdings from the government, and also claimed rights to Caterina's dowry, which was deposited with the state. After a fire completely destroyed the family's palace in 1532, they

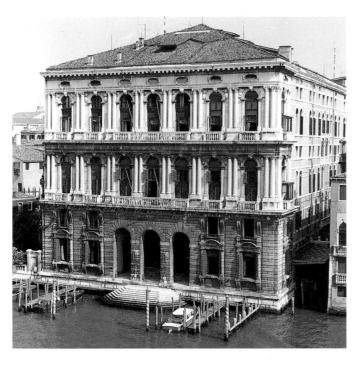

21.26 (above) Palazzo Corner, Venice, c. 1545, commissioned by Zorzi Corner from Jacopo Sansovino

21.27 (left) Palazzo Corner, Venice, plan of lower floor

1 Grand Canal; 2 Entrance portico (riva); 3 Central hall (androne);

prevented major work from beginning until around 1545. Sansovino organized the palace in typical Venetian fashion, providing three large openings on the canal for the receipt of merchandise. The rest of the structure—including an unprecedentedly large courtyard—resembled contemporary Roman palaces. Above the rusticated Doric ground

successfully petitioned to release half the dowry for the new

construction. However, divisions of the family inheritance

story, he set an Ionic and then a Corinthian story, each of their seven bays divided from its neighbors by attached double columns set on pedestals. These features give the façade unprecedented weight and substance.

Titian: Images for the International Elite

The Vendramin Family

While Sansovino was exploiting the architectural vocabulary of Renaissance Rome to give new status and prestige to his public and private commissions in Venice, Titian built upon his own experience at the court of Paul III (see p. 500). Returning to Venice from Rome in 1546 he created a remarkable group portrait of the male members of the Vendramin family (Fig. 21.28). Here Titian domesticizes official works such as Bellini's votive portrait of Doge Agostino Barbarigo (see Fig. 13.33) as well as frescoes he had seen in the papal apartments in Rome. While the painting has the look of an impromptu gathering, it is rooted in prestigious models that betray political motives on the part of Titian and the Vendramin. Titian adapted elements such as the steps, massive altar, flickering candles, and groups of

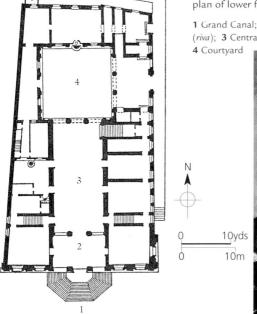

21.28 (right) Male Members of the Vendramin Family, c. 1547, commissioned by Andrea Vendramin from Titian, probably for the Palazzo Vendramin, Venice. Oil on canvas, 6' 7" × 9' 10½" (2.06 × 3 m) (National Gallery, London)

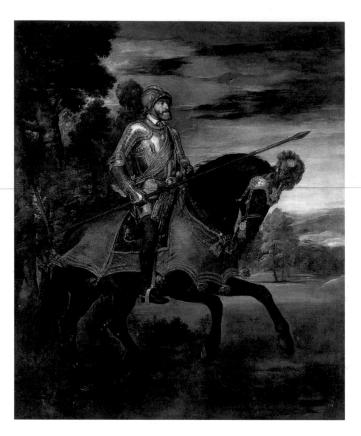

21.29 Equestrian Portrait of Emperor Charles V, 1548, commissioned by Charles V from **Titian**. Oil on canvas, 10′ 10½″ × 9′ 1½″ (3.31 × 2.79 m) (Museo del Prado, Madrid)

Charles wears the armor he actually wore in the decisive battle of Muhlberg where he trounced his Protestant opponents. The armor is preserved in the Royal Armory in Madrid.

onlookers from Raphael's Mass of Bolsena at the Vatican as a suitably impressive setting for the Vendramin family's

adoration of a reliquary of a fragment of the True Cross. Although the relic was owned by the Scuola Grande di San Giovanni Evangelista, the Vendramin family was closely associated with it: one of their ancestors had donated the relic to the Scuola, and an Andrea Vendramin, namesake of Titian's patron, was famous for having rescued it when it fell into a canal. Titian suggests the intimacy of the family's relation to the relic by placing the current head of the family (also named Andrea) in the center of the composition, with one hand on the altar as he looks out of the picture, inviting the viewer's participation. At the left, two other family members, dressed in senatorial red, pay

21.30 *Danaë*, 1554, commissioned by Philip II of Spain from **Titian**. Oil on canvas, 4′ 2½″ × 5′ 10″ (1.28 × 1.78 m) (Museo del Prado, Madrid)

their eloquent devotion to the relic, the middle-aged man reaching out as if to share his adoration with others. Titian records and contrasts the emotions of his subjects; the sober obedience of the adolescents at left and the innocent play of the children at right serve to underscore the maturity and depth of the adults' piety, a civic as well as personal virtue.

Charles V

In 1548 Emperor Charles V called Titian to Augsburg, where he painted a life-sized equestrian portrait that set the standard for regal portraiture for well over a century (Fig. 21.29). Titian captured the emperor at the height of his powers, calm and erect upon a charging horse. The contrast between the emperor's resolute confidence and the horse's bowed, obedient head eloquently conveys Charles's authority over it. His power and invincibility are underscored by the aura of gleaming light reflecting off his armor and the glowing, radiant sky toward which he advances from the dark trees and ominous clouds at the left. In keeping with traditions of royal portraiture, Charles appears as virtuous as a saint and as stoic as a Roman hero. Yet he is also vigorously alive, chin set high and eyes focused forward, the epitome of a human ruler with superhuman powers and responsibilities.

Mythology and Sensuality

Much of Titian's international fame and recognition also rested on the allure of his superb mythological paintings. In a series of paintings he produced for King Philip II of Spain (r. 1555–98) illustrating the loves of Jupiter, the king was literally to imagine himself as a god; and all his

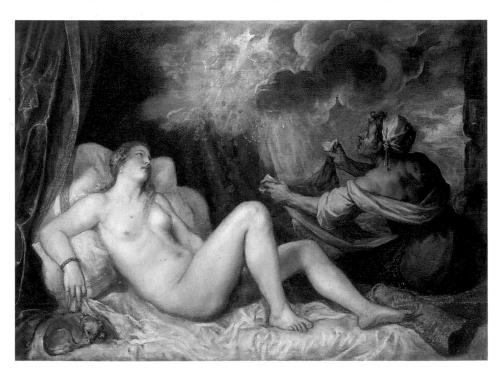

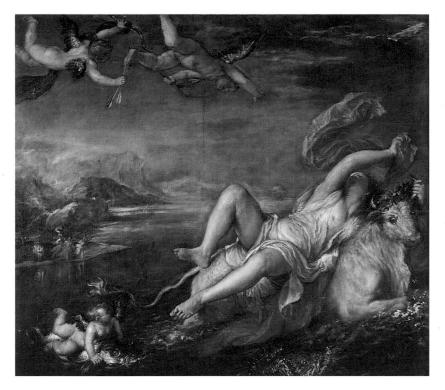

21.31 Rape of Europa, 1559–62, commissioned by Philip II of Spain from **Titian**. Oil on canvas, 5' 9½" \times 7′ 8½" (1.76 \times 2.04 m) (Isabella Stewart Gardner Museum, Boston)

conquests mere mortals. One of the most openly sensual of these images, the *Danaë* of 1554 (Fig. 21.30), represents a development of ideas informing earlier images of female nudes (see Figs. 21.3 and 21.23). The myth relates how Jupiter transformed himself into a shower of gold in order to possess a lovely young woman guarded by an old crone. Given the old woman's avaricious collection

of some of the gold in the form of actual coins, and Danaë's receptivity to Jupiter's advances expressed by her parted legs and dreamy expression, the story's associations with prostitution are clear. Titian had earlier offered to paint Donna Olimpia, a famous Roman courtesan and the reputed lover of Cardinal Alessandro Farnese, in the appropriate guise of Danaë. According to the cardinal's agent, who saw Titian working on that painting in Venice, the image made the duke of Urbino's reclining nude (see Fig. 21.23) look like a nun. In this version for Philip II, Titian's extraordinarily free brushwork—especially on the

21.32 Putto on Dolphin (detail of Rape of Europa), 1559-62, commissioned by Philip II of Spain from **Titian**. Oil on canvas (Isabella Stewart Gardner Museum, Boston)

curtain and sheets, and in the orgasmic outburst in the sky—further enhance Danaë's palpably physical reactions to Jupiter's approach. Only the ostensibly mythological subject and Danaë's classically inspired pose, adapted from statues of ancient Roman river gods, made the painting socially acceptable, although King Philip apparently kept curtains over some of these images so that the modesty of women in the court would not be offended.

Titian's imagination and painterly technique continued to expand as he worked on further paintings for Philip II's erotic cycle. In the *Rape of Europa* (Fig. 21.31), the story of a nymph's abduction by Jupiter in the guise of a bull, whose horns she had been plaiting with flowers—itself a sexually charged image—Titian abandoned the usual representation of a sedate, side-saddle trot. He chose instead to represent an impassioned romp, moving in an ascending diagonal across the picture surface, as in his earlier *Meeting of Bacchus and Ariadne* (see Fig. 21.20). Pushed to the foreground of the composition, the scantily clad Europa rolls on the bull's back in what a male viewer was

surely intended to read as ecstatic sexual abandon, her right leg bent up, her left leg and right arm swept in a single, slightly curving line up the painting. Her raised arm casts a shadow across her face, her own serious expression suggesting that Europa may yet need to be incited to passion by the *amorini* (companions of Cupid) who rush after her, two tumbling in the sky and one riding a dolphin (Fig. 21.32). In the background at an enormous distance from Europa, her maidservants run to the shore vainly flailing their arms, their gestures and forms reflected in the passive waters in

front of them, so different than the seething, foamy brine around Europa, the bull, and the *amorino* pursuing them. Titian's extremely free brushwork is superbly adapted to the composition and contrasts markedly with the more polished surfaces of his earlier work. Here he exploits the actual physical texture and presence of his paint, not just its color. Light glints off thick deposits of color suspended in oil, especially in the foreground, and softens when it encounters more thinly painted surfaces in the distance. Shifting color as well as texture, Titian masterfully turns his brown rocky coast blue and then dissolves it into the sunset tones of the evening sky. Europa's textural, billowing bloodred drape seems all the more dramatic for being set in front of such a remarkable, freely painted sky.

Colorito versus Disegno

The loose, painterly quality of Titian's mature and late works contrasts markedly with the more precise, essentially graphic approach of central Italian painting. Venetian painters had always been more interested than others in effects of glimmering color and light, whether in the gilded richness of Jacobello del Fiore's Justice (see Fig. 7.18) or the mosaic-encrusted apse of Giovanni Bellini's San Giobbe Altarpiece (see Fig. 13.22). In the mid-sixteenth century, literary praise and defense of this propensity became more systematic and took on distinctly patriotic tones. While central Italians such as Vasari were promoting the values they saw most evident in the art of Michelangelo-sculptural solidity, tightly controlled compositions and space, clear delineation, anatomical accuracy—in Venice critics including Pietro Aretino championed an alternative set of values epitomized by Titian-spontaneity, mobility, evanescent colors, and evocative rather than analytic description. To express the central Italian conception of art as something predominantly cogitated and rational, Vasari adopted the noun disegno, meaning a combination of drawing and good design. The Venetians, on the other hand, chose colorito, a past participle which by its linguistic nature acts as both a verb and adjective. Literally signifying the quality of being "colored" and the state of "having been colored," the term emphasized the rich textural and visual effects of oil paint and glazes laid thickly on rough canvas. The values encapsulated in colorito and disegno effectively divided sixteenth-century art into opposing camps.

Titian: The Artist as his Own Patron

Titian's wide ranging patronage gave him extraordinary wealth and status, both of which were manifest in the large house, the Casa ai Biri, which he purchased on the northern edge of the city. Here he met clients, entertained fellow artists and scholarly guests, and set up his own gallery where examples of his painting were available for admiration and analysis, but not for sale.

Giorgio Vasari visited Titian at his home in 1566 and admired a self-portrait "finished by him four years ago, very fine and natural," probably to be identified with a painting now in Berlin (Fig. 21.33). In it Titian proudly wears the gold chains of the Order of the Golden Spur, which Charles V had awarded him along with a knighthood in 1533. Dressed in an expensive fur jacket Titian does not look straight out at the viewer-the simplest pose for an artist who must study his own features in a mirror-but instead lifts his head to the side as if in recognition of some person or force beyond him. Since Titian had earlier used a similar pose for a portrait of his good friend the poet and critic Pietro Aretino, he may have intended this self-portrait as a meditation on his own intellectual and creative powers. Not only is it relatively rare in this period for an artist to paint an independent self-portrait, but unlike most others (see Figs. 6 and 24.9) Titian displays no paintbrush or other indication of his trade. Instead, he emphasizes that his work is intellectual, not manual, the basis for high social standing and respect. The painting is unfinished, tellingly in the hands and arms, which are merely the vehicles for his creative intellect. Bold dashes of paint on the artist's collar, buttons, and sleeves suggest the vigor of his intensely engaged mind and spirit.

A deeply disturbing and haunting *Flaying of Marsyas* (Fig. 21.34) also seems to have been in Titian's house at his

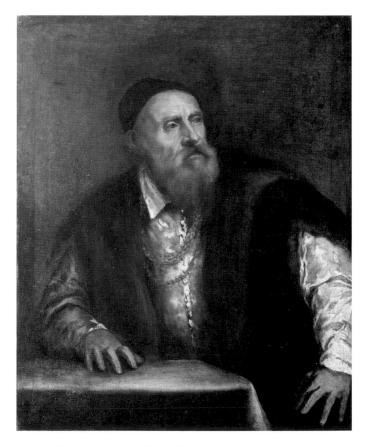

21.33 *Self-Portrait*, 1560s, **Titian**. Oil on canvas, $29\% \times 37\%''$ (75 × 96 cm) (Gemäldegalerie, Berlin)

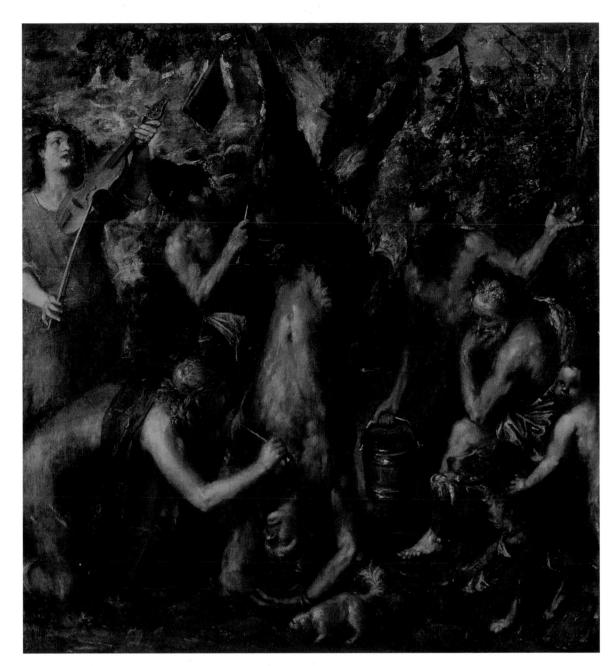

21.34 Flaying of Marsyas, 1570s, probably created by Titian for himself. Oil on canvas, 6' 11½" × 6' 8" (2.12 × 2.07 m). (Kromeriz, Archepiscopal Palace)

death. Titian may have become fascinated with the subject on hearing reports in 1571 that the Venetian nobleman Marcantonio Bragadin had been flayed alive by the Turks, but Titian's rendition is more a meditation on his own spirituality and mortality than on the last gruesome events attending the Turkish Wars. At the center of the canvas the satyr Marsyas hangs upside down from a tree while Apollo crouches to the left and skins him alive. King Midas, a selfportrait of the artist, sits and broods at the right wearing a crown over the donkey ears he earned by foolishly preferring Pan over Apollo in a musical contest. Marsyas, too, challenged Apollo. The raucous, earthy tunes of his pan pipes were no match for the ethereal strains of Apollo's lyre-a metaphor for the superiority of the soul over the body-and Apollo exacted a terrifying revenge. But while the tempestuous background and details like the dog eagerly licking up Marsyas' blood testify to the horror of the event, emphasized by the slashing and oozing oil paint, Titian shows only regret, not pain on Marsyas's face, as Apollo gingerly, even tenderly removes his flesh. This is not the image of Marsyas that the Medici, for example, presented to their visitors in a blood red stone sculpture flanking the entrance to their garden: a thinly veiled warning to any who would challenge their authority. Instead, Titian's painting is best seen as a neo-Platonic meditation on the need to free oneself from the world of the flesh and seek the higher, spiritual self, a painful process to be sure, but one which Titian in his own old age was confronting daily. A second figure of Apollo, or according to some interpretations, Orpheus, the visitor to the underworld, appears in the upper left bathed in cool, clear light raising his eyes, instrument, and bow on high, past the shadowed forms of

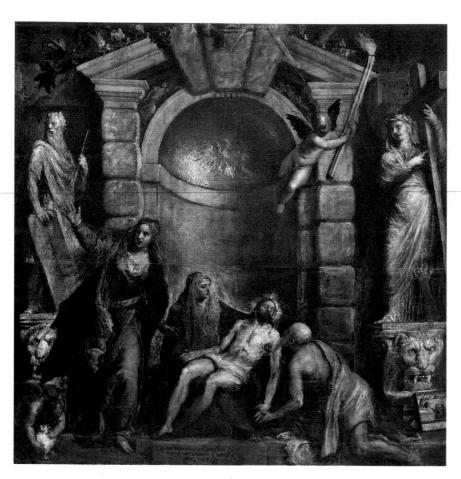

21.35 *Pietà*, begun c. 1570, left unfinished in 1576, painted by **Titian** for his own burial site at the Altar of the Holy Cross, Santa Maria Gloriosa dei Frari, Venice, completed by **Palma Giovane**. Oil on canvas, $11' 6\%'' \times 12' 9\%'' (3.51 \times 3.89 \text{ m})$ (Galleria dell'Accademia, Venice)

Titian's tomb in the Frari is now marked by an extravagant marble monument created 1838–52 by Pietro and Luigi Zandomeneghi.

altarpieces and more recent evocations of the style in paintings such as Giovanni Bellini's *San Giobbe Altarpiece* (see Fig. 13.22), now made evanescent with daubs of dematerializing paint. Although never placed over the altar for which it was intended, the painting continues to elicit deep emotions about life and death, a fitting testimony to Titian, his art, and his beliefs.

Narrative Imagery in the Scuole

the earthbound pan pipes, to some more glorious future. Michelangelo had already imagined a similar fate for himself in the disembodied skin of St. Bartholomew in the *Last Judgment* (see Fig. 22.1), and Titian now uses veils of quivering paint and shifting color to suggest his own more hopeful belief in his redemption.

Titian addressed the same theme in Christian terms in a Pietà, which he painted for the altar above his own tomb in the right aisle of Santa Maria Gloriosa dei Frari (Fig. 21.35). The huge canvas remained in Titian's home, partly unfinished at the artist's death on August 27, 1576. The flying angel and certain parts of the architectural moldings were judiciously completed by Palma Giovane (Jacopo Negretti; c. 1548-1628), who understood that the painting was Titian's personal testament and so chose neither to emulate nor to disturb the master's freely painted forms. Only decades of painterly exploration had made it possible for Titian to create a work of such evocative intensity. Here again he built his figural composition on a diagonal. At lower right, a balding penitent kneels and reaches out to touch the dead but radiant body of Christ. A small votive panel leans against Titian's family coat of arms and the base of the sibyl, suggesting that the penitent should be understood as Titian himself. At the left, a grieving Magdalene runs forward, giving voice to the silent agony at the center. In the background, a massive rusticated niche reverberates with light, which suggests the burnished glow of Byzantine

The confraternal charitable associations known in Venice as scuole continued to be major patrons of architecture and painting in the sixteenth century. One of the artists whose work is most intimately associated with the scuole is Jacopo Tintoretto (Jacopo Robusti; 1519 Venice-1594 Venice). Though not always as rigorous and methodical as his sometime teacher, Titian-he often took on more commissions than he could handle and completed many works at breakneck speed-Tintoretto shared Titian's enthusiasm for complex human drama and used painting to evoke strong emotions. He made his reputation in Venice with the Miracle of St. Mark, which he completed in 1548 for the altar in the main hall of the Scuola Grande di San Marco (Fig. 21.36). No earlier surviving depiction of a story from a saint's life for a Venetian scuola had been so charged with energyperhaps the reason why its members were uncertain whether to accept the finished work. They may also have disapproved because this work and others in the series gave untoward importance to Tommaso Rangone, chief officer of the scuola. He appears alone, rather than accompanied by his fellow officers, at the far left in the Miracle of St. Mark and takes center stage in Tintoretto's other canvases, a disturbing breach of Venetian corporate etiquette.

There is also something unsettling about Tintoretto's blatant quotation of non-Venetian, specifically Roman sources, for a work dedicated to Venice's patron saint. At the center of the composition a tumbling apparition of

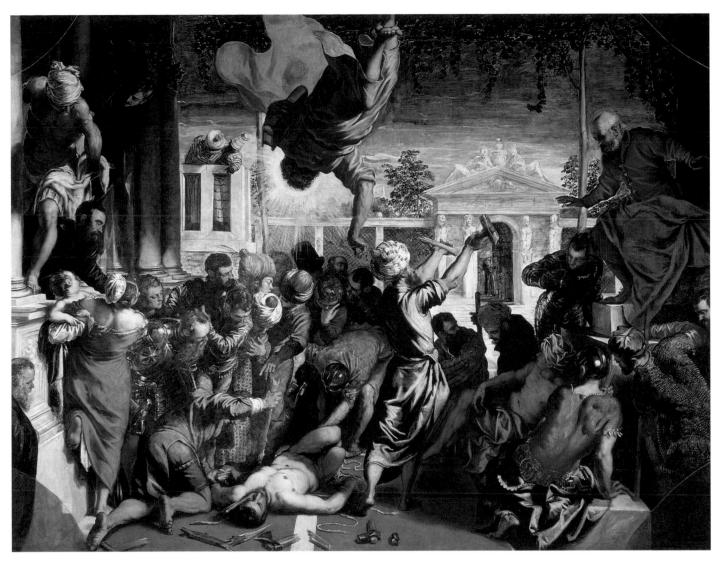

21.36 *Miracle of St. Mark*, 1548, commissioned by the Scuola Grande di San Marco from **Jacopo Tintoretto** for the main hall of the Scuola Grande di San Marco, Venice. Oil on canvas, 12′ 10″ × 10′ 4″ (3.93 × 3.17 m) (Galleria dell'Accademia, Venice)

St. Mark is based on Tintoretto's study of Michelangelo's Sistine ceiling. At the left, the pivoting mother and child evoke similar figures in Raphael's *Fire in the Borgo* (see Fig. 18.31). They and other agitated figures provide the frame for the foreshortened, nude body of a devotee of St. Mark whom legend said infidels repeatedly attempted to mutilate and martyr. St. Mark's intercession rendered their tools ineffective, as shown by the broken implements in the foreground of the painting and the splintered axe held aloft by the turbaned executioner. Pulsating with color, the work gave the Scuola, which finally accepted it in 1562—fourteen years after it was painted—a vivid means of promoting the cult of their patron saint.

Soon Tintoretto earned commissions from other scuole as well. None was more successful in securing his services than the Scuola Grande di San Rocco, not founded until the late fifteenth century but very popular because its patron saint was renowned for offering protection from the plague, an increasingly common threat. The Scuola's

headquarters were not complete until the mid-sixteenth century, so when Tintoretto began working there in 1564 he found an essentially blank slate. After winning the competition by sneaking into the officers' chamber (*albergo*) of the Scuola and installing his full-scale painting of a triumphant San Rocco on the ceiling, he covered the walls with tumultuous scenes of Christ's Passion. In 1577 he promised to provide three paintings a year free to the Scuola (of which he was a member). His paintings, then, became signs of his personal devotion.

For the main upper meeting hall (Fig. 21.37) Tintoretto covered the ceiling and walls with parallel scenes from the Old Testament and the life of Christ that emphasize the charitable aims of the Scuola. The vast open space was characteristic of all the *scuole grandi*, allowing hundreds of members to meet together at a single time. Ineligible for membership in the Great Council, which met in a room of similar proportions but grander dimensions in the Doge's Palace (see Fig. 21.39), *scuole* members actively participated

in their own self-government at the community level. In Moses Drawing Water from the Rock (Fig. 21.38) the subject alludes to the brothers' commitment to provide food and drink for the poor. At the center of the canvas, Moses strikes a rock and powerful streams of water erupt from it, filling plates, bowls, and jars held out eagerly by the parched Israelites. Tintoretto uses many of the same dramatic devices he had employed nearly thirty years earlier for the Scuola di San Marco: sharp contrasts between light and dark, rich color, forceful gestures, exaggerated foreshortenings, and even a figure flying through the sky (in this case God the Father). Appropriate to its placement on the ceiling rather than on a wall, however, the subject is composed from well below. The Israelites seem in danger of slipping down a steep hill into the viewer's space; streams of water appear to pour out over the room. Thanks to the artist's lightning-quick brushstrokes and highlights, the action seems caught for just a moment, not frozen in a tableau as in the earlier painting.

Celebrating the City in the Doge's Palace

Major fires in the Doge's Palace in 1574 and 1577 necessitated the wholesale renovation of its pictorial decoration, and artists received explicit instructions about subject and even composition, the idea being to emulate the visual authority of the destroyed works as closely as possible. Tintoretto painted several large ceiling panels for the elaborate program, which emphasized Venice's military achievements (especially in the eastern Mediterranean), celebrated the city's unique form of government, touted civic freedom, and claimed Venice's parity with the papacy and the Holy Roman Empire. Tintoretto's most important contribution to the enterprise was the replacement of Guariento's 1365 *Coronation of the Virgin* (see Fig. 7.19), located behind the dais on which the doge and leading patricians sat during meetings of the Great Council (Fig. 21.39). Perhaps because

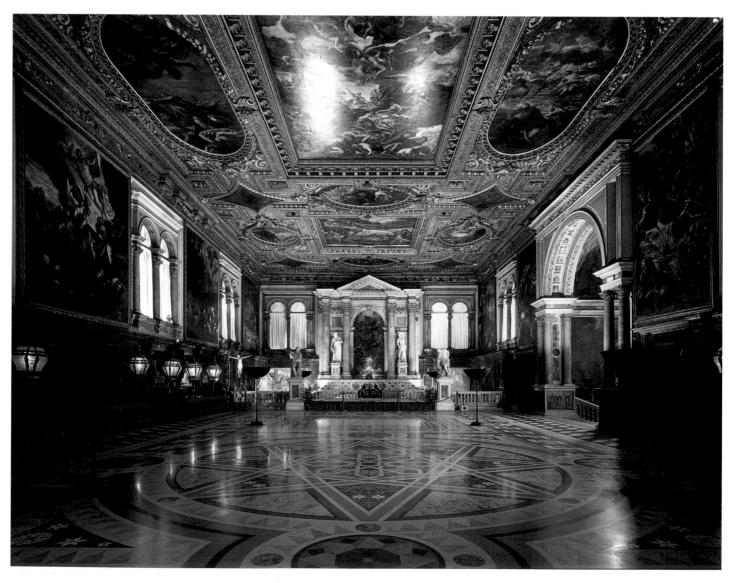

21.37 Interior of Sala Grande, Scuola di San Rocco, Venice, completed 1560, ceiling and wall paintings by Tintoretto

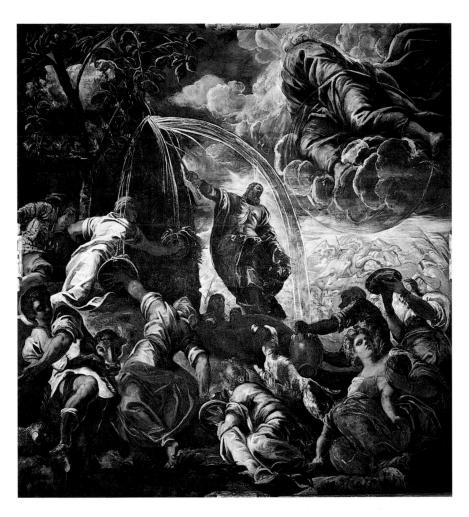

21.38 Moses Drawing Water from the Rock, c. 1577, commissioned by the Scuola Grande di San Rocco, from **Jacopo Tintoretto** for the ceiling of the main meeting hall of the Scuola Grande di San Rocco, Venice. Oil on canvas, $18' \times 17'$ 1" $(5.50 \times 5.20 \text{ m})$

The ceilings and walls of the entire Scuola are covered with paintings by Tintoretto. A commission of three Scuola members was charged with examining, judging, and approving the paintings.

21.39 *Paradise*, after 1588, commissioned by the Venetian government from **Jacopo Tintoretto** for the Great Council Hall, Doge's Palace, Venice. Oil on canvas

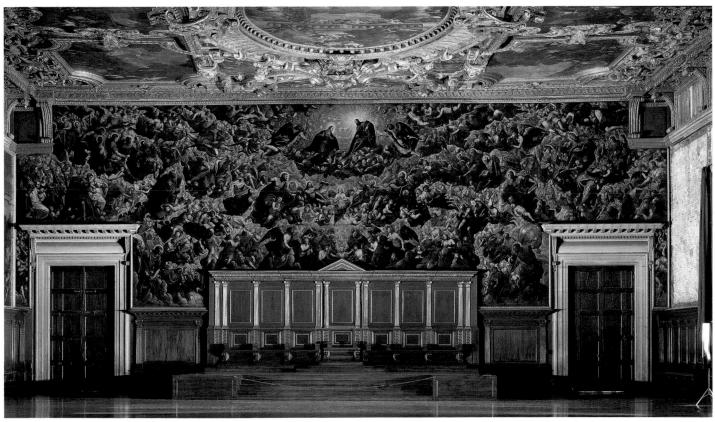

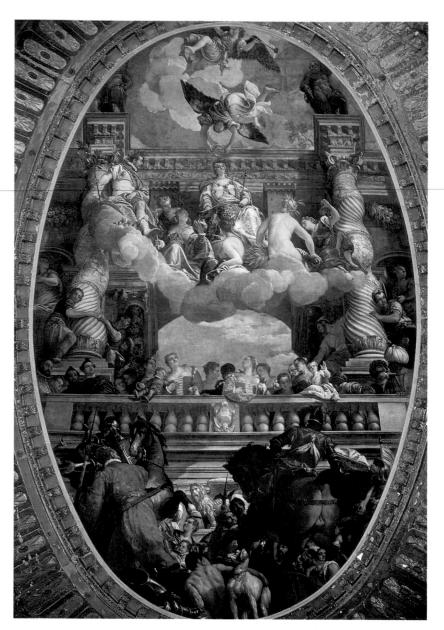

21.40 Apotheosis of Venice, probably 1585, commissioned by the Venetian government from **Paolo Veronese** for the ceiling of the Great Council Hall, Doge's Palace, Venice. Oil on canvas, 29′ 8″ × 19′ (9.04 × 5.79 m)

of his artistic willfulness and discussions about the relative lack of finish in many of his works, Tintoretto was not the first choice for this commission, which was initially assigned to Paolo Veronese (Paolo Cagliari; 1528 Verona-1588 Venice), and Francesco Bassano (Francesco dal Ponte the Younger; 1549 Bassano-1592 Venice). When Veronese died in 1588 the work had not been begun, but it had been decided that it would continue to center around Christ and Mary, preserving the general paradisiacal theme of Guariento's composition. However, the focus of Tintoretto's composition was to be Christ rather than Mary, eliminating the flanking scenes of the Annunciation and setting Christ as the supreme authority, to whom Mary is subsidiary. The seething crowds of saints and angels purposefully suggest a

Last Judgment, reminding Great Council members of the gravity and enduring significance of their deliberations and actions.

Tintoretto's painting had its secular counterpart in Veronese's Apotheosis of Venice, one of thirty-five panels on the ceiling of the same room (Fig. 21.40). Rising above a bank of clouds, the royally garbed personification of Venice sits enthroned between the twin towers of the city's Arsenal, about to be crowned with laurel by flying victories. Arrayed at her feet and offering her wise counsel are personifications of peace, abundance, fame, happiness, honor, security, and freedom. An especially splendid triumphal arch, fronted by twisting columns, marks the top of an enormous balcony which seems to burst through the ceiling into the ether beyond in order to accommodate the multitudes of celebrating people stipulated in the commission. At the base, Venice's smiling subjects seem undisturbed by the enormous size and energy of careening horsemen in their midst, reminders of Venice's considerable military might. Illusionistic foreshortenings and dramatic light effects serve to give political allegory a previously unimagined dynamism and visual excitement.

Patronage of Commercial and Ecclesiastical Projects

Equally crucial to the city's self-image in the second half of the sixteenth century were ongoing improvements to the urban infrastructure, the renovation of civic commercial facilities, and the erection of churches that enjoyed close associations with civic devotion and ritual. With

Sansovino's major enhancements to the area around San Marco well underway (see pp. 479–81), city leaders could pay more critical attention to the mundane and commercial needs of the city. At the same time, the need for divine protection against natural and human disasters inspired the renovation and creation of highly visible and newly monumental houses of worship.

The Fabbriche Nuove

Ever since two disastrous fires in the Rialto business district in 1505 and 1514, city officials had been rebuilding and renovating shops, storerooms, and offices in this extremely vital and cramped part of the city. During the Cambrai Wars expenditures were kept as low as possible, often meaning that new structures reused old foundations and few changes were made to the urban plan, which was a maze of private and public ownership. Finally in 1550 the

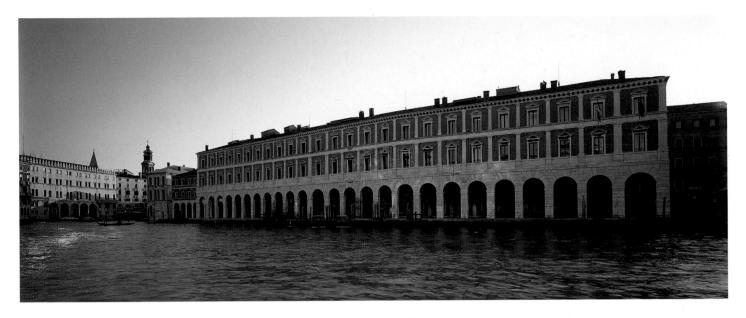

21.41 Fabbriche Nuove, Venice, 1554-56, extended 1557, commissioned by the Proveditori sopra la Fabrica del Ponte de Rialto from Jacopo Sansovino

government decided to demolish some indecorous, decaying wooden shops along the Grand Canal and build a single large structure housing shops and warehouses for the city's fruit market. Commerical leases paid the construction expenses. The elderly Jacopo Sansovino, still the dominant architect in the city, designed and oversaw the project (Fig. 21.41), though a quirk of politics-the architect evidently made some serious enemies during his work on the Zecca and the Library (see Figs. 21.24 and 21.25)—assured that he was never formally elected as supervisor of the work. In order to enlarge the site slightly, Sanosovino was allowed to encroach on the Grand Canal, whose curving course he respected by bending the building at its midpoint. Employing brick and stone for all the walls and foundations, Sansovino made the structure fireproof, not even including any fireplaces in the two upper stories, which were mainly intended for storage but must have accom-

modated some business activities as well. The simple articulation of the building's façade—a rusticated ground floor and simple Doric and ionic pilasters framing single pedimented windows in the repetitive bays above—contrasts markedly

21.42 Rialto Bridge, Venice, 1588–91, commissioned by the Venetian government from **Antonio da Ponte**

Throughout the fifteenth and sixteenth centuries the Venetians replaced hundreds of small wooden bridges with stone structures. A local chronicler indicated that bridges took on new, higher profiles to accommodate the cabins that had become popular on the gondolas of the nobles. At Rialto, the steep curve allowed large ships and barges to pass easily.

with the opulence of Sansovino's design for the San Marco Library (see Fig. 21.25), not a sign of Sansovino's flagging energy as an architect but a manifestation of the structure's commercial function.

The Rialto Bridge

Throughout this period, city officials turned again and again to the prospect of rebuilding the old wooden drawbridge at Rialto (see Fig. 13.27), located just up the Grand Canal from Sansovino's Fabbriche Nuove. Despite numerous complaints, followed by official discussions and plans submitted by Sansovino, as well as Michelangelo and others, the Venetian government did not commit to its reconstruction until 1588, making it the last of the century's major urban renewal projects. The chosen design (Fig. 21.42) is by Antonio da Ponte (1512 Venice?–1597 Venice),

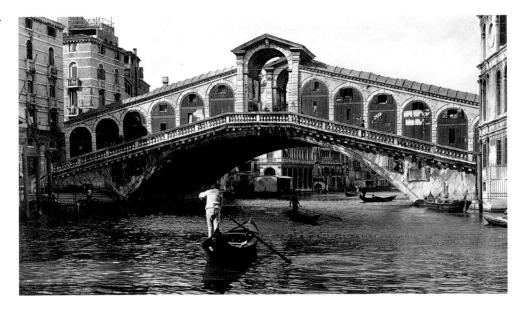

a master builder who worked on some of the most important civic projects in Venice, including military fortifications. His bridge is consummately Venetian, leaping the canal in a single 157-foot (48-meter) span and avoiding much of the complication of earlier proposals. It is also pragmatic, respecting the necessity of providing shops, lit from front and back, on both sides of the bridge and tall enough at the center to allow boats to pass under it easily. The bridge is also sensitive to human needs, featuring a gentle gradient and the reward of an open viewing platform at—its summit. With its completion, the city's commercial center at Rialto was as worthy a site of civic pride as Piazza San Marco.

Palladio

One of the architects whose design for the Rialto Bridge was rejected (probably because government officials were not keen to disturb private businesses by expropriating land on either end of the bridge necessary to fulfill his plans) was Andrea di Pietro of Padua, known as Palladio (1508 Padua-1580 Vicenza). Palladio was given his classical nickname (after Pallas Athene, goddess of wisdom) by Gian Giorgio Trissino, a humanist patrician of Vicenza on the Venetian mainland who discovered the young stonemason and provided him with the education that both unleashed and harnessed his formidable creative talents. Palladio had learned the building trades from the ground up; with tutoring from Trissino and several trips accompanying his patron to Rome, he became his generation's most eloquent promoter of antique building types and by the 1550s had established a thriving practice in Vicenza. In 1554 he published his own little guidebook to the antiquities of Rome, followed in 1556 by illustrations for Daniele Barbaro's commentaries on Vitruvius. Palladio's writings culmi-

commentaries on Vitruvius. Palladio's writings culminated in 1570 with *The Four Books on Architecture*, a treatise organized by building types in which he laid out the rules of ancient architecture, illustrating them with numerous examples from his own buildings. The clean lines and clear geometry of his designs made them suited to graphic representation, assuring the dispersion of his ideas throughout Europe and to colonial America.

San Giorgio Maggiore

In 1565 Palladio began rebuilding the Benedictine church and monastery of San Giorgio Maggiore on the island directly across the lagoon from the Doge's Palace (Figs. 21.43 and 21.44). The form and grandeur of the church depend directly on its location, highly visible from the representational and celebratory center of the city at San Marco. Every year on the day after Christmas the doge and sen-

21.43 San Giorgio Maggiore, Venice, begun 1565, commissioned by Abbot Andrea Pampuro da Asolo from **Andrea Palladio**

The doge and the Venetian senators made an annual visit to San Giorgio on the feast of St. Stephen (December 26).

ators made a solemn visit to the church. In his *Four Books*, Palladio advocated a central plan as the most suitable for a church because it was "most apt to demonstrate the Unity, the infinite Essence, the Uniformity and Justice of God." Here as elsewhere, however, he respected the preference of ecclesiastical and civil authorities for a long nave and ample transepts—in this case to accommodate the annu-

al procession of the doge—devising a Latin cross plan crowned with a dome at its crossing. He also made concessions to the needs of his monastic patrons by placing their choir in the apse, behind the high altar, rather than in the traditional rows in front of it; this was in response to new Church directives that the laity have an unobstructed view of the altar. Palladio's nave,

and pilasters, is impressive and yet welcoming (see Fig. 21.43). Unlike the imposing but dark churches of the Byzantine revival, whose domes were originally unilluminated, the church is filled with light from large ther-

with its rhythmic interplay of attached columns

mal windows directly under the vaults. The rigorous geometry underlying the plan and determining the relationship between

21.44 San Giorgio Maggiore, Venice, plan

Plague in Venice

This account of the plague that devastated Venice in 1576–7 was written by a Venetian notary, Rocco Benedetti, some years after the event, in 1630. Nevertheless, it conveys vividly the terror and despair experienced by the citizens at the time.

The plague continued, killing more people with every hour that passed, and every day inspiring greater terror and deeper compassion for its poor infected victims. Onlookers wept as these people were carried down to their doors by their sons, fathers and mothers, and there in the public eye their bodies were stripped naked and shown to the doctors to be assessed. The same had to be done for the dead, and I myself had to carry down three whom I had lost: my mother, my brother, and a nephew. Neither in life nor in death had they shown any symptom of plague, but they were assessed by the parish doctor as "of concern" and, since there was an order that [two] cases "of concern" were equivalent to one "of suspicion," I was compelled to spend forty days confined at home.

The fate of those who lived alone was wretched, for, if they happened to fall ill, there was no one to lend them any assistance, and they died in misery. And, when two or three days had passed without their appearing and giving an account of themselves, their deaths were suspected. And then the corpse-bearers, entering the houses by breaking down the doors or climbing through the windows, found them dead in their beds or on the floors or in other places to which the frenzy of the disease had carried them

When the bodies could no longer be burned because of the great stench, a cemetery was established a little way off on the Lido, at a place called Cavanella, and there very deep pits were dug. Following the practice at the Lazzaretto, a layer of corpses was placed in them, and then a layer of lime, and then a layer of earth, and so on from layer to layer until they were full, in such

a way that from one day to the next all bodies were buried. The dead from the city who had been assessed as "of concern" were taken for burial in their coffins at Sant'Avario di Torcello. And, because neither the Certosa nor any of the other places assigned for airing goods was big enough, and because goods had to be aired for as long as forty days, so that most were ruined by exposure to air, wind and rain by day and by night, permission was given to those with spacious houses to air [their goods] themselves at home or in other suitable places.

To sum it all up, in maintaining so many people and bearing such expense the Doge spent a huge sum of money. Administration became chaotic, so that all the Savi [officials] were bewildered, not seeing how to provide for so great a need, nor which course to take to protect us from such a hail of arrows, showered down in all directions by the plague.

(from D.S. Chambers and B. Pullan with J. Fletcher. Venice: A Documentary History. Oxford: Blackwell, 1992, pp. 117-19)

all the structural members is relieved by the slight swelling of the applied columns and pilasters—the classical principles of entasis used creatively with the Corinthian order rather than the usual Doric. A softly bulging cushion molding intervenes between the columnar supports and the strongly projecting entablature. The effect is lucid and harmonious, space modeled by, and yet flowing around, the building's structural supports.

The Redentore

The end of a particularly virulent outbreak of the plague in the summer of 1576 resulted in Palladio's receiving a commission for another church, this one built on the adjacent island of the Giudecca. During the plague the doge had vowed that when it ended the city would erect a church to Christ the Redeemer in gratitude. Work began on the church almost immediately; and the following year, on the feast of the Redeemer (the third Sunday in July), the Venetian government established the custom—still observed—of a civic procession over a bridge of boats to a service of thanksgiving in the church.

Palladio's design for the Redentore (Fig. 21.45) gives great prominence to the façade. Raised on a podium and

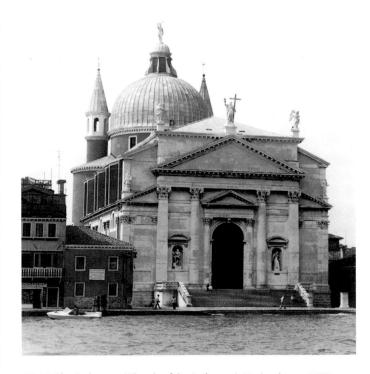

21.45 The Redentore (Church of the Redeemer), Venice, begun 1577, commissioned by the Venetian government from Andrea Palladio

approached by a broad stairway, well suited to the frontal approach dictated by the annual ceremony, the façade employs a subtle arrangement of interlocking triangles, pilasters, and attached columns. Palladio's design provided an ingenious solution to the problem of adapting a Roman temple front to the high nave and lower side aisles of the church. He combined two temple fronts: a tall, narrow one for the center unit fronting the nave with pilasters at either side and attached columns emphasizing the entrance, and a broad, lower one recessed behind the first. For all its complexity, the design manages to convey an impression of serene simplicity. The attic story over the main pediment evokes associations with the Pantheon in Rome, while, rising triumphantly above these classical forms, the bulbous Venetian dome flanked by turrets proudly proclaims the city's Byzantine heritage.

Villa Barbaro

By the mid-sixteenth century, Venice's maritime activities were in permanent decline, weakened both by the Turks and by fellow Europeans, who had rounded the Cape of Good Hope and had begun exploring the Americas. Venetian nobles acquired land in the countryside between their city and Vicenza and built impressive villas, not only because they wanted and needed a country retreat, but also as a gesture of defiance in the face of challenges to their mainland empire. Unlike the suburban villas of papal Rome (see Figs. 22.13 and 22.14) or such pleasure palaces as that built by Federigo Gonzaga in Mantua (see Fig. 19.3), these buildings were the functional centers of large working farms, many

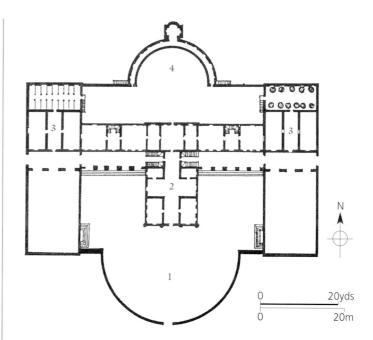

21.47 Villa Barbaro, Maser, plan, from **Andrea Palladio**, *Quattro Libri dell'Architettura*, 1570

1 Courtyard; 2 Main residence; 3 Service wings; 4 Nymphaeum

built on recently drained swamps. To ennoble these sites and bring them into conformity with Venetian nostalgia for the supposedly idyllic rural life of antiquity, a number of Venetian noblemen hired Palladio as the architect for their villas. Palladio centered his villa designs around a main residence fronted by a classical portico.

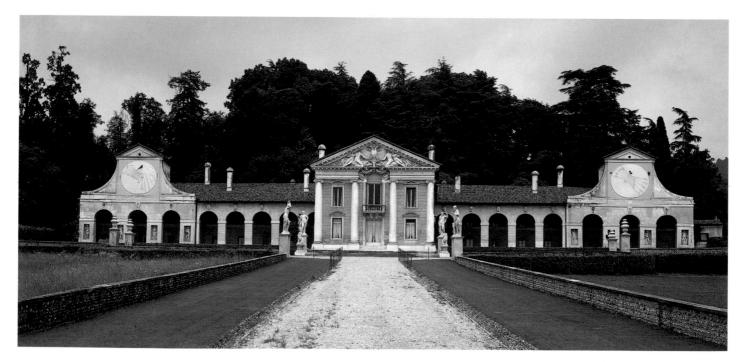

21.46 Villa Barbaro, Maser, 1555-59, commissioned by Daniele and Marc'Antonio Barbaro from Andrea Palladio
Palladio's villas were built of economical materials faced in tinted stucco, unlike his city palaces, which were usually faced in stone.

At the Villa Barbaro in Maser (Figs. 21.46 and 21.47), his patrons, the brothers Daniele and Marc'Antonio Barbaro, explicitly sought to re-create a Triclinium described by Pliny the Younger at his commodious seaside villa outside ancient Rome, opening all four sides of the building to a cross-shaped, barrel-vaulted, central hall. Given the paucity of physical evidence on Roman villas available to Palladio and his patrons, the complex fails as an archaeological reconstruction, but it is an inspired evocation of antiquity; some of its unusually ornate sculptural decoration may be the work of Marc'Antonio Barbaro himself, who was an amateur painter and sculptor. Making a virtue of necessity, Palladio increased the apparent size of the house by extending it with an arcaded gallery which joins it to twin service buildings accommodating stables, storerooms, and wine cellars. The plan Palladio published in his Four Books (see Fig. 21.47) indicates that the side buildings and the agrarian activities that took place in them were to have been partially obscured by enclosed forecourts, while the residence itself was to have been preceded by a classically-inspired

hemispherical entrance wall, repeated in the shape of a **nymphaeum** at the far side of the house. Rigorously symmetrical, as were all his designs, the plan established two clear axes, giving symmetry and order to the villa's multiple functions.

The decoration inside the villa seems to have been entirely assigned to Paolo Veronese whose frescoes and stucco works enhance and elaborate Palladio's rather severe architectural forms. Veronese's rich decorative style and sumptuous but delicate colors made him the favorite painter of the Venetian nobility. The specific program is difficult to elucidate and is often described as lacking a specific subject, but in his translation and commentary on Vitruvius, Daniele Barbaro said that painting, like literature and music, "must have intentions and represent some effect that controls or directs the entire composition." The predominance of allegorical figures and landscapes suggests that Barbaro intended to celebrate the natural world and the virtues of his family.

On the ceiling of the central room at the back of the res-

idence (Fig. 21.48), overlooking the nymphaeum, Veronese took inspiration from Mantegna's famous illusionistic composition in the Camera Picta in Mantua (see Fig. 14.32). At the sides, arching above idealized landscapes, are illusionistic balconies. On one side stands the splendidly garbed lady of the house, Giustiniana Giustinian, next to a swarthy old servant woman with one breast covered by the cloth of her shawl but distinctly outside her bodice, which may indicate that she is Giustiniana's loyal nursemaid (a small dog, symbol of fidelity, sits pertly in front of her). The jarring contrast between the two serves to emphasize Giustiniana's superior social status and fecund youth, while at the same time suggesting the close bonds among all female members of the household. Next to them, the youngest Barbaro boy, still presumably directly in his mother's care, peers at a parrot

21.48 Allegory of Divine Love, after 1559, commissioned by Daniele and Marc'Antonio Barbaro from Paolo Veronese for Villa Barbaro, Maser. Fresco

from the left side of one of the spiraling columns. On the opposite side of the room, two older and presumably more independent boys read and attend to a hunting dog, while a pet monkey gambols across the parapet. Together these figures declare this a domestic space, one which was ordered and administered by Giustiniana in the Barbaro brothers' frequent absences. Tellingly, at the center, in an octagonal oculus, a female figure dressed in white and sitting on a beast probably represents Divine Love, who has conquered strife (the beast) and now imposes order on the universe. Personifications of the signs of the zodiac surround her. Vulcan, Cybele, Neptune, and Juno sit on clouds in the pentagonal corners of Veronese's imagined architecture, alluding to the four elements of fire, earth, water, and air; gods associated with each of the four seasons recline amidst elaborate strapwork in the spandrels between them.

The Villa La Rotonda

The Church dignitary and humanist Monsignor Paolo Almerico chose a site overlooking the gentle hills outside Vicenza, his main place of residence, for his villa. Known as La Rotonda (Fig. 21.49), it differs from other countryside residences in that it was built primarily as a suburban retreat rather than as a working farm. As was the case with all of Palladio's villas, the exterior is rather plain. The setting made it grand and inspired Palladio to give each side of the house, built on a centralized plan (Fig. 21.50), a pedimented loggia, so as to enjoy, in the architect's words, "beautiful views on every side, some of which are limited,

others more distant, and still others that reach the horizon." Each portico is approached by a broad staircase. The extremely sensitive deployment of simple forms—square, rectangle, and triangle—combined with Palladio's unerring sense of proportion culminates in a shallow dome which forms a surrogate crest to the hill, uniting the building and the land upon which it rests. Passageways originally interrupted the center of each of the building's four exterior staircases to allow carts easy access to ground-floor work areas, which contained internal staircases leading to an attic granary. The building's main floor was designed for gracious and luxuriant entertaining, with symmetrically disposed rectangular reception rooms encircling a domed central hall.

The Teatro Olimpico

Palladio's masterful appreciation of ancient buildings and longstanding relationship with Vicentine humanists earned him the unusual honor of being named a member of the Olympic Academy, formed in 1555 to encourage the revival and production of ancient theatrical works. For this group of scholars, Palladio designed his most thoroughly archaeological creation, the Teatro Olimpico (Figs. 21.51 and 21.52), which was completed after his death—as were many of Palladio's projects—by the Veronese architect Vincenzo Scamozzi (1548 Vicenza–1616 Venice). The seating was arranged as a series of concentric steps facing a richly articulated proscenium resembling the façade of a grand palace, with several openings. Scamozzi added street vistas set in perspective behind the openings so as to increase the apparent

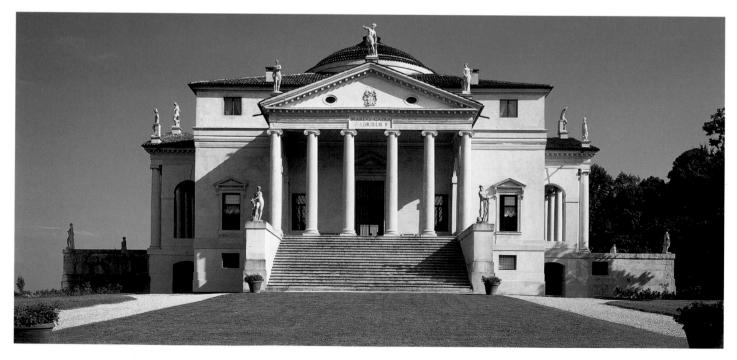

21.49 Villa La Rotonda, Vicenza, begun late 1560s, commissioned by Paolo Almerico from Andrea Palladio

A later owner, Mario Capra, inserted his name on tablets in the middle of each entablature. The interior of the villa was thoroughly redecorated in the eighteenth century.

21.50 Villa La Rotonda, Vicenza, plan of upper floor

21.51 (far right) Teatro Olimpico, Vicenza, plan

1 Seating; 2 Proscenium; 3 Street scenes extending stage area

depth of the stage. Following classical practice, however, nearly all the dramatic action took place in front of the proscenium. Members who contributed funds for the construction received commemoration with a statue, inscription, and their coat of arms on one of

and in niches surrounding the seating. Many donors were decidedly negligent in their payments, however; the inaugural performance, in 1585, of Sophocles' Oedipus Rex, was made possible only because the Academy's president (known as the "prince") took out his own personal loan to underwrite the extravagant costs.

Ancient models had come alive both in Venice and on the Venetian mainland, but Palladio's archaeological recreation at the Teatro Olimpico was exceptional. In order to fashion a new world that celebrated themselves and their city, most

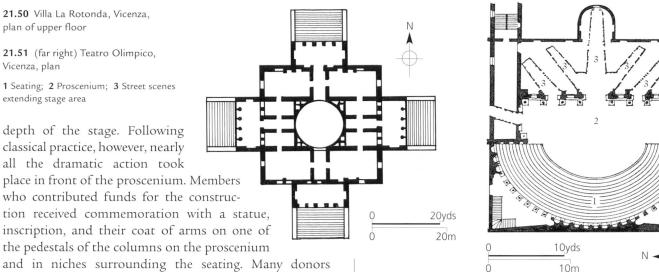

patrons preferred that their artists and architects adapt, respond to, and create novel variations upon ancient precedents while at the same time respecting the city's other long traditions. Masking the realities of a slow and inevitable decline in Venice's fortunes throughout the sixteenth century, this art and architecture helped to sustain the city's independence and triumphalist self-imaging well into the eighteenth century.

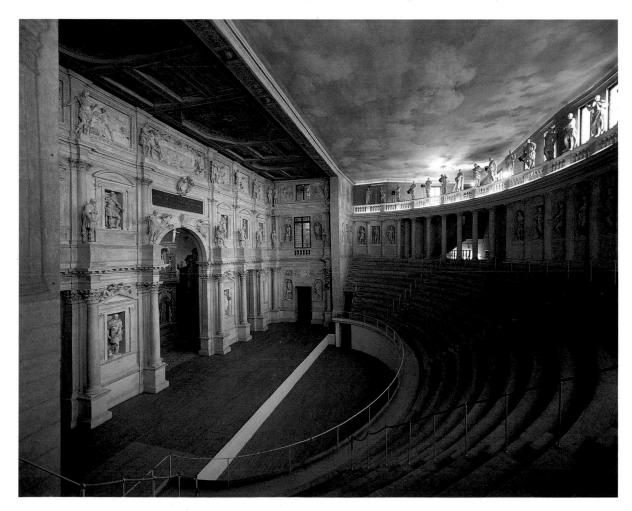

21.52 Teatro Olimpico, Vicenza, 1555-1616, commissioned by the Accademia Olimpica from Andrea Palladio and completed by Vincenzo Scamozzi

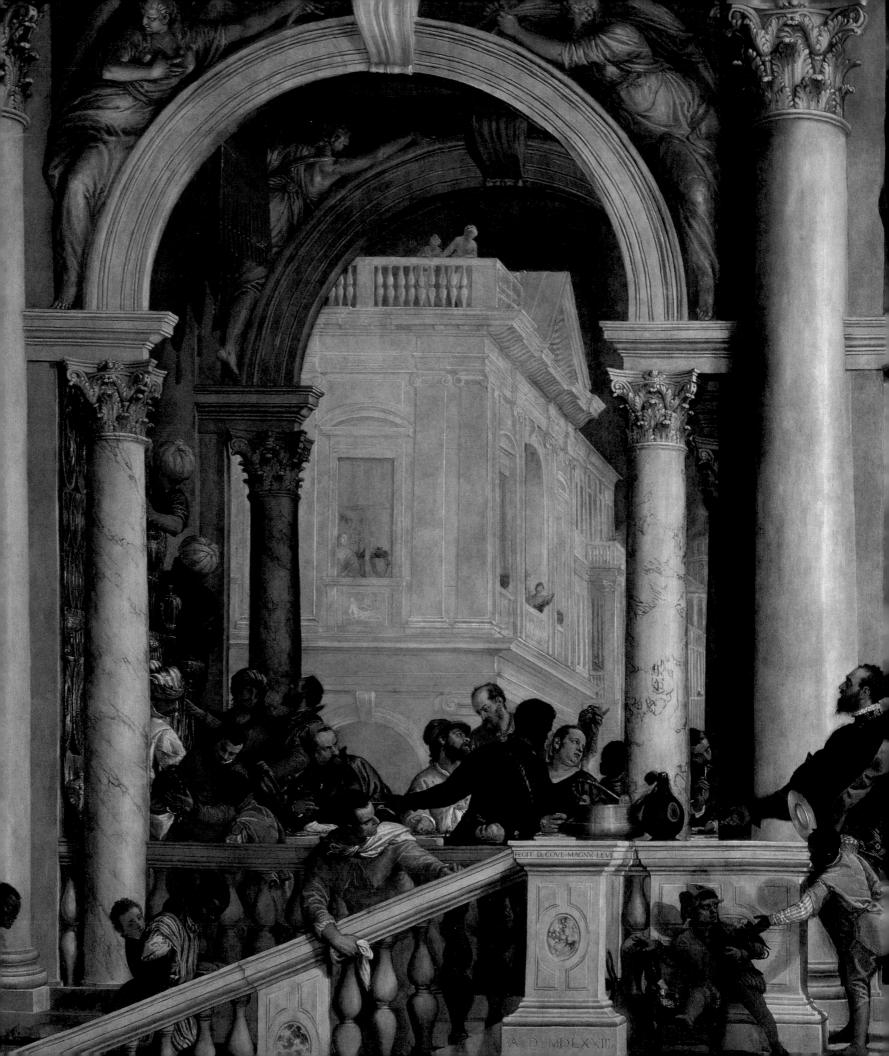

The Later Sixteenth Century

22	The Rome of Paul III	500
23	The Demands of the Council of Trent	513
24	Northern Italy: Reform and Innovation	527
25	Rome: A European Capital City	538

he nature of artistic production changed irrevocably during the later part of the sixteenth century. Major religious reforms, the coalescence of large national states—led by strong kings and queens—and a renewed and truly universal Church proved dominant in a radically reordered geographical world. Increased urbanization throughout Europe, the waning of the international economic power of small independent city-states in Italy, and the emergence of new economic forces within the cultures of Europe as a whole also deeply affected artistic production and reception. Distinct regional styles waned in favor of a uniform style promoted both by the Church and by autocratic rulers sharing similar designs on power. The print medium (both individual images and books) fostered artistic exchange between cities, allowing new ideas to travel much more quickly than before and transforming local styles as artists more and more shared a common body of references. The role of the artist also changed. Artistic academies burgeoned across Europe, a cottage industry of prescriptive artistic treatises arose, and artists and patrons gained direct access to artistic history and ideas through compendia like Vasari's *Lives*. With the explosive growth of cities and an expansion of the burgher class, new genres of painting like the still life also evolved, free of earlier typologies and conventions.

The processes of this exciting transformation of the arts in Italy was complicated as old centers of activity waned and new centers of support grew. By the end of the century Rome had become the center of artistic creativity not only for Italy but for all of Europe, a role that it maintained until the late eighteenth century when Paris superceded it as the European artistic capital.

(opposite) Feast in the House of Levi (detail), 1573, commissioned from Paolo Veronese for the refectory of the Dominican monastery of Santi Giovanni e Paolo, Venice. Oil on canvas. (Galleria dell'Accademia, Venice)

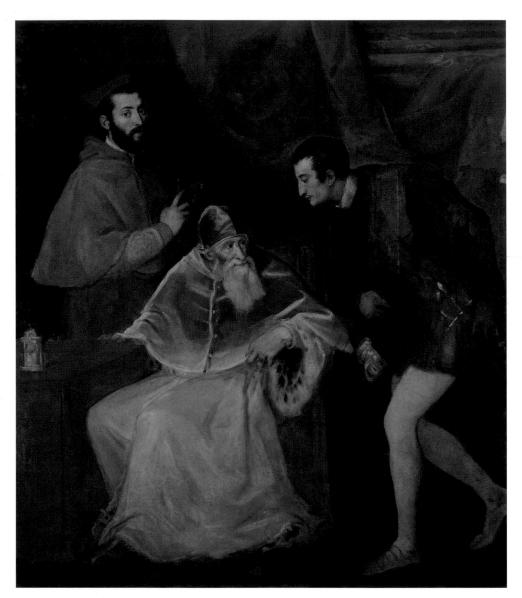

R ome's road to cultural dominance was a response to the devastations of the Sack of 1527 and the inroads made by Protestantism, thus entailing both the reconstruction of the city and the revitalization of the institutional Church. In this regard, the city was fortunate to have a pope, Paul III (r. 1534-49), who not only understood the political and the religious issues of the day but also the value of the visual arts to serve as convincing propaganda. Paul worked closely with Michelangelo, the consummate papal artist and architect, who once more challenged

accepted paradigms and thus provided new models for renewed artistic creativity.

When Alessandro Farnese was elected to the papacy as Paul III in 1534, he was the first Roman to hold that office since Martin V in the early fifteenth century. As a Roman he must have felt keenly the city's humiliation in the Sack of 1527. He faced the double task of bringing new order to the social and political life of the city and of renewing the tenets and practices of the Church that had been heavily challenged by many Protestant reformers. Since Paul enjoyed the longest reign of any of the popes of the sixteenth century, he had ample time to reconstruct the image of the papacy and of the Church. But as triumphalist as his architectural projects were in claiming a universal religious order and a controlling power in the city, Paul's other commissions suggest the struggles inherent in attempts to reassert control over a Church and state that had radically changed prior to his papacy.

Having spent some years of his youth in the Florentine court of Lorenzo the Magnificent, Paul was well versed in the power of art to enhance the position of the patron.

Made a cardinal in 1493 (although not ordained as a priest until 1519), he had also witnessed the development of the arts in Rome under Julius II and Leo X. Paul's projects were carefully chosen, historically charged in their siting and context, and ultimately of a magnitude comparable to those of Julius II and appropriate for someone who, like Julius, claimed a universal rulership. Moreover, they were at a scale indicating that, despite the Reformation and the Sack of Rome, the Church had triumphed over adversity.

Paul's two greatest legacies to the Church were his support of new religious orders, especially the Jesuits, to whom he gave official recognition in 1540, and his opening, albeit reluctantly, of the Council of Trent in 1545. The Jesuits, a powerful new teaching order, soon had an international network of communities. The Council of Trent, which continued intermittently until 1563, gave new guidelines for a post-Reformation Roman Church which were to affect its teachings and its liturgy, and therefore its art, for the next four hundred years.

Michelangelo's Last Judgment

Paul's first major commission in 1534 was for the Sistine Chapel, giving little doubt of his intentions to affiliate his papacy with those of Sixtus IV and Julius II. For the fresco of the Last Judgment (Fig. 22.1) Paul brought Michelangelo back to Rome from Florence, where he had been working on Medici commissions at San Lorenzo. Michelangelo had previously discussed with Clement VII the possibility of a large fresco of the Fall of the Rebel Angels for the entrance wall of the Chapel; but Paul changed both the subject and the placement of Michelangelo's work, insisting on a Last Judgment for the altar wall. The commission entailed the destruction of pre-existing frescoes on that wall, including Perugino's altarpiece and Michelangelo's own work from earlier in the century.

For many years the Last Judgment was so obscured by grime that its outlines, not to mention its original colors, were all but indiscernible. The cleaning of the fresco, finished in 1994, shows that Michelangelo used some of the same intense colors that he had employed on the ceiling of the chapel and that even in the darker areas of the painting at the lower edge, where the dead arise from their graves at the left and the damned are faced with hell on the right, he was concerned with details of the human (and demonic) bodies. The heroically scaled and dramatically posed bodies may be considered a development of Michelangelo's figural style seen in the ceiling above (see Fig. 18.12). Yet their fleshy, overdeveloped muscles also refer to Hellenistic sculpture like the bronze Hercules given by Sixtus IV in 1471 to the Capitoline Hill (where Michelangelo was also working in these years) and to the Roman copy in marble of Lysippus's statue Hercules Resting in the collection of Francesco Piccolomini (Pius III), another of Michelangelo's patrons.

(opposite) Pope Paul III and His Grandsons, Cardinal Alessandro Farnese and Ottavio Farnese, 1546, commissioned by Paul III from **Titian**. Oil on canvas, 6' $6\%''\times5'$ 8%''' (2 \times 1.74 m) (Gallerie Nazionali di Capodimonte, Naples)

This painting is usually euphemistically called "Pope Paul and his Nephews," obscuring the fact that many Church leaders had illegitimate children in this period.

The fresco is unusual in that Michelangelo did not include an architectural frame, as he had done for the ceiling. Its absence implies absence of wall, as if the chapel had been blasted out by the Judgment Day itself. In this terrifying vision, Christ appears in the band of figures aligned with the window area of the side walls (Fig. 22.2). He is neither seated, in the traditional manner, nor standing, but half-crouched, his body turning in a corkscrew movement suspended in space. The Virgin, readily visible in her iceblue drapery, turns in on herself, the only figure in the composition psychologically disengaged from the surrounding tumult, perhaps because her intercessory powers no longer pertain at the moment of the Last Judgment. St. Peter stands in the group of figures to the right; he is the largest figure in the fresco and clearly a potent image of the papal office, wielding the keys to the Kingdom of Heaven symbolically given to him by Christ. A large-scaled St. Simon of Cyrene, the man who helped Christ carry his cross, has a prominent position at the far right edge of the fresco in a pose that appears designed to help him balance the cross on his back but that in its upper body approximates that of Christ at the center of the fresco.

By and large the saints who fill the wide upper band of the fresco are unidentified. Some few, however, are telling in their references. Just beneath Christ and the Virgin, St. Lawrence, a saint used repeatedly in papal iconography at least as early as the frescoes in the Sancta Sanctorum at the end of the thirteenth century (see Fig. 2.3), appears with his symbol of the gridiron. He is paired with St. Bartholomew, whose flayed skin was one of the most important relics collected by Martin Luther's protector, the Elector of Saxony in Wittenberg, where Luther famously tacked his theses to the cathedral door. Michelangelo gave the flayed skin held by St. Bartholomew, at the center right, his own featuresperhaps a mordant comment on his fears about his own salvation, since he is the only one of the resurrected throng not to have regained his bodily form. The flayed skin may possibly also be a reference to the skin of Marsyas, the satyr who challenged Apollo to a musical contest and was flayed for his hubris, since the "divine" Michelangelo was also acting in competition with God in "creating" convincing fictions of human beings in his sculpture and painting, an "affectionate fantasy that made art an idol and sovereign" as he was to write in a later poem.

St. Blaise, holding the carding combs with which he was martyred, and St. Catherine of Alexandria, holding the broken wheel with spikes protruding from its rim which was an instrument of her torture, are among the more curious figures in the painting. A contemporary print by Giorgio Ghisi (1520 Mantua–1582 Mantua) indicates that St. Catherine was originally painted nude (Fig. 22.3), looking up at a threatening Blaise hovering above her. Both were later painted over by Michelangelo's student Daniele da Volterra (Daniele Ricciarelli; 1509 Volterra–1566 Rome). Daniele clothed Catherine so that Blaise would not

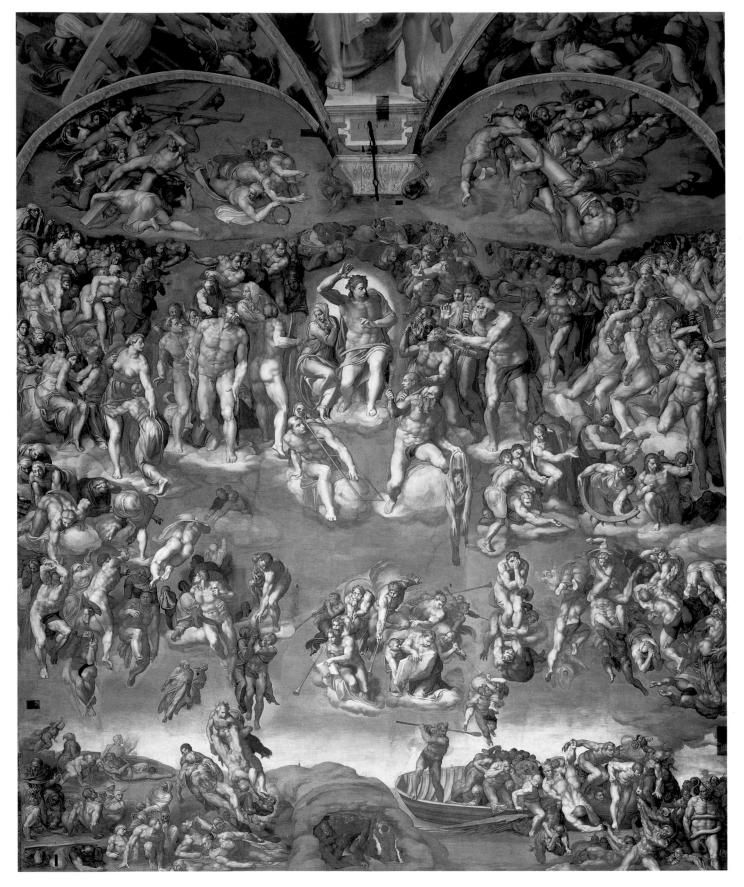

 $\textbf{22.1} \ \textit{Last Judgment} \ (\text{after cleaning}), \ 1534-41, \ \text{commissioned by Paul III from \textbf{Michelangelo}} \ \text{for the Sistine Chapel}, \ \text{Rome. Fresco}, \ 48 \times 44' \ (14.6 \times 13.41 \ \text{m})$

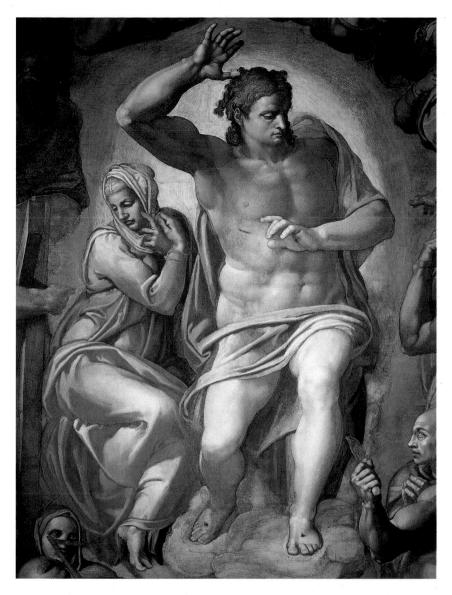

22.2 Christ and the Virgin (detail of Last Judgment), 1534–41, commissioned by Paul III from **Michelangelo** for the Sistine Chapel, Rome. Fresco

appear to be threatening her nude body as he approached from the rear, and he gouged out the existing paint surface and replastered it so that he could reconfigure Blaise's head to look away rather than down at Catherine.

Diminution of scale within these large groups of figures suggests a vastness of space, although there are abrupt changes of scale throughout, size being used conventionally to indicate status. It has been proposed that a turbaned figure at the upper right of this roiling group of figures is a self-portrait of the artist, thus giving him two appearances in the fresco, one as a hollow, sagging piece of flesh held by St. Bartholomew, bodiless amid all the monumentally structured figures in the fresco, and one corporeal among the very physically resurrected crowds of humanity surrounding Christ. Immediately to the left of this possible self-portrait are two nude men embracing and to the right two men kissing, figures that may have had personal meaning for Michelangelo but which others seem to have found disturbing: they were changed in subsequent small painted copies of the fresco as well as in prints made of the Last Judgment.

The inclusion of the Virgin in the mandorla of the Divinity suggests references to earlier Last Judgment iconography (see Fig. 8.2), where Mary, as the personification of Ecclesia, enjoys a position of equality with Christ. Mary's shrinking pose in Michelangelo's *Last Judgment* is a notable change in this iconography and may have opened questions about the Church's power to grant salvation, despite St. Peter's

22.3 Sts. Blaise and Catherine and St. Sebastian (detail after Michelangelo's Last Judgment), 1545–50, **Giorgio Ghisi** (after Michelangelo). Engraving. British Museum, London

22.4 *Man being Dragged to Hell* (detail of *Last Judgment*), 1534–41, commissioned by Paul III from **Michelangelo** for the Sistine Chapel, Rome. Fresco

dominating presence. The issues of doubt that are scattered throughout this fresco are vividly depicted in a figure isolated spatially above Charon's boat (Fig. 22.4). In traditional paintings of the Last Judgment (see Fig. 3.12) figures in the lower right quadrant represented the damned, but in Michelangelo's version, it is difficult to read this bulky figure, his body folding in on itself, his face partially hidden by his left hand, and his right eye staring straight out of the picture, as moving downward toward the residual hell that appears at the far right corner. The figure seems, rather, frozen in space, oblivious to the demons beneath and behind him who are ineffectually attempting to pull him downward. His torment seems completely internal and personal, as if his fate depended on his own individual actions rather than on the examples of institutional intervention and demonic power that otherwise populate the painting. Whether this extraordinarily emotionally charged figure was meant to focus our attention on the utter terror of everlasting damnation or whether Michelangelo disconnected him compositionally from Hell because of his own doubts about the very existence of such an end, is not clear. Ambiguity would have been a form of protection for the artist, guarding him against charges of heresy. Contemporary criticism of the Last Judgment which focused

on the propriety of so much nudity in a papal chapel and not on the ambiguities so pervasive in the fresco, may have had, as a subtext, a diversionary role to play in clouding the painting's disguised messages about the role of the Church in salvation.

The Deposition

Michelangelo's own intense personal questioning of the routes to salvation increased after his meeting with the poet Vittoria Colonna shortly after beginning work on the *Last Judgment*. Through his friendship with Colonna, he met

22.5 Deposition, c. 1546–55, **Michelangelo**; smashed by the sculptor in 1555 and pieced together and continued by his student, **Tiberio Calcagni**. Marble, height 7' 8" (2.34 m) (Museo dell'Opera del Duomo, Florence)

Calcagni seems largely to have completed the small female figure at the left thought to represent Mary Magdalene.

A Word of Advice

In this letter from the poet Pietro Aretino (1492–1557) to Michelangelo, the writer takes the artist to task for what he claims are indecencies in the *Last Judgment*. The irony is that Aretino was himself the author of many lascivious works, including the famous *Sonnetti lussuosi* ("Luxurious Sonnets"), which were illustrated with pornographic images comparable to *I Modi* (see Fig. 18.38). After his hypocritical closing, Aretino adds a postscript promising to tear up his own copy of the letter; but when Michelangelo did not reply, he published a slightly altered version of the letter.

To the Great Michelangelo Buonarroti in Rome

Sir,

When I inspected the complete sketch of the whole of your Last Judgment, I arrived at recognizing the eminent graciousness of Raffaello in its agreeable beauty of invention.

Meanwhile, as a baptized Christian, I blush before the license, so forbidden to man's intellect, which you have used in expressing ideas connected with the highest aims and final ends to which our faith aspires. So, then, that Michelangelo stu-

pendous in his fame, that Michelangelo renowned for prudence, that Michelangelo whom all admire, has chosen to display to the whole world an impiety of irreligion only equalled by the perfection of his painting! Is it possible that you, who, since you are divine, do not condescend to consort with human beings, have done this in the greatest temple built to God, upon the highest altar raised to Christ, in the most sacred chapel upon the earth, where the mighty hinges of the Church, the venerable priests of our religion, the Vicar of Christ, with solemn ceremonies and holy prayers, confess, contemplate and adore his body, his blood, and his flesh?

If it were not infamous to introduce the comparison, I would plume myself upon my discretion when I wrote La Nanna. I would demonstrate the superiority of my prudent reserve to your immodesty, seeing that I, while handling themes lascivious and immodest, use language comely and decorous, speak in terms beyond reproach and inoffensive to chaste ears. You, on the contrary, presenting so awful a subject, exhibit saints and angels, these without earthly decency, and those without celestial honors.

The pagans when they made statues I do

not say of Diana who is clothed, but of naked Venus, made them cover with their hand the parts which should not be seen. And here there comes a Christian who, because he rates art higher than faith, deems a royal spectacle martyrs and virgins in improper attitudes, men dragged down by their genitals, things in front of which brothels would shut their eyes in order not to see them. Your art would be at home in some voluptuous bagnio [bathhouse], certainly not in the highest chapel of the world. Less criminal were it if you were an infidel, than, being a believer, thus to sap the faith of others. Up to the present time the splendor of such audacious marvels has not gone unpunished; for their very superexcellence is the death of your good name. Restore it to good repute by turning the indecent parts of the damned to flames, and those of the blessed to sunbeams; or imitate the modesty of Florence, who hides your David's shame beneath some gilded leaves [see Fig. 17.1]. And yet that statue is exposed upon a public square, not in a consecrated chapel.

As I wish that God may pardon you, I do not write this out of any resentment

(November 1545, in Venice. Your servant, The Aretine)

(from J.A. Symonds, trans. The Life of Michelangelo. London: J.C. Nimmo, 1899, pp. 333-6)

some of those within the Church—such as Cardinal Reginald Pole of England and the Spaniard Juan de Valdés—who wished to introduce reforms into Church beliefs and structures which many within the hierarchy found heretical.

Michelangelo's *Deposition* (Fig. 22.5), planned by the sculptor for his own tomb when he was about seventy, suggests the intensity of his concern for his own salvation. The vertical axis of the group is defined by the sinking but severely torqued and muscular body of Christ and the standing hooded figure of Nicodemus who had provided myrrh and aloes for Christ's burial (John 19:39). Michelangelo gave Nicodemus his own features (a much more positive self-representation than the skin held by Bartholomew in the *Last Judgment*), thus clearly aligning himself with the promise of redemption offered by Christ. Although the Virgin receives the body of Christ, as in conventional Pietà iconography (see Fig. 12.34), Michelangelo displaced her to the right, assuming for himself the primary role, on the central axis of the composition. If the Virgin is

interpreted as Ecclesia, Michelangelo would then have been suggesting heretically that he could take salvation (Christ) into his own hands, thus supplanting the intervention of the Church. It is not surprising that in 1555 he smashed the unfinished statue, which may also have raised eyebrows because Christ's left leg was originally slung over the Virgin's lap, a pose often connoting sexual intercourse, in this case suggesting the marriage of Christ with the Church.

Triumphalist History

Although these works by Michelangelo may give some insight into both his personal conflicts and the deeply felt religious questions he shared with others of this time about Reformation theology and new efforts of reform within the Roman Church, Paul III consistently attempted to declare that his papacy was strong and to blur over the difficulties of previous decades in ways that would suggest unbroken institutional strength. One sign of this was his decision to

restore the Castel Sant'Angelo, the fortress at the entrance to the Vatican to which Clement VII had fled in 1527 at the time of the Sack of Rome. By turning what had been a place of shame for his predecessor into a splendid retreat, Paul, in effect, suppressed its previous ignominious history. In the major room of the building, he hired Perino del Vaga, newly returned to Rome after having worked in Genoa after the Sack (see Fig. 19.15), to paint a series of frescoes depicting ancient emperors-including Alexander the Great, since Paul's name was Alessandro Farnese-a clear sign of the universal power he claimed for the papacy. One entire wall of the building (Fig. 22.6) imitates an earlier image of St. Michael overcoming evil by Raphael and the nudes and shields of the Sistine ceiling by Michelangelo (see Fig. 18.12). Since Perino had worked in Raphael's workshop, these quotations may not seem unusual, especially given the frequency with which works by Raphael and Michelangelo were quoted during the sixteenth century. But the overtones of the Sistine commission are so strong as to suggest that Paul actively encouraged these stylistic references as a way to equate his own papacy with the accomplishments of Julius and Rome before the Sack.

Paul's grandson, also named Alessandro Farnese, used a comparably grand rhetorical vocabulary in paintings that he commissioned from Giorgio Vasari for his palace of the Cancelleria (Fig. 22.7), which had been seized by Leo X in 1513 from Rafaello Riario because of the latter's involve-

ment in an assassination plot against the new pope; the palace subsequently became papal property. As in ancient Roman art, the paintings recording the deeds of Paul III combine history and allegory. In Paul III Directing the Construction of St. Peter's, the standing pope points to St. Peter's in the background, whose building he had immediately taken up upon becoming pope. The colossal size of the project asserts the renewed strength of the Church as well as the centrality of the papacy, since the building celebrates the first pope. Allegorical figures of Architecture hold out the plans of the building for Paul to see, much as personifications of abstract concepts accompany classical images of Roman emperors. Despite the elegant and complex poses of the foreground figures, the didacticism and clarity of this imagery-far removed from the conceits of Mannerismsuggest that the patron had called for a grand yet relatively straightforward narration of the deeds of his uncle.

The complex workings of the papal family within the larger papal court are evident in a psychologically charged portrait of Paul III with two of his grandsons (see p. 500). As the guest of the pope in the Vatican, Titian painted the group portrait either for Paul III, as a gift with political overtones for the Holy Roman Emperor, Charles V, or for the pope's cardinal-"nephew" (in reality his grandson), Alessandro Farnese, who appears at the pope's right hand as the apex of a weighty red and white pyramid anchored by Paul III and the table. Titian captured the undiminished

22.6 Sala Paolina, 1545-47, commissioned by Alessandro Farnese from Perino del Vaga for Castel Sant'Angelo, Rome. Fresco

The room is named for the pope, a clear indication that it met his propaganda needs.

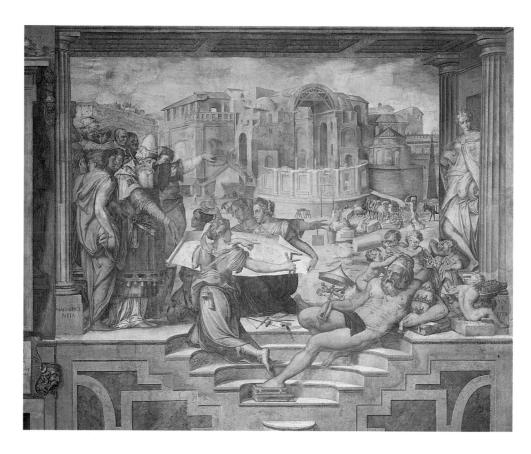

22.7 Paul III Directing the Construction of St. Peter's, detail of Life of Paul III, 1544, commissioned by Alessandro Farnese from Giorgio Vasari for the Sala dei Cento Giorni, Cancelleria, Rome. Fresco

This room is called the Room of the Hundred Days because it was supposedly completed in the amazingly rapid time of 100 days. When Michelangelo was told of this feat he purportedly replied in a typically sharp and succinct manner, "Si vede" or "It looks it."

mental powers of the seventy-eight-year-old pope, physically stooped but obviously aware (perhaps even suspicious) of his other "nephew"/grandson Ottavio Farnese's fawning approach. The painting, never finished, is far from the tradition of formal papal family images typified by the fresco of *Sixtus IV Confirming Platina as Papal Librarian* (see p. 289), and even from earlier somewhat introspective papal portraits such as Raphael's votive portrait of Julius II (see Fig. 18.28), which Titian had used as a model for an earlier portrait of Paul III. Here Titian transformed the personal relations into an emotionally and intellectually compelling narrative, his brushstrokes leaving lightning reflections on the pope's velvet cape and a charged emphasis on the pope's left hand far in excess of its sketchy description.

The pope's grandsons serve as a study in contrasts. Alessandro, one of the most important Roman patrons in his own right and a man of fabulous wealth, stands as an embodiment of the official Church, one assured of his power in a volatile court environment. Ottavio, however, subservient and meek in his bent approach to his grandfather, appears to understand that his role in the world was dependent on the aged Paul III. In 1547, aware that Paul had been unsuccessful in arranging with the emperor for his assumption of the control of the duchy of Parma and Piacenza, Ottavio associated with his father's murderer to gain possession of the cities, an act that undermined Paul's papal and family authority. Paul's shift of political allegiance from Charles V to the French king, and Titian's perceptive—one might say unflinching and unflattering—

reading of the personalities involved may explain why the painting was never completed. Yet the astuteness of Paul III remains a dominant feature of the painting, a witness to his awareness of his office, its history, and the demands that lay at the heart of his patronage.

Urbi et Orbi: The City

The papal blessing is traditionally given "urbi et orbi" ("to the city and to the world"). This double focus of the papacy governed its commissions throughout the early modern period. The popes had to speak to Rome, which they ruled, despite the existence of a Roman senate and civil government, and to the world, for which they claimed to be spiritual rulers and which, in the sixteenth century, had ever-increasing parameters. In 1517, while still a cardinal, Paul III had begun building a palace in Rome that was clearly intended to broadcast his pre-eminence to his fellow citizens. The design for the Palazzo Farnese (Fig. 22.8), by Antonio da Sangallo the Younger (1483 Florence-1546 Terni), then one of Raphael's assistants as architect at St. Peter's, made the building one of the greatest private residences in the city, comparable to Cardinal Riario's Cancelleria (see Fig. 12.26). When Paul became pope in 1534, he enlarged the original design for the façade from eleven to thirteen bays. At Sangallo's death in 1546, Paul assigned the completion of the building to Michelangelo, who planned the third story with its colossal cornice and added the large central window in the façade as a papal

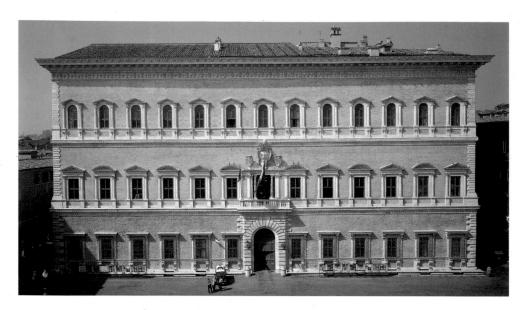

22.8 Palazzo Farnese, Rome, begun 1517, commissioned by Alessandro Farnese (later Paul III) from **Antonio da Sangallo** the Younger, continued by Michelangelo in 1546

benediction loggia. Since Paul III never lived in the building after assuming office, the building functioned as a propagandistic symbol of papal power rather than as an actual papal residence. The building is larger than any other in the area. The huge public square in front of it was apparently meant to be paved in a grid design tied to the width of each bay, thus locking the building with the urban space. The stolid regularity of the façade, with its alternating triangular and curved pediments on the second story, creates an overwhelming impression of strength and grandeur. The central axis of the palace was aligned with a short street leading to the Campo dei Fiori, one of the oldest of the city's markets and a site of civic justice (see Fig. 12.1), again extending the presence of the building—and of the Farnese—through the urban fabric.

The Capitoline Hill

After becoming pope, Paul used his experience of space and scale at the Palazzo Farnese in a more sophisticated manner on the Capitoline Hill (Campidoglio; Figs. 22.9 and 22.10). Since classical times this site had been the political center of the city—and its pre-Christian religious center also, crowned by the Temple of Jupiter. For the visit to Rome in 1536 of the Holy Roman Emperor, Charles V, Paul planned a triumphal procession through the city which was to include the Capitoline Hill. Embarrassingly, the area was too rough and overgrown to accommodate the procession (see Fig. 12.19).

This incident inspired Paul to renovate the area—probably in cooperation with the Conservators (urban magistrates responsible for finances and administration), whose palace was standing there. For the project he engaged Michelangelo. Paul's first move—which was opposed by

Michelangelo-was to transfer the bronze equestrian statue of Emperor Marcus Aurelius from the papal palace at St. John Lateran to the center of the piazza. Paul thus echoed the gesture made by Sixtus IV who, in 1471, had donated other ancient statues to the site including fragments of a colossal statue of Constantine. Paul's own gift was considered particularly significant, for at the time it was thought that the equestrian statue also represented Constantine, the emperor who had legitimated Christianity as a state religion and who, according to papal political fiction had ceded temporal power over Rome to the

papacy when he moved the seat of government to Constantinople in 330.

Whatever misgivings Michelangelo may have had about repositioning the statue, he designed a magnificent architectural space to frame it. The statue stood at the center of the complex on a slightly mounded pavement which was to have been decorated by an interlocking stellate pattern, whose twelve points refer to the signs of the zodiac, thus adding cosmological significance to the site. A long ramp, or cordonata, led from the medieval city below to the top of the hill, directly on axis with the Marcus Aurelius and the center portal of the Senators' Palace, approached by a long double-ramped staircase, one of the first of the renovations to be built (see Fig. 12.19). The niche at the center of the staircase was intended to house a large statue of Jupiter, the king of the gods (it now houses a too-small figure of Roma). A baldachin, another symbol of rulership, was to crown the staircase before the main door of the building. The Conservators' Palace, to the right, was also to be given a new façade, one bay in depth, and an identical building façade was to be constructed across from it to complete the symmetry of the piazza.

The scheme was not completed until the late seventeenth century, a hundred years after Michelangelo's death, and its design was modified in some respects by the Lombard-trained Giacomo della Porta (c. 1532 Porlezza–1602 Rome). However, the result is essentially as Michelangelo intended: a spacious exterior room which could function as a stage set for ceremonial events. Michelangelo's renovations and additions had to take into account already existing buildings and also be responsive to the meanings attached to the site.

The trapezoidal shape of the plan was forced upon Michelangelo by the fact that the old Senators' and Conservators' palaces stood at an 80-degree angle to each other; however, visual distortions at the top of the *cordonata* make the trapezoid look like a square, and the oval

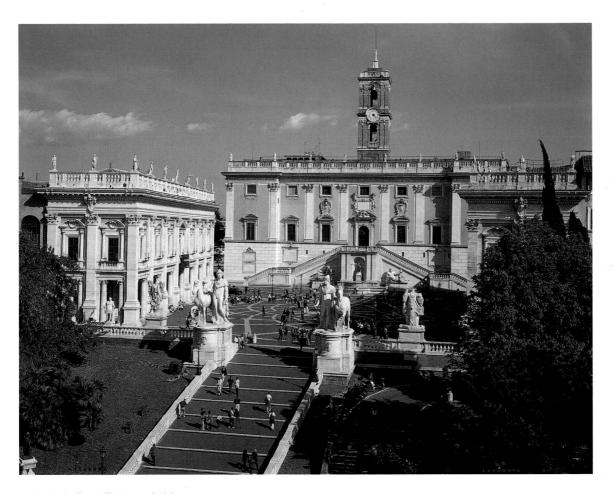

22.9 Capitoline Hill, Rome, decision to rebuild made in 1536, commissioned by Paul III from **Michelangelo**; double stair begun in 1544, *cordonata* (ramp) begun under Pius IV in 1561, Conservators' Palace begun in 1563

The pavement, although apparently planned by Michelangelo, was not laid until 1940 when Mussolini recognized the historical importance of the Capitoline as a symbol of governance. The gilded bronze equestrian statue of Marcus Aurelius, which stood at the center of this architectural complex, has recently been cleaned and removed to the protection of the museum in the Palazzo Nuovo at the left of the site.

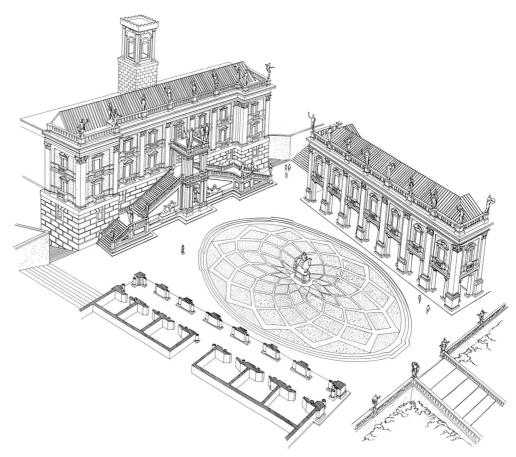

22.10 Capitoline Hill, Rome, reconstruction of **Michelangelo's** project (after **Etienne Dupérac**)

pavement like a circle-geometrical figures considered ideal by Renaissance theorists. Michelangelo structured the façade of the Conservators' Palace, and that of the Palazzo Nuovo across the piazza, with a colossal order, uniting the entire façade. This was a structuring of surface that Bramante had, significantly, experimented with at the Belvedere Palace in the Vatican for Julius II. Corinthian pilasters rise up through both stories-rather than through only one in the traditional manner—and support a proportionately heavy cornice topped with a balustrade. This colossal order unites the entire façade. Within this majestic framework Michelangelo introduced a wryly playful Ionic order, flanking the piers at ground level. The volutes of the capitals twist elastically around each column, and grotesque masks peek out at the very top of the capitals. Michelangelo's inventiveness is everywhere evident in the complex. Two vocabularies are employed at the Conservators' Palace-one decorous and formal, the other willfully manipulating the rules of the order. The first is appropriate as an official language of the state, the second perhaps for the diurnal activities of the site as a bureaucratic center.

St. Peter's

In 1546 Paul appointed Michelangelo chief architect of St. Peter's in a push to complete the project begun by Julius II in 1506. Paul had earlier entrusted the continuation of the construction to Antonio da Sangallo the Younger, his preferred architect. Sangallo's plan for St. Peter's (see Fig. 18.3) had maintained some of the characteristics of Bramante's

second plan for the building, although he extended one arm of the cross to create a nave, thus destroying the centrally planned scheme so important to Bramante. Sangallo constructed a huge wooden model of his plan between 1539 and 1546; by 1543 he had actually vaulted part of the nave, as can be seen in the Cancelleria fresco (see Fig. 22.7). Michelangelo reverted to Bramante's initial central plan, thickened the exterior walls, removed secondary spaces, and in so doing unified the spatial volumes of the structure and made the interior especially luminous (Fig. 22.11). This plan (see Fig. 18.3) necessitated the destruction of an ambulatory on Sangallo's south hemicycle (1548–49), a bold move considering the building costs already incurred.

For the exterior of the building (Fig. 22.12) Michelangelo again used a colossal order and maintained an appropriately formal vocabulary throughout. His employment of the huge flat pilasters around the building's curves and corners creates a rippling, muscular surface, accentuated by the step-like movement of the cornice. Where the hemicycles meet the central square of the plan, Michelangelo added a diagonal wall unit which softens the contours of the building, eliminating the sharp corners indicated on the Sangallo plan. Michelangelo's original design called for a hemispherical dome, which, like Bramante's, would have symbolized cosmological power for St. Peter buried beneath and, by extension, for the papacy. That dome provides one further connection between Julius's conceptions of the Church and Paul's: a single, worldwide religious power despite the inroads of the Reformation sects which, at the beginning of his reign Paul III still thought he could reintegrate into the Roman Church. Even in the form of the

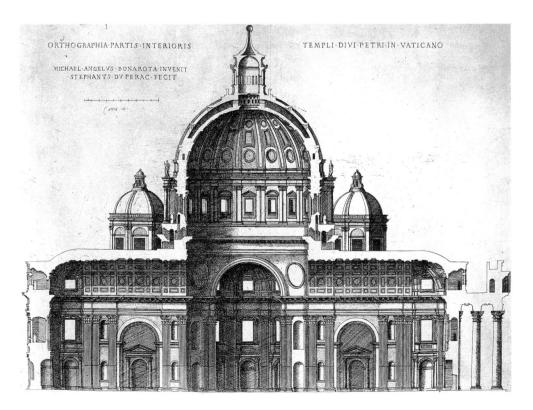

22.11 St. Peter's, Rome, reconstruction of interior presumably based on Michelangelo's plans (after Etienne Dupérac) (Metropolitan Museum of Art, New York)

ogival dome which was ultimately built, this symbolism remains. The dome is raised on a high drum (partially constructed 1555–57) to give it visibility over the mass of the building. Like the walls of the building, the drum is treated as a sculptural volume, with applied double columns disguising the mass of the buttresses that support the dome and with large pediments breaking the wall mass over the windows.

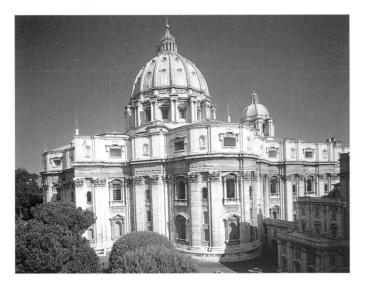

22.12 St. Peter's, Rome, new project of 1546 using plans by Michelangelo.

The building continued after Michelangelo's death in 1564 under Giacomo Vignola. On the death of Vignola in 1573 Giacomo della Porta became the architect of St. Peter's; his project for the dome, significantly altering the hemispherical shape originally planned by Michelangelo, was approved in 1586 and was brought to completion from 1588 to 1590. The lantern was completed between 1590 and 1593.

Private Commissions

The Villa Giulia

After Paul III's grand schemes for the restoration of the city of Rome, the villa planned by his successor, Julius III (r. 1550-55), seems quite playful, even given its nature as a suburban retreat (Figs. 22.13 and 22.14), indicating that religious and political reform did not necessarily extend to personal social activity. The Villa Giulia is the work of several different architects: Vasari, Ammanati, and Giacomo Barozzi da Vignola (1507 Vignola-1573 Rome), with contributions from Julius himself. Although there is a formal entrance-including a papal benediction loggia facing the roadway from the city-the remainder of the villa plays games with the viewer's expectations of architectural space and the standard forms of palace and villa architecture. There is a clear axis set up through the center of the villa, but no way to follow it from the entrance to the small garden at the opposite end of the complex. A loggia screens the first courtyard from the succeeding spatial areas. Beyond that loggia, the space drops two stories into a nymphaeum, access to which is hidden by doorways and stairwells in the

22.13 (below) Villa Giulia, Rome, view into the nymphaeum from the southeast, 1551–55, commissioned by Julius III from Giacomo Vignola, assisted by Bartolomeo Ammanati and Giorgio Vasari

22.14 (above) Villa Giulia, Rome, plan of lower floor

- 1 Entrance to the villa (Vignola);
- 2 Courtyard (Ammanati, 1552); 3 Gardens;
- 4 Nymphaeum (Ammanati)

walls. At the lowest level of the nymphaeum all of the preceding areas disappear from sight, leaving the viewer isolated in a small space with cool, quiet pools and waterspouting statues imitating classical herms, a magical evocation of an actual ancient Roman nymphaeum.

From the entrance of the building the viewer is also invited to follow a semicircular vaulted loggia which leads on either side of the complex to walled gardens, completely unadorned architecturally and thus totally different from the building itself. Within the villa, wit and play disorient the viewer; views are clear but access is denied, and passage from one area to another is enlivened by a continual shift of scale and decoration. The architects have manipulated not only canonic forms but also the visitor's experience of space. In this building both formal elements and the handling of space provide one of the clearest architectural explorations of mannerist style of the period.

The Farnese Hours

Private patronage for personal enjoyment, rather than for public effect, also flourished in Rome. Cardinal Alessandro Farnese commissioned Giulio Clovio (Juraj Klovic; 1498 Grisone [Grizane], Croatia–1578 Rome) to paint a book of hours now known as the *Farnese Hours* (Fig. 22.15). Biblical narratives are paired with apocryphal stories; all are framed with elaborate architectural borders decorated with sensu-

ous nudes, masks, and floral swags, hardly a manifestation of the biblical accuracy and decorum demanded by the Protestant or Catholic Reformation, but certainly something Clovio would have remembered from his training with Giulio Romano before the latter left for Mantua in 1524.

In addition to the wonderfully fanciful Farnese Hours. Alessandro Farnese also commissioned a variant of one of Titian's more lascivious paintings, the Danaë (see Fig. 21.30), where Jupiter has transformed himself into a shower of gold in order to possess the female figure reclining nude on her bed. Even in the works of a single artist such as El Greco (Domenico Theotocopouli; 1541 Candia, Crete-1614 Toledo), who lived for a short time in the Palazzo Farnese while he was in Rome between 1570 and 1575, Alessandro's eclectic taste is evident. The two El Greco paintings that he owned, the traditional biblical scene of Christ Healing the Blind (c. 1570) and an enigmatic and very unusual genre-like image of a Boy Lighting a Candle (c. 1570-75), illustrate the breadth of subject matter in his collection. Such commissions are reminders of the cosmopolitan nature of Rome, a city with an international court and an itinerant international artistic community. No single style or type of subject matter could maintain exclusive control in such an environment. Nevertheless, a significant attempt was initiated during this period to regularize and control religious art and to assert the moral power that such art had traditionally possessed.

22.15 Farnese Hours, pages showing Annunciation to the Shepherds and Augustus and the Sibyl, 1538–46, commissioned by Alessandro Farnese from **Giulio Clovio**. Vellum, each page $6\% \times 4\%''$ (17.2 × 11 cm). (The Pierpont Morgan Library, New York)

The Demands of the Council of Trent

In response to the call for reform within the Catholic Church and to the criticisms made of Rome by Protestant leaders, Paul III convened cardinals and bishops for lengthy discussions about the future of the Church, its doctrines, and its practices. Known as the Council of Trent, after the north Italian city in which four plenary sessions took place beginning in 1545, the Council argued for liturgical and ecclesiastical reform and a return to the principles of the early Church—issues on which Rome concurred with

the Protestants. It also stated unambiguously, however, that the cult of the Virgin and the saints and their relics, which had grown to such enormous proportions through the Middle Ages, was to be retained, maintaining that the saints were not only aids to devotion but also efficacious intercessors for the redemption of the faithful. Additionally, the Council accorded special devotion to the Eucharist as embodying the true presence of Christ. These two points—the intercessions of the saints and the nature of the Eucharist-were obvious reinforcements of traditional positions and in clear opposition to Protestant theology. Thus the changes in the Roman Church legislated by the Council at its closing in 1563 can be seen both as a reformation and as a counter-reformation, one directed to ongoing processes from within, the other directed to challenges from without. To see the changes in Church teachings-and consequently in its art-merely as a "Counter-Reformation" is to see only one part of the picture.

The needs of the reformed Roman Church after the last session of the Council of Trent stimulated both renewed and revised artistic activity, not only in Rome but throughout Catholic Europe. As a Church newly secure after the threats of the Protestant Reformation, Rome attempted once

again to assert its universality, now in a world that included the Americas and parts of Africa, India, and eastern Asia. The arts were an effective form of propaganda with which to articulate the new confidence of the Church and its claims to dominance over the Christian faith. Regulations for the arts resulting from the decrees of the Council were, like earlier Protestant treatises, promulgated through the print medium and helped to bring about a uniformity of style and common concerns for propagating orthodoxy in the arts not only for Italy but for all of Catholic Europe and its colonies as well.

Long after the closing of the Council of Trent its importance was underscored in a didactic and journalistic fresco (Fig. 23.1) painted as part of an otherwise elegant and classicizing decorative program for a chapel built by Vignola's protegé Martino Longhi the Elder (c. 1534 Viggiù-c. 1591 Rome) for one of Rome's leading churchmen, Cardinal Marco Sittico Altemps. Participants in the Council session are spread row upon row across the top of the composition, their faces directed forward or turned in profile as if to record as completely and accurately as possible the individual members. At the lower right of this pictorial chronicle of the event, however, allegorical personifications of the virtues crown a figure representing the Roman Church with a papal tiara. A globe at the lower left shows Europe, Africa, and parts of Asia. Thus, the Church appears not only victorious, but extending far beyond Europe, where Protestantism had recently made such dramatic inroads. In this fresco the didactic stylistic language of the historical chronicle is spliced-albeit somewhat awkwardly-with a classical stylistic revival appropriate for allegories of dominating political power.

Decrees on the Arts

The decrees of the Council of Trent stipulated that art was to be direct and compelling in its narrative presentation, that it was to provide an accurate presentation of the biblical narrative or saint's life, rather than adding incidental and imaginary moments, and that it was to encourage piety. The Council also maintained the efficacy of religious images to convey the messages of the new Church, contrary to the belief of some—although not all—of the Protestant churches:

... the images of Christ, of the Virgin Mother of God, and of other saints are to be placed and retained especially in the churches. . .

. . . let the bishops diligently teach that by means of the stories of the mysteries of our redemption portrayed in paintings and other representations the people are instructed and confirmed in the articles of faith.

... through the saints the miracles of God and salutary examples are set before the eyes of the faithful, so that they may give God thanks for those things, may fashion their own life and conduct in imitation of the saints and be moved to adore and love God and cultivate piety.

Perhaps because the Council's formal decrees on art were both limited and vague in their directives, treatises on art and architecture provoked by the Council proliferated in the last third of the sixteenth century. Those written by churchmen, such as Charles Borromeo's Instructiones fabricae et supellectilis ecclesiasticae (Instructions on Ecclesiastical Buildings and Furnishings, 1577), Gabriele Paleotti's Discorso intorno alle imagini sacre e profane (Discourse About Sacred and Profane Images, 1582) and his later De imaginibus sacris (On Sacred Images, published in Germany, 1594), Robert Bellarmine's Disputationes (1586 edition dedicated to Pope Sixtus V), and G. A. Gilio da Fabriano's Degli Errori de' Pittori (On the Errors of Painters, 1564) were prescriptive; but in general all called for a style different from the courtly conceits of Mannerism. And, importantly, because they were printed they reached an even wider audience than had the International Style of the early fifteenth century, opening the

23.1 The Council of Trent, 1588, **Pasquale Cati da lesi (?)**, Chapel of Cardinal Marco Sittico Altemps, Santa Maria in Trastevere, Rome, built by **Martino Longhi the Elder**. Fresco

The Council is sometimes called the Tridentine Council, after the Latin name for the city, Tridentum. The coat of arms on the left wall behind the cardinals in red is that of Pius IV, the pope at the time of the closing of the Council.

way for the first truly pan-national style in the arts since classical antiquity.

A small painting of Noli me tangere (see p. 513) by Lavinia Fontana (1552 Bologna-1614 Rome), daughter of a Bolognese artist and a prolific portraitist in her own right, indicates some of the character of the art favored by these reformers. Fontana began the small canvas just as Cardinal Paleotti, secretary for the discussions on art and imagery at the Council of Trent, was preparing his Discorso for publication. Paleotti emphasized that the visual arts had particular power because everyone could understand them, even the illiterate; therefore, art had to be historically and doctrinally accurate and accessible. Fontana's subject, Mary Magdalene, the penitent prostitute, encounters the risen Christ, whom she mistakes for a gardener. The subject was common in earlier art (see Fig. 6.11), but doubts had arisen about St. John's account of this episode in the gospels until its canonicity was confirmed by the Council of Trent. Her choice of subject, then, reinforced Church orthodoxy. What is more, the story of the Magdalene was gaining great popularity among reform-minded women-Michelangelo's close friend Vittoria Colonna owned a painting of the saint by Titian that brought tears to her eyes-because of the Magdalene's reputation for extraordinary penance. According to Paleotti and other writers, such paintings would not only teach doctrine but could lead to deep spiritual cognition.

The small size of Fontana's canvas suggests that it was made for private devotion. She derived the elegant poses of her protagonists from a painting of the same subject by Correggio then in Bologna but made several significant changes. Christ is now clearly garbed as a gardener to make his mistaken identity clearer, and the context for their encounter, which had been completely ignored by Correggio, is now self-evident. In the background, the Magdalene appears again with her head down, exemplary in her humility and grief, accompanied by female companions as they approach the empty tomb. They encounter a glowing angel whose resurrection report is visibly confirmed by the presence of Christ in the garden and the intensely yellow sunrise in the distance. Religious art could still be beautiful and full of naturalistic detail, but it had to be legible, believable, and emotionally compelling as well, completely different from the artificial, contrived, and spatially ambiguous nature of Mannerist religious art (see Fig. 20.32).

Reform and Censorship

During the nearly twenty years when the Council of Trent was in session, reforms begun under Paul III took unforeseen and stringently moralistic forms. The Roman Inquisition (or official inquiry into heresy) instituted under Paul III in 1542 took a particularly virulent turn under Paul IV Carafa (r. 1555–59) in an active effort to assert orthodoxy. One of the concerns of the "reformers"—one quite

familiar to modern ears—was to expunge perceived lasciviousness from religious images. It should be noted, however, that overt eroticism continued unabated and uncontested in images made for private contexts. Johannes Molanus's De picturis et imaginibus sacris (On Sacred Pictures and Images), published in Louvain in 1570, quotes an earlier writer in saying that "[t]he most disgusting aspect of this age is the fact you come across pictures of gross indecency in the greatest churches and chapels, so that there one can look at all the bodily shames that nature has concealed, with the effect of arousing not devotion but every lust of the corrupt flesh." Paintings such as Parmigianino's Madonna of the Long Neck (see Fig. 19.10) come to mind when reading such passages. The sensuality of Parmigianino's Virgin cannot help but intrude on any devotional thoughts of the viewer, especially since the Christ Child seems to be slipping away from his mother in order to reveal more of her torso beneath the clinging drapery. It is perhaps not surprising that the painting remained unfinished. But incompleteness is relatively benign in comparison to defacement. Michelangelo's Last Judgment (see Fig. 22.1) stands as a primary example of contemporary attacks on religious images that were considered offensive. Immediately after Michelangelo's death in 1564, Daniele da Volterra and others painted pants over the genital areas of a number of the nude figures in the fresco, which earned them the nickname "braghettoni," or "breechespainters." (These "breeches" were left in place during the recent cleaning of the fresco.) Within the heart of the Vatican, support for such a modification of Michelangelo's work by pope and cardinals—as well as by secular writers like the scurrilous Venetian poet Pietro Aretino—could only have supported the efforts of "reformers" like Molanus.

Although regulations proliferated, they were not, of course, always followed. Veronese's grand painting with life-sized figures of the Feast in the House of Levi (Fig. 23.2 and p. 498), originally painted as a Last Supper for the Dominican monastery of Santi Giovanni e Paolo in Venice, is a case in point. On July 18, 1573, Veronese was called before the court of the Inquisition because it found his treatment of the subject inappropriate. Since the figures about which he was questioned were certainly not part of the biblical narrative, Veronese's reply that he thought such figures would enliven the story did not satisfy the Inquisition. Although Veronese did not substantially alter the painting, the Inquisition took no formal action against him, perhaps because of his judicious tactic of changing the title of the painting from the Last Supper to the Feast in the House of Levi, thereby providing a context for which the festive courtly figures he had already depicted would be appropriate. Although Veronese's response was opportunistic and clever, benefiting from relaxed Venetian attitudes toward the Inquisition, the whole episode does indicate a new concern on the part of the Church authorities for regulating the accuracy of religious painting and asserting a renewed orthodoxy.

Veronese Before the Inquisition

Called before the Inquisition to answer charges against his painting of the *Last Supper* (now known as the *Feast in the House of Levi*), Veronese acquitted himself well, giving some indication of his working practice and of his awareness of art outside Venice.

Venice, July 18, 1573. The minutes of the session of the Inquisition Tribunal of Saturday, the 18th of July, 1573. . . .

Questioned about his profession: Answer: I paint and compose figures.

- Q: Do you know the reason why you have been summoned?
- A: No, sir.
- Q: Can you imagine it?
- A: I can well imagine.
- Q: Say what you think the reason is.
- A: According to what the Reverend Father, the Prior of the Convent of SS. Giovanni e Paolo, ... told me, ... Your Lordships had ordered him to have painted [in the picture] a Magdalen in place of a dog. I answered him by saying I would gladly do everything necessary for my honor and for that of my painting, but that I did not understand how a figure of Magdalen would be suitable there for many reasons which I will give at any time, provided I am given an opportunity.
- Q: What picture is this of which you have spoken?
- A: This is a picture of the Last Supper that Jesus Christ took with His Apostles in the house of Simon . . .
- Q: At this Supper of Our Lord have you painted other figures?
- A: Yes, milords.
- Q: Tell us how many people and describe the gestures of each.
- A: There is the owner of the inn, Simon; besides this figure I have made a steward, who, I imagined, had come there for his own pleasure to see how the things were going at the table. There are many figures

there which I cannot recall, as I painted the picture some time ago . . .

- Q: In this Supper which you made for SS. Giovanni e Paolo what is the significance of the man whose nose is bleeding?
- A: I intended to represent a servant whose nose was bleeding because of some accident.
- Q: What is the significance of those armed men dressed as Germans, each with a halberd in his hand? . . .
- A: We painters take the same license the poets and the jesters take and I have represented these two halberdiers, one drinking and the other eating nearby on the stairs. They are placed there so that they might be of service because it seemed to me fitting, according to what I have been told, that the master of the house, who was great and rich, should have such servants.
- Q: And that man dressed as a buffoon with a parrot on his wrist, for what purpose did you paint him on that canvas?
- A: For ornament, as is customary. . .
- Q: Who do you really believe was present at that Supper?
- A: I believe one would find Christ with His Apostles. But if in a picture there is some space to spare I enrich it with figures according to the stories.
- Q: Did any one commission you to paint Germans, buffoons, and similar things in that picture?
- A: No, milords, but I received the commission to decorate the picture as I saw fit. It is large and, it seemed to me, it could hold many figures.
- Q: Are not the decorations which you painters are accustomed to add to paintings or pictures supposed to be suitable and proper to the subject and the principal figures or are they for pleasure—simply what comes to your imagination without any discretion or judiciousness?
- A: I paint pictures as I see fit and as well as my talent permits.

- Q: Does it seem fitting at the Last Supper of the Lord to paint buffoons, drunkards, Germans, dwarfs and similar vulgarities?
- A: No, milords.
- Q: Do you not know that in Germany and in other places infected with heresy it is customary with various pictures full of scurrilousness and similar inventions to mock, vituperate, and scorn the things of the Holy Catholic Church in order to teach bad doctrines to foolish and ignorant people?
- A: Yes that is wrong; but I return to what I have said, that I am obliged to follow what my superiors have done.
- Q: What have your superiors done? Have they perhaps done similar things?
- A: Michelangelo in Rome in the Pontifical Chapel painted Our Lord, Jesus Christ, His Mother, St. John, St. Peter, and the Heavenly Host [see Fig. 22.1]. These are all represented in the nude—even the Virgin Mary—and in different poses with little reverence.
- Q: Do you not know that in painting the Last Judgment in which no garments or similar things are presumed, it was not necessary to paint garments, and that in those figures there is nothing that is not spiritual? There are neither buffoons, dogs, weapons, or similar buffoonery. And does it seem because of this or some other example that you did right to have painted this picture in the way you did and do you want to maintain that it is good and decent?
- A: Illustrious Lords, I do not want to defend it, but I thought I was doing right. I did not consider so many things and I did not intend to confuse anyone, the more so as those figures of buffoons are outside of the place in a picture where Our Lord is represented.

After these things had been said, the judges announced that the above named Paolo would be obliged to improve and change his painting within a period of three months . . . and that if he did not correct the picture he would be liable to the penalties imposed by the Holy Tribunal. Thus they decreed in the best manner possible.

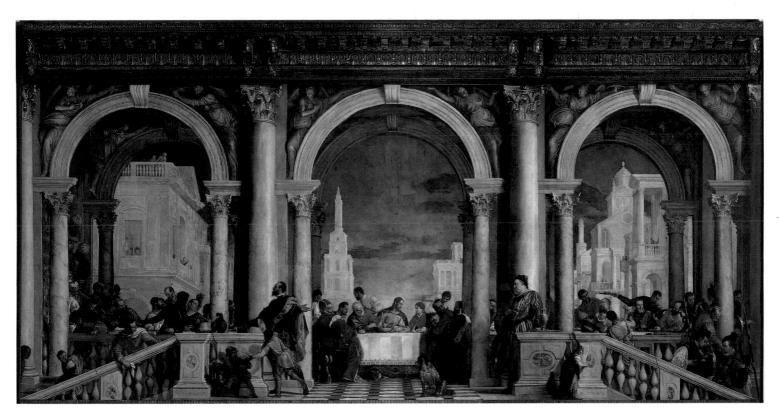

23.2 Feast in the House of Levi, 1573, commissioned from **Paolo Veronese** for the refectory of the Dominican monastery of Santi Giovanni e Paolo, Venice. Oil on canvas, 18′ 3″ × 42′ (5.56 × 12.8 m) (Galleria dell'Accademia, Venice)

Reform and New Religious Orders

In Rome and throughout the rest of the Catholic world, the reforms of the Council of Trent were helped enormously by the new religious orders founded during the sixteenth century. Like the Franciscans and Dominicans in the thirteenth century, these orders-most notably the Jesuits (formally, the Society of Jesus), the Oratorians, and the Theatines-were soon enlisted by the papacy to instill orthodoxy and devotion on the part of the faithful and to convert new members to their ranks. The Jesuits were founded by a Spaniard, Ignatius of Loyola (1491?-1556); their order was confirmed by Paul III in 1540 and grew to worldwide prominence as an agent of teaching, conversion, and reform. Although it is overstating the case to read a "Jesuit style" in the visual arts, their home church of the Gesù in Rome (Figs. 23.3, 23.4, and 23.5) clearly illustrates architectural and pictorial responses to the Council's directives.

The Gesù

The importance of the Gesù in its own time can perhaps be understood by the simple fact that it was the largest church to have been built in Rome since the sack of the city in 1527. Although Ignatius had hoped for a new church for his order virtually from the time of its confirmation, the slow process of acquiring property in the center of Rome and raising ade-

quate funds delayed its construction until December 1550; and then it was based on a rather pedestrian plan for both church and cloister by Nanni di Baccio Bigio (Giovanni Lippi; 1512/13 Florence-1568 Rome), the Florentine assistant of Antonio da Sangallo the Younger. Difficulties with the site ultimately led the Jesuits to involve Michelangelo with the project; he agreed in 1554 to produce drawings and a model, but apparently nothing came of this other than a few drawings-in part perhaps because of Ignatius's death in 1556 and tensions between the Jesuits and Paul IV, who had been elected in 1555. Cardinal Alessandro Farnese intervened in 1561 when the project was floundering, providing funding for much of the building, with the stipulation that no other patron be allowed at the site and that he be buried in the church. Alessandro's name is emblazoned across the façade of the church as a public statement of his patronage.

Giacomo Vignola, whose work at the Palazzo Farnese (see Fig. 22.8) from 1549 brought him in close contact with the family, was associated with the Gesù from 1563, when he provided an unusual oval plan (ultimately not accepted) for the building. The publication in 1562 of his treatise on the five architectural orders, *Regole delli cinque ordini di architettura*, had made him one of the best-known architects in Europe. After Vignola's death the dome of the church was completed by Giacomo della Porta.

The exterior of the Gesù reflects the sculptural treatment of architectural surfaces employed by Michelangelo in his 23.3 The Gesù, Rome, plan

1 Chapel of the Passion

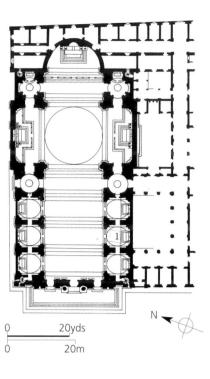

commissions for the papacy. Typically for this period, the façade of the building was considered a separate commission. Alessandro Farnese chose the design of Giacomo della Porta over those submitted by Vignola and Galeazzo Alessi. Recalling and enlarging upon the great fifteenth-century facades of Sistine Rome (see Figs. 12.22 and 12.24), della Porta deployed paired pilasters across the façade to give it additional dignity while retaining the integrity of the architectural surface. Columns frame, and thus accentuate, the central portal and the benediction loggia above it. The combination of double pediments over the portal, broken entablatures across the façade, and the projection of the central unit of the building forward toward the piazza give the surface a muscular strength. Despite the energy of the façade, however, its decoration is quite restrained and decorous, and is thus appropriate to the concept of reform in the Church, supported by the Jesuits.

The interior of the Gesù is an open, single-vessel barrel-vaulted space with truncated transepts and a single wide apse (see Figs. 23.3 and 23.5). Side chapels line the nave, and although there are connecting passages between them, they

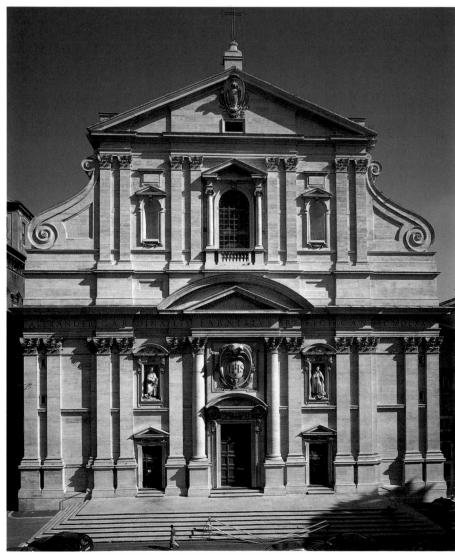

23.4 The Gesù, Rome, present building begun in 1568, commissioned by the Jesuits with the patronage of Cardinal Alessandro Farnese from Giacomo Vignola; façade and dome by Giacomo della Porta

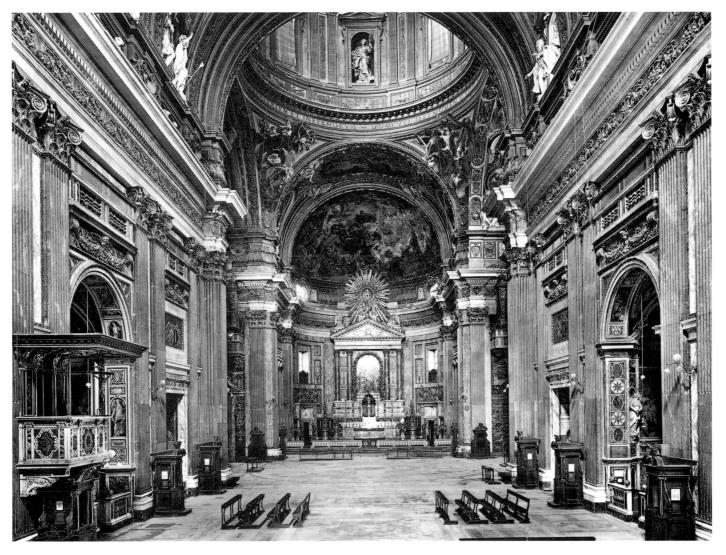

23.5 The Gesù, Rome

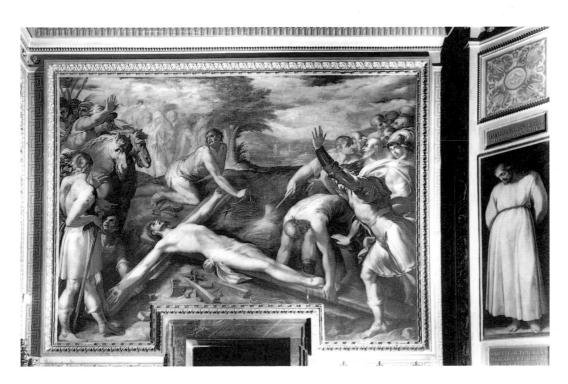

23.6 Crucifixion, c. 1589-90, commissioned by Bianca Mellini from Giuseppe Valeriani and Gasparre Celio for the Chapel of the Passion in the Gesù, Rome. Oil on canvas

function as distinct spaces. The paired pilasters provide a dynamic surface comparable to the exterior of the building. The colossal order, like that used by Michelangelo for St. Peter's (see Figs. 22.11 and 22.12) gives a sense of grandeur to the interior, whose thick cornice extends the length of the nave, and at the same time connects the Gesù to the central church of Christianity and to the papacy. The unified space of the church, recalling Alberti's designs for the pilgrimage church of Sant' Andrea in Mantua (see Fig. 14.27), affords an uninterrupted focus on the altar, as demanded by the Council of Trent, and facilitates preaching by concentrating the congregation in one area.

Painting for the Gesù The painted decoration of the chapels of the Gesù is among the earliest in Rome to respond to the concerns for clarity, historical accuracy, and compelling emotional impact voiced by the Council of Trent and its interpreters. More importantly, the decorative program for the high altar and the side chapels is directly related to Ignatius's Spiritual Exercises (1548), a very popular form of directed prayer and meditation that in its most extensive form involved a retreat of thirty days. The entire project was apparently overseen by Giuseppe Valeriani (1542 L'Aquila-1596 Naples), himself a Jesuit priest who had joined the order in 1572, thus guaranteeing a faithfulness to the wishes of the order's founder for sequenced and cumulative devotional practices. In the chapel dedicated to the Passion of Christ, Valeriani and Gasparre Celio (1571 Rome-1640 Rome) planned and painted the Crucifixion (Fig. 23.6) under the direction of another Jesuit, Giovanni Battista Fiammeri. In this painting they dramatically lit the body of Christ nailed to the cross, pushing it forward and isolating it at the center of the composition, so that it becomes a devotional icon within the historical narrative. The Christ is immediately over the passageway leading from one side chapel to another, suggesting that the figures to the left and right may spill forward into the viewer's space. Jerusalem can be seen over the hillside in the background. The Roman soldier on the right, modeled on an antique statue and thus well within the academic conventions of the period, rushes into the scene, his arms extended in a spasm of emotion, which adds to the immediacy of the scene and is clearly intended to induce a similar internal response in the worshiper. The Lamentation (Fig. 23.7) painted by Scipione Pulzone (Scipio Gaetano; 1500 Gaeta-1598 Rome) for the altar of this chapel, also demonstrates the new style of religious art following the Council of Trent. Pulzone was a pupil of the Mannerist painter Jacopino del Conte and had studied Flemish and Venetian painting as well as the work of Raphael. In the Lamentation, Christ's body takes central place in the composition close to the picture plane. The close focus and the naturalistic rendering of the figures—red-eyed with weeping and yet decorously restrained give immediacy to the drama as each figure shows a concentrated personal reaction to the event, inviting

viewers to share their emotions. Despite the moderation in the movement of the figures and the carefully orchestrated rhetoric of poses and gestures, the glowing unblemished body of Christ—giving no indication of the violence done to it—is placed against the brilliant red garment of Joseph of Arimethea, a purely painterly echo of his recent bloody ordeal.

Upon his election in 1573, Pope Gregory XIII (Ugo Boncampagni, r. 1572–85) declared that 1575 would be a Holy Year. The Holy Year became a public declaration of the success of Church reform; a number of projects begun as

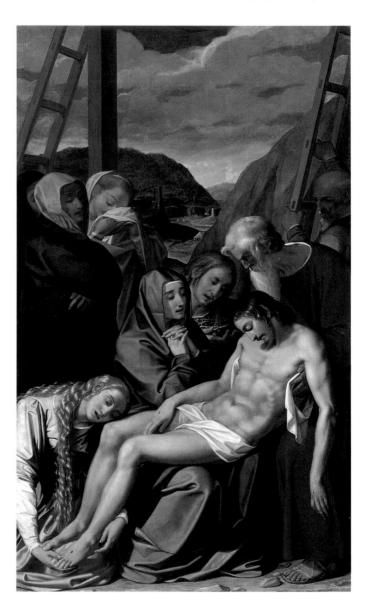

23.7 *Lamentation*, 1591, commissioned 1589/90 by Bianca Mellini from **Scipione Pulzone** for the altar of the Chapel of the Passion in the Gesù, probably through the intervention of the Jesuits and Giuseppe Valeriani. Oil on canvas, 9' $6'' \times 5'$ 8" $(2.9 \times 1.27 \text{m})$ (Purchase, Anonymous Gift, in memory of Terence Cardinal Cooke, 1984 [1984.74] © 1984 Metropolitan Museum of Art, New York)

The painting was most likely removed from the Gesù in 1798 during the French occupation of Italy when virtually everything of value in the church was appropriated by the occupying forces.

part of the reform were brought to completion and the Holy Year itself provided a conceptual closure for the first phase of the reinvigoration of the Church after the Reformation and the Sack. Gregory Martin, an English priest living in Rome from 1576 to mid-1578, wrote a guide to the city in 1581 in which he mentioned the building boom in the city and its effect:

It were to[o] long to number and name the Churches, Chappels, Oratories, and aultars, built, garnished, enriched, namely agaynst this last year of Jubilee 1575. And so we see concerning this poynte also that Rome daily florisheth and excelleth, advancing Christian and Catholike Religion not without cause of the Auncient fathers called Romanum, that is the Romane religion.

The completion of the façade for the Gesù in 1575 (see Fig. 23.4) is but one manifestation of this activity. There were many others. Old altars were removed from the central spaces of the major pilgrimage basilicas such as Santa Maria Maggiore to provide large unencumbered spaces for pilgrims, as well as to respond to the Council's wishes

that congregations have a clear view of the altar and the Eucharistic celebration there.

One goal of the leaders of the newly reformed Church was to bring it back to the purity of its Early Christian beginnings—the very point made by reformers both within the Church, like Erasmus, and outside it, like Luther. Renovations of the main Early Christian basilicas for the Holy Year served to reaffirm this goal. Like his predecessors, Gregory also initiated a program of widening streets and building new fountains as a way of making the city a welcome place for pilgrims and of propagandizing the success of reform. His papal bull of 1574 defended the confiscation of private property in order to effect these alterations by stating explicitly that the "common good and the beautifying of the city must always be considered before the cupidity or even the desires of individuals."

San Stefano Rotondo

The centrally planned sixth-century church of San Stefano Rotondo was restored under Gregory XIII, partly in accordance with his papal bull of 1580 uniting the colleges for

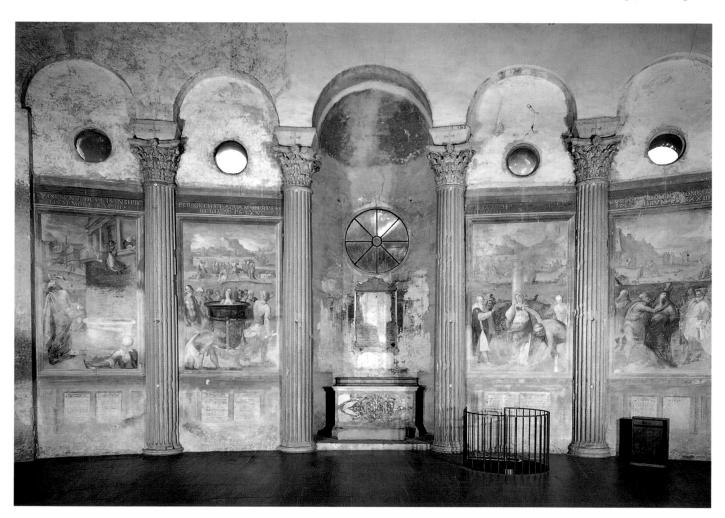

23.8 San Stefano Rotondo, Rome, martyrdom scenes commissioned in 1582 by the German and Hungarian College from Niccolò Circignani and Matteo da Siena

German and Hungarian Jesuits at the site. This church was a center for clergy being trained to return to their home countries to propagate the faith, and in many instances to meet the hostility of Protestant reformers. Around the periphery of its interior, Niccolò Circignani (Il Pomarancio; c. 1517/24 Pomerance-1596 Città di Pieve), who had worked for the pope at the Vatican Palace, led a team of artists that painted a fresco cycle (Fig. 23.8) of thirty-one scenes of explicitly graphic martyrdoms. Beginning with Christ's Crucifixion, it continues through the executions of the Apostles and the early Christian saints-appropriate subjects for this Early Christian martyrial structure. The cycle derives from a book commissioned by Ignatius of Loyola to instruct the faithful and to provide a focus for meditation on the Gospel stories through both notes and images. The frescoes are notable for their blatant didacticism, uniting words to images-rather like captions in a newspaper article-so there can be no doubt about the desire to instruct. Each martyrdom carries a hortatory biblical inscription across the top and each has a double

23.9 Martyrdom of St. John, St. Paul, St. Bibiana, and St. Artemius, 1582, commissioned by the German and Hungarian College from Niccolò Circignani and Matteo da Siena for San Stefano Rotondo, Rome. Fresco, $10' \times 6' \ 10\%'' \ (3.05 \times 2.1m)$

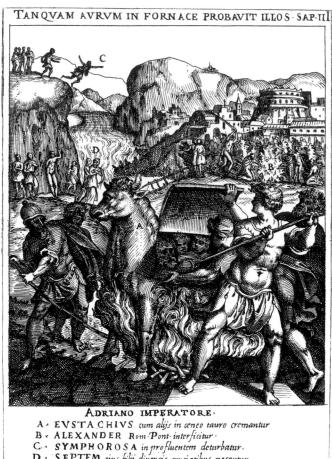

D . SEPTEM cius filij dinersis crucianbus necamur.

23.10 Ecclesiae militantis triumphi sive Deo amabilium martyrum gloriosa pro Christi fide certamina, Rome, 1583, Giovanni Battista De Cavallieri, scene from the ninth fresco of San Stefano Rotondo, Rome, showing St. Eustache and his companions being cremated in a bronze bull, one of the torture instruments of the period. Engraving

The inscription at the top from the Book of Wisdom recalls Old Testament prototypes: Like gold were they tested in the furnace.

caption below-one text in Latin, another translating the Latin into Italian-which identifies the figures in the paintings.

In one of the last scenes in the cycle, representing the Martyrdom of St. John, St. Paul, St. Bibiana, and St. Artemius (Fig. 23.9), the bodies of the four dead saints are sequenced in a neat row from the foreground into the space of the painting, each extending the entire width of the image; other scenes of martyrdom are depicted in the background. Far removed from the conventions of Mannerism, these frescoes depict in a naturalistic, almost journalistic, manner the grisly details of martyrdom. The heads of the closest two men are severed from their bodies, and blood trickles from the neck of St. Bibiana, the third figure from the front. The body of St. Artemius, crushed under the weight of a huge stone, pours blood over the lower stone on which it is laid; his eyes are gouged out and his entrails ooze from his torso.

Large black letters label each group of figures and are coordinated with the legends in Latin and Italian under each scene. The paintings were intended as a meditation on saintly martyrdoms which had strengthened the early Church, and as exemplars of the courage that the students in the German and Hungarian College would need in their dangerous missions. In images such as these—an art of instruction—issues of aesthetics played a minimal role.

The power of the martyrdom scenes at San Stefano Rotondo led to their immediate reproduction in printed form, which made them accessible to an even wider audience. Just as the Lutherans had used the new print medium as an effective mode of proselytizing, so did the later reformers in the Roman Church. In Giovanni Battista de Cavallieri's *Ecclesiae militantis triumphi*, published in Rome in 1583 and again (a measure of its popularity) in 1585, the frescoes of San Stefano Rotondo are reproduced along with their inscriptions (Fig. 23.10) as if they were a catechism for the newly reformed Church returning to its Early Christian roots, an incentive both to piety and to action.

Women as Patrons

An important aspect of Church reforms at the end of the century in Rome lay in the role that women played both in the support of the new religious orders and in notable building projects in the city. Bianca Mellini, of a Roman patrician family, was the patron of the Chapel of the Passion at the Gesù which contained Pulzone's Lamentation (see Fig. 23.7). Although women had always played roles in commissioning works of art (see Fig. 4.23)—most notably as executors of their husbands' estates-the continued growth of the size of dowries that had occurred over the course of the fifteenth century gave women increased economic power within the arts during the sixteenth century, and especially once they had gained the relative financial independence that came with widowhood. Particularly in Rome-where the restitution of the papacy, the success of the Council of Trent, the founding of new religious orders, and the growth of the city as a pilgrimage center called for an astonishing amount of building activity, renovation, and decoration, and where estates were divided between all children rather than just between the male heirs-women played important roles as patrons of the arts. They were especially active with new religious orders which needed their help and which were perhaps more receptive to nontraditional avenues of patronage.

Although most of these women came from wealthy families and had powerful connections in the Roman civil and ecclesiastical hierarchies, they built mainly to provide housing and security for other women wishing sequestered, conventual living and, if they were widows, to free themselves

23.11 San Bernardo alle Terme, Rome, consecrated in 1600, commissioned by Caterina de' Nobili Sforza, stucco statues by Camillo Mariani and others

from the social strictures of their widowhood. They modeled themselves mainly on earlier female donors, some of whom were known from the first developments of church architecture in the Early Christian period. Fulvia Conti Sforza, for example, chose to rebuild her convent church of Sant'Urbano in Rome, originally constructed by Giacoba Bianchi in 1264; she retained the inscription of the first patron over the door of the new building as if to assert a continuing female presence at the site and to legitimate her own patronage.

Since the goal of such women patrons was often to leave the world for the convent or for a female lay religious community and not to use their patronage to advance their position in society at large, their building projects were generally modest and unostentatious. Yet women patrons could also match their male counterparts in asserting their family's prominence through the visual arts. Caterina de' Nobili Sforza built the circular church of San Bernardo alle Terme (Fig. 23.11) out of the ruins of one of the circular pavilions at the corners of the ancient Baths of Diocletian. Each of the bays around the Pantheon-like structure is decorated with an inscription commemorating members of her family. She commissioned Camillo Mariani (1567? Vicenza-1611 Rome), newly arrived from the Veneto, where he had specialized in decorative plasterwork for Palladian villas, to fill the niches with heroic-sized statues referring to her family and to herself (St. Catherine of Alexandria and St. Catherine of Siena). For the first time outside of royal commissions, the independent (and sometimes contested) patronage of women took on a public scale equal to that of male donors.

Church Reform and Local Politics

It would be a mistake to see shifts in dramatic presentation and style simply as a response to the reforms initiated by Trent and by the needs of new religious orders, just as it would be misleading to see early Christian references or new levels of female patronage widespread throughout the Italian peninsula. Still, artists and patrons in other centers were aware of the demands being made by Rome and tailored them to local needs, sometimes opportunistically. In Florence, for example, responses to Tridentine reforms can be seen as a symbiosis of need and intention between the Medici and the papacy. In short, political orthodoxy could be mirrored in the new religious orthodoxy. This was the case in the renovation projects begun in 1565 at the Florentine churches of Santa Croce and Santa Maria Novella (see Figs. 4.8 and 4.10). Cosimo I initiated the redecoration of these major Franciscan and Dominican churches, choosing Giorgio Vasari as his architect in both instances. Vasari removed existing choir screens to permit the laity to see the altar, in accordance with the Council's dictate; he also whitewashed fourteenth-century frescoes and supplanted their outdated style with classicizing architectural tabernacles framing new devotional paintings. The resulting interiors of the buildings have a stripped-down, uniform, and modern appearance. For Santa Croce, Vasari also designed a huge Eucharistic tabernacle which dominated the newly opened central space of the church, giving a focus to the Sacrament, as explicitly demanded by Trent.

Cosimo's reasons for funding these extensive renovations stemmed from his desire to ingratiate himself with the papacy. His generosity was rewarded in 1569 when Pius V named him Grand Duke of Tuscany, a title that Cosimo had sought virtually from the moment he took power in Florence. The extensive obliteration of the past in these churches left their interiors appropriate for the new golden age under his rule. The awareness of Cosimo's other-than-religious motives is evident in the suit that the Alberti family brought against him, claiming that, in removing the choir-screen of Santa Croce, Cosimo was ostensibly claiming the space before the main altar of the church where their ancestors had been buried for over two hundred years.

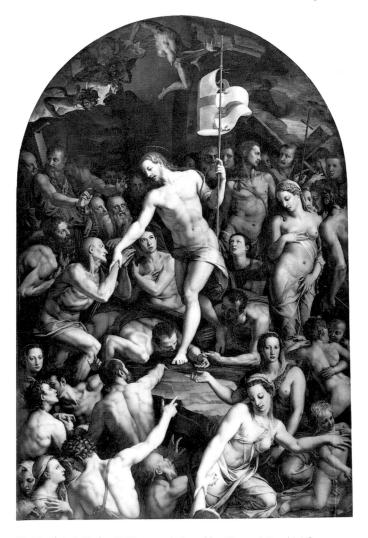

23.12 *Christ in Limbo*, 1552, commissioned by Giovanni Zanchini from **Agnolo Bronzino** for the Zanchini Chapel, Santa Croce, Florence. Oil on panel, 14' $6\%'' \times 9'$ 6%'' (4.43×2.91 m) (Soprintendenza alle Gallerie; formerly Museo di Santa Croce, damaged in the flood of November 1966 and in restoration ever since)

The Alberti claimed the presbytery and choir as their own a space still today marked by their coats of arms high on the piers to the left and right of the main altar. Not surprisingly, the Alberti lost their suit. It is also no surprise that the building committees for these projects were composed of men loyal to Cosimo I and that in most cases these men were allotted the new altar chapels for their own use. Local politics and Church reform enjoyed reciprocal benefits in Florence.

Unlike previous practice, the owners of the new private chapels at Santa Croce and Santa Maria Novella were not allowed to determine the architectural forms of their chapels or to select the subject of the altarpieces that adorned them. The altarpieces were prescribed in Vasari's program. All are of narrative events, as if to bring the viewer into a closer relation with the historical fact of the biblical text and to ensure a more active involvement with its message, as the Council of Trent had stipulated; conventional Madonna and Child representations are completely absent. For Santa Croce, Vasari devised a program of

23.13 Incredulity of St. Thomas, 1572, commissioned by Tommaso and Francesco Guidacci from Giorgio Vasari for the Guidacci Chapel, Santa Croce, Florence. Oil on panel

Christ's Passion and post-Passion histories which provided a continuous narrative from one altar to the next (see Fig. 4.9). A comparison of Bronzino's Christ in Limbo (Fig. 23.12), already in Santa Croce when Vasari began his renovations, and Vasari's own Incredulity of St. Thomas (Fig. 23.13) also demonstrates a change in style from maniera to what has come to be known as the counter-maniera, indicating its opposition to the complexities of Mannerism. Bronzino's altarpiece, painted before Cosimo's and Vasari's renovations, is distinctly like his other high-style works (see Fig. 20.20). Although the figure of Christ is centrally placed in Bronzino's painting, the welter of figures around him and the torsions of their poses compete for the viewer's attention. The complex positions of the limbs, the soft sensuality of the bodies, and the vagueness of the figures were all criticized by Vasari's friend and advisor Raffaello Borghini in his Il Riposo of 1584. Vasari's painting, by contrast, shows Christ and St. Thomas at the center, framed by arches, with the subordinate figures focusing attention toward the narrative center of the painting. Space is rationally constructed and ordered around a single-point perspective system. The twisted pose of the crouching St. Peter to the far right employs Mannerist conventions, but the allegories of Hope and Sorrow floating above are decorously clothed, unlike the fetching angelic figure in Parmigianino's Madonna of the Long Neck, for example (see Fig. 19.10). Vasari, adept in the Mannerist style, could bring it to conform to the demands of the Council of Trent in programs that demanded new naturalism and accuracy to the narrative text.

Perhaps the most developed example of this new style and the devotional reforms that lie behind its appearance is Santi di Tito's (1536 Sansepolcro-1602 Florence) Vision of St. Thomas Aquinas (Fig. 23.14) depicting a miraculous event in the life of the Dominican saint when Christ spoke to him from a painted crucifix. This painting shows Thomas kneeling in religious rapture before a crucified Christ, flanked by St. Catherine of Alexandria, the Virgin Mary, Mary Magdalene, and St. John, who seem to have moved out of the painting depicted on the walls of the niche behind them into physical space. Here Thomas's devotion is so intense that the icon has disappeared to be replaced by the real event. Contrary to his hagiography, Thomas does not levitate in the painting, but exists as a surrogate for the devout viewer kneeling before it—in this case perhaps members of a confraternity dedicated to the saint. Protestant criticisms of icon worship are here answered by the Catholic claim that images are merely a means to approach the figures depicted-in this case a successful means-in order to transform devotional practice into an immediate experience of the divine. A diagonal axis into the painting invites the viewer to imitate the experience, assisted by the gesturing St. Catherine at the left, who, like a figure in a flanking panel in a traditional altarpiece, stands atemporally in relation to the Crucifixion. In this devotional moment she acts as

another human to collapse the lived moment of the prayerful viewer into the ever-present, sacral redemptive moment of Christ's sacrifice.

The realism of the figures and the intensity of their engagement in the drama of the narrative are a radical shift away from the work of Bronzino (see Fig. 20.32), who had been one of Santi's teachers, and from the bombast and quotational classicism of Bandinelli (see Figs. 19.12 and 20.3), who had also taught him. Santi's stay in Rome between 1558 and 1564, where he worked in the papal court, put him in touch with the new spiritual movements there and with the return to the classical traditions of Raphael that he had already known in Florence. Santi also apparently visited Venice in 1571–72 and assimilated at that time both Venetian colorism and dramatic composition.

He was able to integrate these various experiences when he returned to Florence, joined the Accademia del Disegno (1564), and worked with its leader, Vasari, ultimately developing a style quite different from Vasari's and attaining a position as the outstanding painter in the city at the end of the century.

Clearly in Florence, but throughout Italy as well, responses to the Council of Trent, to religious reform, and to a renewed role for the arts in religious practice cannot be viewed in a singular manner. Overlaps between the religious and the political, the individual needs of different patrons, and different local traditions inflected the legislation of the Council and provided various possibilities for following its directives—and avoiding them, as Veronese's trial before the Inquisition vividly demonstrates.

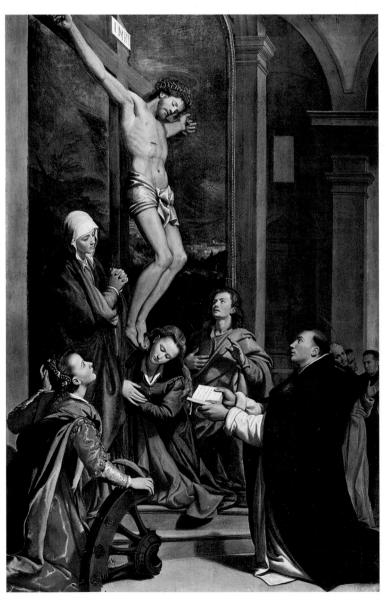

23.14 *Vision of St. Thomas Aquinas*, 1593, commissioned by Sebastiano Pandolfini del Turco from **Santi di Tito** for the del Turco Chapel, San Marco, Florence. Oil on panel, $11'9'' \times 7'7''$ (3.62×2.33 m)

24 Northern Italy: Reform and Innovation

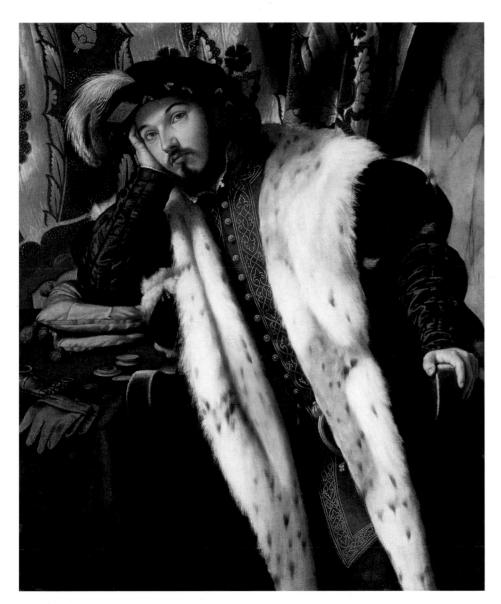

ilan was an especially vibrant center for reform in the visual arts. Bereft of native rulers (the last Sforza had died in 1536) and dominated by Spain, the city looked in the mid-sixteenth century to its local bishop for leadership, as it had done earlier in its history. Charles Borromeo (1538–84; canonized in 1610) was appointed cardinal and archbishop of Milan in 1560 by his very conservative uncle Pope Pius IV (r. 1559–65). While holding this position, he actively directed the last session of the Council of Trent and was instrumental in drafting the decrees it published

in 1563. As a personal witness to the demands for reform made by the Council, Charles gave away all his considerable personal wealth, thus providing the Milanese with a compelling model of religious simplicity and severity. With the assistance of new religious orders such as the Jesuits and the Theatines, both of whom Charles brought to Milan, the city led all of northern Italy in implementing Church reforms.

Devotional Painting

Lombard religious leaders had from the outset of the Reformation been quick to counter Protestant challenges to the Roman Church, perhaps because of their proximity to Germany and also perhaps because of constant threats of northern political domination. Encouraging art that was simple, powerful, direct, and free of preciosity and artificiality (see Figs. 9.19, 9.21, and 16.8), they had laid the groundwork for the prescriptions of the Council of Trent long before the formal publication of the Council's decrees in 1563. It was this Lombard tradition, typified in the mid-sixteenth century by works such as the Ecce Homo (Behold the Man; Fig. 24.1) by Moretto da Brescia (Alessandro Bonvicino: 1498 Brescia-1554 Brescia) which Borromeo may well have had in

mind as he directed the discussions of the Council and as he wrote his own treatise on church art and architecture. Moretto worked largely in Brescia, although he assimilated Venetian painting technique early in his career. Given its proximity to Milan, Brescia was culturally and religiously

(above) Portrait of a Young Man, Perhaps of Count Fortunato Martinengo Cesaresco, c. 1542, **Moretto Da Brescia**. Oil on canvas, $44\% \times 37\%$ " (114 × 94.4 cm) (National Gallery, London)

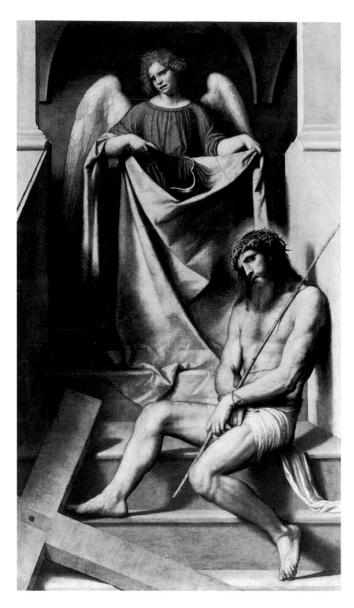

24.1 Ecce Homo, c. 1550-54, commissioned by the Confraternity of the Holy Cross from Moretto da Brescia for their chapel in Brescia Cathedral. Oil on canvas, $84\% \times 49\%$ (214.6 × 125 cm) (Pinacoteca Tosio Martinengo, Brescia)

dependent upon the Lombard capital being part of its archdiocese in spite of belonging to Venice's mainland empire. In the altarpiece Moretto placed the Cross and the pathetic figure of Christ accusingly before the worshiper, the weeping angel in the background demonstrating an appropriately repentant and grieving response. Very limited in its palette and chilled by a gray, sepulchral light, the altarpiece was probably inspired by contemporary devotional books such as Giovanni da Fano's L'arte dell'unione (The Art of Union), which set its mystical reunion with Christ in a palace where the spat-upon, beaten, and crowned Christ was attended by an anguished and sorrowful angel. The dull orange-red steps serve as a none-too-subtle reminder of Christ's blood, shed for humanity. Nothing in the painting detracts the viewer's attention from the object of devotion

or from the appropriate response one should have to this tragic (and a-historical) icon. The painting could hardly be more different from Rosso's Mannerist version of essentially the same subject (see Fig. 18.42).

Even subjects that were not concerned directly with Christ's Passion and Crucifixion took on a new severity in this period. The altarpiece of the Virgin in Glory with St. Barbara and St. Lawrence (Fig. 24.2), painted by Moretto's pupil Giovanni Battista Moroni (c. 1520/24 Albino?-1578 Albino) for a church in Bergamo, is also spare and somewhat forbidding. In keeping with the Church's reaffirmation of the crucial intercessory role of saints, Barbara stands as a gatekeeper to heaven, while the Madonna and Child are set distantly in the clouds. There is little to distract or beguile the eye, the relative emptiness of the landscape and prosaic description of the sky encouraging the worshiper to meditate upon the arduous task of seeking salvation through the Church.

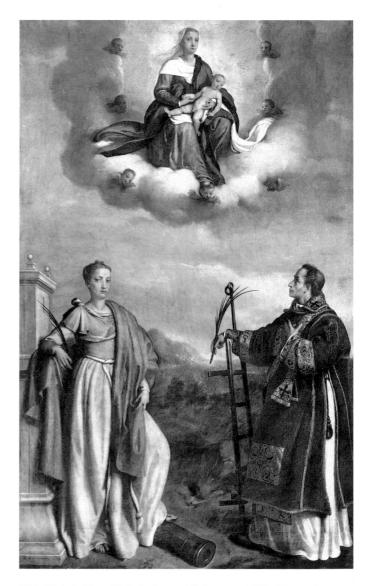

24.2 Virgin in Glory with St. Barbara and St. Lawrence, 1550s, Giovanni Battista Moroni. Oil on canvas (Brera Gallery, Milan)

While altarpieces emphasized sacrificial aspects of Christianity, appropriate to their placement above altars where priests celebrated Christ's sacrifice in the mass, dome frescoes invited worshipers to contemplate the awe-inspiring splendors of heaven. In Milan, Gian Paolo Lomazzo (1538 Milan–1600 Milan) painted the half-dome over the Foppa Chapel in the church of San Marco with an ambitious scene of the *Glory of Angels* (Fig. 24.3), building on the dual example of Correggio (see Fig. 19.6) and Giulio Romano. Rank upon rank of sober-faced but rapturously intertwined angels stand with their heads tipped back to contemplate the vertiginous heights of heaven. Extravagant and self-consciously clever foreshortenings and dense figural groupings could be tolerated because they so effectively evoked a vision of heaven.

Lomazzo ended his career early because of blindness, but he dictated and published two treatises that promulgated his artistic ideas: the Trattato dell'arte de la pittura, scoltura et architettura (Treatise on the Art of Painting, Sculpture, and Architecture, 1584) and Idea del tempio della pittura (Idea of the Temple of Painting, 1590). These books were to be as influential for northern Italy as Vasari's Lives were for central Italian art and art theory. Typical of artists participating in painting academies, Lomazzo constructed a system of ideals-in his case based on neo-Platonism-to which he believed artistic practice should aspire. He uses a round temple form recalling Bramante's Tempietto (see Fig. 18.6) as a device to structure his discussion. The imaginary building's very form recalls the cosmological significance of centralized structures and the concept of the divine that they embody. At the same time, his temple is an idealized fantastical concoction with statues of seven exemplary

artists serving as the columnar support system for the entire structure. While somewhat arcane in its elaboration of the painterly attributes of these seven sixteenth-century artists, each of whom Lomazzo associates with a planet and the conventional astrological notion of personality traits identified with that planet, the Idea del tempio is nevertheless an important discussion of beauty as reflective of divine order. Other parts of Lomazzo's temple give him a chance to talk about such central issues as proportion, perspective, and light.

Milanese Architecture

When the mid-fourth-century octagonal church of San Lorenzo Maggiore (Fig. 24.4) suddenly collapsed on June 5, 1573, Borromeo immediately recognized the propagandistic value of reconstructing the building on its ancient foundations. It had, after all, been built when Milan was serving as the capital of the western Roman Empire. The project was sure to feed civic pride and offered a unique opportunity for demonstrating that the institutional Church of his own day was capable of replicating the accomplishments of Christian antiquity. The technical challenges of building this large structure were brilliantly overcome by the architect and engineer Martino Bassi (1544 Seregno-1591 Milan), who supervised a team that carefully sifted through and measured the ruins. While replicating the quatrefoil plan and general elevation of the original church, including its classical vocabulary, the reconstructed building is, nonetheless, cold and austere. In Charles Borromeo's Milan, austerity had become a primary value which even the example of Roman antiquity could not dislodge.

Some exceptions were made for church façades, but only if, as at Santa Maria presso San Celso (Fig. 24.5), elaboration served a didactic purpose. In this case the Genoese architect Galeazzo Alessi laid out a scheme of unfluted pilasters to serve as a foil for sculptures of prophets and reliefs of scenes from the life of the Virgin. As at the earlier Certosa in Pavia (see Fig. 15.1), the design is largely additive, a distinctively Lombard accumulation of stories and levels unconcerned with accurately reproducing classical precedents which both vexed and inspired architects in other parts of Italy (see Fig. 21.45). Even though the sculptural

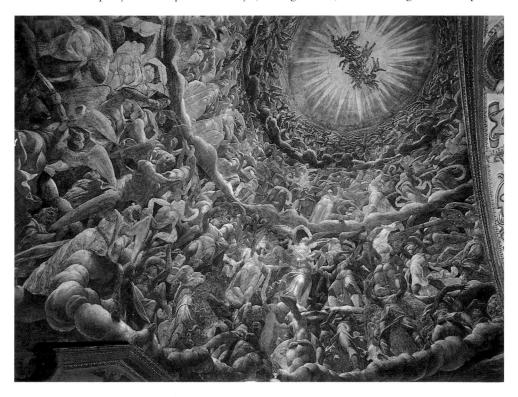

24.3 Glory of Angels, c. 1570, commissioned from **Gian Paolo Lomazzo** for the Foppa Chapel, San Marco, Milan. Fresco

24.4 San Lorenzo Maggiore, Milan, fourth century (rebuilt after 1573 respecting the original plan)

reliefs and free-standing figures recall Michelangelo's unexecuted plan for the façade of San Lorenzo in Florence, and the reclining figures over the doors recall Michelangelo's Times of Day for the Medici Chapel (see Fig. 20.12), the façade still subordinates the sculpture to the tightly structured architectural composition—itself rather severe despite the doubled columns and stepped surfaces.

Echoes of central Italian design can also be seen in the Jesuit church of San Fedele (Fig. 24.6), commissioned by Charles Borromeo. In this instance Borromeo forced the Jesuits to accept the plans of his favorite architect, Pellegrino Tibaldi (1527 Puria di Vasolda-1596 Milan) rather than those of an architect member of their own order, furthering a consistence in his reforming designs throughout his diocese. Yet San Fedele betrays the influence of the Gesù in Rome in its plan and elevation (see Fig. 23.5) and suggests the overlap between local demands and a new religious order's desire for self-identification through design. Tibaldi had been in Rome with Borromeo in 1564 when the Gesù was in its final design stages and when Michelangelo had begun his work at Santa Maria degli Angeli, a project (begun 1563) that

24.5 Santa Maria presso San Celso, Milan, façade designed before 1570 by Galeazzo Alessi and completed by Martino Bassi

Alessi was responsible only for the façade of the building. The building project was begun in 1485; by 1493 Gian Giacomo Dolcebuono appears as its architect. A number of other architects and sculptors contributed their expertise to the building before Alessi added the façade.

24.6 San Fedele, Milan, designed 1567, commissioned by Charles Borromeo for the Jesuits from Pellegrino Tibaldi

involved converting part of the huge complex of the Roman Baths of Diocletian into a Christian church. In the extremely wide church of San Fedele, Tibaldi surpassed Vignola at the Gesù in subordinating the side chapels to the nave, treating them as niches in the nave's supporting walls rather than as discrete and therefore competing elements. Bold but simple moldings and large clerestory windows ensure that the Milanese space is bright and clearly ordered, while giant, free-standing columns and tympanum windows, which derived from Michelangelo's Santa Maria degli Angeli, bring a classical austerity to the church, despite the pink coloration of the surfaces. This triumphalist language of forms seems to have developed in several places at once, a suitable style for the reformed Church in Europe.

Charles Borromeo and the reforms he promoted cast a long shadow over Lombardy and Milan, dampening, though never completely suppressing, the region's propensity for conspicuous display. The archbishop must have looked askance at projects such as the gargantuan family palace built by Tommaso Marino, not far from Milan Cathedral (Fig. 24.7). Marino was a nouveau-riche banker intent on claiming a place for himself among the patriciate. The building's architect, Galeazzo Alessi (1512 Perugia-1572 Perugia), previously worked for the Genoese aristocracy (see Fig. 19.16) and emblazoned his patron's newly purchased title, "Duke of Terranova," across the palace's densely detailed façade, where every window is framed by both aedicules and a columnar main order. The emphasis is on novelty and luxury: bold rusticated blocks alternate with smooth shafts around the ground-floor windows; tapering surrounds, many capped by human and animal heads, enrich the upper stories. The extraordinarily costly

construction was abandoned for lack of funds in 1565. Marino died insolvent in 1572, and the unfinished building was confiscated to pay debts—an architectural warning against self-promotion and reliance on worldly wealth. Yet the extravagant vocabulary of Italian suburban villas, which Alessi had known from his time in Genoa (see Figs. 19.13 and 19.14), had entered the city.

Portraits

In a climate where individuals found it increasingly in their best interest to avoid ostentation for fear of accusations of vanity, or even heresy, the art of portraiture was necessarily suspect. A likely portrait of Count Fortunato Martinengo Cesaresco (see p. 527) by Moretto da Brescia exemplifies Lombard portraiture before mid-century reforms, contrasting markedly with his religious painting (see Fig. 24.1), and, as we shall see, with later portraiture. In the early 1540s Moretto was responding both to Mannerist court portraiture by Parmigianino (see Fig. 19.9) and the light-filled, psychological essays of Titian (see Fig. 21.21), though his work is more thoroughly naturalistic and visually honest. Moretto describes the velvet arms of the sitter's chair as carefully as the sitter's flesh; everything is observed down to the last gold thread and bristle of fur. The young sitter plays the melancholic lover with one hand to his face, reinforced by an amatory inscription which appears on the badge attached to his hat-perhaps referring to his upcoming marriage. Count Fortunato was a literary scholar and friend of figures such as Ludovico Dolce and Pietro Aretino and would have known and perhaps appreciated the moody portraits invented by Giorgione. Yet Moretto here offers a distinctly Lombard alternative to the suggestive and atmospheric qualities of Venetian painting: a clear-eyed realism that contemporaries, including Titian, recognized as their forte. Sixteenth-century writers recommended Lombard painters for producing portraits "from nature"—not always a compliment in highly sophisticated circles which assumed that the artist should improve upon his model and delve deep into a sitter's psyche. Moretto, however, clearly

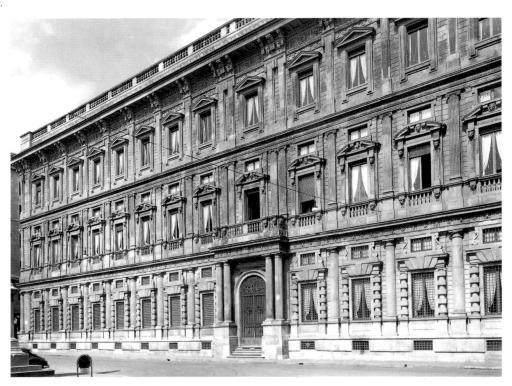

24.7 Palazzo Marino, Milan, begun 1558, commissioned by Tommaso Marino from **Galeazzo Alessi**

combines psychological and visual realism with aplomb and intelligence.

A very different mood pervades the later *Portrait of Gian Gerolamo Grumelli* (Fig. 24.8) by Moretto's student Moroni. The figure is dressed in splendid red attire; bits of classical antiquity along with an obscure motto in Spanish ("more the last than the first") attest to his worldly sophistication. Yet Moroni presents Grumelli's features with a disarming honesty. His cavalier seems not so much standing for a portrait as caught off guard as he goes about his daily business. Crumbling architecture, piles of dust, and fragmented sculpture attest to the fleeting and transitory nature of human fame and endeavor. The image is distinctly self-deprecating rather than self-absorbed, as Count Fortunato's portrait had been, and it is appropriate for the

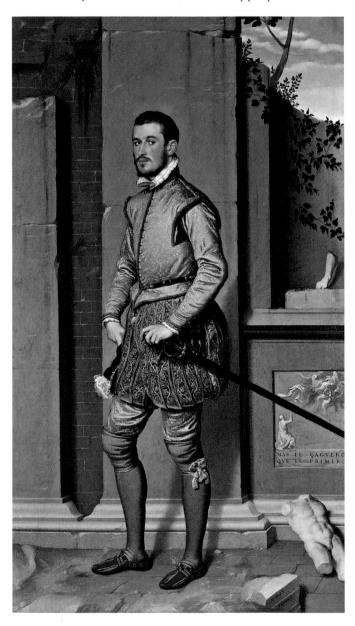

24.8 *Portrait of Gian Gerolamo Grumelli*, 1560, commissioned by the sitter from **Giovanni Battista Moroni**. Oil on canvas (Collection of Count Antonio Moroni, Bergamo)

man who hosted Charles Borromeo on the latter's visit to Grumelli's home city of Bergamo. The realism of the depiction sharpens the sense of Grumelli as the main subject of a framing allegory.

One of the period's most inventive portraitists came from Cremona. The noblewoman Sofonisba Anguissola (1532 Cremona-1625 Palermo) created wry and witty portraits of family members and acquaintances, a subject largely imposed upon her by societal restrictions on female access to models and patrons. She was one of six sisters and one brother, to whom their humanist father gave extraordinary classical educations. He promoted them and their work shamelessly, sending Sofonisba's drawings to Michelangelo and eventually securing her service as lady-in-waiting to the queen of Spain, Elizabeth of Valois (1545-68), a position that gave her opportunities for painting formal court portraits that followed the norms for that type of imagery. While in Spain she married the brother of the Viceroy of Sicily. Upon his death she remarried and moved to Genoa and finally to Palermo in Sicily where she retired and was famously visited in her very old age by Anthony van Dyck. Aristocratic, intelligent, extraordinarily well-connected, and highly talented, she amazed all her contemporaries, even Vasari, who wrote somewhat chauvinistically that "she has shown greater application and better grace than any other woman of our age." He appreciated her craft ("application") and gentility ("grace"), obviously generated as much by Sofonisba's social status as by her artistic accomplishments. Of Sofonisba's inventiveness Vasari says nothing.

Sofonisba's painting of her teacher, Bernardino Campi (1521 Cremona–1594 Reggio Emilia), painting her portrait (Fig. 24.9)—a story within a story—demonstrates how she negotiated her male-dominated world. Anguissola's gaze rivets the viewer of the painting, forcing consideration of what appears to be the inscribing of male authority on the body of the female. Campi's gaze complicates matters, however, since as he paints he, too, looks out of the painting toward what the picture indicates must be his subject, Anguissola. Thus the viewer in front of the painting plays a double role: that of the subject of the painting within the painting, namely Anguissola herself, and of an engaged viewer—watched by both Campi and Anguissola—made complicit in Anguissola's destabilizing of contemporary social norms.

Tellingly, as the actual painter of the canvas, Anguissola placed her head higher than Campi's. Thus, according to the social rules of the period concerning position, she was conferring on herself a status greater than her teacher's—both in terms of social position and in terms of artistic accomplishment. Anguissola's assertion of superiority is ironically underscored by the aligned placement of the two visible hands in the painting: Campi's identifies him as someone who works with his hands for a living, whereas Anguissola's—holding a pair of gloves—indicates her nobility.

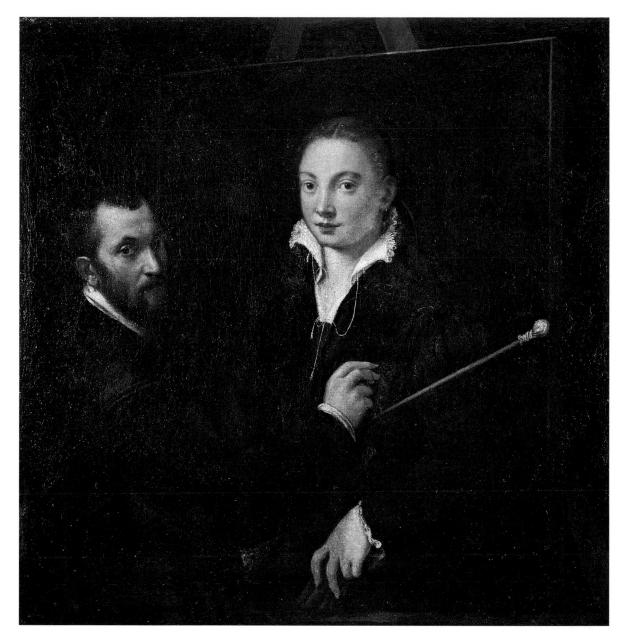

24.9 Bernardino
Campi Painting
Sofonisba Anguissola,
late 1550s, Sofonisba
Anguissola. Oil on
canvas, 42½ × 43"
(108 × 109 cm)
(Pinacoteca
Nazionale, Siena)

24.10 (below)

Portrait of the Artist's Sisters Playing Chess, 1555, Sofonisba

Anguissola. Oil on canvas, 28½ × 38½" (72 × 97 cm) (National Museum Poznan, Poland)

Anguissola herself was the real painter of the canvas, yet she has hidden her right hand which would have been in the action of painting and made her head, the seat of the intellect, slightly larger than Campi's. Thus, Anguissola's construction in the painting of her own artistic and social status as a woman is paired with her presentation of the changing role of the artist from manual labourer to conceptual creator, an inversion of the patriarchal norms voiced by Filarete a century earlier: as presumed patron of the painting within the painting she is the "father" of the image, and as the actual artist she is also the "mother."

That women could be intellectually accomplished and highly rational, even strategic, are the complementary themes of a family portrait showing Anguissola's three sisters playing chess (Fig. 24.10). In this painting, which Vasari saw hanging in the artist's family home in Cremona in 1566, the erotic and chivalric game of chess takes place in

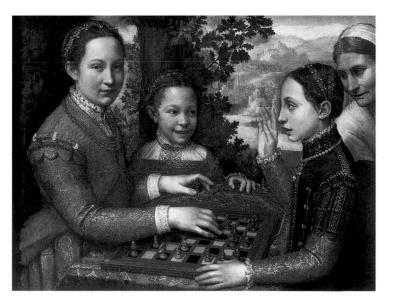

24.11 Asdrubale Bitten by a Crawfish, c. 1554, Sofonisba Anguissola. Black chalk and charcoal on brown paper, $12\% \times 14\%$ (322 × 375 mm) (Gabinetto Disegni e Stampe, Museo Nazionale di Capodimonte, Naples)

an idealized landscape familiar in late medieval courtly images of the game (see Fig. 8.20) and not in the tavern or other questionable locale seen in other contemporary representations of gaming. On the far left Lucia looks out at the viewer, dominating our gaze as her arm and obvious expertise dominate the chess board. She has removed two of Minerva's pieces from the game and this younger sister opens her mouth and raises her hand as if to speak. Their youngest companion, Europa, smiles gleefully at the match, carefully observed by an old maid servant at the far right. The three young Anguissola women are members of a natural noblity capable of entertaining themselves, their status emphasized by the rich surface detail on their brocaded clothes and the fine Turkish carpet set over their table. What is more, the entire game has been invented by their eldest sibling, Sofonisba, whose proud signature on the side of the chess board declares that she painted the subject from life (ex vera)-presumably the life of the mind, not merely quotidian reality.

Obviously self-aware and politely subversive, Anguissola seems to have been willing to challenge even Michelangelo in both craft and wit. Her father had arranged for the most famous artist of the age to be shown one of his daughter's drawings of a laughing child-an obvious ploy to certify her talent for undertaking a task that Leonardo had described in his notebooks as requiring rare talent and nuance in order that the figure not appear pained or angered instead. Michelangelo begrudgingly admitted its proficiency and perversely claimed that showing a crying child would be even more difficult. Anguissola responded with a now heavily damaged presentation drawing (Fig. 24.11) which Michelangelo gave to Tomaso dei Cavalieri, a frequent recipient of Michelangelo's generosity and homoerotic

attention. The scene seems a logical enough response to Michelangelo's remark: one of Anguissola's younger sisters calms their only brother who is being bitten by a crawfish. But the subject itself may not be innocent, possibly referring to the story of a boy and a poisonous scorpion in a collection of fables by the Cremonese humanist Gabriele Faerno. More pointedly, while the girl is calm and assuring, she makes no effort whatsoever to remove the crawfish from her brother's finger. She eyes him coolly as he cries and wags his small hand, trying to shake the crawfish loose. Sofonisba undoubtedly knew the contemporary proverb that referred to the crawfish's tiny brain: "A little of the brains of the crab (or crawfish) would make him wise." Clearly the boy is the witless one of the two figures portrayed. This carefully constructed presentation drawing responds to Michelangelo's demanding comment in a number of different ways that indicate Sofonisba's keen perception of the artistic world in which she worked. At the simplest level, the drawing is a response to Michelangelo's upping the ante of her first gift of a drawing: she has no trouble with the more difficult subject of the crying child, replying simultaneously to Michelangelo's letter and to Leonardo's treatise. But also of interest is that Sofonisba replies with a drawing very far removed in style from Michelangelo's disegno. Her figures are softly drawn in and their edges created more by patches of shadow rather than by Tuscan line. Even allowing for the worn and abraded surface of the drawing, it is clear that Sofonisba is opposing her mode of drawing to Michelangelo's. Then she has taken Faerno's story and made a playful mockery of it by substituting the crawfish for the deadly scorpion, indicating that she both understands the male game of translating literary sources into painting and that she is not

willing to play it. Literary male heroics become domestic trivia. Sofonisba's drawing engages both the artist's skill demanded by Leonardo and Michelangelo and contemporary theory about what constitutes art. Just as the young girl in the drawing is in control of the situation that has the little boy in such distress, Sofonisba is in control of the intellectual and technical demands that governed her existence as an artist.

Still-Life Painting

New forms of portraiture were not the only novelties of subject matter developing in the northern Italian cities during the second half of the sixteenth century. The domestic scenes that were a distinct category of painting within Anguissola's career are paralleled in the new pictorial genre of the still life that emerged there during the 1570s and 1580s. The history of the evolution of still life painting and assessments of its meaning are only now emerging with some clarity. The genre first appeared in Lombardy with the work of Vincenzo Campi (1530/35 Cremona-1591 Cremona) although Bartolomeo Passarroti (1529 Bologna-1592 Bologna) made similar explorations virtually simultaneously in Bologna. A number of reasons might be given for the appearance of still life in northern Italy at this time, especially in Campi's and Anguissola's native city of Cremona, which had been taken from Milanese control by the Holy Roman Emperor Charles V in 1522, eventually passing it on to his son, Philip II of Spain. Situated on a major trading route from Italy to Germany, Cremona seems to have had equal access to both the Italian and northern traditions of painting, with commerce in art moving in both directions. With no local ruling family, the citizenry was dominated by merchants and tradespeople with a strong urban middling class whose fascination with the results of their financial success might have made them sympathetic to the imagery of plenty that typified early still life painting.

Not only did there seem to be a local market for Campi's still life paintings (perhaps sold from the studio outside the normal patronage systems, if the mystery of their early histories is any indication), a foreign market is documented as well. In 1580 Hans Fugger, a member of the leading German banking family, ordered a set of five still life paintings from Campi for his home in Kirchheim, where they still are. Clearly by then Campi had a reputation for such pictures, which themselves derive from similar images by Flemish artists like Pieter Aertsen (1507/08-74) and Joachim Beuckelaer (c. 1533-73) whose paintings were already in the Farnese collections in Parma. These northern painters were themselves part of a commercial and burgher culture in which a growing group of new patrons sought possibilities uniquely theirs for conveying both the events and the meanings of their own history.

Similar though the still lifes of Campi and Passarroti may be to northern examples, they have a number of distinctive characteristics that respond to local traditions and needs. Campi's *Fishmongers* (Fig. 24.12) shows a peasant man in rough clothing at the far left—nearly edged out of the painting—eating a bowl of beans, a fishing net strapped to his back. A plump smiling woman, somewhat more finely clothed, sits in front of him, also eating from a bowl of beans balanced precariously on a small table where there is also a hunk of rough dark bread. A squalling baby sits in her lap, his grimace obviously caused by the crawfish that is

24.12 Fishmongers, c. 1580, **Vincenzo Campi**. Oil on canvas, $57 \times 84\%$ (145 × 215 cm) (Milan, Pinacoteca di Brera)

attached to his extended left hand; the reference, similar to that used by Sofonisba Anguissola in her drawing for Michelangelo (see Fig. 24.11), is already a clue that the painting is more than a simple still life or peasant market scene. In the right two-thirds of the painting an abundance of various fishes is spread out for view, some hanging from hooks, others on a table, and yet others in baskets or on the ground under the table. Like a good market stall, the fishes are separated by type, so that the result is one of distinction and clarity of form rather than simply of plenitude.

But apparently it is not only the fish that is being classed in paintings like the Fishmongers. For, despite the piling up of countless different textures, colors, and surface lights that mark the artist's skill and provide sheer visual delight to the viewer, a more sinister message apparently underlay such images, particularly in the disguised visual puns of a social or a sexual nature. In Campi's painting the coarse man at the far left holding a bowl of beans is a cue both for stupidity and incipient sexual intercourse since beans were thought to increase the production of sperm in males; on the same issue contemporaries also thought that such peasant food led to the generation of ugly and oafish children. The small dog seeming to want to jump on to the lap of the woman is a cue for lust, a cue doubled with the provocative extension of the woman's left foot from her skirt. When Lomazzo referred to such paintings as pitture ridicole (ridiculous or silly paintings or trifles) in 1584 he helped set the stage for reading them as of secondary interest, outside the main stream of serious painting. They were apparently hardly that. In a socially tense environment where urban elites attempted to keep country folk in a state

of subservience, paintings such as these, where the male peasant is made a crude boor, his wife the focus of sexual jokes, and their witless child condemned as if by natural selection to remain as coarse as his father, could act as a powerful visual propaganda to maintain repressive notions of social caste within the culture. They were doubly dangerous for being so seductive to look at and such clever jokes.

Bartolomeo Passarroti's The Butcher Shop (Fig. 24.13) seems to fall into the same category of still life as Campi's Fishmongers, although masquerading as a more evident depiction of a contemporary market stall. Two butchers, one older than the other, look out engagingly over their counter at the viewer. Carcasses of various animals hang behind them, suggestively alternating animal and human across the surface of the painting. The raw meat ("carne" as both meat and flesh) in Passarroti's painting, like the beans in Campi's Fishmongers, is a cue for cupidity and unbridled sexuality. Since red meat was also considered far less refined a diet than game birds, The Butcher Shop also suggests that issues of social stratification are embedded in the image. The anomalous one live animal, a sparrow, perches on the board of hooks behind the head of the left butcher. The bird serves as the signature for the painter whose name means sparrow in Italian, but it also refers to two Greek sculptors, Batraco and Sauro, each of whom signed his work with an image of the animal signified by his name, a frog for the former, a lizard for the latter. Even in a simple detail such as the signature sparrow, the antique is not far away.

The gap-toothed butcher at the right serves as a further clue that the picture may not be as obvious in its meaning as the simple depiction of a meat stall, any more than

24.13 The Butcher's Shop, 1580s, **Bartolomeo Passarroti**. Oil on canvas, 44 × 60" (112 × 152 cm) (Galleria Nazionale d'Arte Antica di Piazza Barberini, Rome)

Campi's painting represents a fish stand. His left arm, leaning on the block between him and the viewer—clearly foregrounded across the plane of the picture—is carefully muscled, perhaps a result of his having lifted and hauled sides of beef like those behind him for years. On the other hand, the muscles and the *contrapposto* pose of the figure recall the heroics of classical sculpture, modest examples of which Passarroti apparently owned and also depicted in portraits of collectors. The arm also suggests Passarroti's own studies of human dissections, first documented in 1574, for a book on anatomy that he was still pursuing in the mid-1580s at the time that the *Butcher Shop* was painted. A chair in anatomy was established at the University of Bologna in 1570, which may have supported his interest in human form.

More significant for Passarroti's subject as a whole is the expanded science curriculum at the university during Passarroti's lifetime-most particularly in the natural sciences, an expansion that led to Ignazio Danti's teaching there. One of the more prominent members of the university faculty was Ulisse Aldrovandi (1522 Bologna-1605 Bologna) who, although a doctor, received the chair of natural sciences at the university in 1561. Under Aldrovandi's leadership the University of Bologna became the center for study of plant and animal life around the world. Eighteen volumes containing over 2900 of Aldrovandi's watercolors show both how wide-ranging his interest was and how precise his observations were in cataloging the specimens that were kept in his natural history "museum" and in the University's botanical garden, founded in 1587 (although his interest in biological aberration such as Siamese twins sometimes was tinged with imagination). His drawings are instructive as a measure of the perceived possibility that one could, indeed, catalogue nature completely, one specimen at a time piling up in endless sheaves of drawings (Fig. 24.14). The variety and overwhelming quantity of Aldrovandi's material is comparable to the incredible varieties of fish and the presentation of meat spread out almost diagramatically in paintings like those of Campi and Passarroti (who knew Aldrovandi), although the naturalist's depictions of plant and animal life are more didactically presented than those of the paintings. Yet the mode of presentation in Campi's Fishmongers is important. Each type of fish is presented as a separate formal unit, carefully laid out across the surface of the paintings as if the taxonomy of species was as interesting to him as it was to Aldrovandi. Despite the clear differences in intention and result in the work of a naturalist like Aldrovandi and painters like Campi and Passarroti, they all seem to share a sense of wonder in the actuality of the objects that form their world.

Recent study also suggests that, at least in later paintings, such imagery disguises enormously erudite references to classical and contemporary humanistic literature, even if such references are themselves also scatological. One ancient writer even postulated that the term "satire" stems

24.14 Page from a volume of drawings of specimens of nature, **Ulisse Aldrovandi**, watercolor, 18½ × 14½" (46.5 × 36 cm) (University of Bologna, Biblioteca, Bologna)

from the Roman word "satura," an offering to the gods of a plate heaped with food. Thus images like Campi's Fishmongers and Passarroti's Butcher Shop suggest the richness of doubled meanings in satire. Even Pliny wrote favorably in his Natural History of a painter, Piraeicus, who had painted "barbers' shops and cobblers' stalls, asses, viands and the like," who had been called a "painter of sordid subjects." Significant for our understanding of the commercial culture of the Italian middling class of the sixteenth century, Pliny also indicated with a verbal pun that these paintings gave "exquisite pleasure" ["consummata voluptas"] and that "they fetched bigger prices than the largest works of many masters." New subject matter, new patronage groups, growing cities, inherent class tensions, and expanded modes of artistic commerce all suggest an expanding role for artistic imagination. However, the artist's inventive imagery was still profoundly tied to the social matrix of which it was part, making the deciphering of these innovative genre paintings of the late sixteenth century a key to unlocking significant shifts and strains within the social order.

25 Rome: A European Capital City

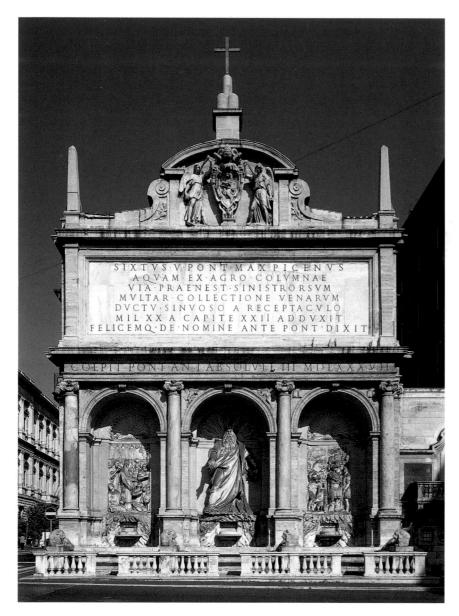

👤 y the end of the sixteenth century Rome had achieved unique status as a true capital city. In little under two hundred years, the city had developed from a run-down ghost of its ancient greatness with cows grazing within its walls to a city that provided the model for urban planning for other large, emerging European capitals like Paris and London. Unlike earlier periods in which Rome was seen predominantly as a religious center, it had been transformed into an image of a worldwide power with claims over more people than any European monarch could imagine and into an international cultural capital supported by the pan-national nature of the papal court, where artists came from throughout Europe to learn and to work. It was not only the successes of the artistic projects already discussed, but the renewed sense that all roads-artistic, religious, political-led to Rome as an international city that gave it its special character—and where artistic ability was measured more critically and by a wider range of viewers than in any other city in Europe.

Sixtus V and the Replanning of Rome

Like so many of his predecessors, Pope Sixtus V (Felice Peretti; r. 1585-90) sought to assert the legitimacy of his office with references to papal history and established Rome as the dominant European power by adding his own contributions to its physical splendor. Despite the brevity of his reign, he essentially completed its development as the model European capital city begun by Paul III and Michelangelo. He was a Franciscan, like Sixtus IV and Nicholas IV before him, and once again commissioned projects whose scope and grandeur belie the rule of poverty central to the Franciscan order. For all these Franciscan popes, the demands of their office and their responsibilities as temporal rulers overrode whatever Franciscan qualms they may have had.

To ensure that his extensive rebuilding of Rome would be remembered, Sixtus commem-

orated his architectural commissions in a series of prints and publications. One of these (Fig. 25.1) shows him surrounded by his building projects in much the same way that early saints' altarpieces showed saints surrounded by

(above) Acqua Felice, Rome, begun 1589, commissioned by Sixtus V from Leonardo Sormani (statue of Moses), Giovanni Battista della Porta (the relief on the left depicting Aaron Leading the Jews to a Well), and Flaminio Vaca and Pietro Paolo Olivieri (the relief on the right depicting Gideon Leading His Soldiers and the Jewish People over the Jordan). Marble

25.1 Invicti quinarii numeri series quae summatim a superioribus pontificibus et maxime a Sixto Quinto res praeclare quadriennio gestas adnumerat, fol. 3, showing a portrait of Sixtus V surrounded by images of his building projects, Rome, 1589, Giovanni Pinadello (apud Franciscum Zannettum) (Metropolitan Museum of Art, New York)

Julius II's plans to link historically important areas of the city with the Via Giulia, Sixtus's concentration on the major basilicas simultaneously suggests the vitality of the reformed Church and recalls its unbroken history back to the Early Christian period. The major axis of Sixtus's grand urban plan extended across the entire city from the Piazza del Popolo at the north, one of the main gateways into Rome and a prominent ceremonial site, to Santa Maria Maggiore, which was the major basilica in the center of the Roman city and also a Franciscan church (see Fig. 12.22). The street then further extended to Santa Croce in Gerusalemme at the southeast, another pilgrimage basilica built near the walls at the opposite side of the ancient city. Named the Strada Felice in honor of Sixtuswhose given name was Felice ("happy" in Italian)—and to suggest a new happiness in the city under his rule, the street was constructed for most of its projected length, from Santa Croce as far as Santa Trinità dei Monti, above the Spanish Steps; it still exists as a prominent axis on the plan of modern Rome. The very expansiveness of this project is a measure of the scope of Sixtus's plans: an entire city unified through an axis of happiness used as an emblem for order in the world through the success of the Roman Church.

Urban Monuments

The Obelisks At considerable expense and through the impressive engineering skills of his architects, particularly Domenico Fontana, Sixtus also moved a number of Egyptian obelisks from their ancient Roman sites to new ones, which pinned down the axes of his urban plan and established new focal points in the city. The prominence of the obelisks in the upper corners of the 1589 print (see Fig. 25.1) indicates Sixtus's pride in these accomplishments. The obelisk now in the piazza in front of St. Peter's (Fig. 25.4) was the most notable example of these repositioned obelisks; others include the one in the Piazza del Popolo, one flanking a chapel built by Sixtus at Santa Maria Maggiore, and one at the Lateran Palace. Others were earmarked for relocation, but these projects were delayed because of time and cost constraints. Sixtus claimed the relocated obelisks as his own and as a manifestation of the triumph of the Church over antiquity, both by adding

narratives of their miracles (see Figs. 1.4 and 1.5). Each of the small illustrations is diagramatically represented and carefully labeled so that there can be no doubt about Sixtus's accomplishments.

Each of the projects depicted on Sixtus's didactic print fits within an overall scheme of urban planning designed to make Rome more accommodating and more impressive to the visitor. Drawing on earlier traditions of widening and straightening streets to provide safety and clear access within the warren of medieval Rome, Sixtus and his architects, most notably Domenico Fontana (1543 Melide, Lake Lugano–1607 Naples) planned major axes through the urban fabric to unite its main pilgrimage basilicas (Fig. 25.2).

Unlike Pope Nicholas V's plans to unite the bureaucratic offices of the papacy in his urban renewal of the Borgo Leonino stretching from St. Peter's to the Tiber, or Pope

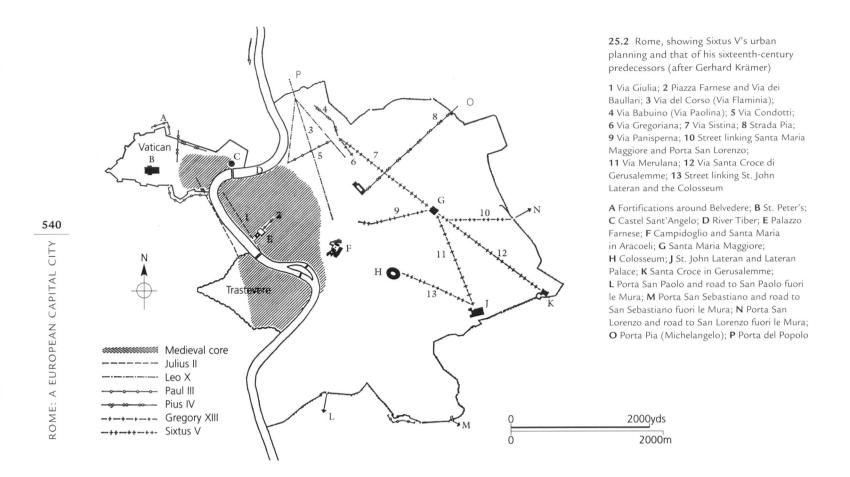

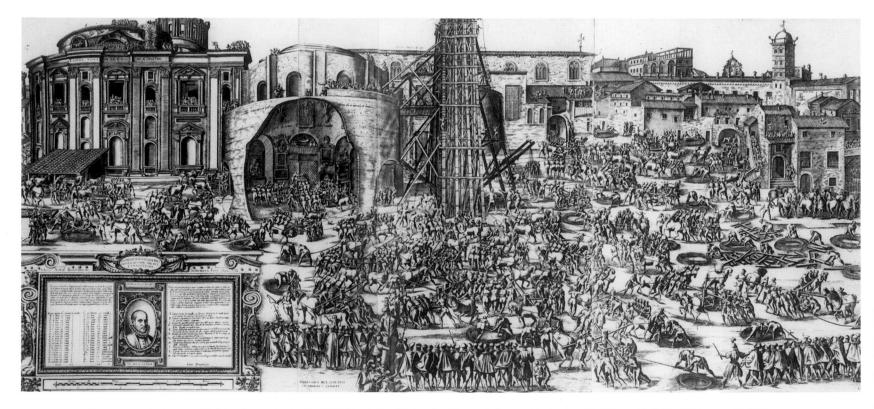

25.3 Moving the Augustan Obelisk at St. Peter's, detail, 1586, Natale Bonifacio after Giovanni Guerra, The Moving of the Vatican Obelisk in 1586, tome IV, 1704.

The print shows the south flank of Old St. Peter's, the atrium of the old basilica with Giotto's mosaic of the *Navicella* on the inside entrance wall, a view into the sacristy of St. Peter's through the wall breached to make room for the pulleys and winches used for moving the obelisk, and the new St. Peter's under construction. See Fig. 25.4 for the completed process which lasted from April to September 1586.

inscriptions to that effect and by capping each of them with his emblem of three stylized mountains (seen in the lower left of the 1589 print) and, in the case of the St. Peter's obelisk, a Christian cross.

The obelisks were associated with the Roman emperors who had originally brought them to Rome from Egypt. Those that Sixtus chose for St. Peter's and for Santa Maria Maggiore were taken from monuments of Augustus and were carefully inscribed as such, providing a clear reference not only to the international power of the first Roman emperor, but to the concept of the pax augustana (age of peace under Augustus) and the ensuing golden age for

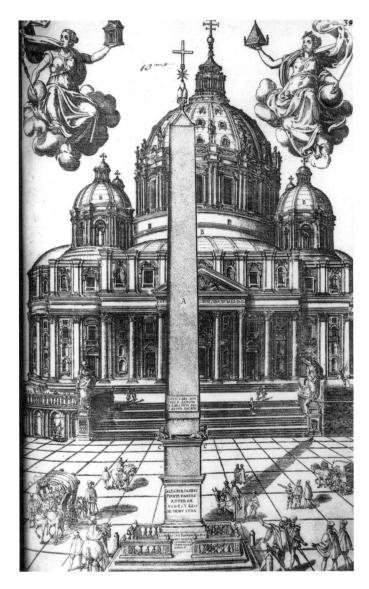

25.4 Della trasportatione dell'obelisco vaticano et delle fabriche di nostro signore papa Sisto V, Rome, 1590, **Domenico Fontana**, **Domenico Basa**, fol. 35r. Engraving

This page from Fontana's book shows the obelisk of Augustus newly moved to the piazza in front of St. Peter's. 800 men, 140 horses, and 40 winches were involved in moving and erecting it, accompanied by the ringing of bells and music by Palestrina. Moving the obelisk was such an extraordinary accomplishment that Sixtus made Fontana a Knight of the Golden Spur and gave him the status of a Roman patrician.

which he was known. The engineering feats involved in moving these obelisks were also of a magnitude reminiscent of ancient Roman technology and were perceived to be so remarkable that Fontana published a folio volume detailing the various stages of the moving process (Fig. 25.3).

Of course the obelisks are also freighted with Christian references. The Augustan obelisk for Santa Maria Maggiore served as a visual reminder that Christ was born during the reign of Augustus, and that the main relics of this event, the cave of the Nativity and the crib, were housed at that basilica. But all the resituated imperial obelisks are associated with churches and thus underscore one of the traditional tenets of the papacy—that it was both a spiritual and a secular power.

The Roman Columns In the lower corners of the 1589 print are images of the historiated columns of Trajan and Marcus Aurelius, too large to consider moving, but appropriated by Sixtus nonetheless. On December 4, 1587, he capped Trajan's Column with a large bronze statue of St. Peter (Fig. 25.5), and on October 27 of the following year he placed a bronze figure of St. Paul atop that of Marcus Aurelius. The artists for these two statues, Leonardo Sormani (? Savona-1589 Rome) and Bastiano Torrigiani (? Bologna-1596 Rome), were part of a stable of artists and architects whom Sixtus used for his numerous projects. Essentially as house artists, they worked well together and understood their patron's wishes. Although working on different projects, they were essentially part of a large workshop directed by Sixtus's master architect, Domenico Fontana, and controlled by the pope. Sormani's muscular St. Peter has an active striding pose, the figure turning on axis as he extends his keys into space. The exaggerated facial features, perhaps necessitated by the great height of the figure from the ground, recall those of earlier papal images as well as the leonine portrait type seen also in the fearsome lion-like features of Michelangelo's *David* (see Fig. 17.1).

In the case of Trajan's Column, Sixtus was returning to a monument that Paul III had had excavated and around which Michelangelo had planned a new piazza, a scheme accepted by the Communal Council in 1558. Sixtus allowed his artists to despoil both Roman and Early Christian monuments to cast these statues. The St. Peter, for example, was made from bronze melted down from half a cannon from the Castel Sant'Angelo; from medieval bronze doors from Sant'Agnese, Old St. Peter's, and the Scala Santa at the Lateran; and from part of a bronze pilaster stripped from the Pantheon. The presence of these two saints on top of monuments to Roman emperors gave graphic expression to the triumph of the papacy and the Church over the ancient world. As if to underscore this triumph, the statues were positioned so that they faced St. Peter's.

The Acqua Felice Sixtus provided special gifts to the Roman people in the form of fountains, the most notable of

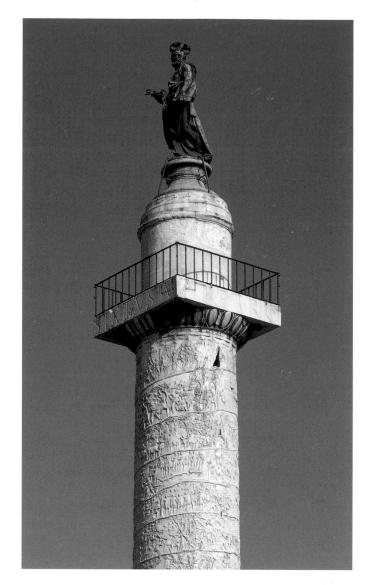

25.5 Column of Trajan crowned with the statue of St. Peter, statue finished and put in place in 1587, statue commissioned by Sixtus V from **Leonardo Sormani, Tommaso della Porta**, and **Bastiano Torrigiani**. Bronze, height of statue 13′ 1½″ (4 m)

which is the rather heavy-handed Acqua Felice (see p. 538), the name referring to his own, to the water's ability to make the populace happy (felice), and to the pleasant sound of the flowing water in the urban setting. It is difficult now to imagine how important this project was for a city whose aqueducts had been in a ruinous condition for centuries and whose limited water sources occasionally forced its inhabitants to carry water from the Tiber. But the Acqua Felice—which appears just below Sixtus's name in the 1589 print-was of such significance that it is mentioned on Sixtus's tomb, along with one other project, the completion of St. Peter's. The fountain takes the form of a triumphal arch, in keeping with the triumphal theme of Sixtus's plan as a whole. In the center arch is a marble statue of Moses striking the rock in the desert to produce a miraculous flow of water for the Israelites. Sormani, again Sixtus's choice of sculptor for the major figure, produced a dramatically posed Moses whose scale not only fills the central arch but carries the power of the figure across the piazza in front of the fountain. Like the St. Peter atop Trajan's column, the Moses had to function within a large urbanistic context, in this case addressing both the piazza and the street at the left, the Via Pia that had been built by Pope Pius IV (r. 1559–65), terminating at the city walls with a fantastical gate designed by Michelangelo.

The connection between Moses and Sixtus as leaders of their people is obvious and carries much of the same meaning that Sixtus IV had wished to convey with the frescoes on the lower walls of the Sistine Chapel from a century earlier (see Fig. 12.29), and that Julius II had intended with the Moses for his tomb (see Fig. 8.11).

Papal Basilicas

Santa Maria Maggiore Sixtus's projects for Santa Maria Maggiore demonstrate that his determined association with earlier important popes began even before his election to office. Sixtus first became a patron of the building in

25.6 Tomb of Nicholas IV, commissioned in 1573 by Felice Peretti (later Sixtus V) from **Domenico Fontana** and **Leonardo Sormani** for Santa Maria Maggiore, Rome. Marble

1573 when the tomb of Nicholas IV, the first Franciscan pope (see page 61), was rediscovered in the left transept. At that time old altars were being cleared from the crossing of the building in preparation for the Holy Year of 1575 and in response to the legislation of the Council of Trent which had stipulated that the main altar should be clearly visible

to the congregation. In Nicholas's honor, Sixtus, then a cardinal and like Nicholas a Franciscan, ordered Domenico Fontana to design a new tomb for the remains of the thirteenth-century pope (Fig. 25.6), and commissioned Leonardo Sormani to provide the sculpture of the seated pope and allegorical figures of Religion and Justice.

CONTEMPORARY SCENE

Art, Pilgrimage, and Processions

Pilgrimage and procession were familiar aspects of urban life in the Middle Ages and the Renaissance. Sites of major relics such as Rome, Assisi, Padua, Chartres, Cologne, Santiago de Compostela, and Canterbury drew pilgrims in a constant stream, their attention focused on the redemptive powers of the saint or saints whose relics they had come to venerate and upon whose intercessions they believed their salvation depended. As the hub of Christianity, Rome had the greatest concentration of shrines and relics in Europe, and its seven (an appropriately symbolic number) major basilicas formed a well-defined pilgrimage route within and immediately outside the walls of the city itself, imitating the extended pilgrimage routes that crisscrossed Europe and extended to the shrines of the Holy Land. An engraved depiction of the Holy Year of 1575

(Fig. 25.7) shows the pilgrims greeted by apparitions of the name saints of the major basilicas. St. Peter with his keys is at the bottom of the print, standing outside his own church in the Vatican, as it appeared at that time, before the lengthening of the nave and the addition of the façade we know today; the dome is only partially completed. Pilgrims kneel before him.

Apart from the basilicas, most of the city has disappeared into barren terrain, a metaphor for the penitential role that pilgrimage was meant to play. The depiction of pilgrims marching two by two from basilica to basilica is misleading, however, in its suggestion of order and decorum. Pilgrimages had their unruly moments: in the Holy Year of 1450 pilgrims pushed and jostled so on the bridge crossing the Tiber from the main part of the city to the Castel Sant'Angelo

and the Vatican that a number fell off the bridge and drowned in the river below.

Such processions served to mark the destined site as a place of importance within the culture and also to suggest the idea of a spiritual journey of preparation for their destination. Processions for religious holidays intensified the piety of the participants through spoken prayer and song, a public reaffirmation of communal devotion to the saints that protected both individuals and state. For example, the procession of Duccio's Maestà through the city of Siena in 1311 was used as an opportunity to reaffirm the city's dedication to the Virgin. Icons, banners (see Fig. 12.18), wooden statues (see Donatello's naturalistically painted crucifix, Fig. 23), or precious relics (see the reliquaries of San Gennaro in Naples, Fig. 6.4, and the jaw of St. Anthony

> in Padua, Fig. 9.20) often provided a visual focus for such processions. But processions through cities were not limited to religious events or even to civic celebrations. Criminals were paraded through cities (see Fig. 12.1) to the place of their execution, the route punctuated with stops to exhort the prisoner to prayerful penitence or to torture him as an example to bystanders of the dangers of criminal behavior. Processions such as these were intended to strengthen the social order by bringing its structures into the visual field of the population at large, just as processions of confraternity members (see Fig. 7.3) enhanced individual social position within the community.

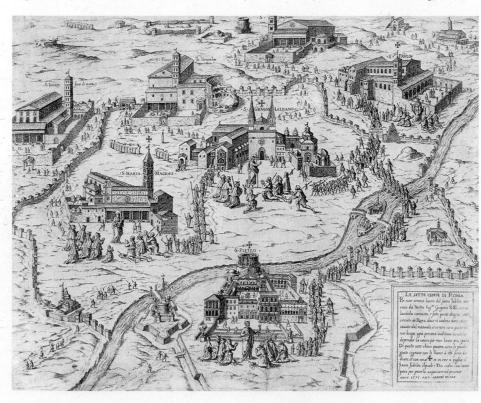

25.7 Pilgrims Visiting the Seven Churches of Rome during the Holy Year of 1575, c. 1575, Antoine Lafréry (Antonio Lafreri). Engraving (Metropolitan Museum of Art, New York) The effect of the tomb is of a decorously correct, if chilly, classicism—a foretaste of Sormani's imperial stylistic associations in Sixtus's later projects. The tomb is as interesting for the inscriptions that the future pope had placed on it as it is for its sculpture and architecture. Explicit mention is made of Nicholas IV as a professor, philosopher, and theologian; as a converter of heretics; as a foreign legate; as a peacemaker between kings; as a restorer of the papacy; as a patron of St. John Lateran and Santa Maria Maggiore; and as a man of justice and religious duty. Although the inscription praises the thirteenth-century pope, the words

could not but echo as a description of the patron. They provide an autobiographical self-fashioning for Sixtus as cardinal that gives a clear picture of his own intentions as patron and later as pope.

Immediately upon his election to the papacy in 1585 Sixtus began work on a large chapel off the right aisle of Santa Maria Maggiore (Fig. 25.8) which was ultimately to house his own tomb as well as that of the saintly Pius V (r. 1566-72), who had been his own great patron. The centrally planned Cappella Sistina, designed by Sixtus's favorite architect Domenico Fontana, is the size of a small church. It is decorated with marble revetment, two large opposing wall tombs (probably also designed by Fontana, but carved by at least four different sculptors, including two Flemish ones), and an extensive painting project. Fontana also masterminded another major engineering feat to enhance the prestige of the chapel. The reliquary shrine of the crib of Christ from Bethlehem was extracted from the rock of the crypt of Santa Maria Maggiore, where it had been the site of pilgrimage throughout the Middle Ages. Encased in a wooden frame, it was moved to Sixtus's new chapel, where it was lowered into a new subterranean site (Fig. 25.9). Thus Sixtus essentially commandeered one of the major relics of the city for his own use and was later to have the honor of being buried adjacent to its miraculous powers.

A decree of the Council of Trent stipulating that the Eucharistic host be conserved on the main altar of a church in full view of the congregation, rather than in some nearby tabernacle or chapel—as had traditionally been the case, required building renovation in virtually every Catholic church. This decree was obviously a response to Protestant denial of Christ's true presence in the Eucharist. Nevertheless, contrary to this liturgical reform (which as a theological adviser to the Council he knew only too well) Sixtus transformed his chapel into a Sacrament Chapel and commissioned Bastiano Torrigiani to make a large and dramatic

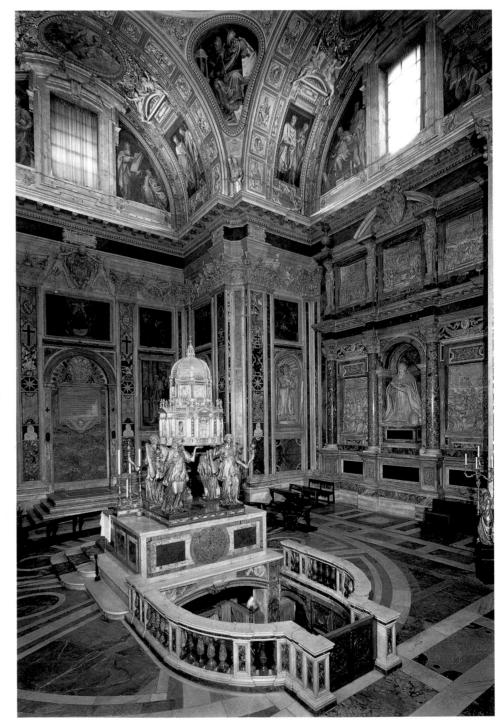

25.8 Cappella Sistina, Santa Maria Maggiore, Rome, begun 1585, commissioned by Sixtus V from **Domenico Fontana**

25.9 Della trasportatione dell'obelisco vaticano et delle fabriche di nostro signore papa Sisto V, Rome, 1590, **Domenico Fontana**, **Domenico Basa**, fol. 53, showing the installing of the manger of Christ in the Cappella Sistina, Santa Maria Maggiore, Rome. Engraving

container for the Eucharist in a form imitating the building itself. This tabernacle is now the focal point of the chapel, aligned with the entrance to the crypt housing the crib. Given the size of the Cappella Sistina, it is possible to argue that Sixtus thus provided a worthy position for the Eucharist which allowed the faithful to focus their worship in a manner intended by the Council. Notably, the two most prominent "worshipers" in the space are the sculpted kneeling figures of the two popes, Pius and Sixtus, who, from the central niches of their tombs, provide a model for the laity.

The messages of the Cappella Sistina are complex and are conveyed through a variety of means. The imperial scale and lavishness of appointment alone convey the enormous power and assurance of the patron as a universal ruler. The siting of the funerary chapel at Santa Maria Maggiore rather than at St. Peter's, then nearing completion,

manifests Sixtus's Franciscan background, as well as his devotion to the cult of the Virgin, revered in this church in a miracle-working icon, the Salus Publica (the public wellbeing), and thus carrying civic overtones. His initiative in providing a suitable funerary monument for Pius V demonstrates filial devotion to the man responsible for supporting Sixtus in his career and for making him cardinal. The two popes facing one another across the expanse of the chapel— Sixtus a Franciscan and Pius a Dominican, their monastic background precisely noted both by inscription and by the saints that flank the tombs (Francis and Anthony for Sixtus, Dominic and Peter Martyr for Pius)-also provide an image of dynastic continuity for the papacy, as well as an image of concord and conversion within the newly reformed Church. The marble reliefs decorating the tombs are typical of sixteenth-century papal tombs in containing both illustrations of important events in the individual papacies and personifications of virtues. They are therefore much like Roman imperial historical reliefs: conventional in their iconography and didactic in their intentions. Interestingly, in the case of Sixtus, the reliefs depict his attempts to make Rome a safe city. Thus, emulating Augustus's establishment of peace throughout the Empire, Sixtus freed the countryside from bandits (Fig. 25.10) and attempted-with only partial success-to make it secure. Like so many of his projects, including the Acqua Felice, these narrative reliefs underscore Sixtus's civic projects, his care as a ruler for his people, rather than simply depicting religious histories.

The Cappella Sistina in Santa Maria Maggiore also displays signs of its patron's wish to emulate its more famous namesake built by an earlier Sixtus across the Tiber (see Fig. 12.28). Its papal status is clearly indicated by the bishop's chair, centrally placed before the wall opposite the entrance. And the painted figures of Old Testament ancestors of Christ in the ceiling echo those of Michelangelo in their style. Such artistic emulation reflects not only reverence for the stylistic models but also the need of a pope to forge links with his predecessors and thus assert his legitimacy.

Sixtus also employed an international group of artists for the sculpture of the Chapel. Although their early histories are undocumented, it seems that both Egidio della Riviera (Gillis van den Vliete; ? Mechelen/Malines-1602 Rome) and Niccolò Pippi (Nicolas Piper; ? Arras-1601/04 Rome) came from northern Europe and brought with them traces of a Flemish style, visible in the decorative aspects of the drapery patterns and the vertical placement of the figures against an increasingly shallow plane to suggest space. These non-Roman details are hardly to be viewed as "foreign" elements that the sculptors had not yet excised from their stylistic vocabularies; rather they might be seen as a manifestation of the incorporative, international nature of the Church. Egidio also worked at restoring ancient sculpture early in his career, as did Vasoldo (Giovanni Antonio Paracca; ? Vasoldo-1597 Rome), so the

25.10 Sixtus V's Temporal Government with Justice and Peace, detail of Tomb of Sixtus V, commissioned by Sixtus V, design by Domenico Fontana, sculpture by Egidio della Riviera (Gillis van der Vliete), Niccolò Pippi of Arras (Mostaert), and Vasoldo (Giovanni Antonio Paracca da Vasoldo), Cappella Sistina, Santa Maria Maggiore, Rome. Marble

The soldiers carry the severed heads of bandits, against whom Sixtus was especially severe.

relief maintains a classicizing style appropriate for the new ruler of Rome, whose heraldic lions appear as supports for the obelisk behind Peace.

The Dome of St. Peter's Perhaps Sixtus's greatest symbolic architectural triumph was the completion of the dome of St. Peter's (see Figs. 22.11 and 22.12). Covering the tomb of St. Peter, the dome emphasized Sixtus's lineage from the first pope and also connected him to Julius II, who had begun the building, and to Paul III, who had reinitiated the construction after Rome was sacked. It also provided him with a cosmological form traditionally connoting universal power. The dome completed the transformation of St. Peter's into a building that differed stylistically from all the other early Christian pilgrimage sites in the city, thus providing a symbol for a renewed, invigorated, and modern Church.

Although Michelangelo seems to have planned an ogival dome, della Porta most likely intervened with his own version after Michelangelo's death to give it its present form, resolving the complex engineering problems of the dome's lateral thrusts. The double shell construction (planned by Michelangelo at the early stages of its development when he envisioned a hemispherical interior dome) allows the dome to rise high above the skyline of the city, providing a focus for attention among all the competing structures and activities of urban life and marking the power of the papacy that was able to build such an extraordinary structure. Over a century earlier Alberti had written that Brunelleschi's dome for the cathedral of Florence "covered the entire Tuscan people with its shadow." Such a metaphorical claim to territorial control certainly would have applied to the dome of St. Peter's as well, suggesting renewed order, stability, and power in the Church in an ever more complicated and expanding world. The potency of that symbolic message was so great that over the next two centuries the dome of St. Peter's echoed repeatedly in both the ecclesiastical and secular architecture of Europe and the Americas, claiming a universal presence for a state religion and an ideal social order as well. The domes of St. Paul's in London, the Pantheon in Paris, and the Capitol in Washington are the most obvious of a long line of such symbolic forms.

The search initiated by Nicholas III at the end of the thirteenth century for a visual language which would convey the dual nature of the papacy—temporal and spiritual—ends with Sixtus, whose plans for the urban transformation of Rome definitively changed European cityscapes, ultimately providing a language of temporal, not spiritual authority. The world—mirrored in the microcosm of the city—had changed, and with it so had the visual vocabulary necessary to express its meaning.

Continuity and Change

The evolving of both the Protestant and Catholic reformations, the coalescing of new nation states, the explosion of mass communication through the printed word, and the astonishing expansion of the known boundaries of the physical world had drastically altered social structures throughout Italy and the rest of Europe. Once again the visual arts responded and gave meaning to experience. Tied to economic sources, they flourished most expansively in the ever enlarging urban centers of Europe, as they had in the major cities of Milan, Venice, Florence, Rome, and Naples discussed in this book. Balancing tradition and innovation, artists and patrons shaped their cities and the art within them with renewed strength and power, more often than not employing a classicizing vocabulary which was to remain the norm until the nineteenth century.

Grand urban centers like the piazza before St. Peter's or the Capitoline Hill, wider streets, and points of triumphal focus—like Sixtus's obelisks—all provided messages about

the importance of the site and the people who governed it. Although the monumentality of these forms and the classical style used to carry their messages were more marked in the arts of the sixteenth century, they were also part of a long series of developments which this book has charted. Paul III's decision to place the equestrian statue of Marcus Aurelius on the Capitoline Hill, for example, was much more than a simple act of Roman revival. It recognized a lively tradition of equestrian imagery from the previous several centuries, encompassing fourteenth-century works such as the monuments of Bernabò Visconti in Milan and Cansignorio della Scala in Verona and the more classicizing fifteenth-century imagery of Donatello's Gattamelata in Padua and Leonardo's proposed Sforza monument in Milan. History and the meanings attached to types of artistic form continued to matter, tying the future to the past by providing a vocabulary that was familiar, accessible, and therefore meaningful to the population at large.

Within such continuities it is important to underscore changes in artistic production. Although artists were by and large still economically tied to a patronage system at the end of the sixteenth century, the Renaissance had begun a transformation of that hierarchical relationship which led ultimately in the modern world to the creation of works of art relatively free of the demands of the purchaser. Ironically, this development also allowed art to be treated as an economic commodity divorced from the functional roles it had previously played within society and thus from widespread accessibility.

Not only did the relationship between patron and artist alter, but so did the social order of the patron and the very nature of works of art available for purchase. Shifts in the economic structures of Europe and the emergence of a middle class meant that a new type of patron with radically different needs made new demands on artists. Furthermore, the removal of traditional religious imagery from some Protestant churches initiated a rethinking of appropriate subjects for painting and sculpture. This led to an explosive expansion of new genres such as portraiture, still life, and landscape within a burgher culture not only in northern European countries but in Italy as well, as the paintings of Campi and Passerotti indicate. Moreover, the expansion of the print trade not only broke down parochial boundaries of local styles, giving artists a virtually international audience, it also put art in the hands of people who would never have been able to afford to commission their own paintings. Prints, because of their size, also insisted on the very personal relationship between viewer and object, opening meditative discourse not simply about the subject matter depicted, but about technique, style, craft, and artistic genius-a discourse that would have paralleled the more structured and self-conscious discussions occurring in the ever-expanding number of academies in Europe.

Development of novel new forms like the still life were paralleled by the evolution of official histories of art that, initiated by Vasari in 1550, grew by the seventeenth century into a significant cottage industry in European intellectual history. In tandem with these histories were increasing numbers of treatises on the arts, beginning with Alberti in the mid-fifteenth century. Some were written by practicing painters, sculptors, and architects, but many of the authors came from outside the arts. Thus artists had to respond not only to the traditions inherent in the objects they produced but also to the literary constructions of their history and to the increasingly academic canons of artistic treatises, all disseminated by the still-novel printed book—a medium that made for a wider and better informed public.

Changes such as these occurred within the period itself. To these must be added subsequent re-evaluation of the Renaissance in our own time. Emerging feminist studies, for example, have rediscovered the names of women artists of the Renaissance and have begun to reinstate their work into accounts of the period. More importantly, they have focused attention on the critical roles women played as patrons within the economic structures of the culture and have analyzed how the very structures of presentation of women-and men-in Renaissance art can throw new light on social order. Interdisciplinary work by economic and political historians and by cultural anthropologists has also expanded understanding of the period by suggesting the richness of the relationships between artists and the various publics they addressed. Rather than discussing simply the artists and their work, studies of the period now consider the relationship between artist and patron, between patron and public, between artist and public, between art and the history of the site in which it was placed. They also look at a range of objects that had earlier been outside the frame narrowly construed as art-the domestic and liturgical arts, for example, where artists are for the most part anonymous, thus existing outside the biographical methods defined by Vasari for constructing artistic history. Recently, the increased overlap between material culture and art has provided new ways to construct the visual field of the period and to suggest how visual ideas entered the lived realities of their viewers.

The facts of the Renaissance are continually reconstructed by new interpretation. This book is part of that process. It has attempted to suggest some of the diversity of current historical thought while still focusing on art as a compelling, provocative, and instructive carrier of meaning. We have repeatedly pointed out that each work of art is not an independent aesthetic object, but a site embodying a complex nexus of social relationships where we can view and analyze both the coordinated and the conflicted ideas of a culture. Studying the arts of the Renaissance, then, gives enlivened meaning not just to the past but to our own time as well.

Genealogies

The following genealogies have been simplified where necessary in the interests of clarity.

Illegitimate line

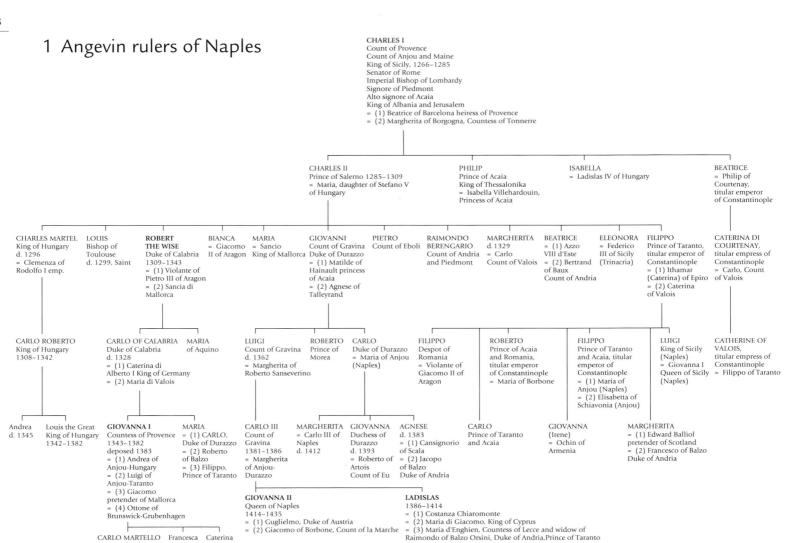

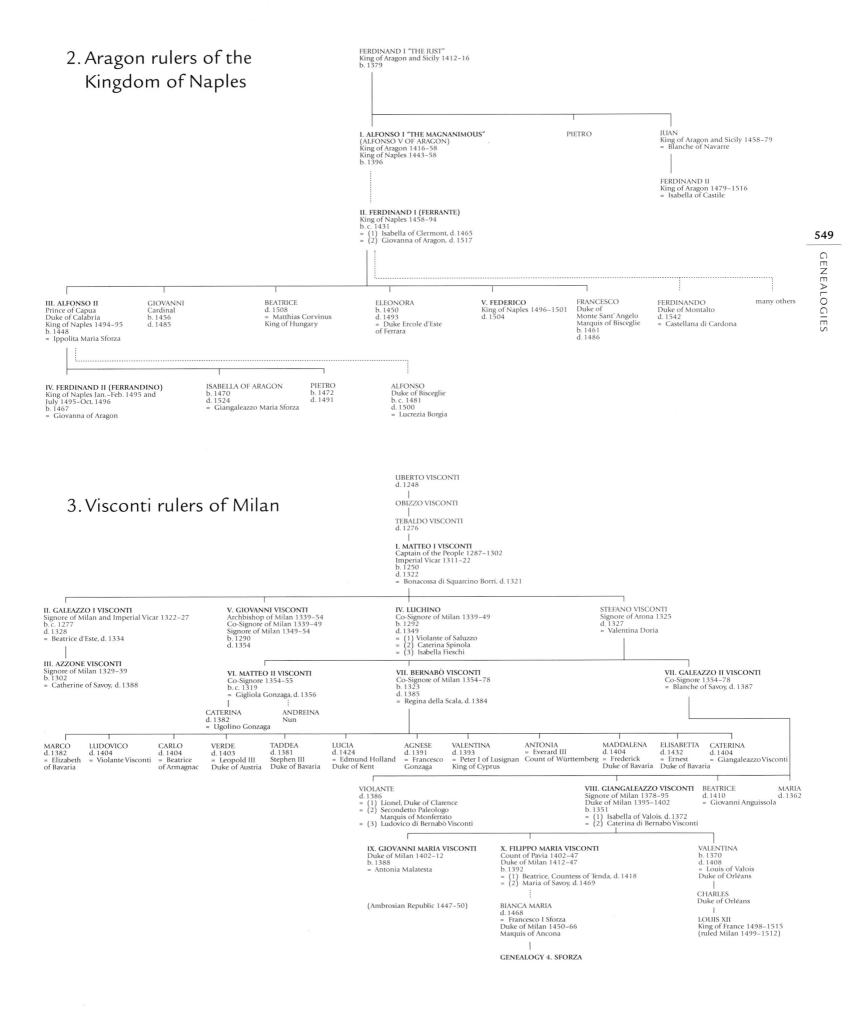

550

GENEALOGIES

MUZIO ATTENDOLO SFORZA

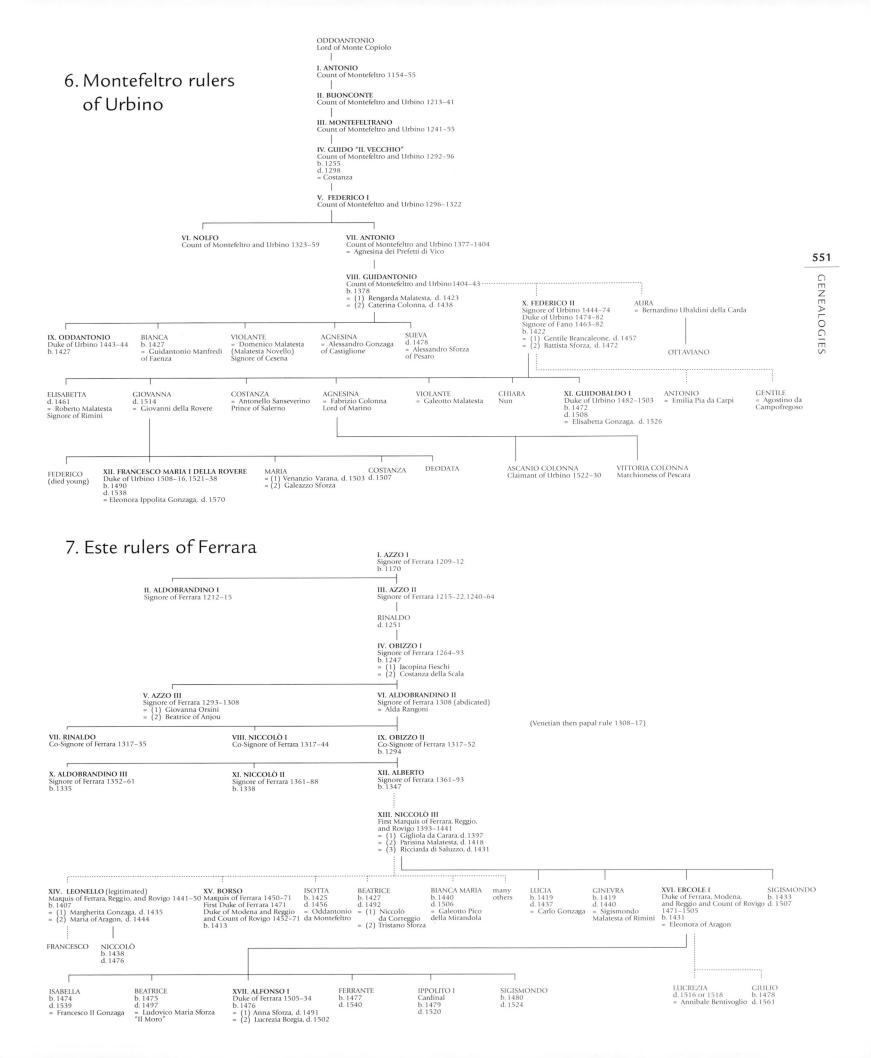

8. Medici rulers of Florence*

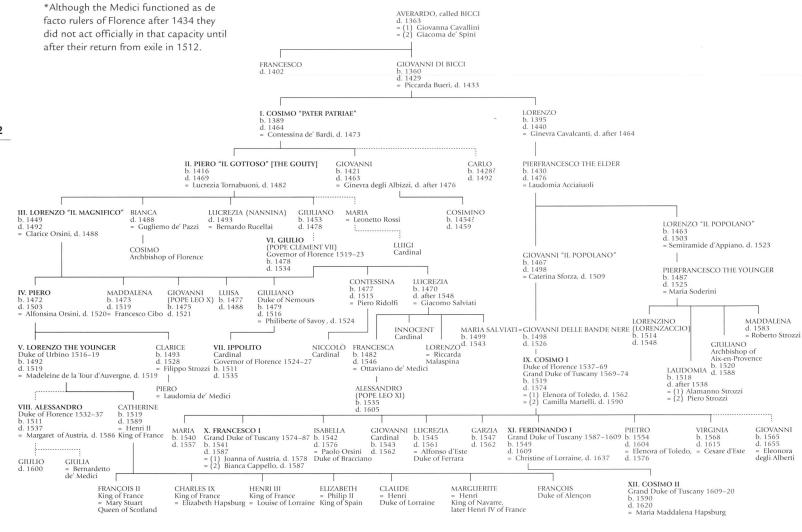

List of Popes

Nicholas III (Giovanni Gaetano Orsini, of Rome), 1277–80

Martin IV (Simon de Brion, of Montpincé in Brie), 1281–85

Honorius IV (Iacopo Savelli, of Rome), 1285–87

Nicholas IV (Girolamo Masci, of Lisciano di Ascoli), 1288–92

St. Celestine V (Pietro Angeleri da Morrone, of Isernia), July 5-December 13, 1294 (abdicated; d. 1296)

Boniface VIII (Benedetto Gaetani, of Anagni), 1294–1303

Blessed Benedict XI (Niccolò Boccasini, of Treviso), 1303-04

Clement V (Bertrand de Got, of Villandraut, near Bordeaux), 1305-14

John XXII (Jacques d'Euse, of Cahors), 1316-34

Benedict XII (Jacques Fournier, of Saverdun, near Toulouse), 1334–42

Clement VI (Pierre Roger de Beaufort, of Château Maumont, near Limoges), 1342-52

Innocent VI (Etienne d'Aubert, of Mont, near Limoges), 1352-62

Blessed Urban V (Guillaume de Grimoard, of Grisac, Languedoc), 1362–70

Gregory XI (Pierre Roger de Beaufort, of Château Maumont, near Limoges), 1370-78

Urban VI (Bartolomeo Prigano, of Naples),

Boniface IX (Pietro Tomacelli, of Naples), 1389-1404

Innocent VII (Cosimo de' Migliorati, of Sulmona), 1404-06

Gregory XII (Angelo Correr, of Venice), 1406–15 (deposed by Council of Pisa 1409; abdicated 1415; d. 1417)

POPES AT AVIGNON

Clement VII (Robert of Savoy, of Geneva), 1378–94 Benedict XIII (Pedro de Luna, of Aragon), 1394–1423

ANTIPOPES AT AVIGNON

Clement VIII (Gil Sanchez Muñoz, of Barcelona), 1423–29 Benedict XIV (Bernard Garnier), 1425–30 [?]

POPES AT PISA

Alexander V (Pietro Filargis, of Candia), 1409–10

John XXIII (Baldassare Cossa, of Naples), 1410–15 (deposed; d. 1419)

Martin V (Oddo Colonna, of Genazzano, near Rome; b. 1368), 1417–31

Eugenius IV (Gabriele Condulmer, of Venice; b. 1383), 1431–47

[Felix V (Amadeus, duke, of Savoy), 1439–49, d. 1451]

Nicholas V (Tommaso Parentucelli, of Sarzana; b. 1397), 1447-55

Callixtus III (Alfonso Borgia, of Xativa, Spain; b. 1378), 1455-58

Pius II (Aeneas Silvius Piccolomini, of Corsignano, now Pienza; b. 1405), 1458–64

Paul II (Pietro Barbo, of Venice; b. 1417), 1464-71 Sixtus IV (Francesco della Rovere, of Savona; b. 1414), 1471–84

Innocent VIII (Giovanni Battista Cibo, of Genoa; b. 1432), 1484–92

Alexander VI (Rodrigo Borgia, of Valencia, Spain; b. c. 1431), 1492–1503

Pius III (Francesco Todeschini-Piccolomini, of Siena; b. 1439), September 22-October 18, 1503

Julius II (Giuliano della Rovere, of Savona; b. 1443), 1503–13

Leo X (Giovanni de' Medici, of Florence; b. 1475), 1513–21

Adrian VI (Adrian Florisz Dedel, of Utrecht, Netherlands; b. 1459), 1522–23

Clement VII (Giulio de' Medici, of Florence; b. 1478), 1523–34

Paul III (Alessandro Farnese, of Camino, Rome, or of Viterbo [?]; b. 1468), 1534-49

Julius III (Giovanni Maria Ciocchi del Monte, of Monte San Savino, near Arezzo; b. 1487), 1550–55

Marcellus II (Marcello Cervini, of Montefano, Macerata; b. 1501), April 9–30, 1555

Paul IV (Giovanni Pietro Carafa, of Capriglio, Avellino; b. 1476), 1555–59

Pius IV (Giovanni Angelo de' Medici, of Milan; b. 1499), 1559-65

Pius V (Antonio Ghislieri, of Bosco Marengo, near Tortona; b. 1504), 1566-72

Gregory XIII (Ugo Boncompagni, of Bologna; b. 1502), 1572–85

Sixtus V (Felice Peretti, of Grottammare; b. 1520), 1585-90

List of Venetian Doges

Marino Morosini, 1249-53 Raniero Zen, 1253-68 Lorenzo Tiepolo, 1268-75 Iacopo Contarini, 1275-80 Giovanni Dandolo, 1280-89 Pietro Gradenigo, 1289-1311 Marino Zorzi, 1311-12 Giovanni Soranzo, 1312-28 Francesco Dandolo, 1329-39 Bartolomeo Gradenigo, 1339-42 Andrea Dandolo, 1343-54 Marin Falier, 1354-55 (deposed and decapitated) Giovanni Gradenigo, 1355-56 Giovanni Dolfin, 1356-61 Lorenzo Celsi, 1361-65

Andrea Contarini, 1368–82
Michele Morosini, 1382
Antonio Venier, 1382–1400
Michele Steno, 1400–13
Tomaso Mocenigo, 1414–23
Francesco Foscari, 1423–57
(deposed)
Pasquale Malipiero, 1457–62
Cristoforo Moro, 1462–71
Nicolò Tron, 1471–73
Nicolò Marcello, 1473–74
Pietro Mocenigo, 1474–76
Andrea Vendramin, 1476–78
Giovanni Mocenigo, 1478–85
Marco Barbarigo, 1485–86

Marco Corner, 1365-68

Agostino Barbarigo, 1486-1501 Leonardo Loredan, 1501-21 Antonio Grimani, 1521-23 Andrea Gritti, 1523-38 Pietro Lando, 1539-45 Francesco Donato, 1545-53 Marcantonio Trevisan, 1553-54 Francesco Venier, 1554-56 Lorenzo Priuli, 1556-59 Girolamo Priuli, 1559-67 Pietro Loredan, 1567-70 Alvise I Mocenigo, 1570-77 Sebastiano Venier, 1577-78 Nicolò da Ponte, 1578-85 Pasquale Cicogna, 1585-95 Marino Grimani, 1595-1605

Time Chart

	1200-1300	1300-40	1340-90	1390-1430
POLITICS	 1204 Venetians sack Constantinople 1215 King John of England signs the Magna Carta 1265 Charles of Anjou claims Kingdom of Naples 1295 Visconti assume power in Milan 1297 The serrata in Venice closes and defines membership in the governing noble class 	1339 Beginning of the Hundred Years' War	1346 Bardi and Peruzzi banks fail in Florence 1347 Cola di Rienzo takes control of Rome 1347 First reported outbreak of Black Death; it strikes Italy with devastating losses in summer 1348 1355 The Nine fall from power in Siena 1385 Giangaleazzo Visconti unites rule of Milan and Pavia	 1395 Giangaleazzo Visconti named Duke of Milan 1397 Medici Bank founded in Florence 1406 Venetians gain control of Padua 1409 King Ladislas of Naples gains control of Rome and Papal States 1425 Florence, Venice, and the papacy ally against Milan 1427 Catasto (property tax) established in Florence
RELIGION	1215 Fourth Lateran Council codifies major aspects of Church doctrine 1223 St. Francis establishes first Nativity scene at Greccio 1228 Canonization of St. Francis 1234 Canonization of St. Dominic 1262 Bonaventure commissioned to write the Legenda Maior; completed 1266 1300 Pope Boniface VIII declares first Jubilee in Rome	1309 Papacy establishes permanent residence in Avignon	1368 St. Catherine of Siena experiences a mystical marriage with Christ 1378 Beginning of the Great Schism	1417 Council of Constance deposes competing popes and elects Martin V 1420 Pope Martin V enters Rome 1431 Joan of Arc burnt at the stake
LITERATURE AND LEARNING	1225 St. Francis composes Canticle of the Sun	1308 Dante begins the <i>Divine</i> Comedy in Ravenna c. 1330 Galvano Fiamma revives classical notion of magnificence	1341 Petrarch crowned poet laureate on Capitoline Hill 1351 Boccaccio completes the Decameron 1379 Publication of Petrarch's Famous Men 1387 Chaucer begins the Canterbury Tales	1396 Florentines invite the Byzantine scholar Manuel Chrysoloras to revive the study of Greek in Italy 1410 Rediscovery of Ptolemy's Geography
VISUAL ARTS	1265 Operai of Siena Cathedral commission pulpit from Nicola Pisano 1266 Venetians enlarge and pave Piazza San Marco c. 1290 Last Judgment for Santa Cecilia in Trastevere commissioned from Cavallini 1299 Palazzo della Signoria begun in Florence	1302 Enrico Scrovegni commissions Giotto to fresco Arena Chapel, Padua 1308 Operai of Siena Cathedral commission Maestà from Duccio 1310 Queen Sancia of Mallorca founds Santa Chiara, Naples 1330 Arte del Calimala commissions bronze doors for Florence Baptistry from Andrea Pisano c. 1330 Azzone Visconti builds palace complex at San Gottardo, Milan	c. 1343 King Robert of Anjou gives directions for his tomb monument in Santa Chiara, Naples 1345 Doge Andrea Dandolo renovates Pala d'Oro in Venice c. 1363 Bernabò Visconti commissions equestrian monument from Bonino da Campione 1370s Lupi family commissions frescoes for St. James Chapel in the Santo, Padua, from Altichiero 1373 Florentines begin construction of Loggia della Signoria	1390 Francesco the Younger Carrara commissions antiqu coins of his father in Padua 1390s Giangaleazzo Visconti commissions Ivory Triptych from Baldassare Embriachi for the Certosa, Pavia 1401 Competition for Baptistry doors, Florence 1414 Queen Giovanna of Naples commissions tomb for her brother King Ladislas from Andrea and Matteo Nofri 1421 Marco Contarini oversees construction and decoratior of his family home, the Ca' d'Oro, Venice c. 1424 Felice Brancacci commissior Masaccio and Masolino to fresco the family chapel, Sar Maria del Carmine, Florence

1430-65	1465-1500	1500-30	1530-60	1560-1600
 1433 Medici exiled from Florence; return following year 1443 Triumphal entry of Alfonso of Aragon into Naples 1447 Establishment of Ambrosian Republic in Milan 1450 Francesco Sforza assumes power in Milan 1452 Borso d'Este acquires title of Duke of Ferrara and Reggio 1453 Fall of Constantinople to the Turks 1454 Peace of Lodi establishes boundaries of major powers in Italy for most of the rest of the century 	1478 Pazzi Conspiracy fails in its attempt to overthrow the Medici in Florence 1479 Venetians establish peace with Turks and Sultan Muhammad II 1486 Portuguese explorers round the Cape of Good Hope 1492 Columbus lands in the Indies 1494 Ludovico Sforza named Duke of Milan 1494 King Charles VIII of France invades Italy 1494 Medici expelled from Florence	1501 Amerigo Vespucci sails to South America 1509 League of Cambrai unites major powers against Venice 1512 Medici return to control in Florence 1519 Magellan begins circumnavigation of the globe 1527 Mercenaries of Charles V sack Rome 1530 Charles V crowned Emperor in Bologna by Pope Clement VII	1537 Cosimo I de' Medici assumes power in Florence	1565 Foundation of St. Augustine, Florida 1569 Cosimo I de' Medici named Grand Duke of Tuscany 1571 Turkish fleet defeated by Spaniards and Venetians at Battle of Lepanto
 1438 Council of Ferrara 1439 Council of Florence unites Eastern and Western Churches 1444 St. Bernardino of Siena dies 1450 Pope Nicholas V declares Jubilee in Rome 	1497 Savonarola institutes "Bonfires of the Vanities" in Florence	1507 Pope Julius II issues indulgences to rebuild St. Peter's 1517 Luther issues his 95 Theses calling for Church reform 1521 Diet of Worms condemns Luther	 1536 John Calvin publishes Institutes of the Christian Religion 1540 Ignatius Loyola founds Society of Jesus (Jesuits) 1545 Pope Paul III opens Council of Trent 1557 Cardinal Carafa issues first Index of Prohibited Books 	 1563 Council of Trent issues final decrees 1566 Publication of the Roman Catechism 1573 Veronese appears before the Inquisition 1582 Pope Gregory XIII reforms the calendar
 1435 Alberti's treatise On Painting 1443 Della famiglia by Alberti 1456 Gutenberg produces first printed Bible 	 1465 First printing press in Italy set up in Subiaco, near Rome 1466 Marsilio Ficino begins translations of Plato's Dialogues 1468 Cardinal Bessarion leaves his library to the Venetian state 1475 Sixtus IV establishes the Vatican Library 1490 Aldus Manutius establishes Aldine Press in Venice 	 1509 Publication of Praise of Folly by Erasmus 1513 Machiavelli writes The Prince 1516 Publication of Orlando Furioso by Ariosto 1517 Publication of Thomas More's Utopia 1528 Publication of Castiglione's Book of the Courtier 	 1537 Aretino declares Titian's manner as his aesthetic model 1543 Publication of Copernicus' On the Revolution of Heavenly Orbs 1543 Andrea Vesalius publishes first scientific text on human anatomy 1550 Vasari publishes first edition of Lives of the Artists 1555 Olympic Academy founded in Vicenza 	 1561 Francesco Guicciardini begins publishing History of Italy 1562 Vasari founds Accademia del Disegno, Florence 1570 Palladio publishes The Four Books of Architecture 1575 Tasso at work on Jerusalem Liberated 1577 Charles Borromeo publishes treatise on church decoration 1596 Shakespeare's Romeo and Juliet
 Doge Francesco Foscari commissions the decoration of the Cappella Nova, St. Mark's, Venice Cosimo de' Medici commits to paying for 	1469 Abbot Donà commissions San Michele in Isola from Mauro Codussi 1476 Federigo da Montefeltro commissions intarsia decorations for his studiolo	1506 Pope Julius II breaks ground for new St. Peter's 1508 Michelangelo signs contract with Julius II for Sistine Ceiling 1516 Abbot Germano Gaiole	1534 Pope Paul III commissions Last Judgment for Sistine Chapel from Michelangelo 1537 Venetian government commissions Library from Jacopo Sansovino	1565 Cosimo de' Medici and Giorgio Vasari strip and refurbish Santa Croce and Santa Maria Novella, Florence 1566 Benedictines of San Giorgio
construction of nave of San Lorenzo, Florence 1447 Ludovico Gonzaga commissions Lancelot frescoes in Mantua from Pisanello 1452 Alfonso of Aragon commissions Sala dei Baroni, Naples, from Guillermo Sagrera 1462 Pope Pius II transforms birthplace into Pienza	in Urbino 1477-81 Pope Sixtus IV builds the Sistine Chapel 1481 Monks of San Donato, Scopeto, commission Adoration of the Magi from Leonardo da Vinci 1485 Scuola di San Marco, Venice, commissions new headquarters from Mauro Codussi after fire c. 1493 Ludovico Sforza commissions new tribune for Santa Maria delle Grazie, Milan, probably from Bramante	commissions Assumption Altarpiece from Titian for high altar, Santa Maria Gloriosa dei Frari, Venice 1525 The Medici commission Hercules and Cacus from Baccio Bandinelli	1548 Titian in Augsburg working for Emperor Charles V c. 1560 Duke Cosimo commissions Uffizi from Giorgio Vasari	Maggiore, Venice, commission new church from Palladio 1568 Cardinal Farnese provides funds for the Gesù 1573 Charles Borromeo orders rebuilding of San Lorenzo Maggiore, Milan

Glossary

- a secco See fresco.
- aedicule A decorative architectural frame around a door, window, or niche consisting of an entablature and pediment supported by two columns or pilasters.
- all'antica In Greek or Roman classical style.
 ambulatory A vaulted passageway or aisle that leads around the apse of a Christian church.
- **antipope** Any pope elected in opposition to another held to have been canonically chosen.
- apse A semicircular or polygonal recess at the end of the major axis of a Roman basilica or Christian church.
- architectonic Relating to architecture or resembling the spatial and structural aspects peculiar to architecture.
- architrave The lowest part of an entablature, beneath the frieze and cornice, resting directly on the capital of a column; also the frame over a door or window.
- **articulated** Defined, normally by distinct architectural features.
- attached column A column that is attached to a background wall and is therefore not completely cylindrical; also referred to as an engaged column.
- **attic story** In classical architecture the story above the main entablature.
- **Augustan** Relating to the reign of the Roman Emperor Augustus from 27 B.C.E. to 14 C.E.
- **baldacchino** A canopy placed over an honorific or sacred space such as a throne or church altar.
- **banderole** A narrow handheld scroll, usually flowing free as if blown by the wind, and normally carrying an inscription.
- barrel vault A ceiling in the form of a semicircular
- basilica In ancient Roman architecture, a large rectangular public building with an open interior space, usually with side aisles separated from the main space by rows of evenly spaced columns. The structure was later adopted as a building type for Early Christian churches.
- **basket capital** A column capital decorated with a latticework pattern resembling basketweave.
- **bole** A red claylike pigment used as the ground for gold leaf.
- **burin** A tool with a sharp, triangular-shaped metal point used for cutting lines to be printed from metal and wood blocks.
- cantoria The Italian word for a balcony for singers and musicians.
- cartoon A full-scale preparatory drawing on paper which is used to transfer the outline of a design onto the surface to be painted; from the Italian "cartone," meaning heavy paper.
- cassone Italian for "large case" or "large chest," referring to carved and painted chests used to hold clothing, often given as gifts to a prospective bride for her dowry by her future husband.

- centering Temporary wooden scaffolding and supports erected in the construction of vaults, arches, or domes.
- chancel The eastern portion of a Christian church, reserved for the clergy and choir and often separated from the main body of the church by a screen, rail, or steps. The term is also used to describe the entire east end of a church beyond the crossing.
- chiaroscuro An Italian word literally meaning "light-dark," used to describe the dramatic contrast of light and dark in painting to create effects of three-dimensionality.
- ciborium A type of baldacchino: a canopy supported on columns over the altar or other place of sacred significance in a Christian church; also used to refer to small architectural wall enclosures used for the reservation of the elements of the Eucharist between religious services.
- cloisonné A multicolored surface made by pouring enamels into compartments outlined by bent wire fillets or strips.
- coffering Recessed panels, square or polygonal, that decorate a vault, ceiling, or the underside of an arch (soffit).
- colorito A term characterizing Venetian painting of the sixteenth century where form is created by the pre-application of pigment on the painted surface and by the building of forms through a successive layering and interaction of pigment; opposite of disegno.
- **Composite order** Architectural system using a column capital consisting of two rows of acanthus leaves at the bottom and Ionic volutes above.
- compound pier A pier or large column with several engaged shafts or pilasters attached to it on one or all sides. These structural supports are found in both Romanesque and Gothic architecture.
- console A bracket, usually formed of volute scrolls, projecting from a wall to support a lintel or other member.
- contrapposto Italian for "set against" or "counterposed." Derived from ancient art, it gives freedom to the representation of the human figure by counterpoising parts of the body around a central vertical axis. Most of the weight is placed on one leg with an S-curve in the torso. Normally movement of engaged and relaxed parts alternates left-right through the figure.
- Corinthian column An order in Greek architecture characterized in part by its elongated and refined forms, including column capitals composed of deeply cut and symmetrically arranged acanthus
- cornice The uppermost, projecting portion of an entablature; also the crowning ornamental molding along the top of a wall or arch.

- counter-maniera Term used to indicate a style opposed to Mannerism, using direct and naturalistic presentation of the subject.
- crenellation A pattern of open notches built into the top parapets and battlements of many fortified buildings for the purpose of defense.
- crocket In Gothic architecture, a decorative feature, usually shaped like a curling leaf, projecting at regular intervals from the angles of spires, pinnacles, and gables.
- **cruciform** Shaped like a cross, such as the plan of a church.
- **cupola** A rounded, convex roof or vaulted ceiling (dome).
- **cusping** In architecture, a pair of curves tangent to the line defining the area, decorated and meeting at a point within the area.
- diaper A pattern of small, identical, nonfigurative, usually geometrical, units adopted as a means of covering a surface or as a background for figurative work.
- **diaphragm arch** A transverse arch across the nave of a church partitioning the roof and the space of the building into sections.
- diptych A work consisting of two images (usually paintings on panel) side by side, traditionally hinged to be opened and closed.
- disegno Literally "design" or "drawing," a term used in central Italian art to describe the creation of figures and volume through a sharply defined drawn line; opposite of colorito.
- **elevation** The vertical organization of the face of a building; also an architectural drawing made as if projecting on a vertical plane to show any one side, exterior or interior, of a building.
- **entablature** The upper part of a classical architectural order above the columns and capitals and comprising architrave, frieze, and cornice.
- entasis The slight swelling in the shaft of a column as it tapers toward the top to give added vertical thrust to the column and a visual vitality to the form
- ex voto An offering made by a worshiper to the deity or saint being prayed to, either in thanksgiving or supplication.
- **fictive** Surrogate, or painted to look as if the image represents an actual object; normally used as part of wall decorations, for example feigning tapestry or niches.
- **figural (or figurative)** Representing the likeness of a recognizable human (or animal) figure; also a work whose principal subject consists of representations of human beings.
- fresco A wall painting technique in which pigments are applied to a surface of wet plaster (called buon fresco). Painting on dry plaster (called fresco a secco) is a less durable technique as the paint tends to flake off with time.

- **frieze** The flat middle division of an entablature usually decorated with moldings, sculpture, or painting. Also used loosely to describe any sculpted or decorated horizontal band.
- gonfaloniere Literally the standard-bearer or the person who carried the flag (gonfalone), a term referring to an elected head of a republican state or, sometimes, a confraternal order.
- gesso A fluid white coating of finely ground plaster and glue used to prepare a painting surface (such as a wooden panel for tempera painting) so that it will accept paint readily and allow controlled brushstrokes.
- giant (colossal) order A form of architectural decoration in which applied columns or pilasters extend over more than one story of a building from the ground to the cornice, uniting the entire structure in a single compositional scheme.
- glair A glaze or size made of egg white.
- grisaille A painting in various shades of gray, sometimes suggesting low relief.
- **Hellenistic** Relating to the time from the death of Alexander the Great in 323 B.C.E. to the first century B.C.E.
- **hemicycle** A semicircle or semicircular structure. **herm** Used in architectural decoration, this is a rectangular plain pillar which terminates in the head and torso of a human.
- iconography Visual conventions and symbols used to portray ideas and identify individuals and attributes in a work of art.
- illusionistic A type of art in which space and objects are intended to appear real by the use of artistic devices such as perspective and foreshortening.
- impasto Oil paint thickly applied.
- impost block A decorative block with splayed sides placed between the abacus and capital on a column or pier.
- intarsia The decoration of wood surfaces (panelled walls, chests, and choirstalls) with inlaid designs created from colorful and contrasting woods and other materials such as ivory, metal, and shell.
- lancet window A tall, slender window with a sharply pointed arch (like a lance), common in Gothic architecture.
- **lantern** In architecture, a small circular turret with windows all around, crowning a roof or dome.
- loggia The Italian term for a room or small building open on one or more sides with columns to support the roof.
- lost-wax method Also known as cire-perdue. A method of casting metal such as bronze by a process in which wax is used to coat an original rough model, which is then worked in finer detail. The finished model is coated with plaster, then heated so that the wax melts away, leaving an empty space into which molten metal is poured.
- mandorla An upright almond (mandorla) shape representing a radiance of light in which a sacred figure, such as Christ, is represented.
- Mannerism A style most commonly associated with the arts of central Italy during the sixteenth century, characterized by its extreme artificiality and elegance.
- martyrium A church or other building erected on a site sacred to Christianity, symbolizing a place of martyrdom or marking the grave of a martyr.
- **membering** The subordinate architectural structural features of a building.
- metope In architecture, the square area between the triglyphs of a Doric frieze, often decorated with relief sculpture.

- **narthex** An enclosed rectangular porch or vestibule at the main entrance of a church which extends across the entire facade of the structure.
- **niche** A concave recess in a wall, often used to house statuary.
- nymphaeum A form of secluded antique garden architecture often involving pools or fountains, meant to call up the playful woodland environments of nymphs.
- oculus In architecture, a circular opening in a wall
- Opera The board of works of a cathedral, normally presided over by an official—sometimes elected, sometimes appointed—called an operatio.
- order One of the architectural systems (Doric, Ionic, Corinthian) used by the Greeks and Romans to decorate and define the post and lintel system of construction; also a monastic society or fraternity.
- **orthogonals** Diagonal lines moving to the centric point in a painting or relief, in accordance with the laws of linear perspective.
- pastiglia Raised plaster detailing.
- **pendentive** An inverted, concave, triangular area of wall serving as the transition from a square support system to the circular base of a dome.
- pietra serena A clear gray Tuscan limestone used in
- **pilaster** A decorative structural feature looking like a flattened column, projecting slightly from the face of a wall.
- **plate tracery** Decorative framing within an opening, usually a window, in which details are inscribed on the surface rather than cut free.
- podestà A chief magistrate in Italian medieval towns and republics.
- poesia Literally "poetry," an evocative form of narrative presentation meant to suggest rather than describe possible interpretations.
- **polychromy** The use of many colors in a painting, sculpture, or building; also the coloring applied to the surface of sculpture and architectural details.
- **polyptych** A painting or relief, usually an altarpiece, constructed from multiple panels and sometimes hinged to allow for movable side panels or wings.
- **predella** The platform on which an altarpiece is set, often decorated with narrative sculpture or painting relating to the main subject.
- **punch work** Decorative designs that are stamped onto a surface such as leather, metal, or the gilded plaster background of panel paintings using a handheld metal tool (punch).
- putto(i) The Italian term for a full-length cherub figure—normally male.
- quatrefoil panel A decorative four-leaf clover shape superimposed on a diamond, used in Gothic architecture and art.
- **reliquary** A receptacle, often made of precious materials, used to house a sacred relic.
- rinceau(x) A garland of leafwork.
- Romanesque An artistic style of the Middle Ages (c. 1000–1200) drawing its name from the use of rounded arches, tunnel vaults, and other features of Roman architecture. In painting and sculpture works are often broad and monumental, with an emphasis on two- rather than three-dimensional design
- **rondels** Small round windows, or motifs resembling such apertures.
- rustication The appearance of rough-cut masonry blocks on a wall achieved by beveling edges so that the apparent joints are indented.

- sacra conversazione Italian term for "sacred conversation"; in art, the depiction of the Virgin and Child flanked by saints in such a way that they occupy a single pictorial space.
- sacristy In a Christian church, the room where the priest's vestments and the sacred vessels are housed.
- schiacciato Italian for "squashed," referring to very thin reliefs often barely incised on a surface.
- **scuola** A Venetian term for a religious confraternity of laypeople.
- sgraffito A decorative technique in which a surface layer of paint, plaster, or slip is incised to reveal a ground of contrasting color.
- soffit The underside of an arch.
- squinch An arch or system of concentrically wider and gradually projecting arches placed diagonally to support a polygonal or circular dome on a square base.
- **stele** An upright slab with an inscription or relief carving, usually commemorative.
- **stringcourse** A continuous horizontal band decorating the face of a wall.
- **tabernacle** A canopied recess containing an image; or an ornamental receptacle for the consecrated host, usually in the form of a miniature building placed on an altar.
- tempera Paint consisting of pigment dissolved in water and mixed with a binding medium, usually the yolk (but sometimes also the white) of an egg. Egg tempera was the principal technique for panel painting from the thirteenth to the fifteenth centuries, when it was gradually superseded by oil painting.
- **tempietto** A small temple-like structure, usually round or polygonal.
- terra verde Italian for "green earth," the color used for the underpaint of flesh tones in tempera painting; sometimes used for monochrome painting.
- tondo A painting or relief of circular shape.
- **trabeated** An architectural system using a horizontal beam over supports (synonymous with post and lintel).
- **tribune** The apse of a basilica; also an alternative term for a gallery—the upper story over an aisle—in a Romanesque or Gothic church.
- triglyph In a Doric frieze, the rectangular area between the metopes, decorated with three vertical grooves.
- trilobed Having three lobes.
- triptych A painting, usually an altarpiece, made up of three panels, the center one of which is usually larger than the other two.
- trompe-Poeil An illusionistic painting intended to "deceive the eye" into believing that the subject depicted actually exists in three-dimensional reality.
- truss In architecture, a framework of wood or metal beams, usually based on triangles, used to support a roof or bridge.
- two-point perspective In linear perspective drawings, the representation of a three-dimensional form viewed from an angle, so that the lines formed by its horizontal edges will appear to diminish to two different vanishing points on the horizon.
- **tympanum** A semicircular area formed by the intersection of a wall and an arch or vault; often decorated with sculpture.
- **vault** An arched ceiling or roof made of stone, brick, or concrete which spans an interior space.
- verism A style capturing the exterior likeness of an object or person, usually by rendering its visible details in a finely executed, meticulous manner.
- volute The spiral scroll on capitals of Ionic columns.

Bibliography

GENERAL

- Ames-Lewis, Francis. *The Intellectual Life of the Early Renaissance Artist.* New Haven: Yale University Press, 2000.
- Barkan, Leonard. Unearthing the Past: Archaeology and Aesthetics in the Making of Renaissance Culture. New Haven: Yale University Press, 1999
- Barker, Emma, Nick Webb, and Kim Woods. *The Changing Status of the Artist.* New Haven/London: Yale University Press, 1999.
- Barolsky, Paul. Michelangelo's Nose: A Myth and its Maker. University Park: Pennsylvania State University Press, 1990.
- —. Why Mona Lisa Smiles and Other Tales by Vasari. University Park: Pennsylvania State University Press, 1991.
- —. Giotto's Father and the Family of Vasari's Lives. University Park: Pennsylvania State University Press, 1992.
- Baxandall, Michael. Giotto and the Orators: Humanist Observers of Painting in Italy and the Discovery of Pictorial Composition 1350–1450. Oxford: Clarendon Press, 1971.
- Blunt, Anthony. *Artistic Theory in Italy,* 1450–1600. Oxford: Clarendon Press, 1959.
- Bober, Phyllis Pray, and Ruth Olitski Rubinstein. *Renaissance Artists and Antique Sculpture: A Handbook of Sources.* New York: Oxford University Press, 1986.
- Burckhardt, Jacob. The Civilization of the Renaissance in Italy. Oxford: Phaidon, 1965.
- Cole, Alison. Virtue and Magnificence: Art of the Italian Renaissance Courts. New York: Abrams/Prentice Hall, 1995.
- Cole, Bruce. *The Renaissance Artist at Work:* From Pisano to Titian. New York: Harper & Row, 1983.
- Cropper, Elizabeth. "On Beautiful Women, Parmigianino, *Petrarchismo*, and the Vernacular Style," *Art Bulletin*, 58, 1976, 374–94.
- Derbes, Anne and Amy Neff. "Italy, the Mendicant Orders, and the Byzantine Sphere," in *Byzantium, Faith and Power* (1261–1557). New Haven: Yale University Press, 2004, 101–33.
- Fantoni, Marcello, Louisa C. Matthew, and Sara F. Matthews-Grieco (eds.). *The Art Market* in Italy, 15th-17th Centuries / Il Mercato dell'Arte in Italia, secc. XV-XVII. Ferrara: Franco Cosimo Panini Editore, 2003.
- Freedberg, David. *The Power of Images*. Chicago: University of Chicago Press, 1989.
- Gilbert, Creighton E. *Italian Art*, 1400–1500. Englewood Cliffs, NJ: Prentice Hall, 1980.

- —. "What Did the Renaissance Patron Buy?," Renaissance Quarterly, 51, 1998, 392-450.
- Goffen, Rona. Renaissance Rivals: Michelangelo, Leonardo, Raphael, Titian. New Haven and London: Yale University Press, 2002.
- Goldthwaite, Richard A. Wealth and the Demand for Art in Italy, 1300–1600. Baltimore: Johns Hopkins University Press, 1993.
- Hartt, Frederick and David G. Wilkins. History of Italian Renaissance Art (5th edn.). New York: Harry N. Abrams Inc. and Prentice Hall, 2003.
- Jacobs, Fredrika H. Defining the Renaissance Virtuosa: Women Artists and the Language of Art History and Criticism. New York: Cambridge University Press, 1997.
- Kempers, Bram. Painting, Power, and Patronage: The Rise of the Professional Artist in the Italian Renaissance. London: Penguin, 1992.
- Kent, F.W. and Patricia Simmons, with J.C. Eade. Patronage, Art and Society in Renaissance Italy. Oxford: Oxford University Press, 1987.
- King, Catherine. Renaissance Women Patrons: Wives and Widows in Italy, c. 1300–1550. Manchester: Manchester University Press, 1998.
- Klein, Robert, and Henri Zerner. *Italian Art,* 1500–1600. Englewood Cliffs, NJ: Prentice Hall, 1966.
- Larner, John. Culture and Society in Italy, 1290–1420. London: Batsford, 1971.
- Lazzaro, Claudia. *The Italian Renaissance Garden*. New Haven: Yale University Press, 1990.
- Martindale, Andrew. *The Rise of the Artist in the Middle Ages and the Early Renaissance*. New York: McGraw-Hill, 1972.
- Norman, Diana (ed.). Siena, Florence and Padua: Art, Society and Religion, 1280–1400 (2 vols.). London/New Haven: Yale University Press, 1995.
- Panofsky, Erwin. *Renaissance and Renascences*. New York: Harper & Row, 1960.
- Parshall, Peter. "Imago contrafacta: Images and Facts in the Northern Renaissance," Art History, 16, 1993, 554–79.
- Reiss, Sheryl E. and David G. Wilkins (eds.). Beyond Isabella: Secular Women Patrons of Art in Renaissance Italy. Kirksville, MO: Truman State University Press, 2001.
- Shearman, John. Mannerism.
- Harmondsworth/Baltimore: Penguin, 1967. Smyth, Craig Hugh. *Mannerism and Maniera*. Locust Valley, NY: J.J. Augustin, 1961.
- Steinberg, Leo. *The Sexuality of Christ in Renaissance Art and Modern Oblivion*. New York: Pantheon, 1983.
- Tinagli, Paola. Women in Italian Renaissance Art. Manchester: Manchester University Press, 1997.

- Vasari, Giorgio. Lives of the Most Eminent Painters, Sculptors, and Architects (3 vols., trans. Gaston Du C. de Vere, ed. Kenneth Clark). New York: Abrams, 1979.
- Verdon, Timothy, and John Henderson. Christianity and the Renaissance. Syracuse: Syracuse University Press, 1990.
- Waley, Daniel. *The Italian City-Republics*. New York/Toronto: McGraw-Hill, 1969.
- Warnke, Martin. The Court Artist, On the Ancestry of the Modern Artist (trans. David McLintock). Cambridge: Cambridge University Press, 1993
- Welch, Evelyn S. Art in Renaissance Italy, 1350–1500. Oxford: Oxford University Press, 1997. reissued 2000.
- White, John. *Art and Architecture in Italy,* 1250–1400 (3rd edn.). Pelican History of Art. New Haven: Yale University Press, 1993.
- —. Studies in Late Medieval Italian Art. London: Pindar Press, 1984.
- Wohl, Hellmut. The Aesthetics of Italian Renaissance Art: A Reconsideration of Style. New York: Cambridge University Press, 1999.

ARCHITECTURE

- Clark, Georgia. Roman House Renaissance Palaces: Inventing Antiquity in Fifteenth-Century Italy. Cambridge: Cambridge University Press, 2003
- Goldthwaite, Richard A. *The Building of Renaissance Florence: An Economic and Social History*. Baltimore: Johns Hopkins University Press, 1980.
- Heydenreich, Ludwig H., and Wolfgang Lotz. Architecture in Italy, 1400–1600. Harmondsworth: Penguin, 1974.
- Toker, Franklin L. "Building on Paper: The Role of Architectural Drawings in Late-Medieval Italy," in L'Art et les Révolutions.

 Section 8. Table ronde: Technique, structure et style de l'architecture gothique (ed. A.M. Romanini), XXVIIe congrès international d'histoire de l'Art.

 Strasbourg: Société Alsacienne pour le Développement de l'Histoire de l'Art, 1992, 31-50.
- Wagner-Rieger, Renate. Die italienische Baukunst zu Beginn der Gotik (Part II Süd- und Mittelitalien). Graz-Cologne: H. Bohlaus, 1957.

PAINTING, DRAWING, AND PRINTMAKING

Ames-Lewis, Francis. *Drawing in Early Renaissance Italy*. New Haven/London: Yale University Press, 1981.

- Bambach, Carmen C. Drawing and Painting in the Italian Renaissance Workshop: Theory and Practice, 1300–1600. New York: Cambridge University Press. 1999.
- Baxandall, Michael. Painting and Experience in Fifteenth-Century Italy: A Primer in the Social History of Pictorial Style. New York: Oxford University Press, 1988.
- Belting, Hans. "The New Role of Narrative in Public Painting of the Trecento: *Historia* and Allegory," *Studies in the History of Art*, 16, 1985, 151-68.
- Bomford, David, Jill Dunkerton, Dillian Gordon, and Ashok Roy. Art in the Making: Italian Painting Before 1400. London: National Gallery Publications, 1989.
- Borsook, Eve. *The Mural Painters of Tuscany from Cimabue to Andrea del Sarto* (2nd edn.). Oxford: Oxford University Press, 1979.
- Burckhardt, Jacob. *The Altarpiece in Renaissance Italy*. Cambridge, England/New York: Cambridge University Press, 1988.
- Castelnuovo, Enrico (ed.). La Pittura in Italia: Il Duecento e il Trecento (2 vols.). Milan: Electa, 1986.
- Cennini, Cennino d'Andrea. *The Craftsman's Handbook: Il Libro dell'Arte* (trans. Daniel V. Thompson, Jr.). New York: Dover, 1954.
- Dunkerton, Jill, Susan Foister, Dillian Gordon, and Nicholas Penny. *Giotto to Dürer: Early Renaissance Painting in The National Gallery*. New Haven/London: Yale University Press, 1991
- Freedberg, Sidney J. *Painting in Italy, 1500–1600*. Harmondsworth: Penguin, 1990.
- Hall, Marcia. After Raphael: Painting in Central Italy in the Sixteenth Century. Cambridge: Cambridge University Press, 1998.
- Landau, David, and Peter Parshall. *The Renaissance Print, 1470–1550.* New
 Haven/London: Yale University Press, 1994.
- Roettegn, Steffi. Italian Frescoes, vol. 1, The Early Renaissance, 1400–1470; vol. 2, The Flowering of the Renaissance, 1470–1510. New York: Abbeville, 1996–7.
- Smart, Alastair. *The Dawn of Italian Painting, c. 1250–1400.* Ithaca: Cornell University Press, 1978.
- Thomas, Anabel. *The Painter's Practice in Renaissance Tuscany*. Cambridge and New York: Cambridge University Press, 1995.

SCULPTURE

- Ames-Lewis, Francis. *Tuscan Marble Carving*, 1250–1350. Aldershot: Ashgate, 1997.
- Jacobs, Frederika H. "The Construction of a Life: Madonna Properzia de' Rossi 'Scultrice' Bolognese," Word & Image, 9, 1993, 122-32.
- Moskowitz, Anita Fiderer. *Italian Gothic Sculpture*, c. 1250-c. 1400. Cambridge: Cambridge University Press, 2001.
- Poeschke, Joachim. Donatello and his World: Sculpture of the Italian Renaissance. New York: Harry N. Abrams, 1993.
- —. Michelangelo and his World: Sculpture of the Italian Renaissance. New York: Harry N. Abrams. 1996.
- Pope-Hennessy, John. *Italian Gothic Sculpture* (3rd edn.). Oxford: Phaidon, 1986.

- —. Italian Renaissance Sculpture (3rd edn.). Oxford: Phaidon, 1986.
- —. Italian High Renaissance and Baroque Sculpture (3rd edn.). Oxford: Phaidon, 1986.
- Seymour, Charles, Jr. Sculpture in Italy, 1400–1500. Baltimore: Penguin, 1966.

ASSISI

- Belting, Hans. Die Oberkirche von San Francesco in Assisi: Ihre Dekoration als Aufgabe und die Genese einer neuen Wandmalerei. Berlin: Mann, 1977.
- Mather, Frank Jewett. *The Isaac Master: A Reconstruction of the Work of Gaddo Gaddi.*Princeton: Princeton University Press, 1932.
- Meiss, Millard. *Giotto and Assisi*. New York: Norton, 1960.
- Offner, Richard. "Giotto, Non-Giotto," *The Burlington Magazine*, 74, 1939, 259-68 and 75, 1939, 96-113.
- Smart, Alastair. *The Assisi Problem and the Art of Giotto*. Oxford: Clarendon Press, 1971.
- Stubblebine, James H. Assisi and the Rise of Vernacular Art. New York: Harper & Row, 1985.
- White, John. *The Birth and Rebirth of Pictorial Space*. New York: Harper & Row, 1972.
- —. "The Date of the 'St. Francis Legend' at Assisi," The Burlington Magazine, 98, 1956, 344-51.
- Wood, Jeryldene. "Perceptions of Holiness in Thirteenth-Century Italian Painting: Clare of Assisi," *Art History*, 14, 1991, 301–28.

FERRARA AND BOLOGNA

- Bull, David. "Conservation Treatment and Interpretation," *Studies in the History of Art*, 40, 1990, 21–52.
- Colantuono, Anthony. "Dies Aleyoniae: The Invention of Bellini's Feast of the Gods," Art Bulletin, 73, 1991, 237–56.
- Fortunati, Vera (ed.). *Lavinia Fontana*, 1552–1614. Milan: Electa, 1994.
- Ghirardi, Angela. *Bartolomeo Passarroti Pittore* (1529–1592). Rimini: Luisè Editore, 1990.
- Goodgal, Dana. "The Camerino of Alfonso I d'Este," *Art History*, 1, 1978, 162-90.
- Gould, Cecil. *The Paintings of Correggio*. Ithaca: Cornell University Press, 1976.
- Hope, Charles. "The 'Camerini d'Alabastro' of Alfonso d'Este," *The Burlington Magazine*, 113, 1971, 641-50 and 712-21.
- Jones, Pamela M. "Art Theory as Ideology: Gabriele Paleotti's Hierarchical Notion of Painting's Universality and Reception," in Reforming the Renaissance: Visual Culture in Europe and Latin America, 1450-1650 (ed. Clair Farago). New Haven: Yale University Press, 1995, 127–39.
- Lippincott, Kristen. "The Iconography of the Salone dei Mesi and the Study of Latin Grammar in Fifteenth-Century Ferrara," La corte di Ferrara e il suo mecenatismo, 1441–1598, The Court of Ferrara and its Patronage, Atti del convegno internazionale Copenhagen maggio 1987 (ed. Marianne Pade, Lene Waage Petersen, Daniela Quarta). Copenhagen, 1990, 93–109.
- Longhi, Roberto. *Officina ferrarese*. Florence: Sansoni, 1968.

- Macioce, Stefania. "Le 'Borsiade' di Tito Vespasiano Strozzi e la 'Sala dei Mesi' di Palazzo Schifanoia," *Annuario dell'Istituto di Storia dell'Arte, Università degli Studi di Roma* "La Sapienza," N.S. 2, 1982–3, 3–13.
- McTighe, Sheila. "Foods and the Body in Italian Genre Paintings, about 1580: Campi, Passarotti, Carracci," *Art Bulletin*, 86, 2004, 301–23.
- Molfino, Alessandra Mottola, and Mauro Natale (eds.). *Le muse e il principe: Arte di corte nel Rinascimento padano* (Exhibition Museo Poldi-Pezzoli, Milan, September 20 to December 1, 1991, 2 vols.). Milan, 1991.
- Rosenberg, Charles M. "The Sala degli Stucchi in the Palazzo Schifanoia in Ferrara," *Art Bulletin*, 61, 1979, 377–84.
- —. "Courtly Decorations and the Decorum of Interior Space," in *La corte e lo spazio: Ferrara estense* (ed. Giuseppe Papagno and Amedeo Quondam). Rome: Bulzoni, 1982, 529-44.
- —. "Per un atlante di Schifanoia: Borsian and Ferrarese imagery in the heavenly zone in the Salone dei mesi," Schifanoia, Notizie dell'Istituto di studi rinascimentali di Ferrara, 5, 1988, 43–9.
- —. The Este Monuments and Urban Development in Renaissance Ferrara. Cambridge and New York: Cambridge University Press, 1997.
- Ruhmer, Eberhard. *Tura, Paintings and Drawings*. London: Phaidon, 1958.
- Sheard, Wendy Stedman. "Antonio Lombardo's Reliefs for Alfonso d'Este's *Studio di Marmi*: Their Significance and Impact on Titian," in *Titian 500* (Studies in the History of Art, 45, Center for Advanced Study in the Visual Arts, Symposium Papers XXV), Hanover/London: University Presses of New England, 315–57.
- Shearman, John. "Alfonso d'Este's Camerino,"

 Il se rendit en Italie: Etudes offerts à André Chastel,
 Rome/Paris: CNRS, 1987, 209-29.
- Travagli, Anna Maria Visser. Ferrara, Palazzo Schifanoia a Ferrara e Palazzina Marfisa a Ferrara. Milan, 1991.
- Tuohy, Thomas. Herculean Ferrara: Ercole d'Este (1471–1505) and the Invention of a Ducal Capital. Cambridge and New York: Cambridge University Press, 1996.

FLORENCE

General

- Brucker, Gene. Renaissance Florence. New York: John Wiley, 1969.
- Fremantle, Richard. Florentine Gothic Painters from Giotto to Masaccio. London: Secker & Warburg, 1975.
- Paatz, Walter. *Die Kirchen von Florenz* (5 vols.). Frankfurt am Main: V. Klostermann, 1952–5.
- Turner, Richard. Florence: The Invention of a New Art. New York: Harry N. Abrams, 1997.
- Wackernagel, Martin. The World of the Florentine Renaissance Artist: Projects and Patrons, Workshop and Art Market (trans. Alison Luchs). Princeton: Princeton University Press, 1981.

Thirteenth and Fourteenth Centuries

- Baldini, Umberto, and Bruno Nardini. Santa Croce: La Basilica, Le Cappelle, I Chiostri, Il Museo. Florence: Centro Internazionale del Libro,
- (ed.). Santa Maria Novella: Kirche, Kloster und Kreuzgänge. Stuttgart: Urachaus, 1982.

- Chiellini, Monica. *Cimabue*. Florence: Scala, 1988. Gardner, Julian. "Andrea di Bonaiuto and the Chapterhouse Frescoes in Santa Maria Novella," *Art History*, 2, 1979, 107–38.
- Hueck, Irene. Das Programm der Kuppelmosaiken im Florentiner Baptisterium. Dissertation Ludwig-Maximilans-Universität, Munich, 1962.
- Kent, F.W. "The Black Death of 1348 in Florence: A New Contemporary Account," in Renaissance Studies in Honor of Craig Hugh Smyth (ed. Andrew Morrough, Fiorella Superbi Giofredi, Piero Morselli, and Eve Borsook). Florence: Giunti Barbèra, 1985, 117–28.
- Ladis, Andrew. Taddeo Gaddi: Critical Reappraisal and Catalogue Raisonné. Columbia: University of Missouri Press, 1982.
- Maginnis, Hayden B.J., *Painting in the Age of Giotto: A Historical Reevaluation*. University Park: Pennsylvania State University Press, 1997.
- Meiss, Millard. *Painting in Florence and Siena* after the Black Death. Princeton: Princeton University Press, 1951.
- Moskowitz, Anita. *The Sculpture of Andrea and Nino Pisano*. Cambridge: Cambridge University Press, 1986.
- Romano, Serena. "Due affreschi del Cappellone degli Spagnoli: Problemi iconologici," *Storia dell'arte*, 28, 1976, 181–213.
- Tintori, Leonetto, and Eve Borsook. *Giotto*. *The Peruzzi Chapel*. New York: Abrams, 1961.
- Trachtenberg, Marvin. Dominion of the Eye: Urbanism, Art, and Power in Early Modern Florence. New York: Cambridge University Press, 1997.

Fifteenth Century

- Alberti, Leon Battista. *On Painting* (trans. Cecil Grayson, ed. Martin Kemp). London: Penguin, 1991.
- Ames-Lewis, Francis (ed.). Cosimo 'il Vecchio' de' Medici, 1389–1464. Oxford: Clarendon Press, 1992.
- Beck, James. *Masaccio: The Documents*. Locust Valley, NY: J.J. Augustin, 1978.
- Bennett, Bonnie, and David G. Wilkins. *Donatello*. Oxford: Phaidon, 1984.
- Bent, George R. "A Patron for Lorenzo Monaco's Uffizi Coronation of the Virgin," Art Bulletin, 82, 2000, 348–54.
- Beyer, Andreas, and Bruce Boucher (ed.). Piero de' Medici "il Gottoso" (1416–1469). Berlin: Akademie Verlag, 1993.
- Borsook, Eve. "L'Hakwood [sic] d'Uccello et la *Vie de Fabius Maximus* de Plutarque," *Revue de l'art*, 55, 1982, 44–51.
- and Johannes Offerhaus. Francesco Sassetti and Ghirlandaio at Santa Trinita. Doornspijk: Davaco Publishers, 1981.
- Boskovits, Miklòs. *Pittura Fiorentina alla vigilia* del Rinascimento. Florence: Edam, 1975.
- Brown, David Alan. Leonardo da Vinci: Origins of a Genius. New Haven: Yale University Press, 1998.
- Burke, Jill. Changing Patrons: Social Identity and the Visual Arts in Renaissance Florence. University Park: Pennsylvania State University Press, 2004.
- Butterfield, Andrew. "Verrocchio's Christ and St. Thomas: Chronology, Iconography and Political Context," *The Burlington Magazine*, CXXXIV, 1992, 225–33.

- Cherubini, Giovanni, and Giovanni Fanelli (ed.). Il Palazzo Medici Riccardi di Firenze. Florence: Giunti. 1990.
- Dempsey, Charles. *The Portrayal of Love:*Botticelli's Primavera and Humanist Culture at the Time of Lorenzo the Magnificent. Princeton:
 Princeton University Press, 1992.
- Edgerton, Samuel Y., Jr. *The Renaissance* Rediscovery of Linear Perspective. New York: Basic Books, 1975.
- Eisenberg, Marvin. *Lorenzo Monaco*. Princeton: Princeton University Press, 1989.
- Friedman, David. "The Burial Chapel of Filippo Strozzi in Santa Maria Novella in Florence," Arte, 9, 1970, 109–31.
- Haines, Margaret. "Brunelleschi and Bureaucracy: The Tradition of Public Patronage at the Florentine Cathedral," I Tatti Studies, 3, 1989, 89–125.
- Herlihy, David, and Christiane Klapisch-Zuber. Tuscans and Their Families: A Study of the Florentine Catasto of 1427. New Haven/London: Yale University Press, 1985 (abridged trans. of Les Toscans et leurs families).
- Holmes, Megan. Fra Filippo Lippi: The Carmelite Painter. New Haven/London: Yale University Press, 1999.
- Hood, William. Fra Angelico at San Marco. London/New York: BCA, 1993.
- Hyman, Isabelle. "The Venice Connection: Questions about Brunelleschi and the East," in *Florence and Venice: Comparisons and Relations* (ed. Nicolai Rubinstein and Craig Hugh Smyth). Florence: La Nuova Italia, 1979, I, 193–208.
- Janson, H.W. *The Sculpture of Donatello*. Princeton: Princeton University Press, 1957.
- Joannides, Paul. *Masaccio and Masolino: A Complete Catalogue*. London: Phaidon, 1993.
- Kent, Dale. Cosimo de' Medici and the Florentine Renaissance: The Patron's Oeuvre. London: Yale University Press, 2000.
- Kent, F.W. "Più superba di quella di Lorenzo: Courtly and Family Interest in the Building of Filippo Strozzi's Palace," The Renaissance Quarterly, 1977, 311–23.
- Lorenzo de' Medici and the Art of Magnificence.
 Baltimore: The Johns Hopkins University Press. 2004.
- Krautheimer, Richard. *Lorenzo Ghiberti*.

 Princeton: Princeton University Press, 1956.
- Lavin, Irving. "Donatello's Bronze Pulpits in San Lorenzo and the Early Christian Revival," in Lavin, *Past-Present: Essays on Historicism in Art* from Donatello to Picasso. Berkeley/Los Angeles: University of California Press, 1993, 1–27.
- Lightbown, Ronald. *Botticelli* (2 vols.). Berkeley: University of California Press, 1978.
- —. *Sandro Botticelli: Life and Work.* New York: Abbeville, n.d.
- Manca, Joseph. "The Gothic Leonardo: Towards a Reassessment of the Renaissance," *Artibus et Historiae*, 34, 1996, 121–58.
- Manetti, Antonio di Tuccio. *The Life of Brunelleschi* (ed. Howard Saalman). University Park: Pennsylvania State University Press, 1970.
- Molho, Anthony. "The Brancacci Chapel: Studies in its Iconography and History," Journal of the Warburg and Courtauld Institutes, 40, 1977, 50-98, 322.

- Pope-Hennessy, John. *Fra Angelico*. Ithaca: Cornell University Press, 1974.
- -... Donatello. New York: Abbeville, 1993.
- Randolph, Adrian W.B. Engaging Symbols: Gender, Politics and Public Art in Fifteenth-Century Florence. New Haven: Yale University Press, 2002.
- Rubin, Patricia Lee, and Alison Wright (eds).

 Renaissance Florence: The Art of the 1470s.

 London: National Gallery Publications Ltd.,
 1999.
- Ruda, Jeffrey. Fra Filippo Lippi. London: Phaidon, 1993.
- Saalman, Howard. Filippo Brunelleschi: The Cupola of Santa Maria del Fiore. London: Zwemmer, 1980.
- —. Filippo Brunelleschi: The Buildings. University Park: Pennsylvania State University Press, 1993
- Sale, J. Russell. Filippino Lippi's Strozzi Chapel in Santa Maria Novella. New York: Garland, 1979
- Seymour, Charles, Jr. *The Sculpture of Verrocchio*. London: Studio Vista, 1971.
- Spencer, John R. *Andrea del Castagno*. Durham: Duke University Press, 1991.
- Sperling, Christine M. "Donatello's Bronze 'David' and the Demands of Medici Politics," *Burlington Magazine*, 134, 1992, 218–24.
- Trachtenberg, Marvin. "Architecture and Music Reunited: A New Reading of Dufay's *Nuper Rosarum Flores* and the Cathedral of Florence," *Renaissance Quarterly*, 54, 2001, 740, 75
- White, John. *The Birth and Rebirth of Pictorial Space*. London: Faber & Faber, 1957.
- Wohl, Hellmut. *The Paintings of Domenico Veneziano*. New York: New York University Press, 1980.
- Zervas, Diane Finiello. "Ghiberti's 'St. Matthew' Ensemble at Orsanmichele: Symbolism in Proportion," *Art Bulletin*, 58, 1976, 36–44.
- —. The Parte Guelfa, Brunelleschi and Donatello. Locust Valley, NY: J.J. Augustin, 1987.

Sixteenth Century

- Ackerman, James. *The Architecture of Michelangelo* (2 vols.). London: Zwemmer, 1961.
- Barzman, Karen-edis. *The Florentine Academy and* the Early Modern State. New York: Cambridge University Press, 2000.
- Cochrane, Éric. Florence in the Forgotten Centuries, 1527–1800: A History of Florence and the Florentines in the Age of the Grand Dukes. Chicago: University of Chicago Press, 1973.
- Conway, J.F. "Syphilis and Bronzino's London Allegory," Journal of the Warburg and Courtland Institutes, 49, 1986, 250–55.
- Cox-Rearick, Janet. Bronzino's Chapel of Eleonora in the Palazzo Vecchio. Berkeley: University of California Press, 1993.
- —. Dynasty and Destiny in Medici Art. Princeton: Princeton University Press, 1984.
- Crum, Roger. "Cosmos, the World of Cosimo: The Iconography of the Uffizi Façade," *Art Bulletin*, 71, 1989, 237–53.
- Forster, Kurt W. "Metaphors of Rule: Political Ideology and History in the Portraits of Cosimo I de' Medici," *Mitteilungen des Kunsthistorischen Institutes in Florenz*, XV, 1971, 65-104.

- Franklin, David. Rosso in Italy: The Italian Career of Rosso Fiorentino. New Haven/London: Yale University Press, 1994.
- Freedberg, Sidney. Painting of the High Renaissance in Rome and Florence. New York: Harper & Row. 1972.
- Gaston, Robert W. "Love's Sweet Poison: A New Reading of Bronzino's London *Allegory*," *I Tatti Studies*, 4, 1991, 249–88.
- —. "Sacred Erotica: The Classical figura in Religious Painting of the Early Cinquecento," International Journal of the Classical Tradition, 2, Fall 1995, 238–64.
- Hall, Marcia. Renovation and Counter-Reformation: Vasari and Duke Cosimo in Sta Maria Novella and Sta Croce, 1565–1577 Oxford: Clarendon Press, 1979.
- Hibbard, Howard. *Michelangelo*. New York: Harper & Row, 1974.
- Mendelsohn, Leatrice. "Saturnian Allusions in Bronzino's London Allegory," in Saturn from Antiquity to the Renaissance (ed. M. Ciaralella and A.A. Iannucci). Ottawa: Dove House, 1992, 101–50.
- Muccini, Ugo. The Salone dei Cinquecento of Palazzo Vecchio. Florence: Le Lettere, 1990.
- Parker, Deborah. *Bronzino: Renaissance Painter as Poet.* Cambridge: Cambridge University Press, 2000.
- Poma Swank, Annamaria. "Iconografia controriformistica negli altari delle chiese fiorentine di Santa Maria Novella e Santa Croce," *Altari controriformati in Toscana: architettura e arredi.* Carlo Cresti (ed.). Florence: Angelo Pontecorboli Editore, 1997, 95–131.
- Rubin, Patricia Lee. *Giorgio Vasari: Art and History*. New Haven: Yale University Press, 1995.
- Seymour, Charles, Jr. Michelangelo's David: A Search for Identity. Pittsburgh: University of Pittsburgh Press, 1967.
- Wilde, Johannes. "The Hall of the Great Council of Florence," *Journal of the Warburg and Courtauld Institutes*, VII, 1944, 65ff. (reprinted, Creighton E. Gilbert, *Renaissance Art*, New York, 1970, 92–132).

GENOA

- Caraceni, Fiorella. A Renaissance Street: Via Garibaldi in Genoa. Genoa: Sagep, 1993.
- Gorse, George, "A Classical Stage for the Old Nobility: The *Strada Nuova* and Sixteenth-Century Genoa," *Art Bulletin*, 79, 1997, 301–27.
- "The Villa of Andrea Doria in Genoa: Architecture, Gardens, and Suburban Setting," Journal of the Society of Architectural Historians, 44, 1985, 18–36.

MANTUA

- Boorsch, Suzanne, Keith Christiansen, David Ekserdjian, Charles Hope, David Landau, et al. Andrea Mantegna (Exhibition, Metropolitan Museum of Art, New York, and Royal Academy of Arts, London). Milan: Electa, 1992.
- Jones, Mark. "The First Cast Medals and the Limbourgs," *Art History*, 2, 1979, 35–44 and illustration.

- Lightbown, Ronald. Mantegna, with a Complete Catalogue of the Paintings, Drawings and Prints. Oxford: Phaidon/Christie's, 1986.
- Paccagnini, Giovanni. *Pisanello*. London: Phaidon, 1974.
- San Juan, Rose Marie. "The Court Lady's Dilemma: Isabella d'Este and Art Collecting in the Renaissance," *The Oxford Art Journal*, 14, 1991, 67–78.
- Weiss, Roberto. Pisanello's Medallion of the Emperor John VIII Palaeologus. London, 1966.
- Woods-Marsden, Joanna. "Ritratto al Naturale': Questions of Realism and Idealism in Early Renaissance Portraits," Art Journal, 46, Fall 1987, 209–16.
- —. The Gonzaga of Mantua and Pisanello's Arthurian Frescoes. Princeton: Princeton University Press, 1988.

MILAN AND LOMBARDY

General

La Storia di Milano. Milan: Treccani, 1953-62.

Fourteenth Century

- Baroni, Costantino. *Scultura gotica lombarda*. Milan: E. Bestetti, 1944.
- Gilbert, Creighton E. "The Fresco by Giotto in Milan," *Arte Lombarda*, 47/48, 1977, 31-72.
- Green, Louis. "Galvano Fiamma, Azzone Visconti and the Revival of the Classical Theory of Magnificence," *Journal of the* Warburg and Courtauld Institutes, 53, 1990, 98–113.
- Merlini, Elena. "II trittico eburneo della Certosa di Pavia: Iconografia e committenza," *Arte cristiana*, 73, 1985, 369-84; 74, 1986, 139-54.
- Moskowitz, Anita. "Giovanni di Balduccio's Arca di San Pietro Martire: Form and Function," *Arte Lombarda*, 96/97, 1991, 7–18.
- Pächt, Otto. "Early Italian Nature Studies and the Early Calendar Landscape," *Journal of the Warburg and Courtauld Institutes*, 13, 1950, 13–47.
- Sutton, Kay. "Milanese Luxury Books: The Patronage of Bernabò Visconti," *Apollo*, 134, 1991, 322-6.
- Toesca, Pietro. *La pittura e la miniatura nella Lombardia*. Turin: Einaudi, 1966.

Fifteenth and Sixteenth Centuries

- Leonardo da Vinci Master Draftsman (ed. Carmen C. Bambach). New York: The Metropolitan Museum of Art, 2003.
- Pittura a Cremona da Romanino al Settecento (ed. Mina Gregori). Milan: CARIPLO, 1990.
- Sacro e profano nella pittura di Bernardino Luini (Catalogue of exhibition in Luino, August 9 to October 8, 1975). Milan: Silvana Editoriale d'Arte, 1975.
- Algeri, Giuliana. "La pittura in Lombardia nel primo Quattrocento," in *La Pittura in Italia, Il Quattrocento*. Milan: Electa, 53–71.
- Ames-Lewis, Francis. "Leonardo's Botanical Drawings," *Achademia Leonardi Vinci*, 10, 1997, 117–24.
- Bayer, Andrea (ed.). Painters of Reality: The Legacy of Leonardo and Caravaggio in Lombardy. New Haven: Yale University Press, in association with the Metropolitan Museum of Art, 2004.

- Bernstein, Joanne Gitlin. "A Florentine Patron in Milan: Pigello and the Portinari Chapel," in *Florence and Milan: Comparisons and Relations* (ed. Sergio Bertelli, Nicolai Rubinstein, and Craig Hugh Smyth). Florence: La Nuova Editrice, 1989, 171–200.
- "Science and Eschatology in the Portinari Chapel," Arte Lombarda, n.s. 60, 1981, 33-40.
- Bora, Giulio, et al. The Legacy of Leonardo: Painters in Lombardy, 1490–1530. Milan: Skira, 1998.
- Brambilla Barcilon, Pinin, and Pietro C. Marani. *Leonardo: L' Ultima Cena*. Milan: Electa, 1999.
- Bush, Virginia. "Leonardo's Sforza Monument and Cinquecento Sculpture," Arte Lombarda, 50, 1978, 47–68.
- Castelnuovo, Enrico. Il ciclo dei Mesi di Torre Aquila a Trento. Trent, 1987.
- Chamberlin, E.R. The Count of Virtue: Giangaleazzo Visconti, Duke of Milan. New York: Scribner, 1965.
- Clark, Kenneth. *Leonardo da Vinci* (rev. and introduced by Martin Kemp). London: Penguin, 1988.
- Cohen, Charles E. "Pordenone's Cremona Passion Scenes and German Art," *Arte Lombarda*, 42/43, 1975, 74–96.
- Curlee, Kendall. *The Sforza Court: Milan in the Renaissance, 1450–1535* (Exhibition, curator Andrea Norris, Archer M. Huntington Art Gallery, University of Texas at Austin, October 27 to December 18, 1988).
- de Klerck, Bram. The Brothers Campi: Images and Devotion: Religious Painting in Sixteenth-Century Lombardy. Amsterdam: Amsterdam University Press, 1999.
- Ferino-Pagden, Sylvia, and Maria Kusche. Sofonisba Anguissola: A Renaissance Woman. Washington, D.C.: The National Museum of Women in the Arts, 1995.
- Fiorio, Maria Teresa. Bambaia: Catalogo completo delle opere. Florence: Cantini, 1990.
- Garrard, Mary D. "Here's Looking at Me: Sofonisba Anguissola and the Problem of the Woman Artist," *Renaissance Quarterly*, 47, 1994, 556–622.
- Gilbert, Creighton. "Milan and Savoldo," *Art Bulletin*, 27, 1945, 124–38.
- Hood, William. "The Sacro Monte of Varallo: Renaissance Art and Popular Religion," in *Monasticism and the Arts* (ed. Timothy Gregory Verdon). Syracuse: Syracuse University Press, 1984, 291–309.
- Humfrey, Peter. *Giovanni Battista Moroni, Renaissance Portraitist.* Fort Worth, Texas: Kimball Art Museum, 2000.
- Kemp, Martin. Leonardo da Vinci: The Marvelous Works of Nature and Man. Cambridge, MA: Harvard University Press, 1981.
- Kiang, Dawson. "Gasparo Visconti's Pasitea and the Sala delle Asse," Achademia Leonardi Vinci, 2, 1989, 101–9.
- Kirsch, Edith. Five Illuminated Manuscripts of Giangaleazzo Visconti. University Park/London: Pennsylvania State University Press, 1991.
- McGrath, Thomas. "Color and the Exchange of Ideas between Patron and Artist in Renaissance Italy," *Art Bulletin*, 82, 2000, 298–308.

- Martindale, Andrew. "Painting for Pleasure: Some Lost 15th Century Secular Decorations of Northern Italy," in *The Vanishing Past:* Studies of Medieval Art, Liturgy and Metrology Presented to Christopher Hohler (ed. Alan Borh and Andrew Martindale). Oxford: BAR, 1981, 109–31.
- Moffitt, John F. "Leonardo's Sala delle Asse and the Primordial Origins of Architecture," *Arte Lombarda*, 92/93, 1990, 1-2, 76-90.
- Morassi, Antonio. "Come il Fogolino restaurò gli affreschi di Torre Aquila a Trento," Bollettino d'arte, 8, 1928, 337–67.
- Morscheck, Charles R. Relief Sculpture for the Façade of the Certosa di Pavia, 1473–1499. New York: Garland, 1978.
- Neher, Gabriele. Moretto and Romanino: Religious Painting in Brescia, 1510–1550: Identity in the Shadow of la Serenissima. Unpublished dissertation, University of Warwick, 2000.
- Norris, Andrea S. "The Sforza of Milan," Schifanoia, Notizie dell'Istituto di studi rinascimentali di Ferrara, 10, 1990, 19–22.
- Nova, Alessandro. *Girolamo Romanino*. Turin: Umberto Allemandi, 1994.
- Ottino Della Chiesa, Angela. *Pittura Lombarda del Quattrocento*. Bergamo: Istituto Italiano d'Arti Grafiche, 1961.
- Rossi, Laura Mattioli. *Vincenzo Foppa: La cappella Portinari*. Milan: Federico Motta, 1999.
- Shell, Janice. "Il problema della ricostruzione del monumento a Gaston de Foix," Il Bambaia, Il monumento a Gaston de Foix, Castello Sforzesco di Milano: un capolavoro acquisito. Milan: Finarte e Longanesi, 1990, 32-61
- Smyth, Carolyn. *Correggio's Frescoes in Parma Cathedral*. Princeton: Princeton University Press, 1997.
- Sullivan, Margaret A. "Aertsen's Kitchen and Market Scenes: Audience and Innovation in Northern Art," *Art Bulletin*, 81, 1999, 236–66.
- Tasso, Francesca. "I Giganti e le vicende della prima scultura del Duomo di Milano," *Arte Lombarda*, 92/93, 1990, 1–2, 55–62.
- Welch, Evelyn S. Art and Authority in Renaissance Milan. New Haven: Yale University Press, 1995
- Wind, Barry. "Annibale Carracci's 'Scherzo': The Christ Church *Butcher Shop*," *Art Bulletin*, 58, 1976, 93-6.

NAPLES

General

- Storia di Napoli. Naples: Edizioni del Giglio, 1981-7.
- Bacco, Enrico. *Naples: An Early Guide*. New York: Italica Press, 1991.
- Causa, Raffaello. *Pittura napoletana dal XV al XIX secolo*. Bergamo: Istituto italiano d'arti grafiche, 1957.
- De Seta, Cesare. Napoli (La città nella storia d'Italia) (5th edn.). Roma-Bari: Laterza, 1991. —. Napoli fra Rinascimento e Illuminismo. Naples:
- Electa, 1991.

Thirteenth and Fourteenth Centuries

Bologna, Ferdinando. *I pittori alla corte angioina* di Napoli, 1266–1414. Rome: Ugo Bozzi Editore, 1969.

- Bottari, Stefano. "Il monumento alla Regina Isabella nella Cattedrale di Cosenza," *Arte antica e moderna*, 1, 1958, 339-44.
- Bruzelius, Caroline A. "Ad modum franciae': Charles of Anjou and Gothic Architecture in the Kingdom of Sicily," *Journal of the Society of Architectural Historians*, 50, 1991, 402–20.
- —. "Hearing is Believing: Clarissan Architecture, c. 1213–1340," Gesta, 31, 1992, 83–91
- Buchtal, Hugo. "Historia Troiana," Studies in the History of Medieval Secular Illustration. London: Warburg Institute, 1971.
- Gardner, Julian. "Saint Louis of Toulouse, Robert of Anjou and Simone Martini," Zeitschrift für Kunstgeschichte, 39, 1976, 12–33.
- Joost-Gaugier, Christiane L. "Giotto's Hero Cycle in Naples: A Prototype of *Donne Illustre* and a Possible Literary Connection," *Zeitschrift* für Kunstgeschichte, 43, 1980, 311–18.
- Leone de Castris, Pierluigi. *Arte di corte nella Napoli angioina*. Florence: Cantini, 1986.
- Lipinsky, Angelo. "L'arte orafa napoletana sotto gli Angiò," in *Dante e l'Italia meridionale*, Atti del congresso nazionale di Studi Danteschi, 10–16 October 1965. Florence: Olschki, 1966, 169–215.
- Musca, Giosuè, Francesco Tateo, Enrico Annoscia, and Pierluigi Leone de Castris. *La cultura Angioina* (Civiltà del Mezzogiorno). Cinisello Balsamo (Milan): Silvana Editoriale d'Arte, 1985.
- Strazzullo, Franco. Saggi sul Duomo di Napoli. Naples, 1959.
- Venditti, Arnaldo. "Urbanistica e architettura angioina," in *Storia di Napoli* (vol. 3). Naples: Edizioni del Giglio, 1987, 667ff.

Fifteenth Century

- Bentley, Jerry H. *Politics and Culture in Renaissance Naples.* Princeton: Princeton University Press,
- Bologna, Ferdinando. Napoli e le rotte mediterranee della pittura, da Alfonso il Magnanimo a Ferdinando il Cattolico. Naples, 1977.
- Castelfranchi Vegas, Liana. "Aspetti e problemi della pittura fiamminga nell'Italia del quatttrocento," ACME, Annali della Facoltà di lettere e filosofia dell'Università degli Studi di Milano, 32, 1, 1979, 81–111.
- Causa, Raffaello. *Pittura napoletana dal XV al XIX secolo*. Bergamo: Istituto italiano d'arti grafiche, 1957.
- Cirillo Mastrocinque, Adelaide. "Cultura e mode nordiche nell'opera di Baboccio da Piperno," *Napoli nobilissima*, 8, 1969, 16–25.
- de Rinaldis, Alda. "Forme tipiche dell'architettura napoletana nella prima metà del quattrocento," *Bollettino d'arte*, 4, 1924–5, 162–83.
- Ferrari, Oreste. "Per la conoscenza della scultura del primo quattrocento a Napoli," *Bollettino d'arte*, ser. 4, 39, 1954, 11–24.
- Filangieri, Riccardo. Castel Nuovo, Reggia Angioina ed Aragonese di Napoli (preface Bruno Molajoli). Naples: L'Arte Tipografia, 1964.
- Hersey, George L. *Alfonso II and the Artistic Renewal of Naples, 1485–1495.* New Haven/London: Yale, 1969.
- —. The Aragonese Arch at Naples, 1443–1475. New Haven/London: Yale University Press, 1973.

- Lightbown, R.W. Donatello and Michelozzo: An Artistic Partnership and Its Patrons in the Early Renaissance (2 vols.). London: Harvey Miller, 1980
- Pane, Roberto. *Il rinascimento nell'Italia* meridionale (2 vols.). Milan, 1975 and 1977.
- Ryder, A.F.C. Alfonso the Magnanimous: King of Aragon, Naples and Sicily, 1396–1458. Oxford: Clarendon Press, 1990.
- Serra, Luigi. "Gli affreschi della Rotonda di S. Giovanni a Carbonara a Napoli," *Bollettino d'arte*, 3, 1909, 121–36.
- Wethey, Harold E. "Guillermo Sagrera," *Art Bulletin*, 21, 1939, 42–60.
- Woods-Marsden, Joanna. "Art and Political Identity in Fifteenth-Century Naples: Pisanello, Cristoforo di Geremia, and King Alfonso's Imperial Fantasies," in *Art and Politics in Late Medieval and Early Renaissance Italy, 1250–1500* (ed. Charles M. Rosenberg). Notre Dame/London: Notre Dame University Press, 1990, 11–37.

PADUA

- Derbes, Anne, and Mark Sandona (eds.). *The Cambridge Companion to Giotto*. Cambridge: Cambridge University Press, 2004.
- Edwards, Mary D. "The Tomb of Raimondino de' Lupi and Its Setting," *The Rutgers Art Review*, 3, 1982, 36-49.
- Mommsen, Theodor E. "Petrarch and the Decoration of the Sala Virorum Illustrium in Padua," *Art Bulletin*, 34, 1952, 95–116.
- Plant, Margaret. "Patronage in the Circle of the Carrara Family: Padua, 1337–1405," in *Patronage, Art, and Society in Renaissance Italy* (ed. F.W. Kent and Patricia Simons, with J.C. Eade). Oxford: Clarendon Press, 1987, 177, 99
- —. "Portraits and Politics in Late Trecento Padua: Altichiero's Frescoes in the S. Felice Chapel, S. Antonio," Art Bulletin, 63, 1981, 406–25.
- Saalman, Howard. "Carrara Burials in the Baptistery of Padua," *Art Bulletin*, 69, 1987, 376–94.
- Stubblebine, James H. (ed.). Giotto: The Arena Chapel Frescoes. New York: Norton, 1969.
- Thomas, Hans Michael. "Sonneneffekte in der Giotto-Kapelle in Padua," *Sterne und Weltraum*, 4, 1995, 278–85.

PISA

- Camposanto Monumentale di Pisa: Affreschi e Sinopie. Pisa: Opera della Primaziale Pisana, 1960.
- Jolly, Penny Howell. "Symbolic Landscape in The Triumph of Death: The Garden of Love and the Desert of Virtue," Politeia, 1985, 27-42.
- Luzzati, Michele. "Simone Saltarelli arcivescovo di Pisa (1323–1342) e gli affreschi del Maestro del Trionfo della Morte," *Annali della Scuole Normale Superiore di Pisa, Classe di Lettere e Filosofia*, ser. III, XVIII, 4, 1988, 1645–64.
- Morpurgo, S. "Le epigrafi volgari in rima del 'Trionfo della Morte', del 'Giudizio Universale e Inferno,' e degli 'Anacoreti' nel Camposanto di Pisa," *L'Arte*, 2, 1899, 51-87.

- Polzer, Joseph. "The Role of the Written Word in the Early Frescoes in the Campo Santo of Pisa," in *World Art: Themes of Unity in Diversity* (ed. Irving Lavin). University Park: Pennsylvania State University Press, 1989, I, 361-66.
- Testi Cristiani, Maria Laura. "Voci dialoganti e coro nella 'Umana Commedia' del Trionfo della Morte," *Critica d'arte*, 54, no. 19, 1989, 57–68.
- Watson, Paul F. *The Garden of Love in Tuscan Art of the Early Renaissance*. Philadelphia: Art
 Alliance Press, 1979.

RIMINI

- Ettlinger, Helen S. "The Sepulchre on the Façade: A Re-evaluation of Sigismondo Malatesta's Rebuilding of San Francesco in Rimini," *Journal of the Warburg and Courtauld Institutes*, 53, 1990, 133–43.
- Kokole, Stanko. "Cognitio formarum and Agostino di Duccio's Reliefs for the Chapel of the Planets in the Tempio Malatestiano," in Quattrocentro Adriatico: Fifteenth-Century Art of the Adriatic Rim, Papers from a Colloquium held at the Villa Spelman, Florence, 1994 (ed. Charles Dempsey). Bologna: Nuova Alfa, 1996, 177–206.
- Lavin, Marilyn Aronberg. "Piero della Francesca's Fresco of Sigismondo Malatesta before St. Sigismond," Art Bulletin, 56, 1974, 345–74.
- Mitchell, Charles. "Il tempio Malatestiano," Studi Malatestiani, 1978, 71-103.
- Ricci, Corrado. *Il tempio Malatestiano*. Milan/Rome: Bestitti and Tumminelli, 1924 (reprinted Rimini, 1974).
- Woods-Marsden, Joanna. "How Quattrocento Princes Used Art: Sigismondo Pandolfo Malatesta of Rimini and cose militari," Renaissance Studies, 3, 1989, 387–414.

ROME

General

Partridge, Loren. *The Art of Renaissance Rome,* 1400–1600. London: Calmann & King and New York: Abrams, 1996.

Thirteenth and Fourteenth Centuries

- Gardner, Julian. "Nicholas III's Oratory of the Sancta Sanctorum," *The Burlington Magazine*, 115, 1973, 283–94.
- —. "Pope Nicholas IV and the Decoration of Santa Maria Maggiore," Zeitschrift für Kunstgeschichte, 36, 1973, 1–50.
- —. The Tomb and the Tiara: Curial Tomb Sculpture in Rome and Avignon in the Later Middle Ages. Oxford: Clarendon Press, 1992.
- Hetherington, Paul. *Pietro Cavallini: A Study in the Art of Late Medieval Rome*. London: Sagittarius Press, 1979.
- Kempers, Bram, and Sible de Blaauw. "Jacopo Stefaneschi, Patron and Liturgist," *Mededelingen* van het Nederlands Instituut, 47, 1987, 83–113.
- Kessler, Herbert L., and Johanna Zacharias. *Rome 1300: On the Path of the Pilgrim.* New Haven: Yale University Press, 2000.
- Krautheimer, Richard. *Rome: Profile of a City*, 312–1308. Princeton: Princeton University Press, 1980.

- Mitchell, Charles. "The Lateran Fresco of Boniface VIII," *Journal of the Warburg and Courtauld Institutes*, 14, 1951, 1-6.
- Nichols, Francis Morgan (ed.). *The Marvels of Rome: Mirabilia Urbis Romae*. New York: Italica Press, 1986.
- Rash, Nancy. "Boniface VIII and Honorific Portraiture: Observations on the Half-Length Image in the Vatican," *Gesta*, 26, 1987, 47–58.
- Redig de Campos, Deoclecio. *I Palazzi Vaticani*. Bologna: Cappelli, 1967.
- Righetti Tosti-Croce, Marina (ed.). Bonifacio VIII e il suo tempo: anno 1300 il primo Giubileo. Milan: Electa, 2000.
- Romanini, Angiola Maria (ed.). Roma anno 1300, Atti della IV settimana di studi di storia dell'arte medievale dell'Università di Roma "La Sapienza", 19–24 maggio. Rome: L'Erma di Bretschneider, 1983.
- (ed.). Roma nel Duecento: L'arte nella città dei papi da Innocenzo III a Bonifacio VIII. Rome: SEAT. 1991.
- Tomei, Alesandro. Jacobus Torriti Pictor: Una vicenda figurativa del tardo duecento romano. Rome, 1990.

Fifteenth Century

- Burroughs, Charles. From Signs to Design: Environmental Process and Reform in Early Renaissance Rome. Cambridge, MA: MIT Press, 1990.
- Ettlinger, Leopold D. *The Sistine Chapel before Michelangelo*. Oxford: Clarendon Press, 1965.
- Geiger, Gail. "Filippino Lippi's Carafa 'Annunciation': Theology, Artistic Conventions, and Patronage," *Art Bulletin*, 63, 1981, 62–75.
- Lee, Egmont. *Sixtus IV and Men of Letters*. Rome: Edizioni di Storia e Letteratura, 1978.
- Magnuson, Torgil. Studies in Roman Quattrocento Architecture [Figura, 9]. Stockholm: Almquist & Wiksell, 1958.
- Miglio, Massimo et al. (eds.). Un pontificato ed una città: Sisto IV (1471–1484). Vatican City: Scuola Vaticana di Paleographia, Diplomatica e Archivista, 1986.
- Piccolomini, Aeneas Silvius (Pius II). The Commentaries of Pius II. Northampton: Smith College Studies in History, vols. XXII/1-2 (1937), XXV/1-4 (1939-40), XXX (1947), XLIII (1957), XXXV (1951).
- Rubinstein, Ruth Olitsky. "Pius II's Piazza S.
 Pietro and St. Andrew's Head," Enea Silvio
 Piccolomini, Papa Pio II. Atti del Convegno per il
 Quinto Centenario della Morte e altri scritti raccolti
 da Domenico Maffei. Siena: Accademia Senese
 degli Intronati, 1968, 221–43.
- Smith, Christine. Architecture in the Culture of Early Humanism: Ethics, Aesthetics, and Eloquence, 1400–1470. New York/Oxford: Oxford University Press, 1992.
- Westfall, Carroll William. In This Most Perfect Paradise. University Park: Pennsylvania State University Press, 1974.
- Zuraw, Shelley E. "Mino da Fiesole's First Roman Sojourn: The Works in Santa Maria Maggiore," in *Verrocchio and Late Quattrocento Italian Sculpture* (ed. Steven Bule, Alan Phipps Darr, and Fiorella Superbi Gioffredi). Florence: Casa Editrice Le Lettere, 1992, 303–19.

Sixteenth Century

- Bailey, Gauvin Alexander. "The Jesuits and Painting in Italy, 1550–1690: The Art of Catholic Reform," in Saints and Sinners: Caravaggio and the Baroque Image (ed. Franco Mormando). Newton (Mass): McMullen Museum of Art, Boston College, 1999 (distributed by University of Chicago Press).
- Bruschi, Arnaldo. *Bramante*. London: Thames & Hudson, 1977.
- Burroughs, Charles. "Michelangelo at the Campidoglio: Artistic Identity, Patronage, and Manufacture," *Artibus et Historiae*, 28, 1993, 85–111.
- Buser, Thomas. "Jerome Nadal and Early Jesuit Art in Rome," *Art Bulletin*, 58, 1976, 424-33.
- Chastel, André. *The Sack of Rome, 1527.*Princeton: Princeton University Press, 1983.
- Ebert-Schifferer, Sybille. "Ripandas Kapitolinischer Freskenzyklus und die Selbstdarstellung der Konservatoren um 1500," Römisches Jahrbuch für Kunstgeschichte, 23/24, 1988, 75–218.
- Fontana, Domenico. *Della trasportatione* dell'obelisco vaticano et delle fabriche di nostro signore Papa Sisto V. Rome: Domenico Basa, 1590 (reprinted Milan: Edizioni il Polifilo, 1978, ed. Adriano Carugo).
- Freedberg, David. "Johannes Molanus on Provocative Paintings," *Journal of the Warburg* and Courtauld Institutes, 34, 1971, 229–45.
- Freiberg, Jack. *The Lateran in 1600: Christian Concord in Counter-Reformation Rome*.
 Cambridge: Cambridge University Press, 1995.
- Hersey, George. *High Renaissance Art in St. Peter's and the Vatican*. Chicago: University of Chicago Press, 1993.
- Herz, Alexandra. "Imitators of Christ: The Martyr-Cycles of Late Sixteenth Century Rome Seen in Context," *Storia dell'Arte*, 62, 1988, 54–70.
- Hibbard, Howard. "Ut picturae sermones: The First Painted Decorations of the Gesù," in Baroque Art: The Jesuit Contribution (ed. Rudolf Wittkower and Irma B. Jaffe). New York: Fordham University Press, 1972, 29–50.
- Hirst, Michael. Sebastiano del Piombo. Oxford: Clarendon Press, 1981.
- Jones, Roger, and Nicholas Penny. *Raphael*. New Haven: Yale University Press, 1983.
- Joost-Gaugier, Christiane L. "Michelangelo's Ignudi, and the Sistine Chapel as a Symbol of Law and Justice," *Artibus et Historiae*, 34, 1996, 19–43.
- Kempers, Bram, "Sans fiction ne dissimulacion": The Crowns and Crusaders in the Stanza dell'Incendio," in *Der Medici-Papst Leo X. und Frankreich* (ed. Götz-Rüdiger Tewes and Michael Rohlmann). Tübingen: Mohr Siebeck, 2002, 373–425.
- Madonna, Maria L. (ed.). Roma di Sisto V: Le arti e la cultura. Rome: De Luca, 1993.
- Magnuson, Torgil. *Rome in the Age of Bernini*. Atlantic Highlands, NJ: Humanities Press, 1982, vol. 1, 1–38.
- Mâle, Emile. L'Art religieux après le Concile de Trente. Paris, 1932.
- Mancinelli, Fabrizio (ed.). *The Sistine Chapel*. New York: Knopf, 1991.

- Martin, Gregory. *Roma Sancta (1581)* (ed. George Bruner Parks). Rome: Edizioni di Storia e Letteratura, 1969.
- Monssen, Lief Holm. "The Martyrdom Cycle in Santo Stefano Rotondo," *Acta ad Archaeologiam et Artium Historiam Pertinentia*, series altera, II, 1982, 175–319 and III, 1983, 11–106
- Ostrow, Steven F. The Sistine Chapel at S. Maria Maggiore: Sixtus V and the Art of the Counter Reformation. Ann Arbor: University Microfilms, 1987.
- Art and Spirituality in Counter-Reformation Rome: The Sistine and Pauline Chapels in S. Maria Maggiore. Cambridge/New York: Cambridge University Press, 1996.
- Partridge, Loren, and Randolph Starn. A Renaissance Likeness: Art and Culture in Raphael's Julius II. Berkeley: University of California Press, 1980.
- Pecchiai, Pio. *Il Gesù di Roma*. Rome: Società Grafica Romana, 1952.
- Pietrangeli, Carlo (ed.). The Sistine Chapel: The Art, the History, and the Restoration. New York: Harmony Books, 1986.
- Robertson, Clare. "Il gran cardinale": Alessandro Farnese, Patron of the Arts. New Haven: Yale University Press, 1992.
- Rowland, Ingrid D. The Culture of the High Renaissance: Ancients and Moderns in Sixteenth-Century Rome. New York: Cambridge University Press, 1998.
- Sette, Maria Piera (ed.). Sisto V: Architetture per la città. Rome: Multigrafica Editrice, 1992.
- Shearman, John. "The 'Dead Christ' by Rosso Fiorentino," *Bulletin: Museum of Fine Arts, Boston*, 64 (338), 1966, 148-72.
- Talvacchia, Bette. *Taking Positions: On the Erotic* in Renaissance Culture. Princeton: Princeton University Press, 1999.
- Valone, Carolyn. "Roman Matrons as Patrons: Various Views of the Cloister Wall," in *The* Crannied Wall: Women, Religion, and the Arts in Early Modern Europe (ed. Craig A. Monson). Ann Arbor: University of Michigan Press, 1992, 49–72.
- Zeri, Federico. *Pittura e controriforma*. Turin: Giulio Einaudi, 1957.

SIENA

General

- Bortolotti, Lando. Siena. Rome, 1983. Cole, Bruce. Sienese Painting from Its Origins to the Fifteenth Century. New York: Harper & Row, 1980.
- Riedl, Anselm and Max Seidel (eds.). *Die Kirchen von Siena*. Munich: Bruckmann, 1985–.
- van Os, Henk. Sienese Altarpieces, 1215–1460 (2 vols.). Groningen: Bouma's Boekhuis, 1984/Groningen: Egbert Forsten Publishing, 1990.

Thirteenth and Fourteenth Centuries

Deuchler, Florens. *Duccio*. Milan: Electa, 1984. Kempers, Bram. "Icons, Altarpieces, and Civic Ritual in Siena Cathedral, 1100–1530," in *City and Spectacle in Medieval Europe* (ed. Barbara A. Hannawalt and Kathryn L. Reyerson). Minneapolis: University of Minnesota Press, 1994, 89–136.

- Kosegarten, Antje Middeldorf. Sienesische Bildhauer am Duomo Vecchio: Studien zur Skulptur in Siena, 1250–1330. Munich: Bruckmann, 1984.
- Maginnis, Hayden B.J. "Ambrogio Lorenzetti's Presentation in the Temple," *Studi di storia dell'arte*, 2, 1991, 31–43.
- —. "The Lost Façade Frescoes from Siena's Ospedale di S. Maria della Scala," Zeitschrift für Kunstgeschichte, 51, 1988, 180–94.
- Martindale, Andrew. Simone Martini. Oxford: Phaidon, 1988.
- Norman, Diana. Siena and the Virgin: Art and Politics in a Late Medieval City State. New Haven: Yale University Press, 1999.
- Pietramellara, Carla. Il Duomo di Siena: Evoluzione della forma dalle origini alla fine del trecento. Florence, 1980.
- Rowley, George. *Ambrogio Lorenzetti* (2 vols.). Princeton: Princeton University Press, 1958.
- Rubinstein, Nicolai. "Ambrogio Lorenzetti and Taddeo di Bartolo in the Palazzo Pubblico," *The Journal of the Warburg and* Courtauld Institutes, 21, 1958, 179–207.
- Starn, Randolph. *Ambrogio Lorenzetti: The Palazzo Pubblico, Siena*. New York: Braziller, 1994.
- Stubblebine, James H. *Duccio di Buoninsegna* and his School (2 vols.). Princeton: Princeton University Press, 1979.
- White, John. *Duccio: Tuscan Art and the Medieval Workshop*. London: Thames & Hudson, 1979

Fifteenth Century

- Christiansen, Keith, Laurence B. Kanter, and Carl Brandon Strehlke. *Painting in Renaissance Siena*, 1420–1500. New York: Metropolitan Museum and Abrams, 1988.
- Mallory, Michael, and Gaudenz Freuler.
 "Sano di Pietro's Bernardino Altarpiece for the Compagnia della Vergine in Siena,"
 The Burlington Magazine, 133, 1991, 186–92.
- Seymour, Charles, Jr. *Jacopo della Quercia*. New Haven: Yale University Press, 1973.
- Southard, Edna Carter. The Frescoes in Siena's Palazzo Pubblico, 1289–1539: Studies in Imagery and Relations to other Communal Palaces in Tuscany. New York: Garland, 1979.
- Symeonides, Sibilla. *Taddeo di Bartolo*. Siena: Accademia Senese degli Intronati, 1965.

URBINO

- Piero e Urbino: Piero e le corti rinascimentali (ed. Paolo dal Poggetto). Venice: Marsilio, 1992.
- Cheles, Luciano. *The Studiolo of Urbino: An Iconographic Investigation*. Wiesbaden: Dr. Ludwig Reichert Verlag, 1986.
- Clough, Cecil. "Federigo da Montefeltro's Artistic Patronage," *Journal of the Royal Society of Arts*, 126, 1978, 718–34.
- —. "Federigo da Montefeltro's Patronage of the Arts," Journal of the Warburg and Courtauld Institutes, 36, 1973, 129-44.
- Heydenreich, Ludwig Heinrich. "Federico da Montefeltro as a Building Patron: Some Remarks on the Ducal Palace of Urbino," in Studien zur Architektur der Renaissance, Ausgewählte Aufsätze. Munich: Wilhelm Fink, 1981.

- Lavin, Marilyn Aronberg. "Piero della Francesca's Montefeltro Altarpiece: A Pledge of Fidelity," Art Bulletin, 51, 1969, 367–71.
- Lightbown, Ronald. *Piero della Francesca*. New York: Abbeville, 1992.
- Meiss, Millard. "Ovum Struthionis: Symbol and Allusion in Piero della Francesca's Montefeltro Altarpiece," in The Painter's Choice: Problems in the Interpretation of Renaissance Art. New York: Harper & Row, 1976.
- with Theodore G. Jones. "Once Again Piero della Francesca's Montefeltro Altarpiece," in *The Painter's Choice: Problems in the Interpretation of Renaissance Art.* New York: Harper & Row, 1976.
- Rotondi, Pasquale. *Il palazzo ducale di Urbino* (2 vols.). Urbino: Istituto statale d'arte per il libro, 1950–51.

VENICE

General

- Brown, Patricia Fortini. "Painting and History in Renaissance Venice," *Art History*, 7, 1984, 263–94.
- —. "The Self-Definition of the Venetian Republic," in City and State in Classical Antiquity and Medieval Italy (ed. Anthony Molho et al.). Ann Arbor: University of Michigan Press, 1991, 511–48.
- Art and Life in Renaissance Venice. New York: Harry N. Abrams and Prentice Hall, 1997.
- Concina, Ennio. A History of Venetian Architecture (trans. Judith Landry). Cambridge and New York: Cambridge University Press, 1998.
- Davis, Robert C. *The War of the Fists: Popular Culture and Public Violence in Late Renaissance Venice.* New York/Oxford: Oxford University Press, 1994.
- Howard, Deborah. *The Architectural History of Venice*. New York: Holmes & Meier, 1981.
- . Venice and the East. London: Yale University Press, 2000.
- Humfrey, Peter. *Painting in Renaissance Venice*. New Haven: Yale University Press, 1995.
- Huse, Norbert, and Wolfgang Wolters. *The Art of Renaissance Venice: Architecture, Sculpture, and Painting.* Chicago: University of Chicago Press, 1990.
- Perry, Marilyn. "Saint Mark's Trophies: Legend, Superstition, and Archaeology in Renaissance Venice," *Journal of the Warburg and Courtauld Institutes*, 40, 1977, 27–49.
- Pincus, Debra. "Venice and the Two Romes: Byzantium and Rome as a Double Heritage in Venetian Cultural Politics," *Artibus et historiae*, 26, 1992, 101–14.
- —. *The Tombs of the Doge of Venice*. New York: Cambridge University Press, 2000.
- Rosand, David. "Venetia Figurata: The Iconography of a Myth," in *Interpretazioni Veneziane: Studi di Storia dell'Arte in onore di Michelangelo Muraro* (ed. David Rosand). Venice: Arsenale Editrice, 1984, 177–96.
- Schulz, Juergen. "Urbanism in Medieval Venice," in City and State in Classical Antiquity and Medieval Italy (ed. Anthony Molho et al.).
 Ann Arbor: University of Michigan Press, 1991, 419–45.

Thirteenth and Fourteenth Centuries

- Arslan, Edoardo. Gothic Architecture in Venice (trans. Anne Engel). London: Phaidon, 1972.
- Demus, Otto. *The Mosaics of San Marco in Venice*. Chicago: University of Chicago Press, 1984.
- Jacoff, Michael. The Horses of San Marco and the Quadriga of the Lord. Princeton: Princeton University Press, 1993.
- Pincus, Debra. "Andrea Dandolo (1343–1354) and Visible History: The San Marco Projects," in *Art and Politics in Late Medieval and Early Renaissance Italy: 1250–1500* (ed. Charles M. Rosenberg). Notre Dame/London: University of Notre Dame Press, 1990, 191–206.
- —. The Tombs of the Doges of Venice. Cambridge: Cambridge University Press, 2000.
- Wolters, Wolfgang. La scultura veneziana gotica. Venice: Alfieri, 1976.

Fifteenth Century

- Brown, Patricia Fortini. Venetian Narrative Painting in the Age of Carpaccio. New Haven: Yale University Press, 1988.
- —. "The Antiquarianism of Jacopo Bellini," *Artibus et historiae*, 26, 1992, 65–84.
- Degenhart, Bernhard, and Annegrit Schmitt. Jacopo Bellini: l'Album dei disegni del Louvre. Milan: Jaca, 1984 (original edition in English, New York: Braziller, 1984).
- Dyggve, E. "Il frontone ad arco e trilobato veneziano: Alcune osservazioni sulla sua origine," in Venezia e l'Europa. Atti del XVIII congresso internazionale di storia dell'arte, Venice, 226-30.
- Eisler, Colin. The Genius of Jacopo Bellini: The Complete Paintings and Drawings. New York: Abrams. 1989.
- Fiocco, G. "Michele Giambono," Venezia: Studi di arte e storia a cura della direzione del Museo Civico Correr, 1, 1920, 206–36.
- Fleming, John. From Bonaventure to Bellini: An Essay in Franciscan Exegesis. Princeton: Princeton University Press, 1982.
- Gentili, Augusto. "Il telero di Giovanni Bellini per Agostino Barbarigo: Strategia e funzione," *Prilozi povijesti umketnosti u Dalmaciji*, 32, 1992, 599–611.
- Gnudi, Cesare. "Jacobello e Pietro Paolo da Venezia," *La Critica d'Arte*, 2, 1937, 26–38.
- Goffen, Rona. "Bellini, S. Giobbe, and Altar Egos," *Artibus et historiae*, 14, 1986, 57–70.
- —. Giovanni Bellini. New Haven: Yale University Press, 1989.
- Goy, Richard J. *The House of Gold: Building a Palace in Medieval Venice.* Cambridge: Cambridge University Press, 1992.
- Humfrey, Peter. *The Altarpiece in Renaissance* Venice. New Haven/London: Yale University Press, 1993.
- Lieberman, Ralph. Renaissance Architecture in Venice, 1450–1540. New York: Abbeville, 1982.
- "Real Architecture, Imaginary History: The Arsenal Gate as Venetian Mythology," Journal of the Warburg and Courtauld Institutes, 54, 1991, 117-26.
- Maek-Gérard, Michael. "Die Milanexi in Venedig: Ein Beitrag zur Entwicklungsgeschichte der Lombardi-Werkstatt," Wallraf-Richartz-Jahrbuch, 41, 1980, 105–131, 142.

- Merkel, Ettore. "Un problema di metodo: La *Dormitio Virginis* dei Mascoli," *Arte veneta*, 27, 1973, 65–80.
- Munman, Robert. "Antonio Rizzo's Sarcophagus for Niccolò Tron: A Closer Look," *Art Bulletin*, 55, 1973, 77–85.
- Muraro, Michelangelo. "The Statues of the Venetian *Arti* and the Mosaics of the Mascoli Chapel," *Art Bulletin*, 43, 1961, 263–74.
- —. "La Scala senza giganti," in *De artibus opuscula XL: Essays in Honor of Erwin Panofsky* (ed. Millard Meiss). New York: New York University Press, 1961, 350–70.
- Niero, Antonio. *Chiesa di Santo Stefano in Venezia*. Padua: Edizioni Messaggero, 1978.
- Pallucchini, Rodolfo. La pittura veneta del quattrocento: Il gotico internazionale e gli inizi del rinascimento. Bologna, 1956.
- —. La pittura veneta del quattrocento, parte I: Il rinascimento (typescript). Istituto di Storia dell'Arte, Università di Padova, Anno accademico 1956-7.
- —. La pittura veneta del quattrocento, parte II: La diffusione del Mantegnismo nel Veneto dal Crivelli a Giovanni Bellini (typescript). Istituto di Storia dell'Arte, Università di Padova, Anno accademico 1957-8.
- —. I Vivarini (Antonio, Bartolomeo, Alvise). Venice: Neri Pozza, [1961].
- Pesaro, Cristina. "Per un catalogo di Michele Giambono," Atti dell'Istituto Veneto di Scienze, Lettere ed Arti, 136, 1977-8, 19-33.
- Pincus, Debra. "The Tomb of Niccolò Tron and Venetian Renaissance Ruler Imagery," in *Art the Ape of Nature: Studies in Honor of H.W. Janson* (ed. Moshe Barasch and Lucy Freeman Sandler). New York: Abrams, 1981, 127–52.
- Planiscig, Leo. Venezianische Bildhauer der Renaissance. Vienna: Anton Schroll, 1921.
- Puppi, Loredana Olivato, and Lionello Puppi. Mauro Codussi e l'architettura veneziana del primo rinascimento. Milan: Electa, 1977.
- Robertson, Giles. Giovanni Bellini. Oxford, 1968. Schulz, Anne Markham. Antonio Rizzo: Sculptor and Architect. Princeton: Princeton University Press, 1983.
- Sheard, Wendy Stedman. "The Birth of Monumental Classicizing Relief in Venice on the Façade of the Scuola di San Marco," in *Interpretazioni Veneziane: Studi di storia dell'arte in onore di Michelangelo Muraro* (ed. David Rosand). Venice: Arsenale Editrice, 1984, 149–74.

Sixteenth Century

- Titian, Prince of Painters. Munich: Prestel, 1990. Ackerman, James S. Palladio's Villas. New York: J.J. Augustin for the Institute of Fine Arts, 1967.
- —. "The Geopolitics of Venetian Architecture in the Time of Titian," in *Titian: Ilis World and His Legacy* (ed. David Rosand). New York: Columbia University Press, 1982, 41–71.
- Anderson, Jayne. "Giorgione, Titian and the Sleeping Venus," in *Tiziano e Venezia*. Vicenza: Neri Pozza, 1980, 337–42.
- Calabi, Donatella, and Paolo Morachiello. *Rialto: Le fabbriche e il ponte, 1514–1591*. Turin, 1987.
- Cocke, Richard. "Veronese and Daniele Barbaro: The Decoration of Villa Maser," *Journal of the Warburg and Courtauld Institutes*, 35, 1972, 226–46.

- Ettlinger, Helen S. "The Iconography of the Columns in Titian's Pesaro Altarpiece," *Art Bulletin*, 61, 1979, 59–67.
- Fehl, Phillip. "Saints, Donors and Columns in Titian's Pesaro Madonna," in *Renaissance Papers 1974* (ed. Dennis G. Donovan and A. Leigh Deneef). Durham, NC: The Southeastern Renaissance Conference, 1975, 75–85.
- Gaston, Robert W. "Vesta and the Martyrdom of St. Lawrence in the Sixteenth Century," Journal of the Warburg and Courtauld Institutes, 37, 1974, 358–62.
- Goedicke, Christian, Klaus Slusallek, and Martin Kubelik. "Thermoluminescent Dating in Architectural History: The Chronology of Palladio's Villa Rotonda," *Journal of the Society* of Architectural Historians, 45, 1986, 396–407.
- Goffen, Rona. *Titian's Women*. New Haven/London: Yale University Press, 1997.
- (ed.). *Titian's "Venus of Urbino."* Cambridge: Cambridge University Press, 1997.
- Gordon, D.J. "Academicians Build a Theatre and Give a Play: The Accademia Olimpica, 1579–1585," in *The Renaissance Imagination:* Essays and Lectures by D.J. Gordon. Berkeley: University of California Press, 1975, 247–68.
- Howard, Deborah. "Giorgione's Tempesta and Titian's Assunta in the Context of the Cambrai Wars," *Art History*, 8, 1985, 271–89.
- —. Jacopo Sansovino: Architecture and Patronage in Renaissance Venice. New Haven/London: Yale University Press, 1975 (second printing with corrections, 1987).
- Huse, Norbert. "Palladio und die Villa Barbaro in Maser: Bemerkungen zum Problem der Autorschaft," Arte veneta, 28, 1974, 106-22.
- Kaplan, Paul H.D. "The Storm of War: The Paduan Key to Giorgione's Tempest," Art History, 9, 1986, 405–25.
- Libbey, L. "Venetian History and Political Thought after 1509," *Studies in the Renaissance*, 20, 1973, 7-45.
- Neumann, Jaromír. *Titian: The Flaying of Marsyas* (trans. Till Gottheiner). London: Spring Books. 1962.
- Palladio, Andrea. *I quattro libri dell'architettura*. Venice, 1570 (facsimile reprint Milan: Hoepli, 1951).
- Reist, Inge Jackson. "Divine Love and Veronese's Frescoes at the Villa Barbaro," Art Bulletin, 67, 1985, 614–35.
- Rogers, Mary. "An Ideal Wife at the Villa Maser: Veronese, the Barbaros and Renaissance Theorists on Marriage," *Renaissance Studies*, 7, 1993, 379–97.
- Schulz, Juergen. "Tintoretto and the First Competition for the Ducal Palace 'Paradise'," *Arte veneta*, 34, 1980, 112–26.
- Settis, Salvatore. Giorgione's Tempest: Interpreting the Hidden Subject. Chicago: University of Chicago Press, 1990.
- Sinding-Larsen, Staale. Christ in the Council Hall: Studies in the Religious Iconography of the Venetian Republic (Acta ad Archaeologiam et Artium Historiam Pertinentia) (Institutum Romanum Norvegiae, V). Rome: L'Erma di Bretschneider, 1974.
- Tafuri, Manfredo. Venice and the Renaissance (trans. Jessica Levine) (Chapter 2: Republican pietas, Neo-Byzantinism, and Humanism. San Salvador: A Temple in visceribus urbis). Cambridge, MA: MIT Press, 1989.

Literary Credits and Picture Credits

LITERARY CREDITS

The authors and publishers wish to thank the following for permission to use copyright material. Every effort has been made to trace or contact all copyright holders. The publishers would be pleased to rectify any omissions notified at the earliest opportunity.

Harry N. Abrams Inc.: from Lives of the Most Eminent Painters, Sculptors, and Architects: Volume II by Giorgio Vasari, translated by Gaston de Vere, edited by Kenneth Clark (New York: Harry N. Abrams, 1979). All rights reserved; Blackwell Publishers: from Venice: A Documentary History by D. S. Chambers and B. Pullan with J. Fletcher (Oxford: Blackwell, 1992); Cambridge University Press: from The House of Gold: Building a Palace in Medieval Venice by Richard J. Goy (Cambridge: Cambridge University Press, 1992); Dover Publications Inc.: from The Craftsman's Handbook, translated by Daniel V. Thompson, Jr. (New York: Dover Publications, 1960); Franciscan Press: from St Francis of Assisi: Writings and Early Biographies, edited by Marion Habig, OFM (Chicago: Franciscan Herald Press, 1972); Paulist Press: from Catherine of Siena: The Dialogue, translated by Susan Noffke (New York: Paulist Press, 1980); Penguin Books Ltd.: from The Book of the Courtier by Baldassare Castiglione, translated by George Bull (Penguin Classics, 1967), © George Bull, 1967; from The Autobiography of Benvenuto Cellini, translated by George Bull (Penguin Classics, 1956), @ George Bull, 1956; Pennsylvania State University: from The Life of Brunelleschi by Antonio Manetti, edited by Howard Saalman (University Park: Pennsylvania State University Press, 1970); Princeton University Press: from "Ghiberti: Commentaries," in A Documentary History of Art by Elizabeth G. Holt (New York: Doubleday, 1957), © 1947, renewed 1957, 1981 by Princeton University Press; from Literary Sources of Art History by E. G. Holt (Princeton University Press, 1947), © 1947, renewed 1975 by Princeton University Press; Yale University Press: from On Painting by Leon Battista Alberti, translated/edited by John Spencer (New Haven: Yale University Press, 1956); "Sonnet 151" from The Poetry of Michelangelo by James Saslow (New Haven: Yale University Press, 1991).

PICTURE CREDITS

Collections are given in the captions alongside the illustrations. Sources for illustrations not supplied by museums or collections, additional information, and copyright credits are given below. Numbers refer to figure numbers except where page numbers are indicated. The following abbreviations have been used: Alinari-Oalinari, Florence; Austin-OJames Austin, Cambridge; Bencini-Oraffaello Bencini, Florence; Bohm-OFrancesco Turio Bohm, Venice; Cameraphoto-OCAMERAPHOTO Arte, Venice; Canali-OCanali Photobank, Milan; Foglia-OFotografica Foglia, Naples; Fotomas-OFotomas Index, Kent UK; Index-OIndex, Florence; Josse-OPhoto Josse, Paris; Lensini-OFoto Lensini, Siena; Morris-OJames Morris, London; Pirozzi-OVincenzo Pirozzi, Rome fotopirozzi@inwind.it; Quattrone-OStudio Fotografico Quattrone, Florence; RMN-ORMN, Paris.

frontispiece & p.12 Quattrone. 1 Museo Bardini, Florence. 2 Böhm. 3 Scala. 4 ©British Museum, London. 5, 9 Quattrone. 7 The Duke of Northumberland, photo Courtauld Institute of Art, London, 8 RMN/Michèle Bellot, 10, 11 Lensini, 13, 15, 16 Quattrone. 14 Scala. 17 Vatican Museums, Rome. 18 Yale University Art Gallery, University Purchase from James Jackson Jarves. 19 Alinari. 21 Foglia. 23 Quattrone. 24 Foglia. 25 Scala. 26 Francesca G. Bewer. 27 ©the Frick Collection, New York. 28 The Governing Body, Christ Church, Oxford. 29 RMN. 30 Lensini. 31 Alinari. 33 Scala. 36 Devonshire Collection, Chatsworth. Reproduced by permission of the Chatsworth Settlement Trustees. 38 Photo Vatican Museums. 39, 42 Quattrone. 40, 41 Alinari. 43 ©Foto Berardi/Index, Florence. p. 46 Quattrone. p. 48, 1.1, 1.5 Scala. 1.2, 1.3, 1.4 Quattrone. p. 56 Canali. 2.1 Fotomas. 2.2 Photo Vatican Museums. 2.3 Photo Vatican Museums/A.Bracchetti, 1994. 2.4 Photo Vatican Museums/ D.Pivato, 1994. 2.5 Alinari. 2.6 Courtesy of the Right Reverend Monsignor D.J. David Lewis, Vicar Capitular and Administrator, Basilica Santa Maria Maggiore. 2.7, 2.9, 2.10 Scala. 2.8 Canali. 2.11 Alinari. 2.12 Photo Biblioteca Vaticana (Vat.Barb. Lat 2733, ff 146v/147r). 2.13 Scala. p. 67 Quattrone. 3.1, 3.3, 3.5, 3.6, 3.7, 3.8 Quattrone. 3.4 Scala. 3.10 Studio Deganello, Padua. 3.11, 3.12 Quattrone. p. 77 Scala. 4.1 Quattrone. 4.2 Alinari. 4.3 LKP Archives/Ralph Liebermann. 4.4 Scala. 4.5 from Marvin Trachtenberg, Dominion of the Eye: Urbanism, Art, and Power in Early Modern Florence, Cambridge University Press, 1997. 4.6 ©Biblioteca Apostolica Vaticana. 4.7 Böhm. 4.8, 4.9 Scala. 4.12, 4.13, 4.14, 4.15, 4.16, 4.17, 4.18 Quattrone. 4.19 Bencini. 4.20, 4.22 Quattrone. 4.21 ©Biblioteca Apostolica Vaticana. 4.23 Bencini. 4.24 Nicolo Orsi Battaglini, Florence. 4.26 Scala. 4.27, 4.28 Quattrone. 4.29 Alinari. p. 99, 5.1, 5.5 Scala. 5.3 Lensini. 5.4, 5.6, 5.7, 5.9, 5.10, 5.11, 5.12, 5.13, 5.16 Quattrone. 5.8 Alinari. 5.14, 5.15, 5.19 Scala. 5.17, 5.18 Lensini. 5.20, 5.21 Alinari. 5.22, 5.24, 5.28, 5.29, 5.30 Quattrone. 5.23 Lensini. 5.25, 5.26, 5.27 Scala. 5.31, 5.32, 5.33, 5.34, 5.35 Alinari. p. 124, 6.1 Foglia. 6.2 The Pierpont Morgan Library/Art Resource, New York/ Scala, Florence. 6.4 Canali. 6.5, 6.6 Foglia. 6.8 Alinari. 6.10 Index, Florence. 6.11, 613, 6.17 Foglia. 6.12, 6.14, 6.16 Alinari. p. 135 Cameraphoto. 7.1 Fotomas. 7.2 Böhm. 7.3, 7.4, 7.6, 7.7 Cameraphoto. 7.5, 7.8, 7.9, 7.10 Bohm. 7.11 Alinari. 7.12, 7.13, 7.16, 7.17, 7.18, 7.19, 7.20 Cameraphoto. 7.14, 7.15 Böhm. 7.20 ©British Museum, London. p. 152 Quattrone. 8.1, 8.2, 8.5, 8.6, 8.8 Alinari. 8.3 Scala. 8.4, 8.7, 8.9, 8.12 Ouattrone, 8.10, 8.16, 8.20 Scala, 8.13, 8.14, 8.15, 8.17, 8.18 8.19 Alinari. p. 174 Quattrone. 9.1 Civica Raccolta delle Stampe 'Achille Bertarelli', Milan. All rights reserved. 9.2. 9.6, 9.7, 9.8 Alinari, 9.5 Studio Fotografico Perotti, Milan, 9.10 Garv Radke. 9.18 Scala. 9.19 Canali. 9.20 Veneranda Arca di S. Antonio, Padua. 9.21 Alinari. 9.24 A.F. Kersting, London. 9.25 Under licence from the Italian Ministry for Cultural Goods and Activities. 9.27 Alinari. 9.28 Biblioteca Nazionale, Florence, Banco Rari 397, fol 115. 9.29, 9.32, 9.33 Scala. 9.34 The Pierpont Morgan Library/Art Resource, New York/Scala, Florence. 9.35, 9.36, 9.38 Alinari. 9.37 Foglia. p. 202 Cameraphoto. p. 204 Quattrone. 10.1 Conway Library, Courtauld Institute of Art, London. 10.2 Alinari. 10.3, 10.4 10.6, 10.7 Quattrone. 10.5 Scala. 10.8, 10.11, 10.12, 10.14, 10.18, 10.21 Alinari. 10.9, 10.10, 10.13, 10.16, 10.17, 10.19, 10.20 Quattrone. 10.22, 10.23 Scala. 10.24 Preussischer Kulturbesitz Berlin, photo Jörg P. Anders. 10.26, 10.28, 10.30 Scala. 10.27 Alinari. 10.29 Quattrone. 10.31 National Gallery, London (centre panel); Alinari (side panels). 10.33, 10.34, 10.35, 10.36, 10.37, 10.38, 10.42, 10.44, 10.45 Quattrone, 10.40, 10.41, 10.46, 10.47 Scala, 10.43, 10.48, 10.49, 10.50, 10.51, 10.52, 10.53, 10.55, 10.56 Alinari 10.54 Quattrone. 10.57, 10.58, 10.59, 10.61 Scala. 10.60 Quattrone. 10.62, 10.64, 10.65, p. 251, 11.2 Quattrone. 11.3, 11.4 Bencini. 11.6, 11.11 Scala. 11.7, 11.8, 11.9, 11.10, 11.14 Quattrone. 11.12 Austin. 11.13 Alinari. 11.15 Preussischer Kulturbesitz Berlin, photo Jörg P. Anders. 11.17, 11.18, 11.20, 11.21, 11.23, 11.24, 11.25 Alinari. 11.22, 11.26, 11.28 Quattrone. 11.27, 11.29 Scala. 11.30 Andrew W. Mellon Collection, ©1996 Board of Trustees, National Gallery of Art, Washington D.C. 11.31 Scala. 11.32, 11.33, 11.34 Quattrone. 11.37 ©Museo Thyssen-Bornemisza, Madrid. 11.38. 11.41, 11.42, 11.43 Quattrone. 11.39 Alinari; 11.44 Bildarchiv Preussischer Kulturbesitz, Berlin. 11.46 LKP archives. 11.47 Quattrone. p. 289 Scala.12.1 Araldo De Luca, Rome. 12.2 Scala (centre panel). 12.3, 12.4 Morris. 12.6, 12.7, 12.8 Photo Vatican Museums, Rome. 12.9 Photo Biblioteca Vaticana (Vat.Barb. Lat 2733, ff 104v/105r). 12.10 Morris. 12.12 Alinari. 12.13, 12.15 Scala. 12.16 Pirozzi. 12.17 Canali 12.18 Alinari. 12.19 RMN. 12.20 Morris. 12.21, 12.25 Alinari. 12.22, 12.26 Pirozzi. 12.24, 12.27 Morris. 12.29, 12.30 Photo Vatican Museums, 12.31 Alinari, 12.32 Scala, 12.33 Morris. 12.34 ©Araldo De Luca, Rome. 12.35 Scala p. 313 Cameraphoto, 13.1 Böhm, 13.2, 13.3, 13.6, 13.7 13.8, 13.9, 13.11 Cameraphoto. 13.10 RMN. 13.12 Alinari. 13.13 Scala. 13.14 Josse. 13.15 Cameraphoto. 13.16, 13.18 Böhm. 13.19, 13.20, 13.21 Cameraphoto. 13.22 Böhm. 13.25 ©The Frick Collection, New York. 13.26 Alinari. 13.27 13.29, 13.30, 13.33 Cameraphoto. 13.28 Böhm. 13.31, 13.32 Böhm. p. 336 Scala. 14.1, 14.2 Alinari. 14.3 Cameraphoto. 14.4 ©British Museum, London. 14.5 Index, Florence/ ©Soprintendenza B.A.S. del Veneto, Verona, 14.6 Biblioteca Estense, Modena Ms Lat. 42 V.G. 12, I. c.280 V. 14.8 Scala. 14.9 Alinari. 14.10 Index. 14.11, 14.13, 14.14, 14.15 Foglia. 14.17 Alinari. 14.18, 14.19 Scala. 14.20, 14.21 Bencini. 14.23 Austin. 14.24, 14.25, 14.27, 14.28, 14.30 Scala. 14.26 LKP Archives, London/Ralph Liebermann. 14.31, 14.32 Quattrone. 14.33 The Royal Collection ©Her Majesty Queen Elizabeth II. 14.34, 14.35, p. 362 Josse. 15.1 Gugliemo Chiolini, Pavia. 15.2 Alinari. 15.3 Istituto Geografico De

Agostini, Milan. 15.4 Austin. 15.5 photo Pineider, courtesy Index Florence. 15.6, 15.7 Mauro Ranzani/Index, Florence. 15.10, 15.12 Scala. 15.13 Gugliemo Chiolini, Pavia. 15.14, 15.15 Quattrone. 15.16 The Royal Collection ©2004, Her Majesty Queen Elizabeth II; RL 12424. 15.17 Bulloz, Paris. 15.18 The Royal Collection ©2000 Her Majesty Oueen Elizabeth II. 15.19 Civiche Raccolte d'Arte, Castello Sforzesco, Milan. p. 376 Photo Vatican Museums. p. 378 Scala. 16.2 RMN. 16.3 Alinari. 16.5, 16.6 Civiche Raccolte d'Arte, Castello Sforzesco, Milan. 16.7 Archivio della Riserva Naturale Speciale del Sacro Monte di Varallo. 16.8 Fotografo Mariano Dallago di Baldissero Torinese; Archivio della Riserva Naturale Speciale del Sacro Monte di Varallo. 16.9, 16.10 Alinari. 16.11 Photograph ©1984 The Metropolitan Museum of Art. p. 387, 17.1, 17.2 Quattrone. 17.3, 17.4 Alinari. 17.6 RMN. 17.7 By kind permission of the Earl of Leicester and the Trustees of the Holkham Estate, photograph Courtauld Institute of Art, London. 17.8 Photo RMN-Lewandowski/Le Mage. 17.9, 17.10, 17.11 Quattrone. 17.12 Pirozzi. p. 397 Photo Vatican Museums. 18.1 Gabinetto Disegni e Stampe degli Uffizi, Florence, courtesy Quattrone. 18.4 ©British Museum, London. 18.6, 18.11 Pirozzi. 18.7 Böhm, 18.10 Josse, 18.12 Photo Vatican Museums, 18.14 Photo Vatican Museums (A.Bracchetti), 18.15, 18.16, 18.17, 18.18, 18.20, 18.22, 18.23, 18.24, 18.26, 18.27 Photo Vatican Museums, 18.19 Conway Library, Courtauld Institute of Art, London. 18.21 Scala. 18.25 @Archivio Musei Capitolini/ Index, Florence. 18.29 Josse. 18.30, 18.34, 18.36, 18.37 Pirozzi. 18.31, 18.32 Photo Vatican Museums. 18.33 V&A Images. 18.35 Alinari. 18.38 @British Museum, London. 18.39 Scala. 18.40 Photo Vatican Museums (M. Sarri). 18.42 Museum of Fine Arts. Boston, Charles Potter Kling Fund 58.527. Photograph ©2004 Museum of Fine Arts, Boston, 58.527. Courtesy, Museum of Fine Arts, Boston. Reproduced with permission. 19.1, 19.2, 19.8 Scala. 19.3 Austin. 19.6 Alinari. 19.9 Foglia. 19.10 Quattrone. 19.11 Scala. 19.12 ©Index, Florence/Kunsthistorisches Institut. 19.13 Index, Florence. 19.14 ©Rijksmuseum-Stichting, Amsterdam. 19.15 Scala. 19.16 Alinari. p. 437, 20.1, 20.2, 20.5, 20.6, 20.8 Quattrone. 20.3 John Paoletti. 20.7 Index, Florence/Tosi. 20.10 Bencini, 20.11, 20.12, 20.13, 20.15, 20.16, 20.17, 20.18 Quattrone. 20.14 Alinari. 20.19 The Metropolitan Museum of Art. H.O. Havemeyer Collection, Bequest of Mrs H.O. Havemeyer, 1929. 20.20, 20.21, 20.24, 20.25, 20.26, 20.28, 20.29, 20.31 Quattrone. 20.22, 20.27 Alinari. 20.30, 20.32 Scala. p. 464 Cameraphoto. 21.1 Quattrone. 21.2 With permission of the Ministero per i Beni e le Attività Culturali. 21.4, 21.5 Josse. 21.6, 21.7 ©Araldo de Luca, Rome. 21.8 Scala. 21.9 Cameraphoto. 21.10 Böhm. 21.11, 21.12, 21.13, 21.14 Cameraphoto. 21.15 LKP Archives/Ralph Lieberman. 21.17 Alinari. 21.19 Widener Collection, ©1996 Board of Trustees, National Gallery of Art, Washington D.C. 21.21, 21.22 Scala. 21.23 Quattrone. 21.24 Böhm. 21.25 Cameraphoto. 21.29, 21.30 @Museo del Prado, Madrid. 21.33 Staatliche Museen zu Berlin-Preußischer Kulturbesitz Gëmaldegalerie, Photo Jörg P. Anders. 21.35, 21.37, 21.38, 21.39, 21.41, 21.43, 21.46, 21.48, 21.49, 21.52, p. 498 Cameraphoto. 21.36, 21.40, 21.42, 21.45 Böhm. p. 500 Foglia 22.1 ©Nippon Television Network Corporation Tokyo 1991. 22.2, 22.4 Photo Vatican Museums. 22.3 ©British Museum, London. 22.5 Quattrone. 22.6 Alinari. 22.7 Scala. 22.8, 22.9 Pirozzi. 22.11 The Metropolitan Museum of Art, Harris Brisbane Dick Fund, 1941. [41.72 (3) pl.26]. 22.12 Morris. 22.13 Alinari. 22.15 The Pierpont Morgan Library/Art Resource, New York/Scala, Florence. p. 513 Quattrone. 23.1 Morris. 23.2 Cameraphoto. 23.4 Pirozzi. 23.5 Alinari. 23.6 Morris. 23.7 The Metropolitan Museum of Art, Purchase, Anonymous Gift, in memory of Terence Cardinal Cooke, 1984. (1984.74) ©1984 The Metropolitan Museum of Art. 23.8 Canali. 23.9. 23.11 Morris. 23.12 Alinari. 23.13, 24.1 Scala. 24.2, 24.4, 24.5, 24.7 Alinari. 24.3 Studio Fotografico Perotti, Milan. 24.6 Publifoto, Milan. 24.8 ©Archivio Electa/Index, Florence. 24.9 Lensini. 24.10 The Bridgeman Art Library. 24.11 Foglia. 24.13 Pirozzi. 24.14 Biblioteca Universitaria Bologna, Volume miscellaneo di animali e piante, c.12. p. 538 Morris. 25.1 The Metropolitan Museum of Art, New York, The Elisha Wittelsey Collection, The Elisha Whittesley Fund, 1949 (49.95.146 pl.4). 25.3 Biblioteca Hertziana, Rome. 25.4 Conway Library, Courtauld Institute of Art, London. 25.5, 25.6 Morris. 25.7 The Metropolitan Museum of Art, New York. Harris Brisbane Dick Fund, 1941 (41.72 1[12]). 25.8 ©Photo Vasari, Rome. 25.9 Conway Library, Courtauld Institute of Art, London. 25.10 Morris.

Numbers in bold type refer to illustrations either as fig. nos. (12 or 1.12), or as page nos. (p. 145)

Index

Α

Accademia del Disegno, Florence 462-3 Adoration of the Child (Filippo Lippi) 261-2, 11.15 Adoration of the Magi (Bartolo di Fredi) 110, 5.17 Adoration of the Magi (Botticelli) 274-5, 11.30 Adoration of the Magi (Gentile da Fabriano) 224-5, 10.29, 10.30

Adoration of the Magi (Ghiberti) 209, **10.6** Adoration of the Magi (Leonardo) 272-4,

11.28, 11.29

Adoration of the Magi (Michele da Firenze) 339, **14.5**

Adoration of the Shepherds (Ghirlandaio) 276-7, 11.33

Adrian VI, Pope 423

Aertsen, Pieter 535

Agnolo di Ventura: Tarlati Tomb 112, **5.20**, **5.21** Agostino di Duccio: San Francesco, Rimini

348-9, **14.18**, **14.19**

Agostino di Giovanni: Tarlati Tomb 112, **5.20**, **5.21**

Alberti family 169, 170, 524-5

Alberti, Leon Battista 294, 322, 546; *Della Pictura* 42, 220, 241; Palazzo Rucellai, Florence 34, 280, **33**; Sant'Andrea, Mantua 353–5, **14.26**, **14.27**; San Francesco, Rimini (Rimini Temple) 347–8, **14.17**; Santa Maria Novella, Florence 280, **11.38**

Albertinelli, Mariotto 390

Albornoz, Cardinal Giles 159

Aldrovandi, Ulisse: botanical studies 537, 24.12

Alessi, Galeazzo 518; [?] Strada Nuova, Genoa 436, **19.16**, **19.17**; Palazzo Marino, Milan 531, **24.7**; Santa Maria presso San Celso 529–30, **24.5**

Alexander III, Pope 137, 151; Scenes from the Life (Spinello Aretino) 121, **5.32**

Alexander IV, Pope 53, 397

Alexander VI, Pope 287, 309-10, 471

Alfonso I of Aragon, King of Naples 201, 343-4

Alfonso II, King of Naples 24

Allegory of Divine Love (Veronese) 495–6, **21.48**Allegory of Good Government (A. Lorenzetti)

116–19, **5.28**

Allegory with Venus and Cupid (Bronzino) 457, 20.23

Altarpiece of St. Clare 53, 1.5

Altarpiece of St. Francis (Berlinghieri) 52-3, **1.4** Altarpiece of St Louis of Toulouse (Martini) 131-2,

p. 124, 6.13

Altarpiece of the Magi (Sant'Eustorgio, Milan) 181, **9.7**

altarpieces 84-6

Altemps, Cardinal Marco Sittico 514 Altichiero da Zevio 151; Oratory of St. George, Padua: frescoes 188, **9.21**; St. James Chapel (Santo, Padua) frescoes 187–8, **p. 174, 9.19**

Altobello Melone 384; *Massacre of the Innocents* 384–5, **16.9**

Amadeo, Giovanni Antonio: Cathedral, Milan (spire) 364, **15.4**; Certosa, Pavia 364, **15.1**; Santa Maria delle Grazie 368, **15.12**

Ambrogio di Baldese: Orphans Assigned to their New Parents 171-2, **8.18**

Ambrosian Republic 362

Ammanati, Bartolomeo: *Fountain of Neptune* 460, **20.26**; Villa Giulia 511–12, **22.13**, **22.14**

Andrea da Firenze see Bonaiuti, Andrea Andrea del Sarto 439, 441, 442; *Madonna of the Harpies* 438, **20.1**

Andrea Pisano

Florence: Baptistry doors 96-8, **4.27-4.29**; Cathedral 95-6

Andriolo de' Santis: St. James Chapel (Santo, Padua) frescoes 187-8, **p. 174**, **9.19**

Angelico, Fra 288; Annunciation 258–9, 11.10; St. Lawrence Distributing Alms 294, 12.6, 12.7; St. Lawrence Receiving the Treasures of the Church 294, 12.6; San Marco Altarpiece 256–8, 11.9

Anguissola, Sofonisba 532; Asdrubale Bitten by a Crawfish (drawing) 534-5, **24.11**; Bernardino Campi Painting Sofonisba Anguissola 532-3, **24.9**; Portrait of the Artist's Sisters Playing Chess 533-4, **24.10**

Annunciation (Fra Angelico) 258-9, 11.10 Annunciation (Lorenzo Monaco) 222, 10.27 Annunciation (Martini) 107-8, 5.13 Annunciation to the Shepherds (T. Gaddi) 91, 4.20 Anthony, St. 72, 188 antiquarianism 286-7; collectors 285 Antonello da Messina 22, 328; Enthroned

Madonna and Child with Saints 328, 13.23; St. Jerome in his Study 329, 13.24

Antoniazzo Romano 300-1; Communion of St. Francesca Romana 301, **12.17**

Antonio da Ponte: Rialto Bridge, Venice 491-2, **21.42**

Apotheosis of Cosimo (Vasari) 461–2, **20.30** Apotheosis of St. John (Donatello) 254–5, **11.5** Apotheosis of St. Thomas (Bonaiuti) 159, **8.9** Apotheosis of Venice (Veronese) 490, **21.40** Aquinas, St. Thomas 155

Aracoeli, The Bambino of 60, 2.5

architects 21, 32, 33-6

Arena Chapel, Padua 72-6, p. 46, 3.6-3.12

Aretino, Pietro 484, 505, 515 Arezzo: Cathedral: Tarlati Tomb **5.20**, **5.21**; San Francesco frescoes 237–8, **10.46**, **10.47**

Aristotle 177

Arnolfo di Cambio: Florence Cathedral 95, 4.26; Palazzo della Signoria, Florence 80-2, p. 77; Portrait Bust of Pope Boniface VIII 64, 2.11; Santa Cecilia, Rome: baldachin 63, 2.9

Art of Dying Well (Unknown Master) 287, 11.48 Arte del Calimala 80, 164, 170, 205–7, 215, 246 Arte della Lana 95, 211

Arte della Seta 167-8, 217, 218

Artist with his Nephews, The (Licinio) 18, 7 artists: status of 17-18, 37

Ascension of St. John the Evangelist (Giotto) 88-9, **4.17**

Asdrubale Bitten by a Crawfish (Anguissola) 534-5, **24.11**

Ass of Rimini, The (Donatello) 264–5, 11.19
Assisi: San Francesco 67–71, p. 67, 3.1–3.5
Assisi Master: Crib at Greccio 71, 3.5; St. Francis
Kneeling Before the Crucifix . . . 70–1, 3.4
Assumption of the Virgin (Correggio) 429, 19.6
Assumption of the Virgin (Titian) 470–1,

21.11, 21.12

Assumption of the Virgin (Vecchietta) 299, **12.15** Aurelio, Niccolò 468 Avignon Papacy 65, 155

В

Baboccio, Antonio: portal, Naples Cathedral 199-200, **9.35**

Bad Government and the Effects of Bad Government in the City (A. Lorenzetti) 119, **5.30** Baiardi, Andrea 432

Baldassare degli Embriachi: ivory altarpiece 191, 9.23, 9.25

Bambaia, Il (Agostino Busti): tomb of Gaston de Foix 382, **16.6**

Bambino of Aracoeli, The 60, 2.5

Bandinelli, Baccio 18, 41, 440, 458-60; Andrea Doria as Neptune 433, 19.12; Fountain of Neptune 460-1, 20.26; Hercules and Cacus 440-1, 20.3; Orpheus statue 440, 11.12; Self-Portrait 17, 18, 6

Baptism of the Neophytes (Masaccio and Masolino) 227, **10.34**

Barbari, Jacopo de': *Map of Venice* 137, **7.2** Barbarigo, Doge Agostino: *Votive Picture* 334–5, **13.33**

Barbarigo, Doge Marco 334 Barbaro, Villa 494–6, **21.46–21.48** Bardi Chapel 41–2, 87–8, **41**, **42**, **4.15**, **4.16** Baroncelli Chapel 90–2, 92–3, **4.19**, **4.20**, **4.22** Bartolo di Fredi: *Adoration of the Magi* 110, **5.17** Bartolomeo, Fra (Baccio della Porta) 475; Bon, Giovanni: Ca' d'Oro p. 313; Porta della St. Anne Altarpiece 390-2, 17.5 Carta 314 Basa, Domenico 25.9 Bon, Pietro 328 Basinius of Parma 348, 349 Bonaiuti, Andrea (Andrea da Firenze): Apotheosis of St. Thomas 159, 8.9; Crucifixion 159, 8.7; Bassano, Francesco 490 Bassi, Martino: San Lorenzo Maggiore, Scenes from the Life of St. Peter Martyr 159, 8.8; Way of Salvation 159-62, 8.6 Milan 529, 24.2; Santa Maria presso San Celso 24.5 532-3, **24.9** Bonaventure of Bagnoreggio, St.: Legenda Maior Battista d'Antonio 218 50, 52, 69, 70 Battle of Anghiari (Leonardo) 392, 393, 461, 17.6 Boniface VIII, Pope 64-5, 131; Pope Boniface VIII 24.12 Battle of Cascina (Michelangelo) 392, 393, 17.7 Imparting a Blessing... 64, 2.10; Portrait Bust (Arnolfo di Cambio) 64, 2.11 Battle of Love and Chastity (Perugino) 361, 14.35 Battle of San Romano (Uccello) 262-3, 388, 11.16 Bonifacio, Natale: Moving the Augustan Obelisk ... Battle of the Lapiths and the Centaurs 541, 25.3 Bonino da Campione: Equestrian Monument of (Michelangelo) 286-7, 11.47 Battle of the Sea Gods (Mantegna) 37, 36 Bernabò Visconti 181-2, 9.8; Funerary Belbello da Pavia 340 Monument of Cansignorio della Scala 182, 9.9; Bellarmine, Robert: Disputationes 514 Milan Cathedral 193, 9.24 Bellini, Gentile 331; Procession in St Mark's Square Bonvicino da Riva, Fra 176, 185 138, 140, 331, 7.3, 7.4 Bordieu, Pierre 16 Bellini, Giovanni 327, 331, 475; Enthroned Borghini, Raffaello 462; Il Riposo 525 di Castello 15, 2 Madonna, Child and Saints 469-70, 21.9; Borgo, Francesco del [?]: Palazzo Venezia, Rome Feast of the Gods 475-6, 21.19; Madonna 300, 12.16 Lochis 329-30, 13.26; St. Francis in the Desert Borromeo, Charles, Archbishop of Milan 527, Carthusians 190-1 329-30, 13.25; San Giobbe Altarpiece 327-8, 529, 530, 531; Instructiones fabricae ... 514 13.22; Votive Picture of Doge Agostino Botticelli, Sandro 306, 307, 353; Adoration of cartoons 26 Barbarigo 334-5, 13.33 the Magi 274-5, 11.30; Birth of Venus 281-2, Bellini, Jacopo 319; Dormition of the Virgin 11.41; Calumny of Apelles 283-4, 11.43; Mystical Nativity 287-8, 11.49; Primavera (drawing) 320, 13.10; Madonna and Child Surrounded by an Aureole of Angels 319, 13.9; 282-3, 11.42; Punishment of Corah 307, Visitation and Dormition of the Virgin (mosaic) 12.29 321-2, 13.11 Bracciolini, Poggio 293; Historia Fiorentina 4.6 Bembo, Pietro 279 Bramante, Donato 33, 364, 367, 375, 423; Benci, Ginevra de': portrait (Leonardo) Belvedere Courtyard, Vatican Palace 397-8, 278-9, 11.36 18.1; Santa Maria delle Grazie 367-8, Benedetti, Rocco 493 15.12; Santa Maria presso San Satiro 367, Benedetto da Maiano: Strozzi tomb 278, 11.34 15.10; St. Peter's 398-9, 510, 18.3-18.5; Benedict, St.: Scenes from the Life (Spinello Tempietto 398, 18.6, 18.8 414-15, 18.29 Arentina) 170, 8.17 Bramantino (Bartolomeo Suardi): tapestries Berlinghieri, Bonaventura: Altarpiece of St. Francis 381-2, 16.5 52-3, 1.4 Brancacci Chapel 226-31, 10.33-10.37 Bernardino of Siena, St. 114, 383, 5.23 Brancacci, Felice 226, 231, 251 Berry, Jean de, Duke of Burgundy 190, 195, 197 Brancacci, Pietro 226, 227, 231 Bregno, Andrea: tomb of Cardinal Pietro Riario Bertini, Pacio and Giovanni: tomb of Robert of Anjou 133-4, **6.17** 305, 12.25 Bronzino, Agnolo: Allegory with Venus and Cupid Bettini, Giovanni: reconstruction of San Francesco (drawing) 35, 34 457, 20.23; Chapel of Eleanora of Toledo Betto di Geri: silver altar 164, 8.10, 8.11 455-6, 20.20, 20.21; Christ in Limbo 525, Celano, Thomas of 52, 53 Beuckelaer, Joachim 535 23.12; Cosimo I 453, 20.17; Eleonora of Toledo Bianchi, Giacoba 524 and Her Son, Giovanni 453-4, 20.18; Bible of Borso d'Este 340-1, 14.6 Martyrdom of St. Lawrence 462-3, 20.32 Biccherna Cover, The Virgin Protects Siena . . . 99, Brunelleschi, Filippo 32, 33, 214, 239, 244, 259; p. 99 Florence cathedral 34 (model), 218-21, 31, Handbook 18-20, 21 10.25; Foundling Hospital, Florence Bicci di Lorenzo: Consecration of St. Egidio 235-6, 217-18, 10.23; Sacrifice of Isaac 206, 207, 10.43 Biringuccio, Vannoccio: De la pirotechnia 31 10.4; San Lorenzo, Florence 252, 11.2, Birth of Athena at the Forge of Vulcan (A. 11.3; single-point perspective 232-3 Lombardo) 474-5, 21.18 Bruni, Leonardo 246; tomb 250, 10.65 Birth of the Virgin (Cavallini) 62, 2.7 Buffalmacco 153 Birth of the Virgin (P. Lorenzetti) 109, 5.15 buon fresco 23 Buongiovanni da Geminiano: Hall of the

Stuccoes 342, 14.9

Buzzacarini, Fina 186-7, 253

Italien 44

324, 325

Buontalenti, Bernardo: Uffizi 20.27

Burckhardt, Jacob: Kultur der Renaissance in

Butcher's Shop, The (Passarroti) 536-7, 24.13

Byzantine art 51, 52, 53-5, 62, 84, 140, 141,

Birth of Venus (Botticelli) 281-2, 11.41 Birth Plate 10.24 Black Death 152, 156-8 Boccaccio, Giovanni: Decameron 157 Bologna: San Petronio (portal) (Quercia) 241-2, 10.51, 10.52 Bon, Bartolomeo, the elder: [?] Judgement of Solomon 313-14, 13.1; Ca' d'Oro p. 313; Porta della Carta 313, 314, 13.2, 13.3

Ca' d'Oro 315-16, p. 313, 13.5 Calcagni, Tiberio 22.5 Calumny of Apelles (Botticelli) 283-4, 11.43 Cambrai, League of 464 Campi, Bernardino: Bernardino Campi Painting Sofonisba Anguissola (Anguissola) Campi, Vincenzo 535; Fishmongers 535-6, 537, Cancelleria 305-6, 506, 12.26, 22.7 Cansignorio della Scala: funerary monument (Bonino da Campione) 182, 9.9 cantorie (Florence Cathedral) 244-6, 10.55-10.58 Caracciolo Chapel 201, 9.38 Caracciolo, Sergianni 201 Caradosso: medal 18.4 Carafa, Cardinal Oliviero 408 Carpaccio, Vittore 464; Miracle at Rialto 331, 13.27; Vision of Prior Ottobon in Sant'Antonio Carradori, Francesco: Istruzione elementare per gli studiosi della scultura 20 Carrara family 72, 186, 466 Cassone with painted front panel 23, 12 Castagno, Andrea del 236, 237; Cappella Nova mosaics 321-2, 13.11; Last Supper, Crucifixion, Entombment and Resurrection 236-7, 10.44, 10.45; St. Jerome and the Trinity 26, 14, 15 Castel Sant'Angelo 506, 22.6 Castellani family 168, 170 Castellani Chapel see Florence: Santa Croce Castellani, Michele di Vanni 168 Castiglione, Baldassare 425, 477; Book of the Courtier 414–15, 477; portrait (Raphael) Catherine of Alexandria, St. 13, 156 Catherine of Siena, St. 163 Cavalca, Fra Domenico 155 Cavalieri, Tomaso dei 534 Cavallieri, Giovanni Battista de: Ecclesiae militantis triumphi... 523, 23.10

Cavallini, Pietro: Birth of the Virgin 62, 2.7; David 129, 6.10; Last Judgement 62-3, p. 56, 2.8

Celio, Gaspare: Crucifixion 520, 23.6 Cellini, Benvenuto 31, 457-8; Cosimo I 452-3, 20.16; Perseus 458, 459, 20.24, 20.25

Cennini, Cennino 42, 221; The Craftsman's

Certosa, the 190-1, 363-4, 9.22, 15.1-15.3 Cesaresco, Count Fortunato Martinengo 531; portrait[?] (Moretto) 531-2, p. 527

Charles d'Amboise 378, 380 Charles I of Anjou, King of Naples 124, 127, 128

Charles II of Anjou, King of Naples 127, 131 Charles Martel 131, 132

Charles V, Emperor 423, 426, 433, 452, 453, 484, 508, 535; Equestrian Portrait (Titian) 482, **21.29**

Chigi, Agostino 418, 421 childbirth 219 Cholet, Cardinal Jean 62, 63 Christ before Caiaphas (Romanino) 385, 16.10 Christ Giving the Keys to St. Peter (Perugino) 308-9, 12.30

crucifixes 30, 50-2; Jacopo di Marco Benato 7.10; Dormition of the Virgin (J. Bellini): (drawing) 320, Christ in Glory and the Creation of Eve (Pontormo) San Damiano Crucifix 49, 50, 1.1 13.10; (mosaic) 321-2, 13.11 456-7, **20.22** drawings 21, 32-3; cartoons 26; sinopie 25-6 Christ in Limbo (Bronzino) 525, 23.12 Crucifixion (Altichiero da Zevio) 187-8, 9.19 Crucifixion (Bonaiuti) 159, 8.7 Drunkenness of Noah (Doge's Palace) 148, 7.15 Chrysoloras, Manuel 338 Crucifixion (Cimabue) 51, 1.3 Duccio di Buoninsegna: Enthroned Madonna and Cimabue 65, 69; Crucifix (San Domenico) 51, 1.2; Child (Maestà) (Rucellai Madonna) 85, 4.13; Crucifix (Santa Croce) 52, p. 48; Crucifixion Crucifixion (Pordenone) 385-6, p. 378 Maestà (Siena Cathedral) 104-7, 5.9-5.12 51, 1.3; Enthroned Madonna and Child 84-5, Crucifixion (Valeriani and Celio) 520, 23.6 Cyriac of Ancona 323 Dufay, Guillaume 218-19 4.12 Dürer, Albrecht 382-3 Ciompi Revolution 163, 221 Circignani, Niccolò: San Stefano Rotondo da Vinci see Leonardo da Vinci frescoes 522-3, 23.8, 23.9 cire-perdue (lost-wax) casting 31-2, 26 Daddi, Bernardo 167; Madonna and Child 60 Ecce Homo (Moretto) 527-8, 24.1 dalle Masegne, Jacobello and Pierpaolo: choir Ecclesiae militantis triumphi... (Cavallieri) city states, Italian 55 screen 143-4, 7.9, 7.10 523, **23.10** Clare, St. 53, 1.5 Effects of Good Government in the City and in the Clement IV, Pope 124 Dalmata, Giovanni 12.9; tomb of Cardinal Pietro Country (A. Lorenzetti) 119, 5.29 Clement V, Pope 65 Riario 12.25 Clement VII, Pope (Giulio de' Medici) 421, 422, Danaë (Titian) 483, 21.30 ekphrasis 338 423, 433, 440, 450, 452, 501 Dandolo, Andrea 140-1, 146; Chronica extensa Eleonora of Toledo 453, 460; Eleonora of Toledo and Her Son, Giovanni (Bronzino) clientelismo 16 141: tomb 143, 7.8 453-4, **20.18** Daniele da Volterra 501-3, 515 Clovio, Giulio: Farnese Hours 512, 22.15 engravings 36-7 Codussi, Marco: San Michele in Isola 325, Dante Alighieri: Inferno 72, 155, 156 13.16-13.18; San Zaccaria 326-7, 13.19; Danti, Ignazio 537 Enthroned Justice Flanked by St. Michael the Scuola Grande di San Marco 13.28 Danti, Vincenzo: Cosimo as Augustus 460, 20.28 Archangel and the Angel Gabriel (Jacobello David (Cavallini) 129, 6.10 del Fiore) 150-1, 7.18 Codussi, Mauro 470 David (Donatello): (bronze) 267-8, 388, 440, Enthroned Madonna and Child (Cimabue) Colaccio, Matteo 12 11.21, 11.22; (marble) 210-11, 10.9 84-5, 4.12 Colleoni, Bartolomeo: equestrian statue 335, 13.28 David (Michelangelo) 38, 286, 388-9, p. 387, 17.1 Enthroned Madonna and Child (Duccio) (Rucellai Colonna family 64, 290 Dead Christ (Rossi Fiorentino) 423, 18.42 Madonna) 85, 4.13 Enthroned Madonna and Child (Guido da Siena) Death of Jacob and Joseph (from Liber Pantheon of Colonna, Vittoria 504, 515 Goffredo da Viterbo) 177-8, 9.4 14.3 colorito 484 Enthroned Madonna and Child with Saints Decameron (Boccaccio) 157 Communion of St. Francesca Romana (Antoniazzo Decembrio, Umberto 195 (Antonello da Messina) 328, 13.23 Romano) 301, 12.17 Deposition (Michelangelo) 504-5, 22.5 Enthroned Madonna and Child with St. Liberale and Consecration of St. Egidio (Bicci) 235-6, 10.43 Deposition (Rosso) 447, 20.8 St. Francis (Giorgione) 469, 21.8 Constantinus 80 Discovery of the True Cross (A. Gaddi) 169-70, 8.16 Enthroned Madonna and Saints Adored by Federico Contarini, Marino 315, 316 contracts, artists' 24 disegno 484 da Montefeltro (Piero della Francesco) Disputà (Raphael) 409, 410, 18.22 350, p. 336 Coppo di Marcovaldo: Florence Baptistry mosaics 80, 4.4 Disputation of St. Catherine (Pinturicchio) Enthroned Madonna, Child and Saints (Giovanni 310. 12.32 Bellini) 469-70, 21.9 Coronation of the Virgin (Filippo Lippi) Doge's Palace see Venice Entombment (Pontormo) 445, p. 437 233-4, 10.41 Domenico di Paris: Hall of the Stuccoes Entombment (Raphael) 395-6, 17.12, 17.13 Coronation of the Virgin (Guariento) 148-50, 342, 14.9 (drawing) 488, 7.19 Coronation of the Virgin (Jacobello del Fiore) Domenico Veneziano 234, 237, 257; St. Lucy Equestrian Monument to Erasmo da Narni Altarpiece 234-5, 10.42 (Gattamelata Monument) (Donatello) 148, 7,17 Dominic, St. 51, 71, 107 265-6, 11.20 Coronation of the Virgin (Leonardo da Besozzo) Dominicans 51, 82, 83, 107, 145, 152, 155, 156, equestrian monuments 181-2, 336, 547 201, 9.38 Coronation of the Virgin (Lorenzo Monaco) 158, 159-62, 180, 365, 383 Equicola, Mario 475 Donatello 209-10, 218, 237, 242, 264, 267, 285, Esau Before Isaac (Isaac Master) 69, 3.3 222-3, 10.28 Este family 336 Coronation of the Virgin (Torriti) 61-2, 2.6 328; Apotheosis of St. John 254-5, 11.5; Ass of Rimini 264-5, 11.19; Baptismal font (Siena) Este, Duke Alfonso d' 474, 475 Correggio (Antonio Allegri) 429; Camera di 240, 241, 10.48, 10.50; Brancacci tomb Este, Beatrice d': tomb (Solari) 369-71, 15.13 San Paolo 19.5; Jupiter and Io 428-9, p. 425; Parma Cathedral Frescoes 429, 19.6 242-3, 10.53; cantoria 244, 245-6, 10.56; Este, Borso d' 340, 341-2; Bible 340-1, 14.6 10.58; Crucifix 30, 23; David (bronze) 267-8, Este, Ercole d' 343 Correr, Antonio 148 Este, Isabella d' 32, 359, 360, 361, 369, 425, 474 388, 440, **11.21**, **11.22**; *David* (marble) Correr, Gregorio 323 Cosmatus, Master: Sancta Sanctorum, Lateran 210-11, **10.9**; *David*[?] marble [attrib.] Este, Leonello d' 266, 336-7, 340; medal 210-11, 10.10; doors (San Lorenzo) 255-6, 337, 14.2 Palace, Rome 59, 2.3 Cossa, Francesco del: Hall of the Months 11.7, 11.8; Equestrian Monument to Erasmo da Este, Niccolò III 336, 340 341-2, **14.8** Narni (Gattamelata Monument) 265-6, Este, Sigismondo d' 343 Craftsman's Handbook, The (Cennini) 18-20, 21 11.20; Judith and Holofernes 268-9, 388, Estouteville, Cardinal Guillaume d' 297-8, 11.23; pulpits (San Lorenzo) 269-70, 11.24, 304, 305 Cremona Cathedral: frescoes 384-6, p. 378, 16.9, 11.25; St. George 212-13, 10.16; St. George Eucharistic Tabernacle (Vecchietta) 21, 10, 11 16.10 Eugenius IV, Pope 218, 255, 289, 292, 302 and the Dragon 213, 10.17; St. John 211, Crib at Greccio (Assisi Master) 71, 3.5 Crivelli, Taddeo: Bible of Borso d'Este 340-1, 14.6 10.13, 10.14; St. Lawrence and St. Stephen 255, Eulogy for Giangaleazzo Visconti (Michelino da Cronaca (Simone del Pollaiuolo): Palazzo Strozzi 11.6; St. Louis of Toulouse 217, 272, p. 204; Besozzo) 196, 9.30, 9.31 Execution of Capocciola and Garofalo (drawing) St. Mark 214, 10.18; Santo altar (Padua) 281, **11.39**, **11.40** Crossing of the Red.Sea (Bronzino) 455-6, 20.21 264-5, 11.18, 11.19 290. 12.1 Crucifix (Cimabue): Santa Croce, Florence 52, Doria Andrea 433, 435; Andrea Doria as Neptune Expulsion from Paradise (Masaccio) 227, 10.35 Expulsion of Heliodorus (Raphael) 413-14, 18.27 p. 48; San Domenico, Arezzo 51, 1.2 (Bandinelli) 433, 19.12; portrait (Sebastiano

del Piombo) 433, 19.11

Expulsion of Joachim (Giotto) 73, 3.7

Crucifix (Donatello) 30, 23

F Faerno, Gabriele 534 Fall of the Giants from Mount Olympus (Giulio Romano) 426-7, 19.2 Fall of the Giants (Perino del Vaga) 435, 19.15 Fancelli, Luca 14.26, 14.27 Farnese, Alessandro see Paul III, Pope Farnese, Cardinal Alessandro 506, 507, 517, 518 Farnese Hours (Clovio) 512, 22.15 Farnese, Ottavio 507 Feast in the House of Levi (Veronese) 515, 516, p. 498, 23.2 Feast of Herod (Giotto) 89-90, 4.18 Feast of the Gods (Giovanni Bellini) 475-6, 21.19 Federico da Montefeltro 349-50, 351; Battista Sforza and Federico da Montefeltro (Piero della Francesco) 350, 14.20; Enthroned Madonna and Saints Adored by Federico da Montefeltro (Piero della Francesca) 350, p. 336; Triumphs of Federico da Montefeltro and Battista Sforza (Piero della Francesco) 350, 14.20 Ferrara 336, 343, 474; Palazzo dei Diamanti 343, 14.10; Palazzo Ducale 474-6, 21.18; Palazzo Schifanoia 341-2, 14.7-14.9 Ferrari, Gaudenzio: Crucifixion Chapel, Sacro Monte di Varallo 383-4, 16.8 Fiamma, Galvano 176-7 Fiammeri, Giovanni Battista 520 Filarete (Antonio Averlino) 16, 291, 292; Medici Bank 365, 15.5; Old St Peter's (doors) 291-2, 12.3, 12.4 Fire in the Borgo (Raphael) 416, p. 376, 18.31, Fishmongers (V. Campi) 535-6, 537, 24.12 Flagellation of Christ (Ghiberti) 209, 10.7 Flaying of Marsyas (Titian) 484-6, 21.34 Florence 77-8, 82, 152, 157-8, 163, 189, 204, 243, 251, 287, 347, 387-8, 437, 439-41, 442, 452, 524, 526, p. 78 (map), 4, 4.6 Accademia del Disegno 462-3 Baptistry 79-80, 4.3; doors: Ghiberti 205-9, 246-50, 10.3, 10.5-10.7, 10.59-10.64; Pisano 96-8, 4.27-4.29; mosaics 80, 4.4; silver altar 164, 8.10, 8.11 Bargello (Palazzo del Podestà) 80 Campanile 95 Cathedral (Duomo) 14, 94-6, 163-4, 204, 4.24-4.26, 10.1; cantorie 244-6, 10.55-10.58; dome 218-21, 10.25; (model) 34, 31; frescoes 243-4, 10.54; Porta della Mandorla 204, 10.2; sculptures 209-12, 389-90, **10.8**, **10.10-10.14**, **17.3** Church of the Annunziata 15 Foundling Hospital (Ospedale degli Innocenti) 217-18, 10.23 Loggia della Signoria 172-3 Medici Palace 259-64, 268, 269, 11.11, 11.12, 11.14 Or San Michele 10.15; Incredulity of St. Thomas 272, 11.27; sculptures 212-17, 10.16-10.22; St. John the Evangelist 167-8, 8.14; tabernacle 167, 8.12, 8.13 Palazzo Davanzati 173, 8.20 Palazzo della Signoria (Palazzo Vecchio) 80-2, 454, p. 77, 4.5, 4.6; altarpiece 390-2, 17.5; Chapel of Eleonora of Toledo 454-6, 20.20, 20.21; Sala del Gran Consiglio 390, 440, 461-2, **17.4**, **20.29**, **20.30** Palazzo Rucellai 34, 260, 280, 33

```
Palazzo Strozzi 281, 11.39, 11.40
  Piazza della Signoria 457-60, 20.26
  Santa Croce 82-4, 86, 524-5, 4.8, 4.9, 8.16;
     altarpieces 92-3, 4.21, 4.22; Bardi Chapel
     41-2, 87-8, 41, 42, 4.15, 4.16; Baroncelli
     Chapel 90-2, 4.19, 4.20; (altarpiece) 92-3,
     4.22; Bruni tomb 250, 10.65; Castellani
     Chapel 168-9, 8.15; Legend of the True Cross
     152, 169-70; Pazzi Chapel 279; Peruzzi
     Chapel 88-90, 4.15, 4.17, 4.18; Refectory
     frescoes 93-4, 4.23
  Santa Felicità: Capponi Chapel 444-7,
     p. 437, 20.7
  San Lorenzo 252-6, 11.1-11.8; frescoes
     462-3, 20.32; Laurentian Library 450-2,
     20.14, 20.15; (design) 32; Medici Chapel
     447-50, p. 251, 20.9-20.13; pulpits
     269-70, 11.24, 11.25; tomb of Piero and
     Giovanni de' Medici 271-2, 11.26
  San Marco 256-9
  Santa Maria degli Angeli 222
  Santa Maria del Carmine: Brancacci Chapel
     frescoes 226-31, 10.33-10.37
  Santa Maria Novella 82-4, 86, 155, 280, 524,
     525, 4.10, 4.11, 11.38; Guidalotti Chapel
     158-62, 8.6-8.9; Strozzi Altarpiece 156, 158,
     8.4; Strozzi Chapel 155-6, 277-8, p. 152,
     8.3, 11.34, 11.35
  San Miniato al Monte 170, 8.17
  Santa Trinità: altarpiece 84-5, 4.12;
     Bartolini-Salimbeni Chapel 221-2, 10.26;
     Sassetti Chapel 275-7, 11.32, 11.33;
     Strozzi Chapel 224-5
  Uffizi 460-1, 20.27
  Via dei Girolami 78, 4.2
Fontana, Domenico 539; Cappella Sistina,
     Santa Maria Maggiore 544-5, 25.8, 25.9,
     25.10; tomb of Nicholas IV 543-4, 25.6
Fontana, Lavinia: Noli me tangere 515, p. 513
Fontanellato, Gian Galeazzo Sanvitale, Count
     of: portrait (Parmigianino) 431, 19.9
Fonte Gaia (Quercia) 32, 122-3, 5.34, 5.35
Foppa Chapel see Milan: San Marco
Foppa, Vincenzo 380; Portinari Chapel frescoes
     365-7, 15.8
Fornarina, La (Raphael) 415-16, 18.30
Forzetta, Oliviero 285
Foscari, Doge Francesco 313, 315, 316, 324, 13.3
Fountain of Neptune (Ammanati) 460, 20.26
Four Crowned Saints (Nanni) 214-15,
     10.19, 10.20
Francesco da Carrara, Lord of Padua 185-6,
     253; medal 186, 9.15
Francesco di Giorgio: Palazzo Ducale, Urbino
     351, 14.23
Francis I, King of France 433, 457
Francis of Assisi, St. 48-9, 50, 51, 52-3, 67, 70,
     71, 87, 88
Franciscans 49, 50, 67, 82, 83, 87, 91, 131, 132,
     155, 169, 383, 538
Franco, Giacomo: Habiti d'huomeni et donne
    venetiane ... 82, 4.7
```

Frederick Barbarossa 137, 151; Emperor Frederick

for Peace (Pisanello) 151, 7.20

Funeral of the Virgin, The (Taddeo di Bartolo)

fresco technique 23-6

120-1, **5.31**

Fugger, Hans 535

Barbarossa Receiving the Entreaties of His Son

```
G
Gaddi, Agnolo 20, 168, 244; Discovery of the True
     Cross 169-70, 8.16; Loggia della Signoria
     (reliefs) 173
Gaddi, Taddeo 20, 21; Baroncelli Chapel frescoes
     90-2, 4.19, 4.20; Presentation of the Virgin in
     the Temple 21, 8, 9; Santa Croce Refectory
     frescoes 93-4, 4.23
Galileo Galilei 72
Gambello, Antonio di Marco: San Zaccaria
     326-7, 13.19
Gaston de Foix 381, 382
gastronomy and art 185
Gates of Paradise (Ghiberti) 246-50, 10.59-10.64
Gattamelata Monument (Donatello)
     265-6, 11.20
Genoa 425, 433, 435-6; Strada Nuova 436,
     19.16, 19.17; Villa Doria 434-5,
     19.13-19.15
Gentile da Fabriano 22, 195, 227, 288; Adoration
     of the Magi 224-5, 10.29, 10.30; Quaratesi
     Altarpiece 225-6, 10.31
George, Prince-Bishop of Lichtenstein 196, 197
Gerini, Niccolò di Pietro: Orphans Assigned to their
     New Parents 171-2, 8.18
Gesù the see Rome
Ghiberti, Lorenzo 42, 185, 214, 216-17,
     218, 224, 237, 256, 285, 328; Baptismal
     font (Siena) 239-41, 10.48, 10.49;
     Baptistry doors, Florence 206-9, 246-50,
     10.3, 10.5-10.7, 10.59-10.64; St. John the
     Baptist 38, 215, p. 12, 10.21; St. Matthew
     215-16, 10.22
Ghirlandaio, Domenico 24, 275, 277, 306;
     Giovanna de' Tornabuoni 278-9, 11.37;
     Sassetti Chapel 275-7, 11.32, 11.33
Ghisi, Giorgio 501, 22.3
Giacomo da Pietrasanta[?]: Sant'Agostino, Rome
     304-5, 12.24
Giambologna: Rape of the Sabines 462, 20.31
Giambono, Michele: Cappella Nova mosaics 316,
     321, 13.6, 13.7, 13.11
Gilio da Fabriano, G. A.: Degli Errori de' Pittori
Giorgione 465; Enthroned Madonna and Child with
     St. Liberale and St. Francis 469, 21.8; Pastoral
     Concert 466-8, 21.4, 21.5; Sleeping Venus 466,
     21.3; Tempesta 465-6, 21.1, 21.2
Giotto di Bondone 22, 33, 92, 129, 177;
     Bardi Chapel frescoes 41-2, 87-8, 41, 42,
     4.15, 4.16; Florence Cathedral 95-6;
     Navicella 65, 2.12; Ognissanti Madonna and
     Child (Maestà) 86, 4.14; Peruzzi Chapel
     frescoes 88-90, 4.17, 4.18; Scrovegni
     (Arena) Chapel frescoes 72-6, p. 46,
     3.6-3.12; Stefaneschi Altarpiece 65-6, 2.13;
     [workshop of] Coronation of the Virgin
     92-3, 4.22
Giovanna I, Queen of Naples 133, 134
Giovanna II, Queen of Naples 201, 343
Giovanni da Fano: L'arte dell'unione 528
Giovanni da Udine 18.39
Giovanni d'Agostino: Tarlati Tomb 112,
     5.20, 5.21
Giovanni d'Alemagna 318, 322; Madonna and
     Child with Saints 318-19, 13.8
Giovanni d'Ambrogio: Prudence 173, 8.19
```

Giovanni del Biondo: St. John the Evangelist

167-8, **8.14**

Giovanni di Balduccio: tomb of St. Peter Martyr Last Judgement (Cavallini) 62-3, p. 56, 2.8 178-80, **9.6** Ignatius of Loyola, St. 517, 522; Spiritual Last Judgement (Giotto) 75-6, 3.12 Giovanni di Turino: Baptismal font (Siena) Exercises 520 Last Judgement (Master of the Triumph of Death) 239. 10.48 Incredulity of St. Thomas (Vasari) 525, 23.13 152-3, 155, 158, 8.2 Giovanni Pisano 102; Siena Cathedral Incredulity of St. Thomas (Verrocchio) 272, 11.27 Last Judgement (Michelangelo) 14, 501-4, 515, 103-4, 5.7, 5.8 Innocent III, Pope 59, 303 22.1-22.4 Giuliano da Maiano: Studiolo, Palazzo Ducale, Innocent VIII, Pope: tomb 309, 12.31 Last Supper (Castagno) 236-7, 10.44, 10.45 Urbino 351-3, 14.25 Innocent XI, Pope 72 Last Supper (T. Gaddi) 93-4, 4.23 Giuliano d'Arrigo 244 Inquisition 515, 516 Last Supper (Leonardo) 39-40, 371-2, 39, Giulio Romano 423, 425, 18.39; courtyard, International Gothic Style 194-9, 197-9 15.14, 15.15 Palazzo del Tè 427-8, 19.3, 19.4; Fall of the Investiture of St Martin (Martini) 108-9, 5.14 Laurana, Francesco: Isabella of Aragon[?] 29, 22 Giants from Mount Olympus 426-7, 19.2; Isaac Master: Esau Before Isaac 69, 3.3 Laurana, Luciano: Palazzo Ducale, Urbino 351, I Modi 420-1, 18.38; Wedding Feast of Cupid Isabella of Aragon: portrait[?] (Laurana) 29, **22**; tomb 125–7, **6.3** and Psyche 425-6, 19.1 Laurentian Library see Florence: San Lorenzo Isaia da Pisa 295; Reliquary Tabernacle of the Giunta Pisano 50 Legend of Guiron le Courtois 184, 9.12 Head of St. Andrew 295-7, 12.9, 12.10 Legend of Lancelot (Pisanello) 355, 14.29, 14.30 Glorification of St. Thomas (Lippo Memmi) 158, **8.5** Isaiah (Giovanni Pisano) 104, 5.8 Legend of the True Cross (Piero della Francesca) Glory of Angels (Lomazzo) 529, 24.3 Isaiah (Nanni) 210, 211, 10.8 237-8, 10.46, 10.47 Godefroyd, Etienne: Reliquary Bust of San Italy 55, **p. 54** (map) Lello da Orvieto: Tree of Jesse 130, 6.12 Gennaro 127, 6.4 Lenzi, Domenico 231 Gonzaga family 353 Leo X, Pope (Giovanni de' Medici) 276, 408, Gonzaga, Eleonora: portrait (Titian) Jacobello del Fiore: Coronation of the Virgin 148, 416, 423, 440 477, 21.22 7.17; Enthroned Justice Flanked by St. Michael Leonardo da Besozzo: Coronation of the Virgin Gonzaga, Federigo 425, 428 the Archangel and the Angel Gabriel 150-1, 201, 9.38 Leonardo da Vinci 21, 32, 272, 364, 371, 374-5, Gonzaga, Francesco 359 Gonzaga, Ludovico 353-4, 355, 356, 357, 359 Jacopino da Tradate: Pope Martin V 193-4, 9.27 378, 379, 393, 439; Adoration of the Magi Gothic style 98, 102, 103, 107, 127, 128, 132, Jacopo da Pietrasanta[?]: Palazzo Venezia, Rome 272-4, 11.28, 11.29; Battle of Anghiari 392, 144-5, 145, 146, 151, 164, 182, 183, 193,300, 12.16 393, 461, 17.6; botanical studies 373-4, Jacopo da Voragine: Golden Legend 169 324. 327 15.16; Equestrian Tomb Monument Gottardo da Ponte 383, 384 Jacopo di Marco Benato: crucifix 7.10 (studies) 381, 16.4; Flying Machine (study) Gozzoli, Benozzo 261; Medici Palace Chapel Jacopo di Piero Guidi 173 374, 15.17; Ginevra de' Benci 278-9, 11.36; frescoes 261, 11.14 Jean D'Autun 127 Last Supper 39-40, 371-2, 39, 15.14, 15.15; Grassi, Giovanni dei 194; notebook 195, 9.29; Jean de Lyon 127 Madonna and Child with St. Anne 379-80, Jesuits 501, 517, 522, 527, 530 392, **16.2**; Madonna of the Rocks 373, **p. 362**; Visconti Book of Hours 194-5, 9.28 Greco, El (Domenico Theotocopouli) 512 Johann, Master 193 Mona Lisa 393-4, 17.8; Sala delle Asse: Gregory I, Pope (Gregory the Great) 60 John the Baptist, St. 13; Ghiberti sculpture frescoes 375, 15.19; Santa Maria delle Gregory IX, Pope 52, 67 38, p. 12 Grazie 368; Sforza Monument (study) 374, John VIII Paleologus 336-7; medal 337, 14.1 Gregory XII, Pope 121 15.18; Two Mountain Ranges (drawing) 379, Gregory XIII, Pope 520, 521 Joseph and Potiphar's Wife (Properzia) 43, 16.1; Vitruvian Man 399, 18.7 Grumelli, Gian Gerolamo: portrait (Moroni) Leonardo di ser Giovanni: silver altar 164, 532, 24.8 Joseph in Egypt (Pontormo) 442, 20.4 8.10, 8.11 Guariento di Arpo 148; Coronation of the Virgin Judgement of Solomon ([?] Bartolomeo Bon) Licinio, Bernardino: The Artist with his Nephews 148-50, 488, 7.19 313-14, 13.1 Guarino da Verona 336, 338 Judith and Holofernes (Donatello) 268-9, Lippi, Filippino 390; Carafa Chapel 310-11, Guidalotti Chapel see Florence: Santa Maria 388, 11.23 12.33; drawings 28; Strozzi Chapel frescoes Novella Julius II, Pope 41, 285, 302, 397-9, 477, 500, 278, 11.34, 11.35; Vision of St. Bernard 275, Guidalotti, Mico 159 539; portrait (Raphael) 414, 18.28; tomb 11.31 (Michelangelo) 399-402, 18.9-18.11 Guido da Siena 107; Enthroned Madonna and Lippi, Filippo 233, 237; Adoration of the Child Jupiter and Io (Correggio) 428-9, p. 425 261-2, 11.15; Coronation of the Virgin 233-4, Guillaume de Verdelay: Reliquary Bust of San Justice with Cicero . . . (Taddeo di Bartolo) 10.41; Tarquinia Madonna 233, 10.40 Gennaro 127, 6.4 121-2, **5.33** Lippo Memmi 5.13; Glorification of St. Thomas Guy de Bourguignon 127 Justus of Ghent 351-3; Studiolo, Palazzo Ducale, 158, 8.5; Maestà 113-16, 5.26 Urbino 14.25 Lippo Vanni: Victory of the Sienese Troops at the Val di Chiana in 1363 116, 5.27 K Hadrian VI, Pope 408 Lomazzo, Gian Paolo: Glory of Angels 529, 24.3; Hanged Men and Two Portraits (Pisanello) Kiss of Judas (Giotto) 74, 3.10 treatises 529 339, 14.4 Kiss of Judas (Roman Master) 69, p. 67 Lombardo, Antonio 476; Studio di Marmi Hawkwood, Sir John: portrait (Uccello) 243-4, 474-5, **21.18** 10.54; drawing 23-5, 13 Lombardo della Seta 187 Healing of the Cripple and The Raising of Tabitha Ladislas, King of Naples 199, 200; tomb 201, Lombardo, Pietro: Santa Maria dei Miracoli (Masolino) 229-30, 10.36 332-3, 13.29, 13.30; Scuola Grande di San Lafréry, Antoine: Pilgrims Visiting the Seven Heemskerck, Martin van: Jacopo Galli's Garden Marco 331, 13,28 in Rome 285, 11.44 Churches of Rome... 543, 25.7 Lombardo, Tullio: Miracle of the Miser's Heart Henry III, King of France 82 Lamberti, Niccolò: St. Mark 211, 212, 10.12 473, 21.17; San Salvatore, Venice 473, Hercules and Anteus (Pollaiuolo) 264, 11.17 Lamentation (Giotto) 75, 3.11 21.15; Scuola Grande di San Marco Hercules and Cacus (Bandinelli) 440-1, 20.3 Lamentation (Mazzoni) 31, 24 331-2, 13.28 Hercules (Pollaiuolo) 32, 27 Lamentation (Pulzone) 520, 23.7 Longhi, Martino, the Elder: The Council of Trent Honorius III, Pope 59 Laocoön and His Sons (Agesander et al) 41, 514, 23.1 humanism 45, 338 285, 40 Loredan, Doge Leonardo 466

Lorenzetti, Ambrogio 116; Allegory of Good Government 116-19, 5.28; Bad Government . . . 119, 5.30; Effects of Good Government in the City and in the Country 119, **5.29**; Purification of the Virgin 109-10, **5.16** Lorenzetti, Pietro: Birth of the Virgin 109, 5.15 Lorenzo Monaco 227; Annunciation 222, 10.27; Coronation of the Virgin 222-3, 10.28; Marriage of the Virgin 221-2, 10.26 Lorenzo the Magnificent see Medici, Lorenzo de' ("il Magnifico") lost-wax casting 31-2, 26 Louis of Toulouse, St. 131, 132; Altarpiece of St. Louis of Toulouse (Martini) 131-2, p. 124, 6.13; bronze (Donatello) 217, 272, p. 204 Luca della Robbia see Robbia, Luca della Luca di Tommé: Madonna and Child 110, 5.18 Luini, Bernardino 380; Madonna, Child and Infant St. John the Baptist 380, 16.3 Lupi family 187 Lupi, Bonifazio 187 Lupi, Raimondino 188 Luther, Martin 382, 423 M Madonna and Child (Niccolò di ser Sozzo and Luca di Tommé) 110, 5.18 Madonna and Child Surrounded by an Aureole of Angels (J. Bellini) 319, 13.9 Madonna and Child with Saints (Giovanni d'Alemagna and Vivarini) 318-19, 13.8 Madonna and Child with St. Anne (Leonardo) 379-80, 392, **16.2** Madonna, Child and Infant St. John the Baptist (Luini) 380, 16.3 Madonna Lochis (Giovanni Bellini) 329-30, 13.26 Madonna of the Baldachin (Raphael) 395, 17.11 Madonna of the Harpies (Andrea del Sarto) 438, 20.1 Madonna of the Long Neck (Parmigianino) 432-3, 515, **19.10** Madonna of the Rocks (Leonardo) 373, p. 362 Maecenas, Gaius Cilnius 16 Maestà 14-16, 1 Maestà (Cimabue) 84-5, 4.12 Maestà (Duccio): Rucellai Madonna 85, 4.13; Siena Cathedral 104-7, 5.9-5.12 Maestà (Giotto) 86, 4.14 Maestà (Lippo Memmi) 113-16, 5.26 Maestà (Martini) 113, 5.24, 5.25 Magdalene Altarpiece (Magdalene Master) 27, 40, 18 Maitani, Lorenzo 33 Malatesta family 336 Malatesta, Sigismondo Pandolfo 224, 347, 348 Manetti, Antonio: Life of Brunelleschi 206, 207, 232 Mannerism 432, 437-9, 441, 442, 446-7, 457, 462, 463, 514, 525; architecture 450 Mantegazza, Antonio and Cristoforo: Certosa, Pavia 364, 15.1, 15.3 Mantegna, Andrea 322-3, 476; Battle of the Sea Gods (print) 37, 36; Camera Picta 356-7, 14.31, 14.32; Pallas Expelling the Vices from the Garden of Virtue 359-60, 14.34; St. James Being Led to his Execution 322, 13.12;

San Zeno Altarpiece 323-4, 13.13, 13.14;

Triumphs of Caesar 359, 14.33

Mantua 353, 425; Castello San Giorgio (Camera Picta) 356-7, 14.31, 14.32; Palazzo del Tè 425-8, **19.1-19.4**; Palazzo Ducale (frescoes) 355, 14.29, 14.30; Sant'Andrea 353-5, 14.26-14.28 manuscript illumination 36, 124-5, 184-5; International Gothic Style 194-6 Manutius, Aldus: Hypnerotomachia Poliphili 35 Marcello, Girolamo 466 Mariani, Camillo: sculptures 524, 23.11 Maringhi, Francesco 233 Marino, Tommaso 531 Mark, Pope St.: banner portrait (Melozzo) 301-2, **12.18** Marriage of the Virgin (T. Gaddi) 92, 4.19 Marriage of the Virgin (Lorenzo Monaco) 221-2, **10.26** Martin da Canal 140; Les Estoirs de Venise 141 Martin, Gregory 521 Martin V, Pope 218, 230, 236, 289, 290, 291, 302; relief carving (Jacopino da Tradate) 193-4, 9.27 Martini, Simone 203; Altarpiece of St. Louis of Toulouse 131-2, p. 124, 6.13; Annunciation 107-8, **5.13**; Investiture of St Martin 108-9, 5.14; Maestà 113, 5.24, 5.25 Martyrdom of St. Lawrence (Bronzino) 462-3, 20.32 Martyrdom of St. Lawrence (Titian) 472-3, 21.13, 21.14 Mary, Queen of Hungary 128-9, 132; tomb 132-3, 6.16 Masaccio (Tommaso di ser Giovanni) 203, 226, 235, 288; Birth Plate [attrib.] 10.24; Brancacci Chapel frescoes 226, 227-9, 230-1, 10.33, 10.34-10.37; Pisa Altarpiece 10.32; Santa Maria Maggiore Altarpiece 290-1, 12.2; Trinity 26, 231-3, 16, 10.38 Maser: Villa Barbaro 494-6, 21.46-21.48 Masolino: Brancacci Chapel frescoes 226, 227, 229-30, 10.33-10.35; Santa Maria Maggiore Altarpiece 290-1, 12.2 Massacre of the Innocents (Altobello) 384-5, 16.9 Massacre of the Innocents (Nicola Pisano) 103, 5.3 Master of the Triumph of Death: Last Judgement 152-3, 155, 158, 8.2; Triumph of Death 152-5, 8.1Matteo da Siena: San Stefano Rotondo frescoes 522-3, **23.8**, **23.9** Mazzoni, Guido: Lamentation 31, 24 mecenatismo 16 Medici family 251, 252, 256, 261, 267, 268, 278, $279,\,287,\,387,\,439{-}41,\,442,\,443{-}4,\,457$ Medici, Carlo de' 285 Medici, Cosimo de' (1389-1464) 226, 251, 253, 254, 256, 257, 258, 260, 261, 267, 269, 364 Medici, Cosimo I, Grand Duke of Tuscany 44, 452-3, 456, 457, 460, 524-5; Apotheosis of Cosimo (Vasari) 461-2, 20.30; bust (Cellini) 452-3, 20.16; Cosimo as Augustus (Danti) 460, 20.28; portrait (Bronzino) 453, 20.17 Medici, Ferdinand I de' 462 Medici, Giovanni de' (1421-63) 255; tomb 271-2, **11.26** Medici, Giovanni de' (1475-1521) see Leo IX, Medici, Giovanni delle Bande Nero 453, 461

Medici, Giovanni di Bicci de' 252, 253, 255

Medici, Giuliano de' (1453-78) 268, 271, 388

Medici, Giuliano de' (1479-1516) 439, 440 Medici, Giulio de', Cardinal see Clement VII Medici, Lorenzo de' (1395-1440) 254, 258 Medici, Lorenzo de', Duke of Urbino (1492-1519) 443-4 Medici, Lorenzo de' ("Il Magnifico") 15, 261, 262, 268, 271, 276, 277, 281, 285, 286, 299, 307, 388, 449 Medici, Lorenzo di Pierfrancesco de' 283 Medici, Piero de' (1416-69) 251, 255, 261, 267, 268, 269, 272, 391; tomb 271-2, 11.26 Medici, Piero de' (1471-1503) 276, 387 Medici Bank 364-5, 15.5 Medici Chapel see Florence: San Lorenzo Meeting at the Golden Gate (Giotto) 73, 3.8 Meeting of Bacchus and Ariadne (Titian) 38-9, 476, **21.20** Mellini, Bianca 523 Melozzo da Forlì 300-1; banner 301-2, 12.18; Sixtus IV Confirming Platina as Papal Librarian p. 289 Menabuoi, Giusto de': Padua Baptistry frescoes 186-7, **9.18** Mercury (attrib. to Baldini) 17, 4 Michelangelo Buonarroti 22, 33, 45, 286, 393, 422, 423, 440-1, 500, 517, 534; Bacchus 285, 11.44; Battle of Cascina 392, 393, 17.7; Battle of the Lapiths and the Centaurs 286-7, 11.47; Capitoline Hill 508-10, 22.9, 22.10; David 38, 286, 388-9, p. 387, 17.1; Deposition 504-5, 22.5; Last Judgement 14, 501-4, 515, **22.1-22.4**; Laurentian Library 450-2, **20.14**, **20.15**, **32**; Medici Chapel 20.9-20.13; Palazzo Farnese 507-8, 22.8; Pietà 311-12, 12.34, 12.35; Sistine Chapel frescoes 26, 38, 402-9, **17**, **37**, **38**, **p. 397**, 18.12-18.18 (see also Last Judgement); Sonnet 151 403; St. Matthew 389, 17.2; St. Peter's, Rome 510, 546, 18.3, 22.11, 22.12; tomb of Pope Julius II 399-402, 18.9-18.11 Michele da Firenze: Pellegrini Chapel reliefs 337, 339, **14.5** Michelet, Jules: Histoire de France 44 Michelino da Besozzo 195-6; Eulogy for Giangaleazzo Visconti 196, 9.30, 9.31 Michelozzo di Bartolommeo: Brancacci tomb 242-3, 10.53; Medici Palace 259-60, 11.11, 11.12; San Marco, Florence 256 Mignot, Jean 193 Milan 55, 174-85, 189, 362, 378, 527, p. 175 (map) Casa Borromeo frescoes 197-8, 9.33 Castello Sforzesco 375, 15.19 Cathedral 191-4, 364, 9.24, 9.26, 9.27, 15.4 Equestrian Monument of Bernabò Visconti 181-2, **9.8** Medici Bank 364-5, 15.5 Palazzo Marino 531, 24.7 Sant'Eustorgio: Altarpiece of the Magi 181, 9.7; Portinari Chapel 365-7, 15.6-15.8; tomb of St. Peter Martyr 178-80, 9.6 San Fedele 530-1, 24.6 San Gottardo: tomb of Azzone Visconti 178, 9.5; tower 176, 9.2 San Lorenzo Maggiore 174, 529, 24.2 San Marco: Foppa Chapel 529, 24.3 Santa Maria delle Grazie 367-71, 15.11-15.13; Last Supper 39-40, 371-2, 39,

15.14, 15.15

Parmigianino 423, 429-30; Gian Galeazzo Nicholas III, Pope (Giangaetano Orsini) 57-8; Santa Maria presso San Celso 367, 529-30, Sanvitale, Count of Fontanellato 431, 19.9; 15.9. 15.10. 24.5 Nicholas III Kneeling before Christ 59, 2.4 Milet d'Auxerre: Reliquary Bust of San Gennaro Nicholas IV, Pope: tomb 543-5, 25.6 Madonna of the Long Neck 432-3, 515, 19.10; Self-Portrait in a Mirror 430, 19.7; Nicholas V, Pope 155, 289, 292-3, 295, 302, 127 6.4 Mino da Fiesole 269, 295; bust of Piero de' 539, 12.19 Three Foolish Virgins... 430-1, 19.8 Nicola Pisano: Pisa Baptistry pulpit 101-3, 5.4, Parnassus (Raphael) 410, 18.23 Medici 260-1, 11.13; tabernacle (Santa Maria Maggiore) 297-8, 12.11, 12.12; tomb 5.6; Siena Cathedral pulpit 101-3, 5.3, 5.5 Pasquino 408, 18.19 Passarroti, Bartolomeo 535; The Butcher's Shop of Cardinal Pietro Riario 12.25 Nofri, Andrea and Matteo: Tomb of King Ladislas 201, 9.37 536-7, 24.13 Minutolo, Cardinal Enrico 199, 200 Pasti, Matteo de': San Francesco, Rimini Miracle at Rialto (Carpaccio) 331, 13.27 Noli Me Tangere (follower of Giotto) 129-30, 6.11 347-8, 14.17 Miracle of St. Mark (Tintoretto) 486-7, 21.36 Noli me tangere (L. Fontana) 515, p. 513 Pastoral Concert (Giorgione) 466-8, 21.4, 21.5 Miracle of the Cloud and Miracle of the False patrons 15, 16-17, 22, 393-4, 547; women 16, Madonna (Foppa) 365-7, 15.8 17, 32, 93, 128-9, 156, 186-7, 359, 360, Miracle of the Miser's Heart (T. Lombardo) offerings (in churches) 15 Ognissanti Madonna and Child (Giotto) 86, 4.14 523-4, 547 473, 21.17 Paul II, Pope 285, 299 300 miracles 60 oil painting 27 Old Testament Picture Book 125, 6.2 Paul III, Pope (Alessandro Farnese) 500-1, Miraculous Draught of Fishes (Raphael) 416-18, Oliveri, Pietro Paolo: Acqua Felice 541-2, p. 538 505-6, 507, 508, 515, 517; Paul III Directing Mocking of Christ (A. and C. Mantegazza) Or San Michele see Florence the Construction of St. Peter's (Vasari) 506, 22.7; Pope Paul III and His Grandsons... Oratorians 517 364, 15.3 Orcagna (Andrea di Cione): Strozzi Altarpiece (Titian) 506-7, p. 500 Modi, I (Giulio Romano) 420-1, 18.38 156, 158, 8.4; tabernacle 167, 8.12, 8.13 Paul IV Carafa, Pope 515, 517 Molanus, Johannes 515 Orphans Assigned to their New Parents (Gerini) Pavia: Castello Visconteo 182-3, 9.10, 9.11; Mona Lisa (Leonardo) 393-4, 17.8 Montorsoli, Giovanni 41 171-2, **8.18** Certosa 190-1, 363-4, 9.22, 15.1-15.3 Orsini, Cardinal Giangaetano see Nicholas III, Moretto da Brescia (Alessandro Bonvicino): Pazzi Conspiracy 15, 307 Pazzi family 279 Ecce Homo 527-8, 24.1; Portrait of a Young Pope ouvraige de Lombardie 195 Pellegrini Chapel see Verona: Sant'Anastasia Man (Count Fortunato Matinengo Cesaresco[?]) 531-2, p. 527 Ovetari, Imperatrice 322 Pere Joan: Triumphal Entry of Alfonso of Aragon into Naples 344, 14.15 Moroni, Giovanni Battista: Portrait of Gian Perino del Vaga: Sala Paolina, Castel Gerolamo Grumelli 532, 24.8; Virgin in Sant'Angelo 506, 22.6; Villa Doria 434-5, Glory with St. Barbara and St. Lawrence Padua 71-2, 185-6, 264 19.13-19.15 528. **24.2** Baptistry 186-7, 9.17, 9.18 Morosini, Michele: tomb 145-6, 7.12 Eremitani Church: Mantegna frescoes Perseus (Cellini) 458, 459, 20.24, 20.25 mosaic techniques 27-8 322. 13.12 perspective: Alberti's system 241; single-point 232-3, 249; two-point 73 Moses Drawing Water from the Rock (Tintoretto) Gattamelata Monument 265-6, 11.20 Perugino (Pietro Vanucci): The Battle of Love and Oratory of St. George: frescoes 188, 9.21 488. 21.38 Chastity 361, 14.35; Christ Giving the Keys to Mystical Nativity (Botticelli) 287-8, 11.49 Santo (Sant'Antonio) 12, 72, 187, 188, p.174; altar 264-5, 11.18, 11.19; Ass of Rimini St. Peter 308-9, 12.30; Sistine Chapel frescos 307 264-5, 11.19; Miracle of the Miser's Heart Peruzzi, Baldassare 419, 18.39; Sala delle Nanni di Baccio Bigio 517 (T. Lombardo) 473, 21.17; Reliquary of the Nanni di Banco 209-10, 214, 218, 328; Four Prospettive, Villa Farnesina 419 jaw of St. Anthony 188, 9.20; St. James Crowned Saints 214-15, 10.19, 10.20; Isaiah Chapel (San Felice) 187-8 Peruzzi Chapel see Florence, Santa Croce 210, 211, 10.8; Sculptor's Workshop 17-18, Scrovegni (Arena) Chapel 72-6, p. 46, Pesaro Altarpiece (Titian) 471-2, p. 464 Pesaro, Jacopo 471 5; St. Luke 211, 10.11 3.6 - 3.12Petrarch, Francesco 185-6, 350; "Africa" 44-5; University 72 Naples 55, 124-6, 199, 343, p. 126 (map), 6.1 De Viris Illustribus 172, 177, 186, 187, 9.3; Castel Nuovo 124 Pala d'Oro, St. Mark's, Venice 141, p. 135, 7.6 Castello Aragonese 343-4, 14.11-14.15 Paleotti, Gabriele 515; De imaginibus sacris 514 Petrarch in His Study (manuscript Cathedral 199-200, 9.35; Tree of Jesse Palladio (Andrea di Pietro) 492; Four Books on illumination) 186 130, 6.12 Architecture 492, 21.47; The Redentore Petroni, Cardinal Riccardo: tomb (Tino da 493-4, 21.45; San Giorgio Maggiore 492-3, Camaino) 110-12, 5.19 Palazzo Penna 200, 9.36 21.43, 21.44; Teatro Olimpico 496-7, Philip II of Spain 482, 535 Sant'Angelo a Nilo: Brancacci tomb 242-3, 21.51, 21.52; Villa Barbaro 494-6, 21.46, Philip III, of Aragon 125 Santa Chiara 132, 6.14, 6.15; tomb of Robert 21.47; Villa La Rotonda 496, 21.49, 21.50 Piacenza, Giovanna da 429 Picture Bearers, The (Mantegna) 359, 14.33 of Anjou 133-4, 6.17 Pallas Expelling the Vices from the Garden of Virtue (Mantegna) 359-60, 14.34 Pienza 298-9, 12.13, 12.14; Cathedral San Domenico Maggiore: Noli Me Tangere 129-30, 6.11 Palma Giovane 486, 21.35 298-9, **12.15** panel painting 26-7 Piero della Francesca 237; Battista Sforza and Sant'Eligio 127, 6.5 San Giovanni a Carbonara: Caracciolo Chapel Paolo Romano 295; Reliquary Tabernacle of the Federico da Montefeltro 350, 14.20; Enthroned Madonna and Saints Adored by Federico da 201, 9.38; tomb 201, 9.37 Head of St. Andrew 295-7, 12.9; St. Paul San Lorenzo Maggiore 127-8, 6.6, 6.7 Montefeltro 350, p. 336; Legend of the True 295, 12.8 Santa Maria Donnaregina 128-9, 6.8, 6.9; Paolo Veneziano: Pala d'Oro 141, p. 135, 7.6 Cross frescoes 237-8, 10.46, 10.47; Triumphs of Federico da Montefeltro and Battista Sforza frescoes 129, 6.10; tomb of Mary of Papal States 55 Paradise (Nardo) 155-6, 8.3 350, 14.21 Hungary 132-3, 6.16 Paradise (Tintoretto) 488-90, 21.39 Pietà (Michelangelo) 311-12, 12.34, 12.35 Nardo di Cione 155, 156; Paradise 155-6, 8.3 Navicella (Giotto) 65, 2.12 Parigi, Alfonso: Uffizi 20.27 Pietà (Titian) 486, 21.35 Pietro da Castelletto: Eulogy for Giangaleazzo Parler, Heinrich 193 Nello di Mino Tolomei 114-16

Parma 425, 429; Camera di San Paolo 429, 19.5;

Cathedral frescoes 429, 19.6; Madonna

della Steccata frescoes 430-1, 19.8

Visconti 196, 9.30, 9.31

Pietro da Milano: Triumphal Entry of Alfonso of

Aragon into Naples 344, 14.15

Niccolò di ser Sozzo: Madonna and Child

110, 5.18

Nicholas de Bonaventure 193

piety and art 114 pilgrimages 543 Pinadello, Giovanni: Invicti quinarii . . . 25.1 Pinturicchio (Bernardino di Betto) 307, 409; Disputation of St. Catherine 310, 12.32 Pippi, Niccolò: tomb of Sixtus V 545-6, 25.10 Pisa 189; Baptistry pulpit 101-3, 5.4, 5.6; Campanile (Leaning Tower) 95; Camposanto frescoes 152-5, 158, 8.1, 8.2; Santa Caterina (Glorification of St. Thomas) 158, 8.5 Pisa Altarpiece (Masaccio) 226, 10.32 Pisanello (Vittore Pisano): Emperor Frederick Barbarossa Receiving the Entreaties of His Son for Peace 151, 7.20; fabric design 32, 29; Hanged Men and Two Portraits 339, 14.4; medals 336-7, 14.1, 14.2; Palazzo Ducale, Mantua (frescoes) 355, 14.29, 14.30; St. George and the Princess 337-8, p. 202, 14.3 Pisano, Andrea see Andrea Pisano Pisano, Giovanni see Giovanni Pisano Pisano, Nicola see Nicola Pisano Pius II, Pope 114, 261, 294-7, 298, 344, 347 Pius IV, Pope 527 Pius V, Pope 524, 545 Pizzolo, Niccolò 322 plague 163, 493; Black Death 152, 156-8 Platina, Bartolomeo 302; Sixtus IV Confirming Platina as Papal Librarian (Melozzo) 302-3, p. 289 poesia 465 Poggio a Caiano: Villa Medici 286, 443-4, 11.45, 11.46, 20.5-20.6 Pole, Cardinal Reginald 505 Poliphilus in a Wood (Manutius) 35 Poliziano, Angelo: Daybook 268 Pollaiuolo, Antonio del 264, 388; Hercules 32, 27; Hercules and Anteus 264, 11.17; tomb of Innocent VIII 309, 12.31 Pollaiuolo, Piero: tomb of Innocent VIII 309, 12.31 Pontelli, Baccio[?]: Santa Maria del Popolo, Rome 303-4, 12.22, 12.23; Sistine Chapel 306, 12.27 Pontormo, Jacopo 439, 441, 447; Capponi Chapel 444-6, p. 437, 20.7; Christ in Glory and the Creation of Eve (drawing) 456-7, **20.22**; Joseph in Egypt 442, **20.4**; Vertumnus and Pomona 443, 20.5; Visdomini Altarpiece 438-9, 20.2 Poor Clares 53, 132, 333 Pordenone 385; Crucifixion 385-6, p. 378 Porta, Giacomo della 508, 22.12; The Gesù 517, 518, 23.4; St. Peter's dome, Rome 546 Porta, Giovanni Battista della: Acqua Felice 541-2, **p. 538** Porta, Tomaso della: statue of St. Peter 25.5 Portinari Chapel see Milan: Sant'Eustorgio Portinari, Folco 279

21, 8, 9

132-3, 6.16

print media 36-7, 547

Primavera (Botticelli) 282-3, 11.42

Primario, Gagliardo: Santa Chiara, Naples 132,

6.14, 6.15; tomb of Mary of Hungary

Portinari, Pigello 364-5 Portrait of a Young Man (Bronzino) 454, 20.19 Prato: Santa Maria delle Carceri 60 Presentation of the Virgin in the Temple (T. Gaddi)

Procession in St Mark's Square (Gentile Bellini) Roberti, Ercole de': Hall of the Months 138, 140, 331, 7.3, 7.4 Pulzone, Scipione: Lamentation 520, 23.7 Punishment of Corah (Botticelli) 307, 12.29 Purification of the Virgin 109-10, 5.16 Quaratesi Altarpiece (Gentile da Fabriano) 225-6, Quercia, Jacopo della 239; Baptismal font (Siena) 239-40, 10.48; Fonte Gaia 32, 122-3, 5.34, 5.35; San Petronio portal, Bologna 241-2, 10.51, 10.52 Raimondi, Marc'Antonio: I Modi 420-1, 18.38 Raising of Lazarus (Sebastiano del Piombo) 422, 423, 18.41 Rape of Europa (Titian) 483-4, 21.31, 21.32 Rape of the Sabines, The (Giambologna) 462, 20.31 Raphael (Raffaello Santi) 32, 393, 422, 423, 425, 475; Agnolo Doni 394, 395, 17.10; Baldassare Castiglione 414-15, 18.29; Disputà 409, 410, 18.22; Entombment 395-6, 17.12, 17.13 (drawing); Expulsion of Heliodorus 412, 413-14, 18.27; Fire in the Borgo 416, p. 376, 18.31, 18.32; Julius II 414, 18.28; La Fornarina 415-16, 18.30; Loggia of Psyche frescoes (Villa Farnesina) 418-20, 18.35, 18.36; Maddalena Strozzi Doni 394-5, 17.9; Madonna of the Baldachin 395, 17.11; Miraculous Draught of Fishes 416-18, 18.33; Parnassus 410, 18.23; School of Athens 409-10, 18.21, 18.24; Stanza d'Eliodoro, Vatican 412-14, 18.26, 18.27; Stanza della Segnatura, Vatican 409-10, 18.20-18.24; Transfiguration 422-3, 18.40; Villa Madama 421, 18.39 Raverti, Matteo: Ca' d'Oro 316, p. 313 Reclining Nude ("Venus" of Urbino) (Titian) 477-8, **21.23** Rediscovery of the Relics of St. Mark (Paolo Veneziano) 141, p.135 Reliquary Bust of San Gennaro (Godefroyd, Guillaume de Verdelay and Milet d'Auxerre) 127, 6.4 Reliquary of the jaw of St. Anthony 188, 9.20 Reliquary Tabernacle of the Head of St. Andrew (Isaia da Pisa and Paolo Romano) 295-7, 12.9, 12.10 Renaissance (term) 44-5 restoration of artworks 14, 37-42 Resurrection (Luca della Robbia) 31, 25 Rialto Bridge see Venice Riario, Cardinal Pietro: tomb 305, 12.25 Riario, Cardinal Raffaello 305 Rienzi, Cola di 55 Rimini 347; San Francesco (Rimini Temple) 347-9, **34**, **14.16-14.19** Ripanda, Jacopo: Triumph of Rome over Sicily 412, 18.25 Riviera, Egidio della: tomb of Sixtus V 545-6, **25.10** Rizzo, Antonio: Scala dei Giganti 334, 13.32; tomb of Doge Niccolò Tron 333-4, 13.31 Robbia, Luca della 31, 218, 25; cantoria 244-5, 10.55, 10.57; Resurrection 31, 25

Robert of Anjou, King of Naples ("the Wise")

131-3; tomb 133-4, 6.17

Roman Master: Kiss of Judas 69, p. 67 Romanino, Girolamo 384; Christ before Caiaphas 385, 16.10 Rome 55, 56-7, 82, 289, 293, 430, 500, 521, 523, 538-9, 543, 546-7, p. 58 (map), 2.1, 25.2 (map), 25.7 Acqua Felice 541-2, **p. 538** Cancelleria 305-6, 506, 12.26, 22.7 Capitoline Hill 302, 508-10, 12.19, 22.9, 22.10 Castel Sant'Angelo 506, 22.6 columns 495-6, 21.48 The Gesù 517-21, 523, 23.3-23.6 Hospital of San Spirito 303, 12.20, 12.21 Lateran Palace 64, 290, 2.10; Sancta Sanctorum 59, 2.3, 2.4 obelisks 539-41, 25.3, 25.4 Palazzo dei Conservatori 412, 18.25 Palazzo Farnese 507-8, 22.8 Palazzo Venezia 300, 12.16 Sant'Agostino 304-5, 12.24 San Bernardo alle Terme 524, 23.11 Santa Cecilia in Trastevere 62-3, p. 56, 2.8, 2.9 St. John Lateran 57, 290 Santa Maria Maggiore 61-2, 521, 542-3; altarpiece 290-1, 12.2; Capella Sistina 544-6, **25.8-25.10**; mosaics 61-2, **2.6**; tabernacle 297-8, 12.11, 12.12; tomb of Nicholas IV 543-5, 25.6 Santa Maria sopra Minerva: Carafa Chapel 310-11, 12.33 Santa Maria del Popolo 303-4, 12.22, 12.23 Santa Maria in Trastevere: Chapel of Cardinal Marco Sittico Altemps 514, 23.1; mosaics 62, 2.7 St. Paul's Outside the Walls 57, 62, 63, 290 St. Peter's: New 389-90, 510-11, 546, 18.3-18.5, 22.11, 22.12; Pietà 311-12, 12.34, 12.35; Tomb of Innocent VIII 309, 12.31; Old 57, 64, 65, 290, 291, 292, 294-7; doors 291-2, 12.3, 12.4 San Pietro in Montorio: Tempietto 398, 18.6, 18.8 Santo Spirito Hospital 56 San Stefano Rotondo 521-3, 23.8, 23.9 Sistine Chapel 306-7, 12.27, 12.28; frescoes 306-9, 12.29, 12.30; ceiling 38, 402-9, 37, 38, p. 397, 18.12-18.18; Last Judgement 14, 501-4, 515, 22.1-22.4; tapestries 416-18, 18.33 Trajan's Column 541, 25.5 Vatican and Vatican Palace 56, 57, 58, 292-4, 2.2, 12.5, 18.2 (see also Sistine Chapel; St. Peter's); Belvedere Courtyard 397-8, 18.1; Room of the Saints 310, 12.32; Stanza d'Eliodoro 412-14, 18.26, 18.27; Stanza della Segnatura 409-10, 18.20-18.24; Stanza dell'Incendio 416, p. 376, 18.31, 18.32 Villa Farnesina 418-21, 18.34-18.38 Villa Giulia 511-12, 22.13, 22.14 Villa Madama 421, 18.39 Rosselli, Cosimo 306, 12.30 Rossellino, Bernardo 33, 280; Pienza square 298-9, 12.13, 12.14; tomb of Leonardo Bruno 250, 10.65

341-2, 14.8

Rossetti, Biagio: Palazzo dei Diamanti 343, 14.10 Rossi, Properzia de' 42-3, 44; Joseph and Potiphar's Wife 43, 44, 43 Rosso Fiorentino 423, 447; Dead Christ 423, 18.42; Deposition 447, 20.8 Rovere, Francesco Maria della: portrait (Titian) 477, 21.21 Rubens, Peter Paul 435-6; copy of Battle of Anghiari (Leonardo) 392, 17.6 Rucellai, Giovanni 260, 280 Rucellai Madonna (Duccio) 85, 4.13 Russi, Franco de': Bible of Borso d'Este 340-1, 14.6 Sacred and Profane Love (Titian) 468-9, 21.6, 21.7 Sacrifice of Isaac (Brunelleschi) 206, 10.4 Sacrifice of Isaac (Ghiberti) 206, 10.3 Sagrera, Guillermo: Sala dei Baroni, Castello Aragonese 343-4, 14.14 St. Anne Altarpiece (Bartolomeo) 390-2, 17.5 St. Bernardino Preaching in the Campo (Sano di Pietro) 114, 5.23 St. Francis in the Desert (Giovanni Bellini) 329-30, **13.25** St. Francis Kneeling Before the Crucifix . . . (Assisi Master) 70-1, 3.4 St. George and the Dragon (Donatello) 213, 10.17 St. George and the Princess (Pisanello) 337-8, p. 202, 14.3 St. George (Donatello) 212-13, 10.16 St. James Being Led to his Execution (Mantegna) 322, 13.12 St. James (Sansovino) 390, 17.3 St. Jerome and the Trinity (Castagno) 26, 14, 15 St. Jerome in his Study (Antonello da Messina) 329. 13.24 St. John (Donatello) 211, 10.13, 10.14 St. John on Patmos (in Castellani Chapel) 168-9, **8.15** St. John the Baptist (Ghiberti) 38, 215, p. 12, 10.21 St. John the Evangelist (Giovanni del Biondo) 167-8, 8.14 St. Lawrence and St. Stephen (Donatello) 255, 11.6 St. Lawrence Distributing Alms (Fra Angelico) 294, 12.6, 12.7 St. Lawrence Receiving the Treasures of the Church (Fra Angelico) 294, 12.6 St. Louis of Toulouse (Donatello) 217, 272, p. 204 St. Lucy Altarpiece (Domenico Veneziano) 234-5, 10.42 St. Luke (Nanni) 211, 10.11 St. Mark Altarpiece (B. Vivarini) 327, 13.21 St. Mark (Donatello) 214, 10.18 St. Mark (Lamberti) 211, 212, 10.12 St. Matthew and the Angel (Savoldo) 386, 16.11 St. Matthew (Ghiberti) 215-16, 10.22 St. Matthew (Michelangelo) 389, 17.2 St. Paul (Paolo Romano) 295, 12.8 St. Peter Healing with His Shadow (Masaccio and Masolino) 227-9, 10.35 St. Peter Martyr, Scenes from the Life of (Bonaiuti) 159, 8.8 St. Peter's see Rome Salimbeni, Bartolomeo 222 Salutati, Coluccio 172 San Gimignano: Palazzo Pubblico 113-16 San Giobbe Altarpiece (Giovanni Bellini)

327-8, **13.22**

San Giovanni Crisostomo Altarpiece (Sebastian Sforza, Galeazzo Maria 261, 262, 364 San Marco Altarpiece (Fra Angelico) 256-8, 11.9 San Zeno Altarpiece (Mantegna) 323-4, Sancia of Majorca, Queen 132, 134 Sangallo, Antonio the Younger 281; Palazzo Farnese 507, 22.8; St. Peter's, Rome Sangallo, Giuliano da: Palazzo Strozzi 281, 11.39, 11.40; Sassetti Chapel 11.32; Villa Medici 286, 11.45, 11.46, 20.6 Sangallo, Sebastiano da[?]: copy of Battle of Cascina (Michelangelo) 393, 17.7 Sano di Pietro: St. Bernardino Preaching in the Sansovino, Jacopo 479; Fabbriche Nuove 490-1, 21.41; Library, Venice 479-80, 21.25; Loggetta, Venice 480; Palazzo Corner 480-1, 21.26, 21.27; St. James 390, 17.3; Santi di Tito: Vision of St. Thomas Aquinas Sassetti Chapel see Florence: Santa Trinità Sassetti, Francesco 275-6, 277, 287 Savoldo, Giovanni: St. Matthew and the Angel 386, Savonarola, Girolamo 287, 383 Scamozzi, Vincenzo 496, 21.52 Scenes from the Life of Alexander III (Spinello Scenes from the Life of St. Benedict (Spinello Scenes from the Life of St. Peter Martyr (Bonaiuti) Scenes from the Life of the Virgin (T. Gaddi) 90, 4.19 Schedel, Hartmann: Liber chronicarum 56, 2.1 Schifanoia, Palazzo see Ferrara School of Athens (Raphael) 409-10, 18.21, 18.24 Sculptor's Workshop (Nanni) 17-18, 5 sculptors' workshops 14, 1; materials 28-32 Scuola Grande di San Giovanni Evangelista 331 Scuola Grande di San Marco 331-2, 487-8, Scuola Grande di San Rocco 487-8, 21.38 Sebastian del Piombo 470; Andrea Doria 433, 19.11; Raising of Lazarus 422, 423, 18.41; San Giovanni Crisostomo Altarpiece Self-Portrait (Bandinelli) 17, 18, 6 Self-Portrait (Titian) 484, 21.33 Sforza family 174, 336, 347, 362-3, 371 Sforza, Battista: Battista Sforza and Federico da Montefeltro (Piero della Francesco) 350, 14.20; Triumphs of Federico da Montefeltro and Battista Sforza (Piero della Francesco)

del Piombo) 470, 21.10

13.13, 13.14

5.10, 18.3

Campo 114, 5.23

Sansovino, Andrea 33, 391

The Zecca 479, 21.24

525-6, **23.14**

Saulmon, Michelet 337

Savonarola, Michele 322

Aretino) 121, 5.32

Aretino) 170, 8.17

Scrovegni, Enrico 72, 75-6

Scrovegni Chapel see Padua

Scuola della Carità 318-19

13.28, 21.37, 21.38

scuole, Venetian 330-3, 486

470, **21.10**

350, 14.21

Sforza, Fulvia Conti 524

Sforza, Caterina de' Nobili 524

Sforza, Francesco 198, 362, 363, 364

Scrovegni, Reginaldo 72

159, 8.8

16.11

Sassetta 257

Sforza, Ludovico ("il Moro") 362-3, 367, 371, 374-5; tomb (Solari) 369-71, 15.13 Sforza Monument (study) (Leonardo) 374, 15.18 sfumato 274 sgraffito 17 Siena 55, 82, 99-100, 114, 120, 189, **p. 100** (map) Baptistry: drawing 34, 30; font 239-41, 10.48-10.50 Cathedral 100, 103-4, 5.1, 5.2, 5.7, 5.8 (see also Duccio: Maestà); altarpieces 104-10, **5.13**, **5.15**, **5.16**; Petroni tomb 110-12, **5.19**; pulpit 101-3, **5.3**, **5.5** Fonte Gaia 32, 122-3, 5.34, 5.35 Palazzo Pubblico 99-100, 112-13, 114, 5.22, 5.23; frescoes 113, 116-20, 120-2, 5.24, 5.25, 5.27-5.30, 5.31-5.33 Signorelli, Luca: Testament of Moses 307-8, 12.29 silverpoint 33 Simone da Orsenigo: Milan Cathedral 193, 9.24 sinopia drawings 25-6 Sistine Chapel see Rome Sixtus IV, Pope 285, 302-3, 305, 306, 307, 350, 508; Sixtus IV Confirming Platina as Papal Librarian (Melozzo) 302-3, p. 289; Sixtus IV with his Nephews . . . (anon.) 303, 12.21 Sixtus V, Pope 538-46, 25.1; tomb 542, 545-6, **25.10** Sleeping Venus (Giorgione) 466, 21.3 Solari, Cristoforo: tomb of Beatrice d'Este 369-71, **15.13** Solari, Guiniforte: Certosa, Pavia 15.2 Sormani, Leonardo: Acqua Felice 541-2, p. 538; statue of St. Peter 541, 25.5; tomb of Nicholas IV 543-4, 25.6 Spavento, Giorgio: San Salvatore, Venice 473, 21.15 Spinelli, Parri 121 Spinello Aretino 170; Scenes from the Life of Alexander III 121, 5.32; Scenes from the Life of St. Benedict 170, 8.17 Squarcione, Francesco 20, 32 stained-glass techniques 27-8 Stefaneschi Altarpiece (Giotto) 65-6, 2.13 Stefaneschi, Cardinal Bertoldo 62 Stefaneschi, Cardinal Jacopo 65 still life painting 535-7 Strozzi family 224, 256, 278, 287 Strozzi, Filippo 277-8 Strozzi, Lena di Palla 226 Strozzi, Maddalena: portrait (Raphael) 394-5. 17.9 Strozzi, Onofrio 224, 256 Strozzi, Palla 224, 226, 251, 256 Strozzi Altarpiece 156, 158, 8.4 Strozzi Chapels see Florence: Santa Maria Novella; Santa Trinità Т Tacuinum Sanitatis (health handbooks) 184-5, 185, 9.13, 9.14 Taddeo di Bartolo: Funeral of the Virgin 120-1, **5.31**; Justice with Cicero . . . 121–2, **5.33** Talenti, Francesco: Florence Cathedral 163, 4.26

Tarlati, Bishop Guido: tomb (Agostino di

Giovanni et al.) 112, 5.20, 5.21

tarot cards 198, 9.34

Tarquinia Madonna (Filippo Lippi) 231, 233, 10.40 Tavola Strozzi 124, 6.1 tempera 27 Tempesta (Giorgione) 465-6, 21.1, 21.2 Testament of Moses (Signorelli) 307-8, 12.29 Theatines 517, 527 Three Foolish Virgins Flanked by Moses and Adam (Parmigianino) 430-1, 19.8 Tibaldi, Pellegrino: San Fedele 530-1, 24.6 Tino da Camaino 200; Petroni tomb 110-12, 5.19; tomb of Carlo of Calabria 29, 21; tomb of Mary of Hungary 132-3, 6.16 Tintoretto, Jacopo 486; Miracle of St. Mark 486-7, 21.36; Moses Drawing Water from the Rock 488, 21.38; Paradise 488-90, 21.39; Scuola Grande di San Rocco 487-8, 21.38 Titian (Tiziano Vecelli) 466-7, 475, 484; Assumption of the Virgin 470-1, 21.11, 21.12; Danaë 483, 21.30; Eleonora Gonzaga 477, 21.22; Equestrian Portrait of Emperor Charles V 482, 21.29; Flaying of Marsyas 484-6, 21.34; Francesco Maria della Rovere 477, 21.21; Martyrdom of St. Lawrence 472-3, 21.13, 21.14; Meeting of Bacchus and Ariadne 38-9, 476, 21.20; Pesaro Altarpiece 471-2, p. 464; Pietà 486, 21.35; Pope Paul III and His Grandsons... 506-7, p. 500; Rape of Europa 483-4, 21.31, 21.32; Reclining Nude ("Venus" of Urbino) 477-8, 21.23; Sacred and Profane Love 468-9, 21.6, 21.7; Self-Portrait 484, 21.33; Vendramin Family 481-2, 21.28 Tornabuoni, Giovanna de': portrait (Ghirlandaio) 278-9, 11.37 Torrigiani, Bastiano 541, 544-5, 25.5 Torriti, Jacopo 65; Coronation of the Virgin 61-2, 2.6 Traini, Francesco 152-3, 158 Transfiguration (Raphael) 422-3, 18.40 Translation of the Relics of St. Mark (mosaic) 140, 7.5 tratteggio 39, 39 Tree of Jesse (Lello da Orvieto) 130, 6.12 Trent: Castello del Buonconsiglio (frescoes) 196-7, **9.32** Trent, Council of 501, 513-15, 517, 520, 524, 525, 527, 544, 23.1 Trial by Fire (Giotto) 87, 88, 4.16 Tribute Money, The (Masaccio) 230-1, 10.37 Trinity (Masaccio) 26, 231-3, 16, 10.38 Triumph of Death (Master of the Triumph of Death) 152-5, 8.1 Triumph of Rome over Sicily (Ripanda) 412, 18.25 Triumphs of Caesar (Mantegna) 359, 14.33 Trivulzio, Giangiacomo 381 Tron, Doge Niccolò: tomb 333-4, 13.31 Tron, Filippo 333 Tura, Cosmè: Hall of the Months 341-2, 14.8 Uberti family 81 Uccello, Paolo 237 Battle of San Romano 262-3, 388, 11.16 Sir John Hawkwood 243-4, 10.54; drawing 23-5, 13 Ufizzi see Florence Ugolino di Nerio: Santa Croce Altarpiece 92, Urbino 349; Palazzo Ducale 351-3, 14.22-14.25 Vaca, Flaminio: Acqua Felice 541-2, p. 538 Valdés, Juan de 505 Valeriani, Giuseppe: Crucifixion 520, 23.6 Valturio, Roberto 348, 349 Varallo: Sacro Monte 383-4, 16.6-16.8 Vasari, Giorgio 53, 103, 203, 269, 392, 432, 439, 442, 462, 484, 506, 524, 532, 533; Apotheosis of Cosimo 461-2, 20.30; drawing books 32, 28; Incredulity of St Thomas 525, 23.13; Lives of the Artists 36, 42-4, 45; Paul III Directing the Construction of St. Peter's 506, 22.7; Sala del Gran Consiglio, Palazzo Vecchio 461-2, 20.29, 20.30; Uffizi 460-1, 20.27; Villa Giulia 511-12, 22.13, 22.14 Vasoldo, (Giovanni Antonio Paracca): tomb of Sixtus V **25.10** Vecchietta (Lorenzo di Pietro): Assumption of the Virgin 299, 12.15; Eucharistic Tabernacle 21, 10.11 Vendramin Family (Titian) 481-2, 21.28 Vendramin, Gabriele 465 Venice 55, 72, 82, 135-8, 313, 324, 347, 464, 479, 490-1, **p. 136** (map), **7.1** Arsenal 135, 324-5, 13.15 Ca' d'Oro 315-16, p. 313, 13.5 Doge's Palace 137, 146, 313; exterior 146, 147-8, 313-14, **7.13**, **7.15**, **7.16**, **13.1**; Porta della Carta 313, 314, 13.2, 13.3; Scala dei Giganti 334, 13.32; frescoes 148-51, 488-90, 7.18, 7.19, 21.39, 21.40 Fabbriche Nuove 490-1, 21.41 Library 479-80, 21.25 Loggetta 480 Palazzo Corner 480-1, 21.26, 21.27 Palazzo Foscari 315, 13.4 Piazza San Marco 135, 137, 140 The Redentore 493-4, 21.45 Rialto Bridge 135, 491-2, 21.42 San Giorgio Maggiore 492-3, 21.43, 21.44 Santi Giovanni e Paolo 145-6, 7.11, 7.12 Santa Maria dei Frari: Corner Chapel altarpiece 327, 13.21; Pesaro Altarpiece 471-2, **p. 464**; tomb of Doge Tron 333-4, 13.31 Santa Maria dei Miracoli 60, 332-3, 13.29, 13.30 St. Mark's 41, 138-40, 140, 144-5, 7.3-7.5; Baptistry 141-4, 7.7-7.10; Capella Nova (Mascoli Chapel) 316-18, 321-2, 13.6, 13.7, 13.11; choir screen 143-4, 7.9, 7.10; Pala d'Oro 141, p. 135, 7.6 San Michele in Isola 325, 13.16-13.18 San Salvatore 473, 21.15, 21.16 Santo Stefano 147, 7.14 San Zaccaria 326-7, 13.19 Scuola della Carità 318-19 Scuola Grande di San Marco 331-2, 487-8, 13.28, 21.37, 21.38 The Zecca (Mint) 479, 21.24 Venier, Doge Antonio 143 Venus and Cupid (Bronzino) 457, 20.23 Venus of Urbino (Titian) 477-8, 21.23 Verona 464; Cansignorio della Scala Monument (Bonino da Campione) 182, 9.9; Sant'Anastasia (Pellegrini Chapel) 337-9,

14.3, 14.5; San Zeno Altarpiece (Mantegna)

323-4, 13.13, 13.14

21.40; Feast in the House of Levi 515, 516, p. 498, 23.2 Verrocchio, Andrea del: Incredulity of St. Thomas 272, 11.27; monument to Bartolomeo Colleoni 268, 335, 13.28; tomb of Piero and Giovanni de' Medici 271-2, 11.26 Vertumnus and Pomona (Pontormo) 443, 20.5 Vicenza: Teatro Olimpico 496-7, 21.51, 21.52; Villa La Rotonda 496, 21.49, Victory of the Sienese Troops at the Val di Chiana in 1363 (Lippo Vanni) 116, 5.27 Vignola, Giacomo: The Gesù Rome 517, 518, 23.4; St. Peter's, Rome 22.12; Villa Giulia, Rome 511-12, 22.13, 22.14 violence and art 82 Virgil 443 Virgin and Child images see Maestà Virgin in Glory with St. Barbara and St. Lawrence (Moroni) 528, 24.2 Visconti family 174, 176, 181, 199, 347; genealogy 196, 9.31 Visconti, Azzone 176-8, 180; tomb 178, 9.5 Visconti, Bernabò 184, 189, 193; Equestrian Monument of Bernabò Visconti 181-2, 9.8 Visconti, Bianca 198 Visconti, Filippo Maria 243 Visconti, Galeazzo 181 Visconti, Galeazzo II 182-3 Visconti, Galeazzo Maria 198 Visconti, Giangaleazzo 189, 190-1, 192-3, 194, 195, 363, 364; Eulogy for Giangaleazzo Visconti 196, 9.30, 9.31 Visconti, Giovanni 180 Visconti Book of Hours (Grassi) 104-95, 9.28 Visdomini Altarpiece (Pontormo) 438-9, 20.2 Vision of Prior Ottobon in Sant'Antonio di Castello (Carpaccio) 15, 2 Vision of St. Bernard (Filippino Lippi) 275, 11.31 Vision of St. Thomas Aguinas (Santi di Tito) 525-6, **23.14** Vitruvian Man (Leonardo) 399, 18.7 Vitruvius 42, 286 Vivarini, Antonio 318, 322; Madonna and Child with Saints 318-19, 13.8 Vivarini, Bartolomeo 427; St. Mark Altarpiece 327, 13.21 W wall painting 23-6 Walter of Brienne 391 Way of Salvation (Bonaiuti) 159-62, 8.6 Wedding Feast of Cupid and Psyche (Giulio Romano) 425-6, 19.1 women: as artists 42-3, 547 (see also Anguissola, Sofonisba; Rossi, Properzia de'); as patrons

Veronese, Paolo 490; Allegory of Divine Love

495-6, 21.48; Apotheosis of Venice 490,

7

523-4, 547

woodcuts 36-7

Zecca, the see Venice Zocchi, Giuseppe: Florence Cathedral 204, **10.1**

workshops: artists' 17-23, 36; painting studios

23-7; sculpture 17-18, 28-32, 4, 5, 20

16, 17, 32, 93, 128-9, 156, 186-7, 359, 360,